WALTER SICKERT

WALTER SICKERT

A Life

Matthew Sturgis

HarperCollins*Publishers*

First published in Great Britain by
HarperCollins*Publishers*
77–85 Fulham Palace Road,
Hammersmith, London W6 8JB

www.harpercollins.co.uk

Published by HarperCollins*Publishers* 2005
1 3 5 7 9 8 6 4 2

A catalogue record for this book is
available from the British Library

ISBN 0-00-257083-1

Typeset in PostScript Linotype Giovanni Book with
Monotype Spectrum display by
Rowland Phototypesetting Ltd,
Bury St Edmunds, Suffolk

Printed and bound in Great Britain by
Clays Ltd, St Ives plc

For Rebecca

CONTENTS

ILLUSTRATIONS

SECTION 2

Portrait of Mrs Ernest Leverson by Walter Sickert, 1895. © *Estate of Walter R Sickert*

Miss Beerbohm by Walter Sickert, 1894. © *Estate of Walter R Sickert. Private Collection*

Sir William Eden. *Reproduced courtesy of Lord Eden of Winton*

Lady Eden by Sir Hubert von Herkomer. *Reproduced courtesy of Lord Eden of Winton*

Augustine Villain, by Walter Sickert, 1901. © *Estate of Walter R Sickert. Photograph National Museums Liverpool (The Walker)*

Clementine Hozier

Signor De Rossi, by Walter Sickert, 1901. © *Estate of Walter R Sickert. Photograph Hastings Museum and Art Gallery*

Mrs Hulton, by Walter Sickert, 1901. © *Estate of Walter R Sickert. Photograph Ashmolean Museum, Oxford*

Charles Cottet, by Jacques-Émile Blanche, 1902. *Speltdoorn/Royal Museum of Fine Arts of Belgium*

Lucien Simon, by Charles Cottet, 1907. *Musee d'Orsay, Paris/The Bridgeman Art Library, London*

Mabel Royds, self-portrait, 1903. *Private Collection*

Maria Luisa Fortuny

Jean Hamilton, 1900

Lady in Red: Mrs Swinton by Walter Sickert, 1905, © *Estate of Walter R Sickert. Photograph Fitzwilliam Museum, Cambridge*

Mrs Swinton photographed in Sickert's studio, 1905. *Islington Libraries*

N.E.A.C. by Max Beerbohm, 1907. From left to right: Walter Sickert, William Orpen, W.G. de Glehn, Augustus John, D.S. MacColl and Henry Tonks forming an arch over Philip Wilson Steer, William Rothenstein, J. S. Sargent, Albert Rutherston (under table), L.A. Harrison and Walter Russell. © *Tate, London 2004*

Spencer Gore, self-portrait, 1914. *National Portrait Gallery, London*

Harold Gilman, by Walter Sickert, *c.*1912. © *Estate of Walter R Sickert. Photograph* © *Tate, London 2005*

Ethel Sands by Walter Sickert, 1913. © *Estate of Walter R Sickert. Private Collection*

Nan Hudson. *Private Collection*

SECTION 3

Sylvia Gosse by Harold Gilman, *c.*1913. *City Art Gallery, Southampton/The Bridgeman Art Library*

Ambrose McEvoy by Augustus John. *National Portrait Gallery, London*

COLOUR PLATES

La Hollandaise, 1906. 50.8 x 40 cm. © *Estate of Walter R Sickert.*
　　Photograph © Tate, London 2005
Théâtre de Montmartre, 1906. 48.9 x 61 cm. © *Estate of Walter R Sickert.*
　　Photograph by kind permission of the Provost and Fellows of King's
　　College, Cambridge
Ennui, c.1914. 152.4 x 112.4 cm. © *Estate of Walter R Sickert. Photograph*
　　© *Tate, London 2005*
L'Affaire de Camden Town, 1909. 61 x 40.6 cm. © *Estate of Walter R*
　　Sickert. Photograph Private Collection/Royal Academy of Arts
Brighton Pierrots, 1915. 63.5 x 76.2 cm. © *Estate of Walter R Sickert/*
　　Photograph © Tate, London 2005
Portrait of Victor Lecourt, 1921–24. 81.3 x 60.3 cm, © *Estate of Walter R*
　　Sickert. Photograph Manchester Art Gallery
Lainey's Garden (*The Garden of Love*), 1928–30. 81.9 x 61.1 cm. © *Estate*
　　of Walter R Sicket. Photograph Fitzwilliam Museum, Cambridge
Summer Lightning, 1931–2. 65.5 x 72.5 cm. © *Estate of Walter R Sickert.*
　　Photograph National Museums Liverpool (The Walker)
Miss Earhart's Arrival, 1932. 71.4 x 183.2 cm. © *Estate of Walter R Sickert.*
　　Photograph © Tate, London 2005

CHAPTER HEADING PORTRAITS

Chapter 1: Walter Sickert aged 2. © *Tate, London 2005*
　　　　　　Walter Sickert aged 9. © *Tate, London 2005*
Chapter 2: Walter Sickert, 1880. © *Tate, London 2005*
　　　　　　Walter Sickert, 1884. © *Tate, London 2005*
Chapter 3: Walter Sickert by Philip Wilson Steer, 1890
Chapter 4: Walter Sickert lithograph by James McNeill Whistler, 1895.
　　　　　　© *The Trustees of The British Museum*
　　　　　　Walter Sickert, self-portrait, 1896 © *Estate of Walter R Sickert.*
　　　　　　Photograph courtesy of Leeds Museums and Galleries (City Art
　　　　　　Gallery)/The Bridgeman Art Library
Chapter 5: Walter Sickert, 1900, photograph by Edward Heron-Allen
　　　　　　Courtesy of Ivor Jones
Chapter 6: Walter Sickert with Clive Bell at Newington
Chapter 7: Walter Sickert by Nina Hamnett, c 1918 *Private Collection*
Chapter 8: Walter Sickert by Walter Barnett, 1921
Chapter 9: Walter Sickert, c.1934. *Islington Libraries*

ACKNOWLEDGEMENTS AND PREFACE

Walter Richard Sickert was a great man and a great artist. Both facts became apparent during the course of his long and colourful life, and have grown ever clearer since. Thus far, however, it is the latter aspect of his achievement that has drawn the most attention. This is very proper: painting was the great passion of his existence, and his pictures survive as testimony of that passion. Much has been written – and written very well – about his art. It is art that continues to stimulate enquiry, debate, and admiration. Sickert's life, by comparison, has received more cursory treatment. In the years immediately before and after his death – in 1942 – a handful of memoirs were produced by people who had known him well at certain periods of his life. Osbert Sitwell, W. H. Stephenson, Robert Emmons and Marjorie Lilly all left vivid accounts of the Sickert they knew. As personal reminiscences they are excellent; as records of the broad span of Sickert's life they are either uninformative or unreliable.

Since then there has been little to add to the record. The one biography to be published was produced in 1976 by the art historian Denys Sutton. It is full of interesting facts and interesting insights, yet it is not quite satisfactory. The fault is not entirely Sutton's; it lies in the book's tangled history. The project had originated in the 1960s with the critic John Russell, but he abandoned the task after leaving England for New York. Sutton then took on his research and extended it, before writing up his findings at some speed amongst the other cares of an exceptionally busy professional life: Sutton was at the same time editing *Apollo* and preparing a two-volume edition of Roger Fry's letters. Inevitably there are lacunae. Errors did creep in. Facts, moreover, are impossible to check as Sutton's publishers refused to include footnotes. It was in the hope of providing a fuller, richer and more scrupulous account of Sickert's very full, very rich, and intermittently scrupulous life that I embarked on this book.

In my work I have been extremely fortunate to receive both encouragement and help from the several scholars who have done so much to build an understanding and appreciation of Sickert's work in the decades since his death: from Lillian Browse, who established the field through her books and exhibitions; from Richard Shone, who has written with such elegance and insight on Sickert's work; from Anna Gruetzner Robins, who

has enriched the understanding of many areas of Sickert's endeavour; and from Wendy Baron, who has achieved an undisputed eminence as the historian of Sickert's art. Without their generosity to a newcomer, my task would have been impossible.

I must thank Henry Lessore, Sickert's copyright holder (and nephew by marriage), for the welcome he has given to the project and for permission to reproduce Sickert's work.

For their generosity in letting me share memories, consult letters, or view pictures I must thank: Donald Ball; John Barnes; Edward Booth-Clibborn; Roy Davids; Beatrix Dufour; George Gammon; Sarah Haydon; the Rt Hon. Sir Edward Heath; Barry Humphries; Pierre Ickowicz; Alan Irvine; Ivor Jones; Mark Samuels Lasner; Roger Neill; Michael Parkin; Gerald Percy; Peter Peretti; William and Alice Sheepshanks; Denys Wilcox; Mrs Woodhuysen.

I also owe thanks to the staff of numerous libraries, galleries, and other institutions, amongst them: Alexander Turnbull Library, Wellington, New Zealand; Altonaer Museum, Hamburg; Archivo de Stato, Venice; Archivo Storico delle Arti Contemporanee, Venice; Artists' Papers Register, Birmingham; Ashmolean Museum Library, Oxford; Bath Public Library; BBC Archives, Reading; Bedford Public Library; Bibliothèque Nationale, Paris; Birmingham University Library; Bishopsgate Institute, London; Bodleian Library, Oxford; British Library; Carnegie Museum of Art, Pittsburgh; Broadstairs Public Library; Brotherton Library, Leeds University; Château-Musée de Dieppe; City Archive, Paris; Collection Frits Lugt, Fondation Custodia, Paris; Court Service, London; Courtauld Institute Library, London; Edinburgh Public Library; Family Records Centre, London; Fonds Ancien, Dieppe; Getty Research Institute, Los Angeles; Glasgow University Library; Guildhall Library, London; Harrogate Museum and Art Gallery; Harry Ransom Humanities Research Center, University of Texas, Austin; Holborn Public Library; Houghton Library, Harvard University; House of Lords Library, London; Hyman Kreitman Research Centre, Tate Britain, London; Islington Public Library; Kensington Public Library; King's College Cambridge Library; King's College London Library; Leeds City Art Gallery; Library of Congress, Washington; Library of the Institut de France, Paris; Library of the Royal Academy, London; Library of the Royal Astronomical Society, London; Lincoln's Inn Library, London; London Library; London Metropolitan Archives; Manchester Central Library; Manchester City Art Gallery; Margate Public Library; Max Beerbohm Archive, Merton College, Oxford; Münchner Stadtmuseum; Musée d'Offranville; Museo Fortuny, Venice; National Art Library, the Victoria and Albert Museum; National Liberal Club; National Library of Denmark, Copenhagen; National Library of Scotland, Edinburgh; National Newspaper Library, Colindale; New York Public Library; Public Record Office, Kew; Reading

Public Library; Richmond Public Library, Surrey; Royal Archives, Windsor; Slade Art School, London; Southport Art Gallery; Southport Public Library; Staatsarchiv, Hamburg; Stadtarchiv, Munich; Theatre Museum Library, London; University College School Library, London; Walker Art Gallery, Liverpool; West Sussex County Record Office, Chichester; William A. Clark Memorial Library, Los Angeles; Witt Library, London.

I am further indebted to the assistance and kindness of: Peter Ackroyd; Jake Auerbach; Gabriel Austin, librarian to the late Lady Eccles; Joanna Banham; Michael Barker; James Beechey; Paul Begg; Guy Bensley; Mireille Bialek; Paul Blewitt; Ruth Bromberg; Richard Brooks; Hans Buijs; Stephen Calloway; Marcus Campbell; Richard Canning; Michael Claydon; Maureen Connett; Gordon Cooke; Guy Corcheval; Rebecca Daniels; the Duchess of Devonshire; Mark Edmonds; Edward Farrelly; Claude Feron; David Fraser Jenkins; Adrian Frazier; Jonathan Freyer; Henrietta Garnett; Joseph Gorman/Sickert; Josefina Grever; Elizabeth Gueho; Steven Halliwell; Robin Harcourt Williams, librarian to the Marquess of Salisbury; Duncan Hannah; Donald Hossack; Tim Hunter; Alan Jenkins; Alexander Kennedy; Nataša Kennedy; Edward King; Rose Knox-Peebles; Jean-Pierre Labiau; Mrs J. Leach; John Lessore; Margaret F. MacDonald; Robert McNab; Annersley Malley; Carol Manheim; Stephen Middleton; Frank Miles; Frank Milner; Rupert Montagu; Nicola Moorby; Joan Navarre; John Julius Norwich; Patrick O'Connor; Leticia Olivera; the late Robert Parsons; Angela Pertusini; Celia Philo; Gerald Ranfurly; Hannah Rothschild; Michael Seeney; Brian Sewell; Robin Sheepshanks; Peyton Skipwith; Alistair Smith; Frances Spalding; Hilary Spurling; B. J. Stokes of the Old King's Club; Tim and Jean Sturgis; Cynthia Sutton; Major-General Sir John Swinton; Dr Wolfgang Till; Angus Trumble; Maureen Ward-Gandy; David White; Paula Weideger; Alexander Wolff; Inglitt Wolff; Chris Yates; Caroline Young.

I have benefited from grants from both the Society of Authors and the Paul Mellon Centre for Studies in British Art.

And in preparing the book I have been greatly assisted by Richard Johnson, my long-suffering editor; by Juliet Davis of the HarperCollins art department; and by Michael Cox, a most careful and sensitive line editor.

Above all, though, I must acknowledge the unstinting patience, generosity, and support of my wife, Rebecca Hossack.

CHAPTER ONE

A Well-Bred Artist

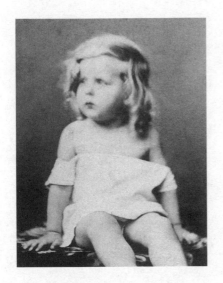

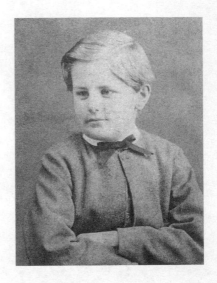

Walter Sickert aged 2

Walter Sickert aged 9

I

THE MÜNCHENER KIND'L'

He is a dear little fellow.
(Eleanor Sickert to Oswald Adalbert Sickert)

Walter Richard Sickert was born on 31 May 1860 in a first-floor flat at 59 Augustenstrasse, Munich, in what was then the independent kingdom of Bavaria.[1] He was the first-born child of Oswald Adalbert Sickert and his wife Eleanor. Oswald Sickert was a Dane, from the town of Altona in the Duchy of Holstein. He was a trained artist, with ambitions as a painter, but he was constrained to work as a hack draughtsman-on-wood for a Bavarian illustrated comic-paper called the *Fliegende Blätter*. Eleanor – or Nelly as she was known by her affectionate husband and her friends and relatives – was English by birth. The couple spoke mainly English at home.[2] Their new son was christened by the English chaplain at Munich: he was given the names Walter Richard.[3] Walter was chosen as being a name that looked – even if it did not sound – the same in both English and German.[4] Richard was the name of the boy's maternal grandfather, the late Revd Richard Sheepshanks, a figure whose presence loomed over the young family, half beneficent, half reproachful.

Richard Sheepshanks had not been a conventional clergyman. He had scarcely been a clergyman at all. He never held any cure. His interest in the celestial sphere, though keen, had been scientific. He made his reputation as an astronomer and mathematician. The Sheepshanks came of prosperous Yorkshire stock. The family in the generation before had made a fortune in cloth, supplying – so it was said – material for military greatcoats to the British army during the Napoleonic Wars. The money from the Leeds factories amassed in this profitable trade allowed Richard and his five siblings to indulge their interests and enthusiasms. One brother, Thomas, chose Brighton and

dissipation.[5] Another, John, dedicated himself to art: he moved to London and built up a large and important collection of English paintings, which he exhibited to the public at his house in Rutland Gate and bequeathed to the nation in 1857, six years before his death.*[6]

Richard turned to the sciences. A brilliant university career at Trinity College, Cambridge, was crowned with a mathematics fellowship in 1817. He briefly contemplated the prospect of both the law and the Church and secured the necessary qualifications for both. (Having taken holy orders, he always styled himself 'the Reverend'.) On receiving his inheritance, however, he was able to direct all his considerable energies to scientific research. He became a member of the Geological and Astronomical Societies, and was for several years the editor of the latter's *Monthly Notes*. He was made a Fellow of the Royal Society, and of the University of London. His interests were many, ranging from demographics to the study of weights and measures. He had a particular passion for fine scientific instruments and devoted most of his income to buying them. He also busied himself in the intellectual and political disputes of the scientific world.[7]

In scientific circles Richard Sheepshanks was greatly respected – much loved by his friends and not a little feared by his enemies. He was, in the restrained words of his close colleague, the astronomer Augustus de Morgan, a man of 'very decided opinions'. And he was not shy of expressing them. His first professional training had been as a lawyer, and throughout his academic career he had a relish for controversies. He was, as he himself put it, well suited to such business, having 'leisure, courage and contempt for opinion when he knew he was right'. He was well armed with a ready, if somewhat sarcastic, wit and a piquant turn of phrase. But in matters of what he considered to be of real importance he would – according to one obituarist – drop these weapons in favour of a more 'earnest deportment' and a more 'temperate' utterance. Despite being of 'hardly middle stature', having red-tinged hair and the inevitable side-whiskers of mid-Victorian fashion, he was, from the evidence of his portraits, a handsome man. He was also excellent company – clever, witty, well read in both the classics and in modern literature, and widely travelled in Europe.[8] He was knowledgeable too about art; and, tipped off by his

* It became the nucleus of the V&A picture collection.

brother John, commissioned Thomas Lawrence to paint a portrait of his beloved elder sister, Anne.[9]

Anne Sheepshanks was as remarkable as her brother. A woman of enormous practical capability, intelligence, and sound sense, she encouraged and supported Richard in all his endeavours. She allied her resources to his, sharing his interests, his cares, and his house. The home they established together at 30 Woburn Place, Bloomsbury – not far from the British Museum – became a lively gathering place for many of the intellectual luminaries of scientific London. They even built their own small observatory in the garden, from which, in an age before saturated street-lighting, they were able to mark the passage of the stars.[10]

The Reverend Richard Sheepshanks – like his sister – never married. His fellowship at Cambridge was dependent upon his remaining a bachelor, and he seems to have been in no hurry to give up his position, his salary, or his independence. Nevertheless, he did not allow professional considerations to stand altogether between him and the opposite sex.

It is not known exactly how or when he encountered Eleanor Henry. Indeed, very little is known about Eleanor Henry at all, except that she was Irish, fair-haired and handsome, and was a dancer on the London stage.[11] Perhaps Mr Sheepshanks picked her out of a chorus line. Or perhaps he met her in the street. At the beginning of the 1830s she was living in Henrietta Street, a little cul-de-sac behind Brunswick Square, near to the Sheepshanks' London home.* The popular reputation of dancers in the nineteenth century set them very low in the moral order; they were ranked beneath even actresses, and set almost on a par with prostitutes. This picture, however, was certainly a distortion. Although 'respectability' was a rather fluid concept during the early Victorian age, most ballet girls actually came from modestly 'respectable' homes, and lived – as far as can be ascertained – modestly 'respectable' lives.[12] Eleanor Henry's position seems to confirm this point. For a start she was married. Her husband was a Mr James Henry. He listed his profession as 'Solicitor', although he does not appear in the law lists of the period and may well have been little more than a lawyer's clerk.[13] At the beginning of the 1830s they were living together

* The whole area has since been remodelled: the square has been replaced by the Brunswick Centre, a 1960s shopping and housing development.

in the house of a Mrs Henry (perhaps James's mother).[14] Despite this unpropitious domestic arrangement, the Revd Richard Sheepshanks succeeded not only in forming an attachment with Eleanor but also in fathering a child on her. A daughter was born on 19 August 1830.[15]

Mr Henry's attitude to, or indeed knowledge of, his wife's liaison is unknown. He did, however, give his surname and his blessing to the infant. It was he, rather than Richard Sheepshanks, who attended the christening at St Pancras Parish Church and who had himself listed as the child's legal father. The little girl was baptized Eleanor Louisa Moravia Henry. The last Christian name is something of a mystery, as the Henrys did not, as far as records show, belong to the Moravian sect.[16]

The young Eleanor Louisa – or Nelly – was brought up in the Henry household. If Richard Sheepshanks provided some assistance he did so covertly. Nevertheless, his interest in his natural daughter does seem to have been real and, given the proximity of Woburn Place to Henrietta Street, he must have had opportunities for observing her. Almost nothing is known of Nelly Henry's childhood, except that it was not happy. The demands of her mother's stage work meant that she was often neglected. She did, however, show an early love for music. Her mother sang to her, and the songs of the passing street performers also caught her ear, making a lasting impression on her memory and her imagination.[17]

The Henrys moved from Henrietta Street in 1833. They disappear from view but almost certainly remained in London, for, at some moment later in the decade, Eleanor broke with her husband and began a relationship with Samuel Buchanan Green, a dancing master from Highgate. She took her daughter with her and, though there is no evidence to suggest that she married Mr Green, she took his name and the young Nelly came to regard Mr Green as her 'step-father'.[18] In November 1838, when Eleanor gave birth to a son, christened Alfred, she listed her name on the birth certificate as 'Green, late Henry'.[19] In 1840, the Greens established a dancing school in connection with the Princess Theatre in Oxford Street. The teaching studio was immediately behind the theatre at 36 Castle Street and the family lived above it – an arrangement that can only have increased the 10-year-old Nelly's love of music.[20]

Perhaps the Revd Richard Sheepshanks disapproved of these new domestic conditions, or maybe the arrival of young Alfred placed a

strain on the resources of the Green household; perhaps the Sheep-shanks' own plans to move out of London precipitated the change. Whatever the reason, at about this time Richard offered to take his natural daughter under his own care, to remove her from the stage-door world of Castle Street, to arrange for her schooling, and to provide in some as yet unspecified measure for her future. The offer was accepted and, at the beginning of the 1840s, the old loosely fixed order was broken up.[21]

Nelly was sent over the Channel to a small boarding school at Neuville-lès-Dieppe. Richard Sheepshanks and his sister closed up Woburn Place and moved to a house on the outskirts of Reading, where once again they built a little observatory in the garden. The Greens continued with their school at Castle Street. And according to family tradition Mrs 'Green, late Henry' also performed on the stage of the Princess Theatre.[22] It is doubtful that she ever saw her daughter again. She might have encountered Richard Sheepshanks occasionally. He returned often to London during the first years of the new decade. He was engaged in the great work of his later life: the establishment of a new set of standard weights and measures, the former one having been destroyed in the fire that swept through the Palace of Westminster in 1832. In a well-insulated subterranean laboratory in the cellars of Somerset House, he carried out tens of thousands of micro-measurements in order to determine the standard yard.[23] It was a staggering exercise of both patience and artistry. He had, it was recognized, 'an extraordinarily skilful eye with the micrometer' and his comparisons 'were so far superior to those of all preceding exper-imenters . . . as to defy all competition on grounds of accuracy'.[24]

In 1850, Eleanor and Samuel Green vanish from the London Direc-tories. According to the family tradition preserved by Nelly, they emi-grated to Australia, where Mrs Green took to drink.[25] It has been supposed that Richard Sheepshanks arranged, if he did not insist upon, this removal, but there is no evidence to support such a theory. Never-theless, the notion of a close relative disappearing to the Antipodes never to be heard of again was powerful in its suggestion. It became one of the defining elements in young Nelly Henry's personal story. And it was a story that in time she would communicate to her own children, thrilling them with its mingled sense of mystery and loss. The actual moment of Eleanor Green's departure from England, however, probably passed unknown across the Channel by her daughter.[26]

Dieppe in the 1840s already had an established expatriate colony. Living was cheap there compared to England. The completion of the London, Brighton and South Coast Railway and the introduction of steam packet-boats meant that it took a mere eleven hours to travel from London to the French port. Mrs Maria Slee's school, set – across the harbour from the old town – on the still verdant slopes of Neuville, was one of several educational establishments in the area catering for English children:[27] the bracing sea air was considered to be beneficial to youth.[28] Mrs Slee's was a happy place, and it offered Nelly the structure and companionship that had been lacking from the lonely and bohemian years of her childhood, and also the security of real affection.

She boarded there not only during the terms but also in the holidays, growing in time to be less a pupil than a part of the family. Mrs Slee was almost a second mother to Nelly; her daughters 'became much attached' to their young English charge, and she to them.[29] It was during these years that Dieppe developed, for Nelly, into a charmed place – the place where 'she was happy and well for the first time'.[30]

She stayed at the school until she was almost eighteen, becoming strong, handsome and accomplished. She learnt to speak French 'with a good accent at least'.[31] Her status and her future prospects, however, remained a mystery to her. She was aware that she was under the protection of a distinguished guardian – a Fellow of the Royal Society – but, although they corresponded, it seems that they did not meet. She did not learn the identity of her protector until 1848, when she was eighteen.[32] Richard Sheepshanks was impressed with the progress made by his daughter, and he was anxious that it should continue. But perhaps not at Dieppe. The year 1848 was one of turmoil and revolution throughout Europe. The French once again overthrew their monarch, the unfortunate Louis Philippe. He fled to England and many English residents in France made the same trip. Anti-British sentiment was rife. Richard took the precaution of arranging for Nelly to leave Dieppe to finish her education in the pretty little Baltic town of Altona near the mouth of the river Elbe. Altona was nominally a Danish town, part of the Danish-controlled duchy of Holstein. But it was just across the river from Hamburg and had strong links with the German states.

Richard Sheepshanks knew the town well because it had a famous observatory, renowned for producing the clearest and most accurate astronomical tables. For many years it had been under the directorship

of his close friend, Heinrich Schumacher. Schumacher was an astron-
omer of international standing, a member of the Royal Society in
London, and the editor of *Astronomische Nachrichten*, the principal
journal in the field.[33] And it was with Professor Schumacher and his
family that Nelly was sent to stay. The events of 1848 had not been
without their effect on the Schumachers. Hostilities had also erupted
between Denmark and Prussia over the disputed territory of Holstein,
and while the conflict continued the professor's salary was not paid.
Richard Sheepshanks was happy to think that Nelly's board-and-
lodging expenses would contribute to the family coffers. The professor
undertook to see to her education, while his wife, his daughter, and
the widow of his son, promised to make her welcome.[34]

Initially, Nelly's position in the household was slightly ambiguous.
Richard had intimated to Professor Schumacher that, although Nelly
was his 'ward', she would 'not improbably' have to make her own way
in the world – perhaps as a governess, that established refuge for
portionless but educated Victorian girls.[35] Certainly Richard Sheep-
shanks' hopes for his ward's education suggested such a path. He
wanted her to study music and drawing, as well as learning German and
mathematics and perhaps even some Latin. But he repeatedly stressed
that 'Nelly' was to be shown no special consideration,[36] and that if she
could be made use of 'as nurse, amanuensis, housemaid, or [in] any
other capacity' it would be 'the best education she could have'.[37]

Such promptings were unnecessary. Nelly had a generous and help-
ful disposition. She speedily endeared herself to the Schumachers
through her acts of kindness and her expressions of gratitude. She also
proved a ready pupil. She learnt, as she put it, 'to sing very well and
to paint very badly'. She devoted herself to embroidery and fine sewing.
She revealed a gift for languages, learning to speak German 'like a
native'.[38] She also picked up Italian and Danish, though it is not known
whether Professor Schumacher found time to teach her any Latin. (He
had replied facetiously to Richard Sheepshanks' suggestion that he
might give Nelly some classical education with the French verse: 'Soleil
qui luit le matin,/Enfant qui boit du vin,/Femme qui sait le Latin/Ne
viennent jamais a bonne fin.'*[39])

The Revd Richard Sheepshanks corresponded regularly with both

* 'A sun that shines in the morning,/A child that drinks wine,/A woman who knows
Latin/Never come to a good end.'

Nelly and Professor Schumacher and was encouraged by news of her progress. He was able to confirm this good impression when he visited Altona in October 1849. Over the previous year his plans for his ward's future seem to have grown and developed. And it was perhaps during, or immediately after, this visit that he revealed to Nelly his true position and declared his intention of formally recognizing her as his child. She preserved always, as the one scrap of writing in his hand, a passage from the letter in which he revealed to her his fatherhood: 'Love me, Nelly, love me dearly, as I love you.'[40] The scrap is undated, but there is a detectable shift in Richard's attitude to Nelly after that October; references to her are more open and more openly affectionate; and his letters end with expressions of 'best love'.[41]

If Nelly's knowledge of modern languages grew *chez* Schumacher so did her sense of fun and her sense of life's possibilities. It was a convivial household in a convivial town, and she was surrounded by people of her own age. Altona had a sizeable English population and Nelly formed several long-lasting friendships. There were frequent picnics, concerts, operas, even balls. She made excursions into Italy and Austria.[42] This round of diversion was interrupted at the end of 1850 by Professor Schumacher's sudden illness and scarcely less sudden death.[43] Nelly, however, had become part of the family by this stage. There was no suggestion that she should leave. She stayed on in the Schumacher household, a companion to the grieving family.

Perhaps it was this family tragedy that introduced her to Professor Schumacher's son, Johannes.[44] He was the artistic member of the family and had been away, studying painting in Rome. He immediately established a rapport with the family's English houseguest, a rapport that deepened the following summer when Nelly nursed him through a bout of illness. She shared his love of Nature, and his enjoyment of climbing mountains. He admired her singing.[45] In tandem with his friendship for Nelly, Johannes also developed a close tie with her guardian. Missing his own father, he took to writing to Richard Sheepshanks, seeking his advice, his encouragement and assistance. He even visited him in London in the autumn of 1852. Early in the following year, Johannes wrote from Italy declaring that he planned to leave Rome to continue his studies in Paris. For a painter, he declared, Paris was the place to learn.[46]

It was the common cry across the art schools of Europe at the time. Italy might boast the treasures of antiquity and the Renaissance, and the great German academies at Munich, Düsseldorf, Berlin, and Dresden could offer a thorough practical training; but the French capital had the glamour of innovation and even revolt. It was there that the new spirit of 'Realism' was asserting itself with most force: at the Salon of 1850, Gustave Courbet had struck a new note with his monumental canvas *The Stonebreakers*. The depiction of the contemporary working man on the heroic scale of antiquity caused a sensation that others were keen to experience and to echo. Students gravitated to Paris from all over Europe and America, to throng the ateliers of Troyan, Gleyre, Couture, and Lecoq de Boisbaudran, hangar-like studios bristling with easels, plaster-casts and ambitions. Johannes Schumacher was not the only son of Altona to be drawn to Paris. He found several others already there. Amongst his confrères was an earnest young art student called Oswald Adalbert Sickert.

Oswald Sickert belonged to Altona's artistic elite. His father, the dashing fair-haired, blond-bearded Johann Jürgen Sickert, was a pillar of the cultural community: an artist, wit, and dandy who – despite his Nordic colouring – was known to at least some of his friends by the Italianate nickname, 'Sickarto'.[47] The son of a long line of Flensborg fishermen, he had trained as a 'decorative painter' and was – at least according to his grandson – for a while the 'head of a firm of decorators who were employed in the royal palaces of Christian VIII of Denmark'.[48] He became, in time, an accomplished landscape painter, and after moving to Altona in the late 1820s was a leading member of the town's exhibiting society. He showed there regularly, and also at the neighbouring Hamburg Kunstverein.[49] He was interested in technical innovations and was a pioneer of both lithography and photography. In 1850 the local directories list his address – at 34 Blücherstrasse – as a 'studio of Daguerreotype'.*[50]

Nevertheless, he did not abandon his first calling. He continued to undertake decorative commissions: the museum in the town still contains a painted 'overdoor' by him of a woman with flowers. In 1855 – at the request of the municipality – he drew up a scheme for

* Sickert preserved a daguerreotype of his grandfather, sitting very still in a dressing-gown and a smoking-cap 'calculated to turn his pious grandson green with envy'. 'From the Life', Morning Post (*18 May 1925*).

providing art training for the town's artisans through 'Sunday Continuation classes'. In it he emphasized the practical benefits and applications of art, insisting on a thorough grounding in geometry and perspective. He considered that it would be 'of more use to a carpenter, a turner or a smith, if his lessons enable him to draw a vase or an ornament correctly, than if his schooling results in nothing more than the adornment of his bedroom with a few trophies'.[51] But if Johann Jürgen thought that art could be useful he also believed that the artist's life should be fun. He was a great promoter of artistic conviviality – a composer of drinking songs and comic verses, and a leading light in the Altona dining society known as the 'Namenlosen' or the 'Unnamed', all the members of which were designated only by numbers.[52]

Having been widowed in 1838 (when Oswald was only ten), Johann Jürgen seems to have done everything to encourage his only child's artistic career. The young Oswald Adalbert showed precocious ability. In 1844, at the age of sixteen, he won a travelling scholarship to Copenhagen to study at the art academy. Once there, he revealed an independent spirit, abandoning the school's classes after his first term and taking private tuition in 'perspective drawing' from the foremost Danish painter of the day, C. W. Eckersberg. He then devoted himself to working in the cast gallery for the whole of the following year. In 1846 he abandoned Denmark for the altogether more prestigious Academy at Munich.[53]

Oswald Sickert stayed in the Bavarian capital for the next six years, submitting himself to the rigours of the Germanic training system. He was supported by his father, who visited him on at least one occasion and encouraged him with regular letters. Each epistle ended, 'somewhat . . . to his son's irritation', with the imprecation – the distilled essence of old Johann Jürgen Sickert's artistic wisdom – 'male gut und schnell' (paint well – paint quickly).[54] But Munich for all its virtues and opportunities had one great limitation: it was not Paris. The main drama, it was felt, was happening elsewhere. The students of Munich were alive to the new currents in French art; and in 1851 they even got a chance to view some of Courbet's work at first hand when he exhibited in Munich, and perhaps even visited the city.[55] Oswald Sickert and his companions soon came to idolize this new master.[56] And the impact of his work prompted many of them to move to the French capital. In 1852 Oswald Sickert joined the exodus, enrolling at the Parisian teaching-studio of Thomas Couture.[57]

Couture was, and remains, famous for his depictions of Classical Rome. His monumental canvas, *Romans of the Decadence*, was the cynosure of the 1847 Salon and was bought by the Louvre. But despite his antique themes, he allied himself closely to the contemporary strains of artistic Realism. His depiction of the dissolute Romans had been intended – and taken – as a comment on the corruption of France under Louis Philippe's rule. He retained a reputation as a radical and independent spirit and his studio was regarded as one of the most exciting in Paris. It attracted students from all over Europe, and from America too. They found Couture's regime both liberating and challenging. His manner had a bracing informality, very different from that of other teachers. He startled more than one student with such direct criticisms as, 'That's horrid! If you can't do better than that you had better stop!'[58]

Although he worked within the framework of tradition – the 'good tradition' of *la bonne peinture* that Sickert later described as being 'sedulously nursed' in that Paris of the 1850s – Couture was always open to the possibilities of new techniques and procedures.[59] To young artists like Oswald Sickert who arrived from the rigorously exacting art academies of Germany, such an approach was electrifying. One young artist who came to Paris from Düsseldorf considered Couture's teaching 'a sublime reaction from the dry-as-dust German painting then in vogue'.[60] Another thanked Couture for freeing him from 'the niggling technique of the Germans' as well as opening up his compositions to a much 'broader vision & conception'.[61] It was Paris that liberated Oswald Sickert. And although he was there a relatively short time (barely a year) it was, for him, a defining artistic experience: he came to regard himself as 'more an antique Parisian than a Dane' – or, indeed, a Bavarian.[62]

But of course, as in most educational establishments, it was the other students – and the place itself – that provided the real education. Oswald Sickert found himself in an exciting milieu. In Paris he had the chance to see more of Courbet's pictures.[63] He travelled in France, and discovered Dieppe as a sketching ground.[64] He mixed with art students not only from Couture's atelier but from the other studios as well. There was a strong Munich contingent, including Wilhelm Füssli, Moritz Delft and Cesar Willich, as well as others from Altona, including – from 1853 – Johannes Schumacher.[65]

It was Schumacher who, on one of their return visits to Altona,

introduced the 24-year-old Oswald Sickert to the family houseguest, Eleanor Henry.[66] The Eleanor he met was an accomplished young woman of twenty-two, vivacious, attractive, and with beautiful fair hair. Oswald Sickert, for his part, was touched with the metropolitan glamour of Paris. He had a fine beard and, despite a retiring manner, seems to have been considered rather a dashing figure by the young ladies of Altona. (Preserved amongst his papers is one letter from an admirer – not Eleanor Henry – who addressed him with more poetic ardour than geo-political exactness as 'Dear German Lord Byron'.[67]) It was not, however, his romantic looks, nor even his fledgling artistic reputation, that seems to have drawn Eleanor Henry to him. It was music. They shared a common passion. Oswald Sickert played the piano with real sensitivity and skill. According to one exacting critic, his 'technique was faulty, but his phrasing was musicianly, and . . . for passion and for singing quality in *cantabile* passages he excelled many public performers'. He had a strong sense of rhythm and was a 'brilliant' sight-reader.[68] Eleanor, the dancer's daughter, had her own sense of rhythm and allied it to a beautiful singing voice. Their romance flourished to an accompaniment of Schubert lieder.

Even amongst the romantically inclined young people of Altona, however, it was recognized that Eleanor's social position was problematic. Although the exact details of her background remained vague, it had become known that she was illegitimate. This, to the conventional mid nineteenth-century mind, was an all-but-ineradicable stain, a bar to any full social acceptance. But to the young Oswald Sickert, brought up in the world of art, schooled in the studios of Copenhagen, Munich, and Paris, such considerations counted for little besides the more real attractions of Eleanor's character and person.[69] He was happy to overlook the supposed taint.*

Oswald was more concerned that Eleanor's guardian might not favour the suit of an as yet unknown Danish artist for the hand of his ward. There were, however, encouraging signs. Johannes Schumacher – himself quite as unknown as Oswald Sickert – had fallen in love with another member of Altona's international colony, an English girl called Annie Williams. He wanted to propose to her but had received no encouragement from Mr Williams, who insisted that Johannes first

* Though he may not have known it, he too had been born out of wedlock. His parents married in June 1828, four months after his birth.

prove he was capable of supporting a wife. Johannes had sought Richard Sheepshanks' advice on the matter and had been much heartened by his tone of encouragement. It was a tone backed up with practical assistance. Sheepshanks commissioned a picture from his young friend and sent him a cheque for £100.[70] This positive attitude towards the romance of one impecunious painter and an English girl with prospects must have given Oswald Sickert some small grounds for optimism.

That optimism was soon tested. In the summer of 1855, Richard Sheepshanks announced that he wished to take Eleanor on a tour of France and Italy. They would travel together with his sister Anne. Eleanor, however, was to meet her father at once in Paris. It was the news of her imminent departure from Altona that precipitated Oswald Sickert to declare his love. He proposed and was accepted. Eleanor was touched not only by the earnestness of his suit but by his willingness to overlook her doubtful status. Nevertheless, she must have had some doubts about how her father would take the news. The engagement was not disclosed. She travelled to France with it as a secret.[71]

The reunion with her father in Paris was a happy and exciting one. Plans for the trip were discussed and, while they waited for Anne to arrive, Richard took Eleanor around the shops to equip her with a new wardrobe. They bought dresses, and lace, and jewellery. In this congenial atmosphere of confidence and acceptance, Eleanor relaxed. She confided the secret of her engagement to her father. The effect was devastating. He ordered her to break the attachment. When she declined, he became furious. Eleanor was reduced to tears but refused to yield. Richard, behaving in the manner traditional to irate parents, cancelled the proposed European holiday. He refused to allow Eleanor to return to Altona but sent her back instead to lodge with Mrs Slee at Dieppe. Although at twenty-four she would have been more a staff member than a pupil, the ignominy of her abrupt return, the exchange of the gay whirl of Altona for the institutionalized tedium of a Dieppoise boarding school (even one as sympathetic as Mrs Slee's), and the separation both from her beloved fiancé and her new-found father, must have been painful.[72]

The Reverend Richard Sheepshanks, ignoring any counsels of clemency, went back to England. By post he continued to rain down further reproaches upon Eleanor, until – on 29 July – he was struck down by a sudden paralysis. After lying for a week unable to talk or move, he

died at his house in Reading. He was just sixty. Eleanor blamed herself. Away in Dieppe, she was convinced that it was her untimely announcement of her engagement that had precipitated the stroke. Medical opinion took a different view, while Richard's friends were convinced that he had overstrained his constitution with his work on the Standard Yard. But such notions, if they reached Neuville, did little to console the distressed Nelly.[73]

Richard Sheepshanks had, at the time he first revealed his parentage, planned to alter his will in order to make provision for Eleanor. But he died before he did so. His sister Anne was his sole legatee. She had managed his affairs and shared his interests throughout his life, and she now readily took up the burden of his responsibilities. Eleanor became her charge. Miss Sheepshanks, unlike her brother, was not implacably opposed to Oswald Sickert's suit – although she perhaps felt that it should be tested by the trials of time and distance. At any event, she arranged for Eleanor, after she had recovered from the shock of the moment, to go as a parlour-boarder to a 'first-class' school in Paris; and by 1857 she had found her a post as resident governess to the two daughters of George Harris, a Harrow schoolmaster, with a salary of £100 a year.[74]

Oswald Sickert, meanwhile, did not lose heart. He kept in touch with Eleanor and he persevered with his painting. There were modest successes. His scenes of contemporary agricultural life seem to have combined a fashionable 'Realismus' with a traditional German taste for landscape.[75] He had a picture accepted by the Berlin Academy in 1856, and the following year he showed at the Kiel Kunsthalle, where the 'fluent tone' and 'mood' of his work was praised.[76] Also in 1857 he exhibited a picture at the British Institute in London, and it is probable that he came over to see it, and Eleanor.[77] He was dividing his time between Altona and Munich.[78] He worked hard and his career advanced – but at a frustratingly slow pace. The market was crowded and sales were hard to get.

Eventually, he was obliged to compromise. In a bid to prove his ability to support a wife he returned to Munich and took a job on the *Fliegende Blätter*, a periodical noted for its comic illustrations. Many of Germany's leading draughtsmen contributed to the weekly's pages, but there was also much unsigned hackwork, and this is what Oswald Sickert was hired to provide.[79] It is not likely that the work was very remunerative, but it does seem to have convinced Anne Sheepshanks

of the suitor's earnestness and capability. The marriage was allowed
to go forward.

Oswald Sickert travelled from Munich to claim his bride. During
the years of trial his ardour had remained undimmed. As Eleanor
confided happily to one of her friends, he loved her 'with all the
strength of a reserved nature concentrated to love one object'.[80] The
wedding took place in the parish church at Harrow on 3 August 1859.
Eleanor was resplendent in a gown of white striped silk. She had
no fewer than five bridesmaids, including her two young pupils. Mr
Harris gave her away,[81] and Mrs Slee came over from Dieppe for the
occasion.[82] Although there is no record of Anne Sheepshanks' attend-
ance at the ceremony, she certainly gave her blessing to it. She also
gave Eleanor an allowance with which to start out on married life.[83]

The honeymoon took the newly-weds through Belgium to Düssel-
dorf, on to the picturesque lake at Königswasser, and thence to Munich.
There the young couple installed themselves in a small flat at 16
Schwantalestrasse. Eleanor brought with her little more than her
beautiful wedding dress, her 'Paris trousseau', and a desire to make a
happy home.[84] They had little furniture beyond a bed and a piano;
but that was probably all that they needed.[85] It was certainly con-
venient; leases tended to be short in Munich and the Sickerts moved
flat three times over the next four years.[86]

The Munich in which they established themselves was a thriving
if rather pretentious little town, with a population of some 130,000.
Although medieval in origin, it was very much a modern city, exuding
a sense of newness, freshness, and cleanliness. Many of the recently
built houses had little front gardens, and many of the streets were
lined with trees. Munich was self-consciously proud to be the capital
of Bavaria, and the home of its royal house. The Wittelsbach monarchs
– the recently abdicated Ludwig I and the reigning Maximilian II –
had conceived the city as a centre of culture and style. They had laid
out broad avenues and spacious parks. They had erected a succession
of mock-classical and mock-Renaissance buildings to complement the
few pre-existing Gothic and baroque churches. The Wittelsbachs had
also established important collections of art – the classical sculptures
of the Glyptotech, the old masters of the Kunstmuseum, and the new
masters of the Neukunst Museum. Munich was full of 'new masters',
or would-be new masters. The numerous major building projects, the
prospects of royal patronage, and the high quality (as much as the

low price) of the Bavarian beer, made Munich a focus for painters, sculptors, draughtsmen, and artists of every sort and every nationality.

There were, according to one resident writing at the beginning of the 1860s, 'about a thousand artists in Munich'. They constituted a distinct and lively social group. They were noted for their conviviality, their 'love of amusement and pageant'.[87] They 'congregated and made merry with cheap *Künstlerfesten*', some more formal than others.[88] Every few years they would arrange an elaborate 'costume ball', taking over the main rooms of the Odeum and transforming them with fantastical decorations, before transforming themselves with no less fantastical costumes. Each spring the artists would decamp en masse to the wooded hills south of the city to celebrate a May-fest with dining, dancing, and revelling. Nor was it just artists who were drawn to Munich. The low cost of living in Bavaria encouraged a sizeable contingent of foreigners, and particularly of English people, to settle in the city. Food was inexpensive; there were no rates; and servants were easy to come by. In 1860 a fixed sterling income went further in Munich than in almost any other capital in Europe.

The cosmopolitan and artistic ambience of the city ensured that Eleanor felt none of the isolation that removal to a new and foreign world might have otherwise entailed. She found two supportive groups ready to welcome her: the artists and the English. Oswald Sickert's long connection with Munich had given him a place near the heart of the city's artistic community. Despite his commitments to the *Fliegende Blätter*, he continued to produce his own work as well, and to exhibit it at the Munich Kunstverein.[89] He had many artist friends (Füssli and Willich had returned to the city from Paris); and Eleanor, with her knowledge of German, was able to welcome them, first at Schwanthalestrasse and then at a new flat in Augustenstrasse. There were English artists, too, in Munich, and many of these were drawn into the Sickerts' convivial circle, along with other less artistic compatriots. Although there was an English 'Minister Plenipotentiary' at the Bavarian court,[90] the main focus for the expatriate community was provided by the Anglican chaplaincy. There was at that time no actual church, but the congregation gathered for services each Sunday either at one of the new hotels or in a room at the Odeum.[91]

It was there that the Sickerts had their first-born child christened, barely a year after their arrival at Munich.[92] Anne Sheepshanks, though she does not appear to have come over for the ceremony, agreed to

stand as godmother to the young Walter Richard. And she must have been glad that the memory of her beloved brother was preserved in the boy's middle name. For Eleanor, the choice may have served in part as an expiation of the lingering guilt and remorse that she felt over her (imagined) part in hastening Richard's end. It was also an acknowledgement (and perhaps a projection) of the link between the Sickerts and their wealthy relatives. Walter was brought up with a lively sense of his maternal grandfather's importance: the '89,500 micrometer observations' that he made in the cellars of Somerset House became part of the family folklore.[93]

The infant Walter Richard was an adored first child. His name was instantly familiarized to 'Wat'. His birth precipitated a move to a first-floor flat at 25 Blumenstrasse. Perhaps there was more room at the new address. There certainly needed to be. Mr and Mrs Sickert – both only, and lonely, children – seem to have been determined to create the full and happy family life that they had never known. Barely eighteen months after Walter's arrival a second child was born, christened Robert. And only a year after that, a third son. Following the tradition of choosing names that worked both in English and German, he was called Bernard or, more Teutonically, Bernhard.* So brisk was the succession of infants that Bernhard had to be suckled by a wet nurse.[94]

The advent of siblings did nothing to dilute the infant Walter's power and position. He was very much the eldest child. As a toddler he was precocious, winning, and lovely to look at. Eleanor, in later years, 'never wearied of telling about his beauty and his perfect behaviour as a baby' – rather to the irritation and surprise of his younger siblings who knew him as a less docile (though still beautiful) child.[95] He had, too, a natural gift for self-dramatization. Even at the age of three his sudden entrance into the family sitting room one evening was so arresting that his parents' friend Füssli, who was visiting, insisted on painting him. The picture – a life-size representation of the very young Walter holding an apple while clad only in a short nightshift, his huge mop of flaxen curls surrounding a 'rosy face and solemn blue eyes' – was in due course presented to the family

* On the baptismal register, Bernard's name is spelled 'Bernhart', though he never seems to have used this form. Robert was given the second name 'Oswald', like his father.

and prominently hung in the living room. Walter grew up under this quasi-heroic image of himself. In later years he would describe it as his 'first appearance on any stage as Hamlet'. It was clear that, even at the age of three, he had a desire to play the title role.[96]

The picture must also have served as a reminder of his ever-changing appearance. The following year he effected the first of what would be many dramatic transformations. Or rather it was effected for him. 'Wat's head looks like a broom,' his mother wrote, 'now that the long curls are off.' The short crop was perhaps well suited to his physique and temperament. 'He is an immense fellow,' his mother declared proudly, 'taller and broader than the generality of boys at his age', though she did admit that he had still 'such a baby face'. This cherubic face, it was noted, masked a fearsome will: 'He is very perverse and wayward, and wants a very tight hand.' Too much 'tenderness' enabled him 'to give way to his temper'.[97] The tight hand, however, was one that only Eleanor could employ. Later in the same year she was remarking, 'Walter is not very easy to leave with the servants, I can make him mind without much trouble. With them *He* is master.'[98] There was, however, no doubting his intelligence. He delighted in books, and with only the minimum of parental encouragement taught himself to read and write before he was four.[99]

In 1864, King Maximilian died and was succeeded by his son, the Wagner-loving eccentric Ludwig II – someone more 'perverse and wayward' than even the 4-year-old Walter Sickert. At almost the same moment, Mrs Sickert gave birth to a fourth child, a girl, christened Helena but known (like her mother) as Nellie. The ever-expanding young family moved once again, to a flat on the first floor at No. 4 Kleestrasse.[100] This new address became the Sickerts' most longstanding Munich home. It was set in a short cross-street running between the Bayerstrasse and the Schwanthalestrasse, close to the large park-cum-showground, the Theresienwiese, where the city's annual Oktoberfest was held. Comforts were rather sparse. If there were no rates to pay on the flat, it was because no services were provided. There was no piped gas, no running water, and, of course, no water closet. There was, however, a maid to help with fetching and carrying, with getting wood for the fires, and water for the basins.

Life in the new flat was crowded, even cramped, but happy. Although there were regular excursions to the shops, to the Botanical Gardens (to feed the fish) and to the Theresienwiese (to roll on the

grass), the whole family spent much of each day indoors. There was no nurse and no nursery. Eleanor sat, looking over the four young children in the living room, sewing and mending, while Oswald worked in a small adjoining studio room.[101] Mrs Sickert was blessed with the rare 'health and energy and courage' necessary to bring up a large family on a small income. Food, she made sure, was always plentiful and nourishing, if simple – very simple. Jam was a rare event; sweets a once-a-year Christmas treat. Even birthdays were marked only with 'plain cake'. The Sickerts adopted the Bavarian custom of having their main meal at midday. A rather frugal 'tea' of bread, butter, and milk, eaten at six, represented the children's evening meal. The parents had a later but scarcely less frugal supper.[102] Bread, rice, potatoes, oats and sago were the abundant staples of the Sickert table. They were often combined with the notoriously thin Bavarian milk into what the family called 'pluffy puddings'.* It was a regimen of unexampled blandness which goes some way to explaining Walter's later relish for the good things of French, Italian, and even British cuisine. Nevertheless, throughout his life, at times of crisis he would seek solace in the comforting familiarity of rice pudding or bread-and-milk.

Mrs Sickert was what her daughter called 'an admirable baby mother', with a real love of young children and a real gift for keeping them occupied, amused, and in order.[103] Under her direction, Walter and his siblings devised their own entertainments. There was little money for toys, and it was thought better that they should make their own. Their mother's workbasket was the principal source of materials, as they constructed miniature box carts with cotton-reel wheels, or transformed wooden button moulds into spinning tops. Their father's old cigar boxes became 'blocks of flats', fitted out with acorn furniture. There was, however, a constant danger that the play – invariably led by Walter – would grow wild. Oswald Sickert was not a natural 'baby father'. He had a 'highly nervous' temperament and found the stress of weekly deadlines and daily distractions hard to endure. Sometimes he would startle the children by bursting into the living room, interrupting their games with a despairing plea, 'Can't you keep these children quieter?' He would, as Helena recalled, immediately regret

* 'Milk and butter are in a state of barbarism,' reported the travel writer Edward Wilberforce. The butter was often rancid. As to the difference between milk and cream in Munich, 'a long experience has shown me that cream is milk with water put in it, while milk is water with milk put in it'.

the outburst; his wife 'had only to turn reproachful eyes on him to bring his arms round her and a tender plea for forgiveness. Then he would steal away and we would look guiltily at each other and behave like mice.'[104] But even without such irruptions, the children's spells of furious practical activity alternated with 'periods of silent contemplation'. Walter might take up a book. He was a voracious reader throughout his childhood.[105] And Mrs Sickert would sometimes lay the flat tin top of the travelling bath on the floor and say it was a raft, on which the children would clamber aboard and 'drift away on dim voyages' of the mind.[106]

It was a cultured home. Music played a large part in family life. Mrs Sickert sang constantly at her work as she watched over her brood. Most evenings she and Oswald would make music together, Oswald accompanying her as she sang, and then playing on for 'an hour or so' on his own. Beethoven and Schumann were favourites.[107] In the Munich of Ludwig II it was impossible to escape entirely from the music of Wagner. His operas were performed frequently at the Hoftheater, breaking up the more conventional repertoire of Meyerbeer, Mozart, Halévy, Weber, and Rossini.[108] Mr and Mrs Sickert went. Eleanor felt that perhaps one Wagner opera was enough.[109] Oswald, however, was more intrigued. When the 'Ring Cycle' was published and a friend brought round the full orchestral score of the four operas, Oswald, in a bravura display of sight-reading, played it straight through, adapting the music to the piano as he went along, the friend scurrying ahead, turning the pages as fast as he could.[110]

Although the infant Walter listened with interest to the talk about Wagner and the 'mad king', and enjoyed the constant flow of music and song that ran through 4 Kleestrasse, there remained a certain distance to his appreciation. Unlike his younger siblings – particularly Bernhard – he had 'no musical gift at all' and was not able even to 'sing true'.[111] He showed a more ready aptitude for the household's other main preoccupation: art. The evidences of Oswald Sickert's profession were all around the flat. And although his studio room may have been sacrosanct, his paintings were on view, as were works by his father and by his friends. His artist confrères were constant visitors. Füssli, besides painting the 3-year-old Walter, executed a 'charming' Ingres-like portrait of Mrs Sickert in her black moiré-antique dress with white lace collar, her hair framing her face in 'smooth shining rolls'.[112] Surrounded by such examples it was not surprising that the 'chief

pleasure' of Walter – and of his brothers – was 'painting, drawing and modelling in wax'.[113] More time was spent in artistic endeavour than in anything else. Almost none of Walter's puerile production has survived. There is, however, nothing to suggest he was a prodigy. Nevertheless, even at five it seems that, unlike the vast majority of children, he was more concerned to record what he saw, rather than to escape into the realms of the imagination. Mrs Sickert sent one friend a 'rather crude drawing' by the 5-year-old Walter of Helena as a babe in arms.[114]

Mrs Sickert was 'at home' at Kleestrasse on Thursday afternoons, and often received visitors.[115] The growth of the family enhanced rather than diminished the Sickerts' thriving social life. There were several other families with young children who gravitated towards them. Eleanor was befriended by the Edward Wilberforces, a young couple who had one son the same age as Robert and another christened only three weeks after Helena. Edward Wilberforce had left the Navy after getting married (to an American with the arresting name of Fannie Flash) and was preparing for a career at the Bar. He had devoted his time in Munich to writing an entertaining and opinionated book on the life of the town.[116] Although there was no 'English Doctor' in Munich, Dr Heinrich von Ranke (grand-nephew of the great historian), who had a practice in Carlstrasse, was a keen Anglophile who spoke excellent English.[117] A specialist in treating children, he became the Sickerts' family doctor and a good friend. Dr Ranke was mildly eccentric, full of 'German fun' and fond of practical jokes; his tiny wife was – like Oswald Sickert – a 'Schleswig-Dane' and – like Eleanor – the daughter of an English astronomer.[118] They too had a bevy of young children, playmates for the infant Sickerts.[119]

Shortly after the Sickerts' move to Kleestrasse, Johann Jürgen Sickert came down from Altona to visit the family in their new home and to see his grandchildren. He was only sixty-one and it was a surprise when, not long after his return home, he died. He was found early one morning at his studio, dead in his chair, in front of his easel.[120] Oswald Sickert had to go and sort out his affairs. He discovered his native town in a curious and unhappy condition. In the summer of 1864 the Prussians, together with the Austrians, had engineered another quarrel with Denmark. It had led to a very brief military confrontation in which the Prusso-Austrian alliance had comprehensively defeated the Danes. The spoils of their victory were the long-disputed duchies of Schleswig and Holstein. Altona and its citizens

had ceased to be subject to the Danish crown. Oswald Sickert – like his father (and his son) – was neither political nor nationalist. Art and music were his concerns. During his long residence in Munich he had come to regard himself as a Bavarian-German of liberal tendencies.[121] But the unrest of war and the clear signs of Prussia's military ambitions in Europe were unsettling. Back in Munich, Eleanor announced that she was 'growing fidgety'.[122]

It was also an unsettling time for the young Walter. Eleanor was becoming increasingly alarmed at his health: 'Wat looks very pale and thin,' she reported, 'but he eats and drinks and sleeps & walks any distance.' He could still manage a trip to the Botanical Gardens to feed the ducks, but found it hard to concentrate for long. Even the prospect of earning a coin for learning to spell some new words was not enough to sustain his interest. He soon grew tired.[123] Munich was known to have a less than healthy climate. Infant deaths were common. (Eleanor was later told by Dr Ranke that she was the only mother on his books to have 'borne four children and brought them alive out of infancy in the city'.) The 'high bitter air' was liable to cause bronchial problems, and indeed all the Sickert children suffered regularly from croup. Walter's complaint, however, was of a different order. The reason for his pallor and lassitude was discovered to be some sort of intestinal blockage or abscess. This seems to have developed into an anal fistula as the body, seeking a new outlet, opened up a narrow channel between the lower part of the rectum and the skin around the anus. An operation became necessary to close up the wound, and restore the natural channel. It was a problematic business. The fistula was kept from healing by the constant entrance into it of material from the bowel. The first attempt by the Munich doctors was unsuccessful. And so was the second. By the middle of 1865, Walter was still suffering.[124]

That summer, Eleanor took the family to Dieppe. It was a punishing journey to make with four small children, in a train without lavatory compartments or buffet car.[125] But the town held such a special place in her affections that she wanted to introduce her offspring to its charms – to the old streets, the castle on its cliff, the Gothic churches of St Jacques and St Remy, to the quaint onion-domed Casino, the long pebbly beach, the bracing northern sea, to the school house on the slopes of Neuville that had been her youthful home; and – of course – to Mrs Slee and her daughters. It was Walter's first experience

to a town that would become at different times his home, his refuge, and his inspiration.

It was also his first introduction to his godmother. Anne Sheepshanks came over from England, full of kind thoughts and offers of practical help. Her first scheme of assistance was to increase and formalize the allowance that she made to Eleanor and establish it under a trust.* Her second concern was Walter's health. After the failure of the two Munich operations, she believed that nothing short of a London specialist would suffice. The acknowledged centre for rectal surgery was St Mark's Hospital, in London's City Road, and it was arranged that Oswald Sickert would bring Walter over to London in October. As Miss Sheepshanks no longer had a house in town, she rented one – at Duncan Terrace, Islington – close to the hospital.[126]

The expedition, following directly upon the holiday at Dieppe, gave Walter a foretaste of another of his future motifs. It was, however, the drama of the operation, and his central part in that drama, rather than Islington's well-proportioned Georgian terraces, that seems to have impressed him most. It became another of the key points in his personal mythology. 'Islington,' he liked to claim in later years, 'has always been kind to me. My life was saved at the age of five . . . [at] St Mark's Hospital in the City Road.' He was proud of the fact that the operation was carried out by Alfred Cooper – then the hospital's Assistant Surgeon, but later a knight and then a lord (and finally the father-in-law of Lady Diana Cooper).[127] After the operation Walter and his father stayed on at Duncan Terrace for three weeks.[128] It was an experience that sharpened Walter's keen sense of his own separateness, and specialness, within the family. By November, however, they were back at Kleestrasse ready for all the excitements of a Bavarian winter.

It was the season when Munich came into its own. One of Sickert's abiding childhood memories was of the city in its Christmas finery: dusted with powdery snow; Christmas trees standing on the street corners; and the darkness of the cobbled Dultplatz aglitter with gaily illumined street stalls dispensing such seasonal delicacies as gilt gingerbread and sugar effigies of the Baby Jesus – delicacies which, for once, he was allowed to enjoy. As an adult he sometimes wished that he

* The trust was set up on 29 June, between Mr and Mrs Sickert, Anne Sheepshanks, and three trustees, Augustus de Morgan, William Sharp, and George Campbell de Morgan (a copy is in the Sutton papers at GUL).

might be five years old again so that he could experience the thrill of it all afresh.[129] The informal drama of the Christmas streets found an echo in more conventional performances too. Another cherished recollection was of a visit to the circus, when a troop of elephants had been ridden round the ring by marmosets in fancy Zouave costumes.[130] It was a first memorable taste of the popular theatre.

But, aside from these festive moments, Munich seems to have left remarkably little impress upon Sickert's infant mind. In later life he spoke of it rarely, and never with enthusiasm. Although he was so responsive to the poetry of other places, Munich's broad avenues and mongrel buildings did not excite him. Its treasures remained unknown: the fashion for taking very young children around art galleries had not begun. He could not escape Otto Klenze's colossal statue of 'Bavaria' – represented as a sixty-foot-high bronze female holding a wreath above her head – which dominated the Theresienwiese, but it failed to impress him. Commissioned by Ludwig I, it was – Sickert claimed in later years – one of the things that first convinced him of the folly of state sponsorship of the arts.[131]

He preferred the countryside around the town, and came to know it well. From the moment that the May-fest signalled the beginning of the summer, Munichers would flock to leave the city. The Sickerts joined this annual exodus, passing a month or two in the Bavarian countryside, lodging with peasants' families, or staying at country inns. They would visit the little villages dotting the shore of the nearby Starnbergersee – the magnificent lake some sixteen miles long just south of Munich. Or they might venture further afield to other lakes in the Bavarian Tyrol – to the wooded shores of the Chiemsee or to the Staffelsee. In an alfresco variation of their Munich life, Oswald would sketch and paint, while Eleanor would look after the children. In the evening they would all gather in the biergarten of the inn.[132]

There were also happy outdoor days spent with the family of the Revd Rodney Fowler, the sometime rector of Broadway in Worcestershire, who became the English chaplain at Munich in 1866. He and his wife, arriving with two daughters, aged five and two, had been at once drawn into the Sickerts' circle.[133] The Sickerts also paid visits to *Laufzorn*, the Rankes' country house. The place, a former hunting lodge of the kings of Bavaria, was supposedly haunted, which may have added to the excitement of the visits.[134] But the main pleasure for the children was in playing in the huge echoing banqueting room,

which contained an improvised swing – a long plank on which several children could sit astride while it was swung, fearfully, lengthways. As Helena recalled, 'Every child had to cling tightly to the one in front and the exercise was performed to a chorus of "*Hutsche-Kutscher-Genung!*" the last word being shouted as loud and as long as possible.' There was also a big hay barn where the children could jump from the rafters into the hay below.[135]

Walter delighted in such games and in such company. He was extremely sociable and made friends easily.[136] Surrounded by boys at home, he seems to have enjoyed being surrounded by girls elsewhere. At the age of six he had managed to become engaged both to one of Dr Ranke's daughters and to the eldest of Mr Fowler's girls. 'It never occurred to me,' he remarked, when looking back on the arrangement, 'that there was any inconsistency.' It was an attitude of mind that he preserved in his relations with the female sex throughout his life.[137]

The Bavarian summers were months of almost idyllic pleasure for the children. It was in the Starnbergersee that Walter discovered the delights of swimming, and there, too, that he learnt to fish.[138] Initially, he had merely tied a piece of bread to a length of string and watched the fishes nibble, but Mr Fowler, steeped in the sporting traditions of the Anglican clergy, showed him – much to Eleanor's dismay – how to bait a hook. Death, however, seems to have intrigued Walter. One holiday game involved the construction of a miniature cemetery from pebbles and moss and twigs.[139] In Walter's memory these summers took on the hues of a golden age. He would look back to them as a time of peace, calm, and certainty. 'When I used to play by mill streams in Bavaria [and] listened to my mother sing the Schoener Muller of Schubert,' he recalled, 'I thought it would always be like that.'

The extraordinary beauty of the Bavarian countryside in early summer – the greenness of the foliage, the clearness of the light, the profusion of flowers – made a profound and lasting impression on all the Sickert children. Walter, though he became the great artist of urban life and urban architecture, retained always a flickering sense that 'woods & lakes & brooks' were 'the nicest things in the world'.[140] It was the quality of light that made them special: the fall of broken sunshine through the overarching canopy of leaves. 'I think,' he declared, 'the loveliest thing in Nature is a sous-bois.'[141] Even as a child he sought to express his admiration in art. From the age of five he wanted to paint such verdant, sun-dappled scenes. It became one of

the recurrent desires of his working life – recurrent, in part, because it was never achieved.[142]

In all the Sickert children's games and activities Walter took the lead. Although Mrs Sickert maintained a clear structure of kindly authority, she rarely attempted any interference between her off-spring, and would not countenance 'tale bearing'. It was her principle that they should all learn to live together.[143] This was a situation that rather suited Walter, who was 'not only the eldest, but by far the cleverest', and the most energetic of the siblings.[144] Robert was a fretful child, Bernhard a fractious one, and Helena too young to exert her own considerable powers.[145] From the outset, Walter imposed his will upon them all, getting his own way either by force of character or by guile – though he was not above climbing out of his cot in the nursery to pull his sister's hair if he felt the occasion warranted.[146] But, as Helena admitted, even at this young age 'he was able to infuse so much charm into life', and to make 'our pursuits so interesting', that 'we were generally his willing slaves'.[147] It became one of Mrs Sickert's recurrent complaints that none of the siblings was able to 'resist' Walter, an indication – as Helena noted – that not all his activities were agreeable to authority. Walter, however, was a fickle leader, with no sense of responsibility to his followers. His restless intelligence needed the stimulation of constant change. For his siblings, the 'tragedy' came – and came frequently – when 'the magician suddenly took flight to some other adventure and the one which had seemed so entrancing, while [Walter] led it, turned to folly in the grey morning after'.[148]

From a very young age Walter was regarded as being separate from and above his younger brothers. The phrase 'Walter and the boys' was a common and early family coinage.[149] He enjoyed a privileged position as the eldest child. In the evenings he alone was allowed to sit up with his parents, not to supper, but at the supper table.[150] Oswald Sickert's long working hours and occasional absences encouraged Walter to develop a sense almost of responsibility towards his mother. In later years he would describe how, during his Munich childhood, he was 'for many years' her 'only rational companion'.[151] He alone amongst his siblings established a bond with his father. The other children were slightly frightened of 'Papa'. It seemed that he never spoke to them unless it was to give an order or to make some disparaging comment.[152] But then he did not speak very much to anyone. He

was extremely taciturn and reserved by nature.[153] Walter, however, he did talk to – after his own fashion. The trip to London had fostered relations between them. Walter always held dear the memory of his father's kindly face looking down at him as he sank under the anaesthetic before the operation – a perhaps rare intimation of tenderness from his diffident parent.[154] It was with Walter that Oswald Sickert took his daily walk on the Theresienwiese.[155] And he impressed his son with his few words. He had, as Walter recorded, 'a wide critical comprehension'. And though he was apt to judge himself as 'coldly as he did everything else', there seems to have been an edge of wit to his verdicts.[156] Many years later, when reading Heine, Sickert was struck by the similarities between the poet's self-deflating irony and his father's own 'expressions & attitude of spirit'. They came, he noted, from the same northern, Baltic world.[157]

Even as a child, Walter was interested in his father's work – his paintings and, more particularly, his drawings. The arrival at 4 Kleestrasse of the *Fliegende Blätter* on Thursday evenings at supper time was 'an event' in Walter's week, and not merely because he was presented with the paper wrapper to wear as a cap. He was interested to hear his father's comments on the reproduction of the wood engravings. And he liked to look at the pictures. Many of the images lived with him throughout his life.* And although it was perhaps the comedy of the situations depicted that provided the initial attraction, he also imbibed an understanding of technique and an appreciation of how scenes of everyday life could be rendered in art. The quality of work in the paper was extremely high and the variety instructive. When he came to review the artistic masters of his Munich childhood Sickert singled out the work of Wilhelm Diez, Wilhelm Busch, and particularly Adolf Oberlander, whom he praised for his 'frankness' and his genius for rendering scenes 'in terms of limpid light, and shade'.[158] The set of bound copies of the *Fliegende Blätter* became part of the Sickert family library and Walter had plenty of opportunities to refresh his memory and refine his knowledge of its artists, but the

* 'I remember an illustration in the *Fliegende Blätter* in the early sixties in which was depicted a little girl guiding her blind grandmother. Finding the road rather even, and therefore tedious, the child from time to time feigned an obstacle, a brick or stone, and said, "Granny, jump," which the old lady obediently did. When someone remonstrated with the child, she answered, "My grandmother is mine; I may do what I choose with her."' 'The Polish Rider', *New Age* (23 June 1910).

foundation of his appreciation and understanding was laid in his early childhood.[159]

During the summer of 1866 the anxieties that Oswald and Eleanor had felt about the political situation in Europe were confirmed. The Prussian Chancellor, Bismarck, having carefully prepared the ground, engineered a dispute with Austria as a pretext for laying claim to Holstein. In what became known as the Seven Weeks War, the Prussians decisively defeated their former allies and their associates (nine German states, including Bavaria, had sided with the Austrians). In August, a peace treaty was signed at Prague giving Prussia full control of both Schleswig and Holstein. A new German constitution was established, and it was decreed that all citizens of Schleswig-Holstein would become naturalized Prussians in October of the following year. Oswald Sickert was concerned at the effect this might have on his young family. He did not wish his sons to be liable at some future date to conscription into the Prussian army (and he was anxious, too, that they should not become what he called 'Beer-swilling Bavarians').[160] The idea of moving to England took serious hold. It was, however, an operation that required some planning.

Walter, in the meantime, began attending a local school, and his brothers soon followed him. It was a huge, impersonal place. Each class had between fifty and eighty boys, and pupils were drawn from all backgrounds. Robert found the noise and the number of boys altogether too much, but Walter remained unfazed. He got on 'very nicely', his mother reported: 'He does not learn much, they do nothing but German & reckoning and these public schools are so large that the bright ones always have to keep pace with the slow ones.'[161] Walter, in his mother's informed – if not unbiased – opinion, was very definitely one of 'the bright ones'.

By November 1867 the Sickerts' plans for moving to England were well advanced. Anne Sheepshanks had given her blessing to the scheme. The Sickerts left Munich the following spring. Walter does not appear to have considered it a deracination. Although in the anti-German decades of the twentieth century he always enjoyed the shock that could be produced by announcing to an English audience that he was a 'Münchener Kind'l', he never thought of himself as a German or a Bavarian.[162] He retained a passing enjoyment of German literature and relish for the tricks of the German language.[163] But these were surface pleasures; they left very little mark on his character. Duncan

Grant, who came to know Sickert well, considered that there was 'very little of the German' in his make-up.[164] Sickert himself admitted only to having 'a certain German quality, which is called in German *sächlich* – devoted to things, ideas, etc. – to the possible disadvantage of people', a quality by which he excused his often disparaging critical comments upon the work of his friends.[165] But while he certainly did possess this cool, critical, northern trait, he was more likely to have inherited it from his father than to have imbibed it amidst the hurly-burly of the Munich *Volksschule*.

The Sickerts, on leaving Munich, did not go at once to England. They passed a long summer at Dieppe. It was a happy interlude. Walter was even enrolled briefly at the Collège du Dieppe.[166] He exchanged German for French. If he did not have an ear for music he had one for languages. Learning by mimicry rather than book study, his accent ran ahead of his understanding. He would pick up whole passages of French speech and recite them perfectly, convincing Frenchmen that he was a young compatriot. The disadvantage of this trick only came when they answered him and he was unable either to understand or to reply.[167] The experience of being lost for words was a new one to him.

II

A NEW HOME

My strongest memories of Walter as a boy are of his immense energy
& the variety & resourcefulness of his interests.
(Helena Sickert)

At the end of the summer of 1868 the Sickerts crossed the Channel
and settled into a new home at 3 Windsor Terrace, Goldington Road,
Bedford.[1] The choice of Bedford was not an obvious one. There were
no ties of family or existing friendship to draw them to this small but
prosperous county town.[2] There was no local art society to attract
Oswald Sickert, and no illustrated satirical magazine to employ him.
The recorded reason for the move was the number of excellent schools
in the town. The five establishments endowed by the prosperous
'Harper Charity' had made Bedford a pedagogic centre with a staple
production, according to one local guide, of 'educated juvenile human-
ity'.[3] Walter and his two brothers were enrolled at the local free school.[4]
But there was, too, perhaps some general principle of economy behind
the choice: Bedford was less expensive than London.

Although Mrs Sickert's allowance was increased to compensate for
Oswald's loss of salary in resigning from the *Fliegende Blätter*, the family
was still relatively 'poor'. The three-storey house in Windsor Terrace
cost just £50 a year, and came fully stocked with a great deal of 'mostly
hideous' furniture, built – as Helena remembered it – 'to withstand
the onslaughts of family life'. There were huge pier glasses, 'a *chiffonier*
with a marble top and curly-wiggly fronts', and a sofa with three
humps, which was soon dubbed 'the camel' and upon which it was
impossible to lie with any degree of comfort. There was also a mahog-
any dinner table around which the family sat on chairs 'with backs
carved to represent swans'.[5] But if Bedford was economical, that was
all that could be said for it.

The town was not a success for the Sickerts. Coming from an international centre of music and art to the chill, provincial atmosphere of Middle England was a dispiriting experience. Mr and Mrs Sickert were 'woefully depressed'.[6] Their German maid, whom they had brought with them, was appalled. She took an immediate dislike to the place. She abhorred the house's dirty coal grates and ranges, 'accustomed as she was to [the] sweet wood ash' of Bavaria. And she complained at the poor quality of the local beer.[7] If the beer was bad, the water was worse. Almost as soon as the Sickerts arrived an epidemic of typhoid broke out in the town.[8] It at once began to work its way through the family. The boys had barely started at their new school when they had to be removed. Walter soon fell ill. Mrs Sickert very nearly died.[9] Only Oswald Sickert and Robert escaped the worst of it. Mrs Stanley, a family friend from Munich days, came to help with the children during the period of Ellen's illness and convalescence. She was an 'adored' surrogate – vivacious and amusing. She would delight the children with her invented stories, one of which concerned the fantastical exploits of the 'Black Bull of Holloway' (probably Sickert's first introduction to the artistic possibilities of that North London suburb). Mrs Stanley's only fault was her kindness. She was apt to spoil her charges, and the young Sickerts, doubtless led – as they were in all else – by Walter, took advantage of her.[10]

Perhaps to remove his influence, Walter, as soon as he had recovered sufficiently from his illness, was sent, not back to his Bedford day school, but to a small boarding prep school at Reading.[11] It was yet another instance of his being singled out for special treatment.[12] Anne Sheepshanks lived nearby, but the proximity must have seemed a cruel jest to the 8-year-old Walter. He felt banished from the comforts of home life. His memories of the school were coloured with Dickensian horror. Many years later he told Virginia Woolf how the place was run by a 'drunken old woman' who, amongst her outrages, once beat a boy who had broken his arm while – as he put it – 'we thirty little wretches lay there cowed'.[13] The headmistress clearly took pleasure in such acts of cruelty, for it became one of Sickert's verbal tics, when undertaking some disagreeable task, to remark, 'And "what is more", as my horrible old schoolmistress in Reading used to say, "I like it".'[14] He was very unhappy,[15] and seems to have tried to project himself back to the lost paradise of Kleestrasse, writing home what his mother described as 'such affectionate letters in such vile German'.[16] In a

delicious break from the tedious (and fattening) regimen of 'bread
and butter and sky blue', he would go for Sunday lunch to his great
aunt.* It was at Anne Sheepshanks' table that he developed a pre-
cocious and enduring taste for jugged hare.[17] But his readiest conso-
lation came from work. As Mrs Sickert noted, despite his uneasiness
of temper, he was 'so fond of study' and showed none of the 'signs
of idleness' that his two younger brothers were already beginning to
evince. Even at the age of nine Walter was 'all ambition and energy'
– blessed with 'a most clear head and accurate memory'.[18]

The Sickerts persevered at Bedford for a year. But the shock of the
typhoid epidemic seems to have convinced them that it was not a
suitable place to raise a family. In 1869, after consultation with Anne
Sheepshanks, it was decided that they should move up to London.[19]
They fixed upon the modestly fashionable – and discreetly 'artistic' –
quarter of Notting Hill, just across the way from the altogether grander,
and more obviously artistic, quarter of Holland Park. Miss Sheepshanks
found for them a little half-stucco-fronted house at 18 Hanover Terrace
(now Lansdowne Walk), facing on to the communal gardens. It had
been built, along with most of the others in the area, in the 1840s
and was both slightly smaller and slightly more expensive than their
Bedford home.[20] There was an attic storey, and a basement, and two
decidedly narrow main floors. Living arrangements were cramped.
Walter and his two brothers had their bedrooms in the attic. Mr Sickert
used one of the first-floor rooms as a studio, while the family 'lived,
worked, ate and played' in the small red-flock-wallpapered dining
room.[21]

By the time the Sickerts left Bedford, the deficiencies of the Reading
boarding school were proving impossible to ignore, and Walter made
the move to London along with the rest of the family. The relocation
was a happy one for all. The Sickerts found old friends and connec-
tions. Their house became a sociable and lively place. The confraternity
of painters came forward to welcome Oswald, among them several
artists whom he had known from his days at Altona, Munich, and Paris.
The sculptor Onslow Ford had worked at Munich and had married a
friend of the Sickerts there.[22] Frederic Burton, a student at Munich in
the 1850s and now a successful and fashionable practitioner, called
on the family. (Oswald was shocked, on entering the room, to discover

* 'Sky blue' was a slang term for bread-and-milk.

one of his sons – almost certainly Walter – showing Burton through a bound volume of the *Fliegende Blätter*, pointing out the paternal drawings.)[23] Hugh Carter, an artist who had spent time at Altona and married a girl from Hamburg, turned out to be a near neighbour at 12 Clarendon Road.[24] The Sheepshanks name carried a weight and prestige in London that it rather lacked in provincial Bedford. In the capital, the achievements of the Revd Richard Sheepshanks and the munificence of his brother John were established facts. And this family fame reflected faintly on the Sickerts, giving them both a glow of glamour and – more importantly – a 'social position'.[25] Although Anne Sheepshanks was living out of London, the many friends she had in town provided a supportive structure for the young family. It was almost certainly through the influence of her friends the de Morgans that, in October 1870, Walter was enrolled (after a brief stint at a London 'Dower School') at University College School in Gower Street.[26]

Mrs Sickert conformed to what she considered were the established modes of English life. She took the children to church on Sunday mornings, walking them off to St Thomas', Paddington, a little iron church off Westbourne Grove.[27] It was a temporary structure, but the vicar, the Revd John Alexander Jacob, had a reputation as a preacher (his *Building in Silence, and Other Sermons* was published by Macmillan in 1875). Oswald Sickert did not attend, although, as a 'tolerant minded agnostic', he accompanied the family as far as the corner nearest the church and often met them coming out. The young Sickerts' own involvement with proceedings was only slightly more engaged. Although they learnt the 'Collect for the day' and were taught their catechism by Mrs Sickert, their approach was so formal that, when asked 'What is your name?' they were liable to reply, 'N or M as the case may be'.[28] Walter showed no inclination towards the spiritual side of life. But churchgoing did have its social compensations. The Carters attended St Thomas'; and the Sickerts as they trooped up Holland Walk would also encounter the Raleighs, a lively family of one boy and five girls, children of the Revd Alexander Raleigh, who lived nearby.[29]

The move to England had a particular impact upon Oswald Sickert's position. From being a cosmopolitan figure in a cosmopolitan milieu, he found himself a foreigner in an essentially English one. English, though he spoke it perfectly, was not his native – or even his second – tongue. Moreover, he no longer had a job or an income. Mrs Sickert

wanted to make over to him the allowance that she received, but the terms of her trust made that impossible. Instead she drew her cheque every month and then handed over the cash to her husband, 'so that she might have the pleasure of asking him for it, bit by bit'. Helena vividly recalled the playing out of this little charade: 'It was her luxury to pretend he gave it to her, and his eyes would smile at her as he drew out his purse and asked, "Now how much must I give you, extravagant woman?" And she would say humbly, "Well, Owlie, I must get some serge for the little ones' suits, and a new hat for Nell, and I want to bring back some fish. Will fifteen shillings be too much?" So she would get a pound and think how generous he was.'[30] The fiction was a happy one but it could not quite obscure Oswald's new, dependent status.

There were, in theory, some advantages to his new condition. Freed from the necessity of hackwork, he could rededicate himself exclusively to painting. London was a not unpropitious place for such a project. Compared to Munich, where the Kunstverein had exercised a virtual monopoly on exhibitions, there were several exhibiting groups and even a few commercial art galleries at which he could show. There were art collectors too. The example of John Sheepshanks had inspired several imitators, as the wealth generated by Britain's ever expanding industrial and commercial imperium sought expression and dignity through art. With such patronage, artists were beginning to grow rich. The new mansions of Holland Park, with their lofty studio-rooms, were monuments to the fortunes being made in paint.[31]

Although Oswald had a painting room in the house, he soon took on a separate studio in Soho Square as well. Soho was some distance from Notting Hill, but it was close to Gower Street, and Oswald would walk the three and a half miles to UCS each morning with his eldest son. The link between them was reinforced. Walter would show off to his father. One of the challenges he undertook was to learn by heart the exotic polysyllabic name of the Indian Maharaja whose tombstone stood in the churchyard they passed each day. (Over seventy years later Sickert was still able to rattle off the name: Maharaja Meerzaram Guahahapaje Raz Parea Maneramapam Murcher, KCSI.)[32] He was initiated, too, into his father's professional world, accompanying him to buy materials at Cornelissen, the artists' supply shop in Bloomsbury.[33] The daily excursions into town, however, also made Walter aware of his father's semi-alien status in their new home. Whenever

they passed the shop of the friendly local cobbler, the man, 'thinking in the English way, that it was necessary to shout and explain things to all foreigners, however well they spoke English', would point at his display of porpoise-hide bootlaces and 'roar at the top of his voice, "Papooze's 'ide!"'[34] Perhaps it was the embarrassment of this daily performance that first inspired the slight note of protectiveness that came to colour Sickert's view of his father – a protectiveness always mingled with real admiration, piety, and affection.[35]

The family maintained a European perspective. From the summer of 1870 onwards the unfolding drama of the Franco-Prussian war consumed their attention. Walter followed the rapid succession of French defeats in the pages of the *Illustrated London News*. It was a conflict that touched the Sickerts with painful closeness, setting familiar Germany against beloved France. Their sympathies lay entirely with the French. It was torture to Mrs Sickert when Dieppe was occupied by Prussian troops in December, and for Oswald when Paris fell at the beginning of the following year. French refugees became a feature of London life. Amongst the self-imposed exiles were several artists: Claude Monet came, and Camille Pissarro. The general exodus also brought a German painter – Otto Scholderer. After training at the Academy in Frankfurt, Scholderer had gone to Paris in 1857 and enrolled at the atelier of Lecoq de Boisbaudran. There he came to know Henri Fantin-Latour, Alphonse Legros, and other members of the Parisian studio world. He returned to Paris at the end of the 1860s, and in 1870 Fantin-Latour, whose great friend he had become, included his diffident red-bearded figure, standing behind Edouard Manet, in the group portrait, the *Atelier des Batignolles*. It is not clear whether he already knew Oswald Sickert before he came to London – he never studied at Munich, nor did the two men coincide at Paris – but they soon became friends. They had a shared love of music, and would often play together, either at Hanover Terrace or at the Scholderers' house at Putney.[36]

Such gatherings had a comfortably familiar air. In more 'English' society – though the Sickerts found many ready friends – there always remained the faint hint of ambiguity about their exact position. The Sheepshanks connection, so beneficial in all other respects, carried with it the taint of Mrs Sickert's illegitimate origins – even if the details of those origins were not known to all and were often confused by those who were aware of them. (At least one friend supposed that

Mrs Sickert was the natural daughter of John, rather than Richard, Sheepshanks.[37]) Amongst most members of the 'artistic' world Mrs Sickert's position would have counted for little, but on the broader social plane the possibility of affront and insult – if remote – could never be entirely forgotten. There clung, too, to the family and to the family home, a slight but distinct sense of difference – of foreignness. The Sickerts played German music, sang German songs, and had German books on their shelves.[38] They preserved the Munich habit of eating their 'dinner' at noon, and having only a light 'tea' or 'supper' in the evening – a fact that occasionally caused the children embarrassment when English visitors called.[39] The family, according with Continental custom, celebrated Christmas on the night of Christmas Eve, and did so in what outsiders considered a 'high Germanic' fashion.[40] These marks of otherness were small, but they were sufficient to give the Sickerts both a sense of closeness amongst themselves and of detachment from the world they found themselves in.

Of these two impulses, 'detachment' was the one that touched Walter most strongly. It became his mark as both a person and a painter. And though essentially an innate trait of his character, the tensions of his London childhood sharpened it and gave it direction. Walter did not retreat into his own world. From the start he engaged enthusiastically with English life and English ways. 'Nobody,' it was later said of him, 'was more English.' But his understanding of Englishness was gained from the outside. It was – as one English friend noted – 'his northern foreign blood' that 'afforded him just the requisite impetus to understand especially well this country and its ways'.[41]

The upheaval of the Franco-Prussian War encouraged the Sickerts to spend their holidays in England. In the summer of 1870, Mr Sickert took Walter and the other children to the seaside at Lowestoft. While he sketched and painted, the boys flew kites and built sandcastles. Walter was much impressed too by the sight of a drowned man, and much excited by the sight of the lovely Mrs Swears, the beauty of the season, who would drive up and down the front in her carriage, her long hair streaming in the wind.[42] In the following years they visited Ilfracombe and Harwich.[43]

Mrs Sickert did not accompany the family to Lowestoft, perhaps because she was pregnant. At the beginning of 1871, Walter got a new brother. Born on 14 February, he was duly christened Oswald Valentine. To simplify the logistics of family life, Walter was taken out

of UCS and sent, along with Robert and Bernhard, to a new school close to Hanover Terrace. The Bayswater Collegiate School was situated at 'Chepstow Lodge', 1 Pembridge Villas, on the corner with Chepstow Place, four doors down (as Sickert liked to point out) from the celebrated Victorian genre painter, W. P. Frith. It was run by William T. Hunt, a young man in his early thirties with progressive ideas.[44]

Helena's chief recollection of her brothers' schooling was of them being chivvied off by their mother in the morning and then coming home in the afternoon without the books necessary for their prep. In the case of Robert and Bernhard such oversights tended to be the result of inattention; both brothers were what was called 'dreamy'. If Walter forgot his books, however, it was probably because he was thinking of so many other things. Although he hated organized games, he was always 'prodigiously energetic', busy with something outside the school curriculum – acting, drawing, even learning Japanese. There were five Japanese boys at the school, sent to England by their feudal clan – Hachizuka – to study English. (All subsequently rose to positions of prominence in Japan.) Walter adopted them, and brought them back to Hanover Terrace. 'We liked them better than the English boys,' Helena recalled. She was particularly fond of Hamaguchi Shintaro – 'a delightful little fellow' with 'exquisite manners' who could play six games of chess at once.[45] But it is uncertain how long the close connection lasted. Walter's enthusiasms for people were not always sustained. Though 'very sociable and charming', he had – as his sister put it – 'a way of shedding acquaintances and even friends'. Sometimes an actual quarrel precipitated the break, but more often there was merely a removal of favour, as his interest shifted on to somebody – or something – new. To the rejected, this exclusion from the charmed radiance of Walter's friendship tended to come as a horrid and unexpected blow, and it was often left to Mrs Sickert to 'comfort' the unfortunates and excuse her son's fickleness.[46]

Many years later, the novelist Hugh Walpole, describing Sickert's character, remarked, '[he] isolates himself utterly from everybody'. It was not that he was 'hermit like or scornful of life'. Far from it: he was 'eager to learn anything about life at all . . . but his personality is so entirely of its own and so distinctive that he makes a world of his own'. And it is clear that even in childhood these traits were evident. While a person stood in some relation to Sickert's current interest they enjoyed the favour of access to his world. But his interests changed

often. As Walpole noted, there was no limit to them: 'morals, families, personal habits, colours, games'.[47] In 1904 Sickert explained to a female friend that he found absolutely everything 'absorbingly interesting', that there was 'no end to the wonderful delights of life'. She felt that he was telling the truth, but considered that 'such delightful fluency and ease [could] only come either from a dead heart or from a love, like God's, that had done with personality and material things'.[48]

Walter, as a young child, did give some hints of a capacity for universal love. His mother reported that, while at Munich, he had asked her one night, before saying his prayers, 'Mama, may I say God Bless all the world? I should like to say it because it would be kind.'[49] But it seems more probable that his extraordinary relish for the incidents of life was another aspect of his detachment. A 'dead heart' is perhaps an unduly pejorative phrase. Although Sickert's behaviour and his pronouncements, as both a child and a man, could sometimes seem unfeeling, even callous in their unflinching objectivity, there was something grand and invigorating about his enthusiasms, his openness to all sides of life, his refusal to accept hierarchies or to make judgements. He infected others, too, with verve. And though he might abandon his friends, many of them remained loyal to him and his memory even after he had moved on.

Walter's schoolboy pursuits were legion. Inspired by the Prussians' defeat of the Emperor Napoleon III, he created a variant of chess, called Sedan, in which the king could be taken.[50] He also conceived a fascinated interest in the case of the Tichborne Claimant and followed its long unwinding closely. Roger Charles Doughty Tichborne, the heir presumptive to the Tichborne Estates at Alresford, Hampshire, had sailed from Rio de Janeiro in 1854 at the age of twenty-five, in a ship that was lost at sea. No survivors were ever found. After the death of his father, Sir James, his younger brother, Alfred, assumed the title and estates, but died in 1866, leaving only an infant son. The old dowager Lady Tichborne, however, had never reconciled herself to the loss of her eldest son, and began to advertise abroad for news of his fate, hopeful that he had perhaps escaped the wreck. She was thrilled to receive word from a man in Australia who claimed to be her long-lost boy. The man set sail for England at the end of 1866 and asserted his claim to be the Tichborne heir. In 1867 he was received by Lady Tichborne, who was living in Paris, and was apparently recognized by her as her son, even though there was no obvious physical resem-

blance, the claimant being a very stout man weighing some twenty stone and Roger Tichborne always having been conspicuously thin. His claim, unsurprisingly, was disputed by other members of the Tichborne family, and the matter went to court.

The trial was long-drawn-out and sensational, with its cast of minor aristocrats, duplicitous servants, old sea dogs, and colonial adventurers. The fat, bewhiskered, rather dignified claimant was the star of the show. Minutely cross-examined about the facts of his supposed early life by a defence intent on proving that he was not Roger Tichborne at all, but Arthur Orton, the opportunistic emigrant son of a Wapping butcher who, anxious to escape from his debts in Wagga Wagga, had embarked upon a career of profitable deception, he remained unperturbed and unperturbable. Public opinion was sharply divided on the question of his bona fides, and remained divided throughout the trial. As Sickert later wrote: 'We are born believers in or doubters of Sir Roger Charles Doughty Tichborne's identity.' He was a born believer.[51]

His belief took a knock when the case collapsed in March 1871 and the claimant was arrested and charged with 'wilful and corrupt perjury'. But the blow was not conclusive. The born believers held firm. While on bail awaiting trial (the new case was delayed for over a year) the claimant made a triumphal progress across England. In May 1872 he was given a hero's welcome and a town parade at Southampton, not far from Alresford. When the second trial finally took place – it ran from February 1873 to February 1874 – the claimant was found guilty and sentenced to fourteen years' penal servitude. Even so, Sickert refused to relinquish his beliefs completely. 'Are we even now quite sure,' he wrote almost sixty years after the event, 'of the rights in the matter of Roger Charles Doughty Tichborne?'[52] The case never lost its appeal for him. The story of a relative disappearing into Australia, perhaps one day to return, exciting enough in itself, had an additional resonance for the grandson of Eleanor Henry.

Walter also sought out drama in more conventional settings. He became stage-struck, or Bard-struck. At school they would read Shakespeare with Mr Hunt in the gardens of Pembridge Square. Walter soon purchased his own Globe edition of the works. He was taken by his parents to see Samuel Phelps, the great Shakespearean actor of the day, playing Shylock, Falstaff, Wolsey, Macbeth (and Sir Peter Teazle), and – enraptured by his performances – soon learnt to imitate his manner.[53]

But always alongside these other enthusiasms ran his constant interest in art. Throughout his schooldays, his sister recalled, 'his most abiding pleasure was drawing & painting'. The 'very little pocket money' he received from his father was put towards buying art materials.[54] He also looked at pictures. He pored over the popular illustrated weeklies, drinking in the dramatic reportage of the *Illustrated London News*, the humorous diversions of *Punch*, and the educational diet of the *Penny Magazine*.[55] He began to be taken to public galleries, and he was excited by what he saw. 'It is natural to all ages,' he later remarked, 'to like the narrative picture, and I fancy, if we spoke the truth, and our memories are clear enough, that we liked at first the narrative picture in the proportion that it can be said to be lurid.' The young Walter's 'uninfluenced interest' was first captured at the South Kensington Museum by John 'Mad' Martin's swirling, almost cinematic vision of *Belshazzar's Feast* and by George Cruikshank's melodramatic series of prints, *The Bottle*, depicting the awful and inevitable effects of drink upon a Victorian family.[56] From the early 1870s onwards, Walter also went with his father to the regular winter loan-exhibitions held in the Royal Academy's gallery at Burlington House.[57] There he was introduced to the works of the old masters. He 'loved' them from the first, perhaps not least because they, too, were often 'narrative pictures' and sometimes 'lurid'.[58]

Almost unconsciously Walter absorbed many of the practical and professional concerns of picture making. At home and elsewhere they were constant elements in the life around him. He spent time too in the studios of his father's friends. He even posed for a history painting, appearing as a young – and rather gawky – Nelson, in George William Joy's picture, *Thirty Years Before Trafalgar*.[59]

In 1873 Mrs Sickert gave birth to her sixth and last child, another boy. He was christened Leonard but was known in the family as Leo.[60] Walter, however, was far removed from the world of the nursery. He was growing up. In the summer of 1874 the family went to the North Devon village of Mortehoe, renting a cottage from the local publican, Mr Conibear. It was a halcyon summer for Walter. The place was a 'real favourite'. Several family friends joined them there. Walter helped on the farm, learning to cut and bind wheat, and how to drive a wagon through a gate. He made friends with the Conibear children. One day

he discovered an octopus washed up on the seashore and, putting it on to a slate, took it up the hill to show to Professor T. H. Huxley, who was also staying in the village for the summer. The eminent scientist took at once to the inquisitive 14-year-old, and they became friends.[61]

An interest in cephalopods was not Walter's only claim to precocity. He would rise early to help the milkmaids with their work – or, rather, to distract them. Years later, when writing to Nina Hamnett, he told her, 'If you go to Barnstaple have look at Mortehoe, which I think adorable, probably because I used to make love to the milkmaids there when I was 14.'[62] Although his love-making may have been no more than flirtation, it is possible that it went further.* The suggestion is easy enough to credit. Walter's excitement at the holiday is palpable. As early as the following March he was writing to Mr Conibear informing him that his parents would *definitely* be taking the house again the following summer, and enclosing two sketches – one of Mortehoe parish church, the other of a rocking horse recently given to Oswald Valentine.[63]

The North Devon headland had charms not only for Walter. His father was inspired by the rugged coastal landscape. One of his paintings, worked up from sketches made that summer, was exhibited at the Royal Academy the following year. It was Oswald Sickert's first exposure at Burlington House, and built upon his showings at the New Water Colour Society, the Dudley Gallery, and Boydell's 'Shakespeare Gallery' in Pall Mall.[64] The achievement gave Walter a first, vicarious, savour of the Academy's extraordinary power as the arbiter of contemporary taste and artistic prestige. It was a pungent taste and one that both attracted and repelled him.

* An echo of his happy time with the milkmaids at Mortehoe perhaps lingers in his 1910 rhapsody upon the glorious physical presence of Juno, in Raphael's *The Council of the Gods* at the Villa Farnesiana, Rome, with her 'fleshy lustrous face, like one of Rowlandson's wenches'; her hands, he remarks approvingly, 'are gross, material hands, the hands, let us say, of a milkmaid' ('Idealism', *New Age*, 12 May 1910). Sickert's friend at Mortehoe, the farmer's son, David Smith, certainly did get into trouble for getting one of the local farm girls pregnant (information from Mr Conibear's great-grandson, George Gammon).

III

L'ENFANT TERRIBLE

I think I could recommend you a boy.
(G. F. Maclear to Reginald Poole)

Within the family, Walter's spirit and his domination of his younger brothers were beginning to cause some anxiety. It was decided that he needed a more challenging environment than could be provided by the little school in Pembridge Villas and that he needed to be separated from his brothers, or, rather, they needed to be separated from him. (Helena, whose health was causing some concern, had already been sent away to school at Miss Slee's now somewhat reduced establishment in Dieppe.[1]) After the matter had been inquired into with obvious thoroughness, the boys were divided up between three of London's leading public schools. Robert went to UCS, and Bernhard to the City of London School (where it was hoped that the formidable Headmaster, Dr Abbot, would 'cure him of laziness'). Walter was enrolled at King's College School. He arrived – aged fifteen – for the autumn term of 1875.[2]

The school was then housed in the basement of the east enfilade of Somerset House, next to King's College itself. It was essentially a day school, though a few of the 550 pupils 'boarded' at the houses of the married masters. The main entrance was on the Strand, where, opposite the gates of St Mary-le-Strand, a broad flight of steps ran down to an inaptly named concrete 'playground' in which no games were ever played. Although the school dining room looked out over the river, and at least some of the classrooms were large high-ceilinged spaces level with the street, the principal flavour was one of subterranean gloom and confinement. The place was sometimes referred to, with as much truth as humour, as 'the dungeon on the Strand'[3]. The first – and defining – feature of the school was a long, narrow, and

dimly lit vaulted corridor off which most of the classrooms led. Dark, even during summer, it was lit by a line of gas lamps that lent their own particular aroma to the inevitable institutional scents of floor polish, cabbage, and unwashed boy. From 11.15 to 11.30 a.m. and from 1 to 1.30 p.m., and at the end of the day's work, the corridor was generally 'a pandemonium of yelling, shouting and singing'. Some of the bigger and 'lustier fellows' of the Lower School would sometimes amuse themselves by linking arms and rushing down the passage, 'to the extreme discomfort of those who failed to get out of their way in time'.[4] For Walter, however, the site was fraught with positive familial associations. It was in the basements of Somerset House that Richard Sheepshanks had carried out his comparative measurements to establish the new official yard.

At King's College School in the 1870s the syllabus was rigorously limited. In the 'Classical Division' to which Sickert belonged the concentration was on Latin and Greek. The study of these was supplemented by courses in mathematics, English literature, French, and divinity. German and drawing were offered as optional extras, and a 'course of lectures on some branch of experimental science' was provided as an afterthought.* It was a system that Sickert came to appreciate. Many years later, when visiting St Felix School, Southwold in the late 1920s to give a lecture on art, he was amazed at the number of subjects being taught. There were at least nine different ones included in the weekly timetable. 'Tiens!' he exclaimed. 'Three subjects are enough. Latin, English and Mathematics. Then the pupils may leave school knowing a *little* about *something* which would give them confidence which is so necessary for their future studies, instead of *nothing* about anything at all.'[5]

The school, presided over by the long-serving Revd G. F. Maclear, had established an excellent academic reputation. There were many good and several excellent teachers. Sickert's form master was the genial Dr Robert Belcher. Walter soon began to flourish under his tutelage. He already had some grasp of both Latin and Greek, but this deepened under the regime of close reading, 'prose writing', and Greek verse composition. Walter developed a real familiarity with – and enduring love for – the language and literature of classical antiquity. Without

* The 'Modern Division' offered a less rigorously academic approach, with vocational courses in book-keeping and map drawing.

laying claim to being a scholar, he continued to read – and to misquote – the classical authors with relish throughout his life. His particular favourite was the clear-sighted, unsentimental epigrammist Martial.[6]

Sickert, so he claimed, was also 'naturally and from heredity interested in mathematics'. He would work out geometry propositions on his daily walk to school.[7] But it was in the modern languages that he really excelled. His polyglot upbringing (and the fact that most of his contemporaries 'took neither French or German classes very seriously'[8]) gave him ample opportunity to shine. He won the Upper School French Prize in Michaelmas 1876, and the Upper School German Prize the following term. And at the annual prize-giving, at Christmas 1877, he carried off the Vice-Master's German Prize.[9]

Art was not one of the strengths of King's College School. Although the great watercolourist John Sell Cotman had taught drawing at the school in the 1830s, and Dante Gabriel Rossetti had briefly been a pupil, they had left no enduring legacy. Art was not part of the curriculum and could only be taken as an extra option at the extra cost of a guinea a term.[10] There is no evidence to suggest that Walter ever studied it. Not that he needed the structure of formal classes to stimulate his interest. He drew incessantly, and achieved some recognition for his work amongst his schoolfellows. On one memorable occasion when he was caught drawing caricatures in class, the form master, instead of punishing him, framed the confiscated picture.[11]

Class work, it seems, only ever absorbed so much of Walter's attention. He was undaunted by the wider stage of his new school, and soon surrounded himself with new friends, among them the school's leading scholar, Alfred Pollard, and Alfred Kalisch (who became the music critic for the Daily News).[12] Sickert's energy and liveliness were captivating, and so were his emerging good looks. One former classmate recalled that even as a schoolboy he had the glamour that attaches to the 'extremely handsome'.[13] He delighted in doing the unexpected. One of the Japanese boys from Mr Hunt's school had also moved to KCS and Walter greatly surprised and impressed his new schoolmates by addressing him in Japanese.[14]

Amongst his other pranks was a scheme to undercut the school tuck shop by setting up his own doughnut stall at break time. KCS pupils had long been complaining at the quality of the fare provided by Mr Reynolds – the local baker who ran the tuck shop – and at 'the enormous profits' that he made from his monopoly. Like many of

Sickert's later commercial ventures, the doughnut stall was not a financial success and was closed down by the authorities. He sometimes claimed that the scam led to his expulsion from the school, but this was an exaggeration.[15] The headmaster was, on the whole, indulgent of Walter's irregularities.[16] He was mindful perhaps of his contributions to other areas of school life.

Dr Maclear took a particular interest in the end-of-year performances put on as part of the Christmas prize-giving. A mixed programme was presented with scenes not only from Shakespeare and the other English classics but also from Greek, Latin, French, and German dramas – all done in their original languages. Sickert excelled in these. He earned an early fame for his performance in the late-medieval farce *L'Avocat Pathelin*, in which his French was considered to be 'perfect'.[17]

Although divinity was a compulsory subject, and each day began with a fifteen-minute service in chapel, the atmosphere of the school was not markedly religious. Walter got confirmed while he was there, but he treated the whole matter with 'genial cynicism' and, having been rewarded with the gift of a watch, promptly gave up going to church on Sundays with his mother and siblings.[18] It was just one of the ways in which he started to emancipate himself from family life. While Robert and Bernhard retreated home from their respective schools, becoming more dreamy and inward looking, Walter took off in new directions. He made his own friends and 'lived a life of his own'.[19]

He began to explore London. It teemed outside the school gates. Alfred Pollard recalled that to attend KCS was to have it 'daily borne in on one . . . that one [was] a citizen of a great city'.[20] A constant tide of human – and animal – traffic passed before the school and through the triple portal of Temple Bar, Wren's baroque gateway linking the City and the West End – the allied worlds of Business and Pleasure. King's College School stood, albeit with a certain aloofness, in the world of Pleasure. Despite the nearby presence of the Law Courts, the surrounding area had a hazardous reputation. It was thick with public houses and theatres. The Strand was the most notorious thoroughfare in Central London: no respectable woman would walk down it unaccompanied for fear of being mistaken for a prostitute. North of the school lay Covent Garden, and the disreputable courts and alleys around Holywell Street – centre of the second-hand-book and pornography trades.

For the King's College School students the pleasures afforded by the area tended to be rather more innocent. As one former pupil remembered, after school (3 p.m. on most days, but 1 p.m. on Wednesdays, and noon on Saturdays) many boys headed off to eat ices at Gatti's in the Adelaide Gallery, or went to Sainsbury's, 'a chemist close to the school who sold splendid iced soda drinks from a fountain'.[21] Sickert, however, was more adventurous and inquisitive. He was, in the words of one schoolfellow, 'the cat that walked by itself'. 'He didn't care to do our things, he was aloof . . . but he could be wonderfully good company when he was in the mood. Everyone liked to be asked to walk home with him from school. He never invited more than two of us at a time. He knew North London like the back of his hand, he could tell us endless stories about the little streets and byways as we went along and pointed out pictures that we hadn't seen.'[22]

His journey home would often be broken by a prolonged loiter in Wellington Street, before the office windows of *Entr'acte* magazine – a review of the contemporary theatrical and music-hall scene. There he could avidly scrutinize the most recent works of the paper's star artist, Alfred Bryan, that were pinned up for display.[23]

Although he admired Bryan's dashing if rather facile work, and that of several other black-and-white men, his great enthusiasm was for the drawing of Charles Keene. Since 1850, Keene had been one of the leading draughtsmen on *Punch*. His assured but loosely executed cartoons captured the vital flavours of Victorian popular life with unrivalled brio. Better than any of his contemporaries, it was said, he could 'emphasise the absurdity of a City man's hat', suggest the 'twist of a drunkard's coat' or 'an old lady's bombazeen about to pop'. And he did it with a delicacy that often left the viewer in some doubt as to whether it was caricature at all. Keene became Sickert's first artistic hero.

It was an admiration that he shared with a select band of discerning spirits. Amongst his schoolfriends was a young boarder, a Scot called Joseph Crawhall, whose facility at drawing exceeded even Sickert's own. Unlike Sickert, he took Mr Delamotte's optional art classes, and he carried off the Middle School drawing prize in both the Lent 1878 and Summer 1879 terms; he had also exhibited a picture at the Newcastle Arts Association. These were distinctions, however, that counted for little in Sickert's eyes besides the more important fact that his father – Joseph Crawhall Senior – was a friend of Charles Keene's. Mr

Crawhall would even send Keene jokes from time to time, which the artist might transform into cartoons, sending back a drawing by way of thanks. The presence of these Keene originals on the walls of the Crawhall home was, Sickert believed, the reason for young Joseph's advanced abilities. He had enjoyed, as Sickert later put it, 'the advantage of growing up in the most distinguished artistic atmosphere' available in Great Britain in the late 1870s.[24]

Sickert, though he had to rely on the printed reproductions in *Punch*, rather than on originals, steeped himself in the same 'distinguished' atmosphere. Outside the circle of aficionados, of course, Keene's work – though recognized as entertaining – was regarded as anything but distinguished. Keene, to the majority, was no more than a hack cartoonist turning out scenes of vulgar life for a comic weekly, in a style that many considered rather 'rough'.[25] But Sickert – with the example of his own father's career on the *Fliegende Blätter* before him – was not inclined to make conventional distinctions between high and low culture; from the start he considered Keene as an artist.

The attractions of Keene's art to the young Sickert were many. It provided a vivid commentary on the familiar aspects of contemporary life – aspects ignored in most other artworks. From looking at Keene's drawings Sickert also began to understand the secret of composition. He observed the way in which 'a situation' was expressed pictorially by 'the relationship of one figure to another', and how figures needed to be conceived 'as a whole', rather than being mere appendages of their facial expressions.[26] He admired Keene's eye for the small but telling physical detail. In a picture of a lady remonstrating with her gardener, he would point out delightedly how the artist had drawn the gardener's trousers, catching 'the bagginess of the knees', the result of a lifetime's weeding: 'You can see he is a gardener.'[27] A love of Keene led Sickert back to discover his forebears: Leech, Cruikshank, Rowlandson, and Hogarth. Bit by bit he pieced together the extraordinarily vigorous tradition of eighteenth- and nineteenth-century English graphic art, with its abiding delight in 'low life' subjects and suggestive narratives.

In tandem with his enthusiastic study of Keene, Sickert also began to explore the National Gallery. Conveniently placed at the other end of the Strand, in Trafalgar Square, he passed it on his way home from school each day. He 'saturated' himself in the collection, and, through the parade of masterpieces, was able to acquaint himself with the

outline of Western art history from the Renaissance onwards. (He always retained a belief that 'chronological' hanging was the best – indeed the only – way to arrange a major public gallery.[28])

The pictorial diet of Keene and the National Gallery gave Sickert an early understanding of the possibilities of art, one that would have been hard to gain at Bedford, or almost anywhere else. As his father remarked with a touch of envy, 'At your age I had never seen a good painting.'[29] But the actual effect of all this stimulation upon Sickert's own artistic experiments is hard to gauge. Nothing survives. The caricatures that he drew during his school lessons almost certainly reflected his study of Keene, Bryan, and the other popular cartoonists. There is no trace of either *Punch* or the old masters, however, in the small, well-constructed drawing of a girl sitting by a river, done in the summer of 1876 on the family holiday to the island of Fohr, off the Schleswig coast.* And it was the desire to imitate his father's Bavarian sous-bois scenes that led him, the following summer, to take his gouaches to Kensington Gardens in order to try and capture the effects of sunlight falling through trees.[30]

The National Gallery was not the only cultural institution that Sickert began to frequent, nor was Charles Keene the only object of his schoolboy idolatry. Almost immediately opposite the gates of King's College School stood the entrance to the Lyceum Theatre. Since 1871 it had been under the management of Mr and Mrs Bateman. They had taken the theatre as a showcase for the talents of their third daughter, Isobel, and had engaged the 33-year-old and barely known Henry Irving as their leading man. The theatre had a commercial reputation for being 'unlucky', which the early Bateman productions did little to overturn. But – at the end of that first year – Irving persuaded his employers to allow him to mount a production of Leopold Lewis's horror-piece *The Bells*. The play proved an immediate and spectacular success. Irving was raised suddenly to a glorious prominence – and the Lyceum was raised with him. His talent, charisma, and commercial acumen transformed the faltering playhouse into one of the leading venues in London. He came effectively to run the place. It was he who chose the productions, took the title roles, and drew the crowds. His style of acting was something strangely new and different, almost over-

* This of course may be because the picture (now at the Walker Art Gallery, Liverpool), though found in Sickert's studio at his death, was not by his hand.

whelming in its intensity. His readings of the classic parts were often very different from those of theatrical convention, charged with a new sense of psychological truth. But in every role he was recognizably Irving. Whatever the costume, he was a curious and unforgettable figure with his gaunt features, distinctive mannerisms, peculiar pronunciation, and halting gait. But if he commanded attention, he also divided opinion. There were those who carped at his idiosyncrasies, denied his power, and questioned his interpretations. Such dissent, however, merely fired his supporters with greater zeal.[31]

The teenage Sickert became one of the most zealous of his defenders.* He attended the Lyceum with a passionate commitment and found himself drawn into the orbit of fellow enthusiasts. Despite his comparative youth he was taken up by a group of students from the Slade, the art school attached to University College in Gower Street. They would attend Lyceum first nights en bloc and then crowd outside the stage door to cheer Irving to his carriage at the end of the evening. To be part of this excited band was an intoxicating taste of freedom and community.[32]

The gatherings were known as 'rabbles', and they were mythologized even as they were enjoyed. Arthur Kennedy, one of the leaders of the group, recorded their exploits in mock heroic verse. Their attendance of a performance of *Richard III* was celebrated by a parody of William Morris's *Sigurd the Volsung*, beginning,

> The master of masters is Irving, and his lofty roof-trees stand
> In glory of gold and marble, by the river's golden Strand.
> They are high, well-built and glorious, and many doors have they,
> But one door is low-browed and mystic and dim and cloudy and
> grey,
> And over its darkling throat, on the very lintel is writ
> In letters of fire of magic, the name of the Mouth of the Pit. . . .
> A goodly company are they of damsels and lofty men
> And ten are high-born maidens, and fearless knights are ten.
> And there on the steps of the threshold they range in a two fold ring,
> Round a radiant lady, their leader, whose name is a month in spring.

The 'radiant lady' reference was to Margery May, a Slade scholar (and the future Lady Horne), who was the most impassioned devotee.

* In 1877, Samuel Phelps, his previous thespian hero, had died at the age of seventy-four. Sickert walked to Highgate for his funeral (RE, 24).

Amongst the listed assembly of 'fearless knights' Sickert was designated as 'a scholar, well-taught in many a thing,/Who journeyed north to join them, from the College of the King'.[33] By this band, Irving was accounted a deity. When the Sickerts' down-to-earth cook poured cold water on their 'Irving delirium' by remarking, 'After all, Irving's only a man when all's said and done', it came – Walter recalled – 'as a shock to Margery May, and certainly to me'.[34]

In imitation of Irving, Sickert began mounting his own Shake-spearean productions in the holidays. He named his troupe the Hypo-crites, or 'Hyps'. During the summer of 1877, while staying at Newquay, he dragooned his siblings and friends into performing a cut-down version of *Macbeth*. It was a radical open-air production staged in an old quarry. The dramatic effect of the setting, however, was slightly undermined when Walter (in the title role) turned his ankle while making his first entrance down the steep scree – and completed the descent upon his bottom, to the ill-suppressed amuse-ment of the three witches.[35] It was not the sort of thing that happened to Irving – and Irving was Walter's model. He developed an arresting impersonation of the great man's style. At the school prize day that Christmas he caused what the headmaster described as a 'sensation' with his rendition of a speech from *Richard III* in the manner of Irving.[36] It was a performance that raised Sickert to a new prominence within the school, eclipsing even his coincidental triumph in the Vice-Master's German Prize.*

Sickert's friendship with the Slade rabble-rousers forged an impor-tant connection in his mind between art and the theatre. Years later he recalled the benefits of this nexus, and urged the 'stage' to draw, once more, closer to the 'brush'. (He suggested that the Old Vic and Sadler's Wells should offer free seats in the gallery to all art students.) 'Actors', as he noted, 'know there is no propaganda like the enthusiasm of young students'; while the stage offered young painters not only an education in English literature but also a potential subject. Even as a teenager, it seems, Sickert recognized the possibility of making pictures 'drawn from the theatre'.[37]

* Sickert's dramatic experiments did occasionally look beyond the example of Irving. Once, he dressed up as a maid and called on the Carters, pretending to be in search of a situation. He took in the whole family until Mrs Carter's parting shot – 'You know I don't allow any followers' – induced him to break into 'an irresistible smile which gave the show away' (Edith Ortmans, *née* Carter, TS, Sutton/GUL).

In the short term, his friendship with the band of stage-struck art students served to open up the London art world for him, bringing him into contact with the more vital currents of contemporary painting. Inspired, as he later admitted, in part by 'intellectual snobbishness' and 'the "urge" to compete in agreeing with ladies a little older' than himself, he began to look beyond the simple pleasures of 'the narrative picture' and to fidget after 'novelty'.[38]

Artistic novelty was in rather short supply in the London of the late 1870s. The great masters of the previous age, Constable and Turner, were dead, and their heirs were not apparent. The Royal Academy had become stultified by its own commercial success, and had dragged most of the other chartered art institutions along with it. The founders of the Pre-Raphaelite Brotherhood – who had promised to reinvigorate art in the 1850s – had gone their separate ways. Rossetti had retreated into seclusion, and no longer exhibited. Holman Hunt stood aloof. Millais had embraced the world, acceding to the Royal Academy, social success, and a highly profitable career as a portrait painter. He was the self-assumed 'head of the profession', and he held that the baronetcy he had received was no more than a proper 'encouragement to the pursuit of art in its highest and noblest form'. He lived in a mansion in Palace Gate, and Sickert would sometimes see him sitting with a friend on a bench in Kensington Gardens, 'a touching and majestical presence', resembling more 'an angelic and blustering personification of John Bull' than a painter.[39] The vast majority of British artists subscribed only too gladly – as one critic has said – to John Wilkie's 'cynical formula that "to know the taste of the public, to learn what will best please the employer, is to the artist the most valuable of knowledge"'. And what the paying public wanted was anecdote, sentiment, moral tone, and workmanship. To a society that saw virtue in labour, 'high finish' was regarded as the one necessary technical requirement. The other – even more important – criterion was subject matter: it had to be either sentimental or edifying, and – if possible – both. The Baby was the dominant motif of most British exhibitions at this period.[40]

And yet within the tradition there were some signs of flickering life. George Frederick Watts, though he claimed that his pictures 'were not paintings but sermons', was producing works of undeniable force and achievement. There was vitality, too, in both the idealized classicism of Frederic Leighton, Lawrence Alma-Tadema, Edward Poynter,

and Albert Moore, and the romanticized realism of a second generation of Pre-Raphaelites – the heirs of Rossetti – led by Edward Burne-Jones and William Morris.

Arthur Kennedy took Sickert and other Slade friends to Burne-Jones's house in the North End Road, West Kensington. There they were allowed to look over the artist's studio and inspect his pictures of gracefully androgynous beings with retroussé noses looking pale and interesting amongst garlands of improbably detailed flora. Sickert was impressed, but grudgingly so. He recognized Burne-Jones as a 'brilliant draughtsman' but remained only half-attracted – and half repelled – by his paintings. The realm of 'strange and exquisite fancy' that the artist had created, though undeniably powerful, was impossibly alien to Sickert, who possessed almost no sense of 'fancy', exquisite or otherwise.[41] Nevertheless, despite his artistic reservations he found himself connected – albeit loosely – to this ardent Pre-Raphaelite world. His sister, Helena, now fourteen, was attending Notting Hill High School and had become friendly both with Burne-Jones's daughter, Margaret, and William Morris's two girls, Jenny and Mary (known as 'Jennyanmay'). They often spent their weekends at each other's houses; Helena would borrow copies of Morris's beautifully produced Kelmscott books and bring them home. Both Morris and Burne-Jones called on the Sickerts, while Morris's disciple, William de Morgan, was already known to the family through his connection with the Sheepshanks.[42]

Sickert encountered Burne-Jones's work again later in that summer of 1877 at the inaugural exhibition of the Grosvenor Gallery in Bond Street. It was the art event of the year. The Grosvenor was a new phenomenon. There had been commercial galleries before, but none conceived on such a scale, nor carried off with such taste. Established by Sir Coutts Lindsay and his wife, it was to be a veritable 'Temple of Art', offering the discerning public the chance to see the most up-to-date work in surroundings that suggested an idealized drawing room, or 'some old Venetian palace', rather than an overcrowded auction house.[43] Burne-Jones was the star of the show, represented by, amongst other major works, *The Seven Days of Creation*, *The Mirror of Venus*, and *The Beguiling of Merlin*. There were pictures by his followers and rivals, minutely detailed, richly coloured representations of myth and legend. One wall glowed with the brooding metaphorical figure-paintings of G. F. Watts, another with the serene, soft-tinted classical beauties of Albert Moore. But it was not these that excited the 17-year-old Sickert.

His attention was arrested by three tall canvases hung to the left of the door in the 'large gallery'. All were interesting, and one was particularly well calculated to appeal: a portrait of Henry Irving as Phillip II of Spain. They were the work of the American-born, Paris-trained artist, James McNeill Whistler.

Sickert, by his own rather heightened account, experienced an artistic epiphany:

> To a few, a very few, these and the other [five] canvases by Whistler [on view] came as a revelation, a thing of absolute conviction, admitting of no doubt or hesitation. Here was the finger of God. The rest became mere paint. Excellent, meritorious, worthy, some of it was, but it was mere paint and canvas. Here a thin girl, now in white muslin with black bows, now in a fur jacket and hat, breathed into being without any means being apparent. She stood, startled, in those narrow frames, and stared at you, with white face and red lips, out of nowhere whence she had emerged. There was a blue sea and a sandy shore, with a man in a light grey coat – Courbet, as I afterwards learnt. There was a snow scene in London in a fog, with a draggled little figure shuffling towards a lighted window. No one who was not there can imagine the revelation which these canvases were at that time.[44]

To most observers the revelation was an unwelcome one. To Millais and W. P. Frith, Whistler was a 'a sort of Gorgon's head', while a critical establishment that set store by subject matter, sentiment, fine detail, and high finish, found his muted, 'impressionistic', often subjectless pictures all but incomprehensible.[45] Their titles – which borrowed from the vocabulary of music: 'Nocturne', 'Symphony', 'Arrangement' – were an affront to sense. The pictures might be 'clever'; indeed – according to Millais – they were 'a damned sight too clever!' They were certainly alien, and probably dangerous. And like most ingenious alien dangers, they seemed to have their origins in modern France. Whistler, it was acknowledged, was a practitioner of something called 'Impressionism', although just what 'Impressionism' might be, most critics thought it safest not to enquire too closely: it was enough to know that it came from France and that Whistler was its sole advocate in England. He was also an advocate who demanded a hearing.

Whistler, at forty-three, was already a conspicuous figure. His distinct and dandified appearance – unruly black locks set off by a shock

of white hair, Mephistophelean moustache, monocle, wasp-waisted coat, short cane, top hat and Yankee swagger – was fixed by the carica- turists. His astringent comments and sharp witticisms were reported, not infrequently by himself, in the press. His Sunday 'breakfast' parties, which lasted most of the afternoon, were notorious. His views on art, interior decoration, oriental porcelain, and gallery design were proclaimed with a self-assurance that often crossed the borders of arrogance. These were things not likely to put off an admiring teenager. Whistler was set up beside Keene and Irving in Sickert's select personal pantheon.

He was a deity in need of adherents. If the Grosvenor Gallery exhibition had a profound effect on Sickert's life, it had an even deeper one on Whistler's. Amongst the pictures he exhibited was one – not much remarked by Sickert – called *Nocturne in Black and Gold: The Falling Rocket*, a small canvas of dark blue-blacks scattered – if not spattered – with points of brightness: the image of a firework display. This was the painting that so enraged Ruskin, the ageing arbiter of Victorian artistic taste: the pot of paint flung in the public's face, for which Whistler had the 'cockney impudence' to be asking two hundred guineas. Whistler responded to Ruskin's intemperate critique with a writ of libel.[46]

The action drew a battle line through the British art world. Neutral- ity was all but impossible. Those who were not with Whistler were against him. And most people were against him. The feelings of bafflement, irritation, and scorn that Whistler's art already engendered in the mind of the gallery-going public became intensified and took on a personal edge as the legal process advanced during 1878. When the case was heard in November, Burne-Jones and W. P. Frith both appeared against Whistler in the witness box; others spoke against him in the press, the studio, and the drawing room. Only a bold few rallied to his standard. Sickert, of course, was of their number. If he did not attend the trial, he followed its progress and lamented its conclusion: Whistler, with much shrillness and no little wit, won the verdict, but gained only a farthing's damages, a huge legal bill, and the general disapprobation of the public. To Sickert, however, he remained a hero. And when, crowing over his nominal victory, Whistler published an annotated transcript of the proceedings, Sickert bought a copy.[47]

* * *

Walter's independent life amongst the unchaperoned worlds of the art school and the stage was the cause of some concern at home. Edith, the daughter of Hugh Carter, recalled that as a child she heard Mrs Sickert lamenting, 'I don't know what to do about Walter, he is so wayward', after which pronouncement she (though only aged about five) would not let Walter hold her hand as he accompanied her and her brother to their kindergarten on his own way to school. 'No,' she informed him with the moral assurance of the young. 'You worry your mother.'[48] The main worry was Walter's interest in girls. He had developed a crush on Edith Carter's mother, Maria, who was barely thirty and very beautiful. Indeed he described her as his 'first love'. And other less exalted loves seem to have followed soon after. Edith remembered one morning, while playing in the Sickerts' garden, seeing Walter – still in his evening clothes – sneak into the house 'by the back alley, in the most extraordinary way'. (She was told not to make any remarks about it.)[49]

It was clear that Walter had begun to strain the bounds of both home and school life. At King's College School he had certainly gained that intellectual 'confidence' from 'knowing a *little* about *something*' which he came to regard as the goal of good schooling. At the beginning of 1878, Dr Maclear wrote to Professor Reginald Poole at the British Museum, recommending Walter for a possible post in the Coins and Medals department.[50] Mrs Sickert was very grateful for this initiative. There was a tone of real relief in her letter of thanks to Maclear for his good offices: 'I assure you that we are very grateful to you for your kindness in helping [Walter] to what we believe to be most congenial work. We sincerely believe that [he] will show himself to be worthy of your good opinion and hope that you will continue to feel a kindly interest in him.'[51] A job would have the double benefit of occupying Walter's energies and relieving the Sickerts' domestic finances.

Anne Sheepshanks, the family's guardian angel, had died two years previously – in February 1876 – and while Mrs Sickert's allowance was continued it was not increased. (After various bequests to Trinity College, Cambridge, and the Royal Astronomical Society, the bulk of Anne Sheepshanks' estate had been left in trust for the support of her last surviving sibling, the recently widowed Susanna Levett.[52]) Nevertheless, at the beginning of 1878 the Sickerts moved from their home in Notting Hill across to the other side of Hyde Park, to 12 Pembroke

Gardens, Kensington. The new house – a three-storey semi-detached villa with an 'extra wing' – was bigger, if only slightly, than Hanover Terrace. Built just fifteen years before, with an eye to suggesting, rather than providing, a modest grandeur, the rooms were all too high for their width, and the staircases too narrow to allow two people to pass. The rent – at £90 a year – marked an increase in the family expenses, and must have made the prospect of Walter entering paid employment additionally attractive.[53]

But it was not to be. Professor Poole was after a pure classicist rather than an all-round linguist. He was impressed by Sickert, however, and offered to assist him if he wished to reapply for another post at a later date.[54] Walter returned to school at the start of 1878 and 'settled down to work in the matriculation class'.[55] He enjoyed the challenge of exams and, concentrating his energies, passed with First Class honours.[56]

His academic achievements were such that they might perhaps have been expected to lead on to university – his friend Alfred Pollard had already gone up to Oxford with a scholarship.[57] But the expense of a university education was beyond the Sickert budget.[58] Walter, it was recognized, must get a job. Initially, when consulted by his father – during one of their walks together on Wormwood Scrubs – as to his hopes for the future, he had suggested rather unhelpfully that he intended to be 'An Universalgenie' (he had been reading a life of Goethe).[59] Universal geniuses, however, were not a commodity in the employment market. Besides, Walter's own views came into sharper focus during his last year of schooling. He was, his sister recalled, 'in no doubt that his vocation lay in painting'.[60]

This was the last thing that his parents wanted to hear. Oswald Sickert had dedicated his life to art and was keenly aware that he had not made his living from it. Although the evidence of great artistic fortunes was everywhere to hand – visible in the huge studio-palaces of Melbury Road, Holland Park – such riches were beyond his reach. And they were receding further. The high watermark of Victorian prosperity was already passing. Painting was an overcrowded profession, and Oswald Sickert was being crowded out. He had come to regard himself as a failure.[61] It was the Sheepshanks' allowance rather than the meagre returns from any sales he might make that paid the household bills. And the Sheepshanks' resources were finite: they could not stretch to provide Walter with the sort of prolonged and dedicated training that Oswald had enjoyed at Munich and Paris. Besides,

although he had 'a great opinion of Walter's abilities in general', neither
he nor Mrs Sickert believed that they were 'specialised in painting'.[62]
He did everything possible to discourage his son from following him
in what he described as his 'chien de métier'.[63]

In the face of such opposition, Walter made some efforts in alterna-
tive directions. He considered applying for the higher division of the
Home Civil Service. But this, he discovered, would require three years'
coaching, which would be just as expensive as university.[64] He wrote to
Professor Poole, asking if places at the British Museum Library might 'be
got separately from [such] general Examinations . . . and if you think
there would be any chance for me'.[65] The answer did not encourage him
to pursue this course. His father urged him towards any career where he
would be sure of earning a living.[66] The law was suggested, and given
serious consideration[67] – although this, too, unless begun in a lowly
clerical capacity, would have required some expensive training.

Beyond these conventional options a more tempting vista
beckoned. The stage. Extraordinarily, the idea was not thrown out of
court. But then, compared to Oswald Sickert's 'dog of a profession',
acting had various attractions. It was not a calling that the Sickerts
knew to be unremunerative – even if this was only because they knew
very little about it at all. It was no longer socially beyond the pale, at
least not in the artistic circles frequented by the Sickerts; and, unlike
almost all other professions, it required no formal and expensive train-
ing, and no fees of entry.

They were encouraged, too, by the example of their friends the
Forbes-Robertsons. John Forbes-Robertson, a prolific art journalist and
lecturer, lived with his wife and five children in a large house in
Charlotte Street, just off Bedford Square.[68] His eldest son, Johnston,
although having begun an art training at the RA schools, had been
obliged 'by force of circumstances' to give it up and seek a more
immediately rewarding career.[69] He had found it on the stage. A family
friend had got him a small part in a play at the Princess Theatre. And
from that beginning he had managed to make his own way as an
actor. He had performed in Samuel Phelps's company, acted with Ellen
Terry on her triumphant return to the London stage, and was steadily
in work.[70] His younger brother, Ian, was just about to embark upon
the same path.[71] Here were models for emulation. And if the stage
offered little security, it was at least susceptible to energy and talent,
and Walter – it seemed – had both.

He rounded off his school career, at the end-of-year Prize Day, by giving a stirring performance as Cardinal Wolsey in a selection of scenes from Shakespeare's *Henry VIII*.[72] To his proud parents, appreciative teachers, and admiring peers, it must have seemed only too likely that he would succeed on his chosen path.

CHAPTER TWO

Apprentice or Student?

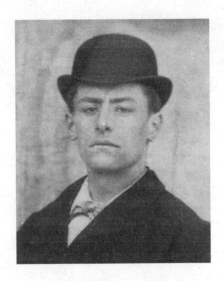

Walter Sickert, 1880

Walter Sickert, 1884

I

THE UTILITY PLAYER

I wonder all the managers in London are not after him.
(Maggie Cobden to Dorothy Richmond)

Sickert's stage career got off to a false start. At the beginning of the
New Year of 1879 he collapsed with a bad case of flu and was laid up
for almost a fortnight. Although, as he wrote to his friend Pollard, he
might have been able to 'excel in all dying scenes, old men & anything
feeble', his availability was unknown. Instead he was obliged to chan-
nel his returning energies into schemes of his own. The days of his
convalescence were spent – when not 'feebly pottering about the neigh-
bourhood with a stick' – in devising plays. After toying with, and
discarding, several ideas he decided to dramatize a novel by the
German, G. F. Richter, and then mount a drawing-room production
of it. Progress, however, was slow.[1]

He hoped, on his recovery, to see Mrs Bateman, who had recently
taken on the management of the Sadler's Wells Theatre; but the main
focus of his ambition was fixed, unsurprisingly, upon the Lyceum.[2]
Irving was now in sole charge of the theatre, opening his first pro-
duction on the penultimate day of the old year, to the rapturous
acclaim of his supporters. He had engaged, as his leading lady, Ellen
Terry, and in her he found a perfect foil for his own greatness. Her
acting was considered to have an unmatched candour, and an emo-
tional depth that owed something to the vicissitudes of her early life.

She came of theatrical stock. The daughter of actors, four of her
ten siblings were also on the stage. In 1864, at the age of sixteen, she
had given up a successful career as a child star and contracted an
ill-advised marriage with the already middle-aged and finicky painter,
G. F. Watts. He had been captivated by her distinctive grace, and
spent much of their short period together recording it in drawings and

paintings. The rest of the time he spent in repenting of his decision
to marry. He had hoped, as he put it, 'to remove an impulsive girl
from the dangers and temptations of the stage', but he soon discovered
that the stage could not be so easily removed from the girl. His new
wife could create more than enough drama in a domestic setting. After
barely a year, they separated.[3] Ellen returned briefly to her family,
before eloping with the mercurial architect and stage-designer E. W.
Godwin. For five years they lived together happily in Hertfordshire, in
sin and ever-increasing debt. Ellen bore two illegitimate children, Edith
and Edward, before she was lured back to the theatre in 1874.* Her
relationship with Godwin did not long survive her return, but in 1877,
after finally receiving a divorce from Watts, she married the actor
Charles Wardle (who performed under the stage name Charles Kelly),
and achieved the haven of stability. At the time of her arrival at the
Lyceum she was thirty-one and considered by discerning judges 'the
most beautiful woman of her times' – even if it remained a mystery
just how she achieved this with her pale eyes, long tip-tilted nose,
broad mouth, and 'tow-like' hair.[4] Her presence at the Lyceum added
a new lustre to the place. The adulation that had previously been fixed
upon Irving alone became fixed upon her as well. She was one half
of a twin-headed deity. And she was another reason for Sickert wishing
to join the Lyceum company.

At the beginning of March he reported excitedly that he was hoping
for 'something' at the theatre. To prepare himself he went every night
'to observe'.[5] He also took up fencing lessons to improve his posture
and fit himself for the swash and buckle of the high Victorian reper-
toire.[6] Through a family friend he was introduced to Irving and put
into contact with the person responsible for hiring the company's
'supers' – the non-speaking extras needed for crowd scenes, stage
battles, and general 'business'.[7] The Lyceum employed dozens, if not
hundreds, of them. Most were mere drudges, 'small wage earners'
adding to their income by taking on an evening job. But there was a
select band of enthusiasts, known in the theatre as 'Lyceum young
men' – ambitious trainees starting out on their theatrical careers. Sickert
joined their ranks. The 'Lyceum young men' enjoyed certain small

* The children were originally given the surname Godwin, but it was subsequently
changed to Craig after Ellen had been inspired by a trip to Ailsa Craig off the coast
of Scotland.

privileges. If any part required some modicum of intelligence or flair – or perhaps even included a line – it was given to one to them. They even had their own green room.[8] It is not known in which production Sickert first 'walked on'; but by the end of the month he was able to get tickets for Alfred Pollard and his sisters to attend the first night of Edward Bulwer-Lytton's *The Lady of Lyons*.[9] For Sickert, at the age of nineteen, to be on stage with Irving and Terry was to savour the full glamour of the theatrical world.[10]

Despite his lowly status he was acknowledged by Irving and treated with kindly consideration.[11] He also came to know Ellen Terry. She lived in Longridge Road, close to the Sickerts' Kensington home, and sent her two children to the same advanced primary school attended by young Oswald and Leonard.[12] Walter developed a crush on her which she graciously indulged. In one letter to Pollard he boasted that he had spent an evening in her company, remarking complacently that friends had begun to suspect that there was some 'MissTerry' about his movements.[13] On another occasion, after he had taken Helena to a musical soirée at a friend's house, he made an impromptu call at Longridge Road on the way home, much to his sister's delight and alarm.[14]

It was perhaps through Ellen Terry that Walter was introduced to E. W. Godwin. Despite their separation, he and Ellen had remained on close terms: he continued to design costumes for her, and to offer advice upon her acting.* Godwin called at Pembroke Gardens early in the year, and soon afterwards invited Walter to dine with him and his young wife – the painter Beatrice Birnie Philip – at their elegantly underfurnished home in Taviton Street, Bloomsbury, where the white and straw-coloured drawing room was dominated by a life-size cast of the Venus de Milo.[15] Although he continued to carry out occasional architectural commissions, Godwin had become increasingly absorbed in his stage work, designing, with a devoted regard for the details of historical accuracy, sets, costumes, and properties. (When asked to make designs for Wilson Barrett's production of *Hamlet*, his first step had been to visit Elsinore.) He had many theatrical friends and connections, and was potentially a very useful contact for an aspiring young actor.

* When Ellen was appearing in Tennyson's classical verse drama *The Cup*, Godwin sketched out for her a series of figures showing which attitudes – according to the evidence of archaeology – would be appropriate for her to adopt in her role as a Greek priestess.

For Walter, however, he had an additional attraction. He was a close friend of Whistler. Sickert's commitment to a career on the stage had done nothing to diminish his passionate interest in the American painter. At the Grosvenor Gallery show that spring, the picture that impressed him most was Whistler's *Golden Girl*.[16] Godwin could tell him more about his hero. He, after all, had designed Whistler's home, the elegant and austere White House in Tite Street, Chelsea, along with much of its furniture. The two men had collaborated on projects: they had created an exhibition stand together for the Paris Exposition Universelle the previous year. They shared a common passion for Japanese art and blue-and-white china. They were both members of the St Stephen's Club and saw much of each other there.

If Sickert's connection with Godwin brought him closer to Whistler's world, it did not quite bring him into Whistler's presence. It was Ellen Terry who, according to legend, was responsible for first drawing Sickert to his hero's attention. It happened one evening at the Lyceum when Walter was not on duty. Wishing to throw a bunch of violets to Ellen at the curtain call, and anxious that it should carry over the footlights, he weighted his bouquet with lead shot. He rather overestimated the amount needed, and the flowers, after spinning through the air, dropped to the stage with a very audible clunk right next to the greatly surprised Henry Irving. Whistler, who was in the house that night, noted this miniature drama with amusement and took the trouble to discover its perpetrator.[17]

The two men met soon afterward. From the beginning of May the Forbes-Robertsons hosted a soirée each Friday at their house in Charlotte Street.[18] They were exciting and crowded occasions: Mr Forbes-Robertson had a wide connection, and his offspring were numerous, talented, successful, charming, and gregarious. At their parties the worlds of art, letters, and the stage met and the generations mingled. Walter could encounter young actresses and old lions.[19] Oscar Wilde, just down from Oxford and embarked upon a career of self-advertisement and poetical affectation, was a regular guest. So was Whistler. It was almost certainly in the crowded studio at Charlotte Street that Sickert was first introduced to his hero.[20] The meeting, however, though momentous, was brief, and it was only on the following day, when Sickert by chance saw Whistler entering a tobacconist's shop and followed him in, that he asked if he might call at his studio.[21]

Whistler, though he consented, barely had a studio in which to

receive his young admirer. Overwhelmed by legal bills after his pyrrhic victory in the Ruskin trial, he had been declared bankrupt at the beginning of May.[22] His collections of oriental china and Japanese prints had been sold off at auction along with many of his own works. The bailiffs were in possession of the White House, and bills were already posted announcing its imminent sale. Dispirited but not crushed by these setbacks, Whistler continued to live on in the denuded house, and to keep up a front of spirited defiance. A semblance of the old life continued. It was said that he pressed the bemused bailiffs into service at his Sunday breakfast parties. He found both the time and the heart to show Sickert over his studio. Although much had been sold, and not a little destroyed (to prevent it falling into the hands of his creditors), there was still plenty to admire.

Sickert wrote enthusiastically to Pollard: 'I went to see Whistler the other day. He showed me some glorious work of his and it was of course a great pleasure to me to talk with him about painting. Such a man! The only painter alive who has first immense genius, then conscientious persistent work striving after his ideal[,] he knowing exactly what he is about and turned aside by no indifference or ridicule.'[23] The account betrayed a depth of engagement that went beyond Sickert's more conventional excitement at the deeds of Irving and Terry.

The tension between his theatrical ambitions and his artistic interests was quickened that summer. In August, when most of the London theatres closed, Walter accompanied the rest of the family to Dieppe. They had rented the Maison Bellevue, Miss Slee's old school house on the heights of Neuville, for the holidays. The school had finally closed, but Miss Slee herself was still in residence. She was not the only addition to the Sickert party that summer. Various other friends came to stay, and Oscar Wilde accepted an invitation from Mrs Sickert to spend some time with them. Walter was initially suspicious of Wilde, considering him something of a poseur; but he was willing to suspend his verdict because, as he explained to Pollard, 'firstly E[llen] T[erry] likes him and 2ndly he likes me'.[24] Extended exposure encouraged him in this revised opinion. Wilde, beneath the deliberate extravagances of his manner, had real charm. Besides winning over the sceptical Walter, he was a source of delight to the rest of the family. His laughter was ceaseless and contagious. He played happily with Oswald and Leo, and made a special bond with Helena, then a bright but rather bolshy 15-year-old. He would discuss poetry with her, despite her

determination to go to Cambridge – the Scientific University. When
he caught her frowning doubtfully at the improbable tales he invented
for Oswald and Leo's amusement, he would appeal to her in a tone
of mock anguish, 'You don't believe me, Miss Nelly. I *assure* you . . .
well, it's as good as true.'[25]

One afternoon he read – or chanted – his Newdigate Prize poem,
'Ravenna', to the assembled company as they sat beneath the apple
trees in the orchard:

> A year ago I breathed the Italian air
> And yet methinks this Northern spring is fair . . .

It was a mellifluous performance, punctuated only by Miss Slee's
schoolmarmish insistence on correcting some minor point of pronun-
ciation, an interruption that Wilde took with good humour.[26] Sadly,
he was not on hand to help Walter write a comic playlet for the
company to act: Walter could have done with the assistance (he felt
'totally devoid of fancy & originality' in the field of comic writing)
and Wilde might have discovered his true vocation earlier.[27]

Another visitor was Johnston Forbes-Robertson, who was on a
walking holiday. His theatrical career was advancing swiftly. He had
just been engaged by Irving for the forthcoming season at the Lyceum.[28]
Although he complained to Helena that he was usually cast in character
parts – often as old men – even his geriatric disguises could not quite
obliterate his broad-browed, straight-nosed good looks, nor muffle his
perfect diction (learnt, so he claimed, from Phelps). At the age of
twenty-six, he was beginning to gain the status of a stage idol. And
yet he still managed to combine this achievement with his first love:
painting. He continued to work on portraits – often of theatrical figures
– in the studio at Charlotte Street.[29]

To Sickert, Forbes-Robertson's life must have seemed both charmed
and desirable: rather than having to decide between painting and
acting, he had chosen both. Might he himself not follow suit, and
become a star of the London stage and an acknowledged artist? For
the moment, however, both goals remained frustratingly out of reach.
And the vision paralysed almost more than it inspired him. He lapsed,
as he told Pollard, in to 'such despair about [himself]' that he was
unable to work. 'As to painting,' he confessed, 'I have done nothing.'
He spent most of his time lying in the orchard reading Thackeray:
Vanity Fair he pronounced 'very perfect'.[30]

Nevertheless he returned to London with a sense of gathering resolve. Although he was still 'appearing' rather than 'acting' at the Lyceum, he sought to speed up the pace of his progress by mounting some drawing-room theatricals of his own. Together with his friend Justin Huntly M'Carthy (son of Justin M'Carthy MP) he put on a series of performances at the M'Carthys' house in Gower Street. They acted scenes from *Love's Labour's Lost* (Sickert taking the part of the curate, Sir Nathaniel) together with the Irving staple, *Raising the Wind* (with Sickert in the Irving role of Jeremy Diddler), and *L'Avocat Patelin* (in which Sickert reprised his successful KCS performance). Walter devised elaborate make-ups and costumes for his various parts. He was so pleased with his get-up as Sir Nathaniel that he arranged to have himself photographed in costume. Walter marshalled his brothers Robert and Bernhard into minor parts but the productions were clearly intended as a showcase for his talents and as such they were not unsuccessful. Despite, as he put it, getting 'lost a little' during one of his Shakespearean speeches, he 'muddled through somehow' and no one noticed. Mr Kelly (perhaps Ellen Terry's husband) promised him a part in a matinée he was putting on at the Gaiety, and also recommended him to 'a very good agency'.[31]

In December, Sickert returned to King's College School to give a performance of Clarence's Dream from *Richard III* at the annual prize-giving. The school magazine – edited by his friend Alfred Kalisch – described the recitation as 'one of the features of the day': 'Sickert surpassed himself, and evoked the greatest burst of applause heard during the evening. The only fault of the performance was its shortness. Sickert's elocution was perfect, distinct without a trace of effort, and his gestures, though few, were most expressive.' The notice ended with the hope that 'he may meet with similar success in his professional career'.[32]

Perhaps on account of this success or by the efforts of his 'very good agency' – but most probably through the good offices of E. W. Godwin – Sickert was engaged almost immediately afterwards as a 'super' by George Rignold.[33] Rignold (a close friend of Godwin's) was mounting a production of Douglas Jerrold's once-popular naval drama, *Black-Eyed Susan*, at the Connaught Theatre in Holborn.[34] According to Sickert's own account, this was his first real break. There was a difficulty in finding among the supers someone who could speak convincingly as the foreman of the jury in the court-martial scene. Sickert,

it was considered, would make the most plausible 'naval officer', so he got the part.[35] By January he had been promoted to 'first servant';[36] and in February he achieved the distinction of his first proper speaking role as 'Jasper' in the English Civil War romance *Amos Clark*. E. W. Godwin and Beatrice were amongst the friends in the audience to witness this debut.[37] It was not a large part. He had only one cue: 'That man Jasper creeping among the laurels', at which he made his appearance. The character – as might be guessed from his name and entry line – was a villain. One day, on mentioning to a family friend what part he was playing, Sickert was warned, 'Take care, don't let it affect your real character, Walter!' There was little danger of that. Although he enjoyed piecing together his performances from the external incidents of costume, make-up, and gesture, he seems not to have lost himself in the characters he portrayed, nor in their situations. He never even bothered to read the whole of *Amos Clark*.[38]

In tandem with these small theatrical advances, Sickert continued to foster his artistic ambitions.* One interesting avenue, however, was closed off to him. He returned from his holidays to find that Whistler had left England. The painter, bankrupt and homeless, was in Venice, having decamped with his mistress, Maud Franklin, and a commission from the Fine Art Society for a series of etchings. In the absence of his hero, Sickert turned for direction to his father, and Oswald Sickert, satisfied that his son was now making progress on the professional stage (and conscious perhaps that a double career might be possible), was happy to offer him every practical assistance. Walter gained his first semi-formal art instruction by working alongside his father at Pembroke Gardens. There would sometimes be life drawing in the mornings, and Oswald painted a portrait of his eldest son, which must have been instructive for the sitter.[39] Walter also worked from the model at Otto Scholderer's studio in Putney.[40]

Sickert always claimed that this early instruction he received from his father and Scholderer provided the sound and necessary basis for his whole development as an artist. He certainly picked up good habits from them. He learnt to look, and to set down what he saw – not

* Sickert was confirmed in his belief that acting need not, indeed should not, be an exclusive concern when – one evening, while waiting in the wings at the Lyceum – a young actor called Arthur Wing Pinero confided to him his ambitions to be a playwright and his excitement at having had a one-act sketch accepted by Irving for use as a 'curtain-raiser' (*The Observer*, 9 December 1934).

what he *thought* he saw. He recalled how Scholderer would chide those who substituted 'the vapid head of convention' for what was actually before them, with the remark, 'Der Gypskopf steckt noch drin' (The plaster cast is still inside it).[41] But besides such particular lessons he also gained something more general: a first understanding of, and connection with, the great tradition of 'the French school'.[42]

The tradition that the two men had imbibed in Paris in the 1850s was a distinctive one. It rested upon the conception that painting was divided into three elements: line, tone (the range of light and darkness), and colour. Following the traditional method, as taught at Couture's studio, these three elements were still applied in three separate operations: an elegant outline drawing was first made on the prepared canvas. To this were added a few simple tonal 'values' in a 'frotté of thin colour', which was left overnight to dry. Another thin layer of lights and shadows could then be added in portions. In the next stage, a transparent coloured glaze of oil paint was laid over this underpainting with 'long haired whipping brushes' in a single process.[43] By the time Oswald Sickert and Scholderer had got to Paris this classical arrangement was already being challenged. The development of ready-made conveniently transported oil paints had encouraged artists such as Courbet to experiment with the medium – to lay the oil paint on more thickly, to treat it as opaque rather than transparent. This effected a radical change in practice. Colour and tone were applied in a single operation (the colours being mixed to the right 'value' of tone on the palette), and line became a subordinate element.[44] Nevertheless, the essential conception of the tripartite division remained as the basis against which these changes were made. And it was a conception that Sickert imbibed from his first teachers. It provided him with the essential framework for his future thoughts about painting, and for their future development.[45]

Sickert's friendship with Justin Huntly M'Carthy brought him into contact with the whole secular, literary, intellectual, and politically committed world of Gower Street. The long, sober-fronted thoroughfare, taking its lead from the 'godless' institution of University College that stood at its head, exhaled a bracing aura of high-minded enquiry. Its hospitable drawing rooms hummed not only with amateur theatricals, but also with political discussions and intellectual debates. It

could not be forgotten that Charles Darwin had written part of *On the Origin of Species* at one end of the street, or that the Italian political exile Giuseppe Mazzini had found a refuge at the other. At the M'Carthys', the dominant topic was Ireland. Justin M'Carthy Senior, born in Cork and having come to maturity during the worst years of the Irish famine, was a fervent believer in the need for Irish Home Rule. His successes as a journalist, novelist and popular historian had both supported and furthered a political career, and in 1879 he was elected as an Irish MP for Parnell's new Irish nationalist party.[46] At the home of Mr and Mrs George Robinson, the subject matter was likely to be both classical and literary, and to be led by the Robinsons' two conspicuously brilliant blue-stocking daughters, Mary and Mabel.[47] Benjamin Leigh-Smith's household – at number 54 – was a beacon for women's rights; his sister, the watercolourist Barbara Leigh-Smith Bodichon, was one of the first benefactors of Girton College, Cambridge, and founder of the Society of Female Artists.[48]

Also staying in Gower Street in 1879 was the New Zealand politician and landscape painter John Crowe Richmond, together with his family. He was over in London not least so that his younger daughter, Dorothy, could gain a good art education. 'Dolla' Richmond, as she was known, had started attending the Slade, and was already achieving a reputation there – amongst the tutors as an artist, and amongst her fellows as both a beauty and a devotee of Henry Irving.[49] On these two latter fronts she was thought to rival even the lovely Margery May. Sickert, when they met, was very much attracted to her, and they began a bantering, flirtatious friendship. But then it was a period for bantering flirtatious friendships, and Sickert's was not exclusive.

His attention was drawn, too, by the Cobden sisters, who were friends of the Richmonds, the Leigh-Smiths, the Robinsons, and several other Gower Street worthies.[50] Ellen, Jane, Annie, and Maggie: the four, unmarried daughters of the late Richard Cobden were something of a social phenomenon. They were young, beautiful, bright, and – in almost every sense of the word – independent.* Their father, the great apostle of Free Trade, founder of the so-called Manchester School, and scourge of the protectionist Corn Laws, had been the recipient of two large subscriptions from a grateful public during his lifetime, and at

* They had an elder sister, Kate, who since 1866 had been married to Richard Fisher. Two brothers and another sister had died in infancy.

his death in 1865 he had divided up the greater part of his estate between his daughters. They were well provided for.* When, in 1877, the death of their mother had left them orphans, they had set up home together at 12 York Place, towards the northern end of Baker Street. Ellen, the eldest girl, was then 29, Jane 26, Annie 24, and Maggie – the 'baby' of the family by some way – just 16.

It was a cultured, vivacious household, and also a political one. The sisters remained proudly conscious of their paternal heritage and kept in close touch with their father's old friends and allies. They espoused advanced causes with great practical energy. They were suffragettes, 'ere ever the Suffragist movement began';[51] they believed passionately in Irish Home Rule; they supported Free Trade; and they worked to relieve the lot of the London poor. They became friendly with William Morris perhaps more on account of his radical principles than his artistic tastes. Their ardent idealism, however, did not make them solemn. They were sociable and humorous, fond of fun.

The liberal journalist (and Parnellite MP) T. P. O'Connor rated them 'as beautiful a bevy of fair English girls' as ever he had seen, with their 'glowing rosy complexions, large, deep, soft, candid dark eyes' – eyes which, he considered, held 'something in the expression that revealed and yet half hid profound possibilities of emotion and compassion'.[52] The term 'bevy' seems well chosen: there was a certain plump, partridge-like quality about them all. But, despite this point of similarity, they were never in any danger of being mistaken for each other: their colouring was in different shades, and so were their characters. Maggie was spirited and skittish with 'a peculiar gypsy beauty'; Annie, dark, capricious, artistic, and – so her sisters thought – hard to please; Jane, with her fair hair and firm chin, was the most forthright and practical of the forthright and practical family; while the gold-tressed Ellen had perhaps the most generous spirit.[53] They guarded their individuality with care. It was a family rule that, except on special occasions, they did not attend events en bloc.[54]

* The exact figures are unclear. Cobden's estate was valued at 'under £40,000' at his death. Although Ellen Cobden, when first setting up home, told her mother she would need an income of £250 per annum, she and her sisters appear to have been even better provided for. Jane Cobden's nephew thought that his aunt had £1,000 a year at the time of her marriage in the early 1890s, although his may have been no more than a symbolic figure, representing substantial wealth. Annie Cobden in 1890, some ten years after her marriage, had an income of around £500 p.a., but it is probable that she had made substantial inroads into her capital by then.

Walter, though he almost certainly met them in Gower Street, soon became a visitor at York Place. There was much for him to admire, even to envy, in the life he found there – a world free from parental controls and financial constraints. And the sisters were all so pretty, so entertaining, and so entertained by him. Already rather smitten by Dorothy Richmond, he became rather smitten by all four of the Cobden girls as well – and by their dog, Topsy. And they, for their part, were all rather smitten by their young, self-confident, handsome admirer, with his thick golden hair and irrepressible enthusiasms. Some hint of Sickert's distinctive charm and the impact it had upon the Cobden clan is contained in Ellen's autobiographical novel *Wistons*. Its hero, Robin Yaldwyn – a barely disguised portrait of Sickert – is described upon his first appearance as being 'more wonderful and more beautiful than it's possible to imagine' – like 'a spirit from some world where no one had ever been unhappy' whose quick sympathies and charm 'made all who came into his presence happier'.[55] He did everything, Ellen noted, in less conventionally romantic terms, 'exquisitely, there was a fine personal stamp upon his smallest action, and he drew up his chair to the table, poured out his tea and buttered his toast in a way that gave distinction to tea and toast and table'.[56] He was, too, 'cheerfully interested in all that personally concerned him; his morning toilette completely absorbed him; he enjoyed washing his hands, brushing his hair; it would have pleased him to dress twice for dinner. Yet with all this love of detail there was nothing fussy or finikin about him.'*[57] Ellen's admiration for Sickert's looks and manner was echoed by her sisters; and, bowered in such appreciative female company, Sickert was in no hurry to decide between its enticing possibilities: with generous indiscrimination he bestowed favours upon all of the Cobden girls.[58]

From this enchanting world he was, however, soon dragged away. Clearly he had not disgraced himself in the role of 'Jasper', for Rignold engaged him as a 'General Utility' actor – to play five small parts – in a touring production of *Henry V*.[59] He chose (or, perhaps, was obliged) not to appear under his own name, adopting instead the self-effacing

* Sickert, though he tolerated and even enjoyed mess, was 'extremely particular about cleanliness'. He had, as one friend recalled, 'a passion for hygiene'. If he discovered that he had picked up and put on a stranger's hat, he would wash his head at the soonest opportunity. He liked to take a daily bath ('Letters to Florence Pash', 3).

alias, 'Mr Nemo'. The tour opened in Birmingham at the beginning of April 1880 to good reviews and 'crammed' houses, before moving – with a blithe disregard for geographical convenience – to Liverpool, Wolverhampton, Bristol, Leicester, and Manchester, playing a week at each venue.[60] Rignold, who took the title role, had conceived the production on a grand Victorian scale, with elaborate period costumes and props. He made one entrance wearing full armour and mounted upon a horse. It must have been a considerable burden for the horse. Rignold, though small, was stout, and even out of armour made what Maggie Cobden described as a rather 'solid' king. His wife was almost equally solid; she appeared as Chorus in a white Greek dress and yellow frizzy wig.[61] For the rest, the company was, according to Sickert, very much 'in the Music Hall line'. Some of the actors had even begun their careers in the circus and did 'tight-rope bizness'. Many of them had some difficulty in 'getting sober by the evening'.[62] What they made of their assured, well-connected, well-educated young Utility Player is not known, but Sickert already had a gift for making friendships across the conventional barriers of class and age.

At Birmingham, Sickert's Lyceum companions, led by Margery May, came down from London to see him; the Cobden sisters also attended a performance.[63] He received baskets of roses from admirers, and the Birmingham theatre critic, C. J. Pemberton, a friend of Ellen Terry, invited him to dinner. Pemberton was encouraging about Sickert's performance, singling out his impersonation of 'the old man' taken prisoner by Pistol for special praise.[64] It was Sickert's favourite part, and he certainly made the most of it. The critic for the *Liverpool Daily Post* gave him a glowing review: 'An admirable bit of acting was that of Mr Nemo as the Captive Frenchman. The spasmodic fright with which he sharply jerked his head to this side and that between his persecutor and his persecutor's interpreter was a notable touch of nature.'[65] The terms of praise suggest that the lessons he had learned from his father and Scholderer found an echo on the stage. Good acting, like good drawing, depended upon direct observation and selection of the revealing detail: and Sickert was acquiring these skills.

He was thrilled with the review, buying up the local newsagent's entire stock of the paper and dispatching copies to relations and friends. Ellen Terry was at the top of his list. The notice, he proclaimed with mock pomposity, had made him a 'public' figure. He delighted in the position, and in the absurdity of that delight. 'My enemies', he

informed Pollard, 'say that now I may always be seen jerking my head at all hours of the day & this is a slander.'[66] It was perhaps to fix the moment of his new-found fame that he had his photograph taken on an excursion to the Liverpudlian resort of New Brighton. Staring out from beneath the low brim of his bowler hat, his head thrown back, his jaw thrust out, he assumed a pose of mingled challenge and disdain.

The company was expected to help strike the set at the close of each week's run, working into the early hours, dismantling flats, and packing up costumes. Nevertheless, life on tour also gave many opportunities for leisure. It was the first time Walter had been away from home since the unhappy days at his Reading prep school, and he savoured his independence. He devoted himself to learning Tennyson's *Maud* ('the most beautiful thing ever written') on long country walks. He loafed around the Liverpool docks, taking an interest in the shipping. At Birmingham he visited a Turkish bath one afternoon. It had, though, an unsettling effect upon his constitution. He was ill all that evening and 'in the character of the Bishop of Bourges' threw up in his dressing room; he needed 'raw spirits' to 'quiet his intestines'.[67] He probably needed raw spirits again when, at Manchester, the stage began to give way under Rignold and his horse. Rignold hastily dismounted but Sickert was left holding the animal's bridle as it stamped its way through the boards. He leaped clear just as the poor beast crashed through the stage.[68] The incident brought the first part of the tour to a dramatic conclusion. There was to be a four-month break before the production was revived for a second set of dates.

Sickert and the rest of the company were free for the summer: free to take on other jobs. Sickert's self-publicizing had not been in vain. One copy, at least, of the *Liverpool Daily Post* had found its mark. As soon as he returned to London he was engaged by Mrs Bateman to play Demetrius in *A Midsummer Night's Dream* at Sadler's Wells. That he felt confident to master such a large part at relatively short notice was, if nothing else, testament to his impressive (and much envied) verbal memory.[69] The production, mounted by Edward Saker, had already been given at Liverpool, Dublin, and Brighton. It was distinguished by the fact that the fairies were all played by children under the age of eleven. The conceit was perhaps more charming in the conception than in the fact. Certainly Sickert's memory of Oberon, Titania, and their fairy throng was of clumping footsteps rattling the boards of the stage – 'so lightly, lightly do they pass'![70] The reviewer

for *Theatre* magazine remained unenchanted by the spectacle, though he did allow that 'the representatives of Lysander and Demetrius ... acted fairly well'.[71] Sickert appeared at Sadler's Wells under his own name, or as nearly as the London printer would allow. In the programme his unfamiliar patronymic was rendered as 'Sigurd'.[72] It was a slight but perhaps telling reminder of his semi-alien origins.*

Back in London, Walter gathered up the strands of his social life. They were all plaited together on 1 July 1880, when the Sickerts hosted a dance at Pembroke Gardens.[73] The family enjoyed creating such occasions, reviving some of the bohemian merriment of Munich days. Preparations were elaborate. 'I often think,' Helena remarked, 'that rich people can't know the full delight of giving dances so well as poor people.'

> We began to prepare about a week or two beforehand. All the furniture was turned out of the biggest room which we habitually used as a dining-room, and we crowded into the front room. The carpet was taken up and the floor re-stained and polished with beeswax and turpentine. My father did the staining, but we all helped in the polishing. For a day or two beforehand, my mother, with the help of Mary and Emily Pollard (two of our best dancers [and the sisters of Alfred Pollard]) made aspics and consommé and jellies and galantines, while on the great day itself I was pressed into service to make 'anchovy eggs' and coffee, and cut sandwiches till my wrist ached. Walter wrote out programmes in his exquisite handwriting and sometimes illustrated select numbers.† The doors of the three ground-floor rooms were taken off, all fenders were removed and we decorated the fireplaces and marble mantelpieces with flowers stuck in banks of moss ... It was my father's job to hang the garden with Chinese lanterns, and so elaborate was my mother's consideration for her guests that she insisted on having all the doorways and the balcony and steps leading to the garden elaborately washed, so that the ball-dresses should not be sullied.

After the paid musicians who had been engaged for the evening had packed up, Mr Sickert happily played on at the piano till dawn for

* Oswald Adalbert had been naturalized in June 1879.

† This is a revelation. Walter's handwriting – as in his letters to Pollard – was terrible.

those revellers – mainly the 'newspapermen and actors' – who still had legs to dance.[74]

Dorothy Richmond came, not in a ball dress but in a 'white burnouse'.[75] What Ellen and Maggie Cobden wore is unrecorded, but they were both there. According to his sister's estimate, Walter was not a particularly good dancer (Bernhard being the only brother to show any aptitude in that direction), but he was certainly energetic.[76] He flirted happily with all three girls, and probably others besides. Nevertheless, despite this generosity with his favours, it was becoming acknowledged in the Cobden–Richmond circle that Ellen Cobden was his especial favourite. And though all retained an easy and affectionate intimacy with Walter, they recognized that Ellen – or Nellie – had at least the first claim upon him.[77] It is difficult to fathom how this came about. No early letters between them exist to illumine the origins and progress of their relationship, and on the surface they were not the most obvious pairing. Ellen was twelve years his senior (Maggie Cobden and Dorothy Richmond were Sickert's almost exact coevals). She was, however, still only thirty-two, and beautiful. Sickert in later life always described her as 'pretty, absurdly pretty', though he struggled to define exactly in what her prettiness lay. When pressed, he recalled her wonderful golden hair: 'That was *hair*,' he would murmur. 'It had lights, it had lights.'[78] Other friends insisted that her eyes were her finest feature. Indeed amongst some of her circle she had the pet name 'Matia' – from the Greek for 'eyes'.[79] A small pencil sketch that Sickert made of her reveals those eyes set in a fine heart-shaped face, which he imbued with both the sweetness and the melancholy of a Botticelli Madonna.[80] Even to Ellen's contemporaries there seemed something 'old fashioned' about her manner and deportment, something suggestive of eighteenth-century France. She was enormously good and kind, but was not a prig. As one friend remarked, 'like all those to whom men and women were more important than anything else she was a born gossip';[81] and behind her slightly formal exterior she could both enjoy and match Sickert's challenge of convention. '[Walter] and Nellie are at present rowing on the Regent's Park water,' Maggie reported of one afternoon excursion. 'It is pouring so they are doubtless enjoying themselves.'[82]

When she left for her summer holiday in Switzerland at the beginning of August, Walter (as Maggie reported to Dolla Richmond) was depressed at the departure of his 'polar star'. Not that the depression

lasted long. He rallied enough to see Dolla off on *her* holiday – she was joining Maggie and Annie Cobden in Germany – and then kept all of them entertained with letters during the course of the summer.[83]

Sickert's own summer holiday was spent in Cornwall. He was part of a theatrical house party gathered by the Forbes-Robertsons at Cadgwith in the remote west of Cornwall close to Lizard Head. Johnston was there together with his brother Ian, his sisters Gertrude and Ida (already a widow in her twenties), and various other young friends. Adding a touch of cosmopolitan glamour to proceedings were the fiery Polish-born actress Madame Modjeska and her husband Count Bozertn Chiapowski. Modjeska, after a brilliant career in Poland, had emigrated to America in 1876, where, despite her rather shaky command of English, she achieved an immense success. It was in the hope of repeating this triumph that she had recently arrived in England. As an advertisement for her talents she had given a series of London matinée performances of *Heartsease* (an English adaptation of *La Dame aux Camélias*). Johnston Forbes-Robertson at once recognized her talent and made her welcome. She was delighted to escape the heat of London for the Cornish coast and remembered the holiday at Cadgwith as a magical time: 'In that congenial circle one lived free from conventionalities, taking long walks on the beach or attending the lawn tennis games at the Rectory.'[84]

The hospitable rector of St Ruan's, the Revd Frederick Jackson, was an old friend of the Forbes-Robertsons.[85] Having so many theatrical celebrities suddenly on his doorstep he begged them to mount a benefit performance in aid of the church repair fund. The idea was eagerly taken up. As none of the local village halls was deemed big enough for such a gala event it was decided to give an open-air performance in the rectory garden. The local coastguards assisted in the construction of the stage: the lawn served as the auditorium, and a screen of mature trees provided the backdrop. The programme was made up of scenes from *Heartsease* and *Romeo and Juliet* (Modjeska, though almost forty, cherished an unquenchable ambition to play Shakespeare's star-crossed lover in the land of the Bard's birth). Johnston Forbes-Robertson took the male leads in both parts of the bill. Sickert was drafted in to play the 'père noble' in *Heartsease,* and to give himself the necessary gravitas he ordered a false beard from a London costumier. Unfortunately, it failed to arrive and he was obliged to improvise. Snipping some hairs from the tail of a white donkey, he made his

own 'Imperial'. It looked most impressive, though when, during the performance, he bent down to plant a kiss upon Modjeska's brow at a moment of grand pathos, she almost put him off by whispering, 'I have never been kissed by a donkey's tail before.'[86] To the end of his life Sickert regarded Modjeska as 'the greatest actress he had known'. Certainly she was the only star he acted opposite.[87]

The holiday also had its unstaged dramas. One rain-sodden picnic at the nearby cove was enlivened when the lifeboat alarm was raised. The crew, which rapidly assembled, was short of several members, so Sickert, along with Johnston Forbes-Robertson and a couple of others, volunteered to stand in. They rowed round the headland into the next bay only to find it had been a false alarm. But Forbes-Robertson, who was sharing an oar with Sickert, could not help noticing that his friend was rather less concerned with the urgency of the moment than with 'the wonderful effect of the white foam dashing against the mighty serpentine rocks' off the rugged coast. Visual and artistic considerations were, it seems, never far from Sickert's mind.[88] And in the intervals between play rehearsals and sea rescues, there must have been opportunities for painting – and being painted. It was probably at Cadgwith that he produced his little panel titled The Orchard,[89] and maybe the holiday also provided him with the opportunity to pose for Johnston Forbes-Robertson – usurping the artist's own role of Romeo for the portrait.[90]

The party broke up in the middle of August.[91] Sickert had to rejoin the Rignold tour up in Yorkshire. They were performing in Bradford at the beginning of September when Madame Modjeska made her debut at the Grand Theatre, Leeds. Sickert led most of his fellow cast members over to see her. If they were impressed by her acting they were amazed by her dressing room: it was equipped with 'Hot and Cold' running water. For days afterwards they could 'talk & think of nothing but this miracle'.[92]

At the end of September the Rignold company arrived in London for a short run at the Standard Theatre, Shoreditch. Sickert was assigned lodgings in Claremont Square, at the top of the Pentonville Road. It was a first return to North London since the brief sojourn at Duncan Terrace in the 1860s. The blend of faded elegance and present grime was very different from Kensington. The tall, narrow, Georgian-brick house (just along from one in which George Cruikshank had lived) looked out not on to a central garden-square, but on to the less lovely

prospect of a covered reservoir (established there by the New River Water Company). The rooms themselves, however, were pleasant, and even included a grand piano.[93]

No sooner was he settled back in London than he presented himself at York Place. Maggie Cobden recorded his arrival in a letter to Dolla Richmond, who was on her way back to New Zealand with her family. 'The subject most interesting to my Dorothy rises before my mind's eye . . . I opened the door to him attracted by the family knock & was much surprised to see our friend standing on the door step with very long hair & a large bunch of roses – he is improved as to appearance by his tour, being fatter & with more colour. But London is already beginning to tell. The family congregated in the hall to talk – imagine us round the oak chest – Walter to the right, rather overcome by the meeting – a little husky as to the voice which I thought to be a cold. Janie and I propped against the matting – my favourite position with a good view of the looking glass – Jessie [Thomas, the Cobdens' cousin] dancing around after her manner with a large sunflower – Nellie arranging roses – the poor roses were overblown & fell in showers on the stone floor.'[94]

Although Walter begged the Cobdens not to come and see him acting at the Standard, he must have known they would. Along with their friend Theodore Beck they crept in, unheralded, two days later and were charmed by the theatre ('a beauty inside'), noting particularly the 'noble curve' of the – alas, entirely empty – dress circle. They considered Walter's acting – on the whole – 'so much better' than at the start of the tour; although his good notices as the 'French Prisoner' had perhaps rather over-encouraged him. When, with 'his eyes rolling & stiff black hair standing upright on his head' he dashed on to the stage, collapsed on to his knees and then – as he thought Pistol was about to kill him – rose up on them in an agony of terror, it reminded Maggie Cobden of 'a Christmas pantomime'. Before the last scene, 'The Grand Tableau of the Entry into London', they sent a note round to announce their presence, and were amused to notice that when Walter next appeared on stage he was clutching the scrap of paper.[95]

Walter met them after the final curtain. He was on a high. He was also ravenously hungry, and on their way home together insisted on stopping at a dairy where he drank off three glasses of milk in quick succession. He escorted the Cobden girls back to York Place on the bus, then stayed to supper and went on talking late into the

night. There was a sort of irresistible, if slightly manic, energy about him. Excitement, drama, self-dramatization, not untinged with self-mockery, touched everything he did over the following weeks. He spent much of his limited free time at York Place. 'Walter is here roughly speaking from morning to night,' Maggie reported and most of the time he was in what she described as a 'rampant humour'.[96] One Sunday evening he insisted on acting out most of *Hamlet* for their amusement, taking the different parts in turn.[97] The limitations of the 'general utility' player were chafing.

He had his photograph taken, looking like the smouldering mat-inée idol he had not yet become. Off the stage he tried out the part of 'host', laying on one hilarious tea party at his book-strewn rooms in Claremont Square, where the company (Nellie, Maggie, Jessie Thomas, Theodore Beck, and a Mr Nicholson) had to make do with an 'average of one knife to 3 persons'. They then all crowded on to the little first-floor balcony and 'speculated on the different deaths [they] should die if it gave way'. Within the merry flow of group activity his particular bond of understanding and attraction with Nellie Cobden quietly strengthened.[98]

There was a brief interruption to these pleasures when, after the Shoreditch residency, the Rignold Company moved down to Exeter on the final stage of the tour. Walter delayed his departure to the last moment in order to snatch an extra day with the Cobden girls. Having told his family that he was travelling down with the rest of the company on the Sunday morning he snuck off instead on a jaunt to Richmond with Ellen and Maggie. It was scarcely a quiet Sunday outing. Walter was 'uproarious' throughout the journey, shrieking Irvingesque snatches of dialogue out of the railway carriage window, and down the communication tube into the next carriage. And when they reached Richmond he insisted on them all racing down a steep field. Then they hired a boat and rowed up stream for an hour. Walter's hair, which had grown into a long golden mane, provoked considerable comment. The holiday fishermen were 'roused from silence at the sight of the yellow locks', and wanted to know 'why he robbed the barber'. Walter remained unfazed by the general interest in his coiffure. He was too busy noting the resemblance of the fishermen on their punts to Leech's drawings of such scenes.[99]

They came home on the bus after stopping at an inn where Walter and Ellen shared a 'tankard of amber ale'. The beer did nothing to

quell Walter's spirits. That evening at York Place, where he stayed till midnight, he was, according to Maggie's account, 'more or less mad', and spent at least some of the time 'pouring eau de cologne on everyone's heads'. As if unable to bear the prospect of separation, he turned up again first thing the next morning on his way to the station. Ellen accompanied him as far as Piccadilly before saying a final farewell.[100]

He looked a romantic figure beneath his flowing mane; his luggage comprised a small carpetbag, a sword, three books, and an Arab blanket. The effect was probably well calculated. Walter was beginning to weave elements of theatricality into his life – to adopt roles, don costumes, and assume guises. By the time of his return to London six weeks later, he had struck a new pose. 'His appearance was a shock,' Maggie told Dolla Richmond. 'All his beautiful locks cut off and the stubby remains brushed straight up his head like a French boy's', or a 'costermonger['s]'. He was, she remarked, altogether 'a changeling'.[101] He had left a Byronic wanderer, and returned as a barrow-boy. Other changes soon followed. He appeared next as a metropolitan dandy in a very smart frock coat.[102] It was but another role in what would become a large – and ever revolving – personal repertoire. In the first instance these masks revealed rather than concealed. They were projections of his own character, dramatizing his interests and his aspirations. The frequent changes, if they suggested a certain restlessness, reflected too a love of variety and of fun. Sickert enjoyed creating a dramatic moment: he knew that his quick changes, outlandish outfits, and extravagant poses had the power to surprise, confuse, even shock.

Despite the mutability of his appearance, he remained constant to the Cobdens. He spent so much of his time with them that his mother finally protested that when next he came to London he should live at York Place altogether. While looking for a new engagement after the end of the Rignold tour, he was free to spend his days *chez* Cobden, and his evenings going to the theatre.[103] He went one evening with Ellen to see Madame Modjeska at the Royal Court (then in Lower George Street, Chelsea); she had gained her desire and, in an echo of that summer's experiment, was playing *Romeo and Juliet* opposite Johnston Forbes-Robertson. At Edwin Booth's *Hamlet* he saw Ellen Terry sitting in a box surrounded by Forbes-Robertsons and attended by Oscar Wilde; they were too busy talking to pay much attention to the play – or any to Walter. These were tantalizing glimpses of a familiar world that remained – even after a year of effort – still just outside his grasp.[104]

That December also revealed, for the first time, the limits of Ellen Cobden's constitution. For all her energy, gaiety, and wit she was prone to sudden collapses and bouts of scarcely defined 'ill-health'. Although she was happy to go with Walter to the theatre, she was less willing to go on to the parties afterwards. Walter would go without her. His high spirits always added 'much to the pleasure' of such occasions, at least according to Maggie Cobden – though some hostesses might have been slightly alarmed at his behaviour. At the Masons' dance just before Christmas he was 'excessively wild', attempting, amongst other antics, to tie some trimming from Maggie Cobden's dress around his head while quoting the lines from *Iolanthe* – 'thy scarf I'll bind about my plumed helm'. On the way home in the Cobdens' carriage in the early hours, he roused the neighbourhood by shouting out the 'curse of Rome' speech from Bulwer-Lytton's play *Richelieu* 'in an Irving voice', ending in 'a sort of frenzied shriek'. The performance startled a timid youth to whom they were giving a lift home. The boy's alarm, Maggie reported, was only compounded when, on setting him down, Walter 'was all suavity and enquired tenderly if we couldn't have the pleasure of taking him right home'. Faced by this sudden and unexpected change in manner the poor fellow fled.[105]

If Walter's frustrated energies sometimes found vent in wildness, he could also direct them into acts of kindness. He charmed the Cobden sisters with improving little gifts: Maggie received, as a Valentine present, a volume of Hans Andersen fairy stories – in German.[106] At Easter 1881 he went down to Midhurst, where the Cobdens had a cottage close to their old family home at Dunford, and made a considerable impression on the locals, who thought he must be Maggie's beau rather than Ellen's.[107] He escorted ever-shifting combinations of sisters to social and cultural events. He was with Maggie at William Morris's riverside house on Boat Race day, together with a large crowd of other guests (including most of his own family). After the excitement of the race – and the lunch – he captained one side in what Helena remembered was 'a delirious game of Prisoner's Base'.[108] And on another memorable excursion Walter led Maggie and Annie to the stage door of the Lyceum and introduced them to their idol, Ellen Terry. They presented her with a little bunch of red and white roses, and were rewarded with thanks and kisses. To help them recover from this great excitement he then took them to a little Italian coffee house where they had hot chocolate and 'maccaroni'.[109]

When the Sickerts hosted another party that summer, Walter delivered a bunch of sweet peas to York Place in the morning to be divided up between the four sisters, who – 'contrary to all rule' – had agreed to attend en masse. On his way over to Baker Street he had, much to his amusement, encountered an old family friend, who, seeing the flowers, remarked, 'Oh, those are for the beloved. I shall see who wears them this evening.' He relished the prospect of her confusion when she was confronted by not one but four 'beloveds'. (There were in fact five 'beloveds', as Jessie Thomas was staying at York Place and came to the party wearing her share of Walter's sweet peas.[110])

Despite his small successes with Rignold and at Sadler's Wells, Sickert's acting career still stubbornly refused to ignite. He continued to get scraps of work as a super at the Lyceum, and he seems to have appeared at the Globe;[111] but there were no substantial roles. It is difficult to know why this should have been. From the very limited evidence available it would seem that he had real, if not an exceptional, ability. He had excellent connections, and no shortage of self-belief. As he declared cheerfully to Maggie Cobden, he was blessed with 'more advantages than most young men on the stage – namely great physical and intellectual [gifts] & a social position'; and indeed Maggie was mystified as to why the London theatre managers were not courting him. He was looking, she considered, particularly 'beautiful' in his new dandified persona: for evening wear he had adopted a splendid opera hat 'of Irving like proportions', which he wore inclined slightly over one eye to 'fascinating' effect. But if it fascinated Maggie Cobden and her friends, it still failed to attract the notice of London theatrical impressarios.[112]

His most arduous theatrical engagement during the first half of 1881 was a morning spent with Ellen Terry, 'flying about Regent Street . . . having Desdemona night-gowns draped upon him' as the actress tried to decide on her costume for the forthcoming Lyceum production of Othello.[113] Indeed the Cobden girls were more actively involved in dramatic pursuits than he was: they were busy rehearsing a rather overdressed amateur production of Romeo and Juliet.[114]

Walter tried not to be too downhearted by his periods of enforced idleness. He perhaps drew some comfort from the sad predicaments of his brothers, now both embarked on careers of their own. Robert, having passed his school years 'in a sort of dream', had been put into the uncongenial surroundings of a London office. Though conscientious, he

was quite unable to interest himself in the duties of a 'merchant's clerk'. But he lacked the energy to test his own gifts, such as they were, for comic writing and drawing. Bernhard was faring even worse as an assistant master at a private school, a job for which his sister described him as 'manifestly unfit'. The boys were 'all over him'.[115] He, like Walter, wanted to be a painter, but his father would not hear of it. And when his teaching career came to a swift and abrupt end, he was found a berth as secretary to the financial editor of The Times – a position made neither easy nor enjoyable by his total inaptitude for figures.[116]

For Walter, at least, days of 'resting' could be pleasurably spent. His free time, though much taken up with the happy distractions of York Place, was not entirely given over to flirtation and courtship. Leisure also allowed him to pursue other interests. He saw something of Godwin. They went together to William Poel's production of Hamlet at St George's Hall. Godwin, according to Sickert's account, 'had to leave early and asked me to write a paragraph or two on the production for his paper, the British Architect'. Although it was Sickert's journalistic debut, he had no hesitation in boldly urging that it would be 'a great loss to the professional stage if Miss Helen Maud [the amateur actress in the part of Ophelia] did not become at once a member of it'.[117] It was a good call. Miss Maud (or Maud Holt as she was known off the stage) married the successful actor-manager Herbert Beerbohm Tree the following year, and enjoyed a successful stage-career at his side. Nevertheless, the notice, for all his prescience, did not lead at once to other writing commissions.*

* Sickert's 'review', which he described so vividly in a letter to The Times in 1934, remains a conundrum. It does not appear in the British Architect. He may – as Godwin's son suggested – have reviewed the play for some other journal. Or perhaps he wrote about a different play. There are several other notices of Helen Maud's performances in the British Architect during the course of the year. E. W. Godwin's diary for 10 December reads: 'Evening to Club. Sigurd [Sickert] came, dined at Criterion & on with him to St George's Hall amateur performance – Still Waters [Run Deep]. Home directly it was over.' In the next issue of the British Architect (16 December 1881, 629–30) an unsigned review appeared declaring that the play 'had a special artistic interest for it gave us another opportunity of seeing Miss Helen Maud act. It is not often that an amateur performance leaves one with any memory or any new light; but in the nature of things, it is at amateur performances that now and again we discover the actor or actress, the unmistakable diamond embedded in the gravel. Rarely indeed do we see on any stage such refined, spontaneous acting as that which Miss Maud showed in playing Mrs Mildmay, curiously free, moreover, from the faults usually incident upon inexperience.'

Walter continued to study under his father and to visit Scholderer's studio, working, as Janie Cobden reported approvingly, 'pretty hard at his drawing'.[118] Staying with the Scholderers at Putney that June was Henri Fantin-Latour, whose freely worked flower paintings were beginning to get a market in England thanks to the efforts of Mrs Edwin Edwards.[119] He was another link in the great 'French tradition' that Sickert was eagerly discovering. Sickert also made a special expedition with Godwin to see *The Sower*, a painting by the recently deceased Jean-François Millet that was being exhibited at Number 8 Pall Mall.[120] It was his introduction to the work of the so-called Barbizon School. He was impressed by Millet's carefully constructed picture: a scene of everyday life built up from deep knowledge and accumulated observations. But it did not carry him away as Whistler's work had done.

Whistler was back in London. After his year-long exile he had announced his return with an exhibition of Venice etchings at the Fine Art Society, closely followed by a show of Venice pastels at the same venue. Sickert feasted upon Whistler's pictures and became increasingly infected with their vision. On the long summer evenings he would sit in Regent's Park with Ellen and her sisters, noting the 'very Whistler like' effects of the gathering dusk. And then he would try to sketch them.[121]

For the last ten or so weeks of the summer, Nellie and Maggie Cobden took a house on the far north coast of Scotland.[122] Sickert, it was agreed, would join them there. He travelled up to Sutherland at the end of July, and was at once charmed by the setting.[123] Rispond House is a fine, almost grand, white-fronted building, set in a perfect little natural harbour near the mouth of Loch Eriboll, a mile or so from the village of Durness. It is a beautiful spot in fine weather, with its little stone jetty, its walled kitchen garden, the hills folding round it, and the clear blue skies stretching northwards towards the Arctic.

The Cobdens were sharing the house with their bluestocking friend Dr Louisa Atkins, who was accompanied by two of her students. Although they dined together, the two parties maintained some lines of informal separation, having the use of the main drawing room on alternate days. The usual tenant of the house, Mr Swanson, an irritatingly garrulous man with a slight facial deformity, had moved into a little house out the back, together with his wife.

Sickert arrived full of his own plans. Maggie described him as being 'very argumentative & grandfatherly'. His first act was to announce

piously that he would be going to bed 'every night at eight in order to get up at 4 & paint'.[124] Perhaps happily for the general harmony of the party he seems to have abandoned this extreme regime, but he did devote much of his time to work.[125] Ignoring the rather frequent winds and rains ('the weather is not all we could desire') – and Mr Swanson's unhelpful suggestions as to the most picturesque vistas – Sickert would spend whole days 'working at some beloved subject' out in the open air, sometimes sustained by nothing more than a piece of oatcake.[126] There were, however, occasional let-ups in the programme, some of them enforced. After painting out of doors for the whole of one dismal afternoon he developed 'a touch of lumbago' and had to rest.[127]

Besides plunging into his work, Walter also plunged into the sea. It was not a great success. Despite being wrapped up in an elaborate costume of his own devising – 'bathing drawers' and a white shirt worn over ankle-length merino combinations – he nearly froze.[128] Maggie, who had given up bathing after a very brief experiment, was delighted to report that when he appeared at lunch after one swimming expedition 'he was blue & red in the face – his jaws chattered & his hands were dead white & shook as though he had the palsy'. Although he persisted for a while, even his ardour seems to have been dimmed. Scottish bathing, he began to suspect, did 'not agree with him'.[129] Under the circumstances, he must have been rather impressed by Nellie's ability to swim each day without ill effect.[130]

Exposure and lumbago were not the only woes Walter endured at Rispond. He badly turned his knee while trying to re-float Dr Atkins in her rowing boat after she had run aground in the little bay. Although the knee cap clicked back into position at once, it needed to be bound up in bandages. He was forced to keep quiet, and not go 'prancing over the hills', for several days. He devoted himself to assuming a new guise, growing his hair and also 'a dear little moustache & beard of delicate red', which, no sooner had it been generally admired, than he threatened to shave off. He also found diversion in the novels of the Brontë sisters. He had brought 'nearly all' of their books with him, and they provided a common theme for the party. By the end of the holiday both he and the Cobden sisters had the Brontës 'on the brain'.[131] (Wuthering Heights was his especial – and enduring – favourite; he felt that it soared 'beyond the frontiers of prose'.[132]) A visit was planned on the way south to the family parsonage at Haworth.

They finally left Sutherland in the second week of October. It took them five days to get home. There were stops not only at Haworth but also at Inverness, Berwick, and York. At York they spent one uncomfortable night at the Leopard, an old inn close to the Minster which Walter seems to have visited during the Yorkshire leg of his *Henry V* tour, and had been recommending fulsomely to everyone 'for the last year.' The Cobden sisters did not share his enthusiasm for the quaint old place. Having groped their way up a pitch-black stairway and been led through a billiard room, they were shown into a tiny bedroom, like 'the garrets in Hogarth's pictures'. They insisted on swapping with Walter, who had a slightly less garret-like room on the floor below, but it was a scant improvement. They got no sleep: all night the clock struck the quarters, and in the early hours a large wagon rolled by sounding, as Nellie said, 'like the Tower of Babel passing'. When they escaped in the morning, they were horrified and amused to meet a London friend – a young clergyman – looking up at the sign and preparing to enter, having been recommended the place by Walter too.[133]

It is not known whether the Cobden sisters saved the man from his ordeal. They certainly moved to save themselves from any further discomfort. 'After a great deal of trouble we have taught Walter the difference between an Inn & a Public House,' wrote Maggie. 'The dear Leopard is unfortunately the latter.'[134] This, of course, is probably what attracted Sickert to it. He was already beginning to develop a relish for the popular, the sordid, and the authentic, for that characterful world first distilled 'in Hogarth's pictures'.

The ten weeks that Walter spent at Rispond House marked a watershed. They provided an unprecedented chance for concentrated work and also for concentrated intimacy with Nellie Cobden. It was an opportunity, too, to plan for the future. He had come of age at the end of May and his formal entry into adulthood may have quickened his sense of resolve. By the end of the holiday he had taken two important decisions. He enrolled for a course at the Slade School of Art, and he became engaged to Nellie. The two things may even have been connected.

Helena Sickert recorded that, at this juncture, Walter was 'helped to follow his true vocation', while Sickert's friend and first biographer Robert Emmons states more boldly that Oswald Sickert, 'seeing that [Nellie Cobden] had a fortune of her own . . . agreed to his son's giving

up the stage'.[135] This, however, may be overstating the case. Nellie
certainly wanted to help Walter. She loved him and had come to regard
him as a rare talent. And for all her proclaimed belief in feminine
independence she regarded it as particularly her vocation to assist the
genius of others. As one of her friends noted, 'she took the part of
men and women whose dreams went far and farther than far, provided
always they had the courage of their desires'. It seemed to her that to
'be born with wings and not to fly' was 'the commonest tragedy' of
modern life.[136] She wanted Walter to escape that fate; she hoped to
help him spread his wings and launch himself into the air. Shelley
was her ideal ('as near perfection as human nature had so far
reached'),[137] and there was, to her, something Shelley-like about
Sickert, with his blond locks, his intense energy, his burning commit-
ment. Nevertheless, while she felt sure of his genius, she – like Mr and
Mrs Sickert – was not yet quite certain where that genius lay: in the
studio or on the stage.

Walter himself was in no hurry to abandon acting completely. His
Slade course was only for one year, and the hours were not long. They
did not preclude the possibility of theatrical engagements, or eclipse
the vision of an artistic reputation being supported by a brilliant stage
career. His first step towards a formal art training did little more than
mark a tilt in balance between the two spheres of his ambition. It was
agreed that Walter and Ellen's engagement should be for eighteen
months: they would marry in the summer of 1883. In the meantime,
Walter would continue to live at home, and the arrangement would
be kept as a family secret.[138] Perhaps after that period the outlines of
Walter's future would be clearer.

The reaction of Nellie's sisters to the engagement was mixed. Maggie
and Annie (as well as Jessie Thomas) were all conventionally 'delighted',
while Jane Cobden thought 'Nellie ought to have gone in for a Cabinet
Minister'. Maggie, however, confided to Dolla Richmond that Walter
was one of the very few people that she herself could have imagined
being married to, adding the rather unconvincing caveat, 'mind, I
wasn't in love with him'. She drew what consolation she could from
the thought that others might be similarly disappointed: 'Won't there
be a shrieking over the length & breadth of the land when [the engage-
ment] is made known.'[139]

* * *

Having decided upon enrolling at an art school, Sickert's choice of the Slade was all but inevitable. He had spent the previous five years consorting with Slade students, Gower Street was familiar territory to him, and Alphonse Legros, the head of the school, belonged to that same mid-century Parisian art world in which Oswald Sickert, Otto Scholderer, Fantin-Latour, and Whistler had been schooled – indeed Legros, Fantin, and Whistler had formed a short-lived triumvirate, le Groupe de Trois. Sickert first attended on 18 October 1881, two weeks after the beginning of the new term, and almost a week after his return from Scotland.[140] Whatever his hopes for the course, they soon foundered. The atmosphere of the school was severe, muted, and academic. The high spirits of the Slade rabble-rousers found no echo inside the teaching studios. The sexes were segregated, classes were small, and the general standard low. First-year students were expected to work exclusively from the cast, toiling from morning to late afternoon with greasy 'Italian chalk' to set down on large sheets of unforgiving 'Ingres paper' the planes and shadows of some classical figure or Renaissance bust. Legros himself, with his sober, baleful features and grey-flecked beard, was a distant figure. Unable, or unwilling, to speak English, despite his long years of residence – and his marriage to an Englishwoman – he communicated largely through his assistants and subordinates. His comments were terse, his direct instruction limited to painting the occasional demonstration picture in front of the class.[141]

Sickert's later verdict on his teacher was harsh, and grew harsher over the years. He recognized the sincerity and, indeed, the achievement of Legros' art – particularly his etching and his imaginative paintings,[142] and he concurred in his deep respect for tradition and the work of the old masters. But he felt that, as a teacher, he was a failure. It was not his métier.

'Legros,' he wrote in 1912, 'has been spoken of as a great teacher, which he wasn't . . . A great teacher vivifies not one or two, but hundreds of students directly, and, indirectly, countless ones. He reclaims whole intellectual territories into cultivation, and leaves his mark on generations.' On all these fronts Legros failed. His professorship, moreover, 'depleted his creative energy, instead of nourishing it'.

> A great teacher is refreshed and inspired, not only by his direct, but by his indirect creation. Legros had no clearly reasoned philosophy of procedure, and did not understand the

closely-woven plexus between observation, drawing, compo-
sition, and colour. The heads he painted in two hours before
his classes, with their entire absence of relation between head
and background, were almost models of how not to do it. It
is scarcely a paradox to say that a professor of painting should
show rather how little, than how much, can properly be done
in the first coat of paint, if the last is to crown a work, as
distinguished from a sketch.[143]

It is doubtful that Sickert had worked out all these objections to Legros'
method during the first weeks of his studentship. In the autumn of
1881 he is more likely to have registered only a vague feeling of
dissatisfaction.

He made no friendships amongst his fellow pupils,[144] and the focus
of his artistic interest rested outside the school. Whistler remained 'the
god of his idolatry', and much time was spent at the shrine.[145] Whistler
was not averse to worship, particularly from so adept a votary. Sickert's
flattery was informed, unflagging, and intelligent. On one visit he
pleased Whistler by remarking that what the ignorant public could
not abide in his portraits was the uneasy sense that 'these devil-may-
care people were laughing at them'.[146] Even better than this, Walter's
admiration was exclusive. He declined, for instance, to share Maggie
Cobden's enthusiasm for a Samuel Palmer exhibition because, as she
remarked, for him 'there is one God, and his name is Jimmy'.[147]

Whistler knew how to reward such loyalty. It was probably his
influence that lay behind the inclusion of one of Walter's Scottish
paintings in a group show at the Fine Art Society that winter. The view
of Loch Eriboll was Sickert's first exhibited picture,[148] and it was perhaps
in the hope of repaying this favour that, at the beginning of December,
Walter took Maggie and Annie Cobden to visit Whistler in his new
studio at 13 Tite Street, across the way from the White House – which,
with ghastly irony, had been bought by Whistler's arch enemy, The
Times's art critic, Henry (Harry or 'Arry') Quilter. They spent 'a very
good time' looking at his pictures, and although Annie thought that
Whistler's hospitality had sprung from 'the goodness of his heart',
Maggie suspected that an unspoken hope that they might commission
portraits lay behind the visit.[149]

Ellen did not accompany them. She was not well again. There had
been signs of a decline in her health during the last days of the Scottish
holiday, and they had become more marked since the return south.

She retired to Aldeburgh on the Suffolk coast to see what sea air and rest could do for her.[150] Walter, however, was kept in London. Rather unexpectedly, his theatrical career had spluttered back to life. Dr Maclear invited him back to perform once again at the KCS Christmas prize day. It was a return to the scene of past triumphs. Doubtless under the influence of Godwin's theories on period dress, he hired an 'authentic' costume from a top outfitters and, splendidly attired in red tights and a black velvet doublet with yellow lined sleeves, revived the scene of 'Clarence's Dream' from *Richard III*. Maggie Cobden was not entirely convinced. She thought his performance 'rather too laboured' and only 'moderately good'. Stripped of its Irvingesque mannerisms, Walter's voice, she considered, lacked the power to carry in a big theatre.[151] Despite these doubts about his powers of projection, Walter secured 'a small engagement' with the Kendals at the St James's Theatre: Johnston Forbes-Robertson had given him an introduction to Mrs Kendal, and she had been 'v. sweet to him'. He was to appear in some minor non-speaking capacity in their production of Pinero's *The Squire*, as well as understudying two of the leading players. And there was a hope that he would 'get on' at this new theatre.[152] The play was scheduled to open at the end of the year.

Ellen returned from Aldeburgh before Christmas. The back drawing room at York Place was set aside for her exclusive use. The prime topic of conversation amongst the sisters was where Walter and Nellie should live after they were married. If the question was slightly premature, it was still fun to consider. Campden Hill was the early favourite. It was agreed that each sister – as a wedding gift – would pay for the furnishing and decoration of a different room.[153] Annie – who was to be responsible for the dining room – had particularly strong views about interior decor, favouring whitewash instead of wallpaper.[154] Walter joined in these deliberations. He would spend his evenings with Ellen, though his days were much taken up with 'benefitting his soul' – and learning his part – by sitting in on rehearsals at the theatre.[155]

The first night of *The Squire* was on 29 December 1881. Walter, despite being only a 'super', threw himself into proceedings with typical energy. He had devised a very elaborate make-up for his fleeting appearance as 'a toothless old man' in one of the crowd scenes, and was so proud of it that he challenged his own mother to recognize him.[156] It is not recorded whether, during the three-month run, Walter ever had to step up to play either of the parts he was understudying.

He did, however, become friendly with one of the actors he was cover-
ing for. Brandon Thomas, or 'Mr Brandon' as he appeared on the
playbill, was a jovial 32-year-old Liverpudlian.[157] He was much inter-
ested in contemporary art, and was a keen admirer of Whistler's
work. Walter greatly impressed him with his knowledge of painting
and, more specifically, with his claims to an actual connection with
Whistler.[158] It was a connection that was strengthened in the New Year.
During the early months of 1882 Sickert's attendance at the Slade
slackened. The demands of the theatre doubtless took their toll, but
they were coupled with his growing sense of dissatisfaction at the
Legros regime. He confided his disillusionment to Whistler, who is
said to have remarked, with characteristic pith, 'You have wasted your
money, Walter: there's no use in wasting your time too!'[159] He invited
him, instead, to come and work at his studio, to exchange the conven-
tional world of the art school for the richer Renaissance concept of
discipleship to a Master.

It was often suggested, particularly by those who knew him in later
life, that 'to understand Sickert it has to be remembered that he was
an actor in his youth'.[160] His delight in costume and taking on roles,
the range and control of his voice, his sense of the dramatic moment,
were certainly very theatrical in their effect, but they were elements of
his character that attracted him to the stage, rather than tics he learned
while touring the provinces as a 'Utility Gentleman'. Nevertheless, his
connection with the profession, however brief and undistinguished,
was important to him. It did colour both his life and his art, and as
the years passed he proclaimed it ever more insistently. Theatrical
allusions came to litter his conversation. He delighted in recalling
thespian anecdotes: the time old Tom Mead, playing the ghost in
Hamlet, appeared by mistake directly behind Irving and – in 'quite a
new effect' – called out, 'Here. Here' to announce his presence.[161] He
used stage vocabulary for non-stage matters, referring to the 'off-
prompt side' of his pictures. And he would recite huge swathes of
Shakespeare impromptu. To the end of his days, his party piece
remained a one-man rendition of a scene from *Hamlet* as played by a
motley touring troupe (based surely on the Rignolds). He enjoyed the
company of actors; he kept abreast of the London stage. In his art he
used the theatre as a subject. But, more than this, his time on the stage

gave him a sense of showmanship – of the actor-manager's role – which he transferred to his artistic career. And though he never played to the audience in his painting, he remained conscious that there *was* an audience. That communication was part of art – along with laughter, outrage, and applause.

II

WHISTLER'S STUDIO

Whistler inducted me into some understanding of painting.
(Walter Sickert to John Collier)

From the staid world of the Slade cast room Sickert found himself
carried off into the hectic whirl of Whistler's professional and private
life. Not that there seemed to be much distinction between the two.
Whistler liked to work amongst a *camarade*. The large studio room at
the back of 13 Tite Street was almost always busy with callers, models,
chaperones, sitters, and assistants. Visitors came from Paris and from
across the Atlantic. And at the un-still centre of this shifting throng
was Whistler himself: the focus of all attention and the source of
all energy. He moved constantly about the room with the lightness,
neatness, and decision of an armed butterfly: flitting from his table-
palette to his canvas wielding his long-handled brushes; poring over
portfolios of choice old papers; lovingly inking up his printing plates;
drafting letters to the press; and all the time firing off fusillades of
sharp laughter and sharper talk.

Sickert found an already established studio retinue. It included a
mild-mannered lunatic – a one-time designer for Minton's pottery –
who would potter about, a shadow to the Master, making innumerable
sketches on scraps of brown paper. Maud Franklin, Whistler's slender,
buck-toothed mistress, though often ill during 1882, was still in evi-
dence as both model and student. Another more openly acknowledged
pupil was the sleek, fair-haired Australian, Mortimer Menpes. Born in
Adelaide in the same year as Sickert, he had come to London to study
under Edward Poynter. He showed a precocious ability as an etcher,
and it was after Whistler had noticed one of his student works that
he had abandoned the National Art School and joined the Master's
entourage, assisting him in printing up the first set of Venice etchings.[1]

Beyond this inner core, a shifting group of other young artists made up a less formal, but no less devoted, honour guard. A trio of magnificently moustachioed Americans, Harper Pennington and the brothers Waldo and Julian Story, came often to the studio, as did Francis James, a delicate watercolourist of delicate flower pictures. The fashionable portraitist Frank Miles, though an object of mild derision amongst the other followers, called by almost daily from his studio across the way (a studio designed by E. W. Godwin).[2]

Of the older generation of Whistler's friends, some few stayed loyal: Godwin, of course, and his young wife; Albert Moore, the painter of self-absorbed classical beauties; Thomas Way, the specialist printer who helped Whistler with his etching. Charles Keene, whose work Whistler admired greatly, was another occasional caller. The prevailing atmosphere, however, was one of youth, and not always very critical adulation. And that was how Whistler liked it. He preferred, so he said, the company of 'les jeunes fous que vieux imbéciles'.[3]

There was one notable absentee. Oscar Wilde, who throughout the previous year had been a constant presence at the studio, was away lecturing in America on art and home decoration. It was a year-long tour. But news of Wilde's triumphs percolated back to Tite Street: he made sure of it by arranging for Whistler to be sent press notices. And the reports of Wilde's transatlantic triumphs served to sharpen the never quite concealed spice of rivalry that lay beneath the bantering friendship of the two men.*

Amongst the many who did come to Whistler's studio, buyers and sitters were disappointingly rare. Whistler's attempts to woo 'Society' at his celebrated Sunday breakfasts achieved only a limited success. Lords, ladies, and plutocrats might come to eat his food and enjoy his wine, but they persisted in regarding him and his art as a sort of ingenious joke. Indeed many of them assumed that Whistler regarded matters in the same light, and thought they were only being polite in laughing.[4] Others were reluctant to pose for different reasons. After the debacle of the Ruskin trial, and Whistler's no less public dispute

* Whistler addressed a series of disparaging open letters to Wilde during the course of the year: 'We, of Tite Street and Beaufort Gardens [home of Mrs Jopling-Rowe], joy in your triumphs and delight in your success; but we are of opinion that, with the exception of your epigrams, you talk like "S[idney] C[olvin] [the Slade Professor] in the provinces"; and that, with the exception of your knee-breeches, you dress like 'Arry Quilter.'

with Sir Frederic Leyland over the bill for the decoration of the Peacock
Room, his reputation was suspect. To have one's portrait painted by
Whistler was, they felt, to risk the ridicule of the artistic world, to say
nothing of the possible ire of the artist if things did not work out as
he wished. Those few who did commission portraits in the early 1880s
were either brave or reckless – brazen *demi-mondaines*, old friends,
independent spirits, and Americans. In the absence of more numerous
commissions Whistler made use of models both professional and ama-
teur. On occasion he even picked people off the street and invited
them to pose at the studio. Failing that, he painted himself or his
studio assistants. Sickert was soon pressed into service as a model.[5]

Whistler's world was totally engrossing – to himself and to those
about him. It was a world dominated by art, or by Whistler's concep-
tion of art. His person and his pictures were the twinned and abiding
themes of his existence, and Sickert – along with Menpes – came to
share the same perspective. Sickert's commitment was total. With the
closing of *The Squire* in March 1882 he abandoned the stage com-
pletely, to concentrate on his discipleship. Menpes has left a vivid
account of the daily round: the early summons by hand-delivered note
('Come at once – important'); the close perusal of the morning post
and papers, followed by the excited elaboration of scathing ripostes
to any insults, real or perceived; the stroll around the shabby streets
of old Chelsea armed with a pochade box (for small oil sketches) or
an etching-plate in search of appealing subjects for a morning's sketch-
ing – a street corner perhaps or a humble shopfront; the lunchtime
omelette back at Tite Street (the creation of the omelette, being a work
of art, fell to Whistler); and then the afternoon of work and talk in
the studio.[6]

Whistler staged his indoor pictures with care. Sickert had to help
prepare the studio for the various models and sitters, either establishing
an elaborately informal *mise-en-scène* with suitable 'aesthetic' props, or
erecting the cumbersome black velvet backdrop against which Whistler
had taken to posing sitters for full-length portraits.[7] Before beginning
his picture Whistler would mix a quantity of all the tones he would
require, and it became Sickert's duty to set out these carefully prepared
paints – in their designated order – on the glass-topped table that
served as Whistler's palette.[8]

Later, the pupils might walk with the Master into the West End to
watch him 'terrorize' his tailor, his hairdresser, or the various Bond

Street art dealers. (His method with these last was to stride through the door of their establishment, pause for an instant, and then exclaim 'Ha, ha! Amazing!' in a loud voice before sailing out again.) Or they might make a brief visit to the National Gallery. From there they would continue on a circuit of evening pleasures – receptions and private views, dinner at the Arts Club in Dover Street, very occasionally the theatre or a concert. (Whistler had no ear for music, and by and large found late-Victorian drama considerably less entertaining than his own existence.) The late hours were spent talking amongst friends at the Hogarth Club, the Falstaff, or the St Stephen's before a walk home along the Embankment to admire the effects of the lamp-lit night over the river.[9]

This well-established routine was carried out against a shifting background of alarms and changes. Whistler, as Sickert soon recognized, liked to live life as a succession of crises.[10] Both unwilling and unable to economize, he existed always on the brink of financial disaster. Other dramas, if less self-willed, were equally disturbing. Within weeks of Sickert's arrival at Tite Street, the erstwhile pottery decorator had to be removed to a lunatic asylum. Several of Whistler's precious portrait commissions came to premature ends. Sir Henry Cole, the head of the Kensington Museums, dropped dead (killed, as Sickert liked to believe, by the exertion of having to pose in a heavy Inverness cape).[11] Lady Meux, a former barmaid married to a brewery magnate, stormed off after a row, and Lady Archibald Campbell was only just persuaded not to abandon her own sittings following a heated difference of artistic opinion.[12] Such aesthetic squalls were common. Once Whistler was engaged upon a portrait he was tyrannical, demanding endless sittings, and treating his sitter as little more than a pictorial prop.[13]

Whistler, though never slow to give offence, was always quick to take it. He was a master in 'the gentle art of making enemies'. He nursed grievances with care: to a suggestion that he should 'Let bygones be bygones' he replied hotly, 'That is just what you must *never* let them be.'[14] He was implacable in opposition, and never forgave. Having fallen from grace, his erstwhile disciples – the devoted Greaves brothers – were either not mentioned or dismissed as 'negligible'.[15]

For Sickert, however, the evidence of such animosities merely emphasized his own privileged position within the charmed circle. And he was very conscious of how privileged it was. To have been suddenly swept into close daily contact with the 'god of his idolatry'

was an extraordinary thing: the acme of his desires. Familiarity bred
only deeper admiration. He found Whistler the man as great as Whist-
ler the painter. In a considered summary of his qualities he described
him as, 'Sunny, courageous, handsome, *soigné*. Entertaining, *serviable*,
gracious, good-natured, easy-going. A *charmeur* and a dandy with a
passion for work. A heart that was ever lifted up by its courage and
genius. A beacon of light and happiness to everyone who was privileged
to come within its comforting and brightening rays.'[16]

Despite his designation as a 'pupil' of Whistler, Sickert was more
a studio dogsbody than a student. He received no formal training at
Tite Street. Whistler – even if he insisted on being addressed as Master
– was not a natural teacher. He had no formulated scheme of how to
proceed. 'All you need to know,' he told Sickert and Menpes, 'is which
end of the brush to put in your mouth.'[17] Beyond this, lessons had to
be learnt indirectly by observation and deduction.

There was plenty of opportunity. Sickert was able to watch Whistler
at work every day – in the streets of Chelsea, and at the Tite Street
studio. Sometimes he was allowed to paint alongside him from the
same model, even on occasion taking his colours off the same palette.
Whistler, though completely absorbed in his own work, might dispense
the odd – and much cherished – word of general encouragement.
Amongst his recurrent utterances were 'Stick it Sickert' and 'Shove along
Walter, shove along.'[18] On very rare occasions he might even give a
specific demonstration of some technical point. Sickert carefully pre-
served a 'little panel of a model' he had painted, 'not very well', and
which Whistler finished 'with some exquisite passages in a lace dress
and velvet curtain'.[19] But the pace of instruction could never be forced.
Any direct question was likely to be answered with the explosion,
'"Pshaw! You must be occupied with the Master, not with yourselves.
There is plenty to be done."' And Whistler would promptly invent
some task for his inquisitive assistant – 'a picture to be taken to
Dowdeswell's [Gallery], or a copperplate to have a ground put on it.'[20]
For Sickert and Menpes there remained always a tantalizing sense of
mystery. 'We felt', Menpes recalled, 'that the Master was in possession
of tremendous secrets about art, but we never got within a certain
crust of reserve . . . in which he kept his real artistic self.' But then, as
they admitted to each other, how could they expect that 'one so great
would readily reveal himself'.[21]

Nevertheless, through the days of close contact Sickert began slowly

to build up an understanding of Whistler's working methods. Whistler was a *prima* painter. He liked to use wet thin paint on wet thin paint, to work quickly, to cover the canvas in a single sitting – or as he put it, to complete the picture in 'one wet'. There was little margin for error, or scope for correction, in such work. It was a method that required great skill, self-confidence, and no little daring. (Amongst the Whistlerian maxims that Sickert most cherished was the assertion, 'We have only one enemy, and that is funk.'[22])

In the hands of a master, the *prima* method could yield a remarkable freshness of effect, a rare and harmonious smoothness of surface. And Whistler was a master. He inspired Sickert with an abiding 'love of quality of execution', a sense 'that paint [was] itself a beautiful thing, with loveliness and charm and infinite variety'.[23] The lore of oil paint – its composition, its preparation, its dilution, and its application – was Whistler's passion. It became Sickert's too. Few artists spent more on materials than Sickert, or experimented more with ingredients. The whole 'cooking side' of painting absorbed his interest throughout his career. Over time, he acquired a knowledge of oil paint beyond that of almost any of his contemporaries.[24] But his knowledge never confined itself to recipes only. As an apprentice at Tite Street, Sickert came to understand that the elusive 'quality' that Whistler – and, indeed, all great artists – achieved in their painting was not merely a matter of materials and technical skill, but something more: 'a certain beauty and fitness of expression in paint'. It might seem 'ragged' or 'capricious', yet it perfectly expressed the artist's response to his chosen (and completely understood) subject.[25] To achieve for himself this perfect and personal harmony between paint, expression, and subject matter became the great and enduring quest of Sickert's professional life: an obsession that coloured almost every aspect of his existence. The quest began in Whistler's studio. And because it was in Whistler's work that he first glimpsed the ideal, it was through imitation that he first sought to achieve it.

The ways in which Whistler deployed his chosen technique were various. He adopted subtly different approaches for different types of picture. The nocturnes were done from recollection. Whistler had learnt the exacting discipline of training the visual memory in Paris as a pupil of Lecoq de Boisbaudran. Legros, too, had studied under Lecoq, but it was in the electric atmosphere of Tite Street, rather than at the Slade, that Sickert was introduced to the practice and became enthused about

it. Lecoq's course had been based on a series of exercises by which the mind was trained to absorb the salient details of a subject (the first lessons involved simple geometric forms) and then accurately to record them away from the motif. Whistler transformed the method into a 'sort of game'. Sickert recalled walks along the river when he and his master would stop and 'look for about ten minutes at a given subject, isolating it as much as possible from its surroundings'. And then, while Sickert checked his accuracy, Whistler would turn his back and try to recall the scene: 'There is a tavern window, three panes wide one each side of the central partition and six panes deep. On the left is a red curtain half drawn . . . The tone of the roof is darker than that of the wall, but is warm in colour, and precisely the same in value as the sky behind it, which is a deep blue-grey.' And so on.[26] Half marks would be awarded for remembering the position, size, and shape of the various objects that filled the scene and full marks for remembering the exact degrees of light and dark falling on them.[27] When he had got all the details right, Whistler would take a last look at the scene before they set off home, walking, for once, in silence 'so that he might keep the impression fresh'.[28] The next morning, at the studio, he would paint the scene.

The Chelsea street scenes, by contrast, were done from life. Working *en plein air* was a relatively new departure for Whistler, but it suited his interests and his methods. Tiny, fleeting impressions of light and colour, devoid of detail, painted on panels only a few inches across, could be readily set down in 'one wet'. Portraits were more problematic. They too were done from life, but on a large – almost life-size – scale. Whistler, who took a delight in all practical theories (a delight that he passed on to Sickert), believed that for the sake of pictorial precision it was important to paint to the scale of vision. He explained to Sickert that the human eye 'could only see at one glance an object which in size was one-third of the distance between the eye and that object. In other words, if you [were] painting a man six feet high you should be 18 feet away from him.' As a result, Whistler needed a very long studio. He was accustomed to place his model against the black velvet background, and alongside his model he placed his large-sized canvas. His painting table was 18 feet away. He would stand at his painting table, carefully survey the model, then, charging his long-handled brush with the requisite paint (considerably thinned with turpentine), would run at full tilt up to the canvas and drop the colour

on the spot. It was an extraordinary performance, and many casual visitors to the studio assumed that it was put on merely for their benefit.

To capture the likeness of a human face and figure on a six-foot canvas in a single sitting was a difficult business. Whistler was not always successful at the first attempt, the second, or even the third and he would demand more and more sittings. But at these there could be no mere correction of the existing work: wet paint could not be put on top of dry paint. At each sitting, Whistler would in effect begin again. The surface of the picture was scrubbed down, and he would repaint the whole canvas. There was no building up of detail, only an ever increasing simplification. But the precious 'unity' of the picture – its 'exquisite oneness' – was maintained through the multiple operations, until Whistler finally achieved the desired effect and announced that the picture was finished.[29] At the end of each sitting there was always a moment of tension, as Whistler pondered his handiwork before passing judgement. Sickert recalled how, once, 'after long standing on a chair with a candle, at the end of a sitting from Lady Archibald Campbell, and long indecision as to whether he should take out the day's work or leave it, we went out along the Embankment to dinner. In the street he decided and said to me, "You go back. I shall only be nervous and begin to doubt again. Go back and take it all out" – which I did with a rag and benzoline.'[30]

Whistler was a printmaker as well as a painter. His earliest prints had been closely worked creations done from drawings, but after his sojourn in Venice he adopted a freer and less laborious approach, working *en plein air* on small copper plates. Sickert described the new technique as 'a free and inspired improvisation from nature'.[31] The method suited Whistler's febrile talent. He was a brilliant sketcher, with a gift for capturing a fugitive scene in a few lines. In part he was able to do this because of his idiosyncratic theory of composition.[32] It was a theory that he passed on to his pupils one evening in a rare moment of direct instruction. Whistler described how in Venice, while drawing a bridge, 'as though in a revelation', the secret of drawing had come to him. 'He felt that he wanted to keep it to himself, lest someone should use it, – it was so sure, so marvellous. This is roughly how he described it: "I began first of all by seizing upon the chief point of interest. Perhaps it might have been the extreme distance, – the little palaces and this shipping beneath the bridge. If so, I would begin

drawing that distance in elaborately, and then would expand from it until I came to the bridge, which I would draw in one broad sweep. If by chance I did not see the whole of the bridge, I would not put it in. In this way the picture must necessarily be a perfect thing from start to finish. Even if one were to be arrested in the middle of it, it would still be a fine and complete picture."' Sickert, Menpes recalled, 'took down every word on his cuff'.[33]

By following Whistler's methods, Sickert – and Menpes with him – hoped to emulate his results. 'If we etched a plate,' Menpes remembered, 'we had to etch it almost exactly on Whistlerian lines. If Whistler kept his plates fair, ours were so fair that they could scarcely be seen. If Whistler adopted economy of means, using the fewest possible lines, we became so nervous that we could scarcely touch the plate lest we should overelaborate.'[34] In their paintings they embraced all the key Whistlerian tropes: the same *prima* method, the same grey grounds, the same restricted range of low tones, the same turpentine-thinned paint, the same simplified forms, and simple compositions. They laid out their paints in the same order as the Master; and – like him – they laid them out on a painting table rather than a palette.[35] Their subject matter was, unsurprisingly, the same, since – whenever possible – they worked alongside their master, recording Chelsea street scenes or figures in the studio. It remained something of a conundrum to them that so much patient emulation did not immediately yield more successful results.

Away from the business of making pictures there were other lessons to be gleaned from the Master. Sickert strove to imitate Whistler in everything. He adopted his dandy's pose: the pleasure of always shocking and of never being shocked. Already handsome and fastidious, Sickert became 'picturesque' in his dress.[36] He also drank in Whistler's whole philosophy of art. Over the supper table at the Hogarth Club, Whistler rapped out his ideas – ideas that he had adumbrated in the witness box at the Ruskin trial and had been honing ever since. The established order of Victorian thought was turned upon its head. In place of the accepted Ruskinian ideal that gave critics authority over artists, and set a value upon art according to how much it might ennoble the spirit or improve society through its uplifting subject matter, its fidelity to nature, its painstaking workmanship, Whistler put forward a host of contrary propositions. He asserted the superiority of the artist to the critic, and claimed for art a complete independence

from all social and moral obligations. He decried the anecdotal and literary elements in painting. Art, he suggested, should be concerned, not with telling a story, but with formal beauty. It should be made only for art's sake. Nature he dismissed as the mere raw material of art, requiring the selective genius of the artist to transform it into something beautiful. And, having established to his own satisfaction that Nature was incoherent and subject matter unimportant, it followed that all subjects were equally possible for the artist, and equally desirable. There was even, he suggested, a virtue in selecting the new or overlooked motif, thus extending the range of art. He himself chose to abstract beauty from what was considered the unpromising ground of contemporary London, the humble streets of Chelsea and the dingy, industrial Thames.[37]

These were intoxicating ideas. Certainly Whistler was delighted with them, and very irritated that Oscar Wilde seemed to have borrowed so many for his American lectures. In his haste to denounce Wilde for picking the plums from his plate he did, however, rather overlook the debt that his own formulations owed to the writings of Charles Baudelaire and Théophile Gautier, the two French critics of the previous generation who had first elaborated an amoral, anti-natural philosophy of art. Sickert, though he later traced the ideas back to their French origins, in the first instance accepted them as Whistler's own, and accepted them enthusiastically.[38]

Whistler was not content merely to spin theories amongst his disciples: he wished to carry his ideas into the camp of the enemy. He has claims to be the first artist in Britain to adopt the now established procedure of seeking to offend the bourgeois public into acquiescence and admiration. His pose was calculated to affront. He courted controversy. He presented himself as opposed by all the forces of the Establishment – and his disciples were eager to accept the truth of this vision. For them, 13 Tite Street had the glamour of a rebel cell. And it was embattled. For the grandees of the Academy such as Millais and Frith, Whistler was – as Sickert recalled – an abomination.[39] Many in the press were hostile, and much of the public uncomprehending. But, as he recognized, all publicity was good, and the media were there to be manipulated. Whistler devoted a great deal of time to lighting the fires of new controversies, or fanning the embers of old ones. Sitters would wait for hours in the studio while he 'polished a little squib' for the editor of some periodical.[40]

Sickert, with his classical education and literary bent, proved useful

in this game. In June 1882, when the *Pall Mall Gazette* lamented the apparently unfinished state of Whistler's *Scherzo in Blue* at the Grosvenor Gallery, it was Sickert, under the soubriquet 'An Art Student', who wrote the 'very convaincu paragraph' defending Whistler's 'artistic sincerity' and explaining that, on the day of the press view, the picture was indeed unfinished, had only been hung to 'take up its space on the walls', and was afterwards removed and completed.[41] It was the first of many such interventions. Over the next decade, Sickert, as he put it, 'insisted in season and out of season on the excellence and importance of Whistler's work' in whatever papers would print his words.[42] He would also write letters as from Whistler, and even attribute to him bons mots of his own invention – though Whistler did have to discourage him from devising them in Latin and other languages he did not know.[43] He also counselled Sickert against too much subtlety. Rather than working away 'in a ponderous German manner, answering objections, controverting statements of fact with tedious arrays of evidence', his advice was 'simply [to] say "Stocking!" Don't you know? Ha! Ha! That's it! That's controversy! "Stocking!" What can they say to that?'[44]

Whistler liked to present himself as a figure 'sprung completely armed from nowhere', owning no allegiances and taking no interest in the achievements of others.[45] Of the old masters he would remark, 'they are all old but they are not all masters'.[46] In expansive moments, though, he might acknowledge a few small artistic debts to Velasquez and Canaletto. He admired Hogarth, and condescended to admit Hokusai as an equal. Amongst his contemporaries he saved his appreciation for the English cartoonists and the French Impressionists. Keene he considered the greatest British artist since Hogarth.[47] Sickert, of course, needed no introduction to Keene's genius. He knew rather less, however, of the French Impressionists. In England, knowledge was remarkably limited of the work being produced by Manet, Monet, Degas, Pissarro, Renoir, and the other painters who, since the mid 1870s, had been exhibiting in Paris under the 'Impressionist' banner. The very word 'Impressionism' had only just made it across the Channel, but there was still much doubt as to what it signified. To the English critical establishment, Impressionism, as far as it meant anything, meant Whistler,[48] and this was probably a view that Sickert shared on his arrival at Tite Street. His time there, however, gave him the chance to discover rather more.

Whistler, as his English critics asserted, did have strong links with the movement. He knew the main protagonists well from his time in Paris. Degas had invited him to show in the exhibition at Nadar's studio in 1874 that gave the Impressionists their name. Though he had declined the invitation, it had not broken the association. In the early 1870s he had exhibited in Paris with Durand-Ruel, the dealer who was championing and promoting Degas, Manet, Monet, and Pissarro. His art shared several of the concerns and tropes of the French Impressionists: modern urban subject matter, simplification of detail, an attempt to capture the effects of light (or, in Whistler's case, darkness), and an unconcern with academic finish. Sickert had a first chance to assess such similarities and gauge their depth in the spring of 1882. That May, Durand-Ruel exhibited a selection of work by Degas, Monet, and others at White's Gallery in King Street, St James's. Sickert visited the show and was greatly impressed. He liked particularly Degas' painting, *Baisser de Rideau*, an enthusiasm that shocked Burne-Jones, who was baffled that anyone should either paint or praise 'the fag end of a ballet'.[49]

That summer, Sickert made an important French connection of his own. Fantin-Latour was in town again, and Sickert went with Scholderer to call on him in Golden Square, at the house of his London agent Mrs Edwin Edwards. He had been sent by Whistler in the hope of persuading Fantin to visit Tite Street. The mission was unsuccessful (Fantin pleaded ill health), but the call was not without profit. In Mrs Edwards' drawing room Sickert was introduced to another visiting Frenchman, a young painter of his own age called Jacques-Émile Blanche. Blanche, the only son of a highly successful Parisian doctor, was over in London with his 'mentor', Edmond Maître, attending a season of Wagner operas.[50] Sickert liked Blanche at once. Unlike Fantin, he was keen to meet Whistler, and it was arranged that he should attend the next Sunday breakfast party.

Over the following week they saw more of each other.[51] Blanche even extended his stay so that he could cross over to Dieppe with Sickert – who was taking Ellen there, probably along with the rest of his family, for the holidays. Blanche rather rued this act of courtesy when he caught a chill on the crossing and was unable to go on to Bayreuth for the premiere of *Parsifal* as he had planned. His misfortune, however, did mean that the friendship begun in London could continue and ripen further over the summer.[52]

It was to prove one of the most productive and enduring of all Sickert's friendships. Sickert relished Blanche's intelligence, his worldliness, his knowledge of contemporary art, his genius for gossip, his helpfulness, his passion for painting. Blanche opened up for Sickert a new side of Dieppe life. His family's house, the Bas Fort Blanc, a hideous half-timbered villa in the modern 'Norman' style, was a centre of intellectual and artistic life. Sickert spent time in Blanche's studio room, which had been decorated with scenes from *Tannhäuser* by Renoir – indeed Renoir was staying just up the coast and was also an occasional visitor.[53] Even if Sickert did not meet him, he certainly heard of his doings from Blanche. It was a further taste of the Impressionist milieu.

Through Blanche, Sickert met Olga, daughter of the Duchesse de Caracciolo, whose villa abutted the Bas Fort Blanc. Olga, though barely into her teens, already possessed a dreamy, fawn-like beauty dominated by great almond eyes set in a pale face. The question of who her father might be remained a matter of excited debate amongst the English and French communities (the Duchesse had numerous lovers and admirers). Many liked to promote the claims of the Prince of Wales. He was the girl's godfather; might he not be her father too?[54] Sickert was amused by such tales, and struck by Olga's peculiar grace. They established a happy, and in due course flirtatious, friendship.[55]

Sickert returned to London exhilarated. He was, as Maggie Cobden reported, 'blooming'.[56] Under Whistler's tutelage he had at last discovered an outlet for his energies. Not that he was entirely free from constraints. He still had no source of income, and perhaps it was to earn money that he undertook several days' work for E. W. Godwin, researching historical costume designs at the British Museum.[57] And it may have been for the same reason that, later in the year, he gave some home tuition to the children of Henry Irving.[58]

If things were going well for him, they were faring poorly for Nellie. She was ill again in the autumn, suffering what seems to have been a regular seasonal relapse.[59] She went down to Margate to recuperate, lodging in the smart Cliftonville area of the town.[60] Sickert visited her there and loved the place. The Kentish resort with its mid-Victorian flavour, its bracing seawater baths and no less bracing taint of cockney vulgarity – not to mention its associations with Turner – became one of his favoured sites. It also proved beneficial for Nellie. She rallied

enough to return to London by the end of the year and throw herself into arrangements for the Suffrage Ball in the coming spring.[61]

Sickert had his own arranging to do. All his time was taken up with the preparations for Whistler's forthcoming exhibition at the Fine Art Society, a second showing of Venice etchings.[62] There was a mad dash to get everything ready on time. For Sickert, it was an accelerated apprenticeship in the art of printing, as Whistler, through selective inking and wiping and other tricks of the trade, strove to imbue each individual print with its own unique character. The work, though hard, was not without its moments of humour. Sickert recalled once dropping the copper plate he was working on. ' "How like you!" said Whistler. Five minutes afterwards the improbable happened. Whistler, who was never clumsy, dropped one himself. There was a pause. "How *unlike* me!" '*[63] In their work they were distracted by the reappearance of Oscar Wilde, who returned from his American tour at the beginning of January 188? and was much at Tite Street, before he headed off at the end of the month to spend his earnings on a three-month stay in Paris.[64]

Despite such diversions, all was ready for the show's opening on 17 February. For Whistler, an exhibition was not merely a gathering of pictures but a quasi-theatrical event. Every detail had to be addressed. An 'amazing' catalogue was produced that quoted some of his critics' most hostile comments, and the Fine Art Society was redecorated in shades of yellow. For the private view the colour scheme extended to the flowers, the assistants' neckties, and even Whistler's socks.[65] It is not known what sartorial concession Sickert made to the occasion, but he was, of course, there. He introduced Brandon Thomas to Whistler, and was thrilled when the actor commissioned a painting from his master.[66]

The opening of the show brought Sickert relief from his studio duties. He was, as his mother put it, 'somewhat free again and able to get on with his own work'.[67] Inspired by Whistler's example he began to etch his own series of London scenes.† And though he continued to

* Sickert was not habitually clumsy. Many contemporaries recall the precision – and decision – of his movements. If he did drop things around Whistler it must have been the result of nervous over-excitement.

† Amongst the views recorded were several of St John's Wood, where Ellen was staying at 10a Cunningham Place, in a house occupied by Miss Leigh-Smith, and the painter, Miss E. M. Osborn.

attend regularly at Tite Street, he took a room nearby at 38 Markham
Square in order to have some measure of independence.[68]

Whistler was not entirely approving. He soon found new work for
his pupil to do. At the end of April he entrusted Sickert with the task
of escorting his painting *Arrangement in Grey and Black: Portrait of the
Artist's Mother* over to Paris for exhibition at the Salon. Besides the
picture, Sickert also took with him copies of the 'amazing' catalogue
and letters of introduction to Manet and Degas. He was to say to them
that Whistler, too, was 'amazing'. The route was via Dieppe. Sickert
retained a clear recollection of 'the little deal case' containing his pre-
cious charge being hoisted from the hold of the boat and 'swinging
from a crane against the starlit night and the sleeping houses of the
Pollet'.[69] In Paris, he lodged at the Hôtel Voltaire as the guest of Oscar
Wilde, to whom he had also been instructed to show the catalogue.
'Remember,' Whistler informed Wilde in a covering note, 'he travels
no longer as Walter Sickert – of course he is amazing – for does he
not represent the Amazing One.'[70] Such magisterial condescension was
not entirely apt. Sickert, naturally gifted with a remarkable degree of
social confidence, had learnt even more poise at Tite Street. He was
no mere cipher.

Having seen Whistler's painting safely delivered to the Salon, he
called on Manet but found the artist too ill to receive visitors. Standing
in the hallway of the painter's flat, Sickert only heard his voice, 'through
the open door of his bedroom', as he instructed his brother, Eugene, to
take 'Whistler's friend round to my studio and show him my pictures'.[71]
Although Sickert left no contemporary record of the visit, he was cer-
tainly impressed by what he saw. Manet's large painting of the bar of
the Folies Bergère was there, though Sickert's most vivid memories
were of a pastel portrait of the Irish writer George Moore, and a picture
showing 'Rochefort's escape from New Caledonia'. He came away with
a general impression of freshness, vitality, and excellence. He recog-
nized Manet's affinities with Whistler – his debt to Velasquez, his
freshness of touch, his command of the *prima* method of painting.
And though, such was his loyalty, he hesitated to rank him with 'the
Master', he acknowledged him as 'a brilliant and powerful' artist, an
'executant of the first rank'.[72]

Sickert called next on Degas at his flat in rue Pigalle. It was to
prove a momentous meeting. Degas was then forty-eight. A crusty
bachelor with an acerbic wit, he was developing a reputation as a

curmudgeon, if not a recluse. There were few artists in Paris who were not a little scared of him and of his sharp-edged tongue. Sickert, if he knew anything of this, was undaunted by it. Many years later, he gave an account of his visit through what he described as the 'piquant distorting media' of Oscar Wilde's recollection of Degas' story of the incident:

> Degas alleged himself to have been disturbed too early in the morning, by a terrific knocking, and ringing. He had opened the door himself, his head tied up in a flannel comforter. 'Here at last,' he said to himself, 'is the Englishman who is going to buy all my pictures'. 'Monsieur', he had said, 'je ne peux pas vous recevoir. J'ai une bronchite qui me mène au diable. Je regrette'. 'Cela ne fait rien', the Englishman is here made to say. 'Je n'aime pas la conversation. Je viens voir vos tableaux. Je suis l'élève de Whistler. Je vous présente le catalogue de mon maître' . . . The visitor had then entered, and proceeded, silently, and with great deliberation to examine all the pictures in the flat, and the wax statuettes under their glass cases, keeping the invalid standing the while, and had ended by 'Bien. Très bien. Je vous donne rendez-vous demain à votre atelier à dix heures'.

The facts, Sickert admitted, were 'singularly exact'.[73]

Sickert, true to his intention, followed up the call with a visit to Degas' studio in the rue Fontaine St Georges. The artist's consternation at his assured young visitor seems to have quickly dissolved into amusement. Degas' 'rollicking and somewhat bear-like sense of fun' came to the fore. It became his joke to regard Sickert as 'the typical and undiluted' Englishman, the authority on all matters of English life and etiquette. He bombarded him with stories of other Englishmen he had known and the foolish things they had said, and quizzed him upon points of national custom. But Degas must have recognized, too, Sickert's real interest in art, and they found common ground in their admiration of Charles Keene.[74]

Sickert was amazed to discover the high regard in which Keene was held by the French Impressionists, several of whom, he learnt, preserved collections of his work cut from the pages of *Punch* 'as models of style'.[75] To them, he was 'the first of the moderns'.[76] Fascinated by his command of chiaroscuro, they regarded him as a fellow 'painter', rather than as a draughtsman.[77] They were as interested in his

backgrounds as his figures, praising his depiction of landscape – 'his snowy streets, his seascapes, his bits of country life' – as 'unequalled'.[78] Monet and Sisley, Sickert was told, derived their handling of trees in sunlight directly from Keene's drawings of the 'rampant foliage' of London squares and country gardens.[79] Keene saw things 'never seen before'; he observed the reflected lights in the shadows and depicted them in lines drawn with diluted ink.[80] These revelations reinforced Sickert's appreciation of his hero, and reinforced, too, his understanding of the dynamic relation between drawing and painting.

It was a relationship that Sickert could trace in Degas' own work. He drank in all that was on view: the ballet scenes, the studies of millinery shops, the figure drawings. There were points of contact with Whistler's art – the engagement with scenes of modern urban life, the fascination with low tone – but there was also the hint of something new: the unconscious drama of people in interiors, the conscious drama of the popular stage, the effects of artificial light, and the sense of pictures not conjured out of paint but built up, planned, and composed in stages from drawings and studies. The full significance of such differences was not at once apparent to Sickert. For the moment it was enough to know that he liked Degas' pictures, and that Degas seemed to like him.

The trip to Paris gave Sickert a broadening sense of French art, and of the Impressionists.[81] This process of education continued back in England. Durand-Ruel held another exhibition in London that spring,[82] and Whistler began having sittings from Théodore Duret, a successful wine merchant who was also the champion and friend of the Impressionists. Sickert worked alongside Whistler, producing his own small portrait sketch of the bearded Duret, and learning more of Manet, Degas, and their contemporaries.[83]

Through much of 1883, Ellen continued to be troubled by her ailments. Her younger sister, Annie, had already beaten her to the registry office (marrying T. J. Sanderson, a reluctant lawyer, would-be bookbinder, and disciple of William Morris),[84] and it was becoming increasingly clear that her own wedding, planned for that summer, would have to be postponed. Ellen did not join Walter and the rest of his family for a late holiday at St Ives.

Thanks to the arrival of the railway, the little Cornish fishing village

was already becoming a magnet for artists and holidaymakers. Amongst the families on the beach that year was Leslie Stephen with his wife, young son, and two daughters – Virginia and Vanessa. Although Sickert thought Mr Stephen looked enormously 'impressive' and Mrs Stephen quite 'superb', he did not attempt to make their acquaintance.[85] It was the real life of the place that drew his attention rather than its artistic and holiday existence. He assumed a jersey and top boots and 'completely won over' the local fishermen, 'fascinating them with his kindly bonhomie'.[86]

He did, nevertheless, do some pictures, amongst them a charming little panel of some children sitting on the beach, which in its lightness and brightness – as well as its novel accent upon the figures – perhaps owed something to his recent Parisian discoveries. (Sickert gave the picture to his housekeeper at Markham Square, to show her that he was not completely wedded to the tones of what she called 'London Mud'.)[87] To be out sketching on the beach was to be amongst fellow artists, and Sickert found himself engaged in conversation with a young painter called Alberto Ludovici. Ludovici was the son of a well-known artist of the same name, and, although still only in his twenties, he had been drawn into the art establishment. Already he was a member of the Society of British Artists, a prestigious if rather stuffy group and a would-be nursery to the Royal Academy, of which his father was treasurer. Young Ludovici was interested to meet a pupil of the infamous Whistler, while Sickert was intrigued to meet a man so well connected to the art institutions of the capital. They parted in the expectation of seeing each other again in London.[88]

At the end of the summer, when the holiday visitors returned to town, Sickert stayed on and was joined by Whistler and Menpes for a winter painting tour. They all lodged with an old lady in Barnoon Terrace, overlooking the harbour. The rooms – in the universal style of seaside boarding houses – were crowded with overstuffed chairs and 'aggressive' ornaments. But even these aesthetic affronts were unable to quash Whistler's enthusiasm for St Ives, for the seascapes, the boats, and the fishermen. The gentle pace of the holiday season evaporated at once. Whistler had to complete a series of pictures for a planned exhibition early in the New Year at Dowdeswell's Gallery in Bond Street. He was up at dawn each morning eager for work, delivering 'reproaches, instructions, taunts and commands' to his tardy followers. Sickert would often be roused by the noise of Whistler outside his

room complaining, 'Walter, you are in a condition of drivel. There you are, sleeping away your very life! What's it all about.' The tone of these complaints became sharper during the course of the stay. Whistler was considerably put out to discover that Sickert was already a favoured personage about the little town and that the fishermen all received him as a 'a pal' – indeed presented him, almost daily, with fish from their catch. Sickert gave these trophies to the landlady and as a consequence she, too, held him in very high favour. Whistler, with an irritation that was not completely put on, considered this to be an inversion of the proper order of things. He complained peevishly to Menpes that, as the Master, he – rather than Sickert – should be the recipient of any gifts. Menpes did his best to console him, explaining, not entirely accurately, that Sickert had visited St Ives in his acting days and had a long-established connection with the fishermen of the place.[89]

Despite these minor ructions, a daily routine was established. The three men would set off to paint each morning (after a cooked breakfast – often of fish provided by Sickert), armed with their pochade boxes, their grey-tinted panels, and walking canes. Many of the other artists they encountered could not believe that they intended to do serious work with so little equipment. Most of the painters who gravitated to St Ives during the 1880s were inspired by a strain of realism that they saw as being derived from Courbet and his disciple Bastien-Lepage. While Whistler and his pupils worked on a tiny scale, capturing fugitive impressions of land and sea, they sought to record the scenes and settings of contemporary rural life by painting large, often highly detailed pictures direct from nature. It was a taxing business for the local peasantry who had to 'pose' for these scenes, and for the artists who had to work long hours in the open air. Sickert delighted in the memory of one artist who required four fishermen to hold down his easel and canvas with ropes while he worked away in a howling gale.[90]

While Menpes stuck close to Whistler, Sickert 'almost invariably went off by himself' for most of the day. But this apparent independence of spirit was tempered by the fact that the paintings he made – 'sometimes five or six a day' – were thoroughly Whistlerian in approach and execution.[91] Sickert remained in awe of his master's handling of the Cornish scenes. Indeed he came to regard Whistler's pochades – done from life or immediate memory – as his real masterpieces: 'No sign of effort, with immense result.' It was, Sickert recognized, 'the

admirable preliminary order of his mind, the perfect peace at which his art was with itself, that enabled him to aim at and bring down quarry which, to anyone else, would have seemed intangible and altogether elusive'.[92] At times, Whistler seemed almost able to command nature. A wave that he was painting appeared to Sickert to 'hang, dog's eared for him, for an incredible duration of seconds, while the foam creamed and curled under his brush'.[93] Sickert strove to achieve the same mastery, and Whistler encouraged his efforts, giving him a 'minute nocturne in water-colour' that he painted as a demonstration piece from a scene they had all studied together.[94]

The party remained in Cornwall till January 1884. It was, in Menpes' recollection, a 'simple happy time'. There were occasional respites from work: days spent fishing from the rocks, with Whistler springing nimbly about in his patent leather pumps. During the long winter evenings there was scope for talk and discussion. Whistler had a chance to refine his ideas on Nature ('a poor creature after all – as I have often told you – poor company certainly – and artistically, often offensive').[95] He also began to evolve plans for the future. Sickert's chance encounter with Alberto Ludovici seems to have awakened a curiosity in Whistler about the Society of British Artists. He was fifty and still an outsider. Contemporaries such as Leighton and Poynter had achieved established positions at the Royal Academy. What, he began to consider, might he not accomplish with the structure and weight of an institution behind him?

Once back in London, Sickert called on Ludovici and mentioned to him Whistler's interest in perhaps becoming a member of the SBA. This 'surprised' Ludovici, but also intrigued him.[96] The society was in a sad way: membership was falling; the most recent exhibition had been so poorly attended as to gain a reputation amongst young couples as a 'most convenient and quiet spot for "spooning"'.[97] Whistler's membership would certainly attract publicity. Sickert introduced his master to Ludovici, who – suitably impressed – began to canvas the SBA committee on his behalf. The members had plenty of opportunity for assessing Whistler's work. It was much before the public that spring. His exhibition of 'Notes – Harmonies – Nocturnes' (many of them done at St Ives) opened at Dowdeswell's in May with the usual fanfare and the usual 'amazing' catalogue.

The work that Sickert had produced in Cornwall over the winter, though not publicly exhibited, was also seen. He had taken a new

studio at 13 Edwardes Square, just around the corner from Pembroke Gardens. As his mother reported proudly, 'several people whose opinions are worth hearing' had been there and pronounced his work 'very good & promising'.[98] Théodore Duret and Jacques-Émile Blanche were both in town and were very probably amongst the visitors. And if they came, it is more than likely that they brought with them their friend, the art-loving Irish novelist George Moore.

Moore, then in his early thirties, was an extraordinary figure. Sickert had already seen the pastel portrait of him at Manet's studio and so was familiar with the tall blond apparition: the long colourless face, bulbous eyes, and orange-tinged whiskers. There seemed something sub-aquatic about Moore. He was likened amongst other things to a codfish and a drowned fisherman. But he was an ardent lover of painting and France, as well as of literature and – so he was always bragging – women. He had lived in Paris for much of the 1870s and had even studied art there before embracing literature as his vocation. He had fraternized with the painters and poets of Montmartre and the Rive Gauche, and it was his proud boast that he had received his education over the marble-topped tables at the Nouvelle Athens – a café in the place Pigalle, where his tutors had been Manet and Degas. Along with his absinthe he had drunk in a knowledge of all the new literary and artistic movements that crackled across the Parisian cultural scene: Realism, Naturalism, Impressionism, Symbolism.

In his own literary experiments Moore had veered from a flirtation with sub-Baudelarian decadence (he wrote a volume of hot-house verse and claimed to have kept a pet python) to a bracing commitment to brutal naturalism à la Zola. In his artistic sympathies, however, he remained true to the Impressionists. Though living in London, he returned often to Paris and continued to see Degas and Duret – Degas admired him, and told Sickert that he was 'very intelligent'.[99] When Manet died, Moore bought two paintings from his widow and continued to keep in touch with the evolving scene.[100]

In 1883 Moore had published a novel, A Modern Lover, that dealt with a fictionalized version of the British art world. The anti-hero, Lewis Seymour, a sort of debased version of the hugely successful Lawrence Alma-Tadema, compromises his artistic integrity (and a succession of women) to devote himself to producing trite, but eminently saleable, classical nudes. His dégringolade is contrasted with the career of another painter – Thompson – leader of 'the Moderns'. Thompson

is an artist who depicts 'acrobats' and 'bar girls' for 'his own heart's praise, and for that of the little band of artists that surround him'. But, after years of struggle and neglect, he achieves success, partly through the canny speculations of his dealer, Mr Bendish. The story was clearly – in part – a transposition of Moore's French experiences into an English setting. Thompson was a composite of Manet and Degas. The 'Moderns' were the Impressionists, and Mr Bendish was based upon Durand-Ruel, the dealer who had promoted them. In England there was, as yet, no comparable group: Whistler still stood alone. Nor was there a dealer, like Durand-Ruel, ready to back such a movement. These were gaps that Moore regretted, and that his book pointed up.[101]

Sickert certainly took note, even if he did not immediately embrace Moore's vision. In the spring of 1884 the influence and example of Whistler's work remained paramount. Sickert was still engrossed in making sketchy etchings in the style of Whistler of London courts and thoroughfares. At the end of May, when he went down to Ramsgate, where Ellen was staying with her sisters, it was with the Whistleresque intention of doing 'some seas';[102] and on a visit to his old Munich friends the Fowlers at Broadway, in Worcestershire, he made pictures of corn stooks and rural slums.[103] It was only in August, when he joined the rest of the family in Dieppe, that he seems to have taken stock. He produced a small etching of the circus rider Leah Pinder. It was his first attempt at depicting a popular theatrical subject – such as Degas (or 'Thompson') might have tackled.[104]

Back in London after the summer, Sickert discovered Tite Street in a state of upheaval. Whistler had taken a lease on a new purpose-built studio at the top of the Fulham Road. He was also looking for a new home. (He and Maud, though their relationship was deteriorating, eventually settled on a house in The Vale, a little *rus-in-urbe* cul-de-sac off the King's Road.) In the midst of these practical arrangements the business of his election to the SBA was coming to a head. The committee was still nervous, but Sickert acted to assure Ludovici as to Whistler's good faith and he, in turn, swayed the havering committee members.[105] On 21 November Whistler was duly elected, just in time to lend the cachet of his name and work to the society's winter exhibition. It was not necessary to be a member in order to submit work for the show and Sickert, following in his master's wake, sent in his small 'portrait sketch' of Théodore Duret, which was accepted. The debt to Whistler was apparent in both the picture's style and its subject.[106]

Whistler's appearance in the ranks of the Society of British Artists created consternation amongst the public, and excitement amongst his followers. The circle of Whistler's young disciples had been growing. Sydney Starr, an accomplished and rather dashing painter from Hull (and a former room-mate of Brandon Thomas's), became a regular at the studio, as did William Stott, who had recently returned from several years' studying and working in France.[107] A Canadian-born artist, Elizabeth Armstrong, then living in London with her mother, also gravitated to Whistler's circle, anxious to learn more about etching.[108] For Sickert, Menpes, Harper Pennington, and the other established followers, these were new friends and allies. Their common enthusiasm for Whistler – and their common ambition to exhibit alongside him at the SBA's gallery in Suffolk Street – obliterated, for the moment, all rivalries.

They banded together into what Sickert called 'the school' of Whistler.[109] They met at each other's studios, and dined together at cheap restaurants.[110] They discussed the Master, his works, and his methods. They undertook to fight his battles and to promote his name. They had, too, their own ambitions. 'Severally and collectively,' Menpes recalled, 'we intended to be great.'[111] But it was not to be an ordinary greatness. They despised their more conventional artistic contemporaries, those 'young men of the eighties', as Sickert later characterized them, 'admirably tailored with nothing of Vandyck about them but the beard, playing billiards for dear life with the Academicians at the Minerva Club!'[112] Their greatness was to be achieved by following the precepts of Whistler; and Sickert, as a designated 'pupil' of the Master, was placed right at the heart of this unfolding project.

In the New Year he assisted with the next phase of the Master's planned assault on the established art world: the Ten o'Clock Lecture. Jealous of Wilde's successes on the platform, Whistler had determined to mount a lecture event of his own, and Richard D'Oyly Carte, the promoter of Wilde's American tour, had agreed to produce it. Whistler worked hard arranging his argument and polishing his paradoxes, and Sickert worked hard with him. Some manuscript sheets of the lecture survive in Sickert's hand, suggesting how active his role was.[113] He also played a part in the practical arrangements, liaising with D'Oyly Carte's assistant (and later wife) Helen Lenoir. He visited her office many times, and amidst the demands of work even found time to produce an ambitious etching of her sitting at her lamp-lit desk poring over her paperwork.[114] When the lecture was given at Prince's Hall on the

evening of 20 February 1885, Sickert caught some of the reflected glory. His significant contribution to the event was certainly recognized by Ernest Brown of the Fine Art Society and Mr Buck of the Goupil Gallery. They invited him to lunch, together with Whistler, in gratitude for a 'much enjoyed' evening.[115]

Whistler was in the ascendant and Sickert rose with him. The portrait that Whistler had made of the Spanish violin virtuoso Sarasate was the main attraction of the SBA's spring exhibition. At the same show, Sickert exhibited no fewer than four pictures – a view of Ramsgate, two Cornish scenes, and a small flower piece.[116] There was, of course, danger as well as opportunity in the association. Critics, although gradually accustoming themselves to taking Whistler seriously, found it convenient to do so at the expense of his imitators and disciples. And the throng of these was ever increasing. Artists beyond the close coterie of Whistler's studio were beginning to adopt his manner – or, more often, his mannerisms. 'The power of strong artistic personality,' remarked the critic from The Academy, 'has probably never been more plainly shown at an English exhibition than at the present collection in Suffolk Street. Mr Whistler is not only there in force, but the effect of his influence on the younger exhibitors is very plain.' It was considered a not entirely beneficial force: 'You can have too much Whistler and Water.'[117] Following the same line, the Pall Mall Gazette thought Whistler's little landscapes 'vastly amusing' in themselves, but 'so bad for the young'. Menpes alone was excused from this general criticism.[118] As a further mark of distinction, the Australian was also the first disciple whom Whistler sought to bring with him into the SBA. He was elected at the beginning of June as a 'member in water colour'.[119]

These incidents served to remind Sickert how much he still had to achieve. He also began to perceive that the pleasure of being one of the 'young lions of the butterfly' was touched with the possibility of being lumped together with various inferior talents. In what was perhaps an attempt to raise himself above the crowd of Whistlerian 'imitators', he allowed himself to look beyond the confines of Suffolk Street. That summer he exhibited for the first time at the Royal Academy with his etching of Miss Lenoir. Along with Menpes he also showed at the Society of Painter-Etchers – a body of which Whistler disapproved (its president was his brother-in-law, Seymour Haden, with whom he had fallen out). The move can hardly have been made without Whistler's

permission, but it marked a first small assertion of self-will. Significantly, he chose to show an etching of young Stephen Manuel that he had made while the boy was sitting to Whistler. 'My etching was good for me,' Sickert recalled, 'being done in once. Whistler's portrait was bad for him. He was not quick enough for the child, who was wearied with the number of sittings.' Sickert, with a cheerful presumption of equality, had then told Whistler of his theory 'that when two people painted from the same thing, the bogey of success sat on one or the other, but not on both palettes'.[120]

Although Sickert's identification with Whistler's aims and methods remained intense, he began to put forward his own ideas as to how they might best be effected. It was probably apropos the Stephen Manuel portrait that he wrote to his master, urging, '[For God's] sake don't attempt to repaint the whole picture to [the] boy's present condition, but merely touch details. The picture is *finished*.' The problems of reworking the entire surface of a large canvas at each sitting – putting one layer of paint on another – also inspired Sickert to make independent experiments. 'I have tried the petroleum oil on the life-size canvas,' he wrote excitedly to Whistler of one new paint recipe: 'it is perfect: not sticky like turps: keeps wet: doesn't sink in: works quicker somehow, and fresher: five of it to one of burnt oil. I wish you would try it.'[121] The tone of self-assurance was new but unmistakable.

III

RELATIVE VALUES

I know that the Sickerts can't expect other people to see in Dieppe
all that it means to them.
(Oswald Valentine Sickert to Eddie Marsh)

It was as an exhibiting artist with pictures hanging in three London
galleries that Sickert finally married Ellen Cobden on Wednesday
10 June 1885 at Marylebone Registry Office. He was twenty-five, she
was thirty-six. The occasion appears to have been a low-key, almost
impromptu affair. According to legend, Sickert nearly missed the ser-
vice waiting for his bus to come.[1] It is not clear that either family was
represented – though both were certainly well pleased with the match.[2]
Mrs Sickert considered Ellen (or 'Nellie-Walter' as she became known
in the family, to differentiate her from all the other Nellies) 'delightful'
and 'so good & loving to me that she always does me good'.[3] Whistler,
too, was supportive, presenting the happy pair with a wedding gift
of a luxurious green-and-white wardrobe painted by himself.[4] The
prolonged engagement, however, if it had not weakened Sickert's real
affection, had done nothing to raise the temperature of his passion.
Three years of waiting had established a pattern to the relationship,
increasing Sickert's sense of independence, and accustoming him to
the security of Ellen's affections and support, while leaving him often
at liberty to pursue his own interests, both in work and at play. The
bohemian world of the Chelsea studios had often drawn him away
from her, and it seems that, even before the marriage, Sickert had
begun to have affairs. It was not a pattern he was anxious to break.*[5]

* Annie Cobden's husband, T. J. Sanderson, had amalgamated his name with that of his
wife, to become T. J. Cobden-Sanderson. There seems to have been no suggestion that
Sickert follow this course. Ellen, however, concerned to preserve the memory of her
illustrious father, frequently – though not invariably – signed herself Mrs Cobden-Sickert.

To many of their friends, the Walter Sickerts seemed a less than obvious pairing. The journalist Herbert Vivian, who met them soon after their marriage, considered that there never had been 'such an improbable *ménage*' as the 'conventional' Ellen and the unconventional Walter.[6] Blanche thought them more like brother and sister than husband and wife.[7] Yet they appear to have been happy. They were united by a common interest in Walter's career and a belief in his talent. Superficially, Ellen made his life comfortable, and he made hers exciting. But there was more. Sickert was capable of great kindness: he nursed Ellen when she was ill,[8] and he made several tender, almost sentimental, portraits of her.[9] And from the evidence of Ellen's partially autobiographical novel, *Wistons*, it would seem that there were moments of 'exquisite passion' in the first days of their marriage.[10] Certainly the romantic conventions were not entirely ignored, and after the wedding they departed for a honeymoon in Europe.[11]

By the height of the season they were at Dieppe. From 19 August they took 'a dear little house' in the rue Sygogne, a narrow street running up from the Front, just behind the Casino.[12] They were in good spirits. Sickert, in his new role as the young husband, had grown a trim pointed beard and moustache and was looking conspicuously smart. (Blanche was amused to note the extent to which the Cobden connection seemed to have 'helped palliate' his 'bohemianism'.[13]) The newlyweds found a cast of friends and relatives assembled and assembling. Sickert's parents and siblings were installed nearby.[14] Dorothy Richmond, over again from New Zealand, came to stay at the rue Sygogne, as did Ellen's sister Jane.[15] Whistler was expected later in September. John Lemoinne, the distinguished editor of the *Journal des Débats*, was also in town with his three daughters. Lemoinne had known Richard Cobden and was anxious to make Ellen's acquaintance. At the Bas Fort Blanc, Blanche had gathered together a trio of rising young painters – Paul Helleu, Rafael de Ochoa, and Henri Gervex, while the next-door villa, 'Les Rochers', had been taken by the popular librettist Ludovic Halévy and his family – an aged mother, pious sister, wife, and two young sons – Elie and Daniel. The Halévys had two house guests: Albert Boulanger-Cavé (a former Minister of the Fine Arts under Louis Philippe), and – as Walter 'learned with delight' – Edgar Degas.[16]

Degas' presence animated the whole party and gave to the five households a common bond of interest. The assembled company passed a happy month together in great intimacy.[17] Everyone loved

Degas. They listened to his stories and went along with his jokes.[18] Ellen found him 'perfectly delightful'.[19] Young Oswald Valentine Sickert felt that he should 'never forget the gentleness and charm of his personality'.[20] The great artist was in holiday mood that summer – playful, communicative, and at ease. He posed for a series of humorous photographic tableaux, commissioned from the indigent local photographer, Walter Barnes: one of them was a pastiche of Ingres' *Apotheosis of Homer*, with Degas taking the central role, flanked by the Halévy sons and the Lemoinne daughters.[21] He also developed an unexpected tendresse for Ellen's sister Jane. When she had to return early to England Degas was one of the party that leapt into a small boat to be ferried across the port in order that they might wave her off. He subsequently remarked to Ellen, 'We have all such an admiration for your sister that we are jealous of one another.'[22]

One of Sickert's abiding memories of Degas that summer was that he was 'always humming with enthusiasm' airs from Ernest Reyer's popular opera *Sigurd*. He had seen the piece over thirty times since its opening in 1884 (his attendance rate had been helped by the fact that he had been granted the privilege of free entry to the Opera earlier that year), but it is tempting to suppose that his choice of it was in part prompted by the homophony between Sickert and Sigurd.[23] Certainly Degas did pay the occasional musical tribute to his young friend, referring to him as 'le jeune et beau Sickert', in a phrase adapted from the song about 'le jeune et beau Dunois'.[24] It was a telling mark of the real amity that grew up between them. The rapport established over those first meetings in Paris two years earlier was built upon. There is an informal photograph of the pair: Sickert standing beside his hero, eager, happy, and alert, with pointed beard, paint box, and straw hat. Degas, as Fantin-Latour had observed to Sickert, was 'un personnage trop enseignant' (a too 'teaching' personage),[25] but this was a quality exactly calculated to appeal to an ambitious young painter, thirsty for knowledge. They went about together, Sickert imbibing all that he could of Degas' 'teaching'. On one informal sketching expedition, made together with Blanche, Helleu, and some others into the fields behind the castle, Degas said something that Sickert considered of 'sufficient importance never to be forgotten': '"I always tried," he said, "to urge my colleagues to seek for new combinations along the path of draughtsmanship, which I consider a more fruitful field than that of colour. But they wouldn't listen to me, and have

gone the other way".' This observation, Sickert noted, was made 'not at all as a grievance, but rather as a hint of advice to us'. The exact meaning of the hint, if not immediately clear, returned Sickert to the idea that drawing might be the key to painting.[26]

Sickert also had the chance to watch Degas at work, when he posed as one of a portrait group that Degas made at Blanche's studio. Working in pastel, Degas began by drawing Sickert, standing in his covert coat at the edge of the group, looking, as it were, off stage. Then he 'gradually added' one figure after another – Boulanger-Cavé, Ludovic Halévy, Gervex, Blanche, and Daniel Halévy – each figure 'growing on to the next in a series of eclipses, and serving, in its turn, as a *point de repère* for each further accretion'.[27] It was a mode of approach that related to the theory of drawing that Sickert had already learnt at Tite Street. Other aspects of Degas' practice were, however, less familiar to the pupil of Whistler. When they had first taken up their pose, Ludovic Halévy had pointed out to Degas that the collar of Sickert's coat was half turned up. He was about to adjust it when Degas called out: '"Laissez. C'est bien." Halévy shrugged his shoulders and said, "Degas cherche toujours l'accident".'[28] On another occasion, during a rest in proceedings, Degas invited Gervex (then a young man under thirty) to come and inspect the work in progress. As Sickert recalled the moment, Gervex,

> in the most natural manner in the world, advance[d] to the sacred easel, and, after a moment or two of plumbing and consideration, point[ed] out a suggestion. The greatest living draughtsman resumed his position at the easel, plumbed for himself, and, in the most natural manner in the world, accepted the correction. I understood on that day, once for all, the proper relation between youth and age. I understood that in art, as in science, youth and age are equal. I understood that they both stand equally corrected before a fact.[29]

Sickert was not yet quite confident of his own command of the 'facts', but he felt that he was advancing in accomplishment.

He strove to impress Degas with his dedication to work. Ignoring the claims of the holiday season – to say nothing of the honeymoon – he would set off each day armed with his pochade box to record the beach and the town.[30] It was a very productive summer. Inspired by Degas' electrifying presence, Sickert found himself painting with a new fluency and confidence, 'running in', as he put it, 'without con-

scious operation'. It was 'an *astounding* difference'.[31] All things seemed possible. Though he did attempt some larger works (which he left hanging out of the windows to dry), most of his output that summer was small in scale – little 'sunlight pochades'.*[32] In what was surely a homage to Degas' example he painted a small scene of the Dieppe Race Course.[33]

Degas came to inspect Sickert's paintings at the rue Sygogne, and was generous in his praise. He admired their finish. Passing the tips of his fingers over the smooth surface of the little panels he 'commended the fact that they were "peint comme une porte" [painted like a door]'.[34] 'La nature est lisse' (Nature is smooth), he was fond of saying.[35] He did, however, raise a first doubt about the Whistlerian absence of detail and human interest in Sickert's pictures. He urged Sickert to look at the works of Eugène Boudin, the painter of small-scale beach scenes who had inspired many of the Impressionists.[36] It was an important tip. As Sickert came to realize, where Whistler and some of the other Impressionists 'tended to use their figures rather as spots to accentuate their landscapes', Boudin proceeded 'in reverse order, from the actors to the scenery'.[37] Degas also questioned another of Sickert's Whistlerian traits: his fondness for low tones. Inspecting some of his darker pictures he remarked, 'tout ça a un peu l'air de se passer la nuit' (it all seems a bit like something taking place at night).[38]

Buoyed up by these signs of Degas' effectual interest, Sickert's energy was irrepressible. George Moore, who was over on holiday, thought that no one had ever been 'as young as Sickert was that summer at Dieppe'. He recalled him 'coming in at the moment of sunset, his paint-box over his shoulders, his mouth full of words and laughter, his body at exquisite poise, and himself as unconscious of himself as a bird on a branch'.[39]

Sickert's mounting self-assurance did, however, lead to some moments of unexpected comedy. One chance encounter came to haunt him. Taken by a French acquaintance to see 'a comrade of his, no longer a youth, who was thinking of throwing up a good berth in

* Sickert was beginning to appreciate the difficulties of working on a large scale directly from the motif. He had attempted to paint the Hôtel Royale on 'a really large canvas', setting up his easel on the hotel terrace. The size of the picture, however, had attracted the attention of all the passers-by, and he had soon drawn a considerable crowd. 'And so,' he concluded, 'I burst into tears, and ran home.' Violet Overton Fuller, 'Letters to Florence Pash', 36.

some administration in order to give himself up entirely to the practice of painting', Sickert was introduced to a sturdy man with a black moustache and a bowler hat. 'I am ashamed to say,' Sickert recalled, 'that the sketch I saw him doing left no very distinct impression on me, and that I expressed the opinion that the step he contemplated was rather imprudent than otherwise . . . his name was Gauguin.'[40]

A happier meeting took place outside the Dieppe fishmarket when Sickert was able to introduce Degas to his father. Oswald Sickert was working on a pastel of the Quai Henri IV, which Degas generously and genuinely admired.* Walter was delighted to be able to bring together two of his artistic progenitors. He was becoming prodigal of artistic 'parents', though he strove to maintain a hierarchy amongst them. Despite all the excitement of Degas' attention, he still thought of Whistler as his principal mentor. The 'butterfly' arrived in Dieppe at the end of September and promptly altered the flavour of the holiday with his nervous energy and restless spirit.[41] Sickert fell into line behind his Master. Blanche was amused to see them head off together with their identical equipment and identical palettes, to set their little folding stools down in front of the same scenes.[42]

This similarity of outward accoutrement, however, masked the subtle shifts in Sickert's work that had occurred over the course of the summer. Degas' influence and advice were already having an effect. Blanche considered that Sickert's 'petite planchettes' – once so sombre – had transformed themselves 'peu à peu sous l'influence de nos impressionistes'.[43] He also registered a change in Sickert's increased interest in 'figure drawing' and in his new accentuation of 'decorative and architectural pattern'.[44] But perhaps more significant for Sickert was seeing Whistler and Degas together. He noted the occasional tone of disparagement that Degas affected at Whistler's grandstanding. Indeed when Sickert had first mentioned to Degas that he was 'expecting Whistler on a visit', the French artist had remarked, 'Le rôle de papillon doit être bien fatigant, allez! J'aime mieux, moi, être le vieux boeuf, quoi?'† It was a first inkling for Sickert of the sometimes

* The praise seems to have been well merited. Oswald Adalbert devoted that summer to working in pastel. Some of the pictures he produced – according to his daughter's estimate – 'showed a remarkable revival of interest in a man of fifty-seven'. Blanche, too, remembered them as 'ravissant' (HMS, 130; JEB, MS 'Walter Sickert').

† 'The role of the butterfly must be pretty tiring. Me, I prefer to be the old ox.'

overstrained tension that Whistler set up between his public pose and his private practice as a painter.[45] And it was reinforced by other similarly caustic comments.* Sickert was amazed to notice that Whistler – the terror of the London drawing rooms – was somewhat in awe of Degas, and wary of his tongue. When Whistler gave an informal lecture one evening at the rue Sygogne on 'The Secret of Art' – a sort of scaled down version of the Ten o'Clock Lecture – Degas, though amused, was not unduly impressed.[46] Sickert's own status, too, was changing. He was now a married man, with an independently wealthy wife, whilst Whistler was still a not very prosperous bachelor. During the course of the holiday Sickert lent his master £5.[47]

The party broke up gradually towards the end of September. Degas returned to Paris ahead of the group, though he urged Sickert and Ellen to come and visit him there before they went back to London: 'He said we must see a great deal of him in Paris at the beginning of next month,' Ellen reported. 'I do think he is perfectly delightful.' And the sincerity of his invitation was reinforced by several kind messages.[48] It was too good an opportunity to miss.

In October, Walter and Ellen were in Paris. They called on Degas and were warmly received; his only sadness was that Jane Cobden could not be there as well. (As Ellen remarked teasingly to her sister, 'You might do worse, Janie dear!'[49]) He invited them to dine with him one evening, together with his 'very best friends', the artist Paul Bartholomé and his wife. There was also an opportunity to see his work.[50] He showed them some of his recent pastels – studies of unselfconscious women washing and drying themselves. Painters, he remarked, were too apt to make 'formal portraits' of women rather than allowing 'their hundred and one gestures, their *chatteries*' to inspire an infinite variety of design. 'Je veux,' he remarked, 'regarder par le trou de la serrure [I wish to look through the keyhole].'[51] The images possessed a startling directness and truth far beyond the coy eroticism or idealized fantasy of conventional late nineteenth-century nudes. Degas wondered how they would be received if he sent them to the Royal Academy. Sickert suggested they would not be received at all. 'Je m'en doutais,' Degas replied. 'Ils n'admettant pas le cynisme dans l'art.'[52]

* 'My dear Whistler, you behave like a man without talent,' Degas declared of one of Whistler's bouts of affectation. On the question of Whistler's love of public controversy he remarked: 'I find it quite possible to pass an arena'.

The same sense of scrupulous detachment, if not cynicism, per-
vaded his pictures of popular performers: ballet dancers, circus acro-
bats, and café singers. He even described how he had employed the
services of a professional draughtsman to help him with the perspective
in his painting of the trapeze artist in *La La at the Cirque Fernando*.[53] The
world of the popular stage was one that Degas loved, and he communi-
cated his enthusiasm to Sickert, discoursing upon his favourite per-
formers and singing snatches of music-hall ditties.[54] Treating Sickert as
a fellow practitioner, he flattered him with a fusillade of technical tips:
'On donne l'idée du vrai avec le faux'; 'the art of painting [is] so to sur-
round a patch of, say, Venetian red, that it appear[s] to be a patch of
vermilion'.[55] They were, for the most part, ideas that Sickert could barely
as yet comprehend, but he seized on them excitedly as coming from
a true master – and a master who was interested in his education.

Degas was impressed and pleased by the ardour of his visitors. He
gave them introductions not only to his dealer, Durand-Ruel, but also
to several private collectors who held good examples of his work.
Amongst the Sickerts' artistic pilgrimages was one to the apartment off
the Champs Élysées of Gustave Mulbacher – a successful coachbuilder
who owned an impressive monochrome painting of a ballet re-
hearsal.[56] Ellen was captivated by the work; she thought Degas' paint-
ings 'simply magnificent', almost 'the finest in the world'.[57]

For Sickert they were a source of revelation and inspiration. Away
from the holiday atmosphere of Dieppe, his friendship with Degas
achieved a new intensity on the common ground of art. Degas' studio
became henceforth 'the lighthouse' of Sickert's existence, and his
friendship one of the great facts of his artistic life. From that time
onwards, whenever he was in Paris Sickert had – as he put it with
scant exaggeration – 'the privilege of seeing constantly, on terms of
affectionate intimacy, this truly great man'.[58]

Walter and Ellen returned to London at the end of November lit
up by the experience of being in Degas' company and studying his
work. Degas even followed up his many acts of kindness by sending
Sickert 'a beautiful letter' that kept his presence alive in their minds.*

* The real affection between Degas and the Sickerts was confirmed early in the New
Year when, to oblige Walter, Degas – who was attending to family business in
Naples – called on the Richmond family at nearby Posilippo. Dorothy Richmond he
had, of course, met at Dieppe in the summer, when the 'jeune Australienne', as he
called her, had figured in some of the comic tableaux photographed by Walter
Barnes.

As Ellen told Blanche, Degas' pictures 'haunt our imaginations'. She admitted that they would probably 'end by giving up the dull necessities of life & buying one of his pictures'.[59] For the moment, however, the dull necessities took precedence. The Sickerts had no home. The house they intended to lease, in a new development at Broadhurst Gardens, near Swiss Cottage, was not yet ready for them. As a result, they were obliged to take lodgings in Albany Street, close to Regent's Park.[60]

CHAPTER THREE

Impressions and Opinions

Walter Sickert by Philip Wilson Steer, 1890

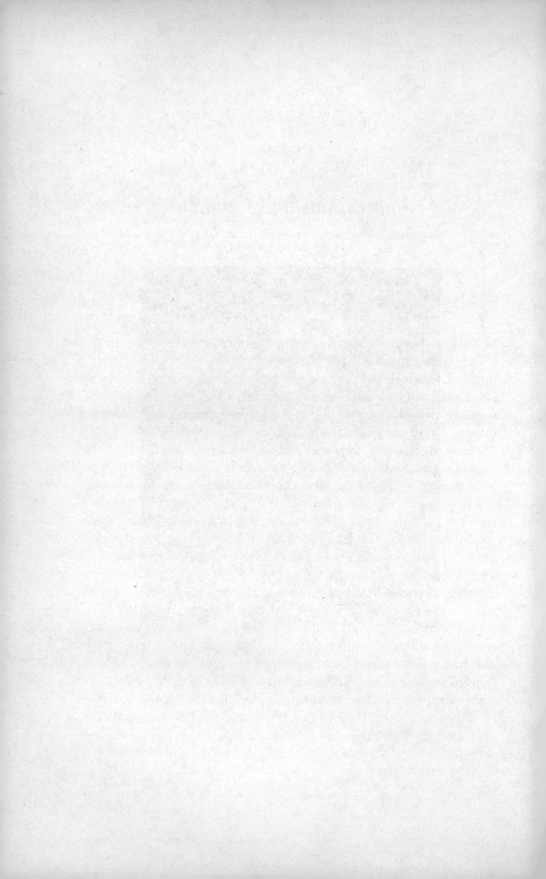

THE BUTTERFLY PROPAGANDA

Always remember the golden rule – in art nothing matters
so long as you are bold.
(Whistler, quoted by Mortimer Menpes)

Sickert had hurried back to London in time for the opening of the
Society of British Artists' 1885 winter exhibition. Whistler's increasing
influence within the society, and the presence of the sympathetic young
painter Jacomb Hood on the hanging committee, had secured a good
showing for Sickert's work and he had three small coastal scenes on
display. Other members of the Whistlerian 'school' were also well
represented.[1] Menpes, as a member, was of course able to show by
right. He had been joined within the ranks of the club by William
Stott though another Whistlerian nominee, Harper Pennington, was
not successful.[2] Although the records of the SBA are not complete
there is no evidence to suggest that Sickert was put forward for member-
ship at this time – or later. Both he and Menpes appeared in the
catalogue with the epithet 'pupil of Whistler' appended after their
names.[3] Such a designation was common currency in French exhibition
catalogues, but the description, if not inappropriate, had the air of an
attempt to a fix a position that was already shifting.

The Whistlerian group within the SBA may have been relatively
small, but its impact was apparent. As Sickert wrote to Blanche (who
also had a picture on view), 'Suffolk Street has this advantage, that
forward work may be seen there on an ample background of the most
backward there is.'[4] More, young 'forward'-thinking artists began to
be drawn to the club. Sickert met several new Whistlerian enthus-
iasts, amongst them Théodore Roussel, 'a very pleasant fellow' whom
Whistler had recently taken up.[5] A Frenchman by birth, Roussel had
become a 'cockney by adoption', settling in London in the mid 1870s,

when he was almost thirty. His twin passions were for Chelsea and Whistler. He took to depicting the former in the style of the latter – painting nocturnes of the Chelsea embankment and making etchings of the shopfronts in Church Street.[6] He was, Sickert told Blanche, 'the most thorough going & orthodox Whistlerite I have ever met', and as such was a welcome addition to 'the Butterfly propaganda'.[7] Trailing doggedly in Roussel's wake was his hunchbacked apprentice – and 'mildly "damned soul" in low-toned riverside views' – Paul Maitland.[8]

Less slavishly indebted to the Master, but none the less admiring, was Philip Wilson Steer. An almost exact contemporary of Sickert's, Steer had only quite recently returned from two years' study in Paris at the thoroughly traditional École des Beaux-Arts. Although he had seen some Impressionist work during his French sojourn, it was Whistler who most impressed him. When he returned to London at the end of 1884, he took a studio in Chelsea and began experimenting in a Whistlerian vein.[9] He also tried out several other artistic styles. The painting he sent to the SBA exhibition that winter – a small Arcadian panel of a female goatherd – owed rather more to Bastien-Lepage than to anyone else. It certainly had a French title – Le Soir – which may have almost been enough on its own to persuade Sickert to seek out its author.[10]

Sickert discovered an ally, a friend, and a foil. Even at twenty-five, Steer's handsome, slightly bovine features proclaimed a staid and comfort-loving temperament. Forward looking and Francophile in his painting, in almost all other matters he was innately conservative and English. He disliked change almost as much as he disliked draughts. His pleasures were many if simple: tea, toast, cats, Chelsea Pottery figurines ('the best bad taste'), and mild flirtations with young models. And he had enough private income to be able to indulge them. Placid, self-effacing, and instinctive, he was in many respects an opposite to the energetic, communicative, and intellectualizing Sickert. But opposites attract, and they formed an instant bond. It helped, too, that they made each other laugh.

Sickert's excitement at these new contacts and opportunities was abruptly curtailed at the beginning of December when his father fell ill – after taking a chill while out sketching – and then 'rather suddenly' died.[11] It was a 'great grief', and an unexpected one.[12] Oswald Adalbert Sickert was only fifty-seven. Although by all the conventional standards he had failed to establish himself as an artist, Walter admired him

greatly, both for his work and his judgement. 'I have never', he later claimed, 'forgotten anything he said to me.'[13] The great sadness was that he had not said more. Walter came to regret all the subjects – especially those relating to painting – they had never had a chance to discuss.[14] Sickert already had a sense that he stood in the third generation of a line of painters. His father's death sharpened that perception, and placed a new onus of responsibility upon him. He preserved amongst his most treasured possessions examples of his father's – and his grandfather's – work, and drew strength from their suggestions of a shared and continuous artistic tradition.[15]

Sickert's immediate duty was to his mother, who was all but inconsolable and little able to attend to the demands of the moment. He moved back to Pembroke Gardens with Ellen in order to help with the funeral and other arrangements.*[16] Ellen got on well with her mother-in-law, but even she struggled to draw Mrs Sickert from the depths of her grief. That feat was eventually accomplished by the unlikely figure of Oscar Wilde. He insisted upon seeing Mrs Sickert and gently coaxed her into talking of her husband and her loss. As Helena recalled, 'He stayed a long while, and before he went I heard my mother laughing.'[17] After she had rallied, Mrs Sickert began to settle into the role of matriarch. Controlling the family finances, she kept her children close about her. Robert and Bernhard, though in their early twenties and struggling away at uncongenial clerical jobs, both continued to live at home. Helena, who had been up at Girton College, Cambridge, studying Moral Sciences (the fees being paid by her godmother), 'found it impossible' to leave her grieving mother. Oswald Valentine and Leonard were still at school.[18]

Walter, for all his real filial affection, was careful to preserve a measure of independence and distance. As the eldest male – and the most powerful personality – he assumed a position of some command. One of his first acts was to persuade his mother that the feckless Bernhard was 'a painter and nothing but a painter' and should be spared the trials of conventional employment.[19] He had had a picture accepted that winter at the SBA, and Sickert had drawn him into the circle of Whistlerites. He remained, however, very much a younger brother: it was understood that he should sign his works in full, while

* Oswald Adalbert Sickert was buried at Brompton Cemetry. His personal estate, which he left entirely to his wife, was valued at just £295. 10s. 11d.

Walter could use their surname unadorned, on the grounds – as Walter explained to him – that 'if we had been girls, I should have been Miss Sickert [as the eldest], but you would have been Miss Bernhard Sickert'.[20]

Walter and Ellen finally moved into their new home at 54 Broadhurst Gardens just before Christmas 1885; their first batch of headed writing paper had black mourning-borders. The house – part of a development of small-scale, four-storey, semi-detached dwellings – was in the fashionable aesthetic style, its red-brick façade broken by white-framed windows, its silhouette dominated by a steeply pointed gable end into which a balustraded picture window had been set. The developer had clearly been seeking to attract an artistic clientele for there was a 'good studio' at the top of the house, connected to the ground floor by a 'speaking tube'.[21] Sickert soon made himself at home in this 'large, airy upper chamber'.[22] He installed an etching bench and a small press, and gathered about him the paraphernalia of painting, as well as various studio 'comforts' given to him by his family: a rug, a footstool, a slop-pail, and a can. There was also 'a comfortable settee' upon which he could retire to think or read.[23]

The one misfortune of the move was that the new plasterwork had reacted strangely with the sky-blue distemper they had chosen for the walls of the three principal rooms – turning the colour to a 'cold mauve'. The effect, Ellen noted, was 'painful as the painted woodwork is the right blue-green', and nothing could be done to correct it until the spring.[24] Such was the horror of the colour combination that, even before they were properly settled, they were thinking of moving. There was talk of building a smaller house 'quite to our satisfaction' close by.[25]

Married life inevitably drew Sickert away from Whistler's immediate ambit. Swiss Cottage was not close to Chelsea, and the business of furnishing a house was a time-consuming one.[26] There were new interests, new connections, and new commitments to accommodate. Ellen had a wide circle of friends, and her sisters came to live close by.[27] The whole world of the Cobdenites – old allies of Ellen's father – was ready to welcome the happy couple and include Walter in the circle. He now found himself dining at political tables.[28] He was a regular guest of Tom Potter, the fat and good-natured MP for Rochdale, whom Gladstone described as the 'depository of Cobden's traditions',[29] and he saw something of the ever more politically inclined William Morris

at Kelmscott House. Having formed no particular political views of his own, Sickert was happy to adopt Ellen's hereditary loyalties. He got on well with her father's old cronies, though he enjoyed vexing William Morris's handcraft sensibilities by wearing a ready-made tie in the worst possible taste whenever he and Ellen visited Hammersmith.[30]

Sickert seems to have been able to flourish in almost any company. Marriage to Ellen opened up new social opportunities for him; but he had already learnt society's ways, and though he was attracted by its rewards he never succumbed to its ethos. He enjoyed flouting its conventions even as he embraced them.* His detachment remained secure. He learnt to play the man of the world, adding to the remarkable social confidence and charm he possessed, even as a boy, an almost princely courtesy. But, as one observer noted, in all his dealings with society there lurked beneath the surface an 'undefinable and evasive mockery'.[31] It was the mockery of the 'artist', but also the mockery of a second-generation bastard with a foreign name.

Despite all distractions, Whistler remained the central focus of Sickert's life, and Ellen adopted it too. Indeed 54 Broadhurst Gardens, in its decor and style, was conceived as something of an *hommage* to the Master. Ellen even referred to it jokingly as 'our Whistler House'.[32] They owned Whistler's picture *A White Note*; the green-and-white wardrobe painted by Whistler was installed; and almost the Sickerts' first act after their marriage was to commission portraits of themselves from Whistler at 100 guineas apiece.† Sickert insisted on regarding this as a very favourable rate – 'practically a fantastic present'.[33] Ellen worked hard to win Whistler's trust. She gained it – along with his gratitude – when she deployed her influence to prevent Harry Quilter – the hostile art critic of *The Times* and new owner of the White House – from receiving a testimonial from her friend John Morley.[34] Whistler responded readily to such overtures.

It was certainly Whistler's influence that secured Sickert a small one-man show at Dowdeswell's Gallery during the dead season of January – a gathering of about twenty 'little panels', mostly of Dieppe.[35]

* His family used to despair at some his 'outrageous' ploys, 'such as turning up at society functions in all kinds of odd clothes': one his favourite outfits was a 'country squire' (reminiscences of a servant of the Sickert family during the 1880s, quoted in LB, II, 14).

† Sickert never hung the walls of his homes with his own work. To have done so would have seemed to him 'a form of incest' (RE, 287).

In the catalogue, Sickert was again captioned as the 'pupil of Whistler'; the critics thought he still had lessons to absorb. 'In what our [French] neighbours call *facture*,' wrote the *Illustrated London News'* reviewer,

> Mr Sickert has certainly caught something of his master's trick; but in the inner perception of the 'things unseen', which Mr Whistler led us often to feel were lurking behind his misty foregrounds, the pupil has still much to learn. If his aim has been to catch fleeting impressions and to transfer them at once to his canvases for subsequent use and study, there is no reason to find fault with the delicacy of his perception; but it is rather a misnomer to call such works pictures, or to attempt to pass them as the result of serious application. For the most part, the colouring is flat and opaque, and in nearly every case far too imitative of his master's 'symphonies' and 'arrangements'.*[36]

The confusion between the sketch and the painting was one of the standard criticisms of Impressionist art. Sickert would have expected it. But he does seem to have resolved – in the wake of the Dowdeswell show – to work on a slightly larger scale. For the future, he decided not to send 'such small things' to the Society of British Artists and the Royal Academy.[37]

A hint of promise was noted by the reviewer in the single-figure picture *Olive*; it was praised as showing 'that Mr. Sickert, when left to think for himself, can produce satisfactory work, and contains the germ of better things'.[38] But even in his figure pictures, though the critic may not have recognized it, Sickert's approach seems to have been directed closely by Whistler's example. Menpes recalled receiving a telegraphed summons to Broadhurst Gardens portending an important discovery. He and Sickert had noted Whistler's recently adopted 'system' of painting with ready-mixed and ready-diluted colours such as 'floor tone', 'flesh tone', and 'blue sky tone', which he kept always on hand. Sickert had at once seized upon the idea – and carried it further. Menpes, as

* Sickert's command of the superficial aspects of Whistler's style could, it seems, deceive some people. In later years, Sickert liked to tell an anecdote of how he had been entrusted to deliver a small Whistler panel to a customer in Dieppe. Crossing over to France on the ferry, the picture had been torn from his grasp by a gust of wind and blown overboard. Undeterred, on arrival at Dieppe, he had assembled some materials and painted his own version of the scene, which he then delivered to the unsuspecting – and completely satisfied – customer. Sickert told this rather fanciful story to Donald Ball in the late 1930s, when Ball was a student at the Thanet School of Art.

he made his way up to the attic studio, could hear an ominous 'dripping sound'. He found Sickert working from a model, surrounded by 'about fifty milk cans', each filled with a different tone: 'lip tone, eye tone etc.'. The paint was so liquid that, as he tried to get it from the pot on to the canvas, it dripped all over the floor. And the operation had to be undertaken at such speed that it could hardly be accurate: most of the eye tone 'went on to the background'. 'I felt that the eye should be in the face,' Menpes remembered, 'but still it was an eye, and it was art, and in art – according to the Whistlerites' dictum – nothing mattered as long as you were reckless and had your tones.'[39]

It was at about this time that the small but growing inner circle of Whistler 'followers' formalized themselves into a club. They decided to hire a room where they might meet of an evening 'for the discussion of art'. Gathered at Menpes' house in Fulham one evening, the seven members consulted a map of London, marking their homes on it with red dots, and then estimating the most convenient central location for their meeting place. Baker Street was fixed upon and a little room was taken there for six shillings a week. Beyond Menpes and Sickert the exact membership of the group is unknown, but the original line-up almost certainly included Sidney Starr, Harper Pennington, and Alberto Ludovici Jr. Théodore Roussel was an early addition.[40] Other possible members were Bernhard Sickert, William Stott, Jacomb Hood, and Philip Wilson Steer. The claims of such female followers as Maud Franklin and Elizabeth Armstrong seem to have been ignored.* Adopting what they considered to be a Whistlerian maxim – 'Nature never makes a mistake in matching her tones' – the group decorated their room as a 'harmony' of sea and sky with sky-blue distemper walls and a sea-green distemper ceiling, whilst the woodwork was painted 'the tone of the Dover cliffs'. Although the scheme was, from a naturalistic point of view, upside down, it was, of course, another Whistlerian axiom that nature was just as beautiful either way up. Headed notepaper was ordered, stamped with a symbolic motif – 'a steam engine advancing, with a red-light displayed, – a warning signal to the Philistines that the reformers were on their track'.[41]

* A study of the artists' addresses in 1885/6 provides some clues, with Menpes, Roussel, and Steer living in Chelsea, Bernhard Sickert in Kensington, Walter Sickert in Swiss Cottage, Starr in Fitzroy Street, and Ludovici in Camden Town. The date of the foundation of the club is conjectural; but, given its Baker Street location, it is difficult to suppose that it occurred before the Sickerts' move to Broadhurst Gardens.

In their earnest discussions around the inadequate paraffin
stove, in their quest for that 'great discovery in the matter of method,
or of pigment, or of manipulation' that would 'revolutionise all the
old canons of art', Whistler remained their guiding light. Théodore
Roussel brought a touch of scientific rigour to their deliberations. Of a
technical bent, he had designed what he called (in his heavily accented
English) a 'tone detector-r-r' – an optical device for matching the tones
of nature. He also worked out a scheme for mixing perfectly pure
pigments from ground-up crystals.[42] But, for all the reverence accorded
to Whistler, the parallel attractions of Degas were not to be ignored.
Sickert, on his return from Paris, enthused his confrères with descrip-
tions of the work he had seen there. As he told Blanche, he only
wished he could 'bring the whole school over to Paris to make the
Mulbacher and other pilgrimages' – that they might examine Degas'
pictures at first hand.[43] Although the followers did not advertise to
Whistler this new interest in Degas – or 'Digars', as Menpes referred
to him – they considered the two artists as twin spirits, Impressionists
both.* They tried to combine the method of one with the subject
matter of the other, producing not entirely satisfactory pictures of 'low
toned' ballet girls.[44]

Another alternative voice was provided by Charles Keene. Sickert
had come to know him well. He visited him at his studio in the King's
Road, and invited him to Broadhurst Gardens.[45] They dined together
at the Arts Club in Dover Street (it was Keene who put Sickert up for
membership there in 1888),[46] and they talked of art. Keene impressed
Sickert on many levels: in his practical attitude to his craft; in his
patient humility ('Think of that great man drawing all those bricks,'
Sickert remarked of Keene's depiction of a garden wall); in his artistic
engagement with the world around him.[47] There were useful tips to
be gleaned. Sickert observed how Keene worked always on a relatively
small scale.[48] He relished his diatribe against the use of nude models
in art schools on the ground that 'the world being filled with clothed
persons, modern painters will have more need to learn how to paint

* The correct pronunciation of Degas' name became one of Sickert's great – and
abiding – causes. 'Day-gas, day-gas, why', he lamented, 'do the English always say
Day-gas.' He never tired of pointing out that Gas was a town in France from which
Degas' ancestors had come, and that the name had originally been spelled De Gas,
making this – and the pronunciation – clear (WS, 'John Everett Millais', Fortnightly
Review, June 1929).

them than to paint nudes'.[49] He noted, too, how Keene used himself as his own clothed model, keeping a variety of costumes hanging on pegs in his studio for the purpose.[50]

In most things Keene offered a rather different perspective to Whistler. There was no pretension about him or his art: he had achieved his greatness 'doing drawings for a threepenny comic paper to make his living' – and that was what he went on doing.[51] His view of Whistler, though generally admiring, was not overburdened with reverence. He surprised Sickert, and set him thinking, by a preference for Whistler's paintings over his etchings.[52] After revealing an heretical admiration for the work of the Berlin realist Adolph Menzel, he confided 'with one of his monumental and comprehensive winks, "Ye know, I like bad pictures. But don't tell Jimmy."'[53]

Though Keene, like Degas, might offer the first hint of an alternative vision, for the time being it remained only a hint. Sickert had little difficulty in reconciling all attractive ideas with those of Whistler. The essential commitment to Whistler's cause and Whistler's interests remained constant. He did a drawing of a Whistler painting for reproduction in the *Pall Mall Budget*, and fired off a letter to the *Daily News* after it had had the temerity to suggest that England lacked a painter who could depict English snow.[54] He even undertook to sort out a dispute that had arisen between Whistler and the Fine Art Society over a missing pair of Venice etchings.[55] His attendance at Whistler's studio may have slackened, but it did not cease. Beatrice Godwin, who had recently separated from her husband, was sitting to Whistler (who greatly admired her), and Sickert made an etching of her in the same pose.[56] He also sat for his own portrait.[57]

Whistler's power base within the Society of British Artists continued to expand. He was active in putting forward his supporters for membership – Starr was elected in the spring of 1886 – but Sickert, as a non-member, remained vulnerable to the vagaries of the picture selection process. The conservative element within the SBA was still formidable and, as Sickert explained to Blanche, while the Whistlerites had been lucky to have Jacomb Hood on the hanging committee, 'next time it may be three idiots'.[58] And perhaps that was how it turned out. Sickert was not represented in the society's April exhibition. The rebuff would have been felt the more keenly because Starr's painting – of Paddington station – was the hit of the show.[59] Some hope for the future was, however, given when Whistler was elected President of the

SBA at the beginning of June, provoking what Mrs Sickert described as 'much glory among the faithful pupils & adherents'.[60]

Sickert did not stay to revel in the glory for long. He went to Paris for a few days: the Salon had recently opened and so, more importantly, had the eighth – and final – Impressionist Exhibition, which included several new works by Degas.[61] His and Ellen's resolve to buy a Degas picture had strengthened, and it was probably on this trip that Sickert arranged the purchase of the pastel *La Danseuse Verte*. It came from the private collection of Charles Ephrussi, though the sale was handled by a dealer. Sickert paid a little over 2000 francs (about £80) for the picture.[62] He also noted a second work, a pastel lithograph, at the dealer Closet's: 'A singer with two white gloves & many globes of light & a green wooden thing behind & fireworks in the sky & two women's heads in the audience.'[63] Back in London, he and Ellen decided that they should buy this picture as well. The price was only £16. Ellen agreed to sell some stocks to pay for it, but the sum was required quickly and Sickert wrote to Whistler pleading for the return of some of the money they had paid him on account for their portraits. Tactfully, he suggested it was needed for living expenses.[64] Blanche was then commissioned to buy the picture – if possible at a discount.[65] Displaying his characteristic helpfulness and efficiency, Blanche delivered the picture in person when he came to London at the end of the month (Sickert repaid the kindness by presenting his friend with a small painting of his own).[66] Blanche was charmed by the Sickerts' new home: a 'maison délicieuse ... pleine de jolies choses' (the cold mauve walls had been repainted)[67] and was amazed to discover the *Danseuse Verte*, which he had known well *chez* Ephrussi, now on their wall. He assumed that Sickert must have 'pas mal d'argent' to be making such acquisitions.[68]

The assumption, as Blanche soon came to realize, was quite false. Sickert had no money. If he had possessed any he would certainly have been extravagant with it. In its absence he was extravagant with his wife's. Throughout the first flush of home-making Ellen seems to have encouraged such expenditure. The house in Broadhurst Gardens was by no means cheap: at just under £80 a year, the rent and rates were not inconsiderable – quite apart from the cost of decking the walls with works by Degas and Whistler.[69] It was only with time that Ellen came to recognize her husband's complete – almost wilful – recklessness in money matters. 'Giving money to Walter', she once

remarked, 'is like giving it to a child to light a fire with.'[70] With no income of his own, and no sales from his pictures, he was almost entirely dependent upon her. She gave him an allowance, but sought to control his excesses by keeping it small.[71] To evade such restrictions he ran up debts and borrowed occasional small sums from Whistler, his mother, and his brothers.[72] Sickert disbursed what he had with a programmatic recklessness. 'I am so convinced', he told one friend, 'that the way to have, is to spend, and that lavish generosity pays, as well as being delightful. The thing is to give, give, give. You always get back more than you give.'[73]

The summer of 1886 was hot. By mid July Ellen had begun to wilt, and Walter's studio under the roof at Broadhurst Gardens had become 'like an oven'. For relief, they fled to the glaciers of Switzerland, stopping to admire some 'wonderful' Holbeins at Basle. Ellen loved Alpine air and Alpine scenery; Walter was less convinced. 'I suppose it is very healthy,' he told Blanche, 'but I prefer Marylebone for a holiday.' He fell ill after taking a dip in the Rhine, and altogether could not wait to be back in London 'with the green danseuse who is better than all the scenery of Switzerland'. He filled the long hours at Pontresina, the little resort town where they were staying, by making a closely worked etching of a young girl standing in the gloom of a dark kitchen – one of several 'Rembrandt interiors' he had noted.[74] They returned to England at the end of September via Munich and Dresden, where – to judge from the series of etchings that Walter produced – they had a rather jollier and more active time in crowded cafés and at the Oktoberfest.[75]

Back in London, Sickert threw himself into the exhibition season with new vigour. Although Whistler's presidency prompted a radical overhaul of the SBA's exhibiting policy (the Suffolk Street galleries were refurbished to Whistler's designs, and the number of works on show was drastically reduced), total control was impossible. The society, in Sickert's words, remained 'half-savage'. There could be no guarantee that work by Whistler's followers would be accepted. But for the efforts of Menpes and Stott, who were acting as 'supervisors', Sickert's picture would have been rejected by a 'stodgy' hanging committee.[76]

The painting, *Rehearsal: The End of the Act*, marked Sickert's promised break from small-scale Whistlerian sketches. It was almost two foot square and depicted a woman slumped on a padded sofa.

The well-informed would, nevertheless, perhaps still have recognized a Whistlerian debt. The model was Helen Lenoir of the D'Oyly Carte Company. Her exhausted pose might be read as the result of her labours in producing the Ten o'Clock Lecture. To reinforce the connection, Sickert's earlier print of Miss Lenoir – *The Acting Manager* – was also on view, with several other works, at the Society of Painter-Etchers. Looking beyond the established outlets, Sickert also sent a figure study titled *Ethel* to the Institute of Painters in Oil Colours, a staid old society that numbered several of his father's friends amongst its members.[77]

His busy round of active self-advertisement was unexpectedly rewarded when he received an invitation to exhibit in the New Year with Les XX, a recently formed avant-garde Belgian art association that had instituted an annual salon in Brussels. At first Sickert suspected Blanche's beneficent influence was behind this coup, being unable to imagine that his own 'unassisted fame could have led any Society, however perspicacious, to single out the genius that [was] modestly hidden in the suburb of Hampstead'.[78] But that, it seems, is almost what had happened. Blanche was not involved. The Belgian painter Willy Finch had noticed Sickert's work on a visit to England, and noticed too, no doubt, its debt to Whistler, of whom he was a great admirer. Acting as a talent scout, Finch had written enthusiastically to Octave Maus, the secretary of Les XX, praising the pictures as 'très raffinées comme art';[79] and Maus had duly sent an invitation. Sickert swelled with pride at this 'marque de la plus haute distinction', as he termed it in his fulsome letter of acceptance. He at once began work on a very large canvas some six foot square.[80]

Sickert's determined application was impressive, and his development, though perhaps less accelerated than Menpes' or Starr's, was certainly discernible to close observers. Whistler, who was not given to praising, noted it. That summer, while going round the Royal Academy show, he had impressed the critic Malcolm Salaman with a stray remark in front of a canvas by the young James Lavery. 'Yes – very nice, don't you know?' he had said in his curiously effective manner. 'But well, you know of all the young men, I should say, the one who will go furthest is Walter Sickert.'[81] George Moore recounted a similar exchange.* And if Moore knew a thing he never wasted any time in

* 'One day walking with [Whistler] I heard the Master mutter – at first it was but a mutter, but gradually the mutter grew more distinct, and I heard him say, "Well, you know, talking of Walter . . . I don't mean that Walter will ever do as much as Manet,

passing it on. Sickert would have been aware both of his progress and of how much was expected of him.

Whistler's admiration was, however, tempered by a keen sense of insecurity. Sickert's extended holiday abroad, his decision to send to the Institute, the other demands upon his life, all vexed the ever touchy Master. Whistler wrote a peevish note to his pupil, complaining that he and his affairs were being neglected. Sickert sprang forward with assurances of continued loyalty and affection. 'My dear Jimmy, You have written to me in a fit of the blues. Indifference you know perfectly well I have never shown towards anything that concerned you, dating back to years before I even knew you, and independence is a quality the merit of which I have never heard you throw a doubt upon – except indeed in the case of Switzerland and there I went for health & not for scenery.' As to the 'matter of the Institute', Sickert explained that it had its 'pleasant side' for Whistler, showing that 'now you have taught me to walk I am not crying to be carried'. Besides, it was a necessity for Sickert to 'peddle' his work where and how he could: 'Painting must be for me a profession & not a pastime, or else I must give it up & take to something practical.'[82] Ellen added her voice to these protestations. She promised to come and pose again for her portrait, and to bring Walter with her – so that he could 'during the sittings attend to any affairs on which he can be useful to you'.[83]

Sickert's reference to painting as his 'profession' was an optimistic statement of intent, rather than of fact. As yet his 'profession' had yielded few tangible rewards. His pictures did not sell. If he was gaining a reputation it was only amongst the tiny coterie of Whistler's followers. He made presents of his paintings to most of the members of the school – to Menpes, Starr, Roussel, and Elizabeth Armstrong – and borrowed back several of these small panels to send in to Les XX. But his new large painting was not finished in time. He sent instead the picture of Miss Lenoir on her sofa, which had just been returned from the SBA show.[84]

The exhibition began in February 1887. Sickert could not travel to

but if we are to consider the relations of Art and Nature, and of English painting to those red things which – " The rest of the sentence I never heard, it was lost in guffaws. By red things the Master meant portraits of officers in uniform, but this by the way. What immediately concerns us is that the Master looked upon Walter Sickert as a great painter.' *Saturday Review* (23 June 1906), 784.

Brussels for the opening, but the press reports made clear the challenging nature of the event. Amongst the vague Symbolist imaginings and Impressionist morsels on view, the painting that attracted the greatest attention was Seurat's *Sunday Afternoon on the Island of La Grande Jatte*. The picture confirmed a development hinted at in the last Impressionist exhibition. Its novel approach to colour – dividing its constituent hues into tiny dots – had been dubbed 'Neo-Impressionism' by the young French critic Félix Fénéon, and already other artists were taking it up. Camille Pissarro and Paul Signac were both represented in the show with 'Neo-Impressionist' works, while the Belgian artists Willie Finch and Théo van Rysselberghe were also beginning to experiment with the technique. Against such scintillating novelty Sickert's contributions appeared both literally and figuratively insubstantial. The reviewer for *L'Indépendence Belge* remarked that although one of his paintings was called *Trois Nuages*, the title would have been apt for almost any of them: 'tant ils sont tous nuageux'.[85] Nevertheless, to be in the exhibition at all was an achievement and a thrill.[86]

If Menpes is to be believed, the innovative work on view in Brussels provoked Sickert and the other members of the Baker Street band to emulation. They became, for a while, 'prismatic' and began to experiment with painting 'in spots and dots'.[87] For Sickert, however, the main effect of his exposure to the swift current of the Continental avant-garde was upon his subject matter.

A NEW ENGLISH ARTIST

'The Boy I Love is Up in the Gallery'
(Music-hall song)

Sickert was in search of a new and personal motif. His little seascapes and townscapes proclaimed a too obvious Whistlerian debt. The ballet, the racecourse, and the bathroom belonged to Degas. And although France offered other possibilities, Degas was insistent that English artists should search for English sources of inspiration.[1] Sickert seems to have considered some conventional options. One friend who met him at this time recalled that he was working away at a series of cathedrals.[2] But the attractions of ecclesiastical architecture did not long engage him. He turned instead to the more daring possibilities of the modern music hall. This was in effect a transposition to a London setting of one of Degas' chosen subjects – the *café chantant* (as depicted in the Sickerts' *Mlle Bécat aux Ambassadeurs*). Although the Victorian music hall might now seem the essence of quaintness, in the 1880s it was something quite different: modern, metropolitan, vulgar, artificial, and daring. It was also distinctly British. Since his first meeting with Degas, Sickert had been toying with theatrical subjects. Besides the 'low toned ballet girls' of the previous year, he had made etchings of the circus, of Punch and Judy shows, and even of the occasional music-hall audience. But it was only now that he began to investigate the subject with real concentration, considering it as a motif for painting.[3]

It was fertile ground. The music halls were a phenomenon of the age. Scores of them were dotted across London and its suburbs. They had – in their short life – evolved from glorified pub theatres to become institutions in their own right. But they were still dominated by alcohol. The bar was always open and a ticket usually included the

price of at least one drink. Shows lasted all evening, from eight till midnight, and the audience – gathered at tables close to the stage, settled in red-plush chairs, or crammed onto benches in the gallery – were part of the show. Spectators heckled the acts, abused each other, and joined in with the choruses, while a chairman kept order and announced the succession of 'turns'. Although some of the smart new halls offered 'ballet' and ingenious novelty acts, on the popular fringe song and dance still held sway, offering a diet of mawkish sentiment, broad humour, rampant jingoism, and sexual allusion. They were themes, and treatments, that appealed to the vast mass of London's working class; and increasingly they appealed to others too. Although the guardians of public morality regarded the halls with horror, as sinks of debauchery and arenas of vice, a few bohemian spirits relished their heady atmosphere. Sickert was a pioneer in the field, but he was not alone. George Moore also had an enthusiasm for the halls, as did Steer and Ludovici. 'What delightful unanimity of soul,' Moore wrote, 'what community of wit; all knew each other, all enjoyed each other's presence; in a word there was life.'[4] Sickert found a rich pictorial drama in the low tones of the auditorium, the garish light of the stage, and in the fleeting arrangements of the performers. But it appealed too because it was both daring and previously untapped. Whistler had never attempted to paint it, and nor had anyone else. It was a chance to stake a claim on something new – and something that was likely to shock.

Once Sickert began work on this new theme, he quickly came to realize that the methods and techniques he had learnt from Whistler provided almost no clue of how to proceed. A pochade box was useless: sitting in the semi-darkness of a music hall unable to see his colours or move his elbows, he could not paint from life. Painting the whole scene from memory – as Whistler did with his nocturnes – was likewise impossible. He could study and observe – but only so much. Compared to a Thames-side warehouse, the auditorium of a London music hall was both too complex and too fugitive to be learnt in full. So he turned instead to the example of Degas. He started to work from snatches of repeatedly 'observed and remembered' movement, from drawings, and from notes.[5] He returned night after night to the same seat in the same music hall to study his scene: to memorize and set down a single significant move or gesture, to note the divisions of light and shade, the subtle grades of tone, and the rich vestiges of

colour. It was as a detached, unobserved member of an excited audience that Sickert evolved his rare power of objective vision – 'the one thing', as he later described it, 'in all my experience that I cling to . . . my coolness and leisurely exhilarated contemplation'.[6] He proliferated tiny drawings, some done in little, lined, laundry books, others on postcards.[7] He captioned them with colour notes, or – more often – with the words of a song or a snatch of dialogue: an aural aide-mémoire. The composition of the pictures was mapped out, the elements marshalled, and the paint applied, not on site but back in the studio. In most of his early experiments he borrowed from Degas the conventions of *Mlle Bécat aux Ambassadeurs* – viewing a single footlit artiste over a ragged silhouette of foreground figures.

At the 1887 spring exhibition of the SBA, Sickert unveiled his first music-hall painting – *Le Mammoth Comique*. The picture – a small canvas of an open-mouthed, evening-suited singer standing against a stage backdrop with the orchestra pit in the foreground – provoked surprisingly little comment. It was admired as being 'clever' by both the critic from the *Daily Telegraph* and by Mrs Sickert;[8] but the debt to Degas was not remarked. Whistler's views on the work are unknown.[9] The President had other things to engage his attention that season. The Prince and Princess of Wales visited the exhibition.* There were hopes that the society would be given a Royal Charter and even that the President might receive a knighthood. (The former came to pass, the latter did not.) Another visitor was Claude Monet, who had come over to stay with Whistler and promised to send work to the next exhibition. Amongst these excitements, Sickert's little music-hall scene was a minor distraction.

At the beginning of June, Sickert – together with Ellen – crossed to the Netherlands to stay at the seaside resort of Scheveningen.[10] The excursion may have been, in part, an act of piety, for Whistler had painted and etched there often. Sickert, too, made numerous small etchings of the beach and its distinctive hooded wicker chairs – or *windstolen* – as well as some rather brighter and less obviously Whistlerian

* Whistler exhibited his painting of Ellen. Mrs Sickert thought it 'not a scrap like her but . . . a fine picture and interesting' (to Mrs Muller, 1887). The canvas was subsequently destroyed.

paintings. Yet even when working in his master's idiom, Sickert's own voice was becoming gradually more apparent. The etchings that he showed that November at the Society of Painter-Etchers – where, greatly to Ellen's delight, he had been elected a fellow – were praised for their 'individuality' and accomplishment.[11]

'Individuality' was not something that Whistler particularly encouraged amongst his pupils. He seems to have ignored Sickert's achievements, and engaged him instead in his own printmaking activities. Under the guidance of his printer friend Thomas Way, Whistler was experimenting with lithography after a break of several years,[12] and Sickert was invited to try his hand at the medium.[13] Rather less flatteringly, he was also charged with carrying the Master's weighty lithographic stone when they set out together of an evening, 'in case inspiration should come during or after dinner'. As a friend recorded, 'at the Café Royal or elsewhere the waiter was enjoined to place an extra table for the stone', but more often than not it was still untouched when Sickert would have to carry it away at the end of the night's entertainment.[14]

Sickert did not seek to build on the achievement of Le Mammoth Comique at the winter exhibition of the now 'Royal' Society of British Artists.[15] He was keeping his powder dry, for all was not well at Suffolk Street. Although Whistler's achievement of royal patronage had won the universal approbation of the SBA membership, on most other fronts he was assailed by complaints. Seeking to bring matters to a head, he put forward a motion calling for members to resign their attachments to all other societies, including even the Royal Academy. This was not a popular move. Many members exhibited and sold pictures with other variously distinguished national and local societies. They saw nothing to gain from complete exclusivity and much to lose. Rather than provoking the conservative element to leave the club, as he had hoped, Whistler provoked them into rebellion. His motion was defeated, and a battle line was drawn. A group of members began to campaign for the President's removal; and although Whistler sought to bolster his position by drafting more supporters into the ranks of the society (Théodore Roussel and Waldo Story both became members in 1887), the vulnerability of his position became increasingly apparent.

It was against this gathering crisis that Sickert began to look beyond the confines of Suffolk Street. The RSBA was, he realized, 'a house divided against itself' and 'the split' would come 'sooner or later'.[16] It was as well to be prepared. As a non-member he relied on the Whistlerian

control of the selection process to secure a showing for his pictures. If Whistler were ousted there could be no guarantee that his work would continue to be accepted, and every possibility that it would not.

Sickert needed to find a new forum for his work. Steer and several other of Sickert's Baker Street confrères had recently exhibited with a society called the New English Art Club, and their example encouraged him to look in this direction.[17] The club had been established only the previous year, in 1886, by a group of artists, the majority of whom had received some training in the Paris studios (indeed one suggested name for the club had been 'The Society of Anglo-French Painters').[18] The original members were 'a mixed crew' and the influence that France exerted over the work took various forms – and existed at various strengths.[19] John Singer Sargent was a founder member, but perhaps the dominant artistic strain was the large-scale plein-airism derived from Bastien-Lepage: scenes of a slightly sentimentalized English rural realism done in 'what [was] known as French technique'.[20] This school was represented by George Clausen, Stanhope Forbes, Henry la Thangue, Henry Scott Tuke, and numerous lesser lights.

Besides the Baker Street group, there were a few other members of the new body who professed an interest in the work of the French Impressionists, even if their own pictures tended to show only the faintest traces of actual influence. It was one of these, Fred Brown, who had invited Steer to exhibit with the club, having been impressed by the quasi-idyllic painting of a goat girl exhibited at the SBA in 1885.[21] Brown, then in his mid thirties, had been teaching at the Westminster School of Art since 1877, offering night classes in drawing and painting to working men and part-time students. He was an inspired and inspiring teacher, and had established a reputation for the clarity of his approach. It was work that kept him in touch with the rising generation of artists – as well as giving him a taste for administrative organization. He emerged as one of the guiding spirits of the new club and drew up its novel, and thoroughly democratic, constitution: there was no president, only an honorary secretary; and exhibitors had the same voting rights as members.[22]

As in the early days of most institutions, there was some jockeying for influence and control. Brown was anxious to secure his own circle of support within the club – hence his invitation to Steer to show at the club's inaugural exhibition in the spring of 1886, and again in 1887.[23] And he was delighted to meet a potential new recruit in Sickert,

who, in turn, was no less delighted to meet Brown. He grasped at once the possibilities of the situation: here was a young, unformed institution that might serve as a home for himself and his confrères. He infected Brown with something of this vision, and plans were soon afoot to seize 'a greater, and, if possible, a dominating influence' in the running of the club.[24] Sickert was able to marshal the other members of the Whistlerian faction: Starr, Menpes, and Francis James all agreed to show with the NEAC in future, as did Sickert's brother Bernhard, and Paul Maitland.[25] The group's position was further enhanced when the club's secretary retired at the end of the year and was replaced by the 34-year-old Francis Bate. Bate was both an admirer of Whistler and a friend of Brown's.[26] He joined the frequent meetings, in which Sickert took the lead, that were taking place to discuss the strategy of the planned coup. They were held in Sickert's studio at Broadhurst Gardens, and, as Brown recalled, 'with Sickert as host, our little conspiracies were not very sombre affairs . . . His gaiety was contagious, his manner charming, his wit bubbling.'[27] Brown, despite his seniority, found himself swept along by his young companions. Sickert later described him as having been 'caught up by our movement as by a cow catcher on a train'.[28]

In the first instance, Sickert seems to have viewed the infiltration of the NEAC as part of the grand Whistlerian project. He tried at every juncture to include his master in his developing plans for the club. But it was a difficult matter to achieve. Whistler, despite his problems, was still committed at Suffolk Street, and he could not very well become a member of a new body after his recent demands for exclusive loyalty to the RSBA. Nevertheless, he did consent to send a print to the NEAC's show in the spring of 1888, and to allow Sickert to show Ellen's canvas, *A White Note*.[29] (Sickert further reinforced the connection by exhibiting a small panel of 'The Vale', which cognoscenti would have recognized as Whistler's home.) But Sickert's horizons were no longer bounded by Chelsea. His own music-hall works took off from the example of Degas, while Steer, in a series of sun-drenched depictions of young girls at the seaside, was experimenting with ever more brilliant colours and ever more broken brushwork, inspired by a study of Monet's technique. Sickert sought to foster these French ties and enhance the club's prestige. Following Whistler's own example in wooing Monet, he approached Degas. There were hopes that the great man might even be persuaded to become a member of the club. At all

events, he gave permission for Sickert to exhibit the *Danseuse Verte*.[30]

Sickert showed his own commitment to the new venture by sending in his largest and most daring picture to date: a tall, thin music-hall scene, some five foot by three foot, depicting *Gatti's Hungerford Palace of Varieties – Second Turn of Katie Lawrence*. He could be confident that it would be accepted, since he was on the selection committee.[31] The machinations of Brown and Bate had packed the jury, and by acting in concert they were able to determine the character of the show. As one hostile critic later recalled, a 'new spirit made itself felt'.[32] In the hanging of the show the two places of honour, in the centre of the long walls of the Dudley Gallery, were given to Steer and Sickert. It was the first of many occasions on which they appeared as the twin pillars of New English Art. As tended to happen on such occasions, the critics displayed their open-mindedness by offering a few words of faint praise for one before damning the other. Steer was represented by *A Summer's Evening*, a large canvas of three nude girls on a beach that combined his radical Monet-inspired brushwork with the more familiar comforts of an idyllic scene. Though some reviewers found its agglomeration of 'red, blue and yellow spots' an unpardonable 'affectation', more were upset by Sickert's picture.[33]

His depiction of Katie Lawrence was derided as resembling 'a marionette', 'a temporarily galvanised lay-figure', and 'an impudent wooden doll . . . with hands down to her knees' and her mouth 'twisted under her left ear'.[34] One paper suggested that Miss Lawrence should sue the artist for defamation.[35] The absence of detail, the lack of 'finish', the want of 'graceful composition', and the vulgarity of the subject matter were all resoundingly condemned.[36] It was acknowledged that these unfortunate traits were programmatic – the 'affected mannerisms' of the 'advanced Impressionists'.[37] Although to many English commentators Whistler remained the prime – if not the sole – 'Impressionist', knowledge of the French members of the school was slowly percolating into the critical consciousness. Following several recent showings of work by Monet, Steer's broken-colour technique was recognized as being in the French artist's manner. And the presence of the *Danseuse Verte* on the walls of the Dudley Gallery ensured that a firm connection was noted between the work of Sickert and Degas.[38]

The critic from the *Magazine of Art*, in a grave attempt at reasonableness, suggested that the 'whole movement' of Impressionism was still very much 'an experiment, and, for the present, [should] be estimated

accordingly'.[39] Degas' experiment, though accounted 'horrible' by many, received some words of grudging praise.[40] But it was generally agreed that Sickert's effort was an abject failure, falling below the level of even 'conventional mediocrity'. The *Pall Mall Gazette* found a kind word for the painting's 'excellent tone' and *The Star*'s anonymous reviewer (perhaps George Bernard Shaw) praised the 'excellently painted top-hat in the right hand corner' of the composition.[41] But that was the limit of critical approbation. The fact that Sickert, with an eye to notoriety rather than sales, was asking a staggering 500 guineas for the picture only increased the sense of outrage.[42] Within a week of the exhibition's opening Sickert found himself, according to one paper, 'the best abused man in London – with perhaps the sole exception of Mr Balfour'.[43]

It was a triumph of publicity – if nothing else. The furore focused attention on to the NEAC, and it placed Sickert at the very centre of the stage. The position was both new and exciting. He was acknowledged – albeit only in London art circles – as standing in the front rank of 'the independent, and often eccentric' young men 'seeking to strike out a new line and throw off the trammels of tradition – and, some would add, of respect'.[44] His attention-grabbing display at the Dudley Gallery was made more pointed the following month when the four modest landscapes that he exhibited at the RSBA failed to draw any but the most cursory critical attention.* It was to be his last association with the society for a decade. After surviving one vote of no-confidence, Whistler was finally ousted from the presidency at a packed general meeting on 4 June 1888. His followers resigned en masse. Sickert, who had never been a member, ceased to send pictures. As Whistler remarked, 'the artists left and the British remained'.[45] For Sickert, the debacle confirmed his good sense in establishing a base at the NEAC. As he wrote to Blanche soon afterwards, affecting a tone of cool assurance, 'Do send us again some work – the more important the better – to the New English Art Club. That will be the place I think for the young school in England. *Faute de mieux*.'[46]

<p style="text-align:center">* * *</p>

* Two of the pictures were, however, admired by the representatives of Liverpool's annual Art Exhibition, and were selected for inclusion in their show at the Walker Art Gallery that autumn.

Inspired by the *succès d'exécration* of his Katie Lawrence picture, Sickert buried himself in his work that summer, spending many evenings drawing at Gatti's and elsewhere.[47] The music hall became his all-but exclusive theme. Copies of *Entr'acte* littered his studio; photographs of star performers were affixed to his easel.[48] Ellen, with her keen admiration for Degas' work, encouraged him in this direction. She would sometimes accompany him to the halls, and they would sup together afterwards at cheap and cheerful restaurants in Soho.[49] But when Sickert became caught up by a subject his appetite for work was all-consuming. He forgot everything else.[50] He would go out *every* night to study the aspects of his composition. He took to following his chosen artistes from hall to hall over the course of one evening so that he might have repeated opportunities of catching the fleeting details of some gesture or expression. It was a regime that inevitably drew him away from Ellen and the life of Broadhurst Gardens. He would return home in the early hours of the morning – after walking half-way across London – to find a sleeping house.[51] He was not good at informing Ellen of his plans – indeed he was not good at making plans. He expected meals to be ready for him on the chance of his appearance, but the chance was often missed. Sometimes he would fail to turn up even when he and Ellen had guests to dinner, sending a last-minute telegram from a distant music hall to explain his absence.[52]

He became friendly with the artistes whom he depicted: with the forthright Katie Lawrence and her unrelated namesake, Queenie; with Bessie Bellwood, the raucous, bright-eyed 'coster genius' who delighted the gallery with her sharp treatment of hecklers.[53] Sometimes he would escort them on their cab rides as they dashed across London from one hall to the next, and at the end of an evening he might go back to their lodgings for an impromptu supper of tripe and onions.[54] He came to love their world and their wit, the freedom of their unabashed engagement with life and language. He relished their sayings: Bessie Bellwood closing an argument with an irate cab driver with the remark, 'Do you think I'm going to stand here to be insulted by a low-down, slab-sided cabman? I'm a public woman, I am!'; Katie Lawrence observing, as their cab horse began to prance, 'Oh! A song and dance horse?'; or her succinct comment when – traversing a building site – she stubbed her toe on a brick, 'Bugger the bricks!' (to which a workman, who was walking behind her, replied, 'Quite right, ma'm, quite right. Bugger the bricks!').[55]

They, for their part, were flattered by the attention of their young admirer. Not that he was a lone presence. Indeed Bessie Bellwood was the acknowledged mistress of the Duke of Manchester, who installed her in a house in Gower Street (causing, it must be supposed, some consternation amongst the high-minded denizens of that thorough-fare) and who could sometimes be seen driving her about in his brougham.[56] Sickert's position as a painter counted for something – though art was not held in very high esteem by these theatrical per-formers. At one of Bessie Bellwood's late-night 'At Homes' she pro-duced an old oil painting, black with grime, that she had picked up at a junk shop. Sickert called for a bowl of hot water and a sponge and began cleaning off the dirt very gently. Bessie soon lost patience, grabbed the sponge from him, and started scrubbing away with a will, to reveal an image of St Lawrence on the griddle. When the next caller was announced she said that she couldn't see him as she was 'giving Lawrence a Turkish'.[57] Sickert's own work was treated even more rudely by his models. When he asked Katie Lawrence if she would care to have one of the several life-sized portraits he had done of her, she replied, 'No, not even to keep the wind out at the scullery door.'[58] It was for his looks, his humour, and his engaging character, that they liked him.

As they advanced, Sickert's music-hall pictures grew avidly complex. He experimented with new and more intricate compositions; he viewed the stage from odd angles; and he played with the subtle shifts in tone and perspective effected by the smoky gilt-framed mirrors that lined the walls of his auditoria. Sickert's fascination with reflected images and reflected light may have owed something to his glimpse of *The Bar of the Folies Bergère* at Manet's studio, and perhaps more to Degas' great interest in the whole subject.[59] But it was a theme that he took up as his own, and in exploring its possibilities his art took a stride forward in both its ambition and achievement. He became, by degrees, a master of low tones and their relations to rival even Whistler. Indeed some contemporaries came to believe that Sickert's specific claim to 'genius' lay in this 'extraordinarily sure sense of tone'.[60] Like Claude Lorraine he had, it seems, the ability to distinguish and order a greater range of light and darkness in a scene than other artists. In part, this was probably a natural gift – like the acute visual perception that allowed his grandfather to carry out his phenomenally accurate micrometer readings. But he honed his skill, and displayed his rare

powers of concentration, amongst the flaring lights and dim reflec-
tions of the Old Bedford, Gatti's, and Collins's Music Hall, Islington
Green.[61]

It is hard to know how far Sickert's relations with his music-hall
friends extended. It is possible, even likely, that he slept with some
of his lionesses comiques: music-hall artistes had a reputation for
sexual licence – the success of their acts was fuelled by the sug-
gestive allure of sex – and Sickert from the first had been unfaithful
to Ellen.[62] Opportunity was not wanting. Sickert's music-hall models
came to the studio to pose, either for supplementary figure studies
or for more formal portraits, and the unsuspecting Ellen was quite
often away, down at Dunford, or off in Ireland monitoring the
iniquities of British rule.[63] Certainly Sickert often took advantage of
her absences.

He was, as his friends acknowledged, a man who 'wanted a good
deal of variety' in his love life,[64] and he was prepared to seek it out.
Some less friendly witnesses referred to him as 'a *coureur des dames*'.[65]
The chase seems to have ranged over the full social scale. His extrava-
gantly good looks – particularly his beautiful hair and his kind eyes
– and his extravagantly good manners gave him an extraordinary charm
'for *all* women – Duchess or model'.[66] And though there is no record
of his having seduced a duchess, tradition holds that he did bed at
least some of his models.[67] (Even in the 1880s, when he painted few
figure pictures, he regularly engaged models; Jacques-Émile Blanche
remembered them as being game for jolly outings down to the Star
and Garter at Richmond, and elsewhere.[68]) Sickert also 'sympathized'
with barmaids, wooing them – and bemusing them – with such im-
practical presents as gilt-edged editions of the classics.[69] But though
the line between artist's model, public-house worker, and prostitute
was an unfixed one in late-Victorian London, Sickert does not appear
to have been drawn to this milieu during his early married life.[70] Most
of his affairs were, it seems, with women from his own social world.
They came to Broadhurst Gardens where Ellen, ignorant of their true
relations, met them 'as friends visiting'. The infidelities either occurred
elsewhere or when she was absent.[71]

Sickert treated his affairs lightly. He did not consider that they in
any way compromised his marriage. He maintained always a perversely
high regard for 'blessed monogamy', but believed it should be 'reason-
ably tempered by the occasional caprice'.[72] He was genuinely shocked

at the idea that any unattached woman should wish him to leave Ellen for her – or, indeed, that any married woman might consider leaving her husband for him.[73] He liked the excitement of being in love, so he fell in love often – though, as he once remarked, 'You can't really love more than 2 or 3 women at a time.'[74] When a friend laughingly compared him to Shelley, 'who thought "the more he loved the more love he had to give"', Sickert answered 'quite seriously, "Precisely, that is just it."'[75] But his conception of love was less exalted than the great Romantic's: he regarded it as no more than a diversion, to be played at 'like a quadrille'.[76]

Those mistresses rash enough to fall in love with him were almost invariably disappointed.[77] They soon discovered that his real and enduring passion was reserved for his art. An affair, to him, was no more than a stimulating recreation, a rest from the business of picture making. And picture making for Sickert had its own almost sexual thrill. He characterized the starting point of any painting as the artist's 'letch' to record a particular scene (and the success of the picture could be judged on the extent to which it communicated that 'letch' to the viewer).[78] Throughout 1888 Sickert's strongest and most recurrent 'letch' was for the darkened interiors of London's music halls.

He stayed on in town late that summer, and was still hard at work during the first week of August when he learnt that Whistler, who had broken with Maud Franklin, was to marry Beatrice Godwin. (She had never divorced Godwin but he had died two years previously.[79]) They made a happy and devoted pair. Beatrice, moreover, was supported by a close band of siblings, who could help her to provide Whistler with a new milieu, and a new stability, at a moment when – ousted from the RSBA – he might otherwise have succumbed to feelings of vulnerability and rejection. This new domestic circle came to provide a first forum for his thoughts and feelings on the great topics of his life: his work, his reputation, and his enemies. Sickert, like the other followers, found himself freer to pursue his own interests. But only so far. Even from a distance Whistler maintained a jealous watch over the doings of his disciples, ever ready to discern acts of presumption or betrayal. Sickert was fortunate to have an ally in Beatrice. She promoted his cause, and ensured that relations be-

tween master and erstwhile pupil continued happily, at least for the while.*

Soon after Whistler's marriage Sickert went over to France for his holiday, but without Ellen. His mother had taken a house at St Valéry-en-Caux, just down the coast from Dieppe, and was there with Bernhard, Oswald, and Leonard.[80] After the pressures of his London work, Walter had a chance to unwind. He found the small fishing village 'a nice little place to sleep & eat in', which, as he told Blanche, was what he was 'most anxious to do now'.[81] The appetite for work, however, very soon reasserted itself. He and Bernhard spent their days in swimming and painting. It was an ideal regime, and Mrs Sickert was able to report that both her older sons 'look & are very well'. Walter was encouraging his brother to experiment with pastel and asked Blanche to send over some special 'glasspaper & sandpaper canvas' from the Dieppe art-supply shop for Bernhard to work on. The medium was one of Degas' favourites, and it was being promoted in England through a series of Pastel Exhibitions at the Grosvenor Gallery. Shortly before crossing to France, Walter had spent a happy hour with the gallery's new director, Paul Deschamps, looking at some Degas pictures they had in stock. He felt confident that under the new regime the Grosvenor's annual pastel show 'should become a sympathetic Exhibition'.[82] He persuaded both Blanche and Bernhard to send to it.[83] Strangely, though, there is scant evidence that Walter himself was working in pastel at this period. Perhaps he felt obliged to leave the ground clear for his easily discouraged brother.† Sickert concentrated his own energies on painting and drawing, producing amongst other things a bright little panel of the local butcher's shop, its red frontage flushed in early autumnal sunshine. The motif was Whistlerian but

* Rose Pettigrew, a young model (sometimes used by Whistler, and etched by Sickert in 1884), recalled Beatrice advising her against having an affair with Steer, who was in love with her, on the grounds 'that Sickert was much more clever than Steer [as] time would tell' (Laughton, *Philip Wilson Steer*, 119).

† Sickert had sent a little 'still life' pastel to Les XX in 1887, but it had not attracted a great deal of attention. In a letter to Blanche, however, he does mention a dinner at the Hogarth Club in the autumn of 1888 at which Sir Coutts Lindsay, owner of the Grosvenor Gallery, asked him with 'une naïveté et une politesse exquise' if he had ever tried pastel – '!'. The level and direction of Sickert's irony, as indicated by his exclamation mark, is difficult to gauge. Had Sickert submitted a pastel that had been rejected? Had he enjoyed an acclaimed success with a pastel elsewhere? Or had he simply not tried pastel seriously yet?

the definition of the painting, and the boldness of the colour, brought it closer to the world of Manet and Degas.[84] He also – in a yet more obvious homage to Degas – made numerous detailed studies of a laundress working away with her smoothing iron.[85]

By early October Sickert was back in London. He found the city in a state of simmering hysteria. Over the previous eight weeks, five East End prostitutes had been murdered and horribly mutilated by an unknown attacker. The two most recent victims had been discovered in the early hours of 30 September. A dedicated killer was on the loose. Theories as to his – or her – identity abounded. The press and the terrified public vied with each other to produce plausible culprits. The killer, it was thought, might be a Jewish immigrant, or a common vagrant, a released lunatic, a rogue slaughterman, a deranged butcher, a jealous prostitute, a mad doctor, or a neurotic medical student. There was even the suggestion that the killings could be the work of a giant eagle.[86] Theories were many, reliable leads few. The police, despite making numerous arrests, seemed no nearer to charging anyone. On 3 October they took the step of publishing two anonymous letters they had received from someone claiming to be the murderer. The first was signed 'Jack the Ripper'. The publication did little to advance the police investigation (it is now generally supposed that the letters were the work of a crank or a journalist), but it did provide the killer with a name – one that was at once taken up, and has never been put down since. Sickert appreciated the drama of the moment. He loved mysteries, and he knew the East End from his days acting at the Shoreditch Theatre and his more recent visits to the outlying music halls at Poplar, Canning Town, and the Mile End Road.[87] The general state of panic did nothing to curb his own nocturnal rambling. Almost as soon as he returned to London he resumed his evening studies in the stalls at Collins's Music Hall on Islington Green.[88] He was probably more amused than alarmed when, walking home late one evening through King's Cross, he passed a group of girls who fled from him shouting 'Jack the Ripper, Jack the Ripper'. It was the only time during his life that anyone suggested that he was the killer.*

There was one more murder, that of Mary Kelly on 9 November. After that, the terror gradually subsided but, as no one was ever caught, the mystery endured. It was supposed that the killer had fled the

* See Postscript.

country or committed suicide. Sickert, however, had other things to concern him. Blanche came over to London briefly for the opening of the Pastel Exhibition at the Grosvenor. He was grateful to Sickert for effecting the entrée and, in what was becoming a regular ritual of exchanges, presented his friend with a picture. The meeting gave them a chance to lay plans. Sickert hoped that Blanche might persuade his friend Helleu to become a member of the NEAC. Such an 'incontestable mâitre' would be a useful addition to the ranks.[89] Sickert also advised Blanche to send something to the RSBA winter show, if only 'to keep the pot boiling', and, forgetting the complications that must ensue, even suggested that he might submit something boring himself.[90] In the event, he recalled his duty to Whistler and felt it wisest not to offend his former master by sending to Suffolk Street. Instead he exhibited one of his small panel pictures – a view of the 'bains du Casino' at Dieppe – at the less contentious Institute of Painters in Oil Colours.[91] It was a useful means of keeping his name, and his work, before the public.

THE LONDON IMPRESSIONISTS

You have given us a great lift.
(Walter Sickert to D. C. Thomson)

The band of 'Followers' that had once gathered around Whistler, or sat about the paraffin stove in Baker Street, was rapidly losing its cohesion. Menpes, already ostracized by Whistler on account of an unsanctioned sketching trip to Japan (an artistic world that had been mapped and colonized but never actually visited by the Master), became a focus for active attack when, towards the end of 1888, a series of highly complimentary articles on him and his work appeared in the press.[1] Whistler was furious, and sought to enlist Sickert's aid in countering such unmerited publicity.[2] Sickert counselled restraint. He wrote to Beatrice, knowing the beneficial influence she exerted over her excitable husband: 'Tell Jimmy not on any account to be drawn by Menpes' rot. It is the one object he would like to achieve ... *He must be let severely alone.* Tell Jimmy he *mustn't say good things about him* because that is advertisement.'[3] Whistler was never likely to take such good advice. He responded with a salvo of vituperative – even vicious – squibs in the pages of *The World* that damned Menpes as a talentless plagiarist. Sickert's own friendship with Menpes did not survive this campaign of abuse. The ferocity of Whistler's feelings would have made it difficult for anyone to remain friends with both men. Moreover, Sickert's relationship with Menpes had always been largely fortuitous: it was fostered by their common bond with Whistler, and once that bond was broken there was little else to keep them together. Menpes, probably to Sickert's relief, did not join the NEAC, or send any more pictures there. Another casualty from the group was William Stott of Oldham, who had been looking after Maud Franklin since the break-up of her re-

lationship with Whistler. Incensed by what he considered to be Whistler's shoddy treatment of his one-time mistress, he had publicly insulted his erstwhile hero one evening at the Hogarth Club, and then got into an unseemly scuffle with him.[4] Elizabeth Armstrong also drifted out of the circle. On a sketching trip down to St Ives she had met and become engaged to the plein-air painter Stanhope Forbes, who, although still a member of the NEAC, was in stark opposition to Sickert's faction. He disapproved of Whistler and Sickert, and urged his fiancée to disassociate herself from such bad – if amusing – influences.[5]

Sickert, with touching solicitude, constantly sought to reassure Whistler of his own enduring loyalty and support, but the main focus of his energies – and the balance of his allegiances – had subtly shifted. He was now an 'Impressionist' rather than merely a 'Whistlerite'. His thoughts were concentrated on the New English Art Club; and, despite repeated solicitations, Whistler still stood out from the group.[6] It had been supposed by several commentators that, once ousted from Suffolk Street, Whistler would find a refuge at the NEAC; but, though he continued to allow his work to be exhibited, he declined to become a member of the new body.[7] It was said that the former President of the RSBA disdained to join a club that was so democratic as to have no president.[8] Certainly he must have realized that he would not be able to regain the same level of command over his 'pupil' as he had once enjoyed.

Whistler's absence from the NEAC gave Sickert a freer hand, and he rose in stature and assurance. In his plans for the infiltration of the NEAC – and the promotion of the 'Impressionist clique' – he adopted many of Whistler's tactics, as well as something of his pose. He became a noted figure in Chelsea and beyond, conspicuous in his 'wonderful clothes'. His 'dashing' dove-grey tailcoat projected an air of theatricality;[9] and the cultivation of a splendid 'large fair moustache' lent him a new distinction – 'like a French cavalryman of the day'.[10] He affected a huge ribboned bow instead of a necktie, and persuaded several other members of the clique to follow this example of 'Latin Quarter' chic.[11]

Beyond the advertisement of dress, he sought to publicize the aims and character of the clique. His pupillage at Tite Street had taught him much about the importance of gaining a voice in the press, even if he felt that Whistler sometimes went too far to secure such coverage

(devoting precious hours on one occasion to wooing the sports reporter of the Fulham local paper in the hope of a flattering mention).[12] Sickert strove to find more sympathetic allies. Of the established critics, only the querulous and somewhat prissy Frederick Wedmore, who wrote in both the weekly *Academy* and the daily *Standard*, had any knowledge, or appreciation, of French Impressionism; but his cautious approbation would need to be backed by new – and more enthusiastic – voices. There were several clamouring to be heard. It was a time of great proliferation in the press. Cheap printing costs and an ever-expanding urban readership had led to an efflorescence of new papers and periodicals, and amongst these publications Sickert found willing supporters.

His great ally was George Moore. The author of *A Modern Lover* was, of course, sympathetic to the aims and ideals of the NEAC's Impressionist clique; and although Moore's only regular column was in *The Hawk*, a small-circulation paper published by his brother, his energy, his wit, and his own growing reputation as a writer striving to transpose French literary innovations into English gave him a profile out of proportion to his immediate readership. For Sickert, his great knowledge of the Parisian scene, his memories of Manet, and his friendship with Degas made him an invaluable repository of information. Sickert and the other young 'Impressionists' respected him enormously. They put up with his eccentricities (he had a habit of turning up unannounced at Broadhurst Gardens, to share his latest 'very important' discovery);* they invited him to their councils; and they listened to his views. Elie Halévy, after spending time in London with the NEAC crowd, described them as being 'ruled over by George Moore'.[13] As Sickert later admitted, news that Moore 'liked, or didn't like, one of our pictures' flew at once 'round the Hogarth Club . . .

* One day Sickert was disturbed at his easel by Moore bursting in and declaring: 'I have been reading a life of Michael Angelo, and it seems that the David was carved out of a piece of marble that had been improperly quarried. I could no more have carved the David out of a piece of marble that had been improperly quarried than I could have flown!' (RE, 97) He also called upon Sickert for help with the great question of how to keep his trousers up. When Sickert patiently explained to him the proper use of braces, he was dumbfound at the revelation. And on another occasion he dragged Sickert and Steer from their studios to take them on an excursion to Peckham Rye, because he had determined that the heroine of the story he was working on should come from there – and he had never visited the place (ML, 26).

And I believe we were genuinely elated or depressed' according to his verdict.[14]

Besides the oracular Moore there were several young painters who had taken to part-time reviewing.* Unsurprisingly, amongst these there were several pro-Whistlerians: the absurdity of allowing non-artists to criticize art had, after all, been one of the planks of Whistler's attack on Ruskin. Alfred Lys Baldry, who had studied under Albert Moore and was an acknowledged admirer of Whistler, contributed regularly to a small-circulation weekly called *The Artist & Journal of Home Culture*. He was at once brought within the ambit of the 'Impressionist' group and encouraged to join the NEAC.[15] Sickert made an even closer friend of the Scottish-born painter George Thomson, who shared with Steer both a studio building and an interest in Monet. Thomson was supplementing his income by writing up exhibitions for the evening papers,[16] and despite a strong Aberdonian burr and a 'rather gruffly gloomy address' Sickert found him a 'gentle and sympathetic' soul.[17] He too began to send to the NEAC and to promote the Impressionist cause in his articles.

Indeed it soon became a complaint against Sickert and his Impressionist clique that they were suborning critics by 'offering wall space not for their articles but for their *works*'.[18] But the line between critics and artists was becoming increasingly blurred. Sickert merely sought to accelerate the process and use it to his advantage – or to the advantage of his group. It was, after all, a surer path than relying on 'letters to the editor' or stray paragraphs in the gossip columns, as Whistler did. Sickert himself played his part, taking a position as art critic for the recently inaugurated London edition of the *New York Herald*.[19] The post gave him a regular platform for promoting his artistic creed, as well – it must be supposed – as some welcome, if meagre, remuneration.

Reckless, opinionated, fluent, fond of specific technical details and broad generalizations, Sickert – it was soon revealed – had a gift for journalism. Words and opinions flowed from his pen. He did give

* Sickert also cherished hopes of George Bernard Shaw, who was then acting as art critic for the newly established Liberal evening-paper *The Star*. He recognized him as 'a critic who knows an artistic hawk from the hernshaw of commerce'. Shaw's tenure of the post, however, was brief, and his independence of spirit not readily susceptible to direction. Sickert soon dubbed him 'George Bernard Cock-sure' (WS to Lady Eden).

some generous approbation to fellow members of the Impressionist clique, but on the whole his procedure was less direct.[20] One almost invariable element in his articles was a word of extravagant praise for Whistler. Matters reached such a pitch that the sub-editor of the paper, meeting Sickert in Regent Street, remonstrated: 'See here, Mr Sickert . . . people are asking whether the *New York Herald* is a Whistler organ.'[21] In truth, however, the regular praise for Whistler was almost always balanced or augmented by praise for Degas and for Keene.[22] Sickert seems to have been concerned to produce a genealogy for his Impressionist group: Whistler and Degas were acknowledged as the founding fathers – with Steer's hero, Monet, included upon occasion. But, though proud of such antecedents, Sickert was anxious not to place his group too squarely in the debt of recent Parisian developments. He did not want to be too easily pigeonholed as a mere follower of Continental fashion. And having proclaimed the connection he sought to blur it. The recurrent introduction of Keene's name served to connect the group with the proud English tradition stretching back through the great eighteenth-century illustrators to Hogarth. It was a ploy sanctioned, if not suggested, by Degas. The French painter had told George Moore (and probably Sickert too) that English artists risked compromising their distinctiveness if they lost touch with their national school.[23] Degas, too, had impressed upon Sickert a conviction that all great art – however novel it might appear – stood upon the traditions of the past: that the achievements of Impressionism were not comprehensible without Poussin and Velasquez, Ingres, Millet, Gainsborough, Constable, and Turner. Sickert's articles constantly sought to connect the movement with this illustrious heritage.

When writing explicitly about the NEAC, as he did with unabashed frequency, he emphasized both the diversity and the independence of the Impressionist clique – pointing out that not all the members were pupils of Whistler, and that not all had studied in Paris, and boasting, on the rather slender grounds that Blanche took an interest in their doings, that 'the younger and more forward spirits of the Modern French School' are more influenced by the 'independent school of painting in England' than vice versa.[24]

Sickert continued to canvass potential new members and new exhibitors for the club – as it was by the votes of these that control of the committees could be maintained. There were several convenient sources. Brown's position at the Westminster School of Art gave him

access to a large and loyal constituency. When, at the beginning of March 1889, he was the recipient of a special dinner at the Holborn Restaurant, over a hundred people – mostly current or former pupils – were present. (Sickert made a speech.[25]) Bate, too, had started 'a school of Impressionists', while Sidney Starr ran a popular class for 'lady-pupils'.[26] Sickert, for his part, maintained pressure on Blanche to find members in France. Besides Helleu, two other young artists – Maurice Lobre and Jean-Louis Forain (whom Sickert had met through Degas) – expressed an interest in joining;[27] and within the club's existing membership Sickert was pleased to make an ally of the Paris-trained John Singer Sargent, who was establishing an enviable reputation with his fluent, large-scale portraits of the London rich. Sargent agreed to propose Lobre for membership. It was a useful gesture. As Sickert acknowledged, he could not afford to be too active in putting people's names forward himself, as it would provoke the hostility of the club's conservative majority.[28]

But, by such tactics, that conservative majority was being gradually eroded. The Impressionist clique continued to control the picture-selection process. The constitution was altered during 1889, and an eight-man 'executive committee' created, with Sickert, Steer, Brown, and Roussel all elected to it.[29] As some contemporary commentators complained, pictures by artists inimical to the aims of the group were now frequently excluded, or 'outrageously skied' at exhibition. In the face of such 'intrigue and effrontery' not a few painters resigned from the club, thus presenting the Impressionist clique with an even clearer run.[30]

Certainly they had it very much their own way in 1889. The connection with the established leaders of French Impressionism was loudly bruited at the annual exhibition.* An uncatalogued selection of black-and-white works, almost certainly put together by Sickert, was hung in the little passage leading through to the main gallery. Besides the inevitable Keene drawings, it included several prints by Whistler (who also had a pastel in the exhibition proper), together with four of the lithographs G. W. Thornley had made from Degas' pictures (and about which Sickert had written in the *New York Herald*).[31] In addition

* Steer, Bate, Brown, and Roussel were all on the selection committee. Whistler, too, had been elected to it, though it is not known whether he served (*Comus*, 1 January 1889).

there were also 'a few photographs from masterpieces by Degas and Manet'.[32] Building upon his success of the previous year, Sickert's own submission to the show was another slice of popular metropolitan life: *Collins's Music Hall, Islington Green*. In its composition, as in its theatrical matter, it proclaimed a continuing debt to Degas – though Sickert, playing his double game, hastened to deny the connection. From the aesthetic high ground staked out by Whistler in the Ten o'Clock Lecture, he defended himself against any suggestions that he was merely aping modern French models:

> It is surely unnecessary to go so far afield as Paris to find an explanation of the fact that a Londoner should seek to render on canvas a familiar and striking scene in the midst of the town in which he lives ... I found myself one night in the little hall off Islington Green. At a given moment I was intensely impressed by the pictorial beauty of the scene, created by the coincidence of a number of fortuitous elements of form and colour. A graceful girl leaning forward from the stage, to accentuate the refrain of one of the sentimental ballads so dear to the frequenters of the halls, evoked a spontaneous movement of sympathy and attention in an audience whose sombre tones threw into more brilliant relief the animated movement of the singer, bathed as she was in a ray of green limelight from the centre of the roof, and from below in the yellow radiance of the footlights.[33]

The rising status of both Sickert and his group was confirmed when he, together with Starr and Steer, was invited to exhibit in the 'British Fine Art Section' of the Universal Exhibition, which opened in Paris that May. (Sickert sent his little panel of the red-fronted butcher's shop[34].) He did not, however, dwell upon his successes. In what was becoming an established pattern, his small assertion of independence was almost immediately countered by an act of obeisance to Whistler. Sickert balanced his NEAC activities and achievements with an offer to arrange a retrospective exhibition of Whistler's work. He also suggested an even more ambitious scheme to produce 'a catalogue déraisonné' of Whistler's prints.[35] It was probably no less than Whistler felt he deserved. He was in ebullient mood. He had been made an 'Honorary Member' of the Royal Academy of Fine Arts in Munich after exhibiting at their International Art Show the previous year; and he was to be the guest of honour at two gala dinners arranged by his

fellow artists that spring. The first was held in Paris on 28 April 1889, the other at the Criterion restaurant in Piccadilly Circus on 1 May. Sickert attended the London event, though he did not help organize it. He was too involved with preparations for the Whistler exhibition, which opened on the same day.

The exhibition venue was an unconventional one. Sickert had been given the use of three little first-floor rooms in an old Queen Anne house at 29 Queen Square, Bloomsbury – the building was the home of the College for Working Men and Women. In this limited space he had gathered together 'a little collection of masterpieces': pastels, watercolours, and etchings, together with several important pictures, including the portraits of Rosa Corda, Thomas Carlyle, and the artist's mother. From Irving, Sickert borrowed the picture of the actor as King Philip (the image that had first awakened him to Whistler's genius). It was an impressive assemblage, as Sickert hastened to point out in the *New York Herald*.[36] For no very obvious reason the Lord Chancellor, Lord Halsbury, was asked to open the exhibition.* Nevertheless, despite this ploy, the show was not a success. It was unable to transcend its unpropitious setting. Press coverage was scant, and visitors rare.

Amongst the few people who did attend were two Americans recently settled in London. Joseph Pennell, then in his early thirties, had already established a reputation as an accomplished draughtsman and illustrator; his wife, Elizabeth Robins Pennell, was a prolific journalist. Together they had succeeded Shaw in writing the art criticism for *The Star*. They were amazed by the show, and 'wrote urgently in the *Star*', urging everyone 'who cared for good work . . . to see this exhibition of "the man who has done more to influence artists than any other modern"'.[37] It was the first blast of what would become an almost interminable fanfare over the ensuing years, as the Pennells established themselves as the jealous champions of Whistler's name and reputation. Their championship came to have awkward consequences for Sickert's own relationship with Whistler but, at this early stage, he was merely happy to meet two sympathetic new critics, and grateful to them for giving the show a generous puff.

* Lord Halsbury was one of very few criminal lawyers to become Lord Chancellor. As Hardinge Giffard, QC – before his ennoblement – he had been a leading counsel in the Tichborne case, a fact that would surely have interested Sickert, and perhaps even accounts for their connection.

If there was a sense of disappointment about the impact of the exhibition, neither Sickert nor Whistler admitted it. They continued to see each other socially. Sickert would still be invited to lunch at Whistler's studio, especially when his favourite 'gumbo soup' was being served,[38] and the Whistlers dined at Broadhurst Gardens.* Nevertheless, beneath the jollity, and the offers of assistance, there remained the sense that Sickert's attention was elsewhere. Nothing came of the plans for a catalogue of Whistler's prints: the current of Sickert's other interests had become too strong. On 25 May 1889, Ellen and he bought Degas' magnificent *Répétition d'un Ballet sur la Scène* at Christie's in the sale of the Henry Hill collection. It was, Sickert noted, similar in composition to the 'monochrome' they had seen at M. Mulbacher's apartment. They paid only £74 for it.[39]

In June, Sickert resigned his post on the *New York Herald*, claiming that 'to do the work thoroughly made too great an inroad on [his] time'.[40] The respite from journalism was only temporary. Perhaps it allowed him to take a short holiday – at some point during the summer he nipped over to Paris to see his picture at the Universal Exhibition. He went round the show with Degas. It was a thrilling, and entertaining, experience. As they crossed the Jardins du Trocadéro, where countless families were picnicking on the grass, Degas observed, 'C'est l'âge d'or en bronze!' They studied the British section 'with some care'. Degas enjoyed 'mystifying people' by making great claims for the work of very minor artists:[41] he certainly shocked Sickert by praising the handling of a waterfall painted by Frank Miles. But on the whole his comments, though barbed with wit, had a strong practical edge. He greatly admired a picture of a country christening by James Charles, but considered that it 'would have been better on a somewhat smaller scale'.[42] Confronted by Whistler's *Lady Archibald Campbell*, he remarked of the elegantly attired lady retreating into the gloom of an undefined background, 'Elle rentre dans la cave de Watteau.'†[43] (Whistler's other submission – *Variations in Flesh Colour and Green: The Balcony* – had been awarded the Gold Medal. It was a work of 1865, and perhaps gave

* The American novelist Gertrude Atherton recalled meeting them there in the late 1880s, when Whistler 'monopolized the conversation at table' with brilliantly witty denunciations of all the other leading artists of the day: Burne-Jones, Millais, Leighton, Watts, and Alma-Tadema.

† 'She is returning to Watteau's cellar.'

Sickert a sense of how long it took for new ways of seeing and painting to be understood or appreciated.) Sadly, Degas' verdict upon Sickert's *October Sun* is unrecorded.

Time spent with Degas – visiting galleries, looking at pictures, talking of art – deepened Sickert's awe and admiration. The exceptional cohesion, or 'purity' as Sickert described it, of Degas' life made a great impression. Instead of deploying his will, his talent, and his wit to make himself 'notorious' – as, to some extent, Whistler had done – he remained always true to his art.[44] As Sickert remarked to Blanche, shortly after returning to London, 'I find more & more, in half a sentence that Degas has said, guidance for years of work.'[45]

Sickert's main undertaking during the latter half of 1889 was to arrange an exhibition by the core members of the NEAC's Impressionist clique.[46] David Croal Thomson, the young – and, as Sickert asserted, 'fearless' – manager of the progressive Goupil Gallery in New Bond Street, had offered them the use of his space in December. Although it was a group venture, necessitating the usual round of discussions and excited studio meetings, Sickert was, as ever, the presiding spirit and the acknowledged spokesman.[47] He helped define the limits of the group: Fred Brown, Francis Bate, Wilson Steer, Sidney Starr, Francis James, and Théodore Roussel were, of course, included; but it was probably Sickert's influence that secured the inclusion of his brother Bernhard and George Thomson, and his indulgence that admitted Paul Maitland.[48]

They chose to exhibit under the name of the 'London Impressionists'. The title was obvious enough, perhaps even inevitable; if they had not adopted it themselves they might well have been given it by others.[49] Sickert, however, continuing the theme of his newspaper articles, worked hard to extend, if not to explode, critical preconceptions. While always admitting the eminence of Whistler and Degas, he insisted upon other perspectives and influences. When quizzed by one interviewer about what an 'Impressionist' was, Sickert – after some evasion – replied, 'A definition is a terrible thing, but the meaning that we should attach to the word, if it is to stand in any way as a declaration of faith on our part, must be a very catholic one. The main article of the creed would perhaps be study and reverence for the best traditions of all time. Velasquez was an Impressionist, and Leech was an Impressionist, and Holbein was an Impressionist.'[50]

Sickert planned to exhibit three complex new music-hall paintings as well as a couple of less contentious pieces. Racing to finish his pictures for the show, he drove himself into a frenzy of activity. When Blanche came over to London in the autumn he found Sickert 'up to [his] ears in work'. Dinner was out of the question: 'I am tied up for the week in a picture of an obscure Music Hall in a northern suburb which necessitates my going without dinner to be in my eighteenpenny stall on the stroke of eight.'[51] And for most of the day he was 'full of appointments with models and serio-comics'. He could meet his friend only for a hurried lunch 'at one o'clock (exactly)'.

As well as sketching from the 'eighteenpenny stalls' and having sittings from 'serio-comics', Sickert deployed other elements in building up his pictures. He spent time that winter working at Heatherley's, the old-established teaching studio in Newman Street. Although he seems, in part, to have used the school merely as a convenient central London workspace, it did offer him a chance to experiment with effects of light, or semi-darkness. One young student retained 'lively recollections' of his visits to the 'dingy old academy': 'It was a winter of much fog and consequent gaslight, and Sickert, with his then preoccupation with "atmospherics," was in his element.' He rarely 'painted from the models', but made 'impressionist studies of figures or groups of students seen through the murk'.*[52]

It was hoped that George Moore might write a preface to the exhibition catalogue, but at the last moment the arrangement fell through.[53] Sickert dashed off a piece in his stead, commencing with a feisty attack on William Morris and the so-called decorative painting of the Pre-Raphaelite school – characterized by its 'absence of convincing light and shade, of modelling, of aerial perspective, of sound drawing, of animation, of expression'. He insisted that what really mattered in painting was 'that subtle attribute which painters call quality'; he dragged in the familiar names, and he ended with his most considered – and personal – definition of 'Impressionism':

> Essentially and firstly, it is not realism. It has no wish to record any thing merely because it exists. It is not occupied in a struggle to make intensely real and solid the sordid or super-

* Sickert retained fond memories of Heatherley's. When he came to fill in his *Who's Who* entry in 1897, for the inaugural 1898 edition, in a deliberate snub to both the Slade and to Whistler he listed it as the sole seat of his 'education'.

ficial details of the subjects it selects. It accepts, as the aim of the picture, what Edgar Allan Poe asserts to be the sole legitimate province of the poem, beauty. In its search through visible nature for the elements for this same beauty, it does not admit the narrow interpretation of the word 'Nature' which would stop short outside the four-mile radius [enclosing metropolitan London]. It is, on the contrary, strong in the belief that for those who live in the most wonderful and complex city in the world, the most fruitful course of study lies in a persistent effort to render the magic and the poetry which they daily see around them, by means which they believe are offered to the student in all their perfection, not so much on the canvases that yearly line our official and unofficial shows of competitive painting, as on the walls of the National Gallery.[54]

The exhibition opened on 30 November 1889 to considerable critical and public interest. It achieved an almost immediate notoriety. Some fifty reviews were published, and by the end of the week the gallery was not merely crowded but 'absolutely blocked'.[55] There were sixty-nine pictures on view, of which Sickert had contributed just four.* What the crowds made of it is uncertain. Of the critics, Moore, Baldry, the Pennells, and Frederick Wedmore rallied, of course, to the standard and lavished a great deal of generous praise on Sickert's music-hall pictures.[56] But other voices prevailed. The vast majority of reviewers were either hostile or nonplussed. They complained of the paint-work and despaired at 'the sheer unmitigated ugliness' of the predominantly urban subject matter.[57]

Sickert's attempts to dissolve 'Impressionism' back into the whole history of art were ignored by his allies and condemned by his enemies in the press. The claim of kinship with Velasquez was treated as presumptuous nonsense.[58] Whatever their stamp, the critics, having only recently gained an outline knowledge of French Impressionism, were only too anxious to display it. The London Impressionists were ranged under the banners of their supposed masters. The influence of Monet's technique was noted on the works of Steer, Thomson, and Bernhard Sickert. The debt owed by Roussel and Maitland to Whistler was too

* Little Dot Hetherington at the Bedford Music Hall, The Oxford Music Hall, The PS Wings in the OP Mirror, and Twilight ['The Butcher's Shop']; a fifth picture, Trefolium, though listed in the catalogue, was not mentioned by any of the critics and seems not to have been hung.

obvious to escape comment, while Sickert – along with Starr – was characterized as an imitator of Degas.[59]

It was an outcome that Sickert had sought to avoid. But if it undermined the group's aspirations towards originality it did not vitiate the impact of the show, or its influence. In the New Year, the Glasgow Institute of Fine Arts' annual exhibition devoted a special section to the work of the 'London Impressionists', along with what one critic described as 'the contributions of certain Scottish painters . . . whose aims are fresh enough – may one say eccentric enough? – to bear comparison with these'.[60] Sickert felt able to commend Thomson for striking 'the timeliest and most effective blow' yet in favour of the Impressionist cause.[61]

IV

UNFASHIONABLE PORTRAITURE

Mr Walter Sickert, if not agreeable, is striking.
(Frederick Wedmore, in The Academy*)*

Even at the moment of establishing himself as the prophet of a new movement – as the leader of the London Impressionists and painter-in-ordinary to the modern music hall – Sickert was beginning to look in new directions, and towards different subjects. There was, more than likely, an economic imperative behind this shift. Aged thirty, and after six years of regular exhibiting as well as considerable publicity, Sickert was still struggling. His art earnings remained minimal.[1] His complex music-hall compositions were time consuming to produce, while their radical subject matter made them all but impossible to sell. For Ellen, the expense of funding both Sickert and Broadhurst Gardens was beginning to tell. Change became necessary on all fronts. It was decided to let the Hampstead house. With Ellen often ill and in need of sea air, and Sickert drawn increasingly back to Chelsea where Steer and most of the other London Impressionists lived, 54 Broadhurst Gardens had come to seem overlarge and underused. A tenant was soon found, and as an immediate step Ellen and Sickert moved back to the Sickert family home at Pembroke Gardens.[2] Although the removal from Hampstead may have been conceived as a temporary measure, they would never return. Indeed they would never live together again under a roof that was unequivocally their own.

In tandem with this relocation Sickert sought new, potentially more remunerative, avenues for his work. He surprised his old mentor Otto Scholderer by claiming that he wished he had concentrated on 'still-life'.[3] Since his early essays in flower painting he had attempted nothing in that line. And he did not return to it now. Instead he embarked upon portraiture.

It was the established wisdom of the studios that portrait com-
missions offered artists the surest – and richest – rewards. Whistler
had supported himself by them, and it was natural for his former pupil
to consider the same course. The difficulty was to make a beginning.
In order to advertise his new departure, and to practise his craft, Sickert,
like many before him, had to start by painting himself and his friends.
He painted Steer (and Steer, who was embarked on the same course,
painted him). He also adopted other, less conventional ploys. Some
of his studies for music-hall pictures began to shade into portraits.
Artistes already came to pose on the stage at Broadhurst Gardens; now
they sat more formally. Sickert made a full-length portrait of Queenie
Lawrence in evening dress – seen in the Whistlerian fashion, glancing
backwards over her shoulder against a dark background. He titled it
with her real name: Miss Fancourt.[4]

If Sickert's own interests inclined him to look to the stage as a source
of portrait work, the Cobden connection suggested the altogether more
promising world of politics. Through Ellen, Sickert had been intro-
duced to many of the leading figures of the old Cobdenite establish-
ment: prosperous men who might want to be immortalized in paint.
Sickert had already made a start in this direction. When Herbert Vivian
had visited his studio in the autumn of 1889 he had noted a pass for
the 'Distinguished Strangers' Gallery' at the House of Commons and
some sketches of at least one 'well-known statesman'.[5] Early in the New
Year, Sickert and Ellen made the acquaintance of another distinguished
political figure: Charles Bradlaugh, the great secularist and former
Liberal MP for Northampton.[6] On his first election to the House of
Commons in 1880, Bradlaugh had provoked an outcry amongst the
Tory ranks when he announced his intention of 'affirming' as an atheist
rather than taking the 'oath' of allegiance. The move was blocked, and
though the issue was much debated it proved intractable. Bradlaugh
was allowed to remain an MP (he was re-elected four times) but his
position was anomalous and he was obliged to speak from the bar of
the House. Although in 1890 he had just given up his seat, he was
still much involved with radical and secular causes.[7] Sickert was greatly
taken with the energetic old politician; and Bradlaugh, radical in all
things, warmed not only to Sickert but also to his art: he agreed to
have his portrait done.[8] There were no formal 'sittings'. Sickert merely
sat in the corner of Bradlaugh's study and made sketches of him while
he was at work, moving about, dictating letters, and receiving visitors.

From these sketches he painted a vivid likeness.[9] The picture, together with the portraits of Steer and 'Miss Fancourt', were Sickert's three submissions to the NEAC that spring.

At Sickert's suggestion the show was not held at a conventional picture gallery but at Humphreys Mansions, a new block of flats in Knightsbridge. It was a domestic setting similar to that in which, Sickert hoped, the pictures might end up. Tea was served – a novel arrangement that nearly defeated the organizers: Sidney Starr had to dash out at the last moment when it was realized that no one had bought any milk.[10] But even liquid refreshment could not persuade the critics of the success of the experiments. The large low rooms were too ill lit to allow the pictures to be seen properly.[11]

Despite the general gloom, Sickert's pictures were noted. His shift to portraiture was welcomed. The portrait of Bradlaugh was almost 'universally pronounced the best likeness of Mr Bradlaugh ever painted';[12] but Sickert's close connection with the music-hall stage and artistic daring was not relinquished completely. Copies of his 'London Impressionists' catalogue preface were kept available for those visitors asking for 'a written explanation' of the movement.[13] And the stage identity of 'Miss Fancourt' was widely reported.[14] Also Steer (Sickert's third portrait subject) was exhibiting – in a rare excursion from conventional matter – a canvas of Mme Sozo on the stage of the Tivoli. In the critical hubbub surrounding the exhibition, a new voice was heard: that of D. S. MacColl, a fiercely intelligent Scots-born artist who had taken over as art critic on The Spectator at the beginning of the year. Having trained under Fred Brown at Westminster he was enthusiastic about the experiments of the London Impressionists, and rather stunned expectations when he expressed that enthusiasm in the staid pages of the nation's leading Conservative periodical.[15] Moore, too, had gained a more prominent position, as art critic for The Speaker, from which to further the cause.[16]

The 1890 spring show confirmed the NEAC as the principal platform for 'new and disputed talent' and Sickert and Steer as its twin – and linked – stars.[17] Having achieved their position, they set about exploiting it by making an attack on the citadel of established tradition. They submitted works to the Royal Academy summer show, and then, when the pictures were rejected, took out newspaper advertisements to announce the fact – a stunt that produced its own harvest of publicity.[18] Barred from Burlington House, they lowered their sights to

12 Pembroke Gardens. Sickert began to hold informal weekend show-
ings at the house of work by himself, Steer, and the other London
Impressionists.[19] They became a focus for young painters. Amongst
those who came was a recent recruit to the NEAC, Florence Pash.

Florence was a forceful and handsome figure: tall, dark-haired, with
heavy-lidded eyes. Though at twenty-eight she was two years younger
than Sickert, she had established herself with remarkable assurance in
the London art world. The daughter of a successful North London
shoe retailer, she had studied painting briefly at South Kensington and
in France under Blanche's friend Henri Gervex, before returning home
and beginning to exhibit with the RSBA and the Society of Women
Artists. She had shown also at the Royal Academy and the Paris Salon.
Capable and independent, she set up her own teaching studio at
132 Sloane Street and conducted painting classes, mainly for 'society
women'.[20] Though too little of her work survives to judge of it clearly,
she seems to have belonged in the 'movement'. She certainly made
some paintings of contemporary street scenes; and perhaps a trace of
Whistlerian influence can be glimpsed behind Sickert's description
of her as 'the principal of a flourishing academy for the propagation
of spacious backgrounds'.[21]

Sickert had first met Florence in the mid 1880s when they were
both showing at Suffolk Street, but it was with the new decade that
the connection developed. Sickert insisted on painting her portrait,
commandeering Bernhard's studio room at Pembroke Gardens for the
purpose. Ellen seems to have been away, but the work was not
infrequently interrupted by the sudden appearance of Mrs Sickert, look-
ing in to see how the picture was progressing, and by Walter's youngest
brother Leonard, who would come in on his return from school and
make shy comments.[22] Despite this close familial scrutiny, it is possible,
even likely, that the friendship with Florence became an affair. The
portrait done at Pembroke Gardens was only one of several that Sickert
made of her that year. Three other paintings, as well as numerous
drawings and pastels, were done at Florence's teaching studio in Sloane
Street. There were also trips together to the music halls, intimate
dinners in a little restaurant near Warren Street, and tram rides to the
suburbs to provide 'a little fresh air & relaxation after a long day's
painting'.[23] Florence flattered Sickert's vanity: sitting to him, seeking
his advice on painting matters, and, so it seems, either buying his work
or giving him some employment. He addressed her in an early letter

as 'Mlle L'Eleve – Mlle la modele – Mlle mon amie – Mlle la Patronne'.[24]

One of their first excursions together was to the Royal Academy. Sickert had a commission from *Art Weekly*, the periodical edited by Francis Bate, for a two-part 'signed review' of the Summer Show.[25] *Art Weekly* was not Sickert's only press outlet that summer. Herbert Vivian, his young journalist friend, announced plans for a 'lively and eccentric newspaper' to be called *The Whirlwind*,[26] and Sickert agreed to be the art critic of this satirical weekly. The first issue, published at the end of June 1890, heralded him with generous hyperbole as 'one of the leading Impressionist painters of the age'. Sickert wrote at once to the 'editor-proprietors', Vivian and his partner the Hon. Stuart Erskine, protesting at the 'shamelessness' of this description. The letter was published in the next issue above the terse note: 'Mr Sickert has forgotten. He wrote the paragraph himself.'[27] The position gave Sickert ample scope for promoting the 'cause', albeit amongst a limited and probably already converted readership. He wrote reviews, letters, general articles, as well as commentaries on pictures by his fellow London Impressionists. The paintings under discussion were reproduced in line-block, sometimes by Sickert himself, as 'The Whirlwind Diploma Gallery of Modern Pictures'.

Sickert also contributed drawings of his own. His excursion into portraiture had had an effect. He was asked to provide a weekly 'full-page cartoon . . . of a person of distinction, taken from life'.[28] His first offering was a drawing of Bradlaugh – probably a study made at the time he was painting the picture shown at the NEAC. Other 'persons of distinction' included Tom Potter MP (at whose table Sickert had met Herbert Vivian), Henry Labouchere, another radical politician and the editor of *Truth*, and the solicitor George Lewis (who, with the ingrained caution of his profession, preferred not to sign the finished picture, lest he should commit himself to something).[29] Sickert also approached Sir Henry Irving about a sitting.[30]

This intensity of production could not be kept up. At the beginning of August, Sickert went over to Dieppe with the usual crowd of Cobdens and Sickerts. Florence Pash was also there, together with a Mrs Forster and her children.[31] Though Sidney Starr (another of 'the leading Impressionist painters of the age') took over the position of art critic on *The Whirlwind*, Sickert continued to send in his 'full-page cartoons', finding plenty of distinguished persons amongst the holiday visitors. He drew a portrait of Blanche sitting with his dog Gyp on his knee,

as well as pictures of John Lemoinne and Sir Charles Rivers Wilson,
one of the Duchesse de Caracciolo's several admirers.[32]

Having maintained his portrait commitment to *The Whirlwind*
throughout his 'holiday', Sickert promptly allowed it to lapse on his
return to London. The sequence of drawings came to an end in mid
September, leaving the editor-proprietors to apologize to their readers
that owing to the 'liveliness and eccentricity' of Mr Sickert, they were
'unable to publish a cartoon this week'.[33] Or indeed any other week.
Only one more drawing was reproduced, a portrait of the artist
Giovanni Boldini, probably done from sketches made at Dieppe,
which appeared on 13 December in the short-lived periodical's ante-
penultimate issue. (Having abandoned the weekly commission, Sickert
did try to persuade Irving to give him a sitting anyway: 'If you ever
have an idle hour to spend & would let me know when you could
come [to my studio] I need hardly say how much I should like to
paint for myself a sketch, which would after all, take no longer than
the line drawing I originally intended.'[34]) Irving, it seems, did not take
up the offer.

It was probably not only 'liveliness and eccentricity' that was keep-
ing Sickert from his journalistic obligations that autumn. His domestic
arrangements were once more in flux. Escaping from the rather
cramped conditions at Pembroke Gardens, Ellen and he moved in
with Jane Cobden.[35] She had recently bought a 'little house' at 10
Hereford Square, South Kensington.[36] Sickert also rented a separate
workspace at 10 Glebe Studios, a purpose-built block in Chelsea, just
off the King's Road, close to his Impressionist confrères.

Although the smart new studio was a significant expense, it was
hoped that it might provide some small return. Perhaps inspired by
the example of Florence Pash, Sickert determined to offer classes there.
Teaching seemed a less taxing and potentially more remunerative
avenue than fringe journalism, and Chelsea must have appeared a
propitious setting for such an enterprise. He issued a prospectus adver-
tising 'Mr Walter Sickert's Atelier', offering daily life classes under his
'immediate supervision'. Students were obliged to supply their own
easels and 'other materials'. Fees of seven guineas a term were 'payable
in advance'.[37] It is not known how many pupils turned up with their
own easels, but there was one at least. Mrs Forster's son, Francis,
became a pupil of the Sickert Atelier.[38]

Chelsea reunited Sickert with several old friends. Whistler and Beat-

rice were living at 21 Cheyne Walk, and Charles Keene had his cluttered, costume-filled studio in the King's Road.[39] The pleasure of seeing Keene again was, however, short lived. It was an exceptionally harsh winter; Keene fell ill and, four freezing snowbound days into 1891, died. He was aged sixty-eight. On his deathbed he had sent for Sickert and Sidney Starr and let them choose any drawings of his that they liked.[40] A large crowd gathered amidst the frozen drifts at Hammersmith Cemetery to pay their respects, including many artists.[41] For Sickert, it was a sad loss. Keene was the first of his three self-chosen mentors to die. He had provided a constant source of inspiration and pleasure, a reminder of the paramount importance of drawing. 'Bad drawing', Keene had been wont to say, 'somehow revolts me.'[42] Sickert might have been expected to contribute an obituary of his hero, but he held back. He felt that George Moore had written the article he would have liked to have written.[43] Nevertheless, he was anxious that Keene should be properly memorialized. He encouraged Blanche to write a piece for the French press and supplied him with a page of biographical anecdotes and facts.[44]

Keene's was not the only death of the New Year. Towards the end of January, Charles Bradlaugh passed away. Although Ellen wrote to his daughter, Hypatia Bradlaugh-Bonner, sending condolences from herself, Walter, and Jane, and announcing an intention of attending the funeral at Woking, the news was not without its positive aspects.[45] Sickert, through his painting at the NEAC and *The Whirlwind* cartoon, had achieved a position almost as Bradlaugh's official portraitist, which he sought to exploit in a small way by offering to paint a memorial picture of the politician's study. And although progress was held up by the February gloom, his own initiatives were soon overtaken by the schemes of others.[46] The National Liberal Club put in hand a subscription to buy the picture exhibited at the NEAC, and a Manchester businessman commissioned a full-length posthumous portrait of Bradlaugh for presentation to the Manchester Secular Society.[47] These were Sickert's first tastes of official approbation, and reward. They were to be enjoyed even if, beneath the sweet savour, there lurked a recognition that success had been achieved via conventional portraiture rather than through the daring representations of London's music halls. Sickert was becoming aware of the practical demands of life – or so Ellen hoped, and he himself fondly believed. A new term began at 'Mr Walter Sickert's Atelier' on 16 March.[48]

The demands of work did not, of course, preclude all chance of pleasure. The convivial life of the streets and studios was always close at hand. Sickert was one of a group of local artists who banded together early in 1891 to form the Chelsea Arts Club in rooms at 181 King's Road. It was to be, not another exhibiting society, but a social and dining club. The venture was at once a great success. Stirling Lee, a convivial sculptor, who had made a portrait medallion of Sickert, became the first club chairman,[49] and Whistler – as the doyen of Chelsea's artistic community – was persuaded to join. But if he brought a weight of achievement to the fledgling institution, it was generally agreed that Sickert added the zest of style. Still in his magnificently moustachioed, dandified phase, he was an adornment to the rather shabby ground-floor and basement premises. More than one fellow member thought him 'the best-looking man in the club'.[50]

Chelsea was pullulating with artistic schemes and intrigues, and Sickert, enthusiastic if capricious, involved himself in many of them. There were plans for a new exhibiting group to be called the Panel Society that would show only works on paper. There would be no selection jury; members would submit their work already attached to a uniformly sized panel. It was hoped that Degas, along with various other French masters, might be persuaded to join. Sadly the scheme came to nothing.[51] On a smaller scale Sickert arranged an exhibition of Steer's work in his studio at Glebe Place. It was, as Sickert liked to boast in later years, Steer's first one-man show.[52]

Aside from exhibition plans Sickert's delight in art-political intrigue found a fresh vent that spring in a concerted campaign against Hubert von Herkomer. Herkomer was a highly successful artist: founder of the flourishing Bushey School of Art, Slade Professor at Oxford, and – since the previous year – a Royal Academician. Seeking rather to overcapitalize on his name, he allowed some illustrations of his – published in a limited-edition poetry book – to be described as 'etchings', whereas they were in fact pen drawings mechanically reproduced by the relatively new process of photogravure. Sickert, as a printmaker, noted this economy with the truth, as did Joseph Pennell, and together they decided to stir up a controversy on the point. In this they were encouraged – even driven – by the deputy editor of the *Scots Observer*, Charles Whibley. He published letters from both Sickert and Pennell (as well as some from himself) pointing out Herkomer's ploy and calling for his resignation from the Royal Society of Painter-Etchers,

if not from the Royal Academy as well.[53] After some evasions, the distinguished RA was eventually goaded into admitting his error. Sickert and Pennell felt vindicated. They had won a victory for artistic and commercial probity: at a time of rapidly evolving print technologies, correct definitions had to be maintained. For both of them, though, it was a victory that would have – in due course – a bitterly ironic sequel.

The NEAC continued to advance under Sickert's direction. The Humphreys Mansions experiment was not repeated and they returned to the Dudley Gallery, where it was planned they would henceforth hold two exhibitions during the course of the year – one in the spring and a second in the autumn. Sickert, as ever, was active on both the selecting and hanging committees. Some six hundred pictures were sent in; only a hundred were hung. He gave space to Blanche's portraits of 'Miss Pash' and Olga Caracciolo, and to Steer's second 'audacious' music-hall piece: *Prima Ballerina Assoluta*.[54] After his own portraits of the previous year and the music-hall pictures of the year before that, Sickert showed a muted Dieppe townscape (a view of the Café des Tribunaux). The critics heaved a sigh of relief. While Steer's picture drew most of the critical flak, Sickert's 'vigorous impression' of the Dieppe streets was welcomed.[55] One reviewer called it 'graceful, accurate and harmonious ... in a low but not dismal key' – remarking that it 'atones for more than one music hall by the same artist'.[56] Another congratulated Sickert on keeping himself 'free from any temptation to diverge into eccentricity'.[57] The work was still recognized as being 'Impressionist', but its conventional subject matter made it less threatening.

At the beginning of May, Sickert – together with Steer and Starr – was invited to give a talk on 'Impressionism in Art' to a meeting of the Art Workers' Guild, a gathering (at least according to its secretary, Herbert Horne) of 'all our most thoughtful artists'.[58] William Blake Richmond was in the chair.[59] Sickert's speech has not been preserved, but it is likely that it reiterated the terms of his 1889 catalogue preface. Starr's views are unknown, while Steer adopted the established ploy of claiming all 'good artists, ancient and modern' as fellow Impressionists.[60] A slightly less familiar note was sounded by a fourth speaker. Besides the three London Impressionists, Horne had also secured the participation of Lucien Pissarro, the 28-year-old son – and pupil – of the celebrated Camille Pissarro. Lucien had recently arrived in England

– so recently indeed that his command of the language was still shaky: he composed his paper in French and had it translated by Selwyn Image. He gave an historical account of the French Impressionist movement, taking it up to the 'Neo-Impressionist' – or pointillist – experiments of his father, Seurat, Signac, and others, stressing 'le division du ton' as the essential characteristic of this current Impressionist school.[61]

It was a narrow definition that set Sickert outside the movement – a fact that became clear to the young Pissarro when he was invited to lunch at Hereford Square. Although impressed by Sickert's Degas pictures, he was less taken by Sickert's own work. Writing to his father after a visit to Sickert's Glebe Place studio, he confined himself to the single exclamation: 'Déplorable!!' Sickert, he considered, like most of his fellow 'English Impressionists', did not know a thing about Impressionism: he painted 'à plat' and with black on his palette.[62] Although it is unlikely that Lucien Pissarro was as forthright in his comments to Sickert, the encounter was not propitious. No easy friendship sprang up between the two men. Amongst the group, only Steer struck Lucien as 'a real artist', in that he 'divides the tones as we do'. Despite this point of agreement, and Steer's generous praise for Camille Pissarro, Lucien was not ushered into the bosom of the New English Art Club. In part this may have been a result of his own shyness; but he was also concentrating his energies at the time, not on painting, but on printmaking and craft book-production, and was more interested in the possibilities of the proposed 'Panel Society', which, guided by the aesthetic Charles Ricketts, had a strong illustrative contingent.[63]

Lucien Pissarro made no mention of seeing Ellen when he lunched with Sickert, and it is quite possible that she was away, recuperating. She had 'overreached herself' again and fallen ill that spring.[64] Nevertheless, along with Walter and most of the rest of the Sickert clan, she was back in Dieppe for at least part of the 1891 summer.[65] Jane was also in the party. She was being courted by the publisher, T. Fisher Unwin.[66] He was an imposing figure, tall, upright, with a beaked nose (slightly flattened at the tip) that curved out over a full beard. His air of dignity was such that it remained uncompromised even by his holiday attire of grey morning coat and straw boater.[67] His pursuit of Jane Cobden was scarcely the awkward rapture of young love (she was forty that year, he was forty-three), but there seems to have been a rather touching bashfulness about proceedings. His own family only suspected romance was in the air on account of the care he began to

lavish on his beard.[68] To the crowd at Dieppe that summer matters seemed clearer. There was much speculation about if – or, rather, when – he would propose. An afternoon at the races seemed almost certain to culminate in a definite engagement. But the moment slipped by unused.[69] Unwin instead made a rather less drastic proposal. He was interested in contemporary French art (he even bought a van Gogh painting along with several other works during the early nineties) and he was eager to canvas Sickert's opinion.[70] At Dieppe he asked Sickert to contribute an essay on 'Modern Realism in Painting' to a volume he was bringing out on the French realist painter, and father of the English plein-air tradition, Jules Bastien-Lepage. Amongst a selection of favourable essays, Sickert was to play devil's advocate.

It was a welcome chance to set down some of his well-rehearsed ideas between hard covers. Sickert contrasted the practice of Bastien-Lepage – very unfavourably – with that of his slightly older contemporary, Millet. The contrast was a familiar one: while Bastien-Lepage had striven to paint photographically accurate scenes of rural life from nature, Millet had made his pictures in the studio, basing them on long observation, profound comprehension of the subject, and a few vestigial studies done on the spot – 'a note sometimes of movement on a cigarette paper'.[71] Sickert's account of Bastien-Lepage's method was a party piece:

> To begin with, it was thought to be meritorious, and conducive to truth, and in every way manly and estimable, for the painter to take a large canvas out into the fields and to execute his final picture in hourly *tête-à-tête* with nature. This practice at once restricts the limits of your possible choice of subject. The sun moves too quickly. You find that grey weather is more possible, and end by never working in any other. Grouping with any approach to naturalness is found to be almost impossible. You find that you had better confine your compositions to a single figure. And with a little experience the photo-realist finds, if he be wise, that that single figure had better be in repose. Even then your picture necessarily becomes a portrait of a model posing by the hour. The illumination, instead of being that of a north light in Newman Street, is, it is true, the illumination of a Cornish or a Breton sky. Your subject is a real peasant in his own natural surroundings, and not a model from Hatton Garden. But what is he doing? He is posing for a picture as best he can, and he looks it. That woman stooping

to put potatoes into a sack will never rise again. The potatoes, portraits every one, will never drop into the sack, and never a breath of air circulates around that painful rendering in the flat of the authentic patches on the very gown of a real peasant.[72]

The 'truths' gained by such a method amounted to no more than 'a handful of tiresome little facts'. Millet's approach offered – at least in the hands of a master like Millet (or Degas, or Whistler, or Keene) – the whole world of 'life and spirit, light and air'.[73] It also produced work that had style – 'style which is at the same time in the best traditions and strictly personal'.[74]

Portraiture, as Sickert suggested, was a genre in which it *was* possible to paint directly from the subject. Studio conditions could be controlled, an unforced and maintainable pose could be chosen for the sitter – Sickert in his own early essays, following the example of Whistler, seems to have adopted just such a course. But he now began to explore other possibilities of approach. He returned from Dieppe to work on two portraits, one of George Moore, the other the Bradlaugh commission for Manchester. Each was different in style but both were painted away from the sitter.

The picture of Moore, which represented the critic, if not actually speaking, on the point of utterance, was made with the aid of only a couple of sittings. Moore recalled that Sickert, like Millet, proceeded by observing intensely and memorizing his impressions, and then working these up later in the studio.[75] In the case of Bradlaugh, the artistic challenge was different: the sitter was dead. Although Sickert had his studies of the elderly politician made the previous year, it had been decided that the commemorative portrait should show Bradlaugh at one of the great historical junctures of his life – speaking from the bar of the House of Commons.[76]

No contemporary photographic record of the incident existed, so Sickert had to assemble the information piece by piece. He was already familiar with the interior of the House of Commons and he was able to borrow the actual suit that Bradlaugh had worn on that occasion for a model to pose in. The likeness itself he painted from a contemporary photograph.[77] It was his first engagement with the medium.

The use of photography in painting was a contentious and much debated subject. The Royal Academy, and most other societies, specifically barred works that had been painted from photographs – although

it was sometimes hard to spot them. Throughout his early critical writings Sickert had consistently attacked the use of photographs by artists. His attitude was fixed in part by the fact that he saw the practice as a corruption of the already corrupt school of plein-air realism. If the early followers of Bastien-Lepage aimed at creating a pseudo-photographic exactitude in their paintings, numerous tyros were seeking to short-circuit the process by painting directly from photographs.[78]

Sickert's comments on the point were sometimes given an edge of personal spite. He lost no opportunity to denounce the unacknowledged – and unrecognized – use of photography in Mortimer Menpes' facile topographic sketches. He contrasted 'drawing [that] is the result of special gifts of brain and eye' and that had been 'arduously and painfully cultivated' with work that has been done for the artist 'by a machine'.[79] From the tenor of his language it seems clear that, at this date, Sickert was still unaware of Degas' – albeit much more subtle – use of photographic sources.

He did, however, temper his criticisms when it came to portraiture, admitting that the camera might be a useful tool. In his review of the 1890 Royal Academy summer show he had praised 'Mr Van Beers' supremely skilful copy in oils of an admirable instantaneous photograph of M. Henri Rochefort'. There was an element of mischief in this, as Van Beers had not admitted his debt, and Sickert was showing off his own inside knowledge. He asserted that M. Rochefort had told him 'that he gave a sitting for a photograph [to Van Beers] and no more'.[80] But some of the admiration was real. Sickert did consider the painting 'a marvel of characterisation' and regretted only that the original photograph could not be exhibited alongside, to reveal what had been gained by its translation into another medium.[81]

In the case of the Bradlaugh portrait, his own procedure was to trace the photograph carefully onto panel, and then pin the tracing up beside his easel, so that he might work from it 'with the same freedom which an artist would use in painting from a drawing'.[82] He made a point of announcing in the press that he was working from a photograph – and that he had got the photographer's permission to use it.[83] The process was considered daring, if not outrageous. Perhaps having maintained his radical credentials through this ploy, Sickert felt able to adopt a relatively conventional approach to the actual painting – giving it a more finished surface than his earlier works. Although at almost eight foot by four foot it was by far the largest

picture he had attempted, progress was quick. It had to be. The painting needed to be ready for the official unveiling at the end of September.

He finished with time to spare and was able to accompany Ellen for a short holiday in Wales. They were guests at the country house of Sir Edward Watkin in Snowdonia. The railway magnate was working on a memoir of Richard Cobden and had been consulting Ellen about details of research.[84] The hills and valleys do not seem to have engaged Sickert's artistic imagination, but he climbed to the top of Snowdon and Cader Idris, and formed some happy memories of the place.[85] The break, moreover, was convenient as it brought him close to Lancashire for the presentation of the Bradlaugh picture on 26 September.[86]

Sir Edward 'delighted' Sickert by insisting on accompanying him up to Manchester for the occasion.[87] It was a Saturday evening and there was a large crowd of nearly six hundred Mancunian freethinkers gathered at the Rusholme Street Hall (formerly home to the town's Plymouth Brethren) to see the picture unveiled. On the platform – above which hung the shrouded picture – Sickert sat with Hypatia Bradlaugh-Bonner and various other dignitaries from the local secularist community. After the meeting was brought to order, a Mr Foote 'delivered an eloquent and much applauded address, in the course of which he unveiled the portrait amid a burst of cheering'.[88] There were then more speeches, including a vote of thanks to Sickert proposed by Mrs Bradlaugh-Bonner, and seconded by Mr Foote. Mrs Bradlaugh-Bonner said that her father had had a 'great admiration for Mr Sickert' and that she had been 'glad when she heard that he had been selected to paint the portrait, and after seeing the picture that evening was more than ever glad!' – an assertion that was greeted with more cheers.[89] Sickert 'briefly returned his thanks', explaining with characteristic scrupulousness that 'most of those present could not see [the picture] properly in the gaslight, and that in any case it could not now rightly be judged of until the colours were thoroughly dried and the picture varnished'.[90] After the formal proceedings were wrapped up, many of the audience, ignoring Sickert's caveats, pressed onto the platform to get a better view of the portrait. They found their initial verdict confirmed: 'general satisfaction was expressed with the force and dignity of the painter's work'.[91] It was an evening of triumph for Sickert, and a happy change from the uncomprehending hostility and much-qualified praise that too often greeted his NEAC exhibits.

Afterwards, Sir Edward took Sickert to Rose Hill, his house at North-

enden, just outside Manchester. He wanted to show off his collection of 'modern paintings' – a mass of conventional works in gold frames, all bought from the Royal Academy summer shows – and, even worse, a portrait by Herkomer.[92] As Sickert liked to recall, '[Sir Edward] asked me to be quite frank – which I was.' Sickert was rather more impressed by a large piece of rock – 'like the tip of a giant's cigar' – which formed the centrepiece of one of the flowerbeds in the garden. Sir Edward informed him that it was the top of Snowdon: the mountain was part of his property, and he had had the tip 'sawn off and given a worthy surrounding'.[93]

The success of the Manchester visit was not long enjoyed. On 29 September Maggie Cobden died suddenly in London after contracting pneumonia. Her health had never been robust, and she had been ill with that vague Victorian malady, neurasthenia, for the previous two years. Even so, her death came as a shock. She was only twenty-nine.[94]

There was, however, scant time for grieving. It is not even certain that Sickert attended the funeral. He was busy with preparations for the NEAC's autumn exhibition. As ever, he was on all the committees. The show opened at the end of November. Sickert's portrait of George Moore was the most talked about picture in the exhibition. Amongst the core of kindly disposed reviewers the picture was considered as 'the club's masterpiece'. Wedmore praised its 'effervescence of vitality',[95] whilst MacColl claimed that it gave 'three several satisfactions':

> From due distance it attracts first by its design and colour, and then arrests by its extraordinary expressiveness. Whether or not it is like its original, it is a notable piece of character painting, and suggests how powerful a weapon lies in the hand of the painter if he chooses, in paint to criticise the critic. But there is a third pleasure as well to be got from the picture, and that is when one gets, so to speak, inside the fence, and examines the handling – how the drawing is built up, the deliberate skill and subtlety of the touches.[96]

It was a moot point just what Sickert's 'criticism' of the critic, Moore, was. Moore in his own review was generous about the painting.[97] In private he was less polite. According to one tradition, he was very much annoyed when he first saw the picture. 'You have made me look like a booby', he said. 'But you *are* a booby,' was Sickert's answer.[98] Certainly Moore had his boobyish aspects. His naivety, his vanity, his

absurd enthusiasms, his technical gaffes (as when he talked of painters using Naples Yellow 'years after it had been banned from every living palette') were inescapable.[99] He had recently provoked the ire of Degas by publishing an article on the artist, full of colour and indiscretions. Yet for all this, Sickert still liked and admired him, and took his criticism seriously. After any NEAC opening he and Steer would still tramp down to the Dudley Gallery to examine the press-cutting book to see what Moore had said of their work.[100] If the portrait looked odd it must be remembered that so, too, did Moore. Even Manet's masterful portrait of him had been jokingly titled 'the drowned fisherman'.

The intended effect of the picture had surely been to reinforce the web of connection in the public consciousness between the Impressionist group and its most eloquent critical champion. It was a familiar enough ploy. And indeed the exhibition sought to establish, or strengthen, several other strands of significant connection. Sargent had been persuaded to lend two paintings by Monet, and Sickert (or, as the catalogue acknowledged, 'Mrs Cobden-Sickert') lent Degas' *Répétition d'un Ballet sur la Scène*. The picture was hailed by MacColl as a 'masterpiece', and its exposure was called 'an event of first-rate artistic importance'.[101] Although the *National Observer*'s assertion 'Now for the first time is a work of Degas publicly exhibited in London' was not quite accurate, it served as a reminder of how relatively unknown Degas' art still was at this time.[102]

Sickert strove constantly to raise Degas' profile in England. When MacColl announced that he was going over to Paris, Sickert hastened to equip him with the names and addresses of dealers and collectors who held works by Degas, so that he might gain a fuller knowledge of the artist's work.[103] Sickert also agreed to contribute an unsigned article on Degas to the 'Modern Men' series in the *National Observer*.[104] This was a delicate operation. Sickert was very anxious not to offend his hero, as Moore had done. He had been uncomfortably implicated in Moore's article, which was illustrated with a photograph of the *Répétition d'un Ballet sur la Scène* 'by permission of Walter Sickert'.[105] This perhaps accounts for the curiously stilted and anodyne tone of the piece that appeared in the *National Observer* at the end of October.[106]

After the tragedy of Maggie's death there was happier news at the end of the year with the announcement of Jane Cobden's engagement to Fisher Unwin. The wedding took place early in 1892 at Heyshot Church near Dunford.[107] Sickert was there with Ellen.[108] For him it was

a useful thing to have an enterprising publisher as a brother-in-law. The association became a close one. After a brief honeymoon, the Cobden-Unwins and the Cobden-Sickerts all lived together at 10 Hereford Square.[109] Unwin for his part greatly appreciated his new connection with a Whistler-trained controversialist. Not everyone shared this view. When the volume on Bastien-Lepage appeared early that spring some critics thought it extraordinary that a book dedicated to the memory of the renowned 'founder of modern naturalistic painting' should contain such a frank attack on his work. One reviewer spoke of the 'exceedingly foolish and impertinent deprecation of Lepage contributed by way of a make-weight to the volume', adding that 'it will suffice to say that it is from the pen of the publisher's brother-in-law. If Mr Unwin is content to exhibit his family affection at the expense of his business sanity, it is after all more his affair than ours.'[110] Even sympathetic critics felt that Sickert, for all his 'admirable incisiveness and wit', had rather overstated his case.[111] But that, of course, was the point. Exaggeration *was* an effective ploy, as both Unwin and Sickert recognized. The book received widespread attention, and amongst a section of the new generation of painters even 'did much to check the vogue for Bastien-Lepage' and to influence artists in the direction of Sickert's own views.[112]

Sickert's association with Unwin also drew him closer to the Pennells. Unwin got on well with Joseph Pennell, whom he regarded as a potential author *and* illustrator. The Pennells were regular guests at Hereford Square, and Sickert and Unwin attended the crowded Thursday evening receptions at the Pennells' flat in Buckingham Street, off the Strand, where a regular ruck of artists, illustrators, writers, and journalists would gather to drink, intrigue, and shout gossip at each other.[113]

Sickert and Pennell's joint campaign against Herkomer had been revived when the distinguished RA was elected a fellow of the Royal Society of Painter-Etchers, an honour that they considered singularly inappropriate in the light of his 'fraudulent attempt to sell, as etchings by himself, illustrations which [were] not etchings'.[114] W. E. Henley, the *National Observer*'s irascible editor, who was delighted to keep the controversy rolling, wrote to Charles Whibley urging him to 'keep Sickert up to the mark'.[115] Sickert needed little encouragement. He wrote an open letter to the RSPE's president, Seymour Haden, expressing his 'surprise' at Herkomer's elevation, and announcing 'with the

profoundest regret' the resignation of his own membership.[116] It was the first of Sickert's resignations. It would not be the last. Over the coming years, no artist resigned more often, or with more aplomb. As a first attempt this severance from the RSPE was well managed: modestly dramatic, artistically self-righteous, and not too self-wounding. He was etching less and less.[117]

One of the things that drew Joseph Pennell to Sickert was Sickert's deep knowledge of, and affection for, Whistler. The Pennells had become impassioned devotees of the Master, always anxious for information about him and his art. He was a regular fixture at their soirées and in their conversation, and Sickert's bond with Whistler, though attenuated by time and fresh allegiances, remained unbroken. When, in March 1892, Whistler had a popular, if not an official, triumph with a retrospective show of 'Nocturnes, Marines, and Chevalet Pieces' at the Goupil Gallery, Sickert was prominent in his support and took time to extol the pictures to the doubtful and the uncomprehending. D. C. Thomson wrote to Whistler of one crowded afternoon when Burne-Jones had spent 'an hour examining every picture and discussed them with Walter Sickert'.[118] Thomson, an inveterate fixer, also arranged for Sickert to review the show in the prestigious *Fortnightly Review*.[119]

Sickert paid handsome tribute to his former master. 'Where else in modern work,' he asked, 'can we see as we see here that paint itself is a beautiful thing?' In his closing description of the bathetically titled *Nocturne in Blue and Silver – Bognor* he secured Whistler's apotheosis: 'The whole soul of the universe is in the picture, the whole spirit of beauty. It is an exemplar and a summary of all art. It is an act of divine creation. The man that has created it is thereby alone immortal a thousand times over.'[120] The article – as Sickert later recognized – marked a period in his relations with Whistler.[121] It would be the last time he wrote of him with unalloyed approbation.

By the time the piece appeared, Whistler was no longer living in London. Aggrieved at the indifference of the official London art world, and believing that he would find truer appreciation in France (where the portrait of his mother had just been acquired by the state), he had moved to Paris. Sickert visited him and Beatrice there at the beginning of May, and was immediately put to work.[122] Whistler was settling into his new workspace and he sent his former pupil out to buy two pruning knives with which they proceeded to rip up all the unfinished and

unwanted canvases.[123] Perhaps Sickert resented such treatment. At any rate, the visit was not an entirely happy one. At a reception, held at the rue de Bac, Sickert was quiet and constrained. And this slight *froideur* was noted by one of the other guests present: a diminutive, bustling, round-headed, round-spectacled young painter called William Rothenstein.[124]

Rothenstein was then only nineteen. The son of a Bradford wool merchant, he had studied briefly at the Slade before moving to Paris in 1889, where he attended the Académie Julian; but most of his education had been gained amongst the studios and cafés of the Latin Quarter. Interesting and talented himself, he had an extraordinary gift for getting to know other interesting and talented people. He had already met many of the established names in the Paris art world, as well as the more radical figures of the moment. His unerring gift had also drawn him to the Whistlers' drawing room.

In May 1892 Rothenstein was basking in the afterglow of his first exhibition: a joint show that he had held with the young Australian-trained Paris-based painter, Charles Conder. *Le Figaro* had noticed their work favourably.[125] Rothenstein took to Sickert at once,[126] and Sickert took to him, christening him 'Puffing Billy' on account of his busy endeavour. (The vague, drifting Conder he dubbed 'The Big Bird'.)[127] For Sickert, over ten years older than his new friend and removed from the hub of the Parisian scene, the meeting with Rothenstein was a reminder that a new generation of artistic talent was emerging – with new ideas. Rothenstein, Conder, and their French contemporaries looked not only to the Impressionists for their inspiration, but also to less obvious sources. They had a reverence for the naive, dreamlike, classically inspired works of Puvis de Chavannes, which to a detractor of the Pre-Raphaelites like Sickert was unexpected.[128]

Whistler's flight to Paris was seen by some hostile critics as a blow to his English followers in the NEAC. Whistler, however, had drifted out of the ambit of the club while still in London and had not exhibited anything since 1889. Other pressures were taking a more ominous toll on the club. Sidney Starr ran off with a married woman whose portrait he was painting: he went to America and did not return.[129] He had been perhaps Sickert's closest artistic ally amongst the group, and a friend too.[130] His sudden removal was a blow both to Sickert and the NEAC. Its immediate impact was, however, obscured. Other ties remained to bind the members in the usual web of mutual support

and promotion: the club's spring exhibition that year included a Roussel portrait of Bernhard Sickert.[131]

Amongst the notices was one in a new Cambridge undergraduate magazine that had been founded by Walter's brother, Oswald,[132] who was developing into a rare and engaging personality. He may have lacked his eldest brother's ambition, energy, and force of character, but he shared much of his charm and wit. He also had a similarly keen sense of discrimination. His sister characterized it as an almost 'religious' attitude to life: 'He used to say that his idea of a holiday was to do what he usually did, but to take ten times as long in doing it. Life was never long enough to allow him to savour to the full the way the sun slanted down on the stucco fronts of houses in Phillimore Place, or dappled a girl's white dress at a garden party.' He had an enthusiasm for buckwheat porridge, and when his sister disparaged it for being faint and sickly, he explained, 'Ah, you haven't found the technique of *Buchwaizen*. It *is* faint, at *first*. But if you wait for a minute or two after you've eaten a spoonful, the most heavenly ghost of a taste appears. Almost as heavenly as the best smells.' To her objection that it would take the whole morning to eat a plateful in this way, he remarked, 'But I thought we were talking about a *taste*! Not about being in time for the office.'[133]

He was, unsurprisingly, a favourite within the family. The consideration that he showed to his widowed mother, even when he was still a schoolboy on his holidays from Clifton, opened up a 'wonderful Indian summer of happiness for her'.[134] As she herself confided, 'I have more pleasure in his company than in anyone else now my darling [husband] has left me.'[135] Both Walter and Helena came to recognize him as 'much the best of us all'.[136] He had gone up to Cambridge in June 1890 to read classics at Trinity but devoted most of his time to the extracurricular pleasures of talk and falling in love.[137] The romances seem to have been transitory. He once shocked an acquaintance by remarking that he was 'miserable if for 10 minutes he was not in love with some woman'.[138] His undergraduate discussions were rather more fulfilling. The circle of his friends included Roger Fry, Dalhousie Young, and G. Lowes Dickinson (all slightly senior to him), as well as immediate contemporaries such as Bertrand Russell, the future novelist Stanley Makower, R. C. Trevelyan, and, most importantly, Eddie Marsh. It was together with these last two that Oswald had founded the *Cambridge Observer* at the beginning of 1892.[139]

Oswald enthused his college friends with his love and knowledge of the arts, and their new magazine had a strong artistic bias.[140] Sickert was delighted to learn of the project. He promised – and provided – drawings for the publication.[141] He went up to Cambridge to meet the editorial team, arriving in the 'dandy flush of his elegant and witty prime', and charming his awed undergraduate audience with worldly anecdotes and caustic aperçus.[142] He was delighted to have new allies and a new audience – delighted, too, to meet a new generation of potential customers. Marsh in particular he found sympathetic and receptive.[143] He was soon prompting his brother to invite Marsh to come and look at an exciting 'new picture' he was just finishing.[144] The canvas was probably a full-length depiction of the serio-comique Minnie Cunningham performing before the footlights, a painting that combined the conventions of the Whistlerian portrait with the controversial glamour of the popular stage.[145] Marsh, even if he did not buy the picture, was admiring; and for Sickert, in the early stages of his career, every hint of approval was cherished.

V

IN BLACK AND WHITE

How few of our young English Impressionists knew the difference between a palette and a picture! However, I believe Walter Sickert did – sly dog!
(Aubrey Beardsley)

Sickert's ground-breaking depictions of the music hall had stimulated the interest not only of fellow painters but also of writers and poets. The cult of the halls had emerged as one of the distinctive features of London literary life in the early 1890s. Herbert Horne and Selwyn Image, who arranged the symposium on Impressionism at the Art Workers' Guild, were noted aficionados, and many of the young poets who attended the regular soirées they held at their communal home in Fitzroy Street shared their interest: none more so than the earnestly intense critic, poet, and self-conscious decadent, Arthur Symons.

W. B. Yeats, although a friend of Symons', was rather bemused by this enthusiasm. He characterized the craze as a 'reaction from the super-refinement of much recent life and poetry'. 'The cultivated man', he suggested, 'has begun a somewhat hectic search for the common pleasures of common men and for the rough accidents of life. The typical young poet of our day is an aesthete with a surfeit, searching sadly for his lost Philistinism, his heart full of an unsatisfied hunger for the commonplace. He is an Alastor tired of his woods and longing for beer and skittles.'[1] But for most of these 'typical young poets', the halls served to emphasize their cultural pretensions rather than obscure them. They regarded the music hall as a subject for their super-refined art and their super-refined criticism, and in this they acknowledged a debt to Sickert's lead.

One contemporary, on the fringes of Symons' circle, recalled the almost nightly appearance at the Crown Tavern off Leicester Square of Horne, Image, and Symons. They would arrive within a few minutes

of the closing of the Empire and the Alhambra (the square's two flourishing music halls) to sup hot gin and water, and talk 'learnedly about the ballet and Walter Sickert and the latest art movement in France'.[2] For Symons in particular, the subjects were important. In his poetry he was attempting an almost direct literary equivalent of what Sickert was doing in paint: fixing highly charged impressions of contemporary London scenes. And though many rushed to label his verse 'decadent' – the current word on the Paris boulevards – Symons himself called it 'Impressionism'.[3]

Symons (who also wrote 'Impressionist' criticism of the music halls in *The Star*) sought Sickert out. They became friendly, and sometimes went together to the halls. It was on one such excursion – to the Tivoli in the Strand – that Sickert had seen Minnie Cunningham. He was enchanted by the 23-year-old Cunningham's blend of knowingness and naivety, by her angular, almost awkward, grace, and by her red dress. He resolved to paint her and, in order to discuss the plan, went with Symons to call on her at Islington, where she lived with her mother.[4] Although Sickert wanted to depict Cunningham on the stage, and certainly made studies of her at the theatre, he also got her to pose at his studio on the not very adequate platform.[5] She confessed to Symons that she was not entirely pleased with the result, complaining that Sickert had made her a little '*too* tall and thin'.[6] Sickert, though, was delighted with the picture – and with the model. It is possible that they had an affair. Certainly she inspired him to an almost unique attempt at verse,[7] and he titled the painting with the suggestive words of her popular turn, 'I'm an old hand at love, though I'm young in years'. Having completed the picture Sickert deposited it, together with some other things, at the Goupil Gallery, where D. C. Thomson continued to foster the connection with the London Impressionist group. Oswald urged Eddie Marsh to go and see it there, explaining, 'They will always show if you ask, even if the pictures are not on view.'[8]

Sickert, amongst his other portrait experiments, was also working on a picture of Whistler's brother, Dr William Whistler, which kept him in touch with Whistler at one remove. His former master was keen to make use of the connection. He wrote asking Sickert to arrange the sub-letting of his London house.[9] Sickert, however, failed to see the business through, despite Whistler's increasingly tetchy promptings.[10] He had his own arrangements to make. He and Ellen hoped to move

out of Hereford Square. There was no suggestion of returning to Broad-
hurst Gardens. They resolved, instead, to take a short lease on the
house of their friends, the Augustus de Morgans, in The Vale, just off
the King's Road.[11] And before then there were the summer holidays.

Mrs Sickert had rented a house for the season in Dieppe, and it is
likely that they joined her there.[12] But by mid September they were
back in England, at Southwold.[13] For his stay on the Suffolk coast
Sickert transformed himself from a London dandy into something
altogether more rugged and nautical. He adopted a beard and let his
hair grow. One impressionable girl, seeing him for the first time,
thought he looked like 'a magnificent Viking'.[14] Steer and Keene had
both worked much at nearby Walberswick, but there is no evidence
that Sickert did any painting at Southwold that summer. He even failed
to take up Fisher Unwin's suggestion that he review a new Unwin
publication for the *Illustrated London News*.[15]

On their return to London, the Sickerts installed themselves at
No. 1, The Vale for the winter. There were four houses in the little
semi-rustic cul-de-sac. Number 1 was a large, rambling place set amidst
an unkempt garden of overgrown poplars and mulberry trees.[16] It was
filled with the de Morgans' accumulated clutter and art – the fireplaces
decked with the lustrous Pre-Raphaelite tiles that Augustus designed
and made, the walls hung with his wife's scarcely less lustrous Pre-
Raphaelite paintings. It was a curious atmosphere for the leader of the
London Impressionists to discover himself in. There seems to have
been an expectation that Sickert would set up his studio in the house,
but the oppressive air of aesthetic medievalism drove him back to
Glebe Place.[17]

Next door was the house where Whistler had lodged in the mid
1880s with Maud Franklin. It had been taken on by two painters –
dedicated to each other and to art: Charles Ricketts and Charles Shan-
non. (As a result of their long, intense – though, quite possibly, chaste
– companionship they came to be nicknamed 'The Sisters of the Vale'.)
Both men worked outside the ambit of the NEAC, though Shannon
had exhibited there on occasion. Ricketts, who had illustrated several
of Wilde's books, was half French and knowledgeable about French
art, but he looked more to the tradition of the Renaissance and the
eighteenth century in his own fastidiously crafted prints and drawings.
Together with Shannon he ran the Vale Press, producing choice illus-
trated editions of classic works. Whistler had always admired both

men, and enjoyed their company, whilst Wilde famously called their sparsely furnished home 'the one house in London where you were never bored'.[18] Sickert concurred, referring to it as 'the [London] centre of intellectual interest and activity, of cultural curiosity in matters of art and connoisseurship'.[19] It was a centre to which he was drawn. Ricketts found his new neighbour a stimulating addition to the circle: 'intelligent, worldly, shrewd & witty' – a combination rare amongst British artists.[20]

Discussions at The Vale revolving upon contemporary culture returned often to the fashionable notion of 'Decadence', not least because Oscar Wilde, the apostle of the movement, was so often present. With Whistler away in Paris, Sickert could tentatively renew his friendship with the Irish writer. He found him grown in standing. Over the previous two years, after a career of courting celebrity almost for its own end, Wilde had finally given earnest of achievement. His 1891 novel *The Picture of Dorian Gray* had amazed and scandalized the reading public. Its theme – the amoral quest for sensation – had served to distil the dangerous essence of *fin-de-siècle* decadence. The essays and 'dialogues' collected in *Intentions* played with similar wit upon the same theme. He had followed up these successes with his first stage triumph, *Lady Windermere's Fan*; and his self-consciously Symbolist play, *Salomé*, had created its own off-stage drama when it was banned from production by the Lord Chamberlain on the grounds that it was unlawful to represent biblical characters on the London stage.[21] Sickert, however, despite an affection for Wilde's person, remained resolutely unimpressed by his works, finding them – as he put it – 'a sort of glorification of nonsense'.[22] Nor could he ever forget Degas' caustic verdict on the writer's affected pose: that he had the air of someone playing Lord Byron in a suburban theatre.[23]

Nevertheless, as the leader of the most obviously 'advanced' wing of British artists, Sickert found his work allied to the literary world of Wilde and his fellow decadents. His picture of Minnie Cunningham, which he exhibited at the NEAC's 1892 winter show, presented a vision that the public found both enigmatic and artificial – and touched too with the dangerous threat of sex.[24]

At the beginning of 1893 Ellen went over to Paris. The portrait that Whistler had made of her in 1887 had been lost or destroyed and he had agreed to paint another. Ellen lodged with the Whistlers in their new house on the rue de Bac while the time-consuming process of

painting and repainting began again. She stayed there till the end of
the month.[25] Seven years of marriage had taken a toll upon her: traces
of grey had crept into her wonderful hair, and she had grown plumper.
Even the well-upholstered Beatrice thought her – at forty-five – a 'funny
little fat lady', though 'a very graceful one'.[26]

Sickert had commitments to keep him busy in London. He had
received a commission to provide a series of portrait drawings for the
Pall Mall Budget.[27] The paper had recently been bought by the American
millionaire William Waldorf Astor, and C. Lewis Hind had been
engaged as editor to make it, amongst other things, a forum for what
was best and newest in art.[28] Hind, besides engaging the brightest
young pen-and-ink draughtsmen, also sought out some of the infa-
mous London Impressionists. He included pictures by Steer and even
Degas, as well as Sickert. Every drawing in the paper, it was noted,
was 'conceived in the spirit of a work of art, and not merely as an
illustration for a periodical'.[29]

Sickert took the opportunity to use up a few of his unpublished
Whirlwind drawings,[30] but the work also gave him a chance to meet
some interesting new figures. Amongst the very 'mixed bag' of celebri-
ties – Lord Curzon, the Maharajah of Bhavnagar, and the noted chemist
Professor Dewar – Sickert made a drawing of the artist John Gilbert.[31]
Gilbert was not a fashionable figure. A 'venerable old man' in his
seventies, a respected RA, and the President of the Royal Society of
Painters in Water Colours, he had made his reputation working – like
Sickert's father – as a 'draughtsman on wood', contributing illustrations
to the *Illustrated London News*, *London Journal*, and other publications.[32]
It was through his illustrations of Shakespeare that Sickert had first
come to know and admire his work, and that admiration had endured.
Gilbert lived up at Blackheath, in a 'charming house', and it was there
that the portrait drawing was made. With 'the indiscretion of that age',
Sickert began to 'preach' to the distinguished Academician on the
principles of art, mounting his favoured hobby horse about the 'non-
sense' of painting and drawing 'from nature'. Gilbert rather deflated
this tirade by assenting cheerfully with the remark, 'I may say I myself
like to have my comforts about me.' It was, as Sickert acknowledged,
a very sound reason for working in a studio: 'It is not easy to do
something extremely delicate as well in an east wind and wet boots
as you can by your own fire in your own study.'[33]

Despite his strictures against 'drawing from nature', Sickert made

his pen-and-wash portrait on the spot, encouraged no doubt by the cosiness of the fire-warmed study. Gilbert admired the picture but thought it might be slightly improved upon and, much to Sickert's delight, offered to 're-touch it'. The artist's few additions allowed Sickert to boast that he had 'collaborated with Gilbert'. And subsequently he took particular pleasure in referring to him as a 'friend' and 'colleague'.[34]

Sickert also called on another of the artistic lions of the day – and another of his unexpected heroes: Sir Frederic Leighton, the 'charming gifted and friendly' President of the Royal Academy.[35] He visited him not at his sumptuous palace off Kensington High Street, but in the more workmanlike surroundings of his 'sculptor's studio' in Osnaburgh Street, just north of Great Portland Street. Sickert seems to have resisted lecturing the PRA on the 'principles' of art. Instead he listened with interest to Leighton's views on drawing to the scale of vision (on which, like Whistler, he insisted), on Impressionism 'as practised by Besnard', and on the compositional challenge posed by the fact that 'life sized public portraits' needed to be hung high up on the wall, 'safe from the artistic shoulders' of the throng.[36] The Leighton drawing was, however, never published, and Sickert's connection with the *Pall Mall Budget* dwindled during the spring as his attention became engaged elsewhere.

At the end of February 1893 the newly established Grafton Galleries in Mayfair had provoked a furore by exhibiting a Degas painting – lent by a private collector – of a man and woman sitting blank-faced at a café table. The picture appeared above the deliberately provocative title *L'Absinthe*, in apparent allusion to the small glass standing before the woman. Absinthe, the high-proof, bright green spirit of the Parisian cafés, was regarded as the corrupting poison of the *vie Bohème*. Conventional voices, led by 'Philistine' in the *Westminster Gazette*, were swift to denounce the picture for its repulsive subject matter, as well as its lack of high finish and fine detail. The allies of Impressionism sprang to the work's defence, claiming that the subject matter was immaterial. They asserted that Degas' great achievement was to have rendered his chosen motif perfectly, to have distilled its essence and conveyed its mood without resorting to literary associations or lapsing into sentimentality.[37] Although Sickert himself wrote only one brief letter to the press – pointing out that the title '*L'Absinthe*' was not Degas' own – he doubtless contributed to the busy round of discussions on the

subject with MacColl, Thomson, and Moore, who all wrote more frequently.[38] The controversy simmered on throughout March, a reminder of the enduring resistance to the aims and achievements of the Impressionist school, and to its London heirs.

Not that the heirs were united: Théodore Roussel and his disciple Paul Maitland resigned from the ranks of the NEAC that spring; and although it seems that their reasons were political rather than artistic, it was – following the departure of Starr the year before – another blow to the power and cohesion of the group.

At the end of March the de Morgans returned from their sojourn abroad and Walter and Ellen were obliged to move back once more to Hereford Square and the hospitality of the Cobden-Unwins. Their unfixed mode of life was proving a strain on Ellen's never robust health. There was no thought of returning to Hampstead: although the tenants at Broadhurst Gardens had moved on, Ellen devoted herself to finding new ones. The arrangements were another call upon her energies. Jane, who was travelling in America with her husband, wrote expressing her concerns: 'I want you not to make a definite arrangement with Mrs de Morgan to take No. 1 The Vale next winter before we have talked over your plans together. I cannot help feeling that house is not a healthy one, it lies so low – & the houses there are so old & tumbled down . . . If Walter has his studio outside there is not much reason for you being there.' She suggested that they take rooms instead at the residential Norfolk Hotel in Harrington Road, South Kensington. They could then lunch and dine at Hereford Square. 'You shall not', she added firmly, 'live in squalor any longer.'[39] The note of exasperation is clearly discernible. Jane held a low opinion of her brother-in-law's sense of responsibility.

It was perhaps in an effort to defuse Jane's displeasure that Sickert chose to ally himself to one of her particular causes. Together with Ellen, she was closely involved in raising a subscription for a memorial to Charles Bradlaugh. Despite their efforts, the appeal was not going well; hundreds of letters had been sent out, barely a dozen replies had been received.[40] Sickert's decision to persuade the Manchester branch of the Secular Society to let him exhibit the imposing full-length portrait of Bradlaugh at the NEAC's spring exhibition was a means of refocusing attention on the deceased secularist.[41]

To the conservative London art critics the picture, for all the daring of its proclaimed reliance on a photograph, revealed unexpected virtues

in its conventional pose, detail, and finish. One reviewer announced that the portrait 'proved that Mr Sickert has reached a level of sound painting'.[42] Others were even more generous.[43] The praise, however, tended to be given at the expense of Sickert's two other portrait submissions – a painting of Miss Geraldine Blunt, daughter of the rector of Chelsea, and a 'sketch portrait' of Théodore Roussel, which one critic considered must be 'a judgement on [the sitter] for having left the ranks of the New English'.[44]

Sickert ensured that, in the wake of the *L'Absinthe* controversy, the club proclaimed its loyalties. He secured two Degas pieces for display – a coloured etching of a 'Café Concert' and a 'Design for a fan', which, given that it was listed as for sale (price £150), may well have been sent by the artist himself.[45] Degas, however, was not the only representative of artistic daring. There were several new exhibitors that year: William Rothenstein had sent in work, as had his friend Conder. And their new 'imaginative' note was sustained and amplified in two drawings by the 21-year-old Aubrey Beardsley, who had been invited to exhibit by his former teacher Fred Brown. His bizarre black-and-white depictions of Wilde's Salomé and an oriental courtesan drew the attention of the critics as something strange and dangerous.

Amongst the NEAC Impressionists such work, though accounted interesting, was seen as a shift away from the realist roots of their own school, back towards the imaginative traditions of the Pre-Raphaelites.[46] But to the wider circle of critics, and to the general public, it was seen as another manifestation of the same general tendency of dangerous innovation, another aspect of decline from accepted academic standards. Popular journalism tended to 'lump' together all aspects of modern culture and denounce them en bloc. This tendency also had its corollary in the 'higher' criticism, where – borrowing from the vocabulary of France – 'Impressionism' and 'Symbolism' were designated as the twin strands of the modern 'Decadent Movement' in both literature and painting. Arthur Symons and other informed commentators, having distinguished these twin elements, then sought to make connections between them.[47] It became the vogue to suggest that work previously accounted 'Impressionist' might also have a hidden 'Symbolist' dimension – that the power of the artist's 'impression' to suggest a mood was akin to the allusive work of the Symbolist poets such as Mallarmé. The beautiful formal image of a Whistler nocturne, say, might be imbued with 'meaning' – albeit vague and

unemphatic. Whistler's friendship with Mallarmé certainly encouraged the theory and over the next fifteen years it became part of the critical framework for discussing Impressionist work. In the mid 1890s, however, the lines of connection were still being defined. They served, in the first instance, merely to bind Sickert's paintings and those of his Impressionist confrères together with all the other 'modern' or 'decadent' manifestations of the moment: Symons's verse, Ibsen's plays, Beardsley's drawings, Conder's fans, Wilde's writings.[48]

Sickert was thoroughly au fait with these developments and the personalities behind them. He kept in contact with Whistler, and he visited Paris often enough to know that the ideas discussed in Chelsea had their origins in the salons and cafés of the French capital. Shannon and Ricketts' house remained the principal London forum for the discussion of such matters. Rothenstein, who returned to England at the beginning of 1893, gravitated at once towards The Vale. Conder and Beardsley followed. Wilde continued to dominate the gatherings there. Steer was often a monumental and silent presence, and Sickert a vital and articulate one.[49] He was, Rothenstein thought, almost 'at his best' at the regular Friday evening 'at homes', 'irresistibly witty and captivating in his talk' – as well charming and deferential to his hosts.[50] The young painter (and future director of the National Gallery) C. J. Holmes recalled him there on one brilliant evening, toying with a crinolined doll, and 'flashing out now and then some lively repartee' to distract the 'verbal combat' unfolding between Ricketts and Wilde.[51]

Sickert refused to be drawn in such debates. He remained wary about the application of 'Decadent' or 'Symbolist' labels to his work or that of his Impressionist confrères. Although in a review of D. S. MacColl's exhibition at the Goupil Gallery he allowed that 'each drawing suggests a mood, and only a moment of that mood', he claimed that there was 'nothing new' in this: 'It is what the serious artists of all time have done in different degrees.'[52] And when writing of Steer's one-man-show at the same gallery, he tried to free his friend from all fashionable associations: 'The painter is evidently not, fortunately for his enduring reputation, *dans le mouvement*. If his work is not destined to become old-fashioned, it is because it has never been new-fangled. He is not *Dieu merci*, "up to date," or *vingtième siècle*, or *nouveau salon*. He is not a decadent nor a symbolist, nor a Rosicrucian.'[53]

Such reservations counted for little. Sickert found himself drawn by personal ties into the current of the '*mouvement*' – at least as it

existed in London. He got on well with Rothenstein, and through him came to know Conder better. He befriended Beardsley and attended the Thursday tea parties that he held with his sister and mother in their Pimlico house. He saw Symons often at the music hall and became friendly with Robbie Ross, a young journalist, and friend of Wilde's, who was beginning to write art criticism in the papers. He was introduced to Max Beerbohm, the precociously brilliant half-brother of the celebrated actor-manager Herbert Beerbohm Tree, and he attended the receptions held by Ada Leverson (Brandon Thomas's sister-in-law), where many of these bright young talents gathered. They were a sparkling group. Sickert seems to have drawn a fresh energy from them, while they were in awe of his already apparent charisma. Despite his own relative youth and lack of worldly success, he possessed a glamour that captivated his juniors, even if it made some slightly envious. 'He had so much,' Rothenstein later recalled, 'wit, talent, looks, charm, it all came so easily to him. And he didn't seem to realize how lucky he was. He always thought that everyone could do as he did if they wanted to.'[54] Rothenstein certainly wanted to do as Sickert did.

But Sickert, too, was stimulated by the association. He enjoyed the verve, intelligence, and wit of his young companions, even if, inevitably, it drew him away from the close-bound world of the London Impressionists. Perhaps in recognition of the new spirit, he adopted a new look. The imposing, but distinctly Victorian, moustache went. The members of the Chelsea Arts Club were saddened by the loss of so impressive an adornment, and only partly mollified when Sickert explained that he had been finding it increasingly difficult to eat soup through such a luxuriant growth.[55] Herbert Vivian was shocked by the sudden reappearance of Sickert's curiously oblong mouth, and feared that he might be mistaken for a post box.[56]

While Sickert's new friends engrossed his interest, Ellen – not for the first time – was abandoned on the margins. Such behaviour was always justified by reference to Sickert's work, which stood as the most important thing in their shared life. Ellen's belief in Sickert's talent was unfaltering. It was a fact for which he was genuinely grateful, even if he often turned it to advantage. In the pages of Ellen's autobiographical novel *Wistons*, it is perhaps possible to trace the reflected outline of his selfishness: the husband's refusal to engage with his wife's friends

('Why should we bore one another?'), and his need to spend time with his own ('My work is so peculiar, so personal that I must occasionally be with people who see things as I see them').[57] His insistence on going where he pleased, and when ('I must attack my work from a new position; ideas are bubbling up, but they escape me here. If I don't get a change it will be fatal to the whole scheme. I daren't risk an hour's delay').[58] His retreats into silence as it suited him: even when they were all living under the same roof, he would ignore his wife and her sister, reading his book at meal times ('But there is nothing I have to say to [your sister], and you must have so much to talk about.').[59] Ellen, certainly, balked sometimes at Sickert's treatment. There were moments of complaint. Sickert later recalled, 'She used to scold me sometimes. And she went very pink when she was angry . . . a sort of carnation . . . charming. I had to fetch my palette and state the tone . . .'[60] But any concerted attempt at remonstrance would be disarmed by the appeal, 'You are on my side about my work, are you not?'[61]

In the face of these tactics the gentle-hearted Ellen was, it seems, all too often inclined to blame herself for their differences: the wife in her novel had many times 'sat in silent judgement' on the errant husband and, 'in her own mind, had given a violent verdict against him; a moment later, with quick revulsion of feeling, she would blame herself alone . . . "What am I," she asked herself, "compared to him?" '[62] Sickert would have made no effort to correct this notion. At each of her retreats, he blithely advanced, claiming even more freedom of action. Ellen struggled to maintain her balance. After the opening of the NEAC's 1893 spring show she did not remain in town long. Overcome by fatigue and depression, she left London for a month in the country. Sickert involved himself in the matter to the extent of suggesting her destination: Mortehoe, the North Devon village where he had spent the halcyon summers of 1874 and 1875.

For the first fortnight Ellen was accompanied by Mrs Sickert. Ellen was amazed to discover that, even after nearly twenty years, many of the locals still had 'the most affectionate remembrance' of the Sickerts from their earlier visits.[63] The 'good bracing air' of the place soon revived her spirits. She enjoyed the 'endless walks & little footpaths all among the rocks & hills', and also the fact that the local people were 'Radicals' and knew all about her father, 'so different', as she remarked, 'from the Sussexers'.[64] She took pleasure in Mrs Sickert's kind companionship and hoped that she would stay on when Walter

arrived towards the end of May.[65] This hope, confided to her sister Jane, betrays a hint, if only a faint one, of the strains that were playing upon her marriage. Perhaps another can be gleaned from the fact that Walter's own return to the bracing Mortehoe coastline had no discernible good effect upon his constitution. Back in London at the end of May he was looking ill.[66]

The Sickerts returned to Hereford Square. With the Cobden-Unwins away in America, they had the house to themselves, and were able to do some entertaining.[67] Jane had hoped that Ellen might have persuaded Walter to return to Mortehoe for August and September. Dieppe was so much his locale that Ellen was apt to feel left on the fringes of things there. Devon, Jane suggested, 'would be . . . more cheerful'.[68] But the plan was not realized. At the beginning of August the Sickerts were back in Dieppe.[69] The town acted with a magical effect upon Sickert. Oswald, who came over briefly with some of his university friends, reported to Eddie Marsh that his brother was 'perfect' there.[70]

There were no other family distractions that year. Bernhard was down the coast at Boulogne, sketching; and Mrs Sickert had taken Leonard – then nineteen – to Berlin, where he was to study singing at the conservatory.[71] (He had a beautiful voice, as well as a sense of music and a sense of taste: he liked Schumann and Schubert. The only anxiety was that – like Bernhard – he had an aptitude for 'laziness'.[72]) Other familiar friends were also absent. Blanche was still in Paris: his father had died on 15 August at home in Auteuil. Sickert sent a brief letter of condolence.[73]

Free of social obligations, Sickert was left to concentrate on his work. He had a studio room on the harbour front at 22 Quai Duquesne, and at the beginning of the summer he had ordered two dozen small panels – 10 × 6 inches – upon which to experiment.[74] The experiments seem to have gone well. Oswald reported that his brother was doing 'fine things', adding as an afterthought, 'I hope he will not spoil them.'[75] He was so engrossed in his self-imposed task that he declined an invitation to join Whistler and Beatrice in Venice.[76]

There were, however, occasional respites from painting. D. S. Mac-Coll was staying nearby in the little village of Ste Marguerite sur Mer, in a house party that included Conder; the American-born writer Henry Harland and his wife, Aline; Aubrey Beardsley's mother and sister; and a young painter called Alfred Thornton. Steer had thought of joining the group but declined when he learnt that MacColl was to be of the

party: 'That man', he said, 'would criticise God almighty to his face.'[77]
Certainly it was a bracing and lively gathering. Work was done, games
were played, flirtations carried on, and plans for the future mapped
out. Art, literature, and life were the constant subjects of debate when
the party assembled under the vine-clad gazebo at the local Hôtel des
Sapins to drink and talk.

The Sickerts went over for lunch one Sunday to sample – and add
to – the convivial atmosphere of the group: 'You can imagine how
pleasant it was,' MacColl reported to his sister.[78] A diminutive American
novelist called Jonathan Sturges had recently joined the party and
greatly amused them all with such deliciously affected comments as,
'I had a little mood on the road coming along here, but I hadn't time
to write it down', and 'I think I ought to make something out of this
"meelew"' – as he pronounced 'milieu'.[79] But aside from such droll-
eries, the principal topic under discussion was the unequal deal that
artists received from publishers. Their work was generally considered
a mere afterthought, used to illustrate the contributions of more
respected – and better remunerated – writers. It was a subject well
calculated to interest Sickert – and, indeed, his long-suffering wife.

There was a chance for further discussion at the end of August
when the party at Ste Marguerite broke up. MacColl, who was working
towards an exhibition at the Goupil Gallery, joined the Sickerts at
their pension in the rue des Tribunaux.[80] They all stayed on through
September and October.[81] MacColl tried to persuade Sickert to write
a book on 'drawing' for a series of art titles being planned by the
publishers Kegan Paul. The moment, however, was 'not fruitful'. Mac-
Coll supplied Sickert with 'foolscap, blotting paper and quill and shut
him into a room', but at the end of three hours the paper was still
virgin except for the words, 'As Bacon had said, "Art is man added to
Nature".' MacColl conceded that 'Perhaps there is not much more that
need be said, but it is not much for a book.'[82]

A seemingly more 'fruitful' venture was the plan that Sickert hatched
together with Alfred Thornton to run a series of art classes over the
winter.[83] Sickert had been obliged to give up his Glebe Place studio
that summer as an economy measure, but another suitable venue
presented itself.[84] It was decided, despite all Jane Cobden-Unwin's
reservations, to rent the de Morgans' house again for the winter.[85]
There would be plenty of room at No. 1 The Vale for students. Until
the house was ready, though, there was little to draw Sickert back to

Rev. Richard Sheepshanks, astronomer, mathematician, lover of ballet-girls and Sickert's maternal grandfather.

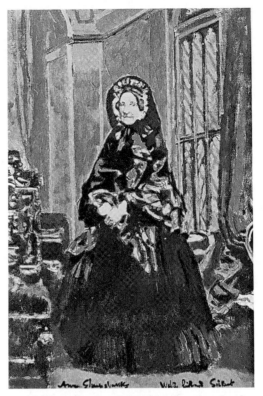

Anne Sheepshanks, Sickert's godmother (and great-aunt), painted by Sickert in the early 1930s from an old photograph.

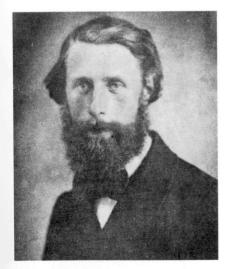

Oswald Adalbert Sickert, Sickert's Danish-born father.

Right Sickert's mother, Eleanor, painted by Oswald Adalbert Sickert; she was always known as Nelly. Sickert confessed that he never knew whether her 'exact name was Ellen, Eleanor or Elinor'.

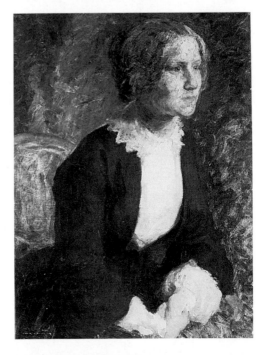

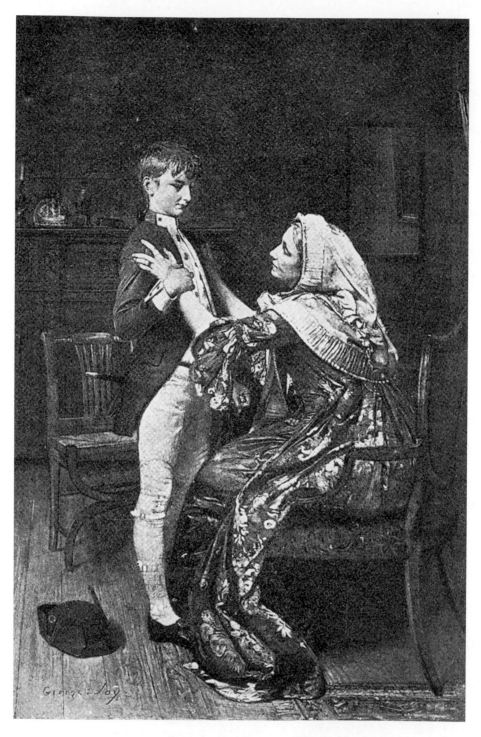

Walter Sickert, aged twelve, posing as the young Nelson for George W. Joy's painting *Thirty Years Before Trafalgar*.

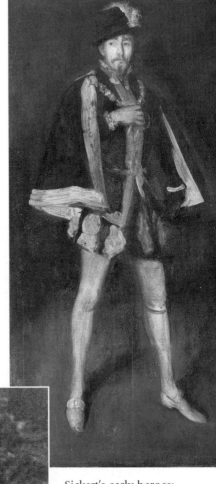

Sickert's early heroes:
Above left Charles
Keene (with bag-
pipes) in one of his
own drawings from
Punch.
Above Henry Irving in
the part of Philip II
of Spain, painted by
James McNeill
Whistler, 1876.
Left James McNeill
Whistler (right) with
Sickert's co-pupil,
Mortimer Menpes.

Opposite Edgar Degas and Walter Sickert at Dieppe during the Sickerts' honeymoon in 1885.

Above Ellen Cobden, Sickert's first wife.

Right Maggie Cobden, who would have considered marrying Sickert, had he asked her.

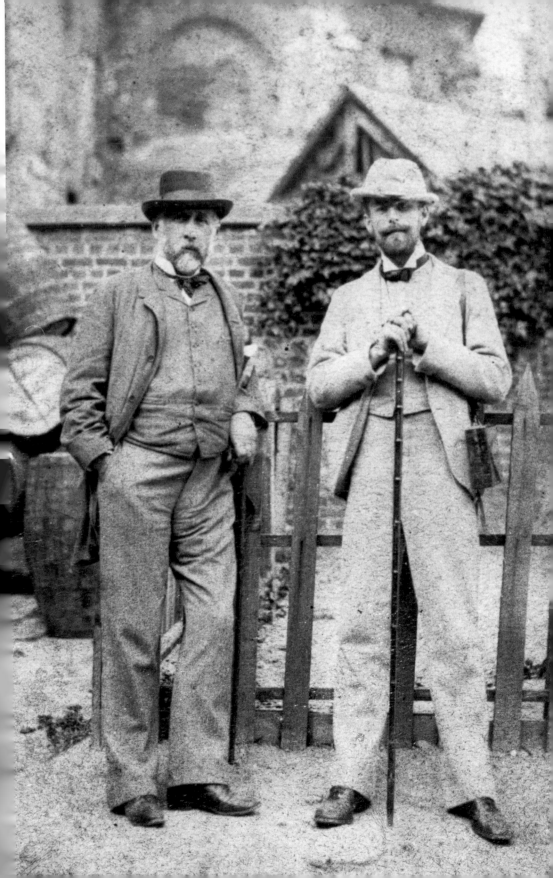

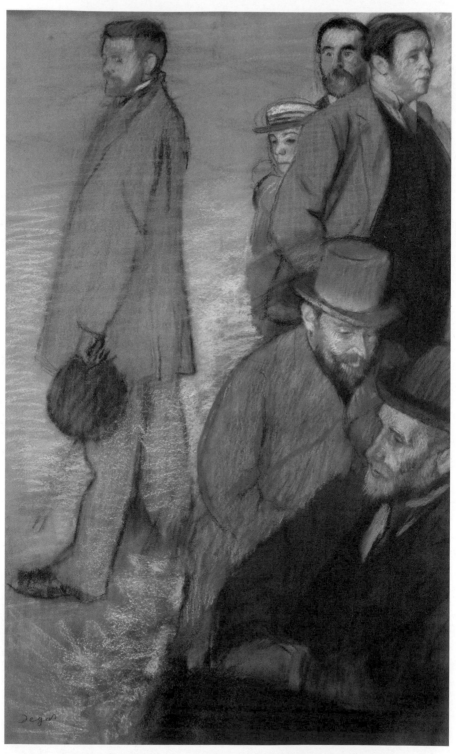

Six Amis, a pastel drawn by Edgar Degas in the summer of 1885.
From left to right: Walter Sickert, Ludovic Halévy, Jacques-Émile Blanche,
Daniel Halévy (in boater), Henri Gervex, Albert Boulanger-Cavé.

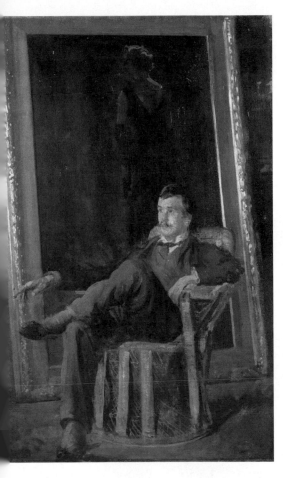

Left Philip Wilson Steer by Walter Sickert, 1890. The picture in the background is of 'Miss Fancourt' – otherwise known as the music-hall singer Queenie Lawrence.

Below George Moore by Walter Sickert, 1891.

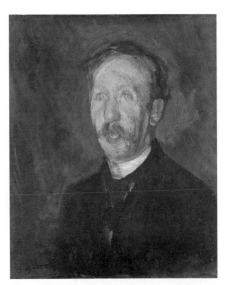

Right Florence Pash, Sickert's friend and patron, by Charles Conder.

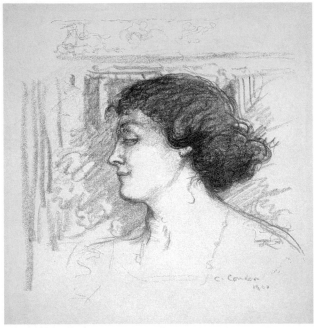

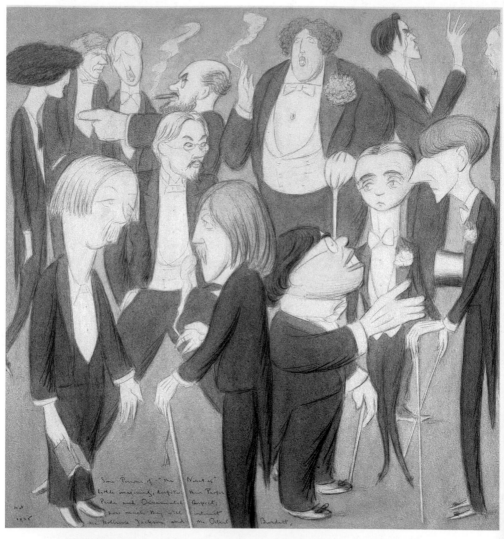

Some Persons of 'the Nineties' little imagining that despite their Proper Pride and Ornamental Aspect, how much they will interest Mr Holbrook Jackson and Mr Osbert Burdett by Max Beerbohm, 1925. From left to right: Richard Le Gallienne, Walter Sickert, Arthur Symons, George Moore, Henry Harland, John Davidson, Charles Conder, Oscar Wilde, Will Rothenstein, Max Beerbohm, W.B. Yeats, Aubrey Beardsley, and Enoch Soames.

London. At the end of October he took Ellen to Paris, depositing her with the Whistlers at the rue du Bac, where she had more sittings for her portrait.[86] The visit gave Sickert an opportunity to ask Whistler to take on the nominal role of 'Patron' for the new art school. Whistler consented to add his name to the 'galaxy of ex-governors and major generals, and an arch-deacon' who were already lending the project their respectability as referees.[87]

While in Paris, Sickert also called on Degas. He found his old friend 'doing splendid work', despite being troubled by an ever-growing blind spot. He was embarked on what Sickert described as a series of 'land-scapes guessed out of greasespots on the tablecloth'.[88] Degas' refusal to be constrained by the direct observation of a single scene, and his ability to turn everything to account in art, were things both new and exciting to Sickert. He challenged Sickert's assumptions with the maxim 'one gives an idea of the truth through the false' – a doctrine he illustrated with the explanation, 'When I want a cloud, I take my handkerchief and crumple it and turn it round till I get the right light, and there is my cloud.'[89]

Sickert returned to London alone at the beginning of November, lodging with his mother and brothers at Pembroke Gardens.[90] Having lingered so long in France, he had barely a week to 'do his NEAC picture – a large thing of the Hotel Royal' on the Dieppe front. But, as Oswald reported, 'he has been painting [the hotel] for years, & knows the drawing off by heart: that is Walter's best way of working really, so he may pull it through'.[91] Such optimism was well founded, even though Walter decided to combine the familiar lines and tones of the long, blandly symmetrical building with various novel elements. Encouraged by MacColl, he decorated the foreground with groups of figures decked out in vast stylized crinolines. It was a touch of fantasti-cal *dix-huitièmerie* that echoed Conder's experiments – and prefigured Beardsley's work – in the same vein. (The source for the figures was not, though, some eighteenth-century French print but a back number of *Punch*: MacColl sent him some drawings of women by John Leech, which he copied.[92]) The result caused general bemusement. Jane Cobden-Unwin, writing to Ellen in Paris, complained that 'the back ground of Walter's picture is uninteresting but clearly defined, but the foreground is simply absurd'.[93]

Classes at The Vale began before the end of the year. They were, as Thornton recalled, rather uneven affairs. 'Girls came in abundance'

to the day classes (which seem to have been taken by Amy Draper, a former Glebe Place neighbour and regular NEAC exhibitor) and in the evening, when there was a model to draw from, several of the local community of artists would look in.[94] Rothenstein became a regular and so did Oswald's old university friend Roger Fry, who was living in Beaufort Street and painting pictures that Oswald described as 'rather strange . . . combining realism with ideal composition'.[95] The designated 'men's day class' was, however, a disaster: 'Not a soul came' for the first few weeks; and when at last an individual did appear, Sickert – according to Thornton's account – lavished all the pains a teacher could upon a pupil: 'he enlarged on the immense value of fish glue for painting grounds; he explained carefully in what "quality" consisted, and defined drawing'. For six days the intense regime was maintained, but on the seventh the pupil 'took a train to the north and, once over the border', so Thornton understood, 'committed suicide'.[96]

Sickert's educational approach was not perhaps well suited to the oversensitive. It combined absolute certainty with abrupt change. In matters of painting technique – as in most other things – Sickert was a man of strong opinions loosely held. It was disconcerting for his students – as it was for his friends – 'at one time to hear that brown grounds were essential and not long after that brilliant white ones were, or next that fish glue in priming was the sole road to technical salvation, and then *toile ordinaire*'.[97]

Despite the passages of concentrated tuition the school did not take up all Sickert's time. Indeed Thornton recalled that the most instructive and amusing part of his association with Sickert was their walks around Chelsea and his friend's 'pungent comments' on the passing street scenes and local characters.[98] Sickert also helped MacColl to hang his exhibition at the Goupil Gallery's new premises in Lower Regent Street, and then helped him even more by writing a glowing review of the show for the *Manchester Guardian*.[99]

For the younger members of the NEAC he remained a focal point. Rothenstein took over his old studio in Glebe Place, buying the various fittings he had left there for a very welcome £5, and inaugurating his tenancy with a bacchanalian dance, at which even George Moore took to the floor.[100] Rothenstein also persuaded Sickert to pose in the draughty hallway of Jacomb Hood's Tite Street studio for a group portrait along with Steer, MacColl, Beerbohm, and a young portrait-painter called C. W. Furse.[101] Sickert also saw a good deal of the Beards-

leys. With the approach of Christmas, Aubrey and his sister Mabel set
up a tree and decorated it with improbable conceits, including 'a very
malicious caricature' that Beardsley had drawn of Whistler. Sickert
carried off this trophy as his Christmas present.[102] He also charmed
Aubrey's mother. She was forty-five (the same age as Ellen), fond of
France, and susceptible to flattery. Together with Robbie Ross he visited
her when she was laid up with sciatica over the Christmas holiday in
a Harley Street nursing home.[103]

Ellen returned to London soon after Christmas. Perhaps it was her
arrival – as much as the school's presence – that prompted Sickert to
rent a small studio room on the second floor at 127 Cheyne Walk, at
the 'shabby end' of the Chelsea Embankment, west of Beaufort Street.[104]
Rothenstein was amazed at the location: 'one of the few ugly houses
on Cheyne Walk'. Sickert's taste for 'the dingy lodging house atmos-
phere' was something new to Rothenstein's experience. It also seems
to have been new to Sickert. Though he had always had a relish for
the low life of the music hall, the room in Cheyne Walk was his first
excursion into the low domestic milieu. It gave an early hint of what
Rothenstein came to regard as Sickert's 'genius for discovering the
dreariest house and most forbidding rooms in which to work'. That
Sickert remained himself so 'fastidious in his person, in his manners,
in his choice of clothes' was a bizarre anomaly. It suggested to Rothen-
stein that, in his quest for the drab, he might be 'affecting a kind of
dandyism à rebours', trumping – as it were – the aspirations to conven-
tional dandyism of Beardsley, Beerbohm, and Rothenstein himself.[105]

The dingy setting did not, at this stage, produce any effect upon
his work. Portraits, music-hall scenes, and views of Dieppe remained
the staple of his output, such as it was. The crowded schedule of
teaching, and the distractions of leisure, left him little time for painting.
He tried to guard his work hours – ruthlessly putting off people who
suggested they might call at his studio room. When Rothenstein took
umbrage at one such rebuff, Sickert chaffed him not to 'misunderstand
my wish to be left alone here. It is nothing personal to yourself. I have
only a few hours a day here. I arrive tired, I want every minute for
work & when I am done I want to leave the place altogether. I have
to answer the door myself, generally, which is 2 flights of stairs. So
don't be a goose.'[106]

* * *

Sickert spent the first day of 1894 wandering through a thick yellow London fog with Rothenstein, MacColl, and Steer, visiting art galleries.[107] At the New Gallery, the established bastion of Pre-Raphaelitism, they encountered Ricketts and Shannon's friends Katherine Bradley and Edith Cooper – an aunt and niece who lived together in Hampstead at a constant pitch of aesthetic intensity, collaborating on poems and verse-dramas under the joint name of 'Michael Field'. From the record they left of the encounter in their journal it seems that Sickert was playing up to his pose of the dandy *à rebours*. They described him as 'barley-coloured, gritty with an uncouth sensitiveness in his features, and humour he keeps in a strong-box. We found him gazing at a Flemish picture, and the grim impressionist confessed he loved to have unprofessional enjoyment of sharp clean detail, when no one was looking! We all had tea together and chose the most creamy confectionery, except Sickert who had a *bun*.' 'Buns for bears', as William Rothenstein commented.[108]

There was an undercurrent of expectancy beneath the cake eating: word of an exciting new venture was in the air. The ideas discussed with MacColl and others at Ste Marguerite and Dieppe the previous summer had crystallized into action. Harland had approached John Lane, an innovative young publisher who was aiming to become the promoter of the 'movement', and had put forward a plan for a new quarterly that would include artistic and literary contributions as distinct and separate entities, rather than having the one illustrating the other. Lane seized on the idea, stipulating only that Beardsley should be the art editor. The periodical, it was decided, should have the format, not of a conventional magazine, but of an 'ordinary French novel': it was to be called the *Yellow Book*.[109]

Beardsley eagerly accepted his new responsibility. The quarterly, in his conception, was to be both modern and daring. With this in mind he hurried at once to Sickert for a contribution.[110] Lane seems to have tried to exert a moderating influence, pressing for the inclusion of such establishment figures as Sir Frederic Leighton and J. T. Nettleship; but the principal artistic contributors were core members of the NEAC, exponents of the 'New Art'. Rothenstein and Steer were Beardsley's other first thoughts.[111] MacColl, however, felt obliged to decline owing to an unfortunate dispute that had arisen between his friend Conder and Henry Harland over some pictures that Harland had taken on consignment. Ricketts and Shannon also held back, feeling that the

new quarterly might compromise the force of their own occasional publication, *The Dial*.[112] Such absentees left more space for Sickert's work and Sickert's name.

Beardsley's first notion had been to get 'drawings' from the various artistic contributors, as it was possible to reproduce line work faithfully with photo-zincography. And Sickert did supply one pen-and-ink work – a slight sketch of a young woman in a hat reading a rather small book; it was an image that, with its suggestions of female independence, education, and emancipation, was calculated to unsettle, if not to shock, a contemporary audience.[113] But Beardsley wanted to make full use of Sickert's infamous reputation as the artist of the music hall, and so decided to include, too, some of his theatrical paintings.

In a feat of remarkable dispatch the first number of the *Yellow Book* was published only a few months after its conception – on 16 April 1894. To mark the occasion there was a celebratory dinner at the Hotel d'Italie in Old Compton Street, Soho. It was a crowded and jubilant affair. Some fifty contributors, prospective contributors, supporters, and well-wishers crammed excitedly into the hotel's upstairs dining room. Steer sat silent and sober amidst the din, next to the amazed Alfred Thornton. Sickert added to the cacophony. There were speeches from the top table, as Harland, Lane, and Beardsley toasted the new venture. Then followed some extempore contributions from the floor. Sickert, it was agreed, made the hit of the evening, rising to say that he 'looked forward to the time when authors would be put in their places by being compelled to write stories and poems around the pictures, which should be supplied to them ready-made by their taskmaster the artists'.[114]

The appearance of the *Yellow Book*, well hyped in advance, provoked a huge – if largely hostile – reaction in the press. The magazine became the phenomenon of the hour and was reprinted twice within days. Although of the 'art' contributors it was Beardsley who drew the most fire (his drawings were damned as – amongst other things – 'ugly', 'meaningless and unhealthy', 'objectless', 'incomprehensible', and 'repulsive'), he was seen as belonging to the world of 'New Art' presided over by Sickert and the NEAC. Several reviewers lumped the two artists together as the twin heads of the awful new phenomenon.[115]

The *Yellow Book* carried Sickert's work to a wider public. It was not, of course, his first appearance in the press, but the 'art' contributions

of the new quarterly – each one printed on its own page and preceded by a title page and a film of glasspaper – enjoyed a different status, and were of a different sort, to the conventional portrait work that he had previously published in *The Whirlwind* and the *Pall Mall Budget*. John Lane, moreover, ensured that the new quarterly had an international profile. Copies were not only sold on the Continent but also in America. Sickert's work became known for the first time across the Atlantic to an audience that – if small – was keenly interested.[116]

The close connection between Sickert and Beardsley, and between the worlds of the NEAC and the *Yellow Book*, was confirmed in the eyes of the popular press by the club's spring exhibition, the opening of which all but coincided with the quarterly's launch. Beardsley exhibited *L'Education Sentimental*, while Sickert reasserted his position as the artist of the 'Halls' with a boldly atmospheric painting of *The Sisters Lloyd*. It was the first stage picture he had shown for over a year and was considered to be so devoid of detail and definition as to be almost unintelligible.[117] Although the painting – along with another of his submissions (a dramatic Whistlerian self-portrait titled *L'Homme à Palette*) – may well have been several years old, they were viewed as belonging very much to the moment.[118] The *Punch* reviewer – 'one more (or less) impressionable' – satirized *The Sisters Lloyd* as the acme of originality: 'One of Mr Sickert's supreme things. Thus to be more original than the original, is to paint the piccalilli and to gild refinéd gingerbread.' He also disparaged what he saw as Sickert and Beardsley's affected use of French titles for their work.[119]

Sickert enjoyed his place at the heart of the *Yellow Book* circle. He went to John Lane's 'smoking party' at the Bodley Head offices, and attended the Harlands' parties at their Cromwell Road Flat.[120] He gave Beardsley his first and only painting lesson, and discussed with him theories of black-and-white decoration. (It was Sickert's not wholly justifiable contention that the success of a black-and-white image depended on there being more white than black on the page.[121]) He followed his own formula in the several pen-and-ink drawings that he made of Beardsley in the draughtsman's orange-and-black drawing room at Cambridge Street.* He also painted a small full-length portrait

* In later years one of these drawings was misascribed as a Beardsley self-portrait. Sickert's scrawled signature was read as a caption – 'Sickest', suggesting – it was thought – the invalid Beardsley's comment on his own condition (WS, 'L'Affaire Greaves', *New Age*, 15 June 1911).

of the febrile young Beardsley in morning suit, hat in hand, a shaft of light striking his sharp, angular jawline.[122]

The picture was published in the second number of the *Yellow Book*, along with reproductions of two more early music-hall paintings. Beardsley thought them 'amazing . . . Quite his best stuff.'[123] Sickert's influence was proclaimed throughout the volume. His former pupil Francis Forster contributed a picture, as did his sometime teaching partner Alfred Thornton.* Sickert's influence secured a place for one of Bernhard's drawings, and also for a short story by Oswald – or 'O' as he discreetly signed himself. Having come down from Cambridge, Oswald was trying to make a career as a writer, and Fisher Unwin had agreed to take some of his stories for his newly established list, 'The Autonym Library'.[124] Sickert delighted in his position of influence. It was, however, one that drew him away from the solitude of the studio. A reaction became inevitable.

* The first season of the Chelsea Life School had ended with the Sickerts' tenancy at The Vale in mid April 1894.

CHAPTER FOUR

The End of the Act

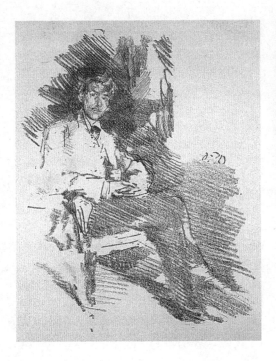

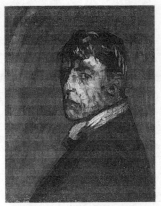

Walter Sickert, self-portrait,
1896

Walter Sickert by James McNeill Whistler, 1895

I

GATHERING CLOUDS

Walter has not done much new work.
(Jane Cobden-Unwin to Ellen Cobden-Sickert)

After their brief sojourn at The Vale, Sickert and Ellen were back in Hereford Square, and despite the competing excitements of the *Yellow Book* Sickert seems to have made some effort to involve himself in his wife's world.[1] He even undertook to make a portrait of the spherical old Cobdenite, Tom Potter. The work got off to a false start when, following an excellent pre-sitting lunch, both Sickert and Potter fell fast asleep at the dining-room table. After that failed experiment Potter, despite his age and girth, took to visiting Sickert at his Chelsea studio. He clearly had colourful ideas about the artistic lifestyle in general – or, perhaps, Walter's in particular: on arriving he would instigate a search of the room, with the excited enquiry, 'Any models under the table, Walter?' It is not recorded that there ever were.[2]

Sickert was restless. He felt the need to refocus his energies. His brother Oswald claimed that he was anxious to escape the social distractions of Chelsea, 'where he is liable to meet a man with a moustache & tennis racquet, who if he knows him, wants him to come in & have a whiskey and pipe, or if he doesn't looks at his coat and thinks it's too short or long behind'.[3] It seems hard to believe that the unfashionable end of Cheyne Walk was thronging with moustachioed men clutching tennis rackets. It was the sociable young contributors to the *Yellow Book* and the sociable young members of the Chelsea Arts Club that he was more likely to encounter. But though stimulating individually, they were tiring en masse. There was a danger of what Sickert termed 'boredom in gangs'.

Several years later he wrote to a female protégée setting out the traps and limits of sociability for the artist:

My experience is exactly the same as yours. I only smoke too much or drink too much when I have to traverse the efforts & fatigues of useless company, or unrefreshing company. We who like work best, & work for all our strength is worth, can only do with company that is nourishing either to body or soul or both. Two things, in company are good, firstly assemblies (luncheon parties, dinner parties, tea parties, supper parties, concerts, music halls, theatres, breakfast parties &c). These we *can enter & leave when we like*. So we are masters of what the French call le dosage, the amount of the dose. Secondly tête-à-têtes . . . Tête-à-têtes with someone who is a comrade are probably the best & most refreshing recreation in the world . . . You are young and can stand a lot but you won't always be. Save your precious nerves. You must not be perpetually in a state of purposeless excitement. The grounds must be allowed to *settle* and *the coffee to clear* . . . Set aside *deliberately & consciously some hours every day to tête-à-tête* rest, amusement & refreshment . . . Don't stand any nonsense from your men friends and lovers. Keep them *tyrannically* to their settled hours – like a dentist – the hours that suit you – and them so far as possible. Don't give any one any rights. Exact an absolute obedience to time *as the price of any intercourse at all*. Don't be a tin kettle to any dog's tail, however long.[4]

The advice was sound. But in Chelsea in 1894, with so many friends and acquaintances close at hand, Sickert found it hard to follow. It is possible, too, that he was embroiled in an unsatisfactory affair with Amy Draper. The evidence is vestigial: no more than a disparaging reference to 'Miss Draper' in one of Jane Cobden-Unwin's letters, the fact that Amy moved from being Sickert's neighbour at Glebe Place to being his neighbour at Cheyne Walk, and Sickert's complaint to Florence Pash of their mutual friend 'A. D.' – described as 'a brute & a fool' to 'want a man to divorce his wife to marry her'.*[5] Having a demanding mistress living only a few doors along from his studio would certainly have done little for Sickert's 'precious nerves'. But if the streets of Chelsea were thick with friends and lovers, they were also heavy with associations. Whistler had so thoroughly made the place his own, through his nocturnes and street scenes, and though some, like Roussel

* Sickert's objections to Amy Draper, not untypically, also took artistic form. He complained to Florence that she 'imitates and assimilates one's work too quickly, and vulgarises it' (WS to Florence Pash, in Violet Overton Fuller, 'Letters to Florence', 18).

and Maitland, might be content merely to echo his achievements, Sickert was not. He needed a new space for himself and his art, and found it just north of the Euston Road. Oswald, borrowing the affected pronunciation of the American novelist Jonathan Sturges, announced that Walter was enjoying the discovery of this new 'meelew', an un-explored territory 'somewhere between Cumberland Market & Regent's Park, far away from the districts of gentility he hates so much'.[6]

Originally laid out at the end of the eighteenth century by the architect John Nash as a service district for the grand stucco-fronted terraces facing on to Regent's Park, the area had never quite found its feet. Not long after its completion it had been decimated by the coming of the railways. The lines running in and out of the nearby terminus at Euston sliced through the estate, bringing noise, dirt, Irish navvies, and semi-itinerant railway workers. The big houses were divided into lodgings and doss houses, and so were the smaller ones. Nash's vision of an area built around three large produce markets (for meat, veg-etables, and horse fodder) all supplied by the Regent's Canal was never fulfilled. Only Cumberland Market (for straw and hay) established itself. The other two market piazzas swiftly evolved into the shabby residential quarters of Clarence Gardens and Munster Square.[7]

Although distant from the incestuous cosiness of Chelsea, the area was not without artistic associations of its own. Cheap rents and rela-tive proximity to the centre of town had tempted several painters and sculptors to set up there. Leighton's studio at Osnaburgh Street was on the northern edge of the district, and the genial, beak-nosed sculptor Fred Winter, who acted as treasurer for the NEAC, had a workspace at 13 Robert Street, one of the short cross streets running between Hampstead Road and Albany Street. Sickert took the room next to Winter's. The place must have fully confirmed Rothenstein's views on Sickert's genius for discovering insalubrious locations. Even by the standards of Camden Town the new studio was unprepossessing – reached 'through a dingy passage of a tenement house reeking of cats and cabbage'. It had previously belonged to a sculptor who found the damp and cold of the room excellent for keeping his clay moist.[8]

Winter and Leighton, like all the artists who worked in the area, considered it no more than a convenient and cheap locale. Sickert was unique in seeing its possibilities as a subject. He detected a charm in its failed grandeur and busy street life. He would have known something of the area already from his excursions to the Bedford Music

Hall at the top of Camden High Street, but now he began to explore
it more thoroughly, to make it his own. It was a further development
of his inverted dandyism. The first paintings that he made of this new
milieu seem to have been night scenes of Cumberland Market and
Munster Square. It is hard not to suppose that they represented a
homage – and a challenge – to Whistler's celebrated nocturnes of
the Chelsea Embankment. Eschewing the aestheticizing haziness of
Whistler's approach, which might turn a factory chimney into a campa-
nile, Sickert set down his urban visions with an unflinching directness,
marking out the stark silhouettes of the blank-faced houses.[9]

Having established himself in his new locus, Sickert returned to
an old one. He and Ellen went over to Dieppe in July. It was perhaps
that summer that Ellen sat to Blanche for her portrait. Walter was busy
with his own work, though he broke off at 12.30 each day to meet
up with his brother, Oswald, who was also there. They would sit
outside the Café de Rouen (across the way from the Café des Tribu-
naux) and Walter would 'draw pictures on the little round tables' and
point out the celebrities of the season.[10] When Walter returned to
London, Ellen did not accompany him. The absence of a settled home
was taking its toll on their relationship, drawing them ever further
apart. They had not taken The Vale again.[11] Ellen went instead to
Innsbruck in the Austrian Alps – the first stop on what proved to be
a long and, for the most part, lonely tour of foreign watering places[12]
– whilst Walter lodged in his new studio at Robert Street.

For all the exalted claims made for the independence of 'art' by
the editors of the *Yellow Book*, the wider commercial world remained
unswayed. Illustration was still the readiest way for an artist to gain a
publisher's commission. Sickert bowed to this truth when taking up
a suggestion that he might provide some drawings for an illustrated
edition of George Moore's realist novel *Esther Waters*. The publisher,
Rudolf Dircks, of Walter Scott & Co., was, however, unconvinced by the
samples Sickert submitted.[13] Sickert continued to be well represented in
the *Yellow Book*. The third number, which appeared in October 1894,
carried three more music-hall or theatrical subjects, including a new
depiction of Collins' Music Hall, which he submitted for the winter
exhibition of the NEAC.[14] For the first time since the Impressionist
clique had seized control of the club Sickert was not represented on
the election or hanging committee. He was away, having joined Ellen
in Venice at the beginning of October.[15]

Nothing is known of Sickert's first visit to what he came to call 'the loveliest city in the world'. He already knew it well at second hand, for it had been a sacred place for Whistler. Sickert had helped print the master's Venetian etchings, and had even made his own versions of two of them.[16] He had also studied the Canalettos in the National Gallery. He does not, however, seem to have rushed to work. No drawings dated to 1894 have been traced. It was simply a chance to be with Ellen. Despite their recent difficulties, Sickert was still deeply attached to – and wholly dependent on – her. Venice became a place of happy association for them, and over the next two years it was where they spent most time together. The holiday, however, was brief. By the end of November Ellen had made her way to Florence, and Sickert was back in London.*

Unencumbered by a wife or a household, Sickert gravitated back to the company of his *Yellow Book* friends. He joined in their excited discussions at the Café Royal and the Hogarth Club and saw much of Rothenstein and Steer.[17] One evening, George Moore got him into a corner and mapped out – in elaborate detail – an idea he had for a new play he was working on.[18] Rather more fruitful were Sickert's encounters with another club regular, the *Yellow Book* publisher John Lane, who commissioned him to make a portrait drawing of Richard le Gallienne for inclusion in the next number of the periodical. Sickert insisted that the exquisitely poetical Le Gallienne (author of such titles as *English Poems* and *The Book Bills of Narcissus*) should sit for him at Robert Street, claiming – somewhat improbably – that the studio was 'specially well organised in the matter of light & warmth'.[19] Sickert took a particular pleasure in introducing his dandified young friends to the uncharted world of Cumberland Market and Camden Town. Although Fred Winter affected to be alarmed when he encountered Sickert leading Max Beerbohm off to lunch at the sawdust-floored local pub, where they served 'a steak-and-kidney pudding the size of a billycock hat for 9d', Sickert had the gift of making himself at home in any company. He won the amused goodwill of the local populace, and the factory girls and street urchins greatly enjoyed their glimpses of Le Gallienne, Beerbohm,

* Ellen maintained a proxy presence in London. Her portrait by Whistler was on view at the New Gallery. Jane thought it 'most artistic and charming', even though 'the face is rather too hazy'. Another picture of Ellen – by Blanche – was showing at the NEAC.

Rothenstein, and the other immaculately turned-out young men of the period.[20]

Another visitor to Robert Street that winter was Whistler. Beatrice had fallen ill and he had brought her back to England to be treated. Sickert welcomed his former master and gave him the run of his studio. Whistler, to escape his anxieties about Beatrice, threw himself into work, starting a number of portrait commissions. A succession of sitters arrived at Robert Street: Robert Barr, a Canadian journalist whom Whistler had met at the Pennells; his daughter, Laura; and Mrs Walter Cave, wife of the prominent architect.[21] Sickert, his space taken over, found it easiest to fall in with Whistler's arrangements and did several pictures from the same models.[22] While Whistler was working on his portrait of Miss Barr, Sickert made 'a very complete' pencil drawing of her, which he sold or gave to the father.[23] Whistler was not the easiest of guests. Reassuming his magisterial position, he 'took up and nearly finished' the painting of Mrs Walter Cave that Sickert had planned and begun. Sickert had to make a second version.[24]

Away from the studio they went about together and tried to rekindle some of the old energy and excitement of their friendship. Jane Cobden-Unwin reported to Ellen that Walter had brought 'Jimmy' along to a dinner party at Hereford Square – 'so they were only ½ an hour late!' They were both on splendid if rather wild form.[25] Despite the hilarity of that evening, it seemed to some that a slight 'coolness' was creeping into relations between the two men.[26] Sickert, having achieved his independent status, was not eager to resume the position of a mere minion, and Whistler turned increasingly to the comforting sycophancy of the Pennells. It was at their Buckingham Street flat, one evening, that he made a small lithographic portrait of Sickert sitting slightly ill at ease in a low chair beside the fire, his expression seeming to hover between concern and defiance.[27]

Whistler's presence at Robert Street was scarcely convenient. Sickert was striving to get ready for a major exhibition, to be shared with his brother Bernhard. It was to be held at van Wisselingh's Dutch Gallery, at 14 Brook Street, off Hanover Square. Goupil's might have been a more obvious choice of venue: its manager, David Croal Thomson, had been the first to support the London Impressionists and had maintained his interest in the members of the group. By comparison, E. J. van Wisselingh was a newcomer to contemporary art – a 'solemn and melancholy Dutchman of great judgement' who traditionally

specialized in 'French and Dutch Masters'.[28] He was, however, an occasional presence at the soirées gathered by Ricketts and Shannon, had held an exhibition of watercolours by the 'London Impressionist' Francis James in 1893, and the following year had mounted a modestly successful show of lithographs by Shannon and Rothenstein. Encouraged by these experiments, he sought out other young artists.[29]

It appears that he originally approached Bernhard, whose small landscape panels were gaining a reputation,* but the plan stalled. Perhaps it was to encourage both parties that Walter agreed to be part of the new project. Bernhard, certainly, was always in need of encouragement. For all his good notices he was still easily cast down and distracted. He had begun to drink heavily, not from any sense of hedonistic abandon, but with the steady deliberate desire to escape the pressures and disappointments of the moment.[30] Walter always felt some shade of responsibility for his brother's artistic career. He, after all, had persuaded their mother to allow and to finance it.[31]

Walter gathered together almost fifty pictures – oils, watercolours, etchings, drawings – for the show, which opened on 19 January 1895 with a crowded private view.[32] The exhibition could – perhaps should – have been a crowning triumph, but oddly it failed to ignite. It provoked neither a *succès de scandale* nor any increased acceptance of Sickert's art. It was a bad time of year: people were away, the newspapers were quiet, and George Moore was not writing in *The Speaker* that January. Also, sharing the exhibition with his brother weakened its impact. Bernhard's small landscape panels were neither conventional enough to set off Walter's experiments, nor striking enough to raise the general temperature.

But the real cause was probably Sickert's choice of pictures. It was less a concentrated show of force than a loose gathering of bits and pieces. Only one picture was a loan (*Jeanval*, 'lent by Mrs Gellibrand'), the others were an assortment of still unsold works, dating back over the previous ten years. There were too many 'sketches and studies'.[33] As Jane Cobden-Unwin reported rather tartly to Ellen, after visiting the show, apart from the portrait of Beardsley ('grotesque, but like him') Walter had not done much new work.[34] Several, though not all,

* As early as November 1893 Oswald reported to Marsh that Bernhard was 'perhaps going to have a show by himself at Van Whistling's [*sic*], but it is not decided'. Oswald considered Bernhard's recent panels of Boulogne 'simply *marvellous*, far better, & swaggerer & prettier & more accomplished than anything before'.

of his music-hall scenes were on view, but they were becoming almost
too familiar – many had already been exhibited at the NEAC and seen
in the pages of the *Yellow Book*.[35] Roger Fry, for one, registered a sense
of anti-climax. The show seemed to him 'less than it would have done
some years ago'. The pictures were, he admitted, 'very clever, but . . .'.[36]
MacColl, in his not ungenerous *Spectator* review, noted that Sickert
lacked Degas' sure 'sense of design' and that the whole exhibition was
'low toned to such an extent that a frame brighter than usual about
extinguishes the picture enclosed'.[37] Even hostile critics could not sum-
mon up much sense of outrage: 'Everyone is acquainted with the
peculiarities of Mr. Walter Sickert's taste,' remarked the reviewer for
the *Illustrated London News* with an affectation of weariness, 'his prefer-
ence for subjects which to most eyes seem, if not unpaintable, at least
unsuitable to pictorial art.'[38]

Perhaps the most praised picture in the exhibition was the oldest.
Sickert's painting of Helen Lenoir slumped on the sofa, first exhibited
in 1886 as *Rehearsal: The End of the Act*, was brought out again and
melodramatically retitled *Despair*. The change was an early instance of
Sickert's cavalier attitude to picture titles, and his ambiguous fascin-
ation with the conventions of popular Victorian narrative art. Its effect
was telling. Guided by the new title, the critics lauded the painting
for its 'real sentiment and harmonious treatment'.[39] Sickert, though
doubtless amused by such comments, had to acknowledge that, over-
all, the show had not been a success. It added little to his standing,
and less to his bank balance, at a moment when some enhancement
of either – or both – would have been welcome. He was left with a
heavy frame bill, a few notices of guarded praise, and a sense of
disappointment.[40] If he needed consolation, he found it away from
the studio.

With Ellen in Italy, Sickert was embarked on a liaison with a woman
called 'Ada'. It is possible, even probable, that this was Ada Leverson,
the sister-in-law of Brandon Thomas. She had already had at least one
affair – with George Moore – and though that romance had burnt out
she remained always susceptible to the talented, amusing, and original.
Sickert was all three,[41] and they certainly saw much of each other at
this time. When Ada wrote to Max Beerbohm, who was travelling in
America in the unlikely role of 'press secretary' to his half-brother
Herbert Beerbohm Tree, she filled her letter with amusing news of him
(news, alas, not preserved by Max).[42] One of her short stories was to

be included in the fifth number of the *Yellow Book* and Sickert secured the commission to draw an accompanying portrait. Nor was the little black-chalk *Bodley Head* the only picture he made of her. There was also a painting, showing her lounging in a hammock, exhibited at the NEAC that spring, along with portraits of Mrs Walter Cave and Max Beerbohm's other half-brother, Evelyn.[43]

It is not certain whether any hint of the affair reached the Cobden-Unwins, but they became increasingly worried about Sickert's behaviour. It had been arranged that he should go out to Venice to join Ellen in May, but they hoped to persuade him to come and stay with them at Hereford Square until he departed.[44] It is doubtful that they succeeded, for Walter was relishing his freedom. Whistler had returned to France in February for the beginning of his trial against his former patron, Sir William Eden. An irascible, hard-riding baronet, with a genuine passion for art, Eden was suing Whistler in the French courts on account of the artist's refusal to hand over a portrait of Lady Eden, despite the fact that it had been paid for.[45] Sickert dashed off a sympathetic note to Whistler about the proceedings, but he had no wish to engage in the matter. His closing claim, 'I am horribly hard at work, seen & heard nothing', seems to have been a tactful fiction.[46]

He was not hard at work. On most days – at two o'clock – he found time to meet Oswald at the Café Royal for an afternoon's idle enjoyment. Oswald, rather to his own dismay, had got a job writing notices for the London office of an American newspaper-publishing company. When he complained about the taxing 'nine to six' regime, Walter reassured him with the observation, 'You needn't bother about it, you'll be kicked out of the business soon enough.'[47] He lasted until October, which, considering his afternoon habits, was an impressive enough stint. Walter's own commitments were slight. A new magazine called, appropriately enough, *The Idler* had been launched, edited by Jerome K. Jerome, though Robert Barr was also involved with its production. Sickert was asked to provide music-hall drawings. The sketches he supplied – characteristic images of Minnie Cunningham, the Sisters Lloyd and others – had for the most part been made during the previous four or five years. Combined with his continuing appearances in the *Yellow Book*, they maintained his reputation as the artist of the modern music hall with the minimum of effort.

Whistler's legal dealings did not go smoothly. The judgement went against him. Although ordered to hand over the portrait to Eden and

pay damages of 1,000 francs, he refused to acquiesce and at once
lodged an appeal, as well as launching an attack on George Moore
who had supported the baronet's case. Sickert managed to avoid being
drawn into the fray, and Whistler's busy indignation was soon drowned
out, lost in the far greater storm of Oscar Wilde's libel action against
the Marquis of Queensberry.

Sickert made no moral judgement about Wilde's homosexuality,
which stood as an open secret and a running joke amongst the *Yellow
Book* set, even if – despite his own enthusiasm for low life – he found
the world of rent boys and pimps in which the Irishman sought his
pleasures incomprehensible and 'hideous'.[48] He did, however, question
the wisdom of Wilde going to law to deny his behaviour. Queensberry,
having deliberately goaded Wilde into action, was aiming to justify
the supposed libel. Those, like Sickert, who knew the true facts of
Wilde's life felt sure that they must be exposed in court. When Robbie
Ross entered into similar proceedings some twenty years later, Sickert
wrote in exasperation at such 'gratuitous folly'. Legal action in such
circumstances was, he considered, sheer hubris, 'the impudent bluff
. . . which is supposed always to call down the lightning'.[49]

Sickert's association with Ada Leverson drew him close to the hub
of events as the great scandal unfolded. Mrs Leverson was one of
Wilde's most devoted friends: her drawing room was a haven for him,
and became a centre for his supporters; and it was her husband, Ernest,
who lent Wilde the £500 necessary to launch his case. The loan was
a generous one, for to many of Wilde's friends it seemed clear that his
action was doomed. Bernard Shaw and Frank Harris both urged Wilde
to drop the case, and Sickert added his voice to this chorus.[50] But
Wilde ignored such advice and, as Sickert had foreseen, the lightning
struck. The case against Queensberry collapsed, the tables were turned,
and the matter referred to the Attorney General. Many hoped that even
at this point Wilde might save himself. But he refused to flee, was
arrested, and sent for trial. Sickert did not stay to witness the protracted
torture of Wilde's two trials as they dragged on from mid April into
May.* He crossed over to the Continent, taking the boat train that
Wilde had eschewed, and headed for Venice.[51]

* The first jury was unable to reach a verdict, the second convicted Wilde, who was
sentenced to two years with hard labour.

BRIDGE OF SIGHS

I have had some rather worrying years since I saw you.
(Walter Sickert to Minnie Cunningham, 31 August 1897)

Ellen had fallen in happily with the Venetian expatriate social scene, and Walter was pleased to join her,[1] delighted to find himself out and about 'wearing white gloves'.[2] The English community in Venice revolved around various fixed points, none more fixed than Lady Layard, wife of the archaeologist Sir Henry Layard. It was the Layards who had financed the construction of the Anglican church in Campo S. Vio, and they regarded themselves as the arbiters of decorum. Their residence was known amongst the livelier members of the expatriate crowd as 'the Refrigerator'.[3] Other spots were rather less chilly. Sir William Eden's cousin, Frederic, had – together with his wife – created a beautiful garden on the Giudecca, known predictably as 'the Garden of Eden', where expatriate society gathered on sunny afternoons. Perhaps it was there, on the shaded pathways (surfaced with boatloads of shells brought from the Lido), that Sickert first made the acquaintance of the Hultons.[4] William Hulton was a painter who had been living in Venice since the mid 1880s. His local standing and connections had secured him a space that spring in the first Venice Biennale, an exhibition of 'International Art' being held in the Giardini Pubblici. (The official English representatives were Leighton, Millais, Burne-Jones, and Alma-Tadema. Whistler was represented by a single work.[5]) Hulton's wife, Constanza, was half-Italian, beautiful, and with a sympathetic intelligence and charm that Sickert found especially alluring.

The artistic and social pleasures of the season were, however, rather undone when Ellen discovered a compromising letter addressed to him from 'Ada'.[6] Ellen may well have been harbouring suspicions about her husband's conduct for some time – she was no fool; but, if

so, she had chosen to ignore her fears. Until now. The discovery of the letter, coupled with the deepening sense of isolation she had endured over the previous eighteen months, provoked a showdown. Sickert admitted his adultery with 'Ada', and also confessed to at least one other affair.* But he pleaded for forgiveness and promised to reform. Ellen was magnanimous,[7] and it was in the belief that a crisis had been averted that, at the end of July, they parted again. Ellen went on to the spa towns of Germany, while Walter returned to London to prepare for the winter exhibition of the NEAC. He was working on a new, and rather different, music-hall picture. He had turned his attention away from the lime-lit world of the stage to the anonymous ranks of the gallery. It was a subtle but distinct shift of focus, and one that he would maintain in his theatrical works over the next two decades, though its exact significance is difficult to determine. Was Sickert celebrating the importance of the crowd? Or was he taking centre-stage himself and recording the performer's view, looking out on the blank-faced audience?

In the autumn of 1895 relations between artists and their public were under a new strain. The Wilde trials had provoked a violent popular reaction: all forms of artistic experiment were condemned by the press and public as part of a general 'Oscar Wilde tendency'. Impressionism found itself lumped together with everything else as part of this dangerous and unwholesome phenomenon. It was a difficult time. A posse of self-righteous authors forced Beardsley from his post at the *Yellow Book*, and though the periodical continued in rather muted mode for another eight issues, Sickert ceased to be a contributor.[8] *The Idler*, too, stopped publishing his music-hall drawings. Sickert made some small effort to counteract the prevailing hostility. He wrote a letter in defence of 'Impressionism' to *The Globe*, emphasizing both the hard work and the reliance on 'tradition' that underpinned it.[9] But such claims won scant support.

Sickert left London for the seaside and consequently missed the news of Blanche's impending marriage to Rose, the oldest daughter of John Lemoinne.[10] It is doubtful that he would have been able to offer his friend any very sound advice on the institution. Although his resolution as regards 'Ada' seems to have been maintained, continence

* Florence Pash, Amy Draper, and Minnie Cunningham are perhaps the most likely candidates.

had become alien to his way of life. He began an affair with one of Max Beerbohm's sisters.

Agnes, known as Aggie, was the beauty amongst the three Beerbohm girls, and in the coded terminology of the day, the most 'high spirited'.[11] In 1895 she was thirty and nominally married to a Mr Neville, whom she had met and wed in India. But the marriage had failed and, separated from her husband, she had returned to the family home at 19 Hyde Park Place. It was there, at the merry Sunday lunch parties presided over by Mrs Beerbohm, that Sickert had come to know her. The disappointment of her marriage had not crushed her spirit. She remained, as Max recorded, 'gay'.[12] Her status as a married woman gave her a degree of social freedom, and she enhanced this by earning her own money – a clever needlewoman, she designed and made dresses for her friends.[13] She was able to visit Sickert at his studio. He painted her, he painted her house, and he inscribed at least one picture to 'Aggie, darling'.[14]

Despite this new dalliance, Sickert returned to Italy towards the end of October and met up with Ellen in Milan. She was coming from Lake Maggiore, where she had been staying with the Cobden-Unwins. Perhaps Walter arrived early for the rendezvous – early enough to produce a small panel painting of Milan Cathedral.[15] From Milan they travelled on to Venice. They had been lent 'a very nice flat' (as Sickert imagined George Moore would describe it) on the Zattere by Miss Leigh-Smith, an old friend of the Cobdens. It was not, however, quite ready for them when they arrived, and they were obliged to spend their first nights back in Venice next door at 'the little Calcina hotel' – an experience that Jane Cobden-Unwin felt could 'not have been comfortable or pleasant'.*[16] Miss Leigh-Smith's flat was both. It had, moreover, a 'good cook' who provided a constant supply of 'good food' and 'good wine'. Not every comfort, however, could be ensured. As Sickert reported excitedly to Steer: 'nearly sat on a *scorpion* in the W.C.'.[17] Such alarms were at least gratifyingly Venetian. More irritating was Miss Leigh-Smith's prohibition against smoking on the premises. As one guest of the Sickerts recalled: 'After dining there we smoked

* Sickert, though he is unlikely to have minded the hardships of even the humblest Venetian hotel, might have been discomforted by the shade of Ruskin. The art historian had stayed at the Calcina on his visits to Venice. The Hotel Calcina is still in business, and would surely now satisfy even Jane Cobden-Unwin's exacting standards of comfort.

our cigarettes leaning out of the window, which was shut down upon
our flanks so that no odour of tobacco should curl back into the
room.'[18]

Venice in winter offered new charms. The white-gloved social round
gave way to a more bohemian, artistic one. Francis James, Sickert's
fellow London Impressionist, was living up at Asolo for his health,
but often came into town to explore the local trattorias. Edwin Ward,
a young landscape painter on his way to India, stopped off for a few
days and was whisked up into the Sickert ménage.[19] Walter also saw
'a good deal' of Horatio Brown, the historian of Venice, who lived
along the Zattere at the Ca' Torresella, together with his aged but
sprightly mother. He charmed them both. A friend reported to Ellen
that 'after meeting him Mrs Brown said Walter was capital company
& then kissed the tips of her fingers & added, "And so good looking
. . . so good looking."'[20] Sickert painted a portrait of Horatio, which
he either sold or gave to the sitter.[21] Just around the corner from the
Sickerts' flat lived the Montalbas, an Anglo-Italian family of three sisters
and a brother. The girls – Clara, Ellen, and Hilda – were all artists and
exhibited successfully in London. Their plump, long-suffering brother
was their devoted attendant. They were stimulating company. The
sisters in particular had a reputation for 'shrewd judgement' and
'caustic wit'.[22] They were also knowledgeable about Venice and its art.
It was Clara Montalba who told Sickert about Canaletto's use of the
camera lucida.[23]

Sickert began to produce his own studies of the city, 'striving', as
Edwin Ward recalled, 'to make pictures of St Mark's and all the angels'.[24]
He worked 'early and late'.[25] Ignoring the example of Canaletto, and
his own frequently expressed reservation about plein-air painting, he
set up his easel in the piazza and set to work direct from the subject.
As he wrote to Steer, 'Venice is really first-rate for work . . . and I am
getting some things done. It is mostly sunny and warmish and on cold
days I do interiors in St. Mark's.' His favoured motifs were surprisingly
conventional: St Mark's (which he found 'engrossing'), the Doges'
Palace, '2 or 3 Renaissance gems, the Miracoli and S. Zaccharia and
the Scuola di San Marco', and the bridge over the Rialto.[26] It was in
his treatment of them that he hoped to challenge convention. He
flattered Steer with the assertion that, 'for all practical purposes the
more experience I have, the more I find that the only things that seem
to me to have a direct bearing on the practical purpose of painting

my pictures are the things that I have learnt from you. To see the thing all at once. To work open and loose, freely, with a full brush and full colour. And to understand that when, with that full colour, the drawing has been got, the picture is done. It sounds nothing put into words, but it *is* everything put into practice.'[27] Sickert did put such technique into practice on occasion: it stands behind his magnificently theatrical and free rendition of the interior of St Mark's now in the Tate Gallery. But it was in fact only one of several styles that he adopted, ranging from the muted and Whistlerian to the busily calligraphic. Though he painted a good deal, he drew even more, building up a store of studies that could be worked on later, as he sought to discover his own vision of the much painted city.[28] A lover of reflections, he began to note the subtle effects of light and colour and architecture thrown back by the waters of the lagoon. *

He was certainly not daunted by the thought of those who had gone before. 'Of course,' he told Steer, 'one gets as familiar with Tintoretto and Titian and Veronese as one was with Reginald Cleaver and F. C. Gould. The more one sees of them (the former I mean) the more preposterous is the pessimistic contention that we who live now should not paint. We aim at and achieve totally different results, results that they neither dreamt of nor could compass. A fine Whistler or Degas or Monet could hang with any of them. It would be intrinsically every bit as good, and for us have the added sparkle and charm of novelty.'[29] The bouncing confidence of Sickert's tone may be deceptive. His own shifting artistic experiments suggest that he had not yet reached the level of his heroes. And his immersion in work was perhaps, in part, a retreat from his wife. While in Venice he grew another beard and, although the psychology of facial hair has not been fully mapped out, it is tempting to suppose that he was seeking to mask some tension or guilt, to disguise himself from himself, if not from Ellen.[30]

A hint of Ellen's plight can be traced in the pages of her novel, *Wistons*. The central couple's visit to Venice is coloured by the wife's mounting resentment at her husband's neglect – his frequent

* A few years later, responding to an enquiry about when one of his Venetian scenes was painted, he declared, 'About 7 o'clock in the evening I should say. San Giorgio gets the light of the setting sun. Your disputants are wrong about the water. Very few people spend their lives noting these things. Why should they? The water *is in shadow*. When a mirror is in shadow it reflects with great clearness & intensity. So it reflects the deep blue of the sky with great intensity at that hour.' WS to Mrs Donaldson Hudson [1907].

disappearances, his engrossment with new friends, his refusal to accommodate himself to anyone else's wishes. At the end of their stay she 'remembered how continually he had been away from her in Venice; how often she had wanted him to be with her, on the piazza at night when it was brilliant with light, and crowded with such foolish people. She had longed for him to look up with her at the dark ceiling overhead ... how often she had wanted him to be with her in the gondola, to hold her hand and tell her prettier things than any one else could think or say.'[31] The most romantic city in the world was a sorry place in which to be alone.

From Venice, Sickert asked Steer for news of the NEAC's 1895 winter exhibition. He wanted to know how his painting of the Old Bedford had been received. Titled *The Boy I Love is Up in the Gallery*, it had become almost a companion piece to his earlier picture of Little Dot Hetherington singing the same song from the stage of the same theatre. Steer's comments are not preserved, but other critics (at least those sympathetic to Sickert) were enthusiastic. Wedmore thought the picture 'quite one of [Sickert's] best'. He attempted to deflect criticism of the base subject matter by asserting that 'the sweeping and fine lines of the composition – the large picturesqueness of the scene – interest the intelligent spectator more perhaps that the actual story'.[32] Moore was inspired to rhapsody. 'I like it because of its beauty,' he cooed. 'It has beauty of tone, colour and composition. I admire it for the fine battle the painter has fought against the stubborn difficulty of the subject.'[33]

Sickert perhaps had a chance to see the picture hanging at the Dudley Gallery when he made a brief trip back to London at the beginning of 1896. He stopped off in Paris. He had undertaken to try to recover the half-finished portrait of the Brandon Thomas's baby (now long since grown). Whistler had held on to the picture, wanting to work on it again, but had then mislaid it in one of his moves. Sickert had offered to try to rescue the canvas from Whistler's studio. 'If you don't let me,' he told Brandon Thomas, 'he's capable of going and painting a landscape over the top of it.' Getting unfinished work out of Whistler could be a very difficult business – as Sir William Eden was discovering. It was a testament to Sickert's charm and continuing rapport with his former master that he succeeded in this delicate manoeuvre. On 12 January he was able to wire Brandon Thomas with the message: 'GOT IT. SICKERT'.[34]

Sickert's visit to London was informative. The literary and artistic world of the *Yellow Book*, broken up in the aftermath of the Wilde scandal, had tried to regroup itself. The scattered forces, headed by Symons and Beardsley, had found a new publisher and a new champion in Leonard Smithers, a trained solicitor who had moved from his native Sheffield to pursue a career in London as a literary pornographer. He had agreed to produce a new, artistic periodical in order to provide a forum for the work of the young outcasts. Sickert arrived in London as the first issue of *The Savoy* rolled from the presses; the art contributors, besides Beardsley, included Rothenstein, Conder, and Blanche. Sickert consented to let them have a drawing of the Rialto for their second, April, number. It was a slight gesture but one that maintained his link with the embattled forces of the London avant-garde. Steer did not contribute.

Sickert was back in Venice in early February 1896 and back in white gloves soon afterwards when he and Ellen attended a lavish charity ball at the Ca-Rezzonico.[35] The splendid venue had been lent by Pen Browning, the son of Elizabeth and Robert Browning, who lived most of time up at Asolo. He was a scandal amongst the expatriate population as he had abandoned his wife and taken up with an Italian mistress called Ginevra (but dubbed 'the indefinite article' by old Mrs Brown). There had been some anxiety amongst the ball's 'lady patronesses' as to whether to accept his offer of the palace: their fears were realized when he arrived in the middle of the party together with his mistress. Ellen was intrigued by the social difficulty this arrival provoked: 'As many of the Italian ladies of the first (& only) circle in Venice have no characters at all I have been inquiring *where* they draw the line. I make out that it is the etiquette that the ladies misconduct themselves at home & their husbands in someone else's home & that what no self-respecting Italian of spirit will stand for a moment is that her husband should break this honoured custom.' Pen Browning's sin had been to invite his mistress to share his house. As a result, Ellen explained to her sister, 'all Italian women support Mrs Browning [and] anathematize her successor'. This, of course, did not prevent everyone from being 'agog' to see the mistress when she arrived at the ball. She was, Ellen noted, dressed very simply in white crepe, with no jewels and only a white flower in her hair. But this virginal apparel served merely to accentuate her 'shrewd hard expression'. Pen was dismissed as 'a repulsive object – so common & dissipated looking'.[36] Given what

Ellen knew of her own husband's tendency to 'misconduct' himself, there was a sort of reckless courage in her description of Venetian manners. Or perhaps she thought that Walter really had reformed himself.

He did make an effort on occasion. When his mother came to stay with them he 'slacked work' and gave her and Ellen 'a good deal of his time'. But it was recognized as a privilege. For the most part he worked according to his own timetable, and worked hard. He sent three Venetian scenes back to London for the NEAC's spring show, where they received 'some very good criticisms'.[37] But he declined an opportunity to write Venetian art reviews for a new tri-lingual magazine called *Cosmopolis* that Fisher Unwin was bringing out.[38] Such selfish absorption was not new and his mother detected nothing amiss: she thought Ellen was looking 'very well', and she was impressed by what Walter was achieving, particularly 'a beautiful picture of St Mark's church', which, she considered, 'ought to bring him credit and (I hope) money'.[39]

Other English acquaintances also arrived in town, amongst them the Zangwills.[40] Israel Zangwill had established a reputation as a novelist of Jewish life with his book *Children of the Ghetto*, published in 1892. He and his wife had been neighbours of the Sickerts up at Hampstead, and this was a happy chance to renew the friendship. They saw much of each other. It was from the windows of the Zangwills' room at the Hôtel d'Angleterre that they would watch the arrival of the big ships and listen to the evening serenata.[41]

Sickert took Israel Zangwill off to explore the byways of Venice. While investigating the stock of a curio dealer in the Casa Remer they ran into Douglas Sladen, a young Australian-born journalist who was travelling in Italy with his 'secretary', Norma Lorimer. 'We were all of us tempted', Sladen later recalled, 'by some very beautiful mediaeval iron gates, which would have been a glory in any nobleman's park, but as we none of us had a park, and even the six hundred francs he wanted for them, added to the cost of transport to England, would have been a considerable sum for any of us, we denied ourselves.' Zangwill 'gave a dinner in honour of the event, at a tiny restaurant on a screwy little canal behind the Piazza of San Marco', after which the party wandered back to the Piazza for coffee at Florian's. The tables on the square were all taken, so they sat inside. 'There was no waiter,' Sladen recalled, 'and Sickert amused himself with drawing an almost life-sized head of Zangwill with a piece of charcoal which he had in

his pocket, on the marble table. It was a bit of a caricature, but by far the best likeness I ever saw of the great Jewish novelist. When the waiter did come, without waiting to take our orders, he went to fetch a damp cloth to clean the table.' Sladen prevented this act of desecration, and when they left told the proprietor 'what a prize he had'. Even so it is doubtful that the portrait survived the evening.[42]

It was perhaps the success of this tabletop sketch that persuaded Sickert to attempt another picture of Zangwill in the more durable medium of oil paint. His penetrating portrait of the writer seen reading in profile against the background of a Venetian canalside, though not exhibited until 1904, was probably begun, if not finished, at this time. Sickert had taken a small studio in which to work at 940 Calle dei Frati, a narrow alley running off the Zattere. It was from there that he wrote to Whistler at the beginning of May, offering his condolences at the news of Beatrice Whistler's death: 'You must always remember now how you made her life, from the moment when you took it up, absolutely perfect and happy. Your love has been as perfect & whole as your work, & that is the utmost that can be achieved. Nor has her exquisite comprehension of you, & companionship with you ceased now. Never let yourself forget that her spirit at your side is now – & will always be – for sanity & gaiety, & work: & you must not fail her now either, in your hardest peril.'[43]

His own marriage could not be described in such terms. He was making Ellen's life neither 'perfect' nor 'happy'. News of Walter's London infidelities reached Venice, and provoked another scene. Some sense of Sickert's exasperating attitude to his own behaviour is conveyed by the scene in *Wistons* when Robin is confronted by his wife over his extramarital liaisons:

> 'Oh, Esther, don't have all this dreadful, deadly, dismal business, it's too depressing. Why not a little elasticity? Let us all be happy and leave each other alone. This horrid Christian habit of inventing sins for everyone! I tell you I don't understand it! I don't know what is meant by it.'
>
> Robin was frowning; it was a bewildered frown, and he looked at Esther with the puzzled, questioning expression of one trying to understand something beyond his own range of experience.[44]

When Esther admits that she is jealous, Robin chides her: 'Jealousy is the most absurd bourgeois business going. It will be as extinct as the

Dodo in another generation. Othello's jealousy will be explained in footnotes, and spectacled German professors will write laborious treatises upon it which nobody will understand.'[45] And as a last resort he retreats behind the familiar defence of art, telling his wife, 'Ah, if you were only really interested in my work how petty and unimportant all these other things would seem!'[46]

Ellen, like Esther, was half inclined to listen to such casuistry, but was too hurt to accept it fully. For her, jealousy was not dead as the dodo; it remained very much alive. Although she and Walter both stayed on in Venice till the end of the month they seem to have lived separately.[47] When Ellen left Venice on 1 June, to return to England via Paris, Walter did not accompany her.[48] They spent the summer of 1896 apart.[49]

They met again early in September at Fluellen, on the Swiss shore of Lake Lucerne.[50] It was a summit on neutral territory. According to the later divorce reports, the intervening months had produced little change. Walter remained unrepentant. His affair with Agnes Beerbohm was continuing. He informed Ellen that ever since their marriage he had 'lived an adulterous life and . . . felt sure [he] could never live a different one'.[51] For Ellen – aged forty-eight and after eleven years of marriage – this frank admission that fidelity was not in his nature proved too much. She parted from Walter on 29 September. What their intentions were at that point is unclear. There was no question of divorce, or even of a formal separation. But it does seem that there was a financial break. Walter could no longer rely on his wife for regular doles. Henceforward he would have to make his own living – something he had singularly failed to do through painting up till then.

THE GENTLE ART OF MAKING ENEMIES

Mr Artist is a deft draughtsman, but a shocking bad critic.
*('W*lt*r S*ck*rt' in* The Sun*)*

Sickert returned to London at the beginning of October 1896 and took rooms at Nash's Hotel in Manchester Square. It was an act of defiant independence. Although the establishment was modest enough, there must have been cheaper places he could have stayed, and his want of money was already acute. Almost his first act was to call on Leonard Smithers to seek payment for the drawing that had been published in *The Savoy*. Smithers had to explain that the periodical did not buy pictures outright but paid only a very modest reproduction fee.[1] Other methods of earning money now had to be found. Journalism and teaching suggested themselves. Amy Draper had finally closed up the Chelsea Life School, and Sickert lacked both the capital and the space to set up another school of his own.[2] He was rescued, however, by Florence Pash. She was still running her art courses for 'titled ladies', now from a large airy studio on the top floor of Members Mansions, in Victoria Street. Students were plentiful and Alberto Ludovici Jr, who had been her 'visiting teacher', had recently moved on.*[3] She asked Sickert to help with some of the classes. He was delighted and touched: 'As Roussell [sic] used to say "I give a hang" or "I care a damn" for your motives. I remain grateful. You are putting me in the way of exactly what I wanted to try. So I am grateful. I choose to be grateful. I feel grateful. I'll see you hanged but I will be grateful.' To

* Florence had had an illegitimate child with Ludovici Jr. The pregnancy was kept secret and the infant was given up for adoption. Some confused hint of this incident seems to lie behind Lillian Browse's otherwise unconfirmed assertion that Sickert had had an illegitimate child during the 1890s that was raised abroad (LB I, 36).

begin with Sickert taught only at the Monday class, but he planned to
increase his attendance to Thursdays as well. Or instead. The variations
would, he thought, tend 'to keep the number up as no one would
know when they mightn't miss a lesson'. But his real hope was that
Florence might start a 'night class', to give him additional teaching,
without the loss of a day's painting.[4]

In his hunt for journalistic work he sought the advice of George
Moore, who was happy to help – partly from good nature, partly because
Sickert had offered to use a new edition of Moore's *Modern Painting* as a
peg on which to hang an article. Moore hoped that Fisher Unwin might
be persuaded to take the piece for *Cosmopolis*.[5] Nothing came of that
scheme, but Sickert soon found a better berth. Moore put him forward
as his own replacement for the post of art critic on *The Speaker*.[6] It was
an alluring prize: a weekly article and a weekly cheque.

Anxious to arrange the practical details of his new life, Sickert failed
to make one important call. Whistler was in London, a touchy widower
of sixty-two. Over the past few years he had endured Sickert's indepen-
dence with a grudging attempt at grace. His own friendship with Ellen,
as well as Beatrice's fondness for Walter, had served to bind him to
his former pupil. But these ties were now loosened. Whistler, moreover,
had always disliked George Moore, and the writer's support for Sir
William Eden in his legal battle with Whistler had brought the rift
into the open. Sickert's connection with the Irishman might, however,
have been overlooked. Totally unforgivable was the discovery that
Sickert, too, had been consorting with the despised baronet.

The affair was an unfortunate one. Sickert encountered Sir William,
and – so it seems – George Moore, at a lunch party. All leaving at the
same time, they decided to look in at a Bond Street art gallery before
parting. By ill fortune Whistler arrived at the gallery soon after they
had quitted it, and was informed by an overzealous doorman that his
friend Mr Sickert had just left with Eden and Moore.[7] It was a double
blow: that Sickert should have been in town and not called to pay his
respects was bad enough; that he should be parading down Bond
Street with not one but two of Whistler's sworn enemies was beyond
endurance. At least it was beyond Whistler's endurance. Sickert, per-
haps hearing of the unhappy course of events, hurried to call on
Whistler and left his card with a conciliatory note. The gesture was
too late and too little. Whistler sweated over an appropriate riposte to
the perceived insults. Beatrice's spirit, which Sickert had hoped would

watch over him, counselling 'sanity and gaiety', was unfortunately absent. Whistler returned Sickert's card with a pitiful letter, which survives in both its draft and finished black-edged form: a sad epitaph for a friendship. 'I fear I really *dare* not Walter! Though doubtless I shall miss you. Benedict Arnold [a notorious traitor in the American War of Independence] they say was a pleasant desperate fellow – and our old friend of the 30 pieces, irresistible! I fancy you will have done it cheaper though poor chap – yet be careful – Remember! and take nothing from the baronet *in an envelope*. Adieu!'*[8]

Sickert, though doubtless shocked at the distilled vitriol of the message, cannot have been completely surprised. He had seen it happen to too many others and did not rise to the bait. He simply returned the note to Whistler, along with his card. It is not certain that they ever spoke to each other again, although in the small circle of the London art world it was impossible that they should not occasionally meet: at such moments Sickert retained his poise. Indeed soon after their estrangement they encountered each other in Bond Street. 'I was walking with some friends,' recalled Whistler, '& along came Walter walking, walking, walking along the road with his white face & looking very fox like, he took off his hat but I made no sign to him.'[9]

Whistler tried to stir up others against Sickert, but with scant success. Shannon and Ricketts refused to be drawn,[10] and most spectators found something embarrassing and unmanly in the spectacle of Whistler's spite. Even his sister-in-law allowed a silence to fall on his strident rants about 'Judas' Sickert.[11] Not that Whistler was chastened. 'Walter's mistake', he shrilled, 'is that he began life as an actor. On stage there is always an exit; now Walter is going to find that there is *no* exit.'[12] Sickert's comment on the debacle was more oblique. When starting work for *The Speaker* at the end of October he chose as his pseudonym the letters 'St P'. Their meaning was deliberately ambiguous. They could stand as an abbreviation for the Latin 'Sickert, pictor' such as a classically trained painter of the eighteenth century might have used to sign his name. Or perhaps the allusion was to St Peter, the disciple who denied his master?†

* Sir William Eden had handed over the disputed payment for his wife's portrait in an envelope.

† Still other interpretations are possible: Around the borders of St Pancras, the parish in which Sickert lived, the letters 'St P' are inscribed in the kerbstones.

The break with Whistler weakened another of the bonds that connected Sickert to his old life. It also complicated his relations with the Cobden-Unwins. Fisher Unwin had become close to Whistler through the Pennells, whose books he was publishing with some success. Whistler wasted little time in abusing Sickert to his in-laws, and Jane, at least, was only too inclined to believe stories about Sickert's duplicity. Whistler, she reported to Ellen, thought Sickert had 'a treacherous side to his character', but – as she added – 'that you know!'[13] Rather than forcing the issue, Sickert avoided it. He did not call at Hereford Square.[14]

To the appalled Cobden clan it seemed that he was wallowing in dangerous waters. It had been agreed within the family that neither Walter and Ellen's separation nor the reasons behind it would be made known. Walter had promised complete discretion. But his behaviour was never discreet. Rumour soon began to circulate.* He continued to see Aggie Beerbohm, and also dined with her brother, though it is unrecorded what the inscrutable Max knew of his sister's liaison with Sickert, or what he thought of it.[15] Sickert moved in 'a very Bohemian set'.[16] He dined out frequently, often – so he later claimed – for the sake of the meal.[17] He went to a party given by Douglas Sladen, reviving the friendship they had made over the tables at Florian's.[18] He saw something of Richard Garnett, the Keeper of Printed Books at the British Museum and a sometime contributor to the *Yellow Book*,[19] and it was perhaps through Garnett that he re-met one of his own former pupils, Ellen Heath. She was a friend of Dr Garnett's son Edward and became his lifelong companion. Sickert would visit her in her studio – 'a little hole of a room off the Euston Road' close to Robert Street. It was a haven for him. He made two portraits of her, and presented her with several pictures. On one occasion when he called he found her painting Bernard Shaw and 'a lively argument' ensued about 'the portrait in particular and art in general of which Sickert got the better'.[20]

Sickert's connection with Sir William Eden prospered. They continued to be seen out and about together, much to Whistler's irritation.

* Ellen was distressed to hear from her friend Mrs Pidgeon that her affairs were being discussed in England, and it was being said that her exile was due to a quarrel 'over a certain Miss Beerbohm who is in the position of a lady but who visited WS at his studio'. 'It seems,' she remarked, 'as if WS had talked & told his own story.' Ellen Cobden-Sickert to Jane Cobden-Unwin [1897].

The baronet bought one of Sickert's paintings and introduced him to the beautiful Lady Eden, subject of the disputed Whistler portrait.[21] But, for all this growing intimacy, Sickert probably had no part in the acceptance of one of Eden's watercolours for the NEAC's winter exhibition – an event that provoked Whistler to new levels of fury.

Sickert's extended absences in Venice over the previous two years had weakened his connection with the club. Though still nominally on the executive committee, he no longer appeared on the selecting or hanging juries. Steer, with whom he had always shared a pre-eminence, had emerged as the sole presiding figure. He regularly topped the selection polls, although his actual influence on the work of the other members was not easy to discern. The broad consensus fostered during the London Impressionist years had broken up. Few of the club's artists still looked towards contemporary French models but sought inspiration in other traditions. Steer himself had begun an idiosyncratic exploration amongst the styles of the eighteenth and early nineteenth centuries: the art of Fragonard, Gainsborough, and Courbet.[22]

Sickert's own submission to that autumn's exhibition was a Venetian scene – a view of the canal running between the Ospedale Civile and the cemetery island of San Michele – perhaps brought back from Italy, more probably done at Robert Street. (He had returned from Venice with numerous small-scale sketches, studies – and, indeed, photographs – of the principal sites, and was continuing to make paintings from them.[23]) With a humorous touch of melodramatic sentiment, Sickert called the picture *From the Hospital to the Grave* – a 'pseudo-romantic' title, as one critic called it, 'such as we generally associate with the provincial contributions to the Royal Academy'.[24] Any funereal overtones were, however, contradicted by the unexpected vividness of the painting. Anxious to escape his reputation for low tones, with their Whistlerian associations, Sickert had lightened his palette. The critic for the *Daily Telegraph* was impressed, finding that the picture 'gladdens the eye with a brilliancy and sparkle of colour, a frank play of light, for which we had not given [Sickert] credit'.[25]

The sparkle of the picture suggested confidence and lightness, an optimism about his new idependence. But perhaps a truer register of his feelings can be read from the almost monochrome self-portrait he made at this time. Glancing back over his shoulder, a frown tugging at the corner of his mouth, a single eye fixed balefully upon the viewer: it is an unsettling image. Its force is enhanced, too, by a new

recklessness in Sickert's handling of the paint – the likeness modelled from broad, almost coarse, brush marks rather than drawn in with his customary precise calligraphic accents. It is a study in disequilibrium. The break with Ellen had touched him more deeply than he was prepared to admit.

It was beneath a constant round of activity that Sickert strove to bury his feelings of uncertainty and vulnerability. He submitted to the regime of dinners and parties, the twice-weekly classes, and the regular call of his weekly article for *The Speaker*. In his journalistic guise, Sickert cast himself in the role of an outsider. While much art criticism, so he claimed, was hamstrung by good manners, he was not afraid of giving offence.[26] He knew, having been schooled by Whistler, the value of controversy, the art of provoking a reaction. Towards the end of the year he saw an opportunity for exercising this art – an opportunity coloured with irony. Whistler, in his new enmity, though he had not succeeded in detaching old friends from Sickert's side, had been eagerly supported by Joseph and Elizabeth Pennell, who had joined themselves to Whistler's cause and person. They guarded him, and his reputation, with a fierce and jealous eye. When Whistler cast Sickert off, they followed his lead. It was not a loss that Sickert felt keenly. Pennell was something of a pompous bore. Even Whistler felt that he must sometimes apologize for keeping such 'bad company'. The days when Sickert and Pennell had collaborated in the pages of the *National Observer* to hound Sir Hubert von Herkomer over his careless use of the term 'etching' were long past, but not quite forgotten. At least not by Sickert.

They returned to his thoughts in December when he came across a recently published set of illustrations by Pennell for Washington Irving's *Alhambra*. The pictures were described as lithographs, but Sickert was aware that they had been drawn not directly on to the lithographic stone, as was traditional, but on to specially prepared 'transfer paper', which was then laid by a professional lithographer on to the stone before being printed up.[27] He saw in this small fact the opportunity for an article: in titling his pictures as lithographs, Pennell was guilty of the same 'looseness of statement' of which they had indicted Hubert von Herkomer six years previously. The illustrations, he suggested, should have been called 'transfer lithographs'. He per-

suaded Frank Harris, the editor of the *Saturday Review*, to commission a piece on this nice distinction.[28]

Sickert always claimed that, in this, he was not motivated by any animus against Pennell.[29] It was merely an opportunity for elucidating a minor but perhaps useful technical point – and earning a small fee while doing so. But such assertions appear disingenuous. Pennell was irritating, both in his toadying to Whistler and in his own pomposity, and Sickert was irritated. More than one of Sickert's *Speaker* articles contained slighting references to the American.[30] Certainly the *Saturday Review* article reads as though fired by a spark of animosity. In it, Sickert argued that there was a difference in kind between work done on the stone and work done on transfer paper; and while he was prepared to admit that each had its virtues, he felt that the former was superior. 'It is urged that a piece of transfer paper is so much more convenient to carry about than a heavy stone, and that you cannot make many flying sketches from nature on stones. That is quite true. So is a barrel-organ easier to carry about than a grand piano. But when we talk of music, we continue to discuss rather performances on the latter instrument.' There was perhaps a memory in this of having to lug lithographic stones about for Whistler. The article acknowledged that Whistler himself had largely abandoned 'pure' lithography for work on transfer paper, but suggested that as 'Mr Whistler is a genius' whose 'lightest utterance is inspired', this mattered little. He could produce great work in any medium. The assertion was a sly attempt to drive a wedge between the Master and his new sycophant.

The article was published shortly before Christmas.[31] Sickert and Frank Harris were hoping that it might stir up a little correspondence from the artistic community to enliven the dull days of January. Instead they received a solitary letter from Lewis & Lewis. The famous firm of solicitors (whose senior partner Sickert had drawn for *The Whirlwind*) announced that they were acting for Mr Pennell and claimed that grave charges had been made against their client, charges that demanded an apology.[32] The Pennells had been spending the Christmas holiday down at Bournemouth with Whistler and the Cobden-Unwins. The article, as Jane Cobden-Unwin reported to Ellen, was the main topic of conversation: Mrs Pennell said her husband had until now chosen to ignore Sickert's jibes, 'but he would be unable to let this attack fall unnoticed'.[33] It was probably Whistler, though, who convinced Pennell

to seek revenge through the courts.[34] He was incensed by the piece
('Walter Sickert's rubbish and mischief', he called it), convinced that
it was a veiled attack on his own practice.[35] His mounting – almost
paranoid – anger was well captured by Jane Cobden-Unwin: '[he]
said that he himself used transfer paper – out-door effects impossible
without it – believed the old lithographers did the same'. Returning to
the subject after dinner, he remarked that '[he] would not say anything
regarding [Walter's] moral delinquencies, but [that] as regards his men-
tal point of view it was low indeed'. Unable to let the matter drop, he
then told Unwin that Sickert had 'taken to writing because he could
not paint & he [had] never properly studied, [and] could never take
trouble to do anything well'.[36]

Harris was not to be bullied by Lewis & Lewis, or by anybody
else. He defended his position, published the ensuing correspondence
between himself and the solicitors, and accepted Pennell's challenge
to 'a legal duel on the pretty point'.[37] Sickert, it seems, was alarmed
at this turn of events. His article had been conceived – at most – as a
slight piece of mischief and a 'capital ad' for both himself and Pennell.
And now Frank Harris in his combative zeal had forced the whole
thing into a libel action – uncertain, except as to expense. He began
to think he might have made 'a mistake'.[38] He may even have tried to
withdraw the alleged libel.* But there was to be no escape.

The date of the case was set for 5 April 1897. Sickert continued to
write for *The Speaker* and did what he could to bolster his legal position
by making frequent, if heavy-handed, references to 'transfer litho-
graphs' – as distinct from pure 'lithographs'. One review of Whistler's
work was actually titled, 'The Master of the Transfer Lithograph'.[39] But
there was a feeling that he was living on borrowed time. A parody of
Sickert's original article appeared in *The Sun*,[40] and Whistler called at
the Fine Art Society and bullied Ernest Brown into taking down a
Sickert lithograph they had on display.[41] More worryingly, as Zangwill

* Many years later, almost certainly referring to this case, Sickert described how 'I
once had occasion to volunteer a written apology in the office of a distinguished
lawyer, which was to have the effect of a withdrawal, nullifying a critical libel I was
alleged to have tumbled into. The distinguished lawyer proceeded to dictate to his
shorthand writer the wording of my proposed apology. "I have learnt with surprise"
– he began. I begged his pardon for the interruption, and pointed out to him that
no one would believe that those four words had been written by me. "You are quite
right," he said. "Perhaps you had better write it yourself."' Perhaps the letter was
never written. *Daily Telegraph* (2 December 1925).

told Jane Cobden-Unwin, the impending trial was bound to scare off editors and prove 'a bad business for Walter's literary prospects'.[42]

Even with the work he had, Sickert was horribly hard up. 'My papers delay paying me,' he complained to Florence Pash. 'I live on nothing but my landladies [sic] credit.'[43] He moved out of Nash's Hotel and took up residence at Robert Street. On home turf he felt better able to outface his impoverished condition. When the rent was overdue, the Robert Street landlord, acting as bailiff, would come and install himself in the studio. Sickert, recalling Whistler's behaviour in such instances, would offer the man a drink and explain that if he were just allowed to finish the picture he was working on the rent could and would be paid. He would then begin work. 'Taking a plumb-line, he might ask the bailiff to see if an upright was correct. Oh! Yes, that was all right. A few minutes later: "And now this one, if you don't mind;" and so on, until the wretched man could stand it no longer, but got up and went away.'[44]

The case of Pennell v Harris and Sickert duly came before Mr Justice Mathew and a London Special Jury. Sickert and Harris had rallied several expert witnesses to their standard. George Moore was anxious to assist, as was William Rothenstein, who had never cared for Pennell. Charles Shannon reluctantly agreed to be called by the defence, and so did two professional printers. Sickert and Harris had separate counsels. With what appears to have been reckless extravagance, Sickert equipped himself with no fewer than three barristers – Mr Bingham, QC, Mr W. H. Stevenson, and Mr R. E. Noble. Harris made do with one. Pennell was represented by Sir Edward Clarke, the QC who had defended Oscar Wilde. His star witness was Whistler.* It was a formidable array to settle so small a matter.

The case hinged on whether there really was any difference in kind between lithographs made on stone and those made on transfer paper. Pennell claimed there was not and that for the defendants to suggest otherwise 'showed that they knew nothing about the subject, or else were acting out of malice'. Sickert argued that certain – rather vaguely stated – effects could only be achieved by working directly on the

* Pennell's witnesses were Sidney Colvin, Keeper of Prints and Drawings at the British Museum; E. K. Strange, Assistant Keeper of the National Art Library at Kensington; D. C. Thomson of the Goupil Gallery; Gleeson White, late editor of *The Studio*; Mr Goulding, the official printer of the Royal Society of Painter-Etchers; and Thomas Way (*The Times*, 6 April 1897, 3).

stone. He also suggested that, as in the case of Herkomer's 'etchings', there was a commercial dimension to the question: for, 'by the transfer process an unlimited number of copies could be produced, whereas the stone wore out in the other process. Hence the copies were less valuable when the transfer was used.' His first line of reasoning was rather undercut by the fact that no distinction between the two processes had ever been acknowledged previously in art circles. Indeed (as Thomas Way pointed out in his evidence) when Sickert himself had published a lithograph drawn on transfer paper in *The Albermarle* it had not been designated as such. Sickert's second contention was dangerous, if not damaging – as it raised the temperature of proceedings. Under cross-examination he was obliged to admit that in accusing Pennell of 'a looseness of language similar to that which he had denounced in Professor Herkomer', he was charging him with a similar 'dishonesty'. But, whatever the merits of the arguments, the trial really served as an opportunity for the airing of grievances, and the scoring of points.[45]

Whistler was swift in attack. Asked if he had been angered by Sickert's article, he replied that he was not angry but he was disgusted that 'distinguished people like Mr Pennell and myself are attacked by an absolutely unknown authority (Mr Sickert), an insignificant and irresponsible person'. When Sickert's counsel suggested that if Sickert were 'insignificant' then he could do no harm, Whistler retorted, 'Even a fool can do harm, and if any harm is done to Mr Pennell, it is done to me. This is a question for all artists.' Asked as to whether he objected to the line in Sickert's article, calling him 'a genius', he drew 'loud laughter' by replying, 'It is a very proper observation for him to make, and I have no objection.' But perhaps the best moment of comedy occurred when Moore appeared in the witness box. He declared that, although he did not know much about lithography, he did know Degas, and Judge Mathew, displaying the time-honoured incomprehension of the English bench, asked, 'What's Degas?' – supposing it to be some new printing process. After two days of such exchanges the jury decided that Sickert's article overstepped the bounds of 'fair criticism' and was intended to be personally offensive to Pennell by accusing him of dishonest conduct. They found for the plaintiff, awarding £50 damages as well as costs.[46]

Sickert strove to put a brave face on the matter. Writing to Lady Eden he declared, 'I must say the whole thing was vastly enjoyable and

amusing . . . Rothenstein was brilliant in the box and Moore excellent, nonchalant and dispassionate.' This seems to have been an over-statement of the case. Rothenstein's recollection was that 'never did anyone cut so poor a figure in the witness-box' as Moore, while he himself fell over his hat as he left the stand.[47] Though Sickert admitted that 'Legally there can be no doubt that the verdict was just. I had called [Herkomer] a thief and then said Pennell was as bad!', he clung to the belief that, 'Artistically the case had established a distinction [between 'transfer' and 'true' lithography] that can never be obscured.'[48] Obscure, however, it did remain. Whistler, meanwhile, rushed to pub-lish the news of his triumph. He telegraphed to his sister-in-law: 'Enemy met & destroyed . . . Sickert in Ambulance.'[49] And he gave a crowing interview to the *Daily Mail*. Sickert strove to counter these attacks. He wrote to the editor of the *Mail* correcting 'four points in your interview with Mr Whistler', and he published in the *Saturday Review* a letter from the secretary of the Royal Academy confirming that they did not accept 'transfer lithographs'.[50] But the facts of his defeat and humiliation were hard to escape.

So too were the legal bills. To Lady Eden, Sickert described the damages as 'very small', claiming that they had been set so low because his counsel, Mr Bingham, had 'managed to impart a patronising good-humoured "come, come now" sort of air into the case'. But £50 was a considerable sum, and the 'costs' were more than the same amount again.[51] It was a huge blow for the already impoverished Sickert, who had no immediate means of paying. He was obliged to borrow money, as well as realizing what little capital he had.[52] The verdict, moreover, served to bring his journalistic career to an abrupt end. Editors, anxious when the case was pending, were now confirmed in their anxieties. Commissions dried up. His contract with *The Speaker* came to an end at the beginning of June. It would be over ten years before he wrote another article in the British press.

IV

AMANTIUM IRAE

I cannot go on bearing this kind of emotion – I cannot trust him.
(Ellen Cobden-Sickert to Jane Cobden-Unwin)

The certainties of Sickert's life were crumbling. He was forced to make
economies. After the 1897 spring show – at which he exhibited three
more Venetian scenes – he resigned his membership of the NEAC, the
club that he had helped to fashion and direct for almost ten years. There
is no suggestion that this was the result of any artistic division from the
other members. He continued to send pictures to the club's exhibitions
and, as an exhibitor, he enjoyed full voting rights. It was very probably
a matter of saving the four-guinea subscription. Nevertheless, his resig-
nation marked a significant break, removing him from the centre of
discussions and from the prestige of a place on the committee.

One of the few elements of continuity was his connection with
Florence Pash's teaching studio. She had followed his suggestion and
started evening classes. There were other scraps of work too: he got a
commission to do a series of caricatures for *Vanity Fair*, and he looked
again at the possibilities of portraiture. Perhaps he did get some com-
missions (he complained to Lady Eden about having to do 'so much
work for business'), but most of his known portraits from this period
seem to have been undertaken at his own suggestion.[1] Perhaps it was
to get his eye in that he made a series of likenesses of the crag-featured
Fred Winter, captured in dramatic profile. He also asked his old friend,
the actress Gertrude Kingston, to sit to him.[2] Maybe he hoped that she
– or one of her admirers – would buy the result. Either way, the plan
was not a success. As she recalled in her memoirs: 'I was his model
for two or three sittings, and then off he went, leaving the picture in
the air, with a "We'll finish it when I get back from Dieppe."' It was
never taken up again.[3]

After the debacle of the court case, Sickert continued to see much of George Moore. They dined together, and Moore undertook to bring Sickert back into contact with Fisher Unwin.[4] Sickert's connection with Moore also drew him closer into the Edens' circle – as did his legal spat with Whistler. It was a shared bond. Sir William was still embroiled in his own case against the painter – the appeal hearing had been set for the end of the year. As Sickert wrote to Lady Eden, applying a generous trowel-load of flattery, 'That anyone who had the privilege of painting you could miss the chance of handing his name down on your portrait is incredible to me. For a butterfly, the cher Maître is certainly a donkey!'[5] Nevertheless, he saw in the case a chance for retribution: 'I shall be rather pleased,' he wrote, 'at Sir William avenging me. It will be, in a manner, poetical justice.'[6] In July, Sickert was invited to stay at Windlestone, the Edens' gracious regency house in County Durham.[7] To escape Robert Street and debt for the comforts of a country-house weekend was a pleasant exchange. The house was full of beautiful things. Sir William owned an impressive collection of paintings, including Dutch and Spanish old masters and what he liked to refer to as his 'own immaculate Degas'. The visit was the first of several over the coming months.[8]

Sickert's mother and brothers were over in Dieppe for the summer, and Sickert joined them briefly. The holiday life of the town that season was disturbed by the inescapable presence of Oscar Wilde, recently released from prison and living on the Normandy coast under the self-advertising alias 'Sebastian Melmoth'. Sickert, though no longer compromised by an allegiance to Whistler, did not attempt a rapprochement with Wilde. Blanche recalled being with him when they saw Wilde sitting outside the Café Suisse and ignored him.*[9] Sickert did not linger long in Dieppe and was in London for the whole of August. He saw Minnie Cunningham – and begged her to come and pose for him again[10] – and went down to Bognor 'for a day or two' to visit Max Beerbohm, who was staying there. He made 'vague notes' for a new caricature of Max, which he subsequently worked up for his *Vanity Fair* series.[11] He also kept up his painting at Robert Street.

That autumn at the NEAC, Sickert exhibited – as a non-member

* A drawing by Sickert of Wilde, although captioned 'Melmoth', was surely not done at Dieppe that year. It depicts a young, longer-haired Wilde, rather than the plump ex-con.

– another Venetian scene worked up from a watercolour drawing;[12] and, seeking to extend his market opportunities, he also sent a picture to the Institute of Painters in Oil Colours.[13] But his efforts to restore a fragile equilibrium to his affairs were soon disrupted. Ellen was back in London, staying with the Cobden-Unwins at Hereford Square.[14] She had spent the year travelling in Italy and Germany, and had been much distressed by the reports she had received of Sickert's life and behaviour. She was upset that he appeared to have discussed their affairs.[15] It was one more betrayal, and Jane was keen to point out others.[16] Whatever hopes Ellen might have had for Sickert's reform, expired. Throughout the summer of 1897 she had been quietly canvassing opinion about the wisdom of a divorce, and in early December she resolved on the painful step.[17]

Jane, though professing herself 'full of sadness', was enthusiastic in her support: 'I fear, as you say, that W. S. will never change his conduct of life – and with no guiding principles to keep his emotional nature straight he follows every whim that takes his fancy. You have tried so often to trust him, and he has deceived you times without number, and all the time he has financially almost ruined you.'[18] Ellen instructed her solicitor, Mr Mathews, to write to Walter with news of her decision. The intensity of Walter's reaction to the news was unexpected. Ellen gave a full account of events to her sister:

> W[alter] wrote & asked Mr M[athews] to come to his studio as he was afraid he should not be able to control his emotion in an affair that was a matter of life & death to him. He was perfectly overcome – cried – said he had behaved like a rascal – That if I would give him one more chance he wd be a different man – that I am the only person he has ever really cared for – that he had no longer those relations with Mrs N[eville – i.e. Aggie Beerbohm] & co & co.
>
> Mr M says he is sure he was sincere – but that taking into consideration his previous life & judging as far as he could of his character from his face & manner [he] does not believe he is capable of keeping any resolve that he made – & his deliberate advice to me is to go on with the divorce. As Mr M was really a good deal touched by & softened towards Walter, I thought this a very strong decision for him to have come to. W. wished me to know that he was making money enough to live on and also that, if after all I decided to go on with the divorce, he would help in every way.[19]

Nevertheless, Sickert did send a message begging Ellen to take a few days to reconsider her decision. She was 'dreadfully upset' by the news of Walter's distress ('I see how far from dead is my affection for him') but felt that she must press on with the action. It was, she believed, the best course, not only for her but also for Walter: 'The shock of this recoil on him himself of the consequences of his own actions may be the best treatment for W. himself. He deserves punishment & ought to have it.' And, since it must be done, it should be done soon. If she left it until later she feared she should 'not have the same elasticity of spirit to bear it'.[20]

Walter was forced to take his punishment. There is no doubt that he felt it keenly. Coming close upon his wounding and costly reverse in the libel court, it was another blow to his pride, his self-confidence, and his pocket. In his dark moments he even wondered whether Whistler and Ellen might be conspiring together to ruin him,[21] and such fears were sharpened by the fact that he really did care for Ellen. For twelve years he had blithely relied on her – on her love, interest, support, and private income. The security she offered had been easy to take for granted. Now that he was losing the prize – and losing it through his own persistent fault – its true value became, of course, painfully apparent. Sickert's pain was further added to by the practical details of arranging the divorce. According to the 1857 Divorce Act, while husbands were able to sue on the grounds of a wife's adultery alone, wives could get a divorce on the grounds of a husband's adultery only if it were combined with some further offence – such as bigamy, rape, cruelty, or (as in the Sickerts' case) desertion for two years. Moreover, proof of both the adultery and the 'further offence' had to be offered in court. It was a humiliating business for all concerned, and a difficult one to bring off, even amongst co-operative parties. It took over a year and a half to dispose matters – eighteen months of self-recrimination, of dealing with lawyers, of constructing evidence, of dreading the court appearance, and fearing the publicity it might bring. Throughout this protracted ordeal Sickert strove to maintain a façade of cheerful equanimity, but it was clear to those who knew him how much he was suffering.

Sickert's claims to have ceased 'those relations' with Agnes Beerbohm may well have been true, if only because she was ill. At the end of 1897 she had to undergo 'a very serious operation'.[22] It was yet another cause for anxiety. The Edens took pity on Sickert and invited

him up to Windlestone for Christmas. They, too, had suffered a partial reverse. The French appeal court had ruled that Whistler should be allowed to keep the unfinished portrait of Lady Eden, so long as he paid Sir William 5 per cent interest on the initial payment he had received. And although Whistler still had to pay the costs of the first trial plus £40 damages, Eden was ordered to pay the costs of the second trial. It was a verdict that suited neither party. Eden contemplated his own appeal, and Sickert rather hoped he would proceed with the idea. 'For one thing,' as he told Lady Eden, 'it might hang up the second edition of the gentle art of making amends [i.e. Whistler's anthology of letters and criticisms, *The Gentle Art of Making Enemies*] for another year or so, which would annoy Whistler very much.'*[23]

The Christmas gathering at Windlestone was a jolly one. Florence Pash was of the party, and Sickert strove to lose himself in the festive mood. He returned to London before the start of the New Year full of 'accumulated Windlestone energy & spirits' and plunged back into the studio, experimenting with 'tempera painting' and making a caricature of Bernard Shaw.[24] Not, however, that he could concentrate solely on work. At Windlestone over Christmas, plans had been laid for an amateur theatrical performance early in the New Year. Sickert had agreed to take one of the leading parts, opposite Lady Eden, in a slight one-act play called *Dream Faces*.[25] With what seems to have been deliberate irony, he was to play an old roué who had devoted his life to pleasure and so lost the chance of love. Back in London he set about devising his make-up and learning his lines. The former clearly took precedence: 'I went this morning to the Strand,' he reported to Lady Eden, 'and found Lucy & French's [theatrical book-]shop shut. But that is no matter. I have bought a moustache and a complexion for the part & spirit gum to stick the moustache on with.'[26] He did subsequently get hold of a copy of the play, and set to studying it. Having bullied one of the other actors about learning lines he was 'in terror not to be word perfect'.[27]

The performance – held 'in a neighbouring Town Hall . . . in aid

* Sickert's fear that his own break with Whistler might be advertised in any new edition of the book was greater than it need have been. Whistler had told the Cobden-Unwins that he would never publish his last letter to Sickert for Ellen's sake – 'we are all too fond of her' (Jane Cobden-Unwin to Ellen Cobden-Sickert, 29/10/1896). In the event, it was Whistler, rather than Eden, who appealed. He eventually won costs in April 1900. But no second edition of *The Gentle Art* appeared.

of some local charity' – was set for 12 January 1898.[28] Max Beerbohm, through Sickert's influence, was invited up to Windlestone for the occasion. He had just shocked Sickert by announcing that he was engaged to Grace Kilseen Conover – 'an excellent young woman who is a super in his brother's theatre!' Sickert hoped that Lady Eden might save 'the little donkey' from what he considered an unsuitable match by filling Windlestone with 'eligible sirens'.[29] But the plan – rather like the play – was not a success.

Beerbohm, many years later, recalled the performance: 'I was sitting next to [Sir William] in the front row . . . The scene [was] a very humble parlour. An immensely tall Windlestone footman bringing in a lamp, in the first scene, seemed to me to strike a false note. Still more false was the note struck by Eden, who sprang furiously to his feet, shouting "Don't put the lamp down on that table. Take it away. It would tumble over and burn the whole Hall down!" He had been very much opposed to the whole production, and indeed neither Lady Eden nor Walter Sickert showed any histrionic ability.'[30] Lady Eden, though, was at least 'word perfect'; Sickert, despite his study of the script, was rather less so.[31]

The play, if it did not reawaken his own theatrical ambitions, did revive Sickert's artistic interest in the theatre. Back in London he went with Rothenstein to the opening night of his old friend Arthur Pinero's play Trelawny of the 'Wells'. 'Here was a play which seemed written for our delight,' recalled Rothenstein. 'What fun it all was; and how enchanting the costumes! And such a chance it provided that Sickert asked Miss Hilda Spong – a magnificent creature who acted a part – to sit for him; while I approached Irene Vanburgh.' Rothenstein subjected Miss Vanburgh to innumerable sittings, but Sickert merely 'had Miss Spong photographed, and from a small print and with few sittings' made his picture.[32]

Having been at work on paintings of Venice using photographs, as well as studies and drawings, it was a natural progression to extend the practice into portraiture. Not that Sickert's picture was a conventional portrait. It was more a theatrical scene, showing the actress on stage in her 'enchanting' costume – a billowing crinoline and 'pork pie hat'. At seven foot square it was many times larger than Sickert's usual modest formats, and it was painted in the bright, sharply defined, flat colours of a contemporary poster. This stylistic handling was apt: the picture was intended to serve as an arresting advertisement for Sickert

and his art. After the buffets of the previous year, he was burying himself in his work. He wrote to Florence Pash, announcing his intention of giving up the evening classes: 'latterly I have found that the work, coming as it does at the end of my own day's work, tires me more than is wise. I find myself overtired at night and consequently not so fit next morning.'[33] He took a new supplementary studio at 169 Albany Street, perhaps to escape from the garrulous Winter and the occasional callers who had come to know his Robert Street eyrie.[34]

Amongst various projects he began a portrait of Lady Eden. He wrote from his new studio asking her, 'to keep in . . . mind the possibility of making an appointment here for me to get my photographer to photograph you in the light I want'. The picture seems to have been conceived not merely as a record of the delightful Lady Eden (and a chance for Sickert to 'stare at [her] uninterruptedly!'), but as an assertion of self and an obliteration of Whistler. 'In the lengthy discussions about your portraits past & present,' Sickert told his sitter, 'it is always a source of amusement to me to know all the time that, whatever else is done, it is I who will probably paint the one of you that will live.'[35] Although it is not clear whether Lady Eden ever submitted to be photographed in Albany Street, Sickert did do at least one picture of her. He exhibited it at the NEAC that April, with the subtitle 'Sketch of Portrait'. A sprightly image of her ladyship reclining on a sofa with a small dog, it was largely ignored by the critics and has not achieved the exalted position that Sickert predicted for it. Nor, as he might have expected, was it bought by Sir William. Sickert soon came to realize the capricious and difficult side of the baronet's character. He was an awkward patron. As Sickert later remarked to Rothenstein, it was *extremely difficult* not to quarrel with a man like [Eden]', but 'cleverer' not to. By exercising a certain 'pliancy' Sickert managed to stay in favour, and ensure that Eden, at least on occasion, continued to buy his work. Such sales were vital, for Sickert had few other patrons. He came to recognize that it was Eden's support during this low ebb in his fortunes that saved his 'skin from being broken'.[36]

On the walls of the Dudley Gallery the sketch of Lady Eden was overshadowed by Sickert's other submission: the unignorable picture of *Miss Hilda Spong as Imogen Parrot in Trelawny of the 'Wells'*. It was 'dedicated to A. W. Pinero', though the playwright, like the baronet, was not to be flattered into a purchase.[37] The critics were unenthusiastic about Sickert's garish new departure. MacColl, writing in the *Saturday*

Review, though admitting that Sickert seemed to have grasped 'the principles' of 'flat decoration', felt that the picture was far too large: 'Surely,' he remarked, 'it would repay him to use the same material for a small colour engraving which would be more the size of his subject; for subjects have their sizes.'[38]

The NEAC was not the only place that Sickert exhibited that summer. Continuing his expansionist policy, he sent pictures to both the RSBA and (for the first time since 1890) to the Royal Academy summer show. On this occasion his work was accepted at Burlington House – despite the fact that it was a music-hall scene, perhaps even done in 1890, the year of his self-advertised rejection.[39] Although in the popular mind Sickert was still regarded as a rebel opposed to the established world of the Academy, he had in fact been tempering his position. He had been 'enchanted' by the election of Edward Poynter to the presidency at the end of 1896, calling it 'a victory for line & dignity as against pot-boilers',[40] and in his articles for *The Speaker* and other papers he had begun to leaven his 'negative' criticisms with positive – if presumptuous – ideas as to who might be included in the Academy's ranks. There was the suggestion that the institution might be best reformed from within. He had promoted the claims of Whistler (before their rupture), of William Stott, of Steer, and Charles Shannon.[41] Readers were left to add Sickert's own name to this list. He expressed a wish, or perhaps a hope, that, rather than electing fashionable artists, the 'Royal Academy should . . . consider its function to be to redress, if possible, a little the balance which has been inclined by commercial success or failure'.[42] Sickert certainly felt the balance inclined against him by 'commercial failure', but there was little sign that the balance might be redressed by the Academy, or by anyone else.

One important showcase remained closed to him. Whistler had been busily involved in the creation of a new exhibiting group, the International Society of Sculptors, Painters and Gravers. In April he was elected its first president (exactly ten years after he had been ousted from the presidency of the RSBA) and the inaugural exhibition opened on 16 May, at Prince's Skating Rink, in Knightsbridge. Although most of the 256 exhibitors were British (100 from England, 41 from Scotland), there was a genuine international flavour – very different from most London exhibitions. Over forty French artists were included, along with twenty Germans, more than a dozen Americans, and a

scattering of Scandinavians, Belgians, and Swiss. Many familiar figures
were included – Rodin, Manet, Monet, Puvis de Chavannes, and Sisley
all had work on show, as did several younger French painters, including
Bonnard, Vuillard, Maurice Denis, and Jacques-Émile Blanche. Sickert,
of course, was not invited to join. When, at one of the early meetings,
the Scottish artist John Lavery had tentatively put forward his name,
Whistler's reaction had been predictable. '"What," he said, making as
though to take something from his breast pocket, "my Walter, whom
I put down for a minute and who ran off? Oh no, not Walter." '[43]

The Knightsbridge show also included a retrospective selection of
work by Aubrey Beardsley, who had died, aged just twenty-five, at
Menton earlier in the year. Sickert grieved his loss. He continued to
see Aubrey's sister Mabel and attended the small receptions that she
held. She was struggling to make a career as an actress, and there was
often a theatrical flavour to her gatherings. It was at one of these that
Sickert first encountered the young impresario, Charles Cochran – an
old schoolfriend of Beardsley's – who would later buy his work.[44]

At the beginning of July, Florence Pash married a six-foot-tall
Canadian called Albert Alexander Humphrey.[45] He was a bluff, open-
hearted industrialist, entirely unconnected with the world of art, who
had come to London on a business trip but, after meeting Florence,
had decided to stay on.[46] He never left. Though Sickert did not attend
the wedding, he wrote Florence a gracious – if tardy – note of blessing:
'You have always been one of my best and most valued friends . . .
and your marriage interests me as much as any thing could do. You
know that I am a believer in love and in marriage and still more in
the conjunction of both. I think you are two very fortunate people.
All I know about your husband is that his marriage proves him to
have taste and wisdom. So he must allow me to congratulate him.'[47]
As a wedding present he gave them his early canvas, *Rehearsal: The End
of the Act*.[48] It is to be hoped that Florence did not recall that at its last
public showing the picture had been titled *Despair*.

CHAPTER FIVE

Jack Abroad

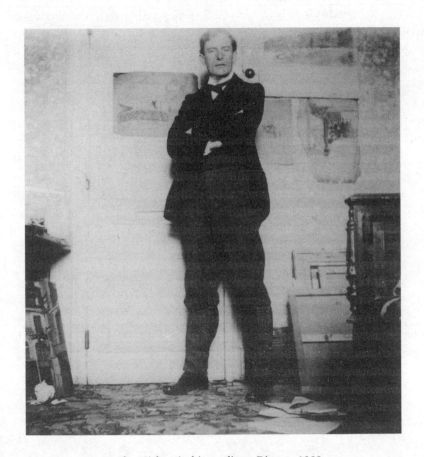

Walter Sickert in his studio at Dieppe, 1900

A WATERING PLACE OUT OF SEASON

These things that being fond of, we have left, and that, deprived of, we desire.
(Martial to Priscus)

For Sickert, the summer of 1898 represented the end of an 'act' in his own drama. The scene changed. He went over to Dieppe, resolving to stay there until the following spring. There were many reasons for the move: Dieppe was cheaper than London; it was a place he loved – and loved to paint; it was freer of distractions than England; and, as he told Florence, he could not 'stand another winter in London. It is too dark and life is too short.'[1] There were, however, difficulties in making such a break. He 'had to borrow money to get abroad'.[2] His debts – including some still unpaid legal expenses – were considerable. He had borrowed £20 from Aggie Beerbohm, but that was only enough to cover immediate living expenses,[3] and he was obliged to turn to his family. Though he had seen little of his sister Helena over the previous years, he approached her now. She had married the Manchester businessman Frederic Swanwick and was living in the north. Swanwick was not a rich man but he agreed to lend Sickert the £600 necessary to clear his debts and make good his escape.[4]

Sickert installed himself at the Maison Lefèvre, 1 rue de l'Hôtel de Ville, an unpretentious but spick and span establishment directly opposite the courtyard of the old town hall, just back from the Casino. It was to become a favoured haunt. Mme Lefèvre was an excellent cook, and the two little interconnected dining rooms – of seven or eight tables – were particularly popular with the French county families.[5] Sickert, with only mild exaggeration, characterized it as: 'Position dignified, [and] carrying social prestige in Dieppe.'[6] Max Beerbohm's friend Reggie Turner called it, 'the smart eating house of Dieppe', adding, 'Princes and people of that sort stay here, when they are ruined.'[7]

Sickert, if not a prince, was certainly a person 'of that sort', and he was ruined. It was an entirely appropriate place for him to settle on.

The one drawback of Lefèvre's was that Whistler had also discovered it. He was briefly in Dieppe that summer and Sickert saw him at least once, 'but not to speak to'.[8] Apart from that encounter, however, there was little to disturb his equanimity. Rothenstein came over for a visit,[9] and the other artists who lingered on in the town as the summer drew to a close were congenial spirits. 'We are a gay party here,' he told Florence, listing his dining companions as Boldini, the Helleus, the Thaulows, MacColl, 'and no one else'.[10] Sickert drew strength from such good company. It was an encouragement to work. He had a studio close to the Casino[11] and he sent back to the NEAC's winter show two Dieppe scenes done with a new-found freedom, even bravura.[12] At the end of the season he was able to announce to Florence, 'I am doing very well, selling and painting with great pleasure and ease in this delicious Dieppe.'[13]

Sickert had always painted with 'great pleasure' in the town; the 'selling' with 'ease', however, was a new departure. Whether the purchasers were English or French – visitors to or residents of Dieppe – he does not say. Sickert displayed examples of his work in the shop of the Dieppe art supplier, M. Clouet, but most sales were arranged privately.[14] It is probable that Jacques-Émile Blanche stood behind this upturn in Sickert's commercial fortunes. He excelled in arranging such things, and was particularly anxious to help his friend during what he knew was a difficult time. Certainly he saw much of Sickert that season, painting a portrait of him looking vulpine yet vulnerable beneath a broad-brimmed hat.* A few private sales were more than enough to ignite Sickert's confidence, and fire his imagination. It was, he at once decided, the way to proceed. He wrote to Brandon Thomas decrying the whole idea of one-man exhibitions and gallery shows: 'I do not believe in vomiting your whole past, present and future in a lump into a small dealer's room for 3 weeks. The virginity of the pictures gone . . . No, like a cunning mother, I now marry my daughters one by one quietly, some well, some badly.'[15] As a sly piece of matchmaking he sent a painting over to the Brandon Thomases with the admonition:

* Rothenstein remembered being present in the studio during the sittings, when he and Sickert 'were in outrageous high spirits' and 'kept shouting, in imitation of a Dieppe street crier, "Voilà le marchand – Thaulow!"' (William Rothenstein to JEB, 26/10/1937).

'I put you on your honour *not to buy it*. You may *sell it* if you like ...
I am rather proud of it & would rather have it taken care of till the
Spring Exhibition on your walls than with its face to the wall in my
studio here.'[16]

Sickert's concentrated study of Dieppe scenes, and the fact that he
had managed to sell some of them, convinced him to rethink the
direction of his work. 'I see my line,' he confided to Florence. '*Not
portraits*. Picturesque work.' He described Dieppe rather hyperbolically
as 'my only, up to now, gold mine': 'I must work it a bit till I can get
a little decent comfort. Since giving up writing and teaching I haven't
done badly but it takes time to make up for a year or two's non
success.' He still hoped to maintain his foothold at Robert Street –
less for painting than for art-matrimonial purposes: 'I shan't do much
work there ... but I should like to keep [it] ... to bring pictures to
and show them in.'[17]

The scheme, inevitably, did not quite work out as planned. Winter
in Dieppe was every bit as cold as in London. Most of Sickert's 'gay'
companions left. The Thaulows were resident in the town, but he
found few other friends amongst the permanent population that first
winter. He caught a chill, and took to his bed, 'rather depressed', where
he read Villon and even a Douay Bible that had been given to him
by Mrs Stannard, one of Dieppe's regular summer visitors. His main
diversion, however, away from the studio, was studying the English
newspapers and periodicals that his friends sent him.[18] They were
welcome, he told MacColl, 'like rain on a thirsty land' – putting him
in touch with 'the cackle of my own town and kind'.* He took to
buying the *Daily Telegraph* – though it cost him '2½d a day *argent
sonnant*' – and reading it 'from cover to cover'.[19] But even the conso-
lations of the British press could not obscure the fact that he was
lonely. He hoped that Florence and her husband might come over for
a short visit, but they did not.[20]

Sales, moreover, with the departure of the holiday crowds, dried
up, and money ran low. He felt that he must leave the relatively
expensive comforts of the Maison Lefèvre, but was unable to do so as
he did not have the money to settle his bill. He had to stay on, getting

* He tried to keep his hand in, engaging in a little dispute with MacColl on the
question of transfer lithography in the letters pages of the *Saturday Review* (14 and
21 January 1899).

deeper into debt, until he finally sold a picture and was able to pay his way out of his 'paradise of an hotel'.[21] Shortly before Christmas 1898 he moved into cheaper, less paradisiacal, rooms on the Quai Henri IV, the row of tall, stone-fronted merchants' houses facing on to the outer harbour. Blanche used to liken the quay – in its scale and aspect – to the Zattere in Venice,[22] and in the soft light of evening it could perhaps suggest something of Venetian calm and grandeur. But for most of the time it was the clattering hub of Dieppoise life. The packet boats from Newhaven moored alongside it, and many of the fishing boats landed their catches there. A rail line ran in front of the houses, ready to take off freight or passengers towards Paris.

If the din of activity was imposing, it was mild compared to the smell. At one end of the quay stood the long, low, covered fishmarket, the fixed centre of a sprawling piscatorial bazaar. Each morning, when the boats returned to harbour, a crowd of impromptu stalls would range themselves around the market-building: wooden trays barely able to contain huge, lolling conger eels, shallow baskets piled with langoustines, and rays laid out flat on the cobbles, all presided over by shrewd, aproned fishwives – the women of Le Pollet. It was a world dominated by women. For generations, while the Polletais men had trawled the waters of the Channel, their womenfolk had carried the catches to market on their backs in great conical baskets, and had sold them on the quayside.

One of the commanding figures of this bustling scene was Augustine Villain. In 1898 she was thirty-three. Tall and handsome, she seemed to confirm in her person the tradition of the Venetian origins of Le Pollet. Her hair was a flaming Venetian red, her skin pale and freckled, and she had the 'carriage of a Veronese'.[23] During the winter months she wore – like the women of Venice – a long black shawl and wooden 'sabots'. Though lacking in formal education, she was strikingly intelligent and quick-witted, and blessed too with a natural, unaffected courtesy. Courtesy, however, has its limits in a fishmarket, and she once provoked a storm by pulling the whiskers of a customer who complained about the price of her wares.[24] Expensive or not, her fish stall was acknowledged to be one of the best in the market. The connections of the well-established Villain clan ensured a good supply of fresh fish from the local fleet, and she had the gift of making her regular customers feel special, keeping back for their delectation choice items of fish and gossip.[25]

Unsurprisingly, such charms had not gone unnoticed. In 1891 she had married Louis Victor Gille, a local book-keeper some ten years her senior. A daughter, Louise, arrived seven months after the wedding. But the marriage did not last. Augustine Villain – or Titine as she was known – was a woman of independent temper and she soon separated from her husband. Her next child, Aimée Yvonne Celestine, born early in 1894, was given the surname Villain. The father was listed as unknown. Yvonne was not her only illegitimate child. She had at least two sons. One of them, Maurice, was born in December 1895; again, the father was not listed. She may also have taken responsibility for other offspring of the Villain clan, for she lived surrounded by children.[26]

Her looks excited the admiration and interest of many of the artists who came to Dieppe each summer and she was courted as a model. Sickert, though he does not seem to have painted her, had certainly noticed her. She lived close to the Quai Henri IV in the Arcade de la Poissonerie.[27] Her robust, humorous take on life, as much as her beauty, was well calculated to appeal to him and she became his mistress. Early in the new year he wrote to MacColl describing his new mode of life with an effervescent excitement that captures his delight in Titine without fully revealing the details of their relationship:

> I am very happy and well here. Such constant sun and daylight. Not only do I take coffee with la belle rousse but that angel in divine shape permits me to share the table of her children at cost price, gives me the use of her bonne, employs a seam-stress à la journée to sew me strange shirts after my own designs, washes me at home [i.e. does my laundry], sits to me, teaches me the idiom of the Pollet, stands between my ignorance and all the greed of a bain-de-mer in face of an English visitor – and I – write her letters for her. 'Madame, le turbot que j'ai eu l'honneur de vous envoyer en gare jeudi était tout ce qu'il y a de plus frais. A quatre heures le matin il était encore vivant: etc.'* Would you like a weekly bourriche? Say 5 shillings' worth including carriage? We guarantee freshness.[28]

Blanche, who did know the nature of Sickert's attachment, was at first approving. Mme Villain was a noted figure, and he felt that the care and attention of a woman 'si intelligent et devouée' could only do his

* 'Madame, the turbot that I had the honour of sending you on Thursday was the very freshest. At four in the morning it was still living: etc.'

friend good ('malgré la naïve qualité des sentiments si humains, que les attache l'un à l'autre').*[29]

Early in 1899 Sickert moved his studio to the Quai Henri IV, setting it up in the room above his bedroom 'to get more sun and light and coke'. (The arrangement was not too claustrophobic for – as Sickert confided to Rothenstein – 'I don't sleep in my own ostensible bed.'[30]) Further economies, however, were still necessary. He decided that he must give up Robert Street, or at least sub-let it to Florence Humphrey – whom he felt had a proper appreciation of all the things that made him love the place. His one anxiety about the arrangement, beyond the fact the stove might need some repairs, was that it would provoke talk about his affairs. He advised Florence not to 'encourage old Winter in'. The sculptor was an inveterate gossip, and, as Sickert explained, 'We don't want the whole New English to be posted hourly of all our doings.'[31]

He was still concerned with what the NEAC thought. The club remained the most important forum for his work, though it was no longer the only one. He planned to send again to the Academy, and from Rothenstein he learnt of a new potential outlet for his pictures: the Carfax Gallery.[32] The guiding spirit behind this new venture was a young man called John Fothergill – a sprightly if elusive figure, 'like a young fawn', who, though barely twenty-two, had already flirted with the worlds of art, architecture, and classical archaeology, attending briefly the Slade, the London School of Architecture, and Edward Penn Warren's studious community at Lewes House in Sussex.[33] But his interest was not easily held. He next conceived the idea of opening a small art gallery where contemporary work 'of a certain character' could be constantly shown. It was a novel and daring enterprise, but he was encouraged in it by Rothenstein and premises were found in Ryder Street, St James's. Fothergill, though not wealthy, put up the capital. Arthur Clifton, a thirty-something solicitor (and son of the Oxford Professor of Experimental Philosophy), agreed to act as business manager, and Sickert's brother Robert was appointed as gallery manager.[34] Rothenstein undertook to be 'responsible for the choice of artists'. At the top of his list was Sickert.[35]

* Not all the Dieppoise were so approving. Simona Pakenham, whose mother lived in Dieppe at the turn of the century, was told that there had been an ugly altercation in the fishmarket one day between Sickert and Mme Villain's former husband, which was only broken up when Mme Villain bit her husband (or, possibly, Sickert) in the calf (Simona Pakenham, TS 'Walter Sickert & My Grandmother').

It was an exciting development. Sickert hoped the gallery would do well, not least, he claimed, so that it would 'put out all the other damned fools': 'Business is a Science,' he declared. 'The London dealers have not mastered it.'[36] More importantly, a successful Carfax would offer him a regular market. Although he was working hard to finish three or four canvases in time for the spring exhibitions, he hoped that the gallery might sell something ahead of the shows so that he could pay up various 'small debts and have a little visit to London'.[37] In the event he managed to sell two paintings himself in Dieppe[38] and came over to London in April 1899, bringing his other pictures with him. He lodged at the Tavistock Hotel in Covent Garden, close to the centre of things, and was thrilled to be back amongst the 'cackle of [his] own town', however briefly.[39] At the NEAC, though not on the committee, he went to inspect the hanging of the show with MacColl. He exhibited a view of the church of St Jacques.[40] His plans to exhibit again at the Academy came to nothing, but he was able to leave several of his pictures with the Carfax Gallery – where Robert Sickert's administrative incompetence was already causing concern. 'I have always thought your employing Robert proved your unfitness as a manager,' Sickert told Rothenstein.[41] It was becoming clear that he would have to be sacked. As Sickert remarked with his customary lack of sentiment, 'We can none of us afford Robert. That is the *truth* of the matter.'[42]

For Sickert, the positive aspects of the trip were overshadowed by some less happy complications. The divorce case was advancing. In December 1898 he and Ellen had exchanged a pair of rather stilted letters designed to confirm Sickert's habitual and unrepentant adultery.* The previous spring, Sickert had gone through the charade of being observed by Ellen's solicitor entering the Midland Grand Hotel with 'an unknown woman' and spending the night there,[43] but it was

* 'Dear Walter, In spite of your having told me, when we parted in Switzerland in 1896, that immediately after our marriage and ever since you have lived an adulterous life and that you felt sure you could never live another one, I have been hoping against hope that you could abandon it but all I have heard of you during the last two years has forced me to give up all possible hope for the future. Yours truly, E. M. Sickert.' Sickert replied: 'My dear Nellie, I have received your letter of December 8 [1898]. It is quite true that I have not been faithful to you since our marriage, & it is equally true that during the two years since we parted I have been intimate with several women. I have chosen my mode of life, & I am unable to alter it. An undertaking on my part would be misleading. Ever profoundly attached, Walter Sickert' (quoted in *The Times*, 19 July 1899).

now decided that additional, and independently witnessed, evidence of
Sickert's adultery was required – and quickly. To add to his cares, Agnes
Beerbohm suffered a sudden relapse: she required a second operation
and needed the money that she had lent to Sickert. Sickert crossed back
to Dieppe with both these delicate matters unresolved. Into the breach
stepped Rothenstein. He generously offered to act as Sickert's banker,
providing the money for Aggie's operation until Sickert could repay it.
He also agreed to stand as the witness of Sickert's adultery. Sickert was
'profoundly touched & grateful'. He told Rothenstein: '[I] would gladly
owe such a unique occasion to you. Why, after all, should a man not
have a "best man" for a divorce as well as a wedding?'[44]

On 6 May, Sickert travelled over to Newhaven with Mme Villain.
They booked into the London & Paris Hotel and Rothenstein came
down from London to watch them entering their room in the evening
and reappearing the following morning. Sickert did not tell Roth-
enstein Titine's full name so that, if subpoenaed, he could truly claim
to be ignorant of it. 'You might say I always called her "Madame",' he
suggested.[45] The little drama completed, Sickert and Titine returned to
Dieppe, and Rothenstein went back to London to report. The stage
was now set. Ellen filed for divorce two weeks later. 'Served with divorce
papers today,' Sickert noted to Rothenstein: 'Desertion. Adultery at
Midland Hotel & at Newhaven, "with a woman whose name is un-
known to your petitioner." So far as it can be that is all right.'[46] The
case was set for 18 July. Despite his attempts to be gay, the strain and
sordor of the whole arrangement was beginning to tell on Sickert. He
was 'suffering from nerves & funks & terrors of all useless sorts'.*[47] He
was anxious about the expense of proceedings, and about the pain
they would cause to those around him. Having long delayed the hour,
he finally steeled himself to tell his mother about the imminent div-
orce, 'for fear it should take her by surprise'.[48] Rothenstein, in an effort
to raise his friend's spirits, sent Sickert a smoked salmon – a strange gift
for a man involved with a fishwife, but perhaps Titine had expressed a
professional interest in the prize piscatorial delicacy of the British table.
She was certainly excited at the prospect of it. 'Titine blushed with
pleasure when I told her of *saumon fumé*,' Sickert told Rothenstein, '&

* One manifestation of Sickert's anxiety was a bout of diarrhoea, which, to his
amusement, Titine described as 'la coqueluche dans le cul' – the whooping cough in
the arse (WS to William Rothenstein [1899]).

kissed me with the mouth full.'[49] Rothenstein's kind gesture rather backfired, however: the fish failed to arrive, and added yet another concern to Sickert's list of worries. (He was convinced it had been stolen by the French postal service.[50])

To ease some of his financial anxieties, Sickert hoped that Carfax might advance him £20 on his canvas *The Rag Fair*, which had failed to sell when exhibited at the NEAC the previous winter. Sir William Eden had been dithering over whether to acquire the picture, but had finally decided against it.[51] Carfax's limited resources were not able to run to such a sum, but Rothenstein exerted himself on his friend's behalf. He approached Fred Brown, asking him whether he might be prepared to buy the picture. Brown was sorry to hear of Sickert's 'troubles financial and matrimonial' although, he was obliged to admit, he had 'always regarded them as a natural and inevitable part of his existence'. Nevertheless, because he liked Sickert 'so much personally', he offered to help by buying the picture for £20.[52] Sickert was touched, and slightly surprised. 'Not Fred Brown? It is really very good of him,' he admitted to Rothenstein, adding, 'Of you I don't speak.'[53] Rothenstein, for his part, urged Sickert to send some finished drawings to Carfax that could be sold for modest prices. Sickert thought small panels – '8 or 9 inches sq' – would be more satisfactory and 'fulfil somewhat the function that drawings do to others, to get, as it were, an occasional fiver or tenner by'.[54]

Rothenstein had a chance to inspect some of Sickert's panels when he visited Dieppe that June. At the end of May he had announced his engagement to Alice Kingsley, the beautiful, broad-featured actress to whom he had been attached for the previous four years. Sickert, even in the midst of his own marital collapse, was delighted for them. He had always rather admired Alice and the 'golden lock' of hair that fell across her eyes. He flirtatiously informed her that one of the main reasons he was so pleased she was marrying Will was that 'it will result in our being a good deal "thrown together", as they say in novels, than which I can imagine nothing pleasanter'.[55] The marriage took place on 11 June and, immediately afterwards, the couple crossed over to Dieppe for their honeymoon. Sickert had prepared the ground for them. 'The bridal chamber is spread at Lefèvre's', he declared. 'Comfort and luxury to be had at 8-frs a head exclusive of wine which, *excellent*, is to be had at 2-frs a bottle . . . I will be on the quai and the quay vive!'[56]

The Rothensteins, however, were only briefly in town. They soon

moved along the coast to the village of Vattetot, but they had ample chance to register the baleful impact of the divorce proceedings on Sickert. Despite an effort at jollity, he could not conceal his very real state of distress. Rothenstein was shocked at his friend's decline. The divorce proceedings had taken a toll on Sickert's confidence and self-belief. Rothenstein felt, too, that the Villain ménage, whatever its charms, was not an entirely satisfactory milieu. 'Walter's nature', he confided to Blanche, 'needs cultured companionship, and he is suffering more than he knows from the drying up, enforced through constant companionship with a good but absolutely uncultured woman, of his social nature; he loves laughing, straw splitting discussions, the society of men like himself, to take him out of himself. At Dieppe he is left to brood over his worries without any relaxation whatsoever.'[57]

Blanche, prompted by the same concerns, invited Sickert to come and stay with him in Paris. Sickert arrived at 19 rue du Docteur Blanche, the Blanche family's imposing suburban palace, in a state of 'dépression morale et physique, tout à fait déplorable' ('altogether deplorable moral and physical depression'). Worry about the impending divorce had almost made him mad. Blanche reported to Rothenstein: '[Walter] a absolument donne l'impression d'un *homme qui perd sa raison*. Je n'exagère pas.' ('[Walter] absolutely gave the impression of a man who had lost his reason. I don't exaggerate.') Despite his own admiration for Mme Villain, Blanche remained unconvinced about the wisdom of Sickert's settling permanently in Dieppe, fearing that he would become isolated, stuck there, as if in quicksand. It was, he suggested, the duty of Sickert's friends to try and uproot him, at least during the winter months. He urged Rothenstein to mobilize allies in London so that Sickert should not be left feeling abandoned and excluded from the art world there. On this score, Blanche feared that Whistler had already done much harm.[58]

As his own contribution he exhorted Sickert to consider exhibiting at a Paris gallery – either Durand-Ruel or Bernheim-Jeune. He believed that Sickert's work showed '*beaucoup* de talent' as long as he did not throw himself into large-scale canvases. 'Son affaire,' he wrote to Rothenstein, 'c'est de légères esquisses dans de petits panneaux. Il est né pour mettre de jolis tons sur un dessin rapide et nerveux. N'est-ce-pas?' ('his business is light sketches on little panels. He was born to set down attractive tones on rapid and sensitive drawings. Isn't it so?')[59] To encourage Sickert in his self-belief he bought a small panel – for

a 'fiver' – and showed a desire to possess more.[60] Generous with his money, he was also generous with his time. In Paris he lived at the centre of an interesting world, and he drew Sickert into it. They went together to Versailles, and Blanche recalled how much Beardsley had loved the place.[61] Sickert made studies of both Le Grand and Petit Trianons, and even sent a painting of the former to the NEAC show later that year; though his 'wilfully aggressive' treatment of the subject (as one critic described it) suggests that his own response to the place, though intense, had been less happy than Beardsley's.[62]

He spent a day going round the two Salons. Amongst the many 'interesting' things, he noted particularly the paintings of Henri Evanpoel, a young Flemish painter (and early friend of Matisse), and those of J. W. Morrice, a Canadian domiciled in Paris. Both artists combined a convinced realism – a love of the Parisian streets – with a bold, even brash, colour sense.[63] Sickert also paid a visit to Rodin, who had agreed to exhibit some of his drawings and small bronzes at the Carfax Gallery. Though Sickert thought the sculptor 'seemed a little sad & worried', he was still greatly impressed by him.[64] He cherished his remark that 'Décidément, la lenteur est une beauté' ('Decidedly, slowness is a form of beauty'), and thought it should 'be inscribed in letters of gold in every studio'.[65]

But the main fillip of the Parisian sojourn was provided by the chance of seeing Degas again. After the pain of the break with Whistler, it did much for Sickert's *amour-propre* to find himself welcomed back into Degas' circle. Almost as soon as he arrived in Paris he called at rue Victor Massé, where Degas had recently acquired a large apartment immediately beneath his studio. He discovered his hero well but 'wrapped up rather in anti-semitism'.[66] The unfolding of the Dreyfus case was polarizing opinion in France; Degas set himself intransigently against Dreyfus – and what he considered to be the Jewish subversion of the French state. His other grievance of the moment could not have been more congenial to Sickert. Degas was angry with Whistler for including one of his pictures in the International Society's exhibition without permission, and had written what Sickert gleefully described as a 'terrible letter'.* After Degas had run through his litany of

* Degas also passed on approvingly one of Blanche's acid comments on Whistler:
'Celui qui ne vit que dans la contemplation de lui-même est un miserable'
('Someone who lives only in the contemplation of himself is a sad wretch'). WS to William Rothenstein [1899].

complaints there was, however, a chance to look at pictures. He had established one floor of his new flat as a 'museum' for his collection, and he led Sickert through a dense 'forest of easels . . . each groaning under a life-sized portrait by Ingres', an early Corot, or a Delacroix. There were also two wonderful still lifes by Manet, of a ham and a pear. But what Sickert liked best was the opportunity to study Degas' 'own astounding pictures' (he noted particularly a pastel of a woman on a blue sofa).[67]

On at least one evening Sickert dined *chez* Degas.[68] They discovered a shared passion for marmalade[69] and went together to the sale of Victor Choquet's collection at the Galerie Georges Petit, where Degas bought Delacroix's painting *The Battle of Poitiers*. There was also an excursion to the house of Ivan Stchoukine, the Russian-born collector who owned works by Manet, Renoir, Degas, and Rops as well as several Goyas. All in all, as Sickert reported excitedly to Rothenstein, 'Degas has been quite delightful.'[70]

After almost a month away, Sickert returned to Dieppe, 'having learnt much & eaten more'. He found waiting for him a (second) smoked salmon and a ham, both sent by Rothenstein – and collected from the post office by an excited Mme Villain. The ham, Sickert announced, would serve to feed him 'morning, noon, & night'.[71] It would sustain him during the final act of his divorce drama. Following Sickert's departure, Blanche reported on his still fragile condition not only to Rothenstein but also to Ellen. The French painter had a great respect and liking for Sickert's wife and had hoped that she might be persuaded against going through with the divorce; but on realizing that this was not to be, he did his best to help her through the difficult process – as he was helping her husband. Ellen was prone to bouts of guilt and self-doubt, and had confided to Blanche an anxiety that Walter might go off the rails completely after their break. Blanche wrote back to her a letter of reassurance, telling her that 'some creatures *must* be tried by fire & that if this reveals gold in Walter's nature', then Ellen could feel justified in her actions. If, 'on the contrary when the fire burns out there is nothing left but dross', she could be thankful to have been released from him. Ellen told her sister that the letter was 'really the greatest comfort' she had had. She clung to the idea that the divorce might 'rouse the dormant moral sense in Walter's nature' – adding, 'It

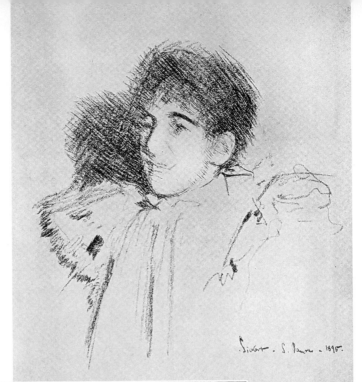

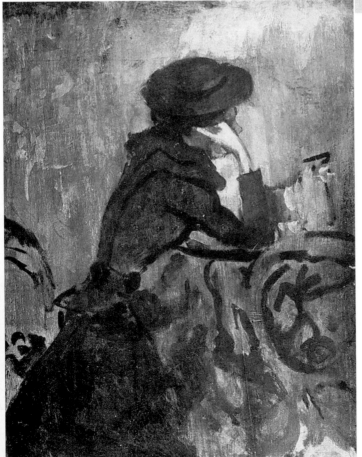

Above Ada
Leverson drawn
by Walter Sickert
for the fifth
volume of *The
Yellow Book*, 1895.

Left
Darling Aggie:
Agnes Beerbohm
by Walter Sickert,
1894.

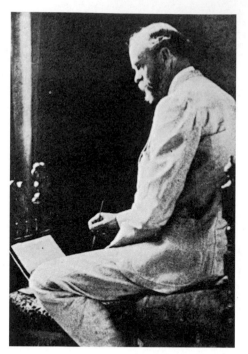

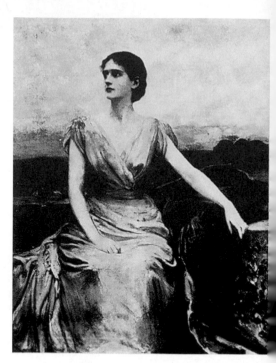

Above Sir William Eden, the irascible water-colourist and collector.

Above right Lady Eden, painted by Sickert's old enemy Sir Hubert von Herkomer.

Below Augustine Villain, the beauty of the Dieppe fishmarket, by Walter Sickert, 1901.

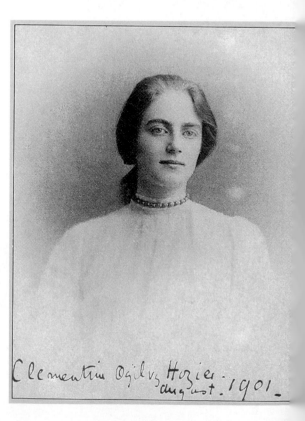

Right Clementine Hozier, future wife of Winston Churchill, who had a schoolgirl crush on Sickert.

Left Signor De Rossi, the ideal Venetian, by Walter Sickert, 1901.

Below Mrs Hulton, dressed for a charity fête, by Walter Sickert, 1901.

Above Charles Cottet, one of the leading young French painters of his day, by Jacques-Émile Blanche, 1902.

Left Lucien Simon, a co-founder of the celebrated Bande Noire, by his fellow member, Charles Cottet, 1907.

Left Mabel Royds, Sickert's sometime pupil and mistress, and the mother of his only child; self-portrait, 1903.

Below Maria Luisa Fortuny, sister of the fabric designer Mariano Fortuny. Sickert proposed to her.

Left Jean, Lady Hamilton, wife of General Sir Ian Hamilton. She enjoyed flirting with Sickert.

Lady in Red: Mrs Swinton by Walter Sickert, 1905;
and (*inset*) the photograph on which the painting was based.

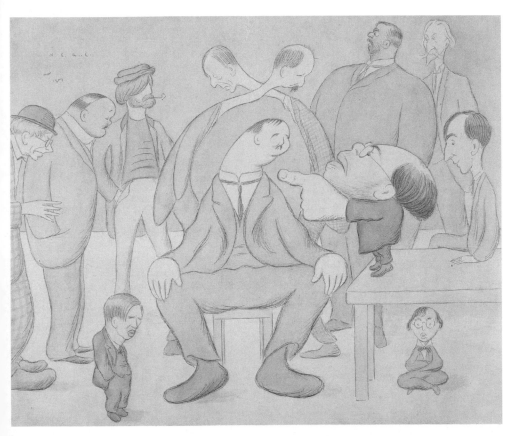

N.E.A.C. by Max Beerbohm, 1907. From left to right: Walter Sickert, William Orpen, W.G. de Glehn, Augustus John, D.S. MacColl and Henry Tonks forming an arch over Philip Wilson Steer, William Rothenstein, J. S. Sargent, Albert Rutherston (under table), L.A. Harrison and Walter Russell.

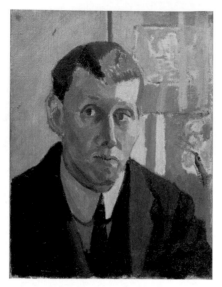

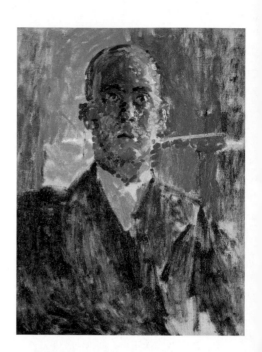

Above Sickert's great friend,
Spencer Gore, self-portrait, 1914.

Above right The doctrinaire and
opinionated Harold Gilman, by
Walter Sickert, 1912.

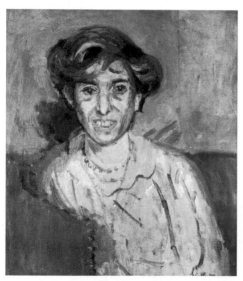

Above Ethel Sands, hostess of
Newington and founder member
of the Fitzroy Street Group, by
Walter Sickert, 1913.

Right Nan Hudson, Ethel Sands'
lifelong companion and fellow
painter.

does seem as if he was stricken down, and no altogether bad person *really* feels anything acutely.'[72] Jane, however, felt that this was laying it on a bit thick. She remarked briskly that 'Jacques Blanche and Walter Sickert's other artist friends have quite an exalted idea of his character. They cannot know what he really is as you do . . . will the man who has led the life [Walter] has since he was one and twenty ever change, I doubt it!'[73]

The divorce hearing was held on 18 July 1899 before Judge John Gorell Barnes. Sickert was not present. Ellen was questioned, evidence was given, and witnesses called.[74] The two awful letters were read out. Sickert's repeated and habitual adultery was clear to the court, as was the fact of the two-year separation. But a difficulty lingered over Sickert's alleged 'desertion', if only because, throughout the 1890s, the Sickerts had had no fixed home from which he could be said to have deserted. They had spent the decade lodging with others, either in England or abroad. Moreover, it was Ellen who, over the past two years, had spent the most time out of England. Had not she, rather than Walter, 'deserted'? It was an awkward point, and one that the judge felt he must consider. Judgement was suspended. This added a final period to what Sickert referred to as the 'never-ending grind & agony of this loathsome divorce affair'. The tension, he claimed, was particularly awful because he knew what Ellen must be undergoing.[75] There was, too, the further anxiety of whether, or in what detail, the case might be reported in the press. On the latter front they were spared the worst. The liberal papers, loyal to the memory of Richard Cobden, refused to report the hearing; but some of the Tory papers – *The Times* and the *Morning Post* – gave full details, even going so far as to quote the letters that Walter and Ellen had exchanged.[76]

On 27 July, after an agonizing week's wait, the judge granted the divorce. He accepted that, although Sickert had not abandoned the family home, his unrepentant behaviour had made it impossible for Ellen to live with him, and that this 'constituted a desertion'. Thus he was able to grant Ellen the full settlement.[77] The intended outcome had been achieved. It was a huge relief. Sickert wrote at once to Rothenstein and Blanche, his two supporters throughout the last stages of the ordeal. 'Very interesting & important judgement technically it appears,' he announced to Blanche in a facetious attempt at objective detachment. 'Mr Justice Gorell Barnes is a Solomon. Fancy being allowed after about 4 years to think of something else than one's own

organs of generation. It seems barely credible.'[78] He later regretted what might have seemed like the undue 'levity' of his tone and wrote again, explaining that it did not represent his true feelings: 'But the first action when a thumbscrew is removed is a sigh of relief that makes one light-headed.'[79]

He received a 'lovely' letter from Alice Rothenstein. She and William were back at Vattetot with a party of artists for a sketching holiday. Conder was there, and William's younger brother, Albert, along with two brilliant young Slade graduates, Augustus John and William Orpen (the latter was engaged to Alice's sister, Grace). Arthur Clifton, the business manager of Carfax, also joined the group along with his wife. Alice hoped that Sickert might come over and visit them. It was an attractive prospect. He wrote back to her: 'The idea of teaching you to swim while Will is in the chiaroscuro, attending to his little pot-boiler, is tempting – I can't tell you how your letter soothed and consoled me. There is something about female consolation of quite extraordinary efficacy. It seems round and soft somehow. I can't describe it. But it touches the spot, softly and caressingly. I can do with some more any time when you have any to spare. I daresay I shall be over, all the same, to Vattetot. I fancy something in the way of a sale is sure to take place and then I am off to don a striped bathing-dress and put my hand under your chin.'[80]

It is not certain, however, that he gave Alice her swimming lesson.[81] There was, after all, female consolation close at hand in Dieppe. Titine, he reported to Blanche, was 'contente' at the resolution of the divorce case.[82] But the hoped for sale was not very forthcoming. Sir William Eden, having decided against *The Rag Fair*, was haggling with Carfax over an unnecessarily complex deal to buy three other Sickert pictures for £20, paid in instalments. The arrangement was not ideal, and Sickert complained to Rothenstein: 'between ourselves, [Eden] is a beast – a mean brute who, half in a funk & with no opinion of his own, is always trying to get something for nothing'. Nevertheless, he urged Carfax not to fall out with him, as his custom gave 'the shop' a profile in St James's, where 'he knows *everyone*'.[83]

Sickert thought he might have found an alternative means of raising money when he spotted 'a darling' little painting by Eugène Boudin – overlooked – in a junk shop. 'What a sky! What crinolines!' he apostrophized to Rothenstein, whom he expected to provide the funds to buy it for the Carfax. Sickert pretended to the shopkeepers that he

was only interested in acquiring the picture because crinolines 'amused' him. He offered 200 francs. Although he was enormously pleased with his slyness, the vendors do not seem to have been deceived. They declined the offer, and when he returned later told him the picture was no longer for sale.[84]

While he was frustrated not to be able to get to Rothenstein ('Nobody here to talk art & fucking with'), Dieppe soon began to fill up with summer visitors.[85] During the summer season there was no danger of Sickert becoming 'isolated'. There were many familiar figures in the crowd: his youngest brother Leonard came over. He had been engaged to sing at the Casino at 80 francs a performance, which – as Sickert remarked – was 'not bad for a beginner'.[86] Henry Harland and his wife were also in town; Mrs Stannard was of course in evidence; and Reggie Turner had put up at the Grand Hotel.[87] Also amongst the first to arrive was Whistler. Sickert passed him in the Grand Rue with one of his Birnie Philip sisters-in-law, looking 'very well and dignified'. It was impossible for them not to encounter each other 'constantly', particularly as they both liked to lunch at Lefèvre's. They achieved an uneasy modus vivendi by eating in different rooms.[88] Whistler, at sixty-five, was looking old. He had been forbidden by his doctor to paint outside, 'at the risk of his life'. 'Poor old Jimmy,' Sickert remarked to Rothenstein. 'It was all such fun 20 years ago.'[89] Recent events had taken their toll on the 39-year-old Sickert too. Turner reported to Max Beerbohm that he 'looked older'.[90] Nevertheless, there was still enjoyment to be had. 'Socially it is amusing here,' Sickert told Rothenstein. 'Though I work all day, the evenings at the Casino are fun. There are some *charming* people, some awful bores & here & there a little customer.'[91]

Sickert's claims to 'work all day' were something of an exaggeration. As he admitted to Blanche, by 'hard at work' he meant 'as hard as my slow-moving nature allows me. Four hours every day.' In his slow progress, however, he was heartened by the discovery of a new approach to picture making. Ernest Brown, the manager of the Fine Art Society, was over in Dieppe and Sickert took him to the studio, after the inevitable lunch at Lefèvre's. Brown advised him that 'water-colours sold always like fire'. Though Sickert was not attracted by the idea of pure watercolour, he set to work at once on a series of 'tinted charcoal drawings'.[92] Brown took two away with him on the steamer when he returned to London and Sickert sent others over subsequently

gi the hope that they might make a little exhibition.[93] The drawings were 'rapid' to do, and Sickert thought he would be able to sell two or three more easily than one painting. Commercial considerations were paramount. As Sickert admitted to Blanche, in time he might be able to think of 'higher things', but for the present his 'sole existence [was] in the shop'.[94]

In his quest for amusement and custom Sickert ranged across the full span of Dieppe's social scene. Each fresh wave of holidaymakers conjured up the prospect of fresh sales. He had hopes that a Mrs Lowrie, a South African 'ex-art-critic' who had moved into Rossetti's old house in Chelsea, might persuade her husband to buy a Sickert for her at the Carfax Gallery;[95] and when he learnt that the Hannays, a wealthy Hampstead solicitor and his wife, had bought the Villa Beau Sejour that summer for £2,500, Sickert made sure that Mrs Hannay came round to see his pictures.[96] He had a success with Robert Barr, the Canadian journalist and author whose daughter he had drawn in London. Braving Whistler's displeasure, Barr bought at least one small picture from the studio, as well as mentioning a plan (sadly never fulfilled) of writing an article on Sickert – 'for Harpers or Scribners' – casting him as 'the Kipling of Impressionism or the Alfred Chevalier of Art'.[97]

Sickert's social forays were never just restricted to the English holiday crowd. Through Blanche he had become a privileged visitor at La Case, the old manor house on the cliff above Dieppe, which was the summer residence of the Comte and Comtesse Greffulhe. It was there that he encountered the dandy poet Comte Robert de Montesquiou, as well as other flowers of French society: the Princes de Caramo Chimay, the Baronne Benoist-Mechin, and Prince Edmond de Polignac. He met the Greffulhes' neighbour, M. Gaston de Saint-Maurice, who, recently returned from a stint in the Egyptian Debt Department, had decorated the portico of his villa with exquisite Moorish tiles.[98] Amongst the rather more staid French bourgeois families of the area Sickert was also popular. He lunched with the Bosmelets and the Mallets, and 'thanks to' Blanche could meet the Mariellys 'le front haut'.[99] It was not Blanche, however, but a Mrs Fenwick Neville who introduced Sickert to the intellectual circle of Mme Lemaire.[100]

Madeleine Lemaire was a noted and highly successful flower painter. It was said of her that only God had created more roses. Known to her loyal adherents as 'The Mistress', she was also the ener-

getic convener of a salon at her Paris home.* Even on holiday in Dieppe she sought out interesting and artistic people for her gatherings. She had quarrelled with Blanche, but she did not hold this against his friend,[101] and Sickert found the atmosphere at her dinner table a stimulating tonic. 'I must confess,' he informed Blanche, 'I like French Society of her kind – apart from incidental considerations. I dislike rich, smart, quite stupid people & cannot bear dirty ill-mannered Bohemian Society.'[102] Amongst the 'incidental considerations' were possible sales (Mme Lemaire bought one painting herself) and the hostess's daughter, Suzette, whom Sickert presented with numerous drawings.[103]

Sickert's most regular customer, however, was Blanche – or so it appeared. Ellen's relief at the settlement of the divorce had been tempered by a continued anxiety about how Sickert would manage without her. He was, as she confided to Blanche, never out of her mind 'day or night'. She hoped that he might return to journalism 'to save himself from the financial muddle he is always in until his work sells',[104] but, with no sign of that happening quickly, she resolved to help him by stealth. She arranged to send Blanche £80 with which he was to buy the occasional small picture 'in such a way as to keep [Sickert] from being in want until he can recover himself & earn money'. It was to be understood that the purchases were being made by Blanche, and Ellen hoped that he might fix things so that he could get pictures in exchange for paying Sickert's weekly bills – as giving him the money outright would only result in extravagance and waste. Absolute discretion was necessary (Ellen, not unsurprisingly, was keeping the arrangement secret from her sister).[105] Blanche put the plan into action. He purchased a little panel version of the 'boys in the gallery [of the Old Bedford]' for £20, and declared an intention to buy the painting of The Stage Box that Sickert had exhibited at the Royal Academy.[106] His intervention enabled Sickert to pay off some pressing debts and to rent from 'a dear old fat French sculptor' some additional studio space.[107]

Amongst the recent additions to the English colony at Dieppe were two unattached women, both of whom excited Sickert's curiosity and admiration. Lady Blanche Hozier and her four 'exquisitely aristocratic

* Mme Lemaire served as the model for Proust's 'Mme Verdurin', a not very flattering portrait of a jealous, preening, and pretentious hostess. The depiction caused a rift in what had been a long friendship between them.

children' were staying at the adjacent village of Puy for the season, while 'the enchanting Middleton family' (a mother, three twenty-something daughters and a grandchild) had established themselves in the Tour aux Crabes, a tiny enclave of three houses set around a courtyard and built inside the curve of an old fortification above the Quai Henri IV. Lady Blanche, the daughter of the 10th Earl of Airlie, was the estranged wife of Colonel Henry Hozier. At forty-seven she was still beautiful and strikingly elegant, though she dressed with a confident disregard for the conventions of fashion: rather than hats, she wore lace mantillas. She had left England precipitously, anxious that her husband might be planning to abduct their children: two pretty teenage girls – Kitty and Clementine – and 11-year-old twins, Bill and Nellie. Dieppe delighted her, not least because of its casino: she was an enthusiastic gambler. She resolved to settle in the town at the end of the 1899 season.[108]

Simona Middleton was a widow whose husband had drunk himself to death some fifteen years previously. Since then she had eked out her income amongst the expatriate colonies of the French coast along with her five children. The two eldest had recently emigrated to New Zealand, but remaining with her were the three younger daughters: Eliza, Polly, and Lilias. They were all 'tiny, fair and delicate'. Polly was married to a civil servant called William Price and had her own young daughter, Phyllis. But she liked to spend time with her mother and sisters and had arranged for Phyllis to go to school at Dieppe.[109]

Sickert came to know them all well. He had taken a studio next door to the Middletons in the smallest of the three properties in the Tour aux Crabes. The house's glassed-in veranda provided a wonderfully light painting room. Mrs Middleton would sometimes entice him in to share their lunch, and he soon enchanted the family. Mrs Middleton considered his visits 'better than a tonic'. The three sisters admired him greatly, and he admired them – particularly Polly.[110] (Sickert referred to her as 'a shrewd & taking little cat with all her wits about her'.[111]) Though he presented all of the Middletons with pictures, Polly received the most. He also drew her often. Coquettishly, she claimed not to like Sickert's depictions of her face; he responded by insisting that in future he would only draw her from behind.[112] It is possible that their flirtatious sparring flared into an affair, before mellowing into a long and fruitful friendship. Certainly they were very close.

Sickert, displaying an unexpected paternal side, would sometimes mind Polly's daughter so that the older Middletons could all go to the Casino together. He would deliver or collect her from school, and let her play in his studio.[113] He delighted in the little girl's ways and her caustic comments – even confiding to one friend that he found his little charge 'so enchanting' that 'it would be truly enough reason for him to live' if he knew he could see her whenever he liked and watch her grow up.[114] She was a very pious child and amongst her foibles was an ambition to marry a parson, so that she would be sure to get to heaven. Sickert, in her opinion, was far too good-looking to be quite good. His 'golden curls', she thought, made him look suspiciously like 'Lucifer'. Apprised of this view, Sickert went to his lodgings and shaved off all his hair. He then reappeared – 'bald as an egg' – to the horrified consternation of Phyllis, and indeed everyone else.[115]

If Phyllis was hard on Sickert, she would surely have been harder on Conder. The 'Big Bird' flitted in and out of Dieppe during the course of the summer.[116] Sickert saw him occasionally but found him something of a trial. On one evening Sickert went to Lefèvre's in response to a note from Conder claiming that they must meet to discuss matters of 'urgent importance', only to discover that the painter had turned up in such a state of inebriation that he had been refused entry. Although Sickert caught up with a chastened and sober Conder the next day at the Café des Tribunaux, and had an 'agreeable – friendly conversation' with him, he was not anxious to repeat the encounter. It was a matter of self-preservation, rather than morality. 'I have no prejudice against Conder,' he told Rothenstein, 'whenever I see him, I like him sincerely . . . [but] I am convinced that you *cannot* associate, i.e. exchange hospitalities and frequent people whose method of life and point of view on conduct differ radically from your own. I will not drink or dine or consort with drunkards. They bore *me* & I am no use to them, & my time & nerves & spirits are too valuable to me & to other people to be "messed about".'[117]

Conder passed his own judgement on Sickert, remarking that he was having 'a great success & is to be seen daily at the Casino in the most brilliant society' before adding rather bitterly: 'He will find it a nice change I should think.'[118] Sickert's liaison with Mme Villain, though a subject of fascinated discussion, was not openly acknowledged. He kept the two parts of his life separate. At the end of the summer, having become increasingly anxious to escape his stuffy, noisy

rooms on the Quai Henri IV, he moved in with Titine. They took a
house together on the other side of the harbour, at Neuville. Rents
were even cheaper there and Sickert could get a 'house for the whole
family, shed & garden & cistern & grenier' for only £20 a year. He was
concerned to spare Titine any of the worries about rent that he had
endured the previous winter. Her 'simple, beautiful peasant woman's
heart' was, he felt, unfitted by 'habits and traditions' to bear such
'agonising anxiety'.[119]

Titine, it transpired, had a 'genius', if not for homemaking, at least
for bargain hunting. She bought a 'commode de nuit' and a bed at a
sale, and spent her free moments at the market carding wool for the
mattress.[120] She also arranged the move. Sickert cherished the vision
of her 'standing like an empress in a cart' while a cupboard was being
lifted out.[121] He was thrilled with the new arrangements. 'I get now a
bedroom (tiled floor),' he explained to Rothenstein, '& a studio on
the ground floor where I can receive anyone decently.' He ordered a
new letterhead, inscribed: Maison Villain, Neuville-lès-Dieppe. A glori-
ous prospect opened up before him. He described to Rothenstein the
happiness of walking back up the steep hill to Neuville at midnight
after dining *en ville* and being welcomed in by Mme Villain. The beauty
of the scene and of the welcome he received gave him a sense 'that
life could be peace & kindheartedness & gratitude & mutual services
& confidence'. It was, he felt, an atmosphere conducive to work: 'Full
Steam Ahead!'[122]

As Dieppe emptied of its summer visitors, Sickert spent more time
working out of doors. Clementine Hozier, who had moved with her
mother and siblings to a house in the Faubourg de la Barre and was
going to school at the Convent of the Immaculate Conception, would
often come upon him sketching in the narrow streets around the
church of St Jacques. She was not attracted by the low tones of his
work. When he taxed her with not liking his pictures, she explained,
'Well, Mr Sickert, you seem to see everything through dirty eyes.' This,
however, did not prevent her from developing 'a schoolgirl passion'
for him.[123] She was struck by the contrast between his good looks –
the thick 'honey-coloured' hair and piercing 'sea-green' eyes – and his
eccentric mode of dress. He often appeared attired as a fisherman, with
a workman's *casquette* on his head.[124]

The Hoziers' house became one of Sickert's favourite retreats. He
often walked down from Neuville to dine there. The food was good,

and he got on very well with Lady Blanche.[125] She had established a reputation as the terror of the local tradespeople, but Sickert liked strong-willed people. He was thought to be the only person who ever dared answer her back.[126] He found himself drawn into the dramas of family life. He was at the house on the winter's evening when Lady Blanche's estranged husband appeared dramatically at the window craving an interview with his daughters and the whole family had hidden behind the sofa. Sickert established an easy familiarity with the Hozier children and seems to have taken a particular pleasure in teasing Clementine. She was more upset than pleased by the full-length caricature of her that he executed with a red-hot poker on the shaft of her hockey stick. Sickert had insisted on depicting her as she appeared fresh from the violent fray of a school match, and the fearsome silhouette was only too vivid. Clementine covered it up with sticking plaster to hide it from her schoolfellows, and was secretly relieved when the stick was broken soon afterwards.[127] On another occasion, when she offered Sickert a chocolate, he affected to believe that she intended the whole box for him and accepted it with effusive thanks.[128]

Sickert returned the hospitality – and satisfied the curiosity – of his friends by inviting them up to the Maison Villain. They were less taken than he was by the charms of the establishment. Clementine Hozier preserved a pungent account of her visit to the bedroom studio in which Sickert 'could receive anyone decently':

> The door [of the house] was open, no bell, no knocker; so I rapped with my knuckles. After a long pause a magnificent commanding woman appeared, and I recognized Madame Villain. She was very big and tall, dressed in a black dress with a blue and white check apron tightly round her shapely waist, her hair stood out round her head like a golden red halo, her sleeves were rolled up, and she stood akimbo displaying beautiful white arms and hands like those in a Vandyck picture. They were covered with tiny freckles, and each almond-shaped nail with a perfect half-moon was (alas) bordered with black. 'Que voulez-vous?' she asked abruptly. I was terrified, but determined to keep my end up. 'Je viens prendre le thé avec Monsieur Sickert.'
> 'Eh bien, il n'est pas là.'
> I was dumbfounded. She then said, 'Mais si vous voulez vous pouvez l'attendre.' She then flung open the door leading into a very dirty bedroom. The bed was unmade and on a

rickety deal table were the remains of a herring. I was profoundly shocked and thought, 'Perhaps Mother can find Mr Sickert a better housekeeper.' I waited – no Mr Sickert – so then I decided to clean up his room. I made the bed, found an old broom and swept the floor, and finally seizing the skeleton of the herring by the tail flung it out of the window upon a rubbish heap just below. I then washed the plate and put it away. Just then I heard loud melodious singing and there he was, with a large bag of hot brioches under his arm.

'What have you been doing to my room?' he asked suspiciously.

'It was very untidy, so while I was waiting for you I cleaned it up; which I think your landlady might have done.'

'Where is my herring?'

'I threw it away.'

'You little interfering wretch, I was just going to paint it. And where, pray, is the handsome plate it was sitting on?'

'I have washed it and put it on the shelf.'

We then consumed the brioches, accompanied by tepid cider, after which Mr Sickert took me home.[129]

Polly Price and Eliza Middleton fared little better. They had to perch on packing cases as they sipped their tea from cracked and saucerless cups. It was a cold day – and the sisters felt it; Sickert had used a diamond to cut small ventilation holes in the window panes, as the windows themselves had become stuck shut from repeated painting, and the wind whistled through.* The floor, to the fastidious Eliza's horror, was strewn with sawdust. Polly, casting around for something to admire in the very bare room, praised the fine carved-oak bureau (the 'secretaire fit for a prime minister'). The next morning, 'to her mingled horror and delight', two fishermen staggered up the steps of the Tour aux Crabes bearing the bureau as a present for her.[130]

The outbreak of the Boer War in the autumn of 1899 placed a strain on Anglo-French relations in the town. French public opinion was strongly against England's military action, and the popular press was loud in its condemnation. Tobacconists displayed satirical postcards showing John Bull – if not Queen Victoria – trampling upon the unfortunate Boers. English residents were insulted. Stones were

* Sickert thought the cold was bracing and the humble surroundings an economy. As he reported to Rothenstein: 'It is bloody healthy here & fucking cheap ("Fucking" here used as an adverb, not as a substantival gerund).' (WS to William Rothenstein [1900].)

thrown. Lady Blanche's youngest daughter, Nellie, was pushed over in the street, and Polly Price had her foot stamped on by one young man, who might have gone further had she not retaliated with a sharp blow to his nose.[131] Sickert, as both a vociferous supporter of the Boer position and an honorary Dieppoise, was not threatened by such indignities.* With amused detachment he noted that the French – misplacing an 'n' for a 't' – shouted 'Shin for you!' at passing English visitors, under the impression that it was a heinous insult.[132]

He did not allow any simmering tension to disturb his hard-won calm. Indeed his convenient new living arrangements, as much as his limited resources, encouraged him to abandon the original idea of dividing his time between Dieppe and London. He finally resolved to give up his Robert Street studio. The place, as he wrote to Florence Humphrey, had become irrelevant for his work: 'Except for portraits there is not light enough in London for my style of work – that is, from drawings.' Florence agreed to take on the studio; and though Sickert gave her the 'throne' and offered to sell her the easel, he burdened her with the business of packing up his other effects. He wanted her to send over two small palettes and a 'little parcel of nothing but small scale drawings, panels, pen drawings & photographs of Venice', as well as a collection of other work: a panel by Steer of Ellen 'writing in blue with black chairs. Back view. And my mother's portrait & father's studies.' Sitting in his studio at Neuville, the wind, he told her, 'seems to puff up from under my cellars as it would lift the house off the hill & I can see the white horses all over the sea from the windows'. He hoped that it might blow her over from England.[133]

In the meantime he settled himself to work – and to domestic life. As far as he allowed them to impinge on his routine, the novel distractions of his new home amused him. He became happily preoccupied with chickens, water-closets, watch dogs, 'children's hair & bottoms'.[134] Although gossip amongst the English colony held that at least one of Mme Villain's 'ribambelle' of children must belong to Sickert, there is no evidence to support the assumption.[135] Nevertheless, he did cherish fond memories of the Villain offspring, telling friends many years later how he used to sit 'dear Yvonne' on her little pot

* Sickert also made other concessions to French feeling. He later claimed: 'I adopted the dialect of the Pollet during the Boer War for the duration.' Annotation to *The Tichborne Trial*, 142.

when she was four years old; or how he had taken the young Maurice
to hospital after he had fallen over running down the road with a
bowl of cream and cut his arm open – 'he had to have several stitches
. . . & bore it like a trump'.[136] But, despite this fondness, he was glad
when they went back to school after the Christmas holidays. The boys
in particular were inquisitive and – for all Titine's laughing prot-
estations that 'ils ne sont pas des tigres' – he had to take care to keep
his paints out of their reach.[137]

Sickert's principal luxury amidst the humble surroundings of his
new home was marmalade. 'I find [it] such a comfort,' he told Roth-
enstein, specifying his favourite brand as 'Keiller's Dundee'. It was a
taste of which one of his visitors would have approved. In the New
Year, Degas – the great champion of marmalade in France – came
to call at the Maison Villain: 'He was charming,' Sickert reported to
Rothenstein. He was introduced to Titine, and they achieved an instant
rapport: she told Degas that 'he was like "la vieille Louise"' – one of
the old fishwives in the market. Sickert then walked his hero down
the hill and across the harbour to breakfast at Lefèvre's. Degas had to
return to Paris that evening, but his visit was a signal honour.[138]

In February 1900 the pleasant rhythm of Sickert's Dieppe life was
jarred by an outbreak of typhoid fever in the town. Kitty Hozier fell
dangerously ill and Sickert helped to nurse her. When her condition
worsened, and Lady Blanche decided that she must send her other
children back to England out of harm's way, it was Sickert who took
them to meet the night boat. Despite the arrival of, first, a professional
nurse and then Lady Airlie, Kitty died on 5 March. It was a terrible
blow; and for Sickert it had the additional sadness of breaking his
connection with Lady Blanche. She decided that she must leave Dieppe
and join her children in England.[139]

It was perhaps the aftershock of this tragedy that led Sickert to title
the Dieppe nocturne he sent to the NEAC that spring with a line from
the Benedicte in the *Book of Common Prayer*: 'O Ye Light and Darkness,
bless ye the Lord, praise him, and magnify him for ever.' Rothenstein
was mystified by the development: 'I hope his severance from Whistler
has not driven him to God,' he remarked to Beerbohm, 'for if he
became religious, I have an uncomfortable feeling it might turn into
religious mania: you know the extraordinary logic of his attitude. Of
course it may be an excellent jest.'[140]

Sickert was not at the NEAC show to reassure him. He was at

another exhibition – in Paris. He went with Polly Price and two other friends to the opening of the Paris Exposition.[141] Amongst the works on show was Degas' *Répétition d'un Ballet sur la Scène* – the painting that Walter and Ellen had bought soon after their marriage. Ellen was considering selling it and had lent it to the exhibition in the hope that it might attract a purchaser.[142] Sickert took Polly to call on Degas, as she was a great admirer of his work. The visit, however, was not a success. Degas was less taken with Mrs Price than he had been with Mme Villain. He was uncommunicative and rude, and refused to show any of his pictures. Sickert, leading Polly away, attempted to excuse Degas' behaviour by explaining that he was '*maniaque*' – or fussy. Degas, overheard the remark, and shouted down the stairs after them: 'Je ne suis pas maniaque', before slamming the door.[143]

At some point, probably in May, Sickert made a brief trip to Venice.[144] Sickert hoped that Florence Humphrey might join him there, though he was concerned that she should not bring Amy Draper with her. As an alternative he suggested that she come with her husband's very pretty Canadian niece, Mrs Lawson, whom he had met recently in Paris and liked. He was anxious to find out from Florence what Mrs Lawson had thought of him, adding, 'She made the impression on me of a woman who wouldn't play at love, like a quadrille, and that is all I am good for.' Mrs Lawson had clearly been intrigued for, in the event, she came out to Venice without Florence, but accompanied by her 6-year-old daughter and by her recently widowed sister, Stella Maris. Sickert had a very jolly time squiring them about, even if the opportunities for playing at love seem to have been limited. When he took them all out in a gondola one moonlit night and exclaimed, 'Isn't it a lovely night, I must kiss someone!' he had to content himself with kissing the 6-year-old Ellen.[145] The trip, however, was not a holiday for Sickert. He needed to work. Given his concern for 'the shop', he must have considered that Venetian scenes would have a commercial potential beyond even those of Dieppe. He did a series of drawings, which he brought with him when he came to London in June and deposited with the Fine Art Society, where his tinted sketches had been selling well.[146] Sickert urged Florence to go and see these 'new Venetian drawings' when she had the chance: 'I really *want* your opinion. Whether they seem effective, which you like, and which you don't &c.' Practically all his 'history', he told her, was 'written in those drawings'.[147]

Sickert's stay in London was brief.[148] He was back in Dieppe *chez* Mme Villain for the summer holiday season. His strange double life continued. He would descend each morning from his retreat at Neuville for a day of work and pleasure on the other side of the harbour. He would lunch at Lefèvre's with Reggie Turner and Max Beerbohm. Oswald, his favourite brother (who was now contributing occasional art criticism to the *Saturday Review*), was also in town with his Cambridge friend Stanley Makower. And he met Rothenstein's younger brother Albert, for the first time, as he passed through town on his way to Cany. Sickert urged the young Slade student to call on him when he was next in Dieppe.[149]

Against the background of such distractions, Sickert was able to tell Florence that he was 'very hard at work as usual[,] tearing after the necessities of life, breathlessly. Full of courage and hope and inclined to think a turn will come in time.'[150] For Sickert, it seems, the greatest necessity in life was studio space. Despite being well provided for, he was unable to resist acquiring new studios. This trait, which became more pronounced throughout his life, began to reveal itself in Dieppe. Each workspace had for him a distinct flavour, and a specific energy. Both, in time, became used up. To keep fresh he needed to move regularly. That summer he discovered two new rooms in which to paint: a little shed in the rue Ango (a narrow side street running up from the Quai Henri IV, which he had drawn 'in a little frontispiece to a number of the Yellow Book'); the other space was on the seafront at 38 rue Aguado. It was well placed for one of his projects that summer: a new picture of the Hôtel Royal – 'the Evening effect only with a few modern figures'.[151] The building had recently been bought by a company that was planning to rebuild it in a completely new style; Sickert perhaps wished to preserve a memory of the place.

He presented the most finished of the several paintings he made of it to the little Musée de Dieppe.[152] It was a small repayment of the debt he owed to the town – and also a useful advertisement to catch the attention of discerning visitors – amongst whom that year was Ellen. Divorce seemed to have cleared away the malaise of their relationship. They saw each other frequently and on the best of terms; Ellen visited the Maison Villain and brought presents for all Titine's children. So well did she and Walter get on that Blanche even began to hope that they might consider remarrying.[153]

Although Sickert continued to sell work in England through both

Carfax and the FAS, and though he dispatched two canvases to the 1900 winter exhibition of the NEAC, the focus of his interest was beginning to shift towards France. Through Blanche's kind offices he had continued to make sales and contacts amongst the French visitors to Dieppe; and – more significantly – he had been offered a one-man show by Durand-Ruel. Presented with the opportunity to exhibit with Degas' dealer, he quickly forgot his reservations about 'gallery shows' and set about gathering together a body of work. He went to Paris at the beginning of December to make ready for the show, staying with the ever-accommodating Blanche, who acted as his 'fair polished guardian angel throughout' proceedings.[154] The exhibition opened on 6 December, in Durand-Ruel's showrooms at 16 rue Lafitte, and ran for two weeks.[155] It was a substantial gathering of over forty paintings and half a dozen drawings – mainly views of Dieppe but with some Venetian scenes, a single music-hall picture, and the portrait of Horatio Brown that Sickert must have arranged to borrow on his visit to Venice. It was one of several loans calculated to give the exhibition an added cachet for the Parisian beau monde. Both Comte Robert de Montes-quiou and Mme Lemaire lent paintings, while Blanche loaned two works.[156] Sickert was not convinced at the quality of all the work. As he wrote to Alice Rothenstein, some of the 'pictures ain't "splendid"', but he felt they must be 'shoved along' just the same.[157]

And 'shoved along' they were. Durand-Ruel knew their busi-ness: the pictures sold. Sickert was ecstatic at this first real savour of success. Paris was at once elevated to the position of *'Der Ziel meiner Hoffnungen! Der Mecca meines Traumes!!!'* ('The goal of my hopes! The Mecca of my dreams!!!'). '*All* my customers in Paris are yiddish. Bless 'em,' he wrote facetiously to Rothenstein. 'So I have told Degas I can be [a] nationalist no more.'[158] Unfortunately there is no record of Degas' reaction either to this proposed political tergiversation or to the exhibition itself. It is hard to suppose that, on the latter score, it was not favourable, or at least encouraging. (Indeed, according to one tradition, Degas urged his friends the Halévys to buy a painting of St Mark's from the show.[159]) Certainly Sickert saw much of his mentor, occasionally lunching and dining with him, and learning a great deal from his company.[160] He recorded his *mots* with the sedulousness of an aspiring Boswell.[161] He went with him to see the first exhibition of Monet's *Nymphéas*, which was showing at Durand-Ruel's other site.[162] It was a display of substantial achievement and experiment, but Degas

refused to submit. Confronted by an array of fashionable women
slumped on the gallery ottomans lost in contemplation of Monet's
large, semi-abstracted visions of water lilies, Degas remarked: 'Je
n'éprouve pas le besoin de perdre connaissance devant la nature' ('I
don't feel the need to lose consciousness before nature').[163] Of his old
Impressionist confrères Degas seems to have had more time for
Camille Pissarro. Sickert shared a stimulating encounter between the
two men, remarking that Pissarro's 'pizzicato is better than ever'.[164]

Hanging around his own exhibition, a few days after its opening,
Sickert ran into Reggie Turner. He invited him back to dinner *chez*
Blanche. It was a jolly occasion – Jules Chéret, the poster artist, was
there – and Turner, to repay the kindness, invited Sickert to dine
with him the next night 'in honour' of Max Beerbohm, whose one-act
dramatic version of his own novella *The Happy Hypocrite* was having
its premiere that evening in London at the Royalty Theatre.[165] They
planned to send a telegram of congratulations to the theatre, but sud-
denly realized they had missed the deadline. Instead, they drank to
the health of Max – and the play's hero, 'Lord George Hell'.[166] Having
achieved a success of his own, Sickert was eager to salute the efforts
of others.

II

CHANGING EFFECTS

I am really doing better work.
(Walter Sickert to Mrs Hulton)

At the beginning of 1901 Sickert returned once more to Venice: '*Ach Venedig!* Kilburn-in-the-sea as it were.'[1] His tone was determinedly brisk and anti-romantic. He went there to work, mindful that his Venetian pictures of the previous year had been admired – and even bought. The sense of a new era opening up was quickened with the news of Queen Victoria's death on 22 January. The new century would furnish a new monarch, and, Sickert hoped, a fresh advance in his art. He began painting the usual round of Venetian scenes. Amongst 'many others' he did a picture of a corner of St Mark's that he planned to exhibit at the Salon that spring.* Setting up his easel in the piazza he attracted crowds of onlookers, all amused at his total absorption, and bemused by his 'impressionist' rendition of the scene.[2] Their bemusement may have been increased by the fact that Sickert was in experimental mood. As he explained to Durand-Ruel, he had learnt much in Paris and had been led towards the discovery of 'une coloration claire tout à fait différente de ce que vous avez vu de moi jusqu'ici' ('a light colouration altogether different to that which you have seen from me up to now'). Perhaps impressed by Monet's method of working in series, he planned to make his own series of paintings of St Mark's 'par effets différent'. He wrote excitedly about the idea: there were to be five pictures, all the same format (100 × 85 cm), and they might, he thought, be shown together.[3]

* * *

* Blanche, it seems, came out to Venice and took the picture back with him, but for some reason it was not shown. WS to Durand-Ruel [2/4/1901].

On the basis of this 'series' scheme, Sickert asked Durand-Ruel for a 500-franc advance, offering to repay the money in three months if they didn't like the pictures. In the meantime, he explained with a candour that can only have alarmed his dealers, he had been obliged to sell some of his sketches to foreign visitors in Venice. Though he promised not to make a habit of the practice, it was necessary because he was behind on his Dieppe rent.[4] Durand-Ruel sent the cheque and expressed an interest in exhibiting a small group of his pictures, enabling him to brag to Florence that he would be having 'an important exhibition at Durand-Ruel's in the winter. Six biggish canvases.'[5] It seems, however, that Durand-Ruel may have discouraged the idea of a single-subject series; certainly there is only one known view of St Mark's in the format mentioned by Sickert.[6]

Venice offered a more stimulating social and artistic milieu than out-of-season Dieppe. The Biennale opened at the end of April. There was a major display of Rodin's sculpture, and Sargent was well represented in the Salone Internazionale. The British contribution was not calculated to make Sickert feel part of his national tradition: although Room H did include some vaguely impressionistic works by Alfred East, John Lavery, and Arthur Peppercorn, it was dominated by Burne-Jones's *Dream of Lancelot*.[7] Sickert had made many friends on his previous visits to the city and was able to pick up the old connections – as well as making new ones. He was delighted to discover 'an agreeable Russian prince' called von Wickenburg had taken the studio next to his at 940 Calle dei Frati.[8] Less satisfactory was an Italian painter who worked at the end of the calle; he would ask daily whether Sickert thought Durand-Ruel might be interested in having an exhibition of his work. Sickert took to going round the other way.[9] He saw much of the Montalbas,[10] met the Countess of Radnor, who had established herself on the mezzanine of the Palazzo di Mula, and befriended von Bulow, a blind German expatriate to whom he read occasionally. He also encountered Edward Heron-Allen, an amusing young English polymath, who was visiting Venice with his new wife.[11] But above all he attached himself to the Hultons.

He could talk painting with Mr Hulton (who, along with Clara Montalba, once again had a picture in the Venetian section of the Biennale), and – indeed – with Mrs Hulton, whom he credited with a 'becoming & singularly inoffensive omniscience'.[12] She provided him also with the bright, sympathetic yet flirtatious friendship that he so

much enjoyed. He spent many of his evenings with the Hultons at the Palazzo Donà.[13] Their two young daughters – the 11-year-old Teresa (known as 'Bim') and Gioconda, two years her senior – immediately fell under his thrall. He encouraged Gioconda's attempts at drawing, providing her with a detailed study of a suit of armour – accompanied by full explanations of the various joints and elements – to help her in her depiction of military saints.[14] Bim he affected to be frightened of, because he knew that she disapproved of his eccentric bohemian dress. The chance of encountering her when out and about in canvas shoes was, he joked, his principal 'sumptuary terror'.[15]

Mrs Hulton had her own sense of sartorial daring. That May she was one of the elegant society ladies who helped organize and run a charity bazaar in the Giardinetto Reale; dressed in a costume of what the press called a 'bizzarria elegantissima', she – along with two countesses – manned a little bamboo café kiosk.[16] The costumes, designed by a friend of Mrs Hulton's, were black and white, topped by broad-brimmed hats trimmed with ostrich feathers: a single note of colour was provided by a pink Liberty silk tied across the black-and-white striped coat. Sickert, struck by the effect, made a tinted drawing of Mrs Hulton attired in her striped jacket and 'amplissimo capello a grandi penne bianche' (a big hat with large white feathers) and presented it to her.[17] It was one of several works on paper that he did in Venice that spring. Continuing his connection with the Fine Art Society, he sent off a batch of coloured drawings for them to 'show to tried loyalists under the rose'.[18] Although some were views of Venice, two were London music-hall scenes worked up from old drawings, and one was a rare excursion into the fantastical: a picture of Pierrot embracing a popolana (a 'woman of the people'). 'I intend to have "imagination",' Sickert announced to Mrs Hulton. 'Why not?'[19]

Sickert observed at least some of the rituals of the English expatriate community. He even began attending services at the English Church in the Campo S. Vio, though he 'firmly declined' to pass round the collection plate.[20] Indeed his churchgoing seems to have been motivated more by an appreciation of social comedy than a desire for spiritual sustenance. 'The first canticle on Sunday broke down altogether,' he reported to Mrs Hulton. 'Angry American glances from many tall ladies in grey silk with grey hair[,] backwards up to the organ loft.'[21] As at Dieppe, however, he did not remain fixed in one sphere. He also entered into the popular life of the town, exploring its byways and

learning its dialect.* He discovered its pulse beating most strongly at a little trattoria, called Il Giorgione, in the artisans' quarter of S. Silvestro, close to the Rialto. ('I have found *such* a restaurant,' he informed the Heron-Allens, shortly after their departure. 'If you are very good I will tell it you in secret next time.'[22]) He would lunch there regularly. Although it was an unpretentious place offering such local staples as *risi-bisi*,† the habitués included the head of the Monte di Pietà, the gondolier of the Papadopoli family, 'the doyen of wholesale butchers', Signore Zanon (a hand-forger of beautiful iron grilles), a commendatore, and several other 'gros bonnets'. Sickert liked to recall the occasion when the restaurant was flooded and these distinguished customers – dressed in their silk hats and fur-lined coats – were carried through the water on the backs of market porters and taken up to eat on the first floor.[23] The *padrone* was a wholesale vegetable merchant called de Rossi.[24] Sickert considered him 'a darling. So Venetian': 'I think', he told Mrs Hulton, 'he is my ideal.'[25] He had what Sickert described as 'un air effaré' – a look of alarm: 'He was always effaré. His eyes were like two black diamonds or holes burnt in a blanket. His hair cropped short . . . but thin & straight.' Sickert captured something of that 'effaré' look – and all of the cropped hairstyle – in the portrait of de Rossi he made that year. Done 'with a certain brio and solely for my own pleasure', he presented the canvas to the 'simpaticissimo e geniale' sitter.[26]

In June, the slightly less 'geniale' Sir William Eden was over in Venice, visiting his cousin and painting watercolours. He had suffered some financial reverses and was retrenching by living on the Continent. Sickert persuaded Mrs Hulton to let him bring the baronet to dinner: 'He painted your house yesterday & is dying to show Hulton his sketches.'[27]

As the summer advanced, Venice began to grow hot. Mrs Hulton took her children up to the cool of the Dolomites. Sickert intended to return to his 'native Dieppe', but put off his departure.[28] 'I begin to

* Sickert peppered his talk and his writings with Venetian phrases. It was another bond he shared with Degas. It was the French painter who passed on to Sickert the Venetian saying, 'Fare tutti mestieri svergognati per compar onoratamente' (Practice all shameful trades in order to live honourably) – a motto in which Sickert took a 'delighted relish'.

† A Venetian soup of rice and peas, which Sickert claimed could become *bisi-risi* (if there were more peas than rice) or *massa fissa* (if it was over-cooked).

think I shall not go away for some time, a month or so. I have "sort of" got my back up about my work,' he declared, '& at the same time under the impression of a kind of anger at my own capacity it is rapidly pulling itself together.'[29] He was encouraged and even helped by Hulton, who had remained in town, and with whom he had 'the most elaborate tête-à-tête dinners'. Although there was more than a hint of exasperated irony in Sickert's description of Hulton continuing to 'correct my drawing, my perspective, [and] my composition', it was tempered by genuine gratitude.[30] He later recalled that Hulton 'was at the time perhaps the only man in Venice who thought there was any justification at all for my trying to paint'.[31] But in his battle to outface what he felt to be the limits of his own capacity Sickert had to rely largely on himself – bucking his spirits by singing a favourite music-hall ditty that ended with the resounding couplet: 'He proved himself at last to be/The bravest of the brave'.[32]

Under the July sun his studio became 'a malsain furnace', but he continued to work there in between bouts of painting outside.[33] Under the recent influence of his Parisian sojourn, he was experimenting with what he described as 'neo French violet shadows';* but, though he was pleased with the results, not everyone else was. When the Montalbas braved the heat to visit his rooms, Ellen Montalba amused him by one of her characteristically frank remarks. He had 'insincerely' excused the innovative shade effects by explaining that 'as the pictures got finished [he] got rid of them', to which she replied: '"O as long as you get rid of them it's all right," with a sigh of sincere relief'.[34] He dispatched a selection of these canvases – 'eight comparative masterpieces', he called them – to Durand-Ruel, 'guarantee[d] as up to date impressions & as Mr D. C. Thomson wrote of Corot in a book, "thoroughly romantic"'.[35] By the end of July Sickert was ready to return to Dieppe, but he left Venice in the expectation that he would be back in due course. He felt he had discovered another 'gold mine' that he could work. Augustus Montalba generously offered 'to stow all of [his] stuff'.[36]

On the way back to the Normandy coast, it is probable that Sickert stopped off in Paris to see his dealers.[37] He was keen to maintain the momentum of interest that he had established with his show at the

* Sickert, writing in the *English Review* in May 1912, claimed that the Impressionists' use of colour in the shadows was in fact a rediscovery of old Venetian practice. But there is nothing to suggest that he held this view while actually in Venice.

end of 1900.* He found Durand-Ruel delighted with the new pictures: from a commercial point of view, Venetian scenes were good. As Sickert relayed to Mrs Hulton, 'apart from purely aesthetic considerations the firm considers them about the right article which is encouraging ... if they go off – back I come'.[38] There was, however, little expectation of sales during the dead season. This was an inconvenience. Sickert was in want of money: even after the advance he had received earlier in the year he still had 500 francs of little debts clinging to him.[39]

The 1901 Dieppe summer was in full swing by the time Sickert arrived. His two youngest brothers were both in town (Leonard scored a success when he sang a song at one of the Casino concerts). Beerbohm – 'the sublime Max', as Sickert dubbed him – had come back again, as had Oswald's friend Stanley Makower and Sickert's 'disciple' Francis Forster. The Heron-Allens, at Sickert's prompting, also came over for a fortnight. Aubrey Beardsley's sister – 'our beauteous Mabel' – was creating general amazement by parading along the front in a low-necked evening gown with what Beerbohm described as 'a train as long as the rue Hôtel de Ville, which she carries swathed over her arm' (Sickert sometimes paraded with her, and treated her to lunch at Lefèvre's on several occasions).[40]

Mme Lemaire continued her interest in Sickert. He reported to Blanche that she 'appears to think highly of my work & speaks as if she wished to exert all the influence she can to try to contribute to my success in Paris, which is fortunate for me, if it means more than politeness'.[41] Even in Dieppe she was able to assist him. It was at her table that Sickert met and impressed Gustave Cahen, a lawyer and amateur of the arts. He was Eugène Boudin's executor (and became his biographer) and had arranged a posthumous exhibition of the artist's work at the École Nationale des Beaux-Arts in 1899. His collection, put together on a modest budget, included – besides numerous Boudins – works by Pissarro, Corot, Courbet, Fantin-Latour, Monet, Renoir, and Sisley. He promised to call on Durand-Ruel and look at Sickert's pictures there.[42] In due course he bought one.[43]

But amongst the social distractions and opportunities for modest self-promotion, the real excitement was the discovery that Camille

* He was also able to play a diplomatic role in the gallery's dealings with Ellen. She was dissatisfied with what she considered Durand-Ruel's dilatoriness in arranging the sale of her Degas. Walter promised his dealer that he would write to reassure her.

Pissarro was staying at the little Hôtel du Commerce, just opposite the doors of St Jacques. He was painting a series of pictures from the window of his room using his own version of the pointillist technique. Sickert sought out the patriarchal old Impressionist one morning and spent some happy hours with him, looking over the 'belles choses' he was working on. Pissarro offered him advice about his palette, urging him towards a further lightening of tone and purity of colour. Sickert wondered whether Pissarro – in time – might even cure him of the use of black.[44]

To fix the moment, Sickert hosted a special dinner for the painter at Lefèvre's, gathering together his young friends and relations, all of whom were anxious to meet such a master.* The evening was a success, marred only by the arrival, at the end, of Max Beerbohm's bumptious half-nephew Evelyn, who, uninvited, burst upon the party 'with a straw hat on the back of his head, saying "Less talking there please"' and proceeded to sit down at the table – much to Sickert's disgust. He did not remove his hat, struck Beerbohm a blow on the shoulder, and was generally 'a very false note'.[45]

As the summer visitors gradually departed, Sickert was faced with the prospect of returning to work. He struggled to make a start, telling Edward Heron-Allen that he was 'doing nothing, to counterbalance having done too much in Venice'. The weather turned stormy. Sickert wrapped himself up in his overcoat, with his thick boots and 'a soft hat' – and wrapped himself, too, in his reading and his own routine. He avoided the larger gatherings of the expatriate colony 'from stinginess and laziness combined'. He lunched alone each day in the back room at Lefèvre's with a copy of Le Matin, and dined alone with either the Daily Telegraph or 'an enchanting little Omar Khayyám' that Heron-Allen had sent him.[46] Then, perhaps inspired by his talks with Pissarro, he gradually took to 'painting out of doors', choosing 'country subjects'.[47] He produced a series of Neuville scenes: 'delicious scraggy hedges, roads, kitchen gardens, old houses, orchards, farms'.[48]

There was a hint of melancholy. He confided to Sir William Eden that if circumstances permitted – and he had £100 a year – he would prefer to live in London.[49] To Heron-Allen he said he would love to

* The full guest list is unknown, but Edward Heron-Allen's diary indicates that amongst Sickert's regular companions that summer were two – otherwise unknown – French painters: Altamuro and Montier. It is likely that they were present.

spend even a single month in the English capital.[50] But even that was
too expensive. He gave up shaving, and began to grow 'a handsome
red beard' – bigger and bushier than before – which he hoped might
evolve into a 'type-Lord Spencer'.[51] But even the prospect of looking
like a Tory grandee could not assuage a nagging sense of displacement.
To Mrs Hulton he confided: 'When I was in Venice I was under the
impression I lived in Dieppe, and had *gone* to Venice, and now I feel
as if I lived in Venice, and had *gone* to Dieppe.' He confessed to
being 'a little tired of Dieppe' seeing it as 'that terrible compliment a
watering-place-out-of-season'.[52]

He tried to console himself with the oft-reiterated thought that
France was the home of painting and that he was in a position to
learn far more on that side of the Channel. Contact with men such as
Degas and Pissarro, the friendship of Blanche and his circle, the chance
to see the pictures in the Paris galleries, and the relative lack of distrac-
tion in Dieppe, all offered opportunity. 'I have learnt here what I
couldn't have learnt in a lifetime at home,' he claimed. 'So I suppose
an all-wise Providence is interested in my technique, & exiles me from
beef, & beer & music-halls, most of my friends, & all my mistresses
so that I may leave behind an oeuvre.'[53]

He sought, and found, a muted pleasure in the simple order of his
days – the modest comforts of the Maison Villain, the small circle of
English and French friends across the harbour in Dieppe. The Neuville
house, he considered, was 'not half bad now'. It was well shuttered
and warm in the winter sunshine.[54] He had a stove in his little back
room, and had pinned up some 'Pompeian and Veronese photos' on
the white plaster walls, as well as three 'beautiful studies' by his father.
Upstairs he had installed an easel in 'a warm room with a little pure
North light'. The English newspapers that Florence and other friends
sent out filled up with amusement 'those vital little half hours of
recuperation after work or meals'.[55] There was 'lots of hot & cold water
& wood & coal & ill bred dogs baying at Kings Charles's wain at night'.
It was, he admitted, a 'little tragic & lonely, but comfortable in a
peasant sort of way'; and, as a contrast, he was able to enjoy 'contact
daily with luxury' by breakfasting at Lefèvre's. He also dined out three
nights a week with friends in town – though he did not dress and
wore his 'thick boots'.[56] To Mrs Hulton he described this dual mode
of existence as 'living in style something between a country gentleman
& a pig', adding that it was 'at least dignified'.[57]

A hint of relief arrived from Paris. With the advance of the 'Winter Season', the art market was picking up and Durand-Ruel were hopeful of sales. Sickert – always ready to take the prospect of a sale for the sale itself – at once announced his imminent appearance in London, together with his halo and his beard.[58] He had been away for three years. On his arrival he took rooms in a funny old-fashioned hotel on the Tottenham Court Road with four-poster beds and feather mattresses. He even extended this enthusiasm for the 1860s to his dress, adopting a distinctive bowler hat, peg-top trousers of French cord, and a coat with large buttons.[59]

He had brought over a Dieppe picture for the NEAC winter exhibition.[60] But though he belonged to the history of the club, Sickert was becoming an increasingly marginal figure in its artistic and political workings. It was Steer who continued to be acknowledged as the presiding genius of the admittedly disparate group – his work accepted and admired by a steadily widening circle of critics. As a confirmation of this achievement, William Rothenstein organized a special dinner in his honour, held at the Café Royal on 21 December. Sickert attended, and did much to dispel the slightly awkward formality of the occasion.[61] After the preordained speeches by Roger Fry, D. C. Thomson, Sargent, and others, the evening lapsed into a smoking concert. There were calls for Sickert to do a turn, and he obliged with his bravura rendition of a scene from *Hamlet* as performed by an inept touring company, assuming all the various parts in turn, from Gertrude – 'a pathetic creature, slightly uncertain about her aspirates' – to 'the ranting King, who marched her off with ludicrous pomp when, with "the cannon to the clou-ouds," he reached his exit and top note'. It was, many considered, the highlight of the evening.[62]

Although pleasant to be back amongst familiar surroundings, three years of absence revealed to him the subtle way in which England had changed and his friends had become more like themselves. On one evening Sickert dined at Steer's house with Fred Brown, Henry Tonks, and George Moore. The conviviality of the evening was rather overshadowed by Moore's loud denunciations of the British treatment of the Boers. It was a topic that the unworldly Steer and his two supporters felt little sympathy with, and Sickert – though he agreed with Moore's sentiments – indulged his host for the duration of the meal and talked of painting. But coming away from Cheyne Walk with Tonks and Moore he gave full vent to his contempt for the British prosecution

of the war. In Moore's highly imaginative, and not entirely reliable, reconstruction of events, he wound up his harangue with the assertion that England was 'at present, the ugliest country', before adding: 'Oh I have changed towards England. I try to forget that I once thought differently for when I remember myself (my former self) I hate myself as much as I hate England.'[63] If the words, and even the sentiments, are closer to Moore's extreme position than Sickert's, they do still give some hint of Sickert's sense of dislocation from the English scene.

While in London Sickert also saw something of Ellen. He was still anxious to help her negotiate the sale of her Degas painting and discussion on the subject provided a happy excuse for meeting. They went about together and at the art dealer's Agnew's in Bond Street they had an amusing, if awkward, encounter with Whistler, who was looking round the galleries with the animal painter John Swan. Ellen was introduced as Mrs Sickert, the name she still used. When Swan confessed that he had not known Sickert was married, Walter evaded the need for embarrassing explanations by saying with factual economy, 'Yes, we were married in '85.'[64] Ellen, after a long delayed start, had been working hard upon her novel, *Wistons*. It was published (under the pseudonym 'Miles Amber') by Fisher Unwin early in the New Year, shortly after Sickert's return to Dieppe. It was generally very well received. *The Athenaeum* compared it, not unfavourably, to Hardy; *The Academy* thought it an 'interesting [and] remarkable' book, while *The Times Literary Supplement* found the characters 'freshly conceived'. Robin – the character so clearly based on Sickert – was praised as 'a capable picture of the artist-egoist' or 'a genius who lives solely by the light of nature'.[65] Sickert was delighted at the book's success. It 'is amazingly good,' he told Eden. 'The best literary judges seem agreed upon it ... It is touching, really witty, and so well bred.'[66] Unabashed by his own barely disguised appearance within its pages, he insisted on sending copies to his friends.[67]

Ellen enjoyed another success that February. Sickert finally managed, through Durand-Ruel, the sale of Degas' *Répétition*. He got an impressive £3,000 for it from an American collector.[68] Given that Sickert – or Ellen – had paid only 70 guineas for the picture at the Hill Sale, barely twelve years before, this, as he did not weary of telling his friends, represented very good business.[69] At Sickert's recommendation, Ellen reinvested £400 in a smaller Degas painting, *La Femme à la Fenêtre*. It was, he told Mrs Hulton, 'a *masterpiece*', while to Eden he

described it as Degas' *'finest* work', admitting that he had had his eye on it 'for 12 years or so'.[70] Sickert was amazed to get it so cheaply; when he asked why it cost less than one of Degas' pastels, Durand-Ruel explained it was 'because the amateur of Degas always wanted ballet girls'.[71] Sickert suggested that Eden should get a Degas too, telling him that 'Durand-Ruel are showing a lot, & Degas is ageing & will not produce much of the same kind'.*[72]

The whole experience of dealing with masterpieces and millionaires was a thrill. It was good business for Ellen, and, in so far as Walter was responsible for choosing the picture and arranging the sale, it represented a small return on the amount he had cost her over the fourteen years of their marriage. For Sickert, though Ellen may have given him a commission for his help with the sale, it had the not altogether beneficial effect of convincing him that he was a brilliant trader in the art commodity market. His tendency to discover over-looked Boudins and other 'masterpieces' in the junk shops of Dieppe, Paris, and London, and to imagine that he could turn them into gold, increased.

* The exact fate of Ellen's other Degas pictures is unknown. In 1907, however, Sickert did tell the Paris-based Irish painter Roderic O'Conor that he had 'bought two Degas for about £70 each; had kept them for fifteen years, and had then sold one for £3000 [*La Répétition*, presumably] and the other for £1200' (Arnold Bennett, *Journals 1896–1928*, 174).

III

GAÎTÉ MONTPARNASSE

The only source of light is Paris.
(Walter Sickert, in the Burlington Magazine)

Sickert's own Venetian canvases, though prominently displayed and impressively framed, remained sadly unsold. They had been 'praised' by Durand-Ruel and by the press but, as he reported to Mrs Hulton, 'that is all up to now'.[1] He was able to monitor the fortunes of his pictures only too closely as he was in Paris one or two nights each week during the spring of 1902. Together with Blanche, he was teaching at Mme Stettler's studio, one of the numerous private ateliers in Montparnasse.[2] The work provided some useful income, and also brought him closer to the hub of French art – if not of 'Life' itself. 'Parigi! Parigi!' he exalted to Mrs Hulton. 'La ville lumière. The Louvre! The Bibliothèque nationale! Conférences, the Comédie Française, the quays, the bookstalls! Life. Youth. Art. Concerts. Operas!'[3] Or, as he put it, in a rather calmer mode: 'Of course it is very interesting in Paris, and one learns a lot.'[4]

Montparnasse was teeming with artists, art students, critics, and models, and Sickert entered into the life of the quartier.[5] Although at first he used Neal's English Library as a convenient base and forwarding address, he soon decided that what he really needed was a Parisian studio. He found a 'very good' one, 'better even than Robert St', in the heart of Montparnasse, near the Lion of Belfort – 'to remind me', as he told Eden, 'of the British Lion, lest I forget'. The rent, he added excitedly, was a mere 450 francs (£18) a year.[6] That April he showed for the first time at the Salon of the Société Nationale des Beaux-Arts. The picture of the Doges' Palace that he had planned to exhibit the previous year, was not merely included this time but welcomed: 'Blanche writes me my things had a success with the jury,' he boasted to Eden, 'which is fairer than simply being accepted.'[7]

He showed off the painting to Clementine Hozier (who, now aged seventeen, was in Paris with her French teacher on a fortnight's visit) when he took her round the Salon as part of a memorable day of cultural sightseeing. At the exhibition, Clementine disgraced herself in Sickert's eyes – or so she later claimed – by picking Sargent's bravura Spanish dancer, *La Carmencita*, as her favourite picture. Sickert, interestingly, promoted the claims of Puvis de Chavannes' dreamlike, spiritual canvas *Le Pauvre Pêcheur* – even though, when Clementine asked him who the greatest living painter was, he affected to look astonished at the question and answered, 'I am of course.' Impressed as she was by his answer, and by the Salon itself, she was almost more struck by the fact that, at the café where they breakfasted and the bistro where they had lunch, Sickert did not have to pay the bill but had it chalked up on a blackboard. His charm and his gift for assimilation had already won him the dangerous luxury of credit. In the afternoon they paid a visit to Camille Pissarro in his garret flat overlooking the Madeleine. They found the 'magnificent old man', with his great silver beard and black sombrero hat, already surrounded by at least ten people 'all drinking tepid beer'. The day ended with dinner at Blanche's home out at Auteuil, where – in contrast to Pissarro's bohemian attic gathering – 'everything was exquisite', from the host's manners to the silver cutlery.[8]

Besides Pissarro, Sickert also sought out other grand old men. Degas remained the principal focus of his admiration and Sickert dined each week at rue Victor Massé.[9] Though very conscious of the privileged access he enjoyed, he was generous of his connection. Encountering an eager young English painter called Gerald Kelly at Durand-Ruel's gallery (where he was inspecting a selection of Renoir's canvases), Sickert offered to introduce him to Degas, saying frankly, 'I know him very well and he'll like you.' They went at once. Kelly was amazed at the untidiness of Degas' studio, and no less surprised when he pulled out at random one of his portfolios and displayed about forty drawings of a woman scratching her armpit, about which he discoursed for the entire visit.[10]

The procedure was a rare one. For the most part Degas liked to look at – and talk of – other artists' work, either from his own ever-expanding collection, or in the galleries. Sickert would spend fascinating afternoons touring the picture dealers with Degas, hearing tales of past masters and being constantly reminded of the continuity of tradition. They were together at the Hôtel Druot, the Parisian auction

house, when Degas 'bought a splendid drawing by Manet framed & signed for *30 francs*'.[11] Sickert absorbed Degas' passion for Poussin, for Delacroix, and for his first teacher, Ingres. They went together to the Louvre to look at Ingres' pictures,[12] and Sickert even helped Degas acquire an Ingres drawing from an acquaintance.[13]

Sickert also came to know Rodin and was amazed to discover the scale of his operations. He thought him like a 'medieval master' with his 'hoard of modellers and carvers' and studio assistants. 'The Venice exhibition of him,' he informed Mrs Hulton, 'hardly gave an idea of what he can do.'[14] Sickert wanted Eden to order 'a marble of Rodin's satyr with his hand on the girl's you-know-what from *behind and underneath*' for Windlestone. It would make the place 'the Mecca of modern art ever after', he suggested, besides bringing 'Eternal youth to all within miles'.[15]

Sickert continued to see good deal of Eden, who was often passing through Paris (and, indeed, Dieppe) on his Continental travels.[16] Although on most topics they maintained a bluff accord, they found themselves in disagreement about the Boer War, which was drawing to its halting and compromised conclusion with the Peace of Vereeniging, by which the Boers surrendered and recognized British sovereignty. But Sickert, for all the flippancy with which he tended to express his anti-war stance, urged Eden not to think that he did not 'regret the loss of valuable lives & the sufferings'.[17] No such caveats were necessary with George Moore who had become so outraged at the British prosecution of the war that he refused to stay in London for the duration. His self-imposed exile took him sometimes to Paris where he would seek Sickert out. One evening they dined together with another friend, a British-naturalized German-Jew who, as Sickert remarked, was 'more loyal of course than any Englishman'. Moore, deep in his anti-British mood, insisted that they all speak French and 'begged not to be addressed in English!', claiming he 'could not bear to hear the [English] language!' – much to the German-Jew's consternation and Sickert's amusement.[18]*

Sickert and Moore made a comic double-act on the boulevards:

* Sickert and Moore, even in the spring of 1902, still thought the British cause hopeless. Sickert informed Eden that 'Moore & I agreed that we shall now have to climb down after an *accumulation* of Ladysmiths, instead of after one. Perhaps old Gladstone & Kimberley were not such fools as we thought them! And we shan't even be able to pretend that we are leaving off from magnanimity this time! Sly old fox, the G.O.M.! Moore & I did penance to his [their?] shades together. They must have been flattered.'

Moore, vague, oracular, innocently bound up in his own views and his own genius; Sickert cheerfully subverting him. Stephen Haweis, a flamboyant young artist-photographer just finishing his Paris education, recalled how he and his contemporaries 'rather enjoyed the off-hand, friendly contempt' with which Sickert treated the acknowledged 'celebrity' Moore.[19] He poked fun at Moore's French: Moore was, Sickert claimed, the only man to ask for 'la note', rather than 'l'addition', when he wanted the bill.[20] He delighted, too, in Moore's lack of self-awareness – his habit, as he put it, of conducting his education in public. 'Moore was divine,' Sickert remarked to Steer after one visit, telling how he had informed some highly cultured Parisians that, '"He for his part had come to an age where he didn't care *what* other people thought; his own *personal independent* taste was, he liked Corot!" with defiance, as of a man holding a most eccentric opinion *alone*. A pro-Boer in Trafalgar Square as it were!'[21]

Sickert had some useful entrées into Parisian society. Perhaps through Degas' influence he was admitted to the artistic salon of Mme Howland.[22] He also had the chance to call on Mme Lemaire and discover that her good intentions towards him were more than mere 'politeness'.[23] At the crowded Tuesday evenings in the glass-roofed studio of her house on the rue de Monceau, the grand families of the Faubourg Saint-Germain – the Greffulhes, the Chevignés, and La Rochefoucaulds – would consent to meet with the less bohemian elements of the Parisian art world. Puvis de Chavannes was a regular. For Sickert such evenings offered an opportunity to seek out both fellow artists and potential customers. Comte Robert de Montesquiou was, somewhat despite his better judgement, often at the Lemaires'.[24] So too was Marcel Proust, whose first book, *Les Plaisirs et les Jours*, had been illustrated by Mme Lemaire a few years previously.*

* It is not certain that Proust ever met Sickert, though he did know of him and was intrigued by both his reputation and his art. Once, when in Dieppe, he had called on Blanche in the hope that he might effect an introduction. But it was at one of the rare moments when Sickert was not in town. (Proust was in Dieppe during the summer of 1895 when Sickert was in Venice.) Proust's curiosity had been aroused by Mme Lemaire's tales of Sickert's character, and by the sight of his pictures. He asked Blanche whether he did not think Sickert was 'plus grand que Corot?' And later, during the First World War, when Proust was visiting Blanche, he implored him to talk of 'Sickertiana'; he suggested that Sickert was even more interesting than Beau Brummell, in that he had combined being a dandy and living with a fishwife (*Jacques-Émile Blanche, Peintre*, 216). For his part, Sickert read *À la recherche du temps perdu* as it appeared and considered it 'the book of the century' (ALS to Mrs Swinton, private collection).

Sickert also found friends and allies amongst the painters of Montparnasse. He entered into the little world bordered by the Café de Versailles, the Closerie de Lilas, the Petite Lavenne, and the Chat Blanc. It was in the upstairs room of the last – a little café-restaurant – that an undefined group of young expatriate painters would gather each evening with their models, their mistresses, and a few of their French confrères to throw bread rolls at each other and talk about art. For this young crowd the presiding artistic heroes were Whistler, Conder, and Puvis de Chavannes. Sickert's intimate knowledge of the first two and acquaintance with the last must have given him a certain standing in such company.[25] But despite his enthusiasm for Le Pauvre Pêcheur and the experiment of his own Venetian Pierrot picture, the imaginative element in art remained stubbornly alien to him. He was drawn more towards other currents of the contemporary scene. Of those who supped at the Chat Blanc, he discovered most common ground with Roderic O'Conor, who had worked with Gauguin in Brittany, and J. W. Morrice, the Canadian painter whose work he already admired and whom he had encountered occasionally at Dieppe. Sickert found him 'charming & gifted & intelligent & modest' and interested in the same things he was.[26]

But Sickert's horizons were not confined by the limits of the quartier. Through Blanche, who remained his closest connection in the capital, he came to know two influential French contemporaries, the painters Lucien Simon and Charles Cottet. Simon was teaching in the same studio as Blanche and Sickert, while Cottet was having a joint exhibition with Blanche in Berlin that May.[27] It was good company to be in. Although Simon and Cottet are now forgotten figures, at the beginning of the 1900s they were considered amongst the great hopes of French painting. Cottet, a stout red-bearded figure, whose rude exterior concealed, according to Blanche, a truly delicate sensibility, had begun his career as a follower of the Nabis – the group that included Vuillard, Xavier Roussel, Maurice Denis, and Bonnard.[28] But he had gradually drifted away from their orbit, finding a common outlook with Lucien Simon.[29] They shared a passion for the primitive world of the Breton coast, making its people, its life, and its light their subject matter. From their love of dark tones and dark scenes they became known as the leaders of the 'bande noire'.[30]

Their crepuscular images of Breton life held a far higher place in the consciousness of the public – and the opinions of the press –

than the experiments of those seeking to extend the achievements of Impressionism in other, brighter, directions. Their names were often linked together, and their contributions to the Salon tended to receive special note, and special praise.[31] Blanche had joined with them in the recently formed group, the Société Nouvelle de Peintre Moderne, and it was natural that he should draw Sickert into the circle. Sickert was impressed: he considered that Cottet and Simon held 'the largest places in the eye of the Paris public among men of our generation',[32] and he had a great personal liking for them both, admiring their honesty and charm.[33] The preference for low tones gave their work a superficial connection with his own. He was delighted, too, with a plan that they should break with Mme Stettler and all open a teaching studio together in the autumn: 'with Simon's name, which is a great draw,' he explained to Mrs Hulton, 'I expect I shall at last make a little money reg'lar which I badly want'.[34]

Sickert never became a member of the 'bande noire', he never painted in Brittany (or, indeed, went there), but his close association with Cottet and Simon perhaps prevented him from being drawn into the intimate circle of the Nabis artists. Nevertheless, the two groups, because of their shared histories, remained in contact. They were perceived as belonging to the same quadrant of the contemporary scene – a perception that strengthened as Bonnard and Vuillard moved increasingly away from the slightly strained symbolism and deformation of their early Nabis work towards a greater naturalism. Sickert's work soon came to be viewed in relation to theirs. Blanche, in talking up Sickert to one prospective purchaser, described his work as being 'autrement fortes et nourries que des Xavier Roussel, Bonnard, etc.' ('stronger and more lively than that of Xavier Roussel, Bonnard, etc.').[35] There was some personal contact. The Paris art world was eager and communicative, and though Bonnard and Vuillard were often out of town, Sickert came to know them both. They criticized each other's work, and developed a real mutual respect.[36]

It was, however, with Cottet, Simon, and Blanche that Sickert spent most of his time, and against whom he first measured his advances. Their relative success sometimes left him feeling frustrated at his own slow progress. He was impatient to establish a reputation in France: 'What I dislike', he complained to Eden, 'is, goodness knows how long this kind of thing lasts. I shall have to stick it till I am as it were "consecrated" by Paris opinion whatever that vague process may be.'[37] There

were some signs that the 'process' was moving forward. He was thrilled at a rumour, relayed to him by Blanche, that Léon Bénédite, the director of the Luxembourg, was 'hesitating about buying' his Salon picture of St Mark's 'for the government'.[38] Although nothing came of M. Bénédite's good intention, it was followed up by another hint of progress.

Sickert attracted the attention of the art dealers Bernheim-Jeune. They had built up their reputation through exhibitions of work by van Gogh, Renoir, and other members of the Impressionist school, but were beginning to look to the contemporary scene. In 1900 they had put together a show with Bonnard, Vuillard and Roussel. Rather than operating on the commission system employed by Durand-Ruel, the Bernheims favoured the more common Parisian method of buying stock at wholesale prices and then putting their own mark-up on it. They bought a batch of Sickert's paintings for a mere 60 francs apiece, and proceeded to apply what Blanche considered their 'scandalous' profit margins, immediately selling two of the Venetian scenes for 1,500 francs each.[39] Although the business was good, the prices were modest enough: 1,500 francs represented rather less than £60. All the pictures went during the course of the summer.[40]

Sickert, commenting to Steer on the Parisian art market, considered that the prices for all contemporary work were 'too low'; but, as he remarked, 'at low prices demand *unlimited*'. It was a school of '*Very* able dealers. Some make, though, *hundreds* per cent. Durand-Ruel, alone very generous, almost quixotic. Takes 10 per cent.'[41] Sickert's initial reservations about such a system were, however, soon modified. He came to see low prices as a virtue, if not a necessity, for contemporary art. He ascribed the impressive reputations gained – and the impressive prices then being achieved – by Degas and the other French Impressionists to the fact that originally they had sold their works to the dealers so cheaply: 'Masterpieces changed hands for £2, for £4. As to £12, "ça c'est déjà un prix".'[42] The dealers, in their turn, though making a good profit, had in fact sold on much of this stock at relatively modest prices, building up a broad pool of modest collectors: dentists, doctors, and other professionals. It was this policy – the sound 'trade of small profits and quick returns' for both artists and dealers – that, Sickert believed, disseminated an artist's reputation and, in time, built up a market. The market, once established, could then rise on the thermal of critical acclaim and judicious 'booming' orchestrated by the 'very able' dealers.

Such bracing air appealed to Sickert. He announced to Blanche that he intended to be 'naturalized' as a Frenchman: 'They say I shall not have any military service.' In international exhibitions he planned to send – not to 'the *English* section, or *German* or *Schleswig-Holsteiner*' – but to the French section. 'I am a *French* painter,' he declared. 'As a pupil of Whistler I derive from the French school. Why not take my place in it?'[43]

Although France was to be the centre of his operations, and the focus of his energies, he did not want to abandon England altogether. He was conscious that he had lost ground there. The Channel remained a great cultural divide. A few figures such as Sargent and Whistler might bestride it, but for the most part dialogue was halting and knowledge minimal. Sickert (with a blithe absence of tact) told Steer of his amusement at Moore's disquisition to an uncomprehending Frenchman on the merits of the latest NEAC exhibition: he talked 'for *half an hour* about whether in one of *your* pictures you had not better have cut off a LITTLE of the sky, with a gesture, quite absorbed, and allusions to Tonks, incidentally, as to the Vendôme column, or any other familiar monument of Paris.'[44] The same scene might have been acted in reverse.

Sickert, domiciled in France, had to make special efforts to maintain his profile in England. He continued to exhibit at the NEAC during 1902, albeit as a non-member, and he had a picture accepted for Manchester's annual art show. If he demurred at Sir William Eden's suggestion that he might care to send a painting to some provincial society of which the baronet was a member, it was only because he felt it likely it would be rejected: 'I very much doubt if my work would appeal to any of the committee & like the Jews, I haven't any wish to proselytise.' He described himself as being still 'in a very small way', and his work as being 'by no means unanimously acknowledged in England'. And though he regretted not being able to oblige Sir William, he had – he explained – to be careful: 'I am like a governess, say, with an uncertain reputation who, if she is clever, takes jolly good care never to go where she *might* be cut.'[45]

Sickert had always planned to 'bolt to Venice in June' for the whole summer,[46] and the Bernheims' success with his Venetian pictures must have encouraged the notion. But, as May 1902 advanced, he began to procrastinate. He was bound up with several projects that he felt unable to leave. There was 'a new set of English Music Halls' done from old drawings, and, anxious to capitalize on the signs of interest in his

work, he had also sent some of his most obviously commercial Venetian drawings to a professional etcher to be made into prints.[47] He found, however, that he was able to work on new Venetian paintings in Dieppe, relying on his drawings, studies, and photographs. Indeed he claimed to Mrs Hulton that he could manage 'better away than on the spot'.* He jokingly suggested that his real need to visit Venice was in order to do some Dieppe pictures.[48]

In fact it was a series of Dieppe scenes that provided the most compelling reason for Sickert to remain in France. He had received an unlikely commission from the proprietor of the Hôtel des Plages for a series of six views of Dieppe. They were to decorate the hotel's newly refurbished dining room. The proprietor, M. Mantren, had conceived the scheme on a modest scale and Sickert had undertaken to do the work for 'tuppence halfpenny'; but, as he explained to Eden, 'I got so emballé with my subjects that I am giving the brute 6 big masterpieces (which he will re-sell I should say) but I can't do anything by halves.'[49] With the exception of a view of some bathers in striped costumes, the motifs he chose were familiar ones: St Jacques, the inner harbour, the rue Notre Dame, the statue of Duquesne – though he had never attempted them before on such a scale. He described his work as 'like playing over a piece of music', adding, 'but for the commission, I should have forgotten the subjects, & now I shall do big 'uns of the same sort for next year's Salon'.[50]

If he made little money from the undertaking, that was unimport-ant. 'I am wise beyond my years,' he explained to Eden, '& take all the work that comes, good bad & indifferently paid. I do 10 times as much, learn 10 times as much & perhaps if I were difficile I should get nothing. I earn more than Monet or Manet did at my age, or Whistler.'[51] Some jobs paid better than others. He made a long-mooted illustration to *Omar Khayyám* – dashed off 'between ten & lunch' – and sold it immediately for 5 guineas.[52] There were, however, limits to what he would do. He declined a suggestion from the English

* Young Phyllis Price, a precocious critic, retrieved one discarded Venetian scene from the wastepaper basket in Sickert's studio. It was done in pastel and had what Sickert described as a 'Pissarro sky'. He told her she could keep it, but was rather taken aback when he learnt that her mother Polly had commandeered the scrap, smoothed it out, and sold it privately in London. Any anger, however, turned to admiration when he learnt that she had got £70 for the picture, more than three times what he might have sold it for (Simona Pakenham, TS 'Walter Sickert & My Grandmother').

publisher G. Bell & Sons that he might write a book about Whistler. 'Would have been amusing!' he remarked: 'Preface by Sir William Eden.'[53]

The summer season of 1902 was a busy one at Dieppe. The end of the Boer War in May had eased the strain on Anglo-French relations, whilst the long-delayed coronation of Edward VII signalled the beginnings of the *entente cordiale*. Sickert's understanding with his French neighbours had always been more than cordial, and he continued his enthusiastic campaign of charm. At Mme Lemaire's he encountered some of the important visiting figures – including the composer, and the beloved of Proust, Reynaldo Hahn.[54] Blanche, as ever, acted as his champion. Although he had moved from the Bas Fort Blanc, taking a lease on the old manor house at Offranville, some five miles outside of town, he was still much in Dieppe.[55] That summer he was organizing the inaugural exhibition of the Société des Amis des Arts de Dieppe. He gathered together works by many of the artists who painted, or had painted, in the town. Although some of those represented were no more than gifted local amateurs, he also sought out works by Monet, Renoir, and Camille Pissarro – and, of course, he included a Sickert. Rather perversely, the painting chosen (perhaps by Blanche, more probably by Sickert himself) was not a Dieppe scene, but a view of the Doges' Palace.[56]

Blanche's efforts on Sickert's behalf were unflagging. He kept a collection of Sickert's canvases in his studio, and he seems never to have encountered a friend without urging them to come and buy one of these 'choses ravissants'.[57] He had a success with the young artist-cum-collector Paul Robert. Sickert was thrilled by his new patron: 'Paul Robert is one of the most delightful things that has happened to me,' he enthused to Blanche. 'For a big fat black Frenchman to say, "Je vous garderai toute ma vie" [I will watch out for you all my life] is really pleasanter than a fortune!'[58] Blanche had recently made the acquaintance of André Gide and was particularly insistent that the young writer should acquire a Sickert. He whetted his appetite with a description of the painter's eccentric domestic arrangements – his ability to stir up the most delicate ideas while surrounded by vagabonds. And, borrowing the title of Gide's recently published novel, he labelled Sickert as an 'Immoraliste', adding – 'Comme il vous intéresserait.'[59]

There were plenty of pictures available for Gide. The hotel commission had turned out exactly as Sickert had predicted. M. Mantren

did not care at all for the '6 big masterpieces'; he thought them too low toned for the convivial setting of a hotel dining room. Though he may have retained two narrow panels, he resolved to resell the four larger canvases at once. Blanche urged Gide to consider getting them for the house that he and his wife had taken at Cuverville, explaining that the 'hôtelier imbécile' was prepared to sell them for '200 fr. les quatre'.[60] Gide missed out on that opportunity. The four paintings were bought up by Frederick Fairbanks, an American musician and composer, who had recently settled in Dieppe and married Eliza Middleton. Notions of American affluence had clearly impressed M. Mantren and, though Fairbanks was far from rich, he paid twice the sum quoted by Blanche.[61]

Gide, however, was not to be let off the hook. Blanche introduced him to Sickert and brought the two men together several times during the summer. There was a jolly Sunday lunch out at Offranville with Reggie Turner, and a rather less satisfactory visit to the Gides at Cuverville.[62] Horrified at the very rudimentary comforts of the place (no running water or electricity), Blanche insisted that, rather than staying the night as originally planned, he and Sickert would return home the same evening. And to compound the 'catastrophe', Mme Gide, instead of serving the special Sauternes that they had been keeping by for guests, accidentally produced a bottle of vinegary plonk – the sort of wince-making beverage known in France as 'chasse cousin' for its ability to drive away even the most tenacious guest. It duly produced its effect on Sickert and Blanche.[63] Despite, or perhaps because of, this unfortunate episode, Gide did determine to buy one of Sickert's pictures.[64]

Nevertheless, for all the excitement of such sales, and the claims to be earning more than Monet had done at the same stage of his career, Sickert's finances remained precarious. Most of his customers bought cheap. Gide had the grace to be distressed that he could only afford to pay 50 francs for a picture, rather than the hundred he was sure it was worth.[65] Others were probably less troubled by such scruples. The Bernheims continued to pay only 60 francs per canvas;[66] and whatever Sickert received for the hotel commission, it scarcely reflected the amount of work he had poured into the project. Moreover, though his sales might be frequent, they were never as regular as his expenses. Sickert had limited notions of economy. He proudly announced to Blanche that he was saving money by eating his lunch

and dinner 'at the Café de la Gaité (sic!)' opposite the church at
Neuville, rather than at the more expensive Café Duquesne on the
other side of the harbour. He could get both meals for 2.50 francs
'including wine'. As he remarked, 'Le "besson" est bon.'[67] The merest
prospect of money always encouraged the envisioning of grandiose
schemes. In the spring, his confidence bolstered by the success of his
Salon picture, Sickert had begun 'fussing whether or not to have a
studio built' at Neuville. He told Eden, 'If I do, it will be a good one
& half way between London and Paris can never be far wrong.'[68]

Over the course of the summer he revised this plan, deciding
instead to set up in a house of his own. The reasons for this decision
remain a mystery. He was still on friendly terms with Mme Villain. It
was her 'inexhaustible purse', combined with his own credit, that
financed the move; and she was almost certainly the model for a series
of intimate drawings of a naked woman reclining on a rumpled
bed that he made that year – his first attempt at depicting the nude
since his student days.[69] Perhaps the distractions and limitations of
life *en famille* had begun to grate; Mme Villain's young tiger cubs were
growing up.

Sickert remained loyal to Neuville, taking a lease on a 'large house'
in the chemin des Pucelles.[70] It was a protracted move as Sickert had
pronounced ideas about making the house and garden ready. But it
was almost certainly there, rather than in the crowded Maison Villain,
that he was '"at home" *rigoureusement*' every day from 4 to 5 during
the holiday season, offering tea and a 'lunch bisquit' to all comers.
Amongst the regular callers was Reggie Turner, who was back once
again in Dieppe. He brought with him one of Sickert's former pupils,
a 'charmant jeune aristo' called Reggie Temple, who was making a
living as a copyist of early Italian paintings.[71] Sickert relished the oppor-
tunity to discuss the old masters and their techniques – he even made
a copy of a Holbein to demonstrate 'peinture de colle' (painting with
size).[72]

A whole team of local workmen was involved in the furbishing of
Sickert's villa. He installed – to his great satisfaction – an elaborate
patent stove 'with two exit pipes, one for the smoke, the other to take
away the bad air'.[73] There were regular discussions with a mason, joiner
and gardener, as well as a man Sickert described as his 'galetier', or
shingler, who was laying out an elaborate grid of garden paths with
stones from the Dieppe beach.[74] Sickert had grand visions of espaliered

rose bushes and fruit trees, and a circular lawn with, rising from its centre, a column surmounted by a statue: either a Tanagra figure, or a Rodin.[75] Although he had to content himself with a bust of Nero, much of the scheme was carried out.[76] Of more practical import was the fixing of a persistent leak in the house's roof, and the creation of a small attic studio.[77]

He struggled to get into his new workspace. At the end of the summer he was disturbed by the arrival of his brother Robert, who, having contracted a disastrous marriage that July, was seeking to obtain an immediate divorce and urgently required what Sickert called 'l'hygène morale et physique du chemin des Pucelles'.[78]

By the autumn, despite Mme Villain's generous assistance, Sickert was broke again, sustained only by credit and the prospects of future sales. At least there were such prospects. He dispatched two canvases to an interested party in Paris – most probably Paul Robert – and not long afterwards he followed in their wake, intent on convincing the Bernheims that it was 'their duty & should be their pleasure to furnish [him] with money'.[79] He found his dealers in receptive mood. Delighted at having sold all the pictures they had taken at the beginning of the summer, they offered him a one-man show in the coming year. Blanche announced: 'C'est un coup à la Sisley que l'on va faire avec lui' (They are planning to make a coup à la Sisley with him).[80] Immediate cash, however, was short. The planned teaching class under the banner of Lucien Simon's name, which Sickert had looked forward to as a means to 'reg'lar' income, seems not to have materialized, and there was no chance of returning to Mme Stettler's. In December, Blanche and Cottet found work at M. Vitti's teaching studio, but there is nothing to suggest that Sickert joined them there.[81]

For all the enticing prospects of the near future, he was left stranded in Neuville without a sou throughout the winter. Blanche strove to help, buying several pictures (either on his own or Ellen's account), and urging others such as Forain and Gide to do likewise.[82] The campaign was not without results: Bonvins, a Dieppe-based painter, earned Sickert's lasting gratitude by calling at the chemin des Pucelles and buying two pictures.[83] John Staats Forbes, the English railway tycoon and collector, also bought three views of Venice, allowing Sickert to continue work on his house and garden, and even to pay off *some* of his debts.[84]

* * *

Living alone in his own home marked a new phase for Sickert. He had become reconciled to the changed conditions of his life: his loss of Ellen, his break from Mme Villain, his rift with Whistler; his exile from England, his precarious financial position. On the last score, he always cited the lesson learnt from M. de St Maurice over the tables at Lefèvre's: 'One of the delightful semi-remittance men who wisely pullulate in French ports spoke of his poverty. "What is your rent in Dieppe?" asked M. de St Maurice. "Twenty pound a year for an eight-roomed house, a small garden with *peupliers d'Italie*, cellarage, and a cistern of 20,000 litres of rain water," said the clean-shaven remittance man. "And your rates and taxes?" "Two pounds a year." "You are not poor at all! If you had falling due, at incessant and erratic dates, claims for £400 at a time, which you had to meet or be ruined, you would understand for the first time what poverty is!"'[85]

Sickert drew from this disquisition the happy conclusion that low overheads and comparative 'poverty' were the best conditions for an artist. Hugely successful painters such as Millais became hamstrung by their own success. They acquired large houses and grand lifestyles, and were then driven to maintain them. Artists should not be driven. They needed leisure: 'Leisure to allow their work, like all organic things, to grow at its own pace.'[86] Sickert felt that he had achieved such leisure in his little villa. He rather ignored the fact that, modest though his own expenses were, they still exceeded his income. The outgoings on his Neuville home remained small enough in themselves, but to them were added the rent of studios in Dieppe, in Paris, and in Venice. He was also running up debts in cafés and restaurants and with his 'colourman'. It was not, however, a problem that he addressed, or even acknowledged.

Contented and alone, he settled into his own ways. He would later recall how he spent the first winter in his new home 'with my thoughts & my work, & my books & followed the October sun in drawings . . . with intense interest but leisurely – all winter before me. There was more sunlight in winter then than there is now in summer. And what intense enjoyment I had of the little eases we label pleasures – the good household bread, the glass of wine, the tobacco – the delicious smell of the burning log of the first fires.'[87] He formed habits, and developed eccentricities. The pattern of his working day – a pattern that, with only small modifications, would endure for the rest of his life – became established as an unequal mix of thinking, reading,

smoking, and painting. The comparatively short time he spent each day putting paint on to canvas was often surprising to those who saw him at close quarters (and knew how much he produced). Though he often claimed to have been 'working for hours', the periods of actual activity were usually short. In between times he read.[88]

There was, he confessed to his friend, the critic Edmund Gosse, little direction in his reading. He relied upon what Blanche described as the 'hasard du petit cabinet'.[89] He remained loyal to the Latin poets, and to the great nineteenth-century French and English novelists. Trollope he adored (taking pleasure in Mr Slope as 'the most detestable character in English fiction'). Of Dickens, he liked *Bleak House* best. He revered Boswell and Burns and Byron. He loved Balzac above all. He read critical essays and popular histories, in English, French, and German. He was always happy to follow up recommendations or receive presents. He was enthusiastic, but not uncritical – indeed some considered his criticism astute. He preferred Richardson to Fielding (Richardson, he said, 'had probed the kernel of life, while Fielding was content with the husk'); he resented the moralizing tendency in George Eliot and could not get on with George Meredith. He found D'Annunzio nauseating and Gissing a phoney; and he enjoyed Henry James as a person more than as a writer.[90]

His literary excursions do not seem to have been a distraction from his work but almost part of it. The illustration he made for *The Rubáiyát of Omar Khayyám* was, however, an almost unique example of direct inspiration.[91] The relation was usually more oblique. Sometimes he would pick up a work 'that held his attention easily while his mind was really engaged in thinking out the next step' in his painting.[92] At other times he might rely on the clarity or energy of a book to fire up his own spirit. After reading Sainte-Beuve's essays he declared it was one of those books that 'make you get straight up & go to your easel with a certainty of what you are about & a happy confidence'.[93] In his more histrionic moods he might even assume something of the character of the author he was reading. He had 'his Burns days, his Byron days . . . his Dr Johnson days'. It was liberating to see life through the eyes of another.[94]

And while he read, he smoked. A Manila cigar became for Sickert both a comfort and a prop. In what seemed rather an affectation to some, he smoked these cheroots the wrong way round – 'lighting that end . . . which most people put in their mouths'.[95] Typically, however,

he justified this apparent eccentricity with recourse to science, claiming that the smallest and most flavoursome leaves were always used at the narrow end of the cigar and it was a shame not to enjoy them; also that a cigar drew better when puffed from the wider end. His friend and childhood neighbour Walter Raleigh, who had spent time in the Philippines, had told him that all Filipinos and Filipinas followed the same sensible course.[96]

At the beginning of 1903, Blanche, in yet another act of generosity, invited Sickert to show, as a guest, with the Société Nouvelle de Peintre Moderne, the group which he had helped found along with Cottet, Simon, and several others.[97] The exhibition was held at Durand-Ruel's in February. Sickert had fifteen pictures on show, some lent by French collectors (including Gide, Blanche, and Paul Robert). Amongst the townscapes (and two still lifes of fish that he had managed to complete in spite of Clementine Hozier) he included a recently completed music-hall painting, a view of the Old Bedford. Much to his delight it was bought by Lucien Simon. The appreciation of fellow painters was always valuable to an artist;[98] but Sickert's reputation was already beginning to move beyond the circle of his fellows. It was Venice that made him popular in Paris. He had included six Venetian scenes in the show and it was these that garnered the widest attention and the most enthusiastic response. 'Paris happens to have taken to me as a Venetian painter de bon côté,' he declared. 'They are very sentimental about Venice, &, Dieu merci, rather ignorant. So I impress them.' He was no longer the painter-in-ordinary to the music hall, nor the Canaletto of Dieppe. This was a new artistic guise: 'le Vénitien par excellence – à Paris'.[99] Bernheim-Jeune was anxious to buy up his Venetian scenes: for his one-man exhibition with the 'obliging "Shylock père et fils"' – scheduled for 15 May – he was contracted to deliver forty canvases.[100]

It was another picture of Venice that he submitted to the New Salon (where he hoped to be elected Sociétaire); and, once more, he was encouraged by rumours of M. Bénédite's – as yet unfulfilled – desire to buy one of his works for the Luxembourg.[101] For the first time he also sent to the Salon des Indépendants, the vast 'no jury' exhibition that had been established in 1884 by Signac, Seurat, and others, as an alternative to the closed Salon system. It provided a chaotic annual forum for practical jokers, amateurs, gross incompetents, conventional

painters of the fourth rank, as well as some artists of merit; and for all its shortcomings, it had established itself as the main locus for artistic experiment. Sickert recognized that many 'interesting reputations', including those of Bonnard and Vuillard, had been made on its hectic walls.[102] To achieve any notice in such a place was hard. Sickert announced himself with several of his largest and most striking works: the garish picture of Hilda Spong in her crinoline, and the four Dieppe 'masterpieces' that Frederick Fairbanks had rescued from the imbecile hotelier Mantren. The ploy was successful. Even in a crowded field – including works by Munch, Monet, Bonnard, Signac, and Matisse – his contributions stood out. Camille Pissarro's son, Georges, commended the Miss Spong as 'épatante'.[103]

The exhibitions certainly increased Sickert's refulgence in Paris. The city, he informed Steer, 'has taken kindly to the brush that struggled rather vainly in Robert St'. He received good notices, and the verdict of the French press was relayed across Europe: 'German papers quote new appearance in Paris of a painter "of the first rank" etc.' As Sickert remarked, 'mayn't all be true, but it makes very pleasant reading'.[104] The 'vague process' of consecration by 'Paris opinion' that he had hoped for seemed to be occurring. 'What is the difference between a successful man & an unsuccessful one?' he asked rhetorically of Mrs Hulton, in the midst of these excitements. 'Very little. This year I am a successful one & last year I was what is called struggling.'[105] Although Sickert had not taken the mooted step of becoming nationalized, he was increasingly viewed as belonging to the French School. The Ministère des Beaux-Arts, impressed by his pictures at the Indépendants, invited Sickert to exhibit in the French section at the large Munich Glaspalast show that summer.

London heard of his Parisian successes with interest. John Staats Forbes, Sickert learnt, 'convinced by the Paris papers that the English estimate of my work may have been mistaken', had 'cleared the Fine Art Society out of 10 Venice drawings that had been peacefully in their drawers for years'.[106] Sickert had high hopes that all this glory might eventually percolate to Signor Fradeletto, President of the Venice Biennale, and lead to an invitation to exhibit there: as he confessed to Mrs Hulton, he had a desire to cut a dash in Venice.[107] His hopes were raised by the fact that Cottet was on the jury of the Biennale that year, and he was soon able to report his success to Mrs Hulton: 'My fame has décroché Fradeletto! "Never did a lover" – No. "Never did a mis-

tress await" etc. as I that plain man's signature! The courteous invi-
tation; lordly tickets & the delicious charge in the invitations[:] "If you
are *vulgar*, you will be chucked out in your own interests." If you eat
peas with your knife when you dine with Fradeletto a polite footman
taps you on the shoulder. "My pardon Sir".[108] As at Munich, Sickert
was invited to appear in the 'French Section'.[109]

Rather than 're-boring' the Venetians with another view of the
Salute, Sickert conceived the idea of sending a music-hall painting. He
was working on a picture of Katie Lawrence performing 'Ta-ra-ra-boom-
de-ay' at Gatti's Hungerford Palace of Varieties, done from sketches
made 'on the spot in 1888'. He hoped to have it ready to send.[110] It was
a crowded schedule, as he was still striving to assemble the two-score
canvases wanted by the Bernheims for their exhibition in May, and
he was also teaching again in Paris.[111]

But all his plans were derailed when he was suddenly struck down
'like Job' by a mystery ailment. The physical symptoms were alarming:
his head was covered with boils, and something, he explained to Eden,
was not right with his 'cock', making it painful to urinate.[112] His first
thought was that it might be VD, for, though – as he admitted – there
was 'no chance of catching anything so sporting' in Dieppe, he had
given himself 'the chance of it once or twice' on his last trip to Venice.[113]
The head surgeon at the Dieppe hospital, Dr Delarue, 'a great pox
man', was, however, able to reassure him on the point. His diagnosis
was the rather less sporting 'gout', and Eden – who seems to have been
something of both a 'pox man' and a gout man himself – supported
the assessment. He and the doctor each prescribed a whole list of
treatments, and the ailment gradually 'yielded to diet, purging &
depuratives & exercise'. But slowly.[114]

In the meantime, Sickert was left prey to attacks of anxiety. He
described himself as 'irritable to a pitch of madness, nervous, appre-
hensive, [in] agonies of fear – of nothing. It all doesn't show, because
I consume my own smoke. Worse for me perhaps. That is one reason
why I have elected to "live in the country".'[115] Although he hated the
discomfort, almost worse was the feeling that he looked hideous. He
admitted to Mrs Hulton that 'one of the few innocent consolations'
of his existence was the consciousness 'of "looking nice" as women
say'. He was glad that he lived alone; he would not have been able to
bear a 'ministering angel' seeing him in his disfigured condition.[116]

Once the worst of the ailment subsided he battled up to Paris to

give his weekly course, but more concerted work remained imposs-ible.[117] The show at Bernheim-Jeune had to be abandoned, postponed until the following year. His other plans also changed. The new music-hall picture intended for Venice had to be sent to Munich instead,[118] and in its place he thought to show the Bedford Gallery painting, bought by Lucien Simon, and one of St Jacques that belonged to Adolphe Tavernier.[119] But this scheme, too, was amended. In the end, despite his scruples about exhibiting a Venetian scene in Venice, he submitted a picture of the cemetery-island of San Michele.[120]

There is no evidence to suggest that he went either to Venice or to Munich for the opening of his exhibitions. He had, it seems, begun an affair with one of his Paris students, a gamine 27-year-old Slade graduate called Mabel Royds. She moved into his flat, assisted him with his own work, and, in time, bore him a daughter, who died almost immediately.*[121] The affair may have been an engaging diversion, but it was not a rest cure. Sickert was still not completely recovered from his illness when summer arrived at Dieppe. Reggie Turner, back once again at Lefèvre's, reported seeing him 'looking ill and low spirited, though he made a gallant attempt to be his charming self.'[122] He did, however, soon rally in the convivial atmosphere of the season. Amongst the English visitors that year were the Orpens, the painter William Nicholson and his family, Marcel Boulestein, the actress Marie Tempest and her husband Cosmo Gordon Lennox,[123] and Max Beer-bohm came over with the actress Constance Collier, to whom he had recently got engaged. She was somewhat alarmed by Sickert at first. He was such a striking contrast to the neat and debonair Max. 'He looked as if he had stepped out of a page of "La Vie de Bohème",' she recalled. 'He wore very baggy trousers in some bright colour, rather

* Sickert's reputation as a womanizer ensured that he had several illegitimate children ascribed to him over the years. This one, however, is the most plausible. The claims of other candidates, from the youthful indiscretion mentioned by Lillian Browse to the self-styled Joseph Sickert (see Postscript), have proved impossible to substantiate. It was widely assumed in Dieppe and beyond that Sickert must have been responsible for at least some of Mme Villain's brood, but this seems unlikely. Indeed Sickert's friend Walter Bayes took care to explode the notion in an extended aside in his book on Turner (*Turner*, 230). It seems clear that Sickert, though well capable of sexual intercourse, was not particularly fecund. His three marriages were without issue (and, interestingly, his five siblings were no more fertile: none of them produced a child). In the absence of Mabel Royds' testimony, some had even supposed that Sickert was sterile. That verdict clearly has to be revised. In so far as these things can be speculated upon, it would seem more likely that he had, rather, a very low sperm count.

long hair, a béret on his head, and a flowing tie ... He was rather fierce when you first met him. He ought to have been gentle according to his looks, but one soon got over that. He was a charming friend to the people he liked.' He liked Constance, and – of course – Max. They spent jolly afternoons sitting outside the cafés, and Sickert took a photograph of the engaged couple (Constance treasured it as both a souvenir of the holiday and the engagement, which was amicably broken off soon afterwards).[124]

The gaiety of the 1903 summer was somewhat overshadowed by the news of Whistler's death. He died in London on 17 July, aged sixty-nine. No rapprochement had been effected. Sickert did not hasten to damn his old mentor with faint eulogies; but the death freed him from another debt to the past.

DAL VERO

I have got hold of some splendid models.
(Walter Sickert to Mrs Hulton)

Sickert's stated prejudice against Venice in winter was – like many of his prejudices – short lived. Towards the end of September 1903 he left Dieppe for the Italian city once again. He also planned to visit Rome and, intriguingly, Sicily, where – Blanche confided to Gide – he would probably get remarried to his former wife. It might be months, even years, before he returned.[1] Again the background to Sickert's relationship with Ellen remains unknown. No letters survive, and it is difficult to judge the seriousness of this suggestion of a remarriage. Blanche was an inveterate gossip and was not above overstating cases to enhance the dramatic effect of the moment. But clearly Ellen and Sickert had been in contact over the summer. Ellen perhaps was on her way to or from Greece, where she spent increasing amounts of time on the estates of her young ward, Irene Noel, and had suggested Sicily as a meeting place.[2]

On his way to Italy, Sickert stopped off in Paris for a couple of days and bought some 'divine brushes'.[3] But the main reason for the stopover was to consult with the Bernheims about his delayed show, which was now rescheduled for the following summer. He took them five pictures, which they bought for 100 francs each. And he made 'excellent arrangements' with regard to them buying anything (or everything) he would send them from Venice.[4] The Bernheims also wished to consult Sickert about a Whistler nocturne they had been offered. With the Master dead, the value of his pictures had risen sharply and many were coming on to the market, some of doubtful authenticity. Sickert, steeped in Whistler's art, could be relied upon to detect a forgery. Not content with having two authorized dealers in Paris,

Sickert also made private arrangements with Blanche's friends Paul Robert and Adolphe Tavernier, leaving five canvases with Robert and two with Tavernier in the hope that they could place them privately.[5]

Still aglow with these propitious arrangements, he arrived in Venice. His friends the Hultons were no longer in residence, having removed to Munich in order that the children might learn German. Sickert, as he put it, would miss the civil hospitality of the Ospedale Civile.[6] And, in another change from previous arrangements, he took – to begin with at least – new lodgings. He had announced his determination not to return to the Zattere: 'it smells', he complained, 'of the British & the Church of England & of Ruskin'. He wanted to be nearer the vulgar world of the vegetable market, close to the Giorgione and the Rialto.[7] He found rooms in the heart of that bustling quarter at 1057 Rio Terra di San Silvestro. Nevertheless, the break with his former locale was not absolute. He retained his studio in the Calle dei Frati.[8]

And there were other elements of continuity: the Dowager Countess of Radnor still occasionally invited him to dinner; Horatio Brown was still at the Ca' Torresella; Sickert also resumed his friendship with the Russian prince von Wickenburg and began 'instilling into him the elements of oil painting', though most of their time was spent in exploring the trattorias of the locality. They went sometimes to the Locanda dal Montin ('a charming long sala, food cheap & good'), but it was the Giorgione that provided the most constant focus. Sickert dined there 'faithfully', and – when the New Year came – he saw it in amidst his old friends with a great feast, where everyone 'drank Valpolicella & sang cherubimbim', and danced; Sickert kissed the barmaid at midnight – and was kissed in turn by Signor de Rossi.[9]

But, alongside this established round, a new and grander world opened up for Sickert amongst the international crowd that gathered in the palaces on the Grand Canal. Although his painting at the Biennale had carried off no prizes – and had, indeed, been all but ignored by the critics* – Sickert was able to swagger a little. 'I have dined at the Casetta Rosa,' he informed Mrs Hulton, with a studied nonchalance. The *casetta* was the celebrated home – and creation – of Prince Fritz Hohenlohe, the sensitive and cultured author of *Notes Vénitiennes*,

* The Italian critics did not share the Parisian enthusiasm for Sickert's work. His picture was ignored in most of the round-ups of the Biennale, though Luigi Callari, in an exceptionally thorough and generally bland review for *Cosmos Illustra*, made a point of describing it as 'insulso' – insipid or silly.

a very slim volume of elegiac impressions of the city and the lagoon. And it was perhaps at the *casetta* that Sickert had 'the honour of meeting the Princess of Thurn and Taxis', Hohenlohe's sister, and the inspirer of Rilke. She 'told someone I looked diabolical', he reported proudly, 'at which I suppose I should be flattered'.[10] He encountered 'dear' Isabella Stewart Gardner, the great Bostonian collector, who was touring Italy in search of masterpieces of art and architecture with which to transform her home into a palace of high culture. The sight of her drawing up in her gondola, propelled by no fewer than four gondoliers (royalty made do with a mere three), became a fixed and fond memory.[11]

Sickert's growing reputation in France earned him an entrée to the Palazzo Dario, close to the Salute, where Mme Bulteau and the Comtesse de la Baume maintained a salon that combined intellectual pretension with the frisson of lesbian chic. The smart, the brilliant, and the rich gathered at their soirées.[12] Mme Bulteau, who contributed to Le Figaro under the pseudonym 'Femina', was a keen student of the English character and had written a monograph on 'L'âme des Anglais'. Perhaps she hoped Sickert might prove an interesting case for study. He found her rather trying, due to her affectation of saying 'each time, apparently what she thinks will surprise most. If you say to Mme Bulteau, "I am sorry Madame, you have a cough (or a cold)"[,] she would say, "I'm glad," which puts a full stop to the conversation.' Although Sickert was quite 'clever enough' to reply in kind to such talk, he preferred the company of the Comtesse de la Baume, who was reassuringly 'grave'.[13]

Sickert encountered some familiar faces at the Palazzo Dario, including John Singer Sargent. The American was in Venice with his mother and sister, painting what Sickert described as 'slap dash gouaches'.[14] There were also useful new contacts to be made. He met Henri Gonse, a rich 'amateur d'art', well known on the Parisian scene, who was in Italy as an attaché at the French Embassy to the Vatican.[15] He bought two of Sickert's paintings, and Sickert went down to Rome to deliver them.[16] Another customer from the Palazzo Dario was an Austrian painter called Johan Schlesinger, a friend of Blanche's; he not only acquired some of Sickert's pictures but also drew his portrait.[17]

The palace next door – the Montecuccoli, which Sickert had painted on one of his previous visits to Venice – had been taken by the recently widowed Princesse de Polignac, whom he had known at Dieppe.[18]

Born Winaretta Singer, she was the heiress of the sewing-machine fortune. She, too, welcomed Sickert into her circle. She had made the Palazzo Montecuccoli a centre for music. Reynaldo Hahn, the young South American-born musician whom Sickert had met *chez* Lemaire, played for her when he came to Venice that year.[19] Sickert greatly admired his *Chansons grises* – a song cycle inspired by the poems of Verlaine: the tunes became part of his impromptu repertoire and he would whistle them on his walks.[20] The Princesse visited Sickert at his studio and was impressed by the portrait of Zangwill there.[21] The echoes of Dieppe were reinforced by the arrival in Venice of Olga Caracciolo, along with her new husband, the dapper Adolphe de Meyer. The Baron's interests, like those of his new wife, were artistic – he became the photographer of Diaghilev's Ballets Russes. The de Meyers took the palazzo next door to the Polignacs, creating a whole block of palatial dwellings open to Sickert. He was delighted to be back in contact with his old Dieppoise friend[22] – it was perhaps this that encouraged him to move from San Silvestro back towards the Zattere and the area around the Salute.[23]

Sickert arrived just too late to meet up with Conder, who – recently married to Florence Humphrey's niece, Stella Maris MacAdams, and much improved in his conduct – had been staying with the de Meyers.[24] There were, however, valuable new contacts to be made amongst the permanent population. Sickert became friendly with Baron Giorgio Franchetti, a young Venetian nobleman who was a regular at Horatio Brown's little gatherings. A wealthy dilettante (his mother was a Rothschild, his wife was the Baroness Hornstein von Hohenstoffeln), he was devoting his fortune, his energy, and his taste to restoring and furnishing the Ca' d'Oro, one of the gems of Venetian-Gothic architecture. Despite being some five years younger than Sickert, he lived amongst the glories of Venice's past, and to a large extent revived them in his beautiful home. He collected Renaissance bronzes and classical statuary and had adorned the walls of his salon with works by Venetian and Florentine masters.[25] He loved music and was a gifted performer. He would sometimes have half a dozen people in to hear him play the piano or harpsichord. Sickert found such musical soirées 'as refreshing as [Franchetti's] views on painting are exasperating'.[26] These 'exasperating' views included a dislike of all modern art and belief in the 'supreme' greatness of Titian's *Ascension* in the Accademia.[27] By the same token, Franchetti – despite his dislike of Sickert's painting –

enjoyed his company: he also admired a Shakespeare reading that he gave to the Circolo Filologico, a small literary society that had been founded a few years previously.[28]

Sickert did try to set some bounds to his socializing. 'I am dining with the Browns tonight,' he told Mrs Hulton, 'to meet the Smiths who I don't think interest me.' His reservations about the Smiths were not a matter of mere snobbery. 'I don't see the use of knowing people', he explained, 'unless, either, you are in love with them, or ... they are what a little girl I know used to call "intelectoral" or both.' It was possible, Sickert thought, to 'get a good deal out of' intellectuals.[29]

Of all the palaces he visited, the one that Sickert was able to get the most 'out of' was the Palazzo Pesaro Orfei, home of the Fortuny family. Old Madame Fortuny belonged to the aristocracy of Spanish art, being the widow of the celebrated painter Mariano Fortuny and daughter of the no less celebrated Frederico de Madrazo, court painter to Isabel II of Spain. Blanche's friend Rafael de Ochoa was her cousin. She had decided to move to Venice for the sake of her adored and talented son, Marianito, who was allergic to horses. Once there, she had financed the purchase of the Palazzo Pesaro Orfei through the sale of a single work by her late husband. The charismatic Marianito soon abandoned painting, to devote his gifts to textile design, glass making, and to the development of stage-lighting effects.[30]

Sickert, who had met Marianito in Paris *chez* Blanche, became a regular at the family's Sunday afternoon receptions – after his morning visit to the Museo Civico.[31] They gave 'delightful polyglot tea with cakes and sweets and Xeres and fair Venetians'. He found the Fortuny family 'really charming people ... with a fascinating cordiality which remains discreet and well-mannered'. He wondered whether all Spaniards were as charming.[32] He was inclined to think so on the basis of his encounters with one of the Fortunys' other regular guests, the painter Martin Rico Ortega. Sickert was enchanted by this 'splendid' old artist, then in his seventies, who had established a reputation with his views of Venice,[33] calling him a 'darling'.[34] Sickert admired Rico's pictures and was impressed by his sartorial extravagances: 'He wears at home a Doge's cap in ruby velvet & abroad, at times, a nightshirt', along with a magnificently cut overcoat of English duffle trimmed with red ribbon. Rico, for his part, gave his young admirer 'golden counsels' about painting. 'They know a thing or two,' Sickert remarked, 'do those old birds!'[35]

If the chance of encountering Rico was one of the initial attractions of attending the Fortunys' receptions, it was soon eclipsed by another: María Luisa Fortuny, the daughter of the house. Known by the nickname 'Foubis', she was then thirty-four, though she retained 'des grâces enfantines'.[36] Sickert – almost ten years her senior – considered her a 'ravishing beauty & marvel of grace'.[37] Blanche thought her like a figure from one of Goya's *Caprices*, 'splendid . . . large and pale'.[38] Only her pallor is confirmed in the photographs that survive. She was, though, an original and distinctive personality – nervous, vital, and intelligent – and Sickert fell in love with her. He told Blanche that she had the air of 'un astre vivant'. He also called her 'a perfect gem, the cleverest [most] intelligent female ever born'.[39] She loved Wagner's music and would sing his arias, accompanying herself on the piano. Her intelligence and her accomplishments were combined with a host of minor eccentricities. She was a guardian not only to the stray cats and dogs of the neighbourhood, but also the local rats. She fed and talked to the birds with the devotion of a St Francis, and she refused to kill insects. She had a distrust of beds and insisted on sleeping upright in a chair. Although these quirks and enthusiasms exasperated her relatives, Sickert seems to have been charmed by them.[40] Certainly they did not deter his suit. He would meet her every evening at six in the Piazza San Marco.[41]

She was, Blanche considered, one of the great loves of Sickert's life. Any thought he might have had of remarrying Ellen was abandoned – at least for the moment. He never travelled to Sicily. Instead, he stopped in Venice and proposed to Señorita Fortuny. She apparently accepted him but then, for some unspecified reason, changed her mind.[42] Perhaps she had been alarmed by unfounded rumours that Sickert was not actually divorced from Ellen. (The fact that Ellen continued to use the surname 'Sickert' or 'Cobden-Sickert' was the cause of some confusion.[43]) Sickert, who was – after his own fashion – much in love, was apparently devastated by María Luisa's refusal and set about trying to persuade her to reconsider. He went so far as to write to Rafael de Ochoa in Paris asking him to intercede on his behalf. Ochoa, along with Marianito, seems to have thought the idea of anyone wanting to marry 'Foubis' was faintly ridiculous. (Marianito burst out laughing when he heard of Sickert's intentions towards his sister, whilst Ochoa considered that life with a woman with so many manias would be impossible.) Sickert's affair became the gossip of the Paris

studios. Degas, on reading his letter to Ochoa, remarked with touching loyalty 'que rien ne pouvait le rendre ridicule' ('nothing can make him ridiculous'). But Sickert continued to hope and continued to love – partly because he liked being in love – but to no avail. It is impossible to trace the exact reasons for the failure of his suit, or discover María Luisa's feelings about the matter: the sources are silent or not extant. In the end, it seems, he was simply frozen out by the Fortunys.[44]

Sickert's passion for María Luisa did nothing to interrupt his painting. He had returned to Venice planning to do more landscapes, and had begun well enough. He had six pictures 'well on the way' when he wrote to Blanche towards the end of the year.[45] But he was soon overtaken by the winter weather. He struggled against the elements for a while. A friendly fish salesman promised to get him a pair of waterproof 'leather soccoli with cork soles (from Burano) between 2 leather ones for standing in to paint';[46] but, even with specialized footware, on many days it was impossible to work outside in the wettest winter for forty years. At the beginning of December an exceptionally high tide flooded the city. Rather than resorting to photographs or picture postcards as a source for his paintings, as he had done in the past, he set off in a new direction.[47]

He turned from landscapes to people: not formal portraits, but figures seen in interiors – what he called genre paintings, or *genrebilder*. As he remarked to Blanche, life in Venice during the winter months was nicer indoors than out, and 'this study with the models is a change, prevent[ing] me wasting my time worrying for the spring. So I am sure of working every day.'[48] He found most of his sitters at the Giorgione. 'I have got hold of some splendid models,' he announced to Mrs Hulton: he was delighted by a 'chiozzoto' – a fisherman from the neighbouring town of Chioggia – with 'a Louis XI felt hat', as well as a blind man with his leader. He found a 'very old woman with a fazzoletto [handkerchief], black with peacock feathers on her head', and also some 'very pretty young ones'.[49]

Sickert's desire to record the popular characters of Venetian life, though encouraged by the inclement weather, was perhaps also inspired by his new-found passion for Carlo Goldoni. There was a season of the great Venetian dramatist's comedies that winter, and Sickert was 'revelling' in it. He had paid '13 francs for an orchestra stall for 12 shows'. Many of the pieces were performed in Venetian dialect and Sickert would study the texts beforehand so that he could

understand them better.[50] He delighted in the vividness of the situ-
ations, the directness of their wit and characterization. His favourite
play, *Le Baruffe Chiozzote*, was particularly rich in sharply drawn por-
traits of the fisherfolk and their foibles.[51] Its moments of true comedy
had 'all the stimulus and snap of the crack of a whip or the shot of a
rifle'.[52] Sickert haunted the theatre, but he did not, as he might have
done previously, attempt to draw or paint the productions themselves.
His artistic imagination was ignited less by the staged events than by
the popular life they reflected with such 'snap'. Though he did persuade
Emilio Zago, the actor-manager responsible for the season, to give him
some 'hurried moments of sitting in his dressing room', it was to the
Giorgione that he went for his models.[53]

Sickert came to regard his drawings of Venetian life as amongst
his most fruitful works. Twenty-five years later he declared – with his
usual spice of exaggeration – that he wished he had done nothing else.
'If I had my life over again I would have accumulated endless drawings
of Venetian life & movement which would have served me [s]till to
paint from till today.'[54] The 'life & movement' that he did depict,
though he first caught its pulse in the crowded dining room of the
Giorgione and the rollicking plays of Goldoni, rapidly resolved itself
into something more intimate and reposeful. The single figure, or the
conversing pair, became his subject. He made several powerful images
of the old woman with the black handkerchief around her skull-like
head, the sunken eyes and withered cheeks rendered with some of the
stark intensity of Munch's screaming spectre. But it was the 'pretty
young' models who engaged his interest most fully. They were the
prostitutes of the quarter: the raven-locked Giuseppina, with her arched
eyebrows and beakish nose; the pert and curvaceous Carolina
dell'Acqua – so named because of her aversion to water (whether for
the purposes of drinking or bathing is disputed) and others of their
circle.[55] He made numerous drawings of them, captured sitting or
lounging or lying on their beds, sometimes alone, sometimes talking
together in unselfconscious abandon. He depicted them clothed –
wrapped in their shawls – or *en déshabillé*; and, returning to the tenta-
tive experiments of that summer in Neuville, he also drew them in
the nude.

His approach was far removed from the stilted and all-too-familiar
traditions of the studio, the Salon and the Academy. His nudes were
neither sentimental nor titillating; they were simply people without

their clothes on – doing things. Returning, as so often, to the example of Degas, he sought the sense of life glimpsed 'through the keyhole' – of women viewed unawares indulging in their *chatteries*. From Degas, too, he borrowed the contrivance with which he created these apparently snatched images of unguarded life. The girls were posed – and not in their own rooms, but in Sickert's studio at the Calle dei Frati. The couch, the bed, the 'beribboned washstand', were so many props assembled. They provided a setting, real but not intrusive, for the true drama of the composition.

Sickert had long recognized that the great artistic interest in the human body – besides its 'eternal beauty' – was its inexhaustible 'capacity for the expression of ideas or emotions'.[56] His figures were not rendered as 'too definite' portraits; their personalities – though suggested – did not obtrude upon the essential plastic idea: an emotion suggested by a pose.[57] Seeking to recapture the freshness of the subject, he, like Degas, viewed his nudes from unexpected angles. In several of his compositions, he borrowed from the example of Mantegna's *Dead Christ* at the Brera in Milan and depicted the model lying on the bed with extreme foreshortening. He confounded other expectations as well. 'The nude', he noted, 'occurs in life often as only partial, and generally in arrangements with the draped', and perhaps 'the chief source of pleasure in the aspect of a nude is that it is in the nature of a gleam – a gleam of light and warmth and life. And that it should appear thus, it should be set in surroundings of drapery or other contrasting surfaces.'[58] He sought such effects in his own compositions, combining his nudes with clothed figures, swaddling them with towels, or laying them out amidst a rumpled mass of bedclothes.*

Sickert relished his new subject, and his new sitters: 'the human figure', he came to believe, was 'the proper study for mankind in the studio as in the library'.[59] It was a new continent of art, and one that he had been led to almost by chance – if the weather had been better he might have gone on painting St Mark's Square. But he found that it appealed to him exactly. Eager to explore its bounds and discover its

* With typical perversity Sickert cited Giorgione – along with Degas – as an example of an artist who understood this rule, as though *The Tempest*, with its allegorical combination of a naked woman and a clothed soldier in an idealized Venetian landscape, owed very much to 'life' (AGR, 263).

secrets, he worked hard. Any money not spent on paints was now spent on models. He described to Blanche the pleasures of his regime. 'De 9 à 4, c'est la joie, ininterrompue de ces gentilles petites modèles obligeantes qui rient et me content des saletés, en posant comme des anges. Qui sont contentes d'être là, et pas pressées. À quatre heures je ne pense que de fermer les volets, me mettre sur mon lit et dormir comme un juste jusqu'à sept heures' ('From 9 to 4 it is the uninterrupted pleasure of these kind, obliging little models who laugh, to amuse me with smutty talk while posing like angels. They are happy to be there, and are not hurried. By four I am ready only to close the shutters, lie on my bed and sleep the sleep of the just until seven')[60] Even when the models were not posing for him (he told Mrs Hulton that he gave them a two-hour break from 11 to 1) he worked at establishing their surroundings, busily concerning himself with 'the chiaroscuro of wash-stands & other domestic objects of furniture'. An 'unkind friend', he joked, had dubbed him 'le maître de table de nuit'.[61]

In painting these scenes, though he used his drawings as guides to the composition, Sickert worked directly from life, and over the course of several sittings. It was an approach that posed several problems. He found himself falling into the bad habit of 're-stating the tones all over an indefinite number of times, and getting no further, not improving the colour, and making the canvas, specially in the darks, more and more disagreeable'. As he noted, 'after twenty such sittings the canvas remains a sketch'. He sought new methods of attack. The stages of his quest to evolve the optimum means of building up his paint surface were charted in his regular letters to Blanche. He varied his preparations. He tried working directly on the 'unembarrassed' canvas. He stacked his paintings around the stove to allow their first coats of paint to dry thoroughly.[62] The technical experiments were geared always to achieving greater clarity, to retaining a sense of immediacy and directness in pictures that were in fact built up over time.

The habit of working in series gave Sickert an opportunity to explore – particularly in his two-figure scenes – the subtle psychological impact effected by composition. Slight variations in the arrangement of his two sitters, as well as in the tones and colours of his painting, could produce large shifts in the emotional temperature of the work: a sense of cheerful conspiracy might give way to one of restive ennui, anxious expectation, or sated weariness. But beneath everything was the pulse of sexual energy. To most contemporary viewers, and particularly those

in Paris, a scene of two women, whatever the state of their dress or
undress, lounging together upon a bed, suggested only one setting:
the brothel. (Blanche always referred to Sickert's nudes as brothel
scenes.[63]) It was a world that had been explored in depth by both
Toulouse Lautrec and Degas; and Sickert, though he never accentuated
the bordello *mise-en-scène* in the way that those artists did, followed
in their path. (According to tradition, he paid at least one visit to a
Venetian brothel for the sole purposes of sketching.[64])

Whether the sexual tenor of the work ever went beyond the canvas
is unknown, but it seems likely. Although Sickert sought to objectify
his models, to dissolve the accidents of their 'character' into light and
shade and paint, such an effort was likely to produce its own reaction.
His models were, moreover, working girls, and whatever the status of
his relationship with María Luisa Fortuny, he certainly did have sex
with prostitutes while in Venice.[65] Indeed, after the let-off of the
previous year, he confessed to Blanche that winter that he had con-
tracted his first dose of the clap ('Je relève de ma première chaude-pisse.
Très gênant. Enfin me voilà tout à fait "grown up".'[66]) It was perhaps
not always to enjoy 'the sleep of the just' that he retired to his bed at
four.

Sickert sent off batches of his new pictures to the Bernheims as he
completed them, the successes along with the failures.[67] He was anxious
to know what Blanche thought of them. In Venice they were appreci-
ated at once by those he showed them to. The two paintings that
Gonse bought were both figure pieces: a nude on a bed and a 'vrai
petit chef d'oeuvre' of a girl in a tartan shawl sitting on a sofa, toying
with a medallion.[68] He could get good prices by selling directly to
customers in Venice. The three pictures he sold to Gonse and Schles-
inger netted him 900 francs altogether. As he remarked to Blanche, he
would 'have had to do nine canvases for the Bernheims for the same
money'.[69] His dealers were understandably concerned to discourage
such free enterprise. They began 'amiably harrying' Sickert from Paris,
begging him not to 'éparpiller' – or 'scatter' – his pictures and under-
taking to buy everything he did. Though they were offering 'something
under cost price' for the pictures, Sickert professed himself to be 'more
than satisfied' with the arrangement.[70] It left him free to paint, and he
did believe that if his work 'got lost in Venice, Austria or England', it
could do him 'no good' where it really mattered: 'in Paris'.[71]

The Bernheims, moreover, did begin to increase the prices, paying

600 francs for four landscapes (two for 200 francs each – a precedent that greatly pleased Sickert – and two at 100 francs apiece). They did not, however, take Sickert up on his offer to sell them the portrait of Hilda Spong for 500 francs,[72] and in order to pay his bills, and what he called 'le loyer de mes enfants' (presumably storage charges for his pictures rather than rent for his 'children'), Sickert still relied on the good offices of Blanche, Tavernier, and Paul Robert, all of whom were buying pictures from – or selling pictures for – him.[73]

With the advance of spring Sickert was able to return to landscape painting for at least part of the time. He had been planning to get 'many toiles de 8 of landscapes' done.[74] He hired a gondolier for 24 francs a week ('de 9 à 7 six jours de semaine') to take him out on the lagoon in search of views. Soon he was reporting that, after ten days of 'temps superbe', he had twelve or fifteen works half completed.[75] His explorations even persuaded him to take a studio on one of the remoter islands, far from the tourist track.[76]

Blanche had not been well and Sickert was urging him to come to Venice for a recuperative holiday. He duly arrived, together with his wife, at the end of April. Venice in the spring was a good place to be; and, besides, he wanted to see Sickert's most recent work. The show at Bernheim-Jeune, delayed from the previous year, had been re-scheduled for early that June, and Blanche was to write the catalogue introduction. Despite this obligation there was still plenty of time for pleasure, and they made – in Sickert's gondola – 'des Wonderful rounds about dans les îles où les touristes ne vont pas'.[77]

Some tourists did go to the little island of Burano, and it was there, amongst the narrow canals, that Sickert and his party came across another group of sightseers. Their gondola drew up alongside one containing the portrait painter Harris Brown and two young women. Sickert knew Brown and the two women were introduced as Jean, Lady Hamilton, and her sister Edie Muir.[78] Though Edie was the younger by more than ten years, and the more conventionally beautiful, it was the 43-year-old Jean who interested the 43-year-old Sickert most.[79] Wrapped up in her coats and shawls she looked, pale, ill, and interesting, her slender, fine-featured face set beneath its piled Empire fringe of red-gold curls. She was the wife of a Boer War hero, General Sir Ian Hamilton. He, however, as Sickert soon learnt, was away in Japan, acting as an official observer of the Russo-Japanese war.

The meeting was brief, but Sickert was intrigued, and so was Lady

Hamilton. She knew Sickert by reputation as the 'wild Impressionistic painter' who had once advertised in the press that '"he had had the honour of having two pictures rejected by the Royal Academy"'. His face, she thought, combined beauty with humour and she asked Harris Brown to pass on an invitation to lunch the following week at the Palazzo Capello, where she and Edie were staying. Sickert, however, called several days beforehand, on the excuse of enquiring after Lady Hamilton's health, having learnt from Brown that she suffered badly from asthma. He found her hosting a small tea party in the palazzo's garden.

Lady Hamilton in her diaries has left a vivid, if romantically coloured, account of his arrival: 'turning I saw coming towards us, through the light and shade of the long pergola, the charming figure of Walter Sickert. It was late – tea all cold. I got up at once and went to meet him, and felt immediately I had known him a long while. I said, "Does a tea party frighten you?" He laughed [and] said, "No," and asked if I was better . . . I said, "Yes, I had felt horribly ill that day at Burano," and knowing he would understand, added, "But some-times, you know, that seems to add to . . . one's feeling of beauty."' More tea was ordered and Sickert impressed Lady Hamilton by the gracious urbanity with which he treated her other – 'rather stodgy' – guests. After tea, Sickert lingered on. He went with Lady Hamilton up to her little drawing room, where they talked of 'Ventnor, and of Charlie Furse and the new [sic] English Art Club'.[80] But it is doubtful whether these conventional topics could have altogether concealed the suppressed erotic charge. Sickert returned many times over the next two weeks, and Lady Hamilton delayed her departure from Venice, partly to recover her health, and partly to see more of Sickert. 'One comes to Venice hoping for romance,' she remarked, and – by and large – discovers only 'the parochial socials about Lady Layard'. From this 'terrible disillusionment', Sickert had rescued her. He was, she considered, 'the only interesting man' she had met 'since coming abroad'.[81]

Lady Hamilton, though she had a distaste for the gross facts of the physical side of sex, had a keenly romantic disposition,[82] and Sickert – frustrated by the course of his affair with María Luisa Fortuny – enjoyed playing the quadrille. They flirted chastely with each other, though matters reached their apex, when – in the absence of the Venetian houseboy – Sickert carried Lady Hamilton up the three flights

of stairs to her bedroom. She found the experience 'exciting', though she was rather worried that the ordeal might prove too much for Sickert.[83]

Despite his Bohemian eccentricities (he arrived on one occasion in a pair of 'the most ridiculous baggy trousers' and on another in 'an *awful* hat'), Lady Hamilton found Sickert both more charming and more attractive on increased acquaintance; and – alone amongst Sickert's friends – she recorded her impressions in copious diary entries. He looked, she thought, like 'a mixture of Shelley, Keats and Lamb'. She was impressed by the 'very distinct quality of distinction' that marked everything he did. It was a stamp of manner often emphasized by his all too apparent poverty – as when he produced a very 'common' checked handkerchief with which to hold the hot teapot handle while he poured the tea with an almost princely grace.[84]

Lady Hamilton was interested in art. She painted a little herself, though she was more embarrassed than pleased when Sickert discovered her at her easel one day and offered to give her some lessons. He amused her more with his piquant descriptions of Venetian art. (Talking of Pinturicchio's painting of St Ursula arriving at her place of martyrdom, he remarked that the martyr's 'little head looking out of the window seemed to be enquiring "C'est ici on tue?"') His own art she struggled to appreciate. She recognized that it was 'the one thing he lives for', and she longed 'to understand and care' for it. He did give her one 'charming' sketch of an Italian girl, but his other present – a drawing of a church – she liked only 'passably', whilst the sight of his music-hall pictures in an old set of the *Yellow Book* baffled her completely. She could see that 'they were full of go and life', but they 'did not please' her.[85]

Sickert's views on life were equally novel to her, though he had, she felt, a 'charming way' of expressing them. He told her that 'none of the brutal facts of life' bothered him at all, and that he 'would not mind having to kill and eat raw flesh' – a revelation that she found interesting if 'unlikely', given his gentle face. He explained that when one tried life it was 'all interesting', that 'nothing was really ugly', it all depended on 'the point of view'.[86]

Much of their conversation, however, skirted around the subject of love. Sickert, ever apt to self-dramatize, cast himself in the role of the lorn lover. At lunch, in response to a fellow guest who, speaking of the delights of living in Venice, 'touched on the absence of those one

loved', he remarked, 'That is holy ground', and refused to discuss the
matter further. And when Lady Hamilton asked him to read Walt
Whitman's love poem 'Out of the Cradle', he 'shut up the book quickly,
with a look of pain, and said "it came too near him"'. After a certain
amount of evasion, Sickert confessed one evening that – yes, indeed
– his life was 'absorbed in another's'. 'He walked about the room, and
said "it sounded sentimental – ridiculous – but as we were talking
seriously it was like this, that his life depended on another's, he only
lived through her – if she lived again, he would wish to live again, if
she died now, he would wish to die, etc".'[87]

Lady Hamilton asked him if he 'felt certain of always feeling like
this', at which he 'seemed surprised, and said "it was no question of
feeling – it was his existence – he had no other" etc. etc. A great many
extravagant things he said which surprised me. I said I have heard men
say these things before – he said "one could only express what one
felt at the moment, and that was how he felt".' There was, he said, 'a
kind of altruism, living in another in this way'; it was 'a rest'. He did
not reveal who it was who absorbed his existence, and Lady Hamilton
was too well mannered to ask. Not knowing of Señorita Fortuny, she
suspected that the object of his absorption might be Ellen. On the few
occasions he had spoken of his former wife, he had done so in terms
that suggested he was still in love with her. Having made his grand
statement of passion, however, Sickert promptly undercut it by
remarking that, 'although absorbed in love', he 'often fell in love with
other people' at the same time – 'people he knew little about and
saw seldom, and asked nothing from'. Perhaps this was intended as a
veiled declaration to Lady Hamilton. She, however, considered it a
very strange way to carry on, particularly for a self-proclaimed 'wor-
shipper of common sense'. It was, she supposed, the result of his
'German temperament'.[88]

She glimpsed, as she thought, something of this attitude in action
when, on her last day in Venice, she had both Sickert and the de
Meyers to tea. The 'cool sweet little Baroness de Meyer' arrived, 'a
poem' – as Lady Hamilton called her – 'looking like a green lettuce
in her delicious green linen dress', accompanied by her 'funny little
Baron'. Lady Hamilton recognized at once that Sickert, who came in
soon afterwards, 'admired' the Baroness; that the Baroness liked him
too she could see 'by the gleam in her mysterious eyes'. The other
guests, Lord and Lady Saville, were bores, and Sickert, after the initial

civilities, sat apart near the Baroness. Lady Hamilton was rather put out and, having wondered whether to invite Sickert to join her and Edie on holiday in the mountains, promptly decided against it.[89] She did write to him, however, from the mountain resort of Vittorio, promising to send a copy of Whitman's poems and asking for his opinion of Shelley. She was, she mentioned, returning to England via France at the end of May. Sickert wired his thanks to her at Paris, suggesting that he would write more fully in due course.[90] His exhibition was opening in the French capital on 1 June, though he had no plans to attend.*

There were 96 works on view at Bernheim-Jeune, of which only 21 were in fact for sale. The others had been loaned by a long and impressive list of private collectors.† In his catalogue introduction, Blanche laid out Sickert's illustrious pedigree, stressing his classical education in an attempt to mitigate the obvious modernity of his vision. He noted his discipleship with Whistler, his closeness to Degas, his reverence for Camille Pissarro (and Pissarro's admiration for him), and he likened Sickert's line to Méyron's and his sense of design to Corot's. His work was not a 'cri de révolte pour flatter l'actuelle avant-garde' ('a cry of revolt destined to flatter the present avant-garde'), but the true expression of a 'charmante nature d'artiste raffiné et consciencieux' ('a charming artist's nature, refined and conscientious').

Sickert, away in Venice, was delighted to receive news of his exhibition. Blanche wrote to tell him that Lady Hamilton had been in and bought two pictures. In her eagerness she had in fact arrived two days early, before the pictures were hung, but had returned the following day for a sneak pre-preview. Blanche, who was assisting with the hang, showed her around. She was genuinely enthusiastic about Sickert's townscapes – 'his studies of Venice and Dieppe' – finding them 'full of appeal – sad – wan – touching'. But his figure paintings disturbed her. They displayed a 'brutal mastery over the reality of things' which

* 8 rue Laffite (1ᵉʳ etage), 1–10 June.

† Lenders included – besides the stalwart Blanche [32], Robert [3], and Tavernier [10] – Daniel Halévy, Lucien Simon, André Gide [6], M. Lemoinne, the sculptor Olivier Sainsère, M. Moreau-Nélaton (the great amateur of Corot and Delacroix), M. Chapuis, M. Rondenay, M. Beclard [2], M. Trouard-Riolle, Mlle Capel, M. Deléas, M. E. Strauss [2], M. Gonse, MM. J. & G. Bernheim-Jeune, MM. Durand-Ruel & fils [2], M. Hoenschel. Of the 96 pictures on view, 32 were views of Venice (including 11 for sale).

she found repellent. She disliked also what she considered to be his Degas-inspired 'déformation voulu de la ligne' (wilful deformation of the line). She bought two Venetian scenes, a view of St Mark's for £32 and of the Salute for £28, turning down the offer of a discount in the vain hope that the extra money might get to Sickert.[91]

Sickert was thrilled to learn of her purchases and wrote anxiously to know what 'impression' the whole show had made on her. She wrote back at once, but Sickert's attention was now elsewhere. When he finally did reply, some two months later, Lady Hamilton guessed that the cause of the delay was hinted at in the letter's closing sentence: 'I have been doing a portrait of the Baroness de Meyer.' As she remarked tartly in her diary, 'I foresaw this and my instinct, as usual, was sure.'[92]

The Bernheim-Jeune exhibition was opened officially the day after Lady Hamilton's visit. Sickert was pleased with the reports of its reception that filtered back to him in Venice. The reviewer for the *Chronique des Arts et de la Curiosité* declared that 'Tout l'ensemble trahit un goût affiné servi par des moyens d'expression d'une subtile délicatesse' ('The whole collection betrays a refined taste used for the expression of a subtile delicateness'), while Arsene Alexandre, in *Le Figaro*, was, Sickert considered, almost 'too kind . . . to give a just idea of the show'.[93]

Sickert was back in his own house at Neuville before the end of August 1904 and soon joined Max Beerbohm and Reggie Turner at the familiar table at Lefèvre's. Max reported that Sickert seemed 'very well this year'.[94] (The presence of Max's sister Aggie perhaps contributed to his well-being.)[95] But for all the apparent familiarity of the scene, the summer held the seeds of a new beginning for Sickert. Amongst the throng of painters passing through the town that season was William Rothenstein's younger brother Albert. He had been painting along the coast at Cany with one of his old Slade contemporaries, Frederick Spencer Gore. Gore was anxious to meet Sickert and Rothenstein was only too pleased to effect an introduction. Sickert's prolonged exile had not dimmed, and had perhaps even enhanced, his reputation amongst the rising generation, and his name had been kept alive in London by his many allies and confrères. It was a fortunate circumstance that two of his greatest friends – Steer and William Rothenstein – were closely associated with many of the brightest young painters: Steer had taught most of them at the Slade, while Rothenstein, only

a few years their senior, had come to know them well through Albert. Both men could relay news of Sickert's current Continental achievements, as well as tales of his fabled exploits during the heroic age of the NEAC and the London Impressionists. Of Sickert's recent productions only tantalizing glimpses could be snatched: the occasional NEAC showing, the rare stock items sent to Carfax or the Fine Art Society; the old music-hall reproductions in the *Yellow Book* and *The Idler*. He was both familiar and mysterious. While Steer had embraced the comforts of middle age and an established position, Sickert had remained defiant and free. At forty-four he could still be regarded as an *enfant terrible*.

Spencer Gore – who, on whatever slender grounds, professed to have 'a great admiration for Sickert's work'[96] – had an extraordinarily attractive personality. That summer he was twenty-six and had been away from the Slade for five years. Tall and gangling and obviously bright, his passionate enthusiasm for painting was tempered with self-deprecation and tact. He was an Old Harrovian, from a family rich in ecclesiastical connections (one uncle was a bishop), but there was nothing formal or pious about him. Sickert characterized him as 'serene and gay and sane'.[97] He was an excellent sportsman (winner of the Harrow Mile and wicket-keeper in the school Second XI) and an enthusiastic amateur actor with a fine line in singing policemen. Amongst his Slade contemporaries – a talented but temperamental crowd that included Augustus John, Wyndham Lewis, and Harold Gilman – he had held a charmed position as the friend of all.[98] Sickert took to him at once when Gore and Rothenstein spent two days and evenings with him talking of life and art. Sickert was avid for news of the London scene, and his two young companions gave a warm account of what was being achieved by some of their contemporaries. The work of Augustus John, Orpen, Ambrose McEvoy, Gwen John, and others was, they suggested, bringing a 'powerful new vitality' to the NEAC. Sickert's interest was 'aroused'.[99] He promised to exhibit at the club's winter show that year – and perhaps even to come and see the work of these young artists.[100]

He had planned to return to Venice at the end of the summer, but he lingered on in Dieppe. He was absorbed in 'finishing some work'.[101] The experiments in painting the nude, begun in Venice, were continued. He produced a series of single figures, sprawled upon the rumpled sheets of metal-framed beds. Mme Villain was, it seems, the

model for at least one of these pictures, appearing with her mop of red hair as *La Belle Rousse*.[102] Following up on his promise to Gore and Rothenstein, he sent the portrait of Israel Zangwill over to the NEAC show along with a picture of a lilac tree. For the moment, however, the main focus of his interest remained on the Continent. He had worked hard to establish a reputation in France and he intended to build on that foundation. His vision, as he explained to Mrs Humphrey, was to raise a bit of capital so that he could erect a proper studio at Neuville in which he would be able to work comfortably during the periods of each year when not in Venice. Furthermore, he hoped that with a bit of money behind him he would be able to hold out for slightly higher wholesale prices from his dealers.[103]

There was, he thought, even a chance of realizing this dream. Over the years of their friendship and collaboration, Whistler had given him several pictures; happily, during the years of their estrangement, he had never thought to ask for them back. Sickert now proposed to sell this little collection. He believed he might raise as much as £1,000 – more than enough for his purposes.

Excited by the idea, he wrote to Mrs Humphrey, who, he believed, must have rescued the pictures from the Robert Street studio.[104] Florence had only recently had a baby so was not able to take a very active interest in the scheme. She did, however, instruct the firm storing Sickert's old studio contents to send over all the pictures they held. The crate arrived, but there were no Whistlers in it.[105] Their disappearance was – and is – a mystery. Whistler might have retrieved them himself. They might have been amongst the damp-rotted canvases Florence had found, and discarded, when clearing out the Robert Street studio.[106] Sickert hoped there had been a mix-up and that Florence was holding onto the pictures herself. But she was not. She did locate one: a slight portrait sketch of Sickert by his former master.[107]

In early December Sickert came over to London to see the picture and to try to arrange for its sale. The de Meyers had recently returned to London and were settled in a grand house at 1 Cadogan Gardens. Sickert, staying at the Langham Hotel, learned that they were hosting what he thought was a small reception on the evening of his arrival – Conder and some other artist friends would be present. He turned up in his travelling clothes – grey tweeds and a pink shirt – only to discover a full-scale party in train with everyone else in formal evening dress. His 'homespun' attire put out some of the fellow guests. Claude

Phillips, the preening *Daily Telegraph* art critic, worked himself up into a fine state, calling it 'a piece of great impertinence'. Sickert claimed to be embarrassed but seems to have rather enjoyed his distinction. Many old friends were delighted and amazed to see him back in London. Gertrude Kingston was there, and so too was Lady Hamilton. She thought he looked like 'the Prince in disguise'.[108]

He called on Florence to see her baby and to collect the Whistler picture. His plan was to sell it to the great American industrialist and Whistler collector, Charles Freer. With a peremptory directness that he perhaps thought appropriate in dealing with a busy tycoon, he wired Detroit: 'Fine oil head of me by Whistler. Want four hundred [pounds]. Sickert.' Within a day he received a reply: 'Send on approval my expense, if satisfactory will keep.'[109]

Perhaps rather surprised by the pace of events, Sickert hesitated. He had arrived at his asking price after consultation with 'a very competent authority', but he now decided that he should get another opinion. The second 'no less competent authority' valued the picture at only £100. This, at least as far as Sickert explained things to Freer, placed him in a quandary. 'You are,' he wrote, 'the last person I should wish to surfaire [overcharge]; so my offer fell to the ground. It seemed to me that the only way to arrive at an impersonal valuation was to put it in the hands of a dealer ... I was also told after I wired that you only bought masterpieces and this is a very slight canvas.'[110] Sickert entrusted the picture to his old friend Ernest Brown, who had left the Fine Art Society the previous year to go into partnership with two young brothers, Wilfred and Cecil Phillips, in Leicester Square. He sold the painting to the Irish collector and patron Hugh Lane.[111]

Sickert's return to the New English Art Club gave him an opportunity to gauge its standing and to test the excited verdict passed on it by Albert Rutherston* and Gore. He found familiar faces there. Steer and Will Rothenstein were still considered the leading lights, and Sargent a gracious visitor from on high. But during the years of his absence other names had risen to an almost equal prominence: William Nicholson and James Pryde, William Orpen, and, above all, Augustus John.[112] Roger Fry, reviewing the show in *The Athenaeum*, felt that the 'traditions

* William Rothenstein's brother changed his name to Rutherston during the First World War, but for the sake of clarity and convenience this spelling is used throughout.

and methods' of the senior members were 'already being succeeded by a new set of ideas': 'They are no longer *le dernier cri* – that is given by a group of whom Mr John is the most remarkable member.'[113]

Sickert was wary of this new star. He admired John's draughtsmanship, and commended his portraiture. He could even recognize the 'intensity and virtuosity' with which the artist had 'endued his peculiar world of women half gypsy, half model, with a life of their own'. But that world – an invention of John's personal fantasy – remained essentially alien to Sickert's creed of the real; and his reservations about the work were carried over into reservations about the man, with his Romany glamour and his complicated domestic arrangements. Relations between the two existed on a level of often exasperated and sometimes amused respect. They kept their distance. Blanche characterized their failure to establish a true rapport as the cockney's natural aversion to the gypsy, though there was perhaps also a subconscious recognition that their personalities were too large, too dominating, and too colourful to be readily accommodated within the same small circle.[114]

Sickert did the rounds of his friends. Amongst the first he called on was his ex-wife Ellen, who was living happily on her own in Gray's Inn.[115] Sickert also enjoyed picking up the thread of his flirtation with Lady Hamilton. In her drawing room at Chesterfield Street he had the chance to see his two pictures again, though Lady Hamilton felt that her appreciation of them was 'rather an acquired taste', which she was struggling 'to hold on to'. She confessed that she had felt it slipping in the face of the Zangwill portrait at the NEAC. Sickert replied, laughing, that – yes – he sometimes 'trampled his sitters under foot'.[116] Sickert dined at Chesterfield Street one Sunday evening, still dressed in the 'grey homespun', but he compensated for the shabbiness of his clothes by the courtliness of his manners. When dinner was announced, he presented his arm to Lady Hamilton with 'such an air' that his hostess was put in mind of 'the Prince in the Fairy Tale'. At dinner, he 'unfolded his theories about life'. Lady Hamilton particularly liked 'what he said about many people's attitude under neglect. "Some one is nice enough to ask you to dine on Monday and then why should you want to go and kick them because they do not ask you to their house the following Monday too."' She seems not to have recognized this as an attempt by Sickert to absolve himself for his own many acts of neglect, both past and to come.[117]

And so, after playing Prince Charming in London for a couple of weeks, Sickert – with fairy-tale abruptness – disappeared back to France.[118]

CHAPTER SIX

Londra Benedetta

Walter Sickert and Clive Bell at Newington

THE LADY IN RED

If I am fulsome I cannot help it.
(Walter Sickert to Mrs Swinton)

Whistler's death had removed an obstacle from Sickert's path. New avenues were now open to him. He was encouraged by Blanche to show with the International Society of Sculptors, Painters and Gravers, of which Rodin had become the new president. There was no longer any reason why Sickert should remain outside a forum that, in its international scope and ambition, seemed so in line with his own outlook. Moreover, the society was planning to follow up its own show at London's New Gallery in January 1905 with a major Whistler memorial exhibition: it would be apt if Sickert, as one of Whistler's most conspicuous pupils, were represented in the earlier show. He sent two Venetian pictures – images that emphasized his increasing distance from the Whistlerian tradition.[1]

Sickert was not in London for the first exhibition but he arrived soon afterwards – along with Blanche and Cottet – for the grand opening of the Whistler retrospective that succeeded it. Blanche and Cottet were acting as an unofficial honour guard and escort for Rodin, who had an unaffected relish for his presidential role. The great sculptor delighted in the fuss that the London hostesses made of him, and was most concerned to do justice to their expectations. He had a special coat made for the trip – a splendid garment fashioned on what he considered to be English lines. He moved about in a nimbus of scent, his broad 'workman's hands' fitted snugly into over-smart 'butter-coloured gloves'. A personal barber attended him twice daily, 'to curl the grey lock on his forehead'.[2]

On the evening of 20 February they all gathered, along with the American Ambassador and a crowd of artistic notables, for a gala

banquet at the Café Royal. Sickert found himself amongst old friends and old enemies: Max Beerbohm and D. S. MacColl were there, as well as Théodore Roussel and Joseph Pennell; the toast to Whistler's memory was given by Sickert's childhood neighbour (and cigar consultant), Walter Raleigh. The next morning Rodin officially opened the show. Curated largely by Pennell, it contained several hundred works, representing most of the phases of Whistler's career. Blanche had lent some paintings to the exhibition; so too, ironically, had Sir William Eden.[3] Several of Whistler's most famous works, including the portraits of his mother and Carlyle, were on display. The exhibition proved a huge success with the press, as well as a huge draw for the public, and marked the confirmation of Whistler's reputation. He became acknowledged as 'an accepted master', and his prices made another upwards spring, assuming magisterial levels. The portrait of Irving as Phillip II of Spain, painted for £100, was sold that year at Christie's for 4,800 guineas.[4]

Sickert's hopes rose with the market. Although he had divested himself of the portrait sketch, and though the various canvases left at Robert Street remained lost, he had unearthed some other scraps of Whistleriana – a panel of a public house given to him at St Ives, a small portrait of H. R. Eldon and a collection of etchings[5] – and he believed that he would be able to sell them well in London. It was a belief, however, that not everyone shared. As Beerbohm confided to Alice Rothenstein, he was sure that Sickert, in his excitement at the possibilities of his scheme, would muddle away any chance of enriching himself: 'If he leaves England with a "tenner" in his capacious pocket I shall be surprised; and he will be more than pleased.'[6] Will Rothenstein also remained bemused and exasperated at Sickert's business dealings. He lamented the 'absurdly small prices' that Sickert asked for his own pictures, feeling that by adopting a too modest view of his own work he encouraged others to do the same. He did his best to save Sickert from himself by assisting at the sale of some of the Whistler pieces.*[7]

* They were bought by an American dealer who, as an inducement, offered to buy one of Sickert's pictures as well. Rothenstein was furious, however, at the 'trifling sum' mentioned and at the lack of respect shown to his friend – the American making no effort to conceal his small regard for Sickert's work. And though Sickert was more than happy to accept the prices mooted, Rothenstein insisted on his getting at least double.

The circus surrounding the opening of the Whistler exhibition con-
tinued for several days. Sickert and Blanche were both at a splendid
reception given for Rodin by Mrs Charles Hunter, in order – so it was
said – that he might meet the most beautiful women in London.[8] Even
in an age of great hostesses, Mary Hunter was a noted figure. Having
married a wealthy coal magnate (a friend and neighbour of the Edens
in County Durham), she had devoted her considerable energy to
spending her husband's fortune. Her gatherings of the great, the
fashionable, and the famous earned for her the nickname Mrs 'Leo'
Hunter. Rodin was just one of the many lions she captured. There
was, however, something more than mere plutocratic self-glorification
about her soirées. They were fun and they were imbued with a true
sense of culture. Mary Hunter had a conventional Edwardian appreci-
ation for pictorial art (she was painted regularly by Sargent, and com-
missioned a portrait bust from Rodin) but a real love for music. Her
sister, Ethel Smyth, was an extremely gifted and – in time – celebrated
composer, and the parties that Mrs Hunter threw were always distin-
guished by the excellence and originality of their musical programmes.

Amongst the performers on the night of the Rodin party was a
young woman in her early thirties who sang some Russian songs.
Although she may not have been one of the acknowledged beauties
assembled for Rodin's delectation, she was certainly attractive: not tall,
but with a fine bearing and a full figure. Her thick dark hair was piled
up above a face alive with an irresistible impish gaiety: the eyes were
dark and bright, the nose almost retroussé, the mouth generous. And
she was talented. The 'incomparable warmth' of her voice was – accord-
ing to one of her listeners – such as to 'cast a strange spell over even
a fashionable audience'.[9] It cast its spell over Sickert: he was enraptured.
The siren was Mrs Swinton. Sickert learned that she had been born
and raised in St Petersburg and made a not unnatural assumption
about her nationality. 'I must know that superb Russian,' he confided
to his hostess.[10] In fact Elsie Swinton was not Russian. She had been
born Elizabeth Ebsworth in 1874, the daughter of a partner in a
successful Anglo-Russian trading company. In 1895 she had married
Captain George Swinton, who was fifteen years her senior. Ill health had
curtailed his military prospects, and – despite keen interests in art, her-
aldry, and genealogy – he had embarked upon a second career in local
government: in 1905 he was the Holborn member on the London
County Council, and Chairman of the Parks and Open Spaces Commit-

tee. Sickert was not alone in thinking Mrs Swinton superb. Sargent had painted a full-length portrait of her at the time of her marriage, a bravura work showing her posed, hand on hip, in a cloud of shimmering white silk. Orpen had also caught something of her poise and her embonpoint in a group portrait of the family, and Conder had only recently paid homage to her in a characteristically vague pastel.[11]

The opportunity of meeting Mrs Swinton occurred almost – if not quite – as soon as it was wished. It was Lady Hamilton who effected the introduction. They were together one evening at a party where Mrs Swinton was once again singing. Lady Hamilton at once 'saw how excited' Sickert was by her. Sickert was lunching at Chesterfield Street the next day and Lady Hamilton 'insisted' upon Elsie, whom she knew quite well, joining the party. Her motives were not entirely generous; she hoped that an hour's conversation might disabuse Sickert of his infatuation. She thought he would find Elsie 'rather stodgy'.[12] The plan was a complete failure. Sickert became even more enamoured. He insisted on telling Lady Hamilton how 'lovely' Mrs Swinton was, what 'a wonderful combination of colour she wore', and other details of unwelcome praise. In exasperation, Lady Hamilton confided to her diary: 'It surprises me that men like Sargent and Walter Sickert admire her so tremendously. I like her, but think she looks "the German Frau".' Charles Furse, she recalled, 'rather laughed at Sargent's admiration. He thought her a sledge-hammer woman.'[13]

Sickert probably liked that in her. In any event, their friendship prospered rapidly. Lady Hamilton was very put out when Sickert turned down her next lunch invitation and she learned that it was because he was taking Elsie to see the Whistlers, and then on to lunch afterwards.[14] (Sickert had taken Lady Hamilton to the exhibition the previous week. It had been a mortifying occasion, with Sickert wearing 'the most awful Ulster and pot hat' and boots that creaked. He also had a camera slung over his shoulder and, after their visit to the show, instead of lunch, he had insisted on going into the park to take photographs.[15]) Sickert soon became obsessed with Mrs Swinton: seeking invitations to houses where he might hear her sing, and writing her letters of fulsome praise. 'You looked divine this evening,' he told her after one of her performances, 'regal and sulky & civil & glorious.'[16] He described himself as her 'parasite in ordinary' and signed his letters to her 'ever your most devotissimo'.[17] With a wilful lack of tact he told Lady Hamilton that Elsie 'went on in his head like a Katherine Wheel'.[18]

Sickert also began to visit Mrs Swinton at the family home in Pont Street. Elsie had given birth to her third child only the previous year, and Sickert was impressed by the way in which she managed to balance the sophistication of her evening performances with a daily round of conventional domesticity: the pram in the hall, the children in the sitting room, and her husband George – tall, thin, moustachioed, and impressively respectable.[19] The children took to Sickert at once, and he to them. He sang Elsie's daughter Mary a goodnight song on her sixth birthday, and showed her and her older brother Alan how to draw.[20]

Sickert also began to make drawings of his own. He had been intending to return to the Continent immediately after the opening of the Whistler exhibition and the conclusion of his own Whistler deals, but the onset of his new infatuation seems to have made him reconsider. He drew Mrs Swinton and planned to paint her.[21] Though he was staying at Morley's Hotel on Trafalgar Square, he took a studio at 76 Charlotte Street, just north of Oxford Street in the area that has since become known as Fitzrovia, but was then still bracketed as part of Soho. The house – if not the room – had once been used by Constable, and on the letterhead he ordered Sickert called it 'Constable's Studio'.[22] The building, however, also had its contemporary associations. Albert Rutherston had his studio there until he moved up the road to 18 Fitzroy Street (the continuation of Charlotte Street, a fact that sometime leads to confusion between the two), and Spencer Gore was living nearby at 21 Fitzroy Street.[23] Sickert's move thus brought him back into close contact with his young friends of the previous summer.

Mrs Swinton came frequently to the studio for sittings: 'it would be a charity', Sickert wrote to her, 'to give me . . . say 11.15 to 12 or 12.30 . . . I shall be at the studio from 11 on the chance. So you *need not let me know.*' He was soon engrossed ('très emballé') with the painting – 'in addition to the original emballement with the model'.[24] He took photographs, made drawings, and also painted her from life. He started not one but several canvases, which he could work at according to the light, his mood, and the dress that she was wearing.[25] One of the greatest challenges was keeping separate the social and artistic strands of his obsession. With mock severity he noted 'a sad tendency' Elsie was showing 'to degenerate from a model to a mere friend'. He went on: 'I find myself going out in silk hats to exhibitions! Nor was

it at all in programme to close my doors to the universe *solely* in order
to give you tea and listen to recitals of "trajedies", with a "j". Allons,
au bon mouvement!'[26] The teatime digressions, however, were in part
of Sickert's own making. As Elsie later recalled, he was never in a hurry
to start. First there would be tea and talk, although beneath the leisured
surface he seemed to be 'gradually "Boiling up inside": then suddenly
he would pull out the desired canvas and begin to work'.[27]

Sickert's extended stay in London was welcomed by his many
friends and connections, and also by his family. His mother was still
living at Pembroke Gardens, providing a home for Robert – increas-
ingly an invalid – and for Bernhard – increasingly dependent on alco-
hol.[28] Leonard, having completed his musical studies, was also there,
giving occasional concert performances and less occasional singing
lessons. Short and stocky compared to his older brothers, he had
nevertheless inherited some of the same indolent unconcern of Bern-
hard and Robert and was in no hurry to quit the nest. Sickert dubbed
him 'the independent dependant', remarking that 'it was no use being
a professor of singing if you told your pupils that they hadn't got a
voice when they hadn't got a voice'.[29]

Oswald, too, had returned to Pembroke Gardens, though as a boon
rather than as a burden. He had abandoned journalism for publishing
and an assured salary, becoming 'lieutenant' to Horace Hooper, an
American entrepreneur who had acquired the rights to the *Encyclopaedia
Britannica* as well as founding the Times Book Club. In his new role,
Oswald had just completed a world tour promoting the encyclopaedia
and was engaged with the establishment of the Times Book Club's
new 'shop' on Oxford Street.[30] His arrival back in England had
coincided with Bernhard's return from a sojourn at an alcoholics'
home, and Oswald strove to preserve his brother's battered equilib-
rium. He slept in the same room as him and did 'all that tenderness
and sweetness could do'. It was perhaps Oswald who encouraged Roger
Fry to give Bernhard occasional writing assignments for the *Burlington
Magazine* (which Fry had recently helped establish). Bernhard also
did some legwork for Fry's American dealer-friend, August Jaccacci.[31]
Although all practical efforts to help Bernhard were doomed to fail at
his next inevitable relapse, Oswald's generous, humorous presence
helped matters along. It also greatly cheered old Mrs Sickert, and
absolved Walter from having to engage himself too heavily on the
home front.[32]

Other aspects of Sickert's former London life were more alluring. He saw much of Ellen, attending her receptions and parties.[33] She was as supportive as ever. He still referred to her as 'my wife', and he announced to both Lady Hamilton and Mrs Swinton that he hoped to persuade her to remarry him. It is hard to know how serious he was, or whether Ellen was tempted. Lady Hamilton laughed at the notion, considering that no one would ever 'be so foolish', and that one might as soon 'marry a piece of thistledown'.[34] Certainly his declared intention did nothing to cool his enthusiasm for Mrs Swinton.

Sickert continued to pick up the threads of his old artistic friendships. He was received warmly by Steer and Moore. He affected to envy Steer, now 'fat as a retired grocer', lapped in comfort at Chelsea with 'his beautiful maid, his getting up past ten, his splendid breakfast by a fire, in slippers, and the *Times*, to doze upon – then some painting in a clean comfortable studio, then a good lunch and port, then another doze – then some more painting, until tea and butter toast and muffins (or café filtre!)'.[35] Steer, together with Henry Tonks and Walter Russell, remained under Fred Brown as one of the presiding influences at the Slade. Sickert thought Brown had become rather 'a dry old stick'; but, as he explained to Mrs Swinton, 'we have done each other mutual services for years, a little, & are real friends'.[36] Another of his London Impressionist confrères, George Thomson, he found less desiccated. They met at a jolly little dinner given by Sir William Eden in the chintz-draped dining room at the Cavendish Hotel, Jermyn Street. Thomson, like the others, had taken to teaching, becoming Professor of Painting at Bedford College, London.[37] But enjoyable though Sickert found these encounters with his past, they tended to confirm the gulf that had opened up between him and his contemporaries. The Slade-bound world of Brown, Tonks, and Steer – and their faithful crony George Moore – seemed remote. He had not grown either old or fat or stick-like, nor had he achieved the established position of a 'professore of pittura'.[38]

He found a more lively ambience at the Rothensteins' literary-artistic gatherings at Church Row, Hampstead, and the bohemian parties thrown by the Conders at their house off Cheyne Walk. Will Rothenstein, with his gifts for friendship and art politics, and his willingness to serve others, had kept in touch with the currents of the day. At Church Row, Sickert could meet Augustus John and Jacob Epstein and other members of the NEAC's younger faction, as well as

poets and novelists.[39] The Conders offered a slightly different flavour.
They had achieved their social apotheosis earlier in the year with a
magnificent fancy-dress party to which the Baroness de Meyer had
come as Hamlet and Marie Tempest as Peg Woffington. Madame
Eugenia Errazuriz, a severe South American beauty known as 'the
Madonna of Fashion', had carried off the prize – of a Conder fan –
for the most beautiful frock, though Conder may have felt unable to
vote in favour of Florence Humphrey's outfit – a dress, made by Aggie
Beerbohm, which he had painted himself.[40] Although the Conders'
regular evening 'at homes' were not of course conducted at quite the
same pitch, they were still touched with glamour; and beneath the
glittering surface Sickert could catch a real sense of artistic community.
Accepting an invitation to an informal dinner, he wrote enthusiastically
to Stella Maris: 'Splendid move! Everyone will be grateful [at not having
to dress for dinner]. You must give the democracy a chance! Remember
Degas said "it is painters *alone* who make the reputation of painters!"
And as we are all jealous beasts, we must be conciliated and meet
often.'[41]

Sickert came to like and appreciate Conder greatly. He gave him
his first lessons in etching and made a collection of his drawings.[42] He
much admired Conder's fan paintings, and tried his own hand at one,[43]
but he was not, however, convinced by his friend's portrait work. He
told George Swinton that it amused him how Conder always seemed
to depict 'a composite of the women he admires'. The pastel of Mrs
Swinton – wearing her diaphanous green dress, made for her by Aggie
Beerbohm – he described as 'a resultant' between Mrs Swinton,
Madame Errazuriz, and Baroness de Meyer '& very like all three!' Never-
theless, Sickert borrowed the picture so that he could study it while
working on his own portraits of Mrs Swinton.[44]

Sickert saw Agnes Beerbohm at the Conders', and even painted her
there one evening, alongside his host and various other artistically
inclined guests.[45] They also met independently, and one evening she
took him to see *Rigoletto*.[46] Whether they resumed what Ellen had
once termed their 'former relations' is unknown. Sickert's concurrent
infatuation with Mrs Swinton and desire to remarry Ellen cannot be
taken as any absolute guarantee against the possibility. Indeed Sickert
remarked to the guests at one of Lady Hamilton's dinners that when
he went to the opera 'he would like a woman to sit on either side of
him & hold his hand all the time' – a recital that left one young listener

'thrilled with horror'.[47] His 'thraldom' to Mrs Swinton gave him a new enthusiasm for music in general, or so he told her.[48] Amongst the concerts he attended was one at the Bechstein Hall given by his friend and sometime patron Frederick Fairbanks. It was a regular Dieppoise reunion: Fairbanks' wife – the former Eliza Middleton – had come over for it, and Lady Blanche Hozier greeted Sickert warmly as he was taking his place.[49]

Sickert continued to lunch or dine almost weekly with Lady Hamilton, who seems to have enjoyed the slight element of risk involved in the association, for Sickert had a dangerous reputation. One evening, after attending a performance of Euripides' *The Trojan Women*, with Sickert's friend Gertrude Kingston as Helen,* they dined together at the 'Stage Society'. Before they went into dinner, Mrs West, an acquaintance of Lady Hamilton's, 'looking fierce and buxom stalked up' and asked to be introduced to 'Mr Sickert'. Lady Hamilton reluctantly obliged: 'She looked at him, & neither of them spoke; [Sickert] never does if introduced to anyone, he waits in a sympathetic silence. Then without a word, [Mrs West] turned her back & walked away.' Sickert was unperturbed, though he did ask – to Lady Hamilton's secret satisfaction – 'Who *is* that dreadfully vulgar woman?'[50]

There were, however, limits to Lady Hamilton's daring. When she and Sickert left the dinner, after a speech by Bernard Shaw, they discovered that it was a beautiful evening: 'the air was enchanting and there was a mysterious moon'. Sickert proposed they go on to a music hall or take a hansom down to the river and walk a little along the Embankment. Lady Hamilton seized at the second option, but half way there became anxious that she did not have her front-door key and would have to rouse the servants if she got home late – and that they might disapprove. She insisted on turning back. Sickert, she noted, 'agreed at once when he saw I *really* wished it, and told the cabby he was sorry, but we must go back. He really has extraordinary charm in the way he does things. He is cool, delightful and amusing, and smoothed away the feverish irritation from my soul.'[51] Sir Ian Hamilton's return from his long sojourn in Japan towards the end of April eased some his wife's social anxieties, but did nothing to break the routine of Sickert's visits.[52]

* Lady Hamilton was very surprised at how good she was in the role – 'those untimely hips lost in perfect drapery'.

Over Easter, when others were leaving town, Sickert announced that he would be retiring to his 'country seat in Soho'.[53] It was a chance to work, not only on his pictures of Mrs Swinton, but also on a series of nudes. The motif, discovered and elaborated at Neuville and Venice, was now transferred to London. He made use of some of Albert Rutherston's models, particularly an amusing and 'pert' coster-girl called Emily.[54] The new setting and the new sitters were rendered in a new medium: he began working in pastel. The innovation was both apt and convenient. The lush sensuousness of pastel was well fitted for such subject matter. It offered, too, a greater freedom than oil paint, allowing Sickert to push further his experiments with loose handling and broken effects. And it was suited to his work patterns: a pastel, as he remarked, 'is always ready to be got on with'.

The impetus behind this new departure was – as so often – probably provided by the example of Degas, who had made the medium of pastel his own – the vehicle for much of his late work. Sickert cherished the recollection of watching him complete a pastel of the 'Inundation of Egypt', which 'he fixed and re-fixed' with 'a ball syringe'. Degas had then claimed to regard 'pastel work' as a branch of painting – rather than drawing – in that it related 'colours in mass' or 'proceeded by the juxtaposition of pastes as considered in their opacity'. But, as Sickert observed, this was only 'what he said at a given date, and to a given person. It in no wise follow[ed] that, by advising a certain course, he was stating that he had himself refrained from ever taking another.'[55] And it was this knowledge of Degas' heterodox practice that doubtless encouraged Sickert, having adopted the medium, to seek his own way with it, using a more broken technique than Degas advocated.

The example of Degas may also have stood behind Sickert's first tentative experiments with sculpture, though he was drawn not towards the creation of small figure pieces, such as Degas produced, but to portraiture. He began modelling a bust of Mrs Swinton, telling her, 'Sculpture really is more satisfying when the preoccupation is a purely portrait one. No tiresome background. Not one silhouette, but *all* the silhouettes. The clear form singing out.'[56]

If Sickert worked over Easter, there were opportunities for recreation soon after when Mrs Swinton took him for a day on the river. 'Really,' he claimed, 'without exaggeration, my first holiday for, I don't know, ten years or so.' He added in a self-deprecatory aside, 'Perhaps you wonder why I don't do better if I have always worked so hard! I do.'

Even on their pleasure trip he had not been able quite to forget the work in hand. 'I profited by my opportunities of staring at you for a whole day,' he told her, '& between 10 and 1.30 p.m. last night I set up a *new* bust which promises . . . So you will be in paint & plaster in the salon d'automne I hope! "What sport!" as Blanche says you English say to everything. I am very anxious to finish the bust while I am still under the obsession. Of course it may last for ever* [* The obsession, not the making of the bust!!!] but there is nothing like making sure.'[57]

The obsession was certainly strong upon him – and also upon Mrs Swinton. When she sang at one Belgravia party, Lady Hamilton noted that Sickert 'sat where he could see her, and gazed on her like a pale flame, and it seemed to me she was singing only to him. She stirred and excited one's senses, and troubled me with the mystery of sex, but that is beyond & outside me and gives me a feeling always of oppression perhaps of desolation.' Although some friends considered that 'all this' was 'very bad' for Elsie, Lady Hamilton thought it 'splendid' that she was being 'gloriously "swept far out to sea"'. She added: 'Poor George, he makes me think of the fisherman watching the genii [*sic*] streaming out of the bottle – Will he ever be able to put her back again? He did once – it was a marvellous feat, but not this time.' Elsie became – on her performing nights – quite magnificent, 'really beautiful and powerfully magnetic', and Lady Hamilton was happy to 'feel that it was me who helped her to this hour of glorious life', adding that 'she has had a dull time with George'.[58]

With Sickert, the time was rarely dull. But, though his relationship with Elsie was clearly charged with 'the mystery of sex', it is difficult to know what resolution it enjoyed. None of Sickert's surviving letters hints at anything more than an impassioned friendship – but, then, that is not so surprising. Perhaps other, more compromising, letters were destroyed. Almost none survives after 1906, and yet the relationship was not a passing one. Other sources make it clear that Elsie remained 'off her head' about Sickert for the next three or four years,[59] and it is hard to suppose that it could have continued at such a pitch without consummation. Those close to Mrs Swinton confirm that Sickert was the great love of her life and report that she did consider leaving her husband for him, only to be put off by Sickert, who demanded to know what George had done to deserve 'such treatment'.[60] Sickert appeared to see no inconsistency in combining serial

adultery with strong views about the sanctity of marriage: certainly he
always remained on good terms with Captain Swinton and continued
to be welcomed into the family circle. When the Swintons – on account
of George's position at the LCC – had to entertain a party of delegates
from the Municipal Council of Paris, Sickert came to the dinner and
'talked French nobly' all evening.[61]

With the advance of the summer, the Swintons joined the fashion-
able exodus from town, embarking on the compulsory round of house
parties, shooting parties, and visits to relatives.[62] Sickert's movements
during the summer are rather less easy to follow. He seems to have
flitted back and forth between Dieppe and London more than once,
reaching a state when he was not sure 'whether my cases are there or
here'.[63] He retrieved his large picture of Hilda Spong from Bernheims
and – rather to her horror – insisted on lending it to Lady Hamilton.
Sir Ian had been given the command of the Second Army Corps and
with it a grand house at Tidworth, in Wiltshire, as an official residence.
Sickert thought his painting might find a home there, though Lady
Hamilton was less sure. She did not know 'where the devil to hang'
the 'vulgar woman in a violet crinoline'. It affronted her, and yet – as
she confided to her diary – 'there is something I rather like in the
colour, in spite of the brutal treatment. I feel it often in his work, I
have not yet in the man, and yet I feel vaguely it must be there.'[64]

Sickert returned briefly to Dieppe and was at Lefèvre's to celebrate
Max's birthday on 24 August along with Reggie Tuner and William
Nicholson. There was a general feeling that the quality – or at least
the quantity – had 'fallen off' since the previous year. Electric light
had been installed and to pay for this modernization, though all the
prices remained the same, all the portions had been reduced. There
was barely enough for Max's meagre appetite, let alone Sickert's.[65] But
come the end of the summer, Sickert was back in London. He had
long been hankering to return to England for at least part of each year,
but had balked at the expense. His unplanned sojourn during the
spring and summer had convinced him that it might after all be man-
aged and he felt able to re-establish a London base. For living quarters
he remained loyal to his former North London milieu, renting a pair
of shabby rooms at 6 Mornington Crescent, just down the Hampstead
Road from his old Robert Street studio – close to the Euston Baths for
his morning swim. His rooms faced on to a bosky communal garden
(since obliterated by the Carreras cigarette factory, now 'Greater

London House'). From his windows he could almost see the Bedford Music Hall and the statue of Richard Cobden that stood in front of it. This latter proximity allowed him to start introducing the remark 'I was standing under the statue of my father-in-law' regularly into his conversation.[66] He kept on his workspace at Charlotte Street but, with typical profligacy, took on another one as well. In an act of perverse piety, he rented a room at 8 Fitzroy Street – the building where Whistler had worked during the late 1890s.[67] The room was close to Albert Rutherston and Gore, almost too close. Albert, who spent much of his time leaning out of his studio window, would hurry round whenever he saw that Sickert had a lady caller. On such occasions, however, Sickert would keep the door firmly closed.[68]

London offered Sickert the combined attractions of novelty and familiarity. He was thrilled to be back amongst its sights and sounds – happy, too, to be back on what he considered home ground after the sometimes lonely years of exile. Nevertheless, despite the flurry of lease-taking, he did not conceive of his move as being either permanent or total. Over the previous half decade he had continually refreshed himself and his art by moving between Dieppe, Venice and Paris, each arrival producing its own access of energy and excitement. London was now officially added to this circuit. His letterheads continued to list his Dieppe address alongside his London one, and his professional outlook remained Continental. He surely meant the opposite of what he wrote when, in a letter to Mrs Swinton about the art world, he remarked: 'remember that Paris is to London what the paddock is to the course'.[69] He chose to show that October – not with the NEAC, but in Paris, at the Salon d'Automne, a new exhibiting body that, though founded only two years previously, was already rivalling the more anarchic Indépendants as the leading forum for non-academic work. The portrait bust of Mrs Swinton he had planned to send does not seem to have been completed, but he dispatched eight pictures, four of them pastels.

The salon that year achieved a clamorous notoriety with the exhibition of some uncompromisingly bold works by a group of young artists that included Henri Matisse, André Derain, and Maurice de Vlaminck. These experiments with pure colour and simplified form – all grouped in Salle VII – had a brutal energy and novelty of vision that shocked the public, bemused the press, and excited a small circle of enthusiasts. The perpetrators, most of them in their early thirties,

were dubbed 'Les Fauves' – the wild beasts. Their work was denounced in some quarters as a failure, in others as a confidence trick. Sickert's rather more cautious experiments could not but appear muted by the first glare of this novelty. In the critical reactions to the show that year his work was largely ignored. For all their daring, Sickert's colours remained less arresting, his tones lower, and his forms more resolved, than those of Matisse and his savage confrères. And if some scented a new spirit abroad in the world of art, Sickert remained unimpressed. Paris, as he noted, was rather over susceptible to the charms of novelty and experiment – critical, but almost 'too responsive to *every* and *any* effort of art'; he believed that the squall created by Les Fauves would soon pass.[70]

By contrast the NEAC show that October was a mild, unthreatening affair. Although Sickert expressed an interest in the assured and dextrous work of Orpen, it was probably because the artist had painted a portrait of Mrs Swinton[71] – and perhaps it was the spice of competition that sent him back to work on his own pictures of her. Elsie came for regular teatime sittings at his new Fitzroy Street studio, even though Sickert seems to have been working as much from photographs as from life. He was excited by his progress. 'Get *all* your friends to order portraits,' he urged her, ' – "not of themselves – but – you". (air of "Drink to me only") Next time anyone else wants a portrait I shall say[,] "No, but I will paint you a portrait of Mrs. Swinton".'[72] Sickert held a small gathering at Fitzroy Street to show off the first of the finished works: Mrs Swinton – seen sitting, three-quarter length in a bright red gown against the fanciful background of a wind-whipped sea on which a yacht was battling. It was an image steeped in 'the mystery of sex'.

Lady Hamilton, who came with two women friends in an 'electric brougham', gave an amusing account of the occasion: 'Alas! We found a dismal gathering there – a few penny candles burning and dim groups of people hovering about – the beautiful Walter looking very seedy and down at heel was distributing vile looking tea, but as courtly and charming and distinguished in manner as ever. He introduced us both to a very grim & respectable looking Mother, and showed us his portrait of Elsie Swinton. I asked, "Is it a Negress?" to his disgust; he had tried a contre-jour effect with disastrous result. Elsie Swinton is certainly one woman it in no way resembles. Edith [Beaumont] said it was beautiful – *how could she*? Then we subsided into seats and

someone sang – a rather splendid voice but not always in tune & not in proper control.' After the visit Lady Hamilton had to admit that she would 'never make a Bohemian. I could not live that life of squalor.'[73] Mrs Swinton's own views on the picture are unrecorded. She did not buy it, and Sickert did not give it to her – though he presented her with many others, including a whole set of early etchings, which she had discovered him on the verge of burning.[74]

That Christmas Elsie invited him to join the family at Llandough Castle, South Wales, the home of her parents. The Ebsworths, still only in their fifties, were an energetic pair, devoted to good works, good fun, and physical exercise. The Llandough estate had its own cricket ground and golf course, and Mr Ebsworth had presented the shivering residents of the local town with an outdoor swimming pool. The gathering that Christmas, however, seems to have been more theatrical than sporting: Sickert decorated Elsie's 'Visiting Book' with two charming watercolour sketches of the children in fantastical costumes – a record, perhaps, of some elaborate drawing-room production: a fairy tale ending to a fairy tale year.[75]

AMBROSIAL NIGHTS

London! Like the evening star you bring me everything.
(*Walter Sickert, in the* New Age)

Sickert's close friendship with Mrs Swinton was inspiring for both parties. For Elsie, it gave her the courage and self-confidence to carry through – against the disapproval of her family – the dream of becoming a professional singer. She made her debut on 5 April 1906 at a Broadwood Concert in the Aeolian Hall.[1] Sickert, of course, was in the audience – rapt, admiring, and full of practical suggestions. 'I came back to my first and constant impression,' he wrote to her after the evening. 'Your singing is divine. The delicious, fresh, tender, powerful voice. I heard only praise round me and behind me! "How beautifully she sings". Someone liked the Brahms Schlummer song [*Immer Leiser*]. Some one else better the last than the penultimate Russian &c. In the waits [between songs] you might smile your bon enfant smile. You made a rather pincée moue. Probably nervousness. But as you have the only mouth worth mentioning in London make the best of it. Bless you!'[2] Elsie had much to smile about. Her triumph over what Sickert reminded her was the '*notoriously cold*' Broadwood audience was soon followed by others.[3]

Sickert, too, was working with quickening brio and confidence. The need for money persuaded him to take on a few portrait commissions. The sparkling and moneyed figures who flitted within the intersecting social circles of the Conders, the de Meyers, and Mme Errazuriz were always interested in the chance of having their likenesses preserved for posterity. He made pictures of Mrs Robert Campbell, Gertrude Kingston's sister-in-law, as well as painting the daughter of Mme Errazuriz, and Prince Antoine Bibesco, the dashing attaché at the Roumanian Embassy in London and an early patron of Vuillard.[4] But he did

not allow his need for the occasional 'Roumanian cheque' to absorb all his energies. He was helped by sales from other sources. There were still a few more scraps of Whistleriana left: Rothenstein's brother-in-law paid '40 bloody quid' for one 'little Whistler' that he turned up. Sickert also urged Blanche to offload as much old stock as he could amongst his French friends and clients – 'without reserve: like spring sale of winter's goods'.[5]

Supported by such transactions he was able to continue with his own work. London had regained – or retained – the power to inspire him. His experiments of the previous year had convinced him that his pictures of naked figures lounging on iron bedsteads could be fruitfully transposed to a London setting. He resumed his series of 'squalid misshapen nudes', returning to oil paint after the flirtation with pastel, conjuring from thick paint the dingy lodging-house world of weary flesh and soiled bedsheets, of London light filtered through grimed windows.[6] To enhance the mood of grim reality he began to pose his models, not at the Fitzroy Street studio, but in his rooms at Mornington Crescent.[7]

He extended, too, the range of his other genre pictures: painting clothed figures, seen sometimes in almost portrait close-up, in the same muted London interiors. Although he posed friends such as Aggie Beerbohm and Mrs Swinton for some of these intimate domestic scenes, he also sought out less familiar and less distinguished sitters. He was evolving a theory that it was best to use paid models, rather than intimates. The 'great principle' of 'inspiration' was, as he later put it, to banish *your own person, your life . . . your affections and yourself from your theatre . . .* There is a constant snare in painting what is part of your life. You cannot avoid with yourself or another artist or member of your own house or family a spoken or silent dialogue which is *irrelevant* to *light and shade*, irrelevant to colour . . . The *nullity* and *irrelevance* to yourself of the personality of the model is *tonic*, has *incredible virtues*.'[8] In search of these virtues he took to the streets.

Jeanne Daurmont, a young Belgian-born milliner, recalled many years after the event how Sickert had picked her up, after overhearing her one morning in Soho asking a policeman – in French – where she could get some coffee:

> He said he spoke French and could direct me. When he'd done so, he took a step or two back, looked me up and down, and said, 'Madame,' – it is always Madame with him, not

Mademoiselle, and we always spoke French together afterwards
– 'Madame, I am a painter. Here is my card. Will you please
come to my studio at that address in Charlotte Street at eleven
o'clock tomorrow morning and pose for me?'[9]

Over the next three months Jeanne posed for him regularly, often with
her sister Hélène.[10] He paid them ten shillings an hour, which was –
as they correctly understood – 'a lot of money'. One painting of the
sisters he entitled *The Belgian Cocottes*, and certainly they all had a very
jolly time together. 'Sometimes he'd pick me up in his arms,' Jeanne
recalled, 'and lift me in the air like a doll.' On one occasion – having
sold a painting – he bought Jeanne an evening dress and took her for
drinks at the Café Royal and then on to the Savoy for dinner. But she
was not prepared to admit to any impropriety. The reference to her as
a cocotte was, she insisted, merely 'his little joke': 'Ah, ce monsieur
Sickert, qu'il aimait a rigoler.'[11]

Sickert also returned to his first great subject: the London music
halls. He began to frequent his former haunts, making drawings, then
paintings, then prints. He invited Florence Humphrey, who had accom-
panied him on so many of his excursions in the early nineties, to come
and look at his new work.[12] To Blanche he wrote: 'I have started many
beautiful Music hall pictures. I go to the Mogul Tavern nearly every
night.'* He became absorbed in two 'magnificent' pictures of the scene,
each measuring '30 inches by 25', as well as embarking on six litho-
graphs of his music-hall drawings.[13] This revived enthusiasm for the
popular stage and its artistic possibilities was a stimulus to his growing
friendship with Spencer Gore. The younger painter, encouraged by
Sickert's example and by his own theatrical interests, was working on
a parallel series of music-hall pictures and he and Sickert began to
visit the halls together.[14] Sickert found Gore's company both an encour-
agement and a tonic. He later claimed that Gore became, during this
period, 'the most important person in the world to [him]', giving him
'a second youth & an example which revived my courage & made me
believe in my work again'.[15] But to begin with, it was Sickert who
directed Gore's efforts. It was probably his influence that secured Gore
his first showing at the NEAC that year, and encouraged him to show
at the Salon des Indépendants.[16] (Sickert was always urging his young

* The Middlesex Music Hall in Drury Lane was known variously by its familiars as
the Old Middlesex, the Mogul Tavern, and the Old Mo'.

English confrères to exhibit and sell in France whenever possible.[17]) Sickert also introduced Gore to the world of his dingy genre pictures: they both painted versions of a nude seated – against the light – on the bed at Mornington Crescent.[18]

But despite these early experiments with interiors and theatrical scenes, Gore's primary enthusiasm was still for landscape. From the teaching of Steer, he had been led back to an interest in Monet and the French Impressionists, and their handling of scenery. Sickert characterized Gore, that spring, as a budding 'Corot-Monet', enjoying this difference of approach, as he enjoyed Gore's company.[19] Their friendship developed quickly. In May, Sickert lent Gore his house at Neuville for the summer months – he himself had to stay on in London to complete his picture for the NEAC. After a break of nine years he was rejoining the club. Just as he had marked his debut in 1888 with a major music-hall picture, so he decided to make his return with another: a view of the gallery of the Old Mo', extravagantly dubbed *Noctes Ambrosianae*.*

Although he had the painting in train, he continued to refresh his vision from direct observation, if not of the Old Mo' itself, of other auditoria. He told Stella Maris Conder that he was going 'nightly to music halls in the East End mostly'.[20] Despite this self-imposed regime he did manage to dine, at least at weekends, with the Rothensteins and with Blanche, who was in London that May. He also attended Elsie Swinton's concerts and even hosted the occasional 'levée' in his studio.[21] For the first time, however, he felt the physical necessity of pacing himself. After attending one of the Conders' Friday evening 'at homes', at which he had indulged in nothing more than a sandwich and 'a glass of champagne or champagne cup', he had been laid up in bed all Saturday and Sunday unable to face anything more than 'a little warm milk'.[22] There were other signs of age. He had taken to wearing spectacles – at least on occasion.[23] When Lady Hamilton heard the news she wondered whether she could ever bear to see him again, his beautiful looks compromised by steel-rimmed frames. In fact when she did catch sight of him wearing his glasses, at one of Elsie's concerts, she was relieved to note that they could not quite obliterate

* The title was borrowed from a popular series of imaginary conversations – supposedly taking place in Ambrose's Tavern – published in *Blackwood's Magazine* between 1822 and 1835.

his 'charming face and smile'.[24] Sickert, for his part, seems rather to have relished his new accessories and adopted them as a stage prop quite as much as an ocular necessity. In one portrait drawing they served to transform him into an owlish Victorian curate.

Anxiety about money eventually prompted Sickert to abandon his Charlotte Street studio.* He decided he could make do with just two London addresses and set about decorating his rooms at Mornington Crescent – putting up some of the doubtful treasures he had discovered in the galleries and junk shops of Dieppe, Paris, Venice, and London. 'I have hung my lodgings at Camden Town with my private collection,' he told Stella Maris: 'Longhi – Rowlandson – Conder – Manet – Degas – Rembrandt and "Vinci".' (A French model of his acquaintance, he explained, when quizzed as to her favourite painter used to say, 'Moi, c'est Vinci.'[25])

What had traditionally been the NEAC 'spring' show did not open until the third week of June that year. The club had lost its familiar venue with the recent demolition of the Dudley Gallery and was temporally relocated at 'The Galleries' – a not very large upstairs space in Dering Yard, St James's. *Noctes Ambrosianae* was Sickert's sole submission. Its power was at once acknowledged, if only by the converted. The dark but still lustrous tone, built up with layers of coloured underpainting; the almost abstract quality of the looming faces scattered along the lines of the gallery rails; its frank depiction of the vulgar world: all were arresting. Amongst his old friends and young admirers it became 'easily the most discussed painting of the show'. Frank Rutter, the *Sunday Times*'s art critic (and a new English champion of Impressionist art), welcomed it,[26] but George Moore was exaggerating when he claimed that the 'word on everybody's lips' was '"Sickert has come back"'.[27] Sickert's following remained small. More than one reviewer pointedly chose to ignore his contribution altogether; and if others discussed the picture, it was only because they felt it jarred so with everything else on view – in its subject matter, its force, and its daring.[28] During the years of Sickert's exile, the tone and temper of the NEAC

* Sickert may have planned to use Charlotte Street for drawing classes. He once claimed that he had run a very unsuccessful school from Constable's Studio, his only students being some Siamese twins.

had shifted and mellowed, though it perhaps took his return to make the change apparent. *The Times*'s critic was not alone in noting that the overall mood of the club's exhibitions was now much 'less eccentric' than it had been back in the Nineties. He remarked with approval that once brazen experimenters, such as Steer, had 'quieted down', while many of the younger men were producing 'quiet unpretending work' of real merit. And, in an unambiguous snub, these changes were characterized as a salutary 'reaction against Degas and the Music Halls'.[29] It was made clear to Sickert that he had become separated from the prevailing trends of English painting.

His brother, Bernhard, plotted his position in a review of the contemporary scene that he wrote that year for the *Burlington Magazine*. He characterized the 'two distinct currents' in contemporary English art as the 'academic' and the 'eclectic'. Both were retrospective. The former – a continuation of the Victorian tradition – aimed 'to treat past events with all the wealth of costume and accessories now obtainable', while the latter 'more recent' trend attempted 'an eclectic reconstruction' of its 'past visions'. The first school was presided over by Alma-Tadema, the second was dominated by Ricketts, Shannon, and Conder, and encouraged by the arrival of Augustus John. Neither group engaged with the realities of contemporary life. The legacy of the London Impressionists, it seemed, was dead.[30] If a few artists at the NEAC still described themselves as 'Impressionists', it was a very faint impression they gave of either their French or their London forebears. Sickert himself dismissed their efforts as no more than an 'educated colour vision' applied to a limited range of overtly tasteful subjects. Puritan standards of propriety and a fatal sense of good manners crushed the vitality out of their pictures.[31] Sickert's frank engagement with everyday contemporary subject matter – his determination to distil an unexpected beauty from the apparent ugliness of the modern world – marked him out as a lone voice.[32]

Those who appreciated it were few. In 1906 Sickert could boast only a handful of British admirers, and most of them could not afford to buy pictures. The London art market was still small, insular, and unadventurous. Although there was great wealth, there was little knowledge or curiosity, and no daring. Prices were high and art tended to be the preserve of the very rich – an adjunct of fashion, power, and wealth. The garish historical scene, the flattering society portrait, the prestige landscape, and the tasteful still life were the favoured motifs,

and the Royal Academy was the approved source. Those with enough self-confidence to support even the more conventional artists of the New English Art Club were few. Sickert appealed to a yet smaller group.

There was the millionaire Edmund Davis, who, having made a fortune from the gold mines of South Africa, was putting together a self-consciously 'modern' art collection with the guidance of Ricketts and Shannon. Although, following his mentors' lead, he tended to favour work of an imaginative temper (his dining room was decorated by Conder), he was amongst the first to seek Sickert out on his return to London and buy his work.[33] Davis was soon followed by Judge William Evans, a true enthusiast whose Bayswater house was hung from skirting board to cornice with contemporary paintings. He and his wife were always avid to 'get a little bit of' any new and interesting artist. And the painter of *Noctes Ambrosianae* they regarded as being both.[34]

Sickert also found a welcome at the Grove, the Hampstead home of Hugh and Mollie Hammersley. Mr Hammersley made money in the city and spent it very largely at the New English Art Club. His wife, a Scotswoman, was strikingly handsome (if not quite beautiful), intelligent, and debilitated by tuberculosis. She was obliged to spend part of each year at a sanatorium in Germany and much of each day in bed. Despite these constraints she hosted a small but regular gathering of artistic and literary men on Sunday afternoons. Steer, Tonks, and Ronald Gray were her most constant devotees, but the Rothensteins, the MacColls, Max Beerbohm, Henry James, George Moore, Augustus John, and Sargent (who, needless to say, painted her portrait) were also regulars. Sickert, introduced to the Grove by Ronald Gray, at once became a member of the charmed inner circle[35] and established with Mrs Hammersley exactly the sort of brisk flirtatious relationship he so much enjoyed. When she sent him a copy of Pepys's diary, he complained, 'When you loved me you sent me *rags*. Books are excellent but, I am afraid [,] compared to *rags* they may show a slight cooling of affection.'[36] He was one of the 'happy few' – along with Steer, Tonks, Sargent, and Moore – invited to stay on to dinner or come early for lunch. He brought a brightness and edge to proceedings. Gray recalled that 'Sickert was perhaps the most quick-quitted' of the company, and 'did not mind hurting people's feelings'. He enjoyed making fun of Moore, who – increasingly – was 'not amused' by Sickert's irreverence.[37] The Hammersleys inaugurated their 'very effectual interest' in Sickert's

work that summer by buying two canvases – a Dieppe shop scene and a Venetian picture of Carolina dell'Acqua.[38]

Another collector who became a friend was Walter Taylor. Taylor was an accomplished watercolourist who had studied in Paris and at the Westminster School of Art under Fred Brown. Although a contemporary of Sickert's, he appeared much older – indeed his nickname was 'Old Taylor'.[39] Osbert Sitwell recalled him, with his 'red face and white imperial [beard], his prominent nose, slow movements, leisurely gait', as having the air of an elderly seaside dandy. He was always dressed with a severe elegance. 'Everything about him was leisurely, not least so his voice, with something of an inescapable boredom in its low, single-toned, unemphatic flow.'[40] But despite the pose of ancient weariness, Taylor was in fact eager for novelty. He 'prided himself on keeping up to date, even in advance of the times'. The table in his stately and well-furnished Bayswater drawing room was always ranged with 'the very latest novels and biographies', and the walls were adorned with the most challenging of new pictures. He made his way to Sickert's studio and 'bought six pictures straight off'. As Sickert later recalled: 'I thought I was made for life.' He certainly made a friend for life. He came to refer to his patron, rather proprietorially, as 'My Taylor'.[41]

Although Sickert's re-engagement with London life marked no immediate breakthrough in his commercial prospects, it did fire him with new energy. That summer in Dieppe, Blanche found his old friend refreshed and rejuvenated by the 'conditions toutes nouvelles' of his new existence. Back in Dieppe, 'les perles tombent des ses pinceaux, avec une régularité incroyable' ('pearls fall from his brushes with an incredible regularity').[42] Contributing to Sickert's sense of concentrated vitality was the presence of Gore. They lived and worked together at the Neuville house.

During the course of the summer they were joined by Gore's contemporary at the Slade, Hubert Wellington – a great admirer of Sickert's work. Gore had invited him to Dieppe in order that he might meet his hero. He lodged nearby at a small hotel in Le Pollet, but after the day's painting he would go round to Sickert's villa for an evening of coffee and what he described as 'incomparable conversation' around the bare-scrubbed table. Sickert's generosity to his young admirers was remarkable; at least it was remarked on by Wellington: '[He] was in no way stand-offish. He treated us as younger brothers in the craft.'[43]

That painting was a 'craft' he always insisted upon. His 'key theme' was the importance of tradition.

His companions were eager for innovation and experiment, but he kept drawing them back to the lessons of the past. When Gore announced his intention of visiting the Gauguin retrospective at the Salon d'Automne, Sickert suggested that, interesting though that might be, 'it would be even more worthwhile to run up to Paris for the day to see a picture by Jean-François Millet'. He told them that even from Manet – though 'of course' one loves his work 'as one may love a cocotte' – there was 'not much to learn'. It was the earlier generations of painters who preserved the real secrets. He reinforced his theme with the display of several works by his father – the pupil of Couture – on the walls of his little attic studio. One of them was a picture of old J. J. Sickert 'painting out of doors in a tall stove pipe hat'. Sickert let it be believed that his grandfather had gone sketching with Corot. The claim, though fanciful, served to connect Sickert and his young interlocutors to the great tradition leading back through the Impressionists to the school of 1830. All 'good modern painting', he insisted, 'derive[d] from France': 'To draw and model a head, to construct it, in three or four mixed tones of simple colours – this, at least in a first stage, is the foundation which underlies the practice of la bonne peinture in the French tradition: Nicolas Poussin is the great master, the link between the past and present.' He claimed that 'the men of 1830 did this, Ingres as well as Géricault and Delacroix; Couture hands it on to Millet, and so to Courbet and the rest.'[44]

Besides these lectures he also inspired Gore and Wellington with a new confidence in their own abilities. 'Young men,' he told them, 'have probably greater talent than they know; if only they would trust themselves to that and let it develop naturally. But they will pride themselves on their knowledge, of which they have none. Judgement is impossible for young men.' As Wellington recalled, Gore's work advanced rapidly in this stimulating atmosphere.[45] Sickert, too, was struck by his young friend's progress, the assurance of his 'objective work [done] straight from nature on Impressionist lines'.[46] And though, of course, he urged Gore to consider working from drawings, he regarded that summer as 'the Coming of Age' of his protégé's talent.[47]

Sickert was in Paris for the opening of the Salon d'Automne.[48] The exhibition that year, besides including the retrospective section devoted to works of Gauguin that Gore had been so anxious to see, contained

what the *Gazette des Beaux-Arts* called 'all the most recent ways of seeing and painting from Cézanne to Matisse'. Sickert had ten pictures on view, including *Noctes Ambrosianae*, which had already achieved the status, in his eyes at least, of 'un petit chef d'oeuvre',[49] together with a 'a group of sombre-coloured sketches, chiefly of London night scenes'.[50] Although not at the extreme edge of experiment offered by Matisse's compelling daubs, his work was still accounted daring, being shown alongside Georges Rouault's lustrous, emphatically outlined pictures of circuses in what one paper called the 'Maniac's department'.[51] Indeed several reviewers thought the two artists' work comparable, if only in what they characterized as its pessimism.[52] The French had a certain fascinated relish for the seamy side of London life, and they found it in Sickert's art. Louis Vauxcelles, writing in the periodical *Gil Blas*, described Sickert's night scenes enthusiastically, as showing 'les pauvresses qui déambulent dans les ruelles de White-Chapel [*sic*], abruties de gin ... C'est le poème nocturne de la misère et de la prostitution londoniennes' ('the poor women who wander the alley-ways of Whitechapel, drunk on gin ... It is a nocturnal poem of London's poverty and prostitution').*

But Sickert remained wary of his fellow 'maniacs'. He continued to disparage Matisse and he does not seem to have fostered the connection with Rouault. There is no evidence that he sought him out, and he is silent about his art. Indeed, amidst the clamorous riot of work on view, the picture he admired most was a quiet Venetian scene, *Le Canal de Giudecca*, by an artist listed as Mme Hudson. He even contemplated writing to her to suggest an exchange of pictures but failed to carry through the idea.[53]

The Salon d'Automne stimulated him to action in other directions. Despite having three studios waiting for him at Dieppe and two in London, he stayed on in Paris throughout the autumn. He took a room at the Hôtel Voltaire, where he had put up over twenty years before on his memorable trip to deliver the portrait of Whistler's mother to the Salon, and began working there. He started on a series of what Blanche called 'indecent' nudes.[54] Some showing women washing belonged to the Degas tradition, others had a yet more abandoned

* The night setting and intimate atmosphere of some of Sickert's pictures encouraged another critic, in the *Gazette des Beaux-Arts*, to describe Sickert, rather to his annoyance, as 'hesitant entre M. Bonnard et M. Whistler'.

air: *La Maigre Adeline* – flung back across the bed, her feet dangling – or Jeanne – a model who had posed for Cézanne, lolling in a 'beautifully lit alcove' bed – in their *intimiste* composition perhaps show the influence of Bonnard.[55]

It was a productive and happy period. 'I had the most enchanting little model, the thinnest of the thin like a little eel, and exquisitely shaped, with red hair . . . [she] was called Blanche and called the part she sat upon "ma figure de dimanche" and had endless other most endearing sayings. I think the drollest comedy situation ever invented was given by her, as illustrating the correct attitude of a figure-model towards a lady she supposes to be the painter's wife. She was sitting fully dressed with a big hat and plumes on a summer's day, before a sitting, drinking a cup of tea with me. A lady whom she erroneously imagined to be my wife entered unexpectedly to visit me. "Oh pardon madame", exclaimed Blanche, rose, hurled her hat, her dress, and her clothes off and threw herself onto the bed in the position of my picture! For her to be caught hob-nobbing *dressed* was the inconvenience.'[56]

Although he had always been interested in the effects of underpainting since he had first stained his canvases grey in imitation of Whistler, he now began to experiment with more elaborate preparations. He gave Rothenstein an excited account of a 'magnificent new recipe' that he was trying out: 'Paint on an absorbent white canvas in four tones – one green and three of violet, work from nature with four brushes till your whole picture is prepared, let it dry and paint over.' He urged his friend to try it. 'It will save you years of tears.'[57]

Hoping to build on the achievement of *Noctes Ambrosianae*, Sickert also began to make pictures of the Paris music halls – the Eldorado, the Gaieté Rochechouart, the Gaieté Montparnasse, and the Théâtre de Montmartre. He reported to Rothenstein on the progress of six 'important' paintings; they were, he considered, real '*busters*'.[58] In early November he could write: 'I want another fortnight here to finish 4 or 5 pictures as good as *Noctes Ambrosianae*, only red and blue places, instead of black ones.'[59] The shift from black to red and blue suggests that Sickert's exposure to the savage hues of the Fauves and the 'flaming eccentricities' of Rouault had not been entirely without an influence.

During his time in Paris Sickert saw Degas 'a good deal' and, either with or without his hero, spent much time haunting the picture sellers and junk shops. He gathered together a bundle of pictures including

a Delacroix 'Lion', a Millet drawing of 'a tricoteuse', and a Daumier charcoal sketch, which he sent over to Rothenstein in the hope that he could sell them – presumably through, or to, the Carfax Gallery. Amongst the collection was a painting by Gérôme, which, in keeping with his current enthusiasm for the old and unfashionable, Sickert exalted in glowing terms. 'I really love it,' he announced, 'as I do not often love a picture.'[60] He told Mrs Swinton (whose help he also sought) that unless an unrefusable offer came in, he hoped to 'stick to' it.[61] He had a fanciful idea that he would bequeath it to the National Gallery as 'a little antidote to their Whistler-Monet drivel'.[62]

Rothenstein, though he doubted the authenticity of at least one of the works, agreed to do what he could. Sickert, as ever, was in urgent need of funds: living in a hotel was not a very economic mode of existence. Also, as he explained, he was being sued for a quarter's back-rent by 'Mrs fucking Lawrence', his landlady at Constable's Studio. His plight was a mystery and an exasperation to Blanche, who called his friend 'la Génie de désordre'.[63] He had only just written to Gide telling him that Sickert 'parait enchanté et vendre tout ce qu'il fait' ('appeared enchanted and sold everything he did'),[64] and certainly Sickert was making sales to private clients in Paris.[65] He was thrilled to discover that Léon Lhermitte, the painter and friend of Fantin-Latour, was an admirer of his work and intended to buy a picture.[66] With his dealers, Sickert was still 'haggling' over prices. It was one of the reasons why he wanted to be sure of money from other sources, so that he did not – as he told Rothenstein with cod anti-semitism – have to 'capitulate *entirely*' to those 'bloody jews', the Bernheims.[67] Rothenstein, to Sickert's 'relief', was able to sell some of the 'old masters', but it was Walter Taylor ('Bless Him') who helped most, buying *Noctes Ambrosianae* for £40. Bolstered by these pieces of good fortune Sickert was able to hold out against the Bernheims, eventually selling them twelve pictures for 1,400 francs. He also secured from them the promise of a major solo exhibition – '40 to 50 canvases' – in the New Year.[68]

It was a real coup. Bernheim-Jeune were in the process of opening a new branch of their gallery, just around the corner from their main space on the Boulevard de la Madeleine. The new space, entered through a small door on the rue Richepanse, was to be devoted to the most interesting of contemporary art under the direction of the austere but brilliant Félix Fénéon – an arresting figure; tall, thin, and angular,

with close-cropped hair, a tufted goatee beard, and thick dark eye-brows. As a young art critic in the 1880s he had established his repu-tation by championing Seurat and the divisionist technique of his followers, which he labelled 'Neo-Impressionism'. He had sub-sequently edited a succession of avant-garde literary journals and was responsible for publishing such important symbolist texts as Rim-baud's *Les Illuminations*, Gauguin's *Noa-Noa*, and Mallarmé's *Diva-gations*. His literary and artistic sympathies, however, were eclectic. When, in 1894, he was briefly imprisoned for his anarchist views (and suspected involvement in a bomb plot), he devoted his time to translating Jane Austen's *Northanger Abbey* into French. He was liked and respected by painters. When news emerged of his planned career change from journalism to picture dealing, Paul Signac announced that he would be 'the only dealer who knows what's what in painting'; and in his new role as a gallerist, Fénéon's first enthusiasm remained for the heirs of Seurat's Neo-Impressionist tradition: Paul Signac, Charles Cros, Maximilien Luce, and Théo van Rysselberghe. He was happy to support the Bernheims' existing stable of Nabis artists – Bonnard, Vuillard, and Maurice Denis – but he also looked beyond these two core groups to a few 'other good painters'. He approached Matisse, and made arrangements with Sickert.[69]

Sickert was amongst the first artists to show at the new gallery. His exhibition opened on 10 January 1907. It ran for only nine days, but even in that brief span garnered a considerable amount of attention. There were over eighty works on view – nudes, streetscapes, music halls, informal figure studies, and images from Venice, Paris, Dieppe, and London. The influential Louis Vauxcelles, writing in *Gil Blas*, called it 'une des plus considerables expositions qu'on nous ait offertes cet hiver' ('one of the most considerable exhibitions that we have been given this winter'). Sickert's artistic parentage was already well estab-lished and it was duly reiterated: he was a pupil – if not an 'adorateur' – of Whistler, and a follower of the Impressionist school of Degas, Pissarro, and Monet, but one who had been influenced also by contact with 'notre jeune école'. Nevertheless, in their often highly coloured descriptions of the work, the French critics cast Sickert as much in a literary as an artistic tradition: he was the Baudelarian dandy contem-plating and recording the dreary and sordid world of the modern city with an unflinching 'philosophic bitterness'.[70] Everything, wrote one reviewer, 's'érigent en une atmosphere fulgineuse qui frissone d'ango-

isse et semble lourde d'un fatidique spleen' ('is set in a smog that shivers with anxiety and seems heavy with a fateful melancholy').[71] Another remarked on the pervasive sense 'de lassitude, d'ennui ou d'affût' ('of lassitude, of ennui or of grind') conveyed by the work.[72] Sickert had in part encouraged the connection. His catalogue, dispensing with a formal introduction, was adorned only with an epigram from one of his favourite authors, the late-Roman poet, Martial. As Paul Jamot remarked in the *Chronique des Arts*:

> Le visiteur qui, guidé par lui, vient de poursuivre la sensation bizarre et, tour à tour, les plus frélatés ou les plus ingénus de paradis artificiels à travers les cabarets ou les cabinets de toilette de Montmartre, les bouges des faubourg londoniens ou les music-halls des petites villes anglaises, les ruelles ou les chambres meublées de Venise, n'est pas étonné que ce peintre anglais très francisé se plaise, comme Baudelaire, à lire les poètes latins.*[73]

For Sickert to have succeeded at all in Paris was a considerable achievement. Conder's exhibition at Durand-Ruel the previous year had been a relative failure. 'I know enough of France', Sickert had remarked to Blanche (who had written the catalogue preface), 'to know that the element of paradox, the flippant view of life, the inconsequent God-damn-me-dandyism, the fascinating petulant kiss-my-arse attitude which we love in our friend's work is not to the taste of the logical serious Latin.'[74] His own, no less dandified, but graver vision found more favour. And yet, though Daniel Halévy was interested in buying three of the pictures from the show,[75] Sickert did not linger to consolidate his position.

* 'The visitor who, guided by him, comes to pursue the bizarre sensation and, by turns, the most corrupt or the most innocent of artificial paradises across the cabarets and dressing rooms of Montmartre, the low dives and music halls of the London suburbs, the lanes and furnished rooms of Venice, is not surprised to learn that this very Frenchified English painter, like Baudelaire, enjoys reading the Latin poets.'

III

MR SICKERT AT HOME

I want to keep up an incessant proselytising agency to accustom people
to mine and other painters' works of a modern character.
(*Walter Sickert to Nan Hudson*)

Sickert, at forty-six, was a still vital presence. In the description of
Hubert Wellington, he appeared as 'a tall, clean-shaven, rather burly
man. His brown hair was still abundant and wavy. He moved in a
leisurely fashion, but was immensely vivacious. Under bushy eyebrows
his eyes watched one with the keen, quizzical look of the constant
observer. His mouth, held rather tightly at the corners, was always
ready to turn from a slightly ironical smile to a whole-hearted guffaw
... Altogether a striking, friendly figure, though provocative and even
potentially mischievous.'[1]

There was perhaps more scope for mischief and provocation in
England than in France. Certainly Sickert did not linger in Paris to
build upon his success but returned to London. The lure of place was
upon him. The atmosphere of Camden Town, the stimulation of new
friends, the presence of old friends, the attractions of Mrs Swinton – all
drew him back. The move, though, was not a retreat into comfortable
familiarity so much as the opening of a second front, for Sickert had
determined to achieve a position in London to match his standing in
Paris. His next batch of notepaper gave the Boulevard St Jacques and
Mornington Crescent as his twin addresses, and he planned to divide
his time between the two. The favourable reception of his recent
London pictures in Paris encouraged him to believe there might be a
market for such work on the Continent. English subjects, he recog-
nized, would be 'a unique weapon for the Paris market'. He could
make them as *canaille* (coarse) as he liked – the French, after all, had
had a relish for the sordid side of English life since the time of Géricault

and Gustave Doré,[2] and Sickert had a deep affinity with that grim urban world, as well as an acute sensory response to its distinctive charm. 'London is spiffing!' he rhapsodized, on arriving back there after one holiday. 'Such evil racy faces & such a comfortable feeling of a solid basis of beef & beer. O the whiff of leather & stout from the swing-doors of the pubs! Why aren't I *Keats* to sing them?'[3]

But Sickert did not intend merely to use London as a subject and a production base: he wanted to establish a market in England as well. The challenge was not an easy one. After eighteen months of flitting back and forth across the Channel he had become only too aware of how different the English art world was from the French. London was not the art capital of Europe. Most artists were too polite to criticize each other's work frankly, and without such mutual criticism progress was slowed.[4] There was no stratum of small collectors willing to trust their own judgements and buy pictures they liked at 'moderate prices'. In cultural matters, England was, as Sickert termed it, a 'Goosocracy', presided over by 'supergeese' – rich society women with a vague sense that they ought to interest themselves in 'Art', and with nothing but vanity, ignorance, and money to guide them.[5] Sickert realized that to survive, let alone, prosper, in this world, he must change it.

The New English Art Club, for all its reputation as a dissenting forum, had lost much of its power and direction.[6] It was certainly no Salon d'Automne. Sickert's work stood out as 'macabre', if not positively dangerous.[7] Nevertheless, the club remained – amongst British art institutions – the only 'box' Sickert would contemplate being put into.* It could perhaps be reformed from within, as Sickert and his Impressionist clique had reformed it back in the 1880s. But such an undertaking would require both time and allies. Change, Sickert believed, was something 'best done in gangs'.[8] On his return to London he set in train a scheme that he had been deliberating for some time – a scheme to expand his own informal Saturday studio receptions by joining with other like-minded artists into a sort of co-operative.

* Blanche secured Sickert's election to the International Society of Painters, Gravers and Sculptors and was then much put out to receive a 'swaggering' note from his friend 'displaying any amount of flippancy' and announcing that he did not, after all, wish to become a member (ALS JEB to William Rothenstein, 2/11/1906 [Harvard]). The group, Sickert told Rothenstein, was 'not a sound & respectably founded society': 'It doesn't matter for foreigners but we can't at our ages get into wrong boxes in our own country.' He was 'enchanted' to learn that Rothenstein was going to 'stand out too' (ALS WS to William Rothenstein [Harvard]).

Together they would rent a space and show their work as a group on Saturday afternoons.

He wanted, as he put it, to '[ac]custom people to *see* work in a different notation from the current English one' – work of what he called 'a modern character'.[9] It would provide a forum for painters who were already 'producing *ripe* work, but [were] still elbowed or kept out by timidity etc.'.[10] And, no less importantly, it would make it clear that 'we all have work for sale at prices that people of moderate means could afford. (That a picture costs less than a supper at the Savoy.)'[11] The aim was to provide 'little pictures for little patrons'.[12] The tone of the gatherings would be informal: 'no one will feel we are jumping at the[ir] throats to buy. That comes of its own accord. People pay attention to things seen constantly and judiciously explained a little.' By forming a group Sickert would have, he believed, more chance of attracting an audience: 'Because it is more interesting to people to see the work of 7 or 9 people than one.' The benefits of association, moreover, would not be merely commercial. Sickert recognized that 'our co-religionary contemporaries teach us more even than better & older work, because we see it in the doing, and the nature it is done from.' In the exchange of ideas, Sickert naturally assumed that he would be taking the lead. 'I particularly believe,' he announced at the outset, 'that I am sent from heaven to finish *all* your educations!!' Though he also hoped, 'by richochet, to receive a certain amount of instruction from the younger generation'.[13]

In assembling his cast from amongst this younger generation Sickert turned first to his two Fitzroy Street friends, Albert Rutherston and Spencer Gore; and, doubtless at Gore's prompting, he also gathered in their old Slade contemporary Harold Gilman, who, though living out of London with a wife and three small children, was often up in town.[14] Gilman was then thirty: tall, bald, with a slight limp, and intensely serious about his painting. His father was a Church of England parson, and Gilman often affected something of the 'pompous drollery' of the Anglican pulpit in his talk.[15] He combined it, however, with what one friend described as 'a good deal of the nonconformist conscience': he was apt to seize hold of theoretical principles and then follow them with a 'rigid and unbending' dedication.[16] In 1907, though, he was working on a series of smoothly painted, and undoctrinaire, domestic interiors. Sickert thought them 'very good indeed'.[17]

Alongside these young, or youngish, talents Sickert sought out some

more established figures. He signed up William Rothenstein, a stalwart of the NEAC committees and hardly a man whose work was 'elbowed' out of the galleries by timidity or anything else, and Walter Russell, who taught at the Slade and whose landscape watercolours were regular features at both the NEAC and the Royal Academy. Sickert even hoped to persuade George Thomson, the erstwhile London Impressionist, to join the group. But he seems to have declined.[18]

Sickert did not confine his search to the immediate circle of his friends. He had discovered that the 'Mme Hudson' whose painting he had so much admired at the Salon d'Automne was not a Frenchwoman, as he had assumed, but a 38-year-old American, Anna, or Nan, Hudson, whom he had in fact met briefly. They had dined together in a party at Foyot's restaurant in Paris along with Ernest Thesiger and others. Sickert had liked her a great deal, and been interested in her friend and companion, a fellow painter and fellow American called Ethel Sands. As he later recalled the evening: 'it was refreshing to find some-one spiritually and intellectually on the slightly higher level for which I have always had a sneaking snobbish and perhaps pedantic hanker-ing. We talked about Gorki's *Nachtasyl* [*The Lower Depths*], and you and Thesiger spat at each other as we left the room, like two cats. With my bi-sexual prejudices that also pleased me. Ethel was silent but I concluded she was probably amazing and took her on trust into my immediate affections as well.' Sickert met them again in London at the Conders' and was confirmed in his good opinions.[19]

Nan Hudson was the scion of an East Coast army family and there was a trace of something military in her frank, generous manner, upright bearing, strong jawline, and dislike of society. Having inherited a fortune from her maternal grandfather, she had come over to Europe in the 1890s to study painting in Paris. There she had met Ethel Sands, four years her junior, and they had begun a lifelong friendship. Although they lived together as a couple (and were treated as such by Sickert), their sexual status remains unknown. Some contemporaries were content to regard them as a pair of lesbians, but there seems to have been more of companionship, shared interests, and mutual sup-port in the relationship. Ethel Sands' mother had been a famous society beauty, though her own beaked nose, equine teeth, and beanpole figure appeared to confound the fact. The lovely Mrs Mahlon Sands had been much admired by Henry James, and the moneyed expatriate world in which Ethel had been brought up was held within the familiar

Jamesian triangle of England, France, and East Coast America. Ethel
was left an orphan by her mother's early death in 1896 and, at the
age of twenty-three, she had taken control not only of her own life
but also of the lives of her two young brothers. Having completed her
studies at the Parisian atelier of Eugène Carrière, she took a lease on
the manor house at Newington in Oxfordshire as a base for her siblings
and an English summer residence for herself. Despite a reserved
manner, she was a natural hostess and soon began to establish a circle
of interesting friends. Much of her time, however, was spent abroad,
travelling and painting on the Continent with Nan, who was never
really happy out of France. In 1906 Ethel had taken a house in Lowndes
Square, and she and Nan were more often in London.[20]

Sickert was delighted to reconnect with them. It gave him a chance,
if nothing else, to acquire Nan's Venetian painting. A swap was effected.
Sickert hung Nan's picture in his sitting room at Mornington Crescent
under one of his 'old masters' – 'a big black beautiful C17th canvas',
another view of Venice.[21] Although both were independently wealthy,
neither Nan nor Ethel were mere amateurs. They took their painting
seriously: they were familiar with the French art world; they exhibited
at the Salon d'Automne; and, as far as can be gleaned from the few
surviving examples of their work, they had been influenced by Vuillard,
who may indeed even have taught them briefly.[22]

Sickert, in his attempt to create what he termed 'a Salon d'automne
milieu in London', recognized their value.[23] Besides the merits of their
work – and the attraction of their private incomes – they would add
a stabilizing influence to the mix he was hoping to create, 'a milieu
rich or poor, refined or even to some extent vulgar, which is interested
in painting and in the things of the intelligence, and which has not,
what for various reasons several artistic milieux we know had, an
aggressively anti-moral attitude. To put it on the lowest grounds, it
interferes with business.'[24]

Sickert took a short lease on a first-floor room (with store room)
at 19 Fitzroy Street, where the group could show their pictures 'year
in, year out under the formula "Mr. Sickert at home"'. The rent of £50
a year was to be divided equally between the eight members. Sickert
busied himself with the preparations. He was soon asking Nan and
Ethel for an additional £2 each towards 'gas fittings, chairs &c.': the
chairs, he insisted, were a bargain at only '21 shillings a dozen!' Unable
to wait until 19 Fitzroy Street was ready, Sickert decided to launch the

group 'At Homes' with a 'last day' in his old studio at Number 8. There was to be a concert. A piano was brought in. Gore assisted in arranging 'dishcloths, cigarettes, cake-cutting, frame deliveries' and promised the attendance of his sister, who – Sickert noted with approval – 'sings delightfully'.[25]

The concert element of the afternoon seems to have been a success, but the picture showing was less satisfactory. Sickert felt he had to apologize to Ethel that her picture, though much admired, had been 'badly exhibited'. But then, as he explained, the space at the old studio was not ideal – 'we shall be better at No. 19'. He sent Nan and Ethel a floor plan of the new space, an L-shaped room, across the main part of which he proposed they should set up a line of easels for showing the work on. 'We are all contributing easels,' he told them. 'Will you send *one* between you. Slight weighted dark wood only. No elaborate raking arrangements.' Also marked prominently on Sickert's plan were a 'buffet' and a 'table for tea', though not – as at Number 8 – a piano.[26]

The launch of the new venture provoked remarkably little reaction. Although the afternoon 'At Homes' were discreetly advertised in the *Westminster Gazette*, they were, to begin with, visited only by friends, relatives, and colleagues.[27] Numbers were low. 'We had a *very* small party on Saturday,' Sickert reported to Nan, after one early gathering at which Tonks seems to have been almost the only guest. Sickert's old confrères were curious to see what he was doing. George Moore and Jacques Blanche were amongst the first callers,[28] and younger artists came too, amongst them W. B Yeats's painter brother, Jack. (Sickert admired his pictures of boxing matches.[29])

Clients were even rarer. The Rothenstein connection brought in Hubert Wolfe (a fellow Bradfordian just embarking on a successful career in the Civil Service) as well as Michel Salaman, who, after studying with Albert Rutherston at the Slade, had abandoned painting for the pleasures of fox hunting and picture buying.[30] The Hudson–Sands axis secured a whiff of Kensington: they wasted no time in inviting such well-connected friends as Hilda and Audrey Trevelyan (daughters of Sir Alfred Trevelyan).[31] But Sickert was the main draw. He already had some patrons. The Swintons, the Hammersleys, Judge Evans, Sir William Eden, and Walter Taylor all supported the new venture. Florence Humphrey attended out of loyalty, and the ever faithful Ellen bought several works.[32] His Parisian reputation, if it meant nothing to most English observers, had begun to secure for him

a certain 'esteem' amongst the tiny crowd of cultured people whose outlook was 'mildly cosmopolitan and more or less up to date'. Hugh Lane, the energetic Irish impresario and collector, was also drawn to Fitzroy Street.[33]

But Sickert realized that he must carry his campaign into the haunts of the supergeese; and so, from the depths of Camden Town, he would make occasional forays into the world of gentility, donning what Will Rothenstein referred to as 'the lying uniform' in order to 'tout discreetly for customers at the tables of the wealthy'.[34] His charm, wit, good looks, and single status made him a valued guest, and his connections were impressive. Olga de Meyer even introduced him to the King. Edward VII, though encouraged by the fact that the baroness admired his pictures, wondered why Sickert was not yet a Royal Academician. Those who knew slightly more of his art, understood why he was not. To the majority, his 'style of painting' remained obscure, even threatening. At one dinner of Lady Hamilton's, Sickert was obliged to give an eloquent defence of 'the line his particular lot of artists took', arguing, in the face of some entrenched opposition, 'that it [was] better to strike an individual note, however tiny, than [to] keep on the old traditional lines that [were] worn out'.[35] His propaganda was not unsuccessful. Lady Protheroe and Mrs Donaldson-Hudson were amongst the society women who came to Fitzroy Street, and Mrs Charles Hunter broke her rule of buying only Sargents and Mancinis in Sickert's favour. She came to an 'At Home', picked out a view of St Jacques, and 'threaten[ed] to buy more'.[36]

At the gatherings Sickert took centre stage – welcoming the guests, explaining the art, and closing the occasional sales, though he tended to undercut his 'air of "grand seigneur"' with his comically ineffectual attempts to wrap up any purchases that were made.[37] Other members were usually in attendance, some more than others. Gore was a regular, but William Rothenstein's connection with the group seems to have been nominal,[38] and Sickert's hope that Nan and Ethel, as the only female members, would be the hostesses of Fitzroy Street, and 'behave as sich', was largely unfulfilled: social commitments at Newington meant that their attendance was infrequent – so infrequent indeed that Albert Rutherston recalled them more as patrons than as fellow artists.[39] At the close of play, Sickert would gather up any remaining members – and favoured guests – and lead them off for a cheap dinner at L'Étoile or the Café Royal.[40]

The social 'At Home' formula seems to have been intended in part to defuse any notion that the group represented a movement or '-ism' that could be too neatly characterized, and too smartly dismissed. But though the artistic ties that bound them were light, they did exist. All the Fitzroy Street artists shared a vague pro-French feeling, a willingness to experiment, and they all listened to Sickert. As a seeker after beauty in the dim begrimed world of Mornington Crescent, he urged his colleagues to follow him away from the safe pastures of conventional subject matter. It was a theme he reiterated often and that achieved its most succinct expression in his claim that 'The more our art is serious, the more it will tend to avoid the drawing-room and stick to the kitchen. The plastic arts are gross arts, dealing joyously with gross material facts . . . and while they will flourish in the scullery, or on the dunghill, they fade at the breath from the drawing room.'[41] So-called 'aesthetes and people of taste', he declared, 'oddly enough, have no natural sense of beauty at all'; indeed 'aesthete' – a word or label that, back in the 1880s, he might have accepted with defiant pride – he now considered his worst insult: '*le plus gros mot* que je connaisse'.[42] His stance set him apart from the memory of Whistler, the arch aesthete, and connected him more with the robust native tradition of Hogarth and Rowlandson, Cruikshank and Keene. His confrères – and consoeurs – followed his lead, and began to adopt his vision. 'It is astonishing,' he told Nan, 'what one common little lodging-room and one little drab ("une petite souillon" *charming* word) contain of beauty for us, you and me, and others who understand.'[43]

And those who came regularly to the Saturday afternoon gatherings at Fitzroy Street would have found few drawing-room scenes amongst the Sickert-inspired array of subjects: deliberately un-august town-scapes, intimate informal portraits, figures in drab interiors, nudes at their toilette or lounging upon iron bedsteads. Ethel Sands recalled how, when Spencer Gore's uncle, the Bishop of Oxford, was expected at Fitzroy Street one Saturday, there was a panicked scramble to find some canvases *not* of women on beds that could be put on the easels for the episcopal inspection.[44]

Despite their fitful attendance at Fitzroy Street, Sickert continued to see much of Ethel and Nan. Initially, he was drawn more to the latter. He liked her paintings best, and he established a warm and easy relationship with her, half flirtatious, half blokish. They discovered, too, that they were both plagued by the same 'cursed and mysterious

ill', some sort of irritable bowel condition.[45] The friendship with Ethel, though, developed more slowly. Sickert was drawn into their social world, both in London and Oxfordshire, meeting new people and picking up the pulse of the new age. It was at Newington, one weekend, that he first encountered the other rising cultural hostess of the day – Lady Ottoline Morrell. Six-foot tall, strong featured, and chestnut haired, she was more 'striking' than conventionally beautiful, and her presence had a touch of theatrical excess. At thirty-three she was just embarking on her dedicated career of nonconformity. She was the daughter of a duke and the wife of a Liberal MP, and though she had not yet acquired Garsington Manor as the focus for her social gatherings, she entertained a growing circle of artists, writers, intellectuals, politicians, and aristocratic relatives at her London home in Bedford Square. The distance across the Tottenham Court Road to 19 Fitzroy Street was short and Lady Ottoline made her appearance there. Sickert enjoyed her extravagant, self-dramatizing personality and lavished a good deal of fulsome praise upon her 'beautiful hair' and 'Florentine head'.[46] But their mutual attraction was soon overtaken when Lady Ottoline developed a passion for Augustus John and began a short-lived affair with him. Sickert was at the dinner party, hosted by Ethel at Lowndes Square, where they met.[47]

He managed to make some sales through Fitzroy Street, but they were small and infrequent: a panel for a very modest £5, a sketch for the same amount. (A Walter Russell watercolour or a Gore canvas cost twice as much.[48]) On one red-letter Saturday he sold two paintings at £3 each to Hugh Lane and Mrs Salaman, as well as hearing that Carfax had off-loaded a 'forgotten' Dieppe scene to one of their regular customers.[49] France remained his principal market. He wrote to the Bernheims in the spring suggesting a show in November of some forty 'belles toiles' and twenty drawings.* He wanted to send the paintings

* The previous winter (1906) Sickert had announced plans for holding an exhibition of his drawings in London at van Wisselingh's gallery – where he had had his first show with Bernhard eleven years before. It was clearly a scheme he had been meditating for some time. Before going over to France in the late summer he had left forty drawings with the framers in London, and he asked Rothenstein to send van Wisselingh to see them in order to fix prices and percentages. 'Funny to think,' he added, 'of the present value in the market of a Shannon drawing & one of mine & their relative importance' (ALS WS to William Rothenstein [Harvard]). Van Wisselingh, it seems, was less amused by the thought; though he continued to exhibit both Shannon and Ricketts throughout the decade, the Sickert drawings show was quietly shelved. Perhaps Sickert hoped to find a new outlet for the drawings with Bernheim-Jeune.

over six at a time, which would give Bernheims a chance to comment on the work and make suggestions (he promised to be guided by their views). But, more importantly, such an arrangement would provide him with 'une petite fleuve tranquille d'argent, a raison de 300 francs par toile' ('a gentle little stream of money, at the rate of 300 francs a canvas'). Without a little regular income for buying materials and paying rents, he was concerned that his work would grind to a halt.[50] Bernheims yielded to Sickert's 'gentle firmness', and arranged to give him £12 a canvas for at least the next batch of pictures. It was, as he told Nan, 'a mercy': 'I must make hay, hurrying slowly, while the sun shines.'[51]

Nevertheless, despite this source of regular income, Sickert recognized that it was important to keep up his 'uneasy attempt to get a market in London', and he remained anxious about his standing in England. 'I am clear-sighted enough,' he wrote to Nan, 'to realize that the backward position I am in, for my age, and my talent, is partly my own fault. I have done too many slight sketches, & too few considered, elaborated works. Too much study for the sake of study, and too few résumés of the results of study. It is only just that the world will not keep a painter in comfort who works only for himself & does nothing for it. I shall try this summer to do a few really complete & cumulated canvases in Dieppe & Paris.' *Noctes Ambrosianae*, he reflected, 'not without shame', was 'one of, perhaps, not more than half a dozen museum-pieces that I have done in twenty-seven years! And that is *too few*. It would be unjust to expect my right place yet on such slender claims.'[52]

It was with the intention of producing more elaborated works – if not more 'museum-pieces' – that he began working on a life-size self-portrait head, lit by a crosslight, which he thought would 'become something in time'.[53] He described it as a 'punching ball', and it proved a productive exercise. Soon, as he reported to Nan, he was working on a whole 'batch of heads . . . 35 minutes on one canvas & 35 minutes on the next, et ainsi de suite'. It was, he claimed, the only way to 'keep fresh'. He also became 'entangled in a bunch of a dozen or so interiors' at his first-floor lodgings in Mornington Crescent – painting 'a little Jewish girl of 13 or so with red hair' and a nude on alternate days.[54] Although he was working against a background of early summer downpours ('What people who don't work do in this weather I can't imagine') he described his pictures as a 'set of studies in illumination'. In them he began to experiment with, and extend, his technique.[55] His

early training with Whistler had given him a preference for thin, diluted pigment. He distrusted thick paint, finding it often 'clumsy' and even 'beastly'. Yet he acknowledged that, properly handled, it could also provide a certain 'weight and quality' – virtues he felt his own work sometimes lacked. But how to properly apply it? That summer he began to experiment. He started to lay on his paint more thickly, to cover his canvases more densely, and to introduce more colours into his palette.

Nan and Ethel received regular bulletins of his progress. He shared his discoveries with an urgent generosity, anxious that others should enjoy the benefit of his efforts. Using thick, wet oil paint, he found, made 'rather fat too shiny waves of paint with edges', the 'kind of quality of the meeting of a brook with an incoming wave of the sea – the opposing waters running up into a kind of little hill'. Paint, he declared, '*must* be wet and thin or dry and thick': 'You push, hammer if you like, crush paint . . . on till it is as *flat as a pastel* rub, or as a postage stamp on an envelope. You cease to touch the canvas *the moment* one coat covers the whole canvas. You repeat this as often as you like at intervals of *say* a week allowing complete drying.' He urged Nan and Ethel to adopt this procedure, adding ingenuously, 'You understand I am not asking you to change your methods.'[56]

Of these new works, Sickert sent only one of the self-portraits to the NEAC show in the summer, along with five earlier pictures. The painting – showing him reflected in the mirror of the parlour mantle-piece and surrounded by fragments of classical statuary – was admired. *The Academy* reviewer called it 'delightful' and hoped it would project Sickert's reputation – and prices – beyond the shadow of Whistler.[57] To Sickert's 'amazement and joy', the painting was bought by the Hammersleys for their 'Hampstead Uffizi'.[58] They also bought three more of his paintings that summer – one of the little red-haired Jewish girl and two nudes – for a total of £60, almost twice what he would have received from Bernheims. It was 'a stroke of luck', he told Nan, as well as making 'a rather important collection' of his work in a London home.[59] There were now six Sickerts at the Grove. He was duly grateful. 'Your very effectual interest in my work,' he told Hammersley, 'has made my life much easier & more agreeable latterly. If I do as much & as well as I intend to do, you will have a considerable hand in setting me up debout.'[60] To Mrs Hammersley he wrote: 'I am so glad you like my picture. I believe I am improving and it is high time.'[61]

The NEAC show won Sickert a new admirer – the young, and painfully shy, Edith Sitwell. A cousin of the Swintons, she asked Elsie to take her to tea at Sickert's studio, an event that she recalled as both delightful and terrifying. When Mrs Swinton had mentioned to Sickert that her cousin particularly admired *La Vecchia* (one of his exhibits at the NEAC), Edith had felt 'peculiarly stricken'. Sickert had remarked, 'Then she must either be very clever or mad', and, turning to her, had asked, 'Which is it?' Mad, mad, she had replied in confusion, to which Sickert answered: 'Well, then, I must give you a drawing.' A few days later, when he went to tea with Mrs Swinton, he took with him a drawing of a music-hall audience, which he presented to the awed Edith.[62]

Amongst the other exhibitors at the NEAC that summer was Lucien Pissarro. In the autumn, Sickert invited him to join the Fitzroy Street Group.[63] Pissarro, then aged forty-four, was only just emerging from a period of artistic isolation. Though he had been living in London since 1890, his commitments to the Eragny Press – as well as his own ill health – had drawn him away from the company of painters. In 1905, having come to terms with the death of his beloved father, he had begun to paint again, and to exhibit. Gore was much impressed by his work, and may have prompted Sickert to approach his old acquaintance about joining the group. Sickert on account of his admiration for Camille Pissarro was inclined to respect his son; and even if he found it hard to achieve an easy rapport with the grave and touchy Lucien, he persevered with the connection. He would sometimes attend the Sunday afternoon gatherings that Pissarro and his wife held at their West London home in Stamford Brook – studious but hospitable affairs spent in tea-drinking, serious talk, and the study of Pissarro's excellent collection of prints and illustrated books.[64]

Sickert stayed on in London as the summer advanced. He had lent his Neuville house to the Gilmans, and there was plenty to occupy him in town.[65] He kept Fitzroy Street open on Saturdays and was delighted to sell a Gore sketch to Sir William Eden for £10 – 'that opens another house in England to his work,' he enthused to Nan. 'His start has been most satisfactory when I think that this time last year he was practically unknown.'[66] His own paintings progressed, though he found time to go down to Newington for at least one brief visit,[67] and by post he kept up a constant stream of chiding. 'I thought you were both going to work *daily* and *produce* and *improve*,' he told

Nan and Ethel. 'Otherwise what do you get out of helping to pay for
our studio? I meant you to improve by leaps and bounds! What in
heaven's name *do* you do? Anyhow? As they say in America.' He even
threatened them with expulsion from the group. 'We shall allow you
to go on to the end of the year. After that we must reconsider. (We
may still allow you to help us to sell our pictures).'[68]

At the end of July, Sickert had a visit from his old Venice confrères
Schlesinger and Baron Franchetti. He opened up 19 Fitzroy Street for
them and a few others one Thursday morning.[69] Schlesinger also had
his mother in tow, and Walter took them both to lunch with his own
mother at Pembroke Gardens. This hospitality was reciprocated when
the Schlesingers invited Walter and Mrs Sickert to join them in a box
at Covent Garden for Donizetti's *Lucia di Lammermoor*.[70] There were
also a few unscheduled dramas. The woman who lodged on the first
floor at Mornington Crescent, and whom Sickert had 'successfully
avoided knowing', affected a dramatic introduction one evening by
rushing into his room at midnight 'with her whole head ablaze like a
torch, from a celluloid comb'. Sickert put her out by 'shampooing' her
quickly with his hands. Amazingly he didn't burn himself, and she
was none the worse for her ordeal – except, as Sickert remarked to
Nan, 'she is bald'.[71]

Sickert, too, had his own problems. He was infuriated to learn
from Augustus John, who had recently been in Paris, that his name
was 'posted & printed on the prospectuses & posters' of Blanche's class
in Paris – 'La Palette' – in spite of his 'emphatic refusal to have anything
to do with it'. Fortunately, he remarked, 'there is my friend Cottet, on
whom one can rely absolutely, so I have written to him to stop it at
once, which he will do ... what an uncomfortable atmosphere'.[72]
Sickert, though he always enjoyed Blanche's company and recognized
his many acts of kindness, was finding his old friend an increasingly
uneasy ally and tried to set a distance between them.[73] Their association
was 'too inconvenient & too compromising'. Blanche's art politics were
'diametrically opposed' to Sickert's own:[74] he had not followed him
into the Salon d'Automne, his favoured forums being the International
Society, the New Salon, and various small exhibiting groups in Paris
and elsewhere. His work – increasingly bravura portraits of increasingly
grand sitters – had achieved a fashionable cachet, but Sickert saw a
danger in his triumphs. The society painter, he believed, was inevitably
compromised by the expectations of his clients and by the milieu he

was expected to record. 'Livery is an honourable wear,' he remarked disobligingly of his friend's practice, 'but liberty has a savour of its own.'[75]

Sickert, the master of the 'misshapen nude', the 'iron bedstead', and the darkened alleyway, enjoyed the savour to its full. The nudes he had been working on that summer were, he considered, particularly daring. 'I am very curious to see what you think of my work,' he told Nan. 'The subjects are risqué.'[76] He was so pleased with them that he announced plans to rent the floor above as a 'warm studio' in order that – after the summer – he could continue the series.[77] It is difficult to know what he meant by the term 'risqué'. He had, after all, been painting nudes lying in various abandoned poses for the past four years. Some new element seems to be suggested. And it was, perhaps, at this moment that he took the bold step of introducing a second figure into his compositions: a clothed man to set beside the naked woman. The juxtaposition certainly would have deserved the epithet 'risqué'.

It was, however, one of his more conventional nudes that he chose to send to the Salon d'Automne, along with the 'punching ball' self-portrait showing him in his bowler hat and spectacles.[78] Sickert followed his pictures across the Channel almost immediately ('I am having the sheets on the first floor washed during my absence in France!' he told Nan). He went to his house at Dieppe – the Gilmans, having 'managed to quarrel' with his maid, had moved out. After his intensive work on the Mornington Crescent interiors, he took to the streets, painting, as he put it, 'landscapes for the weaker brethren'.[79] In the holiday atmosphere he even attempted a few plein-air experiments. Judge Evans, who was in Dieppe that year, commissioned a picture from him and Sickert dashed off a view of the rue Cousine 'direct from the subject in the open air'.[80] Evans' claim that it was the last plein-air painting that Sickert made is certainly not true, but it did mark a rare reversion to the method.

At the end of September Sickert went up to Paris in time for the opening of the Salon d'Automne. Although he was elected 'sociétaire' that year, the exhibition was unsettling – a telling index of the pace and daring of the Parisian avant-garde. Braque's first Cubist experiments may have been rejected by the committee, but the works of Matisse and his followers continued to push and stretch at the limits of pictorial representation. 'My work', Sickert told Mrs Hammersley,

'looks very old-fashioned here.' He was irritated, too, that *Gil Blas* still referred to him as the 'Whistlerian Sickert' – 'Why "Whistlerian" I don't know,' he complained. The epithet seemed particularly inapt as the exhibition was full of crass Whistlerian imitators that year.[81]

Paris, however, still held many pleasures. 'Here I am again,' he told Mrs Hammersley, 'in my beautiful studio behind the Santé with a revolver under my mattress & many masterpieces on the stocks, some new, some old.' He at once set about finishing some of the more recent masterworks – views of the Parisian music halls as well as 'one or two street scapes when the weather allows'.[82] He even went out to Versailles again, to paint the gardens there.[83] Degas was still alive: old, infirm, yet defiantly vital.[84] And there was also the chance to see other friends. He went with Cottet one evening to a performance of *Julius Caesar* at the Odéon. He trawled the junk shops, and was greatly pleased with a 'pair of most exquisite little Chinese bronzes', picked up for 10 francs: a 'lady and a gentleman', the shopkeeper had explained, turning them over to reveal their 'finely modelled' private parts.[85] But, for all such amusements, it was with reluctance that he contemplated the prospect of having to stay on in France. It was economy that dictated it. 'My sufferings alas I see no end to,' he lamented to Hammersley. 'I love English life as she is lived – for instance at establishments like the Grove or Mornington Cres, and [yet] my working centre will, I fear, be mostly here.'[86] The lament seems to have been a familiar one, for Hammersley was already trying to secure Sickert's return by finding him some regular teaching work.[87]

Perhaps he was successful. Certainly Sickert was able to return to England sooner than he had anticipated.* He was back in '*Londra Benedetta*' in time for the NEAC's 1907 winter exhibition, at which he showed one of his Parisian music-hall works, along with five other small pictures.[88] The relatively muted critical response convinced him that his exhibition works must, in future, be not only more elaborated but larger. 'I have reluctantly come to the conclusion,' he told Mrs Hammersley, 'that I must do a biannual [or twice-annual?] poster for

* Although there is no clear record of Sickert having a teaching post in 1907, a Ms Alison G. Blake told Denys Sutton that she had studied under Sickert at the Lambeth School of Art at that date (writing to Sutton in May 1968 at the age of 78, she recalled that she had been 'about sixteen' at the time). The future Mrs Langford Reed also attended classes at Lambeth under Sickert (Sutton/GUL). I have not been able to trace the school's records.

the New English Art Club to get my desserts publicly ... The press haven't time to look at small things.'[89]

On his return to London, Sickert discovered that Camden Town had become infamous. On 12 September Emily Dimmock, a 22-year-old prostitute who lodged at St Paul's Crescent, Camden Town, had been found murdered, sprawled half-naked on her bed with her throat cut. Robert Wood, a young commercial artist who was known to have consorted with her, had been arrested and charged with what was at once dubbed 'the Camden Town Murder' or 'the affair at Camden Town'. Sickert was soon able to acquaint himself with the story – the papers were full of it.* Wood's trial began on 12 December and continued for four days. They were days of continuous revelation. The sad and salacious details of Emily Dimmock's life were laid out in court and broadcast in the press. It was an existence made up of casual prostitution, of duplicity (Dimmock's common-law husband worked night shifts in the restaurant car of the London to Sheffield express), of meetings in pubs and assignations in cheap lodging-house rooms. Wood's dramatic acquittal – and the crowds that gathered outside the Old Bailey to acclaim it – only heightened the drama surrounding the case. Thenceforth Camden Town became indivisibly linked in the popular mind with sordor, sex, and, above all, murder.[90]

It was perhaps at this juncture that Sickert's Mornington Crescent landlady told him, during one of their regular conversations while she was dusting his room, of her suspicions about a previous lodger. She was convinced that, almost twenty years before, Sickert's room had been lived in by no less a murderer than Jack the Ripper. He had been a seemingly harmless veterinary student. Sometimes, however, he would stay out all night. The landlady and her husband would hear him sneak back into the house in the early morning. He would then pace about his room, before going out to fetch the morning papers – papers proclaiming another grisly murder in the East End. After one such night they noticed signs in his room that he had burnt

* It is possible that Sickert might have heard news of the crime even in France (he sometimes did track down copies of the English papers while abroad); but part of his lament to Hammersley about his Parisian exile was a yearning for 'the exciting green *Westminster* [*Gazette*] and the solid pink *Globe*', which suggests that on this occasion he was bereft of such home comforts.

his suit on the fire, but before they could resolve upon telling the police of their suspicions, the boy's health collapsed. His mother came up to collect him and took him back to the family home in Bournemouth, where he died a few weeks later. With his departure from London, the murders ceased. Sickert was delighted with the tale. He took care to note down the name of the student in the margin of the book he was reading (Casanova's memoirs), and he retold the story often – once to the journalist and author Marie Belloc Lowndes, who used it as the basis of her 1913 novel, *The Lodger*. To cement the connection, he even titled one of the dingiest of his Mornington Crescent interiors, *Jack the Ripper's Bedroom*.*[91]

The title certainly lent a novel sense of drama to a rather dull picture. Sickert was beginning to perceive the possibilities of nomenclature. And there might, he recognized, be an opportunity to relate his 'risqué' two-figure bedroom compositions to the recent killing of Emily Dimmock. The images were already provocative; if they were designated as *The Camden Town Murder* it would carry them to a new level of shock. Although there was a tradition, encouraged by Sickert, that Henry Wood actually posed for several drawings of the scene, Sickert's intention was never merely illustrative.[92] (None of the pictures to which he subsequently gave 'Camden Town Murder' titles conform to the known facts of the killing.[93]) His interest remained focused as ever upon what he termed the 'plastic facts' of the scene: the visual impact of its arrangement of light and shade. Only when a picture was finished did he append a title, as though lighting the blue touch-paper of a firework. A title could charge an image with associations, or suggest a narrative trail along which viewers could wander as they chose.

Rarely since *Rehearsal: The End of the Act*, his picture of 1886, had Sickert given suggestive 'literary' titles to his work, but he now returned to the practice with enthusiasm. He tried it out, not with a bedroom

* Even though Sickert was pleased to believe the theory, there is little reason to suppose it was correct. Sadly, Sickert's copy of Casanova's memoirs was lost (lent to Albert Rutherston and then destroyed in a bomb blast). Nevertheless, dutiful 'Ripperologists' have followed up the lead. N. P. Warren established that of the 131 students at the Royal Veterinary College in Camden Town (the only veterinary college in England at that date) who cut short their studies before the end of 1888, one – named Joseph Reid – did come from Bournemouth. The Camden Rate Books and the 1891 and 1900 Census Returns show that the Joneses, who owned the house from before 1888 to after 1906, did take in lodgers, many of them from the medical professions (Matthew Sturgis, newsletter of the Camden History Society, March 2004).

scene, but with an image of one of the 'divine coster girls' he painted immediately on his return from France.[94] He had depicted her at Mornington Crescent dressed in 'the sumptuous poverty' of her class, the worn-out 'Sunday clothes' trimmed with 'sham rabbit' and other false finery, and on her head an 'American Sailor' – the 'trompe l'oeil hat' that, Sickert learnt, 'all the coster girls wear with a crown fitting the head inside & expanded outside to *immense* proportions'.[95] The picture was exhibited at the NEAC's summer show as *The New Home*. Critics responded eagerly to narrative prompting of the title. 'Here', wrote the reviewer from the *Pall Mall Gazette*, 'is a young woman ill at ease, apparently her hat not yet removed – her head and bust seen large against the mantelshelf – and she taking very unkindly to the second-rate, sordid lodging, to which she is condemned by an unkindly fate.'[96]

Gore, much to Sickert's pleasure, had taken a room just around the corner from Mornington Crescent, at 15 Granby Street. They became inseparable. 'I give him paternal advice,' Sickert told Mrs Hammersley, '& he accompanies me to Shoolbreds [restaurant] & the Horseshoe so that I am able to talk *all day long* about painting.'[97] Gore also accompanied him to the nearby, and recently enlarged, Bedford Music Hall. Sickert had begun work on a tall canvas – six foot by twenty-eight inches – depicting 'a sensational caryatid in plaster, lit from below'. (It was, he explained, 'the only kind of nude permitted in Bond St'.[98]) Gore made a sketch of the same scene.[99] They also painted together, and Gore introduced the distinctive bowler-hatted figure of Sickert into the background of his picture *Someone Waits*.[100]

Gore was pushing his own painting technique ever more towards Impressionist and Neo-Impressionist models, and in his experiments he turned for enlightenment to Lucien Pissarro. For Gore, as for all the Fitzroy Street artists, Pissarro came to be regarded as a 'fountain of true principles'.[101] He held, as Sickert later recorded, 'the exceptional position at once of an original talent, and of the pupil of his father, the authoritative depository of a mass of inherited knowledge and experience'.[102] The 'knowledge and experience' that Lucien had inherited from his father related largely to the adoption and development of Neo-Impressionist theories and techniques. In his own work, he employed a loose 'divisionist' approach similar to his father's later manner, building up his compositions with a solid mosaic of carefully applied touches of light-toned pure colour.

Amongst the denizens of Fitzroy Street this was an approach that

had its most immediate impact on Gore.[103] In apparent acknowledge-
ment of the fact, Sickert arranged a special show of Pissarro's and
Gore's work at Number 19 one Saturday.[104] He admired Gore's control
of thick paint, the sureness, reticence, and variety of this touch –
'impasto in the hands of a delicate and searching draughtsman'[105] –
and moved forward with his own essays in the technique. He deployed
smaller dabs of thicker paint, and increased the range of his colours;
he even very slightly lightened his tones. And though he did not
abandon black (as Pissarro advocated), he did start to use the violets
and greens beloved of the Impressionist tradition, and to 'observe
colour in the shadows'. His claim that, under the influence of Gore
and the Pissarros – *père et fils* – he 'recast' his painting entirely along
neo-Impressionist lines, was an overstatement.[106] But he was open to
such influences, and readily adapted them to his needs.

Sickert continued to refine and improve the arrangements at Fitzroy
Street. Besides Pissarro, Albert Rutherston's Slade friend John Dickson
Innes seems to have been signed up, and Augustus John was also
persuaded to lend his cachet to the group.[107] The showing method at
the regular Saturday 'At Homes' was changed. The easels, as Sickert
explained to Ethel and Nan, would all start empty, with the work
arranged by artist in stacks facing the wall. Sickert, and anyone else
who was present, would then take visitors through each artist's stack
in turn.[108]

Despite Sickert's commitment to Fitzroy Street and his belief in its
efficacy, he remained alive to other exhibiting opportunities. He got
work ready for the Salon des Indépendants and the Bernheims, for
an Anglo-French exhibition at White City, and a mixed show at the
Whitechapel Gallery.[109] He also gave a picture to Hugh Lane for his
planned gallery of modern art at Dublin.[110] At the end of 1906 he had
been re-elected to the executive committee of the NEAC and was
taking an active part again on the club's selection juries.[111] Through
his influence Gore's work began to be accepted regularly.[112] He also
did much to enliven proceedings. The painter A. S. Hartrick recalled
that he 'always stopped for further consideration not only those strange
works that came up in plush frames, but those weird daubs sent to
every exhibition open to all comers. Sometimes it was in the spirit of
blague, but also because he had a genuine liking for the naive. If a
picture from the *douanier* Rousseau had turned up he would have
insisted on it being treated with respect.'[113]

With such inclusive instincts he was very interested to learn of plans being laid by Frank Rutter, the *Sunday Times* art critic, for a large-scale non-jury London exhibition along the lines of the Parisian Salon des Indépendants. It was to be called the Allied Artists Association. Sickert, together with Gore and Pissarro, and some twenty other artists of various stamps and allegiances, lent his enthusiastic support to the venture, and took an active role in the debates about the association's constitution. At the first meeting, to some suggestion that 'the best' pictures be given a special prominence in the show, he memorably replied, 'Sir, for the purposes of this Association, there are no good pictures and no bad pictures. There are only pictures by shareholders.'[114] Equality of opportunity was, he felt, the vital thing. Though he admitted that any completely open exhibition would always attract 'a mass of incompetent work' and some deliberately absurd or outrageous stuff, he believed the price was worth paying.[115] He had hopes that the Allied Artists Association would emulate the success of the Indépendants in establishing new reputations, and even reviving old ones.[116]

The AAA held its first exhibition at the Royal Albert Hall in July 1908. There were over three thousand works on show.[117] All the Fitzroy Street artists sent pictures. Sickert had been voted (third on the list) by the other founder-members to serve on the 'hanging committee', taking responsibility for the display in one section of the hall.[118] With such a huge number of varied works to accommodate, it was exhausting work both mentally and physically. Sickert, very sensibly, supervised proceedings from a chair placed in the middle of the floor.[119]

He enjoyed the discordant vitality of the show, and amongst the cacophony he even picked out some harmonious notes. Gore and Gilman directed his attention to the work of Robert Bevan, which in its use of strong colour and firm drawing seemed to suggest a French heritage – indeed, on seeking him out, they discovered that, though English-born, he was Paris-trained and had even known Gauguin at Pont Aven in Brittany in the 1890s. He was duly invited to show at Fitzroy Street.[120] Sickert was also much attracted to some large decorative panels by Walter Bayes, who was both an artist and a critic (he wrote anonymously in *The Athenaeum* and the *Saturday Review*). But, though he had praised Sickert's work in print, he had not, it seems, made the artist's acquaintance until Frank Rutter effected an introduction at the exhibition. Bayes recalled that at this first meeting he found

Sickert 'eloquently holding forth to a group of bemused spectators before one of my pictures'.[121] Bayes, too, was brought by Sickert into the Fitzroy Street orbit: he certainly came to the Saturday gatherings, and may even have shown work there on occasion.[122]

Since his return to London, Sickert had been hoping to find a steady teaching job (if he had indeed worked at Lambeth, the engagement seems to have been short lived). A new opportunity, however, soon presented itself. George Swinton alerted him to an opening in the art department at the Westminster Technical Institute, one of the LCC's adult-education schools. Sickert wasted no time in mobilizing a battery of important friends and connections: besides the Swintons, Lady Ottoline Morrell's half-brother, the 'blessed' Lord Cavendish Bentick, exercised his influence on Sickert's behalf; and C. J. Holmes, then Slade Professor at Oxford, wrote him a glowing testimonial.[123] With such illustrious referees it was no surprise that he secured the post.

Before the new school year began he went over to Dieppe for a summer holiday. His mother was there for at least some of the season. Her favourite son, Oswald, had got married in April to Elizabeth Kennedy, a musician, and could no longer offer her quite such constant care.[124] Blanche painted two portraits of her that summer, both from photographs – one showing her together with an attentive Walter, seated at the breakfast table at Neuville. Perhaps it was her presence that persuaded Elsie Swinton to send her son Alan over to stay, together with his tutor. The visit was not a success, lasting only one night: the tutor fell sick and insisted on returning to London at once.[125] Sickert, however, had plenty else to occupy him. Max and Reggie Turner were again at Lefèvre's, together with William Nicholson. Blanche was at Offranville with his wife and two unmarried sisters-in-law. George Moore was also in town.[126]

Perhaps to escape the distraction of so many friends, Sickert briefly experimented with plein-air landscape painting. Rising early, he would take a 6 a.m. train into the countryside and then 'drag up into the forest with great boxes & a relay of 6 canvases'. Unsurprisingly, he found that he was not strong enough to stand such a regime,[127] and it was on a more familiar, and more easily reached, street corner in the centre of Dieppe that he was approached by a well-connected art student called Charles Moresco Pearce. Pearce had met Sickert at Will Rothenstein's and, largely out of a sense of emulous admiration, had

persuaded his mother to bring him to Dieppe for the summer. Sickert proved 'very friendly' and invited his aspiring admirer to his studio – a plain, fair sized room in a back street – where he showed him 'a number of paintings, mainly of streets and houses; rich and sumptuous in their colour'.[128] This was followed by an invitation to tea up at Neuville. Beerbohm, meeting Pearce at the Casino, warned of the 'Homeric' quality of Sickert's collations: 'everything was on so vast a scale: the jug of tea and milk, the huge and massive bowls from which one drank, the colossal loaf round and flattish about 2 feet in diameter, which he clasped to his bosom and cut off great slabs for his guests'. Beerbohm did not, however, prepare him for the surprising ugliness of Sickert's brick-built house. It was, Pearce thought, 'entirely devoid of charm', the bare rooms adorned only with some photographs of old pictures – 'Paul Veronese predominantly' – and the one 'admirable little picture by Sickert's father'.[129] Nevertheless, there was scope for instruction.

Sickert was delighted to have an eager pupil. When Pearce invited Sickert to lunch at his hotel and asked him to look over some of his drawings, Sickert studied them carefully. He was not, as Pearce recalled, very 'complimentary', but was 'extremely encouraging'. He also delivered a comprehensive lecture on the art of drawing – derived, as he explained, from Degas and the old masters.[130] It was good preparation for his new role at the Westminster Technical Institute.

THE ARTIST AS TEACHER

He put so much energy into teaching it is no wonder he found it tiring.
(Florence Humphrey)

The Westminster Technical Institute stood in the leafy enclave of Vincent Square near Victoria station and ran mainly vocational courses for the building trades. The majority of students were working men and women who came to study plumbing, technical drawing, and building law. The art school had a semi-autonomous position within the institute, was under its own headmaster, Mouat Loudan, and had its own ethos. There were nine staff members, including Steer's friend Philip Connard, who took an illustration class. They had their own well-furnished staff room, crowded with 'empire sofas' and 'red leather chairs like an Old Bailey solicitors' waiting-room'.[1] The 1908 autumn term began on 21 September. Sickert was to have two nights' teaching a week (Mondays and Wednesdays), taking two parallel figure classes on each evening, one for women and another for men. He was to teach both 'drawing and painting from life' for a weekly wage of a little over £3.[2] At the outset Sickert had only five students in his women's class, and probably not many more in the men's, but he was not disheartened. He had his income; and, no less importantly, teaching provided him with an outlet for two of his great enthusiasms: performing to an audience, and talking about the practical business of making pictures. As he announced to one class, he ought to be paying the students for the privilege of teaching them, rather than vice versa.

His method, influenced by his time in the Paris teaching ateliers, was distinctive. He seldom went round each student in turn, but would 'pounce' on a particular pupil and then deliver an extempore lecture on their work that everyone else could listen in to.[3] His lectures

were wide ranging, and prone to digression. One student recalled that the lessons were never 'just about drawing and painting, but about everything under the sun'. It was only necessary for someone to ask an 'intelligent question' to set him off on a fascinating tangent.[4] Nevertheless, as always, he did have very definite things to say about drawing and painting. Drawings, he insisted, must be made to the scale of vision, advising the students to 'mark off the size of the model on their drawing boards'. Then followed the three steps: 'the tentative line', the 'shading', and the 'definitive line' (Sickert would write them on the top of his – or his students' – drawing paper). The tentative line, he suggested, should be 'like a piece of string thrown down loosely on the paper', defining the main contours not only of the model but also of all the background and foreground objects: if a stovepipe crossed behind the model's head it had to be drawn in. The main areas of dark and light were to be indicated with shading, which Sickert believed should be made with 'delicate parallel strokes running in the direction of the incidence of [the] light'. As a last phase, a more accurate defining line should be attempted around the forms.[5]

All mistakes had to be corrected by drawing over the errors. Sickert abhorred rubbing out. It became one of his memorable turns to fall upon a student who was using a rubber, seize the offending object, and hurl it out the window, crying 'Never use an *india rubber!*'[6] The ploy worked well except in the case of one female student, 'a large Russian blonde', who was so incensed by the assault on her property that she chased Sickert round the studio berating him. He had to take refuge in the staff room. She must have been a formidable character for, after the incident, she continued to attend the classes, and to use her rubber, ignoring Sickert as he ignored her.[7]

Sickert also put forward a similarly well-ordered 'recipe for painting'. Following his own new practice, he recommended that all the necessary colour tones should be prepared on the palette in advance, and then applied in discrete dabs – 'like postage stamps placed side by side', with no smudging or blending. He did not approve of 'strong, bright or sharp colours', and urged the students to consider 'only the pattern made by the subject in its setting'.[8]

Sickert's clear views and theatrical flair, as well as his good looks, very quickly attracted pupils. The classes grew almost weekly. Soon he had over fifty pupils.[9] He likened himself to a successful matinée idol.

When the school secretary told him of yet another batch of young women who wished to sign up for his course, he stuck his thumbs in his waistcoat and declared with mock complacency: 'Ah you see, I am the Lewis Waller of the Art Schools.'[10] He was so popular that many of the institute's full-time students would stay on after their work to attend his evening classes.[11]

During his sojourn at Dieppe Sickert had made an exciting find in one of his ateliers. He had come across an old unbitten plate that Whistler had etched at Robert Street with a portrait sketch of Robert Barr.* The discovery of an unknown Whistler etching was something of a coup, and potentially a lucrative one. Despite the protests of Rosalind Birnie Philip, Whistler's 'sister-in-law, heiress and executrix', Sickert decided to bite the plate and print up an edition of forty-five impressions. He then arranged for the print to be exhibited in October at the Baillie Gallery in Baker Street as the 'pièce de résistance' in a mixed show that included several of his own pictures.[12]

The Baillie Gallery was not the only place where Sickert's work was on show beside that of his former master. The collection assembled by Hugh Lane as the basis of a Dublin Gallery of Modern Art had gone on view at the beginning of the year. Whistler's portrait of the young Sickert hung close by Sickert's painting of *The Old Church, Dieppe*.[13] It marked Sickert's first appearance in a British public gallery. Sickert's attitude to the close association that still existed in the public mind between himself and his former master remained ambiguous. During the long years of Whistler's artistic isolation he had always exalted Whistler's name and acknowledged the great debt that he owed him – even after the personal estrangement of the lithography libel trial. Now, however, the situation had changed, Whistler's stock was high and rising, both in London and in Paris. And though there was a benefit to be had in catching some of the reflected glory, as Sickert was happy to do at the Baillie Gallery show, there was a danger too in being obscured by the bright glare of Whistler's fame. Sickert addressed this problem in a long piece that he wrote for the

* In etching, a copper plate is coated with an acid-resistant hard ground. The image is then drawn with a sharp instrument on the ground, exposing the copper beneath. The plate is then 'bitten': acid is washed over its surface, etching into the exposed copper and leaving the covered areas untouched. The ground is subsequently removed with solvents before the bitten plate is inked up and printed.

Fortnightly Review discussing three recent Whistler biographies (one by his brother Bernhard, another by the Pennells).* In it he effected, if not a repudiation of his former master, then at least a realignment of their respective positions.

In his article Sickert saluted Whistler's 'divine talent for painting' but suggested that his achievement had been compromised both by his temperament and his circumstances. He had fatally deserted the sound traditions of Paris and 'la bonne peinture' for the lilies and languors of Chelsea. He had succumbed to the lure of fashionable aestheticism, attempting to distil a 'very syrup of purest taste': assembling compositions of exquisite people wearing exquisite clothes, surrounded by exquisite objects in exquisite interiors, and then wondering why they did not result in better paintings. Whistler's greatest achievement, Sickert asserted, was in his small, informal works, particularly his nocturnes and pochades. His preferred method did not allow him to build up considered works. He concluded that Whistler should no longer be ranked with Degas and Keene as a master to be followed, but as a brilliant sprite – to be admired in passing.[14]

Sickert was very pleased with his article. It was rich – perhaps over rich – in wit and fancy: one early reader described it as 'real pâté de foie gras with too many truffles'.[15] He read the piece in advance to Steer and Tonks when he lunched with them at the Slade. He also sent a proof copy to Mrs Hammersley.[16] It marked a triumphant return to paid journalism after a break of almost ten years. The criticisms that Sickert laid out in this article were reiterated and amplified over the coming months and years.†[17]

Sickert's journalistic success was matched by his ever-growing success as a teacher. Before the end of the first term some twenty of his students 'petitioned for an extra costume class'. 'So,' as he remarked

* William Heinemann, who published the Pennells' book had – rather bizarrely – suggested that Sickert might care to collaborate on the project. Sickert declined with the comment, 'We will let them scold their way through 300 pages. And when their portrait of my fascinating and impish master in the character of the American Ecce Homo is complete, you and I might do a readable little monograph on the subject.' Sadly that project was never taken up.

† The review was not, it seems, Sickert's only literary endeavour that year. In a letter to Mrs Hammersley, written in the autumn of 1908, he refers to 'my Berlin book', hoping that his brother Oswald would persuade the Times Book Club to 'push' it in London when it came out. But the volume – apparently a guide to the Berlin Art Galleries – remains unknown and was probably never published.

to Mrs Hammersley, 'my little maintenance will probably go up to £4 a week & I am a saved man.'[18] To Lady Ottoline Morrell he claimed that, with this additional day's teaching and the money it brought in, for the first time in many years 'all my paths will be peace!'[19]

On his non-teaching nights Sickert took to sleeping at his mother's house in Pembroke Gardens. It was more comfortable than his Camden Town lodgings, and the regime of an early supper and bed restored his 'creative go'.[20] Though he seems to have used his room at Mornington Crescent less and less, he kept his close connection with the area, renting a studio at the corner of Granby Street and Hampstead Road in what he termed 'the Dickens barrack' (in the 1820s the build-ing had housed the Wellington House Academy where Charles Dickens had been briefly educated).* He tried to get 'some happy hours [there] every day painting between 10 & 4'.[21] He may have been occasionally distracted by his immediate neighbours, amongst whom was a theatri-cal family. Sickert loved to get the old grandmother talking about her days at the Strand Theatre in Surrey Street years before. The youngest daughter, though only aged about eleven, was already planning to follow her siblings and parents on to the stage and was training for the chorus at Covent Garden under the stage name of Emily Powell. Sickert found her delightful – not least because she darned his socks for him.[22]

Sickert needed to be in Camden Town. He was working again on his New Bedford Music Hall picture, which he had set aside early in 1908 – distracted in part by the arrival of a troupe of Sicilian actors at the Shaftesbury Theatre. The naturalness and power of their per-forming was something both new and shocking. He had become quite 'mad' about them, an enthusiasm he shared with Augustus John. He went to see their performances almost nightly, and with his command of Italian was able to befriend some of the actors – especially the leading lady. He invited her to his studio and, along with John and

* Although the building's postal address was 247 Hampstead Road, Sickert – when not referring to it as 'Wellington House' – generally called it 'Granby Street'. In 1908 he had told Nan Hudson and Ethel Sands of another property scheme: a plan to take 'a tiny, odd, sinister little house' at 60 Harrington Street. With characteristic optimism and impracticality, he claimed that it would be 'cheaper' as well as 'roomier' than his Mornington Crescent lodgings – with an annual rent of £45 and all the things he liked: 'air, light & no gentility near'. There was 'sun one side or the other all day' and it was still only 'a ½ d tram to Shoolbreds for lunch'. He hoped to move in at Christmas, but there is no evidence that he ever did.

several other artist-admirers, drew her portrait.*[23] Although he had intended to return to the Bedford picture 'someday', he was only too aware that 'given the uncertainty of human affairs' it might very probably remain 'in a state of intention'. The 'someday', however, was precipitated by a studio visit from the Hammersleys, who urged him to finish the picture and seem to have agreed to buy it in advance of completion, along with another unfinished 'nocturne' of Cumberland Market.[24] With such effective encouragement Sickert was soon back at his place in the stalls, refreshing his vision, and relishing the performances of Daisy Wood (sister of the celebrated Marie Lloyd), who was 'enchanting' the crowds that season with the memorable ditty, 'Oop! I addy, I ay' ('I don't know if I have spelt it right', Sickert admitted to Hammersley. 'I quote by ear only.'[25])

Sickert's return to Pembroke Gardens brought him back into daily contact with his hapless brothers. Robert was now a permanent invalid. He had lost the use of one eye, and had it replaced with a glass one. But Bernhard was the more desperate case. Although he continued to paint, and had completed his small book on Whistler, his alcoholism and drug taking had worsened and led to frequent domestic crises. His behaviour placed a great strain upon the household, not least because its cause was never openly acknowledged. Walter forced a resolution. After yet another 'outburst' it was decided that Bernhard must again be sent to a 'home'. He was dispatched to Osea Island in the Thames Estuary, to a retreat that had been set up in a fit of conscience by the brewing magnate F. N. Charrington.[26] The whole sad affair took its toll on Mrs Sickert. 'Poor old mother,' Sickert remarked, 'it has somewhat affected a heart which at eighty is not as strong as it [once] was.' Walter was glad to be close at hand. 'We pass many pleasant hours together,' he told Mrs Hammersley. It reminded him of his early childhood in Bavaria when for much of the time, as the eldest son, he had been his mother's 'only rational companion'.[27]

Bernhard returned from Osea 'weaned by force from drugs and alcohol' but scarcely improved in other respects. His mental state, as

* *Mimi Aguglia Ferrau*, shown at the NEAC in 1909. Sickert infuriated Lady Hamilton by throwing over an invitation to a 'play party' at the last minute on learning that they would not be going to 'the Sicilians'. He told her 'he thought no one could possibly go to see another play just now while the Sicilians are here'. Lady Hamilton was not impressed. 'What savages people are,' she remarked – of the Sicilians, it seems, rather than Sickert. '[They] are just uncivilised animals on the stage, reminiscent of the zoo.' (Lady Hamilton, MS diary, 13/2/1908.)

Sickert confided to Nan, remained, disquieting: 'Megalomania (like his brother Walter *tu dites*) & lethargy, colossal incurable sluggishness and indifference.'[28] In order to break this dangerous cycle Bernhard was sent away from London. Walter found a place for him in the house of friend and fellow painter J. R. Hughton, 'a charming man' with 'an excellent wife', who lived at Little Easton, near Dunmow in Essex.[29] Sickert had hopes that Bernhard's removal into the country would prove a 'blessing': his talents were as a landscape painter yet his existence, in Sickert's estimate, was 'poisoned at source' by the fact that it seemed necessary for him to live in town with his mother. The country-side of north Essex appealed to Bernhard, and he found himself able to work 'happy & contented all day', undertaking pictures 'with the prospect of finishing them'. Sickert went down to see his brother on several occasions, and took pains over him.* 'Poor little devil,' he commented to Nan. 'He has been through years of torture and the fact that it has been his own imbecility doesn't make him less to be pitied.'[30]

'L'affaire Bernhard', as Sickert termed it, took up a great deal of time and emotional energy,[31] and his own work suffered as a consequence. He found relief in another new workspace. He took a room, as an etching studio, at 21 Augustus Street, close to Mornington Crescent, in what had been Gimbles' Vinegar Factory, and set to work on a suite of prints, begun the previous year, relating to his 'Camden Town Murder' paintings. He referred to them, at least to Mrs Hammersley, as 'the Sordid Series'.[32]

He was also striving to get pictures either finished or ready for a concerted Continental campaign that spring. Four of his pictures – including *Noctes Ambrosianae* – were on show in Berlin in April, where they caused quite a stir at the very conservative Art Association.[33] But Sickert's main focus was on France – he was due to have a major one-man show at Bernheim-Jeune in the early summer. Félix Fénéon, accompanied by Paul Signac, came over to London at the beginning of April and sought Sickert out, presumably to discuss arrangements.[34] Sickert gave advance notice of his exhibition by showing at both the Salon des Indépendants and at the newly established Salon du Printemps.[35]

* Sickert contributed to the Dunmow Artists' Picture Show organized by Bernhard in November 1911. He sent two pictures, titled – with a splendid lack of tact – *A Tiff* and *Off to the Pub*.

Sickert's exhibition at Bernheim-Jeune that June was, by British standards, a strange affair: some ninety works (seventy-five paintings, ten drawings, and four pastels) were displayed at the Bernheims' gallery for six days and then auctioned off at the Hôtel Drouot. The collection, which included twenty works from the Bernheims' stock collection, was a mixed bag. Sickert called it a 'jumble of good & bad, finished & unfinished'.[36] A catalogue was produced to accompany the show, with a generous preface by his French patron, Adolphe Tavernier. But even with this puff, the prices achieved were only 'très médiocres'.[37] A painting of the Hôtel Royal, Dieppe, topped the bidding at 440 francs (about £17) and another townscape, of Le Pollet, made 350 francs. But for the most part the prices averaged a paltry 100 francs (£4) – more than the Bernheims had paid for the pictures, but well short of their usual 500 per cent markup, and below, too, what one paper recognized as the work's 'intrinsic value'. The whole sale raised only 9,180 francs.[38]

Sickert came away with 'a tiny profit', but announced himself well satisfied.[39] After all, he approved of low prices and market forces. Only in May he had written a letter to the Morning Post decrying the British policy of supporting contemporary art with public money and urging artists not to live in a 'fool's paradise' of grants and prizes, but to become 'good Europeans' and submit their 'chastened persons with due contrition to the harsh and wholesome spankings of our kindly cruel stepmothers, Christie's and the Hotel Drouot'.[40] In the wake of his own wholesome chastisement, he must have drawn some comfort from the number of fellow painters who bought work. Besides the ever-faithful Blanche, Bonnard, Maximilien Luce and Herman Paul all acquired pieces at the sale,[41] and Signac, who was out of Paris, commissioned Fénéon to get something for him, adding 'even if it's a bit lewd, I'll go along'. Fénéon, with typical daring, chose for his friend L'Affaire de Camden Town – the first of Sickert's murder-titled pictures to be exhibited.[42] The image – in which a severe clothed male figure looms over a vast nude, apparently cowering on an iron bedstead – was quite as disturbing as the title. The gross material facts are everywhere insisted upon: the woman's forcefully delineated sex is the very focus of the composition. Her flesh is rendered in thickly applied dabs of paint. The chamber pot is conspicuous beneath the bed. To commemorate the purchase, Sickert presented Signac with an inscribed preliminary sketch as a pendant piece.[43] Despite the modest returns,

and at least one hostile review that suggested that Sickert had lost his way, the exhibition maintained Sickert's presence in the French market and reinforced his position.[44] There was still a demand for his pictures. Only a few months after the sale Tavernier pressed '£18 and a cigar' on Sickert in exchange for 'three trifles',[45] and the approval of Fénéon and Signac encouraged Sickert to send two further 'Camden Town Murder' paintings to that year's Salon d'Automne.[46]

Certainly his work was more readily appreciated in Paris than in London. When Frederick Wedmore included Sickert, as one of half a dozen contemporary British painters, in his survey book *Some of the Moderns*, he felt the need to excuse the presence of an artist who had, till then, been all but ignored by the home public, on the grounds that 'in France where frankness and spontaneity are recognised, he had received great homage'.[47] Sickert's francophile credentials were further acknowledged when he appeared – ranged together with George Moore, Hugh Lane, MacColl, Steer, and Tonks – as one of the figures in William Orpen's painting *Homage to Manet*. The group was depicted in Lane's London drawing room, beneath Manet's portrait of Eva Gonzales, listening to George Moore read from his *Reminiscences of the Impressionist Painters*. Sickert hovers on the edge of the company, his thumbs hooked into his waistcoat. He looks like a late arrival, and was – in truth – a late addition to the composition.[48] His place was amongst the rising generation.

His confrères at Fitzroy Street and his continuing presence on the NEAC committees kept him in close contact with young artists. At the NEAC's 1909 summer exhibition he was impressed by the work of Vanessa Bell, the beautiful 30-year-old daughter of Leslie Stephen (Sickert had seen her as a child on the sands at St Ives over twenty-five years before). She had recently married the brilliant young art critic, and occasional visitor to Fitzroy Street, Clive Bell. Sickert gave Vanessa some words of generous praise and wrote enthusiastically to Clive, remarking, 'I can't get over your wife being an interesting painter.'[49] He came to know Gore's Slade friend, the scintillating if irascible Wyndham Lewis, who was back in London after spending much of the previous six years abroad. Sickert found him a 'remarkable and original talent' as both writer and draughtsman: when Lewis confided his plans to bring out a collection of stories, Sickert hastened to put him in touch with John Lane as a likely publisher.[50]

Sickert was also drawn to Ambrose McEvoy, another of the same

Slade generation, and a close friend of Albert Rutherston and Augustus John. Although of English birth and Scottish descent, McEvoy's father had been born in America and served in the Confederate Army. Whistler had been a family friend and had encouraged the young Ambrose in his artistic ambitions. He had inspired him, too, to adopt something of the dandy's pose. Tall, thin, and angular, with his fringe flopping down into his strikingly large eyes, he looked the part. He even sometimes affected a monocle. Despite his 'artistic' appearance, however, he had a keen and lively sense of fun. He astounded the guests at one 'intolerably pompous' dinner by springing up and performing an impromptu jig around the table, And his earliest art earnings came from doing cartoons for the comic paper *Nuts*. Although he later achieved a reputation and a good living as a brilliant painter of fashionable women, in 1909 – at the age of thirty-one – he was still groping his way towards a personal style after long years studying the works and the techniques of the old masters. He flitted inconsequentially between dull Rembrandtesque interiors and vague Claude-inspired landscapes.[51] Perhaps hoping to find a direction, if not a master, he became a regular visitor at the Fitzroy Street 'At Homes',[52] where Sickert took him up and instructed him in the rudiments of etching.[53]

During his rather truncated 1909 summer holidays – for, as a teacher, he was now obliged to keep term times – Sickert went, as ever, to Dieppe and was joined there by McEvoy.[54] Released from his duties to his students – and his brother – Sickert buried himself in work. Rising at six, he would take an early morning swim, relishing the big breakers ('you have to look sharp and dive through'). Then he would paint right through until 7 p.m. 'Life seems to grow shorter & shorter as one grows older,' he lamented to Nan, 'less time for reflection & more urgent action imposed.'[55] His latest method was to paint 'small panels out of doors in a series of 5 or 6 sittings a day' and then use them as the basis for painting 'usual sized pictures' – and one 'large one' – back in the studio 'on grey days'. It was a procedure that McEvoy encouraged him in: '[he] told me a saying of Constable's which will become a guiding mot with me henceforth. Asked if he sold his little pochade studies he said no – I sell *the harvest not the seed*. I shall hoard [my own pochades] henceforth & yearly work from them.'[56]

Despite the pressure of time and need for urgent action, Sickert

did allow himself – and McEvoy – a two-day holiday to Rouen and
its environs: 'Most interesting hot arid country, hot, *towny* town,' Sickert
wrote to Mrs Swinton. 'Such pictures! . . . The finest Ingres perhaps in
the world. And a portrait of an admiral by Jean-François Millet, beyond
words. And many other jumbled & most interesting things. Five great
decorations by Puvis de Chavannes & a lot of his studies.' The next day
they took a steamer down the Seine and explored the local countryside,
stopping at La Bouille to drink three bottles of the sweet local cider.[57]
It was a rare moment of indulgence. Sickert was trying to cut down
on his cider consumption. He had developed a 'hideous pot belly' and
wrote urgently to Mrs Swinton asking her to recommend a diet. ('A
woman's fat', he told her, 'is so much the more to the good. A man's
is absurd [and] uncomfortable.'[58])

Although McEvoy could provide Sickert with interesting art-
historical references and amusing company, he found himself rather
overwhelmed by Sickert's artistic energy and began painting in a
manner almost indistinguishable from his companion. Not that Sickert
minded such sincere flattery.* Over the course of the summer it seems
that they saw also something of Mme Villain. McEvoy was anxious
that his young son should learn French and wrote to his wife from
Dieppe urging her to start the boy off by reading him Beatrix Potter's
Peter Rabbit in translation;[59] and at the end of the holiday, Mme Villain
sent her son Maurice, then aged thirteen, over to England. Sickert
deposited the boy with the McEvoys, claiming it would be only for a
single night: he stayed for six months and succeeded in passing on
some words of French to the McEvoys' son, as well as shocking their
young daughter by going to bed with his boots on.[60]

Sickert had returned to London to be ready for the start of a new
term at Westminster. In a flurry of practical resolutions he decided to
alter his 'arrangements'. As he explained to Mrs Swinton, living at his
mother's was proving too tiring on 'LCC nights' and too expensive,
as he found himself taking taxis halfway across town. In order that he
might be able to be 'in bed five minutes after [leaving] Vincent Sq.',

* According to John Rothenstein, at the NEAC's 1909 winter show 'there was a
painting of a favourite Dieppe subject of Sickert's painted in that artist's highly
personal style. This painting brought Sickert much commendation. "Better than
anything you've ever done", remarked a brother artist with a fulsome smile. "I'm
afraid", Sickert answered, "it is", and referred him to the catalogue. The painting was
the work of McEvoy, done in the course of [his] visit to Sickert at Neuville.' *Modern
English Painters*, 207.

he took a pair of south-facing rooms at 64 Grosvenor Road, Pimlico – close to the McEvoys at No. 104. The rooms looked over the river, close by Vauxhall Bridge and cost him 9 shillings a week, with an additional 2/6 for the services of an 'excellent' cleaning woman. He also rented a large top-lit studio (5 Brecknock Studios) on the Brecknock Road, a ha'penny tram ride up from Mornington Crescent, on the borders of Islington. The rent there was a further £22 a year. The space was intended to allow him to produce 'big paintings', such as he was planning – not for the first time – to concentrate on.[61] He perhaps put some finishing touches there to the Hammersleys' New Bedford picture. Certainly he asked them to deliver it back to him for a brief 'inspection'.[62] In the short term, the Brecknock studio provided a convenient store for all Bernhard's studio paraphernalia and 'stuff'.[63] As a small economy, Sickert intended to get rid of his room in the Dickens barrack; but, as with so many of his planned economies, it was put off and then forgotten. The Augustus Street studio was kept on 'for etching and contemplation'.[64]

In so far as there was time for 'contemplation', Sickert seems only to have contemplated new schemes and new activities. When C. J. Holmes was appointed director of the National Portrait Gallery Sickert wondered whether he might have a chance of taking over from him as Slade Professor at Oxford.[65] In the event, Holmes kept his chair along with his new post, and Sickert soon found other outlets for his excess energies. He had proposed starting an etching class at Westminster but received only two applications. One of them was from a talented painting student called Madeleine Knox. He suggested to her that they set up their own 'etching school', independently, at a site on the Hampstead Road.[66]

'School' was perhaps too formal a name for the modest venture. Pupils were few at first. They included Ambrose McEvoy, and Sylvia Gosse, the youngest child of Sickert's old friend Edmund Gosse. Sickert had known her throughout her childhood and had encouraged her youthful interest in art. In 1909 she was twenty-eight and, having graduated from the Royal Academy schools, was trying to pursue a career as a painter. Shy and self-effacing, she was wary of showing her work or seeking advice, but her father, the great literary fixer of the age, had no such inhibitions. Seeking an opinion, he showed Sickert some of Sylvia's recent paintings. After close scrutiny Sickert declared, 'One thing I am certain of: she should become an etcher. I

shall teach her etching. She can come to me and we will do etching together.'[67]

Sickert also made a return to journalism. From the beginning of the New Year he contributed a regular column to *Art News*, a cheaply produced weekly newspaper founded by Frank Rutter as an organ of the AAA. When Lady Hamilton wrote, inviting Sickert to tea (and to inspect his pictures on the walls of her drawing room), he was obliged to decline:

> My dear Lady Hamilton, I should like to see you, & not the least – 'not a bit in the world' as they say down in Devon – how beautiful my pictures look. 'Anything but that!' 'J'en ai soupé de mes sales toiles!' . . . Alas I can never come to tea. I can neither ever lunch, nowhere. I breakfast at 6 & dejeuner at Euston Station platform 6 at 12 sharp every day. I am lost to the world & gained to posterity. When I tell you that *three* days a week I give 30 students lessons from 5.30 to 9.45 at Westminster – that I visit my private etching school 5 days a week – paint pictures at my studio in *Islington* [Brecknock Rd] & portraits in *Granby Street* [the Dickens barrack] & etchings in Cumberland Market [Augustus St] & receive here [19 Fitzroy Street] on Saturday afternoons (where *real* friends would come in their staff-motors attended by aide-de-camps) – that I write a column a week of vituperation of your, & my, friend Sargent & other R.A.s in an obscure weekly called the Art News (Blanes Buildings no. 13; to be had at all stationers) you will understand that I am in the middle of my Spion Kop (see how I try to suit my language to the comprehension of my hearers!) Enfin – my habits since I swam in a gondola are changed but not my feelings, Always your tout devoué, Walter Sickert.*[68]

Sickert soon added yet more to this self-imposed load. He removed the 'private etching school' to new, larger premises across the street, at 140 Hampstead Road, and expanded the curriculum to include both drawing and painting. Number 140 was set back from the street behind a high front-garden wall but at the rear overhung the railway tracks coming out of Euston. It was, in the recollection of an early pupil, 'one of those old broken houses that seemed to have had another house torn from its side'.[69] Sickert endowed it with a fictitious dignity by christening it Rowlandson House, in honour of the great eighteenth-

* Spion Kop was the site of long-drawn out and bloody conflict in the Boer War.

century draughtsman (who had never lived anywhere near the Hampstead Road).[70]

The new school attracted some serious and able young artists. Malcolm Drummond, a Slade graduate who had first encountered Sickert at Westminster and then started attending his etching classes, was the 'foundation pupil'. Charles Moresco Pearce was another of the first intake. So, too, was Sylvia Gosse. And amongst the largely female studentship, Sickert was much impressed with the talents and dedication of Jean McIntyre. But the predominating element remained wealthy, fashionable, and dilettante. 'The women', it was said, 'were as remarkable for their beauty as for their talent, perhaps more so.'[71] Madeleine Knox remembered a Miss Oldham as '*very* ornamental'; but she was collected for lunch each day by her 'young man' and seldom returned for the afternoon class. Sickert took a mock-serious interest in the status of his pupils. When a 'Lady Hylton' signed up for the school, he remarked disparagingly that she was giving herself airs, and was 'probably only a knight's wife'. He was very pleased to discover that she was a peeress proper – even though she only lasted one term.[72] The demand was for drawing and painting; the etching classes were banished to the top floor.[73]

Sickert captivated his students, particularly the young female ones. 'We were all enslaved,' recalled Enid Bagnold, the future author of *National Velvet*, who joined Sickert's classes as a 21-year-old. 'The day glittered because of him.' His attitude to his pupils was 'like an Old Master' – 'protective, disrespectful, chiding and half-contemptuous'. He would refer to them as 'my flock – poor creatures' and was apt to 'hammer' them with his wit. When Enid Bagnold had applied to join the school he had inspected some of her drawings in front of the class, and then remarked innocently, 'But perhaps you paint?' – to the great amusement of the other students.[74] He could become exasperated with those who had absolutely no ability and was capable of such outbursts as, 'You have no talent at all! Go home!'[75] But, for the most part, he was encouraging – and frequently generous. Elfrida Lucas, another of his poor flock, recorded how he once lent her his own palette and brushes.[76]

His teaching, honed by a year at Westminster, was becoming expert – perhaps too expert. He provided not so much a grounding as a pictorial formula. Enid Bagnold recalled that his lessons tore like 'lightning . . . across clouds of muddle and broke them up'; but they also

offered dangerous 'shortcuts to success': by following his prescribed methods it was possible for pupils to create plausible looking (and very Sickert-like) paintings without any real artistic gift. He was a teacher, she wrote, who 'could make a kitchen maid exhibit once'.[77] George Moore satirized his method: the absence of 'drawing' in his recommended motif – 'A gable end with a sweep of pavement', which, simple as it was, could even be taken from a squared up photograph; the arbitrary colours and limited tones – 'how vermilion worked into ultra-marine will produce a symbolic sky that harmonises with the brown roofs in which Indian red is used largely'; and the achievement of 'quality' (and the avoidance of a twice-painted surface like 'linoleum') arrived at by applying the paint in 'a series of little dabs'.[78] By such formulae, Sickert enabled Enid Bagnold to exhibit not once but twice at the NEAC, though – as she remarked – 'that didn't make me an artist'.[79]

The practical running of the school fell largely to Miss Knox, while Sickert cheerfully sabotaged her efforts. If students were hard up he allowed them to attend classes without paying fees,[80] and when Miss Knox informed him that they had signed up enough pupils to net £100 a year after expenses, he rushed ahead to test her estimate, running up large bills, ordering materials, easels, and not one but two patent stoves.[81] Despite his extravagances, he remained confident that the school would soon pay. 'If I could get 20 [students],' he told Nan Hudson, 'I should get a studio for nothing out of it.' He was determined, he said, to make his living 'independently of the sale of pictures'.[82]

The school also provided a useful resource for his friends. Gore, who only lived around the corner, would come in and paint in the garden, and then go off to lunch with Sickert and others at Shoolbred's or the Euston Station Hotel.[83] He even gave a class briefly.[84] Gilman, too, worked occasionally at Rowlandson House, 'coming in and out' as he pleased; and so did McEvoy.[85] When Blanche was in town – if his regular studio was sub-let – he would work at Rowlandson House – it was there that Sickert painted his portrait, muffled in a scarf and wearing a top hat from Lock's in St James's.[86] Sickert taught at the school every morning from 10 a.m.[87] After lunch he would have a nap in one of the rooms with a handkerchief tied round his head 'to keep his jaw up'. Then, after tea, he would do his own work from one of the 'cockney models' he had hired for the students before heading off

to Westminster to take his evening class.[88] He still slept, on his teaching evenings, at Grosvenor Road; on the other nights he stayed 'in Camden Town' – though at which of his several addresses there remains unclear.[89]

It was a taxing regime which, combined with his writing commitments, left little time for his own painting. He overworked himself completing a Dieppe scene that Hugh Lane had commissioned for the newly-established Johannesburg Art Gallery.[90] His health began to trouble him again, though it does not seem to have affected his appetite: Madeleine Knox recalled that he continued to eat huge amounts.[91] His nerves, however, were frayed. He burst into tears over lunch at the Euston Station Hotel with Elsie Swinton at the news of Edward VII's death in May 1910. (At least he claimed it was the news of the King's demise that provoked the breakdown. Madeleine Knox suspected that it might have had more to do with some crisis in his relationship with Mrs Swinton, who was also in tears.[92])

He did give up his work for Art News, but not before taking on another weekly assignment, for the New Age. There was no financial advantage in this new arrangement, as the magazine, under the idealistic editorship of A. R. Orage, did not pay its contributors – an illustrious group that included H. G. Wells, Arnold Bennett, Hilaire Belloc, Katherine Mansfield, and Ezra Pound. The magazine was subtitled 'An Independent Socialist Review of Politics, Literature, and Art' and there was much editorializing about the role of art in both society and politics. Perhaps Sickert's aversion to the drawing room as a subject for painting encouraged Orage to suppose him a socialist. Certainly in some of his art politics he favoured socialistic ideals – or his rather personal idea of them. In one early article, for instance, he wondered whether the AAA was not 'a working object lesson in Socialism', asking: 'Is it not a solvent, going concern founded by the poor to help themselves?'[93] But, away from art, Sickert's political views remained unfixed, and hardly susceptible to classification.

If it was true that he loved the lower classes as a subject for his art, he had no desire to change their lot. He did not want to see them made comfortable, tidy, or prosperous. He liked them as they were. He had imbibed little from his long association with the Cobden tribe and continued to rejoice in differences and distinctions.[94] As an advocate of private patronage rather than state support of the arts, he deplored a system that taxed the charwoman and the labourer to

provide cultural amenities and rewards for the better off. He wanted his clients to have money so that they could spend it as they pleased. 'All an artist can hope for,' he told one patron, 'is that the rich grow richer and the poor, poorer.'[95] A 'reactionary by conviction', he had a high regard for the hereditary principle and thought 'democracy' had its limitations – not that he thought much about any political question.*[96] He contemplated joining the Conservatives, and perhaps even did so.† But he was not an obvious party man. He might have claimed, like his friend Max Beerbohm, to be a 'Tory Anarchist'.

Sickert had suggested that Nan Hudson should come with him to Dieppe for the summer, but he then wrote to put her off. The house at Neuville would be full. He had to take charge of his invalid brother, Robert, as their mother was going to be away from home; and McEvoy was coming back to 'finish work begun last summer'. Sickert rather regretted the change of plan when McEvoy was delayed by illness. Nan's company would have been welcome: he was kept indoors by 'incessant storms & rain', and to make matters worse the quiet of the house was disrupted when the maid's husband had to be taken to hospital after his finger was badly bitten in a fight with an *apache*. Nor did the change of scene do anything to improve Sickert's fragile condition. He continued to feel strangely unsettled. 'I am not well & don't know what is the matter with me,' he confided to Nan (who had gone instead to Venice). 'My nerves are shaken.' He struggled to locate the cause of his anxiety: the recent troubles with Bernhard; his own 'cinquantenaire' (he had passed his fiftieth birthday on 30 May 1910). In a sudden access of intuition he wondered if 'smoking is a much worse poison than we imagine', though he felt that, even if it were, his one cigar a day was not excessive. For the most part he tried to obliterate his worries through work. He kept up the hebdomadal 'hurdy gurdy' for the *New Age*, and he painted with dogged determi-

* The unfixed nature of his convictions was often apparent. When he was complaining to the cartoonist Lansbury that democracy was an error, and that 'you can't do without blood and breeding', Lansbury answered promptly, 'But isn't a carthorse nobler than a thoroughbred?' As Sickert remarked, 'He had something there you know.'

† ALS WS to Nan Hudson ('I am thinking of joining the Tories'). A telegram (31/3/1927) to J. Grieg, art editor of the *Morning Post*, includes the aside, 'Since last century [I have been] on books of Conservative association in Park Street [and] can enter into attitude of Morning Post with which I am in complete sympathy.'

nation. 'Overwork', he declared, 'seems to me less fatiguing than rest.'[97]

This opinion was revised during the course of the summer; and, though Sickert still found it difficult to rest, he did at least give up the *New Age* column.[98] Blanche was in town, and they would sometimes lunch together. Despite their artistic divergence, much of the old amity remained. 'Every time I see him,' Sickert told Nan, 'I think him one of the most intelligent & most agreeable men I ever met.'[99] It was only afterwards that he would fret at his friend's propensity to gossip: 'he is liable to twist things he hears or doesn't into monstrous fibs and for no particular object except, I think, passion for curiosity. Not that it does any real harm, but it is uncomfortable.' He enjoyed almost more his trips out to the Blanches' home at Offranville. Jacques' wife, so genuine and simple ('in the French sense of the word'), was, as ever, 'extraordinarily kind' to him.[100]

Sickert lingered on at Neuville till the very end of the summer, finishing a picture for Blanche.[101] His technique was constantly evolving. The experiments with thick, impasted paint had reached something of an impasse, and he had returned to a more loosely handled and summary approach, accenting his thinly painted compositions with deft flurries of highlights in an effort to recapture a sense of immediacy.

Still fretting over his '(probably) fanciful sufferings', he had consulted Mrs Swinton, who got her doctor to make some helpful suggestions. But, as the season descended deeper into cold and wind, Sickert felt that England and 'Le Rosbif' was what he needed most. 'Perhaps the sea air is bad for me,' he suddenly wondered. He was obliged, however, to wait for the storms to subside before he could return to London.[102]

Roast beef and London air did little to restore his health or equilibrium, especially when set against the now almost ceaseless round of his teaching duties. If anything, his condition worsened. He told Nan that he was constantly ill – but without ever having quite to take to his bed: 'My difficulty', he explained, 'is no home comfort, & a delicate digestion. I find I can do with nothing but milk at night after the classes.'[103] With a touch of melodrama, he declared that he must 'rapidly' revise the whole plan of his life, which until then he had 'fatuously based on the really rather rare strength & energy I have [always] enjoyed'. He declared that he had given up his Brecknock studio, although, as so often with such declarations, this was more a

statement of intent than of fact, and the intent was not followed through. He did manage to hand over the running of the Fitzroy Street 'At Homes' to Robert Bevan – 'in anticipation of the possibility' that his condition might worsen. 'My enforced retirement is of course a disadvantage,' he told Ethel and Nan, 'but the others are all keen and productive and after all if I had died they would have had to manage without me.'[104] Friends rallied to offer assistance. Ethel and Nan suggested that he might come and enjoy some 'home comfort' at Lowndes Square – a 'terrible threat' which, he told them, he hoped to escape. His 'divinely good & generous [ex-]wife' turned up at the news of his illness 'with the proposition that [he] was to have a long rest & give up work altogether for a time, of course at her expense'. He declined this offer too, though he did remark: 'It is wonderful to think there are such people in the world.'[105]

Some practical help did arrive from other quarters. By 'the mercy of Providence', as he termed it, the recently established Contemporary Art Society bought his 1891 portrait of George Moore. He felt duly chastened as he had 'done nothing but abuse' the society since it had been set up the previous year, by MacColl, Robbie Ross, Roger Fry, the Morrells, and other right-thinking art lovers.[106] Blanche, too, announced the sale of some Sickert pictures in Paris.[107] The money was welcome. His incapacitated condition had placed an undue strain on Madeleine Knox at Rowlandson House – she herself had a weak heart and soon became quite as unwell as Sickert, making it seem unlikely that she would be able to continue. With his unexpected windfall he was able to buy her out, reimbursing at least some of her capital.[108] Sylvia Gosse agreed to become the new co-principal.[109]

Sylvia's practicality and quiet good sense soon put the school into some kind of order. She had plans for a children's class in the afternoon, and she spared Sickert the exhaustion and irritation of dealing with the weakest pupils. Under her stewardship the school, much to Sickert's amazement and delight, even began to 'pay expenses'.[110]

Sickert started to rally. Freed from the chore of organizing matters at Fitzroy Street, he nevertheless resumed his attendance there on Saturday afternoons and remained the central figure of the place. He started a new painting of Nan Hudson, arranging 'daylight sittings', from 11.00 a.m., at his studio on the corner of Granby Street. Perking up considerably, he told her to 'come in some "creation" you fancy yourself in because I fancy you in anything'.[111] He was also working from

his paid models. 'Oh why aren't you both drabs and ruined?' he asked Nan and Ethel. 'I would allow you 30s. a week.'[112] Soon there were also plans in train for a one-man show of his drawings at the Carfax Gallery, which, since Robbie Ross's defection to journalism, had come under the sole control of Arthur Clifton. Sickert's digestion improved, and he graduated from warm milk to Scotch broth.[113] On teaching nights he would take a taxi from Vincent Square to the Criterion in Piccadilly Circus for a bowl of soup.[114]

But even the excellence of the Criterion's soup could not obscure a void at the heart of his life: the want of a home. He decided that what he most needed was a wife. It merely remained to find a suitable candidate. Although he continued to see Ellen regularly (dining with her almost every week), the notion of a remarriage had faded from the agenda.[115] She was now sixty-two and in uncertain health. At Rowlandson House – and at the Westminster Technical Institute – he was surrounded by young, adoring females. Although Enid Bagnold claimed that he had a 'doctor's morality' about his students, this seems scarcely to have been the case. Indeed he kissed her on several occasions in a manner unlikely to have been approved by the BMC.*[116] Many of the students 'chased' after him, and he did not always try too hard to escape. He also did some chasing of his own, though the claim of Lucien Pissarro's daughter, Orovida, to have been the only Rowlandson House pupil with whom he did *not* have an affair was something of an exaggeration.[117] Sylvia Gosse (who, for all her intense devotion to Sickert, never became his mistress) recalled that he suffered 'a temporary infatuation with at least one attractive pupil at [the] school whom he thought he was in love with but was not sure!' As she remarked, he was 'rarely in love with anyone for long, so it came to nothing'.[118] Falling back upon more familiar ground, he asked Madeleine Knox whether she would marry him, but, after all she had suffered from his waywardness over the running of Rowlandson House, it was not perhaps surprising that she found herself 'able to resist his charms'.[119] From these pressing amatory concerns Sickert – along with the rest of the London art world – was distracted by the great Art Quake of November 1910.

* His invitation to her, however, concluding 'I should then ask you *alone* for which I thirst – and have always thirsted – & shall continue to thirst', was only a 'mock affectionate' effusion (Denys Sutton, TS 'Visit to Enid Bagnold [Lady Jones] 15/5/1968').

CHAPTER SEVEN

Contre Jour

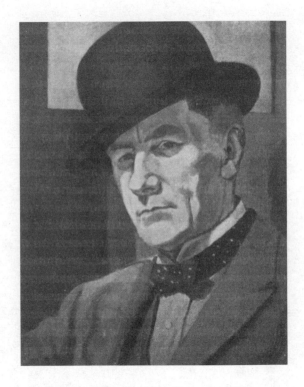

Walter Sickert by Nina Hamnett, *c*.1918

LES AFFAIRES DE CAMDEN TOWN

Tout le monde a du talent à vingt-cinq ans.
La difficulté est d'en avoir à cinquante.

(Degas, quoted by Walter Sickert)

William Rothenstein was away in India at the time, but even he registered the event. 'There was', he wrote, 'a shower of cinders one day while I was sitting on the banks of the Ganges and one of the Juggernaut Gods is said to have been found leaning to one side – both facts were accounted for later ... by the Post-Impressionist earthquake in London.'[1] The mythologizing of the celebrated exhibition 'Manet and the Post-Impressionists' began early, and has continued long. Besides the prodigies that disturbed the sub-continent, the show has been credited with signalling – if not effecting – a change in 'human character', with ushering in a new era of modernity, with introducing the British public (and many British painters) to 'modern art'. Although all these claims are liable to a great deal of qualification, there is no denying that the exhibition did have a profound impact: some 25,000 people paid a shilling each to visit the Grafton Galleries, off Bond Street, during the exhibition's three month duration (8 November 1910–15 January 1911). It dominated debate in the British press and polarized opinion in the British art world.[2]

Roger Fry, the show's curator, had certainly hoped to provoke a reaction, but it is doubtful that even he had expected to achieve quite so much. He was not used to such dramas. Although he had continued to paint and to exhibit since his days at the Chelsea Life School, his reputation was as an expert on the masters of the Italian Renaissance, a brilliant lecturer, and a penetrating critic. He had only recently returned from a stint in America where he had been acting as an art adviser to the Metropolitan Museum in New York. Having failed to get the Slade

Professorship at Oxford, when C. J. Holmes finally gave up the post in 1910, he had decided to pursue a career as an independent critic, artist, and impresario. A chance meeting with Clive and Vanessa Bell on the platform of Cambridge railway station had drawn him into the intellectual world of Bloomsbury. He shared with Clive Bell a knowledge of recent French art and a belief in its pre-eminent importance. He translated Maurice Denis' article on Cézanne for the *Burlington Magazine*; he visited Matisse in his studio, and he persuaded the fashionable Grafton Galleries to give him an empty slot in their schedule for a survey show of modern French painting.[3]

The pictures were assembled in an unplanned, if not haphazard, fashion on a trip to Paris with Clive Bell and Desmond MacCarthy, a young literary critic. They toured the dealers gathering in an eclectic assortment of recent and not so recent work. There were canvases by Manet, Cézanne, Gauguin, and van Gogh, as well as pictures by younger artists such as Matisse, Rouault, and Picasso. Casting around for an umbrella term under which to group so diverse a band, Fry, in some desperation, came up with the name 'Post-Impressionists', noting that – if nothing else – it was chronologically accurate, except in the case of Manet. As a result the show was called 'Manet and the Post-Impressionists', the title neatly echoing that of Théodore Duret's book *Manet and the French Impressionists*.[4]

A special press preview stirred up what Fry later called a 'wild hurricane of newspaper abuse from all quarters'. It was followed by an even wilder hurricane of popular abuse three days later when the show was officially opened to the public. Insular and inward looking, the majority of British gallery-goers had managed to remain in wonderful ignorance of the achievements of van Gogh, Cézanne, and Gauguin (all of them dead by 1910) and were even less aware of the recent experiments of Matisse and Picasso. Revelation came as a shock. The reaction was extreme. Rude blasts of indignation vied with harsh squalls of laughter. *The Sketch* announced its round-up of pictures from the exhibition under the heading, 'Giving Amusement To All London: Paintings By Post-Impressionists'.[5] Desmond MacCarthy recalled how one visitor, a 'stout elderly man of good appearance, led in by a young woman, went into such convulsions of laughter on catching sight of Cézanne's portrait of his wife that his companion had to take him out and walk him up and down in the fresh air'. Some, however, failed to find anything to laugh at. Wilfrid Scawen Blunt considered the show

a 'swindle' rather than a practical joke, since there was 'no trace of humour in it'. The critic from the *Daily Express* denounced the work on view as 'paint run mad', and the medical profession was consulted to confirm the accuracy of this verdict.[6]

On the art world its effects were various, even confusing. The conservative faction was predictably offended. Sir William Blake Richmond RA announced that the exhibition made him ashamed of being a painter – perhaps he was the elderly Academician who attempted to restrain Oliver Brown from entering the Grafton with the cry, 'Don't go in, young man, it will do you harm. The pictures are evil.'[7] This, of course, was only to be expected; but elsewhere, as Eric Gill wrote to Rothenstein, 'the sheep and the goats are inextricably mixed up'. He went on: 'John says "it's a bloody show" & Lady Ottoline says "oh, charming". Fry says, "What rhythm!" & MacColl says "What rot".'[8] Where MacColl led, the New English Art Club was apt to follow. Steer, who rarely voiced strong opinions, confined himself to the laconic observation, 'I suppose they have private incomes.' But his reticence was more than made up for by Tonks, who 'did all the foaming of the mouth necessary' for the whole group.[9]

Amongst many of the younger generation of painters, however, there was burning enthusiasm. Vanessa Bell and her Friday Club friends found in the exhibition 'a sudden liberation and encouragement to feel for oneself which were absolutely overwhelming',[10] and in Fitzroy Street the show was received with equal excitement. Although the work of the various painters on view was not unknown to the Francophile members of the group, the chance to see such a concentration of it – and so conveniently – was welcome.[11] But while Gore, Gilman, and the others sought eagerly to draw new lessons from the work, Sickert remained detached. He adopted a tone of wise but slightly weary benevolence, expressing mild surprise that a show by such established artists as Gauguin, van Gogh, Manet, and Cézanne (artists whose work he had known for years) should be causing so much fuss.

Of the younger contributors he remained wary. Matisse's work he condemned as 'nonsense' and suggested that they had been included only to provide convenient copy for the press – and thus useful publicity for the show. Picasso and Maurice de Vlaminck – or 'Flamineck', as he called him – were similarly dismissed. Even his praise for the older artists was hedged with elaborate qualification. Cézanne, he suggested, while capable of masterpieces, had become 'immensely

overrated' due to the 'great "operations"' of the Parisian dealers, who
had promoted his work since his death; and while he admitted that van
Gogh's work might be 'interesting and stimulating', even, on occasion,
'undeniably great', the execution – 'these strips of metallic paint that
catch the light like so many dyed straws' – struck him as repellent. In the
case of both painters he insisted upon their debt to the Impressionists
and, indeed, the Pre-Impressionists – to the traditions not only of Degas
and Pissarro but also of Corot, Courbet, Daumier, and Delacroix.[12]

His views found little favour. It was the very apparent novelty of
the show – the extraordinary brightness of the colours, the weird
distortions of form, the disconcerting simplifications of design – that
so excited spectators, whether favourably or unfavourably. They were
not inclined to surrender this thrill in the New. Sickert, who had spent
the previous three years trying to establish a 'Salon d'Automne' milieu
in London and introduce a reluctant British public to work in a
'modern notation', suddenly found himself overtaken, his voice
drowned out by the clamour of Roger Fry's Post-Impressionist circus.
The Salon d'Automne had arrived in London without his assistance,
and not in a manifestation he approved of. Sickert, for so long used
to leading, found himself being hurried along by others.

The exhibition, amongst its many effects, revealed to the Fitzroy Street
artists the severe limitations of the NEAC. The club had ceased to be
an agent of progress but it was now exposed as a force of reaction. To
the younger members of the Fitzroy Street Group it seemed clear that
their work – only grudgingly admitted up to now – was likely to be
even less welcome in future. Discussions that had previously centred
upon the possibility of gaining control of the various committees
and reforming the club from within now veered towards the idea of
establishing a rival body. Gilman, the most doctrinaire and the most
eloquent of the group, was the 'prime mover' in this scheme, but
Sickert fully supported him.[13] If there were to be changes, it was as
well that he should have a say in them. A decision was reached on
the matter at one of the informal dinners that usually followed a
Saturday 'At Home'. Around the table at Gatti's, Sickert, Gore, Gilman,
Robert Bevan, and a recent recruit to the group, the French-born and
French-trained Charles Ginner, resolved to found a new and 'advanced'
exhibiting society. As they emerged from the restaurant, Sickert –

dramatizing the moment – announced, 'We have just made history.'[14] Further meetings followed around other tables in other restaurants. Lucien Pissarro, Walter Bayes, and another Paris-trained newcomer, James Bolivar Manson, were brought in to thrash out the details of the new group's membership and constitution; and though Gilman and Gore continued to take the lead, both still looked instinctively to Sickert for guidance. When a name had to be chosen for the new body, it was Sickert who came up with 'The Camden Town Group', claiming that 'the district had been so watered with his tears that something important must sooner or later spring from its soil'.[15]

At a practical level Sickert backed Gilman's call for membership to be restricted to men only, lest – so it was explained – 'some members might desire, perhaps even under pressure, to bring in their wives or lady friends and this might make things rather uncomfortable between certain of the elect, for these wives or lady friends might not quite come up to the standard aimed at by the group'.[16] The move had the effect of excluding Fitzroy Street's two female painters, Nan Hudson and Ethel Sands; but, as Sickert brusquely informed them: 'As you probably know, the Camden Town Group is a male club, and women are not eligible. There are lots of 2 sex clubs, and several one sex clubs, and this is one of them.'[17]

The initial membership was sixteen. Almost all of them came from the core of the Fitzroy Street Group. A few were drawn in from the periphery: Augustus John, for all his reservations about the Post-Impressionist show, was invited to join – he was too much of a draw to be excluded. Several loyal disciples were also added. Sickert exerted himself to secure the inclusion of his protégé and former pupil Malcolm Drummond.[18] There was some debate over whether to admit Wyndham Lewis, whose work was already experimenting with the wilful distortions of Cubism, but Gilman's advocacy carried the day. Gordon Lightfoot, a member of Vanessa Bell's Friday Club, was the only artist included from beyond the immediate ambit of Fitzroy Street. Sickert remained in familiar surroundings, but, though he was the senior member of the new body, there seems to have been no suggestion that he take on the presidency. His recent ill health, and his consequent retirement from the helm of the Fitzroy Street Group, placed him outside the frame. Gilman, as the most vociferous figure, might have hoped for the position, but Gore, with his rare gift of tact, was thought to be more suitable and was duly elected president, with

Manson undertaking to serve as secretary. Sickert played the godfather role. It was he who persuaded Arthur Clifton to let the group have the use of the Carfax Gallery for their inaugural show.[19]

Sickert was in good odour with the gallery. They had held an exhibition of his drawings at the beginning of 1911 and, in what seems to have been an immediate response to the challenge posed by the Post-Impressionist exhibition, Sickert had chosen to show several of his works with a clothed man and a naked woman lounging in the familiar setting of a dingy lodging-house bedroom. The drawings, though small, were arresting. They depicted a world still entirely outside the canon of accepted British subject matter, and did so with a shocking directness. Though some of Sickert's allies in the press praised the exhibition's power, the common reaction was one of scandalized horror. Sir William Blake Richmond, only just recovered from his visit to the Grafton Galleries, wrote to Robbie Ross complaining at his praise of Sickert's 'disgusting Bordello exhibition'. He thought the work 'worse than the P[ost] I[mpressionist]s'. 'Sexualism in art', he opined, 'can only be redeemed by grand treatment. This is worse than Slum Art, worse far than Prostitution, because it is done by a man who should know better.'[20]

Sickert followed up this *épate* at the Camden Town Group's first show in June 1911. Two of his four submissions were paintings based on the controversial Carfax drawings. Already shocking in their subject matter, he gave them an additional edge by titling them *The Camden Town Murder Series: Numbers 1 and 2*. It was the first time he had shown such paintings or used such titles in London. He certainly wished to cause a stir; and amongst the assembly of brightly coloured landscapes and sun-speckled interiors the pictures did provoke their inevitable due of scandalized disapproval – as well as some useful publicity. Their specific Camden Town settings confirmed Sickert's position at the heart of the toponymous group. Even so, the impact was less than it might have been. For all the modernity and daring of their subject matter, their titles and their handling, Sickert's Camden Town Murder pictures were not the most innovative works on view. Wyndham Lewis' two highly stylized drawings of 'The Architect' were something quite other. They seemed to presage a whole new world of form derived from the experiments of the youngest Post-Impressionists. They attracted even more abuse than Sickert's paintings.

* * *

Despite his commitments to the Camden Town Group, the Carfax Gallery, the Westminster Technical Institute, and Rowlandson House, a considerable part of Sickert's energy remained directed towards romance. On 2 July 1911, at a Bloomsbury party, he gave Vanessa Bell what she described as 'an extraordinary account of his love life'.[21] Sadly, she does not provide details, but those that can be pieced together suggest that her choice of adjective was just. After the disappointments of the previous year, Sickert had fixed his attention on another Rowlandson House pupil, Christine Angus. The 34-year-old daughter of a well-to-do leather merchant who lived in Porchester Square, Bayswater, she was not an obvious choice. Consumption had taken its toll on her health and vitality; her gait was hampered by a slight limp; nor – amongst the glittering crowd of young Rowlandson House students – was she conspicuously beautiful. Her sister rather ungenerously called her 'plain almost to the point of ugliness'. Sickert always claimed that she looked like a pelican, though he seems to have counted this in her favour and remained enchanted by her appearance, especially her dark-blue eyes.[22]

She was talented: an accomplished needlewoman whose tapestries and embroideries were already sought after.* She possessed an undeniable, if quiet, sense of style. As one friend recalled, 'It was a distinction that depended as much on manner and bearing as on appearance. She called up images of far off things; she was excessively thin through the hips and shoulders and her waist was childishly small; her poise, stiff, angular, immobile, was Egyptian; her slanting eyes and fixed smile were early Greek. She never fidgeted or fussed; she never lounged, sat or stood carelessly; her collected gestures revealed a curious, jerky grace, her arms moved forwards and backwards but never sideways, like a Dutch doll.' Always immaculately turned out, she wore her dark hair in a chignon; her clothes always 'fitted her style and character'. Sylvia Gosse considered her a joy to look at, whilst another friend described her as 'the most distinguished woman he had ever met'.[23]

Her character, though unassertive, was strong. Sickert admired what he called her 'Scottish' qualities: intellect, sanity, independence – and humour.[24] And although many people, unaware that she was ill and confounded by her reserve, found her unexceptional on first acquaint-

* A blue 'damask tunicle' embroidered by Christine is preserved at Westminster Abbey; it was used at the Coronation in 1937 (LB II, 32).

ance, almost all came, in due course, to appreciate her rare and gener-
ous spirit.[25] Sylvia Gosse thought that no one 'could fail to love her'.[26]
And Sickert did love her – or thought he did. The progress of his
courtship is unrecorded. As far as the Angus family knew, Christine
never met Sickert outside her classes at Rowlandson House. Neverthe-
less, he does seem to have proposed to her. She may have hesitated
about accepting him: no engagement was announced, and her family
remained ignorant of any attachment.

It was not Sickert's only secret. At the same time that he was wooing
Christine, he was also carrying on an affair with one of his students
at Westminster. She remains a mysterious and alluring figure. Accord-
ing to George Moore (who never met her), she was a beautiful creature
with red hair, a swan neck, and a creamy complexion. He referred to
her as Edith.[27] Madeleine Knox thought that her father might have
been a clergyman, although Sickert later referred to his liaison with her
as that 'thrilling' time 'when I tried so hard to secure the adventurous
experience of marrying beneath me'. She, like Christine, was definitely
a Scot – a 'Stuart of Appen on both sides' (to which declaration Sickert
had replied that, 'as a German', he could claim only to be a 'Sickert
of Appenrodt');[28] and she seems to have had an animal allure rather
different from the air of elegant restraint projected by Miss Angus.

Sickert proposed to her too, and was accepted – the engagement
was posted in the press. Christine was perceptibly, and understandably,
perturbed when she saw the notice.[29] Sickert offered her no expla-
nation. He did write blithely to Ethel and Nan at the end of May: 'I
am marrying at once, a young woman from the Highlands and Camden
Town . . . Will you extend your invitation [to Newington] for Whitsun-
tide to her?'[30] His friends, however, were denied the opportunity of
meeting this new Mrs Sickert. On the appointed Saturday, instead of
Sickert and his bride, a telegram arrived: 'Marriage off too sore to
come.'[31]

According to the account that Sickert gave Florence Humphrey, he
arrived at the Camden Town Registry Office to find the girl together
with another man whom it turned out she was also engaged to marry.
As the registrar explained to her, 'You can't marry two men! You had
better all go for a walk and talk it over.' The girl and Sickert's rival
then took a walk by themselves. When they came back, the bride
announced that she 'had decided to marry the other man'.[32] George
Moore later embellished this bathetic tale into a full comic opera. In

his telling of the story, later published in *Conversations in Ebury Street*, Sickert and his bride were due to come for a small celebratory dinner, laid on by Moore at his Ebury Street home. Steer and Tonks were the other guests, and they all crowded onto the balcony to see the happy couple alight from their taxi. They were half mystified, half alarmed, when only Sickert emerged. To their anxious enquiries he could only answer, in a barely audible whisper, 'She married the other man.' A fuller account of events had to wait until after dinner, when Sickert then told the sad tale in a 'low stricken voice'. His intended bride, he explained, had not cared for the Camden Town Registry Office, 'it seemed paltry in her eyes'.

> I said, 'We shall never see the street again.' 'If you have any real affection you speak of for me, you wouldn't have asked me to marry you in so mean a street. I really would not like my people to know I was married in Camden Town.' 'It was once a very pretty village,' I replied, and with various arguments, all of them good and honest, I persuaded her to come upstairs, but she barely crossed the threshold when her courage seemed to fail her. There are no pictures on the wall, and seeing that nothing would satisfy her but her own parish, I said, 'You haven't given notice.' She answered she had. 'But we shall never get to Pimlico before the registry office closes.' 'Why do you want to be married today?' she asked, turning suddenly, and feeling that I could not say the right thing in any circumstances, we got into a taxi and went for a drive. Anywhere, no matter where, so as the drive be long, I cried; and the taxi driver seeming to understand, took us over Hampstead Heath, and the same things were said over and over again all the way to Barnet.[33]

Taking fright at these semi-rural surrounds, the girl insisted that they turn back. The driver, however, insisted on going into Barnet as the cab was running out of petrol, and he wanted his dinner. By the time this twin refuelling operation was accomplished, it was late. On the return journey the cab broke down in the middle of Hampstead Heath and they were compelled to spend the night in the vehicle, the fractious bride-to-be dozing on Sickert's shoulder, the driver snoring on the front seat. In the morning they began pushing the taxi back towards Central London. Luckily they soon met another cab, which Sickert hailed. It took him and his fiancée to the Hammersleys' house, nearby.

Mr Hammersley came down in his dressing gown to let them in. He
gave the bedraggled pair breakfast and the food seemed to raise the
girl's spirits for she then announced that 'her mind was made up' and
that they could get married at Camden Town after all. But when they
arrived back at the registry office, she exclaimed,

> 'Look, look. There's Ernest,' and she pointed to a tall fellow in
> a blue suit and a grey hat leaning on his cane at the door of
> the office. 'Are you going to marry me or him?' I asked, and
> she replied: 'I don't know what I am going to do now. You
> had better settle it between you.' We agreed to leave it to her,
> but she said: 'You must settle it between you.' 'If you can't
> make up your mind to marry me,' I said, 'I suppose you had
> better marry him. I can't wait any longer.' And I left her with
> Ernest, whom she married no doubt.[34]

Although it is difficult to reconcile the two accounts exactly, they do
provide a vivid suggestion of the awful event.

Sickert himself left no detailed record. 'As you may imagine,' he
wrote to Nan and Ethel, 'my misadventure does not lend itself to
literary treatment.'[35] He tried to remain philosophical: 'At my age most
people I suppose have learned that nothing is intolerable. My old
mother, who is a realist, says "Never mind. Better luck next time!"'
Nevertheless, the wound stung. 'Oddly enough,' he admitted, 'the
happiness that this dratted monkey from the Highlands allowed me
to entrevoir [glimpse] is such that I would willingly do the whole
thing over again.'[36] Even in the first flush of his disappointment and
humiliation, he had told Moore that he would rather have been 'miser-
able with her than happy with anybody else'.[37] The mood, however,
passed quickly – very quickly.

Only days after the debacle, Ethel and Nan were amazed to receive
a second telegram: 'Reverted quite justifiably to a previous engagement.
Married I am well and reasonable!'[38] In his unmarried state he was
certainly behaving in a most unreasonable way. Although *he* may have
felt justified in reverting to his 'previous engagement' to Christine
Angus, *she* had even more justifiable doubts about the arrangement.
She refused him.[39] Sickert then embarked on a full-scale campaign,
'courting her by express letter and telegram', and presenting her with
numerous drawings – touchingly inscribed to 'Miss Angus'. In the face
of her continued refusals his energies did falter briefly. When he spoke

to Vanessa Bell at the beginning of July, he complained that he was 'too old' to do any more proposing, and 'should accept the next person who proposed to him'. (Vanessa facetiously wondered whether this was supposed to be a hint to her.[40]) In the event, Sickert went on proposing to Christine. She became so overwhelmed by the unceasing onslaught that her health, always delicate, buckled. Her brother Harold was at the time staying in a sanatorium at Chagford, Devon, and it was decided that she should join him there for a recuperative visit. Sickert went to Paddington to see her off, but instead of bidding her farewell he boarded the train and travelled down to Devon with her. In a display of characteristic extravagance, he changed her ticket from third to first class. Although it is unlikely that this gesture won over the level-headed Christine, by the time they returned from Chagford she had consented to marry him.[41]

There remained, however, the matter of Mr Angus's consent. Although Christine had a modest income of about £175 a year, her father doubted whether this would be enough to support a household and a husband.[42] Christine, having made up her mind, was firm: she declared that she would rather marry Sickert without any money than not marry him at all.[43] Sickert, too, was not to be put off easily. When the family tried to discourage him with accounts of Christine's frail health, he stoutly replied, 'All the more reason that I should look after her.'[44] But how? Mr Angus, a businessman with no experience of the art world, had a very modest opinion of a painter's earning potential. The little he knew of Sickert's work was not encouraging.

He had almost certainly registered Sickert's showing of the two Camden Town Murder paintings at the Camden Town Group's inaugural show in June, but they were scarcely calculated to enhance Sickert's standing as a potential son-in-law.* Rather more propitious was the large retrospective exhibition of Sickert's paintings of Dieppe, Venice, and the London music halls that opened at the Stafford Gallery, in Duke Street, St James's, in the second week of July – the largest gathering of Sickert's work in London to that date. Though the

* The Angus family were certainly not philistines, and when Christine's sister, Andrina, got married to a Mr Ronald Schweder, Sickert boasted to Nan that – during the reception at the Hyde Park Hotel – he had 'made the acquaintance of innumerable Scots aunts and uncles in law including 2 persons – one venerable & one young – who seemed to welcome their relationship to the painter of the Camden Town murders as rather a distinction than otherwise'.

critical reaction was varied, there was widespread recognition of Sickert's real weight of achievement: *The Times* called him 'a serious and original artist', and the exhibition a display of 'the pure art of painting'.[45] Roger Fry hailed Sickert as 'a master', in the sense that 'everything he produced is really done; he does not make shots at things; the particular thing that he set out to do is actually and almost infallibly accomplished'.[46] Perhaps more significantly, at least to a businessman like Mr Angus, the directors of the Manchester City Art Gallery were sufficiently impressed by the show to buy *Mamma Mia Poveretta* for their collection.[47] It was Sickert's first sale to an English public gallery.

Mr Angus began to perceive that a painter might actually secure a living. On making enquiries he was told (it is not known by whom) that Sickert 'was quite able to command an income of £600 a year'.[48] This optimistic forecast was lent plausibility when, immediately afterwards, an anonymous purchaser bought Sickert's great white elephant – the 1898 portrait of Hilda Spong in *Trelawny of the the 'Wells'*.* The unknown purchaser was in fact Sylvia Gosse. She offered the picture to the Tate, who refused it; but Robbie Ross arranged for it to be accepted by the Johannesburg Art Gallery. This double stroke of good fortune carried the day: Mr Angus gave his consent.[49] Arrangements were hastily made. Sickert had to break a dinner engagement with Florence Humphrey, explaining: 'I did not know that I was going to marry rather suddenly . . .'[50] To Nan and Ethel he wired: 'Marry Saturday a certain Christine Angus[.] Jeweller would not take wedding ring back.'[51]

The wedding took place at Paddington Registry Office on 29 July. It was a hot day. Gore was best man. Christine's younger sisters were in excited attendance. Her brother was one witness, Oswald Sickert was the other. According to legend, when Sickert gave his profession as 'painter' the registrar – much to his delight – enquired, 'house?'[52]† Christine radiated a 'serene dignity' throughout the occasion. After the wedding breakfast the couple held their 'first official and conjugal

* Lady Hamilton had sent it back after she left Tidworth at the end of 1908, since when Walter's brother Oswald had been giving it house room at his flat in Berners Street, near Oxford Circus.

† In fact the wedding certificate lists Sickert as a 'drawing master'. It is his deceased father who appears as 'artist (painter)'.

reception' at 19 Fitzroy Street – adding an air of hymenal festivity to the regular 'At Home'.[53] Amongst the presents they received was a pair of fine Venetian candlesticks from Prince Antoine Bibesco. Sickert was particularly pleased with a capacious 'Wellington Cloak' from Christine's brother.[54]

One of those most happy at news of the wedding was Ellen, who at last felt relieved of her responsibility towards Sickert. She dropped his patronym from her name and reverted to plain Cobden.[55] Nevertheless, connections were maintained. Much to her sister Jane's irritation, she kept in touch.[56] She sent Sickert the manuscript of her second novel for his comments, and it is probable that she continued to buy his work.[57]

For their honeymoon Sickert and Christine went to Dieppe. They found several members of the Camden Town Group already there, together with an almost full complement of Sickerts. As Wyndham Lewis reported to a friend in London, besides Walter there was 'the brother without any teeth [Bernhard?], the one-eyed brother [Robert], the one without any brains [Leonard?] and also his poor paralytic old mother. How with so many infirmities they manage to get even so far as Dieppe is a mystery to me.'[58] Mrs Sickert was delighted with her new daughter-in-law – finding her 'such a good woman & clever, and fond of my boy'; she gave her a large old brooch (the only piece of jewellery Christine ever wore).[59] In a photograph taken that summer they appear sitting happily together under Walter's complacent gaze. While in France they heard the news that one of Sickert's paintings – a view of the Boulevard Aguado – had been presented to the Musée de Luxembourg in Paris as part of the bequest of British art made by the collector Edmund Davis.[60] It was a further confirmation of Sickert's rising status.

On their return to London, Walter and Christine moved into a house at 14 Harrington Square, barely a hundred yards from Rowlandson House. Their new home was unnecessarily large and rather sparsely furnished. For Christine, Camden Town must have seemed poor, even squalid, after genteel Bayswater; but if the setting was unlikely, to many observers it seemed no more unlikely than the marriage itself. Sickert's artistic confrères could not understand what he saw in his quiet, diffident bride, whilst Christine's friends feared that the demands that her new life and husband placed upon her would undermine her already weakened health. Sickert expected her to play

the hostess at the Fitzroy Street gatherings, a role for which her natural reserve and limited supply of energy left her ill equipped.[61] It was away from the crowded world of the studios that their marriage flourished, and those who knew them well soon came to recognize the strength of their bond, and the great benefits it brought to Sickert's life.

Christine loved Sickert deeply, and he, for all his unchanged and unchanging selfishness, seems to have loved her, after his fashion. Though marriages must always remain mysterious to outsiders, those who knew the Sickerts well always stressed the happiness of their relationship. Sickert admired the gaiety of Christine's disposition, and also its quiet strength.[62] Sylvia Gosse, who remained the couple's unassuming guardian angel, considered that Christine was 'everything to Walter, understanding and supporting – delightful – educated'.[63] Marriage could not, of course, make Sickert 'reasonable', as he had claimed. But it could – and did – make him 'well'. Christine provided him with the long-forgotten luxury of a home. She shared his 'passion for cleanliness', and if their house was scantily furnished, it was scrupulously clean.[64] She protected him from the distractions and abrasions of the outside world, and from at least some of his own reckless actions, offering him security while making remarkably few demands. Her nature – if not self-effacing – was self-sufficient. She had her own work to do, and Sickert took great pride in her achievements. The pair of tapestry slippers that she made for him were amongst his most treasured possessions, and when she designed a special Christmas card for them to send out, Sickert insisted on making all the deliveries by hand, so that he could enjoy the reactions of the recipients. Christine made no effort to alter Sickert's routines. He continued to have his morning swim in the Euston Baths and his morning breakfast at the Euston Station Hotel. If she learnt of his occasional infidelities, she ignored them; and although she occasionally fretted over his extravagances ('What a little Scot you are!' he would mock), she preferred not to check them directly.[65] Her few surviving letters reveal her assurance and her humour; she treated her sometimes difficult husband with an amused – yet admiring – indulgence.[66]

At the end of 1911 the Camden Town Group held its second exhibition at the Carfax Gallery. The show built on the achievement of its prede-

cessor, confirming the serious intent of the group, the diverse approaches of its members, and the eccentricity of Wyndham Lewis. Duncan Grant, a stalwart of Vanessa Bell's Friday Club, had been elected to replace Lightfoot and to maintain some slight connection with the artistic world beyond Fitzroy Street. Over the winter there was much debate as to whether the group should expand further and draw in even more diverse elements. Sickert spoke against the plan, preferring to keep the group small and exclusive, but the majority of members – led by Gilman – favoured expansion. Discussion, however, was suspended when it was pointed out that the limited space at Carfax would mean that any increase in the total number of members would lead to a reduction in the number of pictures each member could show. Nobody wanted that. Gilman proposed that a new and larger gallery should be found; but until then the group would continue in its existing form.[67]

That winter Sickert found himself drawn into another group. He was elected to the Society of Twelve. The group, which held an annual exhibition of prints and drawings, had been founded six years previously. The original members included Will Rothenstein, Augustus John, Ricketts and Shannon, William Nicholson, Conder, George Clausen, and Gordon Craig (the son of Ellen Terry and E. W. Godwin), along with such specialist practitioners as the etchers Muirhead Bone and D. Y. Cameron. In 1906 the membership had seemed at the leading edge of the art establishment; half a dozen years later they were already in danger of appearing conservative – not that Sickert set any store by such distinctions. His interest was focused on the practicalities of printmaking, and the techniques of printing.[68]

He had grown suspicious of the modern trend amongst printmakers – and print dealers – to set great store and value by the creation of different 'states' of the same plate, through tricks of inking, wiping, and printing that produced almost unique images. In reaction to this perceived preciousness he advocated what he called 'visiting card printing'. All the relevant visual information, he suggested, should be etched on to the plate, which could then be printed up by a professional printer. He gave a witty exposition of his ideas in 'The Old Ladies of Etching-Needle Street', a long article that he contributed to the English Review, the periodical edited by Ford Madox Ford.[69]

During the first part of 1912 Sickert wrote a monthly piece for this self-confessedly 'heavy' journal alongside his regular contributions to

the *New Age*. He took up deliberately unfashionable positions on most
of the art issues of the day – art school teaching (too much of it), state
support for the arts (a bad idea), Sir Edward Poynter's paintings (greatly
underrated). His abiding theme was the – as he saw it – misguided
vision of modern art being championed with such success by Roger
Fry and Clive Bell. The Post-Impressionist exhibition had propelled
the Bloomsbury critics to a pre-eminent position as the arbiters of
artistic modernity. In their articles, lectures, and books, they pro-
claimed Cézanne as the Messiah of the new movement, with Matisse
and Picasso his brightest disciples. Recasting the art-for-art's sake ideas
of Whistler for a new generation, they insisted that a work of art should
be considered in purely formal terms, as an arrangement of shapes
and colours. Subject matter, Bell contended, was at best irrelevant, at
worst pernicious. The success of a work of art was to be judged only
on its achievement of what he termed 'significant form' – a rather
vaguely defined standard of formal beauty.

To such grand claims (and to the 'Double Dutch' in which they
were often expressed) Sickert took cheerful exception. Much as he
loved practical theories, he had a profound distrust of all a priori
intellectual ideas about art. He disliked, too, the exclusivity of the
Bloomsbury creed: the belief that all good art must derive from the
tradition that they had mapped out. And as Fry and Bell sometimes
overstated their case, so Sickert overstated his refutations.* Although
he was content to acknowledge Cézanne's occasional successes, he
maintained that the Frenchman was too limited an artist (too poor a
draughtsman, too awkward a painter) to provide a useful model for
others. He also doubted whether the 'tedious invention' of Picasso or
the 'empty silliness' of Matisse owed anything to Cézanne's example,[70]
and he felt that none of them came close to creating the 'significant
form' perceived by Bell and Fry. Not that he believed that formal values
could or should be the sole measure of art. In his own paintings over
the previous eight years – his figure studies, his domestic interiors,
and low-life genre scenes – he had reacquainted himself with the
dramatic possibilities of art and had ranged himself, as he put it,
against the 'no-meaning theory' of art expounded by Whistler

* Sickert backed up his press campaign with practical jokes. When Clive Bell
remarked upon the 'peculiarly idiotic' picture hanging over Sickert's mantelpiece,
Sickert told him he had put it there 'pour emmerder Fry'.

and Bloomsbury. It was ground upon which he was prepared to stand and fight.

Once again, Sickert had taken on too much. He had to turn down a suggestion that he write a book on drawing for Chatto & Windus,[71] and with the advent of the summer he tried to reorder his commitments, doubtless encouraged, if not prompted, by Christine. They moved out of Harrington Square to a less enormous house, at 68 Gloucester Crescent, where they could manage (though not entertain) without a servant.[72] It was still only a short walk to the Hampstead Road, to the school and the studio. In June 1912, at the end of the summer term, Sickert gave up both his work for the *English Review* and the night classes at the Westminster Technical Institute, handing over his teaching duties to Gore and Gilman.[73] He also resolved to get rid of his villa at Neuville. It was no longer an ideal location, and the steep walk that led up the hill was over-taxing for Christine.[74] Staying there over the summer, they decided to try and find a new place in the countryside outside Dieppe. Sickert enlisted the help of his friend Polly Price, who still returned each year to see her mother at the Tour aux Crabes. She put him in touch with M. Anjouy, a framemaker in the rue de l'Eppe who had a thorough knowledge of local properties. Sickert sketched out for him his ideal of a simple little house with a stream running beside it into which he might urinate if it pleased him. M. Anjouy was impressed by this last specification; as he reported to Mrs Price, 'Il est bien rustique, ce Monsieur Sickert!'[75] They discovered something close to their ideal in the little village of Envermeu some ten miles out of Dieppe on the road towards Arques. The Villa d'Aumale was a modest rustic property in the middle of the village with a stream running through the garden.[76]

The Sickerts went back to London at the end of the summer but already with the thought that they might return to live for at least part of each year at Envermeu.[77] The plan, however, was not put into immediate effect. Relieved of some of his weekly burdens, Sickert was better able to enjoy his London life. When Ethel Sands brought Blanche, Hilda Trevelyan, and some others to a Fitzroy Street gathering early that autumn, she found the newly unencumbered Sickert 'sleek and happy'. He was now free to work all afternoon, drawing at his Granby Street studio.[78]

He had assembled a shifting group of models to work from. Ignoring his own strictures about the 'good artistic hygiene' of banishing

one's own circle from one's art, he sometimes made use of friends. Both Gilman and Ginner appeared in his pictures, though usually in some semi-theatrical disguise. For the most part, however, Sickert preferred to gather in local characters from the streets and bars of Camden Town: a retired prizefighter; a funny little man 'who took an interest in the Royal Family'; Marie Hayes, his sometime charwoman; various 'divine' costers and other cockney sparrows. Prominent in this colourful cast was the stout white-haired figure of 'Hubby'. He was understood to be an old schoolfellow of Sickert's, though the connection can only have been nominal, since it dated to the brief and distant days at Bedford.[79] Hubby had run away to sea and spent some years in the merchant marine sailing in Eastern waters, before returning to England to a life of drunkenness, vagrancy, and petty crime. Alerted perhaps by Sickert's rising public profile he had made his way to Granby Street, arriving there with a suitcase – not his own – that he had picked up at Euston Station.[80] Sickert took him in as both model and studio factotum. It is his distinctive form that holds the centre of many of the small dramas of domestic strife and triumph that Sickert set down at Granby Street. The scenes, though stage-managed with increasing flair, were muted and unemphatic – in both their moods and their titles: *Off to the Pub*, *A Few Words*, *Jack Ashore*, *My Awful Dad*. The high drama of the Camden Town Murder paintings was replaced by the simmering tension of the tiff.

Sickert had come to believe that art should avoid extremes and 'rare phenomena' – that 'the most productive subjects are found in ordinary people in ordinary surroundings: neither too large nor too small, neither very rich nor very poor, neither very beautiful nor very ugly'.[81] Certainly his most celebrated picture of the period was a distillation of the banal: two people in a room doing nothing. He titled it *Ennui*. And yet his rendition of this very ordinary scene was both beautiful and suggestive. Whole essays have been written conjuring up imagined (and often contradictory) stories of these two not very beautiful figures in their not very ugly parlour. Sickert was pleased with the effect. He insisted with increasing vehemence that he was a 'literary' painter and that all 'great' art – from the Renaissance to Charles Keene – was essentially 'illustration, illustration, illustration'.[82] 'All the greater draughtsmen tell a story,' he declared. And the fact that his own stories were always unspecific – suggested by the title but supplied by the viewer – did not discourage him from allying himself to the great

tradition. 'When people, who care about art, criticise the anecdotic "Picture of the Year", the essence of our criticism is that the story is a poor one, poor in structure or poor as drama, poor as psychology . . . A painter may tell his story like Balzac, or like [the popular novelist] Mr [Robert] Hichens. He may tell it with relentless impartiality, he may pack it tight, until it is dense with suggestion and refreshment, or his dilute stream may trickle to its appointed crisis of adultery, sown thick with deprecating and extenuating generalisations about "sweet women".'[83] Sickert aimed at the 'relentless impartiality' of the Balzac model; and if he sometimes rather overstressed the illustrative content of his work, it was because such claims served as a resounding counter-blast to the 'anti-literary' theories of his old master, Whistler, and his present bugbear, Fry.

Sickert urged Ethel Sands to come and draw with him at Granby Street.[84] Always generous with technical advice, Sickert had Ethel and Nan's work back in his sights, and was once more full of urgent sugges-tions. Perhaps he felt some indirect responsibility for their productions. The two women had had a joint exhibition at Carfax in June, and – rather to Sickert's amusement – several reviewers had remarked upon their debt to him.[85] No less amusing to him was the fact that George Moore had taken up – or had been taken up by – Ethel and Nan. Sickert was determined to assert his pre-eminence.[86] Relations between him and Moore, often prickly, had bristled up in recent years. Moore particularly resented Sickert's increasingly slighting references to his practical art knowledge. That July, Sickert had written a letter to the *Pall Mall Gazette* disparaging Moore's pretensions as an authority on drama following the unsuccessful production of his play *Esther Waters*. He concluded with the swipe, 'It is a pity that we cannot now have a painting by Mr Moore as a sequel to his criticism of painting.'[87] Moore responded with an intemperate attack on Sickert in the *Fortnightly Review*. His article began, 'No one is blinder to proportions, anatomies, and gestures than Walter Sickert', and went on to claim that he had only achieved what he had by 'always keeping well within his [considerable] limitations'.[88]

Sickert, however, having dismissed Moore's credentials as an art critic, was not likely to be offended by such an assault. Ethel Sands found him chuckling over the article when she next called on him, and when she and Blanche urged him to come to a dinner party at Moore's home, he readily accepted. Unfortunately, Blanche omitted

to mention the invitation to Moore, who was extremely put out to find Sickert at his table. He 'sulked straight through dinner', as Ethel reported with guilty delight to Nan. Sickert, doubtless amused by Moore's discomfiture, remained bland and unperturbed, even when – after dinner – Moore roused himself to be 'very rude'. Nevertheless, he left early; and although the two men met again barely a week later at Edmund Gosse's, Moore refused to be mollified.[89]

The Camden Town Group's third exhibition opened in December 1912. The venue and the membership remained the same, but other elements in the equation had changed. The show revealed Sickert's isolation within the group. There was a new flavour to much of the work on view: bold and bright in colour, firm in outline. The influence of Gauguin and van Gogh on Gore, Gilman, Ginner, and Bevan in particular had become ever more apparent. Sickert's favoured themes had faded from the work of his confrères. Now landscapes predominated, rather than figures. Sickert was responsible for the only naked woman in the exhibition. She appeared dappled by sunlight sitting across a narrow bed from a dejected working man, in a picture which – for all its obvious Camden Town setting – he had titled *Summer in Naples*. Manson, who, despite his membership of the Camden Town Group, did not scruple to review the exhibition in glowing terms, acknowledged Sickert's unique separateness, calling him, 'the pill in the jam of modern art'.[90]

The jam was being ever more thickly spread. The Camden Town Group's show was rather overshadowed by Roger Fry's 'Second Post-Impressionist Exhibition', which had opened at the Grafton Galleries in October 1912 and was still running. Alongside its display of continental Post-Impressionist work (dominated by the twin talents of Matisse and Picasso, and the presiding presence of Cézanne), it contained some pictures by British artists. Although amongst those represented there were some members of the Camden Town Group (including Gore, Wyndham Lewis, and Duncan Grant), most were from outside the group. It became convenient for the critics to emphasize the distinctions rather than the connections. The Camden Town Group found itself being characterized as a *via media* between the excesses on view at the Grafton Galleries and the more conventional attractions displayed at the NEAC.[91]

Sickert placed himself above such trite formulations. His writings and his actions defied them. He continued to exhibit at the NEAC.

(That winter he showed a painting of a 'Cinematograph', carrying his own music-hall genre into a new phase of conspicuous modernity.) Other members of the group, however, were anxious not to lose touch with what they saw as the advance guard being led by Fry. When the Grafton Galleries exhibition was granted an extension at the end of the year some re-hanging was necessary, and there seems to have been a suggestion that the Camden Town Group might be invited to exhibit 'en bloc' in the revised scheme. Manson's comment, in a letter to Pissarro, 'I fancy Sickert can look after himself!', suggests that Sickert may have demurred from the plan, which – in any case – was not carried out.[92]

Across the London art world, arrangements, allegiances, and hierarchies were in a state of constant flux, with each new 'survey exhibition' suggesting a new alignment. Sickert held his place in this artistic ferment, but his position was increasingly hard to define. On the international stage he was drifting to the periphery. His work was included alongside pictures by Steer, Shannon, Conder, and John in a curiously conservative gathering of British painting assembled by the Association of American Painters and Sculptors for a large international survey show to be held at the 69th Regiment Armory on Lexington Avenue, New York. It was the exhibition that introduced America to 'Modern Art' and established the reputation of – and the market for – the recent Parisian schools in painting. Amongst the most important loans to the show were works by Signac, Vuillard, Bonnard, and Matisse provided by Fénéon at Bernheim-Jeune. A few years previously Sickert's work would surely have been included in such a gathering, and he would have been welcomed into America as a daring Parisian rather than as a provincial Brit.[93]

Although Sickert had given up his regular pulpit in the press, he still continued to proselytize. He wrote occasional letters to the newspapers and, in February 1913, he gave two lectures on art at Cambridge. He was much pleased with his reception at the university of his forefathers and, as Ethel Sands reported, returned to London envisaging himself 'already as the Slade Professor with £300 a year'.[94] That dream remained unfulfilled, but later in the year he was invited to talk on 'the new movement in painting' at Leeds University.[95] Setting himself against the theorizing of Bloomsbury, he planned to write a book on the practical aspects of painting and approached the publishers Macmillan about the project. He hoped that they would offer encour-

agement but not burden him with a definite commission, which, he
explained, he would 'loathe . . . & wither under'. To break up the task
of composition, he planned to send Ethel and Nan regular notes on
technique. 'Keep them as they accumulate,' he urged them. 'They will
serve me as a sort of dictionary for my eventual book.'[96] The book
never did eventuate, but the letters of technical advice certainly did.
One missive ran to over nine pages, covering such topics as the virtues
of drawing to the scale of vision and his current view on the best
method of applying pigment to canvas ('PAINT LIKE A VERY STIFF STREET
SWEEPING MACHINE ON MACADAM'). Another letter to Ethel rounded off
its budget of advice with the observation, 'Your education, Mademoiselle,
or rather my tinkering at your education[,] will only cease when
a wide deal box with plated handles disappears through the buttery
hatch at Golder's Green [crematorium].'[97] She must sometimes have
wondered whether he was jesting.

Sickert carried his assault forward on all fronts. Keen to do some-
thing that should 'live as long as paint', he began another portrait of
Ethel, done from an informal photograph.[98] He sent her detailed advice
– and even detailed drawings – to help her with her own work.[99] He
urged her to come and sketch with him at Granby Street. He made
her numerous presents. Indeed Ethel had to tell him that she and
Nan could not go on accepting drawings from him. He dismissed her
scruples, however, promising not to give them anything valuable, only
'little things'. And in confirmation he sent Nan a drawing of a peasant
woman, squatting down to defecate on the ground, with the deadpan
comment, 'isn't it a pretty hat'.[100]

Both Ethel and Nan also bought examples of Sickert's work – Ethel
even commissioned him to draw a portrait of her 4-year-old nephew,
Christopher. Due to the fashionable anxiety about 'microbes', the
sitting took place not at insalubrious Granby Street, but in the spotless
comfort of Ethel's Chelsea house. Sickert produced 'a really charming
drawing', though he joked that it marked his capitulation to the
lure of fashionable portraiture. Contemplating his handiwork, he
remarked ruefully: 'Sickert a drawing-room artist at last.'[101] Ethel's
brother Morton, who was embarked on a political career, had also
begun to assemble what would become a major collection of Sickert's
work. Sickert was not shy of his young patron. At one early expression
of interest he sent Hubby round to Morton's house with fourteen
pictures for him to choose from.[102]

While plans for the expansion of the Camden Town Group were stalled for want of a larger gallery space, it was an easier matter to increase the more catholic and less formal membership of the Fitzroy Street Group. Gilman pressed for the admittance of Jacob Epstein, who as a sculptor was not eligible for the painters-only Camden Town Group.[103] Sickert was doubtful. Epstein's work, increasingly anti-natural and mechanistic, belonged to the Wyndham Lewis quadrant of extreme contemporary practice and was outside the range of Sickert's comprehension. He could not connect such experiments with anything he knew of art. (He likened Lewis to a racehorse who arbitrarily refuses to abide by the rules of the sport, announcing, 'You can't handicap me ... I'm no longer a horse. I'm a hippogriff!'[104]) But the younger members of the circle carried the day. Gore offered Sickert some reassurance, telling him that the 'danger' was 'exaggerated' and that 'we shall be able to insist on not having anything too too'. Sickert tried to remain positive, telling himself – and Ethel – that 'les jeunes are good for us',[105] though he then qualified this muted approval with the ominous, 'We shall see what we shall see.' As a counterbalance to the Epstein–Lewis axis, he also put forward two candidates of his own: Sylvia Gosse (who was not successful) and René Finch (who was).*[106]

Despite Sickert's attacks on the critical and curatorial positions of Roger Fry and Clive Bell, at a personal level relations between Fitzroy Street and Bloomsbury remained cordial. Bell and company, though sometimes irritated by Sickert's antics, and often dismissive of his pretensions to scholarship, continued to admire his work and the deep practical knowledge on which it was founded. Sickert assumed and enjoyed a privileged position at their gatherings and got on well with almost all of the 'Bloomsberries'. He even admired Virginia Woolf's novels, though he did complain that in one of them she opened a parenthesis and never closed it – 'a most unladylike failing'.[107] When, a few years later, Fry conceived the (never executed) idea of painting a 'great historical portrait of Bloomsbury' – assembling Lytton Strachey, Maynard Keynes, Clive Bell, Duncan Grant, Vanessa Bell, Virginia

* René Finch, the sister of Rufus Isaacs and the wife of the artist Harald Sund, achieved a notoriety later that year at the AAA exhibition when her Fauvist painting *Reginald*, showing a male nude with blue pubic hair, caused such outrage that it had to be withdrawn. (Sickert remarked with amusement that – besides its artistic value – her *Reginald* had 'enriched the English language with a much needed-euphemism'.) Finch was a chic and gamine figure who, as Sickert reported, had her hair cut *à la* Augustus John to attend the group 'At Homes'.

Woolf, Molly and Desmond MacCarthy, Mary Hutchinson, and him-
self – he thought he might even add the figure of 'Walter Sickert
coming in at the door and looking at us all with a kind of benevolent
cynicism'.[108]

Fry and the Bells not infrequently attended the Fitzroy Street 'At
Homes'. At one 'glorious' gathering, Sickert was delighted to be able
to introduce them to the now elderly Théodore Duret, friend and
chronicler of the Impressionists; and over the Easter holiday, when he
had remained in town to finish 'one or two etchings', Sickert invited
himself to lunch with Clive and his 'darling Vanessa'. 'Undercut of
roast beef,' he reported enthusiastically, 'yorkshire pudding & custard
tart & a bottle of claret!' His playful flirtation with Vanessa Bell
extended to a resolution that they should go swimming together in
the Serpentine.[109] The Bells' serious admiration for Sickert's work
encouraged them to visit his studios, both Granby Street and the Breck-
nock, in order to choose a picture. Sickert wanted them to buy *Summer
in Naples*, but they opted instead for 'a head – thinly painted with a
blackish background & bluish window & nice eyes'.[110]

Fry continued to drive forward with his progressive projects. With
the expansion of the Friday Club's artistic membership, he and the
other original painters in the group – Bell, Grant, and Frederick Etchells
– seceded to found a separate, new body, the Grafton Group. Despite
the name the group held its first exhibition, in March 1913, at the
Alpine Club Gallery. Fitzroy Street was represented in the mix: both
Spencer Gore and Wyndham Lewis showed work. Nor was the Grafton
Group Bloomsbury's only new venture that spring. In April, Fry –
along with his co-directors Bell and Grant – established the Omega
Workshops just around the corner from 19 Fitzroy Street, at 33 Fitzroy
Square. It was an artists' co-operative where painters and sculptors
could gain a small income by working part time, designing and deco-
rating pottery, furniture, and home furnishings along appropriately
'Post-Impressionist' lines. The Sickerts bought a lampshade.[111]

II

AN IMPERFECT MODERN

Walter, how skill'd a conjurer Time is!
Now that I'm old and grey (though still quite clever)
You're an authentic juvenile, and few things
Warm my heart more than to perceive you ever
Nailing your flag to some unseasoned mast –
A doer of the newest of new things,
And deem'd unruly by the boys of 'Blast'.

(Max Beerbohm, 'To W.S. – 1914')

Walter and Christine went over to France briefly after Easter 1913, stopping at Envermeu to supervise the building work being carried out at the Villa d'Aumale before going on to Paris.[1] There was little to keep Sickert in the French capital: he could summon up scant enthusiasm for current French painting. He called instead on the 79-year-old Degas, probably for the last time. He found his old friend ill and depressed – unable to work due the ever-growing blind spot in his vision, and unable to rest on account of an inflamed bladder. He had also been obliged to move from his beloved apartment in the rue Victor Massé to a new place in the rue de Clichy. Sitting forlorn amongst the unfinished works in his studio, he wondered with grim humour how many would be finished for him after his death by unscrupulous dealers.[2]

The Sickerts were back in France and at Envermeu by the end June, ready for a long summer holiday. Sickert kept Ethel and Nan informed of his thoughts, work practices, and living habits in weekly bulletins. Always responsive to changes of scene, he delighted in his new house, removed from what he now characterized as the noisy and enervating distractions of Dieppe, where 'endless people' were forever stopping him and insisting upon shaking hands. At Envermeu he could sit in 'perfect solitude' in a farmyard or field with his work and his thoughts.[3] He was also greatly pleased by the house's telegraphic address:

'Enmerdeux' – which, as he told Nan, was the Norman slang for 'good bye'.[4]

The change of pace suited him. His digestion had been giving him one of its periodic bouts of grief and he placed himself under 'Dr' Nan's care, following her prescriptions 'to the letter'. As an experiment, he gave up alcohol for the summer: 'If I were offered health & alcohol I would take *both*, but if it is health *or* alcohol, I can't understand anyone hesitating.'[5] If the quiet rural life was soothing to him, it was ideal for Christine. She 'sings to herself over her work when she is alone,' he reported, 'a sure signal I fancy of contentment. I think she likes sewing & embroidery as much as I like smoking and reading which I can quite understand.'[6] But, much as Sickert enjoyed his moments of nicotine-fuelled literary leisure, he liked working even more.

For the first time since 1908 he began to paint the countryside. Rising at six each morning he would set off with his paint box and 'a big toile de 6' on his back in search of a subject. 'I find I can do 6 kilometres of tramp', he boasted, 'without any fatigue at all.'[7] Within this radius he found many appealing scenes to make pictures of, and described them with ebullient lyricism to Ethel and Nan: the simple little dovecote in the neighbouring hamlet of Torqueville, standing in a farmyard stacked with 'innumerable mossy timber beams, writhing like snakes on the ground'; the Château of Hibouville 'peeping from its woods with an avenue and a cornfield in front'; a subject 'like a dream out of Midsummer Night's Dream! An oval gap among trees framed at the bottom with sprinkled tiny flowers like Waldmeister. Through the gap the path continues between trunks, the whole inside like a glowing transparent green cave . . . the rhythm and swing is incredibly beautiful.'[8] In rather less lyrical vein he mentioned another 'motive' that interested him very much: an obelisk on rising ground – 'I am looking down on it and the plain below rises above the whole length of the obelisk with a river and willows. So the obelisk serves as a measure of the receding plain.'[9]

He described one of his compositions as a 'Corot-Millet subject Germanized a little' – 'Schubert & Klaus Groth' in mood.*[10] His mind went back increasingly to the rustic holidays of his childhood in the

* Klaus Groth (1819–99) was a North German poet and folklorist. His celebrated volume of sentimental rustic verse, *Quickborn*, was written in the low Holstein dialect.

wooded hills of Bavaria and felt that there must be something heredi-
tary about his own artistic response to the sun-dappled scenes around
Envermeu. 'My grandfather and my father did endless drawings &
paintings of such subjects,' he explained to Ethel. 'I feel so at home
in them.'[11] He regarded his own arrival at landscape painting as the
achievement of a long-held ambition. He had, he claimed, always
wanted 'to paint streams & willows & sous-bois more than anything
since [he] was five years' old: and now he had 'the whole theatre . . .
under a hat'.[12]

In his regular bulletins to Ethel and Nan he mapped out the techni-
cal challenge confronting him. Having tested the limits of both thin
and thick paint, he was seeking a middle way between what he called
'starving' and 'slopping'. He worked towards a method of building up
his pictures with numerous layers of thin paint – an accumulated
'series of touches' put on over numerous sittings until, as he put it,
'one day *something happens*, touches seem to *"take"*, the deaf canvas
listens, your words *flow* and you have done *something*'. An 'infinity' of
operations was necessary to achieve a surface quality on which 'the
"touches" take' and 'become *visible* and *sonorous*'. That at least was the
ideal.[13]

Sickert's enthusiasm for the 'perfect solitude' of Envermeu, though
real, was somewhat overstated. He soon established a routine of a
regular visit to Dieppe each Saturday, to go to the market, visit his
colourman, have a swim, and shake hands with those 'endless people'
he otherwise avoided. Ginner was in town, as were Etchells and Wynd-
ham Lewis (the latter staying at a bug-infested pension in Le Pollet
recommended by Sickert).[14] Sickert was also glad to see something of
J. W. Morrice, his Paris-based Canadian friend; 'I like him so much,'
he told Nan, 'and I admire in him that he comes off and he *does* and
doesn't[,] like me, eternally *prate* of doing.'[15] (This seems to have been
a small hint that the landscape pictures were going slightly less well
than he had hoped.[16]) On Sunday afternoons the Sickerts were 'at
home' and the painting colony of Dieppe would gather for tea in the
garden at the Villa d'Aumale. The Blanches sometimes came from
Offranville and the 'delicious famille' of his long-standing patron,
Adolphe Tavernier, were also occasional guests. Towards the end of
the summer Walter Taylor came out to stay at Envermeu, which Sickert
found 'a great pleasure'. They would sometimes head off by train for
a day's sketching together.[17]

They also went swimming at Dieppe, though water was scarcely Taylor's element. He generally stuck close to shore, while Sickert struck out. On one occasion, however, Sickert, when almost half a mile from the beach, was alarmed to notice that Taylor was following him and was already in difficulties. To his horror he saw Taylor sink beneath the waves and disappear. Sickert feared the worst, and during the long swim back agonized over the loss of his friend and the practical problems he would face in recovering the body. To his amazement, however, as he approached the shore, he saw Taylor sitting happily in the sun. 'Good God, man!' he called out. 'I saw you sinking!' 'Yes,' Taylor replied, in his imperturbable drawl, '. . . I . . . did . . . sink . . . but . . . when . . . I . . . reached . . . the . . . bottom . . . I . . . said . . . to . . . myself, "If . . . I . . . walk . . . uphill . . . I . . . shall . . . get to . . . the . . . shore". And . . . so . . . I . . . walked . . . uphill and . . . here . . . I . . . am!'[18]

Amongst his other projects of the summer Sickert grew a new beard. He was doubtful whether Ethel would approve, but hoped she would overlook it. He claimed that he had grown it merely to save himself the trouble of shaving – and to hide the fact that he was now missing several teeth. But it seems also to have been intended as a symbol of magisterial dignity, if not prophetic power. It was white: 'it *amuses* me to be hoary, immensely,' he declared: '"An old hoar hare" as Shakespeare says.'[19] Others, too, were impressed by it. 'Showy, flashy ladies' gave him the eye in the train, and the pretty young girls playing cards in Victor Lecourt's tea garden at the Clos Normand (where Sickert would sometimes refresh himself after working on his obelisk picture) would 'twinkle' at him confidentially. As he boasted, 'A cinquante-trois ans c'est déjà pas mal!'[20] Christine, however, thought he looked like the monkey used to advertise 'Monkey Brand' soap.[21]

Life at the Villa d'Aumale was greatly smoothed by the arrival of Marie Pepin, a Norman peasant who became the Sickerts' servant and cook. She was a bustling, capable character, full of simple kindness and the sort of homely wisdom that Sickert relished. Her ruddy face – below its piled-up mass of black hair – glowed always from constant applications of yellow soap; her plump figure was like a cottage loaf.[22] At the end of the summer the Sickerts brought her back to Camden Town with them. She was amazed at London. In the absence of hand pumps in the streets she at first wondered how the inhabitants got their water.[23]

Classes at Rowlandson House began again on 6 October. The school was 'booming', and Sickert, refreshed by his holiday, set off with renewed brio each morning to 'bully for cash'. 'I have already broken in the will of two rather sad, but hopeful, & quite sympathetic new spinsters,' he reported cheerfully to Nan, within days of the new term beginning. He was greatly pleased, too, with his acquisition of a second-hand Broadwood grand piano for £15.[24] He had it installed at Granby Street. Malcolm Drummond's wife, Zina, who was an accomplished musician, declared it 'a beauty'. He was drawing her that autumn – complete with her amazing plait that reached down below her waist – and after one sitting she played for him 'like a siren'.[25]

Sickert's main concern, however, was the still unresolved question of the Camden Town Group's reformation. A vital impetus was provided when William Marchant offered the spacious Goupil Gallery in Regent Street as a venue for future shows. Expansion became not merely possible, but essential. Sickert's first instinct was to amalgamate the Camden Town and Fitzroy Street groups with Fry's Grafton Group into what he termed 'The Hilldrop-Grafton Combinator'.* It would, he told Nan, 'make *the* only interesting crowd in London'.[26] He approached Vanessa Bell with the idea, and was planning to sound out Gilman and Ginner, when the scheme was overtaken by events. A terrible row erupted between Fry and Wyndham Lewis over a commission to design a 'Post-Impressionist' interior for the *Daily Mail*'s 'Ideal Home Exhibition'. The organizers had, it seems, originally intended to get Gore and Lewis (as the principal decorators of the Cabaret Theatre Club) to carry out the project together with Fry; but the message got garbled on its way to Fitzroy Square, and Fry assumed that the commission was for the Omega Workshops alone, and accepted it on those terms. When Lewis uncovered this trail of confusion he was furious. He sent out a vituperative 'round robin' denouncing Fry's action. Fry protested his innocence, but the affair caused an irreconcilable breach in the ranks of London's avant-garde. The younger members of Fitzroy Street sided with Lewis. Sickert too, despite his fondness for Fry and his disapproval of the round robin's

* Hilldrop Crescent was close to Brecknock Road where both Sickert and Wyndham Lewis had studios. In 1910 it had achieved a notoriety as the street in which Dr Crippen had lived – and had murdered his wife. Sickert (according to his *Times* obituary) was much interested in the case, not least, no doubt, because the unfortunate Mrs Crippen had been on the music-hall stage.

wording, was not entirely sure that Lewis and his supporters did not have a point. It was clear that any amalgamation with the Grafton Group had become impossible.[27]

There were, however, other options. Just how many was revealed in October 1913 with the opening of Frank Rutter's large survey show at the Doré Gallery, 'Post-Impressionists and Futurists'. It presented a chronological overview of recent Continental art movements. For the first time, the parade of 'isms' that have come to define the progress of modern art were ranged in order and marched past the British public: Impressionism, Neo-Impressionism, Post-Impressionism, Intimism, Fauvism, Cubism, Futurism, with each 'movement' being displayed in tandem with related examples of British work. Sickert, along with most of the other Camden Town painters, appeared as a British Intimist, whilst Wyndham Lewis was at the head of the band of British Cubists that included C. R. W. Nevinson and Edward Wadsworth. The most notable absentees, besides Augustus John, were the Bloomsbury trio of Roger Fry, Vanessa Bell, and Duncan Grant. Although the exhibition suggested to many critics the rather doubtful power of modern British art compared to Continental examples, it also revealed – if only to the exhibitors – the range of interesting British work available beyond the immediate orbit of Fry and the Grafton Group.[28]

On 25 October a meeting was convened at 19 Fitzroy Street with Sickert in the chair to discuss the reformation of the Camden Town and Fitzroy Street groups, and the creation of a 'New Society'. Progress towards this goal was made at a series of further meetings over the following weeks. It was decided that the new society should be called the London Group – a name suggested by Epstein. As a first step the Camden Town Group was merged back into the larger Fitzroy Street Group, and several new members were elected, allowing them to play a role in the final deliberations about the new body's constitution and membership. Of the six new arrivals Nevinson, Etchells, Cuthbert Hamilton, and Wadsworth belonged to Lewis and Epstein's Cubo-Futurist school, and a fifth, Bernard Adeney, had affiliations to it. Sickert, who had been doubtful about the original admission of Lewis and the subsequent election of Epstein, now found himself overrun by their friends and supporters. The mood and character of Fitzroy Street were decisively altered. These iconoclastic new recruits had scant interest in the great tradition of Whistler and Degas and French Impressionism, or in Sickert's role as a living link in this golden chain. They

might admire Sickert as a character, but as an artist they did not look to him.

Sickert, whatever his misgivings, continued to chair the discussions at Fitzroy Street: it was even suggested that he should be the first President of the London Group. But he declined the honour, and Gilman was elected instead.[29] The artistic divisions within the fledgling group (and the limitations of the group's constitution) were, however, revealed when the first elections were held at the beginning of December. None of the fourteen proposed candidates could muster the required 50 per cent vote to secure election. The system had to be amended, and Sickert's patience with the new arrangements frayed further.[30]

He was given a glimpse of what the future might hold that December at Brighton. Gore, as President of the Camden Town Group, had been invited to put together an exhibition of 'English Post-Impressionists, Cubists and Others' at the Brighton Art Gallery. Although the show, like the new London Group, sought to include 'all modern methods', the fault lines running through the camp were made explicit by the division of the exhibition into two distinct sections – and the catalogue into two distinct parts, each with its own introduction. Manson introduced the main section, while Lewis provided a polemical preface to the specially designated 'Cubist Room'. Sickert was asked to give an address at the exhibition opening. The task was not an easy one, for, as he later confessed to Nan, 'the Epstein-Lewis-Etchells room made [him] sick'. Rather than confronting the problem, he avoided it. His speech – a splendidly discursive and perverse affair – spent rather more time praising the Royal Academy than explaining or defending the experiments of the artistic avant-garde. On that front he went no further than declaring the importance of artistic freedom of speech. His comments – in his own mind at least – amounted to a deft public disengagement of responsibility for the works in the 'Cubist Room'.[31]

A break had become inevitable. It occurred early in the New Year. Sickert resigned from both the Fitzroy Street Group and the London Group. Writing to Nan and Ethel, he excused himself with the remark: 'I am afraid you will think me more "swing of the pendulum" than ever. But like the lady in bridal attire who bolts at the church door the Epstein–Lewis marriage is too much for me and I have bolted . . . You who have watched the stages will not think me merely frivolous.'

The final straw had arrived at a Fitzroy Street 'At Home' when Epstein's 'so-called drawings' were put up on display together with Lewis's 'big Brighton picture'. The Epsteins, Sickert reported, were 'pure pornography – of the most joyless kind soit-dit and the Lewis pure impudence'. He felt that,

> once and for all, that *never again for an hour* could I be respon-
> sible or associated in any way with showing such things. I
> don't believe in them, and, further, I think they render any
> consideration of serious painting impossible. I hope you don't
> think my conduct, to Gore and Gilman chiefly, cowardly or
> treacherous. You know that they have dragged me step-by-step
> in a direction I don't like, and it was only a question of the
> exact date of my revolt . . . I won't set foot in [Fitzroy Street]
> again after my sensations when the Epsteins were on the easels
> and various charming and delightful people open-mouthed
> looking to me for explanations or defence.
> I couldn't
> I couldn't and[,] as Hubby sings[,]
> It's no use to try.[32]

Sickert's relief was palpable. Free from the strain of having to accommodate, if not unite, the opposing forces gathered at Fitzroy Street, he could now assume a new role as the independent maverick of modern art. He had resumed his connection with the *New Age* at the end of 1913, and was not only contributing weekly articles again to the magazine but was also selecting a series of black-and-white illustrations under the title 'Modern Drawings'. The arrangement, he explained to Nan, was ideal: 'It gives me such a free hand both to publish drawings of my own & other people's and write what I damn please. And being a weekly I influence all the other critics. I really become the conductor of the critical orchestra in London.' From his rostrum he could direct what he termed a 'campaign of extermination'.[33]

He returned frequently to 'the folly of the *soi-disant* followers of Cézanne'.[34] In another piece he dealt 'delicately but firmly', as he told Nan Hudson, 'with the pornometric aspect of Cubism' as evidenced in the works of Epstein, Lewis, and the young sculptor Henri Gaudier-Brzeska: '[Their] gospel amounts to this. All visible nature with two exceptions is unworthy of study, and to be considered pudendum. The only things worthy of an artist's attention are what we have hitherto called the pudenda!'[35] He mounted a sustained critique of 'rugged

impasto', such as was favoured increasingly by both Ginner and Gil-
man following the example of van Gogh. Thickly applied touches of
paint were not 'durable', nor were they 'a sign of virility'; and, far from
producing 'brilliancy', they gave a 'grey reticulation' of tiny shadows
to a picture surface.[36] When his comments drew an angry riposte from
Gilman, published under the heading 'The Worst Critic in London',
Sickert replied with a measured review of Gilman and Ginner's joint
exhibition at the Carfax Gallery, ambiguously titled, 'The Thickest Pain-
ters in London'.[37] If he often exaggerated, he always made good copy,
and provoked some good moments of controversy. He was delighted
when Wyndham Lewis responded to the attacks on his work with a
'witty and descriptive' assault on Sickert's 'bedroom realism' – his
'cynical and boyish playfulness with Mrs Grundy'.[38]

Sickert's performances in the *New Age* were bravura displays,
illumined with much wit and occasional flashes of sound sense, but
his hopes of becoming the 'conductor of the critical orchestra in
London' were not realized. The conservative press scarcely looked to
him as a leader, and progressive writers were all too busy playing their
own tunes. And although they were rarely in harmony with each other
– Ginner and Lewis both attacked Fry and his Bloomsbury colleagues,
and were attacked by them in turn – they did create a general hum of
counter-opinion. Even in the pages of the *New Age*, Sickert's views
were being challenged, and not only by Lewis's occasional squibs. The
weekly appearance of Sickert's 'Modern Drawings' was interrupted by
T. E. Hulme's rival series, 'Contemporary Drawings', which offered
examples of challenging Cubist work by Lewis, David Bomberg, and
others, as a contrast to the more obviously conventional pictures
Sickert selected – often from the portfolios of his Rowlandson House
pupils.

Sickert's defection from the Fitzroy Street Group quickly brought
that institution to an end. When the lease on No. 19 expired in March
1914, Bevan gave up the premises and the group ceased to be.[39] New,
smaller, allegiances formed and reformed. Wyndham Lewis took off
his band of young radicals and founded the Rebel Art Centre. Within
weeks of its inception, however, Nevinson defected (or was expelled)
after he had – without Lewis's permission – collaborated with the
Italian Futurist F. T. Marinetti on a manifesto for 'Vital English Art'.
He found a berth with Bevan, Ginner, and Gilman in what they called
the Cumberland Market Group. In imitation of the old Fitzroy Street

practice they held Saturday afternoon 'At Homes', as well as exhibiting together at the Goupil Gallery. Pissarro and Manson joined forces with other kindred spirits and arranged a show at Carfax. Sickert, however, remained outside. Each realignment in the ever-shifting scene tended to emphasize his increasingly imminent isolation. Even though 'Sickertism' was acknowledged as one of the 'modern' isms, beyond his own classrooms Sickert seemed to be its only practitioner.[40]

One of the few cohesive elements in this fragmenting scene was removed at the end of March with the death of Spencer Gore. At the end of the previous year Gore had moved from Camden Town to suburban Richmond, as a more suitable setting in which to bring up his two young children, but he continued to see Sickert whenever he came into town. Although, artistically, Gore had moved out of Sickert's immediate orbit, ties of affection still kept them close. The Sickerts had taken to holding open house on Saturdays at Gloucester Crescent, and Gore had come to lunch with them on the eve of the last Fitzroy Street 'At Home'. He made a 'very good meal' and although he did not look well, as Sickert later remarked, 'he always look[ed] ill & I had got to consider it the surest sign that he was in excellent health'. On this occasion, however, the conclusion proved false. Within days Gore was lying at home dangerously ill with pleurisy and pneumonia. On 27 March he died, aged just thirty-five.[41]

Sickert went down to Richmond the next day with Arthur Clifton, the sad journey hampered by thronging Boat Race day crowds. They found Mrs Gore 'cool, & collected & sensible'. '"Why do these things happen, Mr Sickert?" she said.' He had no answer. They saw Gore's body 'lying on his bed very emaciated', and learnt that – at the last – his concerns, as ever, had been for art and other people. One of the last things he had said was, 'Ask the Doctors to have some tea.' And in his final delirium it was 'paintings and effects' that filled his mind: the medicine bottles at his bedside 'were still lifes and then crowds'.[42]

The funeral was held near his family home at Hertingfordbury in Hertfordshire. Afterwards Sickert, along with most of the other mourners, spent an hour in the Gores' 'charming little garden'. Sickert's immediate concern was for the provision of his friend's widow and children. Although Gore's family was planning to provide them with an income of £100 a year, there were also moves to secure a pension from the Artists' Benevolent Fund or the Civil List. Sickert helped assemble a committee (presided over by Clifton) with the aim of

buying a Gore picture for a public gallery, and he supported the idea of mounting a 'memorial exhibition' at Carfax.[43] He also wrote a glowing obituary tribute to his friend in the *New Age*: it was titled 'A Perfect Modern'.[44] But amidst these practical distractions there remained the numb pain of bereavement.[45]

'It is', he told Nan and Ethel, 'a sickening loss to me of course. He was so serene and gay and sane. His example since I knew him always gave me a kind of renewal of youthful courage.' Gore's death was 'like losing a son' and, as such, 'less natural than losing a father', although, as at his father's death, Sickert was left with the regret that there were so many things they had not 'talked out' together. He suspected that the pressures of family life had taken their toll on Gore's health – though 'the happiness he had in his wife & children is a thing one could not wish him to have missed'.[46] He drew some small consolation from the thought that 'Death in a case like Gore's is devoid of the worst sting. He had never been unhappy, or old or ill and has escaped the only intolerable things – deterioration of intellect or the sufferings of self-contempt or the state when nothing has a savour. He seems to have set up with every person he met of all degrees of intelligence a personal relation of the most definite and binding kind. A wonderful gift. He was everybody's man while being most discriminating.'[47] Gore had provided Sickert with his strongest and closest link to the younger generation of painters; and although Sickert's regular journalistic chastisements of his youthful confrères had already begun to fray that tie, Gore's death weakened it still further.

Shortly after the shock of Gore's sudden death, Sickert's own health suffered an alarming crisis. The danger passed, and Christine was soon able to give an archly amused report of her husband's condition. Writing to his old NEAC friend Ronald Gray, she explained:

Walter has given us a terrible fright, but is now almost well. He seemed so ill – indeed was – for ten days, that the doctors wavered between typhoid and appendicitis, and when it was proved that it could not be the first, an august specialist was summoned who pronounced it to be undoubtedly the second, and that he must be operated upon in two days. This news had such a cheering effect on the invalid, and the excitement of being waited upon by two trained nurses, who sterilized the whole house and telephoned for the entire stock of all chemists and hospital contract people in London, which arrived

throughout the two days in an interminable procession – cul-
minating in the distinction of being prayed for in church, com-
pletely dispersed all symptoms, and when the retinue, with the
mysterious black bags, arrived – there was nothing for them
to do. They were amazed, however, and declared him a puzzle
to science, so he is to be X-rayed.[48]

To help him recuperate after this shock, Christine took the invalid
down to Brighton to stay with Walter Taylor. 'By a sort of beneficent
arrangement of nature,' Sickert told Ethel, 'what I have been through
has made me very sleepy & as well as good nights of sleep, I have
been sleeping in dear Taylor's comfortable armchairs.' Despite this
somnolent regime there were some jolly excursions. They went to the
Aquarium. Sickert was much taken with the swimming action of the
ray, thinking it was like the skirt dancing of Loie Fuller, 'only with
more grace'. He became excited at the thought of making drawings of
'the theatrical light & shade in the tanks', but the plan was never
followed up.[49] Encouraged by the effects of seaside air, he returned to
Brighton for another short visit a few weeks later and took to the
water himself. The sea was still too cold but the seawater baths were
'delicious'. For perfect well-being, he declared, 'Give me peace and
Brill's Baths before breakfast!'[50]

Rather to Fred Brown's irritation, Sickert rejoined the NEAC. Brown
considered Sickert had been disloyal in attacking – in the press – the
NEAC constitution, which he had helped formulate,[51] and hoped that
he would behave better in future. The hope was not entirely justified:
Sickert was as exacting as ever. He complained to Nan after he had
seen the proofs of the NEAC catalogue that, although he had marked
those of his pictures with foreign titles to be set in italics, this had not
been done. The explanation given by the secretary was that 'it would
create jealousy if any of my work was emphasised by italics! "Starred"
was his expression.'[52]

If Sickert registered the resentment of his colleagues at the NEAC or
the London Group, he was comforted by the continuing and practical
support of Arthur Clifton. Sickert's one-man exhibitions at the Carfax
Gallery had become annual events, maintaining his profile – and
advancing his prices. At the 1914 show, amongst the forty-three works
on view was his large painting of *Le Vieux Colombier*, which he had
made the previous summer at Envermeu. It was priced at a hefty 250
guineas – almost ten times the average price of the other pictures on

view. Clifton was convinced of Sickert's genius. He told Ethel Sands that he was 'one of the few painters who will live' – a verdict that Ethel thought it wisest not to pass on to Sickert as it might be 'bad for his megalomania'.[53] Clifton backed his enthusiasm with an exclusive contract worth £200 a year. The sum, as Sickert explained to Ethel, was not 'in payment of all claims' but 'a minimum maintenance': 'I get net all sales I make to him at his price and the price minus his commission of all other things he or I sell. Arrangement terminable at 6 months notice. Of course I shall get a great deal more. But a fixed income payable quarterly is convenient.'[54]

The chimera of an ordered and tranquil existence flickered before him. He made one of his periodic attempts to disencumber himself of all the obligations he had so eagerly gathered up over the preceding months and years. He ceased to contribute to the *New Age* (vowing not to undertake any more unpaid journalism), and he decided to close up Rowlandson House at the end of the summer term. The riches that would flow from Carfax, if they could not be expected immediately, would be arriving soon enough. 'Clifton is certain that a year or so will see me making four or five hundred a year,' Sickert reported.[55] In the meantime it might be necessary, for a brief while, to retrench ('what the aristocracy is always doing'). Sickert proposed giving up the Gloucester Crescent house and the Brecknock Road studio as economy measures, though – typically – he failed to do either, and instead took on yet another lease: for a studio at 24 Red Lion Square.[56]

He had been carried away by a fresh squall of sudden optimism. Clifton, he learnt, was trying to arrange with the American dealer Knoedler for an exhibition of his drawings in New York. It was a cherished dream: 'Enfin! I have desired this for 30 years or so.'[57] And Ethel Sands held out the prospect of immediate reward by asking him to paint a series of music-hall pictures for her new house in Vale Avenue (the recent red-brick redevelopment of the old semi-rural Vale on the King's Road). The paintings were to fill the walls of the dining room, creating a complete decorative scheme. Sickert was thrilled at the idea and at once began imagining the finished effect – done simply in two or three tones, 'as little Pissarro as possible, rather more Flandrinesque'.*[58] He

* Sickert's reference is to Hippolyte Flandrin (1809–64), who carried out a series of important mural schemes in Paris at St-Germain-des-Prés, St-Séverin and elsewhere. The encaustic painting technique he employed for these austere Neo-Classical decorations resulted in a subdued colour scheme.

went round to the house, which was still being fitted out to Ethel's exacting standards, to see the dining room and consult with the architect. Given the intended scale of the canvases, Sickert thought he might have to work in a scene-painter's dock.[59] He had planned to make use of his store of old music-hall drawings, but soon realized that they were the wrong proportions for the wall spaces they were meant to fill. 'They are not suited to them and were not intended for them and it would be a botch,' he told Ethel and Nan. 'I am not sorry as I have a profound instinct to do you something new. So I shall go tonight to the Bedford and make studies with the dining room in my mind, of course the only possible way. Why should I, with my fine instinct for filling a space, compile a patchwork of dead drawings . . . Besides my love for you both is alive and not dead. It is not yet a matter of archaeology.'[60] Back in the familiar surroundings of the Bedford, Sickert was soon 'allumé'.[61] He mapped out a study for the whole mantelpiece-side of the room. But then the first impetus faltered.

He was drawn away by other concerns. Life at the studio was disturbed by Hubby's relapse to his former ways. He took to arriving at Granby Street 'silly-drunk', which, as Sickert remarked to Nan, 'so far from being useful to me upset my whole day's work & my nerves & [made] my heart beat with anger and pity'. Although Sickert had hoped that he was holding Hubby 'tight by paying the missus', the poor man had fallen back in with 'the organisers of criminal coups, confidence tricks, cheque frauds, thefts, whores, bullies &c'. Sickert felt he must dispense with Hubby's services: 'I haven't the strength,' he told Nan, 'to spend the rest of my life holding him up. It is a great grief to me. You see I can't have a man in my employ getting money by unavowable sources. For all thanks he says I am fickle and am glad of an excuse to get rid of him. "I see your game," he said, "It's the money you are after!" It's like a death, only worse, and I miss his kind silly old face and his sympathetic pomposity. Of course it means drink and, eventually, prison. I have staved it off for a couple of years that is all.'[62] Although Sickert seems to have relented slightly, the old arrangement was broken and Hubby, if he did not abandon his studio duties completely, was no longer the constant presence he had been.

Hubby was not the only one of Sickert's friends to find himself in difficulties. For several years Robbie Ross had been being hounded by

Lord Alfred Douglas, who – converted from the 'sins of youth' – had become a rabid homophobe. Acting in conjunction with a bigoted and bullying journalist called T. W. H. Crosland, Douglas had carried on a concerted campaign of vilification against his former friend. By the spring of 1914 Ross, unable to endure the attacks further, issued writs of criminal libel and conspiracy against his two persecutors. This, of course, was what they wanted. Although Douglas was away in France unable to answer the charge, Crosland ostentatiously presented himself to the police and declared that – with the evidence that he and Douglas and their private detectives had gathered – he would justify any supposed 'libel' against Ross.[63]

Sickert was distressed for his friend. Encountering him at Carfax, he noted that 'his dear kindly old face looked as if he was going through hell'. But he felt that his course of action was entirely misguided. As he explained to Nan, 'I have always held the same opinion of these matters. If you live as dear Robbie lives, obviously in a glass house you must not keep infuriating . . . people with stones in their hands. You can't have everything and dear R. wanted social recognition, concurrently with habits that are not recognized in England.' To try to defend such an untenable position in court could only end in tragedy.[64] After protracted magistrates' hearings, the case was set for the end of June. Sickert wrote to Ross on the eve of the 'ordeal', to assure him of his – and Christine's – 'whole hearted sympathy & unalterable friendship and affection': 'I need not give you any counsels of courage. Remember to remain always on the cool & reasonable intellectual level. Watch what is happening to yourself with detachment as if it were happening to someone else. Nothing is intolerable. No one can take away from you the great & loveable qualities which have given you an impregnable position in all our hearts.' He extended an open invitation to him to drop by 'at any time merely to pass an hour or have a meal with an old friend & talk of countless interests we have & shall always have in common'.[65]

Sickert's real feelings of sympathy did not, however, carry over into any understanding of Ross's conduct. 'What a hideous underworld R's case stirs up!' he exclaimed to Nan. 'How people of intelligence can come within miles of such a milieu is incomprehensible.'[66] By the time the jury, directed by the unashamedly prejudiced judge, had pronounced that Crosland's claims were justified, Sickert was in Envermeu with Christine; he wrote from there to Nan and Ethel: 'It is

impossible to be more grieved & concerned than I am. I see in such terrible clearness what will happen. He thought himself obliged to stop certain rumours by an action. He has only augmented them. He will see that he has unchained a sequence of events which will culminate in the very thing he resents the imputation of being proved up to the hilt in open court.' Crosland's victory left the way open for the Director of Public Prosecutions to investigate the allegations against Ross. 'Courage,' Sickert contended, 'in some cases is such a stupid thing.'

> Don't quote this view of mine to a soul. But you understand how much more I suffer & fear for him than if I had the convenient tea-table view that he is a wickedly maligned person. How simple that would be. Society is very lenient to an offender who lies low and says nothing. But if you call the attention of the whole of society through the law courts and all the evening papers to the immaculateness of your reputation, that reputation must not notoriously depend upon whether certain letters will or will not be able to be kept unpublished . . . Why can not every one be reasonable and love one person of the opposite sex to the end of time and pick forget-me-nots and crocuses by a mill-stream?[67]

Sickert even asked Clifton if he thought Robbie would care to come over to Envermeu for a bit: 'We should love to have him.' Ross, however, chose to recover himself in the less bracing atmosphere of his sister's home at Pangbourne.*[68]

At Envermeu – with the holidays before him – Sickert at once began to slough off 'the fatigues of a year'. He returned to the themes that had engrossed him the previous summer, but did not rush at the task. As he explained to Ethel in one of his regular technical bulletins, much of his time was spent, at first, merely in 'thinking & staring at nature . . . trying to get a clear view of how to proceed'.[69] He decided that he must recast his working method. The previous year had involved 'too many tramps with a *heavy box*. Too many direct canvases

* Although the Director of Public Prosecutions decided not to take the matter further, Lord Alfred Douglas's return to England later in 1914 set in train a second libel action – and a second humiliation for Ross. The jury was unable to reach a verdict and Ross, rather than facing the protracted agony of a retrial, withdrew the action. Sickert was not surprised at this fresh reverse, but he was confident that it would not make any difference to Ross's standing: 'We all like him & none of us had the least desire for him to whitewash himself.'

begun. Too few *finished*.' And with the big canvases that he had worked on back in London, he found that 'all the savour had been forgotten'. He resolved that, this year, he would study fewer subjects: 'study them with drawings and little pochade panels. And then *here*, at home, at Envermeu, paint larger studies (toiles de 12 or so) & pochades while the memory is fresh.'[70]

He selected subjects in which there was a strong sense of design and 'a distinct effect of light and shade'. Then, as he explained to Nan and Ethel, he would take the drawing, 'square it up and paint on the canvas away from the subject. Then look at the subject again and so on.' Returning to the technique he had tried out at the Hôtel Voltaire in 1906 and then abandoned, he experimented with tonal underpaintings, working this time in undiluted paint. It could, he found, 'be brushed on quite smoothly and any number of coats would arrive at being both thick *and* smooth'. The early results were encouraging. 'I'll tell you what happens,' he enthused. 'Your execution becomes so clean and normal and you do not do too many things in one coat.' The execution reminded him of Corot 'at his best period only weightier and with more possibility of cumulated intensification in added sittings'.[71] He was soon announcing confidently, 'I feel so sure of my progress on the lines I have laid down. Deliberately finished elaborate canvases carried out in paint suavely, as delicately and as nervously sharp as my drawings.'[72] Life, he thought, would be 'interesting if I now at 54 *at last* do some things worthy of a matured intellect'.[73] His only anxiety was whether he would have '20 years more just to show what I have been educating myself for?'[74]

He returned to the obelisk subject and made several new pochades of it, working with his paintbox on his lap for ease and speed. He found that he was 'again running in' as he had in the glorious summer of 1885, 'quicker than any deliberate conscious operation'. It was, he remarked, 'an *astonishing* difference'.[75] Woodland scenes, however, he abandoned. For all their lyric charm, he had to admit that 'sous-bois' might not be 'exactly [his] line'.[76] It was the town, not the country, that excited him. His trips back into Dieppe became more frequent. He met up with old friends and former pupils to enjoy the gossip of the studios. And he began making studies for several new subjects.[77]

*　　*　　*

The power of the town to inspire his vision remained as fresh as ever. 'At Dieppe the other day,' he reported to Ethel and Nan after one of his visits, 'I sat down on the *plage* my eye having been caught by the stars and stripes flying with the Union Jack and the tricolour in front of the (new) Hôtel Royal. On the left in such sparkling sunlight that it was grey and black a back row of cut bushes then forward sprays of tamarisk, then a border of grey-blue flowers and then in front geraniums. I literally as Whistler used to say "rattled it off". Something has given me back my youth and my talent. And the flower beds were bounded by a wire . . . and at intervals benches without backs painted hedge-sparrow-egg-green, on the right the row of houses the Hôtel Royal the flags and the tobacco factory with its two chimneys.'[78]

For entertainment, however, Envermeu and its environs could offer diversions of their own. On some evenings there was an impromptu 'kinema' in the *place*. Sickert thought 'the village herd' in the light of the acetylene lamps looked 'splendid – like Goya's etching of the circus house'.[79] Christine's sister Marian came out to stay with them on brief visit.[80] There were pleasant local excursions, including a visit to Mme Fourget ('a skeleton of a woman with a noble nose and a receding chin') at her 'extraordinary old priory'. She had sad news of Degas – 'very unhappy & old & desolate' – in Paris; it was a torment for Sickert to think of 'that dear old brilliant warmth & wit going out invisibly into cold cinders'.[81] On Sundays Sickert always insisted on a day out, to 'rest the ménage' as he put it, and to 'compel' himself to take a break from work.[82] They had happy walks in the Hibouville woods gathering blackberries, raspberries, and even wild strawberries.[83] There was a less successful day trip to the overcrowded little resort at Treport: 'hell on earth'.[84]

Christine gave him a fright when she 'managed to tumble down a slippery stairs from top to bottom'. As he confessed to Ethel, 'of course I was *angry* with her', but, 'mercifully', she escaped with no more than 'a big bruise on her thigh'.[85] Her troubles, also, were put into some perspective by the daily news. 'Nobody talks of anything but the probable war,' Sickert reported at the end of July. Over a summer of mounting tensions, conflict between the German–Austrian alliance and the rest of Europe had come to seem inevitable. 'Of course it is ruin to everyone here, & a probable death in most families.' There were unnerving portents. A gendarme arrived at Envermeu and commandeered all the horseshoes and hay. At Dieppe, the sea seemed to

have a 'chill of terror'. On 3 August Germany declared war on France.[86]

At Envermeu the impact of the awful news was almost instant. The village, which had suffered during the 1870 Prussian occupation, descended at once into panic. Conscription papers arrived, and the harvesting of the cornfields was stopped by order. Sickert strove to place the horror at a distance. He lamented the 'folly' that prevented a French peasant from getting his crops in 'because Austria is quarrelling with Servia [sic]' and buried himself in work 'in self defence'. Wrestling with the problems of perspective in his obelisk painting, he declared that he could deal with only 'one war at a time'.[87] The Kaiser's war, however, would not wait.

III

RED, WHITE, AND BLUE

When I was younger all changes were just so much more fun.
Now all changes frighten me.
(*Walter Sickert to Ethel Sands*)

Within days of the outbreak of war the Sickerts had moved into a
hotel at Dieppe. Envermeu was too cut off, and was likely to become
more so as all trains were being used for troop transport. They found
the town already in the turmoil of mobilization: 'No port. No boats
. . . The casino used for the recruits. All the young men are off to the
front and the women are crying.' Sickert thought it, 'like a dreadful
nightmare'. One woman had hysterics – the unfamiliar sound was like
a dog barking.[1] Lady Blanche Hozier, armed with a 'laisser passer
partout' was a ubiquitous presence, and brought an element of comedy
to the drama. She established an armchair on the quayside from which
she could observe the steamers carrying away the flocks of British
holidaymakers and expatriates. The port officials explained her pres-
ence to each other – and to themselves – with the awed and whispered
observation, 'C'est la mère de Churchill.'[*][2]

News that Britain too was mobilizing was greeted with enthusiasm
by the French, and with relief by Sickert; 'If we hadn't,' he remarked,
'we would have been lynched.' Not that Sickert himself would ever
have been in danger from the Dieppois. Indeed when the captain of
one French steamer arriving from England was asked, 'Est-ce
l'Angleterre marche?' he replied, 'Je ne sais pas. Entout cas je sais que
Sickert marche, je l'ai vu marcher a 5 hr ce matin.' ('Is England march-

* She was in fact the mother-in-law: Clementine Hozier had married Winston
Churchill, already a prominent politician, in 1908: the news was greeted by cheers
in the Dieppe fishmarket. In 1914 Churchill was First Lord of the Admiralty.

ing?' 'I don't know. But I do know that Sickert is marching. I saw him marching along at 5 o'clock this morning.')[3] It was a gratifying proof of Sickert's position in the town, and there were other reassuring moments amidst the prevailing uncertainty. Returning to Envermeu to collect some clothes and pictures, Sickert's cab had stopped at a checkpoint, but before he could produce his 'laisser passer' (with its awful photograph) the soldiers – all local youths – waved him through with, 'Bonjour Monsieur Sickert.' It was, he told Ethel, 'a charming sensation'.[4] His local reputation had its practical uses too. All the Dieppe banks remained closed during the first days of the war, and although an 'English art-critic en retrait' had pressed a very welcome 50-franc note into his hand, for the most part Sickert had to survive on credit, which was willingly given.[5]

After the first flurry of agitation and activity, the town settled into an eerie and desolate calm. Sickert found the deserted seafront under the August sun 'appalling': it seemed to him like 'the day of judgement'. But he took consolation from the views of a 'military expert' who predicted confidently that the war would be over by November. Till then he planned to stay on at Dieppe.[6] He and Christine moved into a flat in the rue de l'Hôtel de Ville that had been rented for the summer by some friends of friends, and then abandoned.[7] A vestigial social life could be enjoyed amongst the 'permanent English colony', and Blanche was still at Offranville, stuck without his chauffeur, and 'so désolé that his servants ha[d] the giggles'.[8] But the evidences of the impending conflict could not be ignored. The town was being made ready to serve as a major centre for the wounded. The schools, along with the Casino and at least one hotel, were converted for hospital use. Sickert wanted to be busy. He applied to join the Garde Civique and was most disappointed to be turned down.[9] As an alternative he hoped to take up voluntary medical work. He presented himself to the Red Cross authorities three times a week, 'to show I am ready for my turn but as yet we have no wounded'.[10]

In the meantime he felt that 'going on hard' with his work was the best thing he could do; it was 'reassuring' to those around him and it might even earn him money so that he could 'employ people'.[11] He took a studio room in the attic of Dr Peppault's house, at 10 bis rue Desmarets, and he returned to the 'countless' subjects that he knew and loved – sketching the streets and quays of the town. He also made a study of Adolphe Tavernier's daughter at the piano. It was a pleasant

escape to draw while listening to Beethoven, and allowed him to forget the war, if only for a while.[12] News of the German advance through Belgium could not, however, be ignored. The Battle of the Frontiers towards the end of August confirmed French fears. The Germans soon began to press into France. When reporting the fact that the enemy had reached as far as Roubaix (near Lille), a Dieppois had added, 'C'est ennuyeux.' Sickert remarked, 'I never knew the word *ennuyant* imply so much!' Shortly afterwards, a German plane flew over Dieppe, and the Sickerts decided it was time to 'clear out'.[13]

They returned to London, to their Gloucester Crescent house. England was in the grip of patriotic fervour, but Sickert felt dispirited, consumed by helplessness, 'writhing like a worm on a pin with impotent fury and concern for France'.[14] His 'constant personal terror' was for his 'dear Dieppe'. It had hurt him to abandon so many friends there: 'the shopmen & market women & old men' who could not leave.[15] He even mapped out an impracticable plan for the relief of the town (should it prove necessary) and sent it to his old friend Eddie Marsh, who had become Churchill's private secretary at the Admiralty. In the midst of the national crisis Marsh found time to write 'a charming note . . . saying Winston would think over what I had said'.[16]

As a small private initiative the Sickerts 'with great difficulty' managed to bring over Marie Pepin for the duration.[17] Christine's efforts to teach Marie English were unavailing and had to be given up. ('I got impatient,' Christine lamented, 'and Marie got distressed.') And though she was happy to battle it out with the shopkeepers of Camden Town, often driving a hard bargain, her lack of the language, in the long run, was something of a handicap. Christine had to accompany her everywhere. Indeed Sickert took to calling his wife 'la dame de compagnie de Madame Pepin'.[18]

Sickert's anxieties over Dieppe were compounded by his distress at the accounts of German atrocities in Belgium – nuns raped, children killed, women butchered.[19] As a German native, if not a German national, he felt strangely compromised. 'I am so glad my dear father did not live to see this,' he told Ethel. 'I love everything I remember of Germany, but France and England are my homes. How many of these poor German bakers and barbers in London must feel the same thing.'[20] When Prince Louis of Battenberg was forced to resign his position as First Sea Lord after a campaign of vilification, Sickert could only be grateful that his own modest profession kept him safe from

such attack. Nevertheless, in the climate of distrust he remained sensitive about his un-English surname. Hundreds of suspected foreign 'spies' were being rounded up across London. A 'district inspector' called at Gloucester Crescent, and Sickert was tactfully urged to go *at once* to the Home Office with proof of his father's naturalization: various 'pains and penalties' were mentioned incidentally, 'in a friendly way'. Sickert was much gratified, and no less relieved, when the young civil servant who saw him said, 'Mr Walter Sickert? I am delighted to make your acquaintance.' His reputation, he felt, had saved him from the cells.[21]

Sickert regretted that he had not been in the Territorial Army; if he had he might – even at fifty-four – have been eligible to fight. He fondly imagined that he would have made a very good soldier: 'I suppose an eye for drawing is an eye for shooting.'[22] His brother Leonard was serving as a 'special constable', drilling – along with Walter Russell, Augustus John, and others – in the courtyard at the Royal Academy, and spending his nights guarding the Campden Hill reservoir.[23] But even such unglamorous duties were closed to Sickert. In his frustration he wrote again to Marsh with another improbable scheme: 'I wonder if I could be of any use speaking on platforms for recruiting purposes. I could be discreet & stick precisely to any government brief with which I was instructed.' The offer was not taken up.[24]

There were private sorrows as well as public anxieties. On 4 September 1914, soon after the Sickerts' return to England, Ellen Cobden died down in Sussex aged sixty-six. She had been suffering from cancer. Having provided for Sickert so generously while alive, she left him nothing in her will.

Sickert was obliged to console himself with work. During his absence in France, Sylvia Gosse had arranged for him to move from his studio at 24 Red Lion Square to a new space at No. 26. He found the three interconnecting rooms there 'perfection beyond anything I could imagine'.[25] The main room faced south into the square, giving plenty of light. The piano was soon installed. He gathered in Hubby and Marie Hayes to model for him again, and also recruited Emily Powell – or 'Chicken' as he called her – who, now grown up, had followed the rest of her family onto the stage. A cheeky gap-toothed cockney charmer, she was singing in the chorus at Covent Garden. Sickert loved her almost Hogarthian esprit and began working on a

picture of her sitting at the piano. After the pleasures of listening to
Mlle Tavernier playing Beethoven, he enjoyed the rather different thrill
of Chicken banging out the 'panto'. He would accompany her 'at the
top of his voice'.[26]

Sickert was concerned at how his former Camden Town Group
colleagues would weather the war. Most, he thought, would 'pull
through' all right. Gilman had taken over Gore's teaching at West-
minster, and was earning enough to keep 'a superfluous woman' and
spend his evenings at the Café Royal. Ginner had an allowance from his
father and had never 'lived' by his painting. Bayes supported himself by
teaching and writing, while the poor Drummonds would merely be
as hard up as they always had been. A painter 'as good as John' would
go on selling 'war or no war'. If 'a great many of the smaller eccen-
tricities' were 'forced into some more intelligent occupations', that was
to be welcomed.[27] Sickert disapproved of the notion that there should
be any special state support for artists during the crisis. 'Art is all right,'
he told Eddie Marsh. 'It will look after itself. I have always believed
Art requires no more encouragement than do[es], say, sunshine or
philoprogenitiveness.'[28]

Nevertheless Sickert did recognize that his own sales were likely to
be uncertain. Although Clifton had assured him that their existing
financial arrangement would be maintained, he did not like 'the risk
of being entirely dependent on a man not himself rich, with a delicate
wife'. His own delicate wife's dividends had, meanwhile, ceased to be
paid. As a contingency plan he considered making a lecture tour of
America. Nevinson had told him that he might easily get £10 a lecture,
and he could supplement such fees by writing for the press and selling
his own drawings. Racing away with the idea, he also imagined that
Charles Freer might like him to compile a catalogue of his great Whist-
ler collection. By such means he would be able to 'live off the land'
for a few months at least.[29]

He did not hurry his arrangements, however, convinced that the
war must be over quickly. The combination of 'the *furia francese*' and
the 'sullen dogged steady tenacity' of the British must, he felt, prevail.[30]
Besides, the alternative was too awful to contemplate: as Tavernier had
remarked, 'If we don't win la vie perdrait tout son intérêt.'[31] Neverthe-
less, Sickert's optimism was forever being confounded by events, and
he had to ask Ethel to be lenient of his rash judgements: 'All your life,'
he explained, 'you are seeing the best informed people and conver-

sation is the only real well of understanding. Marie Hayes and Chicken and Hubby are dears but not exactly informing.'[32] In an effort to gain a fuller understanding of affairs he took to reading the *Corriere della Sera*, feeling that a neutral Italian newspaper might give him the news 'without partisan window dressing'.[33] He had tea with Lady Hamilton, whose husband had been given the command of the Home Army, and also visited Lady Blanche Hozier, who was now back in London. (Despite being Churchill's mother-in-law she seems to have been even less well informed than Sickert was: he had to dissuade her from going back to Dieppe to plant some rose bushes in her garden there, pointing out that the Germans had probably 'planted some mines' of their own in the Channel.[34])

When Ethel announced that she and Nan intended to establish a voluntary hospital in France, Sickert was discouraging. He remarked that he had it on good authority (the French wife of a Belgian officer) that even if the Government did not 'put spokes in their wheels', it would simply not send them any wounded soldiers to treat.[35] But, as with so much information in time of war, this proved unreliable; and Sickert was soon revising his opinion after a 'very interesting dinner' with the Hamiltons at which he and the Lord Chancellor, Lord Haldane, had been the only guests. Arriving first, Sickert had been delighted when the new parlour maid who opened the door asked him if he were Lord Haldane. But even this pleasure had paled besides the thrill of hearing Sir Ian and the Lord Chancellor discussing 'every phase and aspect of the war' with total freedom. It was, he told Ethel and Nan, 'a bit of luck for an insignificant pékin like me to hear two men like that'.* He told Sir Ian of his friends' hospital plans and found him enthusiastic, sure that the French Government would send them plenty of 'fodder'.[36]

Sickert, after his early frustrations, had found a way of making his own small contribution to the war effort. He was embarked on some paintings 'suggested by the war'. 'One has a kind of distaste', he admitted, 'for using the misfortunes of others to further ones own ends', but such pictures, in so far as they had any effect, must, he felt, be 'useful' – and at their best could have 'a definite patriotic and recruiting value'. 'Besides if military painters had always been too bloody delicate they never would have got anything done at all.'[37] He bought a British

* *Pékin* was French military slang for a civilian.

army uniform from Gamages department store and introduced the
figure of a listening soldier into a painting of Chicken at the piano.
He also retitled one of his adaptable compositions of a nude and a
clothed man seated on a bed, *The Prussians in Belgium*.[38] Belgian subjects
would, he thought, be particularly telling and particularly 'useful' in
the current climate. He proposed to do a Belgian-inspired picture as
a contribution to the recently established Belgian Relief Fund, as the
only way he could subscribe.[39]

To assist this plan he asked Lady Hamilton whether she might get
Sir Ian to furnish him with a letter to the authorities 'having charge
of the Belgians in London hospitals', explaining that he wanted to
'*borrow* some Belgian uniforms and accoutrements' from wounded sol-
diers. (The letter, Sickert suggested, would be 'a guarantee that I am a
British subject, & in spite of my German name, not a spy, and that I
would not pawn the uniforms & accoutrements'.[40]) Sir Ian obliged
with a 'splendid letter' urging the relevant authorities to fall in with
the 'laudable intention' of 'Mr Walter Sickert, the well-known artist'.[41]
The effect was almost immediate. Uniforms began to arrive. 'They are
exactly what I want,' Sickert told Ethel excitedly. 'The artilleryman's
forage cap with a little gold tassel is the sauciest thing in the world.'[42]
He set to work at once on 'a really Daumieresque scheme of an artillery-
man who has seized a gun & is standing on mattresses on a piano
firing through a loophole above a door!'[43] Although the initial compo-
sition may have been based on a newspaper photograph of the siege
of Liège, Sickert revised it thoroughly through numerous drawings and
figure studies. He invited Belgian soldiers, whom he encountered in
the London cafés, to come and pose for him. He conceived the work
on a grand scale, selecting a canvas some six feet high by five feet
wide. At such a size it would, he thought, be 'only suitable for a public
gallery',[44] but then he intended it as a public picture with a public
purpose.

The scale of the painting also posed a technical challenge. It had
to be painted in stages. In solving the problem, Sickert pushed further
with his underpainting experiments of the summer just past. He
mapped out the entire picture in a 'camaïeu' – a thin light tonal
underpainting done in three evenly spaced shades of one colour and
one shade of another, the 'blond shadows' looking, so he said, 'like
some Empire dinner service'. He worked almost directly from a model,
but not quite. 'After 10 minutes of strenuous pose by the man in

uniform with his gun,' he explained to Ethel, 'I walk into the next room & put on canvas still always in camaïeu the bit I have just drawn & observed while it is fresh.' Only when the 'whole thing [was] absolutely complete in light and shade and drawing' – and completely dry – did he 'slip the last skin of colour on'. His enthusiasm for this new approach, like all his enthusiasms, needed to be communicated: 'It is the best way on earth to do a picture,' he informed Ethel and Nan, along with a raft of technical details.[45]

It was a procedure that would have been understood by the pupils of Couture's studio in 1850, and by almost nobody else since. While his contemporaries and juniors were working to turn over the traces of traditional practice, Sickert chose to embrace the forgotten examples of the past. But there was nothing antiquarian in his stance. The technique was perfectly matched to his aims, his intentions, and his temperament. It suited his desire to construct pictures in ordered stages over a period of time, and allowed him to work from drawings and to repaint without losing the quality of freshness in a thick mud of impasto. Unlike many of Sickert's other enthusiasms, this one lasted and grew. He came to consider it as 'the ideal use of oil paint at its best' – the grail for which he had been searching. Through various refinements, and with occasional lapses, it remained the cornerstone of his practice for the remainder of his life.

Sickert worked all out to get the 'big Belgian canvas' finished for the NEAC's winter exhibition. He thought that if he could show it before the topical 'enthusiasm for the Belgians has cooled' it would have a better chance of selling. 'I want to do something for them,' he told Ethel and Nan, 'and it will probably be all I can do.'[46] He sent the picture – titled *The Soldiers of King Albert the Ready* – in time for selection on 24 November, priced at 'five hundred bloody guineas'.[47]

Sickert enjoyed his new role as a 'military painter'. He immediately began work on another large-scale Belgian subject.[48] The picture was intended for the special War Relief Exhibition to be held at Burlington House early in the New Year. Sickert's involvement with the exhibition brought him into close and gratifying contact with the Royal Academy. He boasted to Nan and Ethel of 'dining in the bosom of the R.A.' one evening: 'There being Belgian guests I made a speech partly in French.'[49] Such performances, coupled with his enthusiastic pronouncements about the Academy in the pages of the *New Age*, led some of Sickert's old friends to suspect that he was planning – or hoping – to become

an RA himself. Fred Brown reported the rumour with disapproval to Will Rothenstein, but claimed that the Academicians remained wary: Sickert's 'reputation for disloyalty [having] spread outside the precincts of his own circle'.[50]

Engrossed in the serious business of painting, Sickert adopted a rather facetious view of Nan and Ethel's advancing plans for the Volunteer Hospital at Veules-les-Roses, along the coast from Dieppe. He insisted on regarding it as a sort of rest cure-cum-dating agency for the two spinsters. When Ethel set off at the end of November he sent her on her way with a not very inspired ditty: 'With your syringe on your shoulder/And your thermometer by your side/You'll be curing some young officer/And be making him your bride.'[51]

He also pressed upon her and Nan a long list of friends and 'contacts' whom they might want to look up in France. Some of them were even potentially useful: his brother-in-law, 'Fiddy' Colqhoun (husband of Christine's sister), was acting surgeon at Boulogne. Imagining that they would have a relaxed schedule, he offered them the run of his studio at Dieppe and urged them to visit his 'antepenultimate', Mme Villain: 'she can't read or write,' he told them. 'So you can give me news of her' – and of her various offspring: her two sons at the front and her daughter, Yvonne.[52]

More than news, however, Sickert wanted information for his paintings. He asked Nan and Ethel to try and get hold of a French private's uniform for him – the full rig: a '*Képi*, tunic, haversack and *pantalon rouge*, and if possible a *pickel-haube* too.'[53] It was important, he felt, that 'the French uniform should be seen' in any exhibitions where military pictures were on view.[54] He also requested photographs, 'ideas', and little pencil sketches to help him with his compositions; 'but don't', he added thoughtfully, 'go into the firing line to do them'.[55] By way of thanks he promised them 'half the *money*' from any paintings that he derived from such material.[56]

Great though Sickert's excitement was in his military paintings, his enthusiasm for his new painting technique exceeded it. He wanted to test it on new subjects. Henceforth, he announced, he would, 'like the Kaiser', be waging war on 'two fronts'.[57] His second theatre of operations was Ethel's dining room in Vale Avenue. The project, during its months of neglect, had grown in his imagination. When he went back to the house to reacquaint himself with the space, he found it smaller – 'lighter and easier' – than he remembered.[58] He ordered the necessary

canvases and set up the Brecknock Road studio ready for work on them. The task, whatever it involved in studio work, also necessitated frequent visits to the New Bedford. Sickert would make tiny studies in his account book, using an 'unupsettable ink bottle'.[59] On Monday nights he would take Christine and Marie with him.[60] Marie, despite her lack of English, revelled in the spectacle, and her comments added a new element to Sickert's own enjoyment. As some nimble soubrette spun acrobatically across the stage she would announce solemnly, 'Moi, je ne pourrais pas fair cela.'[61]

Patriotic feeling ran high at the New Bedford. Victoria Monks – or 'John Bull's Girl', as she was popularly billed – would lead the house in rousing renditions of 'We've got a Navy, a British Navy'.[62] The 'fury of controlled vituperation' that she brought to such performances was, Sickert considered, 'worth an army corps to us', though he noted too that, by 'one of those not infrequent ironies of fate', Miss Monks was in fact of German extraction and had been born Victoria Gruhner.[63] The verdict of 'John Bull's Girl' and the New Bedford audience was that once the British troops took the offensive it would be 'a walk over'. Sickert tried to believe with them.[64]

But there was little to encourage such a prognosis. The signs of escalating conflict were all too evident in London. There were soldiers everywhere, Sickert reported, and the capital itself was not immune from danger. The first Zeppelin raids occurred at the beginning of October 1914. Sickert was not unduly worried. He slept through at least one early attack,[65] and he greatly approved of the blackout policy that such raids soon precipitated: it lent a new pleasure to London life. The night-time streets were lit – or unlit – as they had been back in the 1890s, 'when everything was Rembrandt'. 'I wish', Sickert told Ethel, 'the fear of Zeppelins would continue for ever so far as the lighting goes.'[66] Some of the other effects of the raids were, however, less appreciated. He was upset when the London Music Hall at Shoreditch ('one of my favourite haunts') was 'gutted' by an incendiary bomb, though relieved he had not been there.[67]

The war came close in other ways. Elsie Swinton's son, Alan, just eighteen years old, was sent to the Front as a subaltern in the Scots Guards. 'What a debut,' Sickert remarked.[68] And Ottoline Morrell's brother, Lord Henry Cavendish Bentick, one of Sickert's 'precious customers!', also set off for the trenches.[69] The terrible dangers and privations that they would be facing, though perhaps little understood by

Sickert, were not totally unrecognized: through Clifton he had already begun to receive commissions for portraits of deceased officers. His first such painting was of Lieutenant-Colonel Adrian Grant Duff of the Black Watch, whose 'touching little widow' was a niece of Sickert's friend and fellow painter Douglas Fox-Pitt.[70] Taking the likeness from a photograph, but also making separate figure studies from a model wearing the appropriate uniform, Sickert built up the picture in stages, using his new camaïeu method.[71] 'The system of preparations is such a good one,' he purred. 'The touches of real colour go on the dead colour like a fresh slight sketch.'[72] He hoped to make such a success of the painting that he would get 'more of the same kind to do', but his attention was soon deflected elsewhere, and what he grandiloquently termed 'the pompes funèbres department' of his work never really took off.[73]

Despite the constant and unsettling reminders of war the outward forms of London's social and cultural life were maintained and Sickert, for all his immersion in work, did venture forth into the fray, at least occasionally. He remained in contact with his old 'Camden Townish' confrères, dining with them occasionally at the Café Royal and the Eiffel Tower, and attending the 'At Homes' of the Cumberland Market Group.[74] But his loyalties were never exclusive. When Roger Fry was in bed with flu, Sickert paid him a visit. (He found the invalid looking 'exactly like Irving as Richelieu'.[75]) He also took Lady Hamilton to a drawing-room cabaret at the Omega Workshops. After a vers libre recital there was a marionette performance by Goldsworthy Lowes Dickinson. The great success of the show was 'a nigger figure' with a 'swinging appendage'. As Sickert remarked, 'Advanced art & literature seem to suffer from a reductio ad caudam. "Plain tails from the hills" should be the title of the modern movement.'[76]

Ethel and Nan were kept au courant with his doings in Bloomsbury and beyond: the intimate lunches with Walter Taylor or Clive Bell; tea with Mrs Swinton; calls on Lady Blanche Hozier.[77] He dined with his brother Oswald and his wife, in their 'really charming flat by the Middlesex Hospital', and also with the Trevelyans,[78] and enjoyed the colourful Thursday-evening salons at the Morrells' house in Bedford Square, where he might find 'dear Lytton Strachey' carrying the banner of pacifism, or see an 'M.P. in khaki being taught French by a French actress on a sofa'[79] – although, after one evening at Lady Ottoline's dinner table, he did remark that the company had perhaps been made

up of 'too many quite young Slade girls': 'I ask myself has her ladyship no contemporaries. It is odd to have a museum of infants as a salon.'[80] He kept his own young admirers under strict control. When Ruby Peto, a former Rowlandson House pupil, asked whether she could come and paint with him, he exclaimed with cheerful brutality, 'Why, it was just to get rid of women like you I gave up my school.'[81]

Sickert nevertheless did maintain an interest in the young, happily conscious that he still excited their curiosity, and even their admiration. He consented to look at the work of Lady Ottoline's latest protégé, Mark Gertler, and perhaps he even registered how the farouche young East Ender trembled with excitement as he held up his pictures for inspection.[82] He encouraged the talent of the Chilean émigré artist Alvaro Guevara, and he took the trouble to seek out Thérèse Lessore, whose pictures he had noted with interest at several group exhibitions.[83] He admired the sense of vitality and human truth in Lessore's work, her ability to draw, as he put it, not just the street or the woman, 'but the impulse of a bargain in a crowd'.[84] By 'some strange alchemy of genius', the essential being and movement of her subjects – not models, but real people doing real things – were 'torn from them and presented in ordered and rhythmical arrangements of the highest technical brevity and beauty', fixed by the 'cold and not unkindly malice of her vision'.[85]

He found this otherwise overlooked 'genius' living at Holly Place, Hampstead, married not very happily to the painter and London Group founder-member Bernard Adeney. Sickert thought her quite as delightful as her pictures. Small, dark, and poised, he likened her to a 'Persian miniature'.[86] She was thirty-one, though, with her homemade pinafores and frail childish figure, she looked younger. If she was quiet and gentle she also had strong views and the wit to express them well. And her strongest views were about art. Like Sickert, she was a third-generation painter. Her grandfather, Emil Lessore, had worked as an artist on porcelain at Wedgwood in the 1850s, and her father, Jules Lessore, though born in France, had lived and exhibited in London (Sickert had praised his work, albeit very faintly, in a review of the Royal Institute show in 1889).[87] Thérèse, the youngest of three children, had been brought up in an atmosphere of artistic endeavour and achievement. Her brother had worked as an assistant to Rodin, her sister was an illuminator of manuscripts and a disciple of William Morris. Sickert found Thérèse's company, and her work, a stimulant.

He would return from his visits to Holly Place 'bubbling over with enthusiasm' about both.[88]

Such interludes provided a happy distraction from other, less cheerful, cares. Sickert's 'poor old mother' and his brother Robert were both in 'a shaky condition'.[89] Mrs Sickert, though eighty-four, did rally with time ('she finds a glass of port at 3 am good for her'), but she remained anxious at Robert's less tractable illness. 'He has had for months,' Sickert reported, 'a suppurating wound outwards from a tuberculous kidney. He doesn't suffer, eats well & enjoys life in bed with a day & night nurse.'[90] Despite the presence of this professional help, Sickert took to calling at Pembroke Gardens early each evening, after his day's painting and before his evening visit to the music hall. This little interlude became, for a while, part of an 'agreeable routine'. 'You know how I adore routine,' he told Ethel, shortly before abandoning it.[91] Given his mother's worries over Robert, Sickert kept from her the news that Helena had had to have a 'horrid operation'. Fortunately it proved successful, and 'Nellie' bore the hardship of it with characteristic courage and cheerfulness, even though all her 'activities' (for the causes of women's suffrage and world peace) were 'somewhat knocked on the head'.[92]

To complete the difficulties besetting Sickert's womenfolk, Christine too was wilting. She felt isolated at Camden Town, far from her own family, and wanted to move back to Bayswater.[93] Since the closure of Rowlandson House there was no practical imperative to keep the Sickerts at Gloucester Crescent, and so in the spring of 1915 they let the house and moved to an upstairs maisonette at 9 Kildare Gardens, off Westbourne Grove.[94] It was a new milieu for Sickert, but not a particularly inspiring one. The white stucco fronts of Bayswater do not appear to have awakened any artistic impulse in him. The one painting he made in the area was of the Queen's Road tube station – the quickest route of escape.[95] Each morning Sickert hurried back to Red Lion Square, stopping only for his matutinal swim. Most of his day was spent at the studio. He could make his own breakfast and there was a restaurant 'next door but one' where lunch was cheap and the food 'quite adequate'. With only Marie Pepin to help her, Sickert was relieved that Christine should have but 'one serious meal to do', in the evenings.[96]

* * *

Sickert had returned to etching. He installed a press at Red Lion Square with the intention of etching everything he drew – as well as some of the things he had painted. One of his first essays was a plate of the *Ennui* subject. 'I have at last done one etching that is good,' he told Ethel Sands, 'after dabbling with copper off and on for 30 years.' In the same letter he promised to send a proof soon of a New Bedford scene – 'a bit of your drawing room in copper'.[97] The challenge of a different medium would, he felt, complement and stimulate his painting: the rendering of a scene entirely in terms of light and shade had obvious connections with his use of tonal underpainting for his oil works.

Very rapidly, however, his etching began to engross all his energies, while Ethel's dining-room canvases were left, unworked on, at the distant Brecknock Road studio. As ever, Sickert hastened to communicate his current enthusiasm and pass on the lessons he was learning. Red Lion Square evolved into an informal etching school, a gathering place for would-be printmakers: 'Swarms of young men and maidens etch at every window till one,' Sickert reported proudly.[98] They worked on their own prints and helped Sickert with his. Enid Bagnold recalled preparing Sickert's copper plates, waxing and smoking them with a candle.[99] Amongst the youthful crowd were several more established figures: Maurice Asselin, a young French painter, who had exhibited in Roger Fry's Second Post-Impressionist Exhibition and was now living in England, became a regular,[100] Sylvia Gosse helped with printing, and Thérèse Lessore was a presiding presence. It was she who poured out the mugs of coffee when everyone assembled in the 'earlyish mornings' to listen to Sickert – robed in his old dressing gown – discoursing upon art, life, and the topics of the day.[101]

Sickert's concentration on etching, although driven by his artistic curiosity, held out the prospect of other benefits. John Noble, a Paris-trained American painter who was over in London, fired him with accounts of how etching was 'booming in the States'.[102] Clifton too, perhaps, was encouraged by such tales: he agreed to publish through the Carfax Gallery a specially prepared set of sixteen Sickert etchings. It was a substantial commitment, but Clifton, as Fred Brown rather resentfully remarked, having secured his exclusive contract, had been scheming steadily to 'corner' the Sickert market – buying up his stock, raising his profile in the press, and his prices in the auction rooms. A coherent set of properly advertised etchings would be a means of both furthering this 'Sickert boom' and cashing in on it.[103]

Sickert was thrilled to have the backing of such an ally. 'Clifton is really a brick,' he told Ethel. 'You must never let anyone run down dealers. A man spent £200 the other day on pictures [of mine that] Clifton owns ... Clifton at once spent £150 of it in buying more of me.'[104] Nevertheless, Sickert was not beyond subverting his dealer's authority if his own personal views of commercial morality dictated it. When John Middleton Murry, a young critic who had written generously (Sickert thought perhaps even too generously) of his work, wanted to buy a picture, Sickert insisted he should not think of paying 'the extravagant prices to which modern commerce has succeeded in running up modern work'. Artists and men of letters, he remarked, should have 'an exemption from such expenses'. Although he could not offer a discount, there was, he explained, nothing in the terms of his Carfax contract to prevent him '*giving* a drawing or etching' to whom he pleased. He invited Murry to come and 'choose something' one morning, 'but don't', he added, 'tell Clifton'.[105]

Sickert worked hard on the etching project. It gave him an opportunity to explore the medium in depth, and to refine and extend his techniques. In his attempts to create the full range of tones from line, cross-hatching, and the brightness of the naked page, he looked to the example of the seventeenth- and eighteenth-century masters such as Canaletto and the Dutch artist Karel Du Jardin. He carried about with him a proof of Du Jardin's 'cavalier', and told Duncan Grant and Ottoline Morrell – and anyone else who would listen – that it was 'the best [print] in the world'.[106] All the tricks and fads of the modern art-etchers were eschewed. Everything was done to dispel any air of preciousness. The prints were 'lettered by a professional engraver, printed by a journeyman' and published at something like half a guinea each.[107] The first batch of six was ready for exhibition at the NEAC's spring show in May.[108]

Sickert's total engagement with his work left Christine 'mewed up' and alone in the 'stuffy little flat' at Kildare Gardens, 'bored to death'.[109] The return to the familiar comforts of Bayswater had done little to rally her health. Noise from a builder's yard at the back of the house kept her awake early and late, denying the relief of sleep. She was, Sickert recognized, badly in need of change and 'a little country air'. He was too busy – and too short of funds – to take her away himself, but a convenient alternative suggested itself. Ethel Sands and Nan Hudson were back in England for the summer, and, maintaining their

good works, had converted Newington into a nursing home for the war wounded. Sickert bounced them into accepting Christine as an unscheduled patient, with the promise that, once she had recovered her strength, she could help with the nursing duties. She was, he told them, 'a perfect nurse as I know and so unselfish and unausprachsvole'.[110]

Sickert filled the days of his grass-widowerhood with work and more work. 'I have a rather chivvied feeling,' he confessed to Ethel, 'as I am overdrawing rather on the inexhaustible Clifton. It is only this that makes me stick so to the etching for the moment.' He ended each day exhausted, and filled with gloom (anxious about his wife, his work, and the war), but would buck himself up with 'a night's drawing at the Oxford [Music Hall] – 7.45 to eleven or so'. But though he dined occasionally with Walter Taylor and other friends at the Café Royal, he claimed to dislike the place now as much as he had loved it in the nineties.[111] Towards the end of June he went down to Newington to see Ethel and Nan and to collect Christine, taking with him some of his latest etchings. Duncan Grant, who came over from Garsington with Ottoline Morrell, thought them 'lovely'.[112]

Although his printmaking commitments continued to tax him on his return to London, there were also other deadlines to be met. After a year's respite, he had been unable to resist the offer of a new journalistic platform. 'I am', he crowed, 'to write an article ... for the B,U,R,L,I,N,G,T,O,N. Meet me there at the close of day when the clock strikes ten.' They wanted him to a review a new Whistler loan exhibition at Colnaghi's in Bond Street. After his unremunerated contributions to the *New Age*, an article in the *Burlington Magazine* offered the prospect of payment (Sickert called it '3000 words sterling').[113] It also gave him the chance to reiterate and refine his critique of Whistler. As he advanced in his command of the camaïeu technique, with its possibilities of cumulative elaboration and refinement, he chose to portray Whistler as an 'eternal sketcher' – a sketcher of genius, but not a true master.[114] The ghost was at last laid.

In what seems to have been an expression of this final emancipation, Sickert made arrangements to take on Whistler's vast old studio at the back of No. 8 Fitzroy Street. He needed a more conveniently located painting workspace than the Brecknock, which, since his removal from Camden Town, he rarely visited.[115] Although he boasted of getting the Fitzroy Street studio 'rather cheap' it was still a new call

on his resources. To help meet it he continued to contribute articles
to the *Burlington*, and he also made a return to teaching. He had been
invited to give a course of ten lectures at the Central Institute of the
LCC, but this plan was soon followed up by another offer. The LCC
inspector, Sickert reported, 'came & asked me to make of Westminster
[Technical Institute] *the* school of painting'.[116] It was a challenge he
eagerly accepted. Mouat Loudan, the old head of the school, had left,
so Sickert was promised 'a free hand & [the] run of the art school
entirely'.[117] He convinced himself that the return to 'the perpetual
grindstone' would not be as tiring as his old regime had been: 'It was
Rowlandson House 10 am that messed me up,' he told Ethel. 'After
dark I don't care.'[118] The prospect, moreover, of a certain income in
an uncertain climate was both attractive and timely. His sister, though
she had recovered from her operation, had used up her small supply
of savings. She and her semi-invalid husband were on the brink of
'penury'. Sickert was acutely conscious that he had still not repaid
them the money they had lent him during his own troubles at the
end of the 1890s. A teacher's salary would help him to settle the long
overdue debt.[119]

The 'restraints of etching' were also giving him 'a new letch for
the brush',[120] and he planned to do some 'spiffing paintings'. Clifton
encouraged him in this direction. The cost of producing the set of
etchings was proving very high – even though the whole editions
were not printed up.[121] 'I drag so much money out of Clifton,' Sickert
confessed, 'that he sweats gold and I have even insisted on there being
no summer holiday at Carfax's.'[122] Sickert, of course, had no compunc-
tion about taking a summer holiday himself. He and Christine went
down to Brighton in August to spend some weeks with Walter Taylor.
It was a 'delightful change' – with Taylor ever the 'charming host',
and Brighton offering its twin attractions of bracing air and Regency
exuberance. Sickert enjoyed a pre-breakfast swim each morning in the
'rough and somewhat sooty sea'. His friend, the watercolourist Douglas
Fox-Pitt, arranged for him to have 'the run of the Pavilion' so that he
might study its fanciful treasures and artworks at leisure. (He came to
consider that the gallery there was '*the* example of proper picture hang-
ing – pictures considered as a permanent factor in the architecture of
a room and not as items in a lending library. The life-sized or larger
than life portraits or drama-pictures . . . hang on the frieze above the
picture-rail. Below were perhaps a couple of lines of cabinet pictures,

up to perhaps 30 by 25 inches.'[123]) Before and after splendid lunches
of local seafood ('such crabs') there was time for reading in Taylor's
comfortable armchairs.[124] Sickert was embarked on Alfred de Vigny's
1835 collection of morality tales, *Servitude et Grandeur Militaires* ('it
seems to say all there is to be said about the army and the military
spirit').[125]

But, for Sickert, a holiday was only ever a change of scene and
subject matter. The business of picture making went on. He made a
large pencil and watercolour drawing of the Brighton seafront, which
he thought both 'taking and sellable';[126] and he discovered an 'amazing'
new subject in the tatty open-air 'Pierrot Theatre'. Soon he was going
'every night' down to the beach to study the crepuscular scene: the
gangly minstrels in their cinnamon-coloured comic suits and straw
boaters performing their sad antics before a line of largely unfilled deck-
chairs and the blank façades of some seafront terrace. He made drawings
on the spot and began, at once, to set down on canvas what he called a
'day to day rehearsal study', through which he could 'register his daily
impressions'.[127] At first Sickert found the results frustratingly 'mediocre',
when set against the magic of the actual scene; but the difficulties soon
resolved themselves, and he then repainted the complete composition
on a fresh canvas. It was, he told Ethel, 'a bit of all right'.[128] After the
monochromatic restrictions of printmaking he could luxuriate in the
thrill of colour – the shabby pinks and peppermint greens of the stage
bunting, the burnt-orange and mauve of the evening sky. And Sickert's
own excitement at the picture was soon echoed by others.

On his return to London, he installed himself in Whistler's old studio.
The space – at the back of the house, and reached via a labyrinth of
unlit passageways, narrow stairs, and metal gantries – had once been
a ballroom, and through the grime of years it still held a hint of past
Georgian splendour in its elegant proportions, its row of tall windows
(staring blankly out onto the wall of the next door house), and its
time-speckled pier glasses. It was a fine place for a party, and Sickert
soon began hosting informal 'At Homes' there on Saturday afternoons.
Although these were social rather than selling occasions they did give
him an opportunity to show off recent work. The painting of the
Brighton Pierrots was soon snapped up by Morton Sands, and a second
version was completed for another eager purchaser.[129]

Term started at the Westminster Technical Institute on 20 September. 'Here we are, here we are; here we are again!' Sickert carolled on his return to Vincent Square. The sight of the place brought back to him 'the thrilling days' when he had 'tried so hard to secure the adventurous experience of marrying beneath [himself]'.[130] It also brought back memories of overwork and exhaustion, and he determined to husband his energies more carefully this time. The mere fact of change always provided him with additional strength and appetite. 'It was written', he declared cheerfully, 'that I should teach classes at night, & hand tea on Saturday afternoons in a rather noble & dingy studio in Soho. And what is more, as my horrible old schoolmistress in Reading used to say, I like it.' Indeed his considered idea of heaven was:

1. painting in a sunny room an iron bedstead in the morning
2. painting in a North light studio from drawings till tea-time
3. giving a few lessons to eager students of both sexes at night.[131]

The teaching, he claimed, was not only interesting in itself but *taught* him. It also meant that in his own work he was not paralysed 'at every stroke of the brush' by anxieties over whether it would 'pay'.[132] Etching was for the moment given up. The printer had gone into a munitions factory, and the gaggle of informal students disbanded. Sickert left the press and materials at Red Lion Square, where Sylvia Gosse – acting as ever to smooth his path – took them over, along with the lease: 'a blessing to me & . . . useful to her'.[133]

'The Whistler', as Sickert dubbed the studio at 8 Fitzroy Street, now became the centre of operations. He was happy to be back in familiar territory. Some of his first 'At Homes' were held jointly with Maurice Asselin. Sickert made a portrait of his rather rhomboid friend and when, towards the end of the year, Asselin had a one-man show at Carfax, he wrote a catalogue note and a generous review in the *Burlington*. He told Ethel Sands, with typical exaggeration, 'Asselin remains, I might say, my only friend. He is in the country but now & again comes up & we déjeuner with a bottle of white wine at the eighteenpenny French place. I refresh myself in the French common-sense & sanity, & understanding, not only of life but what is rare here, painting.'[134]

The expression 'only friend' can only have been used in the sense of 'only ally', for in Fitzroy Street Sickert was surrounded by old friends. For non-commonsense views about painting Sickert could seek out

Above Sylvia Gosse, Sickert's
self-effacing guardian angel,
by Harold Gilman,
*c.*1913.

Right Ambrose McEvoy by
Augustus John.

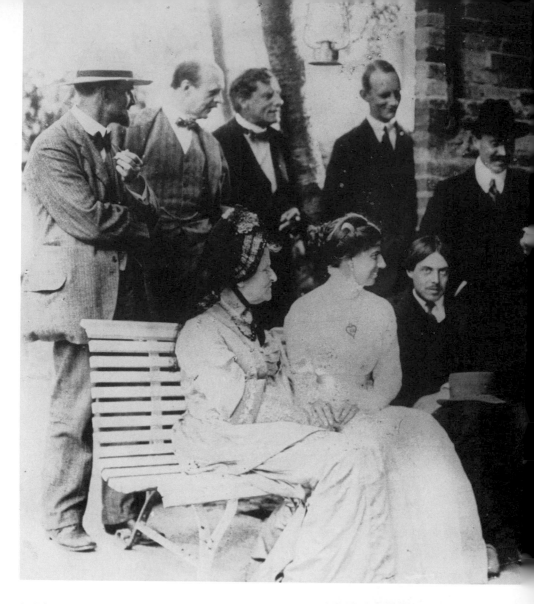

At Dieppe, summer 1911. From left to right:
(standing) Robert Sickert, Jacques-Émile Blanche,
Walter Sickert, Oswald Valentine Sickert, Charles
Ginner, (sitting) Eleanor Sickert, Christine Sickert
(née Angus), Wyndham Lewis, Leonard Sickert,
unknown (in hat), Helena Swanwick (née Sickert).

Right 'Chicken', the gap-toothed cockney model,
Emily Powell, by Walter Sickert, *c.*1914.

Far right Enid Bagnold with 'Anzy' Wylde and his
future wife, Wendela Boreel, 1918.

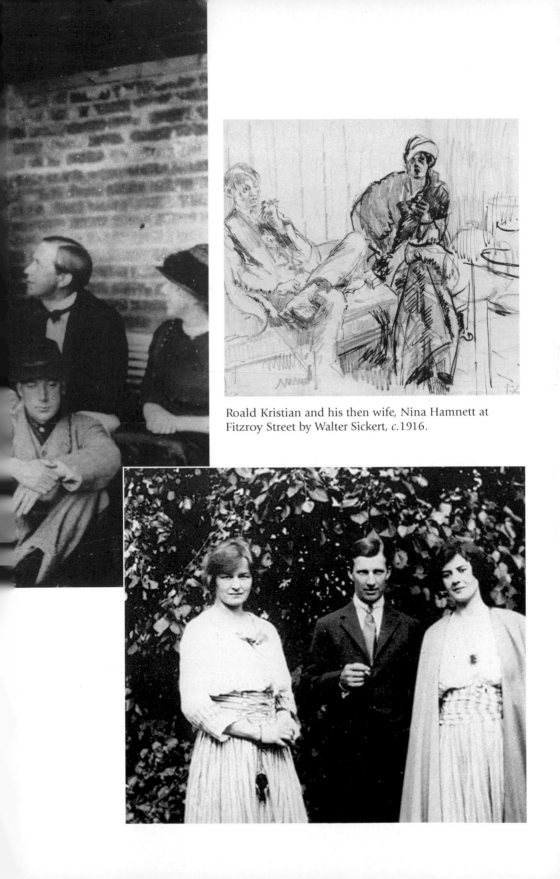

Roald Kristian and his then wife, Nina Hamnett at
Fitzroy Street by Walter Sickert, c.1916.

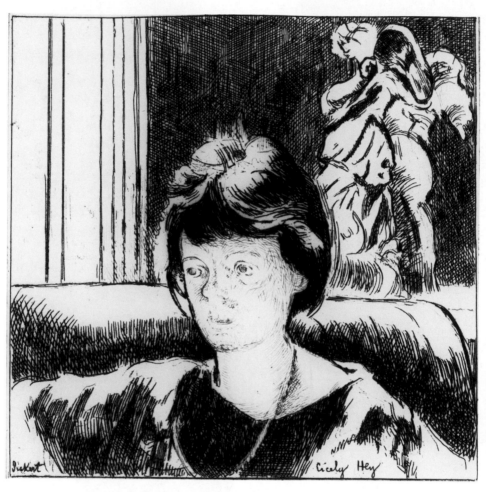

Cicely Hey, by Walter Sickert, 1923. 'God made your face with a chopper,'
Sickert told her.

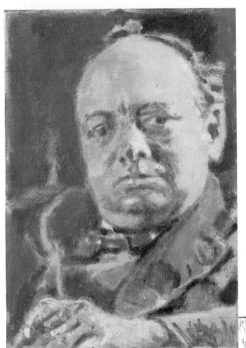

Left Winston Churchill, by his then painting instructor, Walter Sickert, *c.*1927.

Below The hotelier and sportsman Harry Preston with his dog, Sambo, by Walter Sickert, *c.*1927.

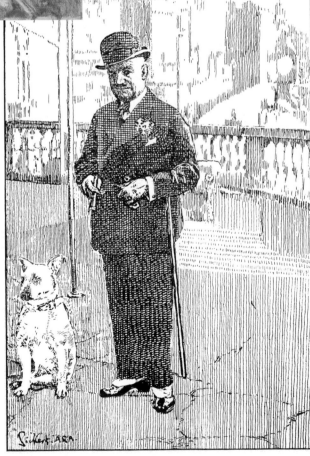

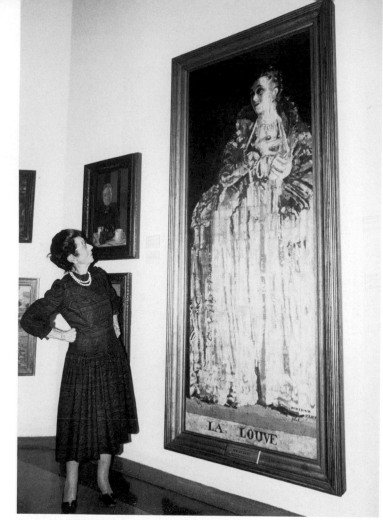

Right Gwen Ffrangçon-Davies inspecting Sickert's 1932 painting of her, *La Louve,* at the Tate Gallery in 1989.

Below The divine Peggy: Peggy Ashcroft, by Walter Sickert, *c.*1934, done from a holiday snap

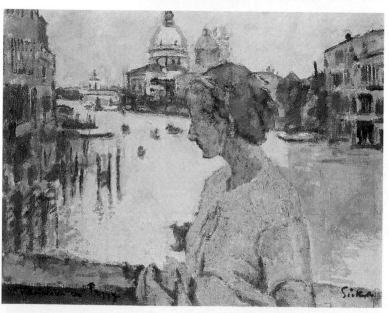

Right Lady Berwick (née Teresa Hulton), whom Sickert had known as a girl in Venice, 1933.

Below Walter Sickert's 80th birthday party, St Peter's, Thanet. From left to right: Walter Sickert, Lady Martin, Sylvia Gosse, Sir Alec Martin.

Walter Sickert and Thérèse Lessore at Bathampton, by Cecil Beaton, 1940.
The painting on the easel is Sickert's view of Temple Bar.

Roger Fry, who, though he continued to live down at Guildford, was often at the Omega Workshops, and also kept a studio in Fitzroy Street only a few doors down from the 'Whistler'. There was much amiable toing and froing. Fry held a jolly supper in his rooms for Sickert, Christine, Robbie Ross, and a few others,[135] and he came over to No. 8 to read a 'slating' of his exhibition that Sickert was writing for the *Burlington*.[136]

Sickert, if he no longer had the inclination or the command to try and direct the development of 'modern art' amongst his contemporaries, opted for a less taxing but more colourful role. He became the paterfamilias of the quartier, taking a keen and amused interest in Fitzroy Street and all that went on in the busy sweatshops, the dingy lodgings, the cheerful restaurants, and the artists' studios. He came to know its characters and their businesses: the tart across the way 'who charged 10d and was very quick';[137] his neighbour, the rosy-faced Eurythmics teacher; the long-suffering barrel-bellied landlord, Mr Hubert; pretty, buxom Dora Sly – 'the fairy on top of the Christmas Tree' – who lived above him at No. 8 and was Charles Ginner's occasional mistress; and her husband, the faintly mysterious and splendidly moustachioed Dr Sly, who was involved – perhaps – in a West End gambling den.[138]

But it was the young artists and students working in the area who were his especial charge. He acted as both pied piper and policeman, gathering them together at his parties, encouraging their work, treating them as fellow professionals, confounding their awed admiration through his own mischievous eccentricities, and discouraging their transgressions.[139] When he learnt that some of them had been pilfering from the local shops and studios, he warned the shopkeepers and threatened the culprits with exposure.[140] It was a surprise to some to discover that Sickert's own unconventional ways rested upon such a rock of conventional middle-class morality. But the stratum was always ready to crop out. On another morning he confiscated a bottle of champagne from a young female student on the grounds that it was 'disgraceful' for girls to be drinking so early in the day (his sense of rectitude did not, however, prevent him from enjoying the bottle himself with his dinner).[141]

Nor did moral considerations hold him back from starting an affair with his Westminster pupil Wendela Boreel, the beautiful, dark-eyed daughter of the Dutch Minister in London. Sickert characterized her

as 'a morsel fit for a sultan'.[142] Telling her that she was too talented
for Westminster evening classes, he installed her in his old rooms in
Mornington Crescent and gave her private tuition in the afternoons.
She became, as she put it, his 'petite nègre'. He took her sketching at
the music hall and he taught her to etch. (Her first print was of a
boxing match that she had gone to with Sickert.) 'I worshipped him,'
she recalled, 'and it seemed quite natural to go to bed with him.'[143]
According to her testimony he was an energetic, if not a particularly
considerate, lover. The first time they had sex, he came inside her three
times before thinking to ask her whether she was 'all right'.[144] His
infatuation with her – though not long lasting – was such that, on
another occasion when he was on top of her, he suggested they should
get married. She had to remind him he was still happily attached to
Christine.[145] If the affair was an exhilarating diversion, it must some-
times have taxed the 55-year-old Sickert. It was probably at this period
that, while walking down Charlotte Street with Augustus John, he
paused before the window of a plumbers' supply shop and announced
with mock solemnity, 'I wish I had a brass cock.'[146]

Sickert also came to know Roger Fry's spirited young protégée and
sometime mistress, Nina Hamnett. A colonel's daughter from the
Home Counties, she had confounded her background to become a
talented painter and a natural bohemian. Quick, amusing, amoral,
fond of drink, and keen on sex, in the years before the war she had
steeped herself in the artistic life of Montmartre, becoming the friend
of Modigliani, André Dunoyer de Segonzac, and the other young turks
of the quartier. She had a lithe gamine figure, and short bobbed hair.
She also had a husband – a Norwegian painter who worked under the
name Roald Kristen. They both put in time at the Omega Workshops
to support themselves. Sickert took them up: he found Kristen intelli-
gent, and Hamnett both talented and amusing. He made a rather
touching double portrait of them having tea at 8 Fitzroy Street and
looking, as Hamnett considered, 'a picture of gloom'.[147]

It was perhaps through Hamnett that Sickert met Matthew Smith,
another newcomer to Fitzroy Street. Smith, shy and self-questioning,
was then thirty-six. He had studied at the Slade and briefly – very
briefly – at the atelier Matisse established in Paris before the war.
Declared unfit for military service, he had retreated to an attic studio
at 2 Fitzroy Street. It was there that, in a sudden access of Fauvist
self-assertion, he painted two violently coloured, rawly delineated

nudes (overcome by the effort of creation he named them *Fitzroy Street Nude I and II*).[148] Sickert called to see them and their creator, and despite his general reservations about Fauves – faux or vrai – was generously encouraging. He told the anxious Smith, 'You paint like a painter and draw like a draughtsman.' Smith was enormously heart-ened by this endorsement, and by Sickert's easy offer of friendship. They found much common ground – a fondness for bric-a-brac shops and eccentric characters, a love of French art, French wine, and French life.[149]

Amongst these new friends, there were also some familiar faces. Ambrose McEvoy called, remembering the studio from when Whistler had used it. Wyndham Lewis would look in for tea and read passages from the manuscript of his novel *Tarr*, which Sickert enjoyed very much more than his painting.[150] Lewis was recovering from a bout of VD and was reassured by Sickert's advice about the condition: 'treat it as a bad cold that lasts for a long time . . . the treatments that dispose of it quickly are all of them apt to lead to complications'.[151] Lewis was in no hurry; once the illness cleared he was due to enlist – along, so it seemed, with everyone else. His fellow Cubists David Bomberg and John Wheatley had both joined up, and even Hubby was in khaki as part of the Army Service Corps.[152] There was an exciting moment when Sickert thought he might be sent by the Prime Minister, Herbert Asquith, 'to sketch for him at the front',[153] but nothing came of the scheme.

He endured his frustration with ill grace, remarking – either tact-lessly or tastelessly – to Nan and Ethel, occupied as they were with 'real sufferings' at Veules-les-Roses, that 'the wearing effect' of the war was really 'worse on us non-combatants'. All his 'soldier friends,' he said, were 'well & happy', while the artists he saw complained that painting was 'much more difficult & laborious'.[154] He did, at least, have the grace to be chastened by Ethel's reply, and he admitted contritely, 'I don't know what I am grumbling about.' His moods, he recognized, were not really dictated by events. When Ethel Sands came back to London for a brief visit in the autumn, she found him more cheerful, relishing the simple pleasures of life. He invited her round for a studio lunch of 'charcuterie & cheese & bananas & olives'.[155]

Separated from the conflict across the Channel, Sickert found him-self involved in one closer to home. As a result of what he termed his 'intellectual opposition' to Gilman's ideas about painting, he dispensed

with his friend's services at the Westminster Technical Institute.[156] He disapproved of the 'feasts of colour' and van Gogh-like impasto in which the students had been indulging under Gilman's instruction, and wanted to bring them back to a stricter diet, reducing them 'to a palette so restricted that it was almost monochrome'.[157] Gilman was outraged, both at the loss of income and the loss of face, and he found many to share his sense of injustice – and not only amongst his immediate circle. Sickert remained unperturbed. 'There is a beautiful & immense anti-Sickert bund rolling up,' he informed Ethel Sands. 'All the Slade professors have without any inquiry as to my views of the case signed affidavits that I am a villain & a knave & a robber or words to that effect.'[158] Fred Brown, who had long held doubts about the direction of Sickert's work, tried to give his disapproval an artistic basis. He wrote to say that 'the sordid nature' of Sickert's pictures since the Camden Town Murder series made it impossible for there to be any continuing friendship between them. 'Enfin!' Sickert exclaimed. 'I am rather unaccustomed to be disliked. It is no doubt a salutary experience.'[159] He did, however, take care to spread some discreet coun-ter-propaganda of his own, and was pleased to report that Brown subsequently 'revised his opinions' and was 'willing to continue in our old relations'; the 'naïf Gilman [had not] it appears . . . confined himself to the truth in his ex parte statements'. Several other old con-frères also 'modified their views' after explanations had been given.[160]

Sickert was glad of it. He still harboured a respect and affection for his Slade and Chelsea friends; and if he frequently wrote against their work, he hoped that he would 'never do anything that would give [his old friends] any pain'.[161] Mutual criticism, however 'severe', was always useful. 'Contemporary friends & colleagues', he suggested in one letter to Tonks, 'serve each other . . . in the function of whet-stones. One hand washes another as the Germans say, and I am all against amputations, were it only from motives of intellectual selfish-ness. But with you, as you know, that is not all.'[162] He saluted the work that Tonks (a trained surgeon) was doing – making accurate, medically informed portrait records of the war wounded.[163] It was certainly to be preferred to Steer's watercolour landscapes. After dining with his old friend at the Hammersleys that winter, he reported: 'I like Steer more & his painting – alas! – less every time I see them both.'[164]

Not all of Sickert's engagements were artistic. Nina Hamnett took him along to a rowdy theatrical party thrown by the Duke of Man-

chester (the son of Bessie Bellwood's protector).[165] He also recorded an 'exhilarating supper' with his brother-in-law, Fiddy Colqhoun, the young doctor married to Christine's sister: 'a bottle of Graves, a good cigar and talk of cancer, syphilis, acephalous babies etc'.[166] And his own family required some attention. His 85-year-old mother had got herself into difficulties. Used always to ordering the same weekly provisions, and uncomprehending of the increased wartime prices, she had been overspending her monthly budget. The invalid Robert was unable to cope with the situation, Oswald was away in the Far East on business for the Times Book Club,* and Bernard (who, to allay anti-German sentiment, had dropped the 'h' from his name) was serving in a Voluntary Aid Detachment nursing unit at Cheltenham.[167] So Walter found himself in the improbable role of the apostle of prudence. He patiently explained the matter to his mother, and went through the 'grocer's book' with her – line by line – to see what she might reasonably do without.[168]

Sickert's own wartime economies were minimal. He did, however, cut down his smoking to 'about one cigar a week'. This, he said, had the effect of making him 'read less and paint more' – although relatively little work survives to support this claim.[169] At the NEAC's winter show he merely exhibited one of his Carfax etchings.[170] He seems to have spent rather more time in talking about work. 'I learn a great deal from a friend who is a restorer,' he told Nan Hudson. 'It is extraordinary how the old [painters] all knew their business all worked from drawings.'[171] He hoped that he might 'live for a spell after the war to illustrate in practice' what he was 'always preaching in theory'.[172] When Ethel Sands returned to England for another short break in the spring of 1916 she could see no evidence of work since the previous autumn. If Sickert looked tired, she assumed it was due to his increased teaching burden: on top of his regular classes he was also giving his series of lectures at the LCC's Central Institute. (Although she heard – from Sickert amongst others – that they were 'very successful', he would not let her attend.) Despite the apparent slowdown in his production, Sickert – with Clifton's encouragement – sought every opportunity for showing his existing work.[173]

He joined the National Portrait Society and the International Society (where Blanche was still involved on the committee),[174]

* He wrote an interesting series of letters on Japanese theatre to Charles Ricketts.

and he rejoined the NEAC.[175] He also swallowed his pride and sent a 'little picture' to the London Group ('I dare say it was a mistake to refrain from exhibiting because dear Epstein's drawings made me sick,' he told Nan. 'One is only responsible for what is in one's own frame.'[176]) He continued to support the AAA, and he exhibited at the Grosvenor salon and the Society of Scottish Artists. But he took no part in the councils of these various groups, and had no loyalty to their precepts: he resigned and rejoined at will – or at whim. They were no more than convenient platforms upon which to appear; and, with his regular one-man exhibition at Carfax planned for the autumn of 1916, Clifton was anxious to ensure that the appearances were frequent. Sickert's name and art were kept continually, if discreetly, in view.

The combination of wide but small-scale coverage confused the critical radars of the commentators. At the same moment that Claude Phillips was remarking in the *Daily Telegraph* that Sickert had been 'so much before the public of late', D. G. Konody, *The Observer*'s art critic, was claiming that Sickert did 'not exhibit much' nor 'court publicity of any sort'.*[177] The variety of Sickert's attachments precluded his identification with any particular group. Although the critics were keener than ever on applying labels and marking boundaries, he defied easy classification. Pondering on whether to send a canvas off to the Grosvenor or the London Group, he mused: 'Shall I be a dasher among the stuffers or a stuffer among the dashers?' In any company, however, his individuality marked him out. At the International Society, where the pervading mood was of 'well-bred' escapism, Sickert's *Gaîté Montparnasse* struck a contrasting note of 'queer, freakish reality'.[178] Even at the London Group, where he showed alongside many of his former pupils, their pallid reflections of his manner merely emphasized his superiority. Sickert, it was declared, was 'more entertaining than Sickertism'.[179]

He was content that it should be so. He did not, as Nina Hamnett remarked to Roger Fry, 'get Modern Art'.[180] In his occasional pieces for the *Burlington* he kept up a constant rearguard action against 'the less intelligent followers of Cézanne', the Cubists, the Futurists, and the

* Sickert's slight reputation north of the border was confirmed in the press coverage attending his appearance with the Society of Scottish Artists. The *Dundee Advertiser* called him 'Walter Pickert', and in *The Scotsman* he was listed as 'Walter Seckert'.

'tangential-line-extension exercises' of his friend Wyndham Lewis, and the critics who promoted them.[181] He regarded it as his role to tell them when they had 'gone too far'.[182] He remained engaged with his fellow artists, but the engagement was increasingly a matter of topography. According to Clive Bell, he was really interested only in his own quartier – the immediate environs of Fitzroy Street. A 'rumour that Robinson of Rathbone Place had invented a new method of rendering rime on park palings' filled him with more excitement than any news carrying from the studios of Paris.[183]

Yet, for all his defiant parochialism and individualism, he was still seen as belonging to the broad current of the 'movement', as being one of the several disparate elements of the 'progressive' scene. While critical opinion was ready to discard Augustus John from the ranks of the 'modern', Sickert's position remained secure. Amongst the younger artists – that 'fierce generation', as Clive Bell called them – that had 'broken so violently with the past' and were, on the whole, 'so dreadfully rude to [their] step parents', he was still treated with 'respect'. Their occasional exasperation at his theoretical positions and journalistic squibs was tempered with a recognition that his criticism – unlike that of the reactionary establishment – was untainted by the notes of either 'base jealousy or baser fear'. Sickert was manifestly disinterested and sincere.[184]

He also possessed an undeniable 'glamour', a compound of his personality, his good looks, and his history. Although he no longer looked to France for either salvation or inspiration, his past connections with the Paris art world remained a potent part of his myth. The war had weakened such ties, but not broken them. French visitors were always welcome, and often present, at Fitzroy Street. Félix Fénéon called and was able to report that he had recently sold one of Sickert's pictures; and his pleasantry – 'Pendant la guerre nous ne pouvons vendre que des Sickert' ('During the war we can't sell anything except Sickert') – though it may not have been strictly true, certainly impressed the hearers.[185]

Sickert, however, never rested upon the past. It was his dedication to the continual development of his own art that perhaps most impressed his juniors, his refusal to stand still. The young John Nash, to whom Sickert offered generous advice and encouragement, was amazed that, though in his mid fifties, he showed 'no signs of getting "groovy" [i.e. stuck in a groove] or tired'.[186] They were 'grateful' for

his example: his unceasing 'effort of invention', his refusal to make commercial compromises, his artistic purity, his essential generosity, and his irreverence.[187]

IV

SUSPENSE

I am learning a good deal about painting.
(Walter Sickert to Nan Hudson)

During the summer of 1916 Sickert and Christine went down to Chag-
ford, the prosperous Devon village that had been the scene of their
engagement.[1] They rented 'Teign View', close to the river, looking
towards Rushford Mill.[2] Cut off from the distractions of town, Sickert
found time and space for work. For the first time he began to paint
the English countryside. There was nothing else to paint. All the
elements of his life were bound in a small compass. He rose early and
made his drawings and colour studies before breakfast – the ideal that
he often proclaimed but seldom achieved in London. He took his
morning swim in the river before lunch.[3] He made pictures of the
village and the surrounding fields. It was a happy time: one of his
fondest memories, he claimed, was of a sunny day in the village church-
yard when Christine came and looked over his shoulder at the drawing
he was doing.[4] The new subject matter he found at Chagford encour-
aged him to experiment with a new style: he adopted bold black
outlines to delineate his forms in what may even have been a tentative
attempt to adapt the manner of Cézanne away from the prying gaze
of Roger Fry. Perhaps he was led in this direction, too, by the example
of Matthew Smith, who with his wife, the painter Gwen Salmon, came
down to stay at Chagford for at least part of the summer.[5] It was a
productive break. Sickert returned from Devon at the end of the holiday
with a stock of new work and – much to the distress of both his
mother and Christine – another 'ugly beard'.[6]

He was pleased to learn that Gilman had recovered from the blow
of losing his position at Westminster and that – together with Ginner
– was setting up his own drawing school in Soho. The rift between

them was at least partially healed. Sickert, for his own part, bore no animosity to his erstwhile colleague. He wrote to congratulate Gilman on the new venture and to record the unexpected 'elation' he felt at seeing him again.*[7] After his tentative reconnection, earlier in the year, with the London Group (of which Gilman was still president), Sickert became a member again in time for the winter exhibition. One of his contributions was a painting – perhaps from a photograph – of Augustine Villain's son Maurice as a young boy, to which he appended the topical title, *Maurice Villain – Croix Militaire*.[8] Maurice, recuperating from his war wounds, came over to England and lodged once again with the McEvoys, who had always remembered him fondly.[9] The London Group's exhibition coincided with Sickert's solo show at the Carfax Gallery. The two dozen paintings on view represented a gathering from Clifton's substantial holdings. Included were several of the recent Chagford canvases, prompting some approving observations about Sickert's rejection of 'sordid' subject matter.[10]

Despite the war the art market remained buoyant, and Sickert's Carfax show represented something of a breakthrough. It was not a huge commercial success, but a definite step forward. Clifton's concentrated campaign of promotion was proving effective. Sickert's prices were, in his own words, 'furiously up'. 'Mere drawings', as he boasted to Mrs Swinton, were fetching as much as £30 or £40.[11] He was excited by this upturn in his popularity and his prospects, and eager – in theory – to encourage both. When he embarked on a new composition (later exhibited as *Suspense*) of a young woman seated at a fireside he was, according to Clive Bell, particularly 'anxious to do something charming that the public would really like'. In a self-conscious attempt at cynical commercialism, he tried out several models for the picture, two 'undeniably taking' and a third who was 'positively pretty'. But his ingrained artistic sincerity was not so easily subverted. He found himself choosing instead a fourth model – 'a dumpy, stumpy, thoroughly unattractive female' – who, though less likely to appeal to the 'beauty-loving public', was undeniably, if inexplicably, the most appropriate for the design of the painting.[12]

* Wyndham Lewis described how Gilman, for his part, would 'look over in the direction of Sickert's studio, and a slight shudder would convulse him as he thought of the little brown worm of paint that was possibly, even at that moment, wriggling out onto the palette that held no golden chromes, emerald greens, vermilions, *only*, as it, of course, should do'.

Arnold Bennett was amongst those who bought from the Carfax exhibition. Clifton told him that Sickert was the 'greatest artist of the age', a verdict that Bennett noted approvingly in his diary.[13] Sickert was delighted to receive an invitation from Bennett to lunch at his club early in the New Year, though he had some anxieties about the other proposed guest: George Moore. The froideur between them had continued, and although Sickert claimed that he would always be 'enchanted' to see Moore, he doubted whether the feeling was mutual. In fact Moore was only too pleased to heal the rift. The lunch was a jolly occasion, Sickert arriving (much to Bennett's amazement) fresh from a morning's skating on the Regent's Park Pond – he had his skates still with him and no overcoat. Moore and Sickert were charming to each other, reminiscing a good deal, much of the time in French. Bennett considered that, of the pair, Sickert was much the 'more normal'; more reserved, but less detached from the war and realities of life.[14]

The lunch restored the outward form of friendship between Sickert and Moore, even if it could not rekindle the old warmth. Moore became an occasional visitor at Fitzroy Street, assuming his pose as the penetrating and privileged critic of art. But Sickert was less than ever inclined to listen.[15] He was much better pleased by the arrival of another old friend. Walter Taylor had rented 'a floor' at No. 18 Fitzroy Street, and Sickert took him in hand at once, lending him furniture and some of his 'most cherished bibelots' from which to do a still life.[16] They would meet up for convivial little lunches at the 'Whistler'.

Sickert was now doing all his own cooking on a stove in the studio. He breakfasted on 'Scotch brose'* and a 'rasher'; lunch might involve a slice of grilled salmon, a salad of *mache* (lamb's lettuce) and two hard-boiled eggs, and a tumbler of wine. The 'tea meal', as he put it, was 'suppressed' in favour of a small dinner at five ('a cutlet or a little stew').[17] The studio cooking regime was a great economy after the daily expense of the Euston Station Hotel, Shoolbred's, and the other local eateries. And the food was better.[18] The same excitement at the possibilities of ingredients and materials that informed his love of painting found an echo in his cookery. (Sickert despaired of Roger Fry, complaining that his motto was, 'I don't care *what* I eat – so long as it

* A dish of oatmeal mixed with boiling water or milk and dressed with salt and butter. It differs from porridge in that the oatmeal mixture is not cooked.

comes out of a tin!'[19]) He tackled his new interest with a comprehensive relish, assembling a battery of expensive saucepans and patent labour-saving gadgets.[20] He became an authority upon produce: the fresh bread delivered daily from the local bakery was, he insisted, amongst the best in London. He delighted in the first of the season's asparagus, or in the gift of a hare to be jugged. The celebrated hotelier Rosa Lewis came up from the Cavendish Hotel to teach him how to cook roast quail and other secrets.[21] He sought out olives and other treats amongst the French and Italian delicatessens of Soho, and tracked down the best quality coffee beans. Coffee was important to him, as all meals were rounded off with a demitasse of the stuff made after an elaborate and highly personal method. Various descriptions of this extraordinary process survive: boiling water was poured into a small saucepan over the freshly ground coffee and then brought back up to the boil thirteen times before being served. The significance of the number thirteen – either to Sickert or to coffee making – is unknown, but it was always insisted upon. The testimony of guests as to whether the resultant brew was delicious or disgusting is divided, though all admitted the compelling drama of the procedure.[22] Cookery, for Sickert, was a theatrical performance. It provided him with a new role for his repertoire, a new costume for his wardrobe. He acquired not only an apron, but also a fantastically tall chef's hat in which he could take his stand by the stove.[23]

He gathered people round his table and fed them. Edith Sitwell called and brought her brother, Osbert.[24] He had been invalided back from France with a cut finger and was now stationed in London at the Chelsea Barracks. Already, at twenty-four, he was establishing himself not only as a poet but as a patron and encourager of artists. Sickert he adored. They shared enthusiasms for the eccentricities of the Victorian past and for the human comedy of London life. Osbert revelled in Sickert's wit, and drank in his anecdotes of Keene and Degas, Whistler and Wilde, of the time Frank Harris had referred to Goethe with such emphatically bad pronunciation that everyone assumed he was talking about the actress Gertie Miller. Osbert also introduced his young brother, Sacheverell (just down from Eton and in the Guards), to the wonders of Fitzroy Street, adding another ally to Sickert's cause.[25] Others followed in their wake. The vagabond poet, W. H. Davies, who lodged in a mouse-infested room by the British Museum, became a regular guest. Sickert enjoyed his verse and his company. Davies gave

Sickert two volumes of his poetry and Sickert repaid him with numerous etchings. He also drew his portrait. While working on the sketch, he asked Davies what he was engaged on, and was delighted with the reply, delivered in a soft Welsh lilt, 'I'm joost obsaiving.'[26]

In the summer of 1917 the Sickerts went to Bath. Walter was thrilled with the place. 'Bath is *it*,' he informed Ethel Sands. 'There never was such a place for rest & comfort & leisurely work. Such country, & *such* town. And the mellifluous amiability of the west-country gaffers & maidens, all speaking the dialect which became the American we know & love.' He felt a family connection with the place, as his great-uncle John Sheepshanks had lived for a while in a grand house at the end of Camden Crescent.[27] He rented 'The Lodge' on Entry Hill, and took a studio room at 10 Bladud Buildings near the heart of the town. His old friend and former teaching colleague, Alfred Thornton, was, he discovered, living close by. They spent pleasant hours together strolling the streets and squares, Sickert always alive to the pictorial possibilities of the passing scene, a chance trick of light, or unexpected vista – an opening that 'disclosed a window with women's hats'.[28]

Rather than depicting such glimpsed moments, however, as once he might have done, Sickert focused his attention on the town's more august sites: the bowed façade of 'Mr Sheepshanks' House', the sweep of Lansdown Crescent, the Belvedere, the span of Pulteney Bridge. After Venice, Dieppe, and Camden Town, Bath became a new townscape to be explored, studied, and defined, in numerous carefully annotated drawings. Squaring up his compositions for transfer on to canvas, Sickert came to love the look of squared-up drawings. Or so he asserted. He told Osbert Sitwell that the grid pattern imparted an 'added savour' to a design, a clearer sense of 'the direction of all visible lines compared to the perpendicular'. By the same token he affected to believe that electricity pylons marching over the Downs would lend a new beauty to the scene.[29]

Over the course of the summer he grew yet another beard, claiming it was a 'war economy'.[30] It also gave him more time to work. One of Christine's sisters came down to keep her company, as there were few other social diversions.[31] When Keith Baynes, a young painter and a protégé of Thornton's, who lived with his parents not far from Bath at Bradford-on-Avon, invited the Sickerts over for tea, Christine had to explain that they could only come on Sunday, as 'unfortunately my

husband refuses to leave his work any day but [then]'. The visit, how-
ever, seems to have been a success. Baynes became a friend and, when
he moved up to London soon afterwards, took a studio in Fitzroy
Street.[32]

Sickert's thoughts that summer also turned upon teaching. Fred
Brown had announced his intention of retiring from the Slade, and
Sickert was tempted to apply for the position. There was some support
for his candidacy. He told Wendela Boreel that he was 'being men-
tioned vaguely' for the post.[33] But he held back, leaving the way clear
for Tonks, who, though the obvious successor, was still grateful to be
given a clear run.[34] Out of contention for that position, and rested by
a summer of 'leisurely work', Sickert sought another outlet for his
energies. Memories of the strain of Rowlandson House had faded. He
issued a prospectus for a new 'teaching studio'. It was a characteristic
production:

> Bath, 1917
> Mr Sickert retains the option of accepting such students only
> as he believes are likely to profit by his method of training. To
> avoid correspondence, it may be found convenient to state the
> principles by which Mr Sickert would be guided in his accept-
> ance of students. Unlikely to benefit would seem to be:
> (i) painters whose practice is already thoroughly set in methods
> [sic] its continuance in which Mr Sickert would be unable to
> encourage and indisposed to check; (ii) students who have
> already studied with him long enough to have absorbed – or
> failed to absorb – the little he has to teach. An intelligent
> student who cannot learn whatever is to be learnt from a
> teacher in three years will learn no more in thirty. Mr Sickert
> prefers not to be a party to the creation or perpetuation of
> what may be called the professional or eternal students, with
> no other aims than to haunt the art schools as an occupation
> or distraction in itself.[35]

He sent a copy of the flyer to William Rothenstein, who had moved
down to Gloucestershire shortly before the war, urging him to send
on 'des élèves, des nourrissons'.[36] But, despite canvassing the West
Country for pupils and nurslings, Sickert expected to gain most of
his students by creaming off the more dedicated talents from his
Westminster classes.[37]

The opening of the 'Sickert atelier' precipitated a fresh set of living

and working arrangements. Kildare Gardens had never been a satisfactory home, and whenever Christine was out of London, Sickert would flee Bayswater, moving into the Tavistock Hotel, an old-fashioned, semi-commercial institution in Covent Garden.*[38] With the focus of life fixed once more back in North London, a new home was found in Camden Town, at 81 Camden Road.[39] Inspired by a dismal row of laurel bushes struggling for light in the tiny patch of front garden, Sickert announced his new address as 'The Shrubbery'.[40] Further north than his previous Camden homes, Sickert changed his allegiance from the Euston to the Kentish Town Baths in nearby Prince of Wales Road.[41] (A brief experiment with the YMCA baths in the Tottenham Court Road, close to Fitzroy Street, had not been a success. On arriving he had enquired whether it was necessary to belong to any particular denomination, only to receive the reply, 'No, but there is an age limit.'[42])

One of Sickert's cherished pieces of advice to young painters wishing to get ahead was, 'Take a large studio! – [And] if you can't afford to take one, take two!'[43] It was amongst the few admonitions that he was prepared to follow himself. With the 'Whistler' given over to his new students, Sickert moved the theatre of his own operations across the road to an even larger studio at the back of No. 15 Fitzroy Street.† It too was reached along a labyrinth of passages, stairs, and gantries, and – also like No. 8 – it had a distinguished pedigree: W. P. Frith had painted his high Victorian masterpiece, *Derby Day*, there and in honour of the association Sickert christened it 'The Frith'.[44] It was a vast, bare, carpetless barn of a place, muffled in dust and shadow. Sickert's assemblage of familiar furniture – the iron bedstead, the horsehair sofa, the battered armchairs, the small deal dining table, the picture rack, the easel and the glass-topped table-palette – made little impact upon the room's dingy hugeness. Yet he was enormously

* On one occasion he had suggested that Christine should join him there on her arrival back in town, forgetting that the Tavistock was a 'bachelor' establishment and that women were not permitted. Too late to put Christine off, he had to beg the management to waive the rule, explaining 'that he had arranged to meet his wife here for a holiday'. The manager of the hotel acquiesced, adding – 'But it must be your *wife*, and it must be a *holiday*!'

† Sickert's enthusiasm for taking studios was a source of endless amusement to his friends. Once, when he and McEvoy were walking down Charlotte Street, they saw a sign announcing, 'Studio To Let'. McEvoy seized Sickert's arm and drew him away, admonishing, 'Be a man, Walter! Pass it, pass it!'

pleased with his new surroundings, not least because they were new.

He created new *mise-en-scènes* upon its stage: the homely parlour with its bric-a-brac-laden sideboard, the robber's lair illumined by a single bull's-eye lantern, or the commodious Dean's bedroom. (He had been reading Trollope's Barchester novels and was much taken with the world of the mid-Victorian Anglican Church.) Each setting demanded a new costume, or a new look and a new pose. He seems to have hoped that these elaborate preparations might inspire him to work. He would knot his ruffian's red kerchief loosely about his neck, pull his cap down low over one eye, and contemplate some new reworking of the Camden Town Murder subject. But to small effect: he struggled to make headway.[45]

The 'Frith', in so far as it inspired him to action, inspired him to be sociable. He transferred his regular Wednesday afternoon 'At Homes' there (though the rarer Saturday evening receptions were, it seems, still held in the 'Whistler', where the piano could provide music for dancing). Christine acted as hostess, assisted by Marjorie Lilly and Christine Cutter, two young Slade graduates who shared a cupboard-like studio room in the bowels of the building. The gatherings became larger and ever more convivial. Sickert tried to introduce as rich a mixture as possible. Besides the artists and models of the quartier, there would be actors, former pupils, dilettantes, his brothers, society women, young writers (Aldous Huxley was a regular), Bloomsbury intellectuals, unpretentious neighbours, foreign visitors, and 'a never ending stream of khaki'.[46] The flavour remained always 'delightfully Bohemian'. The painters Claud Marx and Ethelbert White would sing popular ditties, accompanying themselves on the guitar,[47] while Sickert presided – the magisterial, uproarious, careless but courteous ringmaster.[48]

He also began to hold breakfast parties at the 'Frith' ('everyday including Sundays').[49] It was a chance for him to don his chef's hat and to cook up coffee and eggs. He was in conspicuously vital form at these gatherings – spry, hungry, and awake after his morning swim.[50] As one awed young visitor noted, the 'fare seemed to inspire [him] to flights that the ordinary mortal can only attain through the good offices of Verve Cliquot or Bollinger'.[51] He would entertain his guests with a stream of anecdote, song, and extempore performance. Amongst the constantly recurring themes of his discourse were the great Victorian mystery figures of his youth – the Tichborne Claimant and Jack the Ripper. But there were also more topical concerns. The arrival of the

morning papers might prompt a eulogy on the genius of Haselden (the *Daily Mirror* cartoonist) or a disquisition upon some artistic issue of the day. Osbert Sitwell recorded how, when a group of Félicien Rops etchings en route to an exhibition in London were impounded by HM Customs on the grounds of obscenity, while the rest of the liberal art establishment rose up in horror at the news, Sickert took the opposite tack. 'They ought to make the Customs House into the Ministry of Fine Art,' he said. 'Here Rops has deceived all the critics for years into thinking him a great artist. But you can't monkey about with the Customs House! You can't take *them* in! They saw through it in a minute, and said, "That's not *Art*: that's PORNOGRAPHY!" – and they're quite right ... But nobody before them had had the wits or the courage to say it! ... I wish one of them could be given Konody's job on the *Observer*.'[52]

Besides the breakfast parties, and the Wednesday receptions, he was happy to create other distractions. Christine Cutter and Marjorie Lilly would come in for tea on his non-teaching days. He professed to be shocked at their limited knowledge of French literature and instituted a series of readings from Balzac ostensibly to correct this fault – and to improve their French pronunciation. His audience, however, suspected that the readings were for his own amusement, so carried away with the performance did he become.[53]

During the day he had to attend to the students at his atelier, setting up elaborate compositions for them to draw, and three evenings a week saw him at the Westminster Technical Institute. There were other calls, too, on his time: articles to be written, invitations to be answered, dinner parties to attend. Although, for the most part, he welcomed such commitments, they were always liable in time to provoke a sudden spasm of reaction. Marjorie Lilly vividly recalled the travails of his popularity: the little queues of supplicants that gathered outside the 'Frith': aggrieved painters seeking his support, models in want of engagements, students asking for advice, journalists after copy, hostesses anxious to assure him of their 'forgiveness because he had not turned up at [their] dinner party' the previous evening.[54] It became a daily struggle to make space, if not for painting, then for the periods of solitude and contemplation he needed in which to build up towards work: the quiet hour with *The Times* in the morning, the post-prandial chapter of some favourite author. He would have to drive his visitors away, or deflect them.

His mood was restless. During the autumn of 1917 he was lit up by a sudden 'craze' for gouache painting – or his rather personal interpretation of it, in which the pigment was applied to ready-wetted paper. It was a brief affair. He insisted on his students experimenting with the technique and was so much more impressed with their results than with his own that his enthusiasm soon waned.[55] Trying to settle, he returned to oil paint. After the pictures he had done in Bath over the summer he was seeking a new motif. *Suspense*, the painting he had exhibited that spring at the London Group, was put back on the easel, and lingered there, in the hope that it might suggest a way forward. He toyed briefly with the idea of painting flower studies, pinning up examples of his old friend Fantin-Latour's works as encouragement. But then, receiving an unexpected gift of some pheasants, he started to paint them instead – working, not from drawings, but from life. He had a sudden vision of decorating the dining room at Camden Road with a whole series of large-scale comestible still lives – partridges, hares, snipe, lobsters. Christine discouraged the project, which she perhaps knew was unlikely ever to reach completion. She liked the dining room as it was; and they already had a painting by Asselin of some crabs.[56] Her instincts were sound: the decomposition of the pheasants advanced rather more quickly than the composition of the picture. The strong whiff of putrefaction was one of the first things to greet the nostrils of Margaret Cannon-Smith when she presented herself at the 'Frith'.[57]

She was one of Sickert's best students at Westminster, and he had invited her to come and work for him as a studio assistant. Having embraced the painting methods of the old masters, he thought that he should also adopt their work practices.[58] He offered Miss Cannon-Smith a wage of £1 a week, a sum she was very happy to accept. (She did not mention to Sickert that his cheque was returned by her bank.) Her first task was to 'prepare' a new version of *Ennui*, transferring a detailed squared-up drawing of the composition on to canvas, and then laying in the tonal underpainting.[59] The appearance of an assistant at the studio confused and perturbed some visitors. To them it seemed that Sickert was producing pictures 'not entirely his own'. The charge greatly amused him, but he had no wish to offend potential customers, so he persuaded Marjorie Lilly and Christine Cutter to give up their 'cupboard' for Margaret's use, letting them have some space in the 'Frith'.

Sickert's identification with the old masters found further expression in his rambles around the junk shops of the Tottenham Court Road. Besides accumulating bric-a-brac for his dresser, he was always making 'discoveries' amongst the stacks of begrimed and battered canvases: a possible Rubens, an undoubted Delacroix, an overlooked Manet. 'He had no standards,' Clive Bell remarked with some exasperation. 'He acquired a mass of junk . . . and persuaded himself that it consisted mainly of paintings by Tintoretto. "Whom else can it be by?" he would query with an impressively knowing air.'[60] The air of assurance was doubtless put on in part to offend the rigorous connoisseurship of Bloomsbury. But the pictures were also useful to him. They served as sounding boards for his disquisitions on the techniques and achievements of the old masters and he would hold forth brilliantly upon the merits of his discoveries, merits that – as Osbert Sitwell noted – were real enough because he put them there.[61] And then, having drawn the lessons that he wanted to draw, his fancy would move on. 'Suddenly,' Marjorie Lilly recalled, 'we would find him gazing severely at his vaunted masterpiece. "Do you think . . . perhaps . . . it's not a Rubens after all?" '[62]

The continuity between the present and the great artistic traditions of the past was one of the themes that Sickert drew out in the long obituary article that he wrote for the *Burlington* on Degas, who had died in Paris after years of declining health on 27 September 1917. Ethel Sands, over from France in October, called on him at the 'Frith', and found him at work on the piece. She managed to persuade him to leave out various gratuitous jibes at Blanche and Moore (with both of whom Degas had quarrelled) and concentrate upon more useful recollections. Sickert delivered the article in person to the *Burlington*'s offices, wrapped in brown paper and labelled 'ENGLISH PROSE! THIS SIDE UP! WITH CARE!' The label, like so many that Sickert affixed to his creations, was more teasing than accurate: the article contained sustained passages of French, German proverbs, and even an exhortation in Venetian dialect.[63]

The article was Sickert's last for the *Burlington*, and pretty much his last piece of regular journalism for some five years. He had, however, been flattered by a suggestion from the publisher Grant Richards that he bring out an anthology of his articles. Sickert, having failed to write several books, thought he could at least 'collect' one and he began assembling some of his old pieces under the provisional title 'Straws

from Cumberland Market'.[64] Although Margaret Cannon-Smith recalled Sickert going through the proofs, the book never appeared, victim perhaps of wartime economies or Sickert's waywardness with deadlines and business correspondence. (Sickert allowed letters to pile up unanswered if not unopened on his desk, until he lost heart completely and consigned the whole lot to the wastepaper basket.[65])

The war showed no signs of abating. At the beginning of 1918 meat rationing was imposed, and the difficulties of home life increased. Christine taxed her health queuing for the week's supply.[66] Despite the barrage balloons Zeppelin raids continued, causing some damage and more anxiety. Sickert, however, still professed to find them a blessing, particularly – as he explained to Fry – when they coincided with his teaching evenings at Westminster. At such times he would lead his pupils down into the spacious and stoutly constructed cellars of the institute and pass the time in smoking, drinking, and talking to the captive students – and he would 'get a guinea for doing so'.[67] He calmed the fears (though rather disappointed the hopes) of the young girl in the Fitzroy Street milk shop by telling her that there was about as much chance of her being killed in an air raid as of her marrying the Prince of Wales. Nevertheless, Margaret Cannon-Smith, having spent one evening crowded with Sickert and the other denizens of the house in the basement of 15 Fitzroy Street, suspected that his apparent equanimity was achieved only with some effort.[68]

His understanding of the unfolding conflict remained narrow and personal. He hoped that the Russian Revolution was not 'incommoding' Mrs Swinton, whose family had interests there, adding cheerily, 'Apart from that Lenin seems to be about the only sensible person in Europe!'[69] When George V fell off his horse on a visit to the Front, Sickert sent him a telegram of commiseration, and was most disappointed not to get a reply. (The fact that most of the telegram had been in German, and likened the King to a frog in a ballad by Wilhelm Busch, seemed to him only a limited explanation for the royal reticence.[70]) But the awful human cost of the conflict penetrated into Fitzroy Street as it penetrated everywhere. When Gladys Davidson, one of his former pupils, lost her brother in France, Sickert wrote confessing, 'There is no consolation for such sorrows. Your brother & all who have fallen leave us under a debt of admiring gratitude.'[71] The husband of one of Christine's close friends was another casualty who touched their lives (Christine went down to Devon to comfort her),[72]

and Alan Swinton had to have his foot amputated.[73] But for Sickert the cruellest blow was the death of a favourite ex-Westminster pupil called Joe. There was, Marjorie Lilly recalled, something particularly moving about this boy, with his frank open face, his shock of fair hair, and his shy smile. During his military training he would, whenever possible, come to the Wednesday 'At Homes' in Fitzroy Street together with his girl. They would sit side by side, the girl chattering away excitedly to Christine about their plans, Joe staring silently at Sickert, his hero, in an 'ecstasy of wonder'. The bright future mapped out by the girlfriend never arrived. Shortly after being sent to France Joe was killed. Sickert, on hearing the news, shut himself up in his studio for three days. When he emerged he never mentioned Joe again.[74]

Concentration on work was, as Sickert advised Gladys Davidson, the best means of dealing with loss, but it was a course he struggled to follow himself. He had abandoned his efforts to depict the conflict. Although he pored over the pages of Goya's *Los Desastres de la Guerra*, he felt unable to move beyond them.[75] There were no more military pictures. He even balked at donating a painting to a Red Cross Bazaar organized by Asquith's daughter, Elizabeth, on the grounds that it was an 'amateur' affair ('one must really draw the line *somewhere*').[76] His concern to pay off at least some of 'the debt of admiring gratitude' that he felt was owed to those giving their lives at the Front found a simpler and more modest expression: soldiers were always made welcome at Fitzroy Street. He allowed them free access to the teaching studio, letting them draw from his models, lending them materials, giving them advice.[77]

For all his real horror at the conflict, he would sometimes become exasperated into flippancy. The journalistic demonization of Germany distressed him, and he responded with his particular brand of subversion. When Osbert Sitwell invited him to dine in the guards' mess at St James's Palace, he shocked the impressionable young officers by announcing that he had been born in Munich.[78] Elsewhere he was even louder. One awed young breakfast guest at the 'Frith' recalled Sickert standing by the stove singing *Deutschland Uber Alles*; and when dining with Max Beerbohm and Clive Bell at the Café Royal, he more than slightly alarmed his companions with an exuberant stream of German drinking songs and German jokes.[79]

The shifting succession of Sickert's masks, costumes, and personae moved as if in a constantly turning kaleidoscope. The pace increased.

The beard came and went.[80] The disguises, though certainly useful to Sickert in their different ways, hinted too at his simmering restlessness and anxiety. The stress of the war played upon his nerves more than he knew, or acknowledged. Small things upset him greatly. He became suddenly plunged into gloom after reading Joseph Conrad's novella *The End of the Tether*; the tale of the blind sea captain struck a chord of horror in his imagination and left him shaken.[81]

Anxious for change, Sickert embarked on a search for a new 'hide out'. The 'Whistler' was full of pupils, the 'Frith' had become a social hub. He needed a place in which to work and be alone. He also wanted the stimulus of novelty (not that it needed to be that novel). He confined his search to the area around Fitzroy Street. Marjorie Lilly accompanied him on the punishing round of dingy lodging houses. 'We want Paradise,' Sickert would explain to the nonplussed landladies. But none of the succession of shabby 'third floor backs' ignited the spark of his interest: 'A thousand apologies,' he would declare with courtly regret, 'but, no I'm afraid this isn't quite Paradise.' Eventually, however, the ideal *was* discovered: a 'crooked room at the top of a crooked house' in aptly named Warren Street. Furnished with a heavy round table and a battered ottoman, the place conjured up for him a world of pictorial possibility. He sensed that he might be able to work there.[82]

If his painting resumed, his contrariness remained unaltered. He broke with Arthur Clifton and the Carfax Gallery – the reason he gave to Ethel Sands was that Clifton had 'cashiered his twenty-five years' wife' and run off with Madeleine Knox, who had been working with him at the gallery. Sickert, for all his own infidelities and his profession not to 'care a cuss about m'rality', held idiosyncratic and strangely rigid views about the inviolability of the marriage bond.[83] He was 'genuinely shocked' and upset by Clifton's action, which seems to have been exacerbated in his eyes by the fact that the first Mrs Clifton, as a Catholic, refused to countenance a divorce.[84] By setting up home together, Clifton and Miss Knox would, Sickert pompously informed them, be 'committing adultery in Public'; 'It isn't done,' he fumed.[85] (When he reiterated this sentiment to Clive Bell, the open-minded Bloomsburyite pointed out that it certainly was done – all the time.[86]) Sickert declared that, on a personal level, he was prepared to forgive Clifton. 'It is my way to love the erring the more,' he told Ethel, 'in that, erring, they have more need of my sympathy.' But on

the professional front he remained 'furious' with his friend.[87] 'I thought it probable', he explained to Ethel, 'that fewer customers might visit his establishment & didn't see why *I* should be fined some hundreds a year for *his* adultery. So he no longer has the agency for my work.'[88]

Sickert retrieved all his stock from Carfax, despite the fact that Clifton had advanced him some £1,500.[89] He began selling the work direct from the 'Frith', and for a while was excited by the new role of picture dealer. The studio was rearranged yet again, the pictures stacked neatly facing the wall. 'Never give people too much to see at once,' was his marketing maxim: 'One picture at a time is sufficient.'[90] According to Marjorie Lilly, that 'one picture' was almost invariably a small, rather dark version of his 'Vieux Colombier' subject – the little dovecote with a foreground of tangled tree trunks. It was placed on an easel in the middle of the room, a single point of focus. The ploy was not particularly successful. Visitors tended to be more intrigued by all the pictures they could *not* see, and bemused at Sickert's ceremonious, polite but firm, refusal to show them these hidden treasures.

It took both determination and guile to get beyond this opening gambit. One successful and satisfied customer was a Japanese collector. Perhaps he had some connection with Sickert's former Japanese schoolfellows, for he was welcomed into the 'Frith' and given a good lunch. Sickert even produced a bottle of Madeira. Afterwards, evading the lure of the 'Vieux Colombier', the man made a brisk selection of several choice works from the stacks, including the large version of *Suspense*. Taking the measure of Sickert, he handed over the cheque immediately and arranged for a van to collect the works – ready for shipping to the East – before there could be any change of mind.[91] Sickert had no very fixed price structure. He told the impecunious young publisher, Grant Richards, never to be afraid to make an offer for a picture, however modest. Allowances could always be made for the impoverished. Rich 'amateurs' however, who offered £5 for things worth 20 guineas deserved, he felt, 'a poke in the eye with a blunt stick'.[92]

For all his apparent egoism, Sickert found it easier to promote others rather than himself. Visitors were often deflected with the assertion that, 'If you're after English painting you should collect Gore. He's your man! Now there's a painter for you!'[93] And he was particularly thrilled when he managed to sell a painting by Thérèse Lessore to one of his clients for £5 (it was, she claimed, the first sale she ever

made).[94] Fortunately, his many commitments kept him away from the 'Frith' for long periods, and Christine Cutter and Marjorie Lilly were given permission to show drawings – if not paintings – to prospective purchasers in his absence. They tended to leave customers alone to browse at their leisure over the tableloads of sketches. It proved a much more successful marketing strategy. Sales were brisk, and Sickert was able to boast to Ethel Sands that he was 'selling easily' without a dealer. He found himself benefiting, too, from the high prices that Clifton had spent the previous years building up.[95]

The first faint aroma of success produced its usual intoxication. Sickert was convinced that a new phase of untroubled financial existence was opening up for him. He decided to relinquish most of his classes at Westminster, offering the work to Nina Hamnett and the young Bernhard Meninsky, and it seems that his 'atelier', too, was abandoned. He told Ethel Sands that, after the summer holidays, his new arrangement would be to keep the 'Frith' simply 'for Wednesday receptions and deals, Whistler's studio for work with a bolted door'.[96]

After the productive pleasures of the previous year he planned to go back to Bath for the summer. He went down briefly at the end of May to make arrangements about taking The Lodge again, and was thrilled at the prospect of returning there. 'Bath is spiffing,' he had telegraphed to Nina Hamnett in his excitement.[97] But, back in London, he found numerous distractions to delay him. Christine and Marie went on ahead, and were kept in daily expectation of his arrival. He sent regular telegrams announcing his imminent appearance, only to follow them up with others detailing new delays.[98] He was busy reorganizing the 'Frith' and 'Whistler', carrying furniture between the two.*

He also saw much of Nina Hamnett, who was now free of her husband. She would breakfast with him each morning on 'a large cup of coffee, two eggs, marmalade and a large cigar'. Sometimes she would

* Sickert had a personal approach to furniture moving. Marjorie Lilly recalled that almost her first introduction to Sickert occurred when, hearing a large crash from the 'Frith', she had rushed in to find an enormous cupboard lying on the floor, with a pair of carpet slippers protruding from beneath. But, as she dashed forward to offer assistance or first aid, the cupboard slowly rose to an upright position, and Sickert 'dusty and dignified, emerged from the rear. "I've had lessons in moving furniture," he explained. "You lie on the ground with the thing on your stomach, heave and there you are."' ML, 17–18.

pose for him, not infrequently in the nude. They also lunched and dined together, and went exploring around the backways of Camden Town.[99] It is difficult to suppose that there was not some sexual element in this consuming friendship. Nina was, or had been, having an affair with Roger Fry, and this, if nothing else, would surely have prompted Sickert to try to suborn her loyalties – both sexual and artistic. After he finally did get himself down to Bath he bombarded her with letters, urging her to adopt his approved method of painting (from squared-up drawings) and inviting her to join him. When she explained that she did not have the money for a holiday, he sent her £15 saying that he wanted to buy one of her pictures.[100]

Space was limited at The Lodge but Sickert found rooms for Nina in a little house 'halfway down Beechen Cliff' – and on his way down to the studio.[101] The landlady was the widow of an 'ideal policeman', and the view out over the rooftops was, he declared, breathtaking.[102] Sickert met Nina at the station. He had confided to her that he was not particularly well. 'I am not surprised or injured that 2 years off sixty I may be having to take in sail. My father died when he was two years younger than I am, and I have had a wonderful look in already.' He wondered whether the warm Bath waters were not 'fatiguing' him.[103]

The fatigue was not obvious. The change of scene, as so often before, had stimulated his artistic appetite; and between happy interludes spent poring over old copies of *Punch* or reading Archibald Forbes's life of Napoleon III, he was working well.[104] Engrossed himself, he expected Nina Hamnett to follow the same regime. Only after a full day's work would he allow her to visit him at his studio rooms in Bladud Buildings for tea and talk.[105] Nina was lit up that summer over the poetry and life of Rimbaud and had brought 'all the available literature' on the poet down to Bath with her. When she discovered that he and Verlaine had lodged in London at 35 Howland Street, the building in which she had lost her virginity, she asked Sickert excitedly, 'Do you think they will put up a blue plaque on the house for me or will they put up one for Verlaine and Rimbaud?' To which he replied, 'My dear, they will put up one on the front for you and one on the back for them.'[106] The main topic of conversation, however, was art, and upon this Sickert would hold forth for 'at least two hours' every day. Often they would go out and Nina would watch Sickert 'paint sketches of the river and Pulteney Bridge' so that she might see his

theories put into practice.*[107] She remained, however, unconvinced, finding his pictures 'well painted but vieux jeux'.†[108] He found her modern enthusiasms incomprehensible.[109]

Once or twice a week Sickert invited Nina to dine with him and Christine at The Lodge, but for the rest he left her to the tedium of long lonely evenings at her lodgings (or even longer Sundays, when – as he was not working – she could not call on him at Bladud Buildings). Unsurprisingly she soon lost patience with the regime, and with Sickert. 'How silly he is!' she reported to Fry. His new beard, she felt, made him look like a tramp.[110] After five weeks, feeling that death would be preferable to another day in Bath, she returned to London.

Sickert stayed on until September, when the beginning of the WTI term brought him back to London. The return to town also allowed him to pick up his picture dealing again. He was convinced that his new beard was a useful sales tool: '[It] makes one look a woolly-headed old thing,' he explained. '[And] in business to look a fool and *not* be one gives you an advantage.'[111] When Ethel Sands came over from France in October she found him in ebullient mood: full of himself, bubbling with stories, and elated by his financial successes as a dealer. As regards this last point, Ethel decided to reserve judgement until she had heard Christine's version of affairs.[112] Her scepticism was justified.

Sickert's enthusiasm for selling his own work had veered off in a new, or rather an old, direction. He had reverted to what he regarded as the sane French idea of selling batches of work wholesale to dealers. It was not an approach that was readily understood by the London gallerists. When Oliver Brown, son of his old friend Ernest Brown, called on Sickert in the hope of persuading him to show some work

* Sickert would have been gratified to know how jealous these arrangements were making Fry. 'I suppose it is all too thrilling,' Fry wrote to Nina Hamnett from London, 'and dear W.S. too engaging.' He was particularly horrified when he learnt that Sickert was lecturing Nina not only about painting but also about dress. 'No please don't listen to W.S. about clothes,' he implored, 'do for God's sake be yourself in that.'

† Nina described one of her Bath pictures as 'très loin de Sickert'. In the face of Sickert's barrage of advice, Nina's ploy was 'always [to] say "yes" and [then] go home and do the opposite' (quoted in DS, 190), and although Sickert never called at her lodgings to discover that she was painting a portrait of the landlady – not from drawings, but from life – he does seem to have come to recognize her contrariness.

at the Leicester Galleries, he tentatively suggested that an exhibition combining loans of old work with more recent pictures might be a success. Sickert brusquely replied, 'I know it would be, and fashionable women would come to my studio as they do, I believe, to John's. No it doesn't appeal to me[;] I would sooner "peddle" my pictures.'[113] When Brown haltingly enquired whether he had any paintings currently available that he might be prepared to 'peddle', Sickert made a sweeping gesture towards the high shelf stacked with canvases, running along the wall of the studio: 'Take the lot dear boy!' He then named 'an absurdly small price' for the whole row of pictures. Brown, still in his early thirties and unused to Sickert's extravagant caprices, thought he was being laughed at. 'Sickert made no effort to show me the pictures,' he recalled, 'and I didn't know what to do, so I went.'[114]

Others, though, less conditioned by the traditions of Bond Street, were prepared to seize the opportunity presented by Sickert's passing mood. The chief beneficiary was a young freelance dealer who was introduced to Sickert by Nina Hamnett.[115] Sickert invited him to lunch at the 'Frith' and played the same game with him as he had played with Oliver Brown. This time he was taken up. According to legend, the young dealer, surveying the high shelf, made a 'sporting offer' of £50 for a row of about fifty unseen canvases, and Sickert at once said 'done'.[116] Only when they were taken down was it discovered how fine most of the paintings were – not rough studies, but elaborated works. The dealer was able to sell one of the pictures almost immediately for £100. With the profit he opened the Eldar Gallery in Great Marlborough Street – and arranged to show the remaining forty-nine works there.*[117]

When Osbert Sitwell ventured to expostulate with Sickert over this extraordinary piece of business, Sickert gave his reasons as, 'Supply and Demand ... The young man wanted my pictures, and I wanted his money.' And in answer to Sitwell's fear that the dealer might sell the pictures cheap and 'let down' prices, Sickert replied nonchalantly, 'On the contrary, it's the dealer's job to keep up the prices. That is why a painter goes to a dealer.'[118] He affected not to resent dealers making huge profits from his work. 'Vile life, a dealer's,' he liked to assert, 'walking about in a gallery from ten to five, recommending my

* Nina Hamnett and Thérèse Lessore also showed at the Eldar Gallery in 1918, Sickert contributing catalogue introductions to both shows.

paintings to someone who doesn't want them . . . they deserve to make as much money as they can out of me.'*[119]

In the autumn of 1918 the economic climate may have seemed about to turn for the better. The war was finally coming to an end. On 11 November the Armistice was signed, and England erupted into an ecstatic – if short-lived – euphoria.

* The young dealer repaid Sickert's capricious generosity by presenting him with 'the most marvellous plaster Graeco-Roman mask (2nd Century) . . . with glass eyes & rippling hair'. Sickert set this trophy – in its glass-fronted blackwood case – in his drawing room, where it 'gave [him] a turn' every time he went in (ALS WS to Ethel Sands [Tate]).

CHAPTER EIGHT

The New Age

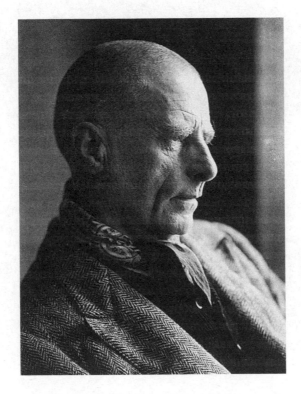

Walter Sickert by Walter Barnett, 1921

I

THE CONDUCT OF A TALENT

Genius has perhaps best been defined as 'the instinct for
self-preservation in a talent'.
(*Walter Sickert, in the* New Age)

Sickert emerged into the post-war British art world as a singular, even
an isolated figure. He was respected, admired, sometimes revered, but
he remained an 'oddity'. The epithet was bestowed by Clive Bell in
his catalogue introduction for the show of Sickert's work at the Eldar
Gallery in February 1919, where the fifty pictures acquired so cheaply
by the young proprietor were exhibited to general acclaim.[1] Virginia
Woolf pronounced the exhibition 'the pleasantest, solidest most
painter-like show in England',[2] and if the criticisms of Sickert's fellow
painters were sometimes more guarded, they were nevertheless admir-
ing in general terms. On a divided and partisan scene Sickert could
be regarded by all sides as an exceptional case.[3] When a gala dinner
was organized at the Café Royal for England's leading – if not only –
Futurist painter, R. W. Nevinson, it was Sickert who took the chair.
His performance, however, was revealing. He delivered a 'very good
speech' – though mostly in Greek 'and therefore incomprehensible to
the majority'.[4] Confronted by such manifestations of his professional
isolation, he found few artistic ties to bind him to Britain.

London, moreover, had – he convinced himself – become too
expensive and too complicated. He needed to be free of the obligations
he had spun around himself, and Christine, whose fragile health had
been taxed by the hardship of the war years, longed for the rest and
quiet of the country. At the end of the Westminster year they – together
with Marie – returned to Envermeu and the Villa d'Aumale. They found
Dieppe stuttering back to life after the trauma of the war, and there
was at least the illusion of continuity: Mme Villain was still in the

fishmarket – though she was now remarried, to a M. Morin;[5] Lady Blanche Hozier was back in residence; Polly Price had persuaded her husband to buy a flat on the front to which they could come each summer; and the Blanches were still at Offranville.[6] Sickert continued to make Saturday visits to the town to shop, to swim, and to meet the holiday crowd: Blanche encountered him there one afternoon lounging on the lawns in front of the Casino with 'quelque jeunes cubistes anglais'.[7]

Although Sickert made some studies of the Dieppe beach, it was at Envermeu that most of his work was done. He focused on the simple pleasures of his new life in a series of small culinary still lifes: the makings of a mushroom omelette, a loaf of bread, a piece of Roquefort, a colander of cherries, a lobster on a tray.[8] He felt liberated, able to work 'free from tubes, trains and interruptions'. Hidden in the country, he explained to Ethel, dealers were no longer able to 'drop in before the paint [was] dry' and carry off his pictures.*[9]

Sickert entered into the life of his adopted home. He took the *Progrès Agricole* (along with the *Manchester Guardian*).[10] He grew a very rustic and spade-like beard, and assumed his own rather personal version of farming attire.[11] He made friends with the village solicitor (who also served as the local auctioneer) and sometimes would accompany him on his tours about the countryside.[12] He was heartened by the news that Ethel Sands and Nan Hudson were planning to buy a house in the area. Nan wanted to make France her home and the years spent at Veules-les-Roses had given both her and Ethel a love for the Normandy landscape. Sickert was at once full of suggestions about properties they might look at, suggestions that they managed to deflect: they fixed eventually, without Sickert's help, on a rustic fairy-tale chateau at Auppegard, some miles inland from Dieppe.[13]

The Sickerts, too, were moving house. Wanting to secure a permanent home at Envermeu, Christine bought the freehold of the Maison Mouton, a long, tall, narrow building on the edge of the village. The house, constructed, as Sickert reported, from the traditional mix of 'timber and cowpats euphemistically known as "matifat"', had served as 'a gendarmerie, a horse dealer's [and] an Inn'.[14] It now housed a

* A few persistent spirits did track him down. John Rayner, who had taken over the running of the Eldar Gallery, called on him that summer, as did another dealer and Sickert enthusiast, R. E. A. Wilson (a childhood friend of Sickert's who had begun picture dealing); neither left empty handed.

tenant farmer. Each of the building's previous incarnations had left its stamp. The bedrooms, which according to Nina Hamnett had once been used as police cells, were all numbered.[15] There was a large courtyard surrounded by extensive stabling, entered via an imposing 'porte cochère'. Sickert, inspired by these equestrian amenities, at once ordered an expensive pair of riding breeches. To fix the moment he also made an informal portrait of Christine at her desk, perhaps writing out a cheque to the vendor – the 'charming old Docteur Leconte'; he titled the picture, with mock formality, *Christine Drummond Sickert, née Angus, Buys a Gendarmerie*.[16]

They could not move in immediately. The tenant farmer's lease ran until the following Easter, and there would, moreover, be some work to do on the house to make it comfortable. At the Villa d'Aumale they became only too aware of the need for comfort. The winter of 1919–20 was a severe one, and though Sickert might warm himself with work, Christine – already worn down – suffered another sharp decline in health. She was probably grateful when Sickert brought her back to England early in the New Year for a short visit. Her tuberculosis was advancing, but neither she nor Sickert seemed willing to confront the fact.

Sickert's new rustic persona caused some amazement in London. Alice Rothenstein recorded his appearance at a dinner in honour of Walter Greaves, sponsored by the Chelsea Arts Club.[17] Sickert, who was the principal speaker, arrived – 'the lower part of him correctly attired for Golfing (*very* thin legs) *and* an upper part quite indescribable surmounted by an absolutely square beard, it was cut off – only just below his chin and stood out very wide each side and horribly disconcertingly square – it was really most embarrassing – his head seemed so short and so terribly square'.[18] Max Beerbohm had also seen the 'new beard' and described its effect as 'Quite the shrewd old farmer, up from the Midlands for the Agricultural show: "You doan't get a noise out of I!" Also a touch of the ventriloquist's puppet – by reason of the hard sharp lines from the corners of his mouth down to the jaw-bone. But he remains Walter. And no ventriloquist could invent the patter *he* can.'[19] At the Greaves dinner Sickert spoke 'several times *most* brilliantly', but, as Alice Rothenstein noted, 'always of his own affairs – Whistler – Pennell lithographs etc. etc. and all the old Chestnuts – he did not once *refer to Greaves*', even though he was supposed to be seconding the toast to the guest of honour.[20]

He exhibited something of the same mercurial brilliance at a dinner given by Osbert and Sacheverell Sitwell at their new house in Carlyle Square. The other guests – several of whom left accounts of the evening – included Arnold Bennett, Wyndham Lewis, Frank Swinnerton, William Walton, and H. W. Massingham (editor of *The Nation*). Sickert, according to Osbert Sitwell, 'led the evening with the audacity of a matador'. He entertained the table with his imitations of George Moore, but strayed on to more dangerous ground by delivering an extended eulogy on Wyndham Lewis's novel *Tarr*. His enthusiasm was genuine, but he may well have exaggerated it when he noticed Bennett, who regarded himself as the elder statesman of the literary scene, bridling. Lewis certainly thought so.

In the ensuing debate Sickert 'danced round' the rest of the company. Bennett's stutter grew worse, and was not helped by Sickert breaking in, whenever he was on the verge of uttering some hard-won syllable, with '*Now*, what's he going to say I wonder?' (Bennett noted tartly in his diary that Sickert 'is I regret to say becoming rather mannered'.) As a final dramatic coup Sickert lit a cigar and, 'nipping round the corner of the table, pressed another one on Lewis with the words, "I give you this cigar because I so greatly admire your writings"', before adding, '"If I liked your paintings, I'd give you a bigger one!"'[21]

While Sickert dined out and worked back at Fitzroy Street alongside Thérèse Lessore, Christine was laid low at Camden Road with back pains.[22] They were diagnosed as sciatica, but despite her condition she and Sickert went back over to France at Easter to begin work on their new house. The journey, however, proved too much for her. She could get no further than Dieppe, where she remained, 'immobilized', at the Hôtel de Gare whilst Sickert commuted out to Envermeu to oversee the renovation work.[23] One range of the stabling was pulled down to give a clearer view of the valley from the house. With typical profligacy Sickert gave away all the salvaged building materials which the canny Christine had been planning to sell.[24]

Although, on the surface, Sickert refused to acknowledge that Christine was dying, some part of him did, it seems, grasp the gravity and inevitability of her plight. He later referred to the 'unconscious prevision' that allowed him to go so far as to 'say to [himself] that the house must be ready as soon as possible, "for Christine to live or die in"'. He had to strive 'against time and shortage of labour' – and the consciousness that if he 'turned [his] back on the house for a week'

all operations would cease. And yet in the midst of this 'complicated torture' of emotional anxiety and logistical stress he also managed to do some work of his own: over the course of the summer he produced, as he put it, 'an enormous mass' of Dieppe drawings.[25]

He abandoned the beach and the countryside, and turned his attention back to the pleasures of the town. Working late into the evenings, he made studies of the little summer circus and of the town's *cafés chantants*. Vernet's on the Quai Henri IV became a favourite haunt – and doubtless one of the 'dancings' that he visited with Claude Valéry (son of Paul Valéry) who was his crony for the summer.[26] He recorded its narrow stage, its raffish clientele, its glaring lights. His other major subject was the cardroom at the Casino. Play began there at midnight, and Sickert spent many late evenings – 12 to 3 a.m. – in full evening dress drawing the fashionable players seated beneath the green-fringed lights around the baccarat table. After Lady Blanche, a regular presence, complained of Sickert's sketching – on the grounds that she and the other players might be recognizable in the finished paintings – he took to working surreptitiously on small postcards that could be held in the palm of the hand and concealed within the capacious folds of his opera cloak.[27] Yet even on this tiny scale he was confident that he could assemble all the visual information that he required for his compositions. When he saw Oliver Brown at the Casino one evening, he gaily remarked: 'I am the only one who will make any money in this room.'[28]

It is possible that Sickert hoped that Brown might even help him towards this goal. Brown was almost certainly the subject of an anecdote recorded by Osbert Sitwell in which Sickert, spotting a nervous young art dealer struggling at sea while he was taking his morning swim, 'suddenly burst out of a wave at him with the words, "*Now* will you buy my pictures?"'[29] But in truth there were few pictures for Brown to buy. The old pre-war Dieppe aficionados had not forgotten Sickert, and the paintings he worked on that summer were, he claimed, all 'sold in France before they [were] done, & not to dealers but at retail prices'. It was a situation that, as he put it, made it 'worthwhile to push ... production as much as possible'.[30]

Despite such compelling distractions, Sickert was still able to get the Maison Mouton ready before the end of the summer. Christine, who had moved briefly into a Dieppe nursing home, revived at the news.[31] Indeed she seemed well enough to go back over to London

with Marie to supervise the packing up and removal of the furniture from Camden Road.[32] She retained all her humour and perspicacity, writing to Sickert of Marie's frustration at watching the packers at work: 'I tried to make her sit in an armchair, but it is really a physical impossibility, most curious to watch.' Some of the furniture and pictures from the house were stored with William Marchant in the attic at the Goupil Gallery, other pieces went to Thérèse Lessore's studio.[33] Christine even found both the time and the energy to call at Pembroke Gardens, where the 90-year-old Mrs Sickert failed to recognize her.[34] For Christine, the encounter must have been touched with a realization that even this nonagenarian of ailing powers might yet have a chance of outliving her. Although she kept to herself whatever fears she had, she did write to Sickert on the eve of her return to France, telling him, 'it will be wonderful to see you again, but very strange'.[35]

The move from the Villa d'Aumale was eased by Sylvia Gosse, who had taken a house in Envermeu for the summer. She appears to have had a clearer understanding than most of the true seriousness of Christine's condition. With her usual selflessness and efficiency, she quietly took up many of the Sickerts' domestic burdens.[36] For Jacques Blanche, the return of his friends seemed to herald the dawn of a new era. With Ethel Sands and Nan Hudson establishing themselves at Auppegard, and Hilda Trevelyan staying near Offranville, there were, he believed, the foundations of a new English colony to revive and continue the traditions of the pre-war years.[37] The vision, however, faded almost as soon as it formed. Christine's period of respite ended. The tuberculosis had spread to her spine. She subsided swiftly into what was to prove a terminal decline. Sickert was 'utterly unprepared' to face the crisis.[38] It was Marie Pepin and Sylvia Gosse who nursed Christine during the course of her final illness. Although Sickert later told Mrs Angus that Christine 'had no suffering whatever' and that she remained 'serene and cheerful' to the end, to others he confessed her real stoicism in the face of great pain and prolonged lack of sleep.[39] There were periods of delirium (during one of them she sang the hymn 'Lord of Our Life and God of all Creation') but also moments of lucidity and humour. Sickert held on to the memory that one of her last sallies had been to enquire of Marie when he entered the room, 'Who is that?' And when Marie replied, 'Your husband who loves you', she had smiled and said, 'Fancy that, now!'[40]

Christine had kept her own family in the dark about her advancing

illness, and Sickert, too, had failed to write to them. It was Sylvia Gosse who finally informed the Anguses of Christine's dire condition. Her letter was followed soon afterwards by a telegram from Sickert – addressed to Christine's sister, Andrina Schweder: 'Sinking painlessly most slumbering analysis spinal fluid reveals Kochs tubercle bacillus will wire you when death takes place shall cremate at Rouen the funeral at Anglican Church Dieppe can be postponed week or more after cremation ashes will remain in Envermeu Cemetery unless your father has any other desire – Walter.'[41]

Andrina, together with her father, set off at once for France. Arrived at Envermeu, they were having some difficulty locating the Maison Mouton when they caught sight of Sickert waving to them from the upstairs window of a house. He had adopted a new and startling guise to dramatize his grief: shaving his head completely and accentuating his pallor with a black velvet coat. He seemed, as Andrina recalled, 'pleased and almost cheerful at seeing us. He told us Christine was just alive and took us up to her room. She was lying on the carved wooden bed of which she was so proud. It had belonged to the village priest and had been bought at the sale after he had died. She was of course unconscious and her head was roughly bound with towels like a turban, giving her the most grotesque effect. Walter went up and stroked her cheek and talked gaily to her as to a child.'[42]

Sickert then took Mr Angus downstairs, leaving Andrina to sit with Christine. She found, close to the bed, some scraps of paper on which Sickert had written the last words he and Christine had exchanged. After the doctor had called to give Christine her injection, Sickert insisted upon Mr Angus and Andrina staying to dinner. They ate in the kitchen, together with Marie. As Andrina recalled, Sickert soon 'became as usual the gay and perfect host, pressing us to wine, telling us endless anecdotes, and even singing his favourite little tunes'. Mr Angus was later quite ashamed at having enjoyed himself so much.[43]

After dinner Mr Angus and Andrina went back to Dieppe. They did not see Christine alive again. She died during the night. Sickert was stunned by the blow, inevitable though even he must have recognized it to be. He at once threw himself into a round of diversionary activities. He made a drawing of his dead wife,[44] and also telegraphed to Blanche at Offranville asking him to recommend someone who might be able to make a death mask.[45] Either Blanche was extraordinarily expeditious or Sickert discovered his own local expert, for, when Mr Angus and

Andrina returned the following morning and went up to see Christine's body, they found two blue-clad workmen already in the room – both smoking – one sitting on the bed and the other mixing some clay on a table, ready to take an impression.[46] Meanwhile, Sickert was downstairs selling some pictures to an English dealer who had arrived by chance from London.*

Andrina and her father did not stay for the funeral, returning at once to England to be with Mrs Angus and the other family members. Sickert asked them to call at the post office and cable an obituary notice to *The Times*: such conventional proprieties perhaps afforded him a shield against his grief. He also marked the occasion with another subtle shift of self-image. He claimed to be vexed that Mr Angus had described Christine in the death announcement as 'wife of Walter Sickert' on the grounds that 'he always liked to be known as Walter Richard'. This was the first time that the Anguses, or indeed anyone else, had even heard his middle name mentioned. It would not be the last.[47]

Christine was cremated at Rouen and her ashes buried at Envermeu. The funeral, which became 'a famous occasion' in the locality,[48] was held at noon on a bright, cold October day. Friends arrived from Dieppe and the surrounding countryside, and the whole village turned out to pay their respects. Blanche left a vivid account of proceedings: 'Walter walking slowly, dressed in tweeds, was climbing the hill to the cemetery, supported by the Protestant Minister of Dieppe. He called out to us and waved his hand, looking terribly nervous. The hearse coming from the Rouen crematorium was very late.' There was some concern as to whether something had gone amiss; but, at last, in the distance, the company caught sight of a motor hearse. Nothing of the sort had ever been seen before in that part of the country. Sickert waited for it by the railings of the graveyard. 'As soon as the casket which was used in place of a funerary urn was carried past him, he took it, opened it, pressed it against his breast and bent his head.'[49]

In the letter he sent to Mr Angus Sickert described how he then 'poured [Christine's] dear ashes into the grave', though Blanche

* The dealer was probably John Rayner. A small Sickert painting of Envermeu exists titled *The Way to the Cemetery* and inscribed to 'my friend Rayner'. Although it is signed 'Sickert, Envermeu 1919', tradition states that it was painted on the day Christine died. The date makes this unlikely if not impossible, but perhaps it was inscribed and presented on that day.

recorded that it was 'with a large gesture' that 'he plunged his hands into the casket and instead of throwing the ashes into the grave tossed them into the air'. A sudden gust of wind blew the ashes back over the assembled mourners, covering them with a fine scattering of white dust. It was noted that the parson, who was intoning a prayer, swallowed the largest amount. Sickert later enjoyed debating whether or not this made him a cannibal.[50]

After this bizarre performance, Sickert solemnly shook hands with everyone at the cemetery gate. Then, in accordance with local Norman custom, he invited the mourners back to the Maison Mouton for lunch. Carried away on the tide of emotion and mulled wine, 'he laughed and cried in turn, forcing himself to appear cheerful'. But when the company dispersed he was left alone to his grief.[51]

Those closest to Sickert that autumn – Marie Pepin and Sylvia Gosse – record his utter devastation, his unpreparedness for the blow, and his inability to deal with it. According to Sylvia Gosse, he could not believe that Christine was really dead: 'He was unable to accept it as a fact and was filled with anguish, feeling that he had nothing left to live for.'[52] He later told Virginia Woolf that for two years after Christine's death he had wanted to die, and though there was a touch of exaggeration in the claim, it was not without substance.[53] He struggled, nevertheless, against his despair. There was a melancholy consolation to be had from his memories. 'As you may imagine,' he told Mr Angus, 'I have been living over again our happy years, happy in everything but in her sufferings, & in my inability to prevent them. I have been reading through my letters to her, which she kept, as I have, every scrap of her dear writing.'[54] Amongst her papers he found the 'well known poem' of Philip Bourke Marston – almost certainly 'After', with its pathetically appropriate stanza:

> A little while 'twas given
> To me to have thy love;
> Now, like a ghost, alone I move
> About a ruined heaven.

Detached, ironic, even cynical in so many of his relations, Sickert had a relish, too, for the syrup of Victorian sentimentality – and a belief in its power.

Suddenly anxious about 'possible breakage', he decided to have Christine's plaster death mask recast in bronze. He confessed to Tonks

'a horror' that, without such a permanent aid, his recollection of her face might become 'vague with age'.[55] The whole of the Maison Mouton became in his imagination a shrine to Christine's memory. 'I take, & shall always take,' he informed Mr Angus, 'a melancholy & pious pleasure in continuing to use her house & her loved objects, as she would like them to be used & cared for' – though he could not resist exchanging an Omega lampshade that Christine had chosen for one, decorated with 'roses and cornflowers and blossoms and butterflies on a black ground', that she had painted herself.[56]

He made a valiant effort to direct his feelings into useful channels. 'The fact that she loved me not only as the classic song goes "makes me of value to myself" but gives me a kind of courage & energy, because I know so well what she would wish me to do. I know as well as if she were beside me. She cared about my work & everything I may still achieve will go to the credit of a name she honoured me by bearing.'[57] He converted the bedroom in which she had died into his etching studio, laying out her favourite coral earrings and a crystal pair he had given her in Dieppe on the workbench.[58] The room was, he claimed, 'in some sort of way the only place [he felt] happy in'. He planned to bring his etching press over from London 'so that there may be a series which may be known as coming from the "Envermeu Press"' – thus perpetuating the name of the village where he and Christine had found contentment. One of the first plates he finished – a view of Envermeu from across the fields – was titled in large letters, 'THE HAPPY VALLEY'.[59]

He told Mr Angus that he was working 'all day' – absorbed and interested. 'When daylight is over I lose myself for a few hours in reading & fortunately by nine or ten I am so tired that I sleep at once till morning which brings the interest of a new effort.'[60] This, however, seems to have been an ideal vision, impossible to sustain. His spirits and his energy were prone to evaporate, leaving him bereft of all inspiration. He lacked even the energy to reply to the numerous condolence letters he received from friends back in England.[61]

His one solace was in talking over his memories of Christine with Syvlia Gosse and Marie,*[62] and it was a desire to enlarge the circle of

* Marie was even able to amuse Sickert with some of her comments: '[she] dreamed she saw Christine,' he told Mrs Angus, '& that she said, "Take care of my embroidered chairs. They took so long to do."' ALS WS to Mrs Angus 7/12/1920 (Tate).

reminiscence that prompted him to send an impulsive telegram to two former Rowlandson House pupils, Faith and Elfrida Lucas: 'Come over at once & bring all your pigs.'[63] The Lucas sisters had abandoned their artistic ambitions for a piggery at Ditchling, and Sickert thought they might like to transfer themselves and their swine to Envermeu. The 'charm of the scheme', he explained, lay in the 'combination of pinning an agricultural branch to the soil of my house, giving it in that way a kind of reality outside my own work, catching at the same time as two swineherds, two ladies whose company would [be] a joy & an ornament'.[64] For all its 'charm', the plan was, as Faith Lucas explained, quite impracticable.

Other friends less burdened with livestock did rally to Envermeu. Walter Taylor ('a very sympathetic listener') came to stay,[65] and he was followed, towards the end of the year, by Thérèse Lessore. Although she took her turn at listening, she also busied herself with her own work. It was, as Sickert admitted to Mr Angus, 'rather stimulating company for me to do the same'.[66] He tried to rouse himself to another bout of activity, taking up the drawings that he'd made in Dieppe over the summer months. But he was projecting an assurance desired, rather than felt, when he told Manson, 'I am working under perhaps more convenient conditions than I have ever managed to achieve [before] ... The light here is very good. I have to put my brushes down at half-past three. It is a cheap & comfortable way of living with the minimum of fatigue.'[67] His real sense of restlessness and disengagement seep through in a declaration to Ethel Sands – 'I am getting on with a great deal of work & learning how to paint. I spare you the details': it was an almost unique instance of his failing to elaborate upon the great passion of his life.[68] And certainly – for the moment – painting had lost the power to hold him. 'I go on working,' he admitted to Mr Angus, 'but the savour is gone.'[69]

Every respite was short lived. As he told Andrina, his 'mainspring' was broken: 'I have nothing to recover for.' To Ethel Sands he confided, 'I am very well and, I suppose, as unhappy as it is possible to be ... I always in theory rather despised any one who allowed their happiness to depend on such a fragile thing as the well-being of someone else!'[70] According to Marie Pepin's estimate, he spent at least ten months 'in the depths of despair', able to 'do nothing and see nobody'. All his old Dieppe friends were amazed he could 'take anything so much to heart'.[71]

He supposed numbly that time alone might heal his hurt. 'There is nothing to be done,' he wrote to Elsie Swinton. 'You have to sit and digest granite all your waking hours, with no one to help you.' But to those around him this slow digestion process looked very like despondency. Marie, with her practical peasant wisdom, urged him to 'prendre le dessus' – 'dominate his grief'.[72] And to reawaken his interest in life she prepared all her most tempting dishes.[73] Sylvia Gosse and Thérèse Lessore offered what support they could, and when Thérèse returned to London early in 1921, concerned – as she confided to Ethel Sands – that Sickert was becoming too dependent upon her, Nan Hudson came over from Auppegard to see him. She coaxed him out into Dieppe society, where he flickered briefly into his old flirtatiousness, but then crashed back into depression.[74]

Besides his grief at Christine's death, Sickert became prey to sudden terrors about his own health. There seem to have been no very definite physical symptoms, although this did not lessen his anxiety. To Mrs Swinton he complained that his recent travails had 'in a sort of way finished me. My memory is affected, and my nerve gone.'[75] He felt that he was facing the beginning of the end. It recalled to him a passage in Proust ('*the* French writer of the century') describing 'the first moving in, that you are conscious of, of the malady that is to finish you. Now you are conscious that it has moved in, quite discreetly. Occasionally you are aware of it, like a neighbour on a higher floor next door. Sometimes it goes out of town. But it keeps the apartment. And now and again you know it is back &c.'[76]

In the hope that a season of sea bathing might pick him up, he arranged to take a small flat on the seafront at Dieppe for the summer.[77] There were other reasons, too, to desire a change of scene. 'The melancholy and pious pleasure' that he had hoped to find in living on at Envermeu, surrounded by memories of Christine, was proving no pleasure at all. As he confessed to Andrina, 'when Christine was alive I loved the landscapes because they seemed to belong to her, and the still lifes etc., because they were seen in her house. But I can't bear the sight of those scenes now. They are like still born children.'[78]

Before the summer came, however, he had business to attend to. In her will, Christine had left everything to him. The estate was valued at about £12,000.[79] Sickert was ambivalent about receiving such a sum. He and Christine had no children to benefit from the inheritance and to maintain the Angus connection. The money could almost be viewed

as a fantastic prize handed over by the Angus family to an impecunious old painter whom they might never see again. This view was not, however, one that Mr Angus took: he and his family were truly fond of Sickert. During the protracted delay in proving the will, Mr Angus generously advanced Sickert £500 against the inheritance enabling him to pay off various 'small builder's bills': 'It is always pleasant', wrote Sickert in his letter of thanks, 'not to keep people waiting.'[80] Sickert, for his part, declared an intention of restoring all Christine's money and property, after his own death, to the Angus Trust. It was a magnanimous gesture and, although the astute Mr Angus must surely have had enough knowledge of Sickert's financial acumen to doubt the possibility of there being much left of the estate even within a few years, the sentiment was appreciated.[81]

It was perhaps to resolve such legal matters that Sickert returned briefly to London in the spring of 1921, staying with Walter Taylor at Oxford Square.[82] Having come in to Christine's money, one of his first actions was to pay off the remainder of his long-outstanding debt to his brother-in-law.[83] He also arranged to give some of the furniture and pictures that had been at Camden Road to the Angus family: he particularly urged Mrs Angus to visit Thérèse Lessore at Fitzroy Street and 'choose one oil painting by her belonging to me. You may not quite appreciate the style now, but some day you may be very glad to have an example.'[84] Ethel Sands, on whom he called several times, was relieved to find her old friend in happier spirits. He attended a party at Roger Fry's new house and saw his painting of the Bayswater underground station hung prominently over the fireplace.[85] But Sickert's mood was never stable. When Ethel invited him to dinner, he arrived in a state of bleak depression, in fear of an impending stroke, and convinced he would not live out the year.[86] Even a visit to his aged mother did not seem to convince him of the possibility of longevity.[87] He became elusive and withdrawn, sometimes proposing to dine with Ethel only to cancel by telegram at the last moment, his nerves having failed him. Christine's sister, Marian Colqhoun, urged him to consult a doctor, but he was reluctant.[88]

He returned instead to Dieppe, to try the effects of regular bathing upon both his mental and physical constitution. The results were not instantaneous, but after a month of the regime he did concede that 'as I am getting no worse, I may be getting slowly better'. He was at least able to sleep through the night again.[89] The holiday season

brought familiar faces; and he was pleased to see them; but every small glimpse of pleasure carried with it a pang that he had no one to share it with. 'I met Orpen at the Casino the other night,' he reported to Andrina, 'and he is going to put me down for election to the [Royal] Academy. It would have seemed such fun to be while [Christine] was alive to share it!'[90]

His friends in London continued to worry about him. Recognizing that he was helpless without a wife, Ruby Peto thought that he should marry Hilda Trevelyan.[91] At the beginning of July, Elsie Swinton, having discussed the matter with Ethel Sands, proposed coming over to Dieppe for a brief holiday. Sickert was touched, but put her off on the not entirely convincing grounds that:

> Alas there is no *quiet* place where people accustomed to English comfort can stay. The Hotel d'Ammale is too dirty and neglected. All the country inns are the same *Noisy, Expensive and bad and dirty*. Also with the drought, inland is too dusty, hot and smelly. There are no amenities in France as there are in England or better in Germany, walks, lakes, river boats, benches, places to sit for clean civilized people. In France you have the choice between the baccarat rooms or the beach of the proletariat with yelling filthy children or, maybe, a lousy tramp eating something he has picked up from a dustbin, with relish, be it said, and philosophy. I find myself longing for Bath or Exeter or Chagford or Sandwich or even Cheltenham.[92]

By August, however, his outlook had mellowed. He welcomed Andrina Schweder and her husband when they came over to Dieppe for a holiday. 'He seemed honestly delighted to see us,' Andrina later recalled, 'and from that time a great affection sprang up between us. No one could have been more charming and loveable than he was to us, his very ordinary young relations.'[93] Although Sickert had come to think of sea bathing as his 'salvation', the effects of altruism were probably even more beneficial. A month spent not thinking about himself restored his fragile spirits. He later acknowledged that the Schweders' visit had helped him 'over a sort of turning point'.[94]

He decided to stay on at Dieppe after the end of the summer, keeping his seafront apartment at 44 rue Aguado. He was cheered by a short visit from Thérèse Lessore, who, following in the illustrious steps of her grandfather, Emil Lessore ('a great name at Wedgwood and Sèvres'), had begun decorating porcelain. Sickert was greatly

impressed. She gave him some examples of her work and he began buying up more, often by stealth, commissioning friends and relatives to visit her studio and buy pieces for him.[95] He was excited at the news that she was to go to Staffordshire to produce a whole dinner service for Wedgwood.[96] Her industrious example, as before, acted as a stimulus. He began working again, and not with the fitful restlessness of the previous winter.

'I have sittings by electric light nearly every day in [the] flat at No 44,' he reported to Andrina, 'and am deep in figure subjects again.' Marie's niece served as a model, and soon Marie herself was pressed into service. He began a portrait of a 'French Colonel of the Staff' (who also bought a figure study), and another of the Sous Préfet – 'a beautiful gracious young creature, like a lion of the time of Gavarni'.*[97] Transposing his themes from the shabby rooming-houses of NW1 to the stinted bourgeois interiors of Dieppe, he composed a series of intimate domestic dramas: *The New Tie, The Prevaricator, La Parisienne,* and *L'Armoire à Glace.* Although, as ever, the exact dramatic point of these single figures – glimpsed through the open door of the nondescript bedroom at 44 rue Aguado – remains ambiguous, the scenes are alive with intrigue and interest. Sickert himself provided an elaborate exposition of *L'Armoire à Glace* – a canvas showing a stout woman seated between the foot of a large bed and an even larger mirror-fronted wardrobe:

> It is a sort of study *à la* Balzac. The little lower middle-class woman in the stays that will make her a client for the surgeon and the boots for a chiropodist, fed probably largely on 'Ersatz' or 'improved' flour, salt-substitutes, dyed drinks, prolonged fish, tinned things, etc., sitting by the wardrobe which is her idol and bank, so devised that the overweight of the mirror-door would bring the whole structure down on her if it were not temporarily held back by a wire hitched on an insecure nail in insecure plaster. But a devoted, unselfish, uncomplaining wife and mother, inefficient shopper and atrocious cook.[98]

Although the full detail of this richly coloured back story needs must have remained obscure to most viewers, the controlled energy

* Paul Gavarni (1804–66) was a French satirical lithographer, a contemporary of Daumier. It was said that his works provided 'the memoirs of the private life of the Nineteenth Century'.

and force of the actual painting were inescapable. Sickert's reviving powers were everywhere apparent. They blazed forth in the full-length portrait he began of Victor Lecourt, 'the superb creature who used to run the Clos Normand [inn] at Martin Eglise'. The bald, bearded, ursine figure, standing squarely upon the patterned rug in the front room of Sickert's flat, is caught between the purple light of the evening sky and the glow of the electric bulb. Although it was not completed until 1924, the conception and composition of the picture are full of confidence. As one friend remarked, 'it was not the work of a pining invalid, but one of the liveliest pictures of a lively painter. There is a crunch to it that only the vitality of health, both mental and physical can give.'[99]

Sickert was heartened to discover that his reputation amongst French art buyers was greater than he thought. The initial flurry of sales that he had made on his return to Dieppe had been sustained. 'There is, I see, going to be as much market as I can supply in France for my work,' he reported to the Schweders.[100] The Museum at Rouen, having acquired two of his pictures, was asking for more,[101] and he was concerned to maintain this momentum. Because of the relative weakness of the franc against the pound, however, he had to sell his works for less than they would have fetched in London.* He took care not to let his pictures 'fall into the hands of speculators who would take to England and sell for double', preferring to place them with the 'many solid and established people' who bought things 'not to peddle or pawn, but to stick to, for a while at least'.[102]

The trouble was, this solid and established market remained both private and local. It was too small and too closed to promote Sickert's name amongst what he disparagingly called the 'neo-squinting circles' of the Paris art world.[103] Sickert recognized the fact but was not concerned to address it. The hectic succession of avant-gardes – Dada-ism, Purism, Surrealism – each striving for a self-conscious novelty of effect, did not interest him; and his work did not interest the avant-gardists. There was no formal break with the progressive spirits at Bernheim-Jeune: Sickert simply drifted out of their orbit. He ceased to send to the Salon d'Automne and the Salon des Indépendants. He ceased to visit Paris. Degas was no longer there, and there was little else to attract him.[104]

* The franc had collapsed from 26.72 to £1 in 1918 to 52.47 in 1921; by 1926 it was 152.38 to £1.

Before the end of 1921 Sickert moved from the flat on the rue Aguado to some rooms 'just opposite the entrance of the Petit bains'. He would, he told Andrina, probably never make a 'home' again – only what actors call "diggings" '.[105] Despite a certain social passivity, he was not cut off completely from England. He read the *Morning Post*, and Sylvia Gosse, who was still lodging out at Envermeu, passed on interesting cuttings from the *Saturday Review*. He was also asked to write something on a new Whistler publication for the *Burlington*.[106] Florence Humphrey, herself recently widowed, came out to Dieppe to make a pastel portrait of the composer (and Dieppe native) Camille Saint-Saëns and made one also of Sickert looking watchful and wounded beneath his lowered brows. Florence's friend, the fashionable Australian-born photographer Walter Barnett, was also in Dieppe, having sold up his London studio and moved into the pair of medieval towers next to the Casino. He had long been hoping to take Sickert's photograph and now made a telling portrait of the grieving widower.[107] Another visitor was D. S. MacColl, the *Saturday Review*'s art critic, who sought Sickert out when he was over in Dieppe; they had an enjoyable dinner airing 'various common artistic prejudices'.[108]

Marjorie Lilly, together with her father, also called on him. Mr Lilly was travelling to France on business, and had been commissioned by his boss to buy a Sickert painting. Miss Lilly was encouraged to find Sickert comfortably established in his new flat and being well looked after by Marie.[109] If he was sometimes sad he was not depressed, and a visit to the studio after lunch confirmed that he had been working hard. One of his *café chantant* paintings was selected for the chairman of Mr Lilly's firm, and a price of £70 agreed. Later Sickert took Marjorie out to the bare half-empty house at Envermeu to show her where Christine had died. Excited to be back, Sickert eagerly began pointing things out, but then – suddenly overcome – he fell mute, his head in his hands. After a period of silent musing they went 'next door' to tea with Sylvia Gosse. Back in Dieppe for the evening, Sickert insisted on taking Marjorie to the 'put up', the shabby little tent where he went most nights with Marie to watch a much battered theatrical troupe performing songs and sketches. For a happy, if cramped, hour he sat 'wedged in the crowd, smiling benignly but rather absently on the packed audience'.[110]

Although he seemed to have established a comfortable and productive routine for himself, Sickert was already contemplating a new shift of ground. When he went to see off the Lillys next morning he

told them that he was planning to wind up his affairs in Dieppe and return to London.[111] The move, however, was delayed. In an act of piety, Sickert launched into a fresh round of building work at Envermeu. He had, as he put, 'an instinct to perfect and complete [his] darling's *trouvaille*'. The porte cochère was converted into a garage, the old brick-and-flint garden paths were relaid with concrete to make them 'fit to walk to the W.C. on in thin shoes', and the well was to be made good. Sickert claimed that the work was to make the house sellable to 'some – American', but it seems likely that he was already planning to give the Maison Mouton to the Schweders. After the success of their previous visit he had offered them the use of the house for the coming summer, and he worked hard to get things ready for their arrival.[112]

His efforts to make the place completely comfortable were, however, rather undermined when a cat fell down the well and drowned, contaminating the property's sole source of drinking water. The Schweders had to spend their holiday driving into Dieppe daily to fill a large flagon from one of the pumps there. Despite this inconvenience they loved the house. Sickert, however, was not there to share their enjoyment.[113]

II

PRIVATE VIEW

I can't go out at night just now.
(Walter Sickert to Marjorie Lilly)

Sickert returned to London at the beginning of the 1922 summer.
His 'poor old mummy' had died at the age of 91, after failing for a
year. Sickert had retained a profound but characteristically dispassion-
ate affection for her over the decades, based on occasional intimacy
and regular absences. During the final period of her life – though
Robert and Leonard still lived at home, and Bernard had recently
returned, 'ill, and making himself more ill' – it had been left to
Helena and Oswald to take the lead in assisting her. With the family
servants too old themselves to be much use, Helena oversaw many
of the housekeeping duties, and Oswald (whose work had taken
him to Spain) made his mother a small allowance, in the face of
growing expenses and troubles.[1] Her death was not to be grieved
over. She was, as Sickert remarked to Andrina Schweder, 'better out
of it'. Her life, for some time, had been mostly 'made up of dis-
comfort'.[2] Her death, however, did bring several new cares. Sickert's
anxieties about the administration of her will, particularly in respect
of the invalid Robert and the irresponsible Bernard, proved otiose.
The net value of the estate was nil.[3] The house in Pembroke Garden,
already mortgaged beyond its value, was given up and its contents
cleared. Sickert arranged for some of the paintings by his father and
grandfather to be shown by William Marchant in a special exhibition
at the Goupil Gallery that June and wrote a brief biographical introduc-
tion to the catalogue.[4] If there were profits from the show they must
have gone towards providing for Robert, who was moved into modest
lodgings at Putney (the other brothers moved to separate addresses).[5]

Sickert rewarded Marchant by making him his principal London dealer.*

On arriving back in London, Sickert sublet the 'Whistler' to Duncan Grant, but kept on the 'Frith'. He stayed initially at his old bachelor haunt, the Tavistock Hotel, though he soon acquired a bedsit at 15 Fitzroy Street as a more convenient base.[6] It was a cheerless room, with bare boards, awkward furniture, and a single tall window facing out on to the street, and it seems that Sickert used it as much for working as for living in. Across the entrance to the 'Frith' itself he erected a steel security gate and took to locking up his drawings. He even went so far as to get a large dog to guard the premises.[7] He lived in a chaos of papers, cinders, and paint and cooked for himself on the stove – though without the adornment of his chef's hat. These changes, though they probably reflected something of Sickert's real sense of vulnerability and loss, had an exaggerated and theatrical quality. He had returned to London in a new role: the Recluse. And he wanted people to know it. The part, like so much else, was inspired by the example of Degas. The French painter, as Sickert acknowledged, had used his carefully cultivated reputation for 'brusqueness' and 'reclusiveness' to escape the obligations and the people he wished to avoid – leaving himself free both to work and to enjoy a social life of his own choosing. Sickert hoped to achieve something similar.†

He did not revive his weekly receptions or his breakfast parties. This, as he explained to Tonks, was partly because 15 Fitzroy Street had been designated under the Factory Act, so his WC was no longer his own but shared with 'all employees male & female of the Yiddish tailors above me'; he made do with 'a day-stool' in his studio, which he had to 'watch occasion for emptying'.[8] But his unsociableness was also programmatic. He allowed it to be thought that he was 'unapproachable' and prone to 'shut up moods',[9] and although he certainly did suffer the occasional bout of grief and despondency, it is clear that he was excited to be back amongst his friends, and pleased

* Sickert continued to send copies of his recent prints to Harold Wright, the print specialist at Colnaghi's.

† Sickert lost no opportunity to emphasize his condition. When Osbert Sitwell visited him soon after his return, Sickert was describing how the studio had once been a stable when they were distracted by the sound of scampering footsteps. 'That's not horses,' Sickert remarked dryly. 'It's rats.'

to be back in London. He resumed his regular morning visits to the
Kentish Town Baths. (It became his belief that heaven might be 'a
public bath with mixed bathing and music', and though Henry Han-
cock, the manager at Kentish Town, could not quite run to such luxury,
he did offer the best bathing in London.*) He dined with the Gosses
at Hanover Terrace, with Wendela Boreel and her husband Anzy Wylde
at Eaton Place, and at Oxford Square (off the Edgware Road) with
Walter Taylor.[10] He kept in touch with Christine's family,[11] and was
even seen enjoying himself at the Cave of Harmony, a little cabaret
run by the actress Elsa Lanchester in a Gower Street basement.[12] He
also visited his old NEAC confrères (Tonks found him 'as lively as a
cricket').[13] Roger Fry and the denizens of Bloomsbury welcomed him
back,[14] and became a turn again at the Sitwells' Chelsea soirées and
at Ethel Sands' table.[15] 'Hurrah,' he telegraphed to Mary Hutchinson,
in enthusiastic acceptance of one dinner-party invitation, 'bags I [sit
next to] hostess.'[16] He could still be 'the life and soul' of any gathering,
needing only the smallest excuse to perform his cod Shakespearean
party piece,[17] but now he was better able to dictate the pace of his life
and could turn down invitations without explanation. He could see
people under his own terms.

He had always used his eccentricities, his theatrical poses and dis-
guises, to protect against intrusion into his inner life, but the barrage
now increased.[18] Rather than entertaining at the studio, he would
whisk friends off in a taxicab to enjoy a brief motorized tête-à-tête
while orbiting Regent's Park or the garden squares of Bloomsbury.[19]
Indeed the profligate use of taxicabs became of one of the defining
features of his new personal myth. He would keep cabs waiting
all day with their meters running. He would leave them outside
shops and then forget them. No journey was too short or too long.
He would dispatch cabs down to Cornellisen, his art suppliers in
Covent Garden, to fetch a bottle of varnish or some other small item
that he 'felt he must have at once'. It was said that he once hailed a
taxi to take him across the road; he certainly took them between
London and the south coast. His tips were extravagant, his interest

* Hancock opened the baths on Sunday mornings to special groups, including the
Star & Garter Hospitals for the war wounded. Sickert was allowed to come too. He
made a big impression on the other bathers – and on Hancock's daughter – with his
'striking clothes and gracious comments' (conversation with Hancock's grandson,
Peter Peretti, 27/2/2001).

in the cabbies enthusiastic, and his popularity with the taxi-driving fraternity enormous.[20]

Another no less profligate element of eccentricity that he began to cultivate was the use of telegrams, which became his preferred mode of communication (he never learnt how to use the telephone). He would send telegrams like letters (they might run to several pages), or he would drop them like notes. It was said that he ordered his lamb chops from the butcher by telegram.[21]

There were some subjects, however, on which he remained a tardy correspondent. Marchant became exasperated at his reluctance to answer business letters. He tried to engage Sickert's attention by sending business telegrams, but even these failed to provoke a response.[22] Sickert strove to avoid all chores relating to the sale and promotion of his work. He refused to let Colnaghi's print expert, Harold Wright, come to the 'Frith', telling him, 'the only way I can see anyone is if they invite me to dinner';[23] and though he was happy to learn that John Middleton Murry was preparing an article on his etchings – and offered him some private words of encouragement – he refused to co-operate formally.[24] Nevertheless, he did remain both efficient and accessible enough to supply the *Burlington Magazine* with regular articles, and even to accept the occasional commission from the *Morning Post*. When the Leicester Galleries mounted an exhibition of Degas' sculptures, he readily agreed to contribute a catalogue introduction.[25]

He continued to see much of Thérèse Lessore, who was still living and working in Fitzroy Street, at No. 20.[26] Although she was distressed at first by his new air of secrecy and suspicion, that mood soon passed. The tendency she had noted for Sickert to become dependent upon her, however, did not. While praising Thérèse's work, her dedication, and her character, Sickert imposed himself upon all three. His returning energy, his constant desire to communicate his discoveries about painting, as well as his new vulnerability, made him impossible to resist, and Thérèse found herself drawn more and more into the ambit of his concerns.* She and Sickert became inseparable. They were often to be seen dining together at L'Étoile in Charlotte Street, talking of

* Sickert did make some effort to identify with Thérèse's commitment to pottery decoration. He even decorated three Wedgwood teapots with views of Bath. Only one, however, survived the firing, which may account for his loss of interest.

'nothing but painting'.[27] It was the principal bond of their friendship. Thérèse, it seems, had a terror of sex. Her marriage to Bernard Adeney had remained unconsummated; according to her husband, she 'froze up on any attempt at penetration, became ill and had to be revived'.[28] Sickert may have carried her beyond this fear, though Vanessa Bell and Duncan Grant were convinced that the relationship was platonic – not least because Sickert devoted so much sexual energy to flirting 'hard' with Vanessa whenever they met. Nevertheless, his increasing reliance upon Thérèse began to fuel rumours of an approaching marriage.[29]

Sickert considered that the art world he returned to in London was divided between 'palaeo-stuffers' and 'neo-stinkers'.[30] Old 'stuffers' there certainly were, but – in truth – the 'stinkers' were not that 'neo'. While in Paris the years both during and since the war had seen an acceleration of artistic innovation and experiment, in London there had been something of a relapse. Wyndham Lewis had attempted to regather his Vorticist cohorts under the banner of 'Group X', but, with such vital allies as Gaudier-Brzeska and T. E. Hulme fatalities of the war, the new group had lacked both power and focus and disbanded after its inaugural show. Gilman had died in the great flu pandemic of 1918–19, leaving the London Group under the domination of Fry and his Bloomsbury associates. Fry was still proclaiming the achievements and the influence of Cézanne with undimmed eloquence, but in his own work he had retreated from the experimental formalism of his pre-war years. He drew back from the possibilities of Cubism and abstraction, preferring rather to adopt the master's more obvious tropes – the accentuated planar forms and purple shadows – and apply them to the English scene. It was a style that found both imitators and admirers. Experiment was not quite dead: Matthew Smith tried – with his massive brightly-coloured nudes – to combine the Fauvist tradition with the example of Renoir; Mark Gertler adapted the spatial devices of Picasso and André Derain to the precision of his elaborate still lifes. But they sounded as faint echoes of the Parisian scene, and in the absence of any more vital current of debate the established figures of the pre-war age – Augustus John, William Nicholson, William Orpen – reasserted themselves, regaining all their former prominence (in 1921, John even joined Orpen and Nicholson as a member of the Royal Academy). In

such an unfocused climate, Sickert's already prominent individualism could survive, if not prosper.* No doors were closed to him.

That autumn, he accepted Roger Fry's invitation to exhibit with the London Group, albeit as a non-member, and his painting, titled *The Bar Parlour*, showing two cockney girls seated back to back in a crowded interior, was one of the hits of the show.[31] It signalled a triumphant return and was bought by Maynard Keynes, a man with a keen appreciation of both art and investment value.† Sickert, as Ethel Sands reported, was 'the rage'. His success with the London Group was followed up by the news that the Tate Gallery had bought his Venetian conversation piece *A Marengo* from the Eldar Gallery. It was the first painting of his to be purchased by the national collection; two had already been presented.[32]

Nor were Sickert's successes confined to London. One of his pictures was included in the Annual International Exhibition at Pittsburgh (a forum that he would grace each year for the next decade).[33] He was also delighted to receive a visit at the 'Frith' from Major W. H. Stephenson, who told him that the art gallery at Southport, Lancashire, had recently acquired one of his early Dieppe paintings.[34] Stephenson, a power in the local newspaper world, had cheered him further with tales of his standing amongst the art lovers of the north. Frank Hindley Smith, another Southport magnate, owned several Sickerts in an impressive collection of modern French and British art, and was on

* Sickert seems to have considered that Roger Fry's ubiquity and success represented a threat – perhaps to himself, certainly to his old friend Steer. He sent Steer the following ditty, titled 'Lines to an Expert':

> If he proves a simple codger,
> Unload Steer, and load up Roger!
> And he'll like you all the better if you do!
> For Rogers you may trust in,
> Though the Cézanne boom be bustin'
> And he'll like you all the better if you do!

† Keynes bought at least two other pictures from Sickert during the early twenties, and Sickert presented Keynes with a portrait of the Russian dancer Lydia Lopokova (Keynes' future wife) which, in allusion to Richard Sheepshanks' mathematical career, he inscribed, 'To JMK from a hereditary mathematician'. Sickert greatly admired the diminutive Lopokova. He thought she had a head like 'a plover'. He . even considered doing the decor for a production of *Coppelia* she was planning. When, however, she abandoned dancing in the early thirties and made a brief experiment at acting, he was dismayed. He felt she was throwing away her reputation. 'She had a great name with the public,' he told Viriginia Woolf, 'and now she has lost it.' In art, he considered, it was necessary to recognize one's limitations.

the verge of selling one of them to the Southport Art Gallery.[35] For all his conviction that paintings belonged on the walls of private houses, not public galleries, Sickert was greatly pleased by these official endorsements of his talent. In the wake of the Tate acquisition Ethel remarked to Nan: 'I don't like to think what his megalomania will be soon.'[36]

Even at sixty-two, while many people remained traumatized by the war, unable to move beyond it and content to retreat into the past, Sickert was eager to move forward. His old friend Marcel Boulestein, who enjoyed a 'particularly amusing luncheon' with him and the French painter Jean-Emile Laboureur in a Soho restaurant, characterized Sickert's attitude as a rare absence of 'Pre-War feeling'.[37] Sickert began to sever some of the pre-war ties holding him to France and the past: the house at Envermeu was made over by deed of gift to the Schweders, and Marie Pepin was dispensed with,[38] whilst Fry, on one of his visits to the 'Frith', discovered Sickert whitewashing over several of his old music-hall canvases.[39] He was in search of a new milieu. Towards the end of the war he had made a richly enjoyable excursion by tube to Petticoat Lane. Despite – or perhaps because of – a thick fog that day, the scene had awakened his artistic interest. The dimly glimpsed figures and features of the Jewish immigrants in the gloom of the narrow streets had put him in mind of Rembrandt;[40] and perhaps it was the memory of this visit that encouraged him to look again at the East End.

He developed an enthusiasm for the Jewish Art Theatre and dragged Ethel Sands to Whitechapel to see their performance of *The Dybuk*, along with East End-born Mark Gertler, who proved a useful interpreter as the play was in Yiddish.[41] Notwithstanding the language barrier, Sickert was thrilled by the acting. He made a drawing of the leading Russian actress, Sonia Alomis, which he then etched, captioning the print: 'The Greatest Living Actress'. He tried to immerse himself in the area. He told Ethel that he had actually bought a house in Whitechapel, and although this seems to have been a characteristic exaggeration, he did spend what one friend described as an 'uneasy interlude at some queer place in Aldersgate'.[42]

The area, besides its teeming vitality and its Rembrandtesque echoes, had the added attraction for Sickert of having been the stalking ground of Jack the Ripper. Indeed when the French painter Dunoyer de Segonzac, over in London for an exhibition at the Independent

Gallery, had lunch with Sickert he was treated to a spirited account of 'la vie discrète et édifiante de ce monstreux assassin'.[43] But Jack the Ripper, though he may have stimulated Sickert the raconteur, seems to have had almost no impact upon his art. The sojourn at Whitechapel yielded up no new scenes or motifs. His only Whitechapel drawings remained those of Sonia Alomis and the Vilna Troupe. The impulse that had drawn Sickert to the East End soon faded, overtaken by other interests.

In January 1923, Sickert was invited up to Edinburgh by the Society of Scottish Artists to give a lecture at the Edinburgh College of Art.[44] He arranged to stay with his friends the Prices, William Price having retried from the army (with the rank of Brigadier-General) and been made Secretary for Scotland to the General Post Office. Sickert's arrival at the Prices' home in Glencairn Crescent caused some consternation amongst the sedate burghers of the New Town: he had attired himself in his 'Bill Sykes' costume, a red kerchief about his neck, a peaked cap pulled down low over one eye. Mrs Price was not impressed and insisted on him getting some 'proper clothes' at once. It was in the new and elegant guise of a 'writer to the signet', with a smart top coat, leather gloves, malacca cane, and tall silk hat, that he was – as he described it – 'triumphantly received' into Edinburgh society.[45]

Listing his social successes to Andrina Schweder, he described meeting his 'old friend ex-Lady Drogheda at her hospitable mother's table (Mrs Pelham Burn)'. He also encountered Mrs Sholto Douglas – a fashionable interior decorator who was undertaking the Scottish agency for Thérèse Lessore's painted pottery. He called on the son of the landscape painter William McTaggart[46] and visited the dilettante and aesthete Mark-André Raffalovich, a friend from the distant past of the 1890s.[47] He was given a dinner at the Arts Club (accompanied by 'divine Scottish singing'), was made an 'honorary member of the Scottish Artists', and – best of all – was photographed 'by request' in his silk top hat for the shop window of a smart Frederick Street photographer's. Even aside from these gratifying marks of respect, Edinburgh pleased him greatly. He could swim each morning in the saltwater baths at Portobello, and he took long walks along the Waters of Leith, often accompanied by the Prices' young grandchild Simona, who was being brought up in Edinburgh while her parents were in India. His energy and spirits were infectious. After a visit to St Giles' Cathedral

he took Mrs Price by the hand and insisted on running all the way down the Royal Mile with her.*[48]

Sickert's lecture, though titled (like his aborted anthology) 'Straws from Cumberland Market', was to be a series of 'observations upon the teaching of art' deduced from 'pictures by deceased masters in Edinburgh's Public Galleries'.[49] To gather his examples he made a thorough tour of the Scottish National Gallery with Simona. Confronted by Turner's *Soldiers in the Officers' Mess*, he commented with a generosity and humility that greatly impressed his infant companion, 'None of us will ever be able to paint like that.'[50] The talk, given on a Friday evening before a large audience at the Edinburgh College of Art, was a success. His theme was that the best paintings – the National Gallery's Turners amongst them – were all done from drawings. 'The great decadence of modern painting,' he claimed, had been caused by 'the belief that it is somehow best to paint from nature'. Afterwards there were questions, including one earnest Scottish enquiry about the exact number of sittings Carlyle had given to Whistler for his portrait.[51]

The next morning Sickert was up early to get copies of all the papers in case there were reviews of the talk. 'I am very vain,' he confessed complacently to Mrs Price. He was delighted to find one small error of reportage in *The Scotsman*'s very full account of the evening, and dashed off at once a letter to the editor correcting the point.[52]

Flushed with his own rhetorical success, Sickert, on his return to London, attended a lecture by Roger Fry at Mortimer Hall on the wide subject of 'Art'.[53] He was better suited to being on the platform than in the audience. He particularly enjoyed sabotaging Fry's performances. At one earlier talk Fry had become so provoked by Sickert's highly audible comments that he had marched down to the front of the stage and shouted, 'Shut up, Walter! Shut up!'[54] On this occasion, however, Sickert remained silent. Indeed, as he afterwards explained to Fry with elaborate discourtesy, he hoped that he had not fallen asleep. He did not think he had, but he had been worried because he had not had much rest the previous night. There had been a drunk man at his hotel, and every time Sickert had nearly nodded off he had been woken by the drunk calling out, 'Cuckoo! Cuckoo!' He had experienced a

* Sickert, remembering Mrs Price's gift for business, entrusted her with the Scottish agency for his work. The terms of the arrangement were typically Sickertian: Mrs Price was to take a 50 per cent commission on anything she sold, and keep any pictures that she was unable to sell.

rather similar sensation at the lecture: every time he had been on the point of falling asleep he had been roused by Roger calling out, 'Cézanne! Cézanne!' Fry, accustomed to Sickert's sallies, beamed at this, but the jest had been made only in part for his benefit. Sickert was also seeking to amuse a shy, pale, round-eyed, elfin-looking young woman, whom he had noticed taking the ticket money on the way in. Her name was Cicely Hey. He asked her to come and sit for him the following day.[55]

'Hey', as she was called by her friends, was a painter and designer living – literally and figuratively – on the fringes of Bloomsbury, in a shared house in Taviton Street.* She called on Sickert the next afternoon and, with a clanking of keys, was let into his bed-sitting room. Rather to her alarm, Sickert locked the door behind them. The looming presence of the iron bedstead did little to diminish her anxiety, but she was soon set at her ease. Sickert placed her in a high armchair by the fire and began to draw. He called for no formal poses, and accommodated himself to any slight alterations in her position.[56]

Over the following weeks she returned almost daily.[57] All thoughts of Whitechapel and the East End were banished as Sickert poured his energy into a series of drawings, prints, and paintings of Cicely Hey, or 'Kikily', as he dubbed her, hardening the consonants of her name. The work was intense. He would not be disturbed, Miss Hey recalled, during his 'working hours'. When people came to the door, knocked, and called their names, he would put his finger to his lips and not answer. Nevertheless, his definition of 'work' included many things. There was much time for conversation and instruction. He regaled his sitter with imitations, snatches of song, anecdotes, and stories. Yet though she often left the studio, her 'sides aching with laughter', she recognized the serious intent behind his exuberance. There was a point to everything: the stories 'were kind of parables', and invariably about art.[58]

In his drawings, Sickert concentrated on what he called Cicely's 'funny little beautiful, sane dear face' – though many might have considered her distinctive combination of a snub nose, slight overbite, and widely spaced eyes more 'funny' than 'beautiful'.[59] When Thérèse Lessore, who was expected to share Sickert's enthusiasm for his new

* The other tenants were David 'Bunny' Garnett (whose novel *Lady into Fox* was published in 1922), his new wife 'Ray' Marshall, and R. R. Tatlock, who, as editor of the *Burlington Magazine*, was well known to Sickert.

model, met Cicely, she remarked, 'You've got just the kind of face he likes to paint.'[60] God, said Sickert, had made that face with a 'chopper': its planes and angles caught the light with dramatic exaggeration. As Miss Hey recalled, one pose occurred by chance when she was having tea in Sickert's rooms on a Sunday afternoon. As they sat either side of the blazing fire, Sickert became suddenly excited at the strong light being reflected up from the Sunday paper on her knees, coupled with the contre-jour effect given by the window behind her head. The moment had to be drawn. The sketch was then worked up into a painting that Sickert exhibited at the London Group.[61]

It was bought by R. R. Tatlock, who became engaged to Hey soon afterwards.[62] Sickert's own infatuation with Kikily continued unabated throughout the year, and it is at least possible that it achieved some sort of sexual resolution. Miss Hey later referred to herself as 'the last occupant of the iron bedstead', and there was certainly an undercurrent of erotic innuendo in some of Sickert's letters to her. He took to signing himself 'Dick' and taxed her with his 'new riddle': 'Why does the population remain stationary? Because of French letters.'[63] Against this stands the occasion when, sitting beside Cicely on the studio bed, he caught sight of their reflections in a long mirror and let out a howl of despair. As Denys Sutton remarks, 'One imagines that he had undergone one of those impulses to show one's feelings to a young girl which are curbed when disparity of age is recalled.'[64] Nevertheless, artist that he was, even at the moment of despair he was struck by the 'colour effect' of the scene, and composed a painting from it. He gave the picture the self-mocking title *Death and the Maiden*.[65] Before he went over to Dieppe in August for a brief holiday, Sickert presented Cicely with a faded crimson portfolio containing all the drawings he had made of her. 'One never knows what is done with one's things after one is dead,' he told her. 'I believe in "donum inter vivos".'[66]

The return to Dieppe was not a success. Almost as soon as he arrived news reached him from England that his brother Robert had been run down by a van in Putney High Street and killed. The incident, as Sickert noted with a certain dispassionate curiosity, was partially the result of the monocular Robert wearing a glass eye rather than an eye patch. The van driver, not realizing that the 'eye' turned towards him was sightless, had assumed that Robert could see him coming.[67]

Although Sylvia Gosse had taken a flat on the seafront, and though he saw something of the Prices and other friends, the old magic could

not be recaptured. He continued to work away at his baccarat paintings, but found no new subject to excite him. Without Marie to look after him, life at his flat proved difficult. Good food was scarce,[68] and by the end of September the weather had turned autumnal. 'It has been too cold to bathe for weeks,' he complained in a letter to Cicely. 'This place is simple *hell*, with a wind that goes straight through the house. I am only waiting for the sea to go down to cross. Not that I get sea-sick, but I am too weak to be knocked about.'[69]

It was in this mood of dejection that Sickert encountered Jacques Blanche one evening, walking with Ethel Sands and Hilda Trevelyan, by the old church of St Jacques. Blanche, who had barely seen Sickert since he had called at Offranville to fetch Christine's bronze death mask almost three years before, hailed his old friend. He attempted to elicit a spark of shared outrage at the destruction that developers were even then wreaking upon the old town, but Sickert was not to be drawn. With deliberate perversity he asserted that something 'ugly' added to a building or landscape did not spoil the scene, but rather lent it a new 'pictorial value'. When Blanche continued in his nostalgic vein, discoursing on Sickert's unique affinity with the town and recalling with mounting enthusiasm the names and exploits of deceased friends – Beardsley, Conder, Pissarro – who had shared his love of the place and its picturesque beauty, Sickert remarked with a voice, 'ironique et glaciale: 'Êtes-vous hereux, me fit-il, de pouvoir vibrer encore! – *to vibrate*. Vous me rappelez, et avec la même ardeur, notre Londres de Whistler, le vieux Oxford Musichall, les barcarolles de Venise . . . *By Jove!* Croyez-vous donc à tout cela, vous? Il n'y a pas de *sujets picturaux*. Dieppe, Venise m'ont été commodes.'*[70] The claim was both brutal and untrue, but it did reflect the fact that the town was no longer of use to him. Its memories depressed him. Its sights no long inspired him with the same excitement. It was, in his phrase, an orange that had been sucked. He never painted there again.†

* 'Ah! You are a lucky one, to be still able to feel! – *to vibrate*. You would transport me, with the ardour of youth, back to our London of Whistler, to the old Oxford Music Hall, to the barcarolles of Venice . . . By Jove! Do you still cling to all of that? I tell you there are no subjects that are pictorial in themselves. [It is the painter who makes use of them for his own ends.] Dieppe and Venice were convenient to me. That is all.'

† The visit was not quite his last. He did return to the town fleetingly on at least a couple of occasions over the coming years, but only to gather up work that he had left behind.

The tragedy of Robert's accident was followed by the even worse news of Oswald's death in Madrid after a sudden illness. He was barely fifty, and there had been the prospect that he and his wife would be returning to London for good in the following year. His kindness, humour and good sense would have been a welcome support for Sickert, not least in his responsibilities towards the feckless Bernard, who, despite his self-destructive proclivities, showed no signs of dying. He had been in London the previous year, working on a series of pastels for an exhibition at the Twenty-One Gallery. The pictures – atmospheric views of the Thames – proclaimed an enduring debt to Whistler, or perhaps a failure to develop. But the modest success of his exhibition was not sustained, and so to remove him from the temptations of London it was arranged that he should go and live in the Quaker settlement at Jordans in Buckinghamshire, where he could be looked after by an old family friend.[71]

Sickert continued, at a distance, in the thankless task of assisting him. As his sister later explained to D. S. MacColl, 'Walter was really more generous than would appear from the "modesty" of Bernard's way of living. Gifts of money were worse than useless and even the expensive clothes Walter constantly sent him were pawned ... Unhappily, as I believe is often the case, [Bernard's] clouded mind often led him to mislead people about Walter. I am sorry about this because although Walter has always been reckless about money, he spent a great deal on Bernard, one way or another.'[72]

The success of the Edinburgh talk reignited Sickert's campaigning zeal. He was encouraged to give more such lectures. His old friend Michael Sadler, who had been elected Master of University College, Oxford, persuaded him to give an informal address to the students in hall after dinner. Anthony Powell, then a first year undergraduate, was present on the occasion, and was impressed by Sickert's performance, though he retained a rather clearer memory of the artist's splendid 'light greenish loudly checked suit' than of the detail of his 'no-nonsense art criticism'.[73] He also gave a more formal talk at Oxford's Ashmolean Museum,[74] and early in the New Year he gave a series of three lectures at the Royal Institution in London before setting off to proselytize the north with talks at Southport, Manchester, Liverpool, and Hanley.[75] For all of them he used his favoured catch-all 'Straws from Cumberland Market' title. It allowed him free rein, and if he spoke from notes, he rarely stuck to them. There were topical allusions, old jokes, long

digressions, sly asides, wild exaggerations, and much sound sense. He returned always to his favoured themes: the need to paint from drawings and the virtue of choosing subjects 'at the root of existence'.[76] The thread of his extemporized discourse was stretched, but never broken. He was, in his own description, 'like a bus-driver who is perpetually jumping down to fight some passer by. I apologize to my fares, climb back on the box, and seize the reins. Bank! Bank! Charing Cross!'[77] It was an entertaining ride for his listeners, while for Sickert the lecture platform provided a chance to combine his didactic principles, his conversational flair, and his theatrical gifts.

He became an accomplished orator, though never a blasé one. At the dinner before one lecture, his host was surprised at his nervousness: he ate little, declined the champagne that had been provided in his honour, and made repeated enquiries about the probable character of the audience. Nervous energy, however, was necessary to his performance.*[78] His diction was clear, and as an 'old actor' he knew to 'raise [his] chin and speak to the little boy at the back of the gallery'.[79] He also had an absolute conviction in the importance of his subject and assumed that his audience did too; and if he sometimes talked rather 'above the heads of his listeners', his 'quaint manner and expressions' always held their attention.[80]

The invitation to talk at Southport had come from Major Stephenson, who was keen that Sickert should visit the town – not least so that he might sign the Dieppe painting in the Art Gallery – and Sickert, sometimes so difficult on such occasions, was happy to oblige. Stephenson's wisdom in having the picture authenticated was confirmed the next day when he took Sickert to see Frank Hindley Smith's collection. Mr Hindley Smith was away so they were able to inspect his gathering of modern French and English pictures at leisure. Sickert was impressed – until he paid a visit to the downstairs cloakroom. He re-emerged with a framed drawing under his arm exclaiming, 'Stephenson! What are my legal rights? I have found in a most important room in this house a forgery, a drawing signed "Sickert" and I have never seen it before. It's a forgery. Am I within the law if I put my foot through it.'†[81] Major Stephenson

* Sickert later tried the experiment of eating after, rather than before his lectures, 'as the clergy do', but found it even less satisfactory.

† The story survives in several versions. Osbert Sitwell, who heard it from John Wheatley (who claimed to have witnessed the incident), describes Hindley Smith as a Glasgow, rather than a Southport, millionaire, and adds that Sickert subsequently

managed to convince Sickert that his rights did not extend quite so far as that, but the incident did reveal the new level of Sickert's reputation. He was now worth forging.

Henceforth Sickert was forever stumbling upon 'forgeries' of his work, in the windows of dealers and on the walls of collectors.[82] Some were perhaps no more than over-optimistic ascriptions of painting done in his manner, and of his favoured subjects. His years of teaching had, as George Moore liked to complain, created dozens of 'little Sickerts', all sedulously aping his low-toned views of the Dieppe side streets.[83] Many of them achieved impressive results, and the possibility of confusion increased with every year. At the NEAC's winter exhibition in 1911, *The Athenaeum*'s critic had praised *Quai Duquesne, Dieppe* by Miss Marjorie Breed (one of Sickert's pupils) as 'an excellent Sickert, surely, for the best judges, if time should obscure its authorship'.[84] Sickert's carelessness with his own work did not help matters. His habit of abandoning half-finished canvases in his old studios, or selling off incomplete work in amongst the roped up batches he offered to the dealers, was a temptation for others to finish – and sign – the pictures for him. Although he may have been irritated on occasion by the damage such forgeries did to his reputation – and to his pocket – he soon came to realize the futility of complaint. Instead he adopted a pose of elaborate unconcern. He told Osbert Sitwell of his surprise and delight at coming across one of his old canvases in a dealer's window. He had abandoned the picture half-complete, but found it, now, beautifully finished and embellished with a very fair attempt at his signature. 'I couldn't have improved on the picture myself,' he is supposed to have declared, adding they he would not trouble over finishing any of his canvases in future.[85]

Sickert's proselytizing urge was not satisfied by lecturing. He per-

wrote to him saying, 'I have no objection to your hanging my pictures in your lavatory, but please see that they are genuine'. Marjorie Lilly gives an account of Sickert visiting a friend's house in Manchester, where the dining room was supposedly hung with his work. But, on entering the room, he had been taken aback: not one of the pictures, he claimed, was genuine. Miss Lilly places the incident in 1917, but her dating is sometimes awry. There is no evidence to suggest that Sickert was in Lancashire in 1917, and his work was scarcely worth forging then. Moreover, it is hard to believe that Sickert would not have mentioned such a prior incident to Stephenson. It seems more likely that she is giving a confused account of the 1923 Southport event, or even some subsequent occasion. Sickert forgeries certainly did begin to appear during the 1920s, many of them passing through, if not originating from, the Manchester dealer Charles Jackson.

suaded Major Stephenson to let him write a series of short articles ('say, half a column') on questions of painting for the *Southport Visiter* [*sic*], one of the local papers that the Stephenson family controlled. Ignoring his four decades of journalistic endeavour, and the fact that he was even then appearing each month in the *Burlington*, Sickert told Stephenson that he had 'never written serious articles before' nor achieved his ambition of a 'regular column' in a newspaper. With rather more accuracy he stated, 'I know as much about modern painting (by which I mean 19th and 20th century) as anyone in England, and I can give critical ideas in *comprehensible* language.'[86]

Comprehensible though the language may have been, it could not be easily confined to 'half a column'. Sickert's copy would arrive – usually late, invariably by express – with red-scrawled pleas for additional space. Over the spring of 1924 he entertained, or bemused, the newspaper readers of Southport with his forcefully expressed views on 'Mr Burrell's Collection at the Tate', the flower paintings of Fantin-Latour, Turner's greatness, Roger Fry, the cult of Cézanne, and the deficiencies of the Royal Academy summer exhibition.[87]

In his own painting Sickert remained keen to discover a new 'mee-lew'. He wanted the stimulus of an untried location, the savour of an unsucked orange. Disappointed by Whitechapel, he turned his attention to Islington. During the course of the summer he moved into two first-floor rooms at 26 Noel Street, overlooking the Regent's Canal.[88] The move marked a return as much as an advance. Islington, as he liked to declare, had 'always been kind to [him]'.[89] Noel Street ran at right angles off Duncan Terrace, where he had stayed on his first childhood visit to London and St Mark's Hospital, and was only a short walk from Sadler's Wells, where he had appeared in *A Midsummer Night's Dream*. The street, with its well-kept gardens, its quaint crenellations and other touches of Regency Gothic, provided an airy and light-filled escape from the warren of Fitzrovia. Sickert even had access to what he called his 'battlements', a flat roof at the back of his studio.[90]

After the austerity of 15 Fitzroy Street, he made himself comfortable. He hung the walls of the main room with a dark red-and-gold patterned French wallpaper, telling Major Stephenson with some pride that 'good wallpaper' was one of his weaknesses and that it had cost him £1 per piece.[91] Marjorie Lilly was impressed with the effect. She recalled the place as a 'little paradise': a large window looking on to the canal, an archway connecting the front and back rooms, the opu-

The Lion Comique, 1887.
50.8 x 30.5 cm

The October Sun
(aka *The Red Shop*), 1888.
26.7 x 35.6 cm

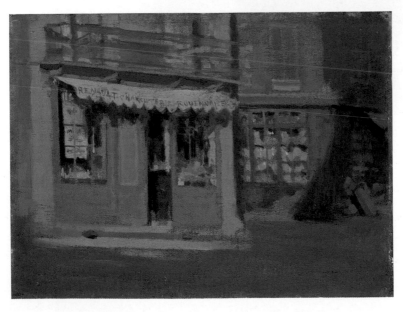

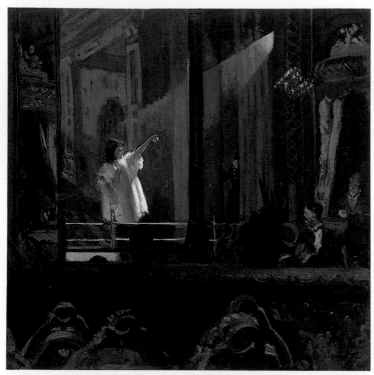

Little Dot Hetherington at the Bedford Music Hall, 1889–9. 61 x 61 cm

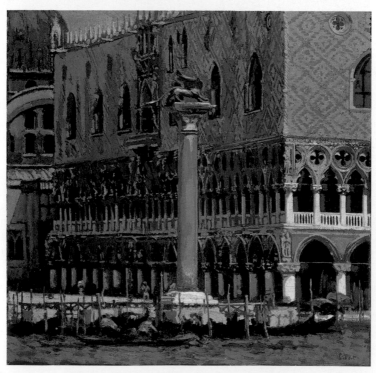

The Lion of St Mark, 1895–6. 90.2 x 89.8 cm

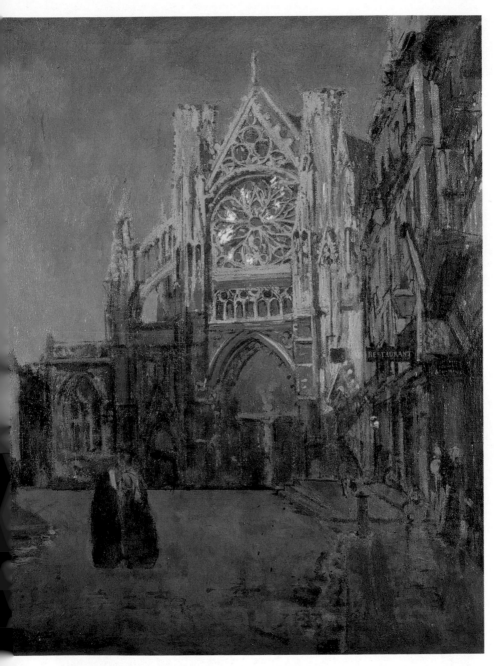

St Jacques, Dieppe, 1902. 130.8 x 101 cm

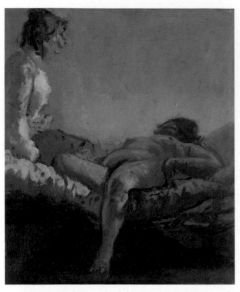

Conversation, 1903–4. 44.4 x 36.2 cm

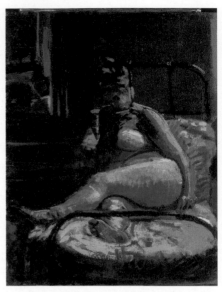

La Hollandaise, 1906. 50.8 x 40 cm

Théâtre de Montmartre, 1906. 48.9 x 61 cm

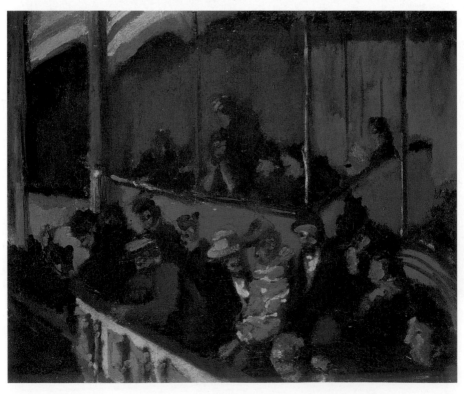

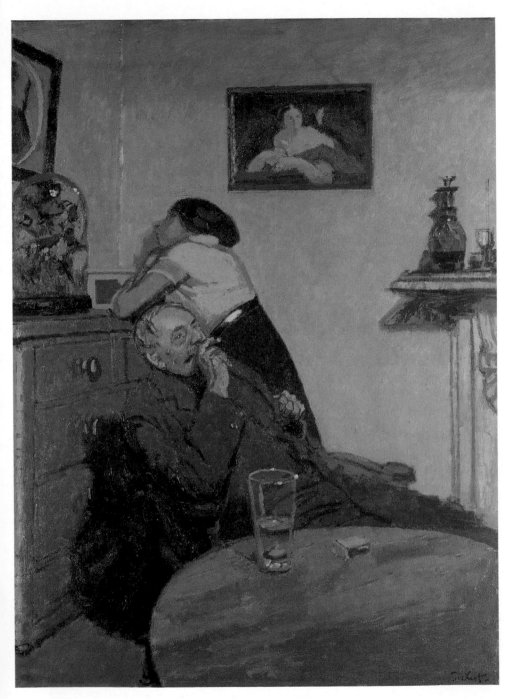

*Ennui, c.*1914. 152.4 x 112.4 cm

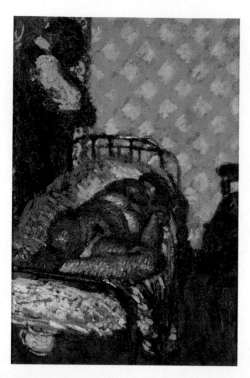

L'Affaire de Camden Town, 1909.
61 x 40.6 cm

Brighton Pierrots, 1915.
63.5 x 76.2 cm

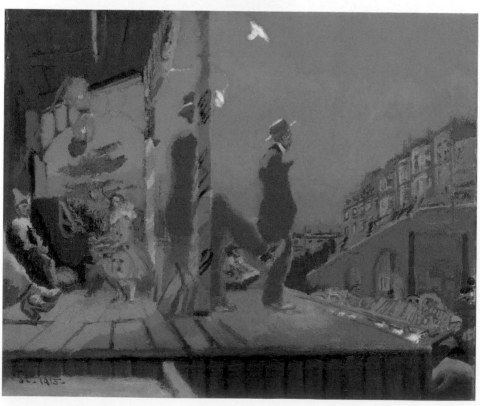

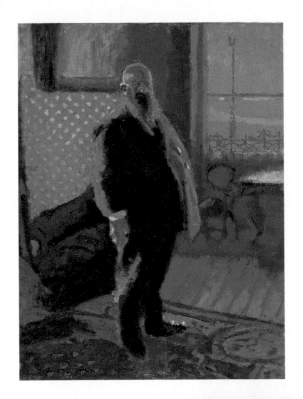

Portrait of Victor Lecourt,
1921–24.
81.3 x 60.3 cm

Lainey's Garden
(*The Garden of Love*),
1928–30.
81.9 x 61.1 cm

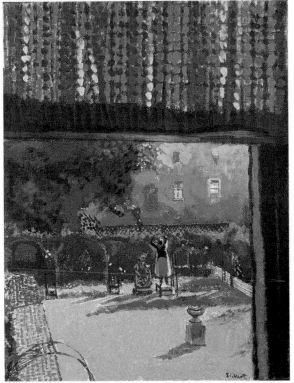

Summer Lightning, 1931-2. 65.5 x 72.5 cm

Miss Earhart's Arrival, 1932. 71.4 x 183.2 cm

lent paper, the odd little collection of framed prints and drawings, the comfortable – if shabby – furniture, and over everything the 'beautiful light'.[92]

Although Sickert kept on the lease at the 'Frith', he ceased to work there. He carried some of his works-in-progress up to Islington, and his last great figure study, the enigmatic *Amphitryon, or X's Affiliation Order*, which Stephenson had seen almost completed at Fitzroy Street and arranged to buy, was given its finishing touches at Noel Street.*[93] For the most part, however, he directed his energy to new subjects, drawn from his new surroundings. He turned, too, to new working methods. In gathering the information for his paintings he all but abandoned drawing – for so long the cornerstone of his practice – and turned instead to photography. Cicely Hey recalled a visit soon after Sickert's move to Islington when she had found him, camera in hand, taking a picture of two girls working on their sewing machines at the window beneath him – the same scene that he was painting. 'Artists *must* use the camera,' he had told her.[94]

Sickert had, of course, used photographs in his work, particularly in his portraits, since the beginning of the 1890s, but they had served as a supplement to his drawings – a source of additional information, rather than the key to the whole composition. For many years he had retained a slightly puritanical attitude to the subject. The camera, he declared, 'like alcohol, or a cork jacket, may be an occasional servant to a draughtsman, which only he may use who can do without it. And further, the healthier the man is as a draughtsman, the more inclined will he be to do without it altogether. For a student who cannot, or will not, learn to draw, the camera spells suicide – neither more nor less.'[95]

Sickert had certainly proved he could manage without, but his whole view of the question softened and shifted with time. He came to regard photography as a precious resource for the painter and found ample support for this heresy in the examples of the past. Canaletto, he knew, 'based his work on tracings made with the *camera lucida*. Turner's studio was crammed with negatives. Moreau-Nélaton's biography of Jean-François Millet contains documentary evidence that Millet found photographs of use. Degas took photographs. To forbid

* The mythological title refers to the story of how Zeus, king of the gods, disguised himself as Amphitryon so that he could sleep with Alcmene, Amphitryon's wife. The allusion, Sickert explained to Stephenson, was to a celebrated fellow RA, one of whose affairs had resulted in his being served with an Affiliation Order.

the artist the use of available documents, of which the photograph is the most valuable, is to deny to a historian the study of contemporary shorthand reports. The facts remain at the disposition of the artist.'[96]

For Sickert, photography had several undeniable attractions. Wedded as he was to the use of tonal underpainting for his pictures, he valued the fact that a black-and-white photograph provided a basic tonal record of any scene without the distractions of colour or the artifice of line. It was a shortcut to a camaïeu. Photography also opened up the possibility of new subject matter. Fugitive scenes could be caught in the instant and on the sly.

Sickert excitedly dragged Cicely Hey round the streets of Islington in search of such 'copy', as he called it. Although after witnessing Sickert's highly conspicuous attempt to take an undetected photograph of a butcher sharpening a knife, she concluded that he had 'no idea of photography at all'.[97] It was quite impossible for him to pass through the streets of Islington unnoticed – the more so when he had a companion, like Miss Hey, with him. The ebullience of his conversation was always liable to bubble up into song or Shakespearean declamation. He would insist on talking to local characters, or pointing out people almost in front of him, suggesting that they might make interesting subjects. He would pause in walking if ever there was some particularly important point he wanted to make, and at such moments a little crowd would often gather round. Cicely Hey was amazed to note that the street children, far from jeering at him, listened with awed attention, as they might to a Punch and Judy show, while Sickert himself remained quite oblivious to the effect he was having.[98] Such conditions were not propitious to documentary photography, and perhaps unsurprisingly there are no known Sickert paintings of Islington butchers sharpening their knives. For his 'copy' he turned instead to the architecture of the streets, which could at least be photographed discreetly from the studio window in Noel Street without becoming self-conscious.[99]

Sickert began to expand into a new and 'very English' persona – a robust, late-Victorian ideal of Englishness that he had invented for himself. Simpson's in the Strand became his favoured place for lunch, and he attacked the fare with a hearty and very English relish that often amazed his companions. On one occasion, when having lunch with Oliver Brown, he ordered a plentiful helping of saddle of mutton before noticing that tripe and onion was on the menu and

ordering a full serving of that as well.[100] It was at Simpson's, too, while lunching with Major Stephenson, that Sickert mentioned his interest in another long-established English institution. 'He was in good form,' Stephenson recorded, 'and greatly amused me with his talk.' When he claimed that his 'one ambition' was to become a member of the Royal Academy before he died, Stephenson assumed that this was yet another jest. Sickert, however, was serious, and when Stephenson realized the fact, he resolved to do something about it. He mentioned Sickert's ambition to the Royal Academician Philip Connard, whom he saw later in the day, and convinced him to further it.[101]

Sickert's name had been put forward already. Orpen – true to the suggestion he made at Dieppe – had nominated him three years previously, in July 1921, and in April 1922 – just after Sickert's return to England – a fair body of Academicians, including Connard, Augustus John, and Charles Shannon, had added their support as seconders. But there matters had languished. A doubt seems to have hung over Sickert's candidature. His name had gone forward for the various Associate Royal Academician vacancies that occurred but had rarely mustered more than a couple of votes, and often no votes at all. Stephenson's intervention reignited the process. At the meeting held on 18 November 1924, two vacant Associateships had to be filled. Sickert was beaten to the first by the now forgotten Terrick Williams, but comfortably secured the second.[102]

Like many mavericks, Sickert had a high regard for official recognition and was enormously pleased with both himself and his new distinction. On 11 December he was 'introduced' before a meeting of the RA council, signed the Roll of Institution, and received his diploma. 'Walter has his desire at last,' Ethel Sands reported to Nan Hudson. It became a favourite boast that he was 'proud to belong to the Academy of which Turner was a member',[103] and he indulged himself in fond dreams of advancement. Lunching with Marjorie Lilly soon after his election, he was elated. ' "It's almost too good to be true," he said with shining eyes, too absent minded to finish his soup. "I can't believe it . . . but – do you know – I may end up after all as President!" '[104] In the meantime he set about re-signing many of his old pictures – appending the initials 'A.R.A.' in a flowing scrawl.*

* When Sickert was asked what the title 'Associate' signified he replied: 'An Associate is a person who is allowed in but may not take any active part. He is a learner and is only allowed to aspire to greatness. He is like one of the two little ladies who looked

Sickert's visits to Lancashire had brought him into contact with Charles Jackson, the Manchester picture dealer whose gallery in Police Street was a focus for the city's more progressive art lovers.* Jackson had begun dealing in Sickert's work and encouraged Sickert in a plan to establish a course of evening classes in Manchester.[105] He undertook to make the arrangements – spreading the word and placing articles in the local press. One of the pieces was by Augustus John (whose work Jackson also dealt in) and praised Sickert's exceptional gifts as a teacher.[106] A venue was found at St Mary's Parsonage, in a room normally reserved for the city's Geographical Society. It could accommodate the thirty or so eager students – professionals, semi-professionals, and amateurs – who had signed up.

The first class was given on the evening of Monday, 19 January 1925. Sickert arrived smartly turned out in a 'well cut grey suit', a black bowler on his head, and in this elegant rig presented himself as the model for his new pupils. On his second visit, although Jackson had provided a professional model for the evening, Sickert arrived with a picturesque old gentleman whom he had picked up on his way over from the station. To emphasize the importance of drawing real people doing real things, rather than models in artificial poses in empty studios, he stage-managed a little dramatic scene by standing the old man behind the table on the dais and seating the hired model on a chair slightly behind him, in an attitude of earnest absorption, as though she were supporting his position at a public meeting. The students were told to title their drawing, 'The Chairman'.[107]

Sickert was thrilled to be holding classes again. He loved teaching, as the students recognized and appreciated. 'It made him happy,' one of them recalled, 'and no one could radiate happiness more effectively.'[108] The weekly classes proved a great success, rather to the alarm of Manchester's existing art school, which for a moment even thought that it might have to amalgamate with the new body.[109] Sickert's enthusiasm could not be contained within the limits of the evening's lesson. He would continue his discourse afterwards amongst his excited

down at Thais [the wealthy Greek courtesan] when she passed by in the street below, and who said to the other: "Look darling, that's what we'll be one day."'

* Malcolm Easton and Lillian Browse say Sickert was introduced to Jackson by John Wheatley; Sickert said he knew Jackson's brother, Frederick – an NEAC painter. Robert Jackson, in a letter to John Russell, dated the connection to 1923. Sickert returned to Southport and exhibited at the Southport Salon in the spring of 1924.

group of students at the Prince's Restaurant in the Midland Hotel (where he stayed on teaching nights), and even the following morning on the train back to London.[110]

On one journey south he entertained Lucy Wertheim, a wealthy Manchester collector whom he had met through Charles Jackson. (She owned several of his works – and, as a further recommendation, looked like a Renoir painting.) They shared a very jolly lunch on the train, Sickert at one moment commanding the waiter to take away 'that synthetic stuff and bring [some] *real* salt'. He also made the surprising declaration that 'he had often planned to paint the Derbyshire Dales' and that he thought he might finally do so that year. Mrs Wertheim subsequently offered him the use of both her house and her motorcar to facilitate the project, but though he telegraphed back 'Grateful and delighted. Vive Renoir', the plan was not followed through.[111]

The Manchester evening classes suffered a similar eclipse. His initial commitment quickly waned; and as summer approached, Sickert receded. He began to find excuses for not making the weekly journey north. Telegrams of apology would arrive in his stead. The band of painters struggled on in Room 8a without him, striving to follow the principles he had laid down for their guidance. But membership and confidence dwindled. Sickert ignored the occasional pleas and queries that descended from Manchester. He had too much to keep him busy in London.

For Sickert one of the attractions of the Royal Academy was that it was a teaching institution. Academicians were expected to serve their turn as visitors to the RA Schools,* and Sickert's turn came round that June.[112] He was able to retread some his Manchester lessons for his new audience. He created amazement amongst the students when, on his first day in the life room (after delivering a spellbinding discourse on the business of 'picture making' enriched by frequent lapses into French), he instructed the models to put their clothes back on and, rather than posing individually, to take up 'natural positions in a group'.[113] But he very soon went beyond even this innovation.

* One of Sickert's first acts on becoming an ARA was to present 'twelve easels' to the Royal Academy Schools. They were, perhaps, stock that he had acquired for one or other of his own 'ateliers'.

Keen to communicate his own latest discoveries, he brought in a 'pictorial newspaper' from which he selected a photograph of a wedding group for the class to study. (In his quest for good pictorial 'copy' he seems to have recognized that the immediacy of a press photograph offered a documentary objectivity rather beyond his own clumsy attempts with a Box Brownie.) 'He told us,' as one student recalled, 'that this reproduction contained all the relevant data from which to make a picture, and he said he would demonstrate to us how to select shapes, and how to follow the relationship of tones that were necessary in the construction of a picture. He forthwith borrowed paints, brushes and paper, and proceeded to carry out his demonstration.'[114]

This was an approach that, besides puzzling most of the students, provoked the ready prejudices of the press. Newspaper paragraphs were soon declaring that Sickert was teaching his pupils to cheat – by working from photographs. Sickert for once avoided confrontation, and the matter subsided with the end of his teaching stint.*

When Sickert finished writing for the *Southport Visiter* he had suggested to Stephenson that some other northern paper might like a similar series of articles from him. The idea had not been taken up, but Sickert still maintained a permanent presence in the press. Tatlock had been made the main art critic of the *Daily Telegraph* and Sickert followed in his wake, contributing regular articles. He also continued to write for the *Morning Post*. In ebullient mock-oratorical prose he restated his themes and retold his anecdotes with undimmed zeal, though there were some shifts of ground. In a 1924 article he casually referred to the long-derided Matisse as 'a great painter' – though whether this was a piece of shameless journalistic bandwagoning or a considered revision of opinion is unclear.[115] He also augmented his extended articles with frequent letters to *The Times* and other papers. He put himself forward as a Whistler expert, pronouncing with magisterial authority (and – for the most part – accuracy) upon various questions

* Denys Sutton suggests an abrupt termination; the RA records give little information, beyond the council minutes of 14 July 1925, which mention Sickert's 'visitor's report': 'Mr Sickert ARA in the painting School for June recommended the encouragement of painting in the "sublime" manner. He found good capacity & application among the students.' Quite how the intense grandeur of the 'sublime' manner could be adapted to the interpretation of a press photograph of a society wedding was not explained, and is hard to imagine.

of attribution. But he also felt a need, or a duty, to comment upon other artistic questions of the hour.*

It was a fad that endured longer than many of his other passing enthusiasms. For the next dozen years he wrote unceasingly to the editorial pages of the broadsheet press. Sickert's 'public spirit' waxed ever greater.[116] His comments moved beyond art to cover such important topics as kilt-wearing, seawater bathing, fish as food, women's dress, family life on barges, and the use of the word 'poetess'.†[117] Sickert began to conceive of himself as a public figure, with public duties and responsibilities. He became careful of his position. He did not attend the dinner to celebrate MacColl's retirement as Keeper of the Wallace Collection on the grounds that the occasion would be 'a *platform*' and 'two thirds of what will be said will be diametrically opposed – if there is such a thing as a diameter in aesthetics – to my convictions. If I am silent, my name will go out as on a platform I have been opposed to for nearly forty years. And a complimentary dinner is hardly an occasion for scowling [at] the guest the evening.'[118]

Sickert's almost weekly appearances in the national press gave him a new public profile, which he took pains to accentuate. Ever since his complaint to Mr Angus about the phrasing of Christine's obituary notice in *The Times*, he had been reminding people that his middle name was Richard.[119] He now began to incorporate it into his signature. During 1925 he appeared in the press under a multiplicity of denominations: Walter Richard Sickert, W. R. Sickert, W. Richard Sickert, and – from early October – Richard Sickert.[120] Having changed his appearance so often, it was perhaps no surprise that he should seek to change his name as well. Various motives have been advanced. Marjorie Lilly believed that he was inspired by feelings of family piety, wishing to proclaim the connection between himself and his grandfather Richard Sheepshanks, while Andrina Schweder understood that the change

* He became exercised over what pictures were suitable for school classrooms, advocating enlarged reproductions of classic works rather than modern posters on the grounds that 'Nothing is too good for children'.

† Sickert wrote to the *Morning Post* denouncing the use of the word 'poetess', though Osbert Sitwell recalled him at dinner parties given by the Sitwells calling out, 'Poets and Poetesses! Don't all speak at once!' Osbert also noted that Edith Sitwell, who, under other circumstances, would have objected to the designation, did not mind Sickert using it. From him, she claimed, it had the same ring as 'Tigers and Tigresses!'

was effected merely in order that Sickert might have the euphonious telegraphic address 'Diksik'.[121] But his love of novelty and new beginnings, and his flair for publicity, were probably reasons enough. No other act of his caused so much comment in the press.[122] And if his new self-designation led to a certain amount of confusion, the correcting of that confusion offered further opportunities for advertisement.* (The change was a public, rather than a private, one. All his friends continued to call him Walter.)

It was in the transitional guise of 'Walter R. Sickert' that he appeared in the catalogue of the RA's 1925 summer show. As his main contribution he sent the recently completed portrait of Victor Lecourt,[123] and amidst the feast of staid convention spread out at Burlington House, the picture achieved a definite impact. The boldness of its composition and colouring, the rawness of its matt unvarnished finish, the originality of its conception, carried it beyond the ruck of ordinary portraits. It was quite unlike anything else on view. And if it was considered by some to be 'light relief' from the 'weighty seriousness' of the rest of the Academy, Sickert was used to playing the jester. Exposure at Burlington House carried his art – and his act – into the wider public consciousness.†[124]

Many London dealers were eager to show Sickert's work. The privileged position enjoyed by the Goupil Gallery ended with William Marchant's death in the summer of 1925,[125] and Sickert was happy to encourage competition amongst his rivals – as well as making a few private sales of his own. (He advertised his recent etchings as being available from 15 Fitzroy Street.[126]) But of the jostling contenders it was R. E. A. Wilson who quickly became marked out for special favour. Wilson seems to have been an old friend of Sickert's, but it was only

* It was only too easy for people to assume that 'Walter' and 'Richard' Sickert were two different painters (the memory of Bernard Sickert's existence adding to the confusion). 'Humorous' exchanges – such as: 'Walter Sickert? Oh you know! He's Richard Sickert's brother. Not so well known, but really, I think, the cleverer of the two' – became a staple of the newspaper diary pages.

† Sickert's elevation to the ranks of Associate RAs was followed by other marks of official – and unofficial – recognition. He was elected an Associate of the Royal Society of Painter-Etchers and Engravers, the body to which he had briefly belonged in the 1880s, after a successful show of his prints at the Leicester Galleries, and the New English Art Club, of which he was no longer a member, saluted him by including a mini-retrospective of his work at their summer exhibition. For his own part, he also maintained a lively interest in the London Group and continued to send to its exhibitions.

with his establishment of the Savile Gallery in the mid twenties that he began to sell his pictures.[127] Wilson worked with a dedicated enthusiasm and soon he was mounting regular twice-yearly exhibitions of Sickert's work – both drawings and paintings.[128]

At the end of 1925, after months of evading the problem, Sickert had returned to Manchester with a proposal. The school, he suggested, should be reconstituted as 'The Sickert Atelier'. He would continue to be involved, but at a distance. Weekly classes would be taken on by Harry Rutherford, one of the more talented pupils, and at the end of each term Sickert, in the role of 'visitor', would come up to Manchester to criticize the work of the students and give a lecture. The idea was readily taken up. New premises were found on the top floor of an office block,[129] and Sickert, in the pages of the Manchester Guardian, expressed the hope that the venture would help establish a 'Manchester School of Painters'. The hope was confounded. Harry Rutherford, under the pressure of other work, soon had to relinquish his duties and, with no obvious replacement to hand, the school collapsed before Sickert ever had a chance to visit it.[130]

HOW OLD DO I LOOK?

C'est que c'est très compliquée la vie d'après-guerre.
(*Walter Sickert to Henry Tonks*)

Sickert's health in the four years since 1922 and his return to London had been pretty stable, though not without its dips and bumps. On one occasion Osbert Sitwell, having not seen Sickert for several weeks, tracked him to his studio, where he discovered him recovering from what he called 'an internal abscess': 'I ought to have gone to the doctor,' Sickert explained cheerfully. 'Then you'd have read in the morning paper how Mr Walter Sickert, after undergoing a wholly successful operation, had, during the course of a splendid night, unfortunately succumbed to heart failure.'[1] Now, however, he felt assailed by more persistent ailments. Barely a fortnight into his six-week teaching stint at the Royal Academy Schools, he had to withdraw.* As he complained to Tonks, he felt 'weak and ill' – too weak even to show off his latest prints at Fitzroy Street: 'I am no longer strong enough to bend over & pull out drawers & co. I get palpitations & giddiness.'[2] The doctor ordered rest.[3]† In

* On this occasion in his classes he forbore from pressing the claims of photography as a source for painting, and made the students concentrate instead on their drawing. He continued with his policy of posing the models as a group, creating the illusion that they were actually doing something. And it certainly was an illusion. As a former pupil recalled: 'Because one of the girls in the group found her pose too difficult a man was engaged in her place. He was made to wear a woman's dress and Sickert bought a wig of long black hair for him.' To complete the improbability of the imposture, the model was a brother of Alf Mancini, the boxer. Sickert then showed the students how to turn their drawings into paintings: how to build up a composition, how to square up that image and transfer it to canvas, and how to set it out in a camaïeu underpainting, and then how to add the final layers of colour later after the camaïeu had dried.

† The three paintings Sickert sent to the RA's 1926 summer show (*La Giuseppina*, a view of St-Valéry-en-Caux, and a still life of some herrings) were all old pieces, though not as

search of it, Sickert went down to Margate. And it was in the registry office there, on 4 June 1926, that he married Thérèse Lessore. He was sixty-six, she was forty-one. Over the previous five years she had remained a constant and sympathetic companion, and Sickert had grown increasingly dependent upon her.* She allied herself to his interests and his work, though without succumbing completely to his personality. Her quietness concealed reserves of strength and a natural self-sufficiency. Sickert remarked approvingly that 'Lainey' (as he called her) was the only woman he had ever met who took no notice of what he said but did exactly as she pleased. It proved the basis of a very happy union.[4] The marriage, moreover, as Ethel Sands noted, would entitle Thérèse to a small Royal Academician's widow's pension in the event of Sickert's death, and Sickert – always ready to dramatize events – thought that death might not be far off. The wedding was not a social occasion (the witnesses were plucked from the street).[5] Although Sickert had not consulted the Angus family, he was relieved at their approbation. To Andrina's telegram of congratulation he wired back, 'Yours was the one letter I most needed. Infinite satisfaction and gratitude.'[6] Will Rothenstein also wrote a letter of congratulation but received no reply.[7] Perhaps Sickert never got the note.

Instead of a honeymoon the Sickerts embarked upon an invalid pilgrimage in search of 'quiet and repose'. They abandoned Margate for rural Newbury before, in a reversion to familiar territory, settling at Brighton, where they took a furnished flat at 7 Old Steine, just opposite the Pavilion.[8] The nature and seriousness of Sickert's illness remains unknown. He disappeared from view. The flow of letters to the press ceased for seven months.[9] It has been suggested that he suffered a stroke.[10] If so, it cannot have been a very serious one, and there is no evidence that it impeded either his speech or his mobility. His regime of recuperation included a daily swim in Brill's Baths. He

old as the joke he made about the last. He told the journalist Bernard Falk that, after three weeks on the wall, the fish picture needed to be changed as it had begun to smell.

* It seems that they may have briefly shared a flat together in the basement of 15 Fitzroy Street. A Mrs Emily Uppard recalled Sickert living there in the mid 1920s with his 'second wife'. The Uppard family, who also lived in the house, found Sickert a charming and amusing neighbour, with a great love of children and animals. They all jointly adopted a large black-and-white cat, named Jim. He died while Mrs Uppard and the children were on holiday in the country, and Sickert got Mr Uppard to make a box in which to send Jim down to the country to be buried (ALS Emily Uppard to John Russell, 18 November 1958).

would then potter about the second-hand bookshops, looking for old Victorian illustrated journals and the biographies of bygone celebrities. The afternoons would be spent in poring over his recent 'finds' or sleeping.

This daily round of gentle leisure, coupled with the tonic effects of Brighton itself – and the unexpected news that his painting of Versailles had carried off the special $500 Garden Club Prize at the Carnegie Institute's annual exhibition in Pittsburgh – restored his energies. By the autumn he was firing off letters to *The Times* once more – urging the government to acquire Millet's *Le Coup de Vent* for the nation.[11] Brighton, as the playground of London, was always full of friends, and Sickert responded to the stimulation of company. He was back at his 'ultra-lively' best when, at the beginning of December, Arnold Bennett invited him and Thérèse to dine at the Royal York Hotel along with the music-loving dilettante Frank Schuster and Wendela Boreel's husband Anzy Wylde.*[12]

Despite this recovery, Sickert's illness did mark a climacteric: it was the first step into old age. But, though it slowed his pace and reminded him that he was not immortal, it led to no falling off in his creative power. If anything he became more assured, inventive, eager to push forward with his ideas – anxious to seize what time was left. The return to health heralded a return to work. He took a 'fine studio' in the Kemp Town area of Brighton,[13] and it was probably there that he painted his self-dramatizing self-portrait, *Lazarus Breaks his Fast*. Done from a photograph, it showed him – back from the dead – with a napkin around his neck, tucking into a hearty meal. Lighter in tone, more brilliant in colour, more economic in statement than his previous work, the painting was an emphatic indication of returning potency and continuing development.[14]

* Besides music, Frank Schuster loved entertaining. Siegfried Sassoon, in an obituary address, commented that 'for him to contrive the meeting of two "great men" was a creative effort'. Amongst his triumphs he always counted high the small dinner he hosted on 5 July 1924 at which he introduced Sickert to Elgar (the other guests were Wendela, Anzy, and Sassoon). Sassoon noted in his diary: 'Sickert "knows nothing about music", which makes Elgar want to tell him about it . . . Both like telling stories. E.'s are long-winded and trivial. S's terse and witty. Several times during the evening S. told stories in French: at these moments E. and I laughed tentatively – neither of us really getting the drift of the idiomatic French.' Sickert, he observed, had a 'trick of rounding off a story or pointed remark by throwing up his head and laughing with his mouth a wry hole in his face; rather as if he were going to whistle'.

He also began a new phase of production. A convalescence spent reading old copies of the *London Journal* and *Penny Magazine* had reacquainted him with the work of the popular black-and-white illustrators of the 1870s and 1880s: forgotten figures of his childhood such as Kenny Meadows, Francesco Sargent, Georgie Bowers, Adelaide Claxton – as well as his old friend, Sir John Gilbert. He saw a chance to use these images as the basis for paintings. Like black-and-white photographs, they provided him with a ready-made simplified tonal composition that he could transfer to canvas and then colour at will, not in some prosaic painting-by-numbers fashion, but with a new interpretative freedom.[15] His colour choices were often garish and almost always anti-naturalistic, the verve of the works at once apparent. They were interpretations, not copies. Sickert claimed for his work 'the same liberty as Pope or Butcher & Lang or Schlegel claim with Homer, Virgil with Homer, Fitzgerald in the Omar Khayyam &c'. He even called them 'Translations', before settling on the more evocative 'Echoes'. There was both a happy nostalgia and a critical piety in reclaiming these 'rigorous and "populacier" composition[s]' that would otherwise be lost to view, forgotten in the yellowing pages of old magazines. But Sickert also took a certain mischievous pleasure in focusing attention upon such unfashionable source material, in 'sending the younger painters' to 'rifle the wealth of English sources of inspiration' at a time when most of them were bent on escaping the past.*[16]

On his visits to Brill's Baths he had been greatly impressed by one of the other bathers, a splendid old gentleman with a fine, and heavily tattooed, physique. He asked the man to come and pose for him. Much to his surprise, the tattooed bather turned up at the studio in naval dress uniform and introduced himself as Rear Admiral Walter Lumsden (retired). The title and the uniform, together with the fine bearing, inspired Sickert to begin a life-size full-length portrait, a return to the Whistlerian format, though not to the Whistlerian method.[17]

Despite the pleasures of seaside life, Sickert was not ready to forsake London entirely. He would make occasional forays up to town, often

* Sickert's appropriation and reinterpretation of elements of existing popular culture prefigured – though it almost certainly did not influence – the Pop Art movement of the 1960s. Interestingly, the 'first' of his 'Echoes' – *Suisque Praesidium* – was derived not from a magazine illustration but from the picture on the lid of a pomade jar – an unlikely forerunner of Andy Warhol's tomato soup tin.

omitting to tell Thérèse of his plans,[18] and in the spring he took a
lease on Southey Villa, 15 Quadrant Road – off the Essex Road – close
by Islington Green, and not far from his rooms in Noel Street.[19] He
instituted a highly original scheme of decoration and refurbishment.
The floorboards were bleached and left bare, though in the 'drawing
room' they were partially covered by a carpet in the centre of the floor.
The walls, too, remained untreated, the warm, grey plastered surface
dotted with white blotches, and hung with the collection of 'Tintoretto'
drawings. Between the windows, Sickert set a rococo console table and
a pier glass. His Graeco-Roman bust was placed on the mantelpiece.[20]
Amongst these refinements he also instructed the builders to remove
the conventional lavatories and replace them with Continental-style
floor pans, in order – so he claimed – that he could enjoy the
expression on his visitors' faces when they emerged – or perhaps, better
still, rush to the aid of distressed lady guests.[21] While these works were
in train, though Sickert maintained a close watch with regular site
visits, he remained for the most part down at Brighton.[22]

It was from there that, on 5 May 1927, he travelled up to the Albert
Hall to see his first major boxing match: the title fight between the
cockney Teddy Baldock and the American champion, Archie Bell.
Sickert went as the guest of Harry Preston, a new Brighton friend, the
creator, or restorer, of the town's two best hotels – the Royal York and
the Royal Albion. Preston, an impassioned boxing aficionado, had
assembled a big party for the fight, mainly sporting and military men,
and after the match – a thrilling and dramatic contest in which Baldock
triumphed – they all repaired to the Prince's Hotel in Charlotte Street
for 'a glass of wine' and a session of searching post-fight analysis.
Perhaps surprisingly, the fight – for all its flood-lit drama and popular
appeal – failed to excite Sickert into an artistic response, but he clearly
enjoyed the occasion. He stayed on with the party until it broke up
at about 2 a.m.

His departure was delayed by a moment of comedy. Arriving at
Victoria from Brighton that morning he had found the Grosvenor
Hotel, where he usually stayed, full up. The receptionist had directed
him to another hotel nearby, where he had installed himself, but he
had failed to make a note of its name. And now, at the end of his
evening, he could not remember it. 'It must be somewhere near Vic-
toria,' he told the taxi driver, suggesting that they might drive around
the streets until he recognized something. Fortunately, the cabbie

seems to have known that the Grosvenor often sent guests on to the Belgravia Hotel, and, at his mention of the name, Sickert lit up: 'That's the place!' he told Preston and the other guests waiting on the pavement. 'I remember now. Do you know it has always been my ambition to sleep in that hotel. The Belgravia! What suggestions of luxury! How aristocratic it sounds! When I was young I used to cheer myself up with the dream of one day achieving wealth and fame and staying at the Belgravia. I've only just remembered it. And now I really am going to sleep in this distinguished and opulent hostelry.'[23]

The taste of luxury was brief. As Sickert later complained to Preston, he had not got to bed before three and then had to be up at eight. To have enjoyed the full Belgravian savour he would have needed 'at least ten hours in that swansdown bed'.[24] Sickert, however, was far from ready for the pleasures of indolence. He was racing to complete the portrait of Admiral Lumsden for the Royal Academy's 1927 summer exhibition; but though he sent it up to London at the very last minute, in the back of a lorry with the paint still wet, it was considered by the hanging committee to be still 'in too unfinished a state' for exhibition.[25] Sickert assented 'with thanks' to this verdict, and exhibited instead his mocking self-portrait *Death and the Maiden*, perhaps as a partial explanation for his impatience.[26]

That summer, Sickert re-established contact with one of his old Dieppe friends. Chancing to read a newspaper paragraph about how Clementine Churchill (Hozier as was) had been knocked down by an omnibus in Knightsbridge, he paid a visit to her sickbed. She was easy to find: Winston was serving as Chancellor of the Exchequer and they were living with their young family at 11 Downing Street. It was a happy reunion. Clementine's mother, Lady Blanche, had died two years previously, and Clementine was pleased to be reminded of the old Dieppe days. Sickert and Churchill got on at once. Churchill was a keen amateur painter and Sickert was only too happy to give him advice about his work. The lessons were stimulating affairs, with Sickert insisting upon the measured approach of working from drawings and underpaintings in the face of Churchill's predilection for plunging headlong into 'a riot of colour'. They much enjoyed each other's company, and peals of laughter would descend from the upstairs studio room at Number 11.[27] As a reciprocal gesture, Churchill tried to instruct Sickert

in the basics of sound financial management, but with limited success. Sickert's mind could never retain the necessary information.*

Over the course of the summer the Sickerts were invited down to Chartwell, the Churchills' home in Kent, on several occasions. 'Week-end visits!' declared Ethel Sands, more than a little impressed. 'That sounds . . . very jolly.'[28] And Sickert, wearing red socks with his evening clothes, singing music-hall songs at dinner, and recounting tales of his youth, certainly made them so.[29] But they were also a time for instruction. With the August sun blazing over the garden, Churchill would beg Sickert to tell him how to 'transfer the marvellous greens and purples' he saw all about directly on to his canvas. Sickert, however, refused to countenance such plein-air heresy, and though he did appear briefly in the garden wearing his opera hat, he spent most of his time inside with the curtains drawn, reading French novels.[30] By such treatment Churchill was brought round. He became very intrigued by Sickert's method of producing his camaïeus from photographs, and embraced it with some enthusiasm.†[31] It was from a photograph that Churchill made a small painting of Sickert, Thérèse, and others sitting around the tea table at Chartwell. Sickert repaid the compliment by making his own portrait of Winston.[32]

Sickert re-established himself in London at the end of the summer. Although he returned formally and finally as 'Richard Sickert', there were few other signs of change. He took a lease on a large studio, originally a music room, at 1 Highbury Place, a short walk from Quadrant Road, and announced the opening of a new painting school. It was a less ambitious project than some of his previous ventures – restricted to male students only, and operating without models. The fees were fixed at £20 a year 'payable in advance', although in a slightly bemusing aside the flyer added, 'Following the practice of the Paris ateliers, Mr Sickert will draw no fees himself.'[33]

* Sickert wrote to Sylvia Gosse, asking with cod urgency for the 'name & address of the treasury official or accountant to whom the Chancellor said I should address my apologies for carrying on a trade at a loss'.

† After one of Sickert's visits, Churchill wrote to Clementine: 'I am really thrilled by the field he is opening to me. I see my way to paint far better pictures than I ever thought possible before. He is really giving me a new lease of life as a painter.' Churchill acquired a 'beautiful camera', and – in a refinement that even Sickert does not seem to have considered – a projector, which could throw a photographic image on to a canvas, ready for easy copying.

Only half a dozen pupils signed up for the course. Whether this poor turnout represents Sickert's uncertain standing with the younger painters of the time, the general levels of artistic indifference then prevailing in England, or an ineffectual advertising campaign, is difficult to determine.* Certainly it amazed the small band that did show up. As one of them remarked, 'Imagine, if you can, an *atelier* opened in Paris by Degas at the age of sixty-seven!'[34] Of those who did enrol, several already had some connection with Sickert: his principal dealer R. E. A. Wilson together with his new business partner and backer Mark Oliver; Dr Cobbledick, a distinguished ophthalmologist who had treated Sickert for an eye ailment; and Morland Lewis, one of his Royal Academy pupils.[35] The others included his future biographer Robert Emmons, and the Hon. Paul (later Lord) Methuen.[36]

Classes took an eccentric course. On the first morning, when the students arrived at Highbury Place, they found Sickert standing outside on the pavement watching the demolition of a tree. His head was swathed in a bandage. 'My wife', he explained, 'says I'm suffering from a swelled head! . . . but really, I tell you it's a boil . . . very annoying . . . I can't have my bathe in the morning. You're not allowed to suppurate into the public baths!' When the tree cutters were finished, he invited them in for a drink (although it was only eleven in the morning, a bottle of champagne was sent out for), and over the refreshments he delivered a short humorous lecture on Raphael's *Heliodorus* – a print of which he had pinned up on the studio wall.[37]

This performance set the tone for future lessons. Much time was given over to talking. Each day began with the pupils gathered in a semi-circle about the fire listening to Sickert discourse by the hour. Only when the talk ebbed were they allowed to work at their own paintings – done, in the approved manner, either from drawings (made out of school) or from photographs cut from the *Daily Mirror*. At first Sickert came every morning, wearing a different hat. After his introductory lecture he would make a brief round of the easels, before settling down by the stove with 'the whole of the metropolitan press' and a Manila envelope in which to place cuttings relating to himself, or press photographs that might serve him for paintings of

* Sickert does not seem to have been overanxious about courting potential pupils. It was told that when one long-haired applicant turned up in person at Quadrant Road, Sickert unsettled him by remarking, 'But . . . excuse me . . . are you male or female!'

his own.* But as the year went on he came less often. The students followed suit, and, as Emmons records, the school 'came to an end by a process of evaporation'.[38]

The demise of the school, however, did nothing to break Sickert's connection with R. E. A. Wilson and the Savile Gallery. It was there that he showed – early in 1928 – the first two of his 'Echoes'. But, in a gathering of over forty works from various periods of his production, their curious novelty passed largely unremarked. The portrait of Winston Churchill provoked rather more comment. Frank Rutter in the *Sunday Times* called it 'the most brilliant portrait Mr Sickert has yet executed',[39] and, according to the gossip columns, Lord Ivor Churchill, Winston's cousin, was waiting outside the gallery from 8.30 on the morning of the first day in order to be sure of securing the picture, which he planned to present to the sitter. It cost him £200. He should perhaps have waited.[40]

Eddie Marsh, who accompanied Clementine and her sister Nellie to see the show, thought the portrait made Churchill 'look like [the notorious swindler] Horatio Bottomley in a public house', and the sisters' verdicts were even less favourable. Nellie was so put out by the image that 'she lost her self-control and attacked the manager of the gallery', who fatally told her that 'he didn't suppose she had ever seen Mr Churchill'. As Marsh recorded, 'Much fur flew.' Sickert remained unaware of the furore. He even presented Clementine with one of his studies for the painting: she later put her foot through it.[41] The portrait itself escaped a similar fate, but very soon passed out of the family.[42]

In July 1927 the successful portrait painter Solomon J. Solomon RA – an exact contemporary of Sickert's – died. For the previous nine years he had been President of the Royal Society of British Artists. Various names were canvassed as a replacement: Gerald Kelly, Philip de Làszlo, John Lavery, Glyn Philpot, Ricketts, Shannon, and – the front runner – Richard Jack.[43] But some of the society's younger members, led by Claude Flight and Murray Urquhart (a former Westminster Techni-

* The stove was always a key feature in any Sickert studio. Around the cement base of his Highbury Place stove he had chipped 'Ce Londres que les anglais appellent London', a mot of his friend Comte Robert de Montesquiou.

cal Institute pupil), determined to ask Sickert whether he might consider becoming the new president.[44] Marjorie Lilly was dispatched to Islington to sound Sickert out. He was enthusiastic about the idea. 'In no time,' Miss Lilly recalled, 'he was toying with the idea that he would design a medal for himself with PRSBA on it. A gold ground, he thought, with a blue band . . . yes, a blue band and a black ribbon.'[45] In his excitement he wrote a gracious letter of acceptance to the committee saying how 'extremely touched' he was by the 'confidence' shown in him by the society, and promising 'to be guided as nearly as possible in the exercise of my new duties by the principle of being in every respect the opposite of what my beloved and respected master, Mr Whistler[,] was during his tenancy'.[46] It had to be pointed out to him that he had not yet been elected, and indeed could not *be* elected until he had been made a member of the society. But at a special general meeting on 21 March 1928 these two loose ends were tied up.[47]

There was just time to include Sickert in the society's spring exhibition. As a last-minute addition his picture – a small panel of the Old Bedford – was placed in the middle of the gallery 'isolated on an easel by itself'. Sickert, though he arrived late for his first council meeting, soon adapted himself to the dignity of his new role. He cut a dramatic figure, sweeping through the Suffolk Street galleries in his Venetian cape.[48] 'I should not be surprised', commented one observer, 'if a large number of members feel apprehensive.'[49] He was probably right.

Sickert was full of plans. Even before his official investiture he wrote Murray Urquhart a long letter declaring that he saw in his 'most gratifying election a distinct call to a duty by performing which I can be most useful in my later years'. He wanted the society to reclaim its old tradition 'not of opposition to the RA but the kind of friendly rivalry which is always a mutual stimulus'. He wondered about the possibility of establishing evening classes, to make the society a 'teaching body' like the RA; and he began to ponder the question of how best to hang the society's shows. 'I am sure so-called advanced work should not be grouped together,' he declared. 'I would like to see [the conventional] John Collier & say [the 'advanced' William] Roberts hung side by side to fight it out on the walls with their brushes, not with words. In that way you force the public to make its own comparisons.'[50]

By the end of June, when he called a special general meeting, his

ideas had crystallized into a list of six proposals. He suggested that
the society adopt an alphabetical hang for its autumn exhibition; that
(as an experiment) no pictures larger than 30 by 25 inches be admitted,
and that no member be allowed to show more than two pictures; that
the President should be allowed to invite six non-member British
artists to send one work each to the show; that there should be no
'starring' of his own work; and that the Private View should be open
to all and free. 'Let us go down in history', he urged, 'as the first Royal
Society to recognise that it is not only by "Ladies and Gentlemen" that
Art is to be saved, but by the people.' For many of the members
here were their apprehensions made real. And after some 'discussion',
Sickert was obliged to withdraw all his resolutions, except the first –
and even that was modified. It was decided that the hang would be
made by 'ballot' rather than by alphabetical order.[51] For Sickert, how-
ever, this was more than enough. As he had remarked to Urquhart,
'Every society should have a character of its own. There exist advanced
societies & there exist old-fashioned ones. Why should not the RSBA
emphasize the character of combining both impartially.'[52]

When it came to the existing 'advanced' and the 'old-fashioned'
societies, Sickert displayed his own impartiality and continued to show
with both. The London Group included a special retrospective selection
of his work in its spring exhibition,[53] and at the RA summer show the
now completed portrait of Admiral Lumsden was considered the 'pic-
ture of the year – or at all events the most interesting piece of portrait
painting' on view.[54]

For Sickert the savour of these triumphs was undermined by his
still erratic health. The recovery of the previous year had been only
partial. He suffered recurrent bouts of illness, and gaps – sometimes
convenient – appeared in his memory.[55] He was better off than George
Moore, who had recently been operated on for an enlarged prostate.
(Sickert had visited him at the nursing home, and they had passed a
jolly time, talking scandal in French so as not to shock the nurses.[56])
But he was prone to anxiety. The summer of 1928 was spent ill and
at Bath.[57] There his condition slowly improved, as did his appearance.
The enormous furzebush beard that had sprouted over the previous
months was trimmed down to a more manageable 'pointed' affair.[58]

By September he felt well enough to accept a commission, organ-
ized by Wilson, to paint a portrait of the novelist Hugh Walpole.
Although an author of rather conventional tales, Walpole had

advanced and discriminating tastes in art. He was also a compulsive collector ('it's worse than drink,' he once declared) and had assembled works by Cézanne, Picasso, Derain, and Klee.[59] On the home front he considered that Sickert, together with Augustus John, was 'simply worlds ahead of everyone else'.[60] He already owned several Sickert pictures and had contributed a preface to the catalogue for Sickert's Savile Gallery show earlier in the year – in which, much to Sickert's gratification, he had emphasized the illustrative quality of the works.[61]

The sittings were held at Highbury Place, the school having dwindled away to nothing. Walpole, who had been painted previously – over many, many sittings – by Sickert's old friend Gerald Kelly, was rather concerned when Sickert began even more slowly. 'To Sickert again,' he wrote in his diary on 29 October, after his second sitting. 'He did nothing whatever, complained of the light. It's no use my being fussed by this. He's apparently going to take weeks and weeks and I must just endure it.'[62] But he need not have worried: once work began, it proceeded apace. Sickert, he discovered, having taken measure of the sitter, and captured his spirit in a study 'or two', felt that he had got 'everything' he needed and could paint the rest as he pleased and *when* he pleased: '[He] does his little drawing, takes a photograph and then the rest is "*his* affair", not at all the sitter's.' The whole business was carried out with commendable dispatch: 'In a quarter of an hour', Walpole noted, Sickert could make a drawing that was full of 'drama, irony, suggestion – a novelist's drawing'; and when the photographer arrived, Sickert was 'sharp and autocratic, impatient', standing 'no nonsense from anyone'.[63]

If the sittings were prolonged it was because Sickert enjoyed Walpole's company.* The attraction was mutual, though Walpole acknowledged that it was only because he stood, for the moment, in 'some relation to his art' that Sickert recognized him at all. It was one of many telling observations. While the artist accumulated the material for his picture, the novelist mapped out a portrait of his own:

> Thinking of Sickert . . . he isolates himself utterly from everybody, even his little Oriental-faced wife. It is not that he is hermit-like or scornful of life. Far from it; he is eager to hear

* Walpole told the Fitzwilliam that the picture was painted from life, though his journal seems to refute this, as do the traces of squaring up and underpainting; perhaps Sickert refreshed his vision from the model when the picture was underway.

anything about life at all – morals, furniture, personal habits,
colours, games – but his personality is so entirely of its own
and so distinctive that he makes a *world* of his own. A world
that has all its own laws. For instance he tells me every day
that he prefers Gene Stratton-Porter's *Freckles* to *Madame Bovary*
– a more important book he thinks. It tells you about a little
girl having her hair cut and about butterflies, things he doesn't
know so much about, whereas he knows *all* about the Bovary
woman . . . Wandering about his studio (which is dirty, tumble-
down Camden Town, Charlie Peace, pubs and cabbage) with
his little grey peaked beard (grown since his illness), his most
beautiful eyes (his eyes blue and affectionate, his forehead of
a fine, noble, unstained whiteness), without a collar, an old
grey suit with sometimes a black cap on his head, he walks
like a sick man (he will not, I think, live much longer) and
chuckles and laughs at almost everything. He is most affection-
ate, always wanting to give one something, takes nothing seri-
ously, is French in his lightness, German in his love of food,
Camden Town in his love for his boxing cabman, Regency
in his love of Bath, the old London streets, and [an] artist
unselfconsciously all the time.[64]

Sickert spoke matter-of-factly about his own work, explaining to Wal-
pole that he had to keep at it in order to make money. He remained
'very grateful to Wilson', whom, he claimed, had 'saved his old age'.[65]
Wilson's commitment to the cause was certainly impressive: he not
only showed Sickert's new work, but also bought it on the secondary
market. With the support of Mark Oliver's money, the Savile Gallery
paid a then record price of 660 guineas for a portrait of Cicely Hey
when it came up for auction at Christie's. It was the latest high-water
mark of a rising tide. Though dominated by the Savile Gallery, the
upward drift was only achievable because others too were anxious to
acquire Sickert's work. Robert Jackson, D. C. Thomson, the Leicester
Galleries, Colnaghi – even the staid Arthur Tooth – all paid large
prices for Sickert paintings in the sale room.[66] Sickert, of course, gained
nothing directly by such sales, but the sums paid by the dealers (and
auction sales were then the almost exclusive preserve of dealers) estab-
lished a price level for his other work, and stimulated demand for it.
(The Leicester Galleries assembled an impressive retrospective exhi-
bition of Sickert's work in the summer of 1929.)

If Sickert had retained more of his old stock, instead of selling it

off wholesale to different dealers, he might have been better placed
to benefit from this mini 'boom'. As it was, he had to work even
harder to produce new canvases. The Savile Gallery helped him –
and themselves – by publishing editions of his recent etchings and
engravings; but paintings were what people wanted, and what he strove
to produce. 'A great commercial success coming late in life, though it
is naturally better than nothing has a wearing side,' he observed. 'It
becomes important not to over work, just when production would
pay so well.' Though his health had regained a fragile equilibrium, he
still felt 'weak for [his] age' and easily over-taxed.[67]

His new methods, at least in theory, facilitated production. Working
from photographs, press snapshots,* and old Victorian prints saved
him from some of the chores of drawing and composition. As he liked
to joke of his 'Echoes', 'It's such a good arrangement; Cruikshank and
Gilbert do all the work, and I get all the money.'[68] Moreover, the
technical business of transferring squared-up compositions on to
canvas – and laying in the camaïeux – could be undertaken by assis-
tants and helpers such as Sylvia Gosse, Morland Lewis, and Thérèse.[69]
Nevertheless, Sickert did not rush to press home these advantages. He
was building up a collection of new work for a major exhibition at
the Savile Gallery, but held it off until the spring of 1930 and
meandered towards his deadline along what often looks like an almost
deliberately anti-commercial course.

Having completed the commissioned portrait of Walpole he
embarked on another one for his own amusement; and when, towards
the end of the year, he was asked to paint a picture of Sir Nigel
Playfair, to celebrate the actor-manager's ten years in charge of the
Lyric Hammersmith, he refused to accept any fee, insisting that all
contributions should be sent instead to the fund set up to preserve the
theatre at Sadler's Wells. Sickert did not stint on the work, producing a
huge, broadly worked picture, from a photograph, showing Sir Nigel
in the part of Tony Lumpkin. To its flagrant theatricality he even added
an unexpected touch of realism, consulting with Alfred Munnings, the
master of equestrian portraiture, about the correct distribution of mud
splashes on the boots of a postillion.[70]

* Although Sickert had been advocating the use of press photographs as a basis for
paintings since at least 1925, the first known example in his own oeuvre is the 1928
picture of the Plaza Tiller Girls, derived from a publicity shot.

Thérèse tried to protect him from himself. Ethel Sands reported that she 'won't let Sickert see anybody now. His only fun is official dinners.'[71] But Sickert could make a riot of even the most formal occasion. He enjoyed the Royal Academy banquets with 'the gusto of a boy', and lunching at the French Embassy he displayed all his usual captivating charm and sparkling wit, even if his combination of a brown checked jacket and a top hat electrified the wife of the Ambassador. (When he wore the same disguise to a Buckingham Palace garden party, the footman thought he belonged to a theatrical troupe.[72])

He was a regular at the banquets of the Magnasco Society, a select body of dilettantes established by Osbert and Sacheverell Sitwell, together with Professor Tancred Borenius, 'to foster an interest in the Italian Virtuoso Painting of the seventeenth and eighteenth centuries'. They would hold their annual dinner in a private room at the Savoy, the walls about them hung with appropriate works (lent by members of the society), a small orchestra playing Italian opera music. There were speeches after the dinner, and Sickert, of course, made one. It was at another slightly less formal dinner, hosted by Osbert Sitwell at the Marlborough Club, that Sickert amazed the company by reciting a succession of limericks composed by Dante Gabriel Rossetti. He had learnt them – presumably from Whistler – and passed them on lest they were lost to posterity. Sadly, Osbert Sitwell did not go beyond recording the first two lines of the ditty beginning, 'There is an old painter called Sandys/The victim of his own glandys . . .'[73]

Despite Thérèse's best efforts, Sickert's interests could not be readily contained and he continued to add to his obligations. He began to give occasional lectures to the recently formed East London Art Club, a body set up by the Slade-trained artist John Cooper, to bring art instruction to the 'humble working men and women' of the East End.[74] The group's inaugural exhibition was held at the Whitechapel Gallery that winter. Sickert was not alone in being impressed by it: a selection of works was subsequently shown at the Tate.[75] The students, according to the painter William Coldstream (who, along with Rodrigo Moynihan, helped Cooper to run the club's evening classes), 'were in the main boys employed in the clothing trade and anxious to learn to draw fur – or tarts in for a rest'.[76]

Sickert had no difficulty with this cockney audience. His splendid appearance (he was in a bush-bearded, crop-headed phase of tonsure), eccentric attire, and sense of theatrical aplomb excited their curiosity.

Eschewing pedagogic formalities, he would sit on the raised teacher's table with his legs swinging beneath him, 'an ageless and accomplished comedian'. It was a pose that set his students at ease, and showed off his splendid red socks (which matched the brilliant crimson of his coat lining). His first talk, which began with the observation, 'When one considers the works of that great dramatist Arthur Pinero . . .', won over his play-loving audience completely. They even put up with the liberal sprinkling of incomprehensible French phrases: he had, he apologized, been employing them 'too long to stop'. He urged his listeners to paint (not, of course, from nature) the world around them. Do not, he told them, go to Bognor on a three-week holiday 'with the idea of doing a little painting': 'go into the Tube'.[77]

In October 1929, Sickert carried through his plan for a no-jury hang of the RSBA's winter exhibition. There was some opposition amongst the hangers, but Sickert cheerfully ignored it. (He did apologize at a subsequent committee meeting if he appeared to have laid down the law.) Although the critics – and many of the RSBA's members – thought the effect produced was more of a 'second rate auction room' than an art exhibition, Sickert vigorously defended his policy.[78] He even hoped to extend it.

At the Royal Academy's General Assembly, a few months before, Sickert had suggested that the Academy itself should adopt an alphabetical hang for its summer exhibition.[79] The idea was not adopted at Burlington House, but it did find favour in Whitechapel. Sickert persuaded the East London Group to transform itself into something actually called the 'No Jury Club'. In pressing the virtues of the scheme at a meeting, he had described the variety obtained by the no-jury method as similar to the 'vitality of the old music halls' with their mix of different turns – an analogy that inevitably drew him off into a lengthy digression, with musical asides, on the great acts of the past.[80]

With the demand for his work increasing, Sickert had set about gathering in some of his scattered paintings. After a gap of twenty years he made contact again with his old Venetian friends, the Hultons.[81] He was anxious to recover the portrait he had presented to Signor de Rossi in 1903. The sitter was now dead and Sickert thought it unlikely that his family would care for the picture. He wanted to rescue it from

oblivion and have it '*classified* at Christie's or at my dealers' as part of his oeuvre. Mrs Hulton arranged for her factor to approach the Rossi family with an offer of 3,000 lire (about £40); it was eagerly accepted.[82] Sickert was thrilled – both at the prospect of seeing the picture again, and of making a considerable sum of money. Wilson, he thought, would give at least £200 for the picture at once. Christie's soon trumped this with an estimate of £300 to £700.[83]

Mrs Hulton's younger daughter, Bim, brought the picture over to London in the spring of 1929.[84] Now in her thirties, she had grown, as Sickert declared, into 'a superb plant'. She had also become Lady Berwick, having married Lord Berwick, of Attingham Park, Shropshire, in 1919. Both transformations delighted Sickert. 'Her eyes', he wrote enthusiastically to Mrs Hulton, 'are an amalgam of sapphire and emerald! Also she is the first peeress that I tutoyer.' He was pleased, too, to have his picture back: 'I must admit [it] is a creditable production', he declared, announcing his intention of laying it down 'toward my young wife's tiny probate "later on"'.[85]

The only sad note was the news that the little panel of the Ospedale that Sickert had given to Bim in Venice all those years before had been lost, or stolen, during the war. Sickert promised to replace it. 'A "Come to Italy" poster,' he suggested might be appropriate, bearing the legend, 'Zanipolo [the area where the Hultons lived] builds bonny babies'. Lady Berwick, however, favoured the idea of a portrait of herself, and another of her sister Gioconda, who was over in England on a visit. Sickert duly had them both photographed. But then he failed to start work on the pictures.

Other projects were claiming his attention. Adding to his repertoire of biblical alter egos, he embarked on a self-portrait titled *The Servant of Abraham*. Though the canvas was small in size, it was filled by the looming image of Sickert's bearded head. The picture was his response to the sad fact that grand-scale mural paintings were no longer being commissioned: in their absence he recommended that artists produce 'small fragments of pictures on a colossal scale'.[86] More than ever before, Sickert followed the mood of the moment. Pictures could suggest themselves at any time. When Thérèse's brother, Major Frederic Lessore, the owner of the Beaux Arts Gallery, presented him with a life-size wooden 'lay-figure' that was supposed once to have belonged to William Hogarth, the curious sight of this magnificent if cumbersome gift being carried into the studio fired his imagination, suggesting

to him the image of Lazarus being raised from the dead.[87] It would, he thought, make a splendid painting.

He set about recreating the moment, albeit with a few choice embellishments. From a local undertaker he acquired a shroud in which to wrap the figure,* and he wired Cicely Hey to come and pose as Lazarus' sister. She arrived at Highbury Place to find a photographer in attendance and the studio in total darkness except for the shrouded figure, which 'hung in the space with a spotlight on it'. Sickert directed proceedings. Perched at the top of a stepladder holding the dummy's head, he assumed the role of Christ (though with his spreading white beard he looked very much more like 'God the Father'). Cicely was instructed to look on in wonder at the miracle being worked, throwing as much 'intense feeling' into her pose as she could. (The fact that she was to be photographed from behind in semi-darkness was, for Sickert, no reason to stint on emotional veracity.) The photographer took several shots of this mysterious scene and brought the prints back within the hour. Sickert joined together two of the photos to make a final composition and, having squared it up, invited Cicely back, so that he could 'emphasise certain points' by drawing directly onto the photograph. Such was his excitement at the process that he then began painting his green-and-white monochrome of the scene directly onto the deep red wallpaper of his studio.[88]

The Sickerts retreated back to Brighton for much of the summer, but there were frequent trips up to London. The portrait of Nigel Playfair was the cynosure of the RA's 1929 summer exhibition,[89] and the large retrospective at the Leicester Galleries added to Sickert's stature, if not to his bank balance.† 'This is one of posterity's Old Masters', declared one critic after viewing the show: 'Life, vitality, mental as well as manipulative, are the characteristics of Sickert's art, and

* According to legend, he became so excited at the services offered by the funeral director that he began to give elaborate instructions for his own funeral – including 'six black horse with plumed tassels and purple and black crêpe hangings, and mutes with top hats and crêpe bands down their backs'. All of which the undertaker took seriously, even calling out after him as he left, 'But Sir, Sir, you haven't told me the day, or the time.'

† Sickert told Mrs Hulton that he did not own a single 'scrap' of the work on view – two galleries of oils and one of drawings. But a telegram to Oliver Brown dated 15 April 1929 reads, 'A thousand thanks – young men who pay for goods before delivery will certainly go to heaven', which suggests that he did quietly sell some stock to Brown in advance of the show.

seem to predestine his name to remembrance as one of the masters of our age.'[90]

The affairs of the RSBA also brought Sickert up to town, though perhaps not as often as they might. His hold on the administrative duties of his office remained shaky: letters went unanswered, he failed to attend meetings without either warning or apology, and the attempts of the treasurer to interest him in the society's annual accounts were a rank failure.[91] More than this, he had to contend with a substantial faction opposed to his hanging-by-ballot policy. In June a small core of these rebels proposed to try and oust him from the presidency. Sickert's supporters rallied in his defence, and a deputation was sent to Quadrant Road to alert him to the danger he faced. According to the vivid account left by Murray Urquhart, they arrived just as Sickert was finishing his lunch and found him in skittish mood.

'Well,' he said, ushering them into the drawing-room, 'is this a revolution?' When the deputants anxiously confided the reason for their visit, Sickert said cheerfully, 'Oh yes, I have received a most *proper* letter signed by five members suggesting all sorts of things against me with which I most cordially agree: in fact I should be only too happy to add my name to the list of signatories.' He did, however, balk at the circular's complaint that he was not a good businessman. He said, 'I understood that the only *possible* reason for electing me to the Presidency was that I was the most unbusinesslike man in London. It is notorious.' As to the question of whether he had any thought of resigning, he declared: 'Good gracious no, do you think I will resign because five members want me to? When they can convert themselves into a majority then I shall be forced to go, not otherwise.' 'No,' he continued, 'the only thing that *could* make me resign would be the fact that one of the lady members had rejected my advances – *on the score of age.*' And with this, Urquhart records, Sickert 'threw his head back, opened his mouth wide and roared with laughter. He then said, "Do you really think that an old bird like me is going to fall flat the first time someone says boo to me?"' Sickert resolved to counter the rebels at the forthcoming AGM, when 'the feeling of the Society should be tested'.[92]

He felt confident of victory. 'As a matter of fact,' he explained, 'I am convinced that all the ladies in the Society are in love with me and that the men are all jealous of me, and that all the ladies will vote for me because of it and all the men will vote for me for fear of

offending the ladies!' But at the suggestion that the rebels' proposed candidate, the fashionable portrait painter Philip de Làszlo, was 'to all intents and purposes offering heavy bribes' – such as ventilating and redecorating the staircase at Suffolk Street and turning the basement into a storage space, all at his own expense – in order to gain the presidency, Sickert at once changed tack. 'Bribes,' he exclaimed, 'how splendid! Let's take the biggest bribe we can get.' And then, turning to Miss Asker, who was seated on the sofa beside him, he added, 'You and I can go halves.' When asked what he proposed to do with 'the swag', he replied that he and Miss Asker would 'discuss that in private'.[93]

The voting at the Annual General Meeting did not exactly follow the pattern mapped out by Sickert. He did, nevertheless, retain the presidency – even though he himself threw his vote into the ballot box with a loud laugh, which suggested to most onlookers that he had voted for de Làszlo;[94] and, despite the deep divisions appearing within the club, he pushed through his plan to again hang the winter exhibition by ballot.[95] The exhibition, however, only provoked further dissent, and soon after its opening a motion was carried declaring that the ballot method of hanging was 'unsatisfactory'. Other proposed innovations were also defeated.* Sickert, aware that the 'current of hostility' against him was continuing to rise, sent in a letter of resignation. He observed to the committee that, 'with the delicately poised division between the two parties, you are in for a period of see-saw, from which some desirable compromise will be arrived at. This is a position that need not be deplored since it is the only way that results are achieved in corporate matters. If I had been a quarter of a century younger, I would have stuck it.'[96] As he explained in a separate communication to Murray Urquhart, he felt that, since the society was not prepared *always* to hang by lot, he could not stay on.[97]

His democratic artistic principles were, moreover, being catered for by the East London 'No Jury Club'. Sickert's name had secured the group a small exhibition at the Lefevre Gallery in the West End that

* Sickert, in his letter of resignation, refers to 'two defeats' – probably incurred at the 14 November meeting: one over making the RSBA a 'closed society', the other upon the suggestion – inspired no doubt by the picture-hang at the Brighton Pavilion – to 'create [at future shows] a frieze above the line of cabinet pictures for works, not necessarily large in area, but on a large scale, what used to be called the heroic scale. The exhibitors for the frieze themselves indicating their desire to be placed there.' Sickert's recent self-portrait, *The Servant of Abraham*, was just such a work.

November, but the main unselected show was held at the end of 1929 in the chilly vastness of the Whitechapel Gallery.[98] The accident of the alphabetical hang placed Sickert's painting – a six-foot-high representation of a London policeman – in the middle of the right-hand wall. The Treasurer, conscious of Sickert's desire not to be given any special treatment, was rather alarmed at this development, but he need not have worried. Sickert, when he called to see the show, was too interested in the sixty or so other exhibits (including two by his wife) to comment on his own work.[99]

At some moment over the winter, Sickert made a trip to Venice (it was from there that he sent his telegram of explanation and exculpation to Urquhart). The visit was his first since 1904.[100] Doubtless he saw the Hultons, and reacquainted himself with old haunts.[101] There were plans afoot for him to be given a one-man show within the British section of the forthcoming Biennale. He made no new drawings of the city, although, on what seems to have been an excursion down to the south, he did produce a small panel of Amalfi.[102]

With the demise of the Highbury Place 'atelier', Sickert's teaching aspirations wandered off in new directions. He had long harboured a desire to run 'a school of painting . . . associated with a university' – believing that the worlds of art and academe could offer each other mutual stimulation and support.[103] Early in the New Year an opportunity seemed to present itself. At the opening of an Italian Art exhibition at Burlington House (which he was writing up for the *Fortnightly Review*),* Sickert mentioned his ambition to Sir Michael Sadler. Sadler at once suggested that Leeds (the university of which he had formerly been Vice-Chancellor) might take up the scheme.[104]

Sickert was thrilled. The prospect of becoming 'Professor of Art at the University of Leeds' had a pleasing colour to it, especially for a scion of the great Leeds-based Sheepshanks dynasty.[105] The enthusiasm of Sickert and Sir Michael was not, however, matched by James

* Although he enjoyed this early example of the 'blockbuster' show, he disapproved of it. He thought it ludicrous to risk the safety of old paintings – 'age-old miracles of coloured dust, held together with a breath of perishing glue, on heavy warped and morticed panels' – by transporting them around the globe, and he doubted whether art was served by gathering so many masterpieces in one place: 'Pleasure, and pleasure alone[,] is the proper purpose of art. Speaking as a convinced hedonist I am inclined to think that the concentration of an enormous rush of Society on one spot at one moment detracts from, rather than adds to the pleasures that art can afford.'

Graham, head of the university's Education Department. Though 'alive to the honour and prestige that would accrue' to the university through any association with Sickert, he was anxious about the artist's age. As he very sensibly remarked, 'a man of 70 may fail at any moment' leaving the students 'in the air'. He proposed calling on Sickert in London to assess the question at first hand. Whether the meeting ever took place is not known, but the plan was quietly shelved.[106]

Sickert's non-painting energies were left to find an outlet in his unceasing letters to the press, and in his commitment to the 'No Jury Club'. With a generosity scarcely supported by his bank balance, he sent a cheque for £100 to help the club's finances.[107] After the success of the Whitechapel show, the membership increased to almost a hundred. The Lefevre Gallery was prepared to offer the group another exhibition, but balked at Sickert's insistence that any show must be arranged according to the club's principles – with an alphabetical hang and no frames.[108]

In the spring of 1930 Sickert made a nostalgic pilgrimage to Dieppe to see Mme Villain, who was dying. (When or how he had resumed contact with his former mistress is unknown.) Blanche only learnt of his visit later; the funeral – he was told – had been 'extremely theatrical'. Sickert's presence can only have enhanced its drama.[109]

Ignoring the gathering storm clouds of economic recession, R. E. A. Wilson had built an 'enormous new' space for the Savile Gallery at 29 Bruton Street, Mayfair. It was there that he held a large show of Sickert's recent work in February 1930. Although the two dramatized biblical self-portraits *Lazarus Breaks his Fast* and *The Servant of Abraham* were generally acknowledged as the twin peaks of his recent output, the exhibition also gave the public its first real view of the 'Echoes'. Eight of them were on display – brightly coloured 'transcriptions' from, or 'collaborations' with, John Gilbert, Georgie Bowers, and other forgotten Victorian illustrators.[110]

Their reception was a telling reversal of Sickert's early critical history. Amongst professional contemporaries they were viewed with real hostility. Ethel Sands dismissed them as 'desperately silly'. His old confrères at the NEAC found them incomprehensible, if not pernicious. Vanessa Bell called them 'idiotic' ('[they] fall between so many stools they hardly exist'), while Augustus John thought them a

'sham'.[111] But others were more receptive. The public liked them, and so did many of the critics. T. W. Earp, writing in *Apollo*, considered the 'Echoes' amongst the 'most brilliant' things in the exhibition: 'Their line, necessarily less cramped than that of the original models, flows beautifully. It has the ease and personality of a signature. The colour is pushed to its most expressive limit and [is] admirably harmonious.' Osbert Sitwell considered that they were 'the ultimate fulfilment and justification' of Sickert's genius.[112]

Sickert's nostalgia for the Victorian world of his youth rekindled a fascination with the case of the Tichborne Claimant. When Henry Rushbury, a fellow ARA, admired his new set of whiskers, Sickert explained that he had been inspired to grow them after picking up a framed photograph of the similarly bewhiskered 'Claimant' from an old curio dealer in the Tottenham Court Road.[113] The photograph also produced its own 'Echo', which was exhibited at the London Group show that year. The lure of the past, however, was kept in balance by an engagement with the present. His use of newspaper photographs became ever more topical and explicit. He made a striking portrait of George V in conversation with his racing-manager, inscribing the canvas with a full acknowledgement of the picture's photographic source: 'By Courtesy of Topical Press Agency. 11 and 12 Red Lion Court E.C.4. Aintree 25.3.27'. The painting was even reproduced in the press alongside the original photograph, stimulating debate about the legitimacy of Sickert's method.[114] Sickert's work offered a constant challenge to established notions and comfortable expectations.

CHAPTER NINE

Lazarus Raised

Walter Sickert, *c.*1933

I

OVER THE FOOTLIGHTS

Lift your head after ten years. You'll see you are one among thousands.
Another ten years – among hundreds. On, on . . . And one day,
on a Monday or a Tuesday – with a peacock's feather of luck,
you may do better than you know!
(*Walter Sickert, quoted by Enid Bagnold*)

For all his determined individuality and contrariness, by the beginning
of the 1930s Sickert had achieved an acknowledged position of emi-
nence in the British art world. There were some dissenters, of course.
Sickert's overflowing wit and incorrigible flippancy certainly counted
against him. His refusal to take certain things seriously encouraged
some literal dullards to assume that his own art was not itself serious,[1]
and his 'Echoes' and photographic experiments still divided opinion.
Yet, in the autumn of 1930, the *Daily Mail*, that barometer of conven-
tionality, could declare – with no more than usual journalistic hyper-
bole – that he was 'Our Greatest Living Painter'. According to their
editorial page, there was 'a widespread opinion among all genuine art
lovers' that his seventieth birthday should 'not be allowed to pass
without suitable recognition'. They suggested he be given a retrospec-
tive at the Tate.[2] The proposal was not taken up, but there were many
other evidences of Sickert's standing. When, as part of the nation's
cultural export drive, international exhibitions were assembled, his
contribution was almost always sought. He was a major presence in
shows of 'British Art' in Brussels, New York, and Tokyo and was one
of three specially featured painters – along with Will Rothenstein and
Glyn Philpot – in the 1930 Venice Biennale.[3]

He also remained a figure of interest to the younger generation. In
1930 he showed with the progressive London Artists' Association,
where his picture of Chagford Churchyard was praised for its 'insouci-
ance', and he was one of only two senior figures included in an

exhibition curated by the Young Painters' Society – which was domi-
nated by the daringly abstract works of Ben Nicholson, Henry Moore,
and Barbara Hepworth. (Steer, interestingly, was the other established
artist selected by the panel of 'young' painters.[4])

Sickert still made the occasional visit to Chelsea to see his old
friend. Henry Tonks captured the pair at Steer's fireside in his caricature
portrait *Sodales* (Companions): Sickert – bearded, tweeded, sprawled
expansively in his chair – lecturing the contentedly dozing Steer. Sickert
tried to persuade Steer to follow his practice of using photographs and
prints, only to be deflated by Steer's quietly bathetic observation, 'But
of course that sort of thing wouldn't suit me.'[5] If Steer remained non-
plussed by Sickert's latest work, they found common ground in their
bemusement at most of the other contemporary artistic trends. They
found little to interest them in the constructivist experiments of Ben
Nicholson and Hepworth. Dining at Chelsea one evening Sickert asked
rhetorically, 'Who are the young men? I don't believe there are any?'[6]

Sickert's status in London was not reflected across the Channel. In
Paris, his star had sunk. He was no longer a name in Montparnasse.
Some of his etchings had been shown at the Anglophile Galerie Byng
and at the Musée des Arts Decoratifs, but they were not calculated to
command wide attention.[7] His work no longer fitted into the narrative
of modern art being elaborated in the salons and on the boulevards.
In the autumn of 1930, the Galerie Cardo on Avenue Kléber did mount
an exhibition of his work. The show, freighted with the full dignity of
official approbation, was opened in the presence of Lord Tyrell, the
British Ambassador. Sickert's old ally Louis Vauxcelles gave it a puff
in the *Carnet de la Semaine*, but there was little other coverage. People
asked who Sickert was.*[8]

Although Sickert went over to Paris for the show, he did not stay
long. In December, feeling once more suddenly ill and weary, he
resigned from the East London Art Group. The move was unexpected,
even capricious (his mood of dejection soon passed); but, to those
who knew him, the action was not surprising.[9] His resignation had

* When, the following year, Blanche wanted to sell some of his Sickerts, he chose to
do so through the London dealers, rather than in Paris. He lamented that the Sickert
pictures he had given to the Rouen museum were overlooked, badly kept, and
shockingly hung. 'I do not', he told Will Rothenstein, 'intend giving any more to
public galleries in this country. Sickert's works never will interest much French
visitors.'

the unfortunate effect of terminating the group's association with the Lefevre Gallery, though not before they had their second exhibition there – without Sickert.[10] Perhaps to conciliate his friends at the gallery, Sickert did allow his painting of George V to be shown separately at the end of the month – a move that can scarcely have endeared him to his former East London colleagues.[11]

In the spring of 1931, Sickert presented another exhibition of 'English Echoes'. It was held, not at the Savile Gallery, which was on the point of folding, but by Oliver Brown at the Leicester Galleries. The show went well, but even the rewards of a successful West End exhibition were no proof against the effects of the world economic depression. In September the pound was devalued by 30 per cent as Britain came off the gold standard. A new National Government was formed under Ramsay MacDonald to try to deal with the crisis. Its tough spending measures produced much hardship, but scant signs of recovery. Even Sickert, who lived always in the expectation of profits, took note. He disencumbered himself of his studios at Brighton and Noel Street.[12] Highbury Place (where Thérèse now also had a studio room) became the centre of his operations; he filled it with the clutter of his other workspaces, and hung a copy of Landseer's *The Monarch of the Glen* over the mantelpiece as one more jibe at Roger Fry.[13] He also considered, as he had during the war, the possibility of going on an American lecture tour.[14]

The immediate position was, however, unexpectedly ameliorated by Walter Taylor. He had sold some of his collection of Sickert paintings ahead of the crash at 'a great profit', and, much to Sickert's bemusement, felt so 'ashamed' at this good business that he insisted on passing on some of the proceeds. Sickert used the windfall to buy the freehold of a small semi-detached villa at 14 Barnsbury Park – on the fringes of Islington, close to Pentonville Prison. (It became one of his gambits, when taking cabs from the West End, to ask to be taken to 'Pentonville'.[15]) The transaction was made in Thérèse's name, to help secure her future. Owning the freehold, Sickert claimed, also spared him the worrying feeling – worrying even for a man of seventy-one – of being in a place 'with only twenty-one years to run' on the lease.[16]

It was from this new base that Sickert launched himself into what he came to call his 'most immemorial year'.[17] Though speckled with successful exhibitions and notes of official recognition, the defining

glory of 1932 was the friendship that it brought him with the actress
Gwen Ffrangçon-Davies. He had seen her, at the beginning of April,
appearing in a dramatized version of Mary Webb's novel *Precious Bane*
at the St Martin's Theatre, and was captivated. He wrote to her at once,
describing (amidst an avalanche of stray reminiscences about Wales –
the land of Miss Ffrangçon-Davies' birth) how he and his wife had
been 'overwhelmed' by the power of her acting.[18] He suggested that
they might meet. A lunch was arranged at the King's Cross Hotel.

It proved a great success. Sickert, fuelled by the better part of two
bottles of champagne, charmed her with tales of his early theatrical
life and liberal applications of flattery. On hearing about the lunch
date, Sickert's Islington newsagent had demanded, 'What do you mean
by taking actresses out at your age.'[19] But Gwen Ffrangçon-Davies was
no giddy starlet. In 1932 she was in her early forties, and was living
with the South African actress Marda Vanne, an old friend of Sickert's.
(Both Miss Vanne and Thérèse were present at the lunch party.) Sickert,
nevertheless, dramatized his new friendship as a grand passion.[20]

It was a passion that found its consummation in paint. The 'great
getting together' at the King's Cross Hotel was followed by others.
Sickert invited Miss Ffrangçon-Davies to his studio. He, of course,
wanted to paint her, explaining that she would not have to pose, only
provide him with a suitable photograph. Together they went through
her press-cuttings album. Sickert, dismissing the artificial studio por-
traits, fell upon an unposed dress-rehearsal shot – taken some ten
years before – of Gwen playing Queen Isabella in a Phoenix Society
production of Marlowe's *Edward II*. It was the play in which he had
first seen her perform. He had always retained a memory of the 'sound
of [her] voice in the word "Gaveston"', and since that time, so he
claimed, he had been *fixé* that she was a 'great actress'. The sight of
her in *Precious Bane* had confirmed the fact. In the Marlowe play she
had also appeared to him as 'the loveliest combination of woman
with dress'. The dress in question was a spectacular mock-Elizabethan
creation by Grace Lovat Fraser, and it was the challenge of depicting
the combination that persuaded Sickert to fix on the Queen Isabella
photograph as the ideal source for his picture.[21]

Although Sickert's working methods did not necessitate frequent
'sittings', he kept in close contact with his model and they wrote to
each other often. Sickert hoped that their correspondence might 'read
rather less vulgar' than the Bernard Shaw–Ellen Terry one.[22] Sadly,

Gwen's letters have not survived, but Sickert's are a record of impassioned adulation, so far over the top as to leave vulgarity far behind. The flow of telegrams and letters was unceasing; Sickert often eschewed the conventional postal service and sent his missives by cab.[23] 'Miss Ffrangçon-Davies' soon metamorphosed into 'Carissima Adoratissima', 'Darling adorable incredible friend and love', 'my dear and perpetual inspiration', and 'Angel of Jesus'. He lavished compliments upon her acting and her person: 'You *are* music and love, all your movements are music, your every syllable is music, your peasant's shamble and rushes, your "familiarity with the oven" as my wife said, is music'; 'your head is a harebell, probably the loveliest thing in nature'; 'God in his infinite mercy has given you the exact dosage of hair.'[24]

He kept her informed of his successes: another new show of 'Echoes' at the Beaux Arts Gallery; his 'apotheosis' by honorary doctorate at Manchester University; his invitation back to University College, Oxford, where he plucked a daisy for her from between the railings of the Radcliffe Camera. (Unfortunately Sir Michael Sadler's butler shook it out of his suit pocket when hanging up his clothes.[25]) He shared the sadness – not untinged with relief and guilt – of his brother Bernard's death that August.* He told her of his theatrical encounters – the jolly dinner at the Garrick with Pinero and Michel Salaman, the lunch with C. B. Cochran ('who owns two at least of my best paintings', and who, Sickert thought, had a 'letch' to put Gwen into one of his productions). He promised her a set of etchings – specially printed up for her by Sylvia Gosse. He expatiated upon the joys of Margate. And he looked forward to being able to welcome her to Barnsbury Park when it was ready. The house had not escaped Sickert's personal design touch. The ground-floor windows were, he considered, set rather too low to the street. So he was having them partially blocked up to prevent passers-by from looking in. He had a chair set just beside the window on which he could stand to look out.[26]

They saw each other occasionally in town. 'I shall never lose the feeling', Sickert told her after one encounter, 'of your firm hand guiding

* Bernard died on 2 August 1932, 'in his seventieth year'. *The Times* obituarist considered that he had possessed both 'talent and taste' but 'lacked perseverance'. Sickert described to Gwen the great divide between his own lot ('crowned with laurels') and Bernard's (dying after years of drug and alcohol addiction) as 'a fantastic spoof'.

me through a sea of traffic the evening we had tea in a shop.'[27] He took her to the private view of the Royal Academy's summer exhibition to see his completed version of *The Raising of Lazarus* – a looming six-foot canvas, patched with moments of cool green and faded pink. And from the press photograph that appeared of them coming away from Burlington House, he dashed off a painting inscribed, 'Gwen Ffrangçon-Davies and Anr'. Thrilled to be back in close contact with the theatrical world, Sickert bubbled over with plans. He wanted, so he claimed, to use his 'gifts of criticism and design for the stage'.[28] He sent Gwen copious notes on her performances, and even made suggestions about her stage make-up ('I should have *no* rouge').[29] He also taxed her with elaborate outlines of new sets for what he considered would be the 'inevitable revival' of *Precious Bane*.[30]

Sickert's infatuation with Gwen Ffrangçon-Davies drove his work forward. The picture of her as Queen Isabella – a monumental representation on a canvas six foot by three foot – advanced quickly. When the actress dined at Barnsbury Park in July (the alterations having been completed, and the Sickerts having found a young German cook – 'an ideal gretchen') Thérèse told her that Sickert, only the day before, had surprised her by announcing from his studio, 'Thank God Gwen's dry and on the operating table.' With the underpainting established and the canvas stretched he could begin the final phase – a restrained colour scheme of dirty pink on dark, dark blue. Sickert decided to title the picture *La Louve* (the She-Wolf) – an allusion, presumably, to Queen Isabella's lupine tenacity. He took to ending his letters, 'Your lamb my wolf'. And as a humorous pendant piece he painted a snow scene with a wolf menacing a group of travellers, captioned 'Gwen and her audience'.[31]

Major Lessore passed up the opportunity of showing *La Louve* at the Beaux Arts Gallery, not wishing 'to deal in what are called *monochromes*', so Sickert was able to place it instead with his old friend Wilson, who, after the demise of the Savile, had opened up in new premises in Ryder Street.[32] The painting was exhibited on its own, as a single important work. This was a new ploy that Sickert had been trying out after the successful showcasing of the George V portrait at the Lefevre Gallery. On 30 May 1932 a special private view had been held at the Beaux Arts Gallery to display Sickert's 'Great New Painting' – a view of the American aviatrix Amelia Earhart's arrival at Hanworth Aerodrome after her record-breaking solo flight across the Atlantic.

The arrangement was well calculated to generate the maximum publicity. The topicality of the pictures (Miss Earhart had touched down barely a week before the canvas was exhibited) and the fact that they were so clearly derived from press photographs made them highly attractive to the newspapers. There were opportunities for running reproductions of the paintings alongside their original sources, and for stirring the debate about the use of photography in painting. The pictures were reported as news stories rather than art exhibits.[33]

For the exhibition of *La Louve* special cards were printed (Sickert pressed Gwen for a list of her 'fans' to add to Wilson's mailing list), and at the press preview Sickert struck his own theatrical note, sitting cross-legged on the floor in front of the picture and 'expounding on its merits' to the assembled journalists.[34] The picture was enthusiastically received: 'Mr Sickert's Best Work,' declared the *Daily Mail*; the *Daily Telegraph* hailed it as his 'New Masterpiece'.[35] The CAS acted quickly to buy the picture, and before the year was out it had been accepted by the Tate. 'Terribly Happy and Thrilled,' Gwen telegraphed to Sickert at the news: 'The Tate [has] gone to my Tête.'[36]

It was not the only instance of official recognition that Sickert received that year. After long neglect, the public galleries were starting to acquire his work. The Tate bought several other pieces, some of them dating back to the 1890s. But it was the 'Echoes' that were most keenly sought. The Leicester Art Gallery bought *The Bart and the Bums*, Hull *The Idyll*, and Liverpool *Summer Lightning* (a painting based, according to Sickert, on John Gilbert's depiction of a chance encounter between Gladstone and Lily Langtry). The Louvre, perhaps reminded of Sickert's existence by his Galerie Cardo show, acquired *Hamlet* – also after Gilbert.[37] There were hopes that the Glasgow Art Galleries might accept the picture of George V, which was offered to them by Major Lessore. Indeed Sickert, with characteristic optimism, announced that the deal was done. But after much heated debate amongst the city fathers, the picture was rejected, its photographic origins too disturbing to the puritan conscience.[38] Similarly, the New York Metropolitan Museum's interest in *Miss Earhart's Arrival* failed to crystallize into a sale.[39] But even these reverses attracted attention to Sickert's achievement.

His greatest publicity coup was secured by his decision to sell *The Raising of Lazarus* for the benefit of the Sadler's Wells appeal. The gift, Sickert claimed, was made 'in memory of my perpetual adoration of

Sam Phelps and my gratitude to Isobel Bateman, of whose Sadler's Wells company I was myself a utility member'.[40] Sickert's offer was gratefully accepted by Lilian Baylis, the theatre's director, although to reassure her more conservative governors she felt it necessary to explain, in her annual report, that Sickert had 'deliberately made [his painting] provocative in order to create discussion and give publicity to the theatre's needs'.[41] The picture certainly did create discussion, as did the manner of Sickert's giving.*

He made the ceremonial presentation of the picture to Miss Baylis on the stage at Sadler's Wells. A packed house had assembled for the occasion.† With the picture hung against the black drop-curtain, Sickert and Miss Baylis advanced towards it from opposite sides of the stage, Sickert in his recently acquired scarlet doctoral robes, the stout, bespectacled Miss Baylis in the more sombre black cap and gown of an honorary Oxford MA. When they met, Miss Baylis stooped to kiss Sickert's hand; he drew her up and kissed her on the cheek. A young man then read the passage from St Luke's Gospel describing the miracle of Lazarus' resurrection, before Sickert made a happy extemporized speech celebrating 'the reunion in his person of the stage and art'.[42] He was thrilled to be back on the boards, and – amidst many asides and digressions – reminded his audience that, although he had retired some fifty years before, he still remained 'a member of the theatrical

* Sickert, halfway through his work on La Louve, had wondered whether it would not make a more appropriate gift to the Sadler's Wells fund than the biblical Raising of Lazarus. He contemplated effecting a swap, but the idea was not carried through.

† Before the presentation, Sickert was photographed on the stage with the painting. Thurston Hopkins, the young Fleet Street Agency photographer sent to take the picture, recalled the difficulty he had getting Sickert to stand still for the longish exposure that was needed even with the flash powder. He 'was in skittish mood, joking with the theatre publicity manager, and not taking my instructions too seriously ... After making the first exposure during which Sickert moved I explained to him the problem, emphasising there would just be a blur on the plate unless he kept still throughout the flash.' Numerous exposures had to be made before Hopkins felt confident that he had got at least one sharp image. At the end of the shoot, Sickert asked to be sent proof copies of all pictures. When Hopkins queried whether he wanted to see 'the blurred ones', Sickert surprised him by saying, 'I would like to see them all, especially the ones where I have moved.' Hopkins promised to send them. He registered the painter's curiosity about the blurred images, and felt that he had 'probably stirred an idea in Sickert's mind, and put him "on to something"'. But the idea did not develop. All the blurred photographs were 'binned' at the office before Hopkins could post them on. It is tempting to wonder whether the blurred images might not have inspired him into some painterly experiments, foreshadowing those of Francis Bacon and Gerhard Richter.

profession', and that if he had trouble selling his pictures he would 'come down' on the actors' benevolent fund for maintenance.*[43] In the weeks after the presentation the painting was regularly displayed on the stage before performances. When it was finally auctioned, on 2 December, it was bought for 380 guineas by the Beaux Arts Gallery.[44]

The completion and exhibition of *La Louve* did not mark the end of Sickert's infatuation with Gwen Ffrangçon-Davies. Although he kept up his production of 'Echoes' and paintings from news photographs, he was soon embarked too upon several further pictures of the actress – as 'Elizabeth Herbert' in the Crimean War drama *The Lady with a Lamp*, in formal pose for the lid of a Cadbury's chocolate box, and in an elaborate *Variation on Apollo after Guido Reni*, which he hoped would be his 'chef d'oeuvre up to now'.[45] He continued to work mainly from photographs – both old and specially posed – but under the influence of his abiding obsession he made a rare return to drawing, undertaking some studies of Ffrangçon-Davies's 'beautiful hands' (although, in fact, he spent so long making the coffee after his prescribed method that the sitting was over almost before the drawing was begun).[46] He also had plans to place the actress on a special revolving platform so that he might spin her round 'like eggs & bacon, porridge & toast, at breakfast & make a series of rapid drawings of [her] head & neck' from different angles, to be used by the sculptor Eric Schilsky as the basis for a collaborative portrait bust.[47] Of all these schemes, however, only *The Lady with a Lamp* seems to have been completed. The high-water mark of *La Louve* would, Sickert recognized, be difficult to reach again. 'I have a terror of doing anything *professing* to be you & not perfect,' he explained on abandoning the Cadbury picture.[48] He was restless too. Highbury Place was losing its particular magic. Already he had ceased to use it at weekends – 'because of the accursed football crowd on Saturdays [and] the bloody Salvation Army on Sundays'.†

He found a temporary refuge in the spare room of an art-loving

* Max Beerbohm, on reading the press reports of the occasion, sent a spoof newspaper advertisement to *The Era*: 'Richard Sickert, A.R.A. Resting. Open to engagement as juvenile lead, walking gentleman, singing footman, etc., etc. Handy. Experienced. Can do back-cloths of Venice, Dieppe, Brighton, Camden Town, etc., etc., if required. General utility. Terms on application.'

† The studio was close to Highbury, home of Arsenal FC. Crowds of over 50,000 would mass for the home matches as the team enjoyed an unprecedented run of success, winning the Championship in 1931, 1933, 1934, and 1935.

dentist at 163 Camden Road. The back balcony, on which Sickert stacked his canvases, overlooked the hockey field of Camden School for Girls, and the sight of his camaïeux drying in the sun appeared to interest the schoolgirls, or so Sickert claimed.[49] By the end of the year he had discovered a new studio nearby in a large disused bus garage in Whicher Place.[50] The vast circular space, some seventy foot across, was, he claimed, so perfect that he would never leave it till he was taken off to Kensal Green cemetery.[51] He would arrive there eagerly each morning and prepare himself for the day's work by reading his three current regular newspapers.[52] He invited Gwen to visit him, but it is not certain that she went. The tide of Sickert's obsession was abating.

The focus of his artistic interest shifted from Gwen in particular to the theatre in general, before contracting again on the figure of Peggy Ashcroft. Sickert's generosity to the cause had earned him privileged access to Sadler's Wells and its sister theatre, the Old Vic. He went to everything (except the ballets), and became a well-known figure amongst the company. 'He was,' as Peggy Ashcroft later recalled, 'a tremendous Shakespearean', and would often go to the matinées when 'there was not a very large audience, and you would find that [at] some line that never got a laugh ordinarily, there would be a loud gust of laughter from this one solitary person – even a tremendous burst of applause'.[53] Sickert often brought with him his own 'box photographer' and, to the consternation of the players, would have pictures taken during the productions, or – by special arrangement – at dress rehearsals.[54] The photographs became the basis for a new series of what he called 'theatrical' paintings – large figure studies focused on some, perhaps unexpected, moment of visual and dramatic intensity: Miss Hardcastle ascending the staircase in *She Stoops to Conquer*; Lady Macbeth sleepwalking across the stage; or Lady Teazle 'approaching the footlights'. Peggy Ashcroft, as the company's young leading lady, was often the actress depicted and Sickert soon befriended her, inviting her to his studio and to lunch at Barnsbury Park. She became his muse of the moment. He began making other paintings of the 'divine Peggy', from old press photographs and even holiday snaps. He took her about to his favourite haunts and – according to her own later account – he also took her to bed.[55]

The challenge of a new motif and the thrill of a new friendship still produced an extraordinary galvanizing effect upon him, but the

accesses of 'terrific vitality and gusto' were tempered more and more by lapses into exhausted bemusement. Peggy Ashcroft was struck by his distinctive combination of extreme youthfulness and great old age, and suspected that 'he rather liked playing the part of an elderly person'.[56] It was an act by which he attempted to dramatize and master his real situation. He *was* getting old. And life *was* beginning to get on top of him.

His finances were a mess. He had long enjoyed the sense of irresponsibility conferred by old age. 'As we get older,' he was wont to declare, 'we get *worse!*' Certainly he had grown even more imprudent. The money he had received from Christine – as well as the money he had earned – was all gone: much of it given away, more spent on paints and materials of the best quality, but most blued on taxis, telegrams, clothes, bric-a-brac, and an endless succession of neverended leases. Instead of cash at the bank, he had debts amounting to '£2000 plus some hundred!' Even Sickert felt obliged to add an exclamation mark.[57] He owed large amounts to his landlords, his tradesmen, to the Inland Revenue, and to his dealers.* He had borrowed money from both the Beaux Arts and Leicester galleries on account of pictures that he then failed to deliver. Those who knew him well suspected that his irresponsibility was programmatic. It was recognized that 'he liked being broke', indeed he believed there might be a correlation between poverty and good painting.[58] But he did not like worry, and the debts that he had amassed with such wilfulness were beginning to cause him distress.

His attempts at retrenchment had proved ineffectual. Even with the aid of photographic sources, studio assistants, and long experience, he struggled to make headway with his production. Any work he did produce had already been paid for by his dealers. His attitude to his predicament fluctuated between high anxiety and insouciant disdain. He embarked on his paintings of Lady Berwick and Gioconda Hulton, for which he expected no payment, while at the same time fretting over the distress that his position was causing Thérèse.[59] He also dis-

* Sickert's payments to his long-suffering builders, George Clegg and Son, were rare and late. On one occasion he turned up at Mr Clegg's 'private residence' about midnight with a sugar bag full of notes and cash, about £180. He said it was 'all he had managed to beg, borrow and steal'. In the face of another urgent request for payment he sent Mr Clegg – by taxi – another bag of cash and the Graeco-Roman bust with realistic eyes. He told Mr Clegg to look after it 'as though it was your own mother'.

played an uncharacteristic bitterness at the large loan exhibition of his work held at Agnew's in 1933; despite its success he would, he complained, receive nothing from it.[60]

Some prospect of immediate relief was held out by a commission from the Canadian tycoon Sir James Dunn, who had met Sickert a couple of years previously and had bought two of his paintings. He now asked him to produce six large portraits: of Dunn, his friends, family, and associates. It was a good break for Sickert, though not a great one: at a time when Augustus John was commanding some £2,000 a portrait, Dunn offered Sickert a more modest £250 per picture.[61]

He also received a less tangible but equally welcome piece of encouragement: a fan letter from his old friend Virginia Woolf. She had visited the Agnew's exhibition and greatly enjoyed it. Sickert had barely seen her since his return to England, but he at once resumed their old familiarity. He wrote back chastising her for considering herself – 'as a writer' – an 'alien to the world of painters': 'How can you use such Bloomsbury clichés? I am not a baker but I enjoy a good loaf & co.' He went on to ask her to do him 'a serious service' and write something about his pictures: 'I suggest that you sauter pas dessus all paint-box technical twaddle about art which has bored & will always bore everybody stiff. Write about it, the humour & drama you find in it. You would be the first to do so. I have always been a literary painter, thank goodness, like all decent painters. Do be the first to say so.'[62]

Virginia Woolf was rather attracted by the idea and Sickert pushed home his advantage, playing shamelessly upon her sympathy, claiming that no one else appreciated him and that he had 'the bailiffs in the basement'.[63] 'You must treat an old man like a child,' he told her, 'and not disappoint him.' Clive Bell brought them together over dinner, along with Vanessa Bell and Duncan Grant, to cement the deal. It was a jolly occasion. Sickert, though rather 'sunk and old' to begin with, soon became 'warmed with wine'. He expanded into song, laughter, and reminiscence; he started flirting with Vanessa, and flattering Virginia: 'You are the only person who understands me,' he told her, kissing her hand.[64]

Her 'understanding' was distilled in 'Walter Sickert: A Conversation'. In this imaginary symposium she emphasized the power of Sickert's pictures to suggest narrative and convey mood. Sickert, on receiving a proof of the article, hurried round to Tavistock Square to

tell her that it was 'the only criticism' he had received 'worth having in all his life'. 'That', as Virginia explained to Quentin Bell, 'means it praises him to the skies' – though she felt that, at seventy-four, he was entitled to his vanity. Sickert was anxious that the piece should be published as soon as possible, thinking that it would be a useful 'advertisement for his work'.[65]

His own public profile was raised at the beginning of 1934, when he was elected a full Royal Academician.[66] It was, however, an honour that sat rather uncomfortably with his precarious financial position. Despite the Dunn commission, his plight was still desperate. In an effort to make some money, he approached his friend Alec Martin of Christie's about selling his 'collection of Shakespeare Engraving à la Française'. It was at once clear to the practical and generous Martin that Sickert's debts could not be recovered by the sale of a few old prints. He determined to try to raise a subscription on Sickert's behalf. Canvassing for contributions amongst old friends, associates, and patrons, he sketched a black picture of Sickert's 'serious, almost desperate financial situation'.[67] Although some of those approached would have nothing to do with the scheme – thinking that Sickert had brought his misfortunes upon himself – there remained, as Henry Tonks reported to D. S. MacColl, 'a certain number who, [though] recognizing how many foolish things he has done[,] yet hate to think of a man of his eminence coming near starving'. The desire to help was, he admitted, not 'based on anything logical', but then Sickert had always defied logic. Good sense, however, was not entirely abandoned: it was understood that any money gathered together must be administered by trustees who could keep a 'tight hand on the purse'.[68]

Funds did begin to flow in. Blanche, who had not seen Sickert for a decade, wrote with a mixture of concern and bemusement to Will Rothenstein, 'What mystery!' He could not understand how Sickert – with Christine's inheritance and his own regular sales – was not 'quite safe'. But, as he remarked, 'we never can tell in these awful days'.[69] Rothenstein was just as bemused, and just as generous.[70] Two hundred and five donors subscribed to the appeal, and a sum of £2,050 was gathered in. It was more than expected.[71] The money was handed over to a group of trustees made up of Sir William Llewellyn, the new President of the Royal Academy, Sylvia Gosse, Tonks, and Gerald Kelly.[72] Kelly suggested that Sickert be allowed to declare himself bankrupt so that he, rather than his creditors, would receive the money.

But Sir William was horrified at the idea of a Royal Academician appearing in the bankruptcy court and Sickert himself, although being what Kelly described as 'so very je m'en fous-tist', was also most insistent that this should not happen. Martin was able to compound with many of the creditors.[73] The Leicester Galleries nobly accepted just 40 per cent of their due.[74] Only Major Lessore insisted on being paid in full.[75] A rigorous economy drive was imposed on Sickert. He renounced his remaining leases – some for studios long since abandoned. Both Highbury Place and the bus garage were given up. Having settled all outstanding debts there was still 'a substantial amount' – about £600 – left over, which it was agreed should be dispensed in regular doles of £50 a quarter.[76]

Sickert showed no embarrassment at his rescue. He told Blanche that he had been 'consoled by the fact the hat was sent round for Lord Derby on his birthday. So I am in good company.' And he quoted approvingly Walter Taylor's observation: 'People used to boast of their wealth, now they boast of the amount of their debts.'[77] In his letter of thanks to Martin and the other subscribers, he did confess to being 'rather surprised not to feel more shame at being caught guilty of some mismanagement', but went on: 'It is evident, however, that the friends whose names I have on your list confirm me in my opinion that they must all be convinced of a measure of approbation of my painting and my teaching.'[78]

II

HOME LIFE

An artist should be allowed every kind of fun,
including the fun of growing old.
(Walter Sickert, quoted by Osbert Sitwell)

Alec Martin and his wife had a house down at Broadstairs and, to
remove Sickert from the scenes of temptation and expense, they
arranged for him and Thérèse to spend the summer in a flat nearby,
at Margate. In the atmosphere of ozone and unindebtedness Sickert
at once revived. He was delighted to be on the Kentish coast again,
and thrilled to discover that his old friend Johnston Forbes-Robertson,
now knighted and retired, was also spending the summer at Broad-
stairs.[1] For Sickert, however, there could be no thought of retirement.
He soon took a studio at 10 Cecil Square, in the centre of Margate,
and established a good understanding – as well as a line of credit –
with Mr Lovely, the local artists' supplier.[2] There was plenty of
work on hand. The Leicester Galleries, unperturbed by their past finan-
cial dealings, were soon clamouring for more theatrical pictures, fol-
lowing a successful exhibition of such scenes in the autumn. And he
still had all but one of the portrait commissions to do for Sir James
Dunn.

Sickert, however, could never confine himself to mere obligation.
He entered into the artistic life of the town. With the start of the new
term, he lent his services to the Thanet School of Art, delivering a
course of six lectures on such practical aspects of picture making as
'Drawing from Nature', 'Squaring Up', 'Underpainting', and 'Colour'.[3]
Although Roger Fry had died suddenly of heart failure that September,
Sickert did not let up the attack upon his ideas. 'I think we must face
these matters without exaggerated delicateness,' he told the students,
as he launched into Fry's 'modern nonsense about pictures'.[4]

Winter advanced, and the Sickerts decided to stay on in Kent. They had no wish to return to the London fogs, and Margate was proving to be a congenial and productive setting. It was also, in theory, an economical one. For many Londoners, life on the Isle of Thanet represented an opportunity for retrenchment. Sickert, however, with his gift for extravagance, managed to turn it into an additional expense. He was able to let Barnsbury Park to his long-suffering brother-in-law, Major Lessore, for £80 a year, but then spent exactly the same amount on renting Hopeville, an unnecessarily large, old red-brick house in the village of St Peter's, between Margate and Broadstairs. Sickert described it complacently as a sort of little manor house – 'une espèce de petit gentilhommerie' – although the adjective 'little' was relative. He listed the several plaques set into the walls of the building marking the dates of its extensions – the largest and latest being a three-storey gabled wing added in 1827. The house, next to the village church, was set in a large tree-shaded garden, to which were attached an orchard and several outbuildings. According to a local legend, the infant Queen Victoria, when donkey riding at Broadstairs, had been 'run away with' by her mount and ended up in the garden of Hopeville.

Sickert readily accepted the house's heroic past, but had reservations about its current name, which he changed to 'Hauteville'. Margate, with its regular summer packet boats to Dieppe, Treport, and Le Havre, seemed, at least to Sickert, tantalizingly close to France. After a silence of almost fifteen years, Sickert had renewed contact with Jacques-Émile Blanche: he had written to him after seeing an exhibition of his work in London, and was soon back in regular and friendly correspondence.[5] He urged his old friend to come over for a visit. Having effected a change to the name of the house, Sickert embarked on some rather more involved – and expensive – structural alterations. The whole orientation of the house was reversed. What had been the back door became the main entrance: guests, rather to their consternation, had to pass through a downstairs cloakroom, complete with gleaming white lavatory bowl and pedestal basin, before entering the large kitchen, where a stout, well-scrubbed deal table stood as the hub of daily domestic life.[6]

Amongst the numerous other rooms there was space for Thérèse to have a ground-floor studio room looking out on to the garden, and for Sickert to have another in which to gather his collection of old

photographs and newspaper cuttings.* His main workspace, however, was in the Georgian stable block, which he converted by laying a wooden floor over the cobbles, installing a stove, and opening up a large window in the north wall.[7] As a further amenity he attached to the east side of the house at first-floor level a curious hutch-like construction, in which he could put his paintings to dry.[8] (He had explained to the students at Thanet School of Art that there was nothing quite like an east wind for drying paint on a canvas; it could cut the process down from a fortnight to twenty-four hours.[9])

Sickert furnished the house with what had become his distinctive mix of the interesting and commonplace – a gilt-framed Georgian mirror set above an Art-Nouveau fireplace, a wicker armchair next to a black-and-white blind patterned by Raoul Duffy – the juxtapositions arranged in such a way as to make even the most familiar items look 'somehow startling and new'. On the walls he hung, not his own works, but his familiar assemblage of finds and totems: the Tottenham Court Road Tintorettos, a group of lithographs by some forgotten Victorian illustrator, pictures by his father and grandfather, a portrait engraving of the Revd Richard Sheepshanks. And, in pride of place, a group of little plaster statuettes by the early nineteenth-century French sculptor, Dantan le Jeune.[10]

Sickert, always excited by new things, was excited by his new home. 'Oh I am lucky,' he enthused to one visitor, showing off his bedroom: 'beautiful prints, a curious shaped room, a wall cut off by the stairs which makes it charmingly triangular. Wonderful things to look at.'[11] Having made the house his own, Sickert even signed his creation, writing his name in large black letters on the brickwork by the back door.[12]

It was not a name that meant much to the majority of local residents. Nevertheless, they suspected that their new neighbour might be 'somebody'.[13] His extraordinary outfits – the flowing opera cloak and wide-brimmed hat, or the ill-assorted tweeds, collarless shirt, and black-peaked cap – provoked wonder and even, sometimes, alarm.[14]

* A friend and former pupil, Elfrida Lucas, recalled the sitting room of Sickert's house at Brighton as having 'newspapers covering the floor over which I was requested to step carefully; they were not to protect the carpet from paint as I at first supposed, but spread there in case he wanted to refer to certain articles in them he had found of special interest . . . books were sometimes treated in the same way'.

On one occasion the deputy town clerk asked the police to remove 'a disreputable looking tramp' from the Broadstairs seafront, only to be informed that it was Mr Sickert taking his evening stroll.[15] The painter struck a new and distinctive note in the town. Edward Heath (the future Prime Minister and a son of Broadstairs) recalls being in a carol-singing party that called at Hauteville shortly after the Sickerts moved in: 'Having sung the carols and knocked at the door several times, the curtain of the front room was narrowly drawn aside and [Sickert's] face and shoulders appeared. We held the box up in front of him, whereupon he pulled the curtain back over the window and that was the last we saw of him!'[16]

Very quickly, however, his idiosyncrasies became familiar, and he dispelled the anxieties of his neighbours with his easy amiability. The Mockett family, from whom he was renting Hauteville, continued to live in the next-door property, and became friends. Sickert encouraged their young daughter in her artistic ambitions.[17] Indeed he was a great hit with the local children. The Hauteville garden adjoined the play-ground of the Broadstairs Elementary School, and Sickert would often prop his canvases outside the studio door, ostensibly to dry, but also so that he might hear the unguarded comments of the schoolboys. 'Children', he said, recommending the practice to his fellow artists, 'always know.'[18]

Many of those he encountered in and around the town still retain vivid memories of him: giving them bananas, inviting them in for dishes of bread and milk, serving them tea in bowls. (Alan Irvine, whose family used to holiday at St Peter's, thought that none of the cups in the Sickert house had handles.[19]) He appalled – but secretly delighted – John Lovely, son of the long-suffering Margate colourman, by squeezing a large blob of raw sienna on to the plate from which he was eating at the Hauteville kitchen table, and declaring that it looked exactly like 'cow dung'.[20]

To the small artistic community of the Isle of Thanet, Sickert became a focal point. He followed up his art school lectures with a series of talks – 'piquantes conferences' – on nineteenth-century French art at Margate College, the leading boys' school in the area.[21] He was welcomed by the art-loving vicar of Margate, the Revd F. C. Tyrell.[22] He befriended Mrs Garlick Barnes, a widow with two growing boys, who lived at Kingsgate; she had studied at Heatherley's in the early twenties, but Sickert was keen that she should continue her education

under him.[23] He took an interest, too, in Donald Ball, the only student at Thanet School of Art taking the advanced painting and drawing course. Sickert visited his studio at the school, offered him practical criticisms, and had him to tea on several occasions.[24] Only when asked to visit the sickbed of another art student, the future novelist Denton Welch (who was recuperating at Margate after a serious bicycling accident), did he draw the line. 'I have', he told the well-meaning doctor who suggested the call, 'no time for district visiting.'[25]

Sickert, happily immersed in his work and in the details of his new life, had not thought to mention his relocation to Sir James Dunn. The Canadian financier discovered Sickert's absence and, sensing some loss of control, hurried down to Thanet to check on the progress of his commission. Sickert hated an impatient purchaser: 'How', he used to ask, 'can you expect to see a baby before it is born?'[26] And the gestation period of a large canvas was often long. Sickert estimated that the Dunn pictures took almost three months each to complete, allowing for the two or three extended drying periods between coats.[27] Unperturbed by Sir James's unheralded appearance on the doorstep, Sickert shut the door in his face with the cry, 'Go away! I'm not at home.'[28] Dunn's secretary (and, later, wife), Marcia Christoforides, fared rather better. She drove down to see Sickert and was admitted, even being invited to stay to lunch. Sickert's latest affectation was to insist upon all his guests, female and male, joining him in a post-prandial cigar. Miss Christoforides gravely struggled with her evil-smelling black cheroot and was rewarded for her suffering. Sickert let her photograph the unfinished canvases, and allowed her to take two completed – or nearly completed – paintings back to London, strapped to the sides of her car.

One of the transported pictures was, almost certainly, the huge portrait of Lord Beaverbrook, which Sickert had been working on since the move to Thanet. Although he began the picture from a snapshot taken in Dunn's dining room, he soon revised his composition after chancing upon what he considered to be a much better photograph in the pages of the *Daily Express*. This image of the press baron, 'standing, cross lit', in the loggia of his country house, hands thrust in pockets, his bulldog face set with an expression of assured power and controlled pugnacity, seemed – as Sickert put it – 'quite exceptionally perfect'.[29] He transformed the snapshot into a larger than life-size painting, at once iconic and immediate. The cluttered background

of the Surrey mansion was replaced with the visually dramatic, if biographically improbable, sweep of Margate harbour. (Lord Beaverbrook, despite Sickert's invitation to come down and inspect the 'study embryo' of his portrait, had never been to Margate.) Well pleased with the result, Sickert had told Beaverbrook that the picture would 'certainly rank as one of my best and most important works'. It was, he claimed, 'a political portrait in the grand manner by a painter who appreciates and admires your policy'. Dunn, however, did not care for the painting. Initially he refused even to accept it. Sickert was so irked by the financier's peremptory attitude that he considered abandoning the whole commission there and then, and not executing the already planned portrait of the bon-vivant gossip columnist Lord Castlerosse. But, as he confided to Beaverbrook, he could not readily 'let Castlerosse down after his kindness in favouring me with a sitting'.[30]

The picture of the celebrated peer standing four-square upon the hearthrug at Dunn's London home was ready in time to be sent to the Royal Academy's summer show. It was submitted along with the portraits of Beaverbrook and Miss Christoforides. The Beaverbrook portrait was rejected by the hanging committee. Although there was a suspicion that some 'political animus' lay behind this snub, the stated grounds for the rejection were that it was 'impossible to hang [the picture] with any satisfactory effect, owing to its large scale'.[31] Sickert was inclined to believe the excuse. He wrote to Beaverbrook explaining the situation, and replied to the RA secretary's letter of explanation in conciliatory tone, admitting that he would probably have done the same himself had he been on the hanging committee.[32]

He was feeling well disposed towards the Academy, having just received by post his 'magnificent diploma' as a full Academician. It would, he claimed, 'henceforth be the sunshine of our home here in Thanet'.[33] He was consoled, too, by the news that his portrait of Lord Castlerosse (which was, in fact, even bigger than the Beaverbrook picture) had been given the centre position on the east wall of Gallery VIII. From this prime place the painting achieved a great and immediate success. 'Mr Sickert', reported *The Times*'s critic, 'runs away with the show.' Others concurred. The one dissenting voice belonged, most unfortunately, to Dunn. He took objection to the brownish tinge Sickert had given to Lord Castlerosse's suit. Brown, he considered, as a colour 'lacked distinction'. It required the combined diplomatic

efforts of artist and sitter to convince him that the suit was not in fact 'brown' but 'cinnamon'. Only then would he accept and pay for the picture. 'I think', Sickert remarked to Beaverbrook, 'our friend has a touch of the sadist, and finds positive pleasure in tormenting his friends to show them the undeniable power of money.'[34] It confirmed Sickert in his resolution 'never to do a stroke of work for him again'.[35]

It was not the only severance that summer. Ever eager to enter into artistic controversies, Sickert was quick to protest against plans to remove the Epstein statues from the façade of the former British Medical Association headquarters on the Strand. The building had been acquired by the Southern Rhodesian Government as a High Commission, and they disapproved of the flagrant nudity of Epstein's decorations. Sickert, who had defended the works when they were unveiled in 1908, wrote again to the *Daily Telegraph*. Any prudish anxiety over the physical attributes of the figures was, he contended, absurd: it would require a pair of 'field glasses' to view such details properly – or, rather, 'improperly' – from the street. The statues formed 'part of the architecture' of the building, and were inseparable from it.[36]

Sickert was not a lone voice. The director of the V&A, Sir Eric MacLagan, gathered an impressive list of signatories for another letter deploring the proposed act of 'vandalism'. One name, however, was absent from this roll of the cultural great and good. Sir William Llewellyn, the President of the Royal Academy, had declined to add his signature on the grounds that, although asked to sign as a private individual, his support might be taken as the Royal Academy's official position. Sickert certainly took his *refusal* to sign in just that light, and, in an excess of principled indignation – or attention-seeking caprice – he tendered his resignation, demanding to know, 'If the R.A. cannot throw its shield over a great sculptor, what is the R.A. for?' He took care to send a copy of his letter to the *Daily Telegraph*.[37]

The moment was given a dramatic piquancy when, with the letters in the post, Alec Martin arrived at Hauteville accompanied by Sir William Llewellyn himself. Sir William had been staying with the Martins at Kingsgate for the weekend. Sickert remained unfazed. Maintaining his habitual division between social pleasures and art-political differences, he made no mention of his resignation, and a 'very jolly time' was had. Sir William was wholly unprepared, on returning to London the next day, to be greeted by banner headlines proclaiming

Sickert's break with the Academy. As Alec Martin regretfully recorded, 'He never really forgave him.'*[38]

Sickert was unrepentant. He acquired a copy of the news vendor's poster board announcing his resignation and set it up in his studio.[39] With his flair for self-mythologizing he also painted – from an old press photo – a grisaille self-portrait, in which he appears bowler-hatted, check-suited, and alone, tottering with unsteady determination away from the portals of Burlington House. It is hard, however, to accept this colourless, alienated image as anything other than ironic. Sickert's resignation from the Royal Academy was an act of defiant independence and self-confidence. Having gained the eminence of his officially sanctioned position, he felt able to relinquish it.

Any practical concern over the loss of Thérèse's widow's pension rights seems not to have registered. Even without the showcase of the RA's summer show or the security of the Dunn commission, Sickert was buoyed up by one of his perennial waves of optimism about his financial prospects. The Beaux Arts and the Leicester galleries both remained keen to show his pictures – reaching an informal arrangement by which they held their one-man Sickert exhibitions in alternate years.[40] Despite Alec Martin's pleas that he should work with them on a commission basis, Sickert continued his habit of selling his pictures off at wholesale prices. Whenever he needed £100, he would invite Oliver Brown or Frederic Lessore down to Thanet and let them buy something.[41] This, as Martin fretted, was all right as long as he was able to keep painting; but what if he were to suffer a stroke, or an accident? Sickert, however, liked to feel the prick of necessity. His system, by demanding that he did keep painting, perhaps helped him to do so.

Besides producing work for his two London galleries, Sickert also took on numerous new portrait commissions. The indefatigable Martin ordered pictures not only of himself but also of his wife and youngest son; and, once the Sickerts were established at St Peter's, a steady stream of old friends – the Swintons, Marie Tempest, the Wyldes –

* Despite the evidence of his letter to the *Daily Telegraph*, Sickert later claimed that the Epstein debacle had not been the cause of his resignation. In one of the last letters he wrote to the press he asserted, 'As soon as I learnt that the removal of the figures on Rhodesia House was due to a question of engendering danger to passers-by I acquiesced.' He told the readers of the *News Chronicle*: 'I resigned because a member of the RA when I asked why the portrait of Shaw was not accepted said: "We won't have Shaw in the RA."'

would descend from London, often leaving, after a prolonged and hilarity-filled lunch, with a portrait commission mooted or arranged.[42] Some of Sickert's Thanet neighbours even offered their patronage. He painted portraits of the vicar's wife, and his landlady's sister.[43]

He set up a velvet-draped dais in the middle of his studio, with a club armchair on it, telling one young visitor that it was for painting pretty ladies on. 'And when I've finished,' he added, 'I kiss them.'[44] But the amount of formal sitting – and informal kissing – that went on must have been minimal. Sickert continued to work almost exclusively from photographs – old ones presented by his subjects, snapshots taken by Thérèse, or others secured more dramatically.* Nevertheless, he did sometimes make supplementary sketches. Alec Martin recalled sitting at least once; and Alan Swinton, whom Sickert painted from a snapshot taken after a 'most uproarious luncheon', left his military tunic and medals at St Peter's so that they could be studied at leisure.[45]

Even in the works done from press photographs Sickert occasionally made use of additional material. The atmospheric portrait of the Spanish mezzo-soprano Conchita Superviva was done, so Sickert claimed, under the influence of hearing her voice on the wireless.†[46] He probably listened, too, to the broadcasts of his 'beloved' George V – whose Silver Jubilee in May 1935 he commemorated with a fine portrait done from a news vendor's souvenir-editon poster.[47]

Topical pictures, portraits, theatrical scenes, domestic interiors (usually figuring himself), even the occasional landscape – or townscape – Sickert, well into his mid seventies, maintained an almost unflagging output. He worked hard, though his claim to be putting in fourteen-hour days in his studio has an edge of exaggeration, as well as disguising the fact that his working day included reading, smoking, contemplation, and – very probably – an afternoon nap.[48] Separated

* When Sir Geoffrey Fry commissioned a portrait of his wife, Alathea, he waited some months without hearing further from Sickert. Lady Fry was then surprised one morning, while reading her newspaper in bed, by the unannounced arrival of a photographer. He took a flash photograph of her looking – unsurprisingly – rather startled. There was then another lull, until Sir Geoffrey received a telegram from Sickert telling him to meet the portrait off a certain train.

† For the most part Sickert did not like listening to the radio while working. Thérèse loved music though, and it was probably her influence that lay behind the several musical portraits that he produced during the 1930s – of Sir Thomas Beecham, Totti del Monti, and others.

from his old studio hands, he relied increasingly on the assistance of Thérèse to carry out the squaring up, the underpainting, and even, in time, the overpainting of his compositions. She subsumed her artistic personality in his. He was not far off the truth when he claimed to be looking forward to the day when he could 'dictate' his paintings from bed.[49]

Sickert was now news, in a way that no other artist, except for Augustus John, was. The press coverage of his doings and his paintings was something of a phenomenon, and his removal from London seems only to have increased his celebrity. Reporters travelled down to Thanet to record his eccentricities and the details of his domestic life. They described his dress, his habit of scratching memos on the kitchen wall (and music-hall ditties on his studio door), his working methods, and his predilection for goat's milk – to which some ascribed his amazing energy: others put it down to the copious quantities of wine he drank.[50] Sickert played up to the reporters. But, then, he played up to everybody. The press cuttings proliferated, and Sylvia Gosse would come down specially to stick them into handsome clothbound scrapbooks.[51]

His celebrity was a source of bemusement and irritation to many of his contemporaries. 'He has become shameless,' commented Tonks to D. S. MacColl. 'Anything is good enough which will make him talked about. I detest that type of man. I hope I shall never come across him again.'[52] Others, however, sought to make use of his very public profile. Over the winter of 1935–6 a rebel cabal within the London Group ousted the serving president, Rupert Lee, and elected Sickert in his stead, but only as a screen for their own nominees. Although he must have consented to this arrangement, he had drifted beyond the orbit of the capital's art politics. He contributed nothing to proceedings, attended no meetings, and relinquished his position (along with his membership) soon afterwards.[53]

His trips up to town were rare, but impressive. When Johnston Forbes-Robertson's daughter, Chloe, was ill in hospital, Sickert appeared at her bedside, cropped and washed, wearing a 'superb dark blue suit' and grasping a large bunch of dark red roses. Even his voice was adapted to this new metropolitan guise. He sounded like 'a successful politician' as he enquired, 'in the most precise' terms, about the patient's condition.[54] He made a no less dramatic entry at the party given by Lord Beaverbrook, coming all the way from Thanet, together with Thérèse, in a taxi ('foolishly', as he later admitted). Even more

foolishly he kept the taxi on, with its meter running, throughout the evening. By the time the party ended – at about four o'clock in the morning – the bill was 'considerable'. The taxi driver insisted on being paid in advance before embarking on the return leg of the journey, and as Sickert had no money with him, a friend had to settle the amount. On the way back to Kent, the taxi ran into a telegraph pole and Sickert was thrown down on to his knees, barking his shins badly.[55]

After the incident he took, for a while at least, to wearing a pair of stout, thigh-high leather boots – for 'protection' – though whether the protection was for his still bruised legs, or against possible future accidents, remained unclear. He had these 'sewer boots' on when Denton Welch, partially recovered from his own accident, called at Hauteville for tea; they were the only outward signs of his recent mishap. Sickert quite terrorized the sensitive Welch with his 'dreadful heartiness'. Despite the cumbersome footgear, he improvised a jig on the hearth while declaiming a German drinking song. Noting Welch looking at his almost life-size painting of a miner passionately embracing his wife (one of several canvases stacked around the room), Sickert boomed: 'That picture gives you the right feeling, doesn't it? You'd kiss your wife like that if you'd just come up from the pit, wouldn't you?' The diffident, virginal Welch was overcome with mortified embarrassment.

When George V died at the beginning of 1936 and was succeeded by his son as Edward VIII, Sickert lost no time in depicting the new monarch. He latched on to the 'perfect' photograph of the young King, in the uniform of the Welsh Guards, holding his bearskin defensively before him as he stepped out of his official car into the glare of public life. Sickert soon had a camaïeu of the scene – six foot by three foot – drying outside the house, where, he told Eddie Marsh, it was 'the *coqueluche* of all the board school children who pour into my garden every day at midday to see it . . . "Did *you* do that? Wiv a brush?"'[56] Much to his gratification one passing local shouted over to him, 'That there poster don't need no label, sir!'[57] Sickert sent a sketch of the composition to Buckingham Palace, anxious to confirm some details of the King's uniform that were not clear from the black-and-white newspaper image. He was thrilled to get the pencil drawing back from His Majesty's secretary, annotated 'with the most exact and innumer-

able colour notes'. While he felt that a sitting from the King would be superfluous, he did consider asking whether he might borrow the royal uniform for further inspection.[58] In a new refinement of his conventional practice, he made two versions of the picture, sending one to the Beaux Arts and the other to the Leicester Galleries.*

Although he had assumed the position of an unofficial official painter, he received no official honours. The bashful Steer was given the Order of Merit in 1931. William Rothenstein and William Nicholson were both knighted. Sickert, who would have so much enjoyed such sweets, was passed over. On several occasions there were rumours of possible ennoblement, but these existed most vividly in the imaginations of his fellow – and rival – artists.[59] His eccentricity, his money troubles, and his divorce probably all counted against him. He was, however, awarded a second Honorary Doctorate – by Reading University – appearing at the award ceremony with a spade-like beard that only partially concealed his open collar.[60] More pleasing still was his election, thanks to the influence of Blanche, as a corresponding member of the Académie des Beaux-Arts.[61] It was a compensation for the loss of his 'RA' initials, and a reminder that Paris had not entirely forgotten him.

The French received a further reminder of his existence when, along with Steer and Augustus John, he was included as one of the three living artists in an exhibition of British painting curated by Kenneth Clark at the Louvre. (Blanche felt that he was poorly represented, with too many recent works and not enough stuff that the French would recognize and appreciate.[62]) There were other shows in Amsterdam, Chicago, and Pittsburgh.[63] For Sickert, however, the international world of both art and politics was becoming less and less comprehensible. The rise of Fascism in his beloved Italy left him nonplussed. He reacted to the universal condemnation of Mussolini's invasion of Abyssinia by retreating into the pages of Goldoni and the drama of seventeenth-century Venice. 'They expect me to be sorry for those black men,' he told Robert Emmons hotly. 'What do I know about them?

* It was perhaps apropos these pictures, and the successive approximations towards the artist's ideal vision that series painting allowed, that Sickert remarked: 'When I paint the first, I say God – ; when I paint the second, I say God save – ; and when I paint the third, I say God save the King'. No third version, however, is known. The picture at the Leicester Galleries was bought by Sir James Dunn, who does not seem to have allowed the break with Sickert to cloud his appreciation of the artist's work.

Have they got any literature like this? But *these* people' – shaking his book – 'I can understand. They are our race. They speak our own language in art, in everything that makes our European life. Abyssinia indeed!'[64] As an expression of solidarity, he made a portrait of Baron Aloisi, the diplomat charged with defending Italy's position against world disapproval. He presented it to the Gallery of Modern Art in Rome: the gallery director was inclined to reject it, but was overruled by the Minister of Foreign Affairs.[65]

Sickert's political compass went even more adrift over Hitler. He was excited by the fact that the new German Chancellor had an interest in painting, and perhaps some talent.[66] He claimed to have written him a letter of encouragement and advice, and to have received back a 'very charming' reply.[67] The gathering clouds of war sailed over Hauteville unremarked.[68]

Sickert's horizons shrank more and more to the worlds of the immediate present and the distant past – to the everyday life of Thanet and the memories of his youth. His talk moved in a steady cycle round the familiar themes. Degas, Whistler, and Irving were the recurring characters of his discourse. His voice and his vocabulary, always rich in effects, took on a yet more distinct and 'Ninetyish' timbre, carrying his listeners back 'to the far-away and long-ago days'.[69] He ceased to write to the newspapers. He retreated into old books, or new books on old subjects, annotating their margins with reminiscences, expostulations, and asides.[70] The only known cine-footage of Sickert shows him shuffling happily around the garden at Hauteville, entertaining a party of neighbours, his now ponderous limbs carrying him with what Wyndham Lewis described as 'a slight la-de-da stagger'. He is easy, gracious, faintly theatrical, twinkling, and benign, his old-world courtesy acting as both a welcome and a defence in the face of his excited guests.*

Sickert lent some works to a small exhibition of local artists mounted by Mr Lovely in the upstairs room of his shop,[71] and his influence was noted on the picture submitted by Mrs Garlick Barnes. The desire to pass on his knowledge of painting remained a constant force. He continued to give occasional lectures, and he began to contemplate starting a new school. Sitting in the garden at Hauteville, he

* The film was shot by the 15-year-old sons of Mrs Garlick Barnes, John and Michael Barnes. They became distinguished film historians.

sketched out to Chloe Forbes-Robertson a fanciful scheme for an open-
air academy, at which the models would pose in a large tree, while
the students sat underneath and drew them.[72] In the event he opted
for a more conventional plan. He took a studio in King's Avenue,
Broadstairs, and announced a new 'school of painting'. On the fence
outside, he wrote in large white letters: 'Walter Sickert – MEMBER OF
THE FRENCH ACADEMY'.[73] A taxi would call at Hauteville each morning
and take him the short distance to King's Avenue. He was never ready.
Often, as his former parlour maid recalled, he would appear, 'very
debonair' in a long shirt and jacket, a scarf around his neck, and a hat
on his head, but 'minus his trousers' – to the amusement of the staff
and the exasperation of Thérèse.[74]

The venture did not prosper. Sickert claimed that it was a victim
of its own success, that all the pupils were so gifted and so promising
that he had felt obliged to award each of them a life scholarship, and
was, as a result, obliged to teach them all for nothing.[75] But it is not,
in fact, known that *any* students signed up. The studio did, however,
abut the grounds of Magdalen Court Prep School, and Sickert – never
exclusive in his vocation – called on the headmaster and offered to
teach drawing to the boys. He refused to accept anything but the
standard lowest fee for his services.[76]

Although his London friends and London dealers continued to visit
him, his connections with the capital grew gradually more tenuous. The
rare trips became rarer: the journey up to town was 'too tiring'.[77]
Nevertheless, he still made it occasionally to visit his own exhibitions.
Besides the alternating annual shows of recent work at the Leicester
and Beaux Arts galleries, the Redfern Gallery mounted two exhibitions
of early paintings in 1936 and 1937. Sickert descended upon the
second of these, dressed not in suave man-about-town mode, but in
his Kentish mufti – the pilot's peaked cap, the poacher's coat, and
thick tweed trousers. Master of the dramatic moment, he strode up to
one of the paintings, peered hard at it, and then announced, 'That's
not a Sickert. It's much too good for a Sickert.' Before another low-
toned canvas he exclaimed loudly, 'Crimey! What is it?' The perform-
ance, as he boasted back at Thanet, put 'the cat amongst the pigeons'.[78]

He created similar consternation at the private view of his Leicester
Galleries exhibition in 1938. He was accompanied around the show
by Oliver Brown's partner, Cecil Phillips, a shy, nervous man only too
aware that everybody in the room was listening to their conversation.

Arnold Palmer, the curator from the Pittsburgh Art Gallery, who was in London to see the show, recorded the scene as Sickert drew up in front of *All We Like Sheep* – a picture showing a shepherd driving his flock along a country road:

> There was a small patch of bare canvas, about 2 inches square, near the left side of the frame. The old man bent down, stared at this patch, straightened himself, pointed with a dead cigar to the white spot and roared 'What's that?'
>
> Phillips: (in low, hurried tones) 'Well, Mr Sickert, I – that is, we weren't quite – er – we didn't know, really.'
>
> Sickert: (loudly) 'Didn't know? But you must have known! Anyone can see what that is. It's a mistake. It got missed out – oh yes, it got missed out. Now, I'll tell you what you can do for me. You see this green (pointing his dead cigar at a highly complex passage of greens) well, get a chap to mix you up some of that green – anyone will do that for you – and then you rub a bit on. See? Now, you'll do that, won't you?'

They moved on to the next picture – a view of a Venetian bridge. Sickert looked at it for some time, then shrugged his shoulders. It was impossible to know whether he meant 'Hopeless!' or 'It's as good as I can do' or merely 'Well, there it is!' The next and last picture was a kitchen interior with a woman sitting over a table. Again there was a long silence. Everyone present had given up all pretence of looking at the pictures, and was openly listening. Sickert 'never batted an eyelid', though he was clearly conscious of the audience. At last he sighed, 'Ah, she was a good cook, that girl, but she's gone back to her own country now.' And with that he shuffled out to the street, with a general 'Au revoir, au revoir' to the gallery-goers.[79]

The regular exhibitions maintained Sickert's standing, and engaged the interest of the rising generations of painters. He found himself taken up and 'in some measure canonized' by the radical spirits of the Euston Road School.[80] The school, established at the end of 1937 as a teaching institution, was run by a quartet of idealistic young painters: Claude Rogers, Victor Pasmore, William Coldstream, and Graham Bell. They sought, in their work and their teaching, to rebel against the perceived intellectual and social elitism of the existing avant-garde. Determined to appeal to a 'wider public', they were led away from abstraction and back – or forward – 'towards realism', turning to scenes of contemporary urban life for their subject matter, to muted tones,

restricted hues, and objective restraint. Their first exhibition, in 1938, was entitled 'Paintings of London';[81] and in Sickert – the leader of the London Impressionists, the painter of Camden Town, the patron of the East London Art Group (to which Coldstream and Rogers had both belonged), the interpreter of modern news photographs – they found a ready hero.

Ironically though, for practical assistance, the group relied much upon the generosity of 'elitist' Bloomsbury. Duncan Grant and Vanessa Bell, whose art was almost the antithesis of the Euston Road ideal, were active supporters of the school and they persuaded their friends and relatives to back the venture. They arranged for Sickert to come and lecture at the school in July 1938 and, before the talk, they gave him and Thérèse lunch in Vanessa's studio at 8 Fitzroy Street, next door to the 'Whistler'.[82]

Duncan Grant, recording his impressions of the occasion, found his friend grown suddenly 'old, very old' – with 'no memory for names and very little for people whom he [had] met in the last 20 years' – though very vivid recollections of names and people before that. He was increasingly dependent upon Thérèse for most things. In conversation she became his prompter, supplying the missing names and words. Yet, despite these signs of age, Grant thought that Sickert seemed essentially unchanged in his egoism, his charm, his vitality, his 'sympathy for youth', his lack of cynicism, his deep seriousness about paintings, and his deep unseriousness about everything else.

The lecture itself was rather a rambling affair, with random reminiscences and numerous jokes, and a long digression upon the ideal studio stove. Sickert alarmed Grant by affecting to believe that Roger Fry (dead since 1934) was in the audience, and he upset Simon Bussy (whom he had known for twenty years) by failing to recognize him. Nevertheless, on the important questions of picture making he was succinct and lucid. An air of 'intense seriousness' came over him as he described how to prepare a canvas, and an air of real interest descended over the audience.[83] Sickert certainly enjoyed himself on what was probably his last visit to London. To reprise the occasion, he invited a group of Euston Road painters down to lunch one Sunday at St Peter's. They were treated to a full display of Sickertian eccentricities. At one moment during the meal – after several bottles of hock had been consumed (mainly by the host) – he announced to his assembled guests, 'You know, you boys, I haven't the slightest idea

who you are or where you come from. You might just as well come
from the moon for all I care. [But] one thing I do know, we're having
a jolly good time.'[84]

Though Sickert's age was apparent to others, he was shielded from
many of its effects. He was still able to do most of the things he
enjoyed. His eating habits were revitalized with the acquisition of a
set of dentures.* And if, in his work, he felt any dimunition of power,
he seems to have set it down to the waning inspiration provided by
Thanet. Another orange had been sucked. He began to hanker for the
stimulus of change: change, that is, after his own fashion. He wanted
to return to another of his former haunts. During the summer, he and
Thérèse went over to Bath to reconnoitre. They found a house to rent,
just outside the city, at Bathampton and they arranged to move into
it at the end of the year.[85]

* Lunching with Will Rothenstein at the time of his 1938 Leicester Galleries show,
he had insisted on ordering oysters, claiming that – without teeth – they were all he
could manage.

BATHAMPTON

In spite of senility there was little to feel sad about. His existence seemed idyllic.
(Cecil Beaton)

St George's Hill House, in the little village of Bathampton, on the outskirts of Bath, was, if anything, even larger than Hauteville. Built of the golden Bath stone, and set down with a four-square, late Georgian solidity upon the slope of the valley side, it carried a touch of the town into the country. There was a sturdy flat-roofed porch at the front, while – at the back – tall windows looked out across the large downward-sloping garden to the River Avon and the wooded steeps beyond.

Sickert was unperturbed by the upheaval of moving, 'only excited', as Thérèse reported, 'at the thought of Bath'.[1] But then the main burden of the move was not his. It fell upon Thérèse. With the help of the gardener, and one of the maids who came with them from Thanet, she soon had the house arranged to their satisfaction.[2] Their odd medley of things was distributed amongst the large high-ceilinged, uncarpeted rooms: the leather upholstered armchairs, the Venetian prints, the Dantan statuettes, the classical bust.[3] The dining room, with its rich red-and-gold wallpaper and Regency sideboard, created a 'truly Sickertian setting'. But otherwise the house seemed rather sparsely furnished, in the conventional sense.[4]

Almost every room, however, was set up for painting, with an easel and a work table, and what one friend described as 'pictures of the most interesting kind' – old prints, recent Sickerts, Victorian photographs. And there were books everywhere, masses of them, and of 'every kind from Greek classics, to [the] Sitwells and George Moore'.[5] In the beautiful room that gave on to the garden at the back of the house, Sickert hung his father's pictures, making the place a 'kind of

sacred centre to his life'. Visitors would almost invariably be taken in and shown these works in an act of respect that was also a kind of pious duty – the 'duty of a son to a father'.[6] Sickert, though he worked in the house, and read in the room he called his 'cabin', also had a further studio in a little barn in the garden.[7]

The fact of change still had the power to ignite his interest and his energy. He was, as he told the eager young reporter from the *Bath Chronicle*, who called soon after his arrival, 'charmed by the city and its people both for their own sakes and as subjects for his art'.[8] He was also charmed by Bathampton. The pattern established at Thanet was repeated, if on a slightly decreased and decreasing scale. He evinced, at first, an interest in all that went on in the village, and the village took an interest in him. He encouraged local children in their enthusiasm for art, inviting them to tea with him. He even consented to judge the village fancy-dress competition and to paint a portrait of the winner.[9] He also entered into the art life of Bath. He made friends with Mr Mendum, the town's leading artists' supply man, and with several of the local painters.[10] He found old friends and connections in the area: Keith Baynes' family were living just across the valley at Swainswick; Lord Methuen (as he had become in 1932) was at Corsham Court; and Ambrose McEvoy's widow was also close by.[11] Excited by the arrival of such a celebrity, the Bath Society of Artists asked Sickert to be their vice-president, but he demurred, preferring to become, as he put it, 'an ordinary member'. And as such he sent to the society's annual exhibitions.[12]

Through Lord Methuen, Sickert was introduced to Clifford Ellis, the head of the Bath Art School,[13] and soon after their meeting he wrote offering to come and lecture to the students once a week.* It was an offer that was eagerly taken up, and for the next year he would appear every Friday at 11.00 'bang on the dot' (usually accompanied by Therèse, which perhaps accounts for the unfailing punctuality) and talk to the students till lunchtime. Though he was still a commanding presence, his 'lectures' had become more rambling, and the thread of argument was often dropped or broken. Structure, such as it was, was

* His letter, received on 23 March 1939, began, with a certain amount of poetic licence, 'It has occurred to me that when in due course of time I am gathered to my fathers, I shall be about the only witness of the work and teachings of the important series Degas, Manet, Monet, Whistler & c. I knew them all personally for years, and worked under them.'

provided by the old prints that he brought in, works by long-cherished favourites: Gavarni perhaps, or Daumier, or Keene. (Sometimes, Ellis recalled, 'rather disconcertingly he would bring a whole set of documents to do with the Tichborne case'.) Ellis would project these images onto a screen with an 'epidiascope' (a novel piece of equipment that Sickert adored), allowing Sickert to 'improvise all sorts of interesting things' by way of commentary.[14]

His remarks upon both the artists and their subjects were, as one pupil put it, 'sometimes surprising, often perverse'. He called the Kaiser 'a charming fellow', and when an image of the author of *Esther Waters* was thrown on to the screen announced: 'Oh, there's George Moore, the darling! Why couldn't he have stayed and been with us now?' (Moore had died in 1933.) Favourite painters were praised, but as often for their personal as for their artistic achievements.[15] And yet amidst these rambling anecdotes and asides he would still impart much 'off-the-cuff wisdom'. Ellis recalled how once, when he had been talking about something quite different, 'out of the tail of his eye he had become increasingly irritated by a coloured lithograph hanging on the wall, and finally he stopped and glared at it and he said: "We don't let off fireworks every day; life is more sad, but more beautiful."' Then, looking about him for some illustration of this point he fixed upon his 'long-suffering wife' sitting beside him. '"There, you see, I know that it isn't done to say that your missus is dowdy, but she is, isn't she?" So we all looked and then he said, "Now, look more carefully, and as you look you will see that that dirty red ribbon round her hat is a crimson, and that scarf at her throat is a tiger-skin."'*[16] As homework he gave each student – and staff member – a picture from *Punch* to 'freely interpret in terms of paint': faint echoes of his own 'Echoes'. But this method of working seemed incomprehensible and 'pointless' to his pupils, even though they 'thoroughly enjoyed' the exercise.[17]

Sickert expected no payment, for he not only enjoyed teaching but regarded it as the fulfilment of 'a duty' towards the community of artists.[18] He would wave aside any expressions of thanks with the assertion, 'We, too, belong to the school.'[19] When an exhibition of work by the students was held at the city's Victoria Art Gallery in June,

* Sickert had suggested that Ellis might like to have a shorthand writer take down the lectures, the copyright of which Sickert would then make over to the art school. If the idea was ever tried, Sickert's ramblings would have surely defeated the stenographer.

he sent along some of his own pictures for inclusion, as well as formally – or informally – opening the show. He caused general amazement in genteel Bath by making this first (and only) 'public appearance' dressed in his extraordinary 'suit of ginger coloured tweed with the coat cut in tails', a scarlet and black woollen muffler tucked inside his waistcoat, and a pair of carpet slippers. More remarkable to those who knew him was the brevity of his speech; he excused himself from saying more on the grounds that, as it was, the students already heard his voice 'so often and so insistently'.[20]

He kept working. With Thérèse's assistance he produced 'Echoes', interiors, townscapes, even a few rare landscapes of the Bathampton vistas. And he continued to sell the canvases, as he completed them, wholesale, to Oliver Brown at the Leicester Galleries. Although old prints and recent photographs (often taken by Thérèse) remained the basis for these paintings, he never lapsed into formula. His visual imagination and his eye remained as engaged as ever. Clifford Ellis's wife, Rosemary, was bemused that, on several visits she made to St George's Hill, Sickert would suddenly fix upon a row of books, all of the same colour and size standing on the shelves in his study. It became something of an 'obsession', and in conversation his mind would constantly return to these 'cherry-coloured books' and the 'good sequence' they were in. Mrs Ellis feared that the fixation might be a mark of senile decay, until she saw *In the Cabin*, his oblique self-portrait (with Thérèse) done from a photograph, in which the row of books appeared prominently across the background.[21]

The real signs of Sickert's age were always difficult to distinguish from his theatrical exaggeration of such traits. His beard grew to an unprecedented wildness and woolliness. He put on what Clifford Ellis described as a wonderful 'old man act' – 'not answering questions unless he felt like it'.[22] When William and Alice Rothenstein came over from Far Oakridge on Sickert's seventy-ninth birthday, they found him in good form, in his ginger suit, '[playing] the centenarian beautifully', going upstairs to 'fetch his teeth before lunch', and descending the steps down to the garden 'on his backside'. With his 'Dieppe sailor's peaked cap' cocked over one eye, and his mane-like beard coming up to meet his cap, there was, as Will reported to Max Beerbohm, 'not much of his face to be seen'.[23]

Although Sickert touched on some of his recent achievements, taking great pride in being the only English member of the Académie

des Beaux-Arts, and dismissing the Royal Academy as 'that old place built on a dunghill' (to which Rothenstein replied, 'No, on nothing so fertile'), it was to the past of his youth that his mind kept returning. The retrospective note was becoming ever more insistent.[24]

Sickert had contemplated writing his memoirs, or had – at least – spoken of it.[25] His friend Blanche had completed a magnificent volume of recollection and gossip, *Portraits of a Lifetime*, in 1937, and was embarked upon a second instalment (*More Portraits of a Lifetime*, published in 1939). But it was clear to those who knew him that Sickert would not take up the challenge. Writing, though it had often been a necessity for him, and sometimes a pleasure, had never been relaxation. Though he continued to read, he had abandoned all literary work. He barely wrote a letter, and he sent no more articles to the papers; and his memory, for all its moments of brightness, was continuing 'to fade at the edges', and fade fast.[26] Rothenstein regretted that the rich store of anecdote and knowledge would soon be lost, for – as he put it – 'he has no Boswell'.[27]

Others, too, seem to have shared this concern. They felt there should be some first-hand record of Sickert and his memories. The writer John Davenport, who lived at Marshfield near Bath, was charged with the task by one publisher; but, though he enjoyed several 'splendid' lunches with Sickert, he made no progress with the project.[28] The task, however, was taken on – with rather more practical zeal – by others. W. H. Stephenson produced a small, privately printed volume, giving an account of his dealings with Sickert, and Sickert's old Highbury Place pupil Robert Emmons began work on *The Life and Opinions of Walter Richard Sickert*, a volume that would combine an outline biography with selections from Sickert's writings on art.[29] Sickert, though content to ramble on about Degas and Whistler, did not want to have to try to remember dates and details of his own life. He excused himself from assisting Emmons, who relied instead on Sickert's friends. It was an uncertain process: 'Half my information from Blanche', Emmons recalled, 'was denied by Sylvia Gosse or Thérèse Lessore – and even those two did not always agree.'[30] Sickert lived to see the book, which came out in 1941. The only amendment he made was to correct the exact phraseology of two lines of dialogue, spoken over fifty years previously.[31]

* * *

In September 1939 war was declared. The Sickerts, who had lived through the beautiful summer of that year 'enjoying the present', had not seen it coming.[32] Its immediate impact was on their finances. St George's Hill House was not cheap to run: Thérèse had had to engage a second maid to help her.[33] Sickert 'called for aid again' from the trustees of his fund, and received another £50. There was, however, only about £200 left in the kitty. Alec Martin decided to push for a Civil List Pension, approached Sickert to sound him out, and found him agreeable – convinced that it 'would be a very great honour'.[34] Initially the Prime Minister's office expressed itself as 'rather chary about granting pensions to artists who have had a great deal of money in their time & have simply squandered it'. Gerald Kelly, however, supported by Kenneth Clark, assured them this was not the case with Sickert. Though it was admitted that the artist had 'always been feckless and extravagant', and that 'if ever a contract put him in funds he blued the lot too soon', more stress was laid on his habit of selling wholesale to dealers, which meant that he had had really 'very little money'.[35] In March Sickert was granted a pension of £170 per annum, payable – on Kelly's advice – in quarterly instalments.[36]

The money arrived as a godsend as well as an 'honour'.[37] It was a time of upheaval. The Bath Art School moved to new premises at Green Park. Clifford Ellis was rather ashamed of the new surroundings: the Kingsmead Flats, an unlovely inter-war housing block, stood opposite the school. Sickert, however, remained adept at discovering the beautiful in unlikely places. Looking across to the flats one day, he noted that the residents had all hung their washing out to dry on the iron balconies that ran across the back of buildings: 'Look,' he said, 'how those people with their few poor things are writing poetry for us.'[38] It was one of the last 'surprising' – if not 'perverse' – insights that he passed on to his pupils. Bit by bit, his attendance at the school had slackened. Soon he stopped coming altogether.

His sister Helena died at the end of 1939. Only his youngest brother, Leonard, was still alive. The troubles of the present sent him back to the comforts of the past. His mind ran over and over the same landmarks in his career. Stories about his days with Irving or his meetings with members of the royal family invaded every conversation.[39] His speech became even more archaic, redolent of the nineties in its cadences and vocabulary.[40] The changes brought by the war bewildered him. When a family of evacuees from Balham was billeted

on him, he struggled to comprehend the situation. His memory needed to be constantly refreshed about these strangers walking about 'his' house, and making themselves at home. Meeting them on the stairs or in the hall, if he did remember the reason for their presence (which he was inclined to consider an intrusion), his courtesy would assert itself: 'he would bow graciously to them, and murmur to himself, "Ah, the Balhams!"'[41]

What they made of his habit of singing 'Deutschland Deutschland Uber Alles' in the bath is not recorded.[42] He burst into a rendition of the German national anthem when Cecil Beaton, who was living nearby, came to lunch together with sundry relatives. Beaton remained unfazed by the performance, aware of Sickert's instinct for the dramatic. He was reminded of King Lear when he heard Sickert babbling away, his mind darting in many directions. But he was a contented Lear: 'He was living almost in the past of his youth, with only a few flashes of the war today.' In the happiness he so obviously enjoyed with Thérèse, Beaton read 'a mellow friendship with a certain play-acting allurement of master and mistress, obedience and revolt'. And above everything there still remained the abiding presence of art. Sickert's painting was ever with him. He continued to see everything in terms of pictures to be made.[43]

Beaton found Sickert at work on a picture of Temple Bar, done from an old print. His excuse for choosing the subject was that he used to dive through the side arch when he went to King's College School.[44] He was just putting in an omnibus. 'You see,' he told Beaton, 'I always wanted to be a bus conductor. That coat over there' – he pointed to a buff coat with a dark velvet collar – 'I like it because I feel like a bus conductor in it.'[45] Beaton, to record the visit, took some photographs of the bus conductor manqué and Thérèse pottering about in their garden.

Sickert continued to travel into Bath, but now – as his mind frayed – he got lost. Wandering weary and confused along the steep streets of the city, he would be rescued by his old friends, the Bath taxi drivers. They would swoop down upon him, gather him up, and bring him home. 'And,' as Thérèse noted, 'they never cheated him of sixpence. Even when [he] twice produced a fiver, he was given the right change.'[46]

The honesty of the Bath taxi drivers did not, however, save the Sickerts from ever-deepening financial worries. Winston Churchill, who had become Prime Minister in May 1940, was anxious to help his friend and arranged for the Civil List Pension to be supplemented

from the Royal Bounty Fund.[47] But, in wartime, money did not go far, and Sickert's finances remained perilously 'frail': an unpaid tax bill for over £80 caught up with him, and the 'pressing danger' of other creditors had to be averted. The rent from Barnsbury Park was reduced to £72 a year, and after the depredations of both Schedule A income tax and War Housing Insurance there was little balance left over. The Sickerts did let their spare rooms at Bathampton to an airman with a wife and small son, which helped 'considerably', but added a new disruption to home life.[48]

The maids left to do war work, and Thérèse found herself unable to replace them. All the local charwomen had been 'taken on by the Admiralty'. Her only help in dealing with the house, the grounds, and her husband was 'a crazy lady gardener'. In the face of such difficulties she coped extraordinarily well. Clifford Ellis's wife, Rosemary, was amazed that she managed 'to keep the house spotless in spite of the floor being carpeted with matches & cheroot ends, so that one couldn't drop a pin between them, while one sits there'.[49] But it was achieved at a cost of effort. As Thérèse confided to Keith Baynes, 'it begins to feel rather much'.[50] Her total absorption in her husband had, moreover, cut her off from some of the sources of local help: she had not returned the calls of her neighbours, or responded to their overtures of friendship. She could not now ask for their assistance.[51] Cares, worries, duties, chores, piled upon her.

Sickert, cocooned in his own world, and protected by his wife's solicitude, remained untouched by these anxieties. He relied upon Thérèse completely. One visitor recalls how, whenever she left the room, or even got up to fetch something, he would cry out, 'Don't leave me, Lainey.'[52] She was 'wonderful with him', according to Rosemary Ellis: 'She does not bully or worry him at all.' He, however, became increasingly difficult. Clifford Ellis, who was attempting to model a portrait bust of him, found him an awkward sitter, unable 'to carry in his head for more than about 15 minutes' the idea that he was posing for a portrait. He might 'suddenly say, "Would you like that door closed" and to the reply "yes" would shut himself on the other side of it.' He was prone also to sudden *idées fixes*. He might take a violent dislike to the electric light set in the ceiling of the drawing room and insist that he could only read by 'a lamp'. When none could be produced he would leave the room altogether and sit instead in the 'very cold draughty hall'.[53]

Thérèse feared that such outbursts might be the onset of some 'illness of the mind', but they seem to have been a means of localizing and diffusing his discontents. He took to blaming anything that annoyed him on Bath. 'The excessive cold was the climate of Bath, the need for blacking out was a regulation of the City of Bath.'[54] In such moods the old restlessness came over him, and he announced a desire to move on, to return to Fitzrovia, or even to Dieppe.[55] They were plans that Thérèse gently deflected; and the moods passed.

Although he had given up his Friday lectures at the art school, he believed he was still teaching. Each morning he would set off to his barn studio at the bottom of the garden to 'take his class'. But there was no class. Thérèse would find him there, sitting patiently waiting for the students who never came, and would comfort him with the promise that they would surely come tomorrow.[56] To the very end, though, he kept working, after his fashion. In 1941 he sold two paintings to the Leicester Galleries.[57] The picture of Temple Bar progressed slowly. He also began a portrait of Mrs Charles Knight, wife of the honorary secretary of the Bath Artists' Association. Breaking with the practice of the past two decades, he painted directly from the sitter. But it never advanced far.[58] His power was failing.

The final collapse came in the autumn. Sickert suffered a series of minor strokes, and then a more serious attack. Finally he became confined to his bedroom. Thérèse was no longer able to cope on her own and nurses came in to help during the day – although they were scarcely more able to manage than Thérèse. Sickert, accustomed to total freedom and unaware that he was ill, was not an easy patient. There were frequent disputes, and Thérèse had to expend yet more energy in soothing all parties.[59]

Through the haze of illness, Sickert was dimly aware that the great survey exhibition of his work, curated by Lillian Browse, had opened at the National Gallery in London, and that it was receiving a generous reception. It marked his formal canonization as an old master.[60] The critic T. W. Earp summed up the general opinion when he described the show as 'worthy of the great artist it reveals', and remarked how through all the different phases of his art his 'gusto and curiosity hold sway'.[61]

The 'gusto and curiosity' were not quite extinguished – even if the

means of turning them into art were. When Marjorie Lilly made a final visit to Bathampton that year she found her old mentor sitting at his bedroom window, lost in a pose of 'dumb acceptance', lost too in his hair, which was thicker and wilder than ever, an untamed mane around his suddenly sunken face. Although his memory was almost gone, his mind still revolved constantly upon visual things, his clear blue eyes noting the grades of tone, the juxtapositions of colour, the possibilities of composition from within their deep orbits. He greeted Marjorie with 'the old affectionate warmth', expressing no surprise at seeing her again after so many years. Uninterested in the rice pudding she had brought up for him, his attention kept wandering back to the view from the window, and soon he began to expound, with a halting urgency, on the picture he saw there. 'Then he pointed to the foot of the bed,' Marjorie recalled:

> He wanted a figure in the composition. I seated myself on the bed and his face lit up, he had now got what he needed, the fall of light on the object 'Yes, yes, that's it!' then he fell back in his chair:
> 'But I can't do it today.'
> 'Never mind, you'll do it tomorrow.'
> 'Yes, tomorrow,' he agreed eagerly, 'Tomorrow.'[62]

Sickert died on the evening of 22 January 1942, sitting peacefully in his chair by the window.[63] During the last weeks Clifford Ellis had visited daily – and sometimes during the night – to lift and carry Sickert, tasks beyond Thérèse's bird-like strength. 'No words,' she later reported, 'can say how kind he has been.'[64]

Sickert's body was cremated at Bristol, to the rather mournful strains of an unaccompanied cello, played by Katherine Powell, the daughter of Thérèse Lessore's sister. The small crowd that gathered included his brother Leonard, Oswald's widow, Major and Mrs Lessore, Oliver Brown, Sir Alec Martin, Sylvia Gosse, Clifford Ellis, and Mr and Mrs Powell.[65] Thérèse was, it seems, too exhausted to attend.[66]

The middle years of a world war were not a good time to die. There was little scope for memorializing. The obituaries were generous but conventional.[67] When reading Étienne Moreau-Nélaton's life of Millet, Sickert had noted in the margin beside a description of Théodore Rousseau's elaborate tomb, 'In my case I presume a monument consisting of a Victorian grained deal chest of drawers & an aspidistra

would be indicatissimo.'[68] But such a scheme was beyond the resources of the time – and of his estate, which was valued at a mere £143. 4s. 3d.[69] Instead, his ashes were interred in the churchyard at Bathampton beneath a wartime utility headstone.[70]

Two weeks later a memorial service was held in London at St Martin-in-the-Fields, across the way from the National Gallery where his pictures were still on view. Clementine Churchill came as a representative of the Prime Minister, and Sir Edwin Lutyens attended in his capacity as President of the Royal Academy. Many who had loved him were there: Mrs Swinton, the Rothensteins, Spencer Gore's widow, Sylvia Gosse, Nina Hamnett, Vanessa Bell. Henry Davray reported the occasion for the *Mercure de France*. The closing hymn was 'Glory to Thee, my God, this night, for all the blessings of the light'.[71]

IV

CHEERIO

For all this the path of classic effort is neither a hidden nor a mysterious one.
(Walter Sickert, in the Burlington Magazine)

Sickert died acknowledged as a great man, and even a great artist. But it remained uncertain what his legacy might be. As an indefatigable teacher he had certainly imbued many pupils with his ideas and his ideals. His most prominent followers, however, artists such as Sylvia Gosse, Morland Lewis, or Lord Methuen, tended towards mere imitation of – or variation upon – his style. It was not a heritage likely to enrich his memory, or connect it to other strands of art.

In death, as in life, he remained hard to categorize. He did not fit at all into the prevailing narrative of 'Modern Art' evolved by the critics, art historians, and curators of the post-war world, a narrative that centred upon Paris and New York, and assumed abstraction to be the goal of development. Within a British context, he appeared a reactionary figure compared to the bold experiments of the Vorticists, the timid experiments of Bloomsbury, or the radical achievements of Ben Nicholson and Henry Moore. Within a world context he was simply ignored.*

And yet as the perspective has lengthened, so Sickert's towering presence has become ever more apparent. In 1960, to mark the centenary of his birth, the Tate Gallery mounted a major exhibition of his

* Sickert's work has never had more than a scant exposure in – and a scant appeal for – the American market. This is one reason why his prices have been and, for the moment, remain comparatively modest, certainly when set beside the millions lavished on his French contemporaries Bonnard and Vuillard, and the sums commanded by later British artists such as Henry Moore, Francis Bacon, and Lucian Freud. Sickert's auction record, established in London in 1993 for a version of *The Brighton Pierrots*, is £200,000; and £60,000 will still secure an excellent example of his work, whilst a drawing can be got for a little over £1,000.

work. In 1981 there was a thrilling show at the Hayward Gallery in London of his late paintings (works that had been almost totally neglected since his death), and in 1992 Wendy Baron and Richard Shone curated a magisterial survey of his oeuvre at the Royal Academy. These exhibitions confirmed the immensity of Sickert's achievement. New generations found his work unexpectedly potent, diverse, and rich in suggestion. It seemed to cast a warm shadow forward over much of late twentieth-century art.

Sickert's use of found images – old prints and news photographs – prefigured the 'appropriation' of mass media by Andy Warhol, Richard Hamilton, and other pop artists, whilst his fascination with rendering photographic sources in paint caught an echo in the work of Gerhard Richter and his followers. His employment of studio assistants to prepare, and in some cases even execute, his work, though it consciously harked back to methods of the Renaissance masters, also looked forward to the impersonal production techniques of artists as diverse as Warhol, Bridget Riley, or Damien Hirst.

Sickert's gleeful manipulation of the press, his deliberate use of shocking or topical subject matter, his knack of turning his paintings into 'news', have become the established ploys of the current generation of Young British Artists – and indeed young artists of every nationality. At another level, it has even been suggested that there is a lineal connection between Tracy Emin's unmade bed and the rumpled sheets of Sickert's Mornington Crescent nudes.[1]

The central element of his legacy, however, was his extraordinary reinvigoration of the British figurative tradition. It was an achievement of his whole career, from his early music-hall scenes to his late portraits, though it came into sharpest focus, perhaps, during the early 1900s with his compelling depictions of nudes and his subtly charged 'conversation pieces'. Sickert imbued British figurative art with a new rigour, a new robustness, a new intensity. He freed it from the constraints of taste, prudery, and fashion.

The life he gave it has proved extremely fecund. Looking back over the art of the second half of the twentieth century, it is figurative painting – and British figurative painting at that – that stands as one of the brightest beacons in the landscape. It is in the diverse yet related work of David Bomberg, Francis Bacon, Lucian Freud, Paul Kossoff, Frank Auerbach, David Hockney, William Coldstream, Euan Euglow, R. B. Kitaj, and Howard Hodgkin that the strongest pulse of artistic

vitality is felt. Without the achievement and example of Sickert it seems certain that this would not have been the case.[2] His influence is everywhere apparent.

Although Bomberg attended Sickert's classes at Westminster, and Coldstream heard Sickert lecture, and though Kossoff and Auerbach exhibited – like Sickert – at the Beaux Arts Gallery, it would be wrong to regard them, or any of the other artists, as 'followers' of Sickert in the conventional sense. All, however, acknowledged his power, benefited from his victories, and – in their very different ways – responded to his challenge.

As the Australian–American critic Robert Hughes acknowledged, Sickert's artistic heirs 'now strike us as not just a footnote to, but an essential part of, the visual culture of the past eighty years: neither "provincial" nor "minor" but singular and grand'.[3] It was Sickert who set the standard of singularity and struck the still reverberating note of grandeur.

POSTSCRIPT

WALTER SICKERT: CASE CLOSED

Oh it is splendid to be accused of things.
I have been accused of everything and have always pleaded guilty.
(Walter Sickert, quoted by Denys Sutton)

Walter Sickert was not Jack the Ripper. And in the words of Patricia Cornwell, I am prepared to stake my reputation upon the point. I do so with regret (a regret shared, I am sure, by my publisher): for the commercial prospects of any book claiming that someone is *not* Jack the Ripper must always be very much less than those of one suggesting somebody is. The truth, however, will out.

The tangled story of Sickert's involvement – or non-involvement – with the Ripper crimes is one that can perhaps best be understood by being told from the beginning. During his own lifetime (aside from that midnight encounter with the Copenhagen Street tarts: see page 160) there was never any suggestion that he was the Ripper. It was well known that he had a keen interest in the mystery, as he had an interest in the cases of the Tichborne Claimant, the Camden Town Murder, and Dr Crippen. But his interest dated from the early 1900s and was based primarily on the accident of his renting rooms in Mornington Crescent formerly occupied by the veterinary student who was perhaps the real Ripper (see page 389). For eighty years after the crimes, and for thirty years after Sickert's death, no book or article published on the subject suggested that Sickert was in any way implicated in the killings.

That, however, changed at the beginning of the 1970s; and it changed as a result of one man: Joseph Gorman. Joseph was born in 1925 in Camden Town, one of five children of William and Alice Gorman. He died in 2003. In adult life Joseph took up painting and picture restoring. Amongst the defining points of his personal history was the fact that his mother, *née* Alice Crook, was illegitimate. She

was born in 1884 at the Marylebone Poor House to Annie Eliza Crook. The birth certificate lists no father. Joseph in his later years set about filling in this blank space.

Sickert was his first choice. At some moment in the late 1960s he presented himself at the Beaux Arts Galleries – then run by Helen Lessore, sister-in-law of Sickert's third wife, Thérèse; he announced himself as Joseph Sickert, claiming to be the illegitimate grandson of Walter. The fact, if not impossible, seemed curious and highly improbable. It was odd that he had not presented himself before, and that Sickert had never mentioned having either a living daughter or a grandson. It was odd, too, that Joseph should have adopted the name of his maternal grandfather.[1]

Joseph, however, soon modified his tale. Not content with having Walter Sickert as a grandfather, he subsequently announced that he was instead the grandson of Prince Albert Victor (eldest son of Edward VII), and the *son* of Walter Sickert. (He re-amended his name to 'HRH Joseph Sickert'.) His story became more complex – and it touched, for the first time, upon Jack the Ripper. He claimed that his grandmother, Annie Crook, while working as a shop girl in Cleveland Street, had become secretly married to Prince Albert Victor, who – so he asserted – had been taking drawing lessons from the young Walter Sickert at a studio nearby. She had a child by him (Alice Crook, Joseph's mother). The fact of this clandestine marriage became known to Mary Jane Kelly, a local prostitute and friend of Annie's, who recognized the potential for blackmail: the scandal of the secret liaison, and the constitutional danger posed by the fact that Annie was a Roman Catholic, might have brought down the monarchy. It was to prevent the marriage coming to light, and to scotch the blackmailers, that Lord Salisbury, the Prime Minister, persuaded the Royal Physician, Sir William Gull, together with two fellow Freemasons, to embark on a carefully choreographed killing spree. Mary Kelly, and five female cronies who were party to the secret, had to be rubbed out. Their violent deaths (all carried out in a shuttered coach, and displaying signs of masonic ritual) became known as the Whitechapel Murders, and were ascribed to the elusive fiend Jack the Ripper.

Annie Crook herself, according to Joseph, rather than being murdered, was kidnapped and incarcerated in a mental institution, while her daughter – after surviving two attempts on her life (by runaway coaches) – was spirited away to Dieppe by Walter Sickert, where she

was brought up. She subsequently returned to London and married William Gorman; but then – in later married life – she became Sickert's mistress, and Joseph's father. Walter Sickert, Joseph claimed, was aware of the details of the Ripper plot, though not involved in it. He concealed coded references to it in some of his paintings, and, before his death in 1942, passed on a full description of events to the young Joseph.

It is uncertain exactly when Joseph evolved this extraordinary tale.* It probably lies behind the stray reference in the 1970 edition of Donald McCormick's book *The Identity of Jack the Ripper* suggesting that Sickert 'was believed to have made sketches & paintings of the Ripper crimes'.[2] Certainly when, in 1972, the BBC producer Paul Bonner began researching the Ripper murders for a television series, to be fronted by the fictional *Z Cars* detectives Barlow and Watts, he became aware of it. A contact in the press office at Scotland Yard put Bonner on to Joseph Sickert and, after a certain amount of evasion, Joseph consented to be interviewed. He was paid £50.[3]

The story provided one episode – amongst several – in the series, and Barlow and Watts dismissed it as the least plausible theory. But its potent blend of masonic conspiracy, East End prostitution, and royal sex scandal made it enormously attractive. It was taken up by a young journalist called Stephen Knight. He went back over the story with Joseph, adopting most of its claims but modifying it in one vital characteristic. He made Walter Sickert not merely an informant but a co-conspirator in the plot. (As he justifiably pointed out, how could Sickert expect to know so much about it all if he was not actually there.) His book, *Jack the Ripper: The Final Solution* had a huge commercial success, far greater than that of any previous publication on the subject.

Historians of the murders, however, remained unimpressed. The absurdities of the Joseph Sickert story, in both its original and modified forms, were manifold. It was a conspiracy without a point. If Prince Albert Victor really had contracted a clandestine marriage with a Roman Catholic shop girl it would have posed no threat to the crown. The union, having been made without the sovereign's permission, would have been illegal under the Royal Marriages Act of 1772, and

* The notion that some royal conspiracy might lie behind the murders had a long history, but Joseph Sickert gave it a new form and colour.

could have been simply set aside. And if it were absolutely necessary to kill someone to cover up the scandal, why not just murder Annie Crook and her daughter, rather than five disenfranchised prostitutes who would have had a great deal of trouble getting their story heard in the press or anywhere else?

The idea, too, that the ageing Walter Sickert had recounted the whole story in all its baroque detail to the infant Joseph, and to no one else, taxed credulity. Sickert, it was pointed out, was no longer living in London by the time Joseph was nine, and he died when Joseph was seventeen. Joseph, moreover, had waited almost thirty years before passing on the tale.

On closer inspection, moreover, the story broke down at almost every point. Annie Crook, it was shown, was not a Roman Catholic. She was not incarcerated for life in a mental hospital. Walter Sickert's supposed connection with the events described had no basis in fact. There was no evidence that he ever had a studio in Cleveland Street. In any case, 15 Cleveland Street, the address ascribed to him by Joseph Sickert and Knight, had been demolished in 1887, a year before he was supposed to have been using it. Sickert never met Prince Albert Victor, let alone taught him drawing. There was nothing to suggest either that he had spirited a young ward to Dieppe in the 1880s, or subsequently had an affair with her in the 1920s.[4]

In the face of these revelations, and following a dispute over proceeds from *The Final Solution*, Joseph Sickert retracted some of his claims. In 1978 he told the *Sunday Times* that the story of the masonic Ripper conspiracy was 'a hoax, I made it all up'. He clung, however, to his insistence that he was the natural son of Walter Sickert (and the grandson of Prince Albert Victor).

It is difficult to believe him, and not only because he had already once altered the details of his supposed relationship. Joseph Sickert was a man who added greatly to the gaiety of the nation. He was a 'character', of the sort whom Walter Sickert would certainly have enjoyed. But he contributed little to the world's store of factual knowledge. He had an extremely inventive mind (he informed Colin Wilson that he regularly went to tea with the Queen).[5] When I met him in 2000, he told me many interesting things. None of them, however, seemed to have a basis in fact. He claimed, for instance, to have been left several Sickert pictures in Thérèse Lessore's will. But Thérèse left no will. In the measured words of *The Jack the Ripper A–Z* – 'extreme

caution is recommended in examining any story emanating from or otherwise associated with Mr [Joseph] Sickert'. The idea of kinship with the great was clearly an important part of Joseph's self-mythologizing, and as a native of Camden Town with artistic aspirations it is perhaps not surprising that he latched on to Walter Sickert (founder of the Camden Town Group) as an ideal forebear.*

Neither Joseph's retraction of the royal conspiracy story, nor the discrediting of Knight's book, had much effect. The fantastical tale was simply too good to let go. Indeed Joseph himself, after Stephen Knight's early death, subsequently retracted his own retraction, claiming, instead, that he had not given Knight the 'full' story.

In 1990 the royal conspiracy tale was recycled by Jean Overton Fuller in her book *Sickert and the Ripper Crimes*, this time with Sickert as the sole perpetrator rather than as Sir William Gull's assistant. Ms Overton Fuller claimed to have learnt her version of events from her late mother, Violet, who had been told it by Sickert's friend of the early 1890s, the painter Florence Pash. The claim is certainly false. The collection of Florence Pash's letters from Sickert, edited by Violet Overton Fuller (now at Islington Public Library), was compiled specifically because, having 'read much about Sickert . . . [Florence] did not think that his unfailing kindness and gaiety of heart had been sufficiently emphasized'.[6] Unfailing kindness and gaiety of heart are not characteristics associated with mass murderers. Neither the letters, which date from between 1890 and 1922, nor Florence's discursive notes contain any allusion to Sickert's secret career as Jack the Ripper. Jean Overton Fuller's story, moreover, is very obviously based, not on independent information, but on Stephen Knight's book: it repeats both its assumptions and its errors.

* It is at least possible that Joseph was guided towards his ideal by his friend and mentor Harry Jonas (1893–1990). Jonas, a moderately good painter and, according to Michael Parkin, 'a great romancer', worked with Joseph on the restoration of the interior of the Catholic church in Soho Square. Jonas had had studios in Fitzrovia (first at 21 Fitzroy Street, then at 35 Maple Street) in the late 1930s and early 1940s – well after Sickert had left the area. (Before that he was based in Knightsbridge and Brook Green.) Jonas had never known Sickert. He claimed, nevertheless, to have seen him often. In 1950 he recalled that, in former times, Sickert was 'frequently to be seen walking across [Fitzroy] street from one studio to another with his palette in one hand and his canvas or easel in the other' (Fred Sinclair, 'He Painted Camden Town', *St Pancras Journal*, vol. iii, no. 8, January 1950, 144). Jonas was certainly party to Joseph Sickert's Ripper story. The television interview with Joseph was originally scheduled to have taken place at Jonas's house in Myddelton Square, before being relocated to Joseph's home in Queen's Crescent, Kentish Town (BBC archive file).

One example will suffice. Ms Overton Fuller describes how Lord Salisbury called on Walter Sickert at his studio in Dieppe and paid him £500 for a small picture of a boating scene – a sum way beyond the value of Sickert's paintings at that time. She suggests that this gross overpayment was a bribe, to ensure Sickert's silence over what he knew of the Ripper murders. Exactly the same story occurs in Knight's book. The event, however, never happened. As was pointed out by critics of Knight's account, his tale was based on a careless misreading of an anecdote told by Sickert – and recorded by Osbert Sitwell – about Lord Salisbury purchasing a boating scene for £500 from another Dieppe painter called Vallon. (The story is confirmed by the fact that the picture is still in the Salisburys' collection at Hatfield House. They do not possess a Sickert.)

Overton Fuller's book, claiming to derive from Florence Pash, appeared to offer a spurious independent corroboration to Joseph Sickert's story. It was used by Melvyn Fairclough in his 1991 publication *The Ripper and the Royals* as supporting evidence to back up Joseph's new – and yet more convoluted – account of the royal conspiracy (with Lord Randolph Churchill now replacing Lord Salisbury as the chief perpetrator).

Neither of these new books achieved the success of Knight's tome, though both received the same critical mauling from 'Ripperologists' – and for the same reasons: improbability, impossibility, and factual inaccuracy. Fairclough has since distanced himself from many of the claims made in his book, and the kindest verdict on Overton Fuller's work is that 'it should be treated with extreme caution until valid corroborative evidence is provided'.[7]

Despite the general derision heaped on the publications of Knight, Overton Fuller, and Fairclough, they (together with the original Barlow and Watts TV programme) have fatally served to connect Walter Sickert and the Ripper crimes in the public mind: without them, it should be recognized, no direct connection would exist.

The point is an important one. It meant that in May 2001 when the American crime writer Patricia Cornwell decided to investigate the Ripper killings and reviewed the list of established 'suspects', she found Walter Sickert at the end of the line-up. But for Joseph Sickert's mad royal conspiracy story, and the books derived from it, Sickert would have been safe in decent art-historical obscurity – along with Whistler, Sargent, Wilson Steer, and everyone else; and it is very much to be

doubted that Cornwell, in her search for a culprit, would have fixed upon him there. Chance (or Joseph Sickert), however, had put him in the frame. And there Cornwell, as she described it, 'locked onto' him.

In her book, Cornwell offers no very clear explanation as to how she came to choose Sickert as the likely culprit. It seems to have been a matter of whim, or intuition. By her own account she was directed towards Sickert as a 'very weak suspect' by John Grieve at Scotland Yard on the grounds that 'he had painted some murder pictures'.* Cornwell, however, ignoring the claims of the Camden Town Murder pictures, turned up Sickert's painting of Ada Lundberg performing at the Marylebone Music Hall and decided that the open-mouthed singer looked as if she was 'screaming' while 'the leering menacing men look on'.[8] And that was enough to convince her that Sickert was not just 'evil', but the maniac responsible for the Whitechapel murders. She found her suspicions amply confirmed by his other works. Pictorial clues began to mount up – in her imagination if nowhere else. There was a visual resemblance between one of Sickert's paintings (of a woman reading a newspaper, done in 1905) and a morgue photograph of one of the Ripper's victims. The brownish tint of some liquid in the decanter in his celebrated canvas *Ennui* suggested blood to her. But, though she readily took up the idea of Sickert being the killer, she ditched the whole creaking royal conspiracy pantomime, indeed she makes no reference to the works of Knight et al., or to the ramblings of Joseph Sickert – perhaps aware that to acknowledge them and dismiss them would expose the fragile bond linking Sickert to the crimes. Instead of conspiracy, she opted for science and psychology.

Since criminal profilers informed her that the murders were probably the work of a lone psychopath driven by a hatred of women, she moved quickly forward to the conclusion that this was exactly what Sickert must have been. It is a good sort of theory to hold because it

* Sickert's use of the 1907 'Camden Town Murder' as a title for several pictures has, since the advent of Joseph Sickert's theories, been elided with his interest in the Ripper crimes to produce the unfounded claim that he made paintings of – or based upon – the 1888 Whitechapel murders. He did not. If he had done there is no reason to suppose that he would not have advertised the fact as a useful means of attracting publicity. Others did use such a ploy. Paul Begg, a noted authority on the Ripper crimes, has drawn my attention to an interesting notice in the *Atlanta Constitution* newspaper (1 December 1888), which claims that Whistler was planning to produce a 'horrible picture' of the body of one of the Ripper's victims. There is no suggestion that Sickert planned to follow suit (and no evidence that Whistler ever did such a painting).

can accommodate any objection. That Sickert lived a long, happy, sane, productive life counts for nothing. That none of his friends, family, wives, colleagues, lovers – or biographers – thought he was a homicidal maniac cuts no ice. Such apparent normality is just what one (or rather Ms Cornwell) would expect. Crazed psychopaths are after all notoriously devious.

Having started with her conclusion, Cornwell attempts to justify it. Motives must be found for Sickert's supposed homicidal hatred of women. He had, we are informed, an 'abusive father' and a malfunctioning penis. However these two facts might stand as possible motives, both claims are demonstrably false. Walter's father, Oswald Adalbert Sickert, may have been aloof, introvert, and disappointed by life, and he may sometimes have subjected his family to his moods, but even by the standards of modern American victim culture it is stretching things to call this 'abuse'. Walter, moreover, adored his father and was devastated by his early death in 1885. He frequently referred to him in terms of admiration and affection. He cherished the memory of their daily walks together. He received his first instruction in art from his father, and fondly remarked, 'I never forgot anything he said to me.'

As to Sickert's penis . . . well. As has been mentioned in the text, the infant Sickert was brought to London (by his father) in 1865 to have an operation for a fistula at St Mark's Hospital in the City Road. In later years he would claim that he had come to London to be circumcised, a procedure not obviously necessitated by his condition. From this remark (and an unguarded comment on it by the painter John Lessore, nephew of Sickert's third wife, a man who was three when Sickert died) Cornwell leapt to the conclusion that Sickert's 'fistula', rather than being of the common anal type, was some sort of unspecified complication of the penis and (in a further leap) that the operation was a deeply traumatizing event – probably performed without anaesthetic – that left Sickert severely incapacitated in that department, perhaps even emasculated. There is nothing to support these claims, and much to stand against them.

In the 1860s, St Mark's advertised itself as a hospital that dealt exclusively with 'diseases of the rectum'. For a penile fistula Sickert would surely have been referred to the specialist genito-urinary hospital, St Peter's, Covent Garden. It seems more probable that Alfred Cooper merely took advantage of his patient's anaesthetized state to

effect what he considered would be a helpful and healthy additional service. Mrs Sickert seems to confirm the rectal nature of the problem with her comment in a letter to her friend Penelope Noakes dated December 1865 that, after returning to Neuville from the operation, 'Wat had some baths and now is back eating well and is growing fat & easy'. As to the impact of the operation, Sickert always referred to the procedure in positive terms. He even ascribed his love of Islington to it. It was certainly not a trauma. In later life he would fondly recall the sensation of looking up at his father's face as he sank beneath the effects of the chloroform.[9]

Detailed information about the exact condition of Walter Sickert's genitals is, of course, hard to come by – as it is for most figures of the late Victorian period. He did not, though, as Cornwell hypothesizes at one moment, have to urinate sitting down. (When his friend Anzy Wylde boasted of having shot a kakapo – a species of exotic bird and also a slang term for a chamberpot – Sickert wittily replied, 'I have spent my life overshooting them.'[10]) It is true that on one occasion while contemplating the window display of a plumbers' supply shop in Charlotte Street he did remark to Augustus John, 'I wish *I* had a brass cock', but it would be wrong to read a whole history of penile incapacity into this idle jest.[11] Such evidence as does survive suggests that Sickert's member was in good working order. Even if he had a low sperm count, as has been suggested, he most certainly was not impotent. He fathered at least one child. He slept with numerous women, and those who, in that more discreet age, recalled the fact did so with pleasure.*

He was not, on the evidence of his friends and contemporaries, a woman hater. He loved the company and conversation of women, and there are many records of his generosity and kindness to his female

* Further indirect support for the healthful state of Sickert's member is offered by his liberally annotated copy of the Tichborne Claimant trial, now in Lincoln's Inn library. An important element in the case was the fact that the Claimant had a curiously formed (but fully functioning) penis, and so it was alleged had Roger Tichborne. Roger Tichborne, however, it was also asserted, had become, at least for a period, impotent. When courting his cousin he had written to her mother enclosing a 'withered leaf' – which according to the lawyers, and to Sickert's annotations, was an indication of impotence. Throughout the book Sickert, in his annotations, draws comparisons between his own experiences and those of the various protagonists. But, though he comments several times on the Claimant's penile condition and Roger's impotence, he never relates either to his own experience, as he surely would have done if there had been any connection.

friends. But he was, like many artists, selfish. He would let nothing get in the way of his work; and in his paintings he tended to adopt towards his female subjects, as towards his male ones, a deliberately objective attitude, devoid of sentiment and pathos. It was an attitude that in part he learnt from his great hero Degas (who has been called a misogynist with perhaps more justification, though he has not yet been accused of being a mass murderer). Some observers described Sickert's vision as ironic, others cynical, some even thought it cruel. But this is still a long way from the impulse to go around murdering prostitutes.

Nothing in the established record of Sickert's life connects him with the killings. So, in the absence of anything concrete, Cornwell attempts to accumulate a body of 'circumstantial evidence' with which to implicate him. She invents an imagined history for Sickert. We are told that he frequented the streets of Whitechapel late at night and that he consorted with prostitutes. Even if true, this would be pretty tenuous stuff, but there is scant evidence to support her claims. Although Sickert was never faithful to his first wife Ellen, his infidelities seem to have been with women of his own class rather than with prostitutes. Indeed Sickert's experience of commercial sex appears to have been quite limited. In Venice in the early 1900s, when divorced from Ellen and living alone, he admitted to visiting the local prostitutes once or twice, and got his first dose of clap as a result.[12] It is hard to believe that if he had been consorting with Whitechapel prostitutes throughout the 1880s he would not have picked up something then.

The evidence of Sickert's existing pictures also contradicts Cornwell's claim that Sickert knew the East End well. In his search for subject matter he frequented the music halls of central London, Islington, and Camden Town, but only very occasionally – when working on a picture of a particular music hall artiste – might he follow her from hall to hall into the East End, to Poplar perhaps or Shoreditch. Sickert's known excursions into Whitechapel itself in the 1880s are very few. There is one early etching by him, done around 1884, of Petticoat Lane; and he did a drawing of Emily Lyndale at the Paragon Music Hall in Mile End Road in June 1888. And that is about it. There is no body of evidence to suggest that the streets and courts where the murders occurred, and into which the murderer was able to escape with such ease, were Sickert's habitual stamping ground.

Moreover, for much of the late summer of 1888, when the Ripper

was at work, Sickert was abroad. At the distance of over a hundred years the exact chronology of his holiday is impossible to establish but it can be pieced together in outline. He probably left London around the middle of August: he did a dated drawing in the music hall at Hammersmith on 4 August 1888, but after that there are no references linking him to London for a full two months.[13] At some moment he went to Paris, where he saw the Halévy family and talked to them about Degas,[14] and by early September he was staying with his mother and brothers at St Valéry-en-Caux on the Normandy coast.

On 6 September – six days after the murder of Mary Ann Nichols (the Ripper's first victim) and just two days before the murder of Annie Chapman (his second) – Sickert's mother wrote to her friend Mrs Muller describing the happy time they were all having together in France. 'We are going on very well,' she writes. 'Walter and Bernhard talk and paint and both look and are very well.' She mentioned that Oswald had to be back at his school on 20 September but that she planned to stay on 'for Leo's sake' until 1 October.[15]

Sickert himself wrote from St Valéry to Jacques-Émile Blanche at Dieppe remarking, 'This is a nice place to sleep & eat in, which is what I am most anxious to do now.' He also asked his friend to find out 'if the Dieppe colourman could send my brother some pastel glasspaper & sandpaper canvases'.[16] The letter is undated but its tone suggests that it predates Mrs Sickert's 6 September letter. Sickert seems to be at the beginning of his seaside holiday – content to eat and sleep, and only just beginning to think about work. It also reveals that it was not particularly easy, or convenient, to nip backwards and forwards to Dieppe. Sickert was still at St Valéry with his family on 17 September when Jacques-Émile Blanche visited them on a two-day trip from Dieppe.[17] On 21 September, Ellen Cobden-Sickert wrote to her brother-in-law, Richard Fisher, mentioning that Sickert was in Normandy visiting 'his people' and would be, or had been, gone some weeks.* It seems likely that Walter stayed on in France with his mother until the beginning of October. Certainly he painted a small picture of the butcher's shop at St Valéry flooded with late summer light and he titled it *October Sun*. (The Ripper's third and fourth murders, of

* Patricia Cornwell (*Portrait of a Killer*, 214) is the sole source for this interesting letter, but she does not quote it fully, or give its location. It is not in the Cobden Archive at Chichester.

Elizabeth Stride and Catharine Eddowes, occurred in the early hours of 30 September.)*

All this might seem to add up to a pretty good alibi. Cornwell, however, ignores it. Much of the evidence quoted above she fails to recount at all; and, in so far as she does acknowledge it, she is prepared to strain credulity with the suggestion that Sickert was able to slip away at moments during the holiday (either unnoticed or making excuses to explain his sudden absence), ride into Dieppe, get the night boat across to Newhaven, take the train up to Victoria, cross London, satisfy his lust for blood by killing a prostitute, and then return refreshed to continue his seaside holiday, without provoking the suspicion of his family.† Indeed she fails to recognize that Sickert was staying with his family at all, misinterpreting the expression 'his people' as his 'cliquish artist friends', rather than his relatives.‡

Usually, discussions about the true identity of Jack the Ripper focus on the question of why the murders stopped after the killing of Mary Jane Kelly on 9 November 1888. Did the killer commit suicide, leave the country, die of natural causes, complete some arcane plan, get locked up in a lunatic asylum? This might be thought to present a problem to Cornwell as Sickert went on living – and mainly in London – for a further fifty-four years. Why did he suddenly stop murdering prostitutes? Her answer is simple. She claims that he did not stop. Going through old newspapers and police reports she cheerfully reascribes a host of long unsolved murders to Sickert – most of them

* Against this supposition there stands the evidence of a Sickert music-hall drawing now at the Walker Art Gallery, Liverpool, dated '29 September'. No year, however, is given, and it is by no means certain that the drawing dates from 1888. Sickert was drawing regularly in music halls from 1887 to the early 1890s. Another drawing, of Collins' Music Hall, dated 4 October 1888, shows that he was back in London by that date.

† Although there was a railway station at St Valéry, there was – in 1888 – no direct rail link with Dieppe. The circuitous journey could be accomplished via Rouen in 2½ hours. Alternatively, there was a horse-drawn omnibus service that took four hours. It ran every day during August, except Sundays.

‡ Cornwell's notion that Sickert's holiday in France was an elaborate plot to throw people off his scent does not add up. Sickert, in later life, never made a point of stressing that he was in St Valéry-en-Caux that summer – as he would surely have done if he had been anxious to establish an alibi. Indeed he could never remember which year he had been there. When he came to date an old drawing of a woman ironing done that summer, he marked it 'S. Valery en Caux 1887–8–9?' (drawing at Leeds City Art Gallery).

displaying entirely different characteristics to the Ripper crimes. She pins the Camden Town Murder onto him, and she even decides that he probably murdered his beloved second wife Christine, who died in 1920 after a long battle against tuberculosis.

In the absence of all logical or circumstantial connection between Sickert and the Ripper murders, Cornwell seeks other avenues of connection to justify her theory. The one enduring relic associated with the Ripper's name is the huge cache of letters sent to the press, the police, and other authorities by people claiming to be the murderer: it was in one of these letters, received on 17 September 1888, that the name of 'Jack the Ripper' was first used.[18] The letters are now preserved at the Public Record Office and at the Guildhall Library in London.

At the time, the police dismissed most, if not all, of these letters as the work of cranks, attention seekers, and unscrupulous journalists; several people were even charged and convicted for sending such items. The letters, although long known about, have only recently become available for study. On examining them, the majority of students of the Ripper case have concurred in the original police verdict. They are the work of cranks. It has, after all, become a recognized fact of modern crime investigation that, on the whole, 'Killers don't call, and callers don't kill.' Certainly Stewart P. Evans and Keith Skinner, who edited an almost complete selection of the letters for their book *Jack the Ripper: Letters from Hell*, remain sceptical; and to read through their very full collection of transcripts and facsimiles it is hard not to agree. Faced with this consensus, Cornwell simply ignores it. She has convinced herself that, since most of the letters are signed by 'Jack the Ripper', most if not all of them are the work of the murderer. And since, according to her circular argument, Sickert was the murderer, then they are also the work of Sickert.

Cornwell has striven to make connections between the six hundred or so extant 'Ripper' letters and elements of Sickert's life, and with such a large pool of material to draw on it is of course very possible to forge superficial links. On the grounds that some of the letters include crude sketches of knives and skulls and figures it is asserted that they are the work of an 'artist'. She considers it significant that a few of the letters contain snatches of doggerel, as Sickert too sometimes wrote bad verse. It would be possible to make such connections between letters in the collection and almost any late nineteenth-century figure. The game is made even easier when lack of similarity

counts for as much as similarity. The fact that the many and various handwriting and literary styles of the 'Ripper' letters in no way resemble Sickert's becomes – for Cornwell – an example of Sickert's devious ingenuity, and a reflection of his artistic training.

In making her connections, Cornwell has also sought the assistance of science. She sets great store by the potential of DNA evidence to clear up the mystery. The acronym has the comfort of a mantra for her. She aimed to match DNA found on the 'Ripper' letters to DNA belonging to Walter Sickert. It is an entirely redundant exercise as there is no way of recovering a definitive trace of DNA either from Jack the Ripper (whoever he might have been) or from Walter Sickert against which such findings could be properly checked. No confirmed physical traces of the Ripper's existence survive at all. None of his victims pulled any hair from their attacker's head, or drew his blood with their fingernails. He remains a phantasm. Sickert is scarcely less elusive. His grave at Bathampton might have provided a definitive sample, but – alas – when he died in 1942 he was cremated before being buried. No trace of DNA would have survived the fire. He has no living descendants. Nor did he leave any of his admirers a lock of hair from which the evidence might be gleaned.

Nevertheless, Cornwell has spent her millions buying up (if not cutting up) Sickert pictures, letters, and related artefacts in the hope of recovering 'traces of DNA', as if on objects that have been handled hundreds of times over the past 110 years there can be any way of knowing which of the myriad 'traces' – if any – might have belonged to Sickert. And then she has sought to match them with traces found on letters at the Public Record Office and the Guildhall (a task made difficult by the fact that most of the PRO letters have been heat-sealed in plastic coverings for conservation purposes).

The tests have proved fabulously unrevealing. It transpired that there were insufficient traces of nuclear DNA on the letters and artefacts to provide any information at all. It became necessary to fall back upon something called 'mitochondrial DNA', an altogether less specific indicator. Here Cornwell's long-suffering hired expert did come up with several findings. He even made a partial match between some traces (from amongst many) taken off various Sickert letters and a trace from a 'Ripper' letter at the PRO. The aura of science hovers around this discovery, but it remains almost meaningless. There is no way of connecting the samples in any way with either Walter Sickert

or Jack the Ripper, and it is impossible to know *who* the mtDNA samples belonged to in either instance, or when they dated from. And despite the partial 'match', there is only an infinitesimal chance that the traces belonged to the same person. Mitochondrial DNA matches are common to between 1 per cent and 10 per cent of the population. (Cornwell prefers the 1 per cent figure.) Even assuming that all the samples dated from 1888 and came from UK residents, the range would encompass a group of between 400,000 and 4 million people. Even the bullish Cornwell is obliged to admit that such evidence must always remain both questionable and inconclusive.[19]

She is less circumspect about the findings of another of her team of experts. Peter Bower is a respected paper historian. With his extensive knowledge of paper manufacture, he has been employed by both the Tate Gallery and the police to authenticate drawings and documents. He is a registered 'expert witness'. As part of Cornwell's 'team' he located several 'Ripper' letters in the PRO and Guildhall archives written on the same brands of writing paper as were used – on occasion – by Walter Sickert in the years immediately after the Ripper murders. (With a cache of six hundred letters to work from, the coincidences were not remarkable. According to Nigel Roche, curator of St Bride's Printing Library, there were only about ninety paper mills operating in Britain in the late 1880s, and the brands used for both Sickert's and the 'Ripper' letters were common enough.[20]) In one instance, however, Bower compared two 'Ripper' letters on 'Gurney Ivory Laid' paper with three written by Sickert on the same brand of stationery (from his mother's house at 12 Pembroke Gardens). Close inspection of the paper's weave and texture led him to believe that the said sheets were manufactured together in the same 'batch'. Their 'short-edges' were also trimmed by the same guillotine blade along almost exactly the same line, a coincidence that has convinced him that the pages belonged to the same 'quire' of twenty-four sheets and were almost certainly sold as an item to a single customer. Bower is very confident in his assertions, and certainly they are not to be dismissed lightly. But they do need to be properly scrutinized.

Bower has not – as yet – published his findings in full. Some of his conclusions are listed in the paperback edition of Cornwell's book, and he gave a brief outline of his discoveries at a study day at Tate Britain on 28 November 2003. His claims, however, tend to raise rather more questions than they answer.

If we accept that Sickert's 'Gurney Ivory Laid' letters do indeed come from the same batch as the two 'Ripper' letters, that still puts them in a very large pool. A 'batch' of paper, according to Bower, weighs half a ton. It could serve to make anything between 75,000 and 100,000 sheets of writing paper, which would divide up into over 3,000 quires, and perhaps as many as 4,480. That all these sheets should have been trimmed down with the same guillotine blade seems scarcely surprising as they were all produced by the same small manufacturer at the same site. And although in an only part-mechanized process there would doubtless have been some discrepancy in the alignment of the guillotine blade and the paper, how great can this have been? The guillotine operator would have been trying to achieve uniformity, and if he failed it can only have been within a relatively narrow span: five degrees of error, perhaps – or ten? Without the evidence of the whole batch it is simply impossible to tell. There would not though, surely, have been 4,480 different positions of blade and paper. Neither each cut nor each quire would have been unique, as Bower seems to assert. Most would have been pretty much the same. And given the difficulties involved in micro-measuring a friable organic material such as 100-year-old paper, it is legitimate to wonder just how accurately it is possible to measure even the limited differences that did occur.

Certainly, without fuller information about Bower's workings, other forensic examiners remain sceptical of his very emphatic conclusions. Kim Hughes of Documentary Evidence Ltd, discussing the case in general terms, felt that it would be very difficult for any expert to go beyond a statement that separate sheets of paper came from the same batch and had been cut by the same blade. Allowing for the division of the batch into quires, such a finding would leave the chance of direct connection between Sickert's 'Gurney Ivory Laid' letters and those in the PRO at around 1 in 3,000: a very long way from Bower's assurance of an exact match. Circumstantial evidence, moreover, does not favour a link between the two groups of documents. The handwriting of the two 'Ripper' letters bears no relation to Sickert's script; and the Sickert letters all date from late 1889 or early 1890, well after the Ripper crimes.

Throughout her book, Cornwell proceeds from imaginative hypothesis to bold assertion with seamless assurance. It makes for an exciting read. The publication of her book has been supported by a huge publicity circus, with television programmes, public appearances,

and press interviews. No book on the Jack the Ripper has ever received such promotion, or garnered such sales. But despite its huge commercial success the book has failed to convince informed observers. 'Ripperologists' dismiss its strident claims, while lamenting that so many resources were misdirected at such an obviously duff 'suspect' as Walter Sickert. And amongst Sickert scholars, Cornwell's ideas have been received even more coolly.

The one notable exception is Anna Gruetzner Robins, author of *Walter Sickert: Drawings* and editor of the excellent *Walter Sickert: The Complete Writings on Art*. She does not accept that Sickert was the Ripper but, taking up Peter Bower's claims and extending their scope, she is inclined to believe that Sickert wrote many, if not most, of the 'Ripper' letters preserved at the PRO and Guildhall Library. At the Tate study day she laid out some of her reasons for this belief – mainly perceived visual echoes between the doodles included in some of the 'Ripper' letters and Sickert's own drawings. She also identified the inscription 'R. St. W.' at the bottom of one of the 'Ripper' letters as a coded version of Walter Richard Sickert's signature.

It will be necessary to wait for the full, published exposition of her theory before it can be properly assessed, but at first acquaintance it appeared less than convincing. At least to me. It still seems so very much more likely that the hundreds of 'Ripper' letters sent to the authorities came from hundreds of different sources, as indeed the police believed at the time, rather than from a single writer. Very few of the letters, it should be remembered, were published or even publicized at the time. There would have been no sense of dialogue with either the police or the public to encourage a hoax letter-writer to keep sending off more and more missives. It would have been a very odd thing for anyone (not just Sickert) to send out hundreds of letters if they were producing no tangible effect.

The claim of a strong visual connection between the various 'Ripper' doodles and Sickert's drawings must remain a matter of opinion and connoisseurship. It is not, however, an obvious one. Wendy Baron, the doyenne of Sickert studies, dismissed the connection out of hand.[21] She could trace no hint of his hand in any of the 'Ripper' doodles, and, at a more specific level, the annotation 'R. St. W.' should certainly not be viewed as an abbreviated – and garbled – Sickert signature. It must be read in connection with the preceding two words – 'F. Place' – as 'F[oubert] Place, R[egent] St[reet] W[est 1]'. It is an address.

No rebuttal of any theory, however, will now serve to break the link between Sickert and Jack the Ripper in the popular mind. The connection, while not an established fact, is that more insidious thing – an established fantasy. In the absence of evidence, probability, and indeed possibility, it endures. Sickert most certainly was not a mass murderer. He was not a murderer of any sort. But by a quirk of fate he has been dragged into the swamp of Ripperology, and once enmired it is impossible to escape. He has become by virtue of mere repetition one of the 'usual [celebrity] suspects', along with Prince Albert Victor, Sir William Gull, J. K. Stephen, George Gissing, and William Gladstone. His name is in the cuttings' file and will be endlessly recycled, for the wheel of Ripperology never ceases to turn. As Sickert himself remarked: 'It is said that we are a great literary nation but we don't really care about literature . . . we like a good murder.' And we like a good murder suspect. That such posthumous celebrity should fall upon Sickert is certainly a curiosity. No less certainly, it is a curiosity that Sickert would have enjoyed.

BIBLIOGRAPHY

'Miles Amber' [Ellen Cobden], *Wistons* (1902)

Ronald Anderson and Anne Koval, *James McNeill Whistler: Beyond the Myth* (London, 1994)

Bruce Arnold, *Orpen: Mirror to an Age* (London, 1981)

——, *Jack Yeats* (New Haven and London, 1998)

Gertrude Atherton, *Adventures of a Novelist* (London, 1932)

Philip Bagguley, *Harlequin in Whitehall: A Life of Hubert Wolfe* (London, 1997)

Enid Bagnold, *Autobiography* (London, 1969)

——, *Enid Bagnold: Letters to Frank Harris and Other Friends*, ed. R. P. Lister (London, 1980)

Wendy Baron, *Sickert* (London, 1973)

——, *Miss Ethel Sands and her Circle* (London, 1977).

——, *The Camden Town Group* (London, 1979)

——, *Perfect Moderns: A History of the Camden Town Group* (Aldershot, 1999)

—— and Malcolm Cormack, *The Camden Town Group* (New Haven, 1980)

—— and Richard Shone (ed.), *Sickert*, catalogue of the exhibition held at the Royal Academy, November 1992–February 1993 (London and New Haven, 1992)

Walter Bayes, *Turner* (London, 1931)

Aubrey Beardsley, *Some Unknown Drawings of Aubrey Beardsley*, collected and annotated by R. A. Walker (London, 1923)

——, *A Beardsley Miscellany*, ed. R. A. Walker (London, 1949)

——, *The Letters of Aubrey Beardsley*, ed. Henry Maas, J. L. Duncan, and W. G. Good (London, 1970)

Cecil Beaton, *Ashcombe: The Story of a Fifteen-Year Lease* (London, 1949)

——, *The Years Between: Diaries 1939–44* (London, 1965)

Lord Beaverbrook, *Courage: The Story of Sir James Dunn* (London, 1962)

Max Beerbohm, *Max Beerbohm: Letters to Reggie Turner*, ed. Rupert Hart-Davis (London, 1964)

——, *Letters of Max Beerbohm 1892–1956*, ed. Rupert Hart-Davis (London, 1988)

Clive Bell, Preface to Catalogue of the Sickert exhibition, Eldar Gallery (London, 1919)

——, *Old Friends* (London, 1956)

Vanessa Bell, *Selected Letters of Vanessa Bell*, ed. Regina Marler (London, 1993)

Quentin Bell, *Victorian Artists* (London, 1967)

——, 'Some Memories of Walter Sickert', *Burlington Magazine* (April 1987)

Sir Frank Benson, *My Memories* (London, 1930)

Arnold Bennett, *The Journals of Arnold Bennett 1896–1928*, ed. Newman Flower, 3 vols (London, 1932–3)

——, *Letters to his Nephew* (London, 1936)

——, *The Letters of Arnold Bennett*, ed. James Hepburn, 4 vols (London and Oxford, 1966–86)

Anthony Bertram, *Sickert* (London, 1955)

Sir Walter Besant, *London North of the Thames* (London, 1911)

R. A. Bevan, *Robert Bevan* (London, 1965)

Mireille Bialek, *Jacques-Émile Blanche à Offranville* (Luneray, 1997)

Jacques-Émile Blanche, *Propos de Peintre*, vol. i (Paris, 1919)

——, *Dieppe* (Paris, 1927)

——, *Mes Modèles* [Paris, 1929]

——, *Portraits of a Lifetime: The Late Victorian Era, the Edwardian Pageant, 1870–1914*, tr. and ed. Walter Clement; introduction by Harley Granville-Barker (London, 1937)

——, *More Portraits of a Lifetime* (London, 1939)

——, *La Pêche aux Souvenirs* (Paris, 1941)

——, *Jacques-Émile Blanche, Peintre (1861–1942)* (Rouen, 1997)

Nathalie Blondel, *Mary Butts: Scenes from the Life* (New York, 1998)

Wilfrid [Jasper] Blunt, *England's Michelangelo: A Biography of George Frederic Watts* (London, 1975)

Wilfrid Scawen Blunt, *My Diaries: Being a Personal Narrative of Events, 1888–1914* (London, 1919)

Frederic Boase, *Modern English Biography*, vol. iii (1901)

Violet Bonham-Carter, *Champion Redoubtable: The Diaries and Letters of Violet Bonham-Carter, 1914–1945*, ed. Mark Pottle (London, 1998)

J. B. Booth, *London Town* (London [1929])

Tancred Borenius, 'Walter Sickert and the Whirlwind', *Soho Centenary: A Gift from Artists, Writers and Musicians to the Soho Hospital for Women* (London [1944])

Maureen Borland, *D. S. MacColl* (Harpenden, 1995)

X. M. Boulestein, *Myself, My Two Countries* (London, 1936)

Sophie Bowness and Clive Phillpot, *Britain at the Biennale* (London, 1995)

Jevan Brandon-Thomas, *Charley's Aunt's Father* (London, 1955)

Ruth Bromberg, *Walter Sickert: Prints. A Catalogue Raisonné* (London, 2000)

Fred Brown, 'Recollections: The Early Years of the New English Art Club', *Artwork*, vi (1930)

Milton W. Brown, *The Story of the Armory Show* (New York, 1988)

Oliver Brown, *Exhibition: Memoirs of Oliver Brown* (London, 1968)

Lillian Browse (ed.), *Sickert: With an Essay on his Life and Notes on his Paintings; and with an Essay on his Art by R. H. Wilenski* (London, 1943)

——, *Sickert* (London, 1960)

Carolyn Burke, *Becoming Modern: The Life of Mina Loy* (Berkeley, 1996)

Adrian Bury, *Joseph Crawhall: The Man and the Artist* (London, 1959)

A. C. R. Carter (ed.), *The Year's Art* [1883–]

David Cecil, *Max* (London, 1964)

Hugh and Mirabel Cecil, *Clever Hearts* (London, 1990)

Desmond Chapman-Houston, *The Lost Historian: A Memoir of Sir Sydney Low* (London, 1936)

Hon. Evan Charteris, *John Sargent* (London, 1927)

——, *The Life and Letters of Sir Edmund Gosse* (London, 1931)

Albert Chevalier, *Before I Forget* (London, 1901)

Thomas Cobden-Sanderson, *The Journals of Thomas James Cobden-Sanderson* (London, 1926)

C. B. Cochran, *Showman Looks On* (London, 1945)

Jean Cocteau, *Correspondance: Jean Cocteau, Jacques-Émile Blanche*, ed. Maryse Renault-Garneau (Paris, 1993)

Constance Collier, *Harlequinade* (London, 1929)

John Collier, *The Art of Portrait Painting* (1905)

Maud Collins, *The Story of Helen Modjeska* (London, 1883)

Bryan Connon, *Beverley Nichols: A Life* (London, 1991)

Douglas Cooper, *Courtauld Collection: A Catalogue and Introduction* (London, 1954)

David Peters Corbett, *Sickert* (London, 2001)

Patricia Cornwell, *Portrait of a Killer* (London, 2002)

Janet E. Courtney, *Recollected in Tranquillity* (London, 1926)

Edward [Carrick] Craig, *Gordon Craig: The Story of his Life* (London, 1968)

Edward Gordon Craig, *Index to the Story of My Days: Some Memoirs 1872–1907* (London, 1957; reissued Cambridge, 1981)

Adrian Daintrey, *I Must Say* (London, 1963)

Jan Dalley, *Diana Mosley: A Life* (London, 1999)

T. C. Davis, *Actresses as Working Women* (London, 1991)

Michael de Cossart, *The Food of Love: Princesse Edmond de Polignac and her Salon* (London, 1978)

Edgar Degas, *Degas Letters*, ed. Marcel Guerin (Oxford, 1947)

J. G. P. Delaney, *Charles Ricketts: A Biography* (Oxford, 1990)

Colleen Denney, *At the Temple of Art: The Grosvenor Gallery, 1877–1890* (Cranbury, NJ, 2000)

Guillermo de Osma, *Fortuny* (London, 1980)

Delphine Desveaux, *Fortuny* (London 1998)

Richard Dorment and Margaret F. MacDonald, *James McNeill Whistler* (London, 1994)

J. L. E. Dreyer and H. H. Turner, *The History of the Royal Astronomical Society*, vol. i (London, 1923)

Malcolm Easton, *Sickert in the North* (Hull, 1968)

——, *Aubrey and the Dying Lady* (London, 1972)

Sir Timothy Eden, *The Tribulations of a Baronet* (London, 1933)

George Edgar, *Martin Harvey* (London, 1912)

Richard Ellmann, *Oscar Wilde* (London, 1987)

Robert Emmons, *The Life and Opinions of Walter Richard Sickert* (London, 1941)

B. Fairfax Hall, *Paintings and Drawings by Harold Gilman and Charles Ginner in the Collection of Edward le Bas* (London, 1965)

Bernard Falk, *He Laughed in Fleet Street* (London, 1937)

——, *Five Years Dead* (London, 1938)

Daniel Farson, *Jack the Ripper* (London, 1972)

Marina Ferretti-Bocquillon et al., *Signac, 1863–1935* (New Haven, 2001)

Michael Field, *Works and Days*, ed. T. and D. C. Sturge Moore (London, 1933)

Richard Findlater, *Lilian Baylis: The Lady of the Old Vic* (London, 1975)

Kathleen Fisher, *Conversations with Sylvia: Sylvia Gosse, Painter, 1881–1968*, ed. Eileen Vera Smith (London, 1975)

Sir Johnston Forbes-Robertson, *A Player Under Three Reigns* (London, 1925)

Caroline Fox and Francis Greenacre, *Paintings in Newlyn 1880–1930* (London, 1985)

Adrian Frazier, *George Moore, 1852–1933* (New Haven and London, 2000)

Roger Fry, *Letters of Roger Fry*, ed. Denys Sutton (London, 1972)

Jonathan Fryer, *Robert Ross* (London, 2000)

Ann Galbally, *Charles Conder: The Last Bohemian* (Melbourne, 2002)

Helmut E. Gerber (ed.), *George Moore in Transition* (Detroit, 1968)

William H. Gerdts, *William Glackens* (New York, 1996)

André Gide, *Self-Portraits: The Gide/Valéry Letters, 1890–1942*, ed. Robert Mallet, abridged and translated by June Guicharnaud (Chicago, 1966)

——, *Cahiers André Gide 8: Correspondance André Gide – Jacques-Émile Blanche (1892–1939)*, ed. Georges-Paul Collet (Paris, 1979)

——, *Nouvelles Lettres à André Gide*, ed. Georges-Paul Collet (Geneva, 1982)

Charles C. Gillespie, *Dictionary of Scientific Biography*, vol. xii (New York, 1975)

W. Graham Robertson, *Time Was* (London, 1931)

Algernon Graves (ed.), *A Dictionary of Artists Who Have Exhibited Works in the Principal London Exhibitions from 1760–1893* (London, 3rd edn, 1901)

——, *A Century of Loan Exhibitions, 1813–1912*, 3 vols (London, 1913–15)

David Greer, *A Numerous and Fashionable Audience* (London, 1997)

Reynaldo Hahn, *Notes – Journal d'un Musicien* (Paris, 1947)

Daniel Halévy, Preface to catalogue for Sickert exhibition (Dieppe, 1954)

——, *My Friend Degas* (London, 1966)

Joan Ungersma Halperin, *Félix Fénéon: Aesthete and Anarchist in Fin-de-Siècle Paris* (New Haven, 1988)

Vivien Hamilton, *Joseph Crawhall* (London, 1990)

Nina Hamnett, *Laughing Torso* (London, 1932)

Rupert Hart-Davis, *Hugh Walpole* (London, 1952)

A. S. Hartrick, *A Painter's Pilgrimage* (Cambridge, 1939)

Christopher Hassall, *Edward Marsh* (London, 1959)

W. E. Henley, *The Selected Letters of W. E. Henley*, ed. Damian Atkinson (Aldershot, 2000)

Philip Hoare, *Wilde's Last Stand* (London, 1997)

Basil Hogarth (ed.), *Trial of Robert Wood: The Camden Town Case* (London and Edinburgh, 1936)

C. J. Holmes, *Self and Partners* (London, 1936)

Michael Holroyd, *Augustus John*, 2 vols (London, 1974–5; rev. edn, London, 1996)

Joseph Hone, *The Life of George Moore* (London, 1936)

——, *The Life of Henry Tonks* (London, 1939)

Denise Hooker, *Nina Hamnett: Queen of Bohemia* (London, 1986)

Graham Hough, *The Last Romantics* (London, 1949; repub., 1983)

Laurence Housman, *The Unexpected Years* (London, 1937)

Derek Hudson, *For Love of Painting: The Life of Sir Gerald Kelly, KCVO, PRA* (London, 1975)

Robert Hughes, *Nothing If Not Critical: Selected Essays on Art and Artists* (London, 1990)

William Morris Hunt, *Talks About Art* (London, 1895)

Roger Iredale, *The Grand: The First 100 Years* (Leeds, 1977)

Laurence Irving, *Henry Irving: The Actor and his World* (London, 1951)
——, *The Successors* (London, 1967)
Holbrook Jackson, *The Eighteen Nineties* (London, 1927)
Maxim Jakubowski and Nathan Braund, *The Mammoth Book of Jack the Ripper* (London, 1999)
Augustus John, *Chiaroscuro: Fragments of Autobiography* (London, 1952)
——, *Finishing Touches* (London, 1964)
Stephen Jones et al., *Frederic Leighton: 1830–1896*, RA catalogue (London, 1996)
Basil Jonzen, 'A Visit to Mr Sickert at Broadstairs', *Horizon*, no. 45 (1943)
Louise Jopling [Mrs Jopling-Rowe], *Twenty Years of My Life* (London, 1925)
Richard Kendall, *Degas: Beyond Impressionism* (London, 1996)
Gertrude Kingston [Gertrude Konstam], *Curtsey While You're Thinking* (London, 1937)
Helen M. Knowlton, *The Art Life of William Morris Hunt* (Cambridge, Mass., 1899)
Mary M. Lago and Karl Beckson (eds.), *Max and Will: Max Beerbohm and William Rothenstein, their Friendship and Letters, 1893–1945* (London, 1975)
Bruce Laughton, *Philip Wilson Steer* (London, 1971)
James Laver, *Museum Piece* (London, 1963)
John Lavery, *The Life of a Painter* (Boston, 1940)
George S. Layard, *The Life and Letters of Charles Samuel Keene* (London, 1892)
Celia Lee, *Jean, Lady Hamilton, 1861–1941: A Soldier's Wife* (London, 2001)
Wyndham Lewis, *The Roaring Queen* (London, 1936; reprtd, ed. Walter Allen, 1973)
——, *Blasting and Bombardiering* (1937; 2nd edn, 1967)
—— and Louis F. Fergusson, *Harold Gilman* (London, 1919)
Roger Lhombreaud, *Arthur Symons: A Critical Biography* (London, 1963)
Marjorie Lilly, *Sickert, the Painter and his Circle* (London, 1971)
Jack Lindsay, *Gustave Courbet: His Life and Art* (London, 1973)
Henri Loyrette, *Degas* (Paris, 1991)
Alberto Ludovici, *An Artist's Life in London and Paris* (London, 1926)
Desmond MacCarthy, *Ellen Melicent Cobden: A Portrait* (London, 1920)
D. S. MacColl, *Confessions of a Keeper* (London, 1931)
——, *Life, Work and Setting of Philip Wilson Steer* (London, 1945)
Kenneth McConkey, *Impressionism in Britain* (London, 1995)
Donald McCormick, *The Identity of Jack the Ripper* (London, 1959; 2nd edn, 1970)

Margaret F. Macdonald, *Beatrice Whistler, Artist & Designer* (Glasgow, 1997)

Michael Macleod, *Thomas Hennell: Countryman, Artist and Writer* (Cambridge, 1988)

Sandra Moschini Marconi, *Galleria G. Franchetti alla Ca'd'Oro, Venezia* (Rome, 1992)

Edward Marsh, *A Number of People* (London, 1939)

Lilli Martins, *Die Schleswig-Holsteinische Malerei in 19. Jahrhunderts* (Hamburg, 1956)

W. S. Meadmore, *Lucien Pissarro* (London, 1962)

Mortimer Menpes, *Whistler As I Knew Him* (London, 1904)

F. R. Miles, *King's College School Alumni, 1866–1889: A Register of the Pupils in the School Under the Second Headmaster, G. F. Maclear* (London, 1985)

—— and Graeme Cranch, *King's College School: The First 150 Years* (London, 1975)

Katherine Lyon Mix, *A Study in Yellow: The Yellow Book and its Contributors* (London, 1960)

Helen Modjeska, *Memories and Impressions* (New York, 1910)

Sophie Monneret, *L'Impressionisme et son Époque*, 2 vols (Paris, 1978)

George Moore, *Hail and Farewell: Ave* (London, 1911; reprtd 1937)

——, *Conversations in Ebury Street* (London, 1924)

David Napley, *The Camden Town Murder* (London, 1987)

C. R. W. Nevinson, *Paint and Prejudice* (London, 1937)

Robert O'Byrne, *Hugh Lane, 1875–1915* (Dublin, 2000)

Paul O'Keefe, *Some Sort of Genius: A Life of Wyndham Lewis* (London, 2000)

Sybil Oldfield, *Spinsters of the Parish* (London, 1984)

Richard Ormond, 'Leighton and his Contemporaries', in Stephen Jones et al., *Frederic Leighton, 1830–1896*, catalogue of Royal Academy exhibition (London, 1996)

Cecil Osborne, 'My Memories of Walter Sickert', *St Pancras Journal*, viii, nos 10–11

Jean Overton Fuller, *Sickert and the Ripper Crimes: An Investigation into the Relationship between the Whitechapel Murders of 1888 and the English Tonal Painter Walter Richard Sickert* (Oxford, 1990)

Simona Pakenham, *Sixty Miles from England: The English at Dieppe, 1814–1914* (London, 1967)

Michael Parkin, *Walter Sickert: The Artist, his Wife, his Mistress, his Friends, and One Enemy* (exhibition catalogue, London, 1992)

Elizabeth R. Pennell, *Nights: Rome, Venice in the Aesthetic Eighties; London, Paris in the Fighting Nineties* (London, 1916)

E[lizabeth] R[obins] and J[oseph] Pennell, *The Life of James McNeill Whistler* (London, 1911 edn)

Joseph Pennell, *Adventures of an Illustrator* (Boston, 1925)

Jenny Pery, *The Affectionate Eye: The Life of Claude Rogers* (Bristol, 1995)

Ronald Pickvance, *Sickert* (London, 1967)

Camille Pissarro, *Correspondance de Camille Pissarro V (1899–1903)*, ed. Janine Bailly-Herzberg (Val d'Oise, 1991)

——, *The Letters of Lucien Pissarro to Camille Pissarro (1883–1903)*, ed. Anne Thorold (Cambridge, 1993)

Victor Plarr (ed.), *Men and Women of the Time: A Dictionary of Contemporaries*, 14th edn (London, 1895)

Harry Preston, *Leaves from my Unwritten Diary* (London, 1936)

Hilary Pyle, *Jack Butler Yeats* (London, 1970)

Helen, Countess-Dowager of Radnor, *From a Great Grandmother's Armchair* (London [1927])

Iain Rice, *The Book of Chagford: A Town Apart* (Tiverton, 2002)

Grant Richards, *Memories of a Misspent Youth* (London, 1932)

John Richardson, *Camden Town and Primrose Hill* (London, 1991)

Anna Gruetzner Robins, *Modern Art in Britain, 1910–1914* (London, 1997)

——, *Walter Sickert: Drawings* (Aldershot, 1996)

Margery Ross (ed.), *Robert Ross: Friend of Friends. Letters to Robert Ross . . . Together with Extracts from his Published Articles* (London, 1952)

Robert Ross, *Aubrey Beardsley* (London, 1909)

John Rothenstein, *The Artists of the Nineties* (London, 1928)

——, *The Life and Death of Conder* (London, 1938)

——, *Modern English Painters* (London, 1952, 1957)

——, *Walter Richard Sickert (1860–1942)* (1961)

William Rothenstein, *Men and Memories*, 2 vols (London, 1931, 1932)

——, *Since Fifty* (London, 1939)

W. W. Rouse Ball and J. A. Venn, *Admissions to Trinity College, Cambridge*, vol. v (Cambridge, 1913)

Ernst Rump, *Lexikon der Bildenden Kunstler Hamburgs, Altonas und der näheren Umgebung* (Hamburg, 1912)

Albert Rutherston, 'From Orpen and Gore to the Camden Town Story', *Burlington Magazine* (August 1943)

Frank Rutter, *Whistler* (London, 1911)

——, *Some Contemporary Artists* (London, 1922)

——, *Théodore Roussel* (London, 1926)

——, *Since I was Twenty-Five* (London, 1927)

——, *Art in My Time* (London, 1933)

Christopher St John (ed.), *Ellen Terry and Bernard Shaw: A Correspondence* (London, 1931)

Siegfried Sassoon, *Siegfried Sassoon: Diaries 1923–1925*, ed. Rupert Hart-Davis (London, 1985)

G. H. Scholfield, *A Dictionary of New Zealand Biography* (New Zealand, 1940)

Martin Seymour-Smith, *Robert Graves* (London, 1982)

Evelyn Sharp, *Unfinished Journey* (London, 1933)

Richard Shone, 'Duncan Grant on a Sickert Lecture', *Burlington Magazine* (December 1981)

——, *Walter Sickert* (Oxford, 1988)

——, *From Beardsley to Beaverbrook: Portraits by Walter Richard Sickert* (Bath, 1990)

Bernhard Sickert, *Whistler* (London [1908])

Walter Sickert, *Late Sickert: Paintings 1927 to 1942*, Hayward Gallery catalogue, texts by Frank Auerbach, Helen Lessore, Denton Welch, and Wendy Baron (London, 1981)

——, *W. R. Sickert: Drawings and Paintings 1890–1942*, introduction by Penelope Curtis (Liverpool, 1989)

——, *The Complete Writings on Art*, ed. Anna Gruetzner Robins (Oxford and New York, 2000)

Edith Sitwell, *Selected Letters*, ed. John Lehmann and Derek Parker (London, 1970)

Osbert Sitwell, *Left Hand, Right Hand!* (London, 1945)

——, *Noble Essences* (London, 1950)

Douglas Sladen, *Twenty Years of My Life* (London, 1915)

Mary Soames, *Clementine Churchill* (Harmondsworth, 1981; first pub. 1979)

——, *Winston Churchill: His Life as a Painter* (London, 1990)

Frances Spalding, *Roger Fry: Art and Life* (London, 1980)

——, *Vanessa Bell* (London, 1983)

——, *Duncan Grant* (London, 1997)

——, *Gwen Raverat* (London, 2001)

Robert Speaight, *William Rothenstein* (London, 1962)

Julie Speedie, *Wonderful Sphinx: A Biography of Ada Leverson* (London, 1993)

Hilary Spurling, *The Unknown Matisse* (London, 1998)

Marguerite Steen, *William Nicholson* (London, 1943)

W. H. Stephenson, *Walter Sickert: The Man and his Art* (Southport, 1940)

John Stokes, *In the Nineties* (Hemel Hempstead, 1989)

Matthew Sturgis, *Passionate Attitudes* (London, 1995)

——, *Aubrey Beardsley* (London, 1998)

Denys Sutton, *Walter Sickert* (London, 1976)

H. M. Swanwick, *I Have Been Young* (London, 1935)

Frank Swinnerton, *Swinnerton: An Autobiography* (London, 1935)

Arthur Symons, *Arthur Symons: Selected Letters, 1880–1935*, ed. Karl Beckson and John M. Munro (London, 1989)

Jean-Yves Tadié, *Marcel Proust: A Life*, translated by Euan Cameron (London, 2000)

R. V. Taylor, *Biographia Leodiensis* (1865)

Ernest Thesiger, *Practically True* (London, 1927)

Alfred Thornton, 'Walter Richard Sickert', *Artwork*, vi (1930)

——, *The Early Years of the New English Art Club* (London, 1935)

——, *Diary of an Art Student in the Nineties* (London, 1938)

Lisa Tickner, *Modern Life and Modern Subjects: British Art in the Early Twentieth Century* (New Haven and London, 2000)

J. B. Townsend, *John Davidson* (New Haven, 1961)

Jane Turner (ed.), *The Dictionary of Art*, vol. viii (New York and London, 1996)

Philip Unwin, *The Publishing Unwins* (London, 1972)

'X' [Herbert Vivian], *Myself Not Least* (London, 1925)

Ambrose Vollard, *Degas: An Intimate Portrait* (Toronto, 1986)

Edwin A. Ward, *Recollections of a Savage* (London, 1923)

Sir Edward Watkin, *Alderman Cobden of Manchester* (privately printed, 1891)

Thomas R. Way, *Mr Whistler's Lithographs: The Catalogue* (London, 1896; 2nd edn, 1905)

Frederick Wedmore, *Some of the Moderns* (London, 1909)

Philip Weilbach, *Dansk Kunstnerleksikon* (Copenhagen, 1998; first published 1877–8)

Denton Welch, 'Sickert at St Peter's', *Horizon*, 32 (1942)

Hubert Wellington, 'With Sickert at Dieppe', *The Listener* (23 December 1954)

Lucy Wertheim, *Adventures in Art* (London, 1947)

J. M. Whistler, *The Gentle Art of Making Enemies* (London, 1890)

Jack Whitehead, *The Growth of Camden Town* (London, 2000)

Edward Wilberforce, *Social Life in Munich* (London, 1863; 2nd edn, 1864)

Oscar Wilde, *The Complete Letters of Oscar Wilde*, ed. Merlin Holland and Rupert Hart-Davis (London, 2000)

John Woodeson, *Mark Gertler: Biography of a Painter* (London, 1972)

Virginia Woolf, *Sickert: A Conversation* (London, 1934)

——, *The Letters of Virginia Woolf*, ed. Nigel Nicolson and Joanne Trautmann, 6 vols (London, 1975–80)

——, *The Diary of Virginia Woolf*, ed. Anne O. Bell, 5 vols (London, 1977–84)

Violet Wyndham, *The Sphinx and her Circle* (London, 1963)

Malcolm Yorke, *Matthew Smith: His Life and Reputation* (London, 1997)

NOTES

Abbreviations

ACS	autograph card signed
AGR	Anna Gruetzner Robins (ed.), *Walter Sickert: The Complete Writings on Art* (2000)
ALS	autograph letter signed
Baron/Shone	*Sickert*, RA Catalogue (1992)
BBC tape	Tape recording for 'Walter Sickert 1860–1942. Sketch for a Portrait' (BBC broadcast 1961; recordings made by Cicely Hey, Alec Martin, Helen Lessore, Oliver Brown, Clifford Ellis, Peggy Ashcroft, Gwen Ffrangçon-Davies)
Bedford	Bedford Public Library
Birmingham	Birmingham University Library
BL	British Library
BN	Bibliothèque Nationale, Paris
cALS	copy of ALS
Chichester	West Sussex County Record Office
Courtauld	Courtauld Institute Library, London
cTel(s)	copy of telegram(s)
DNB	*Dictionary of National Biography*
DS	Denys Sutton, *Walter Sickert* (1976)
DSM	D. S. MacColl
Getty	J. P. Getty Research Institute, Los Angeles
GUL	Glasgow University Library
Harvard	Houghton Library, Harvard University, Cambridge, Mass.
HMS	Helena Swanwick, *I Have Been Young* (1935)
Holborn	Holborn Public Library, London
Institut	Institut de France, Paris
Islington	Sickert Collection, Islington Public Library
JEB	Jacques-Émile Blanche

JJS	Johann Jürgen Sickert
JMW	James McNeill Whistler
KCL	King's College London Library
LB I	Lillian Browse, *Sickert* (1943)
LB II	Lillian Browse, *Sickert* (1960)
Leeds	Brotherton Library, University of Leeds
ML	Marjorie Lilly, *Walter Sickert: The Painter and his Circle* (1971)
MS	manuscript
NLS	National Library of Scotland
NYPL	New York Public Library
OAS	Oswald Adalbert Sickert
OVS	Oswald Valentine Sickert
Oxford	Bodleian Library, Oxford
RA	Royal Academy
RAS	Royal Astronomical Society
RB	Ruth Bromberg, *Walter Sickert: Prints* (2000)
RE	Robert Emmons, *The Life and Opinions of Walter Richard Sickert* (1941)
rec.	received
Richmond	Richmond Public Library, Richmond, Surrey
Sutton papers	Denys Sutton Papers
Tate	Hyman Kreitman Research Centre, Tate Britain, London
Texas	Harry Ransom Humanities Research Center, University of Texas, Austin
TLS	typed letter signed
TS	typescript
V&A	National Art Library, Victoria & Albert Museum, London
WB	Wendy Baron, *Sickert* (1973)
Witt	Witt Library, Courtauld Institute, London
WS	Walter Richard Sickert

Chapter One: A Well-Bred Artist

I THE MÜNCHENER KIND'L'

1 No pre-1876 birth records survive in the Munich archives. The date of Sickert's birth is recorded in his entry for *Men and Women of the Time* (1899). The address is supplied from the record of Oswald Sickert's Munich residences in the municipal archives: from May to October 1859, he was at 16/0 Schwanthalerstrasse; from late October 1859 to October 1860 he was as 59/1 Augustenstrasse.

2 The principal sources for Sickert's early life and parentage are: his sister's memoir, H. M. Swanwick, *I Have Been Young* (1935), chap. 1; Sickert's own introduction to an exhibition of work by his father and grandfather, *Johann Jürgen Sickert (1803–1864) and Oswald Adalbert Sickert (1828–1885)*, Goupil Gallery (June 1922), reprtd in AGR, 435. A photocopy of a letter from 'Nelly' (Eleanor) Sickert to Oswald Adalbert Sickert, from 4/1 Kleestrasse, 29 October 1904, is in English and recounts the saying of Walter and the other children in English (Sutton GUL).

3 HMS, 85. The baptismal records of the English Chaplaincy at Munich do not begin until 1862.

4 H. M. Swanwick to DSM, 1/11/1936 (GUL).

5 Correspondence from Richard Sheepshanks to William Sheepshanks, 1855 (private collection).

6 Frederic Boase, *Modern English Biography*, vol. iii (1901); R. V. Taylor, *Biographia Leodiensis* (1865).

7 Richard Sheepshanks assembled an 'array of the best chronometers' and used them on a series of scientific expeditions, establishing the exact longitude of Liverpool, Antwerp, and Kingston-upon-Thames. He was a member of the commission charged with revising the borough boundaries for the Reform Act of 1832.

8 *DNB*, vol. lii; Boase, *Modern British Biography*, vol. iii; R. V. Taylor, *Biographia Leodiensis*; J. L. E. Dreyer and H. H. Turner, *The History of the Royal Astronomical Society*, vol. i (1923), 118, reprints his obituary.

9 ALS Richard Sheepshanks to William Sheepshanks, 17/10/1828 (private collection). It seems that the portrait had been originally commissioned by John, but he refused to pay Lawrence half the agreed price when the picture was only half completed. Richard, feeling that this was a 'gross injustice towards Sir Thomas in which Ann [*sic*] is unfortunately a party', took on the debt himself and arranged for the commission to be finished.

10 Sophia Elizabeth de Morgan, *Memoir of Augustus de Morgan* (1882), 191.

11 HMS, 23, 20.

12 T. C. Davis, *Actresses as Working Women* (1991), 78–9.

13 St Pancras Old Church baptismal register 1830–1832, 70 (Central London Archives).

14 St George's Bloomsbury, Poor Rate; Mrs Henry is listed as the occupier from Lady Day 1827 till Michaelmas 1833 (Holborn).

15 St Pancras Old Church baptismal register 1830–1832, 70 (Central London Archives).

16 Paul Blewitt, the archivist of the Moravian Church, searched their records without success.

17 HMS, 19–20, 30.

18 WS letter to *The Times* (15 December 1932), 10.

19 Alfred Green, birth certificate.

20 WS letter to *The Times*, ibid. The Post Office Directory for 1844 gives the number as 36 Castle Street, not 35. Castle Street is now Eastcastle Street.

21 HMS, 20. In the 1841 Census, Eleanor is not at either 36 Castle Street with the Greens, or Woburn Place with the Sheepshanks.

22 Post Office Directories 1844–50. If she performed, it was under another name: no Miss Henry appears on the rather full playbills of the time, and the only 'Green' listed has the initial 'F'.

23 AGR, 423: WS says 89,500.
24 J. L. E. Dreyer and H. H. Turner, *The History of the Royal Astronomical Society*, op. cit.
25 HMS, 20; DS, 14. Thus far my searches through the Australian passenger records have failed to throw up a plausible-looking Mr and Mrs Green or Henry.
26 HMS, 20, says that Eleanor went to school at Neuville 'about 1842'; ALS OVS to Edward Marsh, 30/8/1895: 'mother came to school here when she was eleven' (NYPL); but Richard Sheephanks to H. C. Schumacher, 17/6/1848, says 'she has been three years in France' (i.e. only since 1845) (RAS).
27 There were two schools for English girls in the area, Mrs Slee's at Neuville and Mme Collas' at Janval
28 Simona Pakenham, *Sixty Miles from England* (1967), 79, 50.
29 HMS, 20–1; Pakenham, op. cit., 78.
30 *Sixty Miles from England*, ALS OVS to Edward Marsh, 30/8/1895 (NYPL).
31 ALS Richard Sheepshanks to H. C. Schumacher, 17/6/1848 (RAS).
32 HMS, 21.
33 Charles C. Gillespie, *Dictionary of Scientific Biography*, vol. xii (1975), 234.
34 ALS H. C. Schumacher to Richard Sheepshanks, 27/6/1848 (RAS).
35 ALS Richard Sheepshanks to H. C. Schumacher, 17/6/1848 (RAS).
36 ALS Richard Sheepshanks to H. C. Schumacher, 24/10/1848 (RAS).
37 ALS Richard Sheepshanks to H. C. Schumacher, 5/4/1850 (RAS).
38 HMS, 21.
39 Ibid.; ALS H. C. Schumacher to Richard Sheepshanks, 27/6/1848 (RAS).
40 HMS, 23.
41 ALS Richard Sheepshanks to H. C. Schumacher, 12/4/1850, 3/6/1850 (RAS).
42 HMS, 21.
43 F. G. W. Struve, MS account of death (on 28 December 1850) of H. C. Schumacher (RAS).
44 HMS, 20.
45 ALS Johannes Schumacher to Richard Sheepshanks, 28/5/1851, 20/11/1851 (RAS).
46 ALS Johannes Schumacher to Richard Sheepshanks, 14/4/1853 (RAS).
47 AGR, 435; 1856 passport permission issued to JJS by the Police Authority of Altona lists his physical characteristics: middle height, blond hair, clear forehead, blond eyebrows, blond beard, oval chin, healthy colouring (Islington); ALS from [?] to 'Sickarto' [JJS], 12/5/1849 (Islington).
48 AGR, 435. The Danish Royal Archives have no record of his employment.
49 Ernst Rump, *Lexikon der Bildenden* (1912), 128.
50 Altona directory 1850; JJS had been at 34 Blücherstrasse since 1845; before that he was at Number 33 for one year; in Philip Weilbach, *Dansk Kunstnerleksikon* (1998 edn) he is listed as a painter and photographer.
51 AGR, 435.
52 Programme for the *Festmalzeit Namenlosen*, 24 April 1855, lists JJS as the organizer (Islington).
53 Philip Weilbach, *Dansk Kunstnerleksikon*, Oswald Adalbert Sickert entry.
54 WS on OAS/JJS: 'My grandfather, who was a painter, and one of the earliest lithographers, used often to end his letters to my father, who was a painter and draughtsman on wood, with the advice, "Paint well, and quickly," somewhat, I gather, to his son's irritation. But my grandfather was right.' (AGR, 307/1912.) WS on JJS and OAS: 'My grandfather, Johannes Sickert, who was a painter and lithographer, used to end every letter to his son with this admonition, "*Male gut und schnell*". And he was right.' (AGR, 341/1914.) 'When his son Oswald was studying in Paris, the letters of Johann Jürgen generally contained as their *Carthago delenda est*, the words, "*Male gut und schnell*", which, being interpreted,

means, "Paint well and quickly".'
(AGR, 435, 1922.)

55 Jack Lindsay, *Gustave Courbet, His Life and Art* (1973), 83.

56 ALS WS to John Collier, from 8 Fitzroy Street [1905] (Fondation Custodia).

57 Weilbach, *Dansk Kunstnerleksikon*; Ernst Rump, *Lexikon der Bildenden*; AGR, 435.

58 William Morris Hunt, *Talks About Art* (1895), 61.

59 Jane Turner (ed.), *Dictionary of Art*, vol. viii (1996), Thomas Couture entry; ALS WS to John Collier, from 8 Fitzroy Street [1905] (Fondation Custodia); WS, 'The Royal Academy', *English Review* (June 1912); reprtd AGR, 318; Richard Ormond, 'Leighton and his Contemporaries', in Stephen Jones et al., *Leighton* (1996), 23.

60 Helen M. Knowlton, *The Art Life of William Morris Hunt* (1899), 9.

61 Richard Ormond, 'Leighton and his Contemporaries', *Leighton* (RA catalogue, 1996), 23.

62 WS, 'Degas', *Burlington Magazine* (November 1917); in AGR, 413.

63 At the 1852 Salon, Courbet showed *Les Demoiselles de Village, Le Portrait d'Urbain Cuenot*, and *Paysage des bourds de la Loue*.

64 ALS OVS to Edward Marsh, 30/8/1895 (NYPL).

65 DS, 15; Hermann A. Mueller, *Biographisches Künstler-Lexicon* (Leipzig, 1882), Wilhelm Feussli [*sic*] entry, says he studied under Couture. Sickert, in the transcript of one of his lectures at the Thanet School of Art, Margate, in 1934, referred to OAS as having been at Couture's atelier 'with his friend [a name imperfectly heard]' (AGR, 661) – Füssli perhaps, or Schumacher?

66 HMS, 20.

67 The note is signed 'Mistress M'; Sickert archive (Islington).

68 HMS, 32.

69 ALS Edith Ortmans to John Russell, 15/10/1958, (Sutton GUL).

70 Johannes Schumacher to Richard Sheepshanks, 11/11/1852 (RAS).

71 HMS, 21; ALS Edith Ortmans to John Russell, 15/10/1958 (Sutton GUL): '[Mrs Sickert] suffered very much from being illegitimate & was deeply fond of Mr Sickert who married her in spite of this.' Edith Ortmans (*neé* Carter) was the daughter of Hugh and Maria Carter, who had spent time in Altona. Mrs Carter had been born in Hamburg (1881 Census).

72 HMS, 21–2.

73 Ibid., 22; Sophia Elizabeth de Morgan, *Memoir of Augustus de Morgan*, op. cit., 191.

74 HMS, 22; Sophia Elizabeth de Morgan, ibid.; DS, 17; CALS Eleanor Henry to Penelope Noakes, 1857 (copy at Tate).

75 Hermann A. Mueller, *Biographisches Künstler-Lexicon* (1882); *Die Dioskuren* (22 December 1861), 430, review of the Munich Kunstverein, describes his picture *The Peasant Girl Bringing Food to the People in the Fields* as being less interesting than his picture *The Harvest*, not least because its achievement of 'realism' is weaker.

76 DS, 15.

77 No. 144, *A Scene from As You Like It*, no price listed; address given as c/o Mr Tiffin, 434 West Strand; DS, 17.

78 cALS Eleanor Henry to Penelope Noakes, 1858 (Tate).

79 AGR, 435. The *Fliegendee Blätter* archive was destroyed in the Second World War.

80 cALS Eleanor Henry to Penelope Noakes, 6/9/1859 (Tate).

81 Ibid.

82 Marriage certificate: the witnesses were George Harris, Mary Robinson, and Maria Benson Slee. Eleanor's origins seem to have created a moment of awkwardness when it came to signing the register. James Henry – the long-vanished 'solicitor' of Henrietta Street – remained, after all, her legal father. The space on the certificate for the listing of her 'Father's name' was, however, left blank, though his 'Profession' was given as 'Solicitor'.

83 HMS, 22.

84 cALS Eleanor Henry to Penelope Noakes, 6/9/1859 (Tate).
85 HMS, 23.
86 They moved to 59 Augustenstrasse on 29 October 1859, to 25 Blumenstr. on 11 October 1860, and to 4 Kleestr. on 17 October 1863 (Munich records).
87 Edward Wilberforce, *Social Life in Munich* (2nd edn, 1864), 113.
88 HMS, 32.
89 Although the Kunstverein's records have been lost, it is known that Oswald Sickert had work on show there in December 1859 (see review in *Die Dioskuren*, vol. v, 18); in December 1860 (see review in *Die Dioskuren*, vol. vi, 430) and in 1863. He also showed in Vienna in May 1864 (see *Die Dioskuren*, vol. ix, 175) where his picture of *The Return from the Harvest* was praised as 'excellent work' and commended for its 'fascinating' colours.
90 FO list 1860: Envoy Extraordinary and Minister Plenipotentiary, Sir J. R. Milbanke, Bt (appt 24 Nov. 1843); secretary to the legation, Alfred Guthrie Bonar; Paid Attachés, G. B. Congrave Londsdale, Wm McMahon, George Sheffield. All these continue till 1867, except for Milbanke, who was replaced by Lord A. W. F. S. Loftus in 1863. There is no mention of Sickerts in ministerial correspondence files at PRO.
91 Murray's *Bavaria* (1863), 78.
92 HMS, 85, states that they were all christened by the English chaplain at Munich, but the English chaplaincy records do not survive for the period before 1862, so the exact date of Walter's christening is not known. The other dates are recorded: Robert Oswald Sickert was baptized on 13 April 1862 by Carter Hall MA, vicar of Hollingbourne, Kent, acting British Chaplain; Bernhart [*sic*] Sickert on 8 March 1863, as above; and Helena Maria Lucy Sickert on 31 July 1864, by Thomas Bedford, English Chaplain (Guildhall Library).
93 WS, Preface to *Exhibition of Paintings by Walter Bayes*, Leicester Galleries, March 1918; reprtd AGR, 422–3; cALS Eleanor Sickert to Penelope Noakes, 1/11/1863 (Tate).
94 HMS, 23. Their birth years are given in Nellie [Helena] Swanwick, 'Notes on Walter Richard Sickert', 1 (V&A).
95 Swanwick, ibid.
96 HMS, 32–3.
97 cALS Eleanor Sickert to Penelope Noakes, from Dachau, 1863 (Tate).
98 cALS Eleanor Sickert to Penelope Noakes, from Munich, 1863 (Tate).
99 cALS Eleanor Sickert to Penelope Noakes, 1/11/1863 (Tate); cALS Eleanor Sickert to OAS, 29/10/1864 (copy in Sutton GUL).
100 The street is now called Lingstrasse; all the houses in it postdate the Second World War.
101 HMS, 27, 23.
102 Ibid., 37; WS, 'Diez, Busch and Oberländer', *Burlington Magazine* (October 1922), in AGR, 448–53.
103 HMS, 26.
104 Ibid., 35.
105 Nellie [Helena] Swanwick, 'Notes on Walter Richard Sickert', 1 (V&A).
106 HMS, 26.
107 Helena recalled in her autobiography that there were 'certain pieces – the first movement of Beethoven's Sonata, Op. 111; Schumann's Carnival and Fantasie and Symphonic Studies and Piano Concerto; the 'Emperor' arranged for piano alone – which come back to me now with all the lovely mystery of airs heard first through sleep and slowly piercing into consciousness' (HMS, 32).
108 Edward Wilberforce, *Social Life in Munich*, op. cit., 239.
109 cALS Eleanor Sickert to Penelope Noakes, 1866 (Tate).
110 HMS, 32.
111 Nellie [Helena] Swanwick, 'Notes on Walter Richard Sickert', 2 (V&A).
112 Cecil Beaton, *The Years Between: Diaries 1939–44* (1965), 46; HMS, 32.
113 Nellie [Helena] Swanwick, 'Notes on Walter Richard Sickert', 1 (V&A); HMS, 26.

114 TLS F. S. Stewart-Killick to Denys Sutton, 7/5/1968, mentions the drawing as having been sent to Miss Noakes [Stewart-Killick's grandmother] in c.1866. It was exhibited at the 1960 Arts Council exhibition of Sickert's work.

115 cALS Eleanor Sickert to Penelope Noakes, 8/12/1863 (Tate).

116 Edward Wilberforce, *Social Life in Munich*, op. cit., p. 239. Wilberforce was not, as Sutton suggests, consul.

117 Murray's *Bavaria* (1863), 43.

118 Martin Seymour-Smith, *Robert Graves* (1982), 8.

119 There were ten Ranke children in all; the eldest became Robert Graves' mother.

120 AGR, 435.

121 HMS, 20.

122 cALS Eleanor Sickert to OAS, 29/10/1864 (copy in Sutton GUL).

123 ibid.

124 ibid.; cALS Eleanor Sickert to Penelope Noakes, ?/10/1865 (Tate); RE, 19.

125 HMS, 36.

126 RE, 19; cALS Eleanor Sickert to Penelope Noakes ?/10/1865 (Tate); ML, 45; 'L.M.H.', *The Sickerts* (pamphlet printed by Islington Council c.1960).

127 RE, 214. Sickert later presented a print to Alfred Cooper's son, Duff Cooper, inscribed 'To Duff Cooper from a lifelong debtor to your father' (information from John Julius Norwich).

128 cALS Eleanor Sickert to Penelope Noakes ?/12/1865 (Tate).

129 ALS WS to Mrs Hulton, 1/1/1904 (Oxford); HMS, 25.

130 WS, 'Solomon J. Solomon', *Art News* (10 March 1910), reprtd AGR, 202.

131 WS, 'The Society of Painter-Etchers', *The Speaker* (20 March 1897), reprtd AGR, 150.

132 HMS, 23.

133 Robert Rodney Fowler: in 1881 Census, at the Rectory, Broadway. Aged 51. Married to Katherine; children: Edith Munro aged 20, Helen Katherine aged 17, Herbert Rodney Ross aged 13, and Aldine

Isobel aged 5. Fowler was Chaplain at Munich 1866–73.

134 Martin Seymour-Smith, *Robert Graves* (1982), 29.

135 HMS, 33; Robert Graves, *Goodbye to All That* (1929), 44–6.

136 Nellie [Helena] Swanwick, 'Notes on Walter Richard Sickert', 1 (V&A).

137 ALS WS to Mrs Hulton, 1/1/1904 (Oxford).

138 HMS, 24.

139 Ibid., 25.

140 ALS WS to Mrs Hulton [summer 1901] (Oxford).

141 ALS WS to Ethel Sands [summer 1913] (Tate).

142 Ibid.

143 HMS, 33.

144 Nellie [Helena] Swanwick, 'Notes on Walter Richard Sickert', 1 (V&A); HMS, 36.

145 cALS Eleanor Sickert to OAS, 29/10/1864 (GUL).

146 HMS, 36; ML, 93.

147 HMS, 36, 91–2.

148 Ibid., 91–2.

149 Ibid., 92.

150 AGR, 448.

151 ALS WS to Mrs Hammersley [1909] (Fondation Custodia).

152 HMS, 35.

153 AGR, 435.

154 ALS WS to JEB [c.23/7/1899] (Institut).

155 ALS WS to Mrs Hulton, 1/1/1904 (Oxford).

156 AGR, 435.

157 ALS WS to Ethel Sands [March 1914] (Tate).

158 AGR, 448–52. Amongst Sickert's books in the Courtauld Institute Library is a copy of H. Esswein's *Adolf Oberlander*, and amongst the annotations is the remark that in '[18]65 he [Oberlander] was 20, my father was 36'.

159 AGR, 435.

160 HMS, 41.

161 cALS Eleanor Sickert to Penelope Noakes, 3/11/1867 (Sutton GUL).

162 WS letter to *Daily Telegraph*, 10/4/1937, in 'Cuttings Book 1906–9/34–38' (Islington); Osbert Sitwell, *Noble Essences* (1950), 201.

163 AGR, 202.
164 Richard Shone, 'Duncan Grant on a Sickert Lecture', *Burlington Magazine* (December 1981), 671.
165 ALS WS to Henry Tonks [1914–18] (Texas).
166 JEB, 'Walter Richard Sickert', MS (Fondation Custodia); Nellie [Helena] Swanwick, 'Notes on Walter Richard Sickert', 2 (V&A); Simona Pakenham, *Sixty Miles from England* (1967), 78–9.
167 Nellie [Helena] Swanwick, 'Notes on Walter Richard Sickert', 2–3 (V&A).

II A NEW HOME

1 Bedford Corporation Rate Book (Bedford).
2 *Bedfordshire 1869* contains no Sickerts, Henrys, Sheephanks, or other familiar names.
3 *Mate's Guide to Bedford* [1890].
4 HMS, 41; Nellie [Helena] Swanwick, 'Notes on Walter Richard Sickert', 2 (V&A).
5 Bedford Corporation Rate Book (Bedford); HMS, 41.
6 HMS, ibid.
7 Ibid.
8 *The Annual Report of the General Infirmary, Bedford, for the year 1868* [Bedford, 1869], 12.
9 HMS, 37. It was, according to Helena, the only time Mrs Sickert was ever ill during her childhood.
10 HMS, 42–3.
11 The school was run by a Miss Neal: Nellie [Helena] Swanwick, 'Notes on Walter Richard Sickert', 2 (V&A).
12 Bernhard, who 'nearly died' of typhoid, seems to have joined him later. Nellie [Helena] Swanwick, 'Notes on Walter Richard Sickert', 2 (V&A).
13 Anne O. Bell (ed.), *The Diary of Virginia Woolf. Volume IV: 1931–1935* (1982), 194.
14 ALS WS to [Ethel Sands] [October 1915] (Tate).
15 RE, 2.
16 cALS Eleanor Sickert to Penelope Noakes, 25/7/1869 (Tate).
17 RE, 20. Sickert mentions that his Reading schooldays left him 'slightly obese' (AGR, 518).
18 cALS Eleanor Sickert to Penelope Noakes, 25/7/1869 (Tate).
19 In the Bedford Rate Book, the house, though still in O. A. Sickert's name, is listed as being empty in July 1869; cALS Eleanor Henry to Penelope Noakes, ?/9/1869, mentions an imminent move to London; HMS, 43.
20 The rent was about £60 a year. Kensington Rate Book for the 'Second Rate' of 1870 gives the 'gross estimated rental' as £60 and the 'rateable value' as £53; a rate of £3.12s. was collected.
21 HMS, 43.
22 Ford married one of the daughters of the Sickerts' friend Baron de Kreusser; Nellie [Helena] Swanwick, 'Notes on Walter Richard Sickert', 2 (V&A).
23 AGR, 435.
24 1871 Census Return.
25 ALS Maggie Cobden to Dorothy Richmond, 15/6/1881 (Chichester).
26 George Campbell de Morgan, one of the original trustees of Anne Sheepshanks' trust fund for Mrs Sickert, had taught mathematics at the school until his death in 1867. UCS Register gives Sickert's dates as 'Oct 1870 to summer 1871'. The 'Dower School' was run by a Miss Manfred; Nellie [Helena] Swanwick, 'Notes on Walter Richard Sickert', 1 (V&A).
27 HMS, 85; *Crockford's Clerical Directory 1876* lists John Alexander Jacob as curate of St Thomas', Paddington. Sir Walter Besant, *London North of the Thames* (1911), 143, describes how, south of Porchester Road, 'near Westbourne Grove, lies St Thomas's Church, a temporary iron building'.
28 HMS, 85.
29 Edith Ortmans [*née* Carter], TS Sutton (GUL); HMS, 85.
30 HMS, 84–5.
31 WS, 'Mural Decoration', *English Review* (July 1912), reprtd AGR, 323–4.

32 RE, 20-1.

33 Louis Cornelissen recalled Walter being brought into his shop in the late 1860s in a Little Lord Fauntleroy suit with long golden curls. Violet Overton Fuller, 'The Letters [of Walter Sickert to Florence Pash]', TS, 6 (Islington).

34 Osbert Sitwell, *Noble Essences* (1950), 202.

35 AGR, 435.

36 Scholderer's first London address was 5 Clarence Road, Putney; ALS Victor Scholderer to Denys Sutton, 19/4/1967 (Sutton GUL). Scholderer exhibited a portrait of O. A. Sickert at the Royal Academy in 1877.

37 ALS Edith Ortmans [*née* Carter] to John Russell, 15/10/1958, (Sutton GUL).

38 AGR, 35.

39 HMS, 66-7.

40 ALS Maggie Cobden to Dorothy Richmond, 21/12/1881 (Chichester).

41 Osbert Sitwell, *Noble Essences*, op. cit., 202.

42 ALS WS to Eleanor Sickert (Islington); RE, 21.

43 cALS Eleanor Sickert to Penelope Muller [*née* Noakes], ?/?/1872, from Ilfracombe CVLA. WS, in his annotated copy of *George Cruikshank* (Great Artists series, 1891), p. 29, notes that the family spent the summer of 1873 at Harwich (Courtauld).

44 RE, 21; AGR, 527. The 1871 Post Office Directory lists it as 'John Davies boys' school', though the Census Return for that year shows that William T. Hunt was living there, as head of the household, together with his wife. By 1872 the PO Directory listing had been amended to William Thomas Hunt, 'collegiate school'.

45 HMS, 60. The other boys included Ogura, Niwa, and Seizoo Inouye. The last named subsequently went to King's College School. F. R. Miles, *King's College School Alumni, 1866-1889* (1985).

46 Nellie [Helena] Swanwick, 'Notes on Walter Richard Sickert', 1 (V&A).

47 Rupert Hart-Davis, *Hugh Walpole* (1952), 300.

48 Jean Hamilton, 'Diary', 14/12/1904 (KCL).

49 cALS Eleanor Sickert to O. A. Sickert, 29/10/1864, (Sutton GUL).

50 Nellie [Helena] Swanwick, 'Notes on Walter Richard Sickert', 3 (V&A).

51 RE, 21; AGR, 443. There are, however, some moments in his writings when Sickert seems to suggest that the Claimant was false; cf. AGR, 340, 546.

52 AGR, 599-600.

53 RE, 2, 24, 213-16; AGR, 366; Nellie [Helena] Swanwick, 'Notes on Walter Richard Sickert', 3 (V&A); ALS Maggie Cobden to Dorothy Richmond, 15/6/1881 (Chichester), describes Sickert giving 'examples of Phelps' acting in *Richard III*'.

54 Nellie [Helena] Swanwick, 'Notes on Walter Richard Sickert', 4 (V&A).

55 AGR, 554.

56 Ibid., 453.

57 Ibid., 226; cf. also Algernon Graves, *A Century of Loan Exhibitions, 1813-1912* (3 vols, 1913-15).

58 WS, 'The Derby Day', *Burlington Magazine* (December 1922), reprtd AGR, 454.

59 Violet Overton Fuller, 'The Letters [of Walter Sickert to Florence Pash]', TS (Islington). Elsewhere, in her notes, Overton Fuller makes reference to Sickert having been painted by Sydney Long, though it is unclear whether this is a mistaken allusion to the Nelson painting or to another picture altogether.

60 Mrs Sickert may have been anxious about the birth. She recorded a little informal will on 28 May 1873, leaving everything to 'my dear husband' (Islington).

61 RE, 21.

62 WS to Nina Hamnett [1919], quoted in ML, 88.

63 ALS WS to Mr Conibear, 12/3/1875, (private collection).

64 Algernon Graves (ed.), *A Dictionary of Artists Who Have Exhibited Works in the Principal London Exhibitions from 1760-1893* (3rd edn, 1901), lists

OAS's known exhibits as: RA 2/ British Institution 1/New Water Colour Society 2/Various 4. In the last category was perhaps *Floxgarten*, exhibited at the Dudley Gallery in October 1872: cf. cALS Eleanor Sickert to Penelope Muller, 28/10/1872 (Tate).

III L'ENFANT TERRIBLE

1 HMS, 43. Old Mrs Slee had died at around the time of the Franco-Prussian War and the school had been taken over by her daughter, Maria (cf. Simona Pakenham, *Sixty Miles from England*, op. cit., 93).

2 HMS, 60–1; F. R. Miles, *King's College School Alumni*, op. cit., 211.

3 Desmond Chapman-Houston, *The Lost Historian: A Memoir of Sir Sydney Low* (1936), 15; for other information on KCS see Frank Miles and Graeme Cranch, *King's College School: The First 150 Years* (1975), Thomas Hinde, *A Great Day School in London: A History of King's College School* (1995).

4 F. R. Anstey, quoted in Desmond Chapman-Houston, *The Lost Historian*, op. cit., 11.

5 Marjorie Lilly, *Sickert, the Painter and his Circle* (1971), 164.

6 HMS, 60. Clive Bell, in *Old Friends* (1956), 17, resented the fact that 'people in studios and cafes' supposed he was a scholar because of his habit of 'quoting, and misquoting, Latin tags'.

7 WS, annotation in *The Tichborne Trial*, 15.

8 F. R. Anstey, quoted in Desmond Chapman-Houston, *The Lost Historian*, op. cit., 13.

9 *King's College Calendars 1876–1877*, 1877–1878.

10 Ibid., 1876–1877.

11 HMS, 60.

12 Ibid.

13 TLS F. Miles to Matthew Sturgis, 13/9/1999.

14 R. S. Brough, letter to *King's College School Magazine* (July 1905), 4.

15 Frank Miles and Graeme Cranch,

King's College School: The First 150 Years, op. cit., 123; RE, 20, appeared to have grasped a confused version of this event, suggesting that it happened at UCS (when Walter was only seven) rather than at KCS. Emmons also says that Sickert had initially told him that he was expelled as a result of the scheme. The KCS records confirm Sickert's later retraction of this claim.

16 HMS, 60.

17 *Sunday Times*, 2/2/1936, in 'Cuttings Book 1906–7/1934–38' (Islington).

18 HMS, 86. Walter was, however, made godfather to Otto Scholderer's son Victor; ALS Henry Bird to John Russell, 28/9/1958, (Sutton GUL).

19 HMS, 92.

20 Alfred Pollard, quoted in Frank Miles and Graeme Cranch, *King's College School*, op. cit., 121.

21 Ibid., 118.

22 ML, 45.

23 *The Observer*, 19/4/1936, in 'Cuttings Book 1906–7/1934–38' (Islington).

24 Adrian Bury, *Joseph Crawhall: The Man and the Artist* (1959), 44; Vivien Hamilton, *Joseph Crawhall* (1990), 9; RS [WS] to *The Times*, 28/4/1935, reprtd AGR, 675.

25 A. S. Hartrick, *A Painter's Pilgrimage* (1939), 95.

26 Clifford Ellis, BBC tape; AGR, 470.

27 Clifford Ellis, BBC tape.

28 AGR, 43.

29 Ibid.

30 ALS WS to Ethel Sands, Sunday [summer 1913] (Tate).

31 Laurence Irving, *Henry Irving: The Actor and his World* (1951).

32 HMS, 92.

33 Ibid., 92–5. Other 'high-born maidens' and 'fearless knights' included the painter Sidney Starr, an etcher called Calwell, together with his sister, a Geoffrey Gray, and the Bells.

34 AGR, 582. The Sickerts' cook was Elizabeth Shervill, born 1841 in Middlesex according to the 1881 Census. WS relished her pungent sayings and put-downs. 'My mother's old cook, when she failed, as she

sometimes did, to understand the earliest efforts of my younger brothers in the formation of a prose style, was wont to console herself by telling them that they were talking "Double-Dutch." ' AGR, 299.

35 RE, 24; Nellie [Helena] Swanwick, 'Notes on Walter Richard Sickert', 3 (V&A); cALS Eleanor Sickert to Penelope Muller, 5/10/1877.

36 ALS Mr Maclear to Mr [Reginald] Poole, 28/1/1878 (BL). The piece he acted was from act V, scene iii; Frank Miles and Graeme Cranch, King's College School, op. cit., 120; HMS, 60.

37 WS to The Times, 12/12/1934, reprtd AGR, 672.

38 AGR, 454.

39 Ibid., 581.

40 Douglas Cooper, Courtauld Collection: A Catalogue and Introduction (1954), 15; Colleen Denney, At the Temple of Art: The Grosvenor Gallery, 1877–1890 (2000), 30–1.

41 WS to The Times, 20/6/1933, reprtd AGR, 626; ibid., 236.

42 HMS, 99–101.

43 Colleen Denney, At the Temple of Art, op. cit., 50–1.

44 AGR, 172.

45 Ibid., 581.

46 [J. M. Whistler], The Gentle Art of Making Enemies (1890), 1–19; Ronald Anderson and Anne Koval, James McNeill Whistler: Beyond the Myth (1994), 215–27.

47 HMS, 75.

48 ALS Edith Ortmans [née Carter] to John Russell, 15/10/1958, (Sutton GUL).

49 ALS Edith Ortmans [née Carter] to Denys Sutton, 29/10/1958, (Sutton GUL); Edith Ortmans TS, Sutton papers; 1881 Census.

50 ALS Mr Maclear to Mr [Reginald] Poole, 28/1/1878 (BL). The letter runs: 'I think I could recommend you a boy, who could in my opinion, suit you very well. He is a very fair Classical Scholar, and knows French and German very well, far better than the average run of boys. His father is a Danish artist, and the boy has been a good deal abroad. I can very highly recommend him. If he should succeed in the competition it would be the very greatest possible boon to his father and mother. He is a nice boy. He did the piece of Richard III which made such a sensation at our Speeches last Christmas and about which Mrs Poole can tell you much.'

51 ALS Eleanor Sickert to Mr Maclear, 4/2/1878 (BL).

52 Anne Sheepshanks died on 8 February 1876; administration was granted on 24 April 1876. Susanna Levett died three years later, and a new administration was granted on 2 April 1879 'to Revd Thomas Sheepshanks of Arthington Hall near Otley in the Co. of York, nephew & one of the persons entitled in Distribution'. Whether the Sickerts were also 'persons entitled in Distribution' at this date is not known, but it seems possible, even likely.

53 Ellen wrote to Mr Maclear from there on 4/2/1878; Nos 1–12 now demolished; rent and 'extra wing' from Kensington Rate Book and Kensington Draft Valuation List 1880–1 (Kensington Public Library); Colin McInnes, The Spectator (11 October 1963), 453–5, describes No. 6 where his mother, Angela Thirkell, lived.

54 ALS WS to Mr Reginald Poole, 25/10/1878 (BL).

55 ALS Mr Maclear to Mr Reginald Poole, 27/3/1878 (BL).

56 King's College Calendar 1879–1880. First Class was not in fact the highest grade; there was also an Honour grade.

57 At Oxford, Pollard became the great friend of A. E. Housman.

58 ALS WS to Mr Reginald Poole, 25/10/1878 (BL).

59 ALS WS to Gwen Ffrangçon-Davies [1932] (Tate).

60 HMS, 61.

61 Nellie [Helena] Swanwick, 'Notes on Walter Richard Sickert', 4 (V&A).

62 Ibid.

63 HMS, 60.
64 ALS WS to Mr Reginald Poole, 25/ 10/1878 (BL).
65 Ibid.
66 RE, 27–8.
67 LB, II, 14. There was, according to a contemporary witness, 'great debate' in the family on the subject.
68 The street is now called Bloomsbury Street to avoid confusion with the Charlotte Street on the other side of the Tottenham Court Road. The Sickerts' early knowledge of the Forbes-Robertsons is suggested by a reference to Norman Forbes[-Robertson] in a letter from WS to Alfred Pollard 27/11/1879; also Helena Swanwick states that Walter started to get to know actors – including the Forbes-Robertsons – from 1878 (MS, V&A).
69 Sir Johnston Forbes-Robertson, *A Player Under Three Reigns* (1925), 62.
70 Ibid.
71 Ian [Forbes-]Robertson, 'Play Book', lists his first performance – on 2 August 1879 – in *Zillah* at the Lyceum: '4 nights, 18 lines spoken'. He had five other little engagements during the course of the year, and earned a total of £26. 10s. (BL).
72 Frank Miles and Graeme Cranch, *King's College School*, op. cit., 120.

Chapter Two: Apprentice or Student?

I THE UTILITY PLAYER

1 ALS WS to Alfred Pollard, 27/1/1879 (private collection).
2 Ibid.; ALS WS to Alfred Pollard 4/3/ 1879 (private collection).
3 Wilfrid Blunt, *England's Michelangelo: A Biography of George Frederic Watts* (1975), 103–20.
4 W. Graham Robertson, *Time Was* (1931), 54; Wilfrid Blunt, *England's Michelangelo*, op. cit., 116.
5 ALS WS to Alfred Pollard, 28–29/3/ [1879] (private collection).

6 ALS WS to Alfred Pollard, 4/3/1879 (private collection).
7 ALS Comora Parker to John Russell, 4/10/1958, (Sutton GUL), recounts how Ms Parker's friend Alicia A. Leith had introduced Sickert to Irving when he first wanted to get on the stage. Subsequently Sickert always signed his letters to her – from 'your unworthy super'. According to the 1881 Census, Miss Leith, then aged 29, was the editor of *Every Girl's Magazine*.
8 George Edgar, *Martin Harvey* (1912), 136–7.
9 ALS WS to Alfred Pollard, 28–29/3/ [1879] (private collection); *The Lady of Lyons* opened on 17 April 1879.
10 Denys Sutton's suggestion that Sickert played the Ghost in Irving's production of *Hamlet* (DS, 28), though attributed to Helena Swanwick, seems to be a misreading of RE, 28.
11 RE, 28.
12 Edward Craig, *Gordon Craig: The Story of his Life* (1968), 54. The 'very advanced' school was run by a Mrs Coles, in Foxton Road.
13 ALS WS to Alfred Pollard, 19/5/ 1879 (private collection).
14 HMS, 98.
15 E. W. Godwin, 'Diary 1879' (V&A). Godwin was at 'Sicard's ho.' [*sic*] on 16 March; 'Sicard' dined *chez* Godwin on 19 March, and on 2 April 'Sicard' took out a subscription to the *British Architect*.
16 ALS WS to Alfred Pollard, 19/5/ 1879 (private collection).
17 William Rothenstein, *Men and Memories*, vol. i (1931), 169.
18 E. W. Godwin, 'Diary 1879' (V&A). Almost every Friday between 9 May and 1 August, Godwin attended the Robertsons' 'At Homes'. He lists some of those – including Wilde and Whistler – who were also there.
19 Gertrude Kingston [Gertrude Konstam], *Curtsey While You're Thinking* (1937), 53.
20 RE, 32, says they 'met at a party'; ALS WS to Alfred Pollard, 19/5/ 1879, indicates that they had met by

the third week of May 1879. The Forbes-Robertsons held receptions on 9 May and 16 May.

21 RE, 32.

22 He was declared bankrupt on 8 May.

23 ALS WS to Alfred Pollard, 19/5/ 1879 (private collection).

24 ALS WS to Alfred Pollard, 27/8/ 1879 (private collection).

25 HMS, 65–6; Merlin Holland and Rupert Hart-Davis, *The Complete Letters of Oscar Wilde* (2000), 83. At the end of the holiday, Wilde presented Helena with a copy of *Selected Poems of Matthew Arnold*.

26 HMS, 64–5; ALS OVS to Edward Marsh, 30/8/1895 (NYPL).

27 ALS WS to Alfred Pollard, 27/8/ 1879 (private collection).

28 He first appeared in *The Bells*, which opened on 20 September 1879; HMS, 64.

29 Sir Johnston Forbes-Robertson, *A Player Under Three Reigns* (1925), 62.

30 ALS WS to Alfred Pollard, 27/8/ 1879 (private collection).

31 ALS WS to Alfred Pollard, 26/10/ 1879 (private collection).

32 *King's College School Magazine*, new series, No. 1 (January 1880), 4. The prize-giving was held on 23 December 1879. Sickert was supported by H. D. Rust in the part of Brackenbury.

33 E. W. Godwin's 'Diary 1879' (V&A) contains several references to meetings and meals with George Rignold during the last quarter of the year.

34 The play ran from 26 December 1879 to the end of February 1880.

35 Oliver Brown, *Exhibition* (1968), 135.

36 ALS WS to Alfred Pollard, 26–27/1/ 1880 (private collection). Sickert remarks that he is performing as 'first servant at Oborne's Theatre'. Oborne was the name of the manager of the Connaught Theatre.

37 E. W. Godwin, 'Diary 1880' (V&A), the entry for 6 February: 'To Connaught Theatre to see Sickert. 1st time speaking part in Amos Clark (Jasper) took wife. Thompson came to our box. Saw Mr Hodson.' I have

to admit that I have read the typescript of *Amos Clark* by Watts Phillips at the BL without discovering a character called Jasper.

38 RE, 28. Sickert amended the exact phrasing in his copy of Emmons' book (Courtauld).

39 AGR, 182; ALS WS to Alfred Pollard, 26/10/1879 (private collection), contains a sketch of a woman in profile with the comment: 'I was drawing a most beautiful girl this morning. This is not a bit like her, but it is all I can remember.' The exhibition of work by O. A. Sickert and J. J. Sickert at the Goupil Gallery in June 1922, included a portrait of Walter Sickert aged 20 by his father.

40 AGR, 182.

41 Ibid., 206.

42 Ibid., 182, 413.

43 Helen M. Knowlton, *The Art Life of William Morris Hunt*, (1899), 8.

44 AGR, 487; Oswald Valentine Sickert, 'The Painting of James Macneill Whistler', *Studio* xxx [1903], 3–10.

45 Osbert Sitwell, *Noble Essences* (1950), 205.

46 Sir Johnston Forbes-Robertson, *A Player Under Three Reigns*, op. cit., 107; *Who Was Who*.

47 Sir Johnston Forbes-Robertson, ibid.; Victor Plarr (ed.), *Men and Women of the Time* (1895).

48 Victor Plarr, ibid.

49 G. H. Scholfield, *A Dictionary of New Zealand Biography* (New Zealand, 1940); G. H. Scholfield, *Richmond-Atkinson Papers* (Wellington, 1960); L. Macdonald, M. Penfold, and B. Williams (eds), *The Book of New Zealand Women* (New Zealand, 1991–2). Dorothy Richmond won a Slade scholarship in 1880, worth £50 p.a.

50 Exactly when and where Sickert met the Cobden sisters is unrecorded. DS, 29, suggests that it was Helena who introduced them, but this is certainly incorrect. Helena came to know the Cobden sisters through her brother. From the evidence of the Cobden sisters' letters (and those of Dorothy Richmond) they clearly

knew him well by the summer of 1880, and it seems likely that they had met him some months before.

51 'X' [Herbert Vivian], *Myself Not Least* (1925), 130.

52 Quoted in Eleanor Pritchard, 'The Daughters of Cobden', *West Sussex Archive Society Newsletter*, No. 25 (May 1983), 18.

53 HMS, 108; Eleanor Pritchard, ibid.

54 ALS Maggie Cobden to Dorothy Richmond, 22/6/1881 (Chichester).

55 'Miles Amber' [Ellen Cobden], *Wistons* (1902), 106, 138–9, 148.

56 Ibid., 97.

57 Ibid., 99.

58 ALS Maggie Cobden to Dorothy Richmond, 22/9/1880 (Chichester).

59 RE, 28.

60 ALS WS to Alfred Pollard, 15/4/1880 (private collection).

61 ALS Maggie Cobden to Dorothy Richmond, 2/10/1880 (Chichester).

62 ALS WS to Alfred Pollard, 15/4/1880 (private collection).

63 ALS Maggie Cobden to Dorothy Richmond, 2/10/1880 (Chichester).

64 ALS WS to T. E. Pemberton, 3/4/1880, (Sutton GUL). Sickert thanks him for his 'kind letter & good opinion of the "old man". It is the part I like best of all I have to do in Henry V.'

65 Quoted in ALS WS to Alfred Pollard, 15/4/1880 (private collection).

66 Ibid.

67 Ibid.

68 RE, 28.

69 William Rothenstein, *Men and Memories*, op. cit., 169.

70 New Sadler's Wells, theatre programme, *A Midsummer Night's Dream*, Monday, 28 June [1880] (Theatre Museum); RE, 29.

71 Patrick O'Connor, 'The Reunion of Stage and Art', in Baron/Shone.

72 New Sadler's Wells, theatre programme, *A Midsummer Night's Dream*, Monday, 28 June [1880] (Theatre Museum).

73 ALS Maggie Cobden to Dorothy Richmond, 22/6/1881 (Chichester), refers to the Sickerts' dance 'last July 1'.

74 HMS, 105–6.

75 ALS Maggie Cobden to Dorothy Richmond, 22/6/1881 (Chichester).

76 HMS, 106.

77 ALS Maggie Cobden to Jessie Thomas, 3/8/1880 (Chichester).

78 ML, 108, 106.

79 Hugh and Mirabel Cecil, *Clever Hearts* (1990), 64.

80 ML, 108.

81 Desmond MacCarthy, *Ellen Melicent Cobden: A Portrait* (1920), 3.

82 ALS Maggie Cobden to Dorothy Richmond, 11/10/1880 (Chichester).

83 ALS Maggie Cobden to Jessie Thomas, 3/8/1880; Maggie Cobden to Jessie Thomas, 7/8/1880; Annie Cobden to Jane Cobden, 19/8/1880 (Chichester).

84 Sir Johnston Forbes-Robertson, *A Player Under Three Reigns*, op. cit., 99–102; Maud Collins, *The Story of Helen Modjeska* (1883), 267; Helen Modjeska, *Memories and Impressions* (1910), 412; Ida Forbes-Robertson, 'Diary', 23 (BL); ALS Helen Modjeska to Gertrude [Forbes-] Robertson, 18/12/1883 (BL).

85 Ida Forbes-Robertson, 'Diary', 22 (BL). The family had stayed with the Jacksons in 1877 and 1878.

86 RE, 27. Modjeska had a reputation for such pranks. Her biographer records one play in which she spent a scene sobbing over a letter while all the time drawing funny caricatures of the actors on the paper.

87 Richard Shone, 'Duncan Grant on a Sickert Lecture', *Burlington Magazine* (December 1981), 671.

88 Sir Johnston Forbes-Robertson, *A Player Under Three Reigns*, op. cit., 101–2.

89 The painting is dated '80' (Witt).

90 DS, 67.

91 Helen Modjeska, *Memories and Impressions*, op. cit., 412.

92 ALS WS to Gwen Ffrangçon-Davies [1932] (Tate); ALS WS to Michael Sadler [26/10/1913] (Oxford). WS remembered her as playing Juliet there, but Roger Iredale, *The Grand: The First 100 Years* (1977), 17, records that when Modjeska was at

Leeds for a week from 11 September 1880, she played in *Adrienne Lecouvrier* and *Heartsease*.

93 ALS Maggie Cobden to Dorothy Richmond, 11/10/1880 (Chichester).

94 ALS Maggie Cobden to Dorothy Richmond, 2/10/1880 (Chichester).

95 Ibid.

96 ALS Maggie Cobden to Dorothy Richmond, 11/10/1880 (Chichester).

97 ALS Maggie Cobden to Dorothy Richmond, 2/10/1880 (Chichester).

98 ALS Maggie Cobden to Dorothy Richmond, 11/10/1880 (Chichester).

99 ALS Maggie Cobden to Dorothy Richmond, 18/10/1880 (Chichester).

100 ALS Maggie Cobden to Dorothy Richmond, 11/10/1880 (Chichester).

101 ALS Maggie Cobden to Dorothy Richmond, 18–30/12/1880 (Chichester).

102 Edward Gordon Craig, *Index to the Story of My Days* (1981 edn), 50.

103 According to a note from Maggie Cobden to Dorothy Richmond (5/12/1880), Walter also performed in a 'benefit' at Birmingham on or around 20 December.

104 ALS Maggie Cobden to Dorothy Richmond, 18–30/12/1880 (Chichester).

105 Ibid.

106 ALS Maggie Cobden to Jane Cobden, 15/2/1881 (Chichester).

107 ALS Maggie Cobden to Dorothy Richmond, 18/5/1881 (Chichester).

108 HMS, 101–2.

109 ALS Maggie Cobden to Dorothy Richmond, 22/6–12/7/1881 (Chichester). Other engagements included the private view at the Grosvenor Gallery at the beginning of May, and a spree to Richmond at the beginning of July.

110 ALS Maggie Cobden to Dorothy Richmond, 22/6–12/7/1881 (Chichester).

111 ALS Maggie Cobden to Dorothy Richmond, 18/5/1881 (Chichester).

112 ALS Maggie Cobden to Dorothy Richmond, 15/6/1881 (Chichester).

113 ALS Maggie Cobden to Ellen Cobden [May 1881] (Chichester).

114 The play was being put on by Frank Benson, who had recently enjoyed a triumph playing Clytemnestra in a Greek-language production of *Agamemnon* at Oxford. ALS Maggie Cobden to Dorothy Richmond, 15/6/1881 (Chichester); Sir Frank Benson, *My Memories* (1930), 148.

115 HMS, 61–2. The 1881 Census shows them all at 12 Pembroke Gardens, together with their cook, Elizabeth Shervill (aged 41), and a housemaid, Ellen Copperwhite (aged 22).

116 HMS, 62.

117 WS to *The Times*, 18/12/1934, reprtd AGR, 672.

118 ALS Jane Cobden to Dorothy Richmond, 12/7/1881 (Chichester).

119 *Fantin-Latour*, catalogue of exhibition at Wildenstein & Co., London (1984).

120 E. W. Godwin, 'Diary 1881' (V&A), entry for 13 April: 'Sigurd called, with him to Harris' p[ainting] room to see model of crypt from my design. Then on to see Millet's "Sower" on show at 8 Pall Mall.'

121 ALS Jane Cobden to Dorothy Richmond, 12/7/1881 (Chichester).

122 ALS Maggie Cobden to Dorothy Richmond, 26/6–12/7/1881 (Chichester).

123 ALS Maggie Cobden to Dorothy Richmond, 24/7–4/8/1881 (Chichester).

124 Ibid.

125 ALS Ellen Cobden to Jane Cobden, 10/8/1881 (Chichester), reports: 'Walter draws all day'.

126 ALS Maggie Cobden to Dorothy Richmond, 24/7–4/8/1881 (Chichester); ALS Maggie Cobden to Dorothy Richmond, 26–30/9/1881 (Chichester); ALS Maggie Cobden to Jessie Thomas, 22/8/1881 (Chichester).

127 ALS Maggie Cobden to Dorothy Richmond, 1–2/9/1881 (Chichester).

128 ALS Maggie Cobden to Dorothy Richmond, 24/7–4/8/1881 (Chichester).

129 ALS Maggie Cobden to Jessie Thomas, 22–25/8/1881 (Chichester).

130 ALS Ellen Cobden to Jane Cobden, 10/8/1881 (Chichester). Ellen reported: 'I am the only one who seems to care about bathing. It makes Walter quite blue, & Maggie felt chilled after it the other day.'

131 ALS Maggie Cobden to Dorothy Richmond, 26–30/9/1881 (Chichester).

132 ML, 28.

133 ALS Maggie Cobden to Jane Cobden, 13/10/1881 (Chichester).

134 Ibid.

135 HMS, 61; RE, 31.

136 Desmond MacCarthy, *Ellen Melicent Cobden*, op. cit., 3, 8.

137 Ibid., 5.

138 ALS Maggie Cobden to Dorothy Richmond, 11/12/1881 (Chichester).

139 Ibid.

140 'Attendance Book 1880–81' (Slade). Term started on Tuesday 4 October.

141 William Rothenstein, *Men and Memories*, op. cit., 22–3.

142 AGR, 150, 155.

143 Ibid., 303.

144 His fellow pupils included H. J. Dicksee, Charles Holroyd, W. G. Storey, Henry Ganz, Ernest Sichel, William Duthie, William Carter, Laurence Hardy, Harrington Mann, Percy Studee, and the future novelist Howard Overing Sturgis. None of them seems to have been a part of Sickert's life. Amongst the female students was Fedora Gleichen, whom he did know in later years. 'Attendance Book 1880–81' (Slade).

145 ALS Maggie Cobden to Dorothy Richmond, 11/12/1881 (Chichester).

146 Ibid.

147 Ibid.

148 *Loch Eriboll* was picture no. 84 in the exhibition, which was titled *The Sea*.

149 ALS Maggie Cobden to Dorothy Richmond, 11/12/1881 (Chichester).

150 ALS Jane Cobden to Ellen Cobden, 10/12/1881 (Chichester).

151 ALS Maggie Cobden to Dorothy Richmond, 21/12/1881 (Chichester).

152 Ibid.

153 Ibid.

154 ALS Maggie Cobden to Dorothy Richmond, 11/12/1881 (Chichester).

155 ALS Maggie Cobden to Dorothy Richmond, 21/12/1881 (Chichester).

156 HMS, 61; DS, 26, in an accidental misreading, has Walter challenging 'his mother to find him in the square near their house, where he was disguised as a toothless old man'.

157 ALS WS to Bram Stoker, 1/2/1882 (Leeds). Stoker (the future author of *Dracula*) was Henry Irving's secretary. Sickert wrote to him asking for a ticket to see the Lyceum production of James Albery's *Two Roses* one Saturday morning, adding, 'I know you will be glad to hear that I have an engagement at St James's for two understudies – Mr T. W. Robertson's & Mr Brandon's parts.'

158 Jevan Brandon-Thomas, *Charley's Aunt's Father* (1955), 61, 84–5.

159 RE, 32.

160 Oliver Brown, *Exhibition*, op. cit., 135; Clive Bell, *Old Friends* (1956), 15; RE, 29; Donald Ball to Matthew Sturgis, 12/11/2000.

161 RE, 28.

II WHISTLER'S STUDIO

1 E. R. and J. Pennell, *The Life of James McNeill Whistler* (1911 edn), 223–5; Ronald Anderson and Anne Koval, *James McNeill Whistler: Beyond the Myth* (1994), 250–1.

2 Ibid.

3 JEB, *Propos de Peintre*, vol. i (1919), 19.

4 AGR, 95.

5 E. R. and J. Pennell, *The Life of James*

McNeill Whistler, op. cit.; Richard Dorment and Margaret F. MacDonald, *James McNeill Whistler* (1994); AGR. Two very incomplete paintings of WS by Whistler survive: one is in the National Gallery of Ireland, Dublin, the other belonged to J.-E. Blanche (LB II, 17).

6 Mortimer Menpes, *Whistler As I Knew Him* (1904), 3 ff.

7 AGR, 647.

8 AGR, 647; John Collier, *The Art of Portrait Painting* (1905), 64–6; information from WS, according to Rutter, *Whistler* (1911), 57.

9 Mortimer Menpes, *Whistler As I Knew Him* op. cit, 10–11.

10 ALS WS to Will Rothenstein [1899] (Harvard).

11 WS, op. cit., in AGR, 647.

12 E. R. and J. Pennell, *The Life of James McNeill Whistler*, op. cit., 210. Lady Meux sent her maid to pose in her stead.

13 AGR, 227.

14 Ibid., 553. When Sickert first arrived at Tite Street he found his hero busy over a pamphlet that rehearsed all the tedious details of some petty dispute about his rights to a certain oriental cabinet. E. R. and J. Pennell, *The Life of James McNeill Whistler*, op cit., 217. The pamphlet was issued as *The Paddon Papers: The Owl and the Cabinet*.

15 AGR, 282.

16 WS, 'The New Life of Whistler', *Fortnightly Review* (December 1908), in AGR, 186–7.

17 AGR, 661.

18 Eric Newton, 'As I Knew Him: A Personal Portrait of Walter Sickert', transcript of BBC broadcast (1 October 1951/BBC Archives, Reading); ALS WS to Ethel Sands [1913] (Tate).

19 AGR, 282; A. S. Hartrick, *A Painter's Pilgrimage* (1939), 133.

20 Mortimer Menpes, *Whistler As I Knew Him*, op. cit., 22.

21 Mortimer Menpes, 'Reminiscences of Whistler', *The Studio*, xxix [1903], 245–6.

22 AGR, 623.

23 ALS WS to John Collier (Fondation Custodia); WS in *Fortnightly Review* 1892; AGR, 93.

24 DSM, *Saturday Review* (19 November 1921).

25 WS, 'Impressionism', preface to *A Collection of Paintings by the London Impressionists*, Goupil Gallery catalogue (1889), in AGR, 60.

26 Bernhard Sickert, *Whistler* [1908], 108–12. Frank Rutter, *Whistler* (1911), 52, confirms that the 'pupil' quoted was WS.

27 ML, 56–7; Alfred Thornton, 'Walter Richard Sickert', *Art Work*, vi (1930), 12. According to William Rothenstein, Legros had urged students to train their memories by observing street scenes. *Men and Memories*, vol. i, 24.

28 Bernhard Sickert, *Whistler*, op. cit., 112.

29 'Pictures by Mr Sickert's Pupils', *Manchester Guardian* (8 October 1930); WS, 'Where Paul and I Differ', *Art News* (10 February 1910), in AGR, 195–6.

30 Frank Rutter, *Whistler*, op. cit., 60.

31 WS, 'Abjuro', *Art News* (3 February 1910), reprtd AGR, 193.

32 AGR, 654.

33 Mortimer Menpes, *Whistler As I Knew Him*, op cit., 22–3.

34 Ibid., 25.

35 Ibid., 24.

36 Louise Jopling [Mrs Jopling-Rowe], *Twenty Years of My Life* (1925), 227.

37 JMW, 'Ten o'Clock Lecture'; Graham Hough, *The Last Romantics* (1983), 175–87.

38 AGR, 520.

39 Ibid., 581.

40 WS, 'The New Life of Whistler', *Fortnightly Review* (December 1908), reprtd AGR, 186.

41 [WS], 'An Art Student Writes to Us as Follows', *Pall Mall Gazette* (7 June 1882), reprtd AGR, 3.

42 WS, 'The New Life of Whistler', op. cit., rprtd AGR, 179.

43 WS, 'Painting and Criticism', *Art News* (21 April 1910), reprtd AGR, 220; WS, 'Is the Camera the Friend or Foe of Art?', *Studio* (7 January

1893), reprtd AGR, 97: WS supported his view with the quip, 'Coelum, non cameram mutat, as Mr Whistler recently said of the much-travelled photo-painter' ('The sky changes, not the camera', a play upon Horace, Epistles i. II: 'Caelum, non animum, mutant, qui trans mare currunt' ['Those who cross the sea change their sky, not their mind']); WS to William Heinemann [as from Whistler] [1896] (Harvard), declining to contribute to some project with a German quotation.

44 WS, 'The Old Ladies of Etching-Needle Street', English Review (January 1912), in AGR, 289–90.

45 WS, 'The New Life of Whistler', Fortnightly Review, op. cit., reprtd AGR, 180.

46 WS, 'Engraving, Etching, Etc.', lecture given at Thanet School of Art, 23 November 1934, reprtd AGR, 658.

47 Mortimer Menpes, Whistler As I Knew Him, op. cit., 24.

48 Kenneth McConkey, Impressionism in Britain (1995).

49 WS, annotation on p. 87 of his copy of Paul Jamot, Degas (1924) (Fondation Custodia).

50 JEB, La Pêche aux Souvenirs (1941), 144. There were two twinned Wagner seasons running in London that spring, one at Her Majesty's Theatre, the other at the Theatre Royal Drury Lane.

51 JEB, ibid. Blanche asserts, 'Je fis alors le vrai connaissance de Walter.'

52 ALS JEB to Mme Blanche [July 1886] (Institut). The letter is printed in Portraits of a Lifetime (1937), 304–5. Blanche mistakenly dates his trip to London, and his missing of the premiere of Parsifal, to 1884, rather than 1882.

53 ALS JEB to Dr Blanche, 15/8/1882 (Institut).

54 JEB, Portraits of a Lifetime, op. cit., 51–7.

55 ALS WS to JEB [autumn 1888]. Sickert admits to cherishing 'toujours une adoration profond quoique discrète' for Olga (Institut).

56 ALS Maggie Cobden to Jane Cobden, 27/9/1882 (Chichester).

57 E. W. Godwin, 'Diary 1882', 2/10/1882 entry: 'Sigurd called – with him to Abbey & on to British Mus intro'd him to MS Dep. & set him to work ... Left at 4 for home – gave Sigurd letters for Miss Ward & Miss [Hilda] Hilton [re the Costume Society?].' There are further references to Sickert working with him at the BM on 3/10 and 6/10 (V&A).

58 Laurence Irving, The Successors (1967), 120.

59 ALS Maggie Cobden to Ellen Cobden, 11/9/1882 (Chichester).

60 ALS Maggie Cobden to Ellen Cobden, 25/10/1882; ALS Jane Cobden to Ellen Cobden, 6/12/1882 (Chichester). Ellen's address was 24 Ethelbert Crescent.

61 ALS Jane Cobden to Ellen Cobden, 20/12/1882 (Chichester).

62 CALS Eleanor Sickert to Penelope Muller [1883] (Tate).

63 WS, 'The New Life of Whistler', Fortnightly Review, op. cit., reprtd AGR, 179.

64 Merlin Holland and Rupert Hart-Davis (eds), The Complete Letters of Oscar Wilde (2000), 195: Oscar Wilde to Waldo Story [31/1/1883].

65 E. R. and J. Pennell, The Life of James McNeill Whistler, op cit., 217.

66 Jevan Brandon-Thomas, Charley's Aunt's Father (1955) 85.

67 CALS Eleanor Sickert to Penelope Muller [1883] (Tate).

68 Thomas Cobden-Sanderson, The Journals of Thomas James Cobden-Sanderson (1926), vol. i, 87, refers to Annie Cobden going on a whim to Chelsea to visit WS, presumably at his new address. But WS also claimed to have seen Whistler painting Mrs Cassatt, work that carried on between April 1883 and 1885.

69 WS, 'Degas', Burlington Magazine (November 1917), 413.

70 Quoted in Richard Ellmann, Oscar Wilde (1987), 127; RE, 127.

71 WS to Morning Post, 11/5/1936, reprtd AGR, 685; WS, 'Self-conscious

Paint', *Daily Telegraph*, (3 June 1925), reprtd AGR, 520. Manet died on 30 April, only a few days after WS's visit.

72 AGR, 520–1; WS, 'Self-conscious Paint', *Daily Telegraph* (3 June 1925), in AGR, 520–1; WS, 'Modern Realism in Painting' (1892), in AGR, 88.

73 WS, 'Degas', *Burlington Magazine*, op. cit., 413–14.

74 Ibid.; WS, 'The Importance of Being Canvas', *Daily Telegraph* (4 March 1925), in AGR, 509.

75 'The Gospel of Impressionism', *Pall Mall Gazette* (21 July 1890), reprtd AGR, 77; Herbert Vivian, 'Mr Walter Sickert on Impressionist Art', *Sun* (8 September 1889), reprtd AGR, 57.

76 RE, 245.

77 'St P.' [WS], 'Two Exhibitions', *The Speaker* (7 November 1896), reprtd AGR, 109; Joseph Hone, *The Life of Henry Tonks* (1939), 217.

78 'The Gospel of Impressionism', *Pall Mall Gazette* (21 July 1890), reprtd AGR, 77.

79 RE, 245; WS, 'The Importance of Being Canvas', *Daily Telegraph* op. cit., reprtd AGR, 509.

80 RE, ibid.

81 Besides his visits to Manet and Degas, he reported seeing Renoir in the street: WS annotation on page 113 of his copy of Paul Jamot, *Degas* (Fondation Custodia).

82 Kenneth McConkey, *Impressionism in Britain*, 42.

83 WS, 'L'Affaire Greaves', *New Age* (15 June 1911), reprtd AGR, 284.

84 They married on 5 August 1882 at Marylebone Registry Office.

85 Frances Spalding, *Vanessa Bell* (1983), 11.

86 Mortimer Menpes, *Whistler As I Knew Him*, op cit., 139.

87 LB II, 62; WB, 299.

88 Alberto Ludovici, *An Artist's Life in London and Paris* (1926), 74.

89 Mortimer Menpes, *Whistler As I Knew Him*, op cit., 135–9.

90 Ibid., 139–40; WS, 'Underpainting', lecture delivered at Thanet School of Art, 9 November 1934, reprtd AGR, 646.

91 Menpes, *Whistler As I Knew Him*, 140.

92 WS, 'The New Life of Whistler', *Fortnightly Review* op. cit., reprtd AGR, 186.

93 WS, 'A Stone Ginger', *New Age* (19 March 1914), reprtd AGR, 345.

94 WS, 'The Works of Whistler', *New Age* (29 February 1912), reprtd AGR, 298.

95 Mortimer Menpes, *Whistler As I Knew Him*, 143; ALS JMW to Helen Whistler (12/1883) [GUL].

96 Alberto Ludovici, *An Artist's Life in London and Paris*, 74.

97 *Pall Mall Gazette* (1 June 1883).

98 cALS Eleanor Sickert to Penelope Muller, 24/5/1884 (Tate).

99 WS, 'Degas', *Burlington Magazine* (November 1917), reprtd AGR, 415.

100 Moore, Blanche, and Duret, together with Whistler, were all at a crowded informal concert that Sickert attended at Dieudonné's Hotel in Ryder Street. The establishment – more boarding house than hotel – was run by two sisters and served as a haven for French visitors to London. The concert was given by Pablo de Sarasate, a Spanish violin virtuoso who was having his portrait painted by Whistler (JEB, *Portraits of a Lifetime*, op. cit., 60): Sickert was present at some of the sittings, and perhaps borrowed the musician's commanding pose for a small self-portrait study which he later exhibited under the title *L'homme à Palette* (Baron/Shone, 60).

101 Adrian Frazier, *George Moore, 1852– 1933* (2000), 91.

102 cALS Eleanor Sickert to Penelope Muller, 24/5/1884 (Tate).

103 ALS WS to Whistler [1884] (GUL), sent from Broadway Rectory. Sickert produced three dated etchings of Hereford and Worcestershire subjects, *The Glovemaker, Worcester, Cornstooks, Poston,* and *Hereford* (RB, nos. 40, 41, 42). The Revd Rodney

Fowler's eldest daughter Edith (to whom Sickert had been 'engaged' at the age of five) had, it seems, ambitions to be a painter, and her presence perhaps encouraged him to work. Edith Munro Fowler was 23 in 1884, and was very probably the same 'Munro Fowler' who exhibited at the SBA between 1884 and 1887 (I have been unable to trace any other – male – Munro Fowlers). In 1884/5 'Munro Fowler's' address was 13 Edwardes Square (the same as Sickert's studio), the following year she [?] was lodging with the Sickert family at 12 Pembroke Gardens.

104 RB, 62, dates the etching '9 August 1884'. WB, 301, reads the date as 1889, but Bromberg's reading seems correct. Bromberg also dates an etching of *The Old Mogul Tavern* to '1884', but this is conjectural.

105 Alberto Ludovici, *An Artist's Life in London and Paris,* op. cit., 74.

106 Sickert did not – at this exhibition – appear listed in the catalogue as 'Pupil of Whistler'; Menpes did not show – though he may have sent – a picture.

107 Ronald Anderson and Anne Koval, *James McNeill Whistler,* op. cit., 274.

108 Caroline Fox and Francis Greenacre, *Paintings in Newlyn 1880–1930* (1985), 77.

109 ALS WS to JEB, 6/12/[1885] (Institut).

110 Mortimer Menpes, *Whistler As I Knew Him,* 26.

111 Ibid., 15.

112 WS, 'All We Like Sheep', *Art News* (14 April 1910), reprtd AGR, 217.

113 Richard Dorment and Margaret F. Macdonald, *James McNeill Whistler,* op. cit., 176.

114 RB, no. 52

115 ALS Ernest Brown to Whistler [1885] (GUL).

116 WS's contributions were: *Paragon and Westcliffe, Ramsgate,* two Cornish scenes, and a small piece, *White Flowers,* priced at 5 guineas. *Clodgy Point,* one of the Cornish scenes, was 10 guineas.

117 *The Academy* (2 May 1885), 318.

118 *Pall Mall Gazette* (20 April 1885), 4.

119 Francis James, an admirer but never a 'disciple', had been elected independently in 1884 at the same time as Whistler.

120 WS, 'L'Affaire Greaves', *New Age* (15 June 1911), reprtd AGR, 284. The incident may have repeated itself when both men made likenesses of H. R. Eldon. Whistler gave Sickert his small painting of Eldon, while Sickert preserved his own etching. WS, 'The Works of Whistler', *New Age* (29 February 1912), reprtd AGR, 298; RB, no. 77.

121 WS to [Whistler] [spring 1885] (GUL).

III RELATIVE VALUES

1 Jean Overton Fuller, *Sickert and the Ripper Crimes: An Investigation into the Relationship between the Whitechapel Murders of 1888 and the English Tonal Painter Walter Richard Sickert* (1990), 14.

2 The two witnesses listed on the marriage certificate were friends of Ellen's – one of them the painter Miss E. M. Osborn, at whose house in St John's Wood she had been staying; the other was an M. E. Dunn.

3 cALS Eleanor Sickert to Penelope Muller, 6/6/1886 (Tate).

4 ML, 106.

5 ALS Jane Cobden-Unwin to Ellen Cobden-Sickert, 24/7/1899 (Chichester); WS to Ellen Cobden-Sickert [12/1898], quoted in divorce proceedings.

6 'X' [Herbert Vivian], *Myself Not Least* (1925), 130.

7 JEB, *Portraits of a Lifetime* (1937), 46.

8 ML, 107; ALS Mrs Ortmans [*née* Carter] to Denys Sutton, 29/10/1958, (Sutton GUL).

9 Art Gallery of New South Wales; ML, 108.

10 'Miles Amber' [Ellen Cobden], *Wistons* (1902), 148.

11 Robert Emmons suggests that they

went to Scheveningen, then on to Munich, Vienna, and Milan. The itinerary is certainly possible, but is not backed by any independent corroboration, and looks suspiciously as though it may have been invented from the fact that (with the exception of Vienna) Sickert made drawings and etchings of these places at about this time. Most of these pictures, however, have now been dated to the years immediately after 1885: Munich, 1886; Scheveningen, 1887; Milan, 1895. Moreover, Sickert exhibited a painting of the *Fourteenth of July* in the spring of 1886, which – if a recent production – suggests he was already in France at that date in 1885.

12 ALS OVS to Eddie Marsh, 30/8/1895 (NYPL); 'M & Mme Sickert, rue de Sygogne, 21' at 'l'apogée de la saison', *Vigie de Dieppe*, 19 August 1885, 1, 2; They had rented it from an English relative of the local artist Mélicourt (JEB, *Portraits of a Lifetime*, op. cit., 45), perhaps through the good offices of 'Les John Lemoinne' (JEB, *Le Pêche aux Souvenirs* (1941) 144). According to the 1889 *Annuaire de Dieppe*, the house belonged to a Mlle Goude.

13 JEB, *Portraits of a Lifetime*, op. cit., 50.

14 They stayed in a villa on the route d'Arques. HMS, 129.

15 HMS, ibid.; ALS OVS to Eddie Marsh, 30/8/1895 (NYPL); ALS Ellen Cobden-Sickert to Jane Cobden [9/1885] (Chichester).

16 JEB, *Portraits of a Lifetime*, op. cit., 50; *Vigie de Dieppe*, 18–19 July 1885, records the arrival of most members of the party.

17 ALS Edmond Maître to Fantin-Latour, 7/10/1885 (Fondation Custodia). The letter is misdated in the catalogue 7/10/1881.

18 Daniel Halévy, *My Friend Degas* (1966), 31.

19 ALS Ellen Cobden-Sickert to Jane Cobden [9/1885] (Chichester).

20 ALS OVS to Eddie Marsh, 30/8/1895 (NYPL).

21 Daniel Halévy, *My Friend Degas*, op. cit., 97.

22 ALS Ellen Cobden-Sickert to Jane Cobden [9/1885] (Chichester).

23 WS, 'Degas', *Burlington Magazine* (November 1917), reprtd AGR, 414.

24 Sophie Monneret, *L'Impressionisme et son Époque* (1978), vol. i, 251. Monneret states that Sickert met both Renoir and Monet, who were staying close to Dieppe that summer, but offers no supporting evidence. Sickert's silence on the subject counts against any such meeting.

25 WS, 'Degas', *Burlington Magazine*, op. cit.

26 WS, ibid., reprtd AGR, 415; WS, 'Post-Impressionists', *Fortnightly Review* (January 1911), reprtd AGR, 278.

27 WS, 'Degas', *Burlington Magazine*, op. cit., reprtd AGR, 414.

28 Ibid.

29 WS, 'A Monthly Chronicle', *Burlington Magazine* (April 1916), reprtd AGR, 407.

30 Daniel Halévy, preface to catalogue *J.-E. Blanche – Walter Sickert à Dieppe 1885–1888* (Dieppe, 1954), 5.

31 ALS WS to Nan Hudson/Ethel Sands, 'Friday' [summer 1914] (Tate).

32 ALS OVS to Eddie Marsh, 30/8/1895 (NYPL); WS, 'Degas', *Burlington Magazine*, op. cit., reprtd AGR, 415.

33 WB, 300.

34 WS, 'Degas', *Burlington Magazine*, op. cit., reprtd AGR, 414.

35 Ibid.

36 Ibid.

37 WS, 'Mr Burrell's Collection at the Tate. II', *Southport Visiter* (19 April 1924), reprtd AGR, 484.

38 WS, 'Degas', *Burlington Magazine*, op. cit., reprtd AGR, 415.

39 George Moore, *Conversations in Ebury Street* (1924), 138.

40 WS, 'Post-Impressionists', *Fortnightly Review* (January 1911), reprtd AGR, 279.

41 HMS, 130.

42 JEB, 'Walter Sickert', in *Jacques-Émile Blanche, Peintre (1861–1942)* (1997), 214.

43 JEB, 'Walter Richard Sickert', MS (Fondation Custodia).
44 JEB, *Portraits of a Lifetime*, op. cit., 46.
45 WS, 'Degas', *Burlington Magazine*, op. cit., reprtd AGR, 414.
46 Daniel Halévy, *My Friend Degas*, op. cit., 31.
47 ALS WS to Whistler [spring 1886] (GUL).
48 ALS Ellen Cobden-Sickert to Jane Cobden [9/1885] (Chichester); Edgar Degas to Ludovic Halévy [9/1885] in Marcel Guerin (ed.), *Degas Letters* (1947), 108, 110; ALS Edgar Degas to JEB, 1/10/[1885] (Institut).
49 ALS Ellen Cobden-Sickert to [Jane Cobden] [1885] (Chichester).
50 Ibid.; WS, 'Degas', *Burlington Magazine*, op. cit., reprtd AGR, 415.
51 Ibid.
52 Ibid.
53 Ibid.; WS, annotation on p. 93 of Jamot's *Degas* (Fondation Custodia).
54 WS, 'Degas', *Burlington Magazine*, op. cit. Degas spoke with enthusiasm of Thérèsa, a popular café-concert singer, whom he depicted in *The Song of the Dog*. He sang the lines 'Là-bas dans la vallée/Coule claire fontaine (bis)', from 'J'ai tué mon capitaine'.
55 WS, 'Degas', *Burlington Magazine*, op. cit.
56 They visited Degas' friend and fellow painter Henri Rouart; to the art-loving dentist, Dr Viau, to Michael Manzi, an 'Italian officer'; and to a doctor who lived in a suburb 'very far away'. ALS WS to DSM (GUL); WS, annotation on p. 84 of Jamot's *Degas* (Fondation Custodia); A. G. Robins, 'Degas & Sickert: Notes on their Friendship', *Burlington Magazine* (March 1988), 225–9.
57 ALS Ellen Cobden-Sickert to [Jane Cobden] [1885] (Chichester).
58 WS, 'Degas', op. cit., reprtd AGR, 413–14.
59 ALS Ellen Cobden-Sickert to JEB, 27/12/1885 (Institut).
60 They lodged at 38 Albany Street; cf. ALS WS to JEB, 6/12/[1885] (Institut).

Chapter Three: Impressions and Opinions

I THE BUTTERFLY PROPAGANDA

1 Bernhard Sickert and Steer both exhibited as did Menpes, Ludovici, and Francis James.
2 Elections were held on 20 November 1885; SBA 'Minute Book 1887–1899' (V&A).
3 Catalogue of 1885/6 SBA Exhibition.
4 ALS WS to JEB, 21/12/1885 (Institut).
5 Ibid.
6 WS, ' "S" in the "Echo" ', *New York Herald* (17 April 1889), reprtd AGR, 38; WS, 'The Whirlwind Diploma Gallery of Modern Pictures', *Whirlwind* (19 April 1890), reprtd AGR, 73; Frank Rutter, *Théodore Roussel* [1926], 10–12; DSM, *Life, Work and Setting of Philip Wilson Steer* (1945), 33; Mortimer Menpes, *Whistler As I Knew Him* (1904), 186.
7 ALS WS to JEB [1/1886] (Institut).
8 DSM, *Life, Work and Setting of Philip Wilson Steer*, op. cit., 33; WS, *Paul Maitland*, catalogue for Leicester Galleries (May 1928), in AGR, 565–6.
9 Bruce Laughton, *Philip Wilson Steer* (1971), 6.
10 Ibid., 32, 8.
11 HMS, 135.
12 ALS WS to JEB, 21/12/1885 (Institut).
13 WS, *Johann Jürgen Sickert (1803–1864) and Oswald Adalbert Sickert (1828–1885)*, catalogue for the Goupil Gallery (June 1922), in AGR, 435.
14 ALS WS to Nan Hudson/Ethel Sands, 'Friday' [1914] (Tate).
15 Clifford Ellis, BBC tape; Hubert Wellington, 'With Sickert in Dieppe', *The Listener* (23 December 1954), 1110.
16 ALS WS to JEB, 21/12/1885 (Institut); WS to JEB [/1/1886] (Institut).
17 HMS, 68.
18 Ibid., 116, 135.
19 Ibid., 62.

20 RE, 18.

21 ALS WS to JEB, 21/12/1885 (Institut); RE, 97. The painter G. A. Storey also lived in the street.

22 Herbert Vivian, 'Mr Walter Sickert on Impressionist Art', *Sun* (8 September 1889), in AGR, 56.

23 ALS WS to JEB, 21/12/1885 (Institut); Herbert Vivian, 'Mr Walter Sickert on Impressionist Art', *Sun* op. cit.; cALS Eleanor Sickert to Penelope Muller, 4/11/1885 (Tate).

24 ALS Ellen Cobden-Sickert to JEB, 27/12/1885 (Institut).

25 Ibid.

26 JMW, to Mrs Jopling, complained that 'Walter Sickert has, of course, been carried off by his wife and the house furnishing.' Quoted in Louise Jopling, *Twenty Years of My Life* (1925), 227.

27 Jane Cobden was at 17 Canfield Gardens; Annie Cobden-Sanderson was often staying with her in-laws not far off at Eldon Road (it was only in 1892 that she and her husband built a house, even nearer, at Frognal).

28 Members of the Cobdens' social circle included John Morley, G. J. Holyoake, and the Manchester railway magnate Sir Edward Watkin. ALS Ellen Cobden-Sickert to Jane Cobden, 18/10/1887 (Chichester); WB, 308; ALS Edward Watkin to Ellen Cobden-Sickert, 23/12/1890 (Chichester).

29 'X' [Herbert Vivian], *Myself Not Least* (1925), 23, 130.

30 RE, 73.

31 Osbert Sitwell, *Noble Essences* (1950), 172.

32 ALS Ellen Cobden-Sickert to JEB, 27/12/1885 (Institut).

33 ML, 106; WS to JMW [1887] (GUL).

34 ALS Ellen Cobden-Sickert to JMW, 8/4/1886 (GUL).

35 *Illustrated London News* (23 January 1886) refers to a 'score of oil paintings'; WS to JEB [1/1886] (Institut) refers to his exhibition of 'little panels of mine, most Dieppe things'. Sickert mentions enclosing a catalogue, but – as yet – no surving catalogue of the show has been traced.

36 *Illustrated London News*, op. cit.

37 ALS WS to JEB [1/1886] (Institut).

38 *Illustrated London News*, op. cit.

39 Dorothy Menpes, 'Reminiscences of Whistler by Mortimer Menpes', *The Studio* xxix (1903), 246; Violet Overton Fuller, 'The Letters [of Walter Sickert to Florence Pash]', 5, describes a similar procedure.

40 Mortimer Menpes, *Whistler As I Knew Him*, op cit., 19.

41 Ibid., 17–18.

42 Ibid., 20; DSM, *Life, Work and Setting of Philip Wilson Steer*, op. cit., 33.

43 ALS WS to JEB, 6/12/[1885] (Institut).

44 Mortimer Menpes, *Whistler As I Knew Him*, op. cit. Amongst the Baker Street followers the ballet theme was touched upon by Ludovici (who exhibited a picture of 'ballet dancers' at the SBA in April 1887) and Steer was making studies for his painting *Signorina Sozo in 'Dresdina'* in 1886 (Bruce Laughton, *Philip Wilson Steer*, op cit., 32). Sickert produced an etching of what appears to be a ballerina in a tutu (RB no. 37).

45 ALS WS to JEB [1891] (Institut), reprtd in JEB, *Portraits of a Lifetime* (1937), 303–4; JEB, *La Pêche aux Souvenirs* (1941), 150.

46 RE, 73; ALS WS to JEB [1891] (Institut), reprtd in JEB, *Portraits of a Lifetime*, op. cit., 303–4. The Arts Club minute books for the late 1880s and early 1890s do not survive.

47 Clifford Ellis, BBC tape; 'St P.' [WS], 'Two Exhibitions', *The Speaker* (7 November 1896), in AGR, 109.

48 WS, 'The Study of Drawing', *New Age* (16 June 1910), in AGR, 248.

49 WS, 'The Nude in Art Schools', *Pall Mall Gazette* (13 November 1913), in AGR, 337–8.

50 Osbert Sitwell, *Noble Essences*, op. cit., 174; ALS WS to JEB [1891] (Institut), reprtd in JEB, *Portraits of a Lifetime*, op. cit., 303–4.

51 WS, 'Mural Decoration', *English Review* (July 1912), in AGR, 326;

'St P.' [WS], 'Du Maurier's Drawings', *The Speaker* (27 March 1897), in AGR, 150.

52 WS, 'The New Life of Whistler', *Fortnightly Review* (December 1908), in AGR, 181; ALS WS to JEB [1891] (Institut), reprtd in JEB, *Portraits of a Lifetime*, op. cit., 303–4.

53 WS, 'The Polish Rider', *New Age* (23 June 1910), in AGR, 250; ALS WS to JEB [summer 1886] (Institut); ALS WS to JEB [1891] (Institut), reprtd in JEB, *Portraits of a Lifetime*, op. cit., 303–4; WS spells him 'Mentzel'

54 ALS WS to the Editor of *Daily News* (January 1886) (GUL).

55 There are several letters from WS to JMW on this subject, datable to 1886 (GUL).

56 JMW's picture was *Harmony in Red*; Sickert's etching is RB no. 109; Ruth Bromberg dates the etching to 1888, after JMW's marriage to Beatrice, but – more plausibly – Margaret F. Macdonald, in *Beatrice Whistler, Artist & Designer* (1997), suggests that it was done in 1885–6, contemporary with JMW's painting.

57 cALS Eleanor Sickert to Penelope Muller, 6/6/1886 (Tate): '[Walter] was at Whistler's yesterday, the great man having sittings of Walter again.'

58 ALS WS to JEB [1/1886] (Institut).

59 *The Academy* (22 May 1886), 369.

60 cALS Eleanor Sickert to Penelope Muller, 6/6/1886 (Tate).

61 Ibid.

62 Henri Loyrette, *Degas* (1991), 775.

63 ALS WS to JEB [6/1886]. Sickert calls the dealer 'Closet' (elsewhere he is jokingly referred to as 'Water-Closet'). But Laughton, *Philip Wilson Steer*, op. cit., gives his name as 'Clauzet'.

64 ALS WS to JMW [6/1886] (GUL).

65 ALS WS to JEB [6/1886] (Institut).

66 *Figures on a Lawn, Poston, Hereford.* Incribed 'To J. E. Blanche, Hampstead, June 29th 1886' (Witt).

67 Henri Loyrette, *Degas*, op. cit.

68 Ibid.

69 Hampstead Rate Book gives the

rental value as £75, with the annual rate at 4 guineas (Holborn).

70 ALS Ellen Cobden-Sickert to JEB [1899] (Institut).

71 ML, 107.

72 WS notebook [1891], in possession of Lillian Browse, lists his various debts, including £5 to his mother, and 21 shillings to Robert. He also owed £6 to 'J', and 6 shillings to 'Mary'.

73 WS to Florence Pash (Islington). It was an attitude that he extended into all areas of his life.

74 WS [in Pontresina] to JEB [summer 1886] (Institut); RB no. 84.

75 RB nos. 84, 81, 82, 83.

76 WS to JEB [winter 1886] (Institut).

77 Hugh Carter, and the marine painter Henry Moore, were both members, as was Fantin-Latour. Sidney Starr exhibited alongside Sickert.

78 ALS WS to JEB [winter 1886] (Institut).

79 Willie Finch to Octave Maus, quoted in WB, 19.

80 cALS WS to Octave Maus [winter 1886], (Sutton GUL): the original letters are in Brussels Museum Archive, 'Fondation Octave Maus'; ALS WS to JEB [winter 1886] (Institut). WS gives the picture size as 1.75 × 1 metre, suggesting that he had perhaps scaled it down.

81 Malcolm C. Salaman, 'Memories of the Art World', *The Studio*, cv [1933], 264.

82 ALS WS to JMW [1886] (GUL).

83 ALS Ellen Cobden-Sickert to JMW, 2/12/1886 (GUL).

84 WS showed *Le Course de Dieppe 1885*, lent by Théodore Roussel; *Trois Nouages*, lent by Elizabeth Armstrong; *Marine, 14 Juillet*, lent by Menpes; *La Saison des Bains*, lent by Starr; *Répetition – La Fin de l'Acte*, a pastel 'still life', and 17 'eux-fortes', including 9 'croquis de Londres'.

85 Quoted in WB, 19.

86 Sickert was also delighted with the 'charmant catalogue' – considering it 'un soufflé d'air frais'. He even suggested to Octave Maus that he might translate the preface as a

counterblast to the 'malsaine esthetique' of the English critics. cALS WS to Octave Maus [2/1887], (Sutton GUL); the *Préambule* by Maus was on *Le Pittoresque*.

87 Mortimer Menpes, *Whistler As I Knew Him*, op. cit., 20.

II A NEW ENGLISH ARTIST

1 Adrian Frazier, *George Moore, 1852–1933* (2000), 208–9.

2 'X' [Herbert Vivian], *Myself Not Least*, op. cit., 130: 'When I first met Walter, he was just finishing a course of cathedrals on Impressionist lines, but shortly after he transferred his artistic affections to music halls, and taught me to appreciate the high comedy of establishments at Islington, Whitechapel and the neighbourhood of the Elephant and Castle.'

3 It is difficult to chart accurately Sickert's early engagement with the music hall. There is an etching of the audience at the Old Mogul Tavern dated on the mount '1884', another of 'Queen's Palace of Varieties' similarly inscribed '1885', and a third of 'Bottings' dated '1886'. But as these were all were gifts to Mrs Swinton, inscribed some twenty years after the event, the exact dating is at least questionable. Wendy Baron dates a drawing of a music-hall singer (inscribed with the lines 'What a . . . honest/He never goes out on a spree/O such a . . . is he') at the Walker Art Gallery, Liverpool, to '*c*.1884'. But, if this dating is correct, it seems to be a lone survival. The first contemporaneously dated drawings of the halls are from 4 February–25 March 1887 (WB, 303), prior to the exhibition of *The Lion Comique* at the SBA in the spring of 1887, and they are followed by numerous others over the next year and a half: 'from March 1887' (sketches for Collins' Music Hall painting: WB, 306); 25 May 1887 (drawings of Katie Lawrence at Gatti's and the Oxford: WB, 303);

December 1887; 1887 (four other sheets of music-hall drawings: WB, 303); 1888 (some 73 sketches relating to pictures of Gatti's: WB, 303); 1888–9 (*Little Dot Hetherington at the Bedford, The PS Wings, The Sisters Lloyd, Vesta Victoria, Red White and Blue, The Oxford Music Hall*: WB, 305–6).

4 Matthew Sturgis, *Passionate Attitudes* (1995), 100.

5 WS, 'Drawing. Messrs Dowdeswell's Galleries', *New York Herald* (1 April 1889), reprtd AGR, 27.

6 WS to Nina Hamnett, quoted in Denise Hooker, *Nina Hamnett: Queen of Bohemia* (1986), 114.

7 Violet Overton Fuller, 'A Short Introduction [to WS's letters to Florence Pash]', 1 (Islington).

8 *Daily Telegraph* (2 April 1887), quoted in WB, 302; cALS Eleanor Sickert to Penelope Muller [1887] (Tate).

9 Whistler is likely to have been pleased at Sickert's choice of subject. Gilbert Hastings Macdermott, the 'lion comique' depicted, was a particular favourite of his: he was always humming his celebrated refrain, 'by Jingo' as he worked.

10 ALS Jane Cobden to Ellen Cobden-Sickert, 1/6/1887 (Chichester). Ellen was just about to cross to Belgium. At some moment during the summer, WS also went to Manchester, where he visited a special Royal Jubilee Exhibition held by Agnew's, and admired Leighton's picture *Summer Moon*. Cf. WS, 'The Royal Academy', *New York Herald* (8 May 1889), reprtd AGR, 47.

11 cALS Eleanor Sickert to Penelope Muller [1887] (Tate); *The Academy* (19 November 1887), 342.

12 Thomas R. Way, *Mr Whistler's Lithography* (1905), records a gap in production between 1879 and 1887–8.

13 RB nos. 101, 102.

14 DSM, *Life, Work and Setting of Philip Wilson Steer* (1945), 32.

15 Instead of another music-hall scene he showed some of his recent

etchings together with three small paintings – a 'sketch' of Scheveningen, a view of *Les Puits Sales* in Dieppe, and an unknown work called *The Raven* (perhaps a reflection of Whistler's enthusiasm for the works of Edgar Allan Poe).

16 ALS WS to JEB [8/1888] (Institut).

17 Starr and Menpes showed in 1886; Steer, Roussel, and Blanche showed in spring 1887.

18 Alfred Thornton, *The Early Years of the New English Art Club* (1935), 3.

19 DSM, *Life, Work and Setting of Philip Wilson Steer*, op. cit., 30.

20 *Pall Mall Gazette*, quoted by Kenneth McConkey, *Impressionism in Britain* (1995), 39.

21 Bruce Laughton, *Philip Wilson Steer* (1971), 9–10; DSM, op. cit., 28; McConkey, *Impressionism in Britain*, op. cit.

22 Alfred Thornton, *The Early Years of the New English Art Club*, op. cit.

23 NEAC catalogue 1886, 1887 (V&A).

24 Fred Brown, quoted in RE, 98.

25 NEAC catalogues (V&A).

26 Bate had praised Whistler's work in a book published that year: Anna G. Robins, 'The London Impressionists', in McConkey, *Impressionism in Britain*, op. cit., 87.

27 RE, 98.

28 DSM, *Life, Work and Setting of Philip Wilson Steer*, op. cit., 33.

29 JMW print, *Grand Place, Brussels*: Ronald Anderson and Anne Koval, *James McNeill Whistler* (1994), 87.

30 ALS WS to JEB [spring 1888] (Institut).

31 *Pall Mall Gazette* (7 April 1888), 13.

32 Charles Kains-Jackson, 'The New English Art Club', *The Artist* (2 December 1893), 356.

33 Quoted in Bruce Laughton, *Philip Wilson Steer*, op. cit., 14.

34 The comments come from the *Magazine of Art, Lady's Pictorial, Sunday Chronicle*, and *Truth* and are preserved in the NEAC press-cuttings book at the Tate.

35 *Truth*.

36 *The Times*.

37 *The Globe* (9 April 1888); *Daily Telegraph* (19 April 1888).

38 *Daily Telegraph*, ibid.; *Manchester Guardian* (9 April 1888).

39 *Magazine of Art* (May 1888), xxx.

40 For example, *The Table, Manchester Guardian*.

41 *Pall Mall Gazette* (11 April 1888), 5; *The Star* (9 April 1888).

42 *Table*.

43 *The Artist* (May 1888), 151.

44 *Pall Mall Gazette* (11 April 1888).

45 Ronald Anderson and Anne Koval, *James McNeill Whistler*, op. cit., 275–82.

46 ALS WS to JEB [8/1888] (Institut).

47 Ibid. Many of the dated drawings are now in the art galleries at Liverpool and Leeds.

48 Herbert Vivian, 'Mr Walter Sickert on Impressionist Art', *The Sun* (8 September 1889), in AGR, 56.

49 RE, 49.

50 Ibid., 309.

51 Ibid., 48.

52 JEB, 'Walter Sickert', in *Jacques-Émile Blanche, Peintre (1861–1942)* (Rouen, 1997), 213–16.

53 RE, 48–9; J. B. Booth, *London Town* [1929], 99; Albert Chevalier, *Before I Forget* (1901), 34.

54 RE, 49.

55 Ibid.

56 Richard Shone, 'Duncan Grant on a Sickert Lecture', *Burlington Magazine* (December 1981), 671. Grant mistakenly refers to Bellwood as 'Bessie Belmont'.

57 RE, 49.

58 Ibid.

59 In his notebooks Degas remarked upon the 'different values' of the glass lampshades reflected in the mirrors of Parisian cafés, as being apt for artistic treatment. Quoted in Wendy Baron and Malcolm Cormack, *The Camden Town Group* (1980), ix.

60 Clive Bell, *Old Friends* (1956), 20.

61 ML, 44.

62 ALS Jane Cobden-Unwin to Ellen Cobden-Sickert, 24/7/1899 (Chichester); WS to Ellen Cobden-Sickert, quoted in divorce proceedings.

63 In September 1887 she, together

with her sister Jane, had attended the trial of the dissident MP William O'Brien at Mitchelstown. ALS Jane Cobden to 'Aunt Mary', 21/9/1887 and 5/10/1887 (BL); *Illustrated London News* (8 October 1887), 425.

64 ALS Mrs Ortmans [*née* Carter] to Denys Sutton, 29/10/1958 (Sutton GUL).

65 ALS Ellen Cobden-Sickert to Jane Cobden-Unwin [spring 1897] (Chichester). The letter contains a reference to 'the son of Lord Leversedge' who 'doesn't like W.S.' and calls him 'a "coureur des dames"'.

66 Max Beerbohm, quoted in David Cecil, *Max* (1964), 204.

67 Adrian Daintrey, *I Must Say* (1963), 71; Raymond Mortimer, 'Sickert: Passionate Observer', *The Times* (13 June 1976).

68 JEB, *Portraits of a Lifetime* (1937), 67.

69 RE, 217.

70 Certainly his first dose of VD, which was the almost inevitable result of such activity, was not contracted until the early 1900s.

71 When Ellen was asked whether she had met any of the women with whom Sickert had had adulterous relations she replied, 'Yes: they visited at my house', but only 'as friends visiting': *The 1889 Law Reports: Probate Division* (London, 1899).

72 WS, 'Encouragement for Art', *New Age* (Supplement, 7 April 1910), in AGR, 215.

73 cALS WS to Florence Pash (private collection); David Greer, *A Numerous and Fashionable Audience* (1997), 71.

74 ALS WS to Florence Pash, op. cit.

75 Lady Hamilton's diary, 17/5/1904 (KCL).

76 ALS WS to Florence Pash, op. cit.

77 RE, 86.

78 Ibid., 172.

79 ALS WS to JEB [8/1888] (Institut).

80 cALS Ellen Sickert to Penelope Muller, 6/9/1888 (Tate).

81 ALS WS to JEB, from St Valéry-en-Caux [summer 1888] (Institut).

82 ALS WS to JEB [8/1888] (Institut).

83 JEB has five pictures listed in the catalogue, Bernhard Sickert has two.

84 WB, 17.

85 Ibid., 38.

86 Maxim Jakubowski and Nathan Braund, *The Mammoth Book of Jack the Ripper* (1999), 89.

87 Although Sickert favoured the North London and West End halls, he did occasionally make forays to the East End when following a particular artiste. He was at the Paragon Music Hall in the Mile End Road on 30 June 1888, making sketches of Emily Lyndale.

88 A drawing of Collins' Music Hall dated 4 October is at the Walker Art Gallery, Liverpool.

89 ALS WS to JEB [autumn 1888] (Institut). Helleu did join the NEAC.

90 ALS WS to JEB, op. cit.

91 ALS WS to JEB [winter 1888] (Institut).

III THE LONDON IMPRESSIONISTS

1 Menpes had compounded his offence by exhibiting the pictures he had done in the East at the Fine Art Society without acknowledging his debt to the Master. Whistler felt that the only appropriate penance would be for Menpes to march up and down Bond Street with a sandwich board proclaiming 'Pupil of Whistler'. Sickert did what he could to assuage Whistler's wrath, writing – as 'An Outsider' – to the *Pall Mall Gazette* to assert that Whistler was 'the greatest original artist of the age'. He also corrected the galling notion – galling at least to Whistler – that Menpes' use of unmitred frames was in any way 'novel': 'Mr Whistler has for years thus framed many of his works.' Whistler was grateful. His anger against Menpes subsided. For the moment he continued merely to cut his former pupil, whom he henceforth dubbed the Kangaroo, as being Australian and having a large pouch for putting things into.

2 ALS JMW to Mrs William Whistler, 22/9/1888 (GUL).

3 ALS WS to Mrs J. M. Whister (GUL).
4 Ronald Anderson and Anne Koval, *James McNeill Whistler: Beyond the Myth* (1994), 299–300.
5 Stanhope Forbes to Elizabeth Armstrong, quoted in Caroline Fox and Francis Greenacre, *Painting in Newlyn 1880–1930* (1985), 78.
6 ALS WS to Charles Hanson [Whistler's secretary] [11/1889] asking that Whistler be forwarded an enclosed voting paper for the NEAC elections, and suggesting how he should vote (Sutton GUL).
7 *The World* (13 June 1889).
8 Alfred Thornton, *The Early Years of the New English Art Club* (1935).
9 The reminiscences of Steer's nephew J. A. Hamilton, quoted in Bruce Laughton, *Philip Wilson Steer* (1971), 37.
10 A. S. Hartrick, *A Painter's Pilgrimage* (1939), 149; 'X' [Herbert Vivian], *Myself Not Least* (1925), 129–30; Steer's portrait of WS (Laughton, *Philip Wilson Steer*, op. cit., plate 82), exhibited at the NEAC April 1890, shows him with his moustache.
11 'X' [Herbert Vivian], *Myself Not Least*, op. cit., 129–30.
12 WS, 'The Thickest Painters in London', *New Age* (18 June 1914), in AGR, 379.
13 Adrian Frazier, *George Moore, 1852–1933* (2000), 208, quoting Henri Loyrette, *Degas* (1991), 609, 794, n. 377.
14 WS, 'The Thickest Painters in London', *New Age*, op. cit., in AGR, 378–9.
15 He did not actually become a member until 1891.
16 DSM, *Life, Work and Setting of Philip Wilson Steer* (1945), 33.
17 Ibid.; ALS WS to JMW [1890] (GUL).
18 Charles Kains Jackson, 'The New English Art Club', *The Artist* (2 December 1893), 357.
19 The paper, despite its name, had been founded in Paris by the imprecatory Jim Gordon Bennett.
20 He praised Steer on several occasions: cf. AGR, 14, 36; also 37–9.

21 WS, 'The New Life of Whistler', *Fortnightly Review* (December 1908), in AGR, 179.
22 Cf. AGR, 12, 27, 32, 35.
23 Adrian Frazier, *George Moore*, op. cit. 209; A. G. Robins, 'The London Impressionists at the Goupil Gallery', in Kenneth McConkey, *Impressionism in Britain* (1995), 89.
24 AGR, 37–8.
25 *Pall Mall Gazette* (6 March 1889), 6.
26 'A Philistine', 'The Gospel of Impressionism', *Pall Mall Gazette* (21 July 1890), in AGR, 76; ALS WS to JEB (Institut).
27 Lobre and Helleu did join. Forain did not.
28 ALS WS to JEB [Institut] 7055 fl 142–3.
29 The 1889 NEAC catalogue mentions – under 'Law 4' – the creation of an 'executive committee' under an honorary secretary. But the committee members are not listed until the 1890 catalogue. The eight original members were: Sickert, Fred Brown, Théodore Roussel, Steer, Sargent, A. L. Baldry, J. E. Christie, and Moffat P. Lindner.
30 Charles Kains-Jackson, 'The New English Art Club', *The Artist*, op. cit., 355–7.
31 WS, 'A Portfolio of Lithographs', *New York Herald* (4 March 1889), in AGR, 12–13.
32 WS, 'The New English Art Club', *New York Herald* (16 April 1889), in AGR, 35.
33 WS, 'The New English Art Club Exhibition', *The Scotsman* (24 April 1889), in AGR, 41–2.
34 Catalogue of British Art for the Paris Exhibition of 1889; WS's *The October Sun* was no. 142.
35 Ronald Anderson and Anne Koval, *James McNeill Whistler*, op cit., 307.
36 WS, 'The Private Galleries', *New York Herald* (4 May 1889), in AGR, 44–5.
37 E. R. and J. Pennell, *The Life of James McNeill Whistler* (1911 edn), 280. At this stage Joseph Pennell was the nominal critic. His wife took over in 1891, but their use of the first-

person plural pronoun suggests a close collaboration.

38 'Autobiographical typescript by Rose Pettigrew', reproduced in Laughton, *Philip Wilson Steer*, op. cit., 117.

39 ALS WS to JEB (Institut); ALS WS to Sir William Eden (Birmingham).

40 Herbert Vivian, 'Mr Walter Sickert on Impressionist Art', *The Sun* (8 September 1889), in AGR, 58.

41 Ambrose Vollard, *Degas: An Intimate Portrait* (1986), 57.

42 WS, 'Degas', *Burlington Magazine* (November 1917), in AGR, 416. WS mistakenly refers to the subject as a 'country wedding'.

43 Ibid., in AGR, 417.

44 Daniel Halévy, *My Friend Degas* (1966), 32.

45 ALS WS to JEB (Institut).

46 The show was announced in the press in mid August. Cf. Anna Gruetzner Robins, 'The London Impressionists at the Goupil Gallery', in Kenneth McConkey, *Impressionism in Britain*, op. cit., 87.

47 ALS WS to D. C. Thomson [10/1/1890] (Getty).

48 Roussel requested Maitland's inclusion, but Sickert seems to have granted it. Cf. WS, 'Paul Maitland', Leicester Galleries catalogue (May 1928), in AGR, 566.

49 Herbert Vivian, 'Topical Interviews' *The Sun* (8 September 1889), in AGR, 56.

50 Ibid.

51 ALS WS to JEB (Institut).

52 'H.G.F.' [H. Granville Fell], *The Connoisseur* (June 1942), 174; *The Connoisseur* (June 1947), 137.

53 George Moore to D. C. Thomson, 18/11/1889, quoted in Adrian Frazier, *George Moore*, op. cit., 207.

54 WS, preface to 'A Collection of Paintings by the London Impressionists', in AGR, 59–60.

55 Anna Gruetzner Robins, 'The London Impressionists at the Goupil Gallery' in Kenneth McConkey, *Impressionism in Britain*, op. cit., 88, n. 8.

56 'It is idle to laugh at Mr Walter Sickert's selection of his [music-hall] themes,' suggested Wedmore, 'when

the wisdom of the choice is attested by the success of the experiment' (*The Academy*, 7 December 1889, 377); while the Pennells, writing in *The Star*, considered that 'his Music Halls are the greatest possible advance over anything he has yet shown' (3 December 1889).

57 Anna Gruetzner Robins, 'The London Impressionists at the Goupil Gallery', in Kenneth McConkey, *Impressionism in Britain*, op. cit., 96.

58 'Fra Angelico' in *Le Follet* (January 1890), in NEAC cuttings book (Tate).

59 Anna Gruetzner Robins, 'The London Impressionists at the Goupil Gallery', in Kenneth McConkey, *Impressionism in Britain*, op. cit., 90.

60 *The Academy* (22 February 1890), 140. Sickert had already registered his enthusiasm for 'the admirable and serious tendencies of the work' of Lavery, James Guthrie, and other Scots, when it appeared at the NEAC, and was happy to feel that the 'Gospel of Impressionism' was finding converts north of the border: WS, 'The New English Art Club', *New York Herald* (14 June 1889), in AGR, 53.

61 ALS WS to D. C. Thomson [10/1/1890] (Getty).

IV UNFASHIONABLE PORTRAITURE

1 One of Sickert's few commissions at this time was from D. C. Thomson. He produced an etched copy of a Corot picture for Thomson's book on the Barbizon school, published in the spring of 1890.

2 ALS WS to D. C. Thomson [April 1890] (Getty). A Mr Secombe took the house initially. Sickert seems to have left his studio room intact as – in April 1890 – he directed D. C. Thomson's men to collect a picture from 'on the easel in the studio'. But by Michaelmas (29 September) the rates were being paid by a Mrs Osteberg, who ran a gymnasium at the end of the street.

3 ALS Victor Scholderer to Denys Sutton, 19/4/1967 (Sutton GUL).

4 NEAC exhibition catalogue 1890, no. 9.

5 Herbert Vivian, 'Mr Walter Sickert on Impressionist Art', *The Sun* (8 September 1889), in AGR, 56.

6 In a letter of 31/1/1891 from Ellen Cobden-Sickert to Bradlaugh's daughter, Hypatia Bradlaugh-Bonner, Ellen refers to her and Sickert making Bradlaugh's acquaintance 'last year' (Bradlaugh Papers, Bishopsgate Institute, item 1992).

7 *DNB*.

8 1891 press cutting in Bradlaugh Papers, Bishopsgate Institute (item 2352). Hypatia Bradlaugh-Bonner 'knew her father had a great admiration for Mr Sickert'. Also, *The Whirlwind* (28 June 1890), quoted in WB, 35, refers to Sickert's first portrait of Bradlaugh being 'highly appreciated' by the sitter.

9 Hypatia Bradlaugh-Bonner in the *National Reformer* (23 April 1893); 'A Philistine', 'The Gospel of Impressionism', *Pall Mall Gazette* (21 July 1890), in AGR, 76.

10 Violet Overton Fuller, TS 'Letters to Florence Pash', 7 (Islington).

11 *Magazine of Art* (May 1890), xxx.

12 *The Whirlwind* (28 June 1890), though the *Magazine of Art* (May 1890, xxx) called it 'a comparative failure'.

13 ALS WS to D. C. Thomson [4/1890] (Getty).

14 *The Academy* (22 March 1890). NEAC cuttings book (Tate).

15 Maureen Borland, *D. S. MacColl* (1995), 68. MacColl's first article appeared on 5 April 1890.

16 Adrian Frazier, *George Moore, 1852–1933* (2000), 200.

17 Maureen Borland, *D.S. MacColl*, op. cit., 67.

18 *The Bazaar* (9 May 1890); *City Life* (30 April 1890), etc. NEAC cuttings book (Tate).

19 Invitation card, Pash Archive (Islington).

20 Lewis P. Renateau, MS 'Life of Florence Pash' (Islington).

21 ALS WS to [Florence Pash] [5/1890] (Islington).

22 Violet Overton Fuller, TS 'Letters to Florence Pash', 1, (Islington).

23 Ibid.

24 ALS WS to [Florence Pash] [5/1890] (Islington).

25 He had been much impressed by George Thomson's 'stunning article' on the exhibition in the *Pall Mall Gazette*, considering it 'the best blow that has been struck yet in the cause', and was anxious to land some punches of his own. The line of his attack was becoming familiar. He denigrated the Newlyn School: the work of Stanhope Forbes and Chevalier Taylor was dismissed as a 'sordid realism that is real in all but the essentials'; he fixed Degas, Whistler, and Keene as the true marks of great art; he promoted the NEAC, suggesting the Academy should reform its exhibition policy along similar lines; and he confused preconceptions by praising James Hook's coastal scene, *A Jib for the New Smack*, as 'what I understand by Impressionism at its best'. WS, 'The Royal Academy Exhibition', *Art Weekly* (10 May 1890), in AGR, 61–3.

26 The paper was described as 'a lively & eccentric newspaper' on its own masthead.

27 WS to the 'Editors-Proprietor of "The Whirlwind"', *The Whirlwind* (5 July 1890), in AGR, 70.

28 *The Whirlwind* (2 August 1890).

29 'X' [Herbert Vivian], *Myself Not Least* (1925), 67.

30 WS to Henry Irving, quoted in DS, 65.

31 Sickert knew Mrs Forster from when she had sat to Whistler for a portrait. Her son, Francis, had ambitions to be a painter and Florence had given him some instruction. Violet Overton Fuller, 'Letters to Florence Pash', 7 (Islington).

32 WB, 306. It was a summer of portraits. Blanche painted one of Jane Cobden and another of Florence Pash, exhibiting the first at the NEAC's winter show in 1891 and the second in the spring.

33 *The Whirlwind* (25 October 1890).

34 WS to Henry Irving, quoted in DS, 65.
35 Sickert and Ellen were living there at the beginning of 1891 when the Census was taken.
36 ALS Jane Cobden to Ellen Cobden-Sickert, 10/10/1889 (Chichester).
37 *Whirlwind* (6 September 1890). Autum Term ran from 15 October to 24 December, Winter Term from 5 January to 16 March.
38 Violet Overton Fuller, TS 'Letters to Florence Pash', 1 (Islington).
39 Keene, though he lived at Hammersmith, had a studio in Chelsea: George S. Layard, *The Life and Letters of Charles Samuel Keene* (1892).
40 RE, 73.
41 *The Artist* (February 1891), 53–4.
42 RE, 73.
43 'St P.' [WS], 'Two Exhibitions', *The Speaker* (7 November 1896), in AGR, 109.
44 ALS WS to JEB (Institut).
45 ALS Ellen Cobden-Sickert to Hypatia Bradlaugh-Bonner, 31/1/1891 (Bradlaugh Papers, Bishopsgate Insititut, item 1992).
46 ALS Ellen Cobden-Sickert to Hypatia Bradlaugh-Bonner, 22/2/1891 (Bradlaugh Papers, Bishopsgate Institute, item 2224): 'Walter is in despair with the weather – he is so afraid that you may be wanting to disarrange your room. He thinks he could complete the picture in one sunny day. If you have any limit as to time, please let him know – but if there are clear weeks ahead do not trouble to reply to this note.'
47 The Minutes of the Art Committee of the National Liberal Club (Book 1) record that on 18 June 1891 'The Secretary reported that the necessary funds had been raised by Mr Sam Digby for the purchase of Mr Sickert's portrait of Mr Bradlaugh' (National Liberal Club); 1891 press cutting in Bradlaugh Papers Bishopsgate Institute (item 2352: the Manchester picture is described as being given by a 'Manchester friend [who] wished to remain unknown'.

It is possible that the anonymous benefactor was Frederick Smallman, the founder of a chain of successful vegetarian restaurants in Manchester, and also a keen secularist. It was he who – according to the Art Gallery Committee Annual Report – later arranged for the painting to be transferred to the Manchester City Art Gallery in 1911.
48 *The Artist* (1 February 1891), 35.
49 A. S. Hartrick, *A Painter's Pilgrimage* (1939), 135.
50 TLS Marjory Pegram to Denys Sutton [5/5/1960], quoting from Ronal Gray's MS autobiography (Sutton GUL).
51 J. G. P. Delaney, *Charles Ricketts: A Biography* (1990), 65–6.
52 ALS WS to Nan Hudson [1907] (Tate). Whistler came and was impressed enough to select a small painting of 'a music hall with a tiny girl dancing on the stage' for the annual Liverpool Corporation autumn exhibition at the Walker Art Gallery, on the committee of which he was serving. JMW to Beatrice Whistler from Liverpool [8/1891] (GUL).
53 WS to the Editor of the *National Observer* (28 March 1891), in AGR, 83–4.
54 JEB's picture of Olga was titled *Pink Rose*.
55 *Atalanta* (April 1891).
56 *The Artist* (1 May 1891), 150.
57 Ibid., 137.
58 Herbert Horne to Lucien Pissarro, 20/4/1891, quoted in Bruce Laughton, *Philip Wilson Steer* (1971), 51–2.
59 Ibid.
60 DSM, *Life, Work and Setting of Philip Wilson Steer* (1945), 36.
61 Lucien Pissarro to Camille Pissarro, 5/1891, in Anne Thorold (ed.), *The Letters of Lucien Pissarro to Camille Pissarro (1883–1903)* (1993), 212–13.
62 Ibid.
63 Ibid.
64 ALS Mrs Priscilla Bright M'Laren to Jane Cobden, 22/4/1891 (BL).
65 There are virtually no letters in the

Cobden archive for 1890, making it hard to trace their movements. Florence Pash, however, recalled that in the year before Jane Cobden's engagement [1891], she was in Dieppe with both the Cobdens and the Sickerts.

66 He had established his own firm in 1882.

67 Philip Unwin, *The Publishing Unwins* (1972), 36.

68 Ibid., 40.

69 Violet Overton Fuller, TS 'Letters to Florence Pash', 8 (Islington).

70 Philip Unwin, *The Publishing Unwins*, op. cit., 41, refers to Unwin owning 'some early impressionist paintings'; a letter from Jane Cobden-Unwin to Ellen Cobden-Sickert, 29/9/1893 (Chichester), refers to 'Fisher's van Gogh'.

71 WS, 'Drawing. Messrs Dowdeswell's Galleries', *New York Herald* (1 April 1889), in AGR, 27; 'New English Art Club', *New York Herald* (14 June 1889), in AGR, 54.

72 WS, 'Modern Realism in Painting', in André Theuriet, *Jules Bastien-Lepage and his Art: A Memoir* (1892), reprtd AGR, 87.

73 Ibid.

74 Ibid., in AGR, 86.

75 Adrian Frazier, *George Moore*, op. cit., 210; George Moore, 'A Book About Bastien-Lepage', *The Speaker* (25 June 1892), 227.

76 WS notebook [private collection] records the date of the incident as 'Feb 7 1882'.

77 *The Artist* (6 November 1891), 347.

78 WS to the Editor of the *National Observer* (2 May 1891), in AGR, 84.

79 Ibid.

80 WS, 'The Royal Academy Exhibition', *Art Weekly* (10 May 1890), in AGR, 64. Sickert both drew and etched Rochefort, a celebrated polemical journalist. The drawing, though published in the *Pall Mall Budget* in 1893, may well have been made in 1890.

81 'St P.' [WS], 'Van Beers and Menpes', *The Speaker* (22 May 1897), in AGR, 170–2.

82 Ibid., in AGR, 171.

83 *The Artist* (6 November 1891), 347. The photograph was by Mr Vanderweyde.

84 Sir Edward Watkin, *Alderman Cobden of Manchester* (privately printed, 1891), 199.

85 Richard Sickert [WS] to Gwen Ffrangçon-Davies [1932] (Tate).

86 *National Reformer* (20 September 1891), 190.

87 R. Sickert [WS] to the Editor of the *Daily Telegraph* (28 September 1936), in AGR, 686–7.

88 *National Reformer* (4 October 1891), 212, 214.

89 Press cutting, Bradlaugh Papers (Bishopsgate Institute, item 2352).

90 *National Reformer*, op cit., 214.

91 Ibid.

92 ALS WS to Gwen Ffrangçon-Davies (Tate); *DNB*. The Herkomer portrait was exhibited at the RA in 1887.

93 WS to the *Daily Telegraph* (28 September 1936), in AGR, 686–7.

94 Details from death certificate.

95 Frederick Wedmore, *The Academy* (12 December 1891), 543.

96 *The Spectator* (5 December 1891).

97 *The Speaker* (20 February 1892).

98 James Laver, *Museum Piece* (1963), 93.

99 WS, 'The Thickest Painters in London', *New Age* (18 June 1914), in AGR, 379.

100 Ibid.

101 Quoted in Maureen Borland, *D.S. MacColl*, op. cit., 71.

102 *National Observer* (12 December 1891), 86–7.

103 ALS WS to DSM [1891] (GUL).

104 W. E. Henley to Charles Whibley, 1/10/1891, in Damian Atkinson (ed.), *The Selected Letters of W. E. Henley* (2000), 204.

105 *Magazine of Art* (October 1890), 420.

106 'Modern Men: Degas', *National Observer* (31 October 1891), 603–4. It has been plausibly suggested by Anna Gruetzner Robins that the article as it appeared was in fact written by Charles Whibley: the

mock-biblical cadences and rhetorical asides are more suggestive of his style than Sickert's. Perhaps Whibley wrote up Sickert's draft notes so that, if ever questioned by Degas about the authorship of the piece, Sickert would be able legitimately to disclaim responsibility.

107 ALS Jane Cobden to Ellen Cobden-Sickert, 27/12/1891 (Chichester).

108 ALS Ellen Cobden-Sickert to Jane Cobden-Unwin, 3/2/1892 (Chichester).

109 ALS T. Fisher Unwin to Jane Cobden-Unwin, 21/3/1892 (Chichester).

110 *The Artist* (1 April 1892), 102.

111 DSM, *The Spectator* (23 October 1892), 565–6.

112 Alfred Thornton, 'Walter Richard Sickert', *Artwork* (Spring 1930), 16.

113 ALS T. Fisher Unwin to Jane Cobden-Unwin, 22/3/1892 (Chichester); Joseph Pennell, *Adventures of an Illustrator* (1925), 168.

114 WS to Seymour Haden, 26/1/1892, in the *National Observer* (6 February 1892), in AGR, 89.

115 W. E. Henley to Charles Whibley, 29/1/1892, in Damian Atkinson (ed.), *Selected Letters of W. E. Henley*, op. cit., 206.

116 WS to Seymour Haden, 26/1/1892, in the *National Observer* (6 February 1892), in AGR, 89–90.

117 The only print he made that year was a lithograph of two girls playing 'cat's cradle' which appeared in a supplement of *The Albermarle* – a little magazine edited by his friend, the realist short-story writer Hubert Crackenthorpe. RB no. 112.

118 ALS D. C. Thomson to JMW, 23/3/1892 (GUL).

119 ALS D. C. Thomson to JMW, 14/4/1892 (GUL).

120 WS, 'Whistler To-Day', *Fortnightly Review* (April 1892), in AGR, 93–4.

121 WS, 'The New Life of Whistler', *Fortnightly Review* (December 1908), in AGR, 179.

122 Maureen Borland, *D. S. MacColl*, op. cit., 73. Whistler had thought that Sickert might be interested in painting Yvette Guilbert, the gamine siren of the Moulin Rouge, but the scheme was never taken up. ALS JMW to Beatrice Whistler [/1/1892] (GUL).

123 Osbert Sitwell, *Noble Essences* (1950), 180.

124 William Rothenstein, *Men and Memories*, vol. i (1931), 123.

125 Robert Speaight, *William Rothenstein* (1962), 46.

126 William Rothenstein, *Men and Memories*, op. cit., 123.

127 A. S. Hartrick, *A Painter's Pilgrimage*, op. cit., 151. D. S. MacColl, passing through Paris, found Sickert and Rothenstein together (Maureen Borland, *D.S. MacColl*, op. cit., 73), and it was perhaps Sickert who encouraged Degas to seek out Rothenstein and invite him to the rue Victor Massé (William Rothenstein, *Men and Memories*, op. cit., 101–3).

128 Robert Speaight, *William Rothenstein*, op. cit., 37.

129 ALS JMW to William Whistler, 14/4/1892 (GUL). It is not clear whether his lady-friend accompanied him to the USA. He settled in New York and took to painting watercolour landscapes and large-scale murals (one of the latter decorates the Congressional Library in Washington). He died in 1925.

130 They had dined together often at the Arts Club and *chez* Brandon Thomas. Whistler made a lithograph of them all together in Brandon Thomas's garden. Cf. Jevan Brandon-Thomas, *Charley's Aunt's Father* (1955), 133.

131 Sickert's contribution was an unexceptional view of Dieppe – 'a delightful harmony evolved out of sky and land and sea', according to *The Artist* (1 June 1892), 167.

132 Christopher Hassall, *Edward Marsh* (1959), 28.

133 HMS, 350–1.

134 Ibid., 341.

135 cALS Eleanor Sickert to Penelope Muller [1887] (Tate).

136 ALS WS to Mrs Hulton [3/03] (Oxford) refers to 'my dear brother Oswald, who is perhaps the most satisfactory member of a family of unequal merit'. Helena concurred; HMS, 350.

137 W. W. Rouse Ball and J. A. Venn, *Admissions to Trinity College, Cambridge,* vol. v (1913), 883.

138 ALS Jane Cobden-Unwin to Ellen Cobden-Sickert, 28/6/1897 (Chichester).

139 Edward Marsh, *A Number of People* (1939), 53.

140 Ibid., 50.

141 Christoper Hassall, *Edward Marsh,* op. cit., 28.

142 Edward Marsh, *A Number of People,* op. cit., 55.

143 Many years later, Sickert introduced Marsh – then a successful Civil Servant and patron of the arts – to an American couple with the line, 'I want you to know Eddie Marsh – I was madly in love with him when he was a choirboy.' The comment was no more than a typical piece of Sickert mischief, though it perhaps did reflect something of Marsh's youthful cherubic charm – as well as hinting at his discreetly veiled homosexuality. The Americans were nonplussed. 'I', Marsh remarked camply, 'didn't know where to look.'

144 '[Walter] thinks it is better than he has done before. He would very much like to see you at his studio, any body who is at all inclined to see things his way, & who is likely to see what he is after, is a help & a pleasure to him.' ALS OVS to Edward Marsh, 17/4/1892 (NYPL).

145 ALS OVS to Eddie Marsh, 27/6/ 1892 (NYPL). Only three months after the initial recommendation Oswald was urging Marsh to look at some of Walter's recent 'things' then at Goupil's, including 'among others, Minnie Cunningham'.

V IN BLACK AND WHITE

1 Quoted in Matthew Sturgis, *Passionate Attitudes* (1995), 101.

2 Grant Richards, *Memories of a Misspent Youth* (1932), 338.

3 Roger Lhombreaud, *Arthur Symons* (1963), 99.

4 Annie Cunningham, Minnie's widowed mother, was only sixteen years older than her daughter. She too had sung on the stage. The 1881 Census lists her – even at the age of 28 – as a 'retired vocalist'. She was evidently a formidable figure. When Symons described Minnie to a friend he wrote: 'she is very pretty, very nice, very young and *has a mama*': Arthur Symons to Ernest Rhys, in Karl Beckson and John M. Munro (ed.), *Arthur Symons: Selected Letters, 1880–1935* (1989), 95. Anna Gruetzner Robins, in Baron/Shone, 20, mistakenly suggests that Minnie was 39 in 1892, confusing her with an American actress of the same name.

5 ALS WS to Minnie Cunningham [31/8/1897] (private collection) refers to how he made her pose 'upon a little stand', rather than 'a proper stage', at Chelsea.

6 Karl Beckson and John M. Munro, *Arthur Symons: Selected Letters, 1880– 1935,* op. cit., 96, n.7.

7 His sonnet ran:
 When I glance through the
 Entr'acte's roll of fame,
 My serio-comic sweetheart, shall I
 see
 That many countries sever you and
 me?
 Or worse, the legend underneath
 your name
 'In Melbourne pantomime the
 leading dame'?
 And, bowing to an agent's stern
 decree
 A twelve month miss your fairy
 filagree
 Of whirling lace, the primrose that
 became
 Your sentimental rhymed
 proprieties,

The quaint recurring couplet's silly
scream,
The click and shuffle of the dusty
stage
Of dancing feet, the limelight's
magic gleam?
Are you at Deacon's, Gatti's? Ah,
kind page!
The Peckham Palace of Varieties!

8 ALS OVS to Edward Marsh, 27/7/
1892 (NYPL).

9 Whistler had heard from his sister-in-
law that some friends of the Sickerts
might be interested in taking the
place. He added the characteristic
barb, 'Of course I should always
regret that we had built that
beautiful dining-room for an
Englishman to sit and eat his beef in.
However he will never know how
beautiful it is – so that's all right.'
JMW to WS (Library of Congress,
Washington).

10 ALS JMW to Mrs William Whistler,
[/8/1892] (GUL).

11 The Sickerts seem to have had a brief
interlude at 39 Drayton Gardens
(ALS Jane Cobden-Unwin to Ellen
Cobden-Sickert, 14/7/1892
[Chichester]), but by the time the
catalogue for the NEAC's winter
exhibition was printed Sickert listed
his address as 'The Vale, Chelsea'.

12 Mrs Sickert and family were at 15
rue des Tribunaux from 11 August
1892 according to the Gazette des
Bains.

13 ALS Jane Cobden-Unwin to Ellen
Cobden-Sickert, 15/9/1892
(Chichester). The Sickerts' address
was 'Hilda Cottage, Southwold'.

14 Evelyn Sharp, Unfinished Journey
(1933), 66.

15 ALS Jane Cobden-Unwin to Ellen
Cobden-Sickert, 18/9/1892
(Chichester).

16 J. G. P. Delaney, Charles Ricketts
(1990), 38.

17 ALS Jane Cobden-Unwin to Ellen
Cobden-Sickert, 23/4/1893
(Chichester).

18 J.G.P. Delaney, Charles Ricketts,
op. cit., 40.

19 Walter Sickert, 'The Royal Academy',

The Sun (17 February 1897), in AGR,
140.

20 J.G.P. Delaney, Charles Ricketts,
op. cit., 49.

21 Wilde had alarmed Whistler by
announcing – in the wake of this
decision – his intention of moving
to France: ALS JMW to WS (Library
of Congress).

22 Margery Ross (ed.), Robert Ross:
Friend of Friends (1952), 158; WS,
'The Royal Academy', English Review
(June 1912), in AGR, 317, called his
paradoxes 'tedious and empty'.

23 'Il a l'air de jouer Lor' Biron dans un
théâtre de banlieue'; WS, 'Self-
Conscious Paint', Daily Telegraph
(3 June 1925), in AGR, 520.

24 The Speaker (10 December 1892),
707.

25 ALS Jane Cobden-Unwin to Ellen
Cobden-Sickert, 21/1/1893
(Chichester).

26 ALS Beatrice Whistler to Mrs William
Whistler, 17/4/1894 (GUL).

27 WB, 35. He was also contributing
sketches to his brother's Cambridge
Observer until the end of March.

28 A. S. Hartrick, A Painter's Pilgrimage,
(1939), 121.

29 The Studio (April 1893), 36.

30 WB, 306.

31 Ibid.; WS, 'Drawing from Nature',
lecture delivered at the Thanet
School of Art 26 October 1934, in
AGR, 632.

32 Sickert, in the above lecture,
mistakenly called Gilbert President of
the 'Royal Institute of Painters in
Water Colours', a different, junior,
and marginally less distinguished
institution.

33 Ibid., in AGR, 633; RS [WS] 'Playing
At Work', Daily Telegraph (3 February
1926), in AGR, 535.

34 RS [WS] to the Editor of the Morning
Post (1 April 1930), in AGR, 604.

35 RS [WS], 'Foreword' to 'New
Paintings by Richard Sickert', Beaux
Art Gallery exhibition (5 July 1935),
in AGR, 679.

36 Ibid.

37 John Stokes, In the Nineties (Hemel
Hempstead, 1989), 35–9.

38 WS to the Editor of the *Westminster Gazette* (20 March 1893), in AGR, 96–7.

39 ALS Jane Cobden-Unwin to Ellen Cobden-Sickert, 28/4/1893 (Chichester).

40 ALS Jane Cobden-Unwin to Ellen Cobden-Sickert, 25/4/1893 (Chichester).

41 The picture was also shown in the 1893 autumn show at the Walker Art Gallery, Liverpool.

42 *The Artist* (1 May 1893), 152.

43 *The Spectator* (22 April 1893), 523–5; *Magazine of Art* (May 1893), xxx; *The Times* (10 April 1893). The *National Reformer* (23 April 1893) gave a round-up of generally favourable press comment. A few reviewers found the picture dark and 'lacking in vivacity'.

44 *The Artist* (1 May 1893), 152. Oswald Sickert, nevertheless, thought the Miss Blunt portrait 'very good' and urged Marsh to 'look close' at it (ALS OVS to Edward Marsh, 5/1893 [NYPL]).

45 Anna Gruetzner Robins, 'Degas & Sickert: Notes on their Friendship', *Burlington Magazine* (March 1988), 228. AGR suggests that it was probably WS who informed the press that the correct title of *Au Café Concert* was *Chanteuses*.

46 DSM, 'Aubrey Beardsley', in R. A. Walker, *A Beardsley Miscellany* (1949), 20–1.

47 Arthur Symons, 'The Decadent Movement in Literature', *Harper's New Monthly Magazine* (November 1893), 857–67. Though Symons' comments were focused on poetry, the vocabulary was borrowed from painting and the argument could be – and was – applied to contemporary art.

48 WS's connections with these other manifestions of the moment were slight enough, but he did make a drawing of Mrs Theodore Wright in Ibsen's *Ghosts* at the Royalty Theatre, Dean Street, in 1891. It was exhibited at the Walker Art Gallery, Liverpool, in 1949.

49 C. J. Holmes, *Self and Partners* (1936), 168.

50 William Rothenstein, *Men and Memories*, op. cit., 174.

51 C.J. Holmes, *Self and Partners*, op. cit.

52 WS, 'Water Colours by D. S. MacColl', *Manchester Guardian* (9 December 1893), in AGR, 98.

53 WS, 'Mr Philip Wilson Steer's Paintings at the Goupil Gallery', *The Studio* (February 1894), in AGR, 99.

54 ML, 30.

55 TLS Marjory Pegram to Denys Sutton, 5/5/1960, quoting from Ronal Gray's MS autobiography (Sutton GUL).

56 'X' [Herbert Vivian], *Myself Not Least* (1925), 130.

57 'Miles Amber' [Ellen Cobden], *Wistons* (1902), 125, 168.

58 Ibid., 202–3.

59 Ibid., 139.

60 ML, 106.

61 'Miles Amber' [Ellen Cobden], op. cit., 139.

62 Ibid., 144; cf. also 140, 148.

63 ALS Ellen Cobden-Sickert to Jane Cobden-Unwin, 16/5/1893 (Chichester).

64 ALS Ellen Cobden-Sickert to Jane Cobden-Unwin, 27/5/1893 (Chichester).

65 ALS Ellen Cobden-Sickert to Jane Cobden-Unwin, 16/5/1893 (Chichester).

66 ALS JMW to William Whistler [6/1893] (GUL).

67 ALS Jane Cobden-Unwin to Ellen Cobden-Sickert, 5/6/1893 (Chichester).

68 ALS Jane Cobden-Unwin to Ellen Cobden-Sickert, 27/5/1893 (Chichester).

69 According to the *Gazette des Bains*, they lodged for two weeks in the rue des Fontaines before moving to their favoured establishment, Mme Goudron's pension at 15 rue des Tribunaux.

70 ALS OVS to Edward Marsh, 9/9/1893 (NYPL).

71 Ibid.

72 Ibid.

73 ALS WS to JEB, 8/1893 (Institut).

74 *The Star* (8 July 1937, in press-cuttings book 1906–9/1934–8 [Islington]) mentions the discovery of one of Sickert's panel pictures on the back of which was a dated order to his colourman, 'Please let me have two dozen this size, but thinner, not devilled.'

75 ALS OVS to Edward Marsh, 9/9/1893 (NYPL).

76 Ibid.

77 Alfred Thornton, *Diary of an Art Student in the Nineties* (1938), 37.

78 ALS DSM to Netta MacColl, 2/9/1893 (GUL).

79 ALS DSM to Lizzie MacColl, 9/1893 (GUL); ALS OVS to Edward Marsh 26/7/1894 (NYPL).

80 The gallery had recently opened a new site at 5 Regent Street, Waterloo Place.

81 ALS Jane Cobden-Unwin to Ellen Cobden-Sickert, 3/10/1893 (Chichester).

82 DSM TS note, ref. 178 (GUL).

83 Alfred Thornton, 'Walter Richard Sickert', *Artwork* (Spring 1930), 13.

84 ALS Jane Cobden-Unwin to Ellen Cobden-Sickert, 29/9/1893 (Chichester).

85 They had found new tenants for Broadhurst Gardens.

86 ALS Jane Cobden-Unwin to Ellen Cobden-Sickert, 6/11/1893 (Chichester).

87 Alfred Thornton, 'Walter Richard Sickert', *Artwork*, op. cit.

88 ALS OVS to Edward Marsh, 6/11/1893 (NYPL).

89 WS, 'Easel and Campstool', *Daily Telegraph* (6 January 1926), in AGR, 533.

90 ALS OVS to Edward Marsh, 6/11/1893 (NYPL).

91 Ibid.

92 ALS Jane Cobden-Unwin to Ellen Cobden-Sickert, 4/12/1893 (Chichester).

93 Ibid. She mentioned to MacColl that she thought 'the figures spoilt the picture', drawing the admission that he had suggested them.

94 Alfred Thornton, 'Walter Richard Sickert', *Artwork*, op. cit., 13. Whistler's only known intervention in the running of the school was to ask Sickert 'to give some sittings to Madame Renoy's little boy' as a favour to him and because the boy had 'a capital head' (GUL).

95 ALS OVS to Edward Marsh, 5/7/1893 (NYPL). Fry, in a letter to his sister on 25/3/1894, reported that Sickert had praised his work.

96 Alfred Thornton, 'Walter Richard Sickert', *Artwork*, op. cit., 13.

97 Quoted in DS, 72.

98 Alfred Thornton, 'Walter Richard Sickert', *Artwork*, op. cit.

99 WS, 'Water Colours by D. S. MacColl', *Manchester Guardian* (9 December 1893), in AGR, 97–8.

100 ALS WS to William Rothenstein (Harvard); ALS OVS to Edward Marsh, 29/1/1894 (NYPL); Robert Speaight, *William Rothenstein*, op. cit., 71.

101 William Rothenstein, *Men and Memories*, op. cit., 166–7. A letter from WS to Rothenstein, post marked 24/5/1894, includes an apology for not being able to sit on 'Thursday morning' as he is going to a dance in the evening.

102 Aubrey Beardsley to André Raffalovich in Henry Maas, J. L. Duncan, and W. G. Good (eds), *The Letters of Aubrey Beardsley* (1970), 230; Robert Ross, *Aubrey Beardsley* (1909), 87.

103 Malcolm Easton, *Aubrey and the Dying Lady* (1972), 86.

104 William Rothenstein, *Men and Memories*, op. cit., 167. WS was writing to Rothenstein from Cheyne Walk before the end of 1893.

105 Rothenstein, ibid.

106 ALS WS to William Rothenstein [late 1893] (Harvard).

107 Michael Field, *Works and Days*, ed. T. and D. C. Sturge Moore (1933), 185.

108 Ibid., 186. DS, 78, inadvertently rendered Rothenstein's comment, 'Buns for beans'.

109 Aubrey Beardsley to Robbie Ross, in

Henry Maas, J. L. Duncan, and W. G. Good (eds), *The Letters of Aubrey Beardsley*, op. cit., 61.

110 Ibid.

111 Steer did not, however, contribute to the first number as he was busy preparing for his Goupil show. C. W. Furse agreed to provide a picture, as did Pennell (who had promoted Beardsley's cause the previous year, publishing the first ever article on him in a new art periodical called *The Studio*).

112 Matthew Sturgis, *Aubrey Beardsley* (1998), 173–4.

113 *Yellow Book*, vol. i. The picture found an echo in one of the drawings Beardsley made for the first number of the new periodical, a picture showing what Beerbohm described as 'a fat elderly whore in . . . a large hat with feathers reading from a book to the sweetest imaginable little . . . girl'. The elderly whore's hat and the book are similar in design to those in Sickert's sketch.

114 Alfred Thornton, *Diary of an Art Student in the Nineties*, op. cit., 43.

115 Matthew Sturgis, *Aubrey Beardsley*, op. cit., 193–4.

116 William H. Gerdts, *William Glackens* (1996), 50.

117 One critic thought the subjects looked 'more like a couple of red-headed mops with bifurcated stems than the Sisters anything': *Truth* (12 April 1894).

118 WB, 304; Baron/Shone, 78.

119 *Punch* (5 May 1894), 204.

120 Katherine Lyon Mix, *A Study in Yellow* (1960), 32.

121 R. A. Walker, *Some Unknown Drawings of Aubrey Beardsley* (1923), 1. Beardsley's oil painting is at the Tate. WS, 'Preface' to *Eighty-Eight Cartoons by Powys Evans* (1926), in AGR, 532.

122 It has been suggested that the picture represented Beardsley leaving Hampstead Parish Church after a memorial service there for Keats; but, since the service took place on 16 July, only days before

the appearance of the second *Yellow Book*, this seems impossible.

123 Henry Maas, J. L. Duncan, and W. G. Good (eds), *The Letters of Aubrey Beardsley*, op. cit., 72.

124 Readers' reports on Oswald Sickert for Fisher Unwin, 6/3/1894 (NYPL). One reader, Edward Garnett, considered Oswald's story to be like 'a really good piece of art work of Walter Sickert's'.

Chapter Four: The End of the Act

I GATHERING CLOUDS

1 Sickert cried off an engagement with Rothenstein to go to a dance. ALS WS to W. Rothenstein, 24/5/1894 (Harvard).

2 RE, 73. Once begun, the picture progressed well. Oswald was soon reporting to Eddie Marsh that 'everybody likes it very much': ALS OVS to Edward Marsh, 26/7/1894 (NYPL).

3 ALS OVS to Edward Marsh, 26/[7]/1894 (NYPL).

4 cALS WS to Nina Hamnett (private collection).

5 ALS Jane Cobden-Unwin to Ellen Cobden-Sickert, 29/9/1893. Amy Draper's address in 1894 was 120 Cheyne Walk; cALS WS to Florence Pash (private collection).

6 ALS OVS to Edward Marsh, 26/[7]/1894 (NYPL); DS, mistranscribes 'meelew' as 'meadow'.

7 John Richardson, *Camden Town and Primrose Hill* (1991); Jack Whitehead, *The Growth of Camden Town* (2000).

8 C. R. W. Nevinson, *Paint and Prejudice* (1937), 127; Violet Overton Fuller, TS 'Letters to Florence Pash', 4 (Islington).

9 Wendy Baron dates these nocturnes to 1896 (WB, 54), but Oswald Sickert's letter suggests that Sickert was working on a picture of his new 'meelew', and certainly the night views are his earliest Camden Town paintings.

10 ALS OVS to Edward Marsh, 15/5/1895 (NYPL).

11 The Chelsea Life School, however, continued at the De Morgans' address for the next five years under the direction of Miss Draper, Sickert being listed merely as 'visitor'. How often he visited – if at all – is not known. A. C. R. Carter (ed.), *The Year's Art*, 1895–9.

12 ALS Jane Cobden-Unwin to Ellen Cobden-Sickert, 16/9/1894 (Chichester).

13 Sickert was equally dismissive of Dircks' suggestion that they consult Moore on the matter. The drawings were returned and the plan came to nothing, though Sickert remained hopeful of perhaps securing some work at a later date. ALS WS to Rudolf Dircks [9/1894] (private collection).

14 WB, 306–7.

15 Sickert mentioned to Dircks that he would soon be in Venice. Ellen was there staying at the Hotel Beau Rivage on the Riva dei Schiavoni (Jane wrote to her there on 26/10/1894).

16 RB nos 47, 48.

17 ALS OVS to Edward Marsh, 27/11/1894 (NYPL).

18 Ibid. Moore's hero was assailed by an uncontrollable urge to kill animals. Having dispatched a sheep and a pig with his penknife, he becomes convinced that there must be insanity in his blood and that it can only be a matter of time before he has an urge to kill his wife. Seeking an explanation for his behaviour, he decides that he is not his father's son but the illegitimate offspring of an apoplectic 'friend of the family'. Despite the dramatic urgency of Moore's telling, Sickert had to confess that he did not think the play would work: somehow 'the sheep & pigs and Mrs Campbell would not quite do'. Moore ruefully agreed that it might not 'suit an English audience'.

19 ALS WS to Richard Le Gallienne (Texas). The catalogue for the sale of John Lane's library lists a letter from Sickert asking for payment for this drawing. WS also made a portrait of the poet John Davidson, which Davidson did not care for: J. B. Townsend, *John Davidson* (1961), 382.

20 William Rothenstein, *Men and Memories*, vol. ii (1932), 7; C. R. W. Nevinson, *Paint and Prejudice*, op. cit., 128.

21 Ronald Anderson and Anne Koval, *James McNeill Whistler* (1994), 385.

22 WS, 'Where Paul and I Differ', *Art News* (10 February 1910), in AGR, 195.

23 WS, 'L'Affaire Greaves', *New Age* (15 June 1911), in AGR, 284.

24 In Rothenstein's account of the incident (*Men and Memories*, vol. i (1931), 169), Whistler, having finished the picture, 'carried it off' and 'sold it as his own work'.

25 ALS Jane Cobden-Unwin to Ellen Cobden-Sickert, 4/1/1895 (Chichester).

26 William Rothenstein, *Men and Memories*, op. cit., vol. i, 169.

27 Elizabeth R. Pennell, *Nights* (1916), 216.

28 Oliver Brown, *Exhibition* (1968), 27.

29 Exhibition catalogues (V&A); J. G. P. Delaney, *Charles Ricketts* (1990), 91–2; Robert Speaight, *William Rothenstein* (1962), 71.

30 Roger Fry to G. Lowes Dickinson, 3/1895, in Denys Sutton (ed.), *Letters of Roger Fry* (1972), 96: Fry calls Bernhard Sickert 'an excellent sedative'.

31 HMS, 62.

32 DS, 75, inadvertently put that Sickert showed 'twenty-nine' pictures. The catalogue lists 39 entries, but one of them is made up of nine etchings to give a total of 47 works. Bernhard showed 26 pictures.

33 DSM in *The Spectator* (2 March 1895), 295.

34 ALS Jane Cobden-Unwin to Ellen Cobden-Sickert, 22/1/1895 (Chichester). There were in fact two portraits of Beardsley on view, the

study in 'distemper' and one of the drawings made for the *Courrier Français*.

35 The six music-hall pictures on view were: *Miss Minnie Cunningham, The Marylebone Music Hall, High Street, Marylebone*, a watercolour of *The Eldorado, Paris*, 'Little Dot Hetherington' at the Bedford Music Hall, *The Metropolitan, Edgware Road*, and *The Old Oxford Music Hall*. Three other pictures have enigmatic titles that probably denote music-hall themes: 'Over, Rowley!'; 'Patriotic, Topical, Extempore', and 'My Love is a Sailor Lad,/A Rover o'er the Restless Sea'. The Pennells lamented the omission of some of Sickert's 'more important canvases'. *The Star* (29 January 1895), 1, writing as 'A.U.' [Artist Unknown].

36 Roger Fry to Mrs Fry, 20/1/1895, in Frances Spalding, *Roger Fry: Art and Life* (1980), 46.

37 DSM, op. cit.

38 *Illustrated London News* (2 February 1895), 152.

39 Ibid.

40 ALS WS to Brandon Thomas [1898] (Getty).

41 Julie Speedie, *Wonderful Sphinx: A Biography of Ada Leverson* (1993), 29.

42 Max Beerbohm to Ada Leverson, 9/4/1895, in Rupert Hart-Davis (ed.), *Letters of Max Beerbohm 1892–1956* (1988), 8.

43 WB, 308.

44 ALS Jane Cobden-Unwin to Ellen Cobden-Sickert, 16/2/1895 (Chichester).

45 Ronald Anderson and Anne Koval, *James McNeill Whistler*, op. cit., 383.

46 ALS WS to JMW [2/1895] (GUL).

47 ALS OVS to Edward Marsh, 20/2/1895 (NYPL).

48 ALS WS to Nan Hudson [4/1914] (Tate).

49 ALS WS to Nan Hudson [5/1914] (Tate).

50 Adrian Allinson, quoted in DS, 246.

51 ALS OVS to Eddie Marsh, 25/5/1895 (NYPL).

II BRIDGE OF SIGHS

1 ALS Jane Cobden-Unwin to Ellen Cobden-Sickert, 16/5/1895 (Chichester). Ellen was staying in a first-floor flat at Canal S. Gregorio 222.

2 ALS OVS to Eddie Marsh, 25/5/1895 (NYPL).

3 Helen, Countess-Dowager of Radnor, *From a Great Grandmother's Armchair* [1927], 190.

4 Rosalie Mander, TS precis of Mrs Hulton's MS memoir, 'Fifty Years in Venice' (Oxford), records that the Hultons met Sickert and Ellen in May 1895.

5 *Symphony in White. No. 2: The Little White Girl*, or, as the Italians referred to it, *Giovinetta bianca*; Sophie Bowness and Clive Phillpot, *Britain at the Biennale* (1995), 52.

6 *The Times* (19 July 1899), 4.

7 Ibid.

8 Beardsley was sacked while volume v was at the press. Though his pictures were hastily removed from the publication, Sickert's did appear.

9 WS, 'Knowledge in Art', *The Globe* (30 July 1895), in AGR, 100–1.

10 ALS WS to JEB (Institut). WS mentions that he had been away on the 'East Coast'.

11 Constance Collier, *Harlequinade* (1929), 137.

12 David Cecil, *Max* (1964), 56.

13 Violet Overton Fuller, TS notes on Florence Pash letters (Islington).

14 Witt Library 2312.

15 ALS Jane Cobden-Unwin to Ellen Cobden-Sickert, 22/10/1895 (Chichester); Witt Library 2319 A.

16 ALS Jane Cobden-Unwin to Ellen Cobden-Sickert, 6/11/1895 (Chichester).

17 WS to Philip Wilson Steer, in RE, 107.

18 Edwin A. Ward, *Recollections of a Savage* (1923), 128.

19 Ibid., 128.

20 ALS Ellen Cobden-Sickert to Jane Cobden-Unwin, 10/2/1896 (Chichester).

21 Sickert exhibited the portrait at Durand-Ruel in December 1900.

22 Ernest Thesiger, *Practically True* (1927), 39.
23 WS to the Editor of the *Daily Telegraph* (4 October 1932), in AGR, 621.
24 Edwin A. Ward, *Recollections of a Savage*, op. cit., 128.
25 Alfred Thornton, 'Walter Richard Sickert', *Artwork* (Spring 1930), 15.
26 WB, 47; WS to Philip Wilson Steer, in RE, 107–8.
27 RE, ibid.
28 Alfred Thornton, 'Walter Richard Sickert', *Artwork*, op. cit., 15.
29 WS to Philip Wilson Steer, in RE, 107–8.
30 Edwin Ward, *Recollections of a Savage* op. cit., 128.
31 'Miles Amber' [Ellen Cobden-Sickert], *Wistons* (1902), 136.
32 *The Academy* (16 November 1895), 417.
33 *The Speaker* (23 November 1895). Sickert's other pictures were a portrait of 'An Afghan Gentleman' and a 'little sketch' of a woman.
34 Jevon Brandon-Thomas, *Charley's Aunt's Father* (1955), 145. Brandon-Thomas quotes Sickert's telegram, and a letter from Whistler, apparently in Paris, to Brandon Thomas, although without the original of the Sickert telegram or the Whistler letter it is hard to confirm the dating. An undated letter at Glasgow from JMW in Paris to Thomas Way in London mentions Sickert bringing some pictures over.
35 ALS Jane Cobden-Unwin to Ellen Cobden-Sickert, 14/2/1896 (Chichester); *Gazetta di Venezia* (18 February 1896), 2 for an account of the decor.
36 ALS Ellen Cobden-Sickert to Jane Cobden-Unwin, 10/2/1896 (Chichester).
37 cALS Ellen Sickert to Penelope Muller, 19/4/1896 (Tate).
38 ALS T. Fisher Unwin to Ellen Cobden-Sickert, 12/2/1896 (Chichester).
39 cALS Ellen Sickert to Penelope Muller, 19/4/1896 (Tate).
40 ALS Ellen Cobden-Sickert to Jane Cobden-Unwin, 15/4/1896 (Chichester). Other visitors included May Dunn and the Muspratts, a family from Liverpool, whose daughter, Hildegarde, Ellen reported, was 'artistic and admires the New English Art School'.
41 ALS Ellen Cobden-Sickert to Jane Cobden-Unwin, 15/4/1896 (Chichester).
42 Douglas Sladen, *Twenty Years of My Life* (1915). Sladen, in his account, written twenty years after the event, gave Sickert's Christian name as Bernard. But, from Sladen's correspondence (preserved at Richmond Public Library), it is clear that it was Walter whom he met with the Zangwills in Venice. There is no record that he ever met Bernhard, or that Bernhard was in Venice. Sickert's frequent changes of name in later life, as well as the fact that his brother followed the same profession, often led to such confusion.
43 ALS WS to JMW [5/1896] (GUL).
44 'Miles Amber' [Ellen Cobden-Sickert], *Wistons*, op. cit., 183.
45 Ibid., 183.
46 Ibid., 184.
47 *The Times* (28 July 1899), 14, describes them having a 'short separation' in May 1896. When their tenancy at Miss Leigh-Smith's had come to an end at the beginning of May they had planned to move in with the Zangwills at the Hôtel d'Angleterre, but this plan was aborted. Walter went to his studio in the Calle dei Frati, while Ellen took rooms in the Calle San Zaccaria.
48 ALS Jane Cobden-Unwin to Ellen Cobden-Sickert at Calle San Zaccaria 4688, 27/5/1896 (Chichester).
49 Sickert, it seems, stayed on in Venice for the summer. A letter from there – dated August 1896 – from an unknown correspondent to a Lilian Richardson, who wanted to buy a small oil painting of *The Salute*, runs: 'W. Sickert want £5.5 for his Salute but will take £3.3.0, so I have closed the bargain. He will send it to you

by post at once if you like; or will bring it to England early in September & post it in England – I advise the latter – I shd send him a cheque if you want to pay at once, as negociable here at his bank' (Christie's catalogue, 6 June 1991, lot 78). Ellen spent July with the Cobden-Unwins at Dover, and in August went to Langenschwalbach in Germany.

50 Sickert arrived on 7 September and lodged at a separate hotel. ALS Jane Cobden-Unwin at St Gotthard to Ellen Cobden-Sickert at Hotel Crochaus, Lac de Lucerne, 7/9/1896 (Chichester), 'I imagine Walter will have passed here in the train at 5.10 today & that he will be with you now.' (In polyglot Switzerland Lake Lucerne goes by several names, and is most commonly called the Vierwaldstättersee.) *The Times* of 28 July 1899 mistakenly records that the meeting took place in 'February', though an earlier report (19 July 1899) makes it clear that it happened in September.

51 *The Times* (28 September 1899), 14.

III THE GENTLE ART OF MAKING ENEMIES

1 Aubrey Beardsley to Leonard Smithers, in Henry Maas, J. L. Duncan, and W. G. Good (eds), *The Letters of Aubrey Beardsley* (1970), 176.

2 ALS WS to Florence Pash [11/1896] (Islington);LB I, 11, suggests that he did conduct some evening classes in his Robert Street studio.

3 Lewis P. Renateau, MS notes 'Life of Florence Pash', 23/5/1952 (Islington).

4 ALS WS to Florence Pash [11/1896] (Islington).

5 George Moore to T. Fisher Unwin 8/ 10/1896, in Helmut E. Gerber (ed.), *George Moore in Transition* (1968), 130-1.

6 George Moore, *Conversations in Ebury Street* (1924), 128.

7 Frank Rutter, *Whistler* (1911), 116-

17; ALS JMW to Miss R. Birnie Philip, 12/10/1896 (GUL) complains that Sickert has 'been in town for days. He has not presented himself to me, but has been parading Bond Street with Sir William Eden & George Moore!'

8 The letter survives in both draft and finished form at the GUL.

9 ALS Jane Cobden-Unwin to Ellen Cobden-Sickert, 25/12/1896 (Chichester).

10 Laurence Housman, *The Unexpected Years* (1937), 126-7.

11 ALS JMW to Miss R. Birnie Philip, 24/11/1896 (GUL).

12 Laurence Housman, *The Unexpected Years*, op. cit., 126-7.

13 ALS Jane Cobden-Unwin to Ellen Cobden-Sickert, 25/12/1896 (Chichester).

14 Ibid.

15 Max Beerbohm to Reggie Turner, 14/ 10/1896 in Rupert Hart-Davis (ed.), *Max Beerbohm: Letters to Reggie Turner* (1964), 113.

16 ALS Jane Cobden-Unwin to Ellen Cobden-Sickert, 28/1/1897 (Chichester).

17 ML, 51.

18 ALS WS to Douglas Sladen, 11/1896 (Richmond).

19 ALS WS to Dr Garnett, 11/1896 (Texas).

20 Christopher St John (ed.), *Ellen Terry and Bernard Shaw: A Correspondence* (1931), 102.

21 ALS Jane Cobden-Unwin to Ellen Cobden-Sickert, 25/12/1896 (Chichester) recounts Whistler's distress at learning that Eden had bought pictures by both Sickert and Steer and had been seen walking in Bond Street with both artists.

22 Bruce Laughton, *Philip Wilson Steer* (1971), 65, 68.

23 WB, 47; ALS WS to Florence Pash, 1899 (Islington).

24 *Daily Telegraph* (19 November 1896).

25 Ibid.

26 'St P.' [WS], 'Du Maurier's Drawings', *The Speaker* (27 March 1897), in AGR, 152.

27 *The Times* (6 April 1897), 3.

28 WS, 'Transfer Lithography', *Saturday Review* (26 December 1896), in AGR, 121-3.

29 Alfred Thornton, *Diary of an Art Student in the Nineties* (1938), 69.

30 The account of Charles Keene in Pennell's book on pen drawing was dismissed as 'ludicrously inadequate': 'St P.' [WS], 'Two Exhibitions', *The Speaker* (7 November 1896), in AGR, 109; also 'The Art of Caricature', *The Speaker* (31 October 1896), in AGR, 107. Pennell, moreover, having dealt with pen drawing, was working on a history of lithography for Unwin. The first chapter – on Senefelder – had been recently published in *Cosmopolis*. Sickert, though he had not done any lithographs himself since 1888, regarded the medium as akin to family property: his grandfather had been a pioneer of the process. He perhaps resented Pennell's claims to specialist knowledge, and delighted in the opportunity to pick him up on a point of technique.

31 Although the edition is dated 26 December, it clearly appeared some days before as Jane Cobden-Unwin wrote to her sister about it on 25 December (Chichester).

32 E. R. and J. Pennell, *The Life of James McNeill Whistler* (1911 edn), 342.

33 ALS Jane Cobden-Unwin to Ellen Cobden-Sickert, 25/12/1896 (Chichester).

34 Alfred Thornton, *Diary of An Art Student in the Nineties*, op. cit., 69.

35 Telegram JMW to Miss R. Birnie Philip, 31/3/1897 (GUL); E. R. and J. Pennell, *The Life of James McNeill Whistler*, op. cit., 342.

36 ALS Jane Cobden-Unwin to Ellen Cobden-Sickert, 25/12/1896 (Chichester).

37 *The Sun* (2 January 1897), quoted in DS, 84.

38 ALS Jane Cobden-Unwin to Ellen Cobden-Sickert, 19/1/1897 (Chichester); also Jane Cobden-Unwin to Ellen Cobden-Sickert, 9/3/1897 (Chichester), recounts how Mrs William Whistler told Jane that Sickert called on her 'a day or two after' Frank Harris received Sir George Lewis's writ and that Harris had said, 'See what you have let me in for.'

39 *The Speaker* (13 March 1897), in AGR, 147.

40 W*lt*r S*ck*rt (M.M.), 'Wanted, A Critic!' *The Sun* (19 January 1897), in AGR, 129-30. Robins seems to consider that Sickert was the author of the piece, but it is surely a mischievous parody of his original article.

41 WS, 'The Allied Artists' Association', *Art News* (24 March 1910), in AGR, 208.

42 ALS Jane Cobden-Unwin to Ellen Cobden-Sickert, 19/1/1897 (Chichester).

43 ALS WS to Florence Pash, 2/1897 (Islington).

44 RE, 105.

45 E. R. and J. Pennell, *The Life of James McNeill Whistler*, op. cit., 344–6; *The Times* (6 April 1897), 3.

46 Ibid.

47 William Rothenstein, *Men and Memories*, vol. i (1931), 337–8.

48 ALS WS to Lady Eden [4/1897] (Birmingham).

49 Telegram JMW to Miss R. Birnie Philip, 6/4/1897 (GUL); also ALS JMW to Lady Seymour Haden [4/1897] crowing over the victory. He thought the case would certainly 'destroy' Moore and Sickert.

50 ALS WS to the Editor of the *Daily Mail* (Birmingham).

51 Robert de Montesquiou, 'Notes et Réflexions Inédites de Robert de Montesquiou', vol. ii, f. 84 (BN) describes how Sickert told de Montesquiou that he wrote the *Saturday Review* article because he needed 'cent francs' and ended up having to pay 'cinq cents guinées'. The sums mentioned are surely symbolic but reflect something of the high expense of the venture. There was no escape. Whistler pressed home his advantage remorselessly. His solicitor, Webb, called on Sickert to arrange payment.

52 William Rothenstein, *Men and Memories*, op. cit., 338.

IV AMANTIUM IRAE

1 ALS WS to Lady Eden [late 1897] (Birmingham).
2 DS, 88.
3 Gertrude Kingston [Gertrude Konstam], *Curtsey While You're Thinking* (1937), 53. When Kingston later asked 'Where is my portrait? You never finished it . . .' he replied, 'Finish it! It is all there, it's just right as it is . . . I don't know where it is.'
4 George Moore to T. Fisher Unwin, in Helmut E. Gerber (ed.), *George Moore in Transition* (1968), 139–40.
5 ALS WS to Lady Eden [late 1897] (Birmingham).
6 ALS WS to Lady Eden [1897] (Birmingham).
7 DS, 89.
8 Ibid.
9 JEB, *Portraits of a Lifetime* (1937), 98. Oscar Wilde, in his letters, mentions Oswald Sickert being in Dieppe that summer, but not Walter.
10 ALS WS to Minnie Cunningham [31/8/1897] (private collection).
11 Max Beerbohm to William Rothenstein [8/1897], in Mary M. Lago and Karl Beckson (ed.), *Max and Will* (1975), 37. Sickert may have offered the editors two other drawings – as well as a portrait of himself – for them to publish 'gratis', but there is no sign that they did: ALS WS to 'My dear Sir' [1897] (private collection).
12 WB, 50.
13 *The Bridge of the Rialto* [363], £26. 5s.
14 ALS JMW to Mrs Whibley [29/11/1897] (GUL).
15 ALS Ellen Cobden-Sickert to Jane Cobden-Unwin [spring 1897] (Chichester).
16 ALS Jane Cobden-Unwin to Ellen Cobden-Sickert, 11/12/1897 (Chichester).
17 ALS Jane Cobden-Unwin to Ellen Cobden-Sickert, 28/6/1897 and 11/12/1897 (Chichester).
18 ALS Jane Cobden-Unwin to Ellen Cobden-Sickert, 11/12/1897 [(Chichester).
19 ALS Ellen Cobden-Sickert to Jane Cobden-Unwin, 10/12/1897 (Chichester).
20 Ibid.
21 ALS WS to JEB (Institut, 7055f.168).
22 ALS WS to Lady Eden (Birmingham, AP22/14/38).
23 ALS WS to Lady Eden (Birmingham, AP22/14/37).
24 ALS WS to Lady Eden (Birmingham, AP22/14/38).
25 Max Beerbohm to Katie Lewis, 6/10/1954, in Rupert Hart-Davis (ed.), *Letters of Max Beerbohm* (1988), 226, states that the play was W. S. Gilbert's *Engaged*; but Max Beerbohm's letter to Reggie Turner from Windlestone on 12/1/1898 confirms that it was Wynn Miller's *Dream Faces*.
26 ALS WS to Lady Eden, 1/1/1898 (Birmingham).
27 ALS WS to Lady Eden (Birmingham AP22/14/38).
28 Max Beerbohm to Katie Lewis, 6/10/1954, in Rupert Hart-Davis (ed.) *Letters of Max Beerbohm*, op. cit.; Max Beerbohm to Reggie Turner, 1/1898, in Rupert Hart-Davis (ed.), *Max Beerbohm: Letters to Reggie Turner* (1964), 127–8.
29 ALS WS to Lady Eden (Birmingham, AP22/14/38).
30 Max Beerbohm to Katie Lewis, 6/10/1954, in Rupert Hart-Davis (ed.), *Letters of Max Beerbohm*, op. cit., 226.
31 Max Beerbohm to Reggie Turner, 1/1898, in Rupert Hart-Davis (ed.), *Max Beerbohm: Letters to Reggie Turner*, op. cit., 127–8.
32 William Rothenstein, *Men and Memories*, vol. i (1931), 335.
33 cALS WS to Florence Pash (Islington).
34 ALS WS to Lady Eden (Birmingham, AP22/14/43).
35 Ibid.
36 ALS WS to William Rothenstein [7/1899] (Harvard).
37 NEAC catalogue, picture no. 7.
38 *Saturday Review* (19 November 1898).

39 *The Stage Box.*

40 ALS WS to Dr Garnett [1896] (Texas); also 'St P.' [WS], 'On Line', *The Speaker* (21 November 1896), in AGR, 112.

41 WS, 'The Royal Academy', *The Sun* (10 and 17 February 1897), in AGR, 136, 140.

42 WS, ibid. (10 February 1897), in AGR, 136.

43 John Lavery, *The Life of a Painter* (1940), 108, n. 7.

44 C. B. Cochran, *Showman Looks On* (London, 1945), 26.

45 The wedding took place on 2 July 1898.

46 Jean Overton Fuller, *Sickert and the Ripper Crimes* (1990), 21–2.

47 ALS WS to Florence Pash [7/1898] (Islington).

48 Jean Overton Fuller, *Sickert and the Ripper Crimes*, op. cit., 22.

Chapter Five: Jack Abroad

I A WATERING PLACE OUT OF SEASON

1 cALS WS to Florence Humphrey [née Pash] (Islington).

2 cALS WS to Florence Humphrey [née Pash] (Islington).

3 He was £20 in her debt at the beginning of the following year; cf. ALS WS to William Rothenstein (Harvard), 28, 25.

4 ALS Ellen Cobden-Sickert to JEB (Institut) states that WS 'borrowed £600 from his brother in law (who is a poor man) & he ought to pay him interest on this sum'; cf. also LB I, 12.

5 ALS Reggie Turner to Max Beerbohm, 24/7/1900 (Harvard).

6 ALS WS to William Rothenstein [6/1899] (Harvard); Max Beerbohm, 'The Maison Lefèvre', in Rupert Hart-Davis (ed.), *Max Beerbohm: Letters to Reggie Turner* (1964), 302.

7 ALS Reggie Turner to Max Beerbohm, 24/7/1900 (Harvard).

8 Max Beerbohm to Reggie Turner, 23/8/1898, in Rupert Hart-Davis (ed.), *Max Beerbohm's Letters to Reggie Turner*, op. cit., 131.

9 ALS William Rothenstein to JEB, 26/10/1937 (Institut). Aggie Beerbohm may well have been in Dieppe with Sickert for at least some of that summer. She was, Turner recalled, a devotee of Lefèvre's, and she may have been Max's informant about the meeting between Sickert and Whistler.

10 cALS WS to Florence Humphrey [née Pash] (Islington); ALS WS to Brandon Thomas (Getty) gives the same list, but ends '& above everything Sickert!'

11 RE, 82.

12 WB, 56.

13 cALS WS to Florence Humphrey [née Pash] (Islington).

14 Edward Heron-Allen, MS diary, 1901 (private collection).

15 ALS WS to Brandon Thomas [late 1898] (Getty).

16 ALS WS to Brandon Thomas [early 1899] (Getty).

17 cALS WS to Florence Humphrey [née Pash] (Islington).

18 cALS WS to Florence Humphrey [née Pash] (Islington]); ALS WS to DSM (GUL).

19 Ibid.

20 cALS WS to Florence Humphrey [née Pash] (Islington).

21 ALS WS to William Rothenstein [early 1899] (Harvard).

22 JEB, *Dieppe* (1927), 14.

23 RE, 82.

24 Simona Pakenham, TS 'Walter Sickert & My Grandmother' (Sutton GUL).

25 RE, 82.

26 Dieppe Marriage and Birth Registers (Dieppe). The search is considerably complicated by the number of Villains living in Dieppe. Titine's father, Amable Augustin Villain – a *charpentier des navires* – remarried in 1882 and in 1890 produced a daughter, Marguerite Louise Rose Villain.

27 That was her address at the time of Maurice's birth.

28 ALS WS to DSM (GUL).
29 ALS JEB to William Rothenstein (Harvard).
30 ALS WS to William Rothenstein (Harvard).
31 cALS WS to Florence Humphrey [née Pash] (Islington).
32 Ibid.
33 William Rothenstein, *Men and Memories*, vol. i (1931), 343; also Michael Holroyd, *Augustus John* (1996), 353.
34 cALS Eleanor Sickert to Penelope Muller, 22/2/1899 (Tate).
35 William Rothenstein, *Men and Memories*, op. cit., 44.
36 ALS WS to William Rothenstein (Harvard).
37 cALS WS to Florence Humphrey [née Pash] (Islington).
38 ALS WS to William Rothenstein [early 1899] (Harvard).
39 He was delighted by *More*, Max Beerbohm's second volume of essays, and learnt of the campaign against Sir William Blake Richmond's mosaic decorations at St Paul's Cathedral, launched by MacColl and eagerly supported by the ranks of the London art schools. ALS WS to Edward Marsh [4/1899] (NYPL); cALS WS to Florence Humphrey [née Pash] (Islington); Maureen Borland, *D. S. MacColl* (1995), 106–7.
40 The picture was titled *The Rose Window*.
41 ALS WS to William Rothenstein [early 1899] (Harvard).
42 ALS WS to William Rothenstein [early 1899] (Harvard).
43 Jean Hamilton, MS Diary, 5/6/1904; 'Sickert v Sickert' divorce papers (PRO).
44 ALS WS to William Rothenstein, 30/4/1899 (Harvard).
45 'Sickert v Sickert' (PRO); ALS WS to William Rothenstein (Harvard).
46 ALS WS to William Rothenstein (Harvard).
47 Ibid.
48 ALS WS to William Rothenstein (Harvard).
49 ALS WS to William Rothenstein (Harvard).
50 ALS WS to William Rothenstein (Harvard).
51 ALS WS to William Rothenstein (Harvard).
52 ALS Fred Brown to William Rothenstein, 3/6/1899 (Harvard). He bought the picture on twelve months' approval. Rothenstein was to keep hold of the canvas during that time and try and sell it for more than £20. If he succeeded he could return Brown his money, but – if not – he had to deliver the picture at no extra charge.
53 Sickert suggested that if Rothenstein were able to raise more than £20 for the picture, Brown should have any profit. ALS WS to William Rothenstein (Harvard).
54 ALS WS to William Rothenstein (Harvard); WS later sent Carfax a 6- × 4-inch panel suggesting they might sell it for 10 guineas. ALS WS to William Rothenstein (Harvard).
55 ALS WS to Alice Kingsley (Harvard).
56 ALS WS to William Rothenstein (Harvard).
57 ALS William Rothenstein to JEB, 26/7/1899 (Institut).
58 ALS JEB to William Rothenstein, 24/7/1899 (Harvard).
59 Ibid.
60 ALS William Rothenstein to JEB, 26/7/1899 (Institut).
61 ALS WS to William Rothenstein (Harvard).
62 WB, 57.
63 ALS WS to William Rothenstein (Harvard).
64 Ibid.
65 Richard Sickert [WS], 'Some French Painters', *Fortnightly Review* (December 1929), in AGR, 595.
66 ALS WS to William Rothenstein (Harvard).
67 Ibid.
68 ALS WS to William Rothenstein (Harvard).
69 Ambrose Vollard, *Degas: An Intimate Portrait* (1986), 31–2. Degas' formidable servant, Zoé, made orange marmalade specially for her master. He would eat it as a treat at dinner with company.

70 ALS WS to William Rothenstein (Harvard). Degas remarked to Stchoukine about his Spanish pictures, 'Vous êtes heureux de colliger les Espagnoles, parcequi'il n'y en a pas.' Sickert, however, took a close interest in them, as he knew Rothenstein was working on a book about Goya. He even offered to put his friend in touch with Stchoukine.

71 ALS WS to William Rothenstein (Harvard).

72 ALS Ellen Cobden-Sickert to Jane Cobden-Unwin [7/1899] (Chichester).

73 ALS Jane Cobden-Unwin to Ellen Cobden-Sickert, 24/7/1899 (Chichester).

74 'Sickert v Sickert' (PRO).

75 ALS WS to William Rothenstein (Harvard).

76 ALS Jane Cobden-Unwin to Ellen Cobden-Sickert, 20/7/1899 (Chichester); *The Times* (19 July and 28 July 1899).

77 *The Times* (28 July 1899).

78 ALS WS to JEB (Institut); WS to William Rothenstein (Harvard).

79 ALS WS to JEB (Institut).

80 ALS WS to Alice Rothenstein (Harvard).

81 There are frequent references to Sickert's plans to go to Vattetot, but no mention of his having been. Also he did not meet William Rothenstein's younger brother, Albert – who was at Vattetot – until several years later.

82 ALS WS to JEB (Institut).

83 ALS WS to William Rothenstein (Harvard). Rothenstein confided to Blanche that 'Eden could, I think, help Walter more than he does' (Institut).

84 ALS WS to William Rothenstein (Harvard).

85 ALS WS to William Rothenstein (Harvard).

86 ALS WS to Brandon Thomas (Getty).

87 ALS Reggie Turner to Max Beerbohm, 9/9/1899 (Harvard).

88 ALS WS to William Rothenstein (Harvard).

89 ALS WS to William Rothenstein (Harvard).

90 ALS Reggie Turner to Max Beerbohm, 9/9/1899 (Harvard).

91 ALS WS to William Rothenstein (Harvard).

92 ALS WS to JEB (Institut).

93 Ibid.; ALS WS to William Rothenstein (Harvard).

94 ALS WS to JEB (Institut).

95 ALS WS to William Rothenstein (Harvard).

96 ALS WS to JEB (Institut).

97 ALS WS to William Rothenstein (Harvard) gives the price as £5. WS told Blanche that 'a nice American' had paid £8 for 'two little panels' (Institut).

98 JEB, *Portraits of a Lifetime*, 104–5.

99 ALS WS to William Rothenstein (Harvard); WS to JEB (Institut).

100 ALS WS to JEB (Institut); ALS WS to William Rothenstein (Harvard).

101 Mrs Neville had introduced Sickert as 'a great friend' of Blanche's. Sickert reported that, though she spoke 'critically' of Blanche's work, she was not wholly against it ALS WS to JEB (Institut).

102 Ibid.

103 Mme Lemaire lent a painting of *Le Halle au Lin* to an exhibition of Sickert's work at Durand-Ruel in December 1900.

104 ALS Ellen Cobden-Sickert to JEB, 30/7/1899 (Institut).

105 Ibid.; JEB, *La Pêche aux Souvenirs* (1949), 214–15. The arrangement did become known. Jean Hamilton was told by the painter Harris Brown that Ellen had 'plenty of money, and arranges to get his pictures bought and so help him'. All Ellen's pictures were bequeathed on her death to her sister Annie Cobden-Sanderson.

106 ALS WS to William Rothenstein (Harvard).

107 Ibid.

108 Mary Soames, *Clementine Churchill* (Harmondsworth, 1981 edn), 46–7, 52; Simona Pakenham, *Sixty Miles from England* (1967), 160.

109 Simona Pakenham, TS 'Walter Sickert & My Grandmother', 2–4 (Sutton GUL); ALS WS to William Rothenstein (Harvard). The

imperfect records at Dieppe make it difficult to determine when exactly the Middletons arrived at Dieppe. LB II, 37, suggests that they had been there since the mid 1890s, but their friendship with Sickert dates from the end of that decade.

110 Simona Pakenham, TS, 'Walter Sickert & My Grandmother', 2–4 (Sutton GUL); *Sixty Miles from England*, op. cit., 142–3.

111 ALS WS to Nan Hudson/Ethel Sands [1/1915] (Tate).

112 Simona Pakenham, *Sixty Miles from Dieppe*, op. cit., 161.

113 Simona Pakenham, TS, 'Walter Sickert & My Grandmother', 4 (Sutton GUL).

114 Quoted in Jean Hamilton, MS Diary, 11/12/1904 (KCL).

115 Simona Pakenham, TS, 'Walter Sickert & My Grandmother', 3 (Sutton GUL); *Sixty Miles from England*, op. cit., 178–9.

116 ALS Charles Conder to William Rothenstein (Harvard).

117 ALS WS to William Rothenstein (Harvard).

118 ALS Charles Conder to William Rothenstein, 19/9/1899 (Harvard).

119 ALS WS to William Rothenstein (Harvard).

120 Ibid.

121 ALS WS to William Rothenstein (Harvard).

122 Ibid.

123 Marguerite Steen, *William Nicholson* (1943), 90.

124 Mary Soames, *Clementine Churchill*, op. cit., 47.

125 Ibid., 45, 47.

126 Simona Pakenham, *Sixty Miles from England*, op. cit., 180.

127 Mary Soames, *Clementine Churchill*, 49.

128 Marguerite Steen, *William Nicholson*, op. cit., 90.

129 Mary Soames, *Clementine Churchill*, 48.

130 Simona Pakenham, TS, 'Walter Sickert & My Grandmother', 3 (Sutton GUL).

131 Simona Pakenham, *Sixty Miles from England*, op. cit., 180.

132 ALS WS to Sir William Eden (Birmingham).

133 cALS WS to Florence Humphrey [*née* Pash] (private collection).

134 ALS WS to William Rothenstein (Harvard).

135 JEB, *La Pêche aux Souvenirs* (1941), 215; JEB to André Gide, 20/7/1902, in Georges-Paul Collet (ed.), *Cahiers André Gide 8* (1979), 122–3.

136 ALS WS to Nan Hudson/Ethel Sands [1/1915]; WS to Ethel Sands [2/1915] (Tate).

137 RE, 83.

138 ALS WS to William Rothenstein (Harvard).

139 Mary Soames, *Clementine Churchill*, op. cit., 52–3.

140 William Rothenstein to Max Beerbohm, in Mary Lago and Karl Beckson, *Max and Will* (1975), 42. Sickert's other submission was a drawing of a girl titled *Das Blonde Kopfchen* (*Morning Leader*, 10 April 1900).

141 Simona Pakenham, TS, 'Walter Sickert & My Grandmother' (Sutton GUL). The party comprised WS, Mrs Price, Judy Welsted, and Mr Coxon. According to Polly Price, 'both the gentlemen' were hers.

142 ALS Jane Cobden-Unwin to Ellen Cobden-Sickert, 22/6/1898 and 30/3/1900; Ellen Cobden-Sickert to Fisher Unwin, 25/4/1900 (Chichester).

143 Simona Pakenham, TS, 'Walter Sickert & My Grandmother', (Sutton GUL); *Sixty Miles from England* (1967), 191.

144 ALS WS to Florence Humphrey [*née* Pash] (Islington), written in the late summer of 1900, mentions recent Venice drawings at the Fine Art Society. There are also Sickert paintings of Venice dated 1900; one of them is inscribed to Polly Price. WS might have gone in the early part of the year. A letter from WS to Lady Eden (Birmingham, AP22/14/40) mentioning that he will be leaving 'for Venezia benedetta where I am overdue' – soon after spending Christmas with JEB in

Paris – though difficult to date, could be from the winter of 1899/ 1900. If he went then, however, the visit was brief. He was in Dieppe during late February 1900, when Kitty Hozier, Lady Blanche's elder daughter, became ill and died (Mary Soames, *Clementine Churchill*, op. cit., 52).

145 Violet Overton Fuller, 'Letters to Florence', 18–19 (Islington). DS, 104, mistakenly claims that Sickert's initial interest was in Stella Maris rather than her sister.

146 cALS WS to Florence Humphrey [*née* Pash] (Islington); ALS WS to William Rothenstein (Harvard).

147 cALS WS to Florence [*née* Pash] Humphrey (Islington).

148 Attending a party of the Lowes Dickinsons in June 1900: Alice Mayor's 'Journal', in Sybil Oldfield, *Spinsters of the Parish* (1984), 54.

149 'O.V.S.' had reviewed the NEAC spring exhibition in the *Saturday Review* (23 April 1900) without mentioning Sickert's contributions: Albert Rutherston, 'From Orpen and Gore to the Camden Town Story', *Burlington Magazine* (1943), 201–2.

150 cALS WS to Florence Humphrey [*née* Pash] (Islington).

151 cALS WS to Florence Humphrey [*née* Pash] (Islington).

152 Musée de Dieppe, minute book, 1900 (second half of year).

153 JEB to André Gide, 25/7/1902, in Georges-Paul Collet (ed.), *Cahiers André Gides*, op. cit., 128; Robert de Montesquiou, MS 'Notes et Réflexions Inédites', ii, f. 84.

154 ALS WS to Alice Rothenstein (Harvard).

155 The show ran until 22 December 1900.

156 The other lenders named in the catalogue were M. Ployer, Mme Price, and Mme Middleton.

157 ALS WS to Alice Rothenstein (Harvard).

158 ALS WS to William Rothenstein (Harvard).

159 Baron/Shone, 108.

160 ALS WS to Alice Rothenstein (Harvard); WS to Florence Humphrey [*née* Pash] (Islington).

161 ALS WS to Alice Rothenstein (Harvard): 'Talking of Whistler & advertisement then of Manet he said that he Degas often said to Manet "Mais vous êtes aussi connu que Garibaldi! [But you are as well known as Garibaldi] What more do you want?" To which Manet [replied] "Alors vous êtes au-dessus de niveau de la mer."[Well, you are above sea level]'

162 The exhibition ran from 22 November–15 December 1900.

163 ALS WS to William Rothenstein (Harvard). WS gave many subsequent versions of the incident. Degas was not an admirer of Monet's late work. He later told Mary Cassatt that Monet had done nothing good for twenty years. Richard Kendall, *Degas: Beyond Impressionism* (London, 1996), 39.

164 ALS WS to William Rothenstein (Harvard).

165 The play opened on 11 December 1900.

166 ALS WS to Alice Rothenstein (Harvard); Reggie Turner to Max Beerbohm, 13/12/1900 (Harvard).

II　CHANGING EFFECTS

1 ALS WS to William Rothenstein (Harvard).

2 Edward Heron-Allen, MS travel diary, 1901 (private collection).

3 ALS WS to Durand-Ruel [rec. 2/4/ 1901] (Fondation Custodia)

4 Ibid.

5 cALS WS to Florence Humphrey [*née* Pash] (private collection).

6 WB, 325.

7 *Gazzetta di Venezia* (27 April 1901), 1–3.

8 ALS WS to Mrs Hulton (Oxford).

9 ALS WS to Mrs Hulton (Oxford).

10 ALS WS to Mrs Hulton (Oxford).

11 DS, 119; Edward Heron-Allen travel diary, op. cit.

12 ALS WS to Mrs Hulton (Oxford).

13 The address was 6383 Calle della Testa, opposite the Ospedale Civile,

and across from Santa Maria Formosa.

14 ALS WS to Mrs Hulton (Oxford).

15 ALS WS to Mrs Hulton (Oxford).

16 *Gazzetta di Venezia* (16 May 1901), 3.

17 *Gazzetta di Venezia* (17 May 1901), 3; Rosalie Mander, TS precis of Mrs Hulton's MS 'Fifty Years in Venice' (Oxford).

18 ALS WS to Mrs Heron-Allen (Getty); WS to Mrs Hulton (Oxford).

19 ALS WS to Mrs Hulton (Oxford).

20 Ibid.

21 Ibid. Mrs Hulton had found the organist, an Italian (Lady Layard's MS journal, 22 December 1900 [BL]). Although there is nothing to suggest that Sickert attended church services at Dieppe, soon after his arrival in Venice he wrote to Mrs Hulton, remarking, 'I am grieved to say I have been breaking the sabbath too frequently lately. And it doesn't agree with me at all.' ALS WS to Mrs Hulton (Oxford).

22 ALS WS to Mrs Heron-Allen (Getty).

23 ALS WS to Mrs Hulton (Oxford).

24 ALS WS to Mrs Hulton (Oxford). De Rossi's son was working in London.

25 ALS WS to Mrs Hulton (Oxford).

26 ALS WS to Mrs Hulton (Oxford).

27 Mrs Hulton, having consented to the plan, came to doubt the wisdom of her decision. On the day of the dinner she and her husband went out on the lagoon with Comandante Ugo Rombo, a dapper little man who took parties on his steam launch. He had a reputation, however, for conveying the evil eye, and it seemed confirmed when they were late returning. Mrs Hulton, who had been warned by Sickert that Sir William became 'easily cross', was sure he would be 'very annoyed if kept waiting by an unpunctual hostess'. She was late. He was kept waiting. But – to her surprise and relief – he was not annoyed and, indeed, 'proved a very pleasant guest'. He even returned and made a portrait of Teresa. ALS WS to Mrs Hulton (Oxford); Rosalie Mander, TS

precis of Mrs Hulton's MS 'Fifty Years in Venice' (Oxford); Lady Layard's MS journal (BL).

28 ALS WS to Mrs Heron-Allen (Getty).

29 ALS WS to Mrs Hulton (Oxford).

30 ALS WS to Mrs Hulton (Oxford).

31 ALS WS to Mrs Hulton (Oxford).

32 ALS WS to Mrs Hulton (Oxford).

33 ALS WS to Mrs Hulton (Oxford).

34 ALS WS to Mrs Hulton (Oxford).

35 ALS WS to Sir William Eden, 15/11/1901 (Birmingham); WS to Mrs Heron-Allen (Getty).

36 ALS WS to Mrs Hulton (Oxford).

37 ALS WS to Sir William Eden, 15/11/1901 (Birmingham); WS to Durand-Ruel (Sutton GUL).

38 ALS WS to Mrs Hulton (Oxford).

39 WS to Durand-Ruel (Sutton GUL).

40 ALS WS to Edward Heron-Allen, 9/10/1901 (Getty); Edward Heron-Allen, MS diary, 1901; Max Beerbohm to Reggie Turner [22/7/1901], in Rupert Hart-Davis (ed.), *Max Beerbohm: Letters to Reggie Turner* (1964), 144–6.

41 ALS WS to JEB (Institut).

42 WS to Durand-Ruel (Sutton GUL).

43 Cahen owned a Sickert drawing of the gallery of the Old Bedford (WB, 311).

44 WS to Durand-Ruel (Sutton GUL); Camille Pissarro to Lucien Pissarro, 26/7/1901, in J. Bailly-Herzberg (ed.), *Correspondance de Camille Pissarro V: 1899–1903* (1991), 346; ALS WS to Nan Hudson/Ethel Sands [1914] (Tate).

45 Max Beerbohm to Reggie Turner [5/9/1901], in Rupert Hart-Davis (ed.), *Max Beerbohm: Letters to Reggie Turner*, op. cit., 146–7.

46 ALS WS to Edward Heron-Allen (Getty).

47 cALS WS to Florence Humphrey [*née* Pash] (Islington).

48 ALS WS to Sir William Eden, 15/11/1901 (Birmingham).

49 Ibid.

50 WS to Edward Heron-Allen, 9/10/1901 (Getty).

51 ALS WS to Sir William Eden, 15/11/1901 (Birmingham).

52 ALS WS to Mrs Hulton (Oxford).
53 ALS WS to Sir William Eden, 15/11/
 1901 (Birmingham).
54 Ibid.
55 cALS WS to Florence Humphrey [née
 Pash] (Islington).
56 ALS WS to Sir William Eden, 15/11/
 1901 (Birmingham).
57 ALS WS to Mrs Hulton (Oxford).
58 ALS WS to Sir William Eden, 15/11/
 1901 (Birmingham).
59 George Moore, *Ave* (1937), 229.
60 *St Jacques* was picture no. 125.
61 DSM, *Life, Work and Setting of Philip
 Wilson Steer* (1945), 146.
62 C. J. Holmes, *Self and Partners*
 (1936), 236.
63 George Moore, *Ave*, op. cit., 226–30.
64 ALS WS to Mrs Hulton (Oxford).
 DS, 113, dates this encounter to
 Christmas 1902.
65 *The Athenaeum* (15 February 1902),
 205; *The Academy* (13 February
 1902), 169; *Times Literary
 Supplement* (14 February and
 7 March 1902).
66 ALS WS to Sir William Eden
 (Birmingham).
67 Ibid.; ALS WS to Mrs Hulton
 (Oxford). It seems that Mrs Hulton's
 original copy went astray in the post,
 as he gave her another the following
 year inscribed 'To Mrs Hulton, W.S.
 March 1903'.
68 Paul Durand-Ruel recalled that the
 picture had been bought by a
 'sénateur Clark' for 80,000 francs.
 The picture, however, became part of
 the H. O. Havemeyer collection and
 was later presented to the
 Metropolitan Museum, New York.
69 ALS WS to Mrs Hulton (Oxford);
 WS to Sir William Eden
 (Birmingham).
70 Ibid. Degas had told him how the
 sitter had come to him during the
 siege of Paris. He had bought her a
 piece of meat, which she 'fell upon'
 raw, 'so hungry was she, & devoured
 whole'. WS annotation in Paul
 Jamot's *Degas* (Fondation Custodia).
71 DS, 113.
72 ALS WS to Sir William Eden
 (Birmingham).

III GAÎTÉ MONTPARNASSE

1 ALS WS to Mrs Hulton (Oxford).
2 ALS Mme Stettler to 'Messieurs' [JEB,
 WS, Lucien Simon], 23/10/1902
 (Institut).
3 ALS WS to Mrs Hulton (Oxford).
4 ALS WS to Mrs Hulton (Oxford).
5 ALS WS to Sir William Eden
 (Birmingham, AP22/23/1).
6 ALS WS to Sir William Eden
 (Birmingham, AP22/23/2). In
 another letter to Eden, WS calls it 'an
 odd studio'.
7 ALS WS to Sir William Eden
 (Birmingham, AP/22/23/7).
8 Mary Soames, *Clementine Churchill*
 (1981), 56.
9 ALS WS to Mrs Hulton (Oxford).
10 Derek Hudson, *For Love of Painting:
 The Life of Sir Gerald Kelly, KCVO,
 PRA* (1975) 15.
11 ALS WS to Sir William Eden
 (Birmingham, AP22/23/2).
12 WS, 'Degas', *Burlington Magazine*
 (November 1917), in AGR, 418.
13 The Italian-born printmaker,
 Calmetta: WS annotation to *Ingres
 d'après une Correspondance Inédite*,
 319 (Courtauld).
14 ALS WS to Mrs Hulton (Oxford).
15 ALS WS to Sir William Eden
 (Birmingham, AP22/23/4). Sickert
 also tried to persuade Eden to
 commission some elaborate gates
 from Vincenzo Zanon – the Venetian
 artist in metal – a regular customer
 at the Giorgione trattoria.
16 They also missed each other on
 occasion. Cf. ALS WS to Sir William
 Eden (Birmingham, AP22/23/1).
17 ALS WS to Sir William Eden
 (Birmingham, AP22/23/8).
18 ALS WS to Sir William Eden
 (Birmingham, AP22/23/2).
19 Carolyn Burke, *Becoming Modern: The
 Life of Mina Loy* (1996), 93.
20 WS, 'The Thickest Painters in
 London', *New Age* (18 June 1914), in
 AGR, 379.
21 WS to Philip Wilson Steer, in RE,
 89–90.
22 Sophie Monneret, *L'Impressionisme et
 son Époque* (1978), vol. i, 287.

23 ALS Madeleine Lemaire to Robert de Montesquiou [29/4/1902] (BN) mentions that 'Sickert n'est pas à Paris', suggesting that the hostess was aware of his movements and that the Count was interested in his whereabouts. Mme Lemaire's salon ran from April to June.

24 *Jacques-Émile Blanche, Peintre* (1997), 209.

25 Clive Bell, *Old Friends* (1956), 153.

26 ALS WS to Nan Hudson/Ethel Sands [1913] (Tate); Sophie Monneret, *L'Impressionisme et son Époque*, vol. ii, 137, mentions that Morrice had introduced Prendergast to Sickert at Dieppe. The meeting had probably taken place in the early 1890s, as Prendergast returned to America in 1894. Morrice became the model for Warren, the painter, in Somerset Maugham's *The Magician* (1908), and the poet Cronshaw in Maugham's *Of Human Bondage* (1915). He also served as the basis for the painter in Arnold Bennett's *Buried Alive* (1908).

27 ALS WS to Mrs Hulton (Oxford); ALS Mme Stettler to 'Messieurs' (Institut); *Jacques-Émile Blanche, Peintre*, op. cit., 224.

28 *Jacques-Émile Blanche, Peintre*, op. cit., 136.

29 Mireille Bialek, *Jacques-Émile Blanche à Offranville* (1997), 49.

30 Other members of the group included Dauchez (Simon's brother-in-law), Maurice Lobre (who had briefly been a member of the NEAC), René Ménard, and Constantin Meunier.

31 *Revue de l'Art Ancien et Moderne*, vol. xi (1902), review of New Salon.

32 ALS WS to Mrs Hulton (Oxford).

33 Ibid.; ALS WS to Miss Hudson [1907] (Tate).

34 ALS WS to Mrs Hulton (Oxford); Mme Stettler to 'Messieurs', 23/10/1902 (Institut).

35 JEB to André Gide, 25/7/1902, in Georges-Paul Collet (ed.), *Cahiers André Gide 8* (1979), 128.

36 WS 'Walter Bayes' in AGR, 422.

37 ALS WS to Sir William Eden (Birmingham AP22/23/7).

38 ALS WS to Sir William Eden (Birmingham AP22/23/2).

39 JEB to André Gide in Georges-Paul Collet (ed.), *Cahiers André Gide 8*, op. cit., 135-6.

40 Ibid. In 1902 there were 25.35 francs to £1.

41 WS to Philip Wilson Steer, in RE, 89.

42 WS, 'Impressionism', *New Age* (30 June 1910), in AGR, 254.

43 ALS WS to JEB (Institut).

44 WS to Philip Wilson Steer, in RE, 89.

45 ALS WS to Sir William Eden (Birmingham, AP22/23/4).

46 ALS WS to Sir William Eden (Birmingham, AP22/23/7).

47 ALS WS to Sir William Eden (Birmingham, AP22/23/1). There is no trace of his music-hall etchings, but several Venice prints were completed. Cf. RB nos. 119-123.

48 ALS WS to Mrs Hulton (Oxford).

49 ALS WS to Sir William Eden (Birmingham, AP22/23/Q). The price has been variously quoted as 40 francs or 100 francs per picture. WB, 7, n. 3.

50 ALS WS to Sir William Eden (Birmingham, AP22/23/Q).

51 ALS WS to Sir William Eden (Birmingham, AP22/23/2).

52 ALS WS to Sir William Eden (Birmingham, AP22/23/1). WS had told Heron-Allen back in October 1901 that he had conceived a 'fine illustration' to the lines, 'And that inverted bowl we call the sky/ Beneath which, crawling cooped we die'.

53 ALS WS to Sir William Eden (Birmingham, AP22/23/2). Bernhard Sickert did write a book on Whistler for Constable & Co.

54 cALS to JEB [1902] (Sutton GUL).

55 JEB, *Portraits of a Lifetime* (1937), 167.

56 JEB to André Gide, 20/7/1902, in Georges-Paul Collet (ed.), *Cahiers André Gide 8*, op. cit., 122; 'Société des Amis des Arts de Dieppe,

Catalogue de L'Exposition des Beaux-Arts' [1902], no. 182 (Musée de Dieppe).

57 JEB to André Gide, in Collet, op. cit., 135–6, 128.

58 cALS WS to JEB [1902] (Sutton GUL).

59 JEB to André Gide, 20/7/1902, in Georges-Paul Collet (ed.), *Cahiers André Gide 8*, op. cit., 123.

60 JEB to André Gide, 25/7/1902, in Georges-Paul Collet (ed.), *Cahiers André Gide 8*, op. cit., 126–7; Simona Pakenham, *Sixty Miles from England* (1967), 202, says Mantren had agreed to pay Sickert 100 francs for each picture but then refused to pay up.

61 Simona Pakenham, *Sixty Miles from England*, op. cit., 202.

62 JEB to André Gide, 5/8/1902, in Georges-Paul Collet (ed.), *Cahiers André Gide 8*, op. cit., 129.

63 Gide's account of the visit is printed as an appendix to Georges-Paul Collet (ed.), *Cahiers André Gide 8*, op. cit., ***.

64 JEB to André Gide, 5/8/1902, in Georges-Paul Collet (ed.), *Cahiers André Gide 8*, op. cit.

65 Ibid.

66 JEB to André Gide [8/9/1902], in Georges-Paul Collet (ed.), *Nouvelles Lettres à André Gide* (1982), 51.

67 cALS WS to JEB [1902] (Sutton GUL).

68 ALS WS to Sir William Eden (Birmingham, AP22/23/J).

69 cALS WS to JEB [1902] (Sutton GUL) refers to 'la bourse de Madame Villain inépuisable'; WB, 328. There does, however, remain some mystery about the pictures. One drawing – as Anna Gruetzner Robins has pointed out – appears to show a second, standing, nude in the background, suggesting a less informal and domestic setting. A. G. Robins, *Walter Sickert: Drawings* (1996), 25–6.

70 JEB to André Gide, 15/12/1902, in Georges-Paul Collet (ed.), *Cahiers André Gide 8*, op. cit., 57. It is now rue Butel-Bourdon.

71 ALS WS to JEB, 5/8/1902 (Institut).

72 cALS WS to JEB (Sutton GUL).

73 RE, 189.

74 Warren Taylor, a son of one of the two families with a concession to gather the distinctive round pebbles from the Dieppe beach, sent Sickert a cartload of stones. cALS WS to JEB (Sutton GUL); ALS WS to JEB (Institut). Writing to Mrs Hulton, early in 1903, Sickert described the paths as 'brick walks' (Oxford).

75 ALS WS to JEB, 5/8/1902 (Institut).

76 Witt 2138A. Another picture of the Neuville garden – dated 1911 – shows a low brick pedestal with an urn on it, with the fields stretching off beyond (Christie's catalogue, 20 June 1995, lot 115).

77 ALS WS to JEB, 5/8/1902 (Institut); WS to Mrs Hulton (Oxford).

78 WS to 'mon pauvre ami' [?], 21/10/1902 (Fondation Custodia). At the age of forty he had married Malvina Cordelia Blagden, the 30-year-old daughter of a gas company agent, at the Kensington Registry Office on 29 July 1902.

79 ALS WS to 'mon pauvre ami', 21/10/1902 (Fondation Custodia); ALS WS to JEB (Institut).

80 JEB to André Gide, 8/11/1902, in Georges-Paul Collet (ed.), *Cahiers André Gide 8*, op. cit., 135–6.

81 ALS Mme Stettler to 'Messieurs', 23/10/1902 (Institut).

82 JEB to André Gide, 15/12/1902, in Georges-Paul Collet (ed.), *Cahiers André Gide 8*, op. cit., 57.

83 ALS WS to Ethel Sands [1914] (Tate).

84 ALS WS to Mrs Hulton (Oxford).

85 Richard Sickert [WS], 'John Everett Millais', *Fortnightly Review* (June 1929), in AGR, 585–6.

86 Ibid.

87 ALS WS to Nan Hudson [1909] (Tate).

88 Osbert Sitwell, *Noble Essences* (1950), 186.

89 ALS WS to Edmund Gosse, 2/1/1924 (Leeds).

90 ML, 22, 24.

91 ALS WS to Edward Heron-Allen,

9/10/1901; WS to Sir William Eden (Birmingham, AP22/23/1). The picture was not undertaken until the following spring.

92 Osbert Sitwell, *Noble Essences*, op. cit., 186.

93 ASL WS to Nan Hudson/Ethel Sands, 'Friday' [1914] (Tate).

94 ML, 17.

95 Clive Bell, *Old Friends* (1956), 22.

96 Osbert Sitwell, *Noble Essences*, op. cit., 197; Quentin Bell, 'Some Memories of Sickert', *Burlington Magazine* (April 1987), 230.

97 Sickert, according to the catalogue in the Sutton papers, was one of six invitees. Of the eight sociétaires (including Frits Thaulow, Aman Jean, and Frank Brangwyn), only four exhibited.

98 WS to Stella Conder, in John Rothenstein, *The Life and Death of Conder* (1938), 192: 'Remember Degas said "It is painters alone who make the reputation of painters!" '

99 ALS WS to Mrs Hulton (Oxford).

100 ALS WS to Mrs Hulton (Oxford).

101 ALS WS to Mrs Hulton (Oxford). Sickert also told Gide (through Blanche) that he could have the Venetian picture in the Salon for 300 francs. Georges-Paul Collet (ed.), *Nouvelles Lettres à André Gide*, op. cit., 66.

102 WS, 'The Allied Artists' Association', *New Age* (14 July 1910), in AGR, 260; ALS WS to Mrs Hulton (Oxford).

103 Georges Pissarro to Camille Pissarro, 24/3/1903, in Janine Bailly-Herzberg (ed.), *Correspondance de Camille Pissarro V (1899–1903)* (1991), 331.

104 WS to Philip Wilson Steer, in RE, 89; ALS WS to Mrs Hulton (Oxford). The phrase was borrowed from Whistler.

105 ALS WS to Mrs Hulton (Oxford).

106 ALS WS to Mrs Hulton (Oxford).

107 ALS WS to Mrs Hulton (Oxford).

108 ALS WS to Mrs Hulton (Oxford).

109 RE, 89.

110 ALS WS to Mrs Hulton (Oxford).

111 ALS WS to Mrs Hulton (Oxford). The classes were probably at the Academie Vitti in Montparnasse; certainly that was where Blanche was teaching.

112 ALS WS to Mrs Hulton (Oxford); ALS WS to Sir William Eden (Birmingham, AP22/23/5).

113 ALS WS to Sir William Eden (Birmingham, AP22/23/3). Sickert's last known visit to Venice ended back in the summer of 1901; this comment, however, throws up the possibility that he made a return trip during 1902. He had told Eden that he planned to go from May to October, but then failed to go. Perhaps he made a brief dash there in September.

114 ALS WS to Sir William Eden (Birmingham, AP22/23/3).

115 ALS WS to Sir William Eden (Birmingham, AP22/23/O).

116 ALS WS to Mrs Hulton (Oxford).

117 Ibid.

118 His other submission was *The Toast*, an old and almost expressionistic depiction of a scene from *Trelawney of the 'Wells'*.

119 WS to Philip Wilson Steer, in RE, 89.

120 Catalogue of *Esposizione Internazionale d'Arte della Città di Venezia*, 'Sala Internazionale' no. 40.

121 Information from Celia Philo, who had it from Marjorie, Mabel's daughter from her marriage to the Scottish painter E. S. Lumsden.

122 ALS Reggie Turner to Max Beerbohm, 'Sunday' [12/7/1903] (Harvard).

123 Constance Collier, *Harlequinade* (1929), 152–3; X. M. Boulestein, *Myself, My Two Countries* (1936), 78; William Nicholson, *Marguerite Steen* (1943), 89. Many years after the event, Sickert made a portrait of Marie Tempest, which he inscribed, 'à ma chère Dieppoise'.

124 Constance Collier, *Harlequinade*, op. cit., 153–4.

IV DAL VERO

1 JEB to André Gide, 26/9/1903, in Georges-Paul Collet (ed.), *Cahiers André Gide 8* (1979), 67.

2 Ellen acted as Miss Noel's guardian from 1900 to 1914. At Ellen's death – in 1914 – she was the principal beneficiary.

3 cALS WS to JEB (Sutton GUL).

4 JEB to André Gide, 26/9/1903, in Georges-Paul Collet (ed.), *Cahiers André Gide 8*, op. cit., 67.

5 cALS WS to JEB (Sutton GUL); JEB to André Gide, 26/9/1903, in Georges-Paul Collet (ed.), *Cahiers André Gide 8*, op. cit.

6 ALS WS to Mrs Hulton, 1/1/1904 (Oxford).

7 ALS WS to Mrs Hulton (Oxford).

8 Cf. the letterheads of the two letters from WS to Mme Bulteau (BN).

9 ALS WS to Mrs Hulton, 1/1/1904 (Oxford).

10 Ibid.

11 cALS WS to JEB [1903] (Sutton GUL).

12 Letters from WS to Mme Bulteau (BN).

13 cALS WS to JEB [1903] (Sutton GUL).

14 Ibid. Violet Paget (who wrote under the name 'Vernon Lee') – an intimate of Sickert's friends Mary and Mabel Robinson – was another regular guest. She had developed something of a crush on Mme Bulteau.

15 WS to JEB, in JEB, *La Pêche aux Souvenirs* (1941), 212.

16 Sickert, it seems, stayed long enough to do a picture of the city, which Sir William Eden subsequently acquired: DS, op. cit., 126.

17 Ibid., 118.

18 The Palazzo is now – and was originally – known as Palazzo Contarini S. Vito.

19 Reynaldo Hahn, *Notes – Journal d'un Musicien* (1947), 184.

20 *Jacques-Émile Blanche, Peintre* (1997), 216.

21 Michael de Cossart, *The Food of Love: Princesse Edmond de Polignac and her Salon* (1978), 80

22 ALS WS to Mrs Hulton (Oxford).

23 ALS WS to Mme Bulteau (BN).

24 Violet Overton Fuller, 'Letters to Florence Pash', 70 (Islington).

25 Sandra Moschini Marconi, *Galleria G. Franchetti alla Ca'd'Oro, Venezia* (1992), 3–6.

26 ALS WS to Mrs Hulton (Oxford).

27 Richard Sickert [WS], 'Italia! Italia!', *Fortnightly Review* (February 1930), in AGR, 599.

28 cALS WS to JEB (Sutton GUL).

29 ALS WS to Mrs Hulton (Oxford).

30 Delphine Desveaux, *Fortuny* (1998).

31 ALS WS to Mrs Hulton (Oxford). With the departure of the Hultons he seems to have stopped going to church.

32 WS to JEB, in JEB, *Portraits of a Lifetime* (1937), 46–7.

33 ALS WS to Mrs Hulton (Oxford).

34 ALS WS to JEB (Institut). Sickert described him to Blanche as the 'Spanish Meissonier of Venetian buildings and such a Grand Seigneur Sevillinaise, de sang mauresque. Yeux verts comme la mer, complexion rose et brune, mais les paysans d'Espagne ont une supériorité sur les nôtres, it must be a question of race etc.'

35 Ibid.; ALS WS to Mrs Hulton (Oxford).

36 Guillermo de Osma, *Fortuny* (1980), 35; ALS WS to JEB (Institut).

37 LB II, 26.

38 JEB, *La Pêche aux Souvenirs*, op. cit.; Jane Hamilton, MS diary, 3/9/1904 (KCL).

39 WS to JEB, in JEB, *La Pêche aux Souvenirs*, op. cit., 214.

40 Guillermo de Osma, *Fortuny*, op. cit., 35; JEB, *La Pêche aux Souvenirs*, op. cit., 213–14.

41 Jane Hamilton, MSs diary, 3/9/1904 (KCL). Harris Brown told her that 'one night as it came near six [Sickert] got very uneasy and said to [Brown], "You need not stay with me if you have anything else you wish to do." '

42 Ibid.

43 JEB, *La Pêche aux Souvenirs*, op. cit., 215.

44 Ibid., 214–16; Guillermo de Osma, *Fortuny*, op. cit., 35.

45 cALS WS to JEB (Sutton GUL).

46 ALS WS to Mrs Hulton (Oxford).

47 WS to JEB, in JEB, *Portraits of a Lifetime*, op. cit., 47; JEB, *La Pêche aux Souvenirs*, op. cit., 212.

48 cALS WS to JEB (Sutton GUL).

49 ALS WS to Mrs Hulton (Oxford).

50 cALS WS to JEB (Sutton GUL); WS to Mrs Hulton (Oxford).

51 ALS WS to Mrs Hulton [received 2/1/1929] (Oxford); *Le Baruffe Chiozzote* translates as 'Squabbles in Chioggia'.

52 WS, 'The International Society', *English Review* (May 1912), in AGR, 314.

53 ALS WS to Mrs Hulton (Oxford).

54 ALS WS to Mrs Hulton [received 2/1/1929] (Oxford).

55 The principal art critic of the *Gazzetta di Venezia* at the time was called A. F. dell Acqua.

56 'St P.' [WS], 'Lord Leighton's Studies', *The Speaker* (26 December 1896), in AGR, 121.

57 Ibid.

58 WS, 'The Naked and the Nude', *New Age* (21 July 1910), in AGR, 262–3.

59 Ibid., 262.

60 cALS WS to JEB (Sutton GUL).

61 ALS WS to Mrs Hulton (Oxford).

62 ALSs WS to JEB (Institut): 'I have learned many things,' he declared, after the disappointment of his first experiments. '*Not* to paint in varnish. *Not* to embarrass the canvas with any preparations. And so to give the paint every possible chance of drying *from the back of the canvas*. To paint with ½ raw oil and ½ turps. To state general tones once and *once only*. And when this first coat is dry, to *finish*, bit by bit.' Soon afterwards Sickert changed his ideas about 'embarrassing' the canvas and modified his approach to putting on the later layers of paint. 'This is my perfected method,' he announced, 'up to now' – suggesting that other yet more perfect methods might soon be evolved: 'Canvases size 8 prepared in grey (black and white) with oil. A good coat. The first session: everything is laid in from nature covering all the canvas and not permitting the model to move until it is all down. That takes about an hour more or less without moving. When the canvas is covered I start another. Three days or more later (canvases kept round a stove that is always lit) I take up the series again. With a large brush I wash the canvas with linseed oil, which I remove afterwards with blotting-paper, and then I finish off, being guided more by *my own work* from the first impression, than by the model, and keeping within the proportions first indicated, whether they *seem right to me or not*.'

63 JEB, *La Pêche aux Souvenirs*, op. cit., 211–12.

64 TLS Denys Sutton to Wendy Baron, 21/11/1974 (Sutton GUL).

65 ALS WS to Sir William Eden (Birmingham, AP22/23/3).

66 cALS WS to JEB (Sutton GUL).

67 Ibid.

68 Ibid.

69 Ibid.

70 ALS WS to Mrs Hulton (Oxford).

71 cALS WS to JEB (Sutton GUL).

72 ALS WS to JEB (Institut).

73 Ibid. Sickert mentions that Tavernier had taken two panels for 40 francs, and Robert wanted two that he could sell for 500 francs each. In another letter written from Venice he urges JEB to buy some 'panneaux' at 40 francs each, recommending 'la gare à Dieppe' and 'Le manoir de Neuville'.

74 cALS WS to JEB (Sutton GUL).

75 ALS WS to JEB (Institut).

76 cALS WS to JEB (Sutton GUL). 'Vous croirez être au Pollet ['You'd think you were in Le Pollet'],' he told Blanche.

77 Ibid. Sickert referred to his boat as a 'sandalo'.

78 Jean Hamilton, MS diary, 4/5/1904 (KCL).

79 Lady Layard, in her journal, considered Edie much the prettier of the two sisters (BL).

80 Jean Hamilton, MS diary, 4/5/1904 (KCL).

81 Ibid., 6/5/1904.

82 Celia Lee, *Jean, Lady Hamilton, 1861–1941: A Soldier's Wife* (2001), 192 ff.

83 Jean Hamilton, MS diary, 17/5/1904 (KCL).

84 Ibid., 14/5/1904.

85 Ibid., 6/5/1904; 17/5/1904.

86 Ibid., 6/5/1904.

87 Ibid., 16/5/1904; 17/5/1904.

88 Ibid., 17/5/1904; 18/5/1904.

89 Ibid., 18/5/1904.

90 Ibid., 30/5/1904; ALS WS to Lady Hamilton (KCL).

91 Jean Hamilton, MS diary, 30/5/1904 (KCL).

92 ALS WS to Lady Hamilton (KCL).

93 'R.M.', 'Petites Expositions', *Chronique des Arts et de la Curiosité* (18 June 1904), 196; ALS WS to Lady Hamilton (KCL); *Le Figaro* (7 June 1904), 4. M. Alexandre praised Sickert as one of the most exquisite and personal artists of the day, and urged collectors to buy his work while it was still so reasonably priced.

94 ALS Max Beerbohm to Eliza Draper Beerbohm, 24/8/1904 (Harvard).

95 cALS WS to Florence Humphrey [*née* Pash] (Islington).

96 Albert Rutherston, 'From Orpen and Gore to the Camden Town Story', *Burlington Magazine* (August 1943), 202. Rutherston says the model Emily Scoble was with them at Cany; Denys Sutton suggests Walter Russell was there too (DS, 126).

97 ALS WS to Ethel Sands, 'Tuesday' [1914] (Tate).

98 John Rothenstein, *Modern English Painters* (1957), 94; Frederick Gore, 'Spencer Gore: A Memoir by his Son', catalogue introduction to d'Offay exhibition (London, 1974). It is worth noting that Sickert referred to Gore as 'Freddy'.

99 Albert Rutherston, 'From Orpen and Gore the Camden Town Story', *Burlington Magazine*, op. cit., 202.

100 Sickert, it seems, did know something of Rothenstein and John, perhaps from their 1899 visit to Vattetot with William and Alice Rothenstein. Writing to Steer in 1903, Sickert congratulated himself on having escaped to France: 'I should have been art critic of the Licensed Victuallers' Gazette by now, and doing articles for them on Johns and Albert Rothensteins! If I had stayed in Robert St' (quoted in RE, 89).

101 cALS WS to Florence Humphrey [*née* Pash] (Islington).

102 Baron/Shone, 41.

103 cALS WS to Florence Humphrey [*née* Pash] (Islington).

104 cALS WS to Florence Humphrey [*née* Pash] (Islington): 'Can you tell me, have you taken care for me, of 3 canvases of Whistler's, a portrait of Mrs Cave on a beginning of mine, one of the pretty art-student wife of a curate, and a little head? . . . I don't remember if you have them or if they are stored by Wheatley with my other things.'

105 cALS WS to Florence Humphrey [*née* Pash] (Islington).

106 Violet Overton Fuller, TS 'Letters to Florence Pash', 4 (Islington).

107 Notes on Florence Pash letters (Islington).

108 Jean Hamilton, MS diary, 9/12/1904; 13/12/1904 (KCL).

109 cTels. WS to Charles Freer 12/12/1904; Charles Freer to WS 12/12/1904 (GUL).

110 cALS WS to Charles Freer (GUL).

111 Oliver Brown, *Exhibition* (1968), 6; notes to Florence Pash letter 22 (Islington).

112 Joseph Hone, *The Life of Henry Tonks* (1939), 81.

113 Quoted in Michael Holroyd, *Augustus John* (1996), 94.

114 WS, 'Fashionable Portraiture', *New Age* (5 May 1910), in AGR, 227; Adrian Daintrey, *I Must Say* (1963), 78; Michael Holroyd, *Augustus John* (1996 edn), 94.

115 Her address was 5 Raymond Buildings, Gray's Inn.

116 Jean Hamilton, MS diary, 9/12/1904 (KCL).

117 Ibid., 11/12/1904.

118 Ibid., 20/12/1904.

Chapter Six: Londra Benedetta

I THE LADY IN RED

1 Sickert also sent to the 1905 Glasgow exhibition, another forum once dominated by Whistler.

2 JEB, *Portraits of a Lifetime* (1937), 113–14; David Cecil, *Max* (1964), 263.

3 *The Times* (21 and 22 February 1905).

4 A. C. R. Carter (ed.), *The Year's Art 1906* (London, 1906), 5.

5 WS, 'The Works of Whistler', *New Age* (29 February 1912), in AGR, 298.

6 Max Beerbohm to Alice Rothenstein, in Mary M. Lago and Karl Beckson (ed.), *Max and Will* (1975), 52.

7 Ibid.; William Rothenstein, *Men and Memories*, vol. ii (1932), 7. The two Whistler panels were sold to the US dealer Mr Hesslein (AGR, 298, n. 1).

8 RE, 137; Jean Hamilton, MS diary, 3/3/1905 (KCL).

9 Osbert Sitwell, *Left Hand, Right Hand!* (1945), 215.

10 David Greer, *A Numerous and Fashionable Audience* (1997), 63.

11 Ibid., 44, 55–64.

12 Jean Hamilton, MS diary, 12/3/1905 (KCL).

13 Ibid., 17/3/1905.

14 Ibid., 12/3/1905.

15 Ibid., 1/3/1905.

16 ALS WS to Mrs Swinton [22/3/1905] (private collection).

17 ALS WS to Mrs Swinton [27/5/1905] (private collection).

18 Jean Hamilton, MS diary, 20/3/1905 (KCL).

19 Mary Percy, 'Reminiscences', quoted in Greer, *A Numerous and Fashionable Audience*, op. cit., 71.

20 ALS WS to Mrs Swinton [27/3/1905] (private collection).

21 DS, 130.

22 ALS WS to Mrs Swinton [27/5/1905] (private collection).

23 Albert Rutherston, 'From Orpen and Gore to the Camden Town Story', *Burlington Magazine* (August 1943), 202. Rutherston soon moved out. By 1906 he was listed at 18 Fitzroy Street. Gore's address in the NEAC catalogue for that year was also given as 18 Fitzroy Street.

24 ALS WS to Mrs Swinton [22/3/1905] (private collection).

25 RE, 137–8.

26 ALS WS to Mrs Swinton (private collection).

27 RE, ibid.

28 ML, 92. Robert, despite his ailments, was compiling a small anthology, *The Bird in Song*, which was published in 1906.

29 ML, 93–4; cALS Mrs Sickert to Mrs Muller, 22/2/1899 (Tate) mentions Leo's 'excellent reviews' for his Manchester concert.

30 Janet E. Courtney, *Recollected in Tranquillity* (London, 1926), 174–5. It was an enterprise that had to be carried on in the face of hostility from many publishers who resented what they considered to be the club's subversion of the Net Book Agreement. Some publishers refused to sell stock to the Club. Oswald's ingenuity and his contacts were important in devising ways to work around such obstacles.

31 WS, annotation in Étienne Moreau-Nélaton, *Millet Raconte par Lui-meme III*, 137 (Courtauld).

32 HMS, 352–3.

33 LB II, 15. Ellen was still at Gray's Inn, though she moved to Buckingham Gate some time after 1907.

34 Jean Hamilton, MS diary, 17/3/1905; 14/4/1905 (KCL).

35 WS to JEB, in *La Pêche aux Souvenirs* (1941), 216.

36 ALS WS to Mrs Swinton [27/3/1905] (private collection).

37 ALS WS to Mrs Swinton [22/3/1905] (private collection).

38 RE, 133.

39 Michael Holroyd, *Augustus John*, op. cit., 121.

40 John Rothenstein, *The Life and Death of Conder* (1938), 191.

41 Ibid., 192.

42 Ibid., 191; cALS WS to Florence Humphrey [*née* Pash] (Islington).

43 Violet Overton Fuller, TS 'Letters to

Florence Pash', 4–5 (Islington). He set down a version of 'The Boy I Love is Up in the Gallery' onto a rather large 'chicken-skin' fan.

44 ALS WS to Mrs Swinton, 19/4/1905 (private collection).

45 Ernest Thesiger, Practically True (1927), 12.

46 ALS WS to Mrs Swinton [27/5/1905] (private collection): 'I was taken to Rigoletto tonight by your dressmaker, bless her! Vous voyez que vos fournisseurs se fréquentent.'

47 Jean Hamilton, MS diary, 17/5/1905 (KCL).

48 ALS WS to Mrs Swinton, 27/5/1905 (private collection).

49 Jean Hamilton, MS diary, 7/3/1905 (KCL).

50 Ibid., 14/4/1905.

51 Ibid.

52 Sir Ian returned at Easter, 23 April 1905.

53 ALS WS to Mrs Swinton, 19/4/1905 (private collection).

54 Albert Rutherston, 'From Orpen and Gore to the Camden Town Story', Burlington Magazine (August 1943), 202.

55 Richard Sickert [WS], 'Easel and Campstool', Daily Telegraph (6 January 1926), in AGR, 533; WS, 'Degas', Burlington Magazine (November 1917), in AGR, 415.

56 ALS WS to Mrs Swinton (private collection).

57 Ibid.

58 Jean Hamilton, MS diary, 10/5/1905 (KCL).

59 Ibid., 7/4/1908; ALS Madeleine Clifton [Knox] to Wendy Baron, 17/9/1973 (private collection), suggests that Mrs Swinton's 'reign' did not come to an end until 1910.

60 Greer, A Numerous and Fashionable Audience, op. cit., 71.

61 Ibid., 45.

62 Ibid., 47–8.

63 ALS WS to Mrs Swinton, 18/10/1905 (private collection).

64 Jean Hamilton, MS diary, 30/7/1905 (KCL).

65 ALS Max Beerbohm to Eliza Draper Beerbohm, 24/8/1905 (Harvard).

66 Osbert Sitwell, Noble Essences (1950), 175.

67 He did not appear listed in the Camden Rate Book until April 1906. The earliest dated letter from 8 Fitzroy Street was to Mrs Swinton on 18/10/1905.

68 ALS WS to Ethel Sands [1915] (Tate).

69 ALS WS to Mrs Swinton [27/3/1905] (private collection).

70 WS to Philip Wilson Steer, RE, 89. Sickert's critical writings are littered with disparaging references to Matisse and his confrères: cf. AGR, 197, 210, 272, 274, 295, etc.

71 ALS WS to Mrs Swinton, 18/10/1905 (private collection).

72 ALS WS to Mrs Swinton (private collection). This happy scheme was not taken up. When, soon afterwards, Jacques Blanche's friend Celia Saxton Noble did ask for a portrait, Sickert obligingly made a painting of her rather than of Mrs Swinton.

73 Jean Hamilton, MS diary, 10/12/1905 (KCL).

74 RE, 138. Mrs Swinton claimed that she never bought a Sickert picture, and only ever received them as presents (information from her grandson, Gerald Percy).

75 Greer, A Numerous and Fashionable Audience, op. cit., 52, 65.

II AMBROSIAL NIGHTS

1 David Greer, A Numerous and Fashionable Audience (1997), 76, 80–1. It was an eclectic programme including a Bach cantata, a piano concerto, and a clutch of Early English madrigals. Elsie contributed songs by Rachmaninov, Gretchariott, and Brahms.

2 ALS WS to Mrs Swinton, 6/4/1906 (private collection).

3 Greer, A Numerous and Fashionable Audience, op. cit., 82, 84. She gave a full solo recital at the same venue the following month, as well as being drawn into the circuit of provincial festivals.

4 cALS WS to JEB (Sutton GUL); WS to Mrs Swinton, [22/3/1905] (private collection).

5 cALS WS to JEB (Sutton GUL).

6 Jean Hamilton, MS diary, 25/3/1906 (KCL).

7 Baron/Shone, 66.

8 ALS WS to Nan Hudson (Tate).

9 Stanley Smith, 'The Sickert Model', transcript of BBC broadcast, 18 July 1960 (BBC Archive, Reading); BBC tape of Jeanne Daurmont, 1961.

10 At Easter, when Sickert sent Mrs Swinton a series of fourteen postcards depicting his current subjects, almost half of them were of the Daurmont sisters.

11 Stanley Smith, 'The Sickert Model', op.cit.; Jeanne Daurmont, BBC tape.

12 cALS WS to Florence Humphrey [née Pash] [7/4/1906] (Islington).

13 cALS WS to JEB (Sutton GUL).

14 Wendy Baron, The Camden Town Group (1979), 112.

15 ALS WS to Mrs F. S. Gore [1914] (private collection); WS to Ethel Sands [1914] (Tate).

16 Wendy Baron, Perfect Moderns (1999), 178.

17 Letter from Gilman's wife to her mother, quoted in John Woodeson, TS 'Spencer F. Gore', 25 (Courtauld); M.A. Report (Courtauld, D497G).

18 Wendy Baron, Perfect Moderns, op. cit., 136.

19 cALS WS to JEB (Sutton GUL).

20 WS to Stella Maris Conder, in John Rothenstein, The Life and Death of Conder (1938), 193.

21 ALS WS to Hugh Hammersley [26/6/1906] (Fondation Custodia).

22 ALS WS to Hugh Hammersley (Fondation Custodia).

23 Sickert made a c.1903 drawing of himself – now at the Ashmolean Museum, Oxford – peering through his spectacles.

24 Jean Hamilton, MS diary, 25/5/1906, (KCL).

25 WS to Stella Maris Conder, in John Rothenstein, The Life and Death of Conder, op. cit., 193.

26 Frank Rutter, Art in My Time (1933), 122.

27 George Moore, Saturday Review (23 June 1906), 784.

28 The Times, Academy, etc., in NEAC cuttings book (Tate).

29 The Times (26 June 1906).

30 Bernhard Sickert, '"Modern Painters" in 1906', Burlington Magazine (January 1906), 221–4.

31 WS, 'The New English and After', New Age (2 June 1910), in AGR, 241–2.

32 Osbert Sitwell, Noble Essences (1950), 175.

33 John Rothenstein, The Life and Death of Conder, op. cit., 290; William Rothenstein Men and Memories, vol. i (1931), 179, 256; J. G. P. Delaney, Charles Ricketts (1990), 184.

34 DSM, Life, Work and Setting of Philip Wilson Steer (1945), 56. Mrs Evans described how she and her husband would visit Sickert's studio and look through his sketches and drawings, choosing one that he would then make a painting from. His usual fee was around £25. LB II, 20.

35 DSM, 104.

36 ALS WS to Mrs Hammersley (Fondation Custodia).

37 Quoted in DS, 139.

38 ALS WS to Mr Hammersley [26/6/1906] (Fondation Custodia); Juliette Lambert Ironing, the picture of Carolina, was described as having 'a Jacopo Bassano thrown in'.

39 ML, 78. Wendy Baron, in Miss Ethel Sands and her Circle (1977), gives Taylor's dates as 1875–1943.

40 Osbert Sitwell, Noble Essences, op. cit., 186.

41 ML, 78.

42 JEB to André Gide, 2/8/1906, in Georges-Paul Collet (ed.), Cahiers André Gide 8 (1979), 149–50.

43 Hubert Wellington, 'With Sickert at Dieppe', The Listener (23 December 1954), 1111.

44 Ibid., 1110–11,

45 Ibid., 1111.

46 WS, 'Whitechapel', New Age (28 May 1914), in AGR, 372.

47 Hubert Wellington, op. cit.; WS, Spencer Frederick Gore catalogue for Carfax & Co. (1916), in AGR, 402.

48 It opened on 5 October 1906.

49 JEB to André Gide, 4/8/1906, in Georges-Paul Collet (ed.), *Cahiers André Gide 8*, op. cit., 149.
50 *Sunday Times* (7 October 1906).
51 *New York Herald* (5 October 1906).
52 *Journal de Soir* (15 October 1906).
53 Wendy Baron, *Perfect Moderns*, op. cit., 24.
54 JEB to André Gide, 12/10/1906, in Georges-Paul Collet (ed.), *Cahiers André Gide 8*, op. cit., 153.
55 WB, 345.
56 ALS WS to Nan Hudson/Ethel Sands [1907/8] (Tate).
57 ALS WS to William Rothenstein (Harvard).
58 ALS WS to William Rothenstein (Harvard).
59 ALS WS to William Rothenstein (Harvard).
60 Ibid.
61 Quoted in DS, 36.
62 ALS WS to William Rothenstein (Harvard).
63 ALS WS to William Rothenstein (Harvard).
64 JEB to André Gide, 12/10/1906, in Georges-Paul Collet (ed.), *Cahiers André Gide 8*, op. cit., 153.
65 ALS WS to William Rothenstein (Harvard).
66 ALS WS to William Rothenstein (Harvard).
67 ALS WS to William Rothenstein (Harvard).
68 ALS WS to William Rothenstein (Harvard).
69 Joan Ungersma Halperin, *Félix Fénéon: Aesthete and Anarchist in Fin-de-Siècle Paris* (1988), 358–9; Hilary Spurling, *The Unknown Matisse* (1998), 328.
70 Raymond Bouyer, *Le Bulletin de l'Art* (December 1906), 20.
71 Robert de Tanlis, *Lemeur* (21 January 1907).
72 Jamot, *Chronique des Arts* (19 January 1907).
73 Ibid.
74 cALS WS to JEB (Sutton GUL).
75 ALS WS to Daniel Halévy [1/1907]; Félix Fénéon to 'chère Monsieur' [Daniel Halévy], 18/1/1907 (Fondation Custodia).

III MR SICKERT AT HOME

1 Hubert Wellington, 'With Sickert at Dieppe', *The Listener* (23 December 1954), 1110.
2 cALS WS to Nina Hamnett (private collection).
3 ALS WS to Nan Hudson [6/10/1913] (Tate).
4 WS, *Walter Bayes* catalogue, Leicester Galleries [1918], in AGR, 422.
5 WS, 'Goosocracy', *New Age* (12 May 1910), in AGR, 230–1.
6 WS, 'The New English and After', *New Age* (2 June 1910), in AGR, 241–2.
7 *Manchester Guardian* (29 November 1906).
8 WS, 'The New English and After', *New Age* (2 June 1910), in AGR, 241.
9 ALS WS to Nan Hudson [1907] (Tate). Sickert's plans are set out in a series of undated letters to 'Miss Hudson' written from 6 Mornington Crescent during the spring of 1907.
10 Ibid.
11 Ibid.
12 WS, 'Little Pictures for Little Patrons', *New Age* (4 August 1910), in AGR, 271.
13 ALS WS to Nan Hudson/Ethel Sands [1907] (Tate).
14 Sickert knew Gilman by sight, and, happening to see the young painter in an artists' supply shop, he followed him outside and hailed him. John Woodeson, TS 'Spencer F. Gore', op. cit., 15.
15 Wyndham Lewis and Louis F. Fergusson, *Harold Gilman* (London, 1919); B. Fairfax Hall, *Paintings and Drawings by Harold Gilman and Charles Ginner in the Collection of Edward le Bas* (London, 1965), 20.
16 Frank Rutter, *Some Contemporary Artists* (1922), 129.
17 Letter from Mrs Harold Gilman, quoted in Woodeson, TS 'Spencer F. Gore', op. cit., 18.
18 ALS WS to Nan Hudson (Tate). It was never likely that Sickert would have approached Conder to join the group, much as he admired his work. His

friend's art belonged to the vanishing world of the fin-de-siècle, not to the Salon d'Automne. Moreover, Conder had suffered a severe mental and physical collapse the previous summer (1906), the result of tertiary stage syphilis. And although he rallied briefly, he never recovered. He died in a mental home at Virginia Water on 9 February 1909. Anne Galbally, *Charles Conder* (2002), 274–80.

19 ALS WS to Nan Hudson (Tate).

20 Wendy Baron, *Miss Ethel Sands and her Circle* (1977).

21 ALS WS to Nan Hudson (Tate).

22 Wendy Baron, *Miss Ethel Sands and her Circle*, op. cit., 52.

23 ALS WS to Nan Hudson (Tate).

24 ALS WS to Nan Hudson (Tate).

25 ALS WS to Nan Hudson (Tate).

26 ALS WS to Nan Hudson (Tate). The hours of the 'At Homes' appear variously in Sickert's letters as 3.00 to 6.00 and 3.30 to 6.30.

27 Clive Bell, *Old Friends* (1956), 14.

28 ALS WS to Nan Hudson (Tate).

29 Hilary Pyle, *Jack Butler Yeats* (1970), 108–9; Bruce Arnold, *Jack Yeats* (1998), 163.

30 William Rothenstein, *Men and Memories*, vol. i (1931), 177; Philip Bagguley, *Harlequin in Whitehall: A Life of Hubert Wolfe* (London, 1997), 86; Albert Rutherston, 'From Orpen and Gore to the Camden Town Story', *Burlington Magazine* (August 1943), 205.

31 Wendy Baron, *Miss Ethel Sands and her Circle*, op. cit., 65.

32 Wendy Baron, *Perfect Moderns* (1999), 178.

33 Clive Bell, op. cit., 14; William Rothenstein, op. cit., 48; ALS WS to Nan Hudson (Tate).

34 ALS WS to Mrs Hammersley [12/1907] (Fondation Custodia).

35 Jean Hamilton, MS diary, 7/4/1908 (KCL).

36 ALS WS to Nan Hudson/Ethel Sands (Tate). The letter, like many dating from late 1907 onwards, is addressed to 'mes très chères'.

37 Ginner, quoted in B. Fairfax Hall, *Paintings and Drawings of Harold Gilman and Charles Ginner*, op. cit., 30; Frances Spalding, *Gwen Raverat* (2001), 149.

38 He makes no reference to his own involvement when describing the Fitzroy Street regime in *Men and Memories*, vol. ii (1932), 7.

39 ALS WS to Nan Hudson (Tate); Albert Rutherston, 'From Orpen and Gore to the Camden Town Story', op. cit., 205.

40 W. S. Meadmore, *Lucien Pissarro* (1962), 110–11. Dinner cost 3s.

41 WS, 'Idealism', *Art News* (12 May 1910), in AGR, 229.

42 ALS WS to Nan Hudson (Tate).

43 ALS WS to Nan Hudson (Tate).

44 Wendy Baron, *Miss Ethel Sands and her Circle*, op. cit., 68.

45 Ibid., 166; ALS WS to Nan Hudson (Tate).

46 ALS WS to Lady Ottoline Morrell (Texas).

47 Wendy Baron, *Miss Ethel Sands and her Circle*, op. cit., 54.

48 ALS WS to Nan Hudson (Tate).

49 ALS WS to Nan Hudson (Tate).

50 cALS WS to [Bernheim's, 1907] (Sutton GUL), quoted in translation in DS, 141.

51 ALS WS to Nan Hudson (Tate).

52 ALS WS to Nan Hudson (Tate).

53 ALS WS to Nan Hudson (Tate).

54 ALS WS to Nan Hudson (Tate).

55 Ibid.

56 ALS WS to Nan Hudson (Tate).

57 *The Academy* (1 June 1907).

58 ALS WS to Nan Hudson (Tate); WS to Mr Hammersley [28/5/1907] (Fondation Custodia).

59 ALS WS to Nan Hudson (Tate).

60 ALS WS to Mr Hammersley, 14/8/1907 (Fondation Custodia).

61 ALS WS to Mrs Hammersley (Fondation Custodia).

62 Osbert Sitwell, *Noble Essences* (1950), 163–4. Edith wrote to her brother soon after receiving the present: 'I want you to see the drawing Mr Sickert has given me. Aunt Floss is such a fool about it. She doesn't think it "pretty". And she doesn't think it quite "Right" to draw four women watching a music-hall.

Church of England saints are the only really suitable subjects for art.'

63 ALS WS to Nan Hudson (Tate).
64 W. S. Meadmore, *Lucien Pissarro*, op. cit.; John Rothenstein, *Modern English Painters* (1957 edn), 102.
65 ALS WS to Nan Hudson (Tate).
66 ALS WS to Nan Hudson (Tate).
67 ALS WS to Nan Hudson (Tate).
68 ALS WS to Nan Hudson (Tate).
69 ALS WS to William Rothenstein (Harvard). The other guests included 'der Frau Mamma Mrs Baldwin' and a Miss Deacon, 'a world famous beauty', possibly Gladys Deacon, the future Duchess of Marlborough.
70 cALS Mrs Sickert to Mrs Muller, 3/8/ 1907 (Tate).
71 ALS WS to Nan Hudson (Tate).
72 Ibid.
73 Sickert excused himself from writing a letter of introduction to Blanche for the Hammersleys on the grounds that his 'sins of omission' had been 'so flagrant towards Blanche' that anyone he introduced to him would be liable to receive a 'disagreeable snub': ALS WS to Mrs Hammersley [1910] (Fondation Custodia). The excuse seems slightly disingenuous as Blanche would never have snubbed a potential customer like Mrs Hammersley.
74 ALS WS to Mrs Hammersley (Fondation Custodia).
75 WS, 'New Wine', *New Age* (21 April 1910), in AGR, 219.
76 ALS WS to Nan Hudson (Tate).
77 ALS WS to Nan Hudson (Tate).
78 ALS WS to Nan Hudson (Tate). Sickert thanks Nan for the Salon d'Automne papers and remarks that he has sent 'my portrait & the heavy woman sitting on the edge of the bed'.
79 ALS WS to Nan Hudson (Tate).
80 *Sickert* catalogue, Agnew's (1960), 43, picture no. 60, *La Rue Cousine, Dieppe*. Sickert told Judge Evans that it was 'the last picture that he ever painted direct from the subject in the open air'.
81 ALS WS to Mrs Hammersley, 1/10/ 1907 (Fondation Custodia).

82 Ibid.
83 ALS WS to Daniel Halévy (Fondation Custodia).
84 Sickert recalled hearing Degas discussing the origins of the Impressionist group with his friend Guillaumin that year. WS, *Camille Pissarro* catalogue, Stafford Gallery (1911), in AGR, 286.
85 ALS WS to Mr Hammersley (Fondation Custodia).
86 Ibid.
87 Ibid. WS remarks (apparently of some effort in this direction): 'A thousand thanks for your kindness. I know from my own experience that I cannot talk half an hour with a young painter without saving him years of *fausse route*, as others – Whistler, Degas, Scholderer & my father have done for me.'
88 WS exhibited: *Avant-scene* (15), *La rue N. D. des Champs* (19), *The Middlesex* (29), *La Gaîté Rochechouart* (33), *Study for Noctes Ambrosianae* (39), *Londra Benedetta* (48). He also showed at Bernheims' 'des portraits d'homme' that December and asked Nan Hudson and Ethel Sands to visit the gallery and find out the prices, having heard that a Miss Montgomery Jeans had bought some of his pictures there.
89 ALS WS to Mrs Hammersley [12/ 1907] (Fondation Custodia).
90 Basil Hogarth (ed.), *Trial of Robert Wood: The Camden Town Case* (1936); David Napley, *The Camden Town Murder* (1987); Lisa Tickner, *Modern Life and Modern Subjects* (2000), 21– 30.
91 Osbert Sitwell, *Noble Essences*, op. cit., 190–1. Sacheverell Sitwell confirmed to Daniel Farson that Sickert's unnamed lodgings were at Mornington Crescent: Daniel Farson, *Jack the Ripper* (1972), 82. Edward Marsh recorded that Sickert had given Mrs Belloc Lowndes the idea for *The Lodger*: Christopher Hassall, *Edward Marsh* (1959), 548. The picture is first recorded in a letter from Sickert to Keith Baynes [1925], though Sickert dated it to 'about

1906' (Sutton GUL). It was subsequently given to Cicely Hey and is now in the Manchester City Art Gallery.

92 Rebecca Daniels, 'Walter Sickert and Urban Realism', *British Art Journal*, iii, 2 (2002), 60–9.

93 Lisa Tickner, *Modern Life and Modern Subjects*, op. cit.

94 ALS WS to Nan Hudson (Tate).

95 Ibid.

96 *Pall Mall Gazette* (3 June 1908).

97 ALS WS to Mrs Hammersley, 12/ 1907 (Fondation Custodia). Augustus John, *Chiaroscuro* (London, 1952), 136, recalled that he often saw Sickert together with Gore and Gilman in 'a certain pub in the Hampstead Road'.

98 ALS WS to Mrs Hammersley [12/ 1907] (Fondation Custodia).

99 Wendy Baron, *The Camden Town Group* op. cit., 114.

100 Wendy Baron, *Perfect Moderns*, op. cit., 137.

101 Walter Bayes, 'The Camden Town Group', *Saturday Review* (25 January 1930).

102 WS, 'Whitechapel', *New Age* (28 May 1914), in AGR, 371.

103 WS, 'A Perfect Modern', *New Age* (9 April 1914), in AGR, 354; Wendy Baron, *Perfect Moderns*, op. cit., 33.

104 The undated invitation card is preserved with the Hammersley archive at the Fondation Custodia. It appears to belong with Sickert's letter to Mrs Hammersley of 12/ 1907 which begins, 'I only send you my trade circulars to keep you au courant with the fermentation of the new school'.

105 WS, 'Whitechapel', *New Age* (28 May 1914), in AGR, 372; WS, 'The Thickest Painters in London', *New Age* (18 June 1914).

106 WS, 'The Spirit of the Hive', *New Age* (26 May 1910), in AGR, 236.

107 Wendy Baron, *Perfect Moderns*, 34. Sickert sold an Augustus John picture to Frances Darwin from Fitzroy Street in March 1908 (Frances Spalding, *Gwen Raverat*,

op. cit., 149). William Rothenstein, *Men and Memories*, vol. ii (1932), 7, mentions Sickert's great interest in Innes.

108 ALS WS to Hudson/Sands (Tate).

109 Ibid. There is no evidence that he showed at White City, though Bernhard did.

110 Robert O'Byrne, *Hugh Lane, 1875– 1915* (2000), 83.

111 The other members included Steer, Tonks, Rothenstein, John, Orpen, C. J. Holmes, and Fred Brown.

112 Gore exhibited in every year – if not in every show – from 1906.

113 A. S. Hartrick, *A Painter's Pilgrimage* (1939), 151. Sickert's published views on Rousseau were not in fact particularly favourable. Writing in the *New Age* in June 1914 he remarked, 'the sense of advertisement has created the intentional, we may almost say the professional, *refusé*, the type of the *douanier Rousseau* in Paris. The fun, the joke, the point of the existence of the *douanier Rousseau* was just that he was a painting coastguardsman, like our annual policeman who is hung in the Academy. It was fun for once to see palm-trees and orange-groves painted by a coastguardsman, and to wonder that they weren't really worse than they were. But the *cocasserie* of French criticism was not to be beaten, and, if I am not mistaken, serious critical articles have recently appeared on the *douanier Rousseau*.' AGR, 382.

114 WS, 'The Allied Artists' Association', *Art News* (24 March 1910), in AGR, 207.

115 WS, 'The Allied Artists' Association' *New Age* (14 July 1910), in AGR, 260.

116 WS, 'The Allied Artists' Association', *Art News* (24 March 1910), in AGR, 208.

117 The figure does not include a large separate display dedicated to contemporary Russian arts and crafts.

118 WS, 'The Allied Artists' Association', op. cit., in AGR, 207.

119 Wendy Baron, *Perfect Moderns*, op. cit., 35. Rutter, who was attempting to coordinate matters, travelled miles each day round and round the vast circumference of the hall as he inspected the various sections. (The following year he used a bicycle.)

120 R. A. Bevan, *Robert Bevan* (1965), 16.

121 Frank Rutter, *Since I was Twenty-Five* (London, 1927), 189; Walter Bayes, 'The Camden Town Group', *Saturday Review* (25 January 1930).

122 RE, 134; Wendy Baron, *Perfect Moderns*, op. cit., 35.

123 RE, 137; ALS WS to Lady Ottoline Morrell (Texas); C. J. Holmes, *Self and Partners* (1936), 288.

124 HMS, 353.

125 TLS Alan Swinton to Denys Sutton, 3/11/1966 (Sutton GUL).

126 Charles Moresco Pearce, TS extract from memoirs (Sutton GUL).

127 ALS WS to Ethel Sands 'Sunday' 27/7/[1913] (Tate).

128 Moresco Pearce, TS Extract from memoirs (Sutton GUL), op. cit.

129 Ibid.

130 Ibid.

IV THE ARTIST AS TEACHER

1 ALS WS to Ethel Sands [1915] (Tate).

2 *London County Council Westminster Technical Institute, Prospectus & Timetable of Evening Classes for the Session Beginning 21st September, 1908.* Sickert's salary is estimated from the fact that when he took on an extra class, later in the term, his salary went up to £4 a week. ALS WS to Mrs Hammersley (Fondation Custodia).

3 ALS Nancy Price to Denys Sutton (Sutton GUL).

4 ALS Dorothy Nightingale [*née* Denison] to John Russell, 28/9/1958 (Sutton GUL).

5 Murray Urquhart, quoted in DS, 146.

6 ALS Nancy Price to Denys Sutton (Sutton GUL).

7 Margaret Crewe-Clements [*née* Cannon-Smith], TS 'Sickert', 1 (Sutton GUL).

8 ALS Kenneth Anns to John Russell, 24/9/1958 (Sutton GUL).

9 DS, 145.

10 Quoted in DS, 146; Lewis Waller (1860–1915) was one of the great romantic actors of the day, and the first of the so-called matinée idols.

11 ALS Dorothy Nightingale [*née* Denison] to John Russell, 28/9/1958 (Sutton GUL).

12 WS to the Editor of *The Times* (22 October 1908), in AGR, 177. From reviews – in his cuttings book at Islington – it seems that Sickert showed both etchings and paintings.

13 Lane's collection was initially hung at 17 Harcourt Street, Dublin. Sickert's picture appeared in Room 2 as part of the 'British Schools'.

14 WS, 'The New Life of Whistler', *Fortnightly Review* (December 1908), in AGR, 178–87.

15 ALS L. A. Harrison to Philip Wilson Steer, 12/1/1909 (GUL).

16 ACS WS to Mrs Hammersley (Fondation Custodia).

17 WS, 'Abjuro', *Art News* (3 February 1910), in AGR, 192–4; 'Where Paul And I Differ', *Art News* (10 February 1910), in AGR, 194–6.

18 ACS WS to Mrs Hammersley (Fondation Custodia).

19 ACS WS to Lady Ottoline Morrell (Texas).

20 ALS WS to Mrs Hammersley (Fondation Custodia).

21 Ibid.

22 ALS Mrs W. E. Watson [Emily Powell, aka 'Chicken'] to Mrs [Alfred] Powell [*née* Lessore] (Sutton GUL]. Though Sickert's best known pictures of 'Chicken' were done in the next decade, in this letter she describes how she got to know him as a girl of about eleven 'when he first came to Hampstead Road and had his rooms there'. WB, 305, lists a painting, *Chicken, Woman at a Mantelpiece*, done in *c.*1907–8.

23 Jean Hamilton, MS diary, 11/2/1908 (KCL); Augustus John, *Finishing*

Touches (London, 1964), 93. Sickert exhibited his portrait of *Mimi Aguglia Ferrau* at the NEAC summer show in 1909.

24 ALS WS to Mrs Hammersley (Fondation Custodia).

25 ALS WS to Mr Hammersley (Fondation Custodia).

26 When Osea Island was sold recently the owner recalled that his first farm manager had told him of Sickert's stay on the island. He was, apparently, 'always daubing' and left many of his canvases behind. The owner mistakenly supposed that the Sickert referred to was Walter, rather than Bernhard, and that was how the *Evening Standard* reported the story (21 November 2000).

27 ALS WS to Mrs Hammersley (Fondation Custodia).

28 ALS WS to Nan Hudson (Tate).

29 ALS WS to Nan Hudson (Tate). Hughton's address was Mill End Studios, Little Easton.

30 ALS WS to Nan Hudson (Tate).

31 Ibid.

32 Ibid. He completed only two etchings in the series.

33 *Morning Post* (23 April 1909).

34 *Signac 1863–1935* catalogue, Metropolitan Museum of Art, New York (2001), 311.

35 The exhibitions were held in March and May 1909 respectively.

36 ALS WS to Nan Hudson (Tate).

37 *Les Nouvelles* (22 June 1909).

38 *Gazette de l'Hôtel Drouot* (22 June 1909); *Les Nouvelles* (22 June 1909).

39 ALS WS to Nan Hudson (Tate).

40 WS to the Editor of the *Morning Post* (11 May 1909), in AGR, 188–9.

41 Photocopy of WS's [?] annotated copy of the sale catalogue (Courtauld).

42 Marina Ferretti-Bocquillon, 'Signac as a Collector', in *Signac 1863–1935* (2001), 64.

43 Ibid. The drawing is inscribed 'a Signac': WB, 349.

44 François Monod, writing in *Art et Décoration*, ended his review: 'M. Sickert s'est égaré, qu'il se reprenne?'

45 ALS WS to Mrs Swinton (private collection).

46 ALS WS to Nan Hudson (Tate).

47 Frederick Wedmore, *Some of the Moderns* (1909), reviewed *Pall Mall Gazette* (20 December 1909), 5.

48 Bruce Arnold, *Orpen: Mirror to an Age* (London, 1981), 228. Orpen's first proposed cast list had been Lane, Moore, Sargent, Steer, MacColl, and Tonks.

49 Frances Spalding, *Roger Fry: Art and Life* (1980), 127; ALS WS to Clive Bell (Tate).

50 Sale of the Library of John Lane catalogue, item 1265, mentions '3 ALS and 1 card' from WS to John Lane, the card being 'To introduce Wyndham Lewis – a man of, we all think, remarkable and original talent.'

51 John Rothenstein, *Modern English Painters*, op. cit., 203–11.

52 McEvoy's pocket diaries for 1908 and 1909 record regular Saturday visits to 'Sickerts' (Tate).

53 RB, 142. Bromberg dates their collaborative print to 1906, but it could well be later. RE, 138, dates McEvoy's pupilage to 1909.

54 McEvoy diary, 30/7/1909 (Tate).

55 ALS WS to Nan Hudson (Tate).

56 ALS WS to Mrs Swinton (private collection).

57 Ibid.

58 Ibid.

59 ALS Ambrose McEvoy to Mrs McEvoy (Tate).

60 DS, 153; Ambrose McEvoy diary, 16/9/1909: 'Came home'; 20/9/1909: 'Sickert arrives – brought Maurice' (Tate).

61 ALS WS to Mrs Swinton (private collection).

62 ALS WS to Mrs Hammersley (Fondation Custodia).

63 ALS WS to Nan Hudson (Tate).

64 ALS WS to Mrs Swinton (private collection).

65 WS to C. J. Holmes, in C. J. Holmes. *Self and Partners* (1936), 263.

66 RE, 138.

67 Kathleen Fisher, *Conversations with Sylvia* (London, 1975), 33. From 'The Book of Gosse' – the record of Edmund Gosse's dinner-party guests – it appears that Sickert dined for the

first time *chez* Gosse on Christmas Day 1909 (W. B. Yeats was another guest). After that he became something of a regular (Leeds).

68 ALS WS to Jean Hamilton (KCL).

69 Enid Bagnold, *Autobiography* (London, 1969), 72.

70 Sickert installed – or kept on – an eccentric caretaker called Hayward (RE, 138); the Camden Rate Book lists the caretaker as 'George Haywood'.

71 RE, ibid.

72 ALS Madeleine Clifton [*née* Knox] to Wendy Baron [1973] (private collection).

73 RE, op. cit.

74 Enid Bagnold, *Autobiography*, 72–3.

75 Kathleen Fisher, *Conversations with Sylvia*, op. cit., 33–4.

76 LB II, 44.

77 Enid Bagnold, *Autobiography*, op. cit., 73–5.

78 Quoted in Joseph Hone, *The Life of George* Moore (1936), 321; George Moore, *Conversations in Ebury Street* (1924), 136.

79 Enid Bagnold, *Autobiography*, op. cit. p 75. Bagnold exhibited at the NEAC in the winter of 1915 and the summer of 1916.

80 RE, 139.

81 Ibid., 138; ALS WS to Nan Hudson (Tate).

82 ALS WS to Nan Hudson/Ethel Sands (Tate).

83 RE, 139.

84 ALS WS to 'my dear friend' [Nan Hudson] (Tate).

85 Enid Bagnold, *Autobiography*, op. cit., 73.

86 JEB, *La Pêche aux Souvenirs* (1941), 413–14. Blanche misdates the incident to 1906.

87 RE, 139; ALS WS to Ethel Sands (Tate) – complaining later that 'It was Rowlandson House 10 am that messed me up.'

88 RE, 139; ALS Nicola Speed [*née* Blake] to John Russell, 10/10/1958 (Sutton GUL).

89 WS to DSM, in RE, 134.

90 ALS WS to 'friend' [Nan Hudson] (Tate).

91 ALS Madeleine Clifton [*née* Knox] to Wendy Baron, 18/9/[1971] (private collection).

92 ALS Madeleine Clifton [*née* Knox] to Wendy Baron 17/9/[1973] (private collection).

93 WS, 'The Allied Artists' Association', *New Age* (14 July 1910), in AGR, 260.

94 Quentin Bell, 'Some Memories of Sickert', *Burlington Magazine* (April 1987), 231.

95 Osbert Sitwell, *Noble Essences*, op. cit., 176.

96 Quentin Bell, 'Some Memories of Sickert', *Burlington Magazine*, op. cit., 231.

97 ALS WS to Nan Hudson (Tate). An *apache* is the French term for a hooligan.

98 The last article appeared on 4 August 1910, in AGR, 267–70.

99 ALS WS to Nan Hudson (Tate).

100 ALS WS to Nan Hudson/Ethel Sands (Tate). See RE, 65, for JEB's description of Sickert's visits.

101 ALS WS to Mrs Swinton [1910] (private collection).

102 Ibid.

103 ALS WS to 'my dear friend' [Nan Hudson] (Tate).

104 Ibid.

105 ALS WS to 'dear friend' [Nan Hudson] (Tate).

106 Ibid.

107 ALS WS to 'dear friend' [Nan Hudson] (Tate).

108 Sickert told Nan that, according to her accounts, Miss Knox had 'sunk' £63 into the school, and perhaps he repaid most of this. But Miss Knox's letters to Wendy Baron make clear that the sum he repaid only represented some of her expenses.

109 Kathleen Fisher, *Conversations with Sylvia*, op. cit., 33.

110 Ibid., 33–4; ALS WS to 'dear friend' [Nan Hudson] (Tate).

111 ALS WS to 'dear friend' [Nan Hudson] (Tate).

112 ALS WS to Nan Hudson (Tate).

113 ALS WS to 'dear friend' [Nan Hudson] (Tate).

114 ALS WS to 'my dear friends' [Nan Hudson/Ethel Sands] (Tate).

115 ALS Madeleine Clifton [*née* Knox] to Wendy Baron, 5/5/[1971] (private collection).

116 Enid Bagnold, *Autobiography*, op. cit., 75, and diary entry for 4/4/1914, in R. P. Lister (ed.), *Edith Bagnold: Letters to Frank Harris and Other Friends* (London, 1980), 4: 'One day as I was sitting folding my Red Cross dress to put away in a chest of drawers whose handles he loves to draw Sickert leant over my shoulder & I turned my face & he kissed me. I was very thrilled.'

117 Orovida Pissarro to Wendy Baron in conversation.

118 Kathleen Fisher, *Conversations with Sylvia*, op. cit., 38; ALS Madeleine Clifton [*née* Knox] to Denys Sutton, 21/6/[1968] (Sutton GUL) suggests that Gosse was not 'one of W.S.'s many mistresses'.

119 LB II, 31; Wendy Baron, *Miss Ethel Sands and her Circle*, op. cit., 81. Madeleine Clifton, in a letter to Wendy Baron (5/9/[1971]), confirmed that she was the girl Sickert proposed to.

Chapter Seven: Contre Jour

I LES AFFAIRES DE CAMDEN TOWN

1 William Rothenstein to Roger Fry, 19/3/1911, in Mary M. Lago and Karl Beckson (ed.) *Max and Will* (1975), 67.

2 Anna Gruetzner Robins, *Modern Art in Britain* (1997), 15–45. The assertion that 'On or about December 1910 human character changed' was made by Virginia Woolf in a lecture to the Heretics Club at Cambridge in 1924.

3 Frances Spalding, *Roger Fry: Art and Life* (1980), 118 ff.

4 Ibid.

5 *The Sketch* (Supplement, 16 November 1910).

6 Desmond MacCarthy, 'The Art-Quake of 1910', *The Listener* (1 February 1943); Wilfrid Scawen Blunt, *My Diaries* (1919), 343–4; *Daily Express* (9 November 1910); Frances Spalding, *Duncan Grant* (1997), 100.

7 William Blake Richmond to the *Morning Post* (16 November 1910); Oliver Brown, *Exhibition* (1968), 39.

8 Quoted in William Rothenstein, *Men and Memories*, vol. ii (1932), 213.

9 DSM, *Life, Work and Setting of Philip Wilson Steer* (1945), 142.

10 Frances Spalding, *Vanessa Bell* (1983), 92.

11 WS, 'Post-Impressionists' *Fortnightly Review* (November 1911), in AGR, 272.

12 Ibid., in AGR, 272–80.

13 Wyndham Lewis and Louis F. Fergusson, *Harold Gilman* (1919), 30; Frank Rutter, *Since I was Twenty-five* (1927), 192, says that at the regular discussions on whether to secede from the NEAC that had been going on since 1908, Sickert argued on a different side each week.

14 Charles Ginner, 'The Camden Town Group', *The Studio* (November 1945).

15 Walter Bayes, 'The Camden Town Group', *Saturday Review* (25 January 1930).

16 Charles Ginner, 'The Camden Town Group', *The Studio*, op. cit.

17 ALS WS to Nan Hudson/Ethel Sands (Tate).

18 Gore introduced his pupil, Doman Turner, and Gilman his disciple William Ratcliffe. J. D. Innes and Henry Lamb were probably brought it at Augustus John's request.

19 Wendy Baron, *Perfect Moderns* (1999), 45.

20 W. B. Richmond to Robbie Ross, in Margery Ross (ed.), *Robert Ross: Friend of Friends* (1952), 215, 196–7. Margery Ross suggests that the letter on p. 215 refers to Sickert's retrospective exhibition at the Stafford Gallery, St James's, in July 1911, but the earlier Carfax show seems more likely.

21 Vanessa Bell to Roger Fry, 2/7/1911, in Regina Marler (ed.), *Selected Letters of Vanessa Bell* (London, 1993), 112.

22 LB II, 32; ML, 109.

23 LB II, ibid.; ML, ibid.; Kathleen Fisher, *Conversations with Sylvia* (1975), 38.

24 ML, 111.
25 Ibid.
26 Kathleen Fisher, *Conversations with Sylvia*, op. cit.
27 George Moore, *Conversations in Ebury Street* (1924), 140.
28 ALS WS to Nan Hudson/Ethel Sands (Tate).
29 LB II, 32.
30 ALS WS to Nan Hudson/Ethel Sands (Tate).
31 Telegram WS to Nan Hudson/Ethel Sands, 3/7/1911 (Tate); telegram WS to Florence Humphrey [*née* Pash], 3/7/1911 (Islington). The July dates on these two telegrams are mysterious, as it seems clear that the incident took place in June. Sickert was planning to bring his new bride down to Newington for Whitsun (which fell that year on 4 June), and in his letter to Nan Hudson and Ethel Sands describing his 'misadventure' he mentions the forthcoming coronation, which took place on 22 June. In view of these facts it seems probable that the debacle occurred on 2 June and that the telegrams were sent the following day. Perhaps the date-stamp at the Euston Post Office had been inadvertently set to the wrong month. Sadly, the registration books at Camden Registry Office, which would list Sickert's forthcoming marriage, have not been preserved.
32 Violet Overton Fuller, TS 'Letters to Florence Pash'.
33 George Moore, *Conversations in Ebury Street*, op. cit., 140–4.
34 Ibid.
35 ALS WS to Nan Hudson/Ethel Sands (Tate). In a letter to Ottoline Morrell Sickert did describe his bride-to-be as 'bolt[ing] under the shadow of my father-in-law's statue at the sound of the bagpipes' (Texas).
36 ALS WS to Nan Hudson/Ethel Sands (Tate).
37 George Moore, *Conversations in Ebury Street*, op. cit., 144.
38 Telegram WS to Nan Hudson/Ethel Sands, 5/7/1911 (Tate).

39 Kathleen Fisher, *Conversations with Sylvia*, op. cit., 38.
40 Vanessa Bell to Roger Fry [2/7/1911], in Regina Marler (ed.), *Selected Letters of Vanessa Bell*, op. cit., 112.
41 LB II, 32; RE, 139–40. RE says that Christine yielded to Sickert's entreaties on the train.
42 LB II, ibid.; RE, ibid. Kathleen Fisher, *Conversations with Sylvia*, op. cit., 38, estimates Christine's income. Browse gives it as between £150 and £200.
43 DS, 165.
44 ML, 108.
45 *The Times* (11 July 1911), 11.
46 Quoted in RE, 142.
47 *The Times* (22 July 1911), 7.
48 DS, 164.
49 RE, 140; WS to Robbie Ross, in Margery Ross (ed.), *Robert Ross*, op. cit., 219: 'Neither Christine nor I have forgotten that it was practically you who made our marriage.'
50 cALS WS to Mr Humphrey (Islington).
51 Telegram WS to Nan Hudson/Ethel Sands, 26/7/1911 (Tate).
52 RE, 140; marriage certificate.
53 cALS WS to Mrs Angus, 7/12/1920 (Sutton GUL).
54 Ibid.; ML, 80.
55 Press cutting dated 7/1912 (Cobden papers/Chichester).
56 ALS Jane Cobden-Unwin to Ellen Cobden, 12/3/1913 (Chichester).
57 ALS WS to Nan Hudson [6/1913] (Tate); LB II, 14, suggests that Sickert ceased to see Ellen after his marriage, but this was not the case.
58 Wyndham Lewis to T. Sturge Moore, in Paul O'Keefe, *Some Sort of Genius: A Life of Wyndham Lewis* (London, 2000), 108.
59 cALS Mrs Sickert to Mrs Muller, 26/7/1916 (Tate); ML, 109.
60 DS, 160.
61 ML, 110–11.
62 LB II, 32.
63 ML, 150.
64 Ibid., 108.
65 Ibid., 109, 111.
66 cALS Christine Sickert [*née* Angus] to Ronald Gray (Sutton GUL).

67 The meeting took place on 2 December 1911. Wendy Baron, *Perfect Moderns*, op. cit., 48–9.
68 RB, 24, 301, 303.
69 WS, 'The Old Ladies of Etching-Needle Street', *English Review* (January 1912), in AGR, 288–96.
70 WS, 'Mesopotamia-Cézanne', *New Age* (5 March 1914), in AGR, 338.
71 DS, 155.
72 cALS WS to JEB [1910] (Sutton GUL).
73 The WTI prospectus for the 1912–13 session leaves the post of drawing-and-painting teacher blank.
74 RE, 141.
75 Simona Pakenham, TS 'Walter Sickert & My Grandmother', 9 (Sutton GUL).
76 RE, 141. The house no longer stands.
77 Sickert mentioned the idea to Gore, who was shocked at the thought that he might lose his friend and mentor. Indeed, as Sickert later learnt, he was so 'broken hearted' he 'couldn't work for 3 days': ALS WS to Ethel Sands, 'Tuesday' [4/1914] (Tate).
78 Wendy Baron, *Miss Ethel Sands and her Circle* (1977), 98.
79 RE, 139.
80 ML, 47.
81 RE, 173.
82 Richard Sickert [WS], 'Fairy Food', *Daily Telegraph* (4 November 1925), in AGR, 528.
83 WS, 'A Critical Calendar', *English Review* (March 1912), in AGR, 300.
84 Wendy Baron, *Miss Ethel Sands and her Circle*, op. cit., 98–9.
85 Ibid., 114, n. 15.
86 Ibid., 104.
87 WS to the Editor of the *Pall Mall Gazette* (23 July 1912), in AGR, 330.
88 George Moore, 'Une Rencontre au Salon', *Fortnightly Review* (November 1912).
89 'The Book of Gosse', 24/11/1912 (Leeds). Mr and Mrs Sydney Low were amongst the five other guests at the dinner; Wendy Baron, *Miss Ethel Sands and her Circle*, op. cit., 103.
90 *Outlook* (14 December 1912), quoted in Wendy Baron, *Perfect Moderns*, op. cit., 52.
91 Wendy Baron, *Perfect Moderns*, op. cit., 55.
92 Ibid., 58.
93 The British element of the show was limited by the fact that most of it came from the collection of the wealthy American art lover John Quinn and reflected his rather romanticized taste. Sickert's two contributions were a view of *S. Remy, Dieppe* and *Noctes Ambrosianae* (lent by Walter Taylor). Milton W. Brown, *The Story of the Armory Show* (1988), 51 ff.
94 Wendy Baron, *Miss Ethel Sands and her Circle*, op. cit., 104.
95 ALS WS to Michael Sadler; cTel Michael Sadler to WS, 11/10/1913, and further letters arranging the matter (Tate).
96 ALS WS to Ethel Sands (Tate).
97 ALS WS to Ethel Sands (Tate).
98 ALS WS to Ethel Sands (Tate).
99 ALS WS to Ethel Sands (Tate).
100 Wendy Baron, *Miss Ethel Sands and her Circle*, op. cit., 104.
101 Ibid., 108.
102 ALS WS to Ethel Sands, 'Easter Monday' [24/3/1913] (Tate).
103 ALS WS to Nan Hudson (Tate).
104 RE, 247; Sacheverell Sitwell, quoted in DS, 187.
105 ALS WS to Ethel Sands, 12/4/1913 (Tate).
106 Wendy Baron, *Perfect Moderns*, op. cit., 58.
107 Quentin Bell, 'Some Memories of Sickert', *Burlington Magazine* (April 1987), 230.
108 Roger Fry to Vanessa Bell, 12/12/1917, in Denys Sutton (ed.), *Letters of Roger Fry* (1972), 423.
109 ALS WS to 'chère amie' [Nan Hudson]; WS to Ethel Sands (Tate).
110 ALS WS to Nan Hudson (Tate).
111 cALS WS to Mr J. H. Angus, 14/12/1920 (Sutton GUL).

II AN IMPERFECT MODERN

1 ALS WS to Ethel Sands, 'Easter Monday' [24/3/] 1913 (Tate).
2 WS, 'Degas', *Burlington Magazine* (November 1917), in AGR, 414.

3 ALS WS to Ethel Sands (Tate).
4 ALS WS to [Nan Hudson] (Tate).
5 Ibid.
6 Ibid.
7 ALS WS to Ethel Sands, 27/7/[1913] (Tate).
8 ALS WS to Ethel Sands; WS to 'Mademoiselle' [Ethel Sands] (Tate).
9 ALS WS to 'Mademoiselle' [Ethel Sands] 'Friday/Saturday' (Tate).
10 ALS WS to Ethel Sands (Tate).
11 WS to 'Mademoiselle' [Ethel Sands] (Tate).
12 ALS WS to Ethel Sands, 27/7/[1913] (Tate).
13 ALS WS to Ethel Sands (Tate).
14 ALS WS to Ethel Sands; WS to 'Mademoiselle' [Ethel Sands], 'Friday/Saturday (Tate); Paul O'Keefe, *Some Sort of Genius* (2000), 132.
15 ALS WS to 'Mademoiselle' [Nan Hudson], 'Friday/Saturday (Tate).
16 Ibid.
17 ALS WS to Ethel Sands (Tate).
18 Osbert Sitwell, *Noble Essences* (1950), 186–7.
19 ALS WS to Ethel Sands, 'Monday night' (Tate).
20 ALS WS to Ethel Sands (Tate).
21 ALS WS to Nan Hudson, 1/10/1913 (Tate).
22 ML, 149.
23 ALS WS to Nan Hudson [6/10/1913] (Tate).
24 ALS WS to Nan Hudson, 10/10/1913 (Tate).
25 Richard Shone, *From Beardsley to Beaverbrook: Portraits by Walter Richard Sickert* (1990), 33.
26 ALS WS to Nan Hudson (Tate).
27 Paul O'Keefe, *Some Sort of Genius*, op. cit., 130–7; Frances Spalding, *Roger Fry: Art and Life* (1980), 173–5.
28 Anna Gruetzner Robins, *Modern Art in Britain* (1997), 116–37.
29 C. R. W. Nevinson, *Paint and Prejudice* (1937), 63–4.
30 Wendy Baron, *Perfect Moderns* (1999), 66.
31 ALS WS to 'my dears' [Nan Hudson/Ethel Sands] (Tate); Wendy Baron, *Perfect Moderns*, op. cit., 68–9.
32 ALS WS to 'my dears' [Nan Hudson/Ethel Sands] (Tate).
33 ALS WS to Nan Hudson (Tate).
34 ALS WS to Ethel Sands, 'Monday' (Tate).
35 ALS WS to Nan Hudson (Tate); WS, 'On Swiftness', *New Age* (26 March 1914), in AGR, 348.
36 WS, 'The New English Art Club', *New Age* (4 June 1914), in AGR, 375.
37 WS, 'The Thickest Painters in London', *New Age* (18 June 1914), in AGR, 378.
38 ALS WS to Ethel Sands (Tate); *New Age* (2 April 1914), quoted in DS, 168.
39 ALS WS to 'my dears' [Nan Hudson/Ethel Sands] (Tate).
40 Manson, quoted in Wendy Baron, *Perfect Moderns*, op. cit., 69. At the *Twentieth Century Art* exhibition held at the Whitechapel Art Gallery in May/June 1942, Sickert and Pissarro were seen – in Sickert's own account – as the twin heads of 'the realistic and objective school', even if most of his former confrères were now following their own paths.
41 ALS WS to Nan Hudson [22/2/1914] (Tate). The Gloucester Crescent At Homes were from 9 p.m. to 12.
42 ALS WS to Nan Hudson, 'Friday' (Tate).
43 Ibid.
44 *New Age* (9 April 1914), in AGR, 353.
45 ALS WS to Mrs Spencer Gore (private collection).
46 ALS WS to Ethel Sands, 'Tuesday'; WS to Nan Hudson (Tate).
47 ALS WS to Ethel Sands (Tate).
48 cALS Christine Sickert [*née* Angus] to Ronald Gray (Sutton GUL).
49 ALS WS to Ethel Sands, 'Wednesday' (Tate).
50 ALS WS to Nan Hudson (Tate).
51 ALS Fred Brown to William Rothenstein, 14/3/1915 (Harvard).
52 ALS WS to 'my dear' [Nan Hudson] (Tate).
53 Quoted in Wendy Baron, *Miss Ethel Sands and her Circle* (1977), 104.
54 ALS WS to Ethel Sands, 'Wednesday' (Tate).

55 ALS WS to Nan Hudson (Tate).
56 ALS WS to 'my dear' [Ethel Sands] (Tate).
57 ALS WS to Nan Hudson (Tate).
58 ALS WS to Ethel Sands (Tate).
59 ALS WS to Nan Hudson (Tate).
60 ALS WS to Nan Hudson (Tate).
61 ALS WS to Ethel Sands (Tate).
62 ALS WS to Nan Hudson (Tate).
63 For full accounts of the trial see Jonathan Fryer, *Robert Ross* (2000) and Philip Hoare, *Wilde's Last Stand* (1997).
64 ALS WS to Nan Hudson (Tate).
65 WS to Robert Ross, quoted in TLS Rupert Hart-Davis to John Russell (Sutton papers/Glasgow).
66 ALS WS to Nan Hudson (Tate).
67 ALS WS to Nan Hudson (Tate). Ethel, it seems, could not decipher Sickert's scrawl, for she reprimanded him over what she took to be his callous attitude to their friend. 'The world is *not* with you,' she wrote back tartly. 'There seems to have been universal indignation over the judge's attitude.' Sickert, apologizing for his illegible hand, hastened to reassure her that he was indeed 'heartbroken for Robbie'.
68 Jonathan Fryer, *Robert Ross* op. cit., 236.
69 ALS WS to Ethel Sands, 'beginning of the Summer' [1914] (Tate).
70 Ibid.
71 Letters from WS to Ethel Sands (Tate).
72 ALS WS to Ethel Sands, 'Tuesday' (Tate).
73 ALS WS to Ethel Sands, 15/7/[1914] (Tate).
74 ALS WS to Ethel Sands, 'Tuesday' (Tate).
75 ALS to [Ethel Sands?], 'Friday' (Tate).
76 ALS to Ethel Sands, 'Sunday' (Tate).
77 Of the friends mentioned in his letters to Ethel Sands and Nan Hudson that summer were the Chownes, Frank Griffiths, the Misses Godwin and Mathers, and Albert Rutherston. The three new subjects he was engaged upon were: Café Suisse, the flags on the front, and an old woman sewing nets on quayside.

78 ALS WS to Ethel Sands (Tate).
79 ALS WS to Ethel Sands, 'Wed.' (Tate).
80 ALS WS to Ethel Sands 'Monday' (Tate).
81 ALS WS to Ethel Sands, 15/7/[1914] (Tate).
82 ALS WS to [Ethel Sands], 'Monday' (Tate).
83 ALS WS to Ethel Sands, 'Sunday' (Tate).
84 ALS WS to [Ethel Sands], 'Monday' (Tate).
85 ALS WS to Ethel Sands, 'Tuesday'; WS to Ethel Sands, 'Wed.' (Tate).
86 ALS WS to [Ethel Sands], 'Friday' (Tate).
87 Ibid; ALS WS to [Ethel Sands], 'Monday' (Tate).

III RED, WHITE, AND BLUE

1 ALS WS to [Nan Hudson/Ethel Sands], 'Tuesday'; WS to Ethel Sands, 'Wednesday' (Tate).
2 ALS WS to [Nan Hudson/Ethel Sands], 'Tuesday' (Tate).
3 Ibid.
4 ALS WS to 'my dears' [Nan Hudson/Ethel Sands] (Tate).
5 ALS WS to Ethel Sands, 'Wed.' (Tate).
6 ALS WS to 'my dears' [Nan Hudson/Ethel Sands] (Tate).
7 ALS WS to Ethel Sands (Tate).
8 ALS WS to Ethel Sands, 'Wed.' (Tate).
9 JEB, *Portraits of a Lifetime* (1937), 283; Simona Pakenham, *Sixty Miles from England* (1967), 218, claims that Sickert did join the guard, but the suggestion seems unfounded.
10 ALS WS to Ethel Sands, 'Friday' (Tate).
11 Ibid.
12 Ibid.
13 ALS WS to Lady Hamilton (KCL).
14 ALS WS to Ethel Sands, 'Sunday' (Tate).
15 ALS WS to Ethel Sands, 'Monday' (Tate).
16 Ibid. The letter ends with the remark that 'a small force of marines would of course be cut up & be worse than

useless'. ALS WS to Edward Marsh (NYPL).

17 RE, 186.

18 ML, 49; RE, 186.

19 ALS WS to Ethel Sands, 'Friday' (Tate).

20 ALS WS to Ethel Sands, 'Tuesday' (Tate).

21 ALS WS to Nan Hudson (Tate).

22 ALS WS to Ethel Sands, 'Sunday' (Tate); ALS WS to Lady Hamilton (KCL).

23 ALS WS to [Ethel Sands]; WS to Ethel Sands, 'Monday' (Tate).

24 ALS WS to Eddie Marsh (NYPL).

25 ALS WS to Ethel Sands, 'Tuesday' (Tate). The letter is illustrated with a plan of the rooms.

26 ALS Mrs W. E. Watson [née Powell] to Mrs Powell, 18/11/[1958] (Sutton GUL).

27 ALS WS to Ethel Sands; WS to Ethel Sands, 'Sunday' (Tate).

28 ALS WS to Eddie Marsh (NYPL).

29 ALS WS to Ethel Sands, 'Sunday' (Tate).

30 ALS WS to Ethel Sands, 'Tuesday' (Tate).

31 Ibid.

32 ALS WS to Ethel Sands (Tate).

33 ALS WS to 'my dear' [Ethel Sands?] (Tate).

34 ALS WS to Lady Hamilton (KCL); WS to 'my dear' [Ethel Sands?] (Tate).

35 ALS WS to Ethel Sands (Tate).

36 ALS WS to 'my dears' [Nan Hudson/ Ethel Sands] [21/10/1914] (Tate); Jean Hamilton, MS diary, 21/10/ 1914 (KCL).

37 ALS WS to [Ethel Sands?] (Tate).

38 Witt Library 2316.

39 ALS WS to Lady Hamilton [10/ 1914] (KCL).

40 Ibid.

41 cALS Sir Ian Hamilton to 'The Belgian Military Attaché & The Secretary of the Committee having charge of Belgians in London Hospitals'; ALS WS to 'my dears' [Nan Hudson/Ethel Sands] [21/10/ 1914] (Tate).

42 ALS WS to Ethel Sands (Tate).

43 ALS WS to 'my dears' [Nan Hudson/ Ethel Sands] [21/10/1914] (Tate).

44 RE, 179; ALS WS to Ethel Sands (Tate).

45 ALS WS to 'my dear' [Ethel Sands?] (Tate).

46 Ibid.

47 ALS WS to Nan Hudson (Tate).

48 ALS WS to 'my dears' [Nan Hudson/ Ethel Sands] (Tate). He constructed a 'magnificent platform 7 foot by 7 foot' in order to 'get Veronese like foreshortenings' of his central figure – a kneeling infantry officer.

49 Ibid.

50 ALS Fred Brown to William Rothenstein, 14/3/1915 (Harvard).

51 ALS WS to Nan Hudson (Tate).

52 ALS WS to 'my dears' [Nan Hudson/ Ethel Sands] (Tate).

53 Ibid.

54 ALS WS to Nan Hudson (Tate).

55 ALS WS to 'my dears' [Nan Hudson/ Ethel Sands] (Tate).

56 Ibid.

57 ALS WS to Ethel Sands (Tate).

58 ALS WS to Ethel Sands (Tate).

59 ALS WS to Ethel Sands (Tate).

60 ALS WS to Ethel Sands (Tate).

61 ML, 49.

62 Patrick O'Connor, in Baron/Shone, 26.

63 WS to the Editor of The Times (1 February 1923).

64 ALS WS to Ethel Sands (Tate).

65 ALS WS to 'my dears' [Nan Hudson/ Ethel Sands] [21/10/1914] (Tate).

66 ALS WS to 'my dear' [Ethel Sands] (Tate). In another letter to Ethel he describes walking home from the music hall with Christine and Marie 'in the pitch black which is lovely'.

67 ALS WS to Ethel Sands [1915] (Tate); LB II, 33, suggests that Sickert was frightened by the air raid (and had been frightened of fireworks as a boy), but certainly all his own pronouncements contradict this.

68 ALS WS to Ethel Sands [10/1914] (Tate).

69 ALS WS to 'my dear' [Ethel Sands] (Tate).

70 ALS WS to Nan Hudson [1915] (Tate).

71 ALS WS to Ethel Sands [1915] (Tate).

72 ALS WS to 'my dears' [Nan Hudson/ Ethel Sands] [1915] (Tate).

73 ALS WS to Ethel Sands [1915] (Tate).

74 ALS WS to Nan Hudson [11/1914] (Tate).

75 ALS WS to Ethel Sands [1/1915] (Tate).

76 ALS WS to Ethel Sands [1915] (Tate). Sadly, Lady Hamilton did not record her views of the performance in her diary.

77 ALS WS to 'my dears' [Nan Hudson/ Ethel Sands] [12/1914]; ALS WS to Ethel Sands [1915]; ALS WS to [Ethel Sands?] [1914] (Tate).

78 Letters from WS to Ethel Sands [1914–15] (Tate).

79 Letters from WS to Ethel Sands [1915]; ALS WS to Nan Hudson [11/1914] (Tate).

80 ALS WS to Ethel Sands [1915] (Tate).

81 ALS WS to 'my dears' [Nan Hudson/ Ethel Sands] [1915] (Tate).

82 John Woodeson, *Mark Gertler* (1972), 139.

83 WS, 'The Whitechapel', *New Age* (28 May 1914), in AGR, 373. Sickert had first seen Lessore's work at the AAA in 1913: cf. WS, 'Thérèse Lessore', *Arts and Letters* (November 1918), in AGR, 428. Osbert Sitwell, in an introductory note to her 1946 memorial exhibition at the Leicester Galleries, claimed that Sickert had not met Lessore until he wrote about her work at the NEAC in 1916. This is certainly wrong. Sickert did not write a review of the 1916 NEAC exhibition, and he knew Lessore before 1916. Perhaps it is a mistaken recollection of Sickert's *New Age* review of 1914.

84 WS, 'Thérèse Lessore', *Arts and Letters* (November 1918), in AGR, 428.

85 WS, 'The Whitechapel', *New Age* (28 May 1914), in AGR, 373.

86 ML, 112.

87 Sickert mentioned Jules Lessore in his piece on 'The Royal Institute', *New York Herald* (18 March 1889), in AGR, 19.

88 ML, 112–13.

89 ALS WS to Ethel Sands [1914] (Tate).

90 ALS WS to Ethel Sands [1/1915] (Tate).

91 ALS WS to Ethel Sands [2/1915] (Tate).

92 ALS WS to Ethel Sands [1915] (Tate).

93 ALS WS to Ethel Sands [1/1915] (Tate).

94 ALS WS to 'my dears' [1915] (Tate). The tenants were Lady Mary Fielding, and her husband, Cecil Wolmer, a Foreign Office mandarin.

95 The picture, which was bought by Roger Fry, is now in the Courtauld Gallery, London. The tube station has been renamed 'Queensway'.

96 ALS WS to Ethel Sands [1/1915] (Tate).

97 RB, no. 29; ALS WS to Ethel Sands [1914] (Tate).

98 ALS WS to Ethel Sands [1914] (Tate).

99 Enid Bagnold, *Autobiography* (1969), 75.

100 ALS WS to Ethel Sands [7/1915] (Tate).

101 Enid Bagnold, *Autobiography*, op. cit., 75.

102 Letters from WS to Nan Hudson [1915]; ALS WS to Ethel Sands [1/ 1915] (Tate).

103 ALS Fred Brown to William Rothenstein, 14/3/1914 (Harvard).

104 ALS WS to Ethel Sands [1915] (Tate).

105 ALS WS to J. M. Murry [1914] (Texas).

106 Vanessa Bell to Clive Bell, 22/6/ 1915, in Regina Marler (ed.), *Selected Letters of Vanessa Bell* (1993), 182.

107 John Middleton Murry, in RB, 27.

108 At the NEAC spring exhibition he showed *The Old Bedford*, *The Bon Dodo*, *A Little Cheque*, *Mother and Daughter*, *The Old Middlesex*, and *Quai Henri IV*. He had already showed *Ennui* at the Society of XII in March.

109 ALS WS to Nan Hudson [6/1915] (Tate).

110 Ibid.
111 ALS WS to Ethel Sands [6/1915] (Tate).
112 Vanessa Bell to Clive Bell, 22/6/1915, in Marler (ed.), *Selected Letters of Vanessa Bell*, op. cit., 182.
113 ALS WS to Ethel Sands [6/1915] (Tate).
114 WS, 'A Monthly Chronicle', *Burlington Magazine* (July 1915), in AGR, 387–8.
115 ALS WS to Ethel Sands [9/1915] (Tate).
116 ALS WS to 'my dears' [12/1914] (Tate).
117 ALS WS to Ethel Sands [7/1915] (Tate).
118 ALS WS to Ethel Sands [9/1915] (Tate).
119 ALS WS to Ethel Sands [10/1915] (Tate).
120 ALS WS to Ethel Sands [7/1915] (Tate).
121 RB, 33.
122 Ibid., 34.
123 WS, 'Foreword' to *New Paintings by Richard Sickert*, Beaux Arts Gallery (5 July 1935), in AGR, 679.
124 ALS WS to Ethel Sands [9/1915] (Tate).
125 Ibid.
126 ALS WS to [Ethel Sands?] [9/1915] (Tate).
127 Ibid.
128 Ibid.
129 Sir William and Lady Jowitt, who bought the 'second' version, recalled commissioning it, having admired the 'first' version (bought by Morton Sands).
130 ALS WS to Ethel Sands [10/1915] (Tate).
131 Ibid.
132 Ibid.
133 ALS WS to Ethel Sands [9/1915] (Tate).
134 Ibid.
135 ALS WS to Ethel Sands [12/1915] (Tate); Nina Hamnett, *Laughing Torso* (1932), 99.
136 ALS WS to Ethel Sands [12/1915] (Tate).
137 Richard Shone, 'Duncan Grant on a Sickert Lecture', *Burlington Magazine*, 123 (1981), 671.
138 ML, 95.
139 Osbert Sitwell, *Noble Essences*, op. cit., 178–9.
140 ML, 43; Clive Bell, *Old Friends* (1956), 23.
141 Nina Hamnett, *Laughing Torso*, op. cit., 97.
142 ML, 111.
143 Michael Parkin catalogue, *Walter Sickert: The Artist, his Wife, his Mistress, his Friends, and One Enemy* (1992), 6–7. The dating of Boreel's artistic career given by Parkin seems doubtful.
144 Told to Michael Parkin by Wendela Boreel.
145 Michael Parkin, *Walter Sickert*, op. cit., 7.
146 Ibid., 12.
147 Nina Hamnett, *Laughing Torso*, op. cit., 82.
148 Malcolm Yorke, *Matthew Smith* (1997), 90. The model for the nudes was either Nina Hamnett or Emily Powell.
149 Yorke, ibid., 91; John Rothenstein, *Modern English Painters*, (1957 edn), 233.
150 ALS WS to Ethel Sands [1/1916] (Tate).
151 Paul O'Keefe, *Some Sort of Genius* (2000), 164–5.
152 ALS WS to Ethel Sands [7/1915] (Tate).
153 ALS WS to Ethel Sands [1915] (Tate).
154 ALS WS to Ethel Sands [9/1915] (Tate).
155 WS to Ethel Sands (Tate).
156 Quoted in TLS Hubert Wellington to Gabriel White, 2/6/1960 (Sutton GUL).
157 ML, 64, 131.
158 ALS WS to Ethel Sands [12/1915] (Tate).
159 ALS WS to Ethel Sands [9/1915] (Tate).
160 ALS WS to Ethel Sands [1/1916] (Tate).
161 ALS WS to Henry Tonks [1916] (Texas).
162 ALS WS to Henry Tonks [1916] (Texas).

163 ALS WS to Henry Tonks [1916] (Texas).
164 ALS WS to Ethel Sands [12/1915] (Tate).
165 Nina Hamnett, *Laughing Torso*, op. cit., 99-100.
166 ALS WS to Ethel Sands [1/1916] (Tate).
167 HMS, 301.
168 ALS Edith Ortmans [*née* Carter] to John Russell, 15/10/1958 (Sutton GUL).
169 ALS WS to Nan Hudson [1916] (Tate); cf. WB, 366-9.
170 *A Weak Defence*.
171 ALS WS to Nan Hudson [1916] (Tate).
172 Ibid.
173 Wendy Baron, *Miss Ethel Sands and her Circle* (1977), 144.
174 In 1914.
175 ALS Fred Brown to William Rothenstein, 22 May 1914 (Harvard): 'Sickert has been re-elected a member, though not many voted for him, at which I'm not surprised – his relations with the club for some years have not been satisfactory.'
176 ALS WS to Nan Hudson [1916] (Tate).
177 *Daily Telegraph* (28 November 1916); *Observer* (19 November 1916).
178 *The Times* (4 May 1916).
179 *Glasgow Herald* (3 June 1916).
180 Nina Hamnett to Roger Fry, in DS, 190-1.
181 WS, 'The True Futurism', *Burlington Magazine* (March 1916), in AGR, 405.
182 WS, 'Nina Hamnett', *Cambridge Magazine* (8 June 1918), in AGR, 426.
183 Clive Bell, *Old Friends*, op. cit., 19.
184 Clive Bell, 'Preface' to catalogue for Sickert Exhibition at Eldar Gallery (1919), 1.
185 ALS WS to Ethel Sands [12/1914] (Tate).
186 ALS John Nash to Dora Carrington [1918] (Tate).
187 Clive Bell, *Old Friends*, op. cit., 3.

IV SUSPENSE

1 Emmons dated the Sickerts' Chagford visit to 1915 (RE, 1830), and Denys Sutton followed suit. But it is clear from other evidence that the visit took place the following year: cf. Malcolm Yorke, *Matthew Smith: His Life and Reputation* (1997), 91; cALS Mrs Sickert to Mrs Muller, 1916 (Tate).
2 Iain Rice, *The Book of Chagford: A Town Apart* (2002), 153.
3 Osbert Sitwell, *Noble Essences* (1950), 186.
4 cALS WS to Elizabeth Angus [11/1928] (Sutton GUL).
5 Malcolm Yorke, *Matthew Smith*, op. cit., 91.
6 cALS Mrs Sickert to Mrs Muller, 26/9/1916 (Tate).
7 Quoted in TLS Hubert Wellington to Gabriel White, 2/6/1960 (Sutton GUL). The school was in Great Pulteney Street.
8 *Glasgow Herald* (24 November 1916) called the picture 'a study in browns of a little boy', while in the *Daily Telegraph* (29 November 1916) the subject was referred to as 'a roguish youth'.
9 DS, 153. McEvoy's daughter, Angela Bazell, told Sutton that on his return to France Maurice had become 'dissipated', but there seems little reason to believe the claim. According to the Dieppe records, he got married in 1920 (to Georgette Guermont, at Rouen), and died at Biarritz in 1975.
10 *Bazaar, Exchange & Mart* (8 December 1916). There were also some suggestively topical genre scenes: *The Nurse* was praised for its 'truth' and lack of 'sentimentality': Florence Nightingale, it was claimed, would have admired it. A painting of 'a small young man with a rifle, and a larger lady' titled *Sinn Fein* was held to sum up 'the tragicomedy, the pity, the folly and the peril' of its subject in 'the best of ways': by 'a simple statement of its factors' (*Evening Standard & St James's Gazette*, 18 November 1916).

11 ALS WS to Mrs Swinton [1917] (private collection).

12 Clive Bell, 'Sickert', preface to catalogue of Eldar Gallery exhibition (1919), 2.

13 Newman Flower (ed.), *The Journals of Arnold Bennett 1911-1921* (1932), 178.

14 Ibid., 186; ALS WS to Arnold Bennett (Texas); ALS WS to Ethel Sands (Tate).

15 ML, 25; Osbert Sitwell, op. cit., 192.

16 ALS WS to Ethel Sands (Tate). ML, 80, says Taylor's rooms were in Fitzroy Square, not Street.

17 ALS WS to Ethel Sands (Tate).

18 ALS WS to Ethel Sands (Tate).

19 Osbert Sitwell, *Noble Essences*, op. cit., 173.

20 ML, 19.

21 RE, 180.

22 Margaret Crewe-Clements [*née* Cannon-Smith], TS 'Sickert', 8 (Sutton GUL).

23 ML, 19.

24 Osbert Sitwell, op. cit., 182.

25 ML, 90.

26 Margaret Crewe-Clements [*née* Cannon-Smith], TS 'Sickert', 3 (Sutton GUL).

27 ALS WS to Ethel Sands (Tate): the letter dates from the following year (1918), when Sickert returned to Bath.

28 Alfred Thornton, 'Walter Richard Sickert', *Artwork* (Spring 1930), 15.

29 Osbert Sitwell, *Noble Essences*, op. cit., 177; WS to the Editor of *The Times* (5 October 1929), in AGR, 593.

30 Wendy Baron, *Miss Ethel Sands and her Circle* (1977), 151.

31 cALS WS to Mr Angus, 13/2/1922 (Sutton GUL).

32 cALS Christina Sickert to Keith Baynes (Sutton GUL).

33 ALS WS to Wendela Boreel (private collection).

34 Tonks wrote Sickert a generous letter of thanks: ML, 169.

35 There is a copy of the propectus in the Rothenstein papers at Harvard. It is also quoted in full in ML, 63.

36 WS, note on envelope enclosing the prospectus, addressed to William Rothenstein (Harvard, 47).

37 Beatrix de Halpert, MS diary, 22/10/1917 (private collection).

38 Osbert Sitwell, *Noble Essences*, op. cit., 183-4. The Tavistock Hotel was also known as the Bachelor's Hotel.

39 They first appear in the Camden Rate Book in October 1917. The owner is given as 'Christine Drummond (Sickert, Mrs)'.

40 ML, 19.

41 ALS WS to Ethel Sands (Tate); Peter Peretti to Matthew Sturgis, 27/2/2001. Peter Peretti's grandfather, Henry Hancock, ran the Kentish Town Bath between the wars.

42 Osbert Sitwell, *Noble Essences*, op. cit., 186.

43 Ibid., 183.

44 ML, 77.

45 Ibid., 15.

46 Ibid., 77-8; Osbert Sitwell, *Noble Essences*, op. cit., 175.

47 ML, 100.

48 Bryan Connon, *Beverley Nichols: A Life* (1991), 61.

49 Osbert Sitwell, *Noble Essences*, op. cit., 184, gives the breakfast hour as from 8 or 8.30 a.m. But Sickert in a letter to Wendela Boreel suggests that it ran from 9.00 a.m. 'till about 12.15'.

50 Osbert Sitwell, *Noble Essences*, ibid., 185.

51 DS, 187.

52 Osbert Sitwell, *Noble Essences*, op. cit., 194-5.

53 ML, 23.

54 Ibid., 40.

55 Ibid., 52.

56 cALS WS to Andrina Schweder [*née* Angus], 19/1/1922 (Sutton GUL).

57 Margaret Crewe-Clements [*née* Cannon-Smith] TS 'Sickert' (Sutton GUL), 5.

58 Ibid.

59 Ibid., 7. Sickert left her free to work out the exact number of tones to be used in the camaïeu, but urged her to use 'as few as possible' and to base them on 'emerald oxide of chromium' for the lights, and 'Venetian red' for the darks.

60 Clive Bell, *Old Friends* (1956), 19.

61 Osbert Sitwell, *Noble Essences*, op. cit., 188.

62 ML, 43.

63 Osbert Sitwell, *Noble Essences*, op. cit., 165. Sitwell does not mention the title of Sickert's article, but the date suggests that it was the Degas piece.

64 Margaret Crewe-Clements [*née* Cannon-Smith], TS 'Sickert', (Sutton GUL), 3; ALS WS to Mrs Swinton (private collection).

65 ML, 40.

66 cALS WS to Elisabeth [*née* Angus] [11/1928] (Sutton GUL).

67 Roger Fry to Vanessa Bell, 6/10/1917, in Denys Sutton (ed.), *Letters of Roger Fry* (1972), 417.

68 Margaret Crewe-Clements [*née* Cannon-Smith], TS 'Sickert' (Sutton GUL), 8.

69 ALS WS to Mrs Swinton, 3/1/1918 (private collection).

70 Quentin Bell, 'Some Memories of Sickert', *Burlington Magazine* (April 1987), 231.

71 cALS WS to Gladys Davidson, 2/10/1916 (Sutton GUL).

72 cALS WS to Mr Angus, 13/2/1922 (Sutton GUL).

73 David Greer, *A Numerous and Fashionable Audience* (1997), 117.

74 ML, 92.

75 Ibid., 54.

76 Ibid., 33.

77 Ibid., 92.

78 Osbert Sitwell, *Noble Essences*, op. cit., 199.

79 Oliver Brown, BBC tape; Clive Bell, *Old Friends*, op. cit., 17.

80 Osbert Sitwell, *Noble Essences*, op. cit., 171.

81 ML, 27. At the end of April 1918, he and Christine took a brief holiday at Sandwich together with the Colqhouns, to try the benefits of the seaside. Cf. cALS WS to Marian Colqhoun [*née* Angus] (Sutton GUL); cALS WS to Dorothy de Halpert, 23/4/1918 (private collection).

82 ML, 45.

83 WS to Ethel Sands (Tate).

84 Margaret Crewe-Clements [*née* Cannon-Smith], TS 'Sickert', 2 (Sutton GUL).

85 ALS Madeleine Clifton [*née* Knox] to Wendy Baron [2/1973] (private collection).

86 Clive Bell, *Old Friends*, op. cit., 23.

87 Margaret Crewe-Clements [*née* Cannon-Smith], TS 'Sickert', 2 (Sutton GUL); WS to Ethel Sands (Tate).

88 WS to Ethel Sands (Tate).

89 DS, 192.

90 ML, 37.

91 Ibid., 38–9. Marjorie Lilly says the visitor was the Japanese Ambassador – at that time Count Sutemi Chada – but Sutton suggests more plausibly that it was the shipping magnate Kojiro Matsukata, a noted collector of Western art, who was also in London at that time. The presence in his collection of *Suspense*, together with three other works (two oils of Dieppe and a watercolour drawing of the Rialto), seems to confirm his suggestion. The Matsukata Collection was broken up in 1959: two of his Sickert paintings are now in other Japanese collections; the whereabouts of the other two are unknown: TLS Chikashi Kitazaki, curator of the National Museum of Western Art, Tokyo, to Matthew Sturgis, 14/8/2000.

92 Grant Richards, *Memories of a Misspent Youth* (1932), 282.

93 ML, 38.

94 Margaret Crewe-Clements [*née* Cannon-Smith], TS 'Sickert', 8 (Sutton GUL).

95 ALS WS to Ethel Sands (Tate). The high prices were confirmed when Judge Evans' collection went on sale at Goupil's in May/June.

96 Ibid.

97 Telegram WS to Nina Hamnett, 31/5/1918, quoted in Denise Hooker, *Nina Hamnett: Queen of Bohemia* (1986), 116. On 16 June 1918 Sickert dined *chez* Gosse: cf. 'The Book of Gosse' (Leeds).

98 Nina Hamnett, *Laughing Torso* (1932), 96.

99 Ibid., 109; Witt Library 2323 (2).

100 Nina Hamnett, *Laughing Torso*, op. cit., 109; Denise Hooker, *Nina Hamnett*, op. cit., 109.

101 ML, 85; Denise Hooker, *Nina Hamnett*, op. cit., 117–18.

102 Hooker, ibid., 118; Nina Hamnett, *Laughing Torso*, op. cit., 109.

103 ML, 86.

104 ALS WS to Ethel Sands (Tate).

105 Nina Hamnett, *Laughing Torso*, op. cit., 109, gives the rendezvous time as 5.30 p.m.; DS, 190, puts it at 4.30 p.m.

106 Nina Hamnett, *Laughing Torso*, op. cit., 44–5.

107 Nina Hamnett to Roger Fry, quoted in DS, 190.

108 Ibid.

109 Ibid., 190–1.

110 Ibid., 191.

111 Walter Bayes, *Turner* (1931), 132.

112 Wendy Baron, *Miss Ethel Sands and her Circle*, op. cit., 155.

113 Oliver Brown, *Exhibition* (1968), 133.

114 ML, 82.

115 Nina Hamnett, *Laughing Torso*, op. cit., 108. The dealer's identity is a mystery. Hamnett does not mention his name, nor do any of the other contemporary accounts. The Tate Catalogue claims that John Rayner was the founder of the Eldar Gallery, but this seems to be refuted by Bernard Falk in his memoir, *He Laughed in Fleet Street* (1937), 279. Falk describes Rayner – a journalist – taking on an existing art gallery from a young dealer who had recently held a successful exhibition of bulk-purchased Sickert pictures.

116 Nina Hamnett, *Laughing Torso*, op. cit., 108. Osbert Sitwell, *Noble Essences*, op. cit., 181, suggests that the sum offered was £40, while Bernard Falk, *He Laughed in Fleet Street*, op. cit., 280, quotes the £50 price.

117 Nina Hamnett, *Laughing Torso*, op. cit., 108.

118 Osbert Sitwell, *Noble Essences*, op. cit., 181.

119 ML, 34.

Chapter Eight: The New Age

I THE CONDUCT OF A TALENT

1 Clive Bell *Walter Sickert* catalogue preface; RE, 185; Bernard Falk, *He Laughed in Fleet Street* (1937), 279.

2 Anne O. Bell (ed.), *The Diary of Virginia Woolf*, vol. i, 240, entry for 15/2/1919.

3 His standing did, nevertheless, receive some formal confirmation when the British Museum accepted his gift of eleven prints for their collection: RE, 35. Sickert had made an earlier donation of six prints in 1914.

4 C. R. W. Nevinson, *Paint and Prejudice* (1937), 128.

5 The wedding between Augustine Villain and Alphonse Marie Joseph Morin took place in Dieppe on 16 August 1915.

6 Simona Pakenham, TS 'Walter Sickert & My Grandmother', 7 (Sutton GUL).

7 Maryse Renault-Garneau (ed.), *Correspondance: Jean Cocteau, Jacques-Émile Blanche* (1993), letter XXIII, 11/9/1919.

8 WB, 379, 375–8.

9 ALS WS to [Ethel Sands?] (Tate).

10 Ibid.

11 Alice Rothenstein to Max Beerbohm, 17/2/[1920], quoted in Mary M. Lago and Karl Beckson, *Max and Will* (1975), 108.

12 ALS WS to [Ethel Sands?] (Tate).

13 Wendy Baron, *Miss Ethel Sands and her Circle* (1977), 156.

14 ALS WS to [Ethel Sands] (Tate). LB II, 34, says that the house had originally been an inn – 'tenue par Monsieur Mouton' – and that the gendarmerie was in fact next door. I have been unable to confirm the details of this point.

15 Nina Hamnett, *Laughing Torso* (1932), 166.

16 ALS WS to [Ethel Sands?] (Tate).

17 The dinner was held at the Florence Restaurant, Soho.

18 Alice Rothenstein to Max Beerbohm, 17/2/[1920], in Lago and Beckson, *Max and Will*, op. cit., 108.

19 ALS Max Beerbohm to Alice Rothenstein, 20/2/1920 (Harvard).

20 Alice Rothenstein to Max Beerbohm, 17/2/[1920] (Harvard).

21 The evening can be pieced together from the accounts of several of the protagonists: Arnold Bennett to Hugh Walpole, 21/1/1920, in James Hepburn (ed.), *The Letters of Arnold Bennett*, vol. iii: *1916–1931* (1970), 121; Osbert Sitwell, *Noble Essences* (1950), 196–7; and Wyndham Lewis, *Blasting and Bombardiering* (1967 edn), 93–4. When Lewis left early, declining to accompany the others on to a party being given by Ottoline Morrell at the house she was renting in Vale Avenue, it was thought that perhaps he had been offended by this barb. In fact he was well pleased with the praise of his novel and only concerned that Bennett – who as chief reviewer for the *Evening Standard* wielded enormous power on the literary scene – would be turned against it and its successors. 'I knew that Sickert had made me an enemy though he had not meant to,' he wrote later, 'for he is the kindest man in the world.' Lewis lunched with Sickert a few days later at his studio in Fitzroy Street.

22 Wendy Baron, *Miss Ethel Sands and her Circle*, op. cit., 163.

23 ALS WS to Ethel Sands (Tate).

24 LB II, 34.

25 ALS WS to James Manson, rec. 28/12/1920 (Fondation Custodia).

26 Robert Mallet (ed.), *Self-Portraits: The Gide/Valéry Letters, 1890–1942* (1966), 293.

27 DS, 196; Oliver Brown, *Exhibition* (1968), 134.

28 Oliver Brown, ibid.

29 Osbert Sitwell, *Noble Essences*, 187.

30 cALS WS to Faith Lucas [2/11/1920] (Sutton GUL).

31 ALS WS to James Manson, rec. 28/12/1920 (Fondation Custodia).

32 cALS Christine Sickert to WS (Sutton GUL).

33 cALS WS to Marian Colqhoun [*née* Angus] (Sutton GUL).

34 cALS WS to 'my dear' [Mrs Angus], 'Friday' (Sutton GUL).

35 cALS Christine Sickert to WS (Sutton GUL).

36 ML, 148–9.

37 JEB, *More Portraits of a Lifetime* (1939), 106–7.

38 ML, 147.

39 cALS WS to Mrs Angus, 7/12/1920 (Sutton GUL); cALS WS to Faith Lucas [2/11/1920] (Sutton GUL); ALS WS to Mrs Spencer Gore, 27/12/1920 (private collection).

40 cALS WS to Mrs Angus, 7/12/1920 (Sutton GUL).

41 cALS WS to Andrina Schweder [*née* Angus] (Sutton GUL).

42 Mrs Schweder's notes, quoted LB II, 34–5, and DS, 198.

43 Ibid.

44 Drawing at Walker Art Gallery, Liverpool.

45 JEB, *More Portraits of a Lifetime*, op. cit., 113.

46 Mrs Schweder's notes, in LB II, 35.

47 DS, 199.

48 Simona Pakenham, TS 'Walter Sickert & My Grandmother', 9 (Sutton GUL).

49 JEB, *More Portraits of a Lifetime*, op. cit., 114.

50 Ibid.; ALS WS to Mr Angus [29/10/1920] (Tate); Simona Pakenham, TS 'Walter Sickert & My Grandmother', 9 (Sutton GUL).

51 JEB, *More Portraits of a Lifetime*, op. cit., 114–15.

52 ML, 149; Kathleen Fisher, *Conversations with Sylvia* (1975), 39.

53 Anne O. Bell (ed.), *The Diaries of Virginia Woolf*, vol. ii, 223–4, entry for 7/1/1923.

54 ALS WS to Mr Angus, 12/12/1920 (Tate).

55 ALS WS to Henry Tonks, 25/1/1921 (Texas). Blanche arranged for the casting at Rouen (*Portraits of a Lifetime* (1937), 151). Later, in 1924, Sickert also commissioned the sculptor Derwent Wood to carve a marble bust of Christine from a portrait done by Nan Hudson. Telegrams WS to Andrina Schweder, 27/10/1924, 29/11/1924 (Tate).

56 ALS WS to Mr Angus, 14/12/1920 (Tate).

57 ALS WS to Mr Angus [1920] (Tate).

58 ALS WS to Mr Angus, 14/12/1920 (Tate).

59 ALS WS to James Manson [28/12/1920] (Fondation Custodia).

60 ALS WS to Mr Angus [1920] (Tate).

61 Kathleen Fisher, *Conversations with Sylvia*, op. cit., 39. Amongst those who wrote were Tonks, Manson, Elsie Swinton, Mrs Spencer Gore, and the sculptor Fedora Gleichen.

62 ALS WS to Mrs Angus, 7/12/1920 (Tate); cTL WS to Faith Lucas (Sutton GUL).

63 Quoted in LB II, 44.

64 cTL WS to Faith Lucas (Sutton GUL).

65 ALS WS to Mr Angus, 14/12/1920 (Tate).

66 Ibid.

67 ALS WS to James Manson [28/12/1920] (Fondation Custodia).

68 ALS WS to Ethel Sands, 20/12/1920 (Tate).

69 ALS WS to Mr Angus, 28/2/1921 (Tate).

70 ALS WS to Ethel Sands, 20/12/1920 (Tate)

71 LB II, 35.

72 ALS WS to Mr Angus, 28/2/1921 (Tate).

73 ML, 147.

74 Wendy Baron, *Miss Ethel Sands and her Circle*, op. cit., 164.

75 ALS WS to Mrs Swinton [7/7/1921] (private collection).

76 Ibid.

77 ALS WS to Mr Angus, 28/2/1921 (Tate).

78 ALS WS to Andrina Schweder [1922] (Tate).

79 The exact value listed was £11,859. 11s.

80 ALS WS to Mr Angus, 28/2/1921 (Tate).

81 ALS WS to Mr Angus, 7/3/1921 (Tate). Mr Angus's employees were less impressed by Sickert's ways. A memo from his 'senior clerk' dated 7/1/1927 remarks, 'I have had a very poor opinion of [Mr Sickert] for a long time. I think I have said this before.' (Tate).

82 Probate was granted on 26 March 1921; Wendy Baron, op. cit., 163.

83 LB I, 12

84 ALS WS to Marian Colqhoun (Tate).

85 Denys Sutton (ed.), *The Letters of Roger Fry* (1972), 507.

86 Wendy Baron, *Miss Ethel Sands and her Circle*, op. cit., 165.

87 ALS WS to Andrina Schweder [1922] (Tate).

88 ALS WS to Marian Colqhoun (Tate).

89 ALS WS to Mrs Swinton [7/7/1921] (private collection).

90 ALS WS to Andrina Schweder [1922] (Tate).

91 Wendy Baron, *Miss Ethel Sands and her Circle*, op. cit., 164.

92 ALS WS to Mrs Swinton [7/7/1921] (private collection).

93 Mrs Schweder's note, quoted in LB II, 35.

94 ALS WS to Andrina Schweder [21/11/1921] (Tate).

95 ALS WS to Andrina Schweder, 19/1/1922 (Tate); ML, 152–3.

96 ALS WS to Andrina Schweder [21/11/1921] (Tate).

97 ALS WS to Andrina Schweder, 19/1/1922 (Tate). Marie appears in *L'Armoire à Glace*.

98 WS to W. H. Stephenson, quoted in Stephenson, *Sickert: The Man and his Art* (1940), 17.

99 RE, 199.

100 ALS WS to Andrina Schweder [21/11/1921] (Tate).

101 ALS WS to Andrina Schweder [19/1/1922] (Tate).

102 ALS WS to Andrina Schweder [21/11/1921] (Tate).

103 Ibid.

104 The exact history of his relationship with Bernheim-Jeune is hard to trace as the gallery, which still exists, refuses all access to its archives.

105 ALS WS to Andrina Schweder [19/1/1922] (Tate).

106 ALS WS to DSM, 27/3/1922 (GUL).

107 Violet Overton Fuller, TS 'Letters to

Florence Pash' (Islington); ALS WS to W. Barnett (Texas).

108 ALS WS to DSM, 27/3/1922 (GUL).

109 ML, 47. Marjorie Lilly gives the address as rue Desmarets, but this was Sickert's studio – in the attic of Dr Poppault's house.

110 Ibid.

111 Ibid.

112 ALS WS to Andrina Schweder [1922] (Tate).

113 ML, 153

II PRIVATE VIEW

1 HMS, 348–9.

2 ALS WS to A. Schweder [1922] (Tate). Mrs Sickert died on 12 February 1922.

3 Probate was granted on 30 March 1922. The gross value of the estate was £747 5s. 7d; net value, nil.

4 Reprinted in AGR, 435.

5 Robert Sickert's address was 33 Cromford Road, East Putney. Bernard moved to 17 Queensbury Mews, London, SW7.

6 ML, 153; ALS WS to John Middleton Murry [1922] (Texas).

7 ML, ibid. From the evidence of his letters, Sickert was still staying at the hotel in January 1923.

8 ALS WS to Henry Tonks [1926] (Texas).

9 ML, 153–4, although, as he admits, Marjorie Lilly was not in London at this time. Cf. also Wendy Baron, Miss Ethel Sands and her Circle (1977), 168–9.

10 He was chez Gosse on 21 May 1923 with Max Beerbohm, Maurice Baring, and others. Wendela Boreel married Leslie 'Anzy' Wylde on 16 July 1924.

11 Letters and telegrams from WS to Andrina Schweder 1924–6 (Tate).

12 He was there with Nina Hamnett's friend Mary Butts and others; Sunday Tribune (9 October 1922), quoted in Nathalie Blondel, Mary Butts: Scenes from the Life (1998), 121.

13 Quoted in RE, 129.

14 Anne O. Bell (ed.), The Diary of Virginia Woolf, vol. ii, 223–4.

15 Osbert Sitwell, Noble Essences (1950), p 196; Wendy Baron, Miss Ethel Sands and her Circle, op. cit., 169.

16 Telegram WS to Mary Hutchinson, 17/7/1922 (Texas).

17 Anne O. Bell (ed.), The Diary of Virginia Woolf, vol. ii, 223–4.

18 RE, 310.

19 ML, 155.

20 LB II, 16, recounts how he left a cab by the back door of the Royal Academy while making a call, and then exited by the front door, forgetting it. See also, Violet Overton Fuller, TS 'Letters to Florence Pash' (Islington); Bernard Falk, He Laughed in Fleet Street (1937), 280; Eric Newton, 'As I Knew Him', transcript of BBC radio broadcast 1951 (BBC Archive, Reading).

21 Bernard Falk, Five Years Dead (1938), 345.

22 Wendy Baron, Miss Ethel Sands and her Circle, op. cit., 168–9.

23 Quoted in DS, 207.

24 ALS WS to J. M. Murry [1922] (Texas)

25 WS, 'Degas, "The Sculptor of Movement"', in AGR, 455–6.

26 The Year's Art 1923.

27 Frances Spalding, Duncan Grant (1997), 249.

28 Richard Adeney, TS 'Memoirs' (private collection).

29 Wendy Baron, Miss Ethel Sands and her Circle, op. cit., 168–9.

30 RE, 199.

31 ML, 55.

32 Wendy Baron, Miss Ethel Sands and her Circle, op. cit., 169.

33 Peter Falk (ed.), Record of the Carnegie Institutes International Exhibitions 1896–1996 (Pittsburgh, 1998). WS exhibited every year between 1923 and 1939 (except 1928–30).

34 The Theatre of the Young Artists, done in 1890 and given by Sickert to a 'lady friend' as a wedding present. Stephenson bought the picture and sold it to the Southport Art Gallery for £80.

35 W. H. Stephenson, Walter Sickert: The Man and his Art (1940), 14.

36 Wendy Baron, *Miss Ethel Sands and her Circle*, op. cit., 169.

37 X. M. Boulestein, *Myself, My Two Countries* (1936), 279.

38 Wendy Baron, *Miss Ethel Sands and her Circle*, op. cit., 169.

39 ML, 154.

40 Ibid., 19–21.

41 Wendy Baron, *Miss Ethel Sands and her Circle*, op. cit., 169.

42 Ibid.; ML, 153. Lilly places the East End sojourn before the Tavistock Hotel, but (p. 158) admits to being out of London at the time. Sickert's builder did some work for him on a house in – or off – Petticoat Lane (TS memories of Mr Clegg jnr).

43 TLS D. de Segonzac to Denys Sutton, 16/11/1968 (Sutton GUL). De Segonzac even came away under the impression that Sickert was living at Whitechapel in the house of 'Jack l'Eventreur', although this was almost certainly the result of a confusion between Sickert's current East End address and his past home at Mornington Crescent, where he believed the murderer had lodged.

44 'Live Pictures', *The Scotsman* (13 January 1923).

45 ALS WS to A. Schweder [16/1/1923] (Tate); Simona Pakenham, TS 'Walter Sickert & My Grandmother' (Sutton GUL).

46 ALS WS to A. Schweder, ibid. The artist referred to was William McTaggart (1835–1910), grandfather of another painter, Sir William McTaggart (1903–80).

47 Simona Pakenham, TS 'Walter Sickert & My Grandmother' (Sutton GUL).

48 Ibid.; WS to Andrina Schweder, 16/1/1923 (Tate).

49 Simona Pakenham, TS 'Walter Sickert & My Grandmother' (Sutton GUL).

50 Ibid.

51 *The Scotsman* (13 January 1923) 10.

52 Ibid. (15 January 1923), 8.

53 The lecture was on 17 January 1923; 'Lectures of Interest', *The Spectator* (13 January 1923), 73.

54 Barbara Bagenal, quoted in Peyton Skipwith, 'Walter Sickert by Denys Sutton', *The Connoisseur* (September 1976), 67.

55 Cicely Hey, BBC tapes.

56 Ibid.

57 Her engagement book shows sittings throughout January and February, then tea and theatre dates (Islington).

58 Cicely Hey, BBC tape, op. cit.

59 ALS WS to Cicely Hey [1923] (Islington).

60 Cicely Hey, BBC tape, op. cit.

61 RB, 266–8.

62 Baron/Shone, 280.

63 ALS WS to Cicely Hey (Islington).

64 DS, 209.

65 Cicely Hey, BBC tape, op. cit.

66 ALS WS to Cicely Hey [1923] (Islington).

67 ALS WS to Gwen Ffrangçon Davies [1932] (Tate).

68 ALS WS to Cicely Hey [1923] (Islington).

69 Ibid.

70 This incident appears in two slightly different versions: JEB, *Dieppe* (1927), 110–11, where it is dated 'around 1923'; and JEB, *More Portraits of a Lifetime* (1939), 107–8. RE, 196, places it in 1922, before Sickert's return to England, and DS, 206, follows this dating. The summer of 1923, however, seems more likely.

71 *The Times* (8 August 1932), 12; H. M. Swanwick to DSM, 29/10/1935 (GUL).

72 H. M. Swanwick to DSM, ibid.

73 A. Powell, 'The Servant of Abraham', *Apollo* (March 1972), 226.

74 RE, 241.

75 RE, 242, mistakenly says the Royal Institute; RE, 242–52, gives a precis of one of the talks. The text of his Southport talk, reprinted from the *Southport Visiter*, is given in AGR, 470–9.

76 RE, 242.

77 Ibid.

78 W. H. Stephenson, *Walter Sickert*, op. cit., 14.

79 Henry Rushbury, MS 'Notes on Sickert', 21/5/1967 (Sutton GUL).

80 W. H. Stephenson, *Walter Sickert*, op. cit., 14.
81 Ibid.
82 Ibid., 14–15.
83 George Moore to E. A. Boyd, 17/8/1914, quoted in Joseph Hone, *Life of George Moore* (1936), 320–1; George Moore, *Conversations in Ebury Street* (1924), 134.
84 Quoted in Wendy Baron, *Miss Ethel Sands and her Circle*, op. cit., 106.
85 Osbert Sitwell, *Noble Essences*, op. cit., 181.
86 WS to W. H. Stephenson, in W. H. Stephenson, *Walter Sickert*, op. cit., 19.
87 Reprinted in AGR, 480–98.
88 26 Noel Street is now 54 Noel Road, not 56 as is sometimes stated. Martin Bailey, 'Sickert's "Hanging Gardens"', *British Art Journal*, iii, 2 (2002), 70–1.
89 RE, 214.
90 ALS Nellie McDermott to John Russell, 1/11/1958 (Sutton GUL). ML, 167, describes the rooms as being on the first floor; Cicely Hey, BBC tape, op. cit., refers to them as on the second floor.
91 W. H. Stephenson, *Walter Sickert*, op. cit., 11, gives Sickert's address as 4 Islington Gardens, but no such street exists.
92 ML, 168.
93 W. H. Stephenson, *Walter Sickert*, op. cit., 40.
94 Cicely Hey, BBC tape, op. cit. The picture was *Laylock & Thunderplump*.
95 WS, 'The Old Ladies of Etching-Needle Street', *English Review* (January 1912), in AGR, 288.
96 WS to *The Times* (15 August 1929), in AGR, 591.
97 Cicely Hey, BBC tape, op. cit.
98 Ibid.
99 Amongst the architectural pictures he completed were *The Hanging Gardens of Islington* and *Fading Memories of Sir Walter Scott*.
100 Oliver Brown, BBC tape.
101 W. H. Stephenson, *Walter Sickert*, op. cit., 40; Malcolm Easton, *Sickert in the North* (1968), iii, gives Connard's name.
102 RA Archives.
103 LB I, 15.
104 ML, 32.
105 ALS WS to the Vice-Chancellor of Manchester University, 11/2/1932 (Islington), lists those who encouraged the venture, including the Jackson brothers, 'Bobby Shores, Bobby Butterworth, Forrest Heart and . . . Westmacott's grandson'.
106 Malcolm Easton, *Sickert in the North*, op. cit., vi.
107 Ibid., viii; Eric Newton, 'As I Knew Him: A Personal Portrait of Walter Sickert', transcript of BBC broadcast 1 October 1951 (BBC Archive, Reading).
108 Ibid.
109 Malcolm Easton, *Sickert in the North*, op. cit., x, n. 24.
110 Eric Newton, BBC tape, op. cit.
111 Lucy Wertheim, *Adventures in Art* (1947), 7.
112 DS, 216, dates the incident to 1924. No teaching records for 1924 survive at the RA, but the date does not seem possible since Sickert was not taken on till December 1924. He did teach in June 1925 (RA Archives).
113 DS, 216; ML, 71.
114 DS, ibid.
115 WS, 'Modern French Painting', *Burlington Magazine* (December 1924), in AGR, 501.
116 WS to W. H. Stephenson, in W. H. Stephenson, *Walter Sickert: The Man and his Art*, op. cit., 19.
117 *Morning Post* (23 May 1925), in AGR, 519; RE, 222.
118 WS to Charles Aitken [1924] (GUL).
119 He had added 'Richard' to his listing in the RA minute book (RA Archives).
120 The variations can be most easily traced in the pages of AGR, 512–28. He did also appear as 'Walter Sickert' in two letters to *The Times* on 30 June and 7 July 1925 (AGR, 522–3), but this may have been an editorial error; and there were a few, occasional, reversions to 'W. R. Sickert'.

121 ML, 58. ML mistakenly says that Richard was WS's father's – not his grandfather's – name. On one occasion, as mentioned, Sickert did sign himself 'Dick' in a flirtatious letter to Cicely Hey.

122 RE, 219.

123 His other contributions were *The Poet and his Muse* (*c*.1907) and *The Freckled Boy*.

124 RE, 210.

125 Telegram WS to Mrs W. Marchant, 27/9/1925 (Tate): 'Deeply grieved. He was rare in his discrimination, in honour, generosity and wit. He will remain a proud memory in the heart of all who knew him.'

126 RB, 40. Sickert exhibited at the Independent Gallery (1924), Leicester Galleries (1925), Dover Gallery (1925), and in Goupil Gallery group shows.

127 The gallery is first listed in *The Year's Art 1927*. Sickert inscribed a copy of his print of Roger Fry to Wilson, with a reference to their childhood friendship (private collection).

128 Sickert exhibited at the Savile Gallery in 1926 (February–March, May), 1928 (February), and 1930.

129 Malcolm Easton, *Sickert in the North*, op. cit., x, gives the address as 26 Brown Street.

130 Ibid.; Eric Newton, BBC tape, op. cit.

III HOW OLD DO I LOOK?

1 Osbert Sitwell, *Noble Essences* (1950), 168.

2 ALS WS to Henry Tonks [1926] (Texas),

3 Lucy Wertheim, *Adventures in Art* (1947), 7.

4 LB II, 41.

5 The marriage certificate gives the witnesses as Alice Margaret Pilcher (who seems to have been a relative of the Registrar, A. C. Pilcher) and Eric Charles Ingmire, who remains unknown. Sickert and Thérèse were staying at the Fort Paragon Hotel.

6 Telegram WS to Andrina Schweder, 6/1926 (Tate).

7 William Rothenstein to Max Beerbohm, in Mary M. Lago and Karl Beckson (ed.), *Max and Will* (1975), 126.

8 RE, 211. Their Newbury address was 26 Chesterfield Road: cf. telegram WS to Andrina Schweder, 24/7/1926 (Tate) in which he describes himself as 'too ill to move'. The Brighton address is given in a telegram from WS to James Grieg, 31/3/1927 (NLS).

9 AGR lists no contributions between 7 April and 9 November 1926.

10 DS, 220.

11 RE, 211–12; cat. Annual International Exhibition 1926 Pittsburgh; *The Times* (9 November 1926), in AGR, 548.

12 Arnold Bennett, *Letters to his Nephew* (1936), 174; Newman Flower (ed.), *Journals of Arnold Bennett*, vol. iii: *1921–1928* (1933), 175. Also present was a Mr Cobb.

13 RE, 212. The studio was either in Lewes Crescent or Sussex Square. Harry Preston, *Leaves from my Unwritten Diary* (1936), 331, records Sickert moving into 'a fine studio in Sussex Square' in May 1927.

14 RE, 199; *The Times* (24 November 1942).

15 Osbert Sitwell, *Noble Essences*, op. cit., 205.

16 Quoted in *Late Sickert* (1981), 102.

17 RE, 210; LB II, 41.

18 ML, 107.

19 The street no longer exists.

20 Rupert Hart-Davis, *Hugh Walpole* (1952), 300; Cecil Osborne, 'My Memories of Walter Sickert', *St Pancras Journal*, vol. viii, 10 (1955), 214.

21 TS memories of Mr Clegg jr. (Private collection).

22 On 19/3/1927 WS wrote to Gerald Christy from Southey Villa (Sutton GUL).

23 Harry Preston, *Leaves from my Unwritten Diary*, op. cit., 331–2.

24 Ibid.

25 RE, 212; RA council minutes of 12 April 1927 (RA Archive).

26 Sickert's letter was read out to the council, at the meeting of 18 April 1927 (RA Archive).

27 Mary Soames, *Clementine Churchill* (1979), 333; Mary Soames, *Winston Churchill: His Life as a Painter* (1990), 60-1; ML, 66-7. Lilly mistakenly suggests that the Churchills were living at Hyde Park Gate.

28 Wendy Baron, *Miss Ethel Sands and her Circle* (1977), 184

29 Jan Dalley, *Diana Mosley: A Life* (1999), 51; Mark Pottle (ed.), *Champion Redoubtable: The Diaries and Letters of Violet Bonham-Carter, 1914-1945* (London, 1998), 237.

30 Ibid.; Adrian Daintrey, *I Must Say* (1963), 73.

31 Mary Soames, *Winston Churchill: His Life as a Painter*, op. cit., 65.

32 Richard Shone, *From Beardsley to Beaverbrook* (1990), 36. Although based on a photograph, Sickert also drew studies for the portrait.

33 Flyer quoted in RE, 253.

34 Ibid.

35 Richard Shone, op. cit., 38; ML, 73.

36 He became 4th Baron Methuen in 1932, on the death of his father.

37 RE, 254.

38 Ibid.

39 Quoted in Shone, *From Beardsley to Beaverbrook*, op. cit., 36.

40 Ibid. Lord Ivor was the younger son of Winston's first cousin, the 9th Duke of Marlborough.

41 Mary Soames, *Clementine Churchill*, op. cit., 714.

42 Richard Shone, *From Beardsley to Beaverbrook*, op. cit., 36. By 1931 the painting was in the possession of the Hon. Baillie Hamilton, MP for Bath.

43 RSBA Committee Meeting minutes (V&A).

44 ML, 168; DS, 222. According to the RSBA archives, the original list of names put forward at the committee meeting on 2 November 1927 was: Melton Fisher, Jack, Kelly, de Làszlo, Lavery, William Llewellyn, Philpot, Ricketts, and Shannon. After a discussion at a general meeting on 5 December 1927, the three leading contenders emerged as Jack, de Làszlo, and Philpot. It was even decided to approach Jack and offer him the presidency. This, however, does not seem to have happened (RSBA Archive/V&A).

45 ML, 168. Curiously, Lilly misdates the incident by seven years to 1934.

46 ALS WS to [RSBA Secretary] (RSBA Archive/V&A).

47 RSBA Archive (V&A).

48 ML, 168. Lilly, who was not a member of the RSBA, and who seems to have been relying on a slightly hostile witness for her account, says Sickert failed to attend his first meeting; the RSBA minutes seem to refute this. They mention that he turned up late to the first meeting on 2 April 1928 and did not attend the next meeting on 7 May, but otherwise his early attendance record was good.

49 H. Furst, *Apollo* 7 [1928], 240.

50 Quoted in DS, 222-3.

51 'General Meeting Minutes' (RSBA Archive/V&A).

52 Quoted in DS, 223.

53 cALS Thérèse Lessore to Keith Baynes, 28/3/1928 (Sutton GUL).

54 *Apollo* 7 [1928], 290.

55 ALS WS to Mrs Hulton [13/11/1928], [2/1/1929] (Oxford).

56 JEB, *Mes Modèles* [1929, Paris], 246.

57 ALS WS to Mrs Hulton [2/1/1929] (Oxford).

58 ML, 168.

59 Baron/Shone, 302. Walpole's celebrated Herries trilogy was not written until the 1930s.

60 Rupert Hart-Davis, *Hugh Walpole*, op. cit., 271.

61 Telegram WS to R. E. A. Wilson, 8/9/1928 (Texas).

62 Rupert Hart-Davis, *Hugh Walpole*, op. cit., 299.

63 Ibid., 300.

64 Ibid.

65 Ibid., 310.

66 In 1929 the Leicester Galleries paid £400 for *Au Café Concert* and Arthur Tooth bought *The Waiting Room* for £160. The following year, Colnaghi

bought *Little Dot Hetherington* for
£520.
67 ALS WS to Mrs Hulton [13/11/
1928] (Oxford).
68 Osbert Sitwell, *Noble Essences*,
op. cit., 205.
69 RE, 202.
70 ALS WS to Elizabeth Angus [1928]
(Tate). There was perhaps an irony
in Sickert's choice of scene, which,
according to Playfair's autobiography,
was played out, in the Lyric
production, in total darkness.
71 Wendy Baron, *Miss Ethel Sands and
her Circle*, op. cit., 89.
72 JEB, *More Portraits of a Lifetime*
(1939), 119, and *La Pêche aux
Souvenirs* (1941), 413.
73 Osbert Sitwell, *Noble Essences*,
op. cit., 198.
74 Cutting from *Morning Post* [?]
(6 November 1928).
75 *The Times* (6 November 1929).
76 Jenny Pery, *The Affectionate Eye*
(1995), 36.
77 Ibid.; Adrian Daintrey, *I Must Say*,
op. cit., 71–2; Cecil Osborne, 'My
Memories of Walter Sickert', op. cit.,
184.
78 RSBA Committee Meeting minutes,
25 October 1929 (V&A); *Apollo* 9
[1929], 68; WS to the *Morning Post*
(6 November 1929), in AGR, 569.
79 June 1929, RA minutes (RA).
80 Cecil Osborne, 'My Memories of
Walter Sickert', op. cit., 184–6.
81 Contact was probably re-established
via the Churchills, who visited the
Hultons in Venice in 1927.
82 Lady Berwick's MS notes to ALS WS
to Mrs Hulton [2/1/1929] (Oxford).
83 Amongst the works Sickert showed
with the RSBA in 1928 was a picture
that – as he told Elizabeth Angus –
he had given to the Envermeu
baker's daughter and since retrieved.
ALS WS to Elizabeth Angus [1928]
(Tate).
84 A telegram from WS to Mrs Hulton,
announcing that he has sent a
cheque for £40, is amongst the
Hulton papers at Oxford, but it is
dated 28/1/1930 and appears to
relate to another arrangement.

85 ALS WS to Mrs Hulton [15/5/1929]
(Oxford). The picture was bought
by Robert Emmons, though for
what price is not known. Perhaps to
advertise the work, Sickert exhibited
a drawing of Rossi at the RSBA's
summer sketch show.
86 *Late Sickert*, 92.
87 RE, 212. Emmons suggests that the
figure was delivered to Noel Street,
though Sutton says Highbury Place
– where the picture was certainly
painted. Sickert was struck by the
sight of the figure being carried up
a flight of steps, which does not
exclude Highbury Place: there is a
short flight of steps in the main hall,
up to the level of Sickert's studio.
88 Cecil Osborne, 'My Memories of
Walter Sickert', 184–6, op. cit.;
Baron/Shone, 294; DS, 232.
89 RE, 212.
90 Herbert Furst, *Apollo*, 10 [1929],
60–1.
91 ML, 169. The RSBA minutes show
that he missed the meetings on
17 April and 8 May, though on the
latter occasion he sent a telegram of
apology (RSBA Archive V&A).
92 RSBA minutes, 19 June 1929; DS,
224.
93 Quoted in DS, 225.
94 Ibid., 226.
95 The proposal was carried at the
meeting on 3 July 1929; RSBA
minutes (RSBA Archive V&A).
96 RSBA minutes (V&A); ALS WS to
Cyril Roberts, 9/12/1929 (RSBA
Archive/V&A).
97 DS, 226.
98 *The Times* (6 November 1929); *The
Year's Art 1930*, 85.
99 Cecil Osborne, 'My Memories of
Walter Sickert', op. cit., 186–7.
Osborne misdates the exhibition to
December 1930.
100 WS painted a portrait of Thérèse
Lessore in around 1926 and titled it
Venezia, but there is no evidence
that it was painted there.
101 Sickert, back in London, sent a
telegram to Mrs Hulton on 20/3/
1930 thanking her for the safe
arrival of some package (Oxford).

102 Witt Library 2326; the picture, a pastel, is dated ''29'.
103 cTL Michael Sadler to James Graham, 3/1/1930 (Oxford).
104 Ibid. Sadler was Vice-Chancellor of Leeds University from 1911 to 1923.
105 Telegram WS to Gioconda Hulton, 28/1/1930 (Oxford).
106 cTLS James Graham to Michael Sadler, 7/3/1930 (Oxford).
107 Cecil Osborne, 'My Memories of Walter Sickert', op. cit., 197.
108 Ibid., 213–14. Osborne misdates the incident to 1931.
109 ALS JEB to William Rothenstein, 26/8/1931 (Harvard). Sickert sent a telegram to Mrs Hulton on 20/3/1930 from Dieppe (Oxford). Mme Villain died on 5 April 1930. The funeral was on 8 April: Vigie de Dieppe (11 April 1930), 3. She was buried in the 'Famille Villain' plot in the Neuville cemetery; her headstone carries her maiden name, adding 'épouse Morin'.
110 The Times (19 February 1930), 12.
111 Wendy Baron, Miss Ethel Sands and her Circle, op. cit., 184; Regina Marler (ed.), Selected Letters of Vanessa Bell (1993), 364; Richard Shone, 'Duncan Grant on a Sickert Lecture', Burlington Magazine 123 [1981], 671.
112 Edward Marsh, A Number of People (1939), 364; Apollo 11 [1930], 295–300; Osbert Sitwell, Noble Essences, op. cit., 206.
113 Henry Rushbury, MS 'Notes on Sickert' (Sutton GUL).
114 Baron/Shone, 300.

Chapter Nine: Lazarus Raised

I OVER THE FOOTLIGHTS

1 RE, 264; Alfred Thornton, 'Walter Richard Sickert', Artwork, vi (1930), 13.
2 Daily Mail (14 November 1930); W. H. Stephenson, Sickert: The Man and his Art (1940), 8.
3 Brussels: Palais des Beaux-Arts, 'Modern English Art', 1929; New York: Agnew's show of

'Contemporary British Artists', 1929; Tokyo: 'British Artists Exhibition', 1931.
4 The Times (15 March 1930).
5 RE, 224.
6 Joseph Hone, The Life of Henry Tonks (1939), 217.
7 The exhibitions took place in 1927.
8 DS, 236; Baron/Shone, 51. The dates of the show were 15 November to 3 December 1930.
9 Cecil Osborne, 'My Memories of Walter Sickert', St Pancras Journal, viii, 11 (1955), 214.
10 Catalogue '2nd Exhibition of Paintings by the East London Group' (December 1930).
11 Baron/Shone, 300. In 1928/9, Sickert made an etching of Duncan Macdonald, the Lefevre director.
12 RE, 222.
13 ALS Reginald May to Denys Sutton, 6/5/1968 (Sutton GUL); Quentin Bell, 'Some Memories of Sickert', Burlington Magazine, cxxix (1987), 229.
14 Telegram WS to Hugh Walpole, 2/10/1931 (Texas).
15 Henry Rushbury, MS 'Notes on Sickert', 21/5/1967 (Sutton GUL), records Sickert's line, 'Pentonville, and don't spare the petrol'; RE, 224.
16 ALS WS to Gwen Ffrangçon-Davies [1932] (Tate). Sickert's numerous (undated) letters to Miss Ffrangçon-Davies have recently been acquired by the Tate. They await cataloguing.
17 ALS WS to Gwen Ffrangçon-Davies [1932] (Tate).
18 RE, 165.
19 Telegram WS to Gwen Ffrangçon-Davies, 6/4/1932 (Tate).
20 ALS WS to Gwen Ffrangçon-Davies [4/1932] (Tate). Marda Vanne had played Phaedra in the Phoenix Society's production of Dryden's Amphitryon in May 1922.
21 Letters from WS to Gwen Ffrangçon-Davies [1932] (Tate).
22 Ibid.
23 Gwen Ffrangçon-Davies, BBC tape.
24 Letters from WS to Gwen Ffrangçon-Davies [1932] (Tate).

25 Ibid.
26 Ibid. Henry Lessore says that Sickert used a bookcase to block the window.
27 Letters from WS to Gwen Ffrangçon-Davies [1932] (Tate).
28 Ibid.
29 Ibid.
30 Ibid.
31 Ibid.
32 Ibid.
33 Baron/Shone, 314.
34 Bernard Falk, He Laughed in Fleet Street (1937), 281.
35 The Connoisseur, 90 (1932), 274, described it as 'a fascinating work . . . almost completely satisfactory'.
36 Quoted in Baron/Shone, 312.
37 WB, 386.
38 ALS WS to Gwen Ffrangçon-Davies [1932] (Tate); Baron/Shone, 312.
39 Baron/Shone, ibid.
40 Quoted in RE, 213.
41 Richard Findlater, Lilian Baylis: The Lady of the Old Vic (1975), 253.
42 John Gielgud was originally scheduled to do the reading but his place was taken by Tony Butts, the brother of Sickert's friend Mary Butts. Letters from WS to Gwen Ffrangçon-Davies [1932] (Tate).
43 RE, 215.
44 The Year's Art 1932, 'Auction Sales'.
45 ALS WS to Gwen Ffrangçon-Davies [1932] (Tate).
46 Gwen Ffrangçon-Davies, interviews, op. cit.
47 ALS WS to Gwen Ffrangçon-Davies [1932] (Tate).
48 Ibid.
49 Ibid.
50 Ibid.; Oliver Brown and Peggy Ashcroft, BBC tape.
51 ALS WS to Gwen Ffrangçon-Davies [1932] (Tate).
52 Anne O. Bell (ed.), The Diary of Virginia Woolf, vol. iv, 193-4.
53 Peggy Ashcroft BBC tape, op. cit.
54 ALS WS to Gwen Ffrangçon-Davies [1932] (Tate). The photographer was the 'superb Woodbine'.
55 Information from Richard Brooks, who interviewed Ashcroft for the Sunday Times.
56 Peggy Ashcroft, BBC Tape, op. cit.
57 WS to JEB, 5/3/1935, in JEB, More Portraits of a Lifetime (1939), 118.
58 Alec Martin, BBC tape; WS, 'Old Masters and New', Morning Post (12 July 1927), in AGR, 558.
59 Letters from WS to Mrs Hulton (Oxford).
60 Anne O. Bell (ed.), The Diary of Virginia Woolf, op. cit., 193-4.
61 Lord Beaverbrook, Courage: The Story of James Dunn (London, 1961), 238-9; Baron/Shone, 320.
62 ALS WS to Virginia Woolf (NYPL).
63 Wendy Baron, Miss Ethel Sands and her Circle (1977), 218.
64 ALS WS to Virginia Woolf (NYPL); Anne O. Bell (ed.), The Diary of Virginia Woolf, op. cit., 193-4.
65 Nigel Nicolson and Joanne Trautmann (eds), The Letters of Virginia Woolf, vol. v, 282, 343.
66 Sickert had begun to be put forward for election to vacant RA positions as they fell due from 10 November 1931. He was unsuccessful in eight contests until he was elected on 6 March 1934, beating S. Jagger by 27 votes to 8 (RA minutes).
67 Alec Martin circular letter, 14/5/1934 (Tate).
68 ALS Henry Tonks to DSM, 5/4/1934 (GUL).
69 ALS JEB to William Rothenstein, 26/6/1934 (Harvard).
70 ALS William Rothenstein to JEB, 21/6/34 (Institut).
71 LB II, 46; Oliver Brown, Exhibition (1968).
72 Alec Martin was to administer the fund, with the help of Sylvia Gosse, Kelly, and John Copper (WS Civil List Pension file, PRO).
73 John Russell typed note, recording information from Alec Martin (Sutton GUL).
74 WS Civil List Pension file (PRO).
75 John Russell, typed note, recording information from Alec Martin (Sutton GUL).
76 cTLS Alec Martin to WS (Sutton GUL); WS Civil List Pension file (PRO).

77 WS to JEB, 5/3/1935, in JEB, *More Portraits of a Lifetime*, op. cit., 118.
78 cTLS WS to Alec Martin (Sutton GUL).

II HOME LIFE

1 RE, 278. Alec Martin, BBC tape, recollections 1960, gives the wrong date.
2 John Lovely, TS 'The Bohemian Bun' (Broadstairs Public Library).
3 Transcripts of the lectures are at Margate Library; they are reprinted in AGR, 632–71.
4 WS lecture, 'Black and White Illustration', 30 November 1934, in AGR, 669.
5 Letters from WS to JEB, quoted in JEB, *More Portraits of a Lifetime* (1939), 117–18.
6 *Sunday Dispatch* (23 January 1938), cuttings book (Islington).
7 Valerie Martin, TS 'Sickert at St Peter's' (Broadstairs Public Library), though RE, 278, records the studio as having a small window and a big light.
8 Valerie Martin, ibid.
9 WS lecture, 'Engraving, Etching, etc.', 23 November 1934, in AGR, 663.
10 Rosemary Gwynne-Jones, MS notes [1967] (Sutton GUL); Basil Jonzen, 'A Visit to Mr Sickert at Broadstairs', *Horizon*, 45 (1943), 194–203; JEB, *More Portraits of a Lifetime*, op. cit., 117–18.
11 Basil Jonzen, 'A Visit to Mr Sickert at Broadstairs', op. cit., 201.
12 *Sunday Dispatch* (23 January 1938); cuttings book (Islington).
13 *The Studio* [January 1938]; cuttings book (Islington).
14 The cap was variously described as being a chauffeur's, a pilot's, and a fisherman's cap.
15 Richard Lewis, 'Walter Sickert at St Peter's', *Kent Life* (5 March 1992), 34–5.
16 TLS Sir Edward Heath to Matthew Sturgis, 20/4/2001.
17 Valerie Martin, TS 'Sickert at St Peter's' (Broadstairs Public Library).

18 Information from John Barnes (son of Mrs Garlick Barnes).
19 Information from Alan Irvine, and Edward Booth Clibborn.
20 John Lovely, TS, 'The Bohemian Bun' (Broadstairs Public Library).
21 JEB, *More Portraits of a Lifetime*, op. cit., 118; RE, 278.
22 Information from John Barnes; Sickert made a portrait of Mrs Tyrell.
23 Ibid.
24 Information from Donald Ball.
25 Denton Welch, 'Sickert at St Peter's', *Horizon*, 32 (August 1942).
26 Oliver Brown, BBC tape.
27 Richard Shone, *From Beardsley to Beaverbrook* (1990), 7.
28 Lord Beaverbrook, *Courage: The Story of Sir James Dunn* (1962), 239.
29 ALS WS to Lord Beaverbrook (House of Lords).
30 Letters from WS to Lord Beaverbrook (House of Lords).
31 Quoted in TLS Humphrey Browne to John Russell, 9/10/1958 (Sutton GUL).
32 Ibid.
33 Ibid.
34 ALS WS to Lord Beaverbrook (House of Lords).
35 Ibid. As Sickert boasted to a group of Brighton art students, when he went to open an exhibition of their work soon afterwards: 'One hears that nobody has any money today. Nonsense – a man I had to sack the other day for being rude was a millionaire.' *Sunday Dispatch* (23 June 1935); cuttings book (Islington).
36 *Daily Telegraph* (11 May 1935), in AGR, 677–8.
37 *Daily Telegraph* (21 May 1935), in AGR, 678.
38 Alec Martin, BBC tape.
39 Information from Alan Irvine.
40 The Leicester Galleries held shows of Sickert's work in 1929, 1931, 1934, 1936, 1938, 1940, and 1942; the Beaux Arts Gallery held shows in 1932, 1933, 1935, 1937, and 1939.
41 Alec Martin, taped recollections.
42 Richard Shone, *From Beardsley to Beaverbrook*, op. cit., 7. Old friends

he painted included Alan Swinton, Wendela Wylde, and Marie Tempest. Vanessa Bell and Duncan Grant visited Sickert in the autumn of 1936.

43 Valerie Martin, TS 'Sickert at St Peter's' (Broadstairs Public Library); Denton Welch, 'Sickert at St Peter's', op. cit.

44 Information from Alan Irvine.

45 *Late Sickert*, 97.

46 *Daily Telegraph* (1 April 1936), cuttings book (Islington).

47 Richard Shone, *From Beardsley to Beaverbrook*, op. cit., 42; Rebecca Daniels, 'Press Art: The Late Oeuvre of Walter Richard Sickert', *Apollo* (October 2002), 30–5.

48 *Sunday Dispatch* (23 January 1938), cuttings book (Islington).

49 Press cutting (Broadstairs Public Library); JEB, *More Portraits of a Lifetime*, op. cit., 118.

50 Cf. cuttings book (Islington); cutting (Broadstairs Public Library).

51 ALS Sylvia Gosse to John Russell, 12/10/1958 (Sutton GUL).

52 Henry Tonks to DSM, 29/5/1935 (GUL).

53 Anne O. Bell (ed.), *The Diary of Virigina Woolf*, vol. v, 9. LB II, 40, says that he was elected president of the London Group in 1926, but I have been unable to confirm this.

54 Rosemary Gwynne Jones, MS notes [1967] (Sutton GUL).

55 ALS WS to Edward Marsh [28/4/1936] (NYPL); Lord Beaverbrook, *Courage: the Story of Sir James Dunn*, op. cit., 240. Denton Welch, 'Sickert at St Peter's', op. cit., erroneously suggests that the accident happened on the way to the party.

56 ALS WS to Edward Marsh [28/4/1936] (NYPL).

57 Valerie Martin, TS 'Sickert at St Peter's' (Broadstairs Public Library); TLS Sir Edward Heath to Matthew Sturgis, 20/4/2001.

58 ALS WS to Edward Marsh [28/4/1936] (NYPL).

59 For example, William Rothenstein to Max Beerbohm, 31/12/1932, in Mary

M. Lago and Karl Beckson (ed.), *Max & Will* (1975), 146.

60 Photograph in AGR, [ii].

61 *The Times* (18 June 1937).

62 ALS JEB to William Rothenstein, 18/4/1938 (Harvard).

63 LB II, 47.

64 RE, 287.

65 Handbill from Galleria Nazionale d'Arte Moderna, Rome.

66 *Daily Telegraph* (10 April 1937), cuttings book (Islington).

67 *Sunday Dispatch* (23 January 1938), cuttings book (Islington).

68 ALS Thérèse Lessore to William Rothenstein, 13/2/1942 (Harvard).

69 Wyndham Lewis, *The Roaring Queen* (1973 edn), 114. The character of 'Richard Dritter' was based on Sickert.

70 A selection of Sickert's books is at the Courtauld Institute Library.

71 Together with a view of St Jacques, and works by his father and grandfather, he sent a portrait-echo of Pauline Tallyrand-Perigord, Marquise de Castellane, completed, according to the local paper, on 'the very day it was hung'. Thérèse Lessore also exhibited.

72 Rosemary Gwynne Jones, MS notes [1967] (Sutton GUL).

73 cTLS J. Walters to John Woodeson, 5/10/1973 (Margate Public Library).

74 Ivy Saffery [*née* Parker], MS 'How I Remember the Late Walter Sickert', 14/2/2000 (Broadstairs Public Library).

75 Osbert Sitwell, *Noble Essences* (1950), 204.

76 *Cavalcade* (15 January 1938), cuttings book (Islington); Baron/Shone, 53.

77 ALS Thérèse Lessore to William Rothenstein, 17/2/1937 (Harvard).

78 *Cavalcade* (1 January 1938), cuttings book (Islington).

79 cTLS Arnold Palmer to John O'Connor, Jr, 4/4/1938 (Pittsburgh).

80 Quentin Bell, 'Some Memories of Sickert', *Burlington Magazine* (April 1987), 231.

81 Frances Spalding, *Vanessa Bell* (1983), 302.

82 Richard Shone, 'Duncan Grant on a

Sickert Lecture', *Burlington Magazine*
(December 1981), 671.
83 Ibid.
84 Basil Jonzen, 'A Visit to Mr Sickert at
Broadstairs', op. cit., 199; Jenny Pery,
The Affectionate Eye (1995), 91.
85 cLetters from Thérèse Lessore to
Keith Baynes, 22/9/1938 and 2/11/
1938 (Sutton GUL).

III BATHAMPTON

1 cALS Thérèse Lessore to Keith
Baynes, 27/12/1938 (Sutton GUL).
2 Ibid.; cALS Thérèse Lessore to Maud
Mockett, 4/1/1939 (Broadstairs
Public Library); Ivy Saffery [née
Parker], MS 'How I Remember the
Late Walter Sickert', 14/2/2000
(Broadstairs).
3 Rosemary Ellis, TS 'Journal, 1940–
1942' (private collection); Cecil
Beaton, *The Years Between: Diaries
1939–44* (1965), 45–9.
4 Ibid.
5 Rosemary Ellis, TS 'Journal 1940–
1942' (private collection).
6 Clifford Ellis, BBC tape.
7 ML, 171.
8 Quoted in the *Bath Chronicle* (8 June
1954).
9 The winner was 'a young man who
went as a jester': Ted Dolman's
reminiscences in *Famous Connections*
(pamphlet at St Nicholas,
Bathampton).
10 Mendum's shop was in Westgate
Buildings. Often on his
peregrinations around the town
visiting second-hand bookshops, and
looking at views, Sickert would visit
the studio of Stephen Kapp at 11a
Broad Street. On one occasion he
presented him with his 'gorgeous
Stetson'; ALS Stephen Kapp to
John Russell, 3/4/1959 (Sutton
GUL).
11 cALS Thérèse Lessore to Keith
Baynes, 18/9/1940 (Sutton GUL);
ALS Anna Bazell (née McEvoy) to
Denys Sutton, 28/5/1968 (Sutton
GUL).
12 *Bath Chronicle* (31 January 1942).
13 Michael Parkin, *Walter Sickert: The*

*Artist, his Wife, his Mistress, his Friends
& One Enemy* (1992), 10.
14 Clifford Ellis, taped recollections,
op. cit.
15 Miss K. M. Fryer, TS 'Memories of
Walter Sickert' (Sutton GUL).
16 Clifford Ellis, taped recollections,
op. cit.
17 K. M. Fryer, TS 'Memories of Walter
Sickert' (Sutton GUL).
18 Clifford Ellis, taped recollections,
op. cit.
19 Clifford Ellis, quoted in the *Bath
Chronicle* (31 January 1942).
20 Ibid.; *Bath Chronicle* (24 June 1939
and 24 January 1942).
21 Rosemary Ellis, 'Journal, 1940–
1942', (private collection); Richard
Shone, *From Beardsley to Beaverbrook*
(1990), 46.
22 Clifford Ellis, op. cit., recalls how his
daughter, aged three, said something
to Sickert; he didn't reply, until she
demanded, ' "Mr Sickert you heard
me." He then answered quite
normally.'
23 William Rothenstein to Max
Beerbohm [7/1939], in Mary M.
Lago and Karl Beckson (eds), *Max
and Will* (1975), 152.
24 He had much to look back over –
possessing, as Rothenstein remarked,
'the richest memories of the 19th
Century painters' (William
Rothenstein to Wyndham Lewis, in
Mary M. Lago and Karl Beckson
(eds), *Max and Will*, op. cit., 152 n.).
To Adrian Allanson, another visitor,
he discoursed upon Degas, Monet,
and Whistler, as well as Wilde (DS,
246).
25 Basil Jonzen, 'A Visit to Mr Sickert
at Broadstairs', *Horizon* 45 (1943),
199.
26 William Rothenstein to W. Lewis, in
Mary M. Lago and Karl Beckson
(eds), *Max and Will*, op. cit., 152n.
27 Ibid.
28 ALS Audrey Denison to John Russell,
8/5/1968 (Sutton GUL). There is no
Sickert material in the Davenport
papers.
29 Stephenson's book was published in
1940.

30 R. Emmons to DSM, 21/3/[1942] (GUL).
31 Sickert's copy of the book is in the Courtauld Institute Library.
32 ALS Thérèse Lessore to William Rothenstein, 13/2/[1942] (Harvard).
33 Kathleen Turner, quoted in the *Bath Chronicle* (5 March 1974).
34 Sickert Civil List Pension file (PRO).
35 Ibid.
36 Ibid.
37 Sickert received nothing (or nothing extra) from his exhibition at the Leicester Galleries the following month. The fifteen pictures on show – a selection of 'Echoes' and landscapes – had all been bought outright by Brown in advance. The only hope was that more might follow. Though sparsely painted, the pictures remained vital, distinct, and even novel. One critic characterized the show as 'Richard – with youthful courage contradicting his own earlier – Walter – self, and making pictures with an absolute minimum of pigments as well as of colours, and painting in the highest possible – against his former practice of almost the lowest possible – tone.' *Apollo* (May 1940), 143. Sickert did not travel up to London for the show.
38 Clifford Ellis, op. cit.; *Bath Chronicle* (31 January 1942).
39 Rosemary Ellis, TS 'Journal 1940–1942' (private collection).
40 Cecil Beaton, *The Years Between*, op. cit., 47–8.
41 ML, 171.
42 Michael Macleod, *Thomas Hennell: Countryman, Artist and Writer* (1988), 220.
43 Cecil Beaton, *The Years Between*, op. cit.
44 Clifford Ellis, op. cit.
45 Cecil Beaton, *The Years Between*, op. cit.
46 ML, 170–1.
47 Sickert Civil List Pension file (PRO).
48 Ibid.
49 Rosemary Ellis, TS 'Journal 1940–1942' (private collection).
50 cALS Thérèse Lessore to Keith Baynes, 14/6/1941 (Sutton GUL).
51 ML, 170.
52 TS note, John M. Gwynne Hughes (Sutton GUL).
53 Rosemary Ellis, TS 'Journal 1940–1942' (private collection).
54 Ibid.
55 ML, 171; RE, 290.
56 ML, ibid.
57 Sickert Civil List Pension file (PRO).
58 *W. R. Sickert Drawings and Paintings 1890–1942*, Tate Gallery Liverpool (1989), 46.
59 ML, 170.
60 'Ariel in Wartime' (BBC broadcast, 5 September 1941).
61 T. W. Earp, press-cutting [1941] at the Bath Public Library.
62 ML, 172.
63 Michael Macleod, *Thomas Hennell*, op. cit., 220. Sickert's death certificate lists heart disease and kidney failure (uremia), due to recurrent urinary infections (chronic nephritis), as the causes of death.
64 ML, 173; TLS Clifford Ellis to John Read, 1/10/1953 (BBC Archive, Reading).
65 *Bath Chronicle* (31 January 1942). The other mourners listed were: Alderman R. G. Cunningham, Mrs Finnigan, Mrs Payne, Mr Paul Bird, Mr Eric Eades, Mr J. Meade, and Mr Ernest Ashman.
66 Ibid.
67 *The Times* (24 January 1942) praised him as 'a great professional'; *The Studio* (May 1942), 133–5; *Burlington Magazine* (March 1942).
68 Sickert's copy of the book is in the Courtauld Institute Library. The annotation is in vol. iii, 88.
69 Probate was granted on 4 May 1942.
70 St Nicholas, Bathampton, pamphlet: 'Famous Connections: Walter Sickert'. The stone was later replaced. Thérèse Lessore survived Sickert by only a few years. She died in 1945 and was buried beside him. She enjoyed a brief revival of her artistic powers after Sickert's death. Osbert Sitwell, in a catalogue note for her memorial exhibition at the Leicester

Galleries in 1946, described her late paintings as her best.

71 Memorial service programme (Tate). The other hymns were 'Praise my soul the king of Heaven', and 'God that madest earth and heaven/ Darkness and light . . .'.

IV CHEERIO

1 Martin Gayford, 'What a fuss', *The Spectator* (4 December 1999), 59.
2 Wendy Baron, 'The Legacy of Sickert', in *From Life*, James Hyman Fine Art catalogue (London, 2003).
3 Robert Hughes, 'English Art in the Twentieth Century', in *Nothing If Not Critical* (1990), 178.

Postscript

WALTER SICKERT: CASE CLOSED

1 Information from Henry Lessore, son of Helen Lessore.
2 MacCormick, a notoriously unreliable source, was unable to recall where this information had come from when quizzed.
3 Correspondence relating to the programme is in the BBC archive at Reading. The Scotland Yard PR officer who put Bonner on to Sickert was called G. D. Gregory. A memo from Bonner (17 May 1973) describes how he had originally been told of the Joseph Sickert 'story' by a Martin Conlon, who then wanted too much money for a full account. So instead he had used Fred Hill, who 'supplied us with the basic Ripper story as told to him some time ago by [Joseph] Sickert'. For this he was paid £75, with the promise of a further £250/£300 if he could provide 'documentary proof of the central facts of the story' and arrange for Joseph to be interviewed.

4 The details of Joseph Sickert/Stephen Knight's story were first – and most comprehensively – exploded by Simon Wood in an article in *Bloodhound* (March 1987).
5 Colin Wilson, 'A Lifetime of Ripperology', in Maxina Jakubowski and Nathan Braund (eds), *The Mammoth Book of Jack the Ripper* (1999), 428.
6 Violet Overton Fuller, TS 'Letters of Walter Sickert to Florence Pash', 1 (Islington).
7 Paul Begg, Martin Fido, and Keith Fisher, *The Jack the Ripper A–Z* (1996 edn), 411.
8 Patricia Cornwell, *Portrait of a Killer* (2003 edn), 14.
9 WS to JEB [23/7/1899] (Institut).
10 Michael Parkin, *Walter Sickert: The Artist, his Wife, his Mistress, his Friends and One Enemy* (1993), 17.
11 Ibid.
12 cALS WS to JEB [1903/4] (Sutton GUL).
13 WS dated drawings at Walker Art Gallery, Liverpool, and at Leeds City Art Gallery.
14 Daniel Halévy, *My Friend Degas* (1966), 32.
15 cALS Mrs Sickert to Mrs Muller, 6/9/1888 (Tate).
16 ALS WS to JEB (Institut).
17 ALS JEB to Dr Blanche, 18/9/1888 (Institut).
18 Patricia Cornwell, *Portrait of a Killer*, op. cit., 259. It should also be noted that on the day the letter was written Sickert was lunching at St Valéry with Blanche.
19 Patricia Cornwell, *Portrait of a Killer*, op. cit., 210, 213.
20 Stephen P. Ryder, review of Cornwell's book on the leading Ripperology website, www.casebook.org.
21 ALS Wendy Baron to Matthew Sturgis, 19/8/2004.

INDEX